Atlas *of* WORLD ART

Edited by
John Onians

OXFORD
UNIVERSITY PRESS

2004

OXFORD
UNIVERSITY PRESS

Oxford New York
Auckland Bangkok Buenos Aires Cape Town Chennai
Dar es Salaam Delhi Hong Kong Istanbul Karachi Kolkata
Kuala Lumpur Madrid Melbourne Mexico City Mumbai
Nairobi São Paulo Shanghai Taipei Tokyo Toronto

This book was designed and produced
by Laurence King Publishing

Published by Oxford University Press, Inc.
198 Madison Avenue, New York, New York, 10016
http://www.oup.com

Library of Congress Cataloging-in-Publication Data

Oxford University Press.
Atlas of world art / edited by John Onians.
p. cm.
Includes bibliographical references and index.
ISBN 0-19-521583-4 (hdb)
1. Art–History–Maps. I. Onians, John, 1942. II. Title.
G1046.E1 O9 2004
702.2'3–dc22
2003055029 2003070225

Printing number: 9 8 7 6 5 4 3 2 1

Printed in the United States of America
on acid-free paper

Managing Editor: Stuart McCready

Cartographic Editor: Ailsa Heritage

Cartography: Advanced Illustration Ltd, Congleton, Cheshire, UK

Copyeditor: Liz Wyse

Designer: Philip Lord

Picture Researcher: Mary-Jane Gibson

Place Name Consultant: Pat Geelan

Cover Design: Pentagram

Printed in Singapore

Contributors

JOHN ONIANS
Director of the World Art Research Programme at the University of East Anglia. He has published widely on topics ranging from the origins of art to twentieth-century Chinese painting. A recent research interest is the biological basis of artistic activity.

Naman Ahuja
Research Fellow at the Ashmolean Museum, Oxford. He specializes in the art of India, with particular interest in ancient sculpture and early medieval painting.

Daud Ali
Lecturer in early Indian History at the School of Oriental and African Studies, London. His recent research has been on medieval Indian polity and the growth and spread of courtly culture.

Anne d'Alleva
Associate Professor of Art History and Women's Studies at the University of Connecticut. Her publications include Art of the Pacific Islands (1998) and Look! An Introduction to Art History and Its Methods (2003).

Paul Bahn
Writer, editor and translator of books on archaeology. His main research interest is prehistoric art, especially rock art of the world, and most notably Palaeolithic art.

Norman Bancroft-Hunt
Lecturer in design and visual theory at the Kent Institute of Art and Design and at Croydon Art College. He has published 15 books on the arts of the Americas, including the award-winning People of the Totem (1979).

Tim Barringer
Associate Professor of History of Art at Yale University. He has written widely on British art and is the author of Reading the Pre-Raphaelites (1999) and Men at Work: Art and Labour in Victorian Britain (2004).

Jane Beckett
Professor of Contemporary British Art at New York University, London. She has published extensively on modernism in Europe and Britain as well as on contemporary art.

John Bennet
Professor of Aegean Archaeology in the University of Sheffield. He has published on the archaeology of the Minoan and Mycenaean cultures, and on Linear B writing.

Elisabeth de Bièvre
Reasearcher in Netherlandish art. She has taught at the University of East Anglia and elsewhere, and published in journals in Britain and the Netherlands. She is preparing The Urban Sub-Conscious. Ecology and Art in the Netherlands, 1200-1700 for publication.

Sheila Blair
Joint Norma Jean Calderwood Professor of Islamic and Asian Art at Boston College and co-author with Jonathan Bloom of The Art and Architecture of Islam: 1250-1800 (1994), Islamic Arts (1997), and Islam: A Thousand Years of Faith and Power (2000). She is the author of ten books and hundreds of articles on Islamic art and architecture.

Jeffrey Blomster
Researcher in ancient New World art. He has conducted excavations throughout North and Central America, focusing on the emergence of complex societies and interregional interaction. He has taught at both Muhlenberg College and Brandeis University.

Jonathan Bloom
Joint Norma Jean Calderwood Professor of Islamic and Asian Art at Boston College and co-author with Sheila S. Blair of The Art and Architecture of Islam: 1250-1800 (1994), Islamic Arts (1997), and Islam: A Thousand Years of Faith and Power (2000). He is also the author of Paper Before Print (2001) and Minaret: Symbol of Islam (1989).

John Boardman
Emeritus Professor of Classical Art and Archaeology at Oxford University. He is the author of several handbooks and monographs on Greek sculpture, vase-painting and gems, and has specialized in studies of the interaction of Greek art with the arts of other ancient peoples.

Anna Brodow
Editor of the the the review Artes in Uppsala, Sweden. She contributes to Svenska Dagbladet and is writing a doctoral thesis on contemporary Swedish artists working with project grants from Konstnärsnämnden 1976–2000.

Miranda Bruce-Mitford
Author of The Illustrated Guide to Signs and Symbols (1996). She has been tutor and lecturer on the Sotheby's and Christie's Asian arts courses at the School of Oriental and African Studies, London, and accompanied tours to Southeast Asia as guest lecturer. She has lectured at the British Museum and written widely on Southeast Asian Art.

Anita Callaway
Kluge fellow at the Library of Congress, Washington. Author of Visual Ephemera (2000) and past editor of the Australian Journal of Art (1996–99), she was a Getty fellow in 2000 and a Centre for Cross-Cultural Research fellow at the Australian National University until 2003.

Bruce Coats
Professor of Art History and the Humanities at Scripps College. He teaches courses in East Asian art history for the Claremont Colleges in California. He writes and lectures about East Asian architecture and garden history and about Japanese prints and paintings.

Herbert Cole
Professor Emeritus of art history at the University of California, Santa Barbara. He is the author, co-author, or editor of eight books on African art and many articles. In 2001 he received the Leadership Award from the Arts Council of the African Studies Association.

Paul Collins
Research Associate in the Department of Ancient Near Eastern Art of the Metropolitan Museum of Art, New York. He has also worked on Ancient Near East projects for the British Museum.

Laura Malosetti Costa
Associate Professor of Art History at the University of Buenos Aires. Her books include Los primeros modernos: Arte y sociedad en Buenos Aires a fines del siglo XIX (2003).

Jocelyne Dudding
Doctoral candidate researching 'Photographs as Cultural Property: New Zealand Images within British Museums'. She is based at the Photograph Collections Department of the Pitt Rivers Museum, Oxford.

Elspeth Dusinberre
Assistant Professor of Classics at the University of Colorado at Boulder. She has worked on archaeological sites in the eastern Mediterranean and is interested in cultural interactions in Anatolia. In 2001 she received the University of Colorado Chancellor's Faculty Recognition Award for her contribution to teaching.

Murray Eiland
Researcher in archaeological science at the J. W. Goethe University in Frankfurt. He has been a Fulbright lecturer at the University of Damascus and writes for several magazines on the evolution of technology and long-distance trade in the ancient Near East.

Stephen Eskilson
Professor of the history of art at Eastern Illinois University. He is a co-author of Frames of Reference: Art, History, and the World (2004).

Alexandra Gajewsky
Researcher of French and German medieval architecture. She studied at Münster University in Germany and at the Courtauld Institute in London. She has taught at the Courtauld Institute, at Birkbeck College and at the Victoria and Albert Museum.

Michael Godby
Professor of History of Art at the University of Cape Town. He has lectured and published on Early Renaissance Italian art, eighteenth-century English art, nineteenth-century South African art, contemporary and nineteenth-century South African art and the history of photography in South Africa.

Martin Henig
Visiting Lecturer in Roman Art, University of Oxford. He has published a number of books on gems, including a catalogue of the gems in the Fitzwilliam Museum, Cambridge (1994), and on Roman Britain. He is editor of The Journal of the British Archaeological Association.

Alison Hilton
Wright Family Distinguished Professor of Art History and Chair of the Department of Art, Music and Theater, Georgetown University. Her publications cover many aspects of Russian and Soviet art.

Mary Hollingsworth
Author of books on Renaissance patronage, now working on the extensive surviving papers of Cardinal Ippolito d'Este. Her first book on Ippolito, The Cardinal's Hat, was published in 2004.

Peter Kalb
Assistant Professor of Art History at Ursinus College. Revising author of H. H. Arnason's History of Modern Art 5th edn (2004), he is also author of High Drama: The New York Cityscapes of Georgia O'Keeffe and Margaret Bourke-White (2003,) and has contributed to Art in America.

Simon Kaner
Assistant Director of the Sainsbury Institute for the Study of Japanese Arts and Cultures in Norwich. He publishes and teaches on many different aspects of East Asian archaeology.

Thomas DaCosta Kaufmann
Professor in the Department of Art and Archaeology at Princeton University. His books include The School of Prague: Painting at the Court of Rudolf II (Chicago and

London, 1985), *The Mastery of Nature* (Princeton, 1993), *Court, Cloister, and City* (Chicago and London, 1995), and *Toward a Geography of Art* (Chicago and London, 2004).

Susan Koslow
Professor Emerita, Brooklyn College, The City University of New York. She has written and lectured extensively on the art of the Netherlands. Her publications include essays on Hugo van der Goes, Dutch perspective boxes, Frans Hals, Rubens, and a monograph on the Flemish still-life and animal painter Frans Snyders.

Ruth Leader-Newby
Researcher in the interaction between art and literary culture. She has taught at King's College, London, and the University of Warwick.

Mark Lindholm
Doctoral candidate in the Department of Art and Archaeology at Princeton University. He researches German Lutheran art in the century following Martin Luther's death.

Frank Meddens
Fellow of the Society of Antiquaries and a director of Pre-Construct Archaeology Ltd. He has carried out extensive fieldwork in Peru and the United Kingdom, and has published widely on Andean and British archaeology.

Jonathan Meuli
Freelance artist and art historian based in Glasgow. He is the author of *Shadow House: Interpretations of Northwest Coast Art* (2001).

Min Mao
Journalist, photographer, illustrator and doctoral candidate at the School of Oriental and African Studies, London. She is a visiting scholar at the Institut français d'Études sur l'Asie centrale, Tashkent.

John Moffitt
Professor Emeritus of Art History at New Mexico State University, where he also taught painting and drawing. His publications include numerous books and over 165 articles in scholarly journals.

Myroslava Mudrak
Associate Professor in the Department of History of Art at Ohio State University. She teaches modern art between the two world wars, with a concentration on early twentieth-century abstraction, and specializes in the art of Eastern Europe, Ukraine and Russia.

Katarzyna Murawska-Muthesius
Formerly Curator of the National Museum in Warsaw, she teaches at the Faculty of Continuing Education, Birkbeck College, University of London. She edited *Borders in Art: Revisiting 'Kunstgeographie'* (2000), and the National Museum in Warsaw guide (2001).

Stefan Muthesius
Research Fellow in the history of art, architecture and design at the University of East Anglia. His books include *Das englische Vorbild* (1974), *The English Terraced House* (1982), *Art, Architecture and Design in Poland: An Introduction* (1994) and *The Postwar University. Utopianist Campus and College* (2000).

Lawrence Nees
Professor of Art History at the University of Delaware. He is the author of *From Justinian to Charlemagne, European Art 565–787* (1985), *The Gundohinus Gospels* (1987), *A Tainted Mantle: Hercules and the Classical Tradition at the Carolingian Court* (1991), and *Early Medieval Art* (2001). He is editor of *Approaches to Early-Medieval Art* (1998).

Kristoffer Neville
Researcher in the arts of the Netherlands, Germany and Scandinavia in the seventeenth century. He is particularly interested in the life and career of the German architect Nicodemus Tessin the elder.

Mike O'Mahony
Lecturer at the University of Bristol in Russian and Soviet art with broad interests in nineteenth- and twentieth-century art in Europe and the United States.

Claire O'Mahony
Director of Programmes for History of Art Continuing Education at the University of Bristol. She specializes in nineteenth- and twentieth-century design and art history in Europe and America.

Morna O'Neill
Doctoral candidate working on Walter Crane at Yale University. She has published on nineteenth-century British photography and was curator of 'Company Culture' at the Yale Center for British Art.

Rodney Palmer
World Art Librarian at the University of East Anglia. He teaches the history of Italian and World art at the University of Leicester and is co-editor of *The Rise of the Image: Essays on the History of the Illustrated Art Book* (2003).

Carole Paul
Author of *Making a Prince's Museum: Drawings for the Late-Eighteenth-Century Redecoration of the Villa Borghese* (2000) and the co-editor of 'Viewing Antiquity: The Grand Tour, Antiquarianism, and Collecting' (*Ricerche di Storia dell'arte* 72, 2000).

Martin Powers
Sally Michelson Davidson Professor of Chinese Arts and Cultures at the University of Michigan. His *Art and Political Expression in Early China* (1991) received the Levenson Prize for best book in pre-twentieth-century Chinese Studies.

Jennifer Purtle
Assistant Professor in the Department of Art History at the University of Chicago. Her research interests are in Chinese visual and material culture from the Six Dynasties to the present.

Christina Riggs
Curator of Egyptology at the Manchester Museum, University of Manchester, and a specialist in the funerary art of Ptolemaic and Roman Egypt.

Chris Scarre
Deputy Director of the McDonald Institute for Archaeological Research in the University of Cambridge, and editor of *The Cambridge Archaeological Journal*. He specializes in the prehistory of western Europe, with an interest also in the Mediterranean and the Classical World of Greece and Rome.

Peter Shinnie
Professor Emeritus in Archaeology, University of Calgary. After service with the Royal Air Force in World War II, he taught and researched at the universities of Khartoum and Ghana.

Marcella Sirhandi
Associate Professor of Art History at Oklahoma State University, with a research focus on nineteenth- and twentieth-century South Asian art. Her publications include *Contemporary Painting in Pakistan* (1992).

Michael Sullivan
Fellow Emeritus of St Catherine's College, Oxford. He has been Lecturer in Art History, University of Singapore, Lecturer in Asian Art, School of Oriental and African Studies, London, and Christensen Professor of Chinese Art, Stanford University.

Timothy Taylor
Lecturer in the Department of Archaeological Sciences, University of Bradford. He is a specialist on the later prehistory of Eurasia.

David Thomson
Author of *Renaissance Paris: Architecture and Growth, 1475–1600* (1984) and many articles. He has lectured at the University of East Anglia and is working on the catalogue for an exhibition on Jean Androuet du Cerceau.

Thomas Tolley
Senior Lecturer in the History of Art in the University of Edinburgh. His publications include *Painting the Cannon's Roar: Music, the Visual Arts and the Rise of an Attentive Public in the Age of Haydn* (2001).

Stephen Vernoit
Author of *Occidentalism: Islamic Art in the 19th Century* (1997) and *Discovering Islamic Art: Scholars, Collectors and Collections, 1850-1950* (2000). He has taught at Al-Akhawayn University in Morocco and at the University of Durham.

Burzine Waghmar
Doctoral candidate in Iranian and Central Asian studies at the School of Oriental and African Studies, London.

Wang Tao
Lecturer in Chinese archaeology at the School of Oriental and African Studies, London. He specializes in Chinese paleography and Bronze Age cultures.

Robert Welsch
Visiting Professor of Anthropology at Dartmouth College and Adjunct Curator of Anthropology at the Field Museum, Chicago. He has conducted field research in Papua New Guinea and Indonesia and published widely on the anthropology of the Pacific.

Isobel Whitelegg
Art historian and curator based at the Department of Art History and Theory, University of Essex. Her research specialism is modern and contemporary art from Brazil.

Benjamin Withers
Associate Professor of art history at Indiana University South Bend. He specializes in early medieval English manuscripts. His articles have appeared in *The Art Bulletin*, *Anglo-Saxon England* and *The Old English Newsletter*. He is co-editor of *Naked Before God: Uncovering the Body in Anglo-Saxon England* (2003).

Ruth Young
Lecturer in South Asian archaeology and Distance Learning Tutor at the University of Leicester. She has done field work in Pakistan, Nepal and Iran, primarily exploring relationships between urban and rural sites.

Barbara Zeitler
Independent scholar based in London. She has taught at the University of California in Los Angeles. Her main research interests are in reactions to Byzantine art beyond the Byzantine empire.

CONTENTS

INTRODUCTION

This *Atlas* gives a new overview of one of the oldest, most widespread and most important of human activities. Art is, with the exception of tool-making, the human activity with the longest and also the fullest record. People have been making and looking at patterns, and carving and painting images and other visually interesting artefacts for more than 30,000 years, and doing so on every inhabited continent. Music has a long history, too, as is shown by the survival of hollow, perforated bones from a similarly early date, but it was not until the first musical notation appeared 2000 years ago that we have any idea of what was played. It was not until 500 years ago that any substantial body of written transcriptions was produced. Transcription of speech in the form of writing was more widespread, but writing has only existed for 5000 years and was only practised in a limited number of places.

It is above all to visual art that we must turn if we want to know about storytelling, religion or any other forms of thought, either before writing was invented, or in areas where it remained unknown. Even for communities in which writing was widespread, art adds a crucial new dimension to our understanding. Art is also of supreme significance in its own right. Through the ages, individuals and communities have invested enormous energies into creating art. In the past, when art was relatively rare, it was the object of the most intense and profound attention, and today, although the growing numbers of objects of visual interest has reduced the amount of attention each is liable to get, visual expression and communication are central to life, and art of all kinds is highly valued. This is why the study of the history of material visual expression mapped in this volume is so revealing and engaging. In this book, people living anywhere in the world can follow the story of the art of their own region, to the extent that it is known. They can also learn the story of their neighbours' art and, indeed, everybody else's. There has probably never been an art book of such potential interest to so many people.

This breadth of coverage of art through time and space was not easy to achieve. A whole new approach to the subject had to be developed. When art is viewed as a worldwide phenomenon it includes many fields, the knowledge of each controlled by a different group of specialists. There is simply too much disparity in the ways each group deals with its subject for it to be easy to bring them together. Archaeologists are the experts in the earliest art, anthropologists in the art of modern pre-literate peoples, and art historians in the art of literate peoples. Some scholars study a particular medium, such as textiles or film; others, like Egyptologists or Sinologists, study a particular region. Even more restricted is the expertise of the few members of each of the tens of thousands of, often remote, art-using communities worldwide who are the guardians of purely local traditions. Each group works with such different assumptions that to present them together as such in a single volume would draw as much attention to their limitations as to their achievements. This is why the *Atlas of World Art* sets out to offer a new framework, one in which each specialist can present his or her knowledge, but in a way that relates to those of the others. This has required all the contributors to rethink their fields, and it should enable readers to go through a similar process. The new framework used here for the presentation of knowledge about art also offers a new context for its understanding. With its combination of great breadth and constant clarity of focus, the *Atlas* allows exceptional insights both into what unites all art and into what makes it so varied.

Since it is this diversity of assumptions that makes it so difficult to develop an integrated understanding of art as a worldwide phenomenon, this new framework sets out to avoid categories that depend on assumptions that are cultural: that is, preconceptions that reflect the values of this or that community or group. Instead, the categories used are founded as far as possible in nature. It may be argued that to use the term 'nature' is still to base oneself in culture, because nature as a concept can be claimed to go back to Greek intellectual traditions, but it is not in that abstract sense that it is used here. The nature referred to here is one familiar to people of all cultures. It is nature as a set of resources and constraints, principally those embodied in the nature of the earth, of time and of man.

THE EARTH, TIME AND MAN

Here, we are concerned with the nature of the earth as it is experienced by humans, whether as hunters or gatherers, farmers or miners, traders or industrialists, wherever and whenever they live, and however they viewed it culturally. Everyone who has sailed the waters known by Europeans as the Pacific, whether they were the humans who first discovered the place we call Easter Island or their successors, such as James Cook, has needed to exploit the same winds and currents, however differently they saw them. In the deserts of Central Asia Marco Polo and Ghenghis Khan were subject to the same constraints. Indeed, the 'nature' referred to here is not just that which supports and constrains humans. It provides the context for the lives of all other animals, it conditions the existence of all plants and determines the relations of all inanimate matter. It is in this sense that this *Atlas* takes as its initial foundation the nature of the earth, of its waters and its atmosphere, of the life forms that grow on, under and above the earth, and the inorganic material of which it is made. The first immigrants to Australia and their successors tens of thousands years later may have given the rocks, timbers, fibres and pigments they found there different names and told each other different stories of their origins, but they could all exploit only their inherent properties. If the later immigrants could not find materials they needed in their new home, they imported them. Once they had brought them to Australia, these could then be used by the first inhabitants' descendants, as acrylic paint has been used with such success. Humans, like all life forms, are limited to the resources that they are able either to find locally or to bring in from somewhere else. In the sense that these different resources establish possibilities and set limits on them, they determine lifestyles. They also determine the nature of all activities requiring material expression, including art-making.

In order to keep us aware of these limitations, this *Atlas* adopts a spatial framework that relates the local and global availability of resources by mapping art onto the earth's spherical surface. Readers should try to keep that continuity of surface in their minds as they look at the sequence of separate two-page spreads into which that surface has been broken. The division into spreads was required by the use of the book format, and this also necessitated further decisions. The book had to begin somewhere on the surface of the planet, and, since the deep sub-oceanic trench along the eastern edge of the Pacific has, for the last 30,000 years, been the single greatest barrier to human movement and exchange, that was taken as the most important dividing line. Coverage moves eastwards from that division because the early occupation of the Americas, like the much later occupation of the

Pacific, took place from west to east. Continents are taken as the principal units because such large land masses have clear boundaries, and also because continuities in their environmental conditions mean that, in general, there is more movement within than between them. The body of water of the Pacific is treated as a large unit on similar grounds. There was a case for treating Europe and Asia together as the single continent of Eurasia, but the vertical division formed by the Urals and the Caucasus always formed a significant barrier to communication, and it was in any case appropriate to treat Africa between the two, since its junction with the northern land mass at Sinai puts it into connection with both. Within each land mass a sequence from north to south was adopted because the northern hemisphere has more continuity of land surface (and so of communication) than the southern. With the exception of the first movements of humans out of Africa before the Atlas starts, the majority of the 'vertical' movements of populations, including the expansion of populations of Asian origin through the Americas, the Bantu expansion into Southern Africa and the expansion of Malay-speaking populations into Indonesia, like the earlier movements of populations from Southeast Asia into Oceania, were in a north-south direction. The Atlas thus covers the globe from North America to South America, from Europe to Africa, and from Asia to the Pacific.

The temporal framework of the Atlas is also natural, in the sense that it is structured around divisions marked by the movements of the two most visible heavenly bodies: the months by the moon, and the day, the seasons and the year by the sun. The largest of these divisions, the year, thus forms the basic unit for the division of time. It was less easy to find a natural basis for defining the larger divisions into periods, but, as the Atlas begins with the appearance of art-related activities among humans, it seemed appropriate that further divisions should be defined by the appearance, or rise to predominance, of other human behaviours. Accordingly, new sections begin either with the introduction of a new way of life, such as agriculture or industry, or with the rise to new importance of an existing behaviour, such as war, religion, exploitation or technology. There is no suggestion that new ways of life have a higher status, or that the sequence represents inexorable 'progress'. When urban merchants, like the Medici, became princes, they tended to take up hunting, and when native Americans gained access to horses and guns with the arrival of European traders, they also largely abandoned tilling the fields to shoot buffalo. Nor were these new ways of life adopted by everybody. The hunting and gathering San of South Africa chose to resist agriculture, while the Inuit were prevented from taking it up by the Arctic climate. New forms of human behaviour are used to mark new periods only because they had so great an impact on a significant portion of the world's population that, for them at least, they changed the nature of the environment in which art was made and used. The sequence only represents a development in the sense that there is also a development in the behaviours of the first inhabitants of Australia. Although they have remained hunters and gatherers, they have, by invention and exchange, been adding layers to their food-gathering, storytelling, dancing and painting traditions ever since they arrived. Because humans have such good memories and are so good at imitation, lifestyles once adopted tend to remain available to later generations even as they experience modification. As each new behaviour emerges, it joins those that already exist, potentially providing successive generations with more and more options.

Based on these principles, time was divided into seven periods. These become progressively shorter. This was mainly because the generally continuous increase in the speed and volume of contacts between populations inevitably accelerated the rapidity of change. Yet another factor was the parallel improvement in access to resources, which meant that with the passage of time more and more art was made – and indeed preserved – and

so more and more needed to be shown. It was in partial acknowledgement of this trend that the latest period, 1900–2000, although of the same length as the previous 1800–1900, has been given more pages. As these dates indicate, the calendar followed is one that was originally European. This was done only because it is now the most widely used. It does not imply any pre-eminence and it is easy to recalibrate the dates to fit any other system. The underlying desire to minimize the influence of cultural criteria led to the calendar being divided into round numbers, so creating something like an objective grid. The departure from strict regularity involved in placing a division not in AD 500 but in 600 acknowledges that, in terms of a majority of the religions whose new importance seemed to call for a division around that time, the later date was more significant. Falling close to the founding both of Islam and the Tang Dynasty, AD 600 was more significant for more people.

Once both spatial and temporal divisions had been arrived at, it was necessary to decide which should determine the Atlas' overall structure. Time was chosen because there was a greater likelihood that something that happened in a particular year would soon have global implications than that something that happened in a particular place would affect things that happened in the same place thousands of years later. This means that instead of going through a sequence of continents, beginning with a chronological series of spreads on the Americas and ending with a series on the Pacific, we move through a succession of periods, beginning with a series of spreads covering 50,000–5000 BC. The use of the Atlas thus involves turning the globe from the Americas to the Pacific seven times, beginning with the earliest period and ending with the century 1900–2000. The reader who wishes to give precedence to spatial divisions and follow changes in a particular continent or region can easily do so by choosing to review the seven sets of period spreads for the relevant area as a group.

It is into this natural framework of space and time that humans are inserted as natural beings. Most books about art in the European tradition assume that it should be treated as part of culture, something that distinguishes humans absolutely from animals, and even from another type of human: those who live in cities and use writing as opposed to those who do neither. In this they take their cue from those among the ancient Greeks and the ancient Jews who held that the human being is in a special category as a superior god-created and god-like being. This notion lies behind many of the prejudices embedded in European art history. It has prevented the study of art as a worldwide phenomenon and has long inhibited the study of the nature and origins of human artistic behaviour. In order to open up enquiry into these and other topics this Atlas takes a quite different point of view, acknowledging that we are animals and seeing the production of culture as part of our nature. This view, although at odds with the European tradition, is compatible with the perceptions of most peoples throughout history, who, whether Indians or Inuit, whether living in Nigeria or New Guinea, have always recognized human kinship with other creatures. It is also in accord with modern science, which recognizes that we share most of our genetic material with other living things. Instead of taking art for granted as a divine gift, this view requires us to explain both the origins of art and its complex and varied history in terms of our distinctive make-up. If we started to make art between 40,000 and 30,000 years ago, and have gone on making and using it up to the present, it is because our biological nature has led us to do so. Our species, Homo sapiens sapiens, or 'modern-type' man, which had emerged from Africa at least 100,000 years ago, was able to complete its spread into Europe and Asia, apparently replacing all its predecessors by 30,000 years ago because it possessed resources that greatly enhanced its success, however challenging the environment in which it found itself. These resources were carried in a brain containing new and more

complex networks, which reinforced important abilities possessed by earlier ancestors. These included a number of tendencies: the ability to look at and mimic each other's movements and expressions; the use of the visual imagination to search for potential food and tool materials; the tendency to pick up, explore, manipulate and modify such materials, and to understand the importance of such actions when performed by others and, as a result, to imitate them. It was the convergence of all these genetically transmitted inclinations favouring success in the competition with other creatures that led to the emergence of the making and use of art and determined many of the properties that it has retained to this day. These include its inherent fascination. One of the reasons for art's abiding power is that the neural networks with which we experience it were originally developed not to provide us with aesthetic pleasure but to ensure our very survival.

FROM NATURE TO CULTURE
The adaptations just referred to, especially the inclinations to look at, to pick up, to manipulate and to modify materials and to respond to the visual experience of materials so modified, are inborn and therefore universal. However, the ways they manifest themselves are transformed through time and space in response to changes in the natural and social environment. This happens because of another distinctive property of our nervous system, its 'plasticity'. Humans are exceptional in that their brains are only fifty percent formed at birth. The fifty percent that develops later is formed both through passive exposure to the environment and through the active intervention of others. It is the combination of these inputs that largely accounts for the differences between humans, including the differences in the ways in which art is both made and used.

The dependence of such differences in art on differences of passive exposure is particularly clear. Looking at anything with particular attention causes the development of neural networks that will help us deal with it better in future, and this results in the formation of visual preferences that will unconsciously influence us should we start to make or look at art. Thus, the knowledge of what precisely people anywhere and at any time were looking at intently will reveal a great deal about their preferences. This knowledge is particularly relevant when we are trying to understand the formation of an artistic tradition, where little or none exists, since in these circumstances we can be certain that the neural networks that shape people's preferences will be formed less by looking at man-made objects than at important features of their natural environment which can easily be reconstructed. Thus, when the first tradition, that of the European Ice Age, was established around 30,000 BC, the psychologically most important objects to which people were exposed were large herbivorous and predatory animals, and these are precisely the objects which they tended to see in the surfaces around them and became inclined to represent. In the same way, an important feature in the visual experience of those who made the first monumental art, that of Egypt, around 3000 BC, were regular fields and rows of plants, which is why paintings and reliefs are arranged in rectangles and why buildings are full of plant-like columns. The environment of the Nile Valley is soft compared to the bare rocky mountains of Greece, and when the Greeks started their own artistic traditions around 600 BC, they replaced the soft lotus-bud capitals of Egyptian architecture with the angular forms we know as Doric and Ionic. Also, since their well-being depended on the physical strength of men rather than the productivity of agriculture, it was life-size and lifelike naked human figures that they saw in, and extracted from, the limestone and marble with which they were surrounded. In the Yellow River Valley of China, where another great tradition was developing at the same time, wealth depended instead upon the irrigation of fields with water that circulated from clouds to rain and back in the form of mist. It was thus visual exposure to such phenomena that helped to shape everything they made, from billowing clothes to sculpted dragons, and which inspired their most typical painting technique involving the irrigation of flat rectangles of silk and paper with black ink. For the peoples inhabiting tropical areas, where survival depended less on the exploitation of a primary resource, such as stone or water, and where a wild and bountiful nature was predominant in people's visual experience, the art traditions that developed were quite different. In this rich natural environment it was powerful animals of all sizes – from lions to spiders – and rampant plant life, that most attracted visual attention, an attention that was often confused as both plants and animals sought to camouflage themselves and protect themselves by adopting each other's attributes. For people brought up in such environments, the masquerade, which allowed humans to participate in a similar mimicry, alternately (and sometimes simultaneously) adopting the appearance of grasses and trees, buffalo and leopards, was an equally natural field of visual expression. In Africa, where large mammals were overwhelmingly powerful, they figured the most prominently. On the islands of the Pacific, where there were no such predominant forces, birds and fish were far more important, and it was their forms that islanders tended to see as they worked the wood of the boats and weapons that were their chief artefacts. In the frozen North, on the other hand, large mammals, such as bear, seals and whales, were again predominant in visual experience. In the absence of flora, these beasts, which were both the principal prey and principal enemy, blended in and out of an environment in which snow, water, ice, mist and wind were in constant flux. In both ivory and bone, materials which came from the animals and were used to make the tools with which they were caught, the Inuit saw the forms of these creatures, and especially their eyes, teeth, paws and so on, which were also the stuff of their stories as well as their shamanic belief systems.

If the main influence on the founding of a tradition is likely to be the environment to which people are passively exposed, the main factors that interrupt it and cause it to change are active forces, whether developing within, or coming from outside, society. Inside a society, a group, such as a secret association or otherwise privileged collective, or an individual, such as a chief, priest, king or wealthy citizen, may sense that a particular form or material can be exploited to influence fellow members of the community. Often such a sense may be awakened by the chance experience of what is already done in another society, but the most powerful external influences are those which come, whether welcomed or not, with military conquest, religious conversion or commercial domination. Such upheavals frequently bring an artistic tradition developed in one area into another, replacing or blending with the one that exists there. Alexander's conquest brought Greek traditions of stone sculpture and architecture deep into Asia, as far as India, and when those traditions became transformed by Indian devotees of Buddha, Shiva and Vishnu, they were then taken further east by traders and monks, often invited by rulers, penetrating China and Japan, Southeast Asia and Indonesia. An even more miscellaneous set of influences brought Egyptian, Mesopotamian, Syrian, Greek and Roman traditions together in the Middle East, from where Muslim missionaries could take this mixed tradition, strong in ceramics and wood- and metal-working, both west to North Africa and Spain and east to Persia, India and beyond. Even more dramatic, because more violent and intolerant, was the impact of the Spanish and Portuguese conquest of the Americas. This absorbed residual local traditions in such media as wood and stone, gold and silver, and textiles into a wave of church-, monastery- and palace-building that represented the dominance of a Christian European monarchy over the pre-existing peoples and institutions. Religious literature played an important role in establishing this dominance, and it was books of a more technical nature, on subjects such as how to use the Classical orders or compose paintings, replicated through the new

Chinese technology of printing, that were the chief instruments of another remarkable diffusion: that of Italian artistic traditions to Western and Northern Europe in the period from the sixteenth to eighteenth centuries, as monarchs, princes and merchants competed in displaying their knowledge of how to revive the admired, lost inheritance of Ancient Greece and Rome. The instruments of official censorship and authorization of publications played an important part in this process, as they did more recently in the case of the propagation of new political and artistic traditions in the wake of the militant expansion of Russian Communism after 1917, which for a time saw Socialist Realist painting and monumental sculpture become orthodoxy from Cuba to China. Equally aggressive, though less militant and more warmly welcomed by individual consumers, has been the impact of the commercial expansionism of the United States, which has used the latest technologies to distribute throughout the world such standardized products as cars and packaged food, films and television programmes, as well as political rhetoric, which have sometimes re-emerged in the artistic expressions of other people.

This story of the impact of military, religious, ideological and commercial forces might suggest there was always a one-way influence of the dominator on the dominated, but the reverse was often the case. The Romans conquered the Greeks, but were themselves conquered culturally and, above all, artistically. The same thing happened when the Mongols conquered the Chinese in the thirteenth century. Similarly, at the time when Britain was at its most expansionist commercially, it put on the Great Exhibition of 1851, which, besides displaying British and European products, also brought to London works from Asia, Africa and the Americas that were critically to influence the formal vocabulary of much of the 'modern' art of the twentieth century. Since then, exhibitions of the art of remote and unfamiliar peoples have become more and more a feature of the life of the wealthier countries, from North America to Japan, and each has tended to have an impact on its visitors. At the same time, artists have left such countries to seek inspiration in exotic locations, while diasporas from Asia, Africa, the Americas and the Pacific have brought artists from such locations to the great metropolitan centres. By doing so, each has unwittingly ensured that their neural networks are transformed, whether by new natural surroundings or artefacts, or by the traditional or modern media of their new homes, with consequences for their output. This reminds us that, whatever the overall patterns of art-related behaviours we observe, they can only be explained if we understand the particular personal experiences of each of the individuals involved, whether as producers or consumers.

THE ATLAS AS CONSTRAINT AND RESOURCE

Like any environment, the *Atlas* offers both a set of resources and a set of constraints. Some constraints are inherent to the project. The most obvious are those that depend on its format, the limitation on the number of maps and on the amount of information that can be inserted into them. Much more important, though, is the fundamental limitation on our knowledge. This applies particularly to the art of the past, where little survives because most was made in impermanent materials. But it also applies to particular areas of the globe. In most of the tropics, for example, where the climate was hostile to the art that was made in a wealth of organic materials, we know virtually nothing of what was produced until the last hundred years or so. In other areas of the tropics, and elsewhere in the world, where there was a lack of organic materials, either because, as in the Andean *altiplano*, the climate did not allow them, or because, as in areas around the

Mediterranean, humans destroyed them through farming and other activities, and where durable materials such as stone, metals and baked clay were used, the picture is much fuller. In some spreads there is simply much less knowledge that can be mapped than in others.

In spite of this inherent unevenness, every effort has been made to achieve consistency of treatment, while still allowing a variety of approaches to be adopted by the contributors. Each spread visually presents a similar set of information on such subjects as: topography, both of landscape and of cities; raw materials, both local and imported, and their processing; art, its production, use, display and displacement; artists and their movements; social institutions; and the boundaries of linguistic and religious groups, ethnic communities, and states. It also provides a verbal essay on their interrelations. The selection of information and of images, as well as the character of the commentary, reflect the interests of the almost seventy authors, who are themselves of many different cultural, ethnic, linguistic, religious, social, sexual and disciplinary backgrounds. Each spread is a highly personal essay, but taken together they present a vast body of comparable material and comparable ideas. It is possible to go through the *Atlas*, assessing the degrees of influence of the different factors noted in many different contexts. The reader can also compare the merits of different explanations and the theoretical assumptions on which they are based. Many of the leading authorities on different areas of art have never before presented their arguments in such a compressed and accessible form. The compression inherent in the volume's configuration brings losses, but also important compensations.

The atlas format adopted here for the presentation of knowledge of human artistic activity may be thought by some to be a vestige of an imperialist project. It is better understood as a first template for one that is egalitarian. No group or culture is favoured. All have equal access to each other's art. Nor is there a primary viewpoint. Instead, the view offered is literally one of a person circling the planet and viewing it from above during the 30–40,000 years that humans have been making art. It is a view helpful to anyone interested in a particular set of activities that are typical of this remarkable animal, those that relate to the visually interesting modification of planet earth's material resources. The *Atlas* lifts its readers out of the positions they normally occupy on the globe. It separates them from the conventional assumptions in which their lives are founded, and provides them with new perspectives. It allows them to descend into other places at other times, to experience strange environments, unusual practices and unfamiliar forms of art.

Those who take advantage of all the opportunities the *Atlas* offers will acquire an unprecedented understanding of art as a worldwide human behaviour. They will also acquire a much-needed awareness of our ignorance about it. The *Atlas* thus challenges its readers, whichever continent or island they come from, to reduce the gaps in their knowledge, whether by new and deeper studies of particular places and times, or by fresh reflections on the broader issues raised. If, wherever they live, they respond to that challenge, or if they simply revel in the pleasures of using a new and visually satisfying intellectual tool, the considerable efforts of the publisher, managing editor, editors, cartographers, contributors and others involved in its production will not have been in vain.

JOHN ONIANS

ART, HUNTING AND GATHERING 40,000-5000 BC

ART IS FOUNDED IN HUMAN NATURE. Many animals are hunters and gatherers, some are also sociable, and a few, like the chimpanzees, our close relatives, are also tool-users. It is in our special combination of these abilities that art has its origins. Our hominid ancestors had been picking up and shaping stones for use as tools for at least three million years, when, about 500,000 years ago, a more human predecessor, *Homo habilis*, began collecting objects of more purely visual interest: coloured minerals, such as ochre, and fossil remains, such as animal teeth. The emergence of these behaviours is connected with this creature's distinctive brain structure linking hand and eye, and enabling it to be successful both at socialization and at gathering and hunting. Inborn visual interests in such features as the redness associated with fruit and other foods, as well as the associated inclinations to reach out for objects having those properties, were becoming so strong that they could be activated by the sight of even inorganic materials.

THESE TENDENCIES WERE EVEN STRONGER in the new species of light-boned, large-brained primate, *Homo sapiens sapiens*, that probably developed in Africa before spreading throughout the world by 35,000 BC. In the brain of *Homo sapiens sapiens*, modern-type man, the links between the visual and motor systems were even stronger, and during the period to 10,000 BC the manipulation, marking and shaping of natural material resulted not only in an expanded use of personal ornaments and random finger drawings, but in the making of painted, engraved and carved representations. These included animals, both edible and predatory, human hands, and a few human figures, especially of women. Some were made on the walls of caves and rock shelters, others on loose blocks, or out of clay or ivory. Many image types were repeated, suggesting that what began as the chance consequences of spontaneous interactions between individuals and their environment became increasingly satisfying, first to their makers, and then to others. Art began to acquire the social function that was to give it such importance in the future.

THE UNIVERSALITY OF THE PREDISPOSITIONS involved is demonstrated by the widespread appearance of this activity from Europe to Africa, from India to South America, and from Siberia to Australia. Yet the

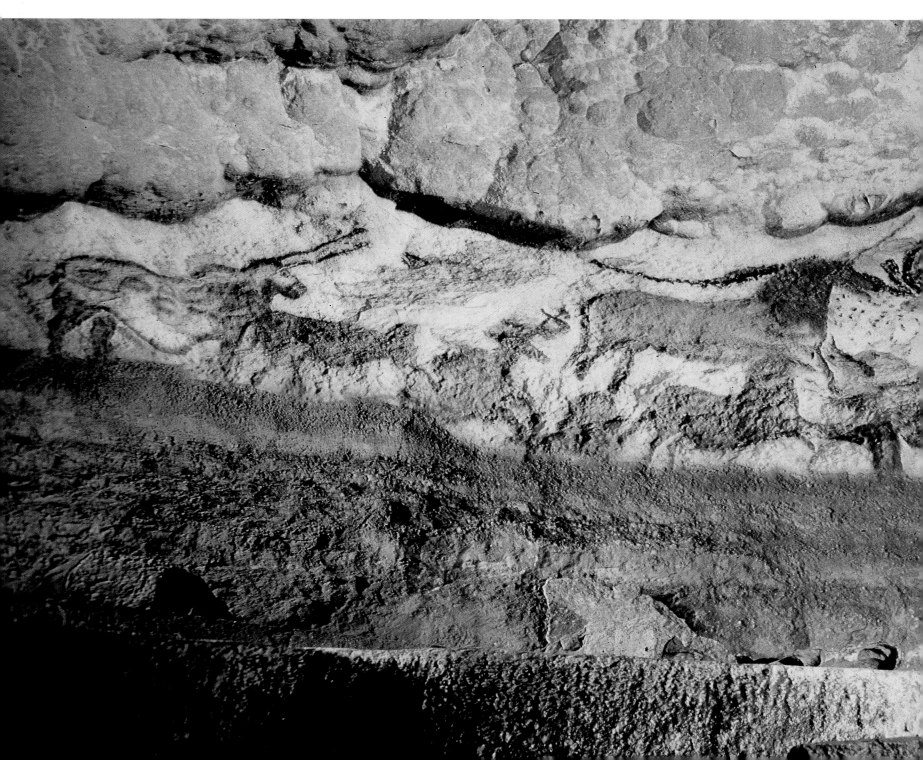

amount of surviving evidence from different areas is highly variable, with most being found in a belt between Russia and northern Spain. This may be due to losses elsewhere, and it is certainly true that the combination of an extremely severe climate and the ready availability of limestone caves in Western Europe encouraged work in more permanent materials in better-protected sites. There are, however, other reasons why such predispositions might have been more intensely activated in the same area. Those who lived in this unusually hostile and unstable environment, close to the edge of the advancing and receding ice sheet, where plant food was relatively rare and the hunting of large animals was both more necessary and more dangerous, would have been more than usually dependent on visual and manual skills. Within this region of greater stress, artistic activity seems to have been often strongest in localities where either survival was most difficult, as at Sungir near Moscow, or where, because of accidents of landscape, food supplies in the form of migrating animals were periodically particularly rich, as at Dolní Věstonice in the Danube Valley or in the Dordogne.

LATER, BETWEEN 10,000 AND 5000 BC, as the climate warmed there was some continuation of earlier traditions of artistic activity, but new types also appear and these are increasingly differentiated regionally, reflecting in part an increasing variety of lifestyles as technologies became more complex and adapted to varying ecologies. In Japan, for example, where there were neither large mammals nor predators, the use of fibres to make baskets, nets and lines enabled hunter-gatherers to exploit the smaller-scale food resources of land, water and air so effectively that populations could become increasingly sedentary, developing the first great ceramic culture. The form and decoration of these pots so frequently referred to fibres that they became known as Jomon, from the Japanese for 'string'. In Europe, too, the resources of water could be intensely exploited, as at Lepenski Vir on the Danube, where many of the fishing community's houses feature stones in which a natural resemblance to a fish has been enhanced by carving. Elsewhere in Europe, it was the skilled individual hunter with bow and arrow who became more important as woodland expanded north behind the receding ice, and the new dominance of man over nature led to male figures acquiring a prominence they had not had before, as in the rock paintings of Spain. Other art became more schematic, whether it was on the Azilian pebbles from southern France, or the paddles from Denmark, as artefacts generally became more important to people than the foods they helped them to gather or kill.

THE GREATEST EXPLOITATION OF TECHNOLOGY and transformation of art, however, was associated with the new understanding of how food production could be expanded through the herding of livestock and the sowing and reaping of grains in West Asia after 7000 BC. Çatal Hüyük in Turkey, the early town whose existence was made possible by this development, is made up of houses whose stone walls are decorated with paintings of animals and landscapes and sculptures of ox heads and leopard. These all testify to a new dominance of man over nature, and this is even clearer in the Jordan valley, where plaster statues celebrate the human body, and clay-covered skulls document a consciousness of the individual.

CAVE PAINTINGS in the 'great hall' at Lascaux in France, c.15,000 BC.

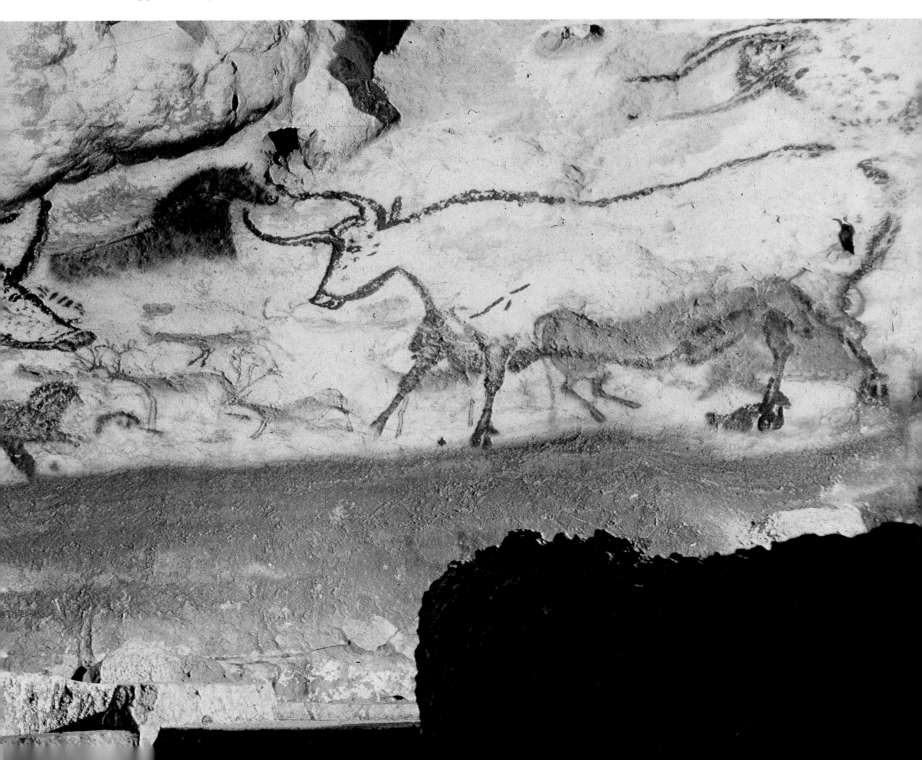

EARLY ICE AGE ART 40,000-20,000 BC

IT HAS BECOME clear in recent years that 'art', however it is defined, did not begin with the Upper Palaeolithic or Early Ice Age period (c.40,000 years ago) or with modern humans. Indeed, even the earliest fossil hominids – Australopithecines of two or three million years ago – seem to have had some kind of aesthetic sense. However, it is from the period after about 40,000 BC that a substantial range of examples of art is known. Contrary to popular belief, this later art – Ice Age art – was not confined to Eurasia; instead, in the last few decades it has become clear that art, both parietal (in caves and rock-shelters, and on rocks) and portable, occurs in this period in every continent. The portable art is relatively easy to date, from its stratigraphic position and associated datable materials. The parietal art, on the other hand, can only be reliably dated where it was covered by occupation layers, or where its figures contain organic material such as charcoal (as at the Chauvet Cave, where some animal figures have produced age estimates of more than 30,000 years).

TECHNIQUES AND MEDIA

Very early dates – of 30,000 and even 42,000 years ago – have been obtained from organic material trapped in the natural varnish covering rock carvings in Australia, which would make the petroglyphs beneath the varnish the oldest dated examples of rock art in the world. However, this dating method remains controversial and of uncertain validity. At present, it is Eurasia which has the greatest number of known sites with art that is more or less reliably dated to this period. The range of techniques and media present at this time is already impressive – in parietal art, there is fingermarking, engraving, and bas-relief sculpture; outline drawing and shaded painting; in portable art, adornments of perforated shells, teeth, bones or stones; engraving on bone, stone, antler, eggshell and ivory; painting on stones, as at Apollo 11 Cave, Namibia, dating to c.25,000 years ago; three-dimensional carving of stone, antler and ivory; and even the production of thousands of fired clay figurines, notably in Central Europe, and dating back to c.22,400 BC. Tests on these figurines from sites in the Czech Republic indicate that they were fired at temperatures from 500° to 800°C, and the shape of their fractures implies that they were broken by thermal shock – in other words, they were placed, while still wet, in the hottest part of the fire or 'oven', and thus deliberately caused to explode. Rather than carefully made art objects, therefore, their lack of finish and the manner of their breakage suggest that they may have been used in some special ritual.

1 THE LOWER SEA LEVELS in the Early Ice Age created land bridges that allowed colonization of Australia and the Americas. There were two alternative routes into Australia, though both required the crossing of large expanses of sea. The Pedra Furada rock shelter in Brazil contains fragments of painted rock which may be the earliest evidence of art in the Americas. However, the bulk of the currently known finds of this period are in Eurasia, some sites containing large numbers of art objects. At Dolní Věstonice in Moravia, for example, hundreds of small terracotta figurines have been found, mostly of animals, which seem to have been fragmented by thermal shock, and hence deliberately caused to explode in a fire, presumably for some ritual purpose.

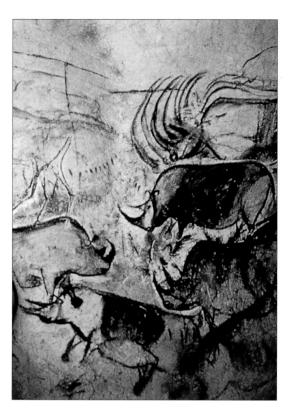

ONE OF THE PAINTED PANELS discovered in the Chauvet Cave in southern France in 1994, possibly dating to more than 30,000 years ago: though this is a matter of great controversy. It shows a number of rhinoceros, while others depict similarly large, dangerous animals – bears, big cats, mammoths.

MATERIALS

The materials used for artworks in this period were all readily to hand, whether inorganic (the various kinds of flint or hardstones) or organic (animals provided an inexhaustible supply of useful, workable materials). Mammoth ivory was a very difficult material to work, but the artisans of the period in Eurasia produced an astonishing array of objects from it, and clearly mastered this medium like the others. Other animals, in different parts of the world, provided bones, teeth, and sometimes antlers or horns. But one should never forget that the archaeological record comprises only those materials which have survived the millennia – untold quantities of art must have existed on rocks in the open air, or in materials that have disintegrated to nothing (wood, bark, fibres, feathers, hides). Body-painting and elaborate hairstyles probably extend far back into pre-history, together with tattooing or piercings; and of course, dance,

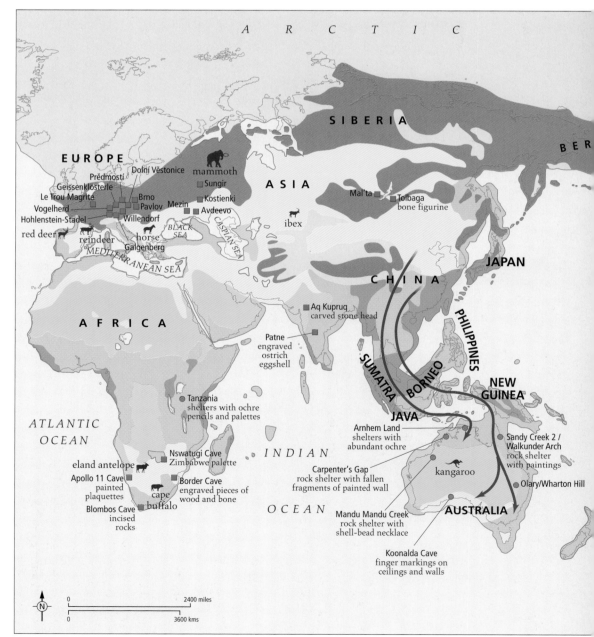

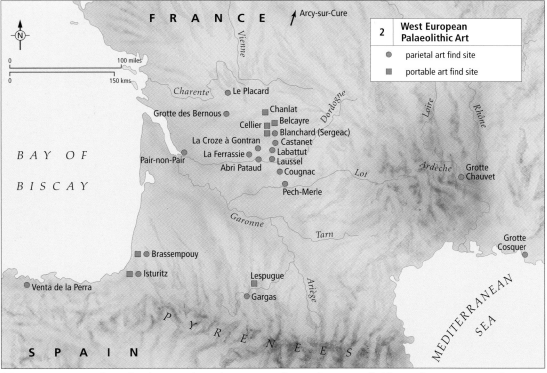

2 LARGE NUMBERS OF EARLY ICE AGE SITES have been found in the southwest of France and down to the Pyrenees. Many of the caves discovered contain several chambers with painted walls, such as the hand stencils in the cave of Gargas, or the panel of spotted horses at Pech-Merle. The oldest rock paintings found so far in the region are those at Chauvet, if the radiocarbon dates are correct (many features of this cave's art suggest a later date). Of the portable art sites, several have yielded female 'Venus' figurines, such as that carved in mammoth ivory from Lespugue and the bas-relief carving of the 'Venus with a horn' from Laussel. More elaborate is a carved head of a figurine found at Brassempouy.

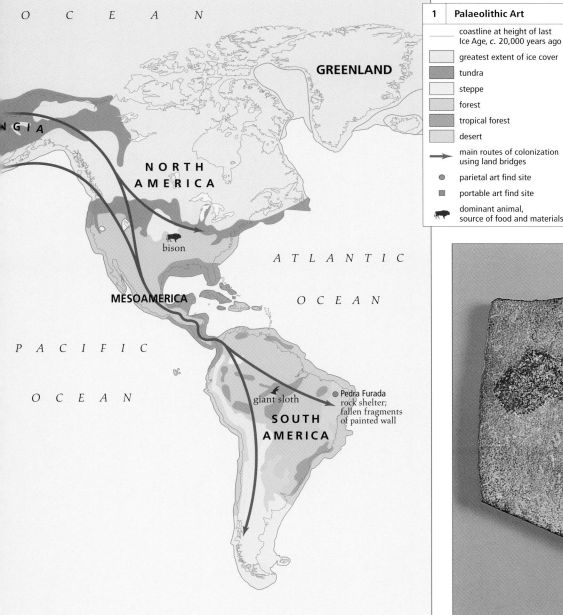

music and song leave no trace. So the surviving examples of Early Ice Age art are merely the tip of the iceberg, a tantalizing glimpse of a wealth of varied artistic activity which probably stretches back in time to the very first fossil humans.

One particularly important find of recent years is the small 'Venus' of Galgenberg (Austria, between Dolní Věstonice and Willendorf), carved in green serpentine, and dated by charcoal around it to c.31,000–32,000 years ago. Its lively pose, so different from those of later, more symmetrical and static female figurines, is quite remarkable.

SUBJECT-MATTER

Where the Early Ice Age art of Eurasia is concerned – and for the moment this is the greater part of the corpus that is reliably dated to this period – one noteworthy aspect that was already evident in the small but sophisticated ivory carvings from several sites in southwest Germany (Vogelherd, and nearby Geissenklösterle and Hohlenstein-Stadel, all more than 30,000 years old), and in the later terracotta figurines from Central Europe is the marked emphasis on depictions of what might be called large, powerful or dangerous animals. This has really come to the fore through the discovery of the Chauvet Cave. The horse, bison and deer that would dominate in later Ice Age art were already present, but the art of Chauvet is dominated by rhinoceros, mammoths and big cats. When combined with the site's striking bear figures, these four categories account for about two-thirds of the cave's animal figures.

In the Gravettian period (c.25,000–20,000 years ago) in Western Europe this situation appears to alter radically towards the heavy emphasis on herbivores that is so well-known in later caves, though it persists somewhat longer in Central Europe, as seen in the portable art of Dolní Věstonice and Russia's Kostienki Culture.

A CHARCOAL DRAWING of an animal-human from the Apollo 11 cave in Namibia. The rock slabs date from about 25,000 years ago and are the earliest dated rock paintings in Africa. This one shows what appears to be a feline creature with a heavy head, deep chest and thin tapering legs. The drawing seems to have been retouched at some stage, with the possible alteration of the hind legs to resemble those of a human.

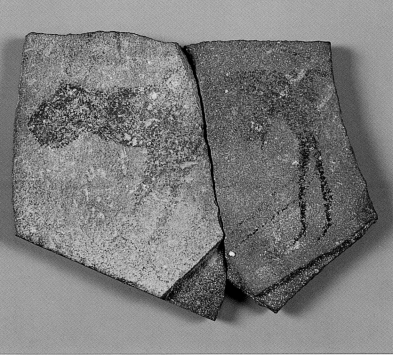

LATER ICE AGE ART 20,000-10,000 BC

IT IS IN THE LATTER PART of the last Ice Age that the great majority of what is called Palaeolithic art occurs; and as in the preceding millennia, examples are to be found on every continent, though it is Eurasia, and especially southwest Europe, which has the most numerous and best-known sites at present.

Outside Eurasia, most examples of art that is attributable to this period are portable objects of different kinds, such as terracotta figurines in Algeria and Siberia, or engraved pebbles in Israel and Japan. Some rock art, however, in the New World and Australia is also assigned to the late Ice Age. Petroglyphs in different parts of the United States have been dated through the still experimental and controversial method of dating organic material trapped in the natural varnish covering them.

AUSTRALIA AND BRAZIL
Some rock paintings in shelters in Brazil are clearly from this period. At Pedra Furada, for example, fragments of painted wall fell off over time and became stratified in datable occupation deposits. Even more definite are the petroglyphs at Early Man Shelter in Queensland, Australia, which were actually masked by occupation deposits dated to 13,200 years ago, making it certain that the petroglyphs were even older.

Other Australian sites are less securely dated – for example, a wasp nest masking a painted human figure at a rock-shelter in Kimberley produced a luminescence date of 15,500 BC, suggesting that the painting must be at least as old as this, whereas radiocarbon analysis of organic materials in paint from two similar figures has yielded results of only 1900 BC or less.

SPAIN, PORTUGAL AND FRANCE
In southwest Europe, the past 20 years have seen the discovery of twelve sites – in Spain, Portugal and France – of pecked and engraved figures on rocks in the open air, identical in style to figures known in Ice Age caves and portable art. In consequence, it is now clear that the rock art of the period forms a continuum from the open-air to the dark depths of caves. Every kind of rock surface was being painted, engraved or sculpted.

Engravings could be made with any kind of sharp-edged stone. Where paint is concerned, it is clear that it was sometimes applied with fingers, and often spat or sprayed from the mouth or by means of an aerograph. In other cases, the artists appear to have used actual crayons of pigment, or applied paint to walls with pads or brushes. No such implements have yet been found in Eurasia, but experiments suggest that a brush of chewed plant fibres or an animal-hair brush (badger hair seems particularly good) would have produced the best results.

There are clear regional differences in techniques and content, even within the relatively small area of France and Spain. For example, work in clay – from finger-markings in cave floors to bas-reliefs and full three-dimensional statues – has been found only in deep caves in the French Pyrenees, while bas-relief sculpture (which, like much portable art, seems to have been originally painted) only occurs in cave entrances or rock-shelters in the Dordogne and Charente areas.

The content of the art is generally divided into three major categories: animals, humans and non-figurative or abstract (the 'signs'). The vast majority of animal figures seem to be adults drawn in profile; there are very few recognizable 'scenes', no ground-lines, no landscapes, no vegetation (other than a handful of plant-like forms, primarily in portable art). The same limited range of animals is always depicted so that this is not a prehistoric bestiary simply depicting the outside world. These animals were meant to convey information or (probably highly complex) messages to the people of the time.

Humans are extremely rare (other than the famous female figurines), but the artists were clearly capable of depicting them when they wished; their virtual absence from cave art thus suggests that human figures were either taboo, unnecessary or irrelevant to whatever motivations lay behind the art's production. Simple 'signs' – dots, lines – are fairly ubiquitous, as one might expect, whereas complex signs tend to be very

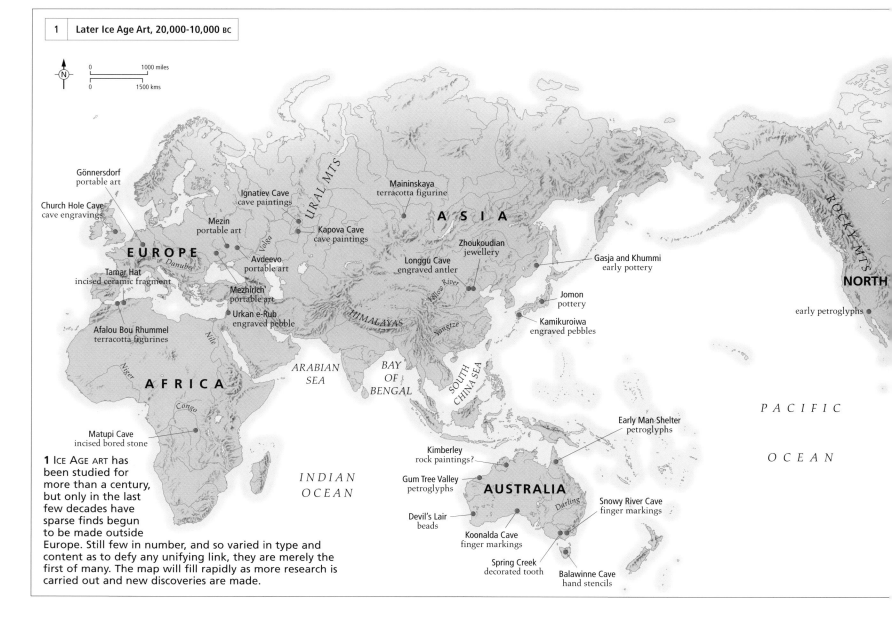

1 **Later Ice Age Art, 20,000-10,000 BC**

0 1000 miles
0 1500 kms

Gönnersdorf
portable art

Church Hole Cave
cave engravings

Ignatiev Cave
cave paintings

URAL MTS

Maininskaya
terracotta figurine

A S I A

ROCKY MTS

Mezin
portable art

Kapova Cave
cave paintings

E U R O P E

Volga

Danube

Avdeevo
portable art

Zhoukoudian
jewellery

Longgú Cave
engraved antler

Gasja and Khummi
early pottery

NORTH

Tamar Hat
incised ceramic fragment

Mezhirich
portable art

Yellow River

Jomon
pottery

Urkan e-Rub
engraved pebble

HIMALAYAS

Yangtze

Kamikuroiwa
engraved pebbles

Afalou Bou Rhummel
terracotta figurines

Nile

ARABIAN
SEA

BAY
OF
BENGAL

SOUTH
CHINA SEA

early petroglyphs

A F R I C A

Niger

Congo

P A C I F I C

O C E A N

Matupi Cave
incised bored stone

Early Man Shelter
petroglyphs

Kimberley
rock paintings?

INDIAN
OCEAN

Gum Tree Valley
petroglyphs

AUSTRALIA

Darling

Snowy River Cave
finger markings

Devil's Lair
beads

Koonalda Cave
finger markings

Spring Creek
decorated tooth

Balawinne Cave
hand stencils

1 ICE AGE ART has been studied for more than a century, but only in the last few decades have sparse finds begun to be made outside Europe. Still few in number, and so varied in type and content as to defy any unifying link, they are merely the first of many. The map will fill rapidly as more research is carried out and new discoveries are made.

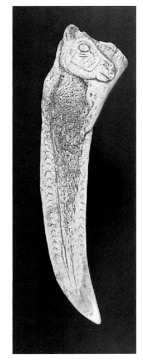

ENGRAVING ON BONE from the floor of the cave of La Garma, northern Spain, dating to more than 12,000 BC, and depicting a young ibex or deer looking back over its shoulder. It bears a marked resemblance to three-dimensional versions of the same motif, carved in antler on spear-throwers from the French Pyrenees in the same period.

localized in space and time, and are generally assumed to be 'ethnic markers' of some kind.

Some decorated caves also served as dwellings; others were never lived in and only visited rarely or even once for the art's production. Some cave art – and all of that in shelters and the open-air – seems meant for public consumption, whereas a great deal of it is extremely private, hidden away in dark depths, crawl-ways or inaccessible niches. In many cases

it seems to have been the arduous journey to reach the place where the art was produced which was important. In such cases, it is likely that the art had a religious motivation.

INTERPRETING ICE AGE ART
Attempts to interpret Ice Age art tend to reflect their times. It was once thought to be the mindless doodlings of idle hunters ('art for art's sake'). Then ethnographic reports from Australia and elsewhere at the turn of the century led to theories of sympathetic magic (hunting magic, fertility magic). Dominant in the first half of the last century, these proved unsatisfactory since there are no hunting or sexual scenes in the art, and in most sites the artists were not drawing the same species as they were hunting.

This approach was superseded in the 1950s and 1960s by French structuralism, which saw cave art as 'mythograms' incorporating a binary system that was essentially sexual symbolism. The Space Age brought an emphasis on interpretations involving archaeoastronomy and

2 CAVES, ROCK SHELTERS AND OPEN-AIR ROCKS – around 300 sites are currently known in Eurasia which have parietal art of this period, most of them in France and Spain. Even more are known with portable art of the same antiquity. This map features only the best-known and best-dated – there are too many sites with art objects to be included, while relatively few of the parietal sites are attributed to the late Ice Age with complete certainty. Most of them are dated primarily by style, though their chronological attribution is highly probable, through various factors such as comparison with well-dated portable art.

notation; the Computer Age saw each cave as a giant floppy disk with retrievable information recorded on its walls; while the New Age brought a return to simplistic notions of a universal 'shamanism', and of images recording trance experiences. There may be truth in all of the above, but it is safe to say that no single explanation will ever suffice for a phenomenon which spans at least 30 millennia over a vast area, and which encompasses such a huge range of media, techniques and imagery.

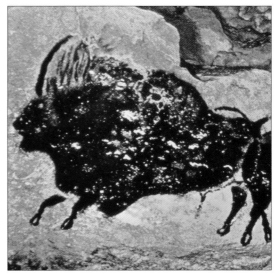

BISON PAINTED IN THE CAVE OF LASCAUX (Dordogne, France), which is generally (but not securely) ascribed to about 15,000 BC. Note how perspective is shown by the simple but effective method of not attaching the legs of the far side to the body.

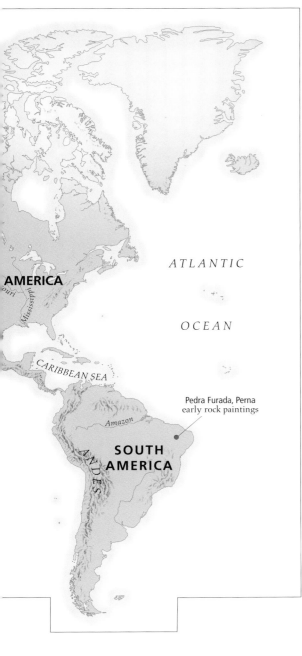

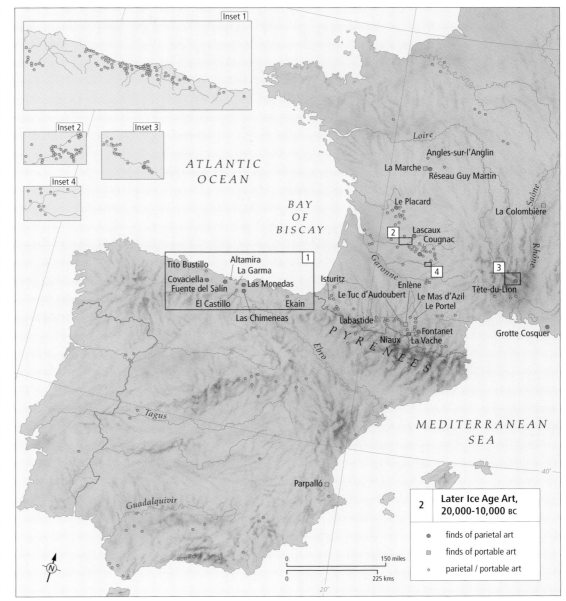

	Later Ice Age Art, 20,000-10,000 BC
•	finds of parietal art
▫	finds of portable art
⊙	parietal / portable art

POSTGLACIAL ART 10,000-5000 BC

ONE OF THE GREAT unanswered questions of prehistory is: why did Ice Age art come to an end? And part of the answer is that it did not. Since most figures in Ice Age cave art remain undated except by style, we have no means of knowing whether it did indeed end abruptly, or carried on for some time after the end of the Ice Age – itself a gradual and uneven phenomenon depending on latitude, climate and so forth.

PROBLEMATIC DATING
In recent years some specialists have dared to wonder if some of the art in the caves might not extend into the early postglacial period, beyond what we call the Ice Age – and recent direct dating of some black figures in the Spanish cave of Ojo Gaureña has produced results of 9470 to 8950 BC – quite late for Ice Age cave art. And likewise we know that the Ice Age portable art of southwest Europe continued for a while at sites such as Pont d'Ambon and the Abri Morin.

In fact, our knowledge of the art of the millennia following the end of the Ice Age is largely confined to such portable objects, precisely because so little parietal art has yet been reliably dated. A few rock art sites in the New World, Australia and elsewhere are known to belong to this period. Elsewhere, dating is still a matter of faith or conjecture. Some rock art sites in India are attributed to the mesolithic (Middle Stone Age) period. So are

HAND STENCILS IN THE CUEVA DE LAS MANOS (southwest Argentina). Huge clusters and superimpositions of stencils, sometimes hundreds of them, in a wide variety of colours can be found in rock shelters in Patagonia. At this site, archaeological excavation suggests that they date back to c.7300 BC. Some specialists do not regard such stencils as 'art', since they are mere impressions, but it is clear from colourful groupings such as this that they were intended to have a striking aesthetic impact.

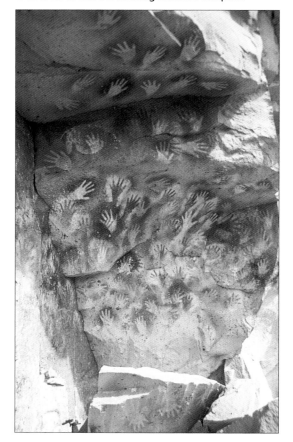

1 AFTER THE ICE AGE, art around the world becomes even more varied, with a tremendous variety of forms and motifs encountered around the globe. The lack of firm dating greatly hampers the development of a unifying theory, but one clear phenomenon is the appearance of art in well-preserved organic materials from waterlogged sites in northern Eurasia, as well as the rapidly growing importance of work in other materials such as plaster and fired clay.

the numerous and enigmatic engraved grids in shelters in the Forest of Fontainebleau (near Paris). Spanish Levantine art (so-called because it is mostly found in the eastern part of the country) consists mainly of rock paintings of small, lively human and animal figures in rock shelters. It has traditionally been ascribed to this period because it often shows hunting scenes with deer or boar – staples during the mesolithic in this part of the world. It also neatly filled a gap between the cave art of the Ice Age and the ceramics of the first farmers. There was never any evidence for the Levantine art being mesolithic, though, and recent work has shown that some if not all of it can be ascribed to the neolithic period (New Stone Age) or even later.

PORTABLE ART IN THE MESOLITHIC
One of the most interesting recent finds from the early postglacial was made at the Syrian site of Jerf el-Ahmar, where a number of stones of about 8000 BC bear a series of pictograms – combinations of lines, arrows and animal outlines – seen by some researchers as an intermediate stage in an evolution from Ice Age art to true writing, which arose about 5000 years later in the form of Sumerian cuneiform. Even more spectacular developments are the plastered skulls and statuettes from Israel and Jordan, dating to about 7000 BC, when clay figurines were becoming widespread in the eastern Mediterranean.

The remarkable site of Lepenski Vir, in Serbia, was a fishing village on the Danube dating from c.6000 BC, and many of its houses were found to contain enigmatic limestone

PAINTED WOODEN PADDLE from a submerged settlement at Tybrind Vig, in Lille Baelt, Denmark. Its decoration was produced by filling incised designs with brown pigment. Ten such paddles, all heart-shaped and of ash wood, were found at this waterlogged site with exceptional preservation. Only two were decorated.

Map labels:
ROCKY MTS
petroglyphs
NORTH AMERICA
Missouri
Mississippi
ATLANTIC OCEAN
Gault Site engraved stones
Aucilla River portable art
Whalebone figurines, 6000 BC
Monte Alegre rock paintings
Amazon
Piauí numerous shelters
Toquepala Cave rock paintings
ANDES
SOUTH AMERICA
Inca Cueva rock paintings
Los Toldos/El Ceibo rock paintings
Cueva de las Manos rock paintings

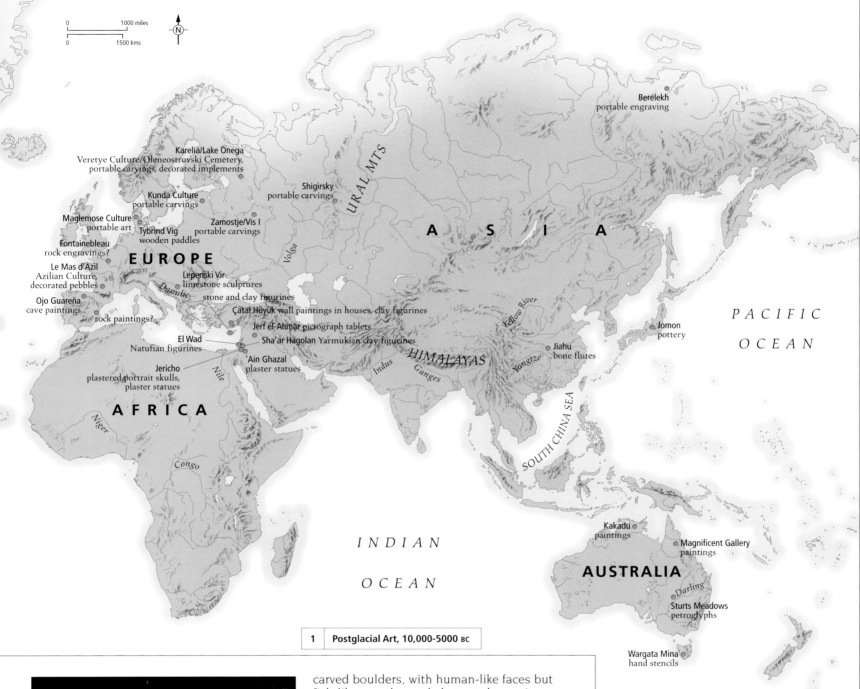

Berelekh
portable engraving

Karelia/Lake Onega
Veretye Culture/Oleneostrovski Cemetery,
portable carvings, decorated implements

Shigirsky
portable carvings

URAL MTS

Kunda Culture
portable carvings

ASIA

Maglemose Culture
portable art

Zamostje/Vis I
portable carvings

Tybrind Vig
wooden paddles

Fontainebleau
rock engravings?

EUROPE

Volga

Le Mas d'Azil
Azilian Culture,
decorated pebbles

Lepenski Vir
limestone sculptures
stone and clay figurines

Danube

Ojo Guareña
cave paintings

rock paintings?

Çatal Hüyük wall paintings in houses, clay figurines

Jerf el-Ahmar pictograph tablets

Yellow River

PACIFIC

OCEAN

El Wad
Natufian figurines

Sha'ar Hagolan Yarmukian clay figurines

Jomon
pottery

'Ain Ghazal
plaster statues

HIMALAYAS

Jiahu
bone flutes

Jericho
plastered portrait skulls,
plaster statues

Indus

Nile

Ganges

Yangtze

AFRICA

Niger

SOUTH CHINA SEA

INDIAN

Congo

OCEAN

Kakadu
paintings

Magnificent Gallery
paintings

AUSTRALIA

Darling

Sturts Meadows
petroglyphs

| 1 | Postglacial Art, 10,000–5000 BC |

Wargata Mina
hand stencils

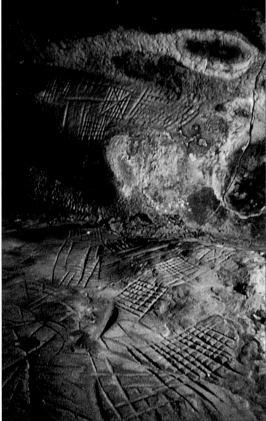

carved boulders, with human-like faces but fish-like mouths, and abstract decoration which might represent scales. These boulders, 20–60 cm (8–24 ins) in height, are among the earliest known examples of 'monumental' three-dimensional sculpture in the world.

The best-known portable art of the early postglacial is that of the 'Azilian' culture (c.8000 BC), especially its small, flat pebbles bearing dots and lines of red paint. These have been found at sites in France, Spain and Italy, but of the almost 2200 known, more than 1600 are from Le Mas d'Azil in the French Pyrenees. Debate still rages over their possible functions – with gaming pieces, proto-writing and notations among those suggested. The Azilian also produced pebbles bearing a series of engraved lines, and these are likewise known over quite a large part of western Europe.

Other than these, the best-known and best-dated portable art objects from this period in Europe are to be found in the north: for example, the carvings of animals in amber, stone and bone from Scandinavia, particularly the Maglemose culture of Denmark (c.7500–5700 BC), such as the amber bear from Resen Mose with its geometrical decoration. A whole range of objects has been found at sites in northwest and western Russia. They include stone and bone carvings of elk heads and ducks from Zamostje; a carved wooden elk head projection on a ski from Vis I; a profusion of geometric decoration on bone objects from the Veretye culture, east of Lake Onega; and items in wood and birch-bark from water-logged sites like the Shigirsky bog in the Urals. One spectacular wooden anthropomorphous idol from Shigirsky, dated to about 6600 BC, was no less than 5.3 metres (17 ft) tall.

It is therefore in this postglacial or 'mesolithic' period that we are afforded our first glimpse of the kinds of materials which have normally not survived. It can hardly be doubted that a vast array of art in perishable materials has irretrievably decomposed and disappeared, not only from this postglacial period but also from the Ice Age itself. At the same time we see the growing importance of new media such as plaster and the advent of more widespread use of ceramics.

THE ROCK-SHELTER OF LES ORCHIDES in the Forest of Fontainebleau, near Paris, France, is one of numerous shelters here which contain enigmatic incised grid-like designs on their floors, walls and ceilings. Archaeological investigation in their vicinity points to a probable mesolithic date, but their significance remains a complete mystery.

ART, AGRICULTURE AND URBANIZATION 5000-500 BC

THE DEVELOPMENT OF AGRICULTURE added a new and larger dimension to humanity's involvement with art. Agriculture was in some sense itself an artistic activity. The selection of plants and animals for breeding involved the expression of aesthetic preferences; the process of preparing fields for planting involved the shaping of the land; and the process of tending the sown plants often required a coordination of visual and manual activity that paralleled that of the artist.

THE RELATION BETWEEN AGRICULTURE AND ARCHITECTURE was particularly close. In those areas where conditions favourable to intense food production allowed the growth of bigger and bigger and more and more permanent settlements, agriculture led directly to urbanization. Between 3000 BC and 1000 BC cities built in fertile river valleys, such as Ur in Mesopotamia, Memphis in Egypt, Harappa in India, and Anyang in China, set new standards in scale, substance and organization, and a similar process of urbanization was beginning in Meso- and South America. Agriculture indirectly affected both people's thinking and their visual preferences. Growth

now became a vital metaphor in many areas of experience, and those who enjoyed the wealth that farming generated constructed ever larger palaces and tombs for themselves and temples for the deities that were their protectors. Agriculture also involved planning, and this, too, became an increasingly central activity and metaphor, as both town and country were increasingly carefully managed. Irrigation and road-building intensified, and both in and around cities the straight line and the right angle became more and more prominent. First in Egypt, and then elsewhere, design principles were transferred from the horizontal layout of fields and houses to the vertical surfaces of walls, so inaugurating the great tradition of painted and sculpted decoration in rectangular panels. At the same time architectural ornaments acquired the properties desired in agricultural products, as the cornices and colonnades of Egyptian and Mesopotamian buildings were made to look like rows of leaves and sown plants.

AGRICULTURAL SURPLUSES COULD BE EXCHANGED for other goods, often from foreign countries, sometimes in the form of raw materials

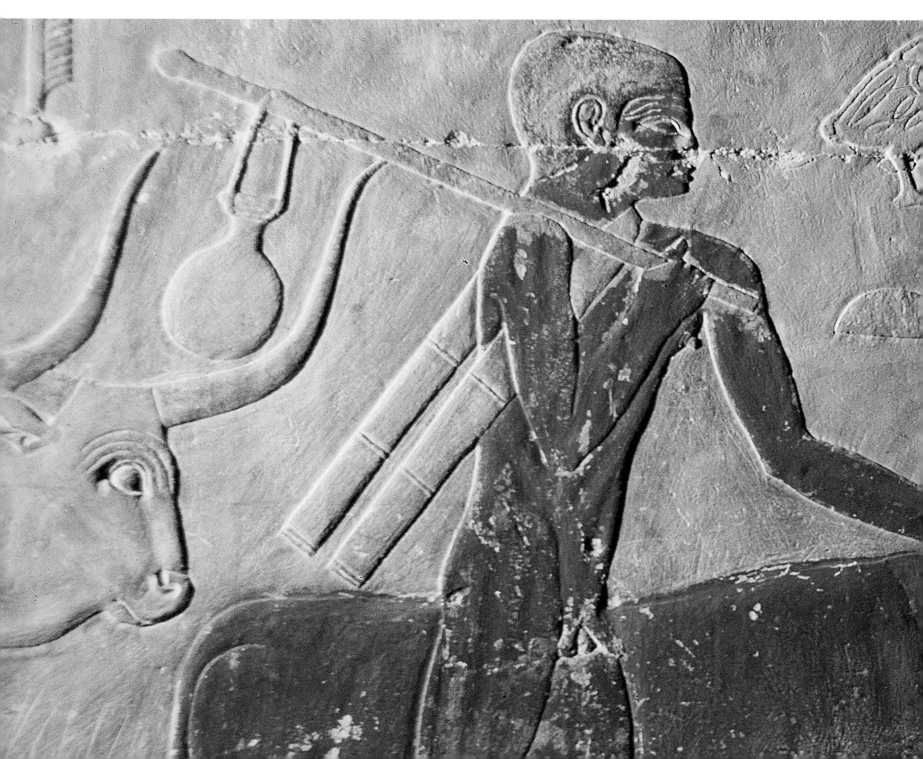

that could then be transformed into objects, ornaments and representations of people, animals and plants. These objects filled the houses and tombs of rulers and the shrines of deities. Stones, such as granite and alabaster, were extracted from quarries and carved; metals, such as gold, silver and copper, were mined, melted and moulded; clay was dug and baked into bricks and pots; trees were cut down and timbers sawn and polished; pigments were extracted from plants and minerals and used to dye fibres and to colour surfaces. All these resources and techniques were used to create pleasure and confidence in the owner or fear or amazement in others. In different areas, different materials received more attention, depending on variations in availability and aesthetic preferences. In Egypt craftsmen worked in granite and a glass-like substance called faience; in China jade and bronze were used; and in coastal South America the focus was on cotton textiles and painted ceramics.

IN REGIONS WHERE THE COMBINATION OF SOIL AND CLIMATE limited the productivity of agriculture, as in the valleys of Europe, the plateaux of Asia, the hills of Southeast Asia and the islands of the Pacfic, communities were on a smaller scale, but were often distinguished by remarkable artefact traditions. In coastal Europe, for example, a shortage of trees, combined with other pressures, brought the erection of massive but simple stone monuments such as the temples of Malta and Britain's Stonehenge.

AGRICULTURE CREATED A NEED FOR LAND, and one of the features of this period is the beginning of the phenomenon of small groups expanding into vast territories, their original homogeneity betrayed by linguistic similarities, as well as belief systems and material traditions. The Bantu who expanded out of West Africa into the rest of Sub-Saharan Africa made little use of permanent materials, leaving us largely ignorant of their art. The same is not true of the peoples who migrated into the western Pacific from Southeast Asia. These founders of Polynesian culture brought with them a refined and elaborate pottery, known as Lapita, only to abandon it after their arrival. On their way they passed, and probably mixed with, the people who had arrived much earlier in neighbouring New Guinea and Australia, whose rock art, although often difficult to date, suggests a continuation of earlier traditions.

THE FIRST POLYNESIANS WERE A CLOSE-KNIT GROUP of courageous and competitive sailors, and so were the Phoenicians and Greeks who expanded to dominate most of the Mediterranean between 1000 and 500 BC, but it is the differences between these rival Semitic and Indo-European peoples that is most remarkable. The Phoenicians founded rich and important cities, such as Carthage, which have left little permanent material trace besides their cemeteries (or *tophets*). The Greeks, by contrast, especially the Athenians, began developing a culture that was unprecedentedly rich in artefacts made of durable materials. The militarization that followed from their need to defend the resources of their narrow, rocky valleys led the Greeks to value the properties of minerals. In mythology they represented themselves as made of stone and metal, and they used the same substances to portray themselves in art. The Greeks had turned themselves into artefacts particularly adapted for war. The success of their culture was to lead others to do the same.

PAINTED LIMESTONE RELIEF from the Tomb of Ti in Saqqara, Egypt, c.2450 BC.

THE WORLD 10,000-3000 BC

AS THE WORLD WARMED UP after the last Ice Age, the glaciers retreated and deserts shrank. The water that had been locked up in the ice sheets was released into the sea to evaporate, condense into clouds and fall as rain. Extensive forests developed in temperate and tropical regions, spreading from late glacial pockets to cover much of the earth's land surface. Forest vegetation supported expanding herbivore populations and the carnivores that in turn fed on them. But arguably the main beneficiaries of the more hospitable climate were the human groups. These grew in size and progressively colonized new areas in both northern and southern latitudes, eventually covering virtually the whole of the world including the inhospitable arctic wastes and the driest deserts.

HUNTER-GATHERERS

The population of the world 10,000 years ago consisted almost entirely of hunter-gatherers, who lived by hunting and collecting wild plant foods. They also fished in rivers, lakes and sea, and many of the choicest locations for early human settlement were along wetland coastal margins. In some areas, such as Denmark or northern Australia, their seasonal coastal encampments were marked by mounds of shells, the debris from the exploitation of marine molluscs.

Despite their growing numbers, these early postglacial peoples have not left such striking imagery as the cave paintings of their Palaeolithic predecessors. Rock art is known from many regions, however, including, for example, Australia, and the central Sahara, which was moister than at present. Many Saharan rock paintings depict parti-coloured figures of domestic cattle, grouped in herds.

Already before the end of the last Ice Age, hunter-gatherers in the Levant had begun to exploit the wild large-seeded grasses which were the ancestors of domestic wheat and barley. Around 12,000 years ago this exploitation shifted in character to include the sowing and harvesting of plants that had been removed from their natural habitat and were being intentionally propagated by human intervention. Agriculture had begun. The immediate stimulus in the Levantine case may have been a temporary shift towards colder drier conditions as the Ice Age approached its end. Whatever the specific cause in the Levant, however, the adoption of cultivated plants, sometimes accompanied by domestic animals, was a development that was to be played out in several regions of the world, in the millennia which followed, in diverse human and environmental circumstances: in China, in tropical Africa, in Central and South America, in the southern USA. It altered the human outlook on the world, the relationship of people to the natural world. This changed understanding may be what was represented by the vivid wall paintings and clay sculptures of Çatal Hüyük in Turkey, perhaps the world's earliest town.

CARVED ALABASTER TROUGH of the late fourth millennium BC from southern Mesopotamia, possibly from the city of Uruk. In the centre stands a reed hut or byre. This type of structure was traditional in the southern marshlands of Iraq up to recent times. Sheep and rams converge from left and right, to be greeted by their offspring. Reed bundles terminating in open loops project from the roof; they are the symbols of Inanna, goddess of fertility. The precise meaning of the scene is unclear, but the reed hut with goddess symbols may represent her temple, and the sheep and goats her sacred herd.

THE IMPACT OF FARMING

The immediate consequence of agriculture was the development of larger and more permanent settlements – cultivation and herding allowed many more people to be supported from a given plot of land and removed the need for regular or seasonal mobility. Larger settlements in turn led to more complex social arrangements, involving personal displays of status and works of communal labour. By the fifth millennium BC, ground stone and carved or perforated shell had been joined by objects of copper and gold in graves as markers of individual identity and importance. Agriculture became more

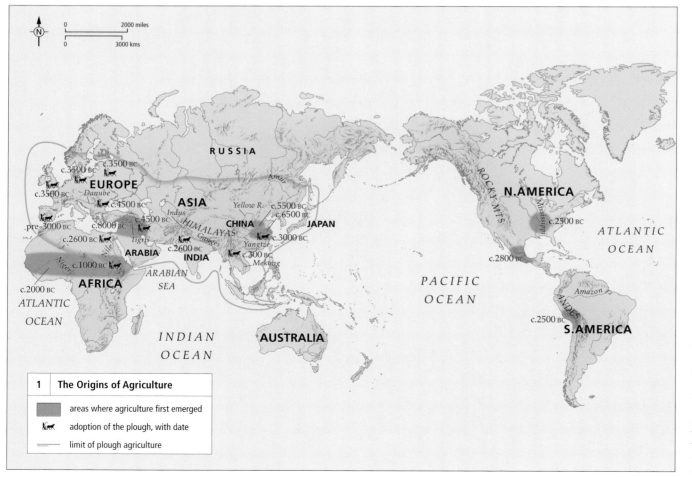

1 THE DOMESTICATION of plants and animals occurred independently in several regions of the world, becoming the dominant mode of human subsistence and leading to a significant growth in population levels. New techniques were developed to increase the amount of food that could be produced. In the Old World, one of the most significant innovations was the plough, drawn by a pair of oxen. The New World lacked suitable domestic animals capable of providing the necessary traction, and cultivation there remained dependent on human muscle power and the hoe.

1	The Origins of Agriculture
	areas where agriculture first emerged
	adoption of the plough, with date
	limit of plough agriculture

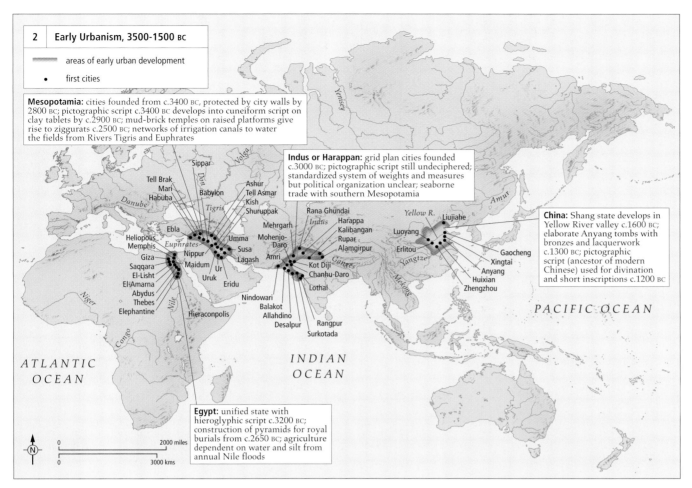

2 Early Urbanism, 3500-1500 BC

— areas of early urban development

• first cities

Mesopotamia: cities founded from c.3400 BC, protected by city walls by 2800 BC; pictographic script c.3400 BC develops into cuneiform script on clay tablets by c.2900 BC; mud-brick temples on raised platforms give rise to ziggurats c.2500 BC; networks of irrigation canals to water the fields from Rivers Tigris and Euphrates

Indus or Harappan: grid plan cities founded c.3000 BC; pictographic script still undeciphered; standardized system of weights and measures but political organization unclear; seaborne trade with southern Mesopotamia

China: Shang state develops in Yellow River valley c.1600 BC; elaborate Anyang tombs with bronzes and lacquerwork c.1300 BC; pictographic script (ancestor of modern Chinese) used for divination and short inscriptions c.1200 BC

Egypt: unified state with hieroglyphic script c.3200 BC; construction of pyramids for royal burials from c.2650 BC; agriculture dependent on water and silt from annual Nile floods

0 2000 miles
0 3000 kms

2 THE EARLIEST CITIES of the Old World were concentrated in four limited regions, each centred on a major river or riverine system. These provided the fertile soils and the water needed to grow regular harvests of wheat, barley, millet and rice. The populations of the first cities were small by modern standards – numbering usually only a few thousand people – but they possessed a wide range of craft skills and administrative functions, including ritual specialists, bureaucrats and traders. These together created both new needs and new potential, giving rise to political and religious art and architecture.

intensive, with the development of ploughing in Eurasia and North Africa allowing still larger areas of land to be brought into cultivation. In drier areas towards or beyond the limit of the rain-fed zone, cooperative effort created systems of canals to bring river-water to the fields. On steeply sloping hillsides, terraced fields were laid out to bring yet more land into cultivation to feed the growing populations.

THE FIRST CITIES
The introduction of irrigation canals in the sixth millennium BC allowed the fertile plains of southern Mesopotamia to be farmed for the first time. Within 2000 years the productive potential of these hot, dry plains had led to the establishment of the world's first cities. In Egypt and the Indus valley, annual river flood regimes gave rise to similar urban developments around 3000 BC, later to be joined by China during the second millennium BC. The states and city-states of these densely peopled lowlands demanded a new scale of social organization and new types of religious and political ideology that were represented in art. Kings and gods required statues, palaces and temples to proclaim their power and emphasize their status. The tombs of rulers took on a new impressiveness in the pyramids of Egypt. The rich offerings placed in elite graves at Ur in Mesopotamia or Anyang in China revealed high levels of craftsmanship and sophisticated symbolism, and were made of costly imported materials.

Representation flourished in other ways too. Writing was invented, originating out of pictographic systems, and used not only for economic control but for ritual texts and literature. The image of the physical world took on new form also in maps and plans, showing the division of landed property, designs for buildings, or the shape of the cosmos. Cities became microcosms of the divine order, with temples and palaces rising in their midst, and rulers assuming the attributes of god-kings.

POLITICAL propaganda is one of the recurrent themes of art from early state societies. This mace head shows one of the first kings of Egypt ceremonially cutting an irrigation ditch, which waters a small stylized patch of four long, rectangular fields. The king wears the crown of Upper (southern) Egypt, and before his face is carved a small scorpion that is believed to represent his name or title. The king is shown as father or benefactor of the people, bringing water to the land, though in fact it was the annual Nile flood and the trapping of receding floodwater in irrigation basins that provided the basis of ancient Egyptian agriculture.

By 2500 BC farming had spread throughout most of the Old World as it was shortly to do in the New. The growing populations of the urban heartlands were sending feelers deep into their mountainous hinterlands, seeking sources of raw materials and spreading ideas as they did so. On the steppes of Eurasia, the horse was domesticated and used to pull wagons and chariots, though not yet for riding. The transformation since the end of the last Ice Age was profound and far-reaching. Human societies dominated most of the land and were rapidly clearing the remaining forests. They were also creating artworks which still today speak to us of elite power, craft skill, and religious beliefs.

THE AMERICAS 5000-500 BC

A SHIFT TO A MORE SEDENTARY, agriculturally based society, frequently associated with increasingly complex social structures, took place in parts of the Americas during this period.

NORTH AMERICA

The formation of larger and more complex social groups was probably the result of environmental changes between 4000 and 2000 BC, which led to the emergence of more varied ecosystems and wider availability of resources. Settlements were concentrated in transitional zones, where several different environments came together. Rock art was widely distributed, indicating that it was an ancient custom in the Americas.

Around 4000 BC the construction of small burial mounds began along the Mississippi River. By 3500 BC copper was being used by the 'Old Copper' culture around the Great Lakes. The burial sites of Osceola and Oconto have yielded many cold- and hot-hammered artefacts.

The first pottery in North America appeared c.2500 BC in the southeast, in South Carolina, along the lower Savannah River valley in Georgia and in coastal Florida. Evidence for the use of basketry and featherwork dates back to c.3000 BC, and is known from Lovelock Cave in western Nevada. The Northwest Microblade Tradition (c.4500 BC–AD 1000) is present in Alaska and Canada. The Arctic Small Tool tradition, established between 4000 and 1000 BC, is typified by small, finely pressure-flaked tools. Palaeo-Eskimo culture arose between 2000 and 1000 BC. It was based on the hunting of sea mammals and caribou. In the winter months,

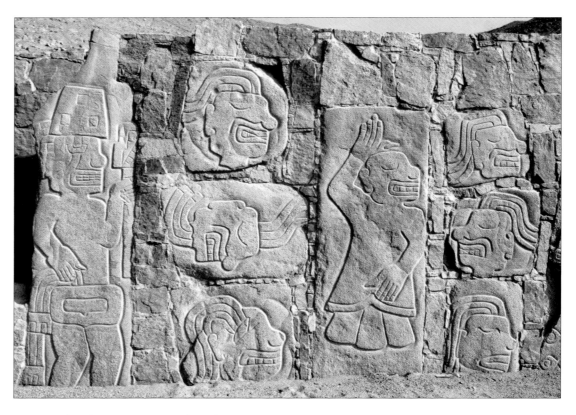

THE TEMPLE OF SECHÍN IN THE CASMA VALLEY PERU, belongs to the late Pre-Ceramic period/Initial period. The stone carvings on the outer perimeter wall depict warriors and trophy heads, with the victors and defeated being depicted wearing different clothes. The carvings have been dated to c.1290 BC. The temple is part of a large ceremonial complex comprising four sites: Sechín Alto, Taukachi-Konkán, Sechín Bajo and Cerro Sechín (illustrated here). The central structure of Cerro Sechín comprises a multi-roomed adobe structure with painted murals.

semi-sunken houses were used. In the summer a transition was made to tent-like structures.

By 1500 BC large earthworks were being constructed, such as the Poverty Point site along the banks of the Mississippi River in Louisiana. The site of Poverty Point measures c.40 hectares (104 acres). Six parallel, half-circular mounds arranged around a plaza formed the core of the site. A mixed agricultural and hunter-gathering economy was practised, with crops such as sunflower, sumpweed, goosefoot and gourd. Wide-ranging exchange networks existed, demonstrated by finds at the site of copper tools from the Great Lakes region, lead ore (galena) from Missouri and soapstone (steatite) from Alabama and Georgia.

The Woodland tradition developed throughout much of eastern North America between 1000 BC and AD 700, and was characterized by cord- and fabric-marked ceramics, incipient agriculture and the

construction of funerary mounds. The Adena culture has large burial mounds, one of the biggest being the Grave Creek. Elaborately carved stone pipes and tablets are known from the burial sites.

In the arid Southwest the Basketmaker culture developed in c.1200 BC, with sites such as Grand Gulch and Marsh Pass. Later Basketmaker culture villages were substantial, with up to 50 pit houses.

MESOAMERICA

Archaic cultures from Mesoamerica are known from the Tehuacán and Oaxaca valleys of Mexico. In the early Preclassic period (2000–1000 BC) it is possible to see transition from hunter-gathering to settled farming in Mexico and Central America. Ancestor worship, a hierarchical structure of society, forms of kingship, sedentary settlement and agriculture all first appeared during this period.

The early Preclassic period saw the rise of Olmec culture on the Tehuantepec Isthmus along the Gulf Coast. The Olmec believed that a human woman had relations with a jaguar, the resulting offspring being a form of were-jaguar. Images of beings with baby-like faces with fanged mouths and cleft foreheads occur frequently in three-dimensional Olmec art carved in jadeite, serpentine and basalt. Were-jaguars appear to have represented a rain god. The most famous examples are the basalt monumental heads, stelae and altars found at La Venta, Tres Zapotes and San Lorenzo.

THE SERPENT MOUND IN OHIO This ritual site may relate to astronomical features in Ursa Major and Ursa Minor, the Big and Little Dipper, and was probably made by the Adena Mound Builder culture some time in the first millennium BC (although recent excavators have suggested a more recent date). The Adena people left their burial mounds in the vicinity of the Serpent Mound structure. No artefacts or burials have been found in its construction fill.

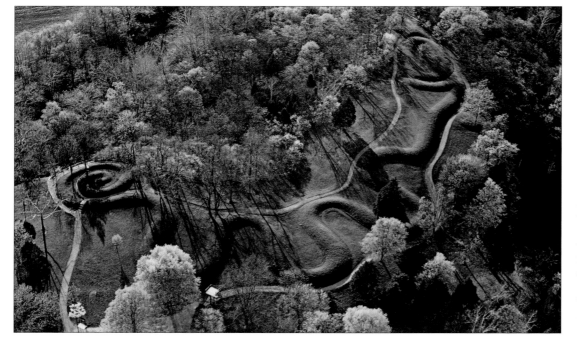

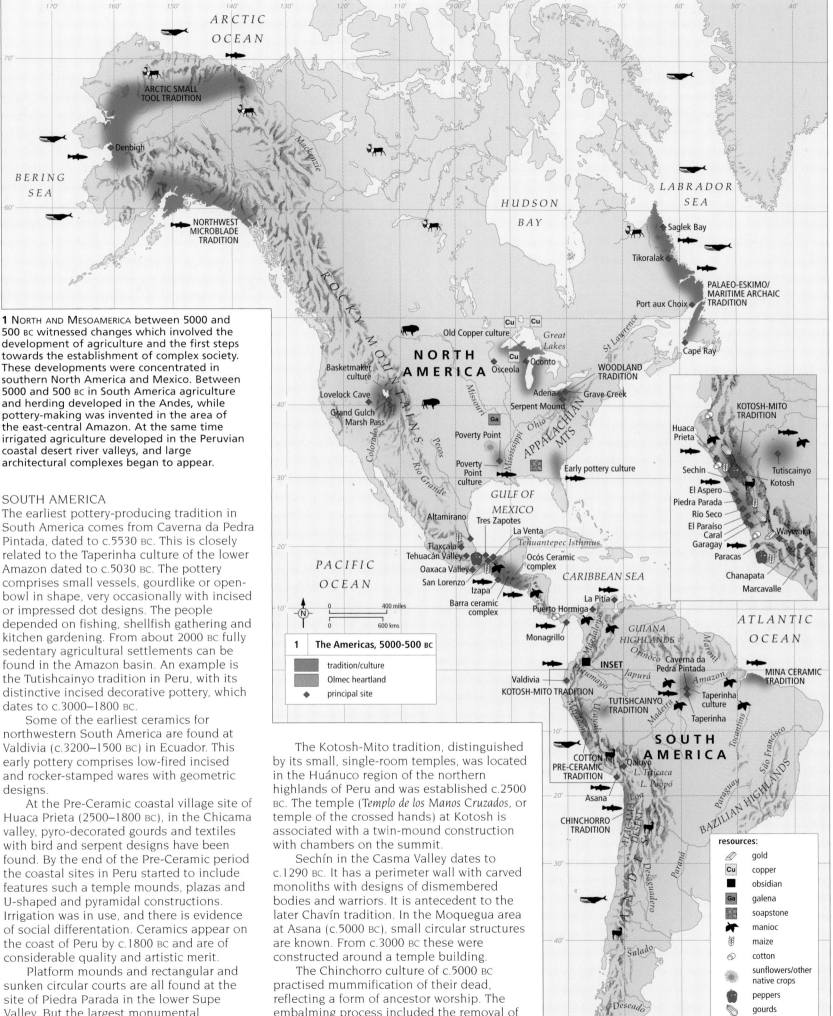

1 NORTH AND MESOAMERICA between 5000 and 500 BC witnessed changes which involved the development of agriculture and the first steps towards the establishment of complex society. These developments were concentrated in southern North America and Mexico. Between 5000 and 500 BC in South America agriculture and herding developed in the Andes, while pottery-making was invented in the area of the east-central Amazon. At the same time irrigated agriculture developed in the Peruvian coastal desert river valleys, and large architectural complexes began to appear.

SOUTH AMERICA

The earliest pottery-producing tradition in South America comes from Caverna da Pedra Pintada, dated to c.5530 BC. This is closely related to the Taperinha culture of the lower Amazon dated to c.5030 BC. The pottery comprises small vessels, gourdlike or open-bowl in shape, very occasionally with incised or impressed dot designs. The people depended on fishing, shellfish gathering and kitchen gardening. From about 2000 BC fully sedentary agricultural settlements can be found in the Amazon basin. An example is the Tutishcainyo tradition in Peru, with its distinctive incised decorative pottery, which dates to c.3000–1800 BC.

Some of the earliest ceramics for northwestern South America are found at Valdivia (c.3200–1500 BC) in Ecuador. This early pottery comprises low-fired incised and rocker-stamped wares with geometric designs.

At the Pre-Ceramic coastal village site of Huaca Prieta (2500–1800 BC), in the Chicama valley, pyro-decorated gourds and textiles with bird and serpent designs have been found. By the end of the Pre-Ceramic period the coastal sites in Peru started to include features such a temple mounds, plazas and U-shaped and pyramidal constructions. Irrigation was in use, and there is evidence of social differentiation. Ceramics appear on the coast of Peru by c.1800 BC and are of considerable quality and artistic merit.

Platform mounds and rectangular and sunken circular courts are all found at the site of Piedra Parada in the lower Supe Valley. But the largest monumental architecture is associated with the Aspero tradition, one of the first Peruvian cultural complexes to show evidence of social differentiation. Mounds served as stages for public ritualized display, for instance at El Paraíso and Río Seco.

The Kotosh-Mito tradition, distinguished by its small, single-room temples, was located in the Huánuco region of the northern highlands of Peru and was established c.2500 BC. The temple (*Templo de los Manos Cruzados*, or temple of the crossed hands) at Kotosh is associated with a twin-mound construction with chambers on the summit.

Sechín in the Casma Valley dates to c.1290 BC. It has a perimeter wall with carved monoliths with designs of dismembered bodies and warriors. It is antecedent to the later Chavín tradition. In the Moquegua area at Asana (c.5000 BC), small circular structures are known. From c.3000 BC these were constructed around a temple building.

The Chinchorro culture of c.5000 BC practised mummification of their dead, reflecting a form of ancestor worship. The embalming process included the removal of cerebral and visceral matter, skeletal bracing, padding, exterior clay and paint enhancement and addition of hair and wigs.

In Andahuaylas at Waywaka, the earliest evidence of gold-working comprises a gold-working kit with a burial, dating to c.1440 BC.

1	The Americas, 5000-500 BC
	tradition/culture
	Olmec heartland
♦	principal site

resources:
- gold
- Cu copper
- obsidian
- Ga galena
- soapstone
- manioc
- maize
- cotton
- sunflowers/other native crops
- peppers
- gourds
- camelids
- caribou
- buffalo
- fish
- sea mammals

EUROPE 7000-2500 BC

AROUND 9000 YEARS AGO the first communities in Europe to cultivate cereals and raise domestic animals appeared in Thessaly and Thrace, dependent on crops and livestock species that they had adopted from their neighbours in Anatolia. Over the succeeding millennia, the new way of life spread steadily across Europe, reaching the Rhineland before 5000 BC and becoming established in Britain and Scandinavia a millennium later.

MESOLITHIC HUNTERS

Hunter-gatherers were restricted in numbers by the availability of wild resources, and in many parts of Europe population levels may have been very low. The scattered distribution of the resources on which they relied also meant that most hunter-gatherer communities had mobile lifestyles, moving between a number of seasonal or temporary settlements and camps during the annual cycle. The exceptions were along coasts and rivers in the Danube Gorges, for example, or in Scandinavia, where rich and varied resources made permanent settlements possible.

The Mesolithic hunter-gatherers of Europe were the direct descendants of those of the last Ice Age, but as the ice sheets retreated and temperatures improved, they were able to recolonize northern latitudes and take advantage of the spread of temperate woodlands and grasslands with their plant and animal food resources. It is therefore at first sight perplexing that Mesolithic art is so rare when compared with the famous corpus of cave paintings and portable art produced during the European Upper Palaeolithic. It is likely that the Mesolithic communities of Europe were just as culturally sophisticated as any hunter-gatherers of the world, but that much of this sophistication was expressed in forms – such as song, dance, oral tradition, clothing or carving – which have not survived. In northern Europe waterlogged settlements in Scandinavia provide an insight into what may have been lost – a decorated wooden paddle, for example, was excavated at Tybrind Vig (*see* p.20). The cemetery of Olenii Ostrov in northern Russia has yielded wooden figurines and batons carved with antler heads. Perishable materials such as wood only rarely survive, however, and hunter-gatherer art in the form of rock engravings is limited to marginal areas such as the Alps and the sub-Arctic.

ART OF THE NEOLITHIC

The spread of domestic plants and animals that marked the transition to the Neolithic age of pottery and farming may have been associated with some movement of population, but it is likely that in many areas of Europe the earlier hunter-gatherers were not displaced by newcomers but actually chose to adopt the new way of life. The transition was both economic and conceptual. An important new distinction had been introduced between the wild and domestic. Human societies began to alter and control their living environment in unprecedented ways. This included the clearance of forest (at first on only a small scale) to grow cereals, and the creation of more permanent settlements. In the southeast these took the form of villages of mud-brick houses, built and rebuilt in the same place to form settlement mounds or 'tells'. Associated with these were figurines, mostly made with the new technology of ceramics. The fact that a large proportion of these figurines are female, and relatively few are clearly male, has led many to interpret them as evidence of a fertility cult, related perhaps to the new concern with the fertility of crops. Some have gone even further, and argued that these figurines represent a cult of female divinities at a time when southeast European societies were predominantly matriarchal in character.

Further west, the impact of the new way of life had a different character, with settlements remaining small and scattered. Above all, a changed view of landscape was revealed through the construction of monuments. These included structures incorporating large and sometimes massive stones (hence

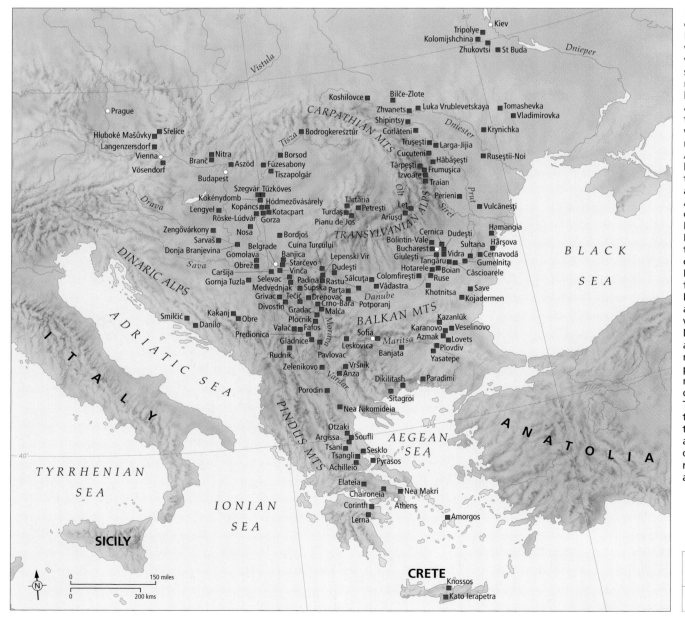

1 THE EARLIEST FARMING communities of southeast Europe had much in common with their neighbours in western Asia. Their settlements of up to 50 or more rectangular mud-brick houses grew to form tells, and some of the houses themselves were decorated with painted designs and modelled clay mouldings. A certain unity of background is provided by the fired clay figurines which again can be paralleled in Anatolia, but are not common at this period in Europe north of the Danube. In conventional terminology, these first farming communities of south-east Europe mark the transition from the foregoing Mesolithic period of hunters and gatherers, who relied on wild resources, to the Neolithic period with pottery and farming. Europe was by no means a unity at this period, and was indeed marked as much by differences as by similarities. These differences show themselves in the way that the new domesticates spread and were adopted, and the changes in settlement and material culture that accompanied them.

1	Early Farming Settlements in Southeast Europe
■	early farming settlements

'megalithic'), which were arranged in rows or circles, or as elements in a chambered tomb. Among the most famous of these chambered tombs are those of Brittany and Ireland, which are decorated with carved motifs. The Irish tombs such as Knowth and Newgrange in the Boyne Valley have elaborate spirals, zigzags and lozenges; those of Brittany include an early group showing animals and axes, and an enigmatic series of carved anthropomorphic images which are sometimes interpreted as evidence of a 'mother goddess' cult. Painted motifs occur in the megalithic tombs of western Iberia – spirals and zigzags similar to those of 'megalithic' art are also found on rock surfaces where they marked out places of special significance in the landscape.

The abstract art of Neolithic western Europe has been related to images of trance and hallucination, which may have been features of the rituals practised at this period. The identification of a mother goddess cult in some of the other motifs (which do include pairs of carved breasts on the walls of megalithic tombs) is, however, very difficult to evaluate. The same is true of claims for a mother goddess cult and a matriarchal society in southeast Europe at this early period – it has been postulated that this ideology of peace was subsequently ended by the rise to dominance of male power. There is evidence enough of violence and warfare in European society from earliest times, however, and the figurines themselves (not all of them female in any case) may have represented living individuals or ancestors as easily as divinities. Nevertheless, they do, along with megalithic art, constitute the two most widespread and longest-lasting artistic traditions of Neolithic Europe.

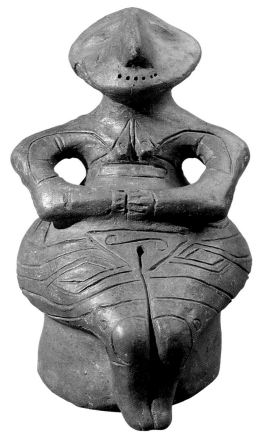

MOST OF THE EARLY FIGURINES of Neolithic southeastern Europe were moulded from clay which was then fired in a kiln. This technology was also used for making ceramics, which was also adopted by these communities at this period. Ceramics and figurines alike were decorated with painted and engraved designs, some of which may mimic patterns that were used in the textiles or clothing of the period. Loss of the less durable remains has, however, deprived us of probably the bulk of the art produced by these early European communities.

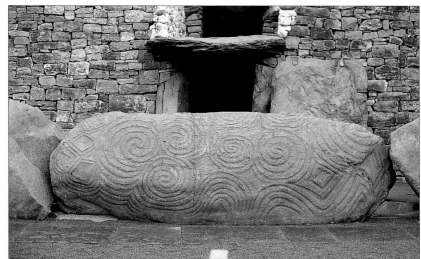

THE ENTRANCE STONE at Newgrange, a chambered tomb in the Boyne Valley of eastern Ireland, provides one of the finest examples of what has come to be called 'megalithic art'. The distribution of similar motifs, from Orkney to Iberia, illustrates the links (no doubt by sea) which connected these otherwise diverse areas of Atlantic Europe in the fifth and fourth millennia BC.

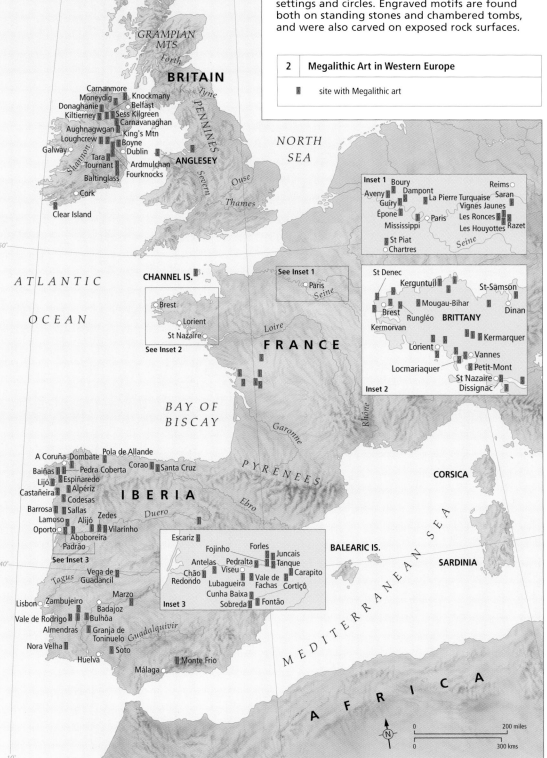

2 MEGALITHIC MONUMENTS were built in several areas of Atlantic Europe during the fifth millennium BC. They range from chambered tombs, of stone or timber construction covered by a mound, to simple upright stones (menhirs) and elaborate stone settings and circles. Engraved motifs are found both on standing stones and chambered tombs, and were also carved on exposed rock surfaces.

2	Megalithic Art in Western Europe
▮	site with Megalithic art

EUROPE 2500-500 BC

THE PERIOD 2500 to 800 BC is conventionally known as the European Bronze Age and was marked by the introduction of weapons and ornaments made of the new material. Bronze itself is an alloy of two metals: copper and tin, in proportions of approximately 90 percent copper and 10 percent tin. This produced a harder and more useful material than copper alone.

LONG-DISTANCE TRADE
The adoption of bronze led to a new traffic in raw materials across Europe. Long-distance transport had been a feature of earlier millennia, when especially prized varieties of flint or hard stone had travelled hundreds of kilometres from their sources. Jadeite from the western Alps, for example, was used for the manufacture of prestigious polished stone axes as far afield as Scotland and southern Scandinavia. Copper sources were much less abundant than hard stone, however, and were concentrated mainly in the Alps and the Carpathians, and in parts of the Atlantic seaboard, notably Britain, Ireland and Iberia. If copper sources were far from widespread, necessitating trade and exchange, the other vital ingredient of bronze – tin – was even rarer. The principal European tin sources exploited in prehistory were in northern Bohemia and the Atlantic seaboard: Brittany, Galicia and south-west Britain. The demand for

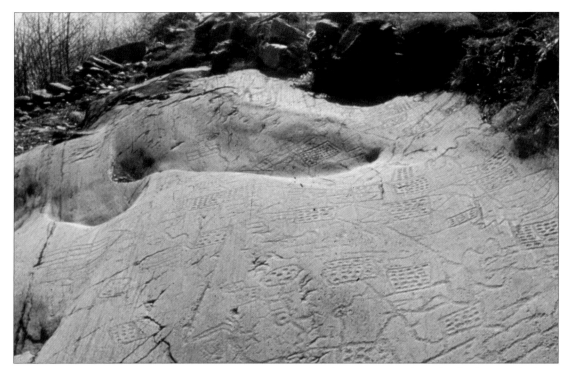

THE BEDOLINA ROCK CARVING is one of the most complex of the many rock art panels found in the Valcamonica region of northern Italy. The shapes of the interlinked motifs and the fact that the carving looks out across a landscape has suggested that it may be a kind of map. The enclosures (mostly rectangular) might indicate fields, and the spots within them may even be individual trees. The lines linking the 'fields' could be trackways or canals, or simply property boundaries. Against this theory, however, must be laid the recognition that we do not know what the scene represents, or if it is indeed intended to be a portrayal of the landscape.

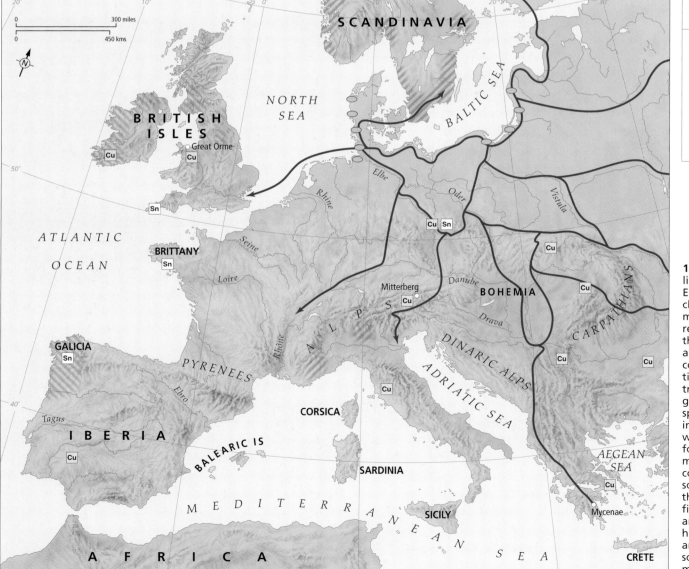

| 1 | Rock Art and Raw Materials, 2000-800 BC |

area of mainly abstract rock art

area of mainly figurative rock art

Cu major source of copper

Sn major source of tin

major source of amber

→ amber trade route

1 LONG-DISTANCE connections linking different areas of Europe became increasingly clear during the second millennium BC and are reflected in similarities in the forms of bronze artefacts across the continent. At the same time, important local traditions emerged which gave certain regions a special character. These include rock art traditions, which in Atlantic Europe focused mainly on abstract motifs (cup-marks and concentric circles). In southern Scandinavia and the Alpine region rich figurative traditions of rock art emerged, depicting humans, animals and artefacts, sometimes in scenes which may represent myths or ritual enactments.

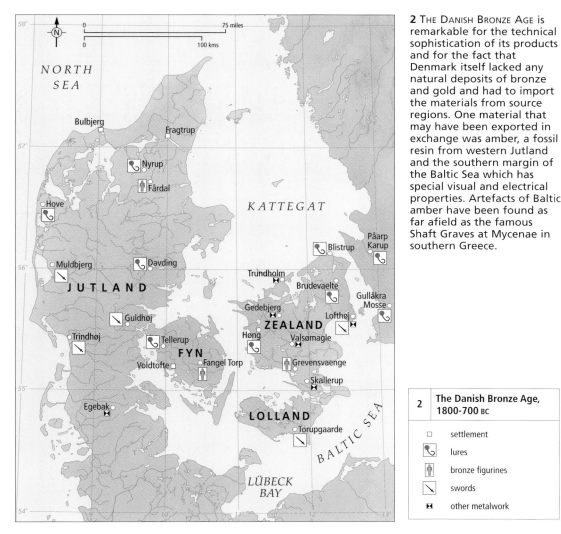

2 THE DANISH BRONZE AGE is remarkable for the technical sophistication of its products and for the fact that Denmark itself lacked any natural deposits of bronze and gold and had to import the materials from source regions. One material that may have been exported in exchange was amber, a fossil resin from western Jutland and the southern margin of the Baltic Sea which has special visual and electrical properties. Artefacts of Baltic amber have been found as far afield as the famous Shaft Graves at Mycenae in southern Greece.

2	**The Danish Bronze Age, 1800-700** BC
□	settlement
🪗	lures
🧍	bronze figurines
╲	swords
⋈	other metalwork

THE RISE OF SOCIAL HIERARCHIES

Fortified or defended settlements indicate a rise in inter-group hostility promoted perhaps by growing ethnic awareness and by a general rise in population density. In western and northern Europe, the appearance of field systems towards the end of the second millennium is another sign of social change, with rights to land now more clearly defined and demarcated. The trend towards the development of more complex societies finds its most extreme expression in the Aegean region, where the first European states emerge in Mycenean Greece and Minoan Crete, with palaces, scripts and a warrior aristocracy subsequently immortalized in the works of Homer. The existence of similar warrior elites is suggested by the appearance of bronze shields, helmets and breastplates across many parts of Europe in the late second millennium BC, coupled with heavier and more effective bronze swords.

Social complexity and the rise of elites was mirrored in the development of an increasingly rich iconography, most clearly seen at the northern and southern extremities of central Europe: in the rock-art traditions of the Alps and southern Scandinavia, and in the elaborate ritual metalwork of Sardinia and the Danish Bronze Age. These traditions continued into the first millennium BC, but changes during the eighth and seventh centuries BC mark a new stage in European prehistory.

By the sixth century BC, a string of 'princely' centres had emerged across central Europe, from Burgundy to Bohemia, marked by hilltop enclosures, richly furnished burial mounds and evidence of contact with the Mediterranean world in the form of Greek and Etruscan imports. By this period, the Mediterranean was fringed by Greek, Etruscan and Carthaginian cities and colonies, and a history of interactions between the Mediterranean and temperate Europe was beginning that was to culminate in the expansion of the Roman empire half a millennium later.

tin from limited and distant sources set up a series of networks across Europe, along which other prized materials such as Baltic amber also circulated. The result was a certain 'international' character to the metalwork traditions of the European Bronze Age, where similar forms are found across wide areas.

THE NEW METALLURGY

Polished stone axes were finely crafted objects, demanding many hours of intensive shaping and polishing to produce the prized end-product. The transformation of the original raw material that they represented, however, was significantly less dramatic than the process of metallurgy, especially where that involved the smelting of metal from the ores and its subsequent casting to produce the desired forms. This demanded new and rather mysterious knowledge, and an entirely new range of technological skills. Large-scale mining for copper was undertaken in some places, such as Great Orme in north Wales and the Mitterberg in the Austrian Alps, where complex systems of shafts and galleries date back to the second millennium BC. The presence of bronze-working tools in a number of third-millennium elite graves in northwest Europe suggests that the possession not only of metal objects but of metallurgical skills themselves may have conferred special status.

It is probably a mistake, however, to characterize this entire period by the use of bronze, since metals were only one of a broad range of indicators reflecting new developments in social and economic life during the second millennium BC. The development of metallurgy was not itself an accidental discovery, and it had been known since the sixth millennium BC in parts of southern Europe and the Near East. Its rapid spread during the late third millennium was as

much to do with social change as technological need, a fact which is brought home by the contexts in which metal objects are found and the character of the objects themselves: daggers, axes, spearheads and ornaments, the latter fashioned in gold as well as bronze. It was only after 1300 BC that bronze was available in sufficient quantity to make a more general impact on European economy. Much more significant were the changes in individual status marked by the appearance of richly furnished graves in several regions of western and central Europe around 2000 BC, then by the widespread adoption of cremation in urnfields six or seven centuries later.

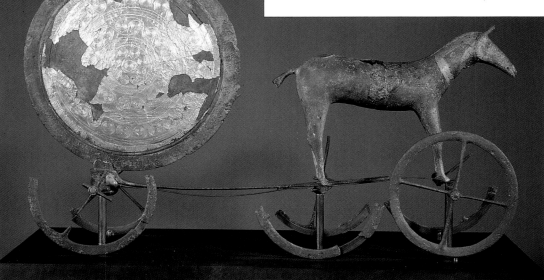

THE BRONZE SUN CHARIOT, found at Trundholm on Zealand in 1902, is among the most elaborate and most clearly symbolic of the products of the Danish Bronze Age. The object was discovered in a bog, were it may have been placed as a ritual offering in around 1650 BC. It represents a bronze disk mounted on four wheels and pulled by a single horse. One face of the disk was covered with a gold sheet, perhaps to represent day, while the other face may indicate night. The chariot may illustrate some kind of solar or astronomical myth or be a miniature depiction of full-sized solar carts that were used in Danish rituals at this period.

THE AEGEAN 2000-1000 BC

THE EASTERN Mediterranean in this millennium formed a 'seascape', rather than a landscape, with major sites on its islands and along its coasts, dominated by the inland powers of Anatolia, Mesopotamia and Egypt. In the Aegean, the emergence of a distinctive culture, called 'Minoan' after the legendary king Minos, on the island of Crete, is marked by the construction around 2000 BC of palaces inspired by eastern Mediterranean prototypes, with a literate bureaucracy using a script of local adaptation.

AEGEAN PALACE CULTURE

Minoan styles of material culture were prevalent in the Aegean islands in the first half of the second millennium as local elites actively appropriated them, or as the Minoans themselves colonized them, as they did, for example, on the island of Kythera. The volcanic eruption of Thera, while too early to have been directly responsible for the destruction of the Minoan palaces in the fifteenth century BC, nevertheless disrupted Aegean communication routes and must have had a significant psychological effect.

These disruptions may have facilitated a shift of political influence in the Aegean from Crete to southern mainland Greece by about 1400 BC,

where a second palatial culture, called 'Mycenaean' after the prominent site of Mycenae, had emerged. The mid-second millennium societies on the Greek mainland appropriated and adapted Minoan styles and, like their Minoan counterparts, maintained bureaucratic records, but in a script called Linear B that recorded the Greek language.

In about 1200 BC political collapse in the eastern Mediterranean – especially the fall of the Hittite empire and the contraction of Egyptian power – ended this widespread palace-based culture. Symptomatic of this turmoil was the destruction of sites, both in the Aegean and the eastern Mediterranean, notably Ugarit. Egyptian texts refer to an ill-defined group called the 'peoples of the sea' who threatened Egypt and may have included Aegean peoples. It may also

be relevant to this picture of turmoil that Cyprus became a predominantly Greek-speaking island by the early first millennium. After 1200 BC, with some short-lived exceptions like Tiryns and Perati, a 'Dark Age' characterized by the absence of major artistic production ensues.

MATERIALS AND EXCHANGE

Locally available materials were used in the Aegean to create monumental architectural forms such as palaces and other elite structures

A WALL PAINTING IN FRESCO TECHNIQUE from a house (Xeste 3) at Akrotiri on Thera is one of a number preserved by a volcanic eruption in the later seventeenth century BC. It depicts three female figures, close to life-size, in an outdoor scene. Typically naturalistic, the figures' ages are distinguished by hairstyle and body form.

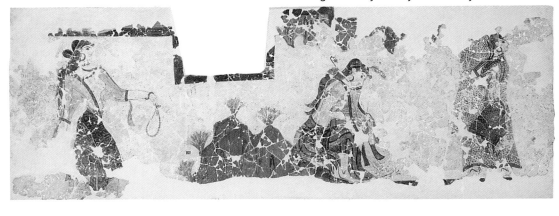

1 AEGEAN-STYLE FRESCOES in Egypt, Syria and Israel and the broad distribution of Mycenaean ceramics document the involvement of the Aegean in eastern Mediterranean exchange networks. First Minoan Crete, then, by the second half of the second millennium, southern mainland Greece participated in maritime exchange routes that ultimately extended from Sardinia to Cyprus, Syro-Palestine and Egypt. Exotic raw materials and manufactured objects travelled along them.

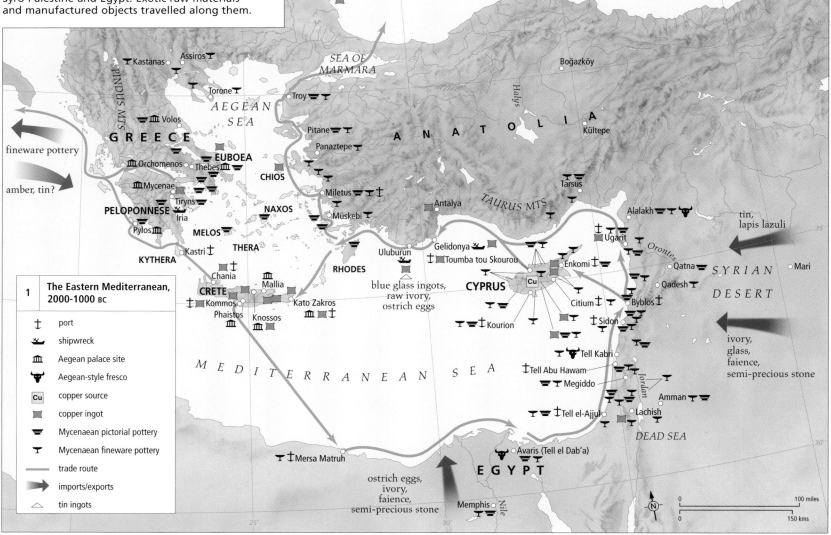

1 The Eastern Mediterranean, 2000-1000 BC

- ‡ port
- ⚓ shipwreck
- 🏛 Aegean palace site
- 🐂 Aegean-style fresco
- Cu copper source
- ▪ copper ingot
- ⊤ Mycenaean pictorial pottery
- ⊤ Mycenaean fineware pottery
- — trade route
- ➤ imports/exports
- △ tin ingots

2 THE MINOAN PALACES dominated the Aegean politically in the first half of the second millennium BC. Their artistic styles were widely emulated. After the eruption of Thera in the later seventeenth century BC and the destruction of most Minoan palaces in the mid-fifteenth century BC, the palaces of southern mainland Greece became politically dominant. Around 1200 BC most palatial centres in the Aegean were destroyed.

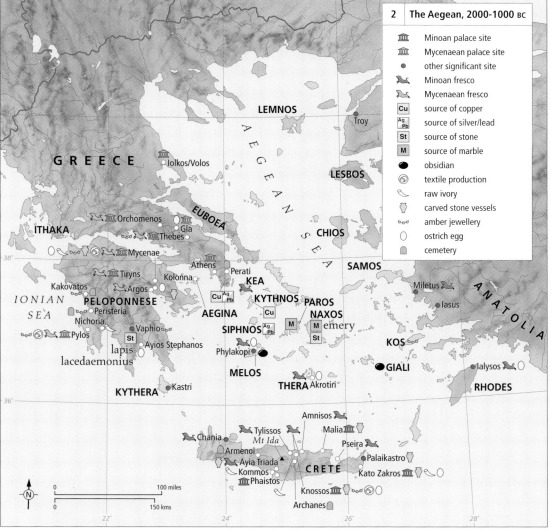

and the paintings that often adorned their walls and floors. Minor works also used indigenous materials – stone vessels (some of them carved with relief scenes); jewellery, including seal stones used in administration, many with figured scenes; fineware ceramics, a widespread class of material. Archaeologically invisible, but attested in Linear B documents of the fourteenth and thirteenth centuries BC, were highly crafted textiles, while metals were also used to produce elaborate objects, such as weapons, vessels and jewellery.

Although there were silver, lead and copper sources in the Aegean, Cyprus became an increasingly important copper source in the later second millennium, its copper transported from eastern Mediterranean shores as far as Sardinia in characteristic oxhide-shaped ingots. On the

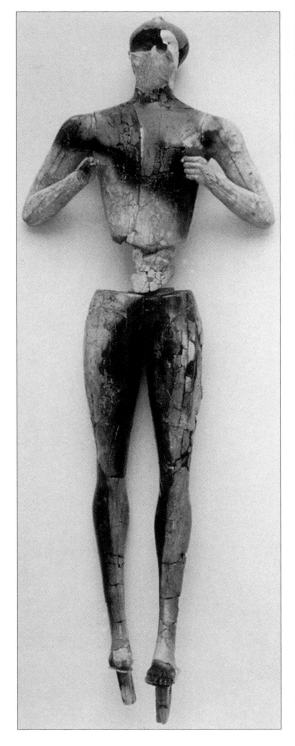

STATUETTE OF A MALE YOUTH, one-third life-size, constructed from multiple pieces of hippopotamus ivory, with added details in serpentine and gold. Remarkable for its detailed carving of muscles and veins and the hairstyle indicating age, it reflects the Minoan enthusiasm for depicting youthful vigour. Probably displayed in a shrine, the statuette was deliberately smashed during a destruction at Palaikastro, Crete in the mid-fifteenth century BC.

other hand, tin, a regular ingredient in bronze by the second millennium, was absent from the Aegean and could only be acquired through long-distance exchange (although a source in the Taurus Mountains may have been exploited in the second millennium).

Along such exchange routes monopolized by the palatial elites also travelled exotic raw materials – ivory, ostrich eggs, glass, precious stones, including Baltic amber and lapis lazuli – transformed by Aegean craftspeople. Manufactured items travelled as well – high-value objects in materials like faience – and, more abundantly, pottery containers.

Although other archaeologically invisible craft works were exchanged, it is the indestructible fineware ceramics – both exchange items and containers for perfumed oil and wine – that signal the extent of Minoan and Mycenaean exchange links throughout the central and eastern Mediterranean. The Uluburun wreck contained many of these materials and offers a vivid insight into eastern Mediterranean exchange in progress in about 1300 BC.

ARTISTIC PRODUCTION AND CONSUMPTION
'Art for art's sake' is an anachronistic concept in relation to eastern Mediterranean artistic production. In the Aegean, monumental art functioned to support and project elite power and ideology, while minor works echoed the

iconography of monumental works and circulated among a wider elite group, frequently finding their way into tombs to accompany the dead, particularly in the Mycenaean period.

Both Minoan and Mycenaean palaces were architecturally complex, and their interior walls and some floors were often decorated with paintings on plaster, many in true fresco technique, while palace-sponsored workshops produced portable art works using both local and exotic materials. Many of the art works produced in the Aegean owed their inspiration to exotic models (chiefly Egyptian and Mesopotamian), but took on local characteristics and circulated within the Aegean region. The wider elite emulated palatial architecture and its decoration and, ironically, our best examples of Minoan-style frescoes were not preserved on Crete, but in Akrotiri on Thera. They include depictions of humans engaged in ritual, of landscapes with wildlife, and, probably, of narrative, notably the famous miniature fresco from the West House depicting a 'seascape'.

Despite the association of large-scale art with the palaces, in the Aegean there is no explicit iconography of rulers and life-size sculpture is virtually unknown (other than the well-known Lion Gate at Mycenae). Nevertheless, Minoan artists frequently represented the human figure, not only in frescoes, but also in small-scale sculpture in ivory, bronze or clay. Such representations are often associated with sanctuaries in Minoan Crete. Ceramic production, by contrast, was not a palatial monopoly, although the palaces were major consumers of fineware. Many fineware ceramics imitated metal vessels in form and decoration, reflecting the high value of metals and the tendency for non-palatial artists to imitate palatial styles in more accessible materials.

THE MEDITERRANEAN 1000-500 BC

THE BEGINNING OF the first millennium BC saw, in much of the Mediterranean world, a profound break with its Bronze Age past. In some places, such as Greece, there was to be a flowering of the arts which owed virtually nothing to the past. The eastern shores of the inland sea were under threat from Assyria to the east and Egypt to the south. Even so, Phoenicia was growing in influence and was responsible for the design of Solomon's temple in Jerusalem, a model for later sacred buildings. Cyprus was emerging as an important meeting point of east and west, and by the eighth century Greeks were probing eastern shores, in Syria.

In Italy and Spain, successors to Bronze Age societies were modest in their arts. The Villanovans in Italy, ancestral to the Etruscans, practised unambitious metalwork related mainly to European crafts. In Sardinia until the eighth century the 'Nuraghic' culture produced more sophisticated bronze figures. In Spain, Iberian art was centred on the silver-bearing areas of the south, and waited for trade with the east before developing a distinctive 'Tartessian' style.

All were to be reawakened by events that added the arts of the Near East to the more mannered 'geometric' arts of ninth- and eighth-century Greece. The Greeks then mediated this orientalizing mood to the rest of

1 COLONIZING THE MEDITERRANEAN FROM THE EAST The flow of people and ideas begins in the eighth century. Colonists from Greece and Phoenicia move west, often along shared routes, but the two cultures create definable spheres of influence. A second phase of consolidation north and south follows in the sixth century – mainly by Greeks – in the Black Sea, France and Libya. Winds and currents promote circulation, allowing different routes to be used on outward and return voyages, ensuring varied contacts and facilitating strong links with the homelands. Northerlies take Greeks traders directly to Egypt. They return by the Levant, making these areas a main influence on the arts.

ATHENIAN BLACK FIGURE VASE – a mid-sixth century jug by Amasis, showing Perseus decapitating Medusa in a popular myth. This is a typical example of thousands exported around the Greek world and beyond. It was found in an Etruscan grave.

the Mediterranean world through vigorous colonization, side by side with equally vigorous trading and settlement by Phoenicians, who carried their own brand of eastern, mainly Egyptianizing, arts.

ORIENTALIZING AND COLONIZING
Greek interest in the east grew by way of a settlement they made on the Syrian coast (Al Mina) and the reciprocal interest shown by easterners in the major cities of central Greece and Crete. It persuaded Greek artisans to develop totally new decorative styles. These are mainly two-dimensional, best studied in vase painting. More realistic figure scenes, with greater detail defining the identity of actors and sometimes helped by inscriptions (the alphabet had just been learnt from the east), soon led to the creation of a lively narrative idiom. To this was added a range of eastern animal and floral motifs which all but overwhelmed Greek geometric styles, with their stick figures and maeander patterns.

By the mid-eighth century, the Greek need for land and other material resources led to a busy period of colonization in southern Italy and eastern Sicily, the foundation of new cities and the introduction through them of the new orientalizing styles to neighbouring peoples. The Greeks colonized the long-familiar shores that were nearest to them.

At the same time, Phoenicians also moved west, through Greek waters and now no longer in competition with Greeks. They moved to shores beyond the main Greek colonizing area – to Sardinia, Spain and North Africa (Carthage). In Spain they stimulated local

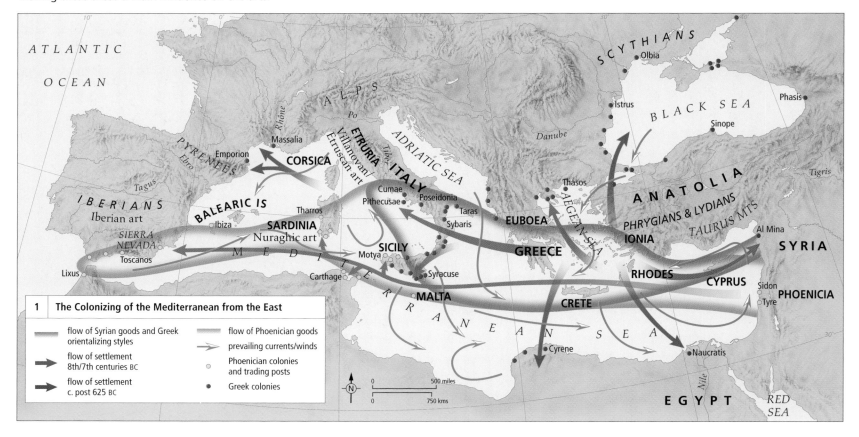

1	The Colonizing of the Mediterranean from the East

flow of Syrian goods and Greek orientalizing styles

flow of Phoenician goods

flow of settlement 8th/7th centuries BC

prevailing currents/winds

flow of settlement c. post 625 BC

Phoenician colonies and trading posts

Greek colonies

2 MAJOR ARTS IN GREECE Development of the monumental arts – sculpture and architecture – depends in part of the availability of satisfactory marble, but also on other material resources, and on local politics. Figurative vase painting and metalwork were sophisticated crafts which reveal much about life, myth and interaction between Greeks and non-Greeks. Some cities – notably Corinth and Athens – were major exporters.

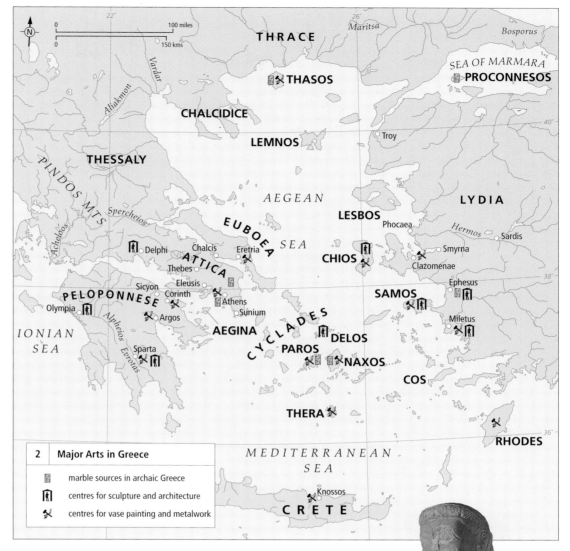

Iberian arts to a more monumental expression of native crafts.

Here, too, some Greeks were active, as also later in the south of France, whence elements of Greek archaic art were carried up into Europe, and had their effect, superficially, on what is generally regarded as early Celtic art. In their Black Sea colonies the Greeks made luxury objects in Greek style – but of local shape – for the Scythians, whose art style was quite different – that of the eastern nomads. In Italy the most important people affected by the newcomers were the Etruscans, a rich and warlike people who were ready buyers of the more sophisticated arts coming from the east. Their luxury arts were much influenced by Phoenician art, while humbler crafts were more Greek – and these won the day, so that by the end of the sixth century Etruscan art looks like a highly idiosyncratic derivative of archaic Greek. This was an art shared by early Rome.

MONUMENTAL ART

By 500 BC Greek artists were well on their way to the idealized realism that characterizes the full classical style, while they had already established orders of monumental architecture that are still copied today. Orientalizing sculpture of the seventh century had been small in scale and generally of soft stone or hammered bronze ('sphyrelaton'), much influenced by Syria. Crete was a major centre.

In the later seventh century the establishment of a trading town in Egypt (Naucratis) opened Greek eyes to the possibilities of colossal sculpture executed in hard stone. This, for Greeks, meant the white marble so accessible in the Cyclades islands, where the earliest studios were located. It was soon augmented by other sources, notably the Pentelic marble of Attica. They also had an advantage in using tools that were virtually of steel, whereas the Egyptians still worked stone by abrasion.

Another major source of influence was Anatolia, where the sculpture and architecture owed much to the example of Mesopotamia, as well as the domination, often beneficial, of rich Lydian kings (such as Croesus). The Greek Ionians embarked on major architectural projects and introduced influential new sculptural modes. By the end of our period the Persian empire had expanded to embrace all the eastern shores of the Mediterranean, but the new masters learned more than they imposed on their Greek, Levantine and Egyptian subjects.

The characteristic figures are standing male nudes (*kouroi*), which look more Egyptian than they in fact are. On them anatomical patterns were devised which gradually conformed more to live forms. Their female counterparts, *korai*, have elaborately patterned, pleated dress which is also designed to reveal the forms of the body beneath, unlike such figures in eastern art.

Meanwhile, relief sculpture, often now applied to buildings, developed narrative themes more familiar to us from the vase painting of the day, especially the 'black figure' incised scenes on vases. They came from

Corinth and Athens, but also from many other centres, including wealthy colonies that responded to all the artistic innovations. Greek formulaic presentation of narrative, developed in the archaic period, was to be the mode for much of Western art thereafter. The vases travelled the whole Mediterranean and beyond, from Germany to Upper Egypt, from Morocco to the Caucasus. Through their sheer numbers they proved important messengers of Greek narrative styles to non-Greek peoples. In this respect they were no less influential than the more prestigious metalwork, which was also coveted but was less informative.

In mainland Greece the Doric order of architecture was devised before 600 BC, a stone translation of wooden forms. The temples are rectangular in plan, with a peristyle of columns, a porch, and a main room to house the cult statue. Altars stood outside. In eastern Greece (Ionia) the more ornate Ionic order developed, based on orientalizing patterns more familiar in furniture. The orders also spread through the colonial world and beyond, the western colonies being adept at combinations of the orders not admitted in the homeland. Eastern arts had no effect on this development and the temple plans were traditional.

The transmuted orientalizing arts of Greece, developed in this period, were to be returned in their new forms to their lands of origin in the following centuries.

KOUROS DEDICATION in white marble – 3 metres (10 ft) high – from an early sixth-century temple to Poseidon at Sunium in Attica. The pose looks Egyptian but is freer since the figure balances on both feet where Egyptian stone figures of this size stand as against a back pillar. The anatomy is strongly patterned, but barely realistic, and the figure is four-square with as yet no sense of volume. Details would have been picked out in paint. Similar figures also served as tomb markers.

AFRICA 5000-500 BC

THE EARLIEST EVIDENCE of artistic activity in Africa can be seen in rock engravings and rock paintings, which are located mainly in the Sahara and in South and East Africa – those parts of the continent where suitable rock faces are located.

Scenes illustrated on rock faces frequently depict animals both wild and, in later times, domesticated. It is difficult to date these works of art, but by 5000 BC they were widespread, and some may be much earlier – examples in Namibia are dated to as early as 25,000 BC.

Apart from pottery remains dating from as long ago as 3000 BC, there is no evidence of visual culture preserved in West and Central Africa before 500 BC. Rock art is all we have from southern Africa for this period.

AGRICUTURAL LIFE IN THE SAHARA
Rock paintings and rock engravings from North and East Africa that date from 5000 BC to 500 BC are significant in that they show the development of herding at about the same time as archaeological excavations in the

eastern Sahara reveal that cereal crops were being cultivated at several sites in what is now desert, but then had plentiful rainfall – for example, Nabta Playa. Large numbers of grindstones provide good evidence for the use of cereals. It is not certain at what point farmers were able to grow domesticated cereal crops to replace the collecting of wild grains, but by 5000 BC it seems that this important advance had been made.

The earliest pottery known in Africa is from a site at Khartoum, where it can be dated to

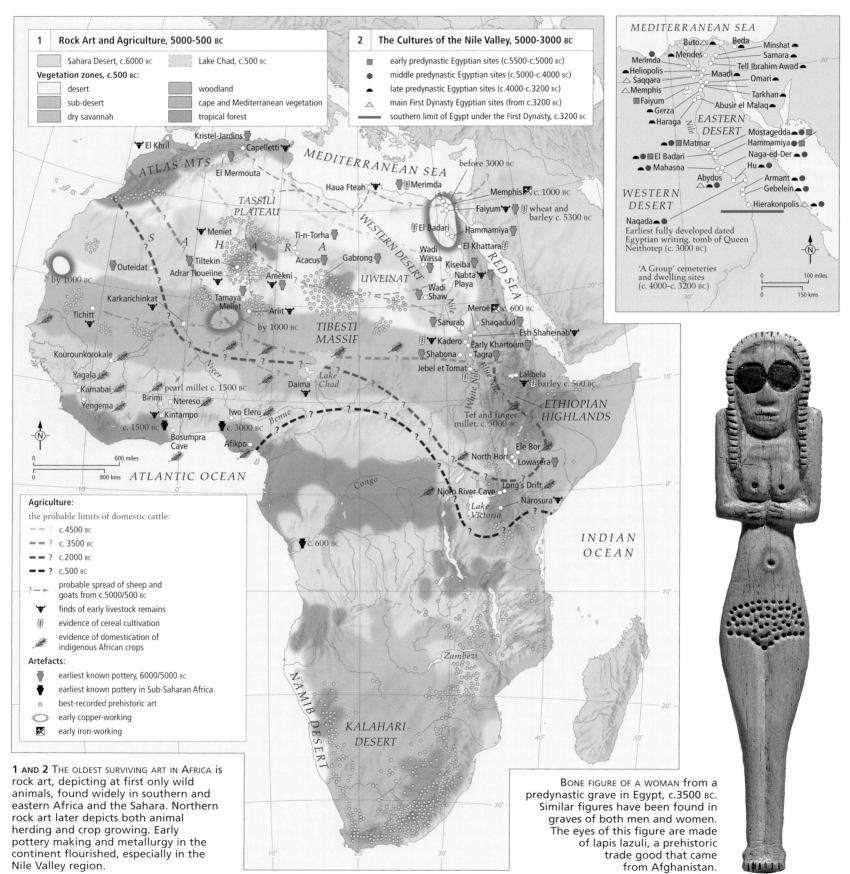

1 Rock Art and Agriculture, 5000-500 BC

Sahara Desert, c.6000 BC Lake Chad, c.500 BC

Vegetation zones, c.500 BC:
- desert
- sub-desert
- dry savannah
- woodland
- cape and Mediterranean vegetation
- tropical forest

2 The Cultures of the Nile Valley, 5000-3000 BC
- early predynastic Egyptian sites (c.5500-c.5000 BC)
- middle predynastic Egyptian sites (c.5000-c.4000 BC)
- late predynastic Egyptian sites (c.4000-c.3200 BC)
- main First Dynasty Egyptian sites (from c.3200 BC)
- southern limit of Egypt under the First Dynasty, c.3200 BC

Earliest fully developed dated Egyptian writing, tomb of Queen Neithotep (c. 3000 BC)

'A Group' cemeteries and dwelling sites (c. 4000-c. 3200 BC)

Agriculture:
the probable limits of domestic cattle:
- ? c.4500 BC
- c. 3500 BC
- c.2000 BC
- c. 500 BC
- ? — probable spread of sheep and goats from c.5000/500 BC
- finds of early livestock remains
- evidence of cereal cultivation
- evidence of domestication of indigenous African crops

Artefacts:
- earliest known pottery, 6000/5000 BC
- earliest known pottery in Sub-Saharan Africa
- best-recorded prehistoric art
- early copper-working
- early iron-working

1 AND 2 THE OLDEST SURVIVING ART IN AFRICA is rock art, depicting at first only wild animals, found widely in southern and eastern Africa and the Sahara. Northern rock art later depicts both animal herding and crop growing. Early pottery making and metallurgy in the continent flourished, especially in the Nile Valley region.

BONE FIGURE OF A WOMAN from a predynastic grave in Egypt, c.3500 BC. Similar figures have been found in graves of both men and women. The eyes of this figure are made of lapis lazuli, a prehistoric trade good that came from Afghanistan.

about 5000 BC. Potshards decorated with a distinctive wavy line pattern are found here and at many other sites in the Sahara. In addition, there have also been finds of a distinctive type of bone harpoon (freshwater fishing was then a mainstay of life in what is now desert) and other items which suggest that a similar level of cultural development extended from the Sudanese Nile Valley across much of the Sahara.

EARLY EGYPTIAN CULTURE

From this time on there was a rather rapid development of cultures along the Nile, both in Egypt and the Sudan. In Egypt the earliest village cultures were found on the edge of the Faiyum and at Merimda on the west edge of the Nile delta. Soon after there were settlements at many places along the Nile. The site at Naqada in Middle Egypt has given its name to the main culture of this period. From about this time there is much evidence of decorated, painted pottery of varying styles, mostly found in burials, and some other artistic items such as female figures frequently made of bone, or sometimes ivory or limestone. From this period there is evidence of village settlements, or even small town settlements. At Hierakonpolis in Upper (southern) Egypt there was a town which may have had as many as 5000 inhabitants.

The beginning of an organized state can be seen during this period. Writing, which made administering the state possible, is known from short inscriptions on large slate palettes, which record the activities of early rulers. By about 3000 BC writing was sufficiently developed to meet the needs of the single state that had by then united Upper and Lower Egypt into one kingdom.

CULTURES OF THE SOUTHERN NILE

Further south, upstream of the First Cataract of the Nile, the situation was rather different, and the cultural remains there can be distinguished from those of Egypt. From about 4000 BC to about 3200 BC the first settled food-producing societies, known as the 'A Group', were occupying the Nile banks between the First and the Second Cataracts, living in mud houses of some size. They had a distinctive pottery style. Wheat and barley were cultivated, while fishing and hunting added variety to the diet.

The 'A Group' were followed in the middle of third millennium by a different culture, known as the 'C Group'. They are distinguished by quite different pottery styles and by evidence from buildings and tombs of a more advanced lifestyle. The presence of imported Egyptian goods in graves reveal contacts with Egypt, and the great number of graves implies an increase in population.

KERMA CULTURE

The Egyptians had entered Nubia and established a series of forts as far south as Semna from about 2000 BC, but withdrew a few hundred years later at the time of a spectacular development of an independent Sudanese culture based at Kerma, the first large town on the upper Nile. The Kerma culture is renowned for its new and spectacular developments in pottery styles, in weapons and in elaborate burials, as well as the building of very large mud-brick structures.

It is not clear what happened in the final stages of the Kerma civilization, but after c.1500 BC the Egyptians once again entered and conquered the northern Sudan (Nubia) and eventually occupied it as far south as the Fourth Cataract, building temples and towns at many places. The furthest upriver they reached was Napata, where a prominent hill, Jebel Barkal, marked a site considered to be especially holy.

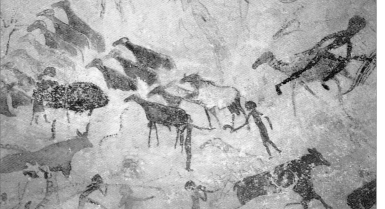

ROCK PAINTING, c.3000 BC, from the central Sahara. It shows men herding what are thought to be sheep and cattle. Similar paintings are widespread across the Sahara. Some, showing wild animals and hunting scenes, are certainly earlier than the ones showing domesticated animals. At this time the Sahara was much greener than now and men and animals were able to move freely.

THE RISE OF MEROË

Near Jebel Barkal, an independent line of Sudanese rulers established the Napatan kingdom some time after 1100 BC. They built palaces and temples, as well as cemeteries of small pyramids. For a short time, from about the middle of the eighth century BC in the reign of Kashta, these Sudanese kings ruled Egypt as its 25th Dynasty. They were defeated and ejected from Egypt after the Assyrian invasion of 671 BC, when King Tanwetamani returned to his own territory, where the Napatan Kingdom continued to develop. After a move of the royal residence to Meroë, in the south, in the seventh century BC, the Napatan kingdom established a fascinating new civilization with its own language and writing.

Meroitic towns, temples and other buildings took something from Egyptian styles, but they were sufficiently different to be clearly identifiable. By 500 BC Meroë was a well-established city with many manufactures and was the most highly developed society in Africa south of the Sahara. The many towns, temples and cemeteries of this period are all situated along the banks of the River Nile as the desert encroaches closely on both sides of the river and made agriculture and animal herding impossible. The one area where the Meroites were able to live away from the Nile valley was near Meroe itself – here in the vast plains between the rivers Nile and Atbara there was considerable activity, although much of it was only toward the close of the period covered in this section.

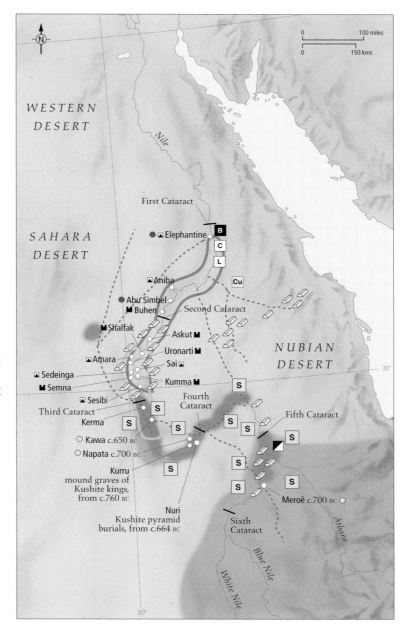

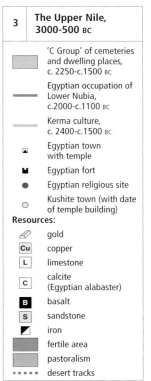

3 EGYPTIANS BEGAN THEIR colonization of the southern Nile from about 2000 BC. Their presence in the northern part of this region left an indelible mark on indigenous cultures along the river. An important state based at Kerma confronted the southern outposts of Egypt. Large brick structures and a distinctive pottery mark this culture. It was superseded by the state that grew up at Napata, three of whose kings also ruled Egypt.

3	The Upper Nile, 3000-500 BC
	'C Group' of cemeteries and dwelling places, c. 2250-c.1500 BC
	Egyptian occupation of Lower Nubia, c.2000-c.1100 BC
	Kerma culture, c. 2400-c.1500 BC
	Egyptian town with temple
	Egyptian fort
	Egyptian religious site
	Kushite town (with date of temple building)

Resources:
	gold
Cu	copper
L	limestone
C	calcite (Egyptian alabaster)
B	basalt
S	sandstone
	iron
	fertile area
	pastoralism
.....	desert tracks

THE NILE VALLEY 3000-500 BC

THE NILE VALLEY, rich in resources, is equipped with natural boundaries: the western and eastern deserts, on the north the Mediterranean Sea and, to the south, river cataracts that make navigation nearly impossible. These factors, coupled with annual floods that supported agriculture, helped a unified state to form in Egypt around 3000 BC. The north-flowing Nile eased communication. Cooperative action to regulate the floods may have contributed to unifying the country under a sole monarch.

Egypt was divided into 42 *nomes*, or administrative districts, which embraced local deities and sacred sites. Cult centres underwent continual development, and landscapes were adapted through the construction of temples, palaces, causeways and monuments. Certain towns had strong and ancient affiliations with gods who attained national importance: Buto, in the Delta, was the home of the cobra goddess Wadjet; El-Kab, south of Thebes, of the vulture goddess Nekhbet. These goddesses personified the north and south of the country and appeared in the two crowns most often worn by kings. Ptah, the god of artists and craftsmen, was based at Memphis, while Amun was a Theban deity.

1 URBAN AND RELIGIOUS CENTRES played an important role throughout Egyptian history. Capital cities such as Memphis and Thebes, in particular, supported the workshops of artists and craftspeople responsible for architectural decoration, statuary and work in precious metals and stones. If necessary, completed works of art could be moved from their place of manufacture to the temple or tomb in which they were to be set up. The raw materials for artistic production were often obtained through expeditions organized by the state. Limestone, sandstone and hard stones such as calcite and granite were quarried in the Nile Valley, whereas metals and coloured stones had to be mined in the Eastern and Nubian deserts.

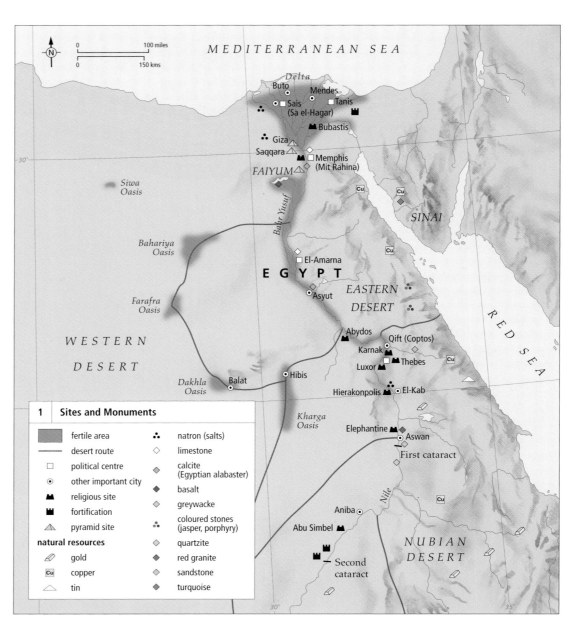

1 | **Sites and Monuments**

	fertile area		natron (salts)
	desert route		limestone
	political centre		calcite (Egyptian alabaster)
	other important city		basalt
	religious site		greywacke
	fortification		coloured stones (jasper, porphyry)
	pyramid site		quartzite
natural resources			red granite
	gold		sandstone
Cu	copper		turquoise
	tin		

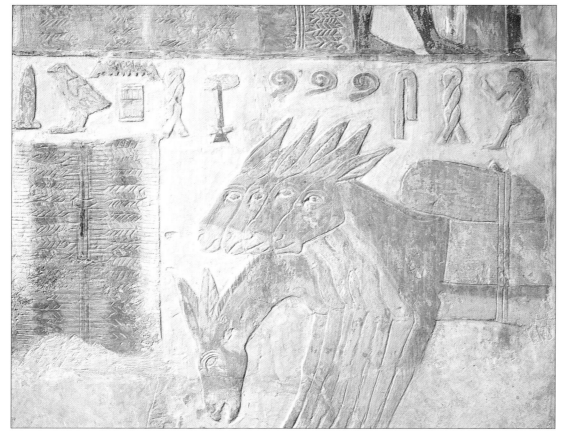

The first kings were buried at Abydos, which was the mythological burial place of Osiris, god of the afterlife, and the site of private cemeteries and chapels, as well.

MATERIALS AND TECHNIQUES
During periods of strong central government, the state had access to metal mines and stone quarries in Egypt and in regions under Egyptian control, such as Nubia and Sinai. The Egyptians began building in stone as early as the Third Dynasty (c.2600 BC), when the Step Pyramid at Saqqara was constructed as a mortuary complex for king Djoser. Stone sculpture in the round and in relief was another early accomplishment, along with virtuoso carving of stone bowls and vases. Coloured stones from distant parts of the country, like red granite from Aswan, were especially prized, as was calcite (known as 'Egyptian alabaster') for its translucency and its veining.

PAINTED AND CARVED WALL RELIEF of donkeys, from the tomb of Metjetji at Saqqara (Old Kingdom, Dynasty 5, c.2300 BC). Scenes of agriculture, animal husbandry and manufacture brought the natural world into the context of a funerary monument in order to evoke the plentiful material resources that were at the disposal of the deceased.

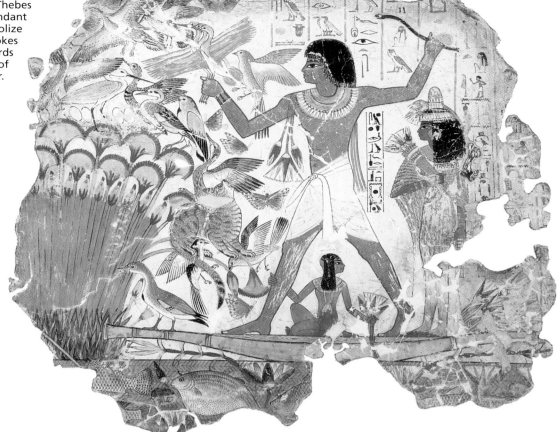

WALL PAINTING from the tomb of Nebamun at Thebes (New Kingdom, Dynasty 18, c.1400 BC). The abundant plant and animal life of the Nile marshes symbolize erotic pleasure, fertility and rebirth. The scene evokes both life and death: Nebamun and a cat attack birds among their nests, while the young daughter of Nebamun pulls lotus flowers from the river.

Copper, gold and tin were mined in the eastern deserts and were vital to Egyptian craftsmanship and art. Copper was used for tools and weapons after being hardened through repeated heating and cooling. Sheets of copper could be hammered over a core to make large metal statues, although examples rarely survive from antiquity.

Copper mixed with tin produced bronze, which was easily worked into weapons, tools, toiletry items like razors and mirrors, and cast statuettes of gods or royalty. Gold was used lavishly in products destined for temples or the royal household, such as gilded furniture and statuary, gold jewellery and vessels, and the solid gold coffins and mummy mask made for King Tutankhamun (c.1320 BC).

Mud and sand were also resources. Sun-dried mud bricks were the most common building material for the earliest tombs and temples and for urban structures throughout Egyptian history. Sand was formed into a paste with quartzite and fired to produce Egyptian faience, a forerunner of glass which took on a distinctive blue or green colour when exposed to heat in a kiln.

Although Egypt is primarily a desert country, wood was available both from native trees, like sycamore and acacia, and from abroad, notably cedar imported from the Levant. Statues, furniture and coffins were among the products crafted from wood.

ART IN SOCIETY

Royal patronage funded temple and palace construction and royal mortuary complexes. Styles established by royal workshops were imitated in work for private patrons. Even lesser-quality works required considerable outlay for the labour and materials involved, putting them out of reach of most people.

Egyptian art from all periods has a homogeneous character, because of the conventions adopted from the outset. Art depicts an idealized world revolving around order and internal logic. In two dimensions, figures and objects are shown in an outline form that combines typical vantage points – the human figure is seen with legs and head in profile, shoulders squared and arms on either side of the torso. To indicate depth, figures are overlapped, and scenes are generally divided into rows called registers. Scale conveys information about the relative importance of figures within a scene, with the most important person as the tallest figure. Statuary also assumes static postures, whether sitting, kneeling or striding forward on the left leg.

A statue of a king might represent his wife and children as reaching only to the height of his knees. Wall decoration and most statues were painted in vivid colours with an abundance of green, red and yellow.

This representational system is linked strongly to how Egyptians perceived the world and their art. A vital role of the king and the temples was to maintain order, or *maat*, in the universe. Timelessness and the cycle of life, death and rebirth were reflected in Egyptian artists' close observation of their natural world in works of all media.

Many objects, particularly statues and architectural decoration, were inscribed with invocations, prayers and identifying texts, and the arrangement of the hieroglyphs was an integral component of the artwork. Whereas the image itself might be ideal and universal, the text gave it a specific identity and helped define its purpose. On a funerary stele, for instance, the text names the deceased and grants them a share of the food, drink, linen and ointments required for the afterlife.

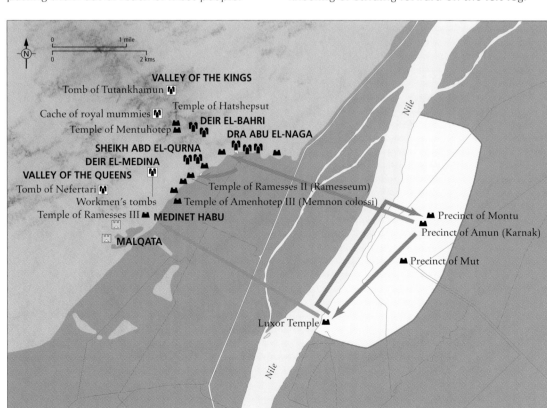

2 THE CITY OF THEBES (modern Luxor), was the site of the state god Amun's temple, Karnak. Nearby temples honoured his consort Mut and falcon-headed Montu. In the annual Opet Festival, during the flood season, Amun was carried to Luxor to be united with the reigning king. For the Beautiful Festival of the Valley, Amun crossed the river to royal mortuary temples on the west bank. People celebrated with feasts and visited family tombs. Every 10 days, a form of Amun – Amunemopet – was carried to Medinet Habu, and the offerings of food and drink made during this procession were believed to nurture the dead in the afterlife.

2	Thebes, 1500 BC
fertile area	concentrations of private tombs
estimated extent of ancient city	route of the Opet Festival
temple	route of the Beautiful Festival of the Valley
palace	route of the Amunemopet procession
tomb	

WEST ASIA 3000-2000 BC

WEST ASIA is a vast geographical area covering ancient Mesopotamia (Iraq), Iran, Syria and Anatolia, and extending in a great arc from the Mediterranean Sea to the Indus River valley. Societies throughout the region maintained commercial and cultural contacts across these great distances, although the routes, trade goods, and artistic styles and motifs that were exchanged varied in different periods. The art and culture of Mesopotamia and Syria is central to an understanding of the region, as it had a profound impact on the surrounding areas.

THE FIRST CITIES

The world's first literate, urban civilization developed in southern Mesopotamia during the late fourth millennium BC. Increasing trade connections between Mesopotamian cities and the surrounding regions led to major innovations. The rise of elite institutions, such

1 OVER SEVERAL CENTURIES centres of urban life, with associated elites, emerged across West Asia. This stimulated a demand for luxury goods and a flow of materials and ideas began to circulate around 2500 BC. Artistic motifs increasingly linked the eastern Mediterranean with the Indus valley. Cuneiform writing, which had developed in southern Mesopotamia, was adopted by palace administrators to the east and the north. Rich graves and monumental architecture are a testament to the wealth of regional rulers.

1	The Art of West Asia, 3000-2000 BC		
	spread of cuneiform		ziggurat
	carved chlorite vessels		schematic female figures
	rich burial		copper standards
	palace		ancient coastline

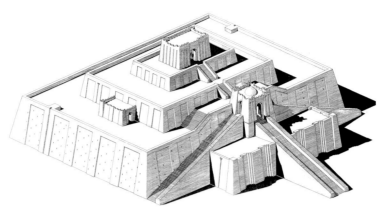

THE ZIGGURAT OF UR. From around 4000 BC, the temples of Mesopotamia were raised on mud brick platforms. During the Third Dynasty of Ur the platforms were elaborated into ziggurats or staged towers. The best surviving example is at Ur. The exterior is decorated with buttresses and recesses to break the monotony of the flat surfaces. Archaeologist Sir Leonard Woolley created this reconstruction, restoring the upper stages and a temple on the summit.

as temples, created greater impetus for artistic creation that would reflect both their power and considerable wealth. Large-scale sculpture in the round and relief carving appeared for the first time, together with metal casting using the lost-wax process. A new realism is apparent in the treatment of the human form, and figures appear as part of narratives, especially on the miniature reliefs carved on cylinder seals. Seals were used to authorize transactions by officials, including the allocation of rations, a development probably linked to the expanding administrations of cities. Simple pictographs, drawn on clay tablets, were the precursors of later cuneiform writing. Objects inspired by southern Mesopotamia, such as cylinder seals, are found from central Iran to Egypt. However, around 3000 BC, this widespread culture collapsed.

The result was that southern Mesopotamia (Sumer) turned inward, although the cities, centered on temples, continued to grow. It appears that no individuals held supreme

power or felt the need to distinguish themselves in inscriptions or monuments. However, finely carved stone sculpture for urban temples continued to be produced, often combining animals and human figures and probably influenced by contemporary artistic traditions of southwestern Iran.

THE EMERGENCE OF AN ELITE

Over time the rise of a secular elite created changes in the social structure. By around 2600 BC, palace architecture began to appear and kings are depicted as warriors or builders, or presiding over banquets. Statues of men and women, many identified by short cuneiform inscriptions, were set up in temples in Mesopotamia and Syria, which were dedicated to specific gods. Similar figures are also represented on stone plaques carved in relief. The growth of this wealthy class led to an increasing demand for luxury items fashioned from materials obtained largely from abroad. Military encounters with many of

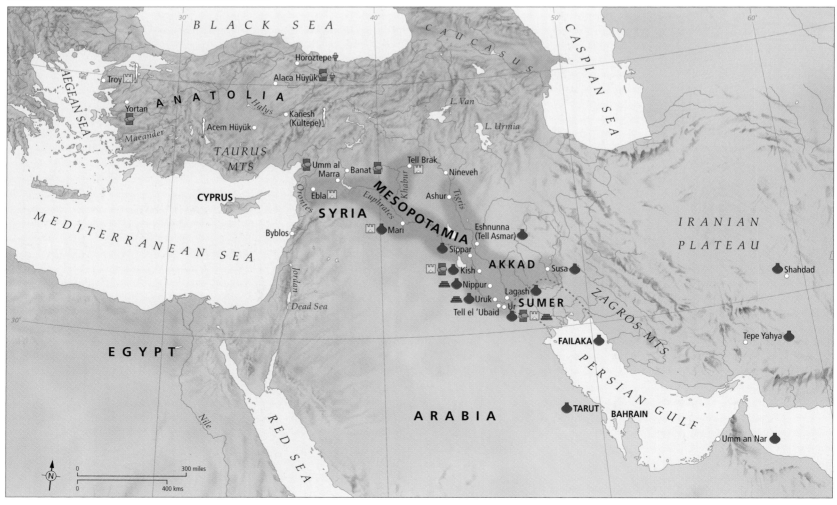

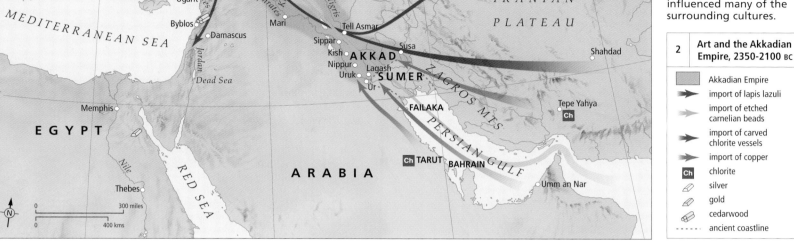

2 MESOPOTAMIA WAS UNITED under the military empire of Akkad, a city thought to lie close to Kish. The Akkadian rulers diverted trade routes through their cities and established connections with the civilizations of Iran, the Indus Valley and Central Asia as well as the resource-rich regions of Anatolia and the eastern Mediterranean. The dynamic art of Akkad influenced many of the surrounding cultures.

2	**Art and the Akkadian Empire, 2350-2100 BC**	
	Akkadian Empire	
→	import of lapis lazuli	
→	import of etched carnelian beads	
→	import of carved chlorite vessels	
→	import of copper	
Ch	chlorite	
	silver	
	gold	
	cedarwood	
-----	ancient coastline	

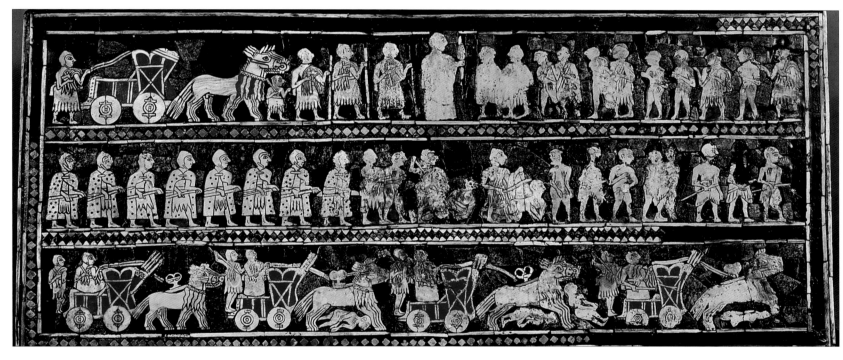

these areas are now attested in cuneiform texts, written in the Sumerian language.

Carved chlorite vessels from Iran increasingly appear in the archaeological record, as do objects made of lapis lazuli from Afghanistan and etched carnelian from the Indus Valley. Although metal deposits are unknown in Mesopotamia, large numbers of metal objects have also been found, especially in the Royal Cemetery of Ur. Sixteen extremely rich graves have been excavated there, and – uniquely in Mesopotamia – were found to contain multiple sacrificial victims. The owners of the majority of the graves are unknown but the wealth buried with them, together with the human victims, suggests that they were kings and queens or religious leaders. Among the grave goods were weapons and vessels in bronze, gold and silver, and an astonishing amount of elaborate jewellery. Inlay was a common feature of many objects including sceptres, musical instruments and, most famously, on the 'Standard of Ur'. Artistic connections are demonstrated by rich finds from Troy and Alaca Hüyük in Anatolia.

THE FIRST EMPIRE

The commercial and military contacts of Mesopotamia reached a peak with the dynasty of Akkad, around 2350 BC. The rulers seem to have been the first to unite the southern plain, extending their control over much of northern Mesopotamia. The dynasty's founder was Sargon of the city of Agade (Akkad) – its location remains unconfirmed. The new dynasty displayed strong cultural continuity with the Early Dynastic period. However, under Naram-Sin (c. 2254–2218 BC) an imperial state was born, the ideology of which is reflected in an art which depicts the monarch as intimately associated with both his city and patron goddess Ishtar. Sculpture displays physical naturalism and sensitivity, with many details shown for the first time. For example, Naram-Sin is depicted on a stele wearing the horned head-dress that was formerly the exclusive prerogative of gods. Commercial links with the Indus Valley were now focused on Akkad.

Ultimately both internal and external forces overwhelmed the Akkadian Empire. Some city-states regained their independence, for instance

THE STANDARD OF UR. Dating from around 2500 BC, this object came from one of the largest graves in the Royal Cemetery at Ur, in which sacrificial victims accompanied the main burial. Its function is not understood though it may have formed the soundbox of a musical instrument. An inlay of shell, limestone and lapis lazuli depicts one of the earliest representations of a Sumerian army. The other side shows animals and other goods brought in procession to a banquet.

Lagash which was ruled by King Gudea. This is expressed in the many statues of the ruler carved from diorite, which was imported from the region of modern Oman. In the same period Ur-Nammu established his rule over the city of Ur and founded the Third Dynasty of Ur which came to dominate southern Mesopotamia (c.2100–2000 BC). The Third Dynasty rulers presided over a prosperous kingdom, with an ambitious programme of building, which included palaces and temples. The most spectacular religious monuments are the great ziggurats, or staged towers, of which the best surviving example is that of Ur-Nammu at Ur.

WEST ASIA 2000-500 BC

FROM AROUND 2000 BC the Assyrians, a north Mesopotamian people whose civilization was centred on the city of Ashur, established trading colonies throughout Anatolia and exchanged Anatolian silver for textiles and tin. The activities of these Assyrian merchants are recorded in many cuneiform clay letters found in their main colony, or *karum*, at the site of Kanesh. The letters provide details about all aspects of their culture – from the varieties of Mesopotamian cloth to relations with their home city – as well as preserving the impressions of Assyrian-style cylinder seals.

Over the following centuries large kingdoms came to dominate Mesopotamia, especially that of Yamhad (with its capital at Aleppo) in Syria and the successive powers of Isin and Larsa in southern Mesopotamia. Around 1760 BC King Hammurabi of Babylon

1 DURING THE PERIOD 1500–1100 BC the states of the Near East were linked through diplomatic exchanges of people, precious materials and artistic motifs. International styles developed, particularly in the eastern Mediterranean where Egyptian images fused with Aegean and Syrian forms. Throughout the region, both palaces and temples reflected the wealth of powerful kingdoms. In Mesopotamia the most impressive religious buildings were the solid stepped towers or ziggurats.

1	International Art, 2000-1000 BC		
🏰	royal palace	➤	silver
🏛	ziggurat	➤	textiles
movement:		➤	copper
➤	tin	➤	glass technology
➤	horses	•	local artistic metal production
➤	lapis lazuli		
➤	gold	⋯⋯	ancient coastline

THIS SOLID GOLD bowl from the site of Ugarit demonstrates high quality craftsmanship in metal and the wealth of this important trading centre. The dense composition and diverse motifs are characteristic of the artwork of the coastal Levant. The figures include gazelles, bulls and lions, and mythical creatures. Elements were borrowed from many parts of the eastern Mediterranean and this hybrid art was distributed along trade networks across the region.

conquered much of Mesopotamia. A large diorite stele known as the Code of Hammurabi is perhaps the most famous work of art of this time. It continues traditions of representation found in the late third millennium BC. The relief decorating the top of the stele shows the king standing before the seated sun god Shamash. Both the king and Shamash are depicted for the first time with eyes in profile, establishing a real gaze between god and ruler.

INTERNATIONAL ART

The second half of the second millennium BC saw new styles of art emerge with the growing political and economic importance of a variety of people. These included the Hittites in Anatolia, a people speaking an Indo-European language who had possibly migrated from Europe in the late third millennium BC, and the Canaanites, who spoke a Semitic language and lived along the Mediterranean coast. Much of the art of this period was heavily influenced by Mesopotamian traditions. For example, in Elam (southwest Iran) the religious imagery of Mesopotamia was used to depict Elamite mythology. However, new art-forms

were encouraged by an extensive system of international contacts that stretched across the entire region. From western Iran to the Aegean, from Anatolia to Egypt, states were in contact and an exchange of goods and art took place at a high level of society. The exchange of gifts between kings allowed them access to precious materials unavailable at home. Babylonia and Assyria, for instance, actively participated in this system and as a result obtained gold from Egypt. In the eastern Mediterranean, exchange of gifts created international styles for elite objects, many displaying a fusion of the dynamic Aegean animal style with Egyptian and Syrian imagery and compositions. This Mediterranean international style survived into the early first millennium BC, especially in the Canaanite (Phoenician) cities

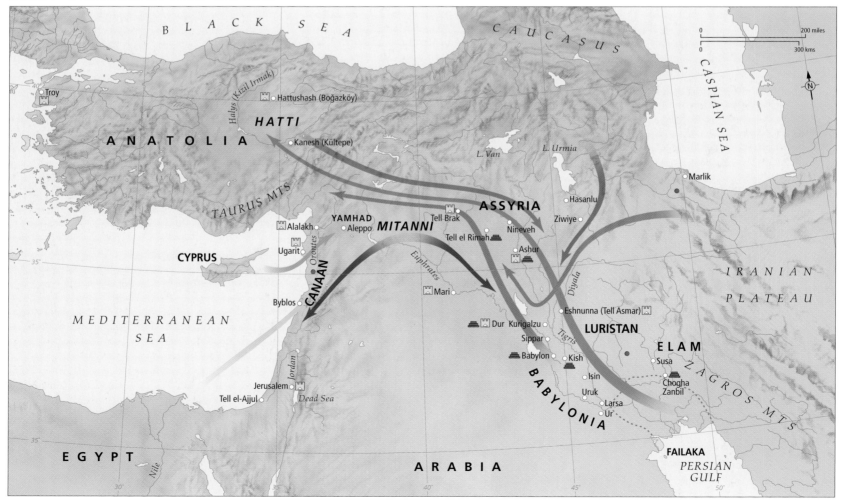

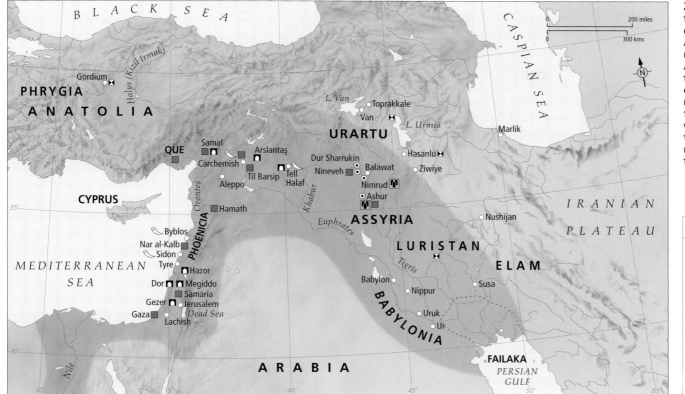

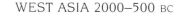

2 BETWEEN 900 AND 612 BC the Assyrians came to dominate much of West Asia. Free-standing stele and rock reliefs were carved in Assyrian style to celebrate the furthest extent of the empire under succeeding rulers. Artistic influences flowed into Assyria from the wealthy Phoenician cities to the west and from the lands rich in metal and horses to the north and east.

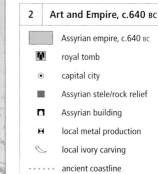

2	Art and Empire, c.640 BC
	Assyrian empire, c.640 BC
🏛	royal tomb
⊙	capital city
◼	Assyrian stele/rock relief
🏠	Assyrian building
⋈	local metal production
✎	local ivory carving
······	ancient coastline

ASSYRIAN WALL RELIEF. Important rooms within Assyrian palaces were often decorated with huge slabs of alabaster carved in relief. Many depict the king who is shown as either the chief priest of Assyria or the conqueror of dangerous forces. The latter could take the form of rebellious people or wild animals such as the lion, an animal that had an ancient association with royalty in Mesopotamia.

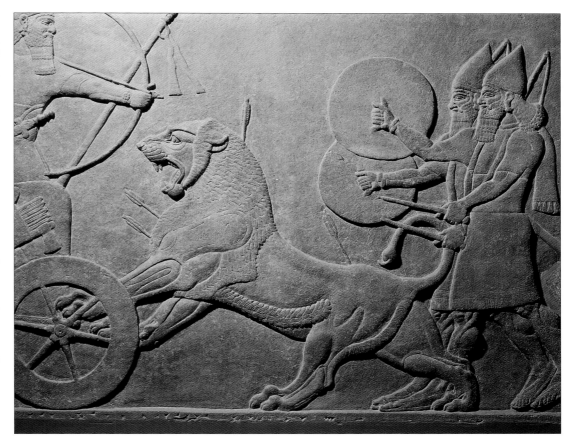

along the coast. In northwest Iran local imagery on finely crafted gold vessels from sites like Marlik and Hasanlu reflects the wealth of settled communities with links to the art of nomadic groups in Central Asia.

THE ASSYRIAN EMPIRE
After a period of relative weakness, the ninth century BC saw Assyria emerge as a world power and by the mid-seventh century, during the so-called Neo-Assyrian period, it dominated the region from Egypt and the eastern Mediterranean to Iran and the Gulf. This imperial power is well symbolized by enormous palaces and temples built at Ashur, Nimrud and Nineveh.

The art of the Neo-Assyrian period consists mainly of architectural decoration in the form of reliefs which, though also a feature of monumental buildings in Syria, were unique in their scale. These carved stone slabs lined the walls of important rooms in both palaces and temples. The slabs, with images and texts recording the activities of the ruler, are carved in low relief, generally in a soft alabaster. Figures are shown in the pose commonly used in Mesopotamian art, with the head and legs in profile and the torso generally shown frontally. The wall reliefs were often complemented or replaced by paintings.

It was probably during the period of Assyrian domination that extraordinary bronze objects were manufactured in the region of Luristan. Elaborate standards with complex animal imagery are part of a repertoire of objects known from cemeteries, although many have been plundered from sites or forged in modern times.

The great wealth of the empire during these centuries is also reflected in other forms of art, often originating outside Assyria. Huge quantities of ivories found in the palaces,

temples and private houses at Nimrud had arrived there as booty or tribute. Carved ivory was used to decorate furniture as well as daggers, cups and dishes and was sometimes overlaid with gold or silver, or inlaid and bejewelled. Three main styles of ivory carving can be identified: a local Assyrian style, similar to the stone reliefs in design; a North Syrian style, with designs related to stone carvings of the north Syrian cities; and a 'Phoenician' style, with designs reflecting Egyptian influence.

As well as their distinctive ivories, the Phoenician city-states also manufactured and exported purple cloth, timber, copper, and jewellery throughout the Mediterranean region. Seeking new markets and sources of raw materials, the Phoenicians, in competition with the Greeks, established trading colonies

throughout the Mediterranean. The most famous Phoenician site was Carthage where many elements in art and religion reflected the city's Near Eastern origins.

The Assyrian empire was briefly succeeded by the Babylonian empire. Under kings Nabonidus and his more famous son Nebuchadnezzar II the city of Babylon was rebuilt to become one of the wonders of the ancient world. Rather than using stone reliefs, as in Assyria, royal buildings were decorated in the traditional Babylonian manner – glazed moulded bricks, often depicting animals sacred to the gods of Mesopotamia, were used to decorate the walls. Babylon and its empire fell to the Iranian Persians in 539 BC, and the Near East was united under a new dynamic imperial power which produced an art that fused various styles from throughout its vast empire.

CENTRAL AND SOUTH ASIA 5000-500 BC

CENTRAL ASIA was an area of trade and movement – not only of people and goods, but also ideas and styles. This had a major impact on the art and culture of this region, while Central Asian materials and styles in turn influenced other regions, particularly to the west. Central Asia, to the north of the Himalaya-Hindu Kush range, was home to a mixture of nomadic cultures which ranged across the lowland area stretching from central Europe right across to China. They are known primarily through their rich graves. Settled peoples exploited river valleys and the fertile loess soils between the mountains and the deserts. To the south of this major physical boundary lies India, a focal point for the exchange of artefacts and ideas.

WESTERN INFLUENCES

The influences of the great cultures to the west (Mesopotamia, Persia and Greece) can be seen in the architecture, artefacts and archaeology of Central Asia, and similarly, contact with China and the north can be seen here. Bronze tools, figurines, weapons and jewellery are among the many finds that have been recovered from both burial and settlement sites to the north of the great mountain ranges, along with fine pottery painted with both geometric designs and wild animal motifs. The recovery of artefacts of lapis lazuli, carnelian and turquoise shows the extent of trading links within this wider region. Indeed, large numbers of seals very similar to those produced within the Indus Valley have been recovered from the site of Altin Tepe in modern Turkmenia. This is significant evidence for trade and contact between South and Central Asia during the Bronze Age.

HARAPPAN CIVILIZATION

The Indus, or Harappan, civilization covered an area of 500,000 square kilometres (193,000 square miles) extending across large areas of Pakistan and northwest India. It was one of the great civilizations of antiquity. Traditional dates place its emergence around 2600 BC and suggest that it appeared rather suddenly, but recent work has shown that early agricultural sites, such as Mehrgarh in the Kachi Plains of Pakistan (7000–3500 BC), are likely to be direct precursors of this great urban civilization, which relied heavily on floodwater irrigation based round the Indus and other rivers.

Characterized by great uniformity of architecture and art (although with many local variations), the Indus is known to have been part of a major trade network, both within South Asia and beyond. Lapis lazuli from Afghanistan and jade from China have been recovered, along with gold (likely to have been imported to supplement more local sources),

1 THE INFLUENCE OF TRADE on the culture and art of many groups in this region is clearly evident. Pottery with distinctive decorations and architectural styles reveal contact with the great civilizations of the west, while jade ornaments, burial patterns and styles of axes and other tools show influences from the north and northeast. In return, etched carnelian beads from the specialized workshops of the Indus have been recovered from Mesopotamian cities.

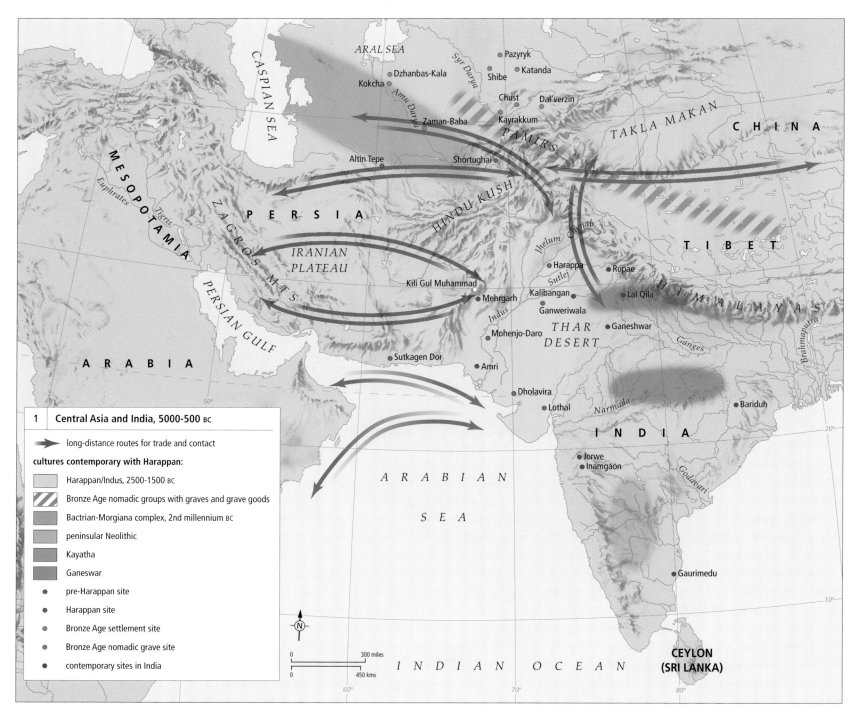

1	Central Asia and India, 5000-500 BC

→ long-distance routes for trade and contact

cultures contemporary with Harappan:

Harappan/Indus, 2500-1500 BC

Bronze Age nomadic groups with graves and grave goods

Bactrian-Morgiana complex, 2nd millennium BC

peninsular Neolithic

Kayatha

Ganeswar

• pre-Harappan site

• Harappan site

• Bronze Age settlement site

• Bronze Age nomadic grave site

• contemporary sites in India

silver (from Afghanistan or even Iran) and coastal shells at inland sites. Etched carnelian beads and lapis lazuli were exported from the Indus region, particularly to the west.

Craft specialization, taken to the point of mass production and great standardization, were trademarks of the Indus, and goods produced included well-fired, wheel-made pottery with distinctive designs and shapes. Bronze-working was significant, and along with tools such as axes and swords, bronze sculptures have also been recovered, one of the most famous of which is the 'Dancing Girl' from Mohenjo-Daro. Stone sculptures have also been recovered, including the well-known limestone 'Priest-King', also from Mohenjo-Daro. The pottery decorations tended to be of single subjects, such as people, animals or birds, rather than narrative scenes.

The production of steatite seals was particularly important, both for local use and for long-distance trade. These seals were carved with script and animal designs, such as tigers, elephants, rhinoceros and bulls, and were very finely made. Terracotta figurines including zebu (humped cattle) and toy carts, have been recovered from a large number of sites. While these are often interpreted as children's toys, they may also be linked to the veneration of cattle, an important source of wealth within the Indus.

The two major cities of Mohenjo-Daro and Harappa are strikingly similar in terms of planning and layout. Both have two main mounds, an eastern citadel and a western occupation area. There is a lack of conspicuous private buildings that could be interpreted as palaces, giving rise to suggestions that this was an egalitarian society. There are major buildings that are thought to be more public in nature, such as the Great Baths at Mohenjo-Daro, and the 'granary' at Harappa. A standard brick size is found throughout the region, with ratios of 1:2:4, suggesting a strong uniformity.

The end of Indus civilization is traditionally thought to have been inexplicably sudden. It is now known that while the major urban areas certainly declined, many traits of the Indus civilization continued into the next, or Early Historic, urban period c.1000 BC. Although relatively short-lived during its mature phase, the Indus civilization without doubt achieved remarkable cohesion of artistic style and design across a huge area, and through traded goods spread artefacts and influence across a very large part of Central and South Asia, and to areas beyond.

TERRACOTTA CART. Humped cattle or zebu were vital to Indus life, and cattle and carts are frequent subjects of numerous terracotta figurines. The purpose of these figurines is open to debate, with suggestions ranging from their connection to ritual or religion (particularly cattle), a decorative or artistic function, or simply use as children's toys.

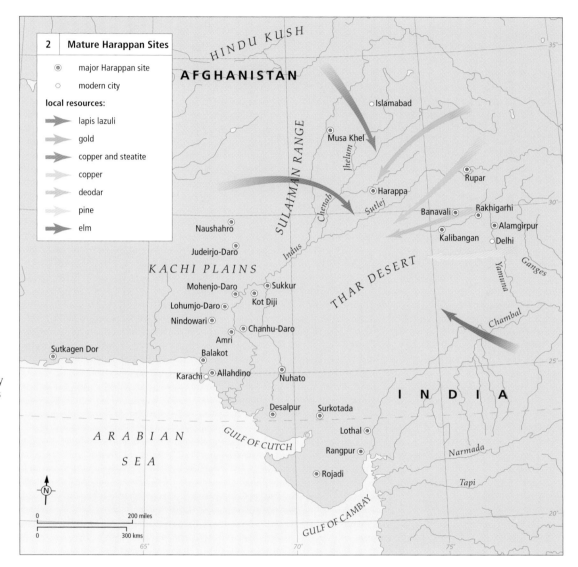

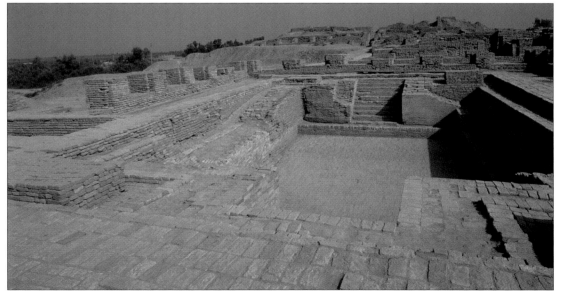

2 THE INDUS IN THE BRONZE AGE is one of the world's great civilizations, and finds of worked goods from copper, gold, lapis lazuli, exotic woods and so forth show an extensive internal trade network between the major cities and the outlying rural areas within South Asia. Craft specialization, uniformity of architecture and standardization of many artefacts are among the main characteristics of the Indus civilization.

THE GREAT BATH AT MOHENJO-DARO. One of the finest examples of Indus architecture built from brick, the Great Bath is lined with bitumen, with a dedicated water supply, and is believed to have been used for both public and ritual bathing. It links two major aspects of Indus civilization: the importance of major public buildings within the urban centres, which can be interpreted as indicators of a strongly egalitarian society, and the sophisticated ways in which water management and other public services were approached. The significance of ritual is less well understood, but in addition to bathing is likely to have included the veneration of cattle.

EAST ASIA AND CHINA 5000-500 BC

THE BIRTH AND GROWTH of civilizations in East Asia took place in a distinctive environment. Japan is an island country where the indigenous Jomon culture developed independently. The earliest pottery in the world has been discovered in Japan: it is hand-built, and densely decorated with incised or cord-impressed patterns. Similar techniques and motifs are also found in Jomon figurative art. The early cultures in the Korean peninsula, on the other hand, share characteristics, such as pottery with geometrical decoration, with cultures in Siberia and northeast China.

China is a vast and geographically diverse country with plateaus, basins, deserts and grasslands. There are huge differences in climate, ranging from the arid Gobi Desert to tropical Hainan Island. Early civilizations in China developed along the two major rivers, the Yellow River (Huang He) and Yangtze River (Chang Jiang). Both have their sources in the Qinling Mountains and flow eastwards to the Pacific Ocean. The Yangtze River has served as a dividing line between north and south from the very beginnings of Chinese civilization.

EARLY NEOLITHIC CULTURES

By the fifth millennium BC, several distinctive Neolithic cultures had emerged in both north and south China. From its origins in the middle valleys of the Yellow River, the Yangshao culture spread both up and downstream. Its distinctive polychromatic painted pottery, made of carefully selected clays and fired at a high temperature, shows a highly developed aesthetic value and skill. The decoration of Yangshao pottery comprised painted geometric and stylized flower patterns, and more realistic animal and human motifs. Religion played an important role in early Neolithic art and interpretations of these works often relate to the belief and practice of Shamanism.

The Neolithic cultures in the south were based mainly on rice-agriculture, differing from the millet-agriculture in the north. Their pottery tradition was also highly developed, usually with incised rather than painted

1 AGRICULTURE BEGAN IN EAST ASIA as early as 10,000 years ago. From around 6000 BC large numbers of farming communities emerged in the Yellow River valleys and on the east coast; millet was grown in the north and rice in the south. By 2000 BC competition and interaction among different cultural zones created a new era, and civilization was born.

1	Neolithic China and East Asia, 5000-2000 BC
	Neolithic cultural zone
■	archaeological site
◉	modern city

JADE DRAGON, Hongshan Culture, c.3500 BC, greenish nephrite. This is the earliest three-dimensional representation of a dragon found in China. The dragon is the most prominent creature in Chinese mythology, symbolizing the concept of transformation and is associated with royalty in much later periods. This jade dragon has a curved body, forming a ring. Its face is similar to that of a pig, with a protruding mouth and wrinkles on its nose. The hole in the back suggests it may have been used as a pendant.

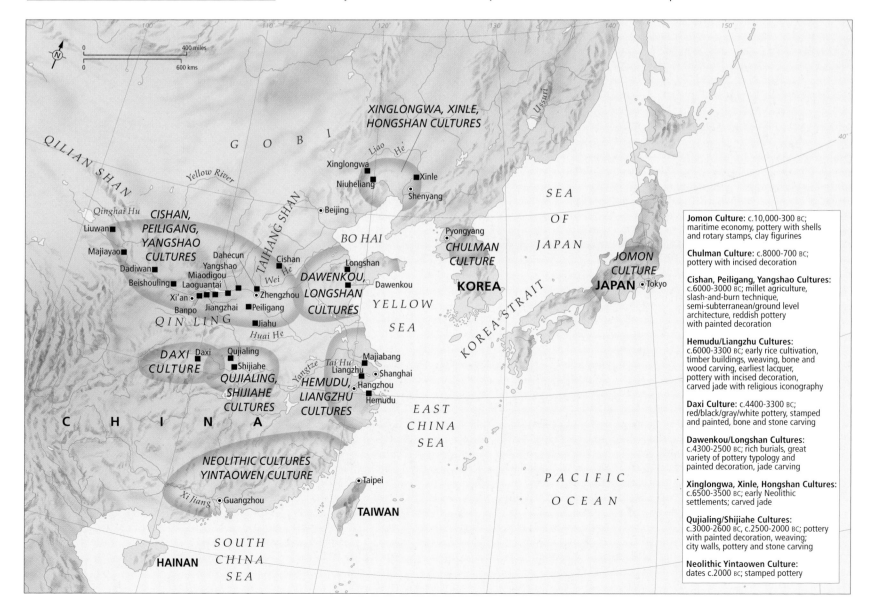

Jomon Culture: c.10,000-300 BC; maritime economy, pottery with shells and rotary stamps, clay figurines

Chulman Culture: c.8000-700 BC; pottery with incised decoration

Cishan, Peiligang, Yangshao Cultures: c.6000-3000 BC; millet agriculture, slash-and-burn technique, semi-subterranean/ground level architecture, reddish pottery with painted decoration

Hemudu/Liangzhu Cultures: c.6000-3300 BC; early rice cultivation, timber buildings, weaving, bone and wood carving, earliest lacquer, pottery with incised decoration, carved jade with religious iconography

Daxi Culture: c.4400-3300 BC; red/black/gray/white pottery, stamped and painted, bone and stone carving

Dawenkou/Longshan Cultures: c.4300-2500 BC; rich burials, great variety of pottery typology and painted decoration, jade carving

Xinglongwa, Xinle, Hongshan Cultures: c.6500-3500 BC; early Neolithic settlements; carved jade

Qujialing/Shijiahe Cultures: c.3000-2600 BC, c.2500-2000 BC; pottery with painted decoration, weaving; city walls, pottery and stone carving

Neolithic Yintaowen Culture: dates c.2000 BC; stamped pottery

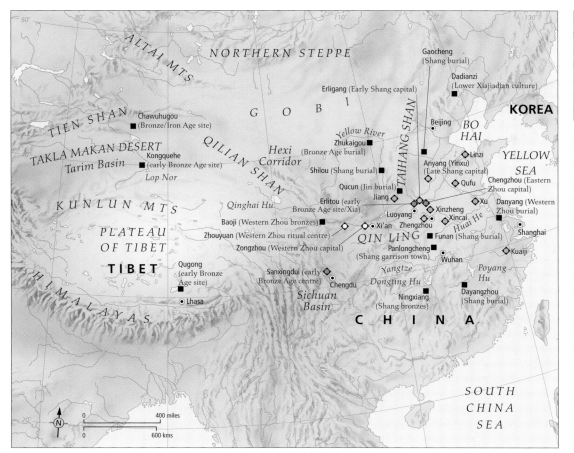

2	Bronze Age China, 2000-500 BC

political centre/capital		major archaeological site
◇	Shang	■
◇	Western Zhou	◉ modern city
◇	Eastern Zhou	
◇	Spring & Autumn	
◇	other important Bronze Age centre	

2 THE CHINESE BRONZE AGE is marked by the ritual use of bronze. The capitals of the Shang dynasty were located in the Central Plains, and Shang people had an advanced calendar and writing system. In 1045 BC the Zhou conquered the Shang and built a new political system. The king was regarded as the 'Son of Heaven', whose mandate was symbolized by the bronze *ding* (cauldron).

The invention of bronze casting, as well as the basic schemes of shape and decoration, were developed from earlier ceramic and jade traditions. The piece-mould technique was very efficient for making hollow vessels and allowed great freedom in surface decoration. The most important decorative feature on Shang ritual bronzes was the *taotie*-motif, the usually highly stylized animal mask comprising two eyes, two ears and a nose, and sometimes horns and claws.

The Shang were conquered in the eleventh century BC by the Zhou, who brought new changes to bronze art. The Zhou people acquired new tastes, and this is reflected in the different forms and surface decoration of their bronze vessels. The *taotie*-motif gradually disappeared, and the phoenix, bird and ox became the favourite motifs. The changes were not merely decorative: underlying them was the huge transformation taking place in the Zhou belief and ritual practice. Bronze vessels became status symbols. They were buried with the dead, and were displayed in ancestral temples. Ancestor worship predominated and a feudal system was established. Meanwhile, a literary tradition was developed – inscriptions on bronze vessels often carried more significance than the decorations.

decoration. Its peak is seen in the Longshan culture on the east coast, where fine black pottery was produced using advanced wheel-throwing techniques and superb kiln control.

RITUAL AND ORNAMENTAL JADE
Early artisans also worked in other materials, such as textiles, wood and bone. The earliest silk production was developed in eastern China. Jade was the most symbolic of all the materials used: owing to its durability, smooth texture, translucency and subtle colours, it was regarded as a spiritual stone, which communicated between man and gods. It also came to symbolize different human qualities. The earliest personal ornaments in jade were found in northeast China, where jade birds, turtles and a dragon with a curved body were found in the elite tombs of the Hongshan culture, which dates to the middle of the fourth millennium BC. Jade was used in a similar fashion in the south, most notably in the Liangzhu culture of the southeast, where the two most important types of ritual jades, the bi-disc, symbolizing heaven, and the cong-tube, symbolizing earth, were first found in a ritual context. The distinctive *taotie*-motif, combining both animal and human features, which first appeared on Liangzhu jades, later became the major motif in the decoration of Shang ritual bronzes.

THE BRONZE AGE
Early use of bronze has been found in northwest China, in the Tarim Basin and on the Tibetan Plateau, but the Bronze Age in China is more closely associated with the three dynasties of the Central Plains: the Xia, the Shang and the Zhou. Historians and archaeologists continue to argue about the existence of the Xia dynasty, but there is no doubt that the Shang dynasty existed. Indeed, archaeology has confirmed that the Shang had a mature writing system and a sophisticated calendar. In contrast to the civilizations of the Near and Middle East, which created prominent stone monuments and sculptures representing their kings and queens, the Shang cast large bronze vessels for use in sacrifice to the ancestors and deities, and buried them in tombs.

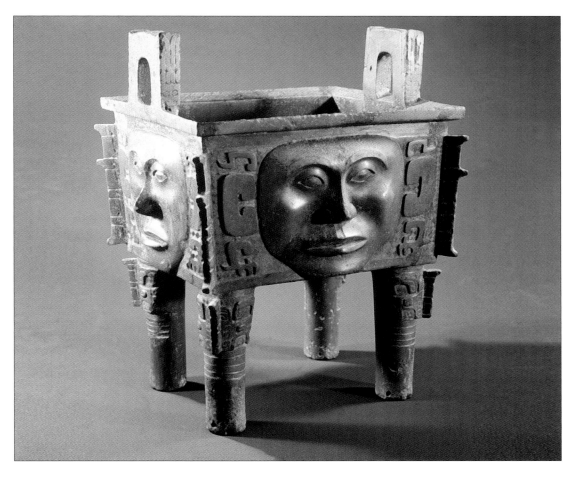

SQUARE BRONZE DING with a human face decoration, Late Shang period, c.1200 BC. Bronze vessels were used in ritual ceremonies in the Shang dynasty, often involving sacrifices to the ancestors. The decoration on this *ding*, or cauldron, is unique. The main motif is a human face, but with two horns and animal claws. The whole scheme is realistic, in a manner more typical of the south than of the metropolitan style in the capital city, Anyang (Yinxu).

JAPAN AND KOREA 5000-500 BC

A SERIES OF FORAGER SOCIETIES was well-established throughout the Korean peninsula and the Japanese archipelago by 5000 BC. These societies subsisted on the natural resources available in the rich temperate forests, which included medium-sized animals, notably deer and wild boar, nuts and wild grains, as well as abundant aquatic resources, such as shellfish, fish and sea mammals. They lived in villages that were often made up of clusters of pit houses, and on occasion constructed large buildings and stone monuments. These villages were sometimes occupied for many generations and suggest a remarkable degree of residential stability for non-agricultural societies.

EARLY POTTERY IN JOMON JAPAN
The manufacture of pottery in the Japanese archipelago has been practised for over 7,000 years. As pottery-making developed, a series of regional traditions emerged and these are recognized by Japanese archaeologists as distinct styles, each with its own favourite forms and decorative motifs. Deep, jar-shaped cooking vessels formed the core of the repertoire of forms, supplemented over time with other vessels for the serving and consumption of food. The basic decorative element was cord-marking, produced by pressing twisted cords made of plant fibres into the leather-hard surface of pottery vessels before firing them in bonfires. In some areas, the upper parts of the vessels became highly elaborated with the development of exotic heavily sculptured rims. Abstract designs became very sophisticated, although representational images were relatively uncommon – one good example of a hunting scene is known from a vessel recovered from the site at Nirakubo in northern Honshu. Other motifs include zoomorphic designs similar to

NEOLITHIC POTTERY from central western Korea was often decorated with incised and impressed geometric patterns, often applied with a comb. This *chulmun* pottery was replaced in the first millennium BC by plain pottery (*mumun*). Many pointed-based cooking vessels were found from settlements of the period, such as Amsa-dong on the Han River, where the remains of 20 pit buildings were excavated. These vessels were used to cook the foods derived from gathering, hunting and fishing and, later, cultivated rice and millet.

frogs and snakes, and anthropomorphic designs also occur, executed in relief appliqué attached to the surfaces of some of the vessels. Pottery vessels were often made in very large numbers, as can be seen in the massive pottery dumps at the site of Sannai Maruyama.

In the Japanese archipelago, from about 5000 BC, pottery was also used to create clay figurines, both anthropomorphic and zoomorphic. Certain settlements were the focus of figurine manufacture and use. At Shakado over 1000 figurine fragments have been recovered. These figurines were possibly made so as to be easy to break into their component body parts (possibly for use in rituals), and complete figurines are rarely discovered. Figures are varied; some have female bodily attributes, while many others appear more masculine, or androgynous. These figurines bear designs which suggest elaborate coiffures, facial tattooing, and decorative clothing, indicating that bodily ornamentation was important to many Jomon societies. Some have distended stomachs, and are thought to have played an important role in fertility rites.

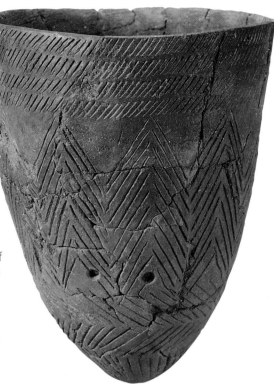

Body symbolism is further demonstrated through the evidence for tooth filing from skulls excavated at sites such as Tsukumo and Yoshigo. This practice may have occurred at age-related rituals and has been used by archaeologists to identify people born in a particular village and those who may have 'married in'. Pottery masks, often suggesting identifiable character traits, are known from a number of sites across the Japanese archipelago. At other sites, large numbers of ear ornaments have been discovered.

THE CRAFTS OF JOMON JAPAN
The manufacture of certain objects, notably greenstone jadeite beads and elaborate earspools, luxury commodities which were transported over great distances, indicates that prestige goods were being circulated among these forager societies. The construction of carefully designed and laid out stone and wooden monuments attests to the ability to control and direct labour. These monuments, including the twin circular arrangements of stones at Oyu and the stone lines at Komakino, which are often aligned on significant topographic landmarks, also suggest a concern with measuring and marking time and the seasons. Certain buildings appear to have been constructed using standardized units of measurement. In addition, the analysis of the design structure of pottery vessels suggests that they express the conceptualization of certain numbers, in particular 4, 5 and 7 which may have had particular significance for Jomon communities.

In recent years a number of waterlogged sites have been investigated which demonstrate how much of the rich material culture of these early societies has perished. Lacquer was used in Japan from before 5000 BC, and its use demonstrates a high degree of knowledge of the potential of the environment, as the extraction and use of lacquer requires a detailed understanding of the not immediately obvious properties of the lacquer tree and its

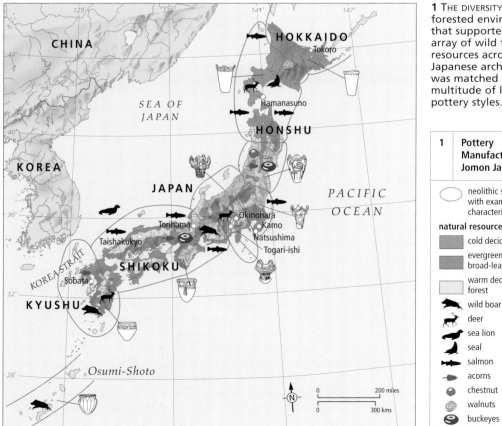

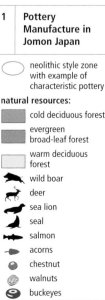

1 THE DIVERSITY of forested environments that supported a rich array of wild food resources across the Japanese archipelago was matched by a multitude of local pottery styles.

1	**Pottery Manufacture in Jomon Japan**

neolithic style zone with example of characteristic pottery

natural resources:

- cold deciduous forest
- evergreen broad-leaf forest
- warm deciduous forest
- wild boar
- deer
- sea lion
- seal
- salmon
- acorns
- chestnut
- walnuts
- buckeyes

sap. Numbers of lacquered objects, including hairpins, were excavated at Torihama on the coast of Honshu. Lacquered bows and bows whose shafts are wrapped in cherry bark were also recovered from waterlogged sites.

THE AGE OF BRONZE

Bronze working, developed in China from the start of the second millennium BC, appeared in the Korean peninsula by about 1000 BC. At the same time a new form of individual burial monuments, dolmens – in which the remains of clan chiefs were interred – appeared on the Korean peninsula. These dolmens are an important regional manifestation of megalithic burial, examples of which are found around the world, and prefigure the monumental mounded tombs in which later elites were interred on both the Korean peninsula and the Japanese archipelago. Prior to 500 BC, however, social power rested in the hands of local leaders and household heads, and it was in this context of relative domestic independence that the great ceramic traditions of the Jomon and Chulmun flourished. Bronze was a new medium for expressive design, and with its use came new locations for display, often in ritual and funerary contexts away from settlements.

DECORATING THE BODY was important in Jomon times. Elaborate pottery ear ornaments became especially popular in the Kanto region of Honshu in the final stage of the Jomon period. Over 1000 ear ornaments were discovered at Chiamigaito in central Honshu, indicating they were produced in a specialist workshop. Large numbers of ear ornaments are only found at a few sites, although strikingly similar designs are found from sites separated by long distances. These ornaments were made from specially selected clay and are sometimes decorated with red pigments. They belong to a tradition of ear ornaments that extends back to 5000 BC.

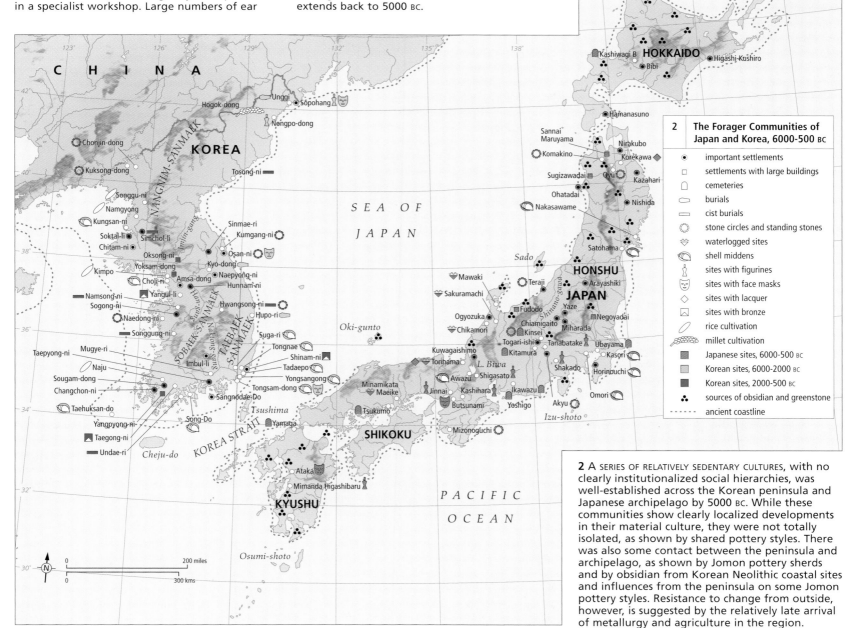

2 The Forager Communities of Japan and Korea, 6000–500 BC

- ⊙ important settlements
- □ settlements with large buildings
- ⌂ cemeteries
- ⌒ burials
- ▭ cist burials
- ✳ stone circles and standing stones
- ∿ waterlogged sites
- ◖ shell middens
- ⸙ sites with figurines
- ⊡ sites with face masks
- ◇ sites with lacquer
- ⊠ sites with bronze
- ⟋ rice cultivation
- ⸪ millet cultivation
- ▪ Japanese sites, 6000–500 BC
- ▪ Korean sites, 6000–2000 BC
- ▪ Korean sites, 2000–500 BC
- ⸭ sources of obsidian and greenstone
- ⋯ ancient coastline

2 A SERIES OF RELATIVELY SEDENTARY CULTURES, with no clearly institutionalized social hierarchies, was well-established across the Korean peninsula and Japanese archipelago by 5000 BC. While these communities show clearly localized developments in their material culture, they were not totally isolated, as shown by shared pottery styles. There was also some contact between the peninsula and archipelago, as shown by Jomon pottery sherds and by obsidian from Korean Neolithic coastal sites and influences from the peninsula on some Jomon pottery styles. Resistance to change from outside, however, is suggested by the relatively late arrival of metallurgy and agriculture in the region.

ART, WAR AND EMPIRE 500 BC–AD 600

DURING THESE CENTURIES the full impact of humanity's domination of the planet emerged. Agriculture became more widespread and urbanization was extended. Above all, warfare was carried out more effectively. The experience of the Persian and Peloponnesian wars, Alexander's campaigns in Asia, and the Warring States period in China in particular, brought great improvements in weaponry, tactics, command and communications, and these allowed rapid conquests to be effectively consolidated into vast, centrally managed territories. The greatest of these are today often called empires after one of the most successful, that centred on Rome.

RULERS WERE OFTEN GENERALS, as was Augustus, the first Roman *imperator* or commander (r.31 BC–AD 14). In all cases they relied on military control, as did Qin Shihuangdi, the first emperor (r.221–210 BC) of an area comparable to modern China, and his Han Dynasty successors, or Chandragupta Maurya (r.321–297 BC) and his grandson Ashoka, who extended their authority over most of India. The new power of such figures enabled them to transform both society and the environment. They could use captives and criminals as slaves to extract and work raw materials. They could levy taxes with which to fund public works. They could standardize measures to facilitate such activities as trade and construction. They could

impose and maintain peace over such large areas that private wealth was generated on an unprecedented scale. As a result, by AD 600, larger portions of the world had been changed by human activity than ever before. The transformation was also far more drastic. This can be seen in the further material enhancement of the areas that had been urbanized earlier. As the pharaohs of Egypt were succeeded by the Persians, the Ptolemies and the Romans and the kings of Assyria by the Persians, the Parthians and the Sasanians, new and larger cities, such as Alexandria at the mouth of the Nile, were established and the numbers of baked-brick and stone buildings rose steadily.

WHEREVER NEW STATES appeared lakes, were drained, canals were cut and ports extended into the sea. Fortifications ringed cities and the walls surrounding the Chinese and Roman empires stretched for thousands of miles. Large areas of the globe were criss-crossed by roads, some of which were paved and carried across rivers on permanent bridges. Food and luxuries were transported along these roads, down the rivers and across the seas for consumption in the great centres. In Rome these luxuries included not only statues looted and bought from Greece, but ancient granite obelisks and modern columns from Egypt. Rome was distinguished by its huge buildings of baked brick, concrete and marble. Not all cities were

built of such permanent materials, but many, like Chang'an, capital of Han China, or Teotihuacan in modern Mexico, had large populations, were extremely extensive and were filled with large structures. Pataliputra (Patna), the Mauryan capital, was the largest city in the world under Ashoka (r.268–232 BC), with as many as 300,000 inhabitants, Jenne on the Niger in Sub-Saharan Africa occupied more than forty hectares (100 acres) by AD 500 and the Huaca del Sol at Moche on the coast of modern Peru was expanded by stages until it incorporated some 143 million adobe bricks. Many of the monuments in these cities, as well as the homes and the tombs of their citizens, were richly decorated and filled with a wide variety of artefacts made of such processed substances as metal and glass. Imperial rule over an unprecedented number of people brought with it a hitherto unprecedented exploitation of nature.

ALL THESE LARGE CITIES and empires depended on lands outside their direct control for particularly valued material, such as amber from the Baltic or lapis lazuli from modern Afghanistan. The human contact and the exchange of goods and currency associated with such trade steadily extended the area of intense material consumption. Technologies were exported as part of the same process. The Celtic peoples of Europe became expert metalworkers, as did the nomadic tribes who followed them into the more northerly areas. The same process also occurred in Central Asia. Japan, too, which had long been relatively isolated, acquired bronze- and iron-working and rice and silk production from China and Korea, and took on the appearance of a more and more centralized state. Further south, on the edge of modern Indonesia, improvements in

seafaring allowed longer and longer voyages into the Pacific, bringing Neolithic agriculturalists deeper into Polynesia and Micronesia. In Africa, ironworking was adopted south of the Sahara and, when exploited for military purposes and associated agriculture, sustained the Bantu expansion southwards at the expense of the existing hunter-gatherers, who began their withdrawal into the forests and deserts where farming was difficult or impossible.

ELSEWHERE, IN ALL CONTINENTS, other groups of hunter-gatherers continued to develop their existing ways of life, which were largely dependent on stone and bone tools, with little outside interference, as did the Australian aborigines or the tundra-dwelling Inuit. The most elaborate artefacts of such people were rock paintings and carvings, vast numbers of which survive from numerous sites in Europe, Asia, Africa, both North and South America and Australia. Although often difficult to date, many must come from this period. The majority of their products were, however, made of less permanent materials such as wood. The main exception were those communities such as the Inuit, Okvik and Ipiutak living on the Bering Straits in northern Alaska two thousand years ago, whose lack of any timber except driftwood led them to exploit walrus ivory, making their traditions more easy to trace. At this period, like all the others that are mapped in this atlas, our ability to document the uncertain record of human material culture depends on wide variations in the natural environment and the lifestyles it supported.

TERRACOTTA CAVALRYMEN, Qin Dynasty, 221–202 BC, discovered in Xi'an near the tumulus of the first Chinese emperor, Qin Shihuangdi.

NORTH AND CENTRAL AMERICA 500 BC-AD 600

FROM 500 BC TO AD 600, traditions as rich, complex and long-lived as any in the 'Old' World coalesced in North and Central America.

THE CULTURES OF MESOAMERICA

Mesoamerica witnessed both important endings and new beginnings in 500 BC. The last expressions of Olmec-style art, the La Venta Horizon, occur between 500 and 400 BC at Gulf Coast sites and in the Mexican Highlands at Chalcatzingo, where artists familiar with the Olmec style carved low-relief sculptures illustrating enthroned rulers and scenes of supernatural animals attacking humans. Bas-relief sculptures, probably marking a coastal trade route, proliferate along the Pacific Coast, from Chiapas, Mexico (Pijijiapan) to El Salvador (Chalchuapa), although most of these date between 800 and 500 BC.

New beginnings are seen in both the valleys of Oaxaca and Mexico with the emergence of the first cities and states. Construction at Monte Albán, located on a hilltop in the centre of the Oaxaca Valley, began around 500 BC. Bas-relief sculptures from this date illustrate ancestors and sacrifices vital in the founding of the city, and include some of the earliest examples of Mesoamerican writing. By AD 200 Monte Albán incorporated much of the Oaxaca Valley and adjacent regions through trade, alliances and possibly conquest. Zapotec craftsmen made greyware pottery and anthropomorphic urns;

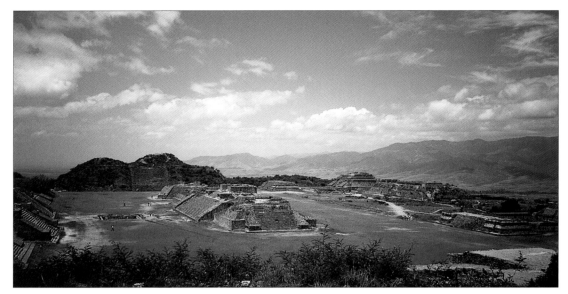

AT ITS PEAK BETWEEN AD 400 AND 600 Monte Albán covered 7.5 square kilometres. The Zapotecs approached urbanism by focusing this hilltop city on a large open space, the Main Plaza, surrounded by roughly symmetrically arranged public and administrative structures. Additional civic-ceremonial features – such as Mound H, in the foreground – lie in the centre of this plaza.

these are found at regional centres well beyond Monte Albán's sphere of influence, from Río Viejo on the coast to Mixtec centres such as Cerro de las Minas and Yucuñudahui.

An entire Zapotec *barrio* (urban area), found at Teotihuacán, symbolizes the complex relationships between states. Much of the population of the Valley of Mexico shifted to Teotihuacán from around 150 BC. By its peak in AD 600, Teotihuacán, with a population of over 100,000 people, was the sixth largest city in the world. Distinctive polychrome pots and stereotyped faces on figurines and masks identify this style throughout Mesoamerica; objects in the Teotihuacán style have been found at Mayan sites such as Copan and Tikal. Teotihuacán's control over important obsidian sources illustrates its importance in regional trade. The influx of distinctive Teotihuacán *talud/tablero* architecture (sloping surfaces alternating with vertical ones) around AD 400 at the early Mayan centre of Kaminaljuyú suggests to some scholars an aggressive element to Teotihuacán interaction. Teotihuacán both influenced and received stimuli from Gulf Coast centres such as El Tajín (known for its many ball courts and scrolling sculptural motifs) and Cerro de las Mesas (known for life-size ceramic sculptures).

Classic Mayan cities emerged throughout the Petén after AD 300, distinguished from earlier Mayan developments such as El

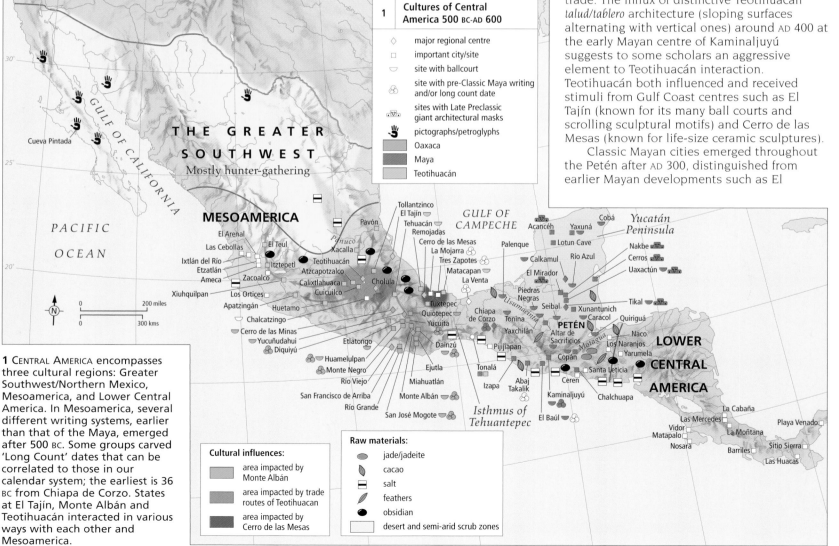

1 Cultures of Central America 500 BC-AD 600

◇ major regional centre
□ important city/site
▽ site with ballcourt
⊛ site with pre-Classic Maya writing and/or long count date
▦ sites with Late Preclassic giant architectural masks
🖐 pictographs/petroglyphs
▨ Oaxaca
▨ Maya
▨ Teotihuacán

Cultural influences:
▨ area impacted by Monte Albán
▨ area impacted by trade routes of Teotihuacan
▨ area impacted by Cerro de las Mesas

Raw materials:
⬤ jade/jadeite
◗ cacao
▭ salt
/ feathers
● obsidian
□ desert and semi-arid scrub zones

1 CENTRAL AMERICA encompasses three cultural regions: Greater Southwest/Northern Mexico, Mesoamerica, and Lower Central America. In Mesoamerica, several different writing systems, earlier than that of the Maya, emerged after 500 BC. Some groups carved 'Long Count' dates that can be correlated to those in our calendar system; the earliest is 36 BC from Chiapa de Corzo. States at El Tajín, Monte Albán and Teotihuacán interacted in various ways with each other and Mesoamerica.

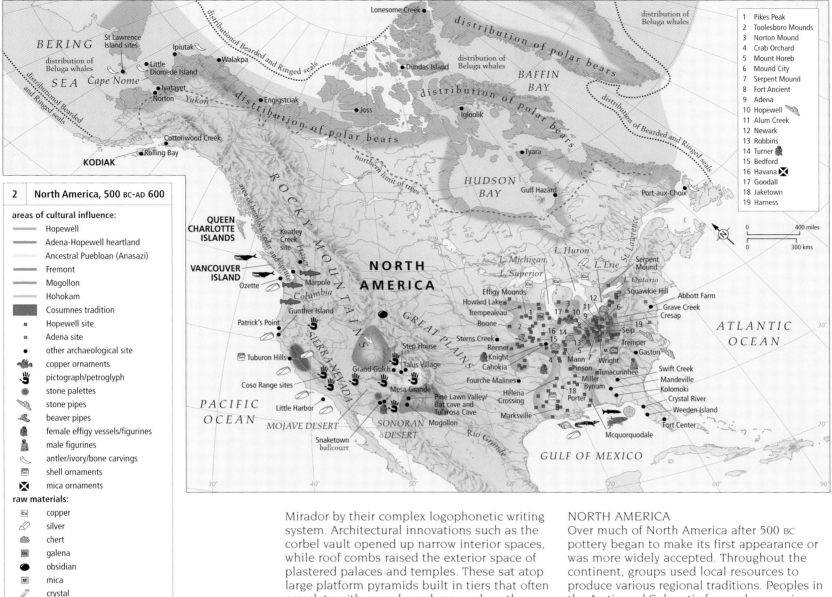

Legend:

1 Pikes Peak
2 Toolesboro Mounds
3 Norton Mound
4 Crab Orchard
5 Mount Horeb
6 Mound City
7 Serpent Mound
8 Fort Ancient
9 Adena
10 Hopewell
11 Alum Creek
12 Newark
13 Robbins
14 Turner
15 Bedford
16 Havana
17 Goodall
18 Jaketown
19 Harness

2 North America, 500 BC–AD 600

areas of cultural influence:
— Hopewell
— Adena-Hopewell heartland
— Ancestral Puebloan (Anasazi)
— Fremont
— Mogollon
— Hohokam
▨ Cosumnes tradition
▪ Hopewell site
▪ Adena site
● other archaeological site
🖐 copper ornaments
🖐 pictograph/petroglyph
◐ stone palettes
🪶 stone pipes
🦫 beaver pipes
⬤ female effigy vessels/figurines
🗿 male figurines
✎ antler/ivory/bone carvings
🐚 shell ornaments
▨ mica ornaments

raw materials:
Cu copper
▱ silver
◓ chert
Ga galena
● obsidian
M mica
◌ crystal
Ch chlorite
🐚 whelk
🐟 barracuda
🐟 shark
🐊 alligator
🐋 whale
🐟 salmon
◉ turtle shell
◗ shell

2 MANY CULTURES AND LIFESTYLES that continue until the present-day were formed between 500 BC and AD 600 in North America. In the Southwest initial versions of the Hohokam, Mogollon, Ancestral Puebloan and Fremont traditions crystallized. The Adena and slightly later Hopewell traditions spread throughout the Midwest and Eastern United States. Resources from the Gulf of Mexico to the Great Lakes and west to Wyoming moved throughout the Hopewell Interaction Sphere, which exhibited at least thirteen regional variants.

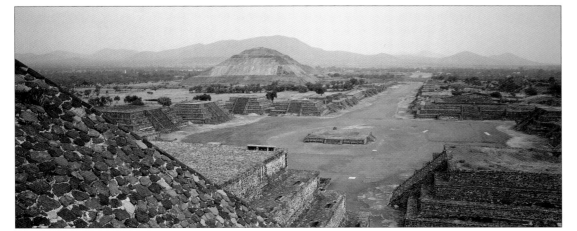

Mirador by their complex logophonetic writing system. Architectural innovations such as the corbel vault opened up narrow interior spaces, while roof combs raised the exterior space of plastered palaces and temples. These sat atop large platform pyramids built in tiers that often correlate with sacred numbers, such as the nine levels (of the underworld) seen at Tikal and Palenque. While some cities, such as Tikal and Calakmul, were larger than others and may have formed 'superstates', most Mayan cities controlled limited land and competed with adjacent city-states.

LOWER CENTRAL AMERICA
While this region interacted with Mesoamerica and South America, it also developed distinct indigenous cultures. Mace heads and ceremonial stools from Las Huacas signal the emergence of ranked societies prior to AD 500. In eastern Costa Rica, large hierarchical sites are identified as the El Bosque complex. Artists excelled in jade-working in northern Costa Rica. By AD 500 gold-working, with hammered and lost wax techniques – probably from Colombia, became important in Panama.

NORTH AMERICA
Over much of North America after 500 BC pottery began to make its first appearance or was more widely accepted. Throughout the continent, groups used local resources to produce various regional traditions. Peoples in the Arctic and Subarctic focused on marine resources, primarily seals, walruses and whales. Artists from Ipiutak carved walruses, bears, humans and fantastic creatures on bone, antler and ivory. By AD 600 Northwest coast peoples mastered carving the abundant cedar from the coastal forests. In the American Southwest and Northwest Mexico the large rocks of the caves and canyons in this semi-arid/desert area served as canvases for styles of pictographs and petroglyphs, many of which have pre-500 BC origins and continued after AD 600.

The Adena complex, with roots stretching back to 700 BC, and the slightly later Hopewell complex, peaked between 100 BC (Adena) and AD 400 (Hopewell) in Ohio. Within the so-called Hopewell Sphere elaborate networks moved disparate raw materials and finished products (such as beaten native copper artefacts) among groups east of the Mississippi River. Both Hopewell and Adena people built large earthworks – often in bird, serpent or geometric shapes – to form sacred enclosures. People of both traditions also built burial mounds, placing individuals in large log tombs. Hopewell peoples elaborated Adena traits, generating fine ceramics, human effigy figures and platform pipes. The Hopewell also exhibited more evidence of conspicuous consumption and social differences.

AT TEOTIHUACÁN IN CENTRAL MEXICO the entire city – including crowded apartments, craft workshops, elegant palaces and towering monumental public structures (such as the Pyramids of the Sun and Moon) – was laid out along a grid. By AD 600 the city covered nearly 21 square kilometres (8 sq miles).

SOUTH AMERICA 500 BC-AD 600

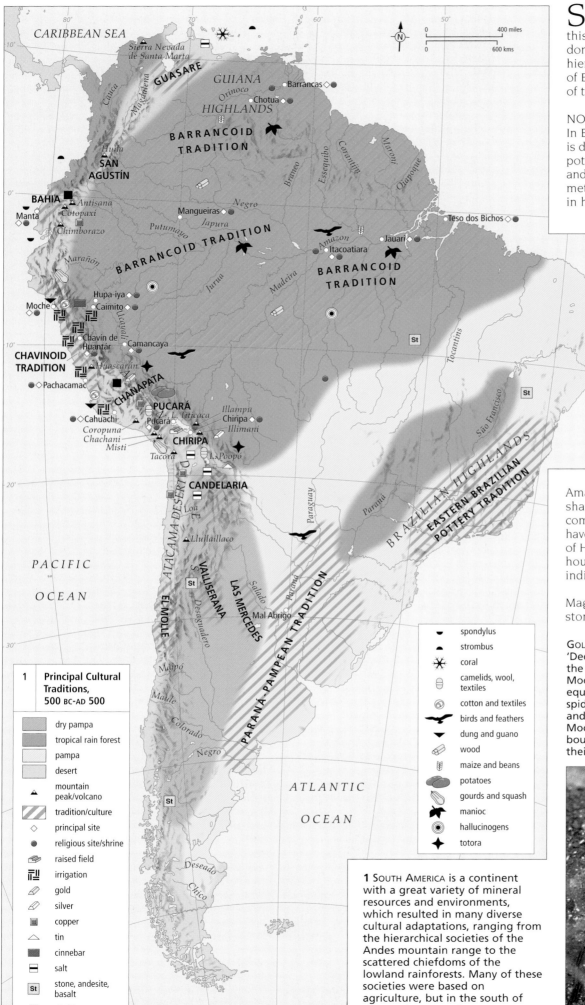

S OUTH AMERICA IS A LARGE and varied
continent and so were its cultures during
this period. The central Andean area was
dominated by complex societies, with elaborate
hierarchies, whereas the cultures of the Andes
of Ecuador, Colombia and Venezuela, like much
of the lowland rainforest, were often chiefdoms.

NORTHERN CULTURES
In Ecuador, the Guangala phase (340 BC-AD 360)
is distinguished by multi-coloured and engraved
pottery with geometric designs, small villages
and a maize-based agriculture. During this phase
metals were used for the first time, particularly
in hammered fish hooks and nose rings.

In the north and north-west
of Venezuela (500 BC-AD 500)
societies were predominantly
agricultural and were producing
pottery. The principal ceramic
tradition was the Barrancoid,
distinguished by its modelled
and incised designs. At sites
such as Barrancas in the Lower
Orinoco valley, houses were
built on piles and on earthen
platforms. Manioc cultivation
probably originated in this area.

The Barrancoid tradition
originated in the central Amazon
basin and its spread was linked
with the Maipuran and Arawak
language families. It was
widespread within the tropical
forest. At Jauari, on the lower
Amazon, there are midden remains, where T-
shaped and notched axes and pottery are
common. The Itacoatiara sites east of Manaus
have ceramics with typical scroll designs. The site
of Hupa-iya of the central Ucayali had un-walled
houses with earthen floors. Spindle whorls
indicate that textiles were being produced.

In Colombia, near the headwaters of the Rio
Magdalena, the San Agustín culture produced
stone monolithic sculptures depicting human

GOLDEN EAR SPOOLS showing the 'Spider God' or
'Decapitator', as excavated from 'Royal' tomb 2 at
the Moche site of Sipán near Chiclayo in Peru. In
Moche art, the spider was seen as a spiritual
equivalent of the model Moche warrior. Just as
spiders capture their prey, bind them with thread,
and extract and consume their vital fluids, so
Moche warriors took their enemies prisoner,
bound them with ropes, and drained and drank
their blood in sacrifice.

Legend

1 Principal Cultural Traditions, 500 BC-AD 500

- dry pampa
- tropical rain forest
- pampa
- desert
- ▲ mountain peak/volcano
- tradition/culture
- ◇ principal site
- ● religious site/shrine
- raised field
- irrigation
- gold
- silver
- copper
- △ tin
- cinnebar
- salt
- St stone, andesite, basalt
- ■ obsidian

- spondylus
- strombus
- ✳ coral
- camelids, wool, textiles
- cotton and textiles
- birds and feathers
- dung and guano
- wood
- maize and beans
- potatoes
- gourds and squash
- manioc
- hallucinogens
- totora

1 SOUTH AMERICA is a continent
with a great variety of mineral
resources and environments,
which resulted in many diverse
cultural adaptations, ranging from
the hierarchical societies of the
Andes mountain range to the
scattered chiefdoms of the
lowland rainforests. Many of these
societies were based on
agriculture, but in the south of
the continent smaller groups
depended more on hunting,
fishing and gathering.

THE 'DECAPITATOR GOD' in painted and modelled plaster work at the 'Temple of the Moon', at the site of Moche. Moche iconography was a complex symbolic language expressing in summary a limited number of themes which were understood by society at large. A number of the characters depicted were actual persons and officers within Moche society.

figures, sometimes with aspects of a jaguar. The oldest sculptures belong to the Isnos phase (c.100 BC). They are found on hill slopes, sometimes in elaborately painted tombs. San Agustín is associated with the construction of large earthworks and gold smelting as well as wire and sheet metalworking.

The Periperí style, which belongs to the eastern Brazilian pottery tradition, is related to the Sambaquí cultures farther south. Houses were post-built. Artefact assemblages are dominated by pounding and grinding tools. Beads from fish vertebrae and shell are common. The pottery is plain and dark brown to black.

SOUTHERN CULTURES

The Paraná-Pampean cultural tradition (first millennium BC) from Uruguay and Argentina emerged from a hunter-gatherer economy. Much of the pottery is plain, although finds from Mal Abrigo, in the Santa Fe area of Uruguay, include modelled animal head lugs.

CENTRAL ANDEAN CULTURES

Within the Andean area, extensive ritual practices continued to be rooted in complex societies with corporate political and religious leadership throughout the Early Horizon (800–200 BC) and the early Intermediate Period (c.200 BC–AD 600).

Chiripa (c.850–400 BC) is located in the Titicaca basin. The site consists of a platform mound with a sunken court and carved stone stelae and plaques, ringed by rectangular chambers. The economy was based on intensive exploitation of lake resources as well as domesticated and wild camelids, seeds and tubers. Textiles and pottery were used, the latter with incised and painted feline and human faces.

To the south, Pucará became dominant in the Titicaca area in around 400 BC. Incised pottery found there was decorated with slip-painted panels, felines, birds, llamas and people. Stone carvings occur frequently. Staircases and sunken courts are common in the terraced hillsides.

Chavín de Huantár, located on a tributary of the Marañon River, has been dated to c.800–200 BC. Its large U-shaped temple platform contains a sunken court and galleries. Elaborate line carvings of mythical beings include elements of felines, snakes, cayman and plants. Within the core of the principal temple there is a series of corridors and channels. It also contains a cross-shaped room with a large columnar sculpture shaped like a very large foot plough and carved to represent a large feline deity. This deity mediated between the supernatural world and that of the living. It has been persuasively argued that the channels and vents found throughout the temple enabled the deity to make sounds.

On the south coast of Peru the coastal Paracas tradition shared elements of both the Pucará and Chavín cultures. Incised pottery painted with organic paints, and highly ornate textiles showing flying shaman designs, are common. Mummies are seated in shallow baskets, wrapped in multiple textiles. Cemeteries show a pattern which suggests that related kin groups were entombed in the same grave.

During the Early Horizon period many innovations in textile production developed, such as tapestry weaving, tie-dye and *batik* techniques. Metallurgical techniques such as soldering, sweat welding and *repoussé* decoration developed, and the frequency of metal use increased. Pottery tended to have incised decoration, burnishing, slip painting and organic paint.

THE MOCHE AND OTHER CULTURES

By the end of the first century BC most of the land which could easily be taken into production was in use. Ceremonial sites were reduced in number and size whereas settlements, including fortified ones, grew and multiplied. Regional kingdoms and chiefdoms were established.

On the north coast in the Early Horizon, Cupisnique style was followed by the Salinar, Viru and Gallinazo traditions. In time, Moche became the dominant culture, amalgamating a series of independent valley-based chiefdoms and kingdoms under one central authority. At Cerro Blanco, the capital of the Moche, there are two principal ceremonial sectors: the Huaca del Sol (Temple of the Sun) and the Huaca de la Luna (Temple of the Moon). On these large platform pyramids prisoners were ritually dismembered at times of crisis. The Huaca del Sol is the largest single earth-built structure in the Americas.

The Nazca culture dominated four river valleys on the south coast. The Huarpa culture, with sites such as Conchopata, Nawinpuquio and Huari, focused on the Ayacucho basin, where terraced fields and irrigation channels formed the basis of an innovative agricultural strategy.

2 ANDEAN CULTURAL DEVELOPMENT during this period was clearly affected by the comparative closeness of very contrasting ecosystems. Because of the very pronounced topography of South America, a range of environmental zones, including coastal deserts, mountains and tropical jungles were all within easy reach. This proximity resulted in the development of a cultural assemblage that was both materially and symbolically very rich.

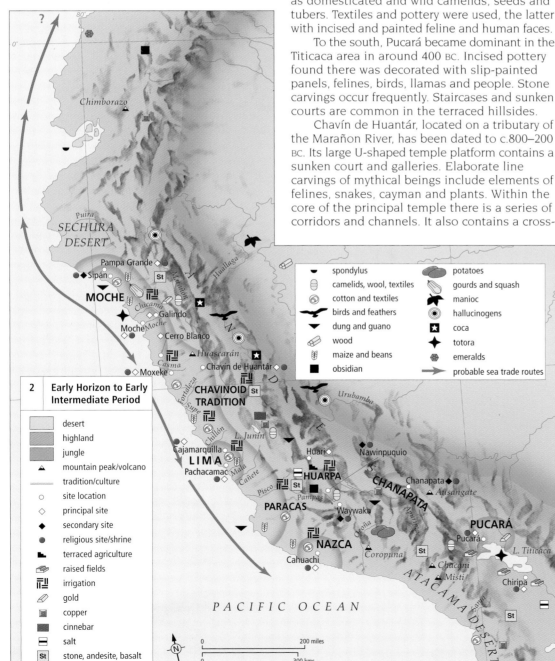

⌄	spondylus
⬚	camelids, wool, textiles
◎	cotton and textiles
⟋	birds and feathers
⌄	dung and guano
▱	wood
⫴	maize and beans
■	obsidian
⬭	potatoes
⟋	gourds and squash
⬲	manioc
◉	hallucinogens
★	coca
✦	totora
⬡	emeralds
→	probable sea trade routes

2 Early Horizon to Early Intermediate Period

	desert
	highland
	jungle
▲	mountain peak/volcano
—	tradition/culture
○	site location
◇	principal site
◆	secondary site
●	religious site/shrine
⬛	terraced agriculture
⬭	raised fields
⫴	irrigation
⬯	gold
▣	copper
▦	cinnabar
⊟	salt
St	stone, andesite, basalt

EUROPE 500 BC-AD 300

THE LATER IRON AGE was the age of the Celts, Thracians, Scythians, Sarmatians, Germans and Dacians. These quasi-national tribal confederacies were in direct competition with and dependent on the swathe of urban empires – Persian, Greek, Macedonian and Roman – to their south (*see* the later spreads in this part). Although called 'barbarian' by the Greeks (from their babble – '*bar-bar*' – of languages), it would be a mistake to judge their arts 'barbaric'. The Celts and Scythians developed two of the most seductive and sophisticated styles in world art: the La Tène Style and the Steppe, or Scythian, Animal Style.

INDIGENOUS STYLES
Grounded in indigenous themes and craft-skills, the La Tène and Scythian styles transformed Classical and Oriental elements in memorable visual syntheses. In the Carpatho-Balkans the styles overlap to create less-integrated fusion styles, such as Thracian, Thraco-Getic and Daco-Sarmatian, which all owe debts to Greek, Achaemenid and central Asian production. Other lesser style zones include the Celt-Iberian, the Insular Celtic, the Germanic-Scandinavian and the Etruscan-influenced southeast Alpine region with its frieze-based *situla* (bronze bucket) style.

Everywhere there was a reawakening of vibrant iconic content after the formulaic themes of the later Bronze Age Urnfield period and the restricted early Iron Age (Hallstatt) repertoire. Significantly, with certain exceptions among the *situlae* and in the most Hellenized Thracian art, the literal narrative approach of the Mediterranean area is eschewed in favour of an emblematic or hieratic style – a significant pre-figuration of medieval heraldry. The rare preservation of wood-carving, as at the Celtic sacred site of Fellbach-Schmiden in Germany, indicates that conventions such as symetrically paired animals extended to more fugitive media: the richness of barbarian tattooing, often remarked on by commentators, can only be guessed at.

The military, political and economic complexity of the period is immense. Most of the art that survives is of a portable nature, made in gilded bronze, silver and gold, used for decking out horses, worn on the body as part of a costume, or displayed at feasts. There is evidence from metrology that the convertible or bullion value of the art was of considerable significance, and that pieces (such as the 165 silver and silver-gilt vessels that make up the Rogozen hoard from Bulgaria) were made to known weights.

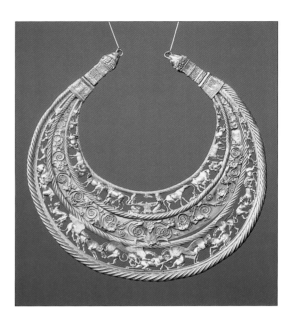

THE TOLSTAYA MOGILA PECTORAL is Graeco-Scythian in style. The central flower and tendril frieze betrays the master goldsmith's training in southern Italy, but the upper and lower friezes carry pastoral and mythological scenes of pure steppe inspiration: above, foals and calves suckle, a boy milks a ewe, two men stretch a sheep skin and another threads an awl for sewing leather; below, horses, stags and boars are attacked by lions and griffins.

1 EASTERN INFLUENCES include the import of Achaemenid artefacts, iconographies and silk to Europe following the Persian occupation of Thrace (513–480 BC), the impact of Scythian nomads on the Hungarian basin and beyond, and the transport of Thracian and Sarmatian motifs, some with north Indian connections, westwards by cavalry auxilliaries under Rome. The Gundestrup cauldron, made with Thracian techniques and depicting La Tène Celts, may have been carried to Jutland in the booty of the Germanic Cimbri around 118 BC.

1	**Eastern Influences**		
▨ Dressel 2-4 lamp distribution, 70 BC-AD 15	— Bosporan Kingdom, 302-63 BC	**artefacts:**	
cultural areas:	— Kingdom of Pontus, 480-63 BC	◔ Geto-Dacian coins and grave stelae	
▨ Scythian (500-150 BC) and Sarmatian (150 BC-AD 300) zone	**sites and burials:**	⊕ Sark-class Dacian *phalerae*	
▨ Southeast Hallstatt zone, until 400 BC	◣ Scythian 'Royal' burials	◎ Oriental silks	
— Geto-Dacian sphere, 400 BC-AD 107	■ Thraco-Getic burials and hoards	▽ bronze *situlae*	
— South Thracian sphere, 500-85 BC	▥ Thracian dynastic tombs	⬚ Scythian animal-style objects	
	• Greek colonies	◌ Achaemenid Persian objects	

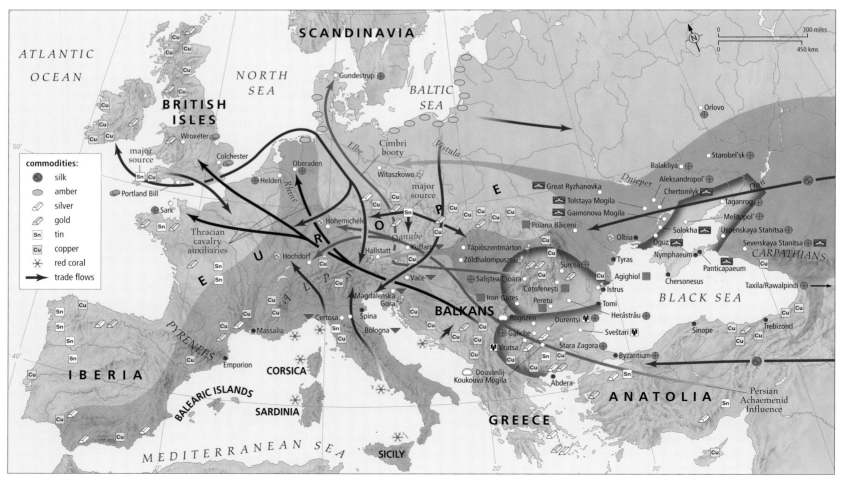

commodities:
- ● silk
- ◗ amber
- ⬭ silver
- ⬭ gold
- Sn tin
- Cu copper
- ✳ red coral
- ➤ trade flows

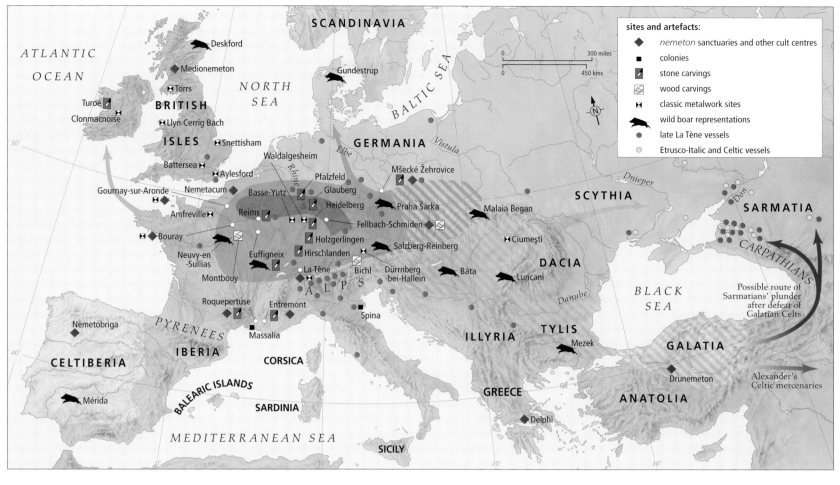

2	The Spread of Celtic Culture

area of origin of La Tène style, 500–450 BC
Early Celtic world (western), 450–400 BC
Early Celtic world (eastern), 450–400 BC
primary Celtic expansion (western), 400–250 BC
primary Celtic expansion (eastern), 400–350 BC
secondary Celtic expansion (western), 250 BC–AD 300
secondary Celtic expansion (eastern), 350–150 BC

sites and artefacts:
◆ *nemeton* sanctuaries and other cult centres
■ colonies
▨ stone carvings
▨ wood carvings
⋈ classic metalwork sites
🐗 wild boar representations
● late La Tène vessels
○ Etrusco-Italic and Celtic vessels

2 THE CELTIC DIASPORA was both ethnic and economic. From a heartland on the French-German border militaristic elites spread southwest into Spain, and eastwards to set up kingdoms in the Balkans and Turkey. Mercenaries, wars and looting carried La Tène objects to south Russia and beyond. It is uncertain to what extent the 'Insular' style in Britain and Ireland was introduced by continental invaders rather than adopted.

THE ICONOGRAPHY OF POWER
These elite artefacts, preserved from the hoards and burial monuments of the wealthy, express ideologies of power the iconography of which may actively obscure the brutal realities of Iron Age life. The obsession with virtuosity, especially in repoussé metalwork, suggests a high degree of competition among intensely aesthetically-sensitive patrons. Gold-, silver- and bronze-smiths, however, may have ranged in social status from mobile entrepreneurs to virtual chattels.

By 500 BC the slave trade, powered by endemic warfare, was crucial. Slaves reached the Classical world via the coastal colonies of the Black Sea and Mediterranean in exchange for wine and finished goods, including pottery finewares, jewellery and precious metalwork. The Greek mercantile credit economy was supported by the massive silver output of the slave-worked mines of the Laurium peninsula in Attica and the islands of Thasos and Siphnos. It was such wealth, displayed in votive offerings, that attracted the Celts south to sack the sanctuary of Delphi in 279 BC. The

expansion of Celtic warrior society is evident in the *nemeton* (sacred grove) sites, which extend from Scotland to Spain to Turkey; small groups, serving as mercenaries under Alexander, may have reached India.

Trading and raiding brought Achaemenid Persian objects into Europe in the fifth century BC, La Tène bowls to the north Caucasus and Kuban in the third century BC, and Thracian and Dacian motifs as far west as the south coast of Britain by the time of the Roman conquest, and exposed local conventions to broader scrutiny. The development of commercial markets intensified in the second and first centuries BC,

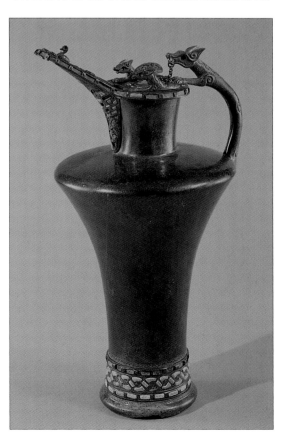

illustrated for example by the distribution of mass-produced decorated clay lamps of the types known as Dressel 2-4, which occur from southern Spain and Sicily through to the Rhine and North Sea coast. The extent to which the later Iron Age societies produced and maintained such distinctive styles over time is fascinating. In Celtic art, the Early Style developed via Waldalgesheim and Vegetal, the Plastic and the Hungarian 'sword style', into the late Insular styles which were still strong in Ireland as late as AD 300.

This is ultimately an issue of ethnic identity, expressed through close control of form and content, the need for which was actually heightened by the fluxes of wars, invasions and resettlements. For the Scythians the beast-fight, whether expressed at a mythical or more realistic level, was central as a metaphor of struggle and conquest. Sword-scabbards, belt-plates, bridle appliqués, and pectorals, such as that from Tolstaya Mogila, all depend on the same theme, one that was continued by their martial successors on the steppe, the Sarmatians. This worn art was displayed on the body, expressing ethnicity and social status on the move. The La Tène Celts had their favourite motifs too (the wild boar and horse, among animals) and a penchant for virtuoso, vegetally-based symmetries. The human form, often almost cryptic in metalwork, found clear expression in anthropomorphic grave stelae and in the elaborate stone sacrificial altars of the south French sites near Massalia.

THE BASSE-YUTZ FLAGON (one of a pair). This early fourth-century BC vessel refines Italic prototypes. Red *champlevé* enamel and Mediterranean coral insets form interlace and chequerboard patterns. The La Tène Early Style figural elements include a maned wolf-form handle with engraved palmettes rising from a human face built of S-curves, a chained stopper with zoomorphic decoration and a small duck swimming down the spout in the direction of the pouring wine.

THE AEGEAN 500-300 BC

DURING THIS PERIOD the Aegean experienced an unprecedented expansion in the production of permanent artworks, many made for private individuals. From 600 BC the Greeks began representing themselves in life-size statues, first of marble and then of bronze, and from 500 BC, especially after the defeat of the mighty Persian Empire, the production of hard and durable artefacts, which could be as large as temples or as small as seals, rapidly increased.

THE RISE OF THE COMMUNITY
The original driving force behind this development was competition between the more or less independent communities that grew up on the many Aegean islands and in the fertile valleys of the European and Asiatic mainlands. The settlements close to the coasts grew rapidly, safeguarding their security by constructing stone walls and forming well-

trained and -equipped citizen armies and navies. Increasingly, skilled craftsmen, soldiers and artists exploited, and improved upon, the available technologies of metallurgy, and stone- and woodworking, as well as developing their skills in navigation, agriculture, ceramic and textile manufacture, warfare and education. They also maximized the resources of their small territories by exchanging their surpluses of raw materials and finished products, including trained and untrained people, over great distances.

Often the degree of a community's, or individual's, success could be measured in displays of artistic patronage at the great cult centres, such as Olympia and Delphi, where people from all over the Greek world, from southern France to North Africa, gathered at the Great Games. Competing cities built treasuries to show off their trophies, and rival athletes were commemorated in increasingly lifelike statues.

THE ATHENIAN EXPANSION
No city was more productive or more successful in this competition than Athens,

principal town of Attica, a large peninsula projecting into the Aegean. Athens maximized the benefit from its own Great Games by sending around Greece and the Mediterranean as prizes special Attic oil lamps made by the best Attic potters and decorated by the best Attic painters. It was competition between its craftsmen that ensured the exceptional quality of the city's products.

In 509 BC the promotion of political competition by the strengthening of democratic institutions fostered a new self-awareness on the part of the citizens of Athens. This would mark many of their actions, whether collective or individual, over the next two hundred years. During this period, political power was often concentrated in the hands of generals, and economic considerations, military policy and civic patronage were closely linked. The discovery of important new veins in the silver mines at Laurium in southern Attica in 483 BC, for example, allowed Athens to immediately expand ship production in time to defeat the Persian fleet at Salamis in 480 BC and made it easier subsequently both to construct new

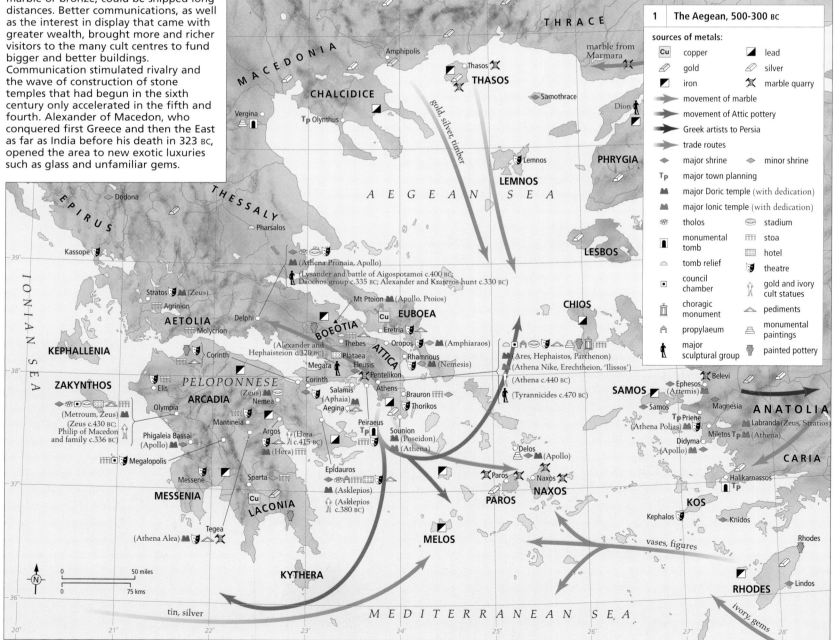

1 AS SHIPBUILDING AND NAVIGATION SKILLS improved, the Aegean became the focus of an efficient multi-directional trade in raw materials and finished goods. Improved metal technology meant that raw marbles and finished statues, in marble or bronze, could be shipped long distances. Better communications, as well as the interest in display that came with greater wealth, brought more and richer visitors to the many cult centres to fund bigger and better buildings. Communication stimulated rivalry and the wave of construction of stone temples that had begun in the sixth century only accelerated in the fifth and fourth. Alexander of Macedon, who conquered first Greece and then the East as far as India before his death in 323 BC, opened the area to new exotic luxuries such as glass and unfamiliar gems.

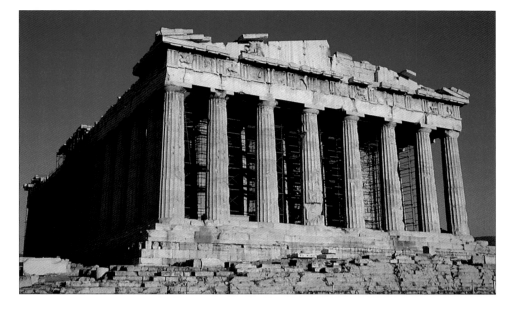

THE PARTHENON, with its combination of Doric forms, typical of the mainland, and Ionic forms and marble material, typical of the islands and Ionian coast, illustrates Athens' desire to lead all Greece. Its sculptures celebrate the city's human and material resources. The west pediment shows the competition for Attica by the rival deities, Poseidon, who produces a fountain of salt water, and Athena, who produces an olive tree. Lower down, on an inner frieze, young women of the city offer the goddess a newly woven embroidered robe.

2 ATHENS CONSISTED of an Acropolis (Upper City) on a great fortified rock and a lower city that centred on the Agora, or Market. The Acropolis was restored and rebuilt after the Persian sack in 480. It was dominated by four magnificent marble buildings, the Parthenon, the Propylaea or Entrance, the Erechtheion and the Temple of Nike. In the lower city less important temples of Apollo and Ares were constructed in the Agora area, as were three stoas, while the theatre of Dionysos was extended and a covered Odeion built nearby. The city's trade was assured by its connection, through a system of walls, with the port of Peiraeus. Its flowering during the fourth century was brought to an end after its conquest by Alexander and by the passing of laws limiting expenditure.

harbours at Peiraeus and to build long walls linking the port to the city. With her position as both a military and trading power greatly strengthened, Athens then entered on an exceptional period of public building, private consumption and personal self-development, during which architects such as Ictinus, sculptors such as Pheidias and teachers such as Socrates, acquired an authority in their fields matching that of the city's leader, the charismatic general, Pericles.

Expensive materials, both local and exotic were widely employed. Marbles of different colours were used for the building and sculptural decoration of the Parthenon (447–32 BC), with its 15-metre-high (49 ft) gold and ivory image of Athena, and for the Erechtheion, with its bronze chimney. One of several new *stoas*, the Painted, was filled with large pictures of Attic victories. Large but less extravagant projects were the carving of new seating for the Assembly from the hill of the Pnyx, the enlargement of the Theatre of Dionysus, and the building of a new covered Odeion to house musical performances.

Since Athens' wealth depended critically on the importation of raw materials, the establishment of the Athenian colony of Amphipolis in 437 BC was vital, in that it safeguarded supplies of gold from nearby Mt Pangaeum and of timber for ship-building from the surrounding forests. The loss of the colony in 424 BC paved the way for the city's defeat at the hands of Sparta in 404.

Nevertheless, public impoverishment had little impact on growing personal expenditure. At the great drinking parties, or *symposia*, in private houses, at which young men would compete in conversation with their teachers, Attic wine was served from painted Attic pottery, which continued to dominate the international market into the fourth century. From the late fifth century large marble

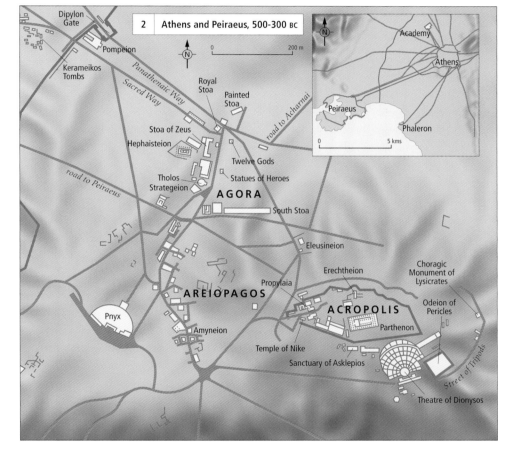

2 Athens and Peiraeus, 500-300 BC

THE ATTIC 'FOUNDRY CUP' provides evidence for some of the phases in the production of a work of art in the early fifth century BC. It illustrates the production process, from the sculptor's furnace and tools, to the painted models that aided standardization, to the final assembling of whole bronze statues.

tomb reliefs in the Kerameikos, or Potter's Quarter, show women rivalling each other in their finery, as they sit in elegant dresses on elaborate chairs taking jewels from rich caskets.

Both at *symposia* and on tombs the celebration of the individual reached new heights, and during the fourth century both body and mind received new attention. At Athens teachers established themselves at the *gymnasia* where young men went for physical training – just as Plato did at the grove of the hero Academus. Such concerns with the self relate closely to the consolidation of the roles of individual patrons and individual artists, especially after the emergence of super-rich rulers such as King Mausolus, the rebuilder of Halikarnassos, or the greatest city-founder of all time, Alexander of Macedon. Mausolus' wife Artemisia employed four famous sculptors on her husband's gigantic tomb. Alexander insisted on patronizing the architect Dinocrates when planning his most famous city, Alexandria in Egypt. He also patronized the sculptor Lysippos when ordering portraits and grand figure groups and the painter Apelles when commissioning important paintings. It is against this background that the first writings on art by architects, sculptors and painters appeared in the sixth and fifth centuries, and by around 300 BC the first critical histories of painting and sculpture by Xenocrates and the first biographies of artists by Douris had made their appearance.

THE EASTERN MEDITERRANEAN 500-100 BC

DURING THE SECOND HALF of the first millennium BC, goods and techniques were brought in an increasing stream from east to west by way of the 'silk route' through Central Asia to the Levant as well as up the Persian Gulf from the Indian Ocean. The conquests of Alexander III of Macedon ('the Great', r.334–323 BC), in their turn brought cultural influences back from the West to the East – so that to some degree we can see a real circulation of culture during the Hellenistic period. This brought with it a transmutation of art and intellectual ideas everywhere, and so paved the way for the Roman empire.

In the fifth and early fourth centuries, the Greek world was made up of autonomous city states, generally small in size and for the most part short of natural resources, ruled directly by their citizens. From the time of the Macedonian conquest of Asia, the most powerful Greek states were infinitely larger, far richer and under the control of kings. These rulers were widely regarded as divine, and called themselves by such epithets as 'Saviour', 'Benefactor' or 'God made manifest'. Even long-standing taboos such as that against incest were overturned in the adoption by the Ptolemies of the age-old Pharaonic custom of brother and sister marriages.

POLITICS AND PATRONAGE

The empire of Alexander briefly encompassed the same territory as the old Achaemenid empire of Persia, which he had overthrown, but after his death it was broken into three by his generals, who established themselves as his heirs. Antigonus Monophthalmos ('The One-eyed') took Macedonia itself and the old European possessions; Seleucus Nicator ('The Victorious') seized the satrapy of Babylonia and most of the rest of Asia, while Ptolemy Soter ('The Saviour') established himself as Pharaoh of Egypt.

Greek literature was encouraged by these rulers. For example, the 'sister-loving' Ptolemy II and his consort Arsinoe, established a

SILVER TETRADRACHM of King Antimachus I (c.181 BC) of Bactria. This masterful portrait shows the king wearing the traditional Macedonian *kausia* head-dress. Although from the most easterly part of the Greek world, this coin shows the typical Hellenistic interest in physiognomy.

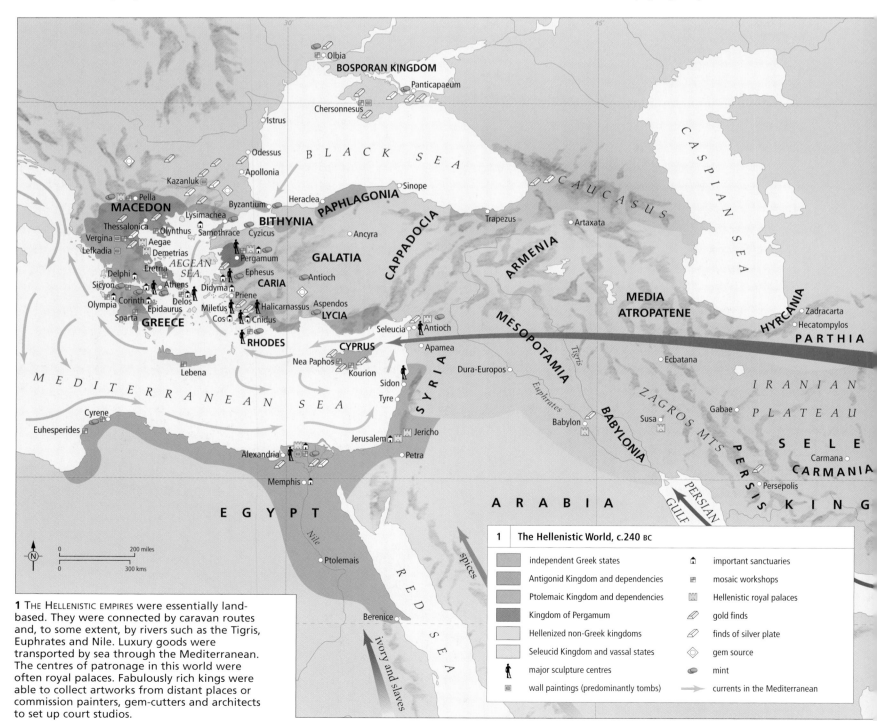

1 THE HELLENISTIC EMPIRES were essentially land-based. They were connected by caravan routes and, to some extent, by rivers such as the Tigris, Euphrates and Nile. Luxury goods were transported by sea through the Mediterranean. The centres of patronage in this world were often royal palaces. Fabulously rich kings were able to collect artworks from distant places or commission painters, gem-cutters and architects to set up court studios.

1	The Hellenistic World, c.240 BC
independent Greek states	important sanctuaries
Antigonid Kingdom and dependencies	mosaic workshops
Ptolemaic Kingdom and dependencies	Hellenistic royal palaces
Kingdom of Pergamum	gold finds
Hellenized non-Greek kingdoms	finds of silver plate
Seleucid Kingdom and vassal states	gem source
major sculpture centres	mint
wall paintings (predominantly tombs)	currents in the Mediterranean

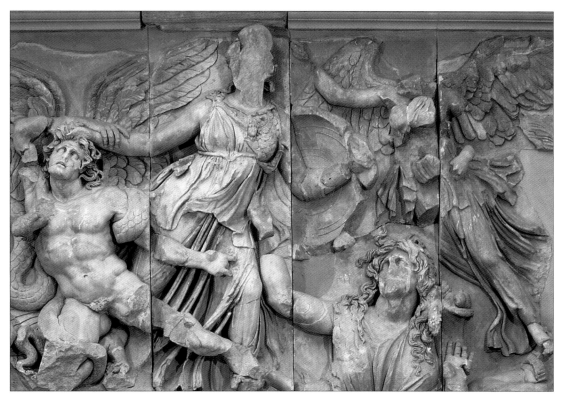

RELIEF FROM GREAT ALTAR OF ZEUS, Pergamum. Eumenes II (r.197–158 BC) had his defeat of the Gauls symbolized as the triumph of the gods over the giants. In this masterpiece of the Pergamene school of sculpture, the contest is given an epic grandeur. The calm efficiency of the Olympian gods (in this detail led by Athena) contrasts with the emotional decadence of their barbarian foes.

anticipating in effect the 33 metre (109 ft) Helios statue which Chares of Lindos created for the independent island state of Rhodes in 304 BC to celebrate the lifting of a siege by the Macedonian Demetrius I Poliorcetes ('The Besieger of Cities'). By contrast other craftsmen such as Alexander the Great's gem-cutter Pyrgoteles specialized in creating the same powerful effects on a miniature scale.

Hellenism was now manifested by the externals of language, manners and taste rather than by race. Even though the old Greek world remained, Sparta, for example, was merely a historical curiosity. Even Athens was valued mainly for its culture, being patronized not by her own citizens but by others such as King Attalus I of Pergamum (r.241–197 BC).

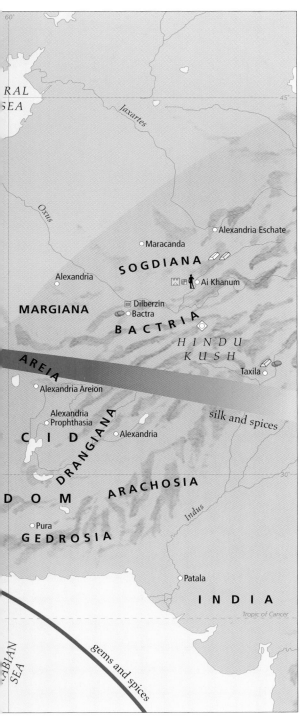

university (the 'Museum'), and a great library in Alexandria, but he, like others of his house, also patronized Egyptian sanctuaries. Traditional art forms continued alongside Greek ones, and inscriptions were set up in hieroglyphic and demotic Egyptian as well as in Greek. Similarly, although Antioch and Pergamum were very thoroughly Hellenized, native cultures and languages, notably Aramaic, continued to flourish away from these centres. From the beginning, there was a tendency for this vast empire to fragment, most particularly Seleucid Asia.

In the later third century in the west of Asia Minor, the native people of Pergamum who had come to think of themselves as Greeks, under the patronage of Pallas Athene, resisted both Antiochus I and invading Gauls. They established a confident and vital state, a major artistic centre epitomized by a lively sculptural tradition but also by mastery of other arts. Concurrently in the Far East, in the old Achaemenid satrapy of Bactria, a line of Greek kings managed to maintain their independence for two centuries, greatly influencing the native arts of northern India.

THE NATURE OF HELLENISTIC ART

The major centres of Hellenistic patronage were the royal courts. They patronized architects and sculptors as well as those involved in the luxury arts, notably silver plate and gold jewellery. This was often set with gems, such as garnets, from the Himalayas. Such materials had not only been hitherto too distant from the Mediterranean world of the Greeks to be imported, but the use of gold, gems, ivory, silks, gold inlaid glass, and even silver plate, would have been regarded with great suspicion by the more egalitarian states of old Greece.

Artistic expression, as shown by the blatant exploitation of emotion in art – as well as in literature as epitomized by the 'new comedy' of the dramatist Menander – laid great stress on individual character. Some artists worked on an enormous scale. Even before the Hellenistic age had begun, King Mausolus (r.377–353 BC) of the Persian satrapy of Caria had ordered Pythias of Priene to build a colossal hero-shrine for him and his wife,

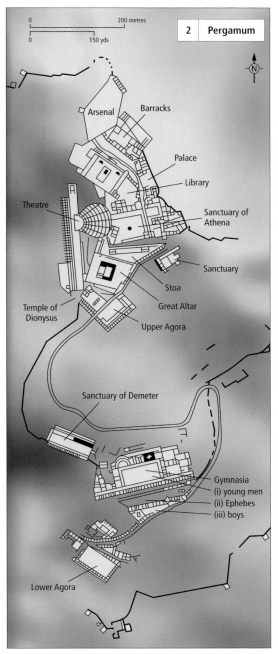

2 PERGAMUM. The city was founded on terrain too irregular to allow a grid pattern. Instead buildings were arranged on a series of dramatically rising terraces. Many of the buildings of Attalus I and Eumenes II, including the Great Altar of Zeus, celebrate the regime's remarkable victories over the invading Gauls.

THE WESTERN MEDITERRANEAN 500-100 BC

THE WESTERN MEDITERRANEAN in this period is, in many respects, a great contrast with the East. Although there were powerful city states in southern Italy (Magna Graecia) and especially eastern Sicily – where the kingdom of Syracuse had much in common with some of the smaller Hellenistic principalities – Greece was not the dominant

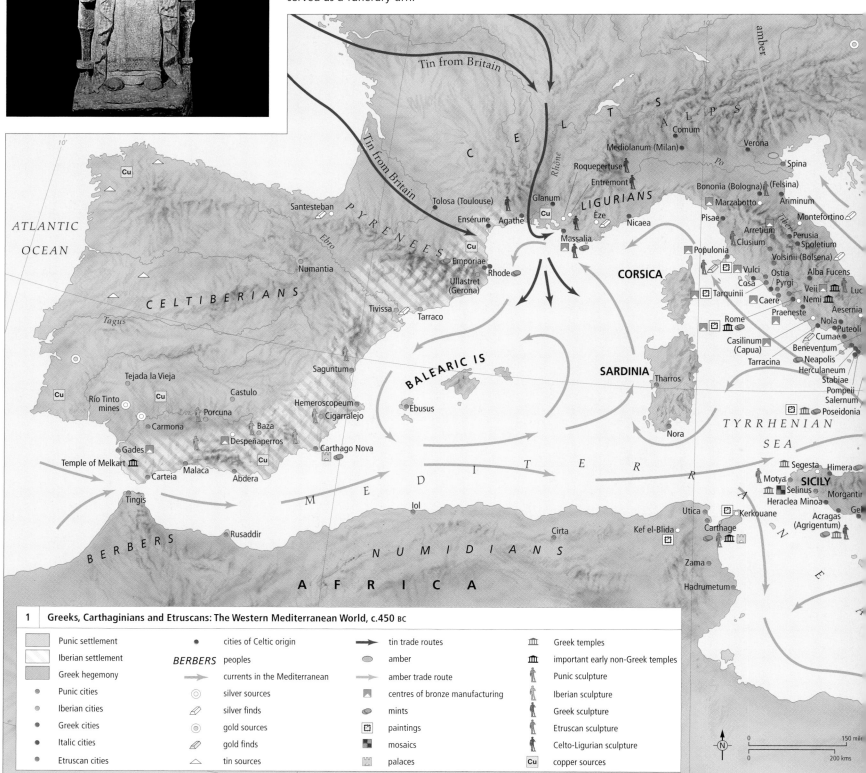

power here. Certainly, through being well-positioned for trade, some Greek communities achieved considerable wealth and influence. Important in this sense were Tarentum on the heel of Italy, well-placed for trade up the Adriatic, and Massalia and her colonies in southern Gaul and in northeastern Spain (notably Emporiae). They grew rich on commerce up the Rhône and in the northern part of Iberia.

DAMA DE BAZA. This limestone sculpture of a goddess seated on an elaborate winged and lion-footed throne shows the mixed traditions of Iberian sculpture in the fourth century. The deity is related to the Punic Tanit and the Greek Persephone, but the jewellery she wears is distinctively Iberian. The statue seems to have served as a funerary urn.

Greek expansion was always limited by the dominant power of the Phoenicians of Carthage, who controlled not only the western part of North Africa (especially Tunisia) but also had important trading posts in western Sicily, Sardinia and southern Spain.

INDIGENOUS PEOPLES

Influential as these essentially eastern-Mediterranean peoples were in moulding the art and culture of the area, indigenous peoples were of at least equal importance, one group increasingly so. Apart from the barbarian art of the Celts and related tribes such as the Ligurians, a high culture developed in eastern Spain characterized by elegant pottery, a superb tradition of bronze casting and, above all, sculpture. Although this owed something

1 Greeks, Carthaginians and Etruscans: The Western Mediterranean World, c.450 BC

Punic settlement	cities of Celtic origin	tin trade routes	Greek temples
Iberian settlement	BERBERS peoples	amber	important early non-Greek temples
Greek hegemony	currents in the Mediterranean	amber trade route	Punic sculpture
Punic cities	silver sources	centres of bronze manufacturing	Iberian sculpture
Iberian cities	silver finds	mints	Greek sculpture
Greek cities	gold sources	paintings	Etruscan sculpture
Italic cities	gold finds	mosaics	Celto-Ligurian sculpture
Etruscan cities	tin sources	palaces	Cu copper sources

to Greek and Phoenician influence, it is very distinctive in its character.

The same can be said of the art of the city states of Etruria, which grew rich through trade, for example, in the eastern Alps through Spina. Etruscan painted tombs, ornate jewellery and engraved gems, and bronze and terracotta sculpture (though obviously Greek influenced) could not be mistaken for the productions of any other people. Other Italian peoples such as Lucanians and Samnites were likewise influenced by Greek artistic styles, though – with a superb position halfway up the western coast of Italy – the Latins of Rome were even better able to benefit from trading and cultural currents within the peninsula. Not only were they in touch with Etruria and Magna Graecia but even with Athens.

By the later fourth and early third century BC, Rome was in the cultural forefront, as it was a political leader in the Mediterranean. Among surviving artworks are the bronzes of Praeneste (one of which bears an inscription

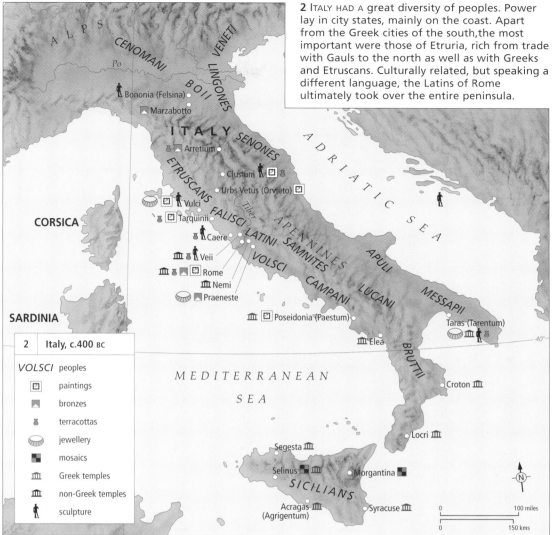

2 ITALY HAD A great diversity of peoples. Power lay in city states, mainly on the coast. Apart from the Greek cities of the south, the most important were those of Etruria, rich from trade with Gauls to the north as well as with Greeks and Etruscans. Culturally related, but speaking a different language, the Latins of Rome ultimately took over the entire peninsula.

2 Italy, c.400 BC

VOLSCI peoples
- ⊡ paintings
- ▨ bronzes
- ⬙ terracottas
- ⌣ jewellery
- ▦ mosaics
- ⛢ Greek temples
- ⛢ non-Greek temples
- ⫯ sculpture

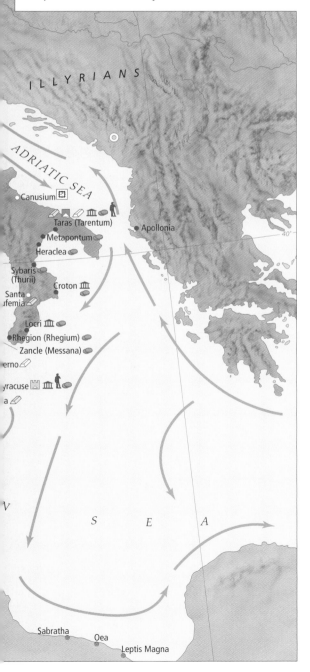

1 THE WESTERN MEDITERRANEAN was culturally very diverse, with only small areas colonized by non-native peoples, Greeks and Phoenicians. Syracuse and Carthage were organized like Hellenistic monarchies, but one native state, the Roman Republic, defeated them and assumed a potential for patronage surpassing all of them. Concurrently, trade routes shown through Gaul and the eastern Alps were taken over by Roman merchants.

recording its manufacture in Rome) and some extremely advanced gems, and coins of thoroughly Greek style but inscribed in Latin.

Initially, Roman expansion was directed against other similar Italian peoples as well as the Greeks in the south. Ultimately, hegemony in the Mediterranean had to be settled with Carthage. Remarkably, Rome managed to defeat this centralized monarchy without rejecting her own republican constitution. The First Punic War (264–241 BC) ended in the Carthaginians being driven from Sicily. The Second Punic War (218–201 BC) began disastrously for Rome, with the Carthaginians under Hannibal invading Italy. However, it ended with the defeat of what was by then the only power which could halt Rome's seemingly inexorable progress.

In the following century, wars against Macedon and other Greeks led to an enormous influx of wealth. Some Romans acquired great personal fortunes, although there was always pressure to give much of the loot from the sack of cities such as Syracuse (211 BC) or Corinth (in 146 BC) to the gods.

THE CULTURE OF THE WEST

Although power in the western Mediterranean was in Roman hands by 200, the cultural influence of the Greeks was overwhelming. In many respects it took the militarily stronger Romans captive. Some Greek cities remained independent and flourished, notably Massalia. Hellenization came mainly from Roman conquerors wishing to emulate what they had seen in Sicily and the east.

FUNERARY STELE from Bologna with a wolf suckling a boy child (mid-fourth century), showing that other Italians shared this device, associated with the Roman myth of Romulus and Remus.

Nevertheless Italian art remained distinctive and far from uniform. Separate styles of gem-carving for signet rings were used in Campania and Etruria, and these were in their turn different from those of the eastern (Hellenistic) world. Etruscan terracotta sculpture, especially the tradition of funerary chests with images of the deceased are similarly idiosyncratic; while the historian Polybius (c.200–118 BC) records a distinctive Roman custom associated with wax funerary effigies. Religious considerations also dictated the continued use of a specific type of temple on a high podium, uninfluenced by the Greek temple type. And of course, the Latin language more than held its own in the West against the progress of Greek.

THE MEDITERRANEAN 100 BC–AD 100

THE PEOPLE OF LATIUM (the plain around Rome) forged a new civilization after throwing off their Etruscan rulers in about 500 BC. It reflected both the Etruscans (whose art was very influenced by the Greeks) and the Greek cities of southern Italy. Greek influence intensified in the third and second centuries BC through eastern Mediterranean contacts – at first commercial and cultural, then political and military, resulting in a vast Roman empire.

The process of eastern Mediterranean conquest was only complete with the defeat of the Ptolemaic empire in 31 BC by Octavian, soon to become Augustus, the first emperor. By the middle of the first century BC, however, plundering Greek cities for treasures of precious metals, gems and statues had already come to seem uncouth. The writings of Romans of the late republic and early empire confirm the Hellenized character of their world. Cicero expected to buy copies of Greek master-pieces for his home and prosecuted the governor of Sicily, Gaius Verres, for looting his province.

ROMAN PATRONAGE

The importance of Rome as a centre of patronage is shown by finds such as that – in the wreck of a ship at Nahdia off Tunisia – of sculptures made in Athenian workshops for export, as well as finds of numerous neo-Attic sculptures from Rome, Pompeii, Herculaneum and elsewhere. Many of the most important artists of the first century BC, such as the sculptor and silversmith Pasiteles and the gem-cutters Aulos and Dioskourides, were Greeks working for Roman patrons.

The same is true in the early empire when Zenodoros set up statues both for the Gallic tribe, the Arverni, and for the Emperor Nero. Early in the second century, Trajan employed Apollodorus of Damascus to build his forum, as Greek in conception and decoration as it was Roman.

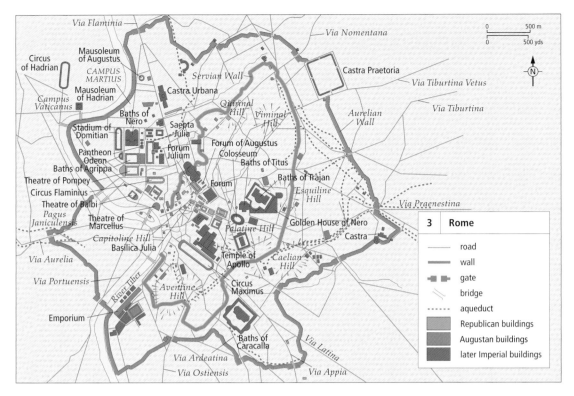

The city of Rome grew prodigiously in the first centuries BC and AD, eventually to a million or more inhabitants. They were provided with ever more temples and public places (the imperial *fora*), with *horti* (public gardens), baths and major centres of entertainment, including theatres, race tracks and the enormous Flavian amphitheatre now known as the Colosseum. These public buildings provided unrivalled displays of art ranging from Greek pedimental groups to gem collections shown to the cognoscenti visiting select temples. There were also the private marvels of the imperial palaces on the Palatine

3 THE CITY OF ROME was the focus of the empire up to the third century AD, but many of its grandest buildings date from the reign of Augustus and his successors, who wished to impress foreign visitors by the grandeur of its buildings and provide 'bread and circuses' for the urban masses.

1 COLONIES CLUSTER IN THE WEST in this view of the Roman Empire shortly after AD 100, when it reached its greatest extent. They were leading centres of Italian culture, but the many important centres of Greek culture would in their turn Hellenize members of the colonial elites, like the young Hadrian – future emperor of Rome – from Italica in southern Spain.

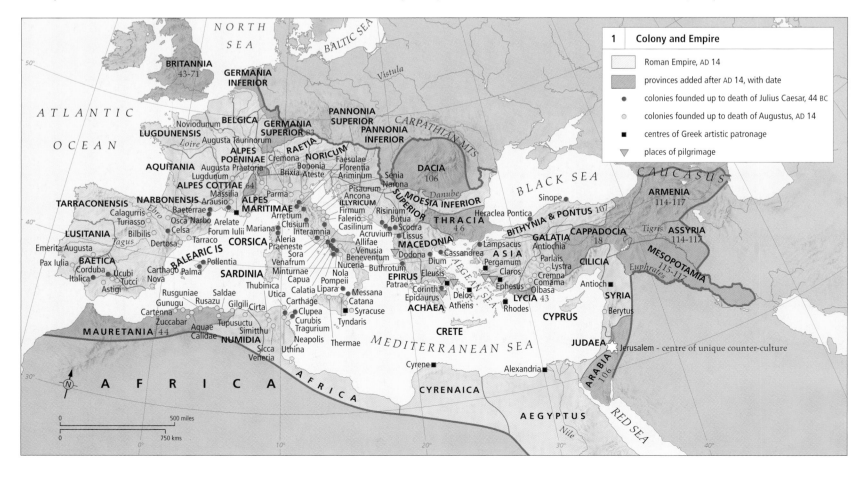

THE GEMMA AUGUSTEA, a sardonyx cameo cut in the tradition of late Ptolemaic cameos but showing a Roman subject – a victorious general visiting the Emperor Augustus after a campaign. The stone may have been imported from India and cut by a Greek artist in Rome.

Hill. In many respects the city was the direct successor of the great Hellenistic royal cities, such as Antioch, Pergamum and Alexandria – though by providing more marble façades, more public sculptures, more exotic beasts and larger spectacles than had ever been seen before, Rome demonstrated her superiority.

THE BRINGER OF CIVILIZATION
Roman culture sometimes appeared upstart when viewed from the east, but it was the bringer of Mediterranean civilization to much of western Europe, including northern Gaul, Germany and Britain. Such provinces fell into

2 THE EMPIRE WAS HELD TOGETHER by ancient maritime trade routes which in part reflect natural features such as currents. Although portable works of art such as silver plate were spread around the Roman world, difficulties in communication – for example, over mountains and through marshy areas – still allowed a diversity of local artistic schools: for example, of interior decoration and sculpture.

Roman hands partly through conquest and partly through diplomacy, an art in which the Romans excelled. Julius Caesar and especially Augustus founded settlements of Romans, generally retired soldiers, throughout the empire but most densely in the west, as bastions of Roman culture.

Greco-Roman culture was not only spread by colonists but even more resolutely by ruling elites among the peoples under Roman sway. Proud to be given Roman citizenship, they vied with each other as public benefactors. Notable for their wealth and influence over their subjects were native princes such as Herod the Great in Judaea (r. c.40 BC–4 BC), Juba II of Mauretania (r.25 BC–AD 23) or King Togidubnus in Britain (second half of first century AD), who lived opulent life-styles in rooms veneered with marble and floored with mosaic. Herod built several palaces including Herodium and Masada; Togidubnus is believed to have lived in a large villa at Fishbourne, famous for its elegant formal garden. Such men re-founded cities: Caesarea Maritima by Herod, Caesarea (modern Cherchel) by Juba and most probably Noviomagus (Chichester) by Togidubnus, endowing them with splendid buildings, notably temples. They also used their wealth to endow temples elsewhere, from Herod's temple to the Jewish God in Jerusalem to the temple of Sulis Minerva at Bath, probably built by Togidubnus.

Some arts appear to have been more homogeneous than others. Silver plate, produced in relatively few centres for very rich patrons, was light and supremely portable. It was spread through the empire and even beyond the frontiers as diplomatic gifts. Businessmen dined off the same plate as army officers took on campaign. On the other hand, sculpture, wall painting and even mosaic was often made locally in provincial workshops.

Only the most important artists normally travelled; the rest stayed and worked in their home towns. It was not easy for those who were not rich to go far, especially overland, and this prevented total homogeneity of culture.

Regional schools in sculpture, painting, mosaics and jewellery added interest to Roman art. They also provided pools of non-Classical ideas such as the frontality and linearity displayed in some of the art of Syria and Egypt, which may have influenced later art.

Augustus wanted to stress Roman and Italian customs and religious rites. In his reign the Latin language, handled by writers of distinction, achieved parity with Greek. Yet mainstream Roman art and architecture, both public and private, could not avoid being a development of the late Hellenistic culture, making use of its existing rich repertoire of mythology, iconography, symbolic personification and vegetal decoration.

ODYSSEY FRESCO from a house on the Esquiline hill in Rome. This scene shows the Laestrygones of Sicily preparing to attack Ulysses' ships, in a landscape showing the rocky terrain of the Mediterranean basin. In the mid-first century BC, classical Greek culture was widely admired and imitated. Shortly after the Odyssey frescoes were painted, Virgil wrote *The Aeneid*, likewise with an Italian setting.

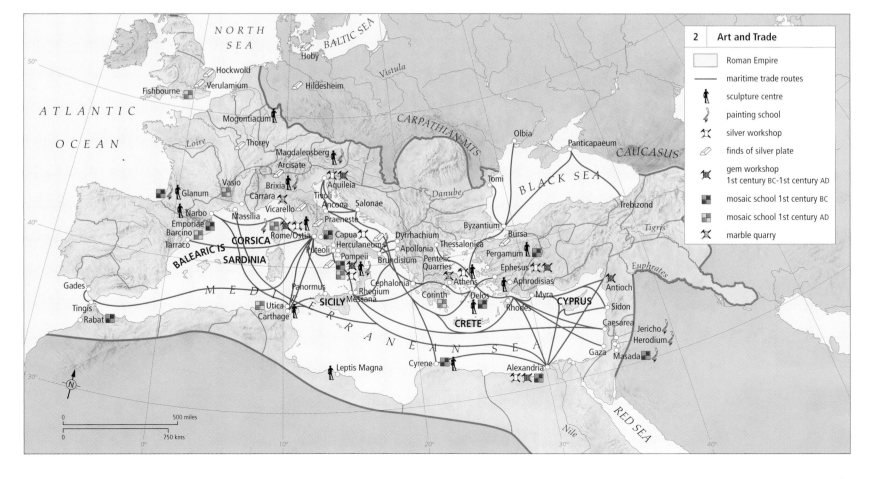

THE MEDITERRANEAN AD 100-300

A KEY FACTOR IN the development of art in the Roman Empire was the wealth derived from agriculture – wine, olive oil, grain, and to a more limited degree, the produce of the sea – which created aristocracies able to purchase art on a large scale. The other determining influence was the geographical scope and variety of the empire. The terrain in many regions was difficult, for example, the mountains of the Balkans, the hinterland of Asia Minor, the Atlas Mountains and even northern Britain, and areas of desert in parts of the Levant, Egypt and North Africa. Thus, communication by sea was often more reliable than that by land, though the Mediterranean has yielded many shipwrecks (the density around France and Italy merely reflects the focus of recent marine archaeology).

Few men travelled through the entire Empire – Hadrian (AD 117–138) was exceptional in this respect. Provinces and even parts of provinces always differed markedly from one another, and almost every town of any size had its own traditions in arts such as sculpture and mosaic as it did in mundane crafts such as pottery. Nevertheless, culture, based on the universal use of Greek and Latin, the idea of the city as the basis for civilized life, and efforts to standardize dress and the appearance (if not the substance) of religious cult lent the Empire unity.

TRANSPORTING ART AND MATERIALS
Despite great difficulties, works of art and raw materials were extensively transported, as shown

BACCHUS SUPPORTED BY A SATYR – an amber figurine of the third century, found in a tomb at Esch in the Netherlands. Amber was a prized luxury, believed to possess magical powers. It was obtained from the Baltic, worked in Aquileia, northern Italy – where amber figurines and ornaments have been found in quantity – and disseminated throughout the Roman world.

by the well-studied finds of silver hoards, and Attic and Proconnesian sarcophagi in *map* 2 (the last two are types of sarcophagi named after their regions of main production).

The trade in marble and metals provides another graphic instance: both were often extracted from almost inaccessible mountainous regions, though the building of roads, bridges and large ships with substantial port facilities made this prodigious exploitation of natural resources possible. From the edges of the Roman world and beyond came the exotic products of India and Sri Lanka (such as gems, perfumes and spices), and of equatorial Africa (ivory and black slaves).

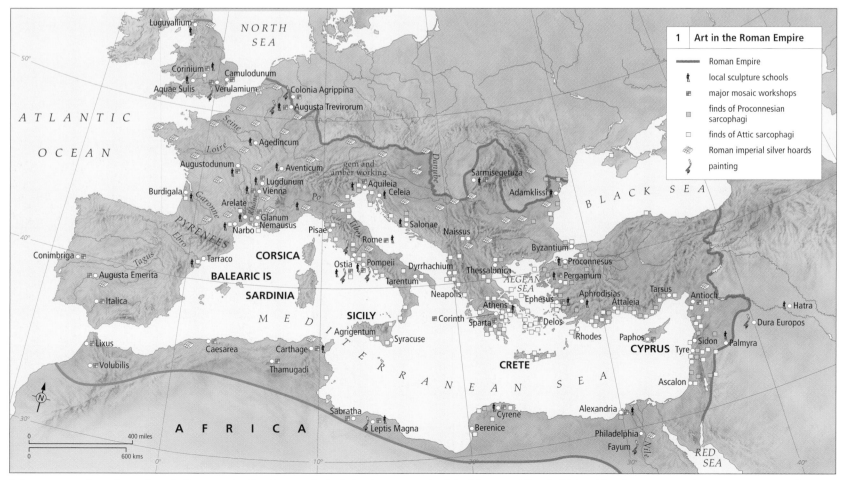

1 SILVER HOARDS have been found all across the Empire, particularly in the north and west, though silverware was equally valued in the east. The quality of the craftsmanship, together with the value of the material, made it a much-traded commodity, though little is known of the individual silversmiths. Mosaic schools arose in almost every major town of the empire, and especially in Asia Minor and North Africa. Mosaic pavements became a very popular art form, and genuine regional schools developed with their own distinctive styles. By contrast, the models for the local sculpture schools frequently came from far away. Often local sculptors adapted classical models in ways that suggested little understanding of the canons of classical art.

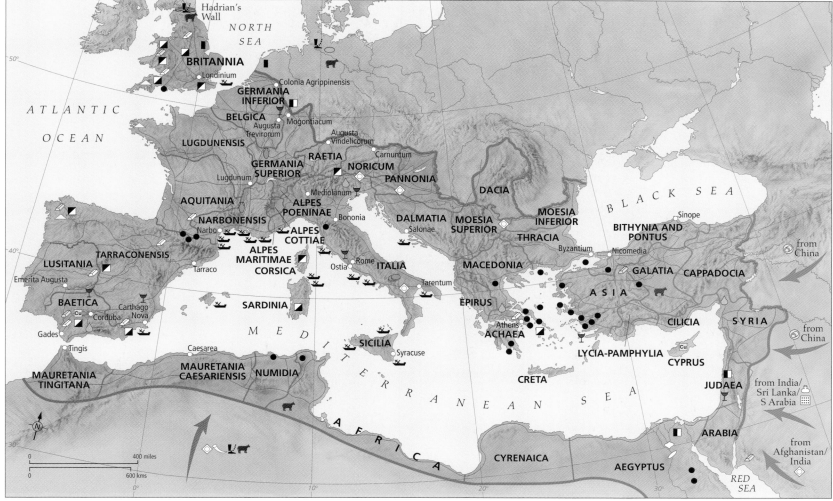

2 Outside the Mediterranean most provinces were self-sufficient in their basic needs, and mainly traded luxury items. Within the Mediterranean trade was important for a wider variety of goods (to make up for occasional crop failures or the lack of certain raw materials). Particularly important for art were the numerous stone quarries. Though most were of only local significance, some provided stone across the Empire, which was transported in unhewn blocks or as partially worked pieces, such as columns or sarcophagi which would be finished on site. There were huge stone depots at Ostia and Rome. Coloured marbles were much sought after for decorating walls and pavements and also for statuary, but the most important trade was in white marble. The best-known quarries for these were in Greece and Asia Minor, such as those providing marble for sculpture from Pentelikon in Greece.

Although by modern standards the Romans did not really change the nature of the planet, the historian Tacitus places in the mouth of a British chieftain Calgacus sentiments that sound modern in their environmental alarm: 'Brigands of the world, they have ruined the land by their indiscriminate robbery, and now they ransack the sea ... Theft, murder and rape, the liars call empire; they create a desolation and call it peace' (Tacitus, *Agricola* 30).

While some of the items imported or extracted had few redeeming features (the slave trade and the trade in wild animals), others allowed the creation of new categories of art, decoration and dress. The coloured marbles from Mons Porphyrites in Egypt became elegant columns in Imperial buildings; amber from the Baltic and a great variety of precious stones from Afghanistan and India, including *lapis lazuli*, garnets and even sapphires were worked into jewellery in Rome, Aquileia and elsewhere; fragments of silk from China have been found as far to the west as York, while the spice trade had a direct effect on art as seen in distinctive pepper pots.

LOCAL SCHOOLS AND MATERIALS
Despite the large numbers of statues carved from marbles quarried in Greece, Asia Minor or Italy (Carrara), in many regions of the Empire, including the northwestern provinces (Gaul and Britain), the Balkans and Syria sculptors worked in local limestones and sandstones. These works are often far more individual, perhaps because they were not normally exported.

Almost every city had its workshops of wall-painters and stuccoists, including Rome (note the catacombs) and Ostia – and ranging from Verulamium and Colonia Agrippina in the west to Leptis Magna in Tripolitania to Dura Europos (with its strikingly beautiful painted synagogue) on the eastern border of the empire. Funerary portraits on wooden panels from the Faiyum in Egypt are good evidence for portable painting, which was probably widespread.

Mosaicists used mainly local stones, together with glass and pottery, and the work of regional workshops can often be recognized, for instance those of Antioch, Cyprus, Carthage and Augusta Trevirorum (Trier). No less than six distinctive schools have been recognized in Britain alone, though even here they drew on a common stock of ideas, originally brought in by artists from other provinces or else recorded in portable media, such as illustrated scrolls and, later, books.

In this respect the most important material in the empire was probably papyrus from the Nile Delta, the main medium for permanent record-keeping (though in northwestern Europe slivers of wood were often used as substitutes). In the late Roman period parchment was used for luxury books, and there was a vast manufacture from animal skins ranging through dyed and gilded leathers to utilitarian objects such as boots and horse-trappings. Ultimately, the art of the Empire rested on insatiable consumerism.

Detail from a mosaic ('The Great Hunt') from the Villa Filosofiana near Piazza Armerina, Sicily, showing the embarcation of an antelope (perhaps at Carthage) destined for the amphitheatre at Rome (c.AD 300, preserved *in situ*).

EUROPE AD 300-600

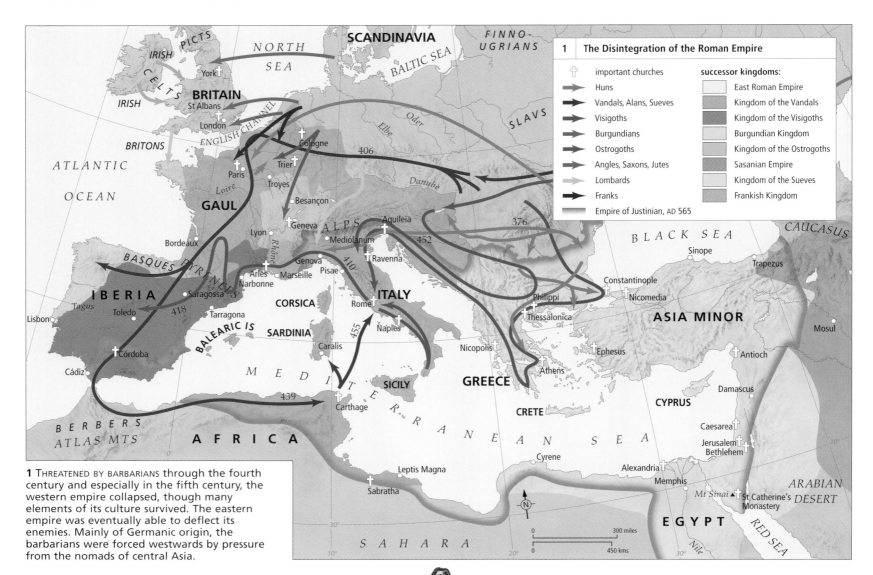

1	The Disintegration of the Roman Empire

important churches

- → Huns
- → Vandals, Alans, Sueves
- → Visigoths
- → Burgundians
- → Ostrogoths
- → Angles, Saxons, Jutes
- → Lombards
- → Franks

Empire of Justinian, AD 565

successor kingdoms:
- East Roman Empire
- Kingdom of the Vandals
- Kingdom of the Visigoths
- Burgundian Kingdom
- Kingdom of the Ostrogoths
- Sasanian Empire
- Kingdom of the Sueves
- Frankish Kingdom

1 THREATENED BY BARBARIANS through the fourth century and especially in the fifth century, the western empire collapsed, though many elements of its culture survived. The eastern empire was eventually able to deflect its enemies. Mainly of Germanic origin, the barbarians were forced westwards by pressure from the nomads of central Asia.

THE LATE ROMAN EMPIRE includes periods of political dislocation, invasion, civil unrest and famine. However, throughout the Roman and former Roman provinces, from Britain to Syria, the art continued to be rich. There is impressive evidence for long-distance trade reaching, as earlier, into sub-equatorial Africa for ivory, to India for gems and spices and even to China for silks, though in Justinian's time the secret of the silk worm and silk manufacture came to Constantinople.

Most patronage was now private, wealth being lavished in particular on the palatial houses of the aristocracy. Mosaic floors survive in considerable numbers and can often be assigned to particular workshops – for instance, those of the Cirencester region in Britain, Carthage in North Africa, Nea Paphos in Cyprus, Sparta in Greece and Antioch and Apamea in Syria. Veined marbles were still widely used and are commented on by writers. There was some use and re-use of marble sculpture. However, the only substantial sculpture trade was in marble sarcophagi, which now often had Christian scenes.

The sarcophagi were often placed in or around churches. Churches and baptisteries were patronized by emperors like Constantine (St Peter's in Rome and the Holy Sepulchre in Jerusalem), or Justinian (Hagia Sophia in Constantinople), or else by churchmen, such as Bishop Patiens at Lyon, Bishop Ambrose at Mediolanum (Milan) or Bishop Neon at Ravenna. The church of St Vitale at Ravenna, though dedicated by Bishop Maximian, was

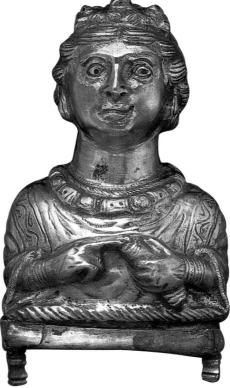

A SILVER-GILT PEPPER POT (*piperatorium*), one of four from a rich treasure buried at Hoxne, Suffolk, in the fifth century and now held in the British Museum in London. This one takes the form of a Late Roman empress. Its style suggests that it was made in northwest Europe, perhaps even in Britain, but the precious pepper it contained was imported from India.

financed by a banker called Julianus. Not only were such buildings – with their marble and mosaic décor – public displays of wealth and power for this life, they ensured the pious donor repose in the next, especially when interred near the remains of holy men. In Palestine, and sometimes elsewhere, especially in Asia Minor (for example, at Sardis), similar patronage was lavished by rich Jews on well-appointed synagogues.

The minor arts are of especial interest. Some of the silver treasures are very large – for instance, those from Mildenhall, England, and from Kaiseraugst, Switzerland, or the so-called Sevso Treasure, possibly from Hungary. Many of the vessels used at table are chased with scenes from mythology, hunting and feasting. Contacts with the east are shown not only by pepper pots to include this much prized spice but by the evident influence of western silver on that of Sasanian Persia, which in its turn was a model for the plate of western China.

Intricate workmanship was much prized, whether in the cutting of sheet gold into openwork patterns, inlaying gold or silver with niello (silver sulphide) or the skilful setting of gems in jewellery. The so-called barbarian peoples in Visigothic Spain, Frankish Gaul and Anglo-Saxon Britain produced their own distinctive *cloisonné* jewellery. Here, too, a taste for texture and the radiance of gems (often brought in from the east, together with cowrie shells and bronze vessels) is a feature.

Glass manufacture was carried on wherever suitable sands existed, especially in the Levant

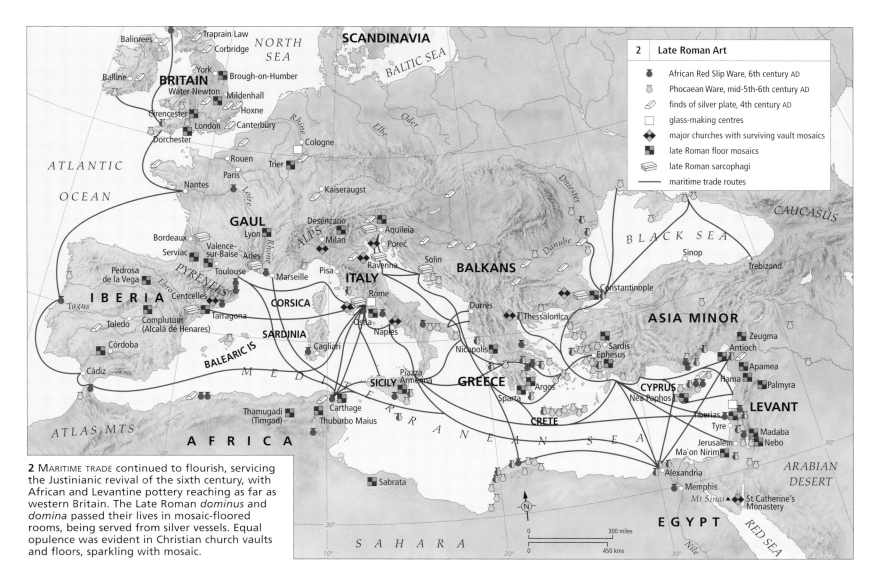

2 MARITIME TRADE continued to flourish, servicing the Justinianic revival of the sixth century, with African and Levantine pottery reaching as far as western Britain. The Late Roman *dominus* and *domina* passed their lives in mosaic-floored rooms, being served from silver vessels. Equal opulence was evident in Christian church vaults and floors, sparkling with mosaic.

and at Cologne. The latter industry, perhaps in part in the hands of Syrian craftsmen, survived the end of Roman control in the fifth century and was involved in making claw-beakers and other barbarian types. 'Cage' cups in glass (cups with an openwork outer layer) seem to have been widespread, made in both western and eastern workshops. It is probable that the models were far more precious vessels in hard stone. Finally, gold glasses – that is, layered glasses ornamented with thin sheets of gold leaf showing portraits, Christian scenes and (very occasionally) Jewish or pagan subjects – are associated with Rome and were sometimes employed decoratively in the catacombs.

The most characteristic of the precious materials used at this time was elephant ivory – normally for small boxes (generally with biblical scenes) or decorative plaques, often hinged together to comprise an invitation to a wedding. Sometimes much larger objects were made, such as Bishop Maximian's throne at Ravenna. Not only was ivory very beautiful and capable of taking excellent carving, but it was also very expensive. Quite clearly ivory was a suitable homage to pay an emperor. One of the finest surviving diptych-leaves shows Justinian on horseback and various offerings being brought to him, including an elephant tusk. Other diptych-leaves show lion and stag hunts, demonstrating the same cavalier attitude to animal resources displayed by 'The Great Hunt' mosaic from Piazza Armerina (*see* p.69).

3 CONSTANTINOPLE was founded by Constantine I in 324 on the European side of the Bosporus, and maintained by his successors as a capital to rival Rome itself, with its great Theodosian walls, several *fora*, the hippodrome, the imperial palace and many churches, especially Hagia Sophia. It remained the eastern capital until 1453.

The superb cypress doors of St Sabina, Rome (early fifth century), carved with biblical scenes, stand for the widespread use of timber, decorative as well as functional. Surviving timber lintels and beams in Cairo and at St Catherine's Monastery, Mount Sinai, suggest that wood-carving achieved real distinction at this time. Large timbers were in fact required to roof all the large basilicas and argue a long tradition of organized forest management.

Underlying the surprising achievements of the Late Empire was an enormous volume of trade. For example, fifth- and sixth-century wine and oil amphorae are found in bulk throughout the Mediterranean and beyond at sites like Tintagel in Cornwall. This exchange of commodities helped to support patronage.

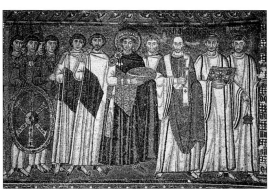

SPLENDID SILKS AND JEWELLED METALWORK in this wall mosaic in St Vitale, Ravenna (AD 546–547) of the Emperor Justinian and his retinue emphasize luxury and eastern contacts.

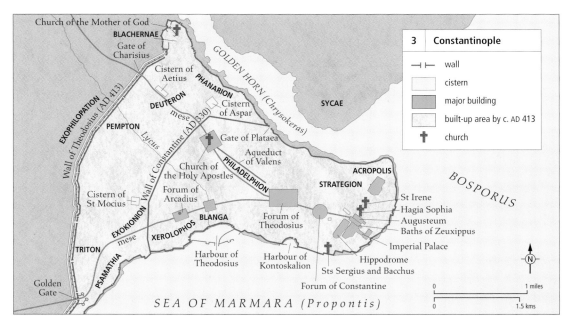

71

AFRICA 500 BC-AD 600

DURING THIS PERIOD there was an increase in human control over Africa's natural resources. The smelting of iron became common throughout much of the continent and, wherever climatic conditions made it possible, there was a development of crop-growing and animal husbandry.

The earliest iron-producing sites were associated with the famous Nok terracotta figures at Taruga in Nigeria, and at Meroë in the Sudan. At both places iron was being smelted and tools and weapons were being made from the sixth century BC.

Throughout the Sahara there are many rock paintings and engravings showing light, horse-drawn vehicles, and their distribution may indicate routes from the Mediterranean towards the River Niger. By the beginning of the second century BC, a large town existed at Jenne, where the earliest cultivation of African rice took place. There, and in many other places along the valley of the Niger, elaborate terracotta figures, many depicting warriors on horseback, were made.

TERRACOTTAS

During the early centuries of this period in Sub-Saharan Africa the main art forms were terracotta heads, and sometimes complete figures, which have been found at several places. The best-known are those of the Nok culture discovered throughout the Jos plateau of northern Nigeria. Many of these pieces were found in the course of mining for tin. At two small ancient villages located at Taruga and Samun Dukiya, examples of terracotta art as well as evidence for iron smelting were found. These domestic traces are dated to between 300 and 100 BC, but some Nok pieces are earlier.

Much further south, pottery heads of humans and one of an unidentified animal and belonging to a different tradition, dating to the fifth century AD or later, have been found at Lydenburg in South Africa. Their use is not known but the two largest could have been used as masks.

CENTRAL AFRICA

This region has been much less studied than the rest of the African continent, and dense forest in some areas has been an obstacle to research. Iron-smelting was widespread from about 500 BC, and characteristic pottery types are known from village sites. Iron-smelting took place throughout the area, and may indicate that Bantu-speaking people settled there. Others moved south in what has become known as the 'Bantu migration'; as a result, related Bantu languages are now spoken widely over the whole of central and southern Africa.

The spread of these languages has been much discussed and there are several theories as to how they came to dominate the area. The Bantu language may have originated in Cameroon, and it has been suggested that agriculture, animal herding, ironworking and pottery-making were all associated with speakers of Bantu languages, who ultimately spread throughout southern Africa.

MEROË

There is more information available about the cultures of the Nile Valley, and the presence of a literate civilization in Egypt enables

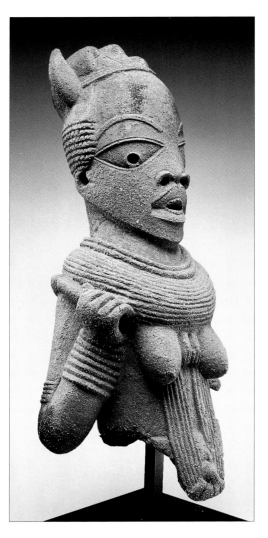

TERRACOTTA HEAD from the Nok culture of northern Nigeria, dated to approximately the fifth century BC. The Nok culture is believed to have lasted for a few hundred years. Many figurines are now known from this artistic tradition and from excavations at Taruga. Nok culture is known to be contemporary with the earliest known iron-smelting from Sub-Saharan Africa. It is likely that many of the heads were part of complete figures but none have yet been found.

archaeologists to precisely date events. The Egyptians penetrated south of the first cataract of the Nile at Philae and subsequently ruled northern Nubia from c.1550 BC. When Egyptian rule was withdrawn from the area in c.1100 BC an indigenous state arose which, by 500 BC, had developed a culture based on two towns, Napata and Meroë. By that date it is likely that Meroë was where the rulers lived, though their burials continued to be near Napata until early in the third century BC. From that date, the rulers were buried at Meroë and continued to be interred there until the collapse of the Meroitic kingdom in the fourth century AD.

The town of Meroë consists of a large area of domestic houses built of sun-dried mud bricks, and a royal palace, parts of which are built of sandstone. There were several temples, also built of sandstone. In one part of the town were the furnaces for iron-smelting, for which ancient Meroë has become famous in modern times.

The people of Meroë developed a writing system based on an Egyptian model but used their signs as an alphabet of 23 letters. The earliest use of this writing system that can be dated is of the early second century BC, although it was probably in use before that date. It gives

2 THIS MAP OF THE NILE to the south of Egypt shows activities, towns and royal palaces in the kingdom of Meroë and the surrounding area until just after the arrival of Christian missionaries in the middle of the sixth century AD. It also shows the area of the Axumite kingdom and the main trade routes of the period which made use of the Red Sea and went via the Gulf of Aden as far as India. Aezanes, king of Axum in c.AD 350, invaded Meroë as described in an inscription in Greek in Axum. Two Axumite inscriptions, again in Greek, as well as a coin have also been found at Meroë.

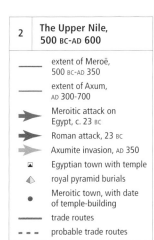

2	The Upper Nile, 500 BC-AD 600

— extent of Meroë, 500 BC-AD 350

— extent of Axum, AD 300-700

➤ Meroitic attack on Egypt, c. 23 BC

➤ Roman attack, 23 BC

➤ Axumite invasion, AD 350

▣ Egyptian town with temple

⬟ royal pyramid burials

● Meroitic town, with date of temple-building

— trade routes

--- probable trade routes

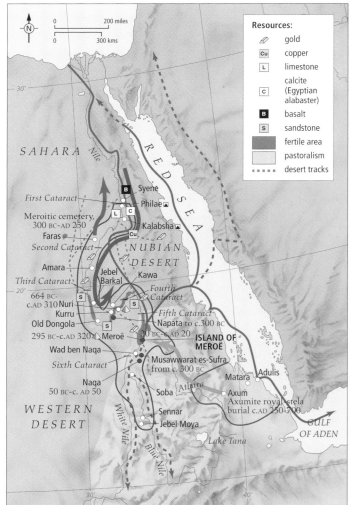

the name of a queen, Shanakdakhete. It is, outside Egypt, the earliest writing in Africa.

AXUM

The city of Axum, located high on the Ethiopian plateau, was the centre of a kingdom which by the fourth century AD was a power in northeast Africa and was responsible for the collapse of Meroë in about AD 350. By this time the people of Axum had developed a writing system for their own language, Ge'ez. This system was originally derived from the writing of ancient south Arabia. The Ge'ez language is now used only in the rituals of the Ethiopian church, but it is the basis for the modern Amharic script. Some inscriptions have also been found in Greek, since a trade route had been opened to the Mediterranean via the Red Sea, and Greek merchants had come to Axum bringing their language with them. The main port was at Adulis on the Red Sea coast, and

traces of foreign merchants' activities have been found there. The inscriptions provide information about the rulers and their military activities, such as the attack by King Aezanes on Meroë, and military expeditions to south Arabia by King Kaleb in the sixth century AD.

Axum is best-known for the massive stone stelae erected to mark royal burials, as well as simpler, monolithic pillars that probably mark important, non-royal burials. Recent archaeological excavations in the area of the group of stelae on the edge of the present-day town of Axum have revealed some of the underlying royal tombs, and though many of these had been plundered, a number of luxury objects brought to Axum by Mediterranean trade have been found.

The Axumite kingdom was, apart from Ptolemaic Egypt, the first in Africa to produce a coinage, and many coins are known. Some have a cross on the reverse showing that

Christianity had reached the area by the early centuries AD and gradually superseded the pagan relgions of earlier times. Because the earliest Christian missionaries came from Egypt, the Ethiopian church became associated with the Coptic church of Egypt, and until recently the head of the church was always appointed by the Coptic patriarch in Egypt.

1 SEVERAL IMPORTANT DEVELOPMENTS took place at this time, of which the most important for subsequent development in Africa was the appearance of iron-smelting. The map shows the two best-known iron-smelting sites, Meroë and Taruga, both of which flourished in the 5th century BC. Another important change was the spread of domestic animals southwards. The main areas of rock art are indicated and the ones in the Sahara are of special interest because they show many illustrations of chariots, which appear to indicate routes across what by this time had become desert.

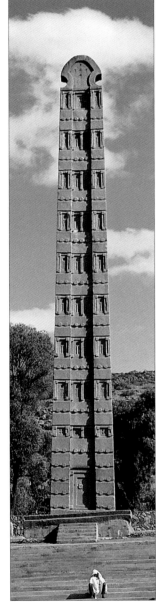

AXUMITE STELA. This monolithic stone stela marks a royal burial at Axum. It is 21 metres (68 ft) in height, and with 3 further metres (10 ft) underground, it represents a royal building with nine storeys. One even taller stela, shattered by a fall, lies nearby. It is likely that royal residences were built with façades like this. Simpler, undecorated pillars may mark important, non-royal burials.

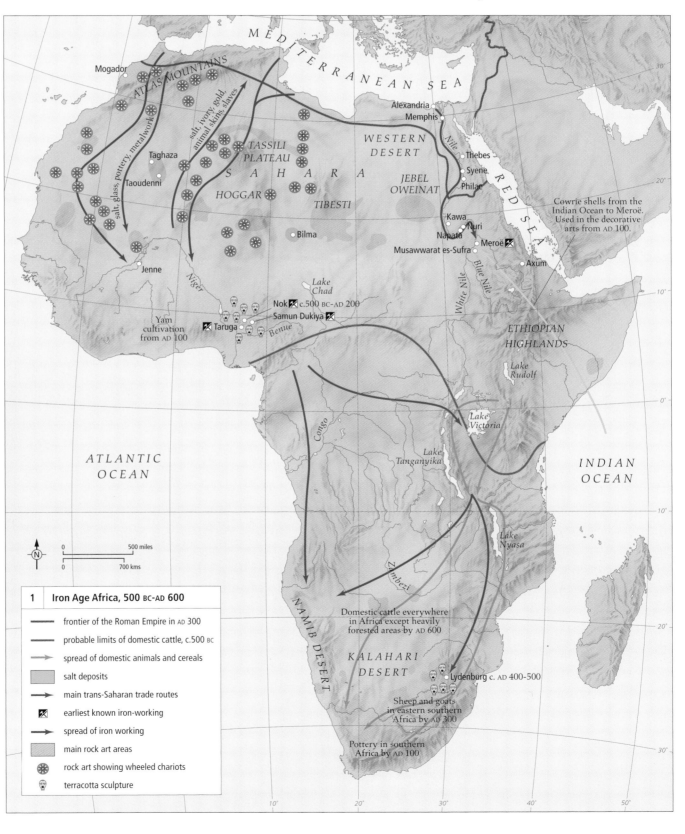

1 | **Iron Age Africa, 500 BC–AD 600**

— frontier of the Roman Empire in AD 300

— probable limits of domestic cattle, c.500 BC

→ spread of domestic animals and cereals

▨ salt deposits

→ main trans-Saharan trade routes

⌗ earliest known iron-working

➤ spread of iron working

▨ main rock art areas

❋ rock art showing wheeled chariots

☠ terracotta sculpture

THE NILE VALLEY 500 BC-AD 300

EGYPT AND EGYPTIAN ART after 500 BC are enmeshed with the Mediterranean and Asia. The country was under Persian control from 525 to 404 BC. Kings based in the Delta were able to reassert native rule only until a second Persian invasion in 343 BC. From then on, Egypt was ruled by foreigners: Alexander the Great in 332 BC, the Ptolemaic dynasty from 304 BC and the Romans from 30 BC. The dominance of Greek culture brought sweeping social, economic and artistic changes.

The Persians governed from Persepolis (in modern Iran) and appointed Egyptian officials, called *satraps*, to act for them locally. There was little interaction between Persian and Egyptian

1 GREEK SETTLEMENT IN EGYPT began with Naukratis, a trading colony founded in the seventh century BC. Alexander the Great added a second Greek city (*polis*) when he established a new capital at Alexandria. A third, Ptolemais Hermiou, was founded soon after by Ptolemy I. The cities were vital to the spread of Greek, and later Roman, culture, especially art and architecture. They provided social centres, such as the gymnasium and baths, as well as theatres and hippodromes. Although such amenities were originally put in place for Greek settlers, they were adopted along with other aspects of Hellenism by a growing portion of the population in urban areas. Antinoopolis was the last Greek *polis* founded in Egypt; it was established by the emperor Hadrian in AD 130 during his tour of the country.

art. Instead, construction of Egyptian temples continued even in physically remote areas like the Kharga Oasis, where a temple was decorated under the reign of Darius I (c.500 BC). All the oases in the western desert, as well as desert routes south to Nubia, became more accessible following the Persian introduction of the camel. Persian rule was resented, and Egyptian rebels tried to re-establish native rule. Alexander the Great and his armies were welcomed as liberators from the Persians.

Egypt became a kingdom ruled from Alexandria by Ptolemy, a Macedonian Greek general whose heirs governed Egypt, Cyprus and parts of Cyrenaica (modern Libya) until 30 BC, when Rome annexed Egypt as a province. At the beginning of the Ptolemaic period, Greek settlers from the eastern Aegean brought their own cultural institutions and art forms but intermarried to some extent with Egyptians. After AD 284, the Emperor Diocletian divided the Roman Empire in two, and Egypt, an early centre of Christianity, became part of the eastern empire, which was governed from Constantinople (modern Istanbul).

TRADE, MATERIALS AND TECHNIQUES

Egypt's natural resources were valuable exports, especially grain, papyrus, precious metals and luxurious stones. Egypt sent wheat to Rome, and later to Constantinople, and also

supplied the Mediterranean world with papyrus sheets for writing material. Stone quarries in the eastern desert provided porphyry, a hard purple-hued stone, for the columns of the Pantheon in Rome and for imperial sculptures. Romans transported works of art from Egypt to Italy, both to symbolize conquest and to satisfy their fascination with an exotic, alien culture.

Within Egypt, extensive construction in these years required ample supplies of building materials. Existing urban areas were added to in order to create new structures with both Greek and Egyptian architectural forms and decorations. Recently established cities such as Alexandria (founded 332 BC) and Antinoopolis (founded AD 130) were built from almost nothing. Traditional Egyptian art was fostered in the many temples built or rebuilt with funding from the state, especially under the Ptolemies. Temples at Dendera, Esna, Edfu, Kom Ombo, Philae and Kalabsha, date from the Ptolemaic and Roman periods.

STATUES CARVED FROM HARD, DARK STONE and given a fine polish were a hallmark of Egyptian art during this period. Sculptors evoked the past by adapting earlier artistic forms, and the short kilt and tightly curled wig on this fourth-century BC statue recall Old Kingdom styles. A hieroglyphic inscription on the back invokes three Egyptian gods.

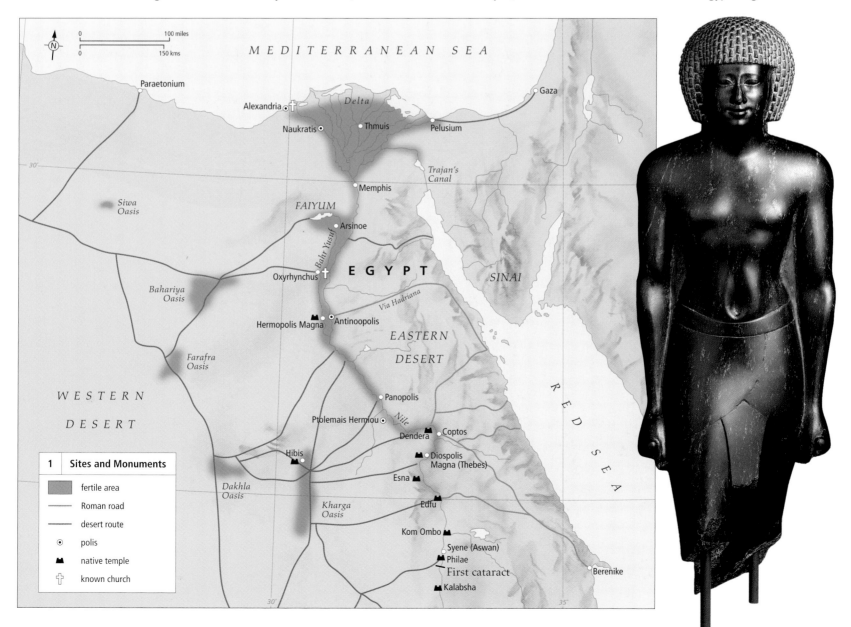

MEDITERRANEAN SEA

Paraetonium
Gaza
Alexandria
Delta
Naukratis
Thmuis
Pelusium
Siwa Oasis
Trajan's Canal
Memphis
FAIYUM
Arsinoe
Bahariya Oasis
Oxyrhynchus
EGYPT
SINAI
Via Hadriana
Hermopolis Magna
Antinoopolis
EASTERN DESERT
Farafra Oasis
WESTERN DESERT
Panopolis
Ptolemais Hermiou
Nile
Dendera
Coptos
RED SEA
Hibis
Diospolis Magna (Thebes)
Dakhla Oasis
Esna
Kharga Oasis
Edfu
Kom Ombo
Syene (Aswan)
Philae
First cataract
Berenike
Kalabsha

1	Sites and Monuments
	fertile area
	Roman road
	desert route
⊙	polis
⛰	native temple
✝	known church

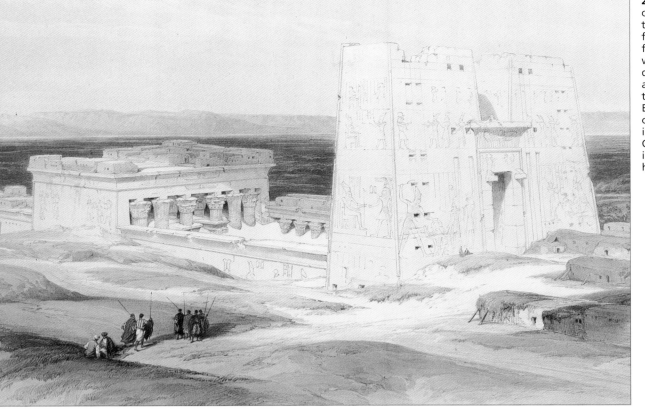

2 TEMPLES TO THE EGYPTIAN GODS continued to be built throughout the Ptolemaic and Roman periods, further developing traditional forms and themes. Sculpted relief was of the highest quality and depicted myths and rites alongside elaborate hieroglyphic texts. The temple of Horus at Edfu, seen here in a nineteenth-century lithograph, is the most intact of the surviving temples. On its outer pylon, Ptolemy XII is depicted as a pharaoh smiting his enemies.

In urban and domestic art, new products and techniques were developed or improved upon, such as glassblowing, bronze casting and mould-made pottery figurines. A popular Egyptian product was faience, a quartz mixture that was moulded, glazed and fired to a green or blue colour for small sculptures, bowls, vases and other objects.

Glass and ceramic vessel forms and decoration styles parallel developments elsewhere in the eastern Mediterranean. They attest to the extent of communication and trade in this region. Egypt's caravan, road and seafaring routes gave it a pivotal military and economic position, and the arts and crafts within Egypt were affected by the movement of people and ideas.

SOCIAL AND ARTISTIC CHANGE
Whereas Persian rule had minimal effect on Egyptian cultural life, the Greeks had a great impact. Greek culture was transmitted first through trade contacts, especially in the Delta, and, under the Ptolemies, through immigrants. As Egypt was transformed into a Hellenistic kingdom and then a Roman province, changes in its administration altered the country's social structure and, consequently, the

make-up of the elite. In the Roman period, status depended not only on wealth but also on social standing, through belonging to the gymnasium, holding a local office, and having Roman, Alexandrian, or metropolitan citizenship, all of which were highly desirable and stringently regulated.

Egypt came to value Greek products and art forms, sometimes adapting them in local materials. For instance, popular figural themes like grotesques (exaggerated depictions of the poor and infirm) were reproduced in terracotta figurines. The postures and costumes standard to Greek and Roman sculpture, where they would be executed in marble, were carved in plentiful Egyptian limestone, as were classical architectural elements such as columns, friezes and capitals. Cities enjoyed Greek and Roman features like baths, theatres and

colonnaded streets with public statuary. Larger buildings and houses might have mosaic floors, and smaller houses might have a painted wall scene or small niche for statuettes, for religious observances at home.

Conventional Egyptian art and architecture became increasingly specialized for use in temples and the funerary sphere. Egyptian deities were widely worshipped and some, especially Isis, had flourishing cults throughout the Mediterranean. Few people funded tombs or statues for themselves, but the decoration of mummies was often elaborate and used versatile materials such as cartonnage, plaster and painted linen or wood. Some funerary art included portraits of the deceased, executed in the naturalistic style of Greek and Roman art and depicting contemporary fashions in hair, clothing and jewellery.

2 LAND RECLAMATION AND GREEK IMMIGRANTS made the Faiyum the most populous and agriculturally abundant region in Egypt. Thousands of papyri from this period have been found there – written primarily in Greek and providing a detailed glimpse of day to day life. Towns and temples in the Faiyum used a variety of art and architecture, and in several local cemeteries, mummified bodies were buried with masks and painted portraits that combined Egyptian, Greek and Roman forms.

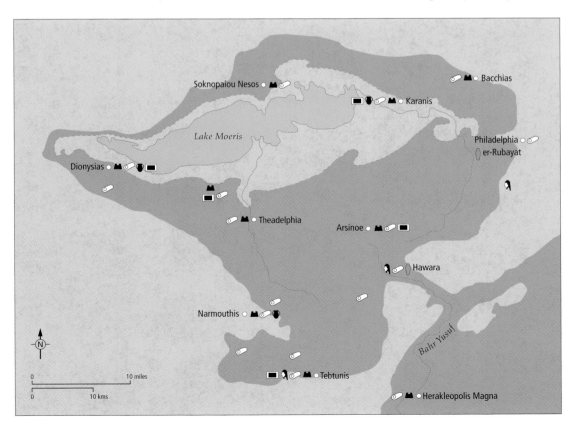

2	The Greco-Roman Faiyum, AD 100

	fertile area		bath complex
	extent of lake in Roman period		papyrus findspot
	extent of lake in Ptolemaic period		glass findspot
	temple		mummy portrait findspot
			mummy mask findspot

NORTH AFRICA AD 300-600

EGYPT AND THE NORTH AFRICAN provinces in the year 300 were stable and prosperous in comparison to the Roman Empire's western and eastern frontiers, and would continue to be so for much of the next three hundred years. However, political and cultural upheaval affected Latin-speaking North Africa in the fifth century, when the Vandals, a tribe originally from central Europe, north of the Danube, invaded the region via Spain in 429. It was reconquered after a century by the Roman emperor in the east, Justinian, who placed the region under a Greek-speaking administration for the first time in its history. At the same time North Africa was also forced to defend itself from raids by the nomadic Berbers, who had gradually encroached on its southwestern frontier during the Vandal conquest.

Unfortunately, little is known of Berber material culture in this period.

TRADE AND THE ECONOMY

Despite these disruptive events, North Africa's agricultural economy remained intact and prospered. It was this economy, based on the export of grain and olive oil, which supported the region's rich and varied artistic production in late antiquity. In Egypt, too, it was the export of grain (especially to Rome, and subsequently the eastern capital of Constantinople), which underpinned artistic production. The manufacture of red slip pottery (exported as a secondary cargo on grain or oil ships) was a major industry, based initially in Carthage and its vicinity, but also successfully copied in Aswan in Egypt. Some of these tablewares displayed a wide variety of stamped decoration, both figural and ornamental. A more valuable export was ivory, which came principally from East Africa via Egypt's Red Sea ports, but also from the North African elephants of Mauritania. Although ivory was often exported in its raw state, there is evidence that Alexandria was a major centre of ivory carving, especially of decorative plaques to cover furniture.

THIS TERRACOTTA PILGRIM FLASK depicts the Egyptian saint, Menas, wearing the costume of a Roman soldier, and flanked by the camels which legend said brought his body to its resting place of Abu Mena, near Alexandria. This was a major place of pilgrimage, and flasks such as this were sold for pilgrims to fill, either with the water of a miraculous spring near the saint's tomb, or oil from the lamps which hung above the tomb. A similar image of the saint appears on a contemporary ivory box, probably carved in Alexandria.

ART AND URBAN LIFE

North Africa had been a centre for domestic floor mosaics since the early second century, and their production continued unabated in the fourth century. Many surviving examples come from Carthage as well as the smaller towns of the region, attesting to the continued vitality of urban life. Subjects represented include race horses, charioteers and the events of the amphitheatre – a longstanding North African fascination – but an increased preoccupation with the lifestyles of the elite, and the agricultural basis of their wealth is also evident. Idealized scenes of life on country estates have been found in Carthage and Thabraca, and a scene of a wealthy woman at her toilet was discovered at a villa at Sidi Ghirib, 20 kilometres (12 miles) from Carthage.

The mixed hoard of fourth- and fifth-century silver plate and gold jewellery found in Carthage is an example of the portable wealth of those who commissioned such mosaics for their dwellings. As ever in North Africa, mythological scenes were less popular, but a fine mosaic of a scene from the *Iliad* survives at Neapolis, while at Caesarea there are scenes from the life of Achilles, and a Judgement of Paris. Production (and in some cases quality)

1 CARTHAGE AND ALEXANDRIA were the two largest urban centres in Late Roman Africa, serving major administrative as well as commercial roles, and their hinterlands accordingly carried the largest density of settlements, following the fertile banks of the Nile in Egypt, and clustering in the Roman provinces of Africa Proconsularis and Numidia to the west. Local artistic products, such as mosaic pavements, wall and panel painting, weaving, and stone carving, which had long been deployed in domestic and secular contexts, were now also used in the service of the Christian church.

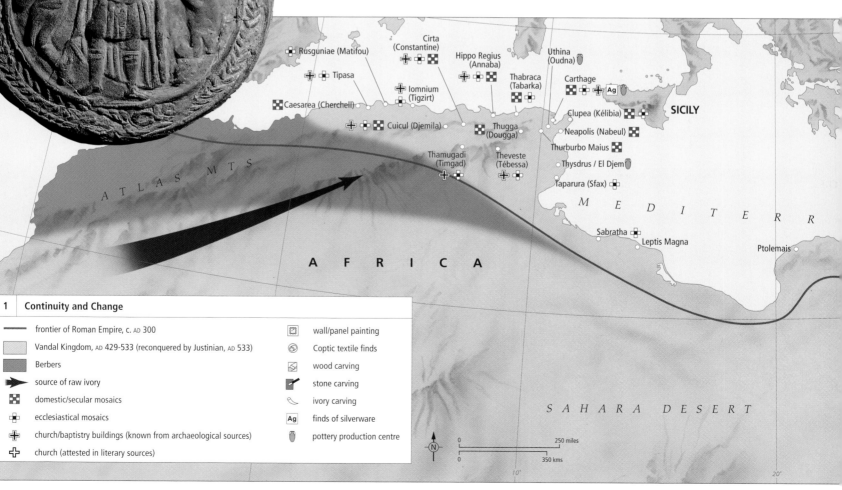

1	Continuity and Change		
———	frontier of Roman Empire, c. AD 300	▣	wall/panel painting
▨	Vandal Kingdom, AD 429-533 (reconquered by Justinian, AD 533)	◉	Coptic textile finds
▨	Berbers	▧	wood carving
➤	source of raw ivory	◗	stone carving
▥	domestic/secular mosaics	⌣	ivory carving
⊞	ecclesiastical mosaics	Ag	finds of silverware
✚	church/baptistry buildings (known from archaeological sources)	🏺	pottery production centre
✚	church (attested in literary sources)		

declined in the fifth and sixth centuries, but sufficient examples exist, especially in the vicinity of the regional capital of Carthage, to show that some Vandals continued to patronize the mosaic workshops, and favoured the traditional subjects of hunting and the spectacles of the amphitheatre and circus.

THE IMPACT OF CHRISTIANITY
Many of the mosaic workshops in this later period may have turned from domestic to ecclesiastical commissions, as artistic patronage became increasingly directed towards church building and decoration. Church floors and even baptismal pools were regularly covered with mosaics (sometimes spectacularly, as at Rusguniae, or in the Justinianic basilica at Sabratha); mosaic pavements were also used in funerary contexts. No wall or vault mosaics survive in North Africa; those in the Monastery of the Burning Bush (now St Catherine's) at Sinai, built by the emperor Justinian, were almost certainly executed by craftsmen brought from Constantinople. Located in the monastery church's apse, they depict biblical events connected with Mount Sinai – Moses before the burning bush and receiving the Ten Commandments – as well as Christ's Transfiguration, when he appeared to the apostles in the company of Moses and the prophet Elijah.

Churches in Egypt were as numerous as those in North Africa, but fewer have been excavated in modern times. The churches and funerary chapels associated with the monastery at Bawit are decorated with frescoes showing saints, the Virgin Mary and angels. Other common forms of decoration include carvings in local limestone and wood carving, used to ornament beams and doors. Limestone carving was also a major medium for private funerary monuments, both pagan and Christian. These carvings are a mixture of decorative patterns and figural imagery, much

of the latter reflecting Graeco-Roman mythological traditions.

The dry climate of Egypt has preserved many of the woollen and linen textiles buried in the graves of the better-off. These often brightly coloured garments and wall-hangings are decorated with both traditional Greco-Roman subjects (including images of gods and heroes) as well as Christian subjects from the Old and New Testaments. The Hellenized Egyptian tradition of funerary portraits painted on wooden panels also contributed to a new form of Christian art: the devotional icon.

A number of striking examples dating to the sixth century have been found at Bawit and Sinai, some painted in the local Egyptian ('Coptic') style and others in a Hellenized, more cosmopolitan, style. One of the 'local' type from Bawit shows an abbot of the monastery, Menas, in the company of Christ, who places a protective arm around the abbot's shoulder. The icon of St Peter from Sinai, with its naturalistic shadows and highlights on the apostle's face, and its illusionistic receding background of classical architecture, is a fine example of the Hellenistic style.

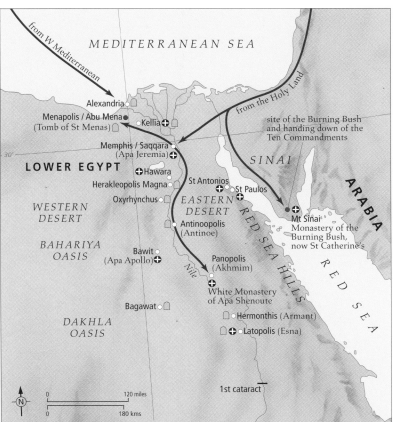

2 CHRISTIANITY WAS widespread in Egypt by the beginning of the fourth century, and had a major effect on the country's landscape. The rise of ascetic monasticism in the villages of Egypt in the fourth century led to the creation of monasteries at the juncture between settled land and desert. Two major pilgrimage sites were also located in Egypt: the shrine of St Menas, near Alexandria, and the monastery at Mt Sinai. These acted as a focus for artistic patronage and production, much of which has a distinctive regional Egyptian character.

2	Art and Monasticism in Egypt
⊕	monastery
→	pilgrimage route
●	pilgrimage site
⌂	Christian cemetery

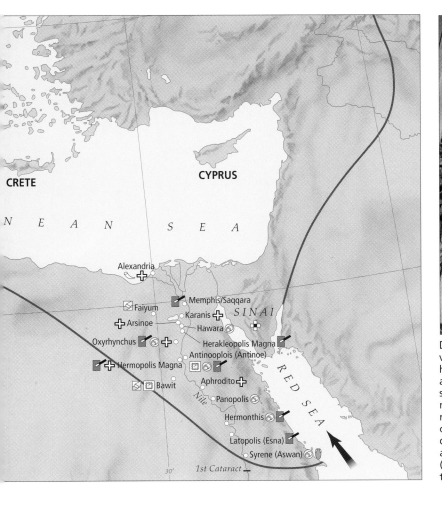

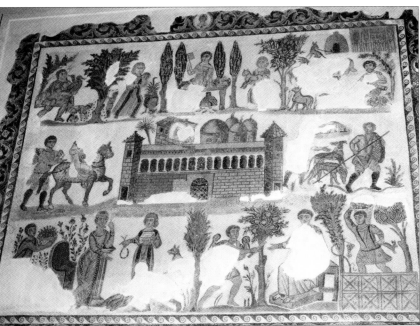

DOMINUS JULIUS MOSAIC. A grand country villa, complete with its private bath house, is surrounded by scenes of rural activity corresponding to the four seasons on this late fourth-century mosaic from Carthage. In the top register the mistress of the house is offered products of the land, amid depictions of olive harvesting (winter) and a shepherd with his flock (summer). The middle register shows the master arriving at the villa on horseback, together with preparations for a hunt, while in the bottom register the mistress of the house is presented with flowers and a necklace. In the lower right-hand corner a grape-harvester (representing autumn), is shown behind the master who is being handed a scroll addressed to 'Lord [Dominus] Julius'. Such scenes of agricultural prosperity hint at the source of the wealth of the North African urban elite.

WEST ASIA 500-300 BC

THE ACHAEMENID PERSIAN EMPIRE was vast and its people diverse. Its 26 different subject peoples spoke different languages, worshipped different deities, lived in different environments and had widely differing social customs. The Achaemenid kings had to devise a system of empire strong enough to keep themselves in control and flexible enough to provide for the needs of all their subjects. The art and architecture of the period both reflect the diversity of the empire and proclaim the notion of a stabilized, harmonious world under the control of the Persian king. The last ruler of this vast empire, Alexander of Macedon (the 'Great'), used the pre-existing Achaemenid ideological channels and methods to maintain control.

Achaemenid art is preserved in many media, including official architecture built of stone and mud brick, architectural sculpture in stone and brick, glazed bricks, wall paintings on wood and stone and plaster, rock reliefs and free-standing sculpture in stone and metal. On

1 THE ACHAEMENID PERSIAN EMPIRE (c.550–330), founded by Cyrus II, centred on southwest Iran and lower Mesopotamia. Under Darius I (521–486) it reached its greatest extent, stretching from the Aegean Sea to the Indus River, from Egypt to the modern Central Asian republics. When Alexander of Macedon conquered the empire in 331, he retained much of the Persian administrative system and made use of many pre-existing artistic channels to propagate his new ideology of empire.

ELABORATE METAL VESSELS like this bowl were probably imbued with great symbolic significance during the Achaemenid period. They were made throughout the empire in a particular, recognizable, style, brought to the king at his capitals in Iran, and redistributed from there. Ownership of such a vessel signified membership in the Achaemenid elite, a polyethnic group of people responsible for imperial administration.

a smaller scale, there are seals (preserved both as stone artefacts and also as impressions left on the documents they ratified), coins, jewellery, weapons, horse trappings, vessels of stone and glass and metal, personal effects such as mirrors, ornamental wood and ivory carvings and textiles. These artistic remains complement the Greek and Near Eastern texts to provide a complex image of the empire.

THE ART OF KINGSHIP

The concept of a harmonious world order is the central theme of the entire programme of

Achaemenid imperial art. Achaemenid art was founded on ancient local artistic traditions: throughout the empire, the Achaemenids took local art and reformulated it to place the figure of the king in positions previously occupied by deities. Thus it became the king who, artistically, held the universe in harmony. An example of this is the Apadana relief (illustrated opposite): depictions of people bearing gifts to enthroned gods, and assuming particular pious gestures in the presence of deities (such as the traditional Mesopotamian hand-over-wrist gesture, not shown here), had a long-standing history. But here it is the king who is the focus of the action. To reinforce that sense of focus, the Achaemenid kings devised a new ideologically charged kind of palace including a columned audience hall at its core.

This idea of showing the king in the central role traditionally attributed to deities was repeated time and time again, in many different contexts throughout the empire. Drawing from different local traditions, the king is depicted as godhead on architectural and free-standing sculptures, on seal-stones and coins and on embossed metal vessels. Imperial texts make it clear that the kings saw themselves as in direct communication with the deity Ahuramazda, holding their positions because of divine favour. It is a recurrent theme both on imperial architectural sculpture and on Achaemenid seal-stones.

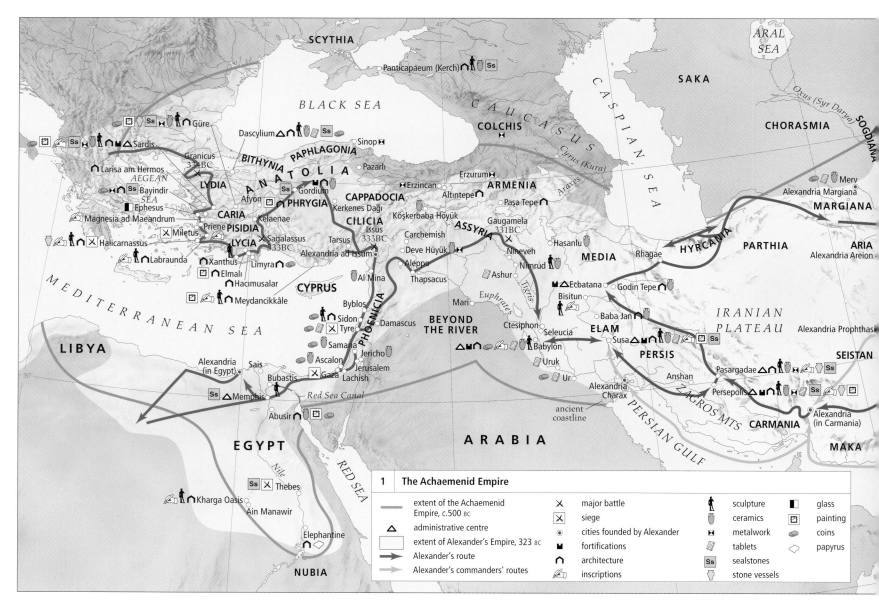

1	The Achaemenid Empire

	extent of the Achaemenid Empire, c.500 BC	✕	major battle	👤	sculpture	◨	glass
△	administrative centre	⊠	siege		ceramics	⊡	painting
☐	extent of Alexander's Empire, 323 BC	⊙	cities founded by Alexander	⋈	metalwork		coins
→	Alexander's route	▬	fortifications		tablets	◇	papyrus
→	Alexander's commanders' routes	⋒	architecture	Ss	sealstones		
		✍	inscriptions		stone vessels		

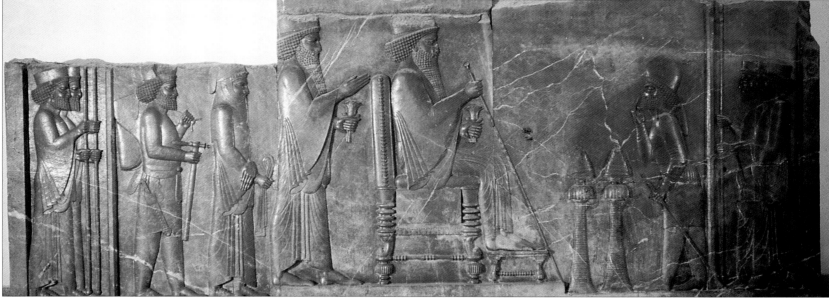

Seal-stones were widely used throughout the empire to ratify official and personal documents and to claim ownership of commodities. They demonstrate the choice by an individual of a single artistic emblem to indicate him or herself. The most frequently depicted image in Achaemenid art (both monumental and small-scale) is the figure of a hero, often to be identified as a king, mastering beasts. In individual as well as official imperial art the image of the king exerting control over nefarious forces to maintain a balanced, symmetrical whole, was widely favoured. Art had therefore become a

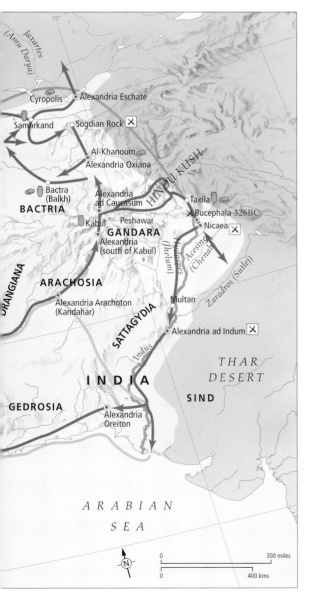

widely popular and effective way to proclaim the stability of the empire, a stability that was founded on the figurehead of the king himself.

There was remarkable coherence of style in particular artefacts throughout the empire. Metal vessels found in Anatolia, like the one illustrated opposite, resemble very closely those found in the southern and eastern reaches of the empire as well as those depicted on the Apadana reliefs at Persepolis. Indeed, there is little stylistic variation in particular categories of artefact across hundreds of years and thousands of miles. A particular artistic style was itself identified with the king, and ownership of objects created in this style proclaimed nearness to the king, and hence membership in the Achaemenid elite.

ALEXANDER OF MACEDON

When Alexander of Macedon conquered Darius III in a series of battles in the late 330s, he was able to take over an empire that already possessed an elaborate administrative hierarchy and ready-made channels for propaganda through the manipulation of artistic imagery. For the rest of his life (he died in Babylon in 323) much of his attention was focused on warfare. He also founded many new cities to house troops loyal to him who would oversee administration of the region in his name. But much of what had existed before his arrival remained the same during his short reign. It is clear, for instance, that official Achaemenid art was perceived as being specifically Persian; and it was used even after Alexander's death to reinforce the ethnic identity of Persians.

CONCLUSION

Developing a new artistic style and iconographic vocabulary that drew on antique Mesopotamian and other regional traditions was part of the overarching Achaemenid strategy to incorporate widely disparate peoples and places into the new empire. Through ideologically charged art, the Achaemenid Persians emphasized the new world order that relied upon the good offices of the Persian king. Imperial Persian art was designed for widespread dissemination. Its overarching message was one of a world under control, a world in which the population joined in harmonious, even joyous, service to the king who maintained the empire. This art was so widely recognized that it might be used to identify people as Persian, or members of the Achaemenid elite, throughout the empire and even after its demise.

RELIEF FROM THE APADANA, or audience hall, at Persepolis. It shows the king enthroned, with his heir and other retainers standing behind him. In front of him are two incense burners of a type found as far away as Güre, in Anatolia. A man bows towards the king, kissing his hand: he is the foremost of many figures shown on the Apadana reliefs, including Persians as well as the 26 subject peoples of the land, bearing gifts of animals, textiles, and metal crafted into Achaemenid-style vessels.

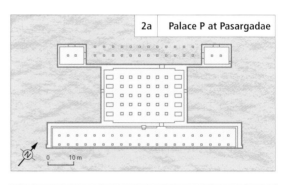

2a Palace P at Pasargadae

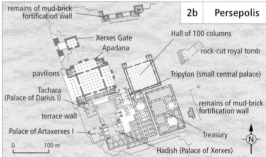

2b Persepolis

remains of mud-brick fortification wall
Xerxes Gate
Apadana
Hall of 100 columns
rock-cut royal tomb
pavilions
Tripylon (small central palace)
Tachara (Palace of Darius I)
remains of mud-brick fortification wall
terrace wall
Palace of Artaxerxes I
Treasury
Hadish (Palace of Xerxes)

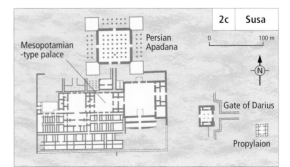

2c Susa

Mesopotamian-type palace
Persian Apadana
Gate of Darius
Propylaion

2 CYRUS II BUILT AN EXAMPLE of the Achaemenid many-columned audience hall at Pasargadae, amid tremendous formal gardens. Darius and his successors elaborated on the idea. At Persepolis, the entire fortified terrace was built up with columned halls which fulfilled different functions (audience halls, living quarters, treasury). Even at the ancient city of Susa, Darius and his successors built a new many-columned palace to complement the city's ancient Mesopotamian palace.

WEST ASIA 300 BC-AD 600

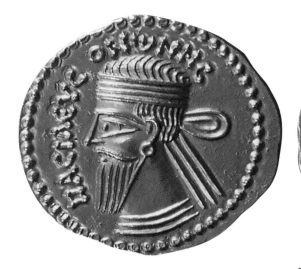

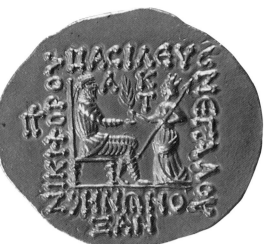

TWO EMPIRES IN SUCCESSION, the Parthians and the Sasanians, contained Roman and then Byzantine expansion into western Asia. Under them, the region became progressively less Greek. Eastern culture was re-asserted after being challenged by the conquests of Alexander the Great.

Both visual art and language underwent a gradual change over time. The Greek quest for beauty and Roman realism were disregarded for symbolic art. While scholars from previous ages suggested that this was regression into barbarism, the art of this region emerges as one that contributed greatly – particularly through architecture and textiles – to Roman and early medieval European styles.

THE ART OF THE PARTHIANS

The Parthians, originally an Indo-Iranian-speaking people from the steppes, defeated the Greek successors to Alexander and established a confederation of states under a monarch who collected taxes and raised armies. Mithradates I (r.171–138 BC) proclaimed his independence by issuing coins bearing his portrait with a royal diadem. The reverse bore an image of Arsaces – ancestor of the dynasty – seated holding a bow. Coins in the same

1 THE PARTHIAN MIGRATIONS from Central Asia were dictated by geography. Separated from Iran and subsequent nomadic attack by the Zagros Mountains, Mesopotamia offered rich cultural traditions, and was the centre of the empire. Most surviving Parthian architecture is from the west. The powerful trading cities on the Euphrates, the traditional border with Rome, fused Eastern and Western motifs into a new style.

style were issued till the end of the empire, though they range from the early style which employed Greek artisans, to later issues that reflected the nomadic heritage of these people.

The Parthians rapidly moved through Iran and into the fertile Mesopotamian lowlands, where they encountered ancient civilizations with their own distinctive cultures and art forms. Ceramics from this period show strong regional trends.

Mithradates II (r.124–87 BC), perhaps the greatest monarch, reconquered Mesopotamia. By 113 BC, the Greek city of Dura-Europus was taken, and the Euphrates River was established as a border with Rome. This city became a trading metropolis, and struck Parthian tetradrachms (coins four times the weight of the standard drachm), a preferred silver coin in the west.

PARTHIAN GOLD DRACHM of Vonones I (r. AD 8–12) struck at Rhagae to commemorate his victory over his rival Artabanus II (r. AD 10–38). Parthian portraits of rulers on coins, in contrast to rock art, were hardly ever shown full face. The coin is a mixture of east and west: the use of Greek for the inscription contrasts with the representation of the king as a horseman dressed in trousers. Parthian gold coins are very rare.

Greek language and art was predominant in the first phase of the Parthian period. In the last centuries of the empire there was an increasing use of the Parthian language (an Iranian dialect written in Aramaic), as well as distinctive art forms. The art of the Parthians is rather hard to define, as they were more collectors than originators. In general it reflects the many nationalities incorporated into their empire, but there are some nearly universal features. Reflecting nomadic origins,

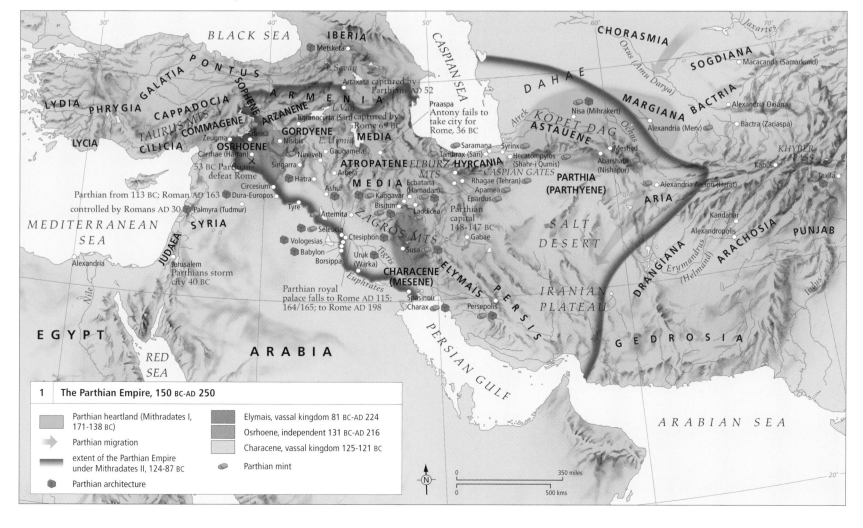

1 The Parthian Empire, 150 BC-AD 250

Parthian heartland (Mithradates I, 171-138 BC)

Parthian migration

extent of the Parthian Empire under Mithradates II, 124-87 BC

Parthian architecture

Elymais, vassal kingdom 81 BC-AD 224

Osrhoene, independent 131 BC-AD 216

Characene, vassal kingdom 125-121 BC

Parthian mint

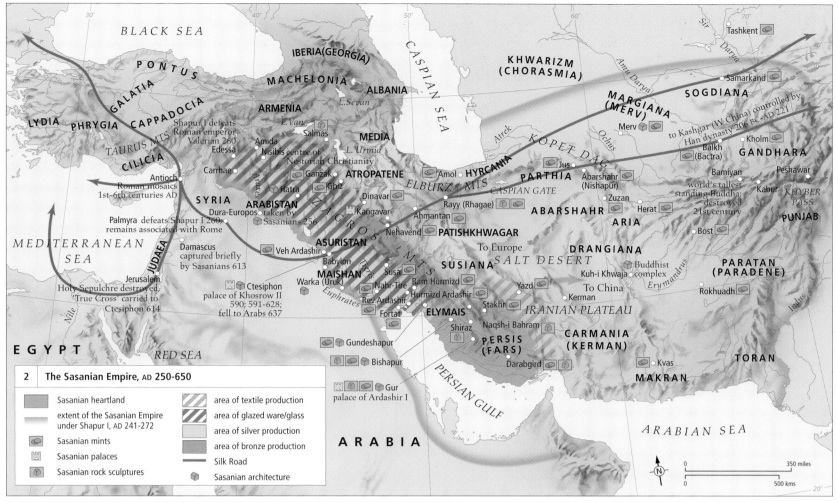

2 The Sasanian Empire, AD 250–650

- ▨ Sasanian heartland
- ▭ extent of the Sasanian Empire under Shapur I, AD 241–272
- Sasanian mints
- Sasanian palaces
- Sasanian rock sculptures
- ▨ area of textile production
- ▨ area of glazed ware/glass
- ▨ area of silver production
- ▨ area of bronze production
- — Silk Road
- Sasanian architecture

2 DRAWING UPON THEIR ANCESTORS' cultural achievements in Fars province, the Sasanians are known for their luxurious court. They controlled the trade route between China and Rome, and manufactured cloth and silver vessels that were extensively traded. Sasanian mints, widely spaced but under central control, produced a mass of coins that were known from Europe to China.

horsemen – armed for war and in baggy trousers with pointed hats – are popular. Animals are rendered in a 'steppe art' style. Figures in a flying gallop, with legs outstretched, are common, as are a variety of other poses that depict animals in motion executed with bold lines. Parthian pictorial art is noted for looking at a figure in full face, which is a marked departure from the earlier use of profile.

THE ART OF THE SASANIANS
In AD 224 a Sasanian king Ardashir I (r.224–241) from Fars defeated and killed the Parthian monarch. This signalled the end of Parthian art. With their homeland in the centre of the ancient Persian empire, the Sasanians were reminded, through ruins, of a golden age of culture with an elaborate court art. Resenting the Parthians as usurpers of this heritage, they sought to erase them from the historical record.

The Sasanian dynasty adhered to the Zoroastrian faith as a state religion. Silver coins were now made from a broad, flat blank rather than a short, thick flan, and were typically struck with an elaborately crowned king on one side, and two attendants and a Zoroastrian fire altar on the other. This dichotomy between church and state draws attention to a powerful priestly class that was unknown in the Parthian empire. Gone was the loose confederation of states with religious tolerance. Persecutions of religious minorities, including the Christian Armenians, occurred in cycles. This kindled Armenian nationalism – reflected in the

building of churches with Christian stone sculptures – particularly after the partition (AD 387) of the kingdom between Persia and Rome.

The Sasanians are credited with introducing the medieval period to the Middle East. The language of the Sasanian empire was Middle Persian, and appears as a more universal language than Parthian. Unlike the preceding empire, this period is noted for greater control over regional dynasties.

Sasanian art is of an entirely different nature from that of the preceding dynasty. The Sasanians supported court artists and produced luxury goods for trade. While it is likely that a trade in silk from east to west was a major factor in earlier periods, at no other time is there such a wealth of evidence for trade between China and Rome. Elaborate royal portraits, with crowns that differed from ruler to ruler, can be found on everything from coins to vessels and statues. Sasanian silver bowls have been found in the Russian steppes, textiles have been recovered from the dry western Chinese deserts, and Sasanian glass has even been found in Japan.

Sasanian rulers also carved rock sculptures. Some of the best (Naqsh-e Rostam and Naqsh-e Rajab) are near the ancient Persian capital of Persepolis. Royal courts were also active in creating grand architectural monuments. Khosrow II built a vast palace – with an intact mud-brick barrel vault – at Ctesiphon (Taq-i Kisra). Many Sasanian limestone and mortar buildings still survive in Fars. The most important is the palace of Ardashir I at Gur (Firuzabad).

After Khosrow II (r.590; 591–628) the empire went into a sharp decline. Devastated by fighting, plague, and a succession of weak rulers, the Sasanian capital Ctesiphon fell in 637 to advancing Islamic Arab armies. In a short space of time, Zoroastrian religious

imagery disappeared from the artistic repertoire, though the tradition of luxurious court art – such as textiles and metalwork – was left intact.

SASANIAN TEXTILES, such as this one decorated with the mythological winged horse Pegasus, drew on a long history of weaving, and employed ancient Iranian as well as Greek motifs. Pegasus, of Greek inspiration, would have been known from Classical art. The pearl roundel that frames the image is typical of the Sasanians, and appears in Far Eastern art at about this time. Finely woven and brightly coloured with bold designs, such textiles were in demand from Europe to China.

CENTRAL ASIA 500 BC-AD 600

FROM THE MID-FIRST millennium BC onwards Central Asia was a place of great change and development. Trade and ideological expansion stimulated artistic growth in a variety of ways, leading to a rich cultural heritage that we can trace through artefacts and styles.

The Achaemenids (Persians) controlled much of this area between c.539–311 BC, and their awareness of the rich natural resources of Central Asia is reflected in the natural goods such as camels, horses, and bulls, and the worked items, such as jewellery and skins that were exports from both Bactria and Gandhara. Achaemenid influence in art can be seen in the items recovered from the frozen tombs of the Altai in Siberia. Achaemenid elements, such as columns with animal sculpture, persist into the Buddhist art of the later Mauryan Emperor of India, Ashoka.

THE HELLENISTIC IMPACT

The legacy of the Macedonian conqueror Alexander the Great in Central Asia is thought to include planned cities such as Ay Khanum, Shaikhan Dheri (Charsadda) and Sirkap (Taxila) as well as Greek mythological scenes in sculpture and pottery. When Alexander conquered the Achaemenids in c.331 BC, the Greeks then ruled in much of Central Asia, including Bactria and Sogdiana. Their attempts to move further east into Northern India were

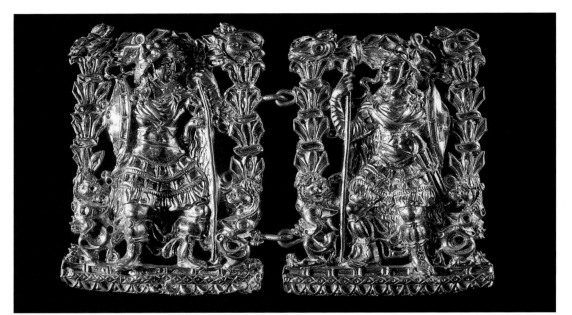

foiled by a number of smaller Indian states, which eventually emerged into the great Mauryan Empire. Ashoka (r.268–232 BC) is perhaps the best known of the Mauryans, and this is largely due to his ardent promotion of Buddhism. Indeed, it was Ashoka who sent his son Mahinda as a friend and missionary to convert the ruling family of Sri Lanka to Buddhism.

FROM THE 'GOLDEN MOUND', a pair of open-worked gold clasps representing warriors between columns or trees. They are classically dressed but with Graeco-Bactrian plumes on Macedonian-type helmets. Menacing dragons at their feet betray Eurasian 'animal style' influence. Unearthed from a female grave, this is one of 20,000 artefacts discovered in 1978 at Tillya-tepe or the 'Golden Mound', a 2100-year-old necropolis in Bactria. The priceless 'Treasure of Bactria' was last seen and inspected by international archaeologists in 1993.

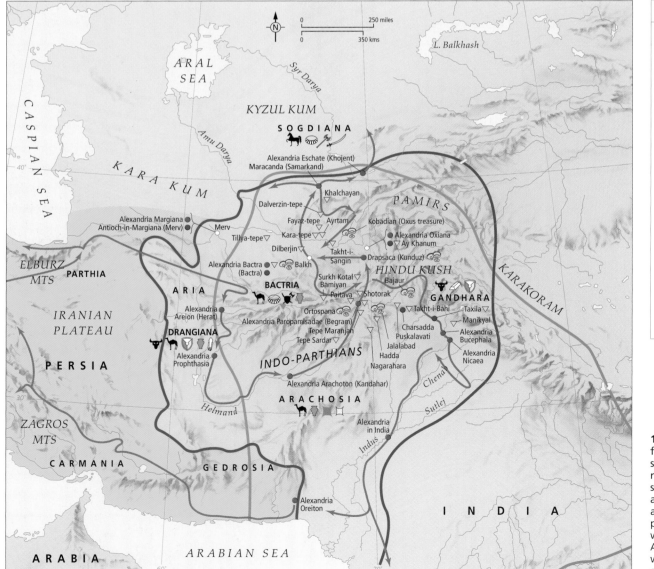

1	Empires and Tribute
→	campaigns of Alexander the Great
●	cities founded by Alexander
●	Hellenized cities
—	Kushan Empire
▽	sites with Kushan art
—	Graeco-Bactrian Kingdom
▨	Parthian Empire
🐚	sites of hoards
Achaemenid tribute:	
🐂	bulls
🐫	camels
🐴	horses
⬭	silver
⊚	rings/jewellery
⛨	lances and shields
⚔	weapons
🪓	battle-axes
⚔	swords
⬡	vessels
▤	animal hides
⊏	leather goods
▯	lion-skin cloaks

1 GREAT EMPIRES OF CENTRAL ASIA from the Persians to the Kushans show just how desirable this region is. Rich natural resources such as camels and bulls, as well as access to a variety of raw materials as well as the indigenous skills to produce fabulous jewellery and weapons, have meant that Central Asia has been conquered by western, eastern and indigenous groups over many centuries.

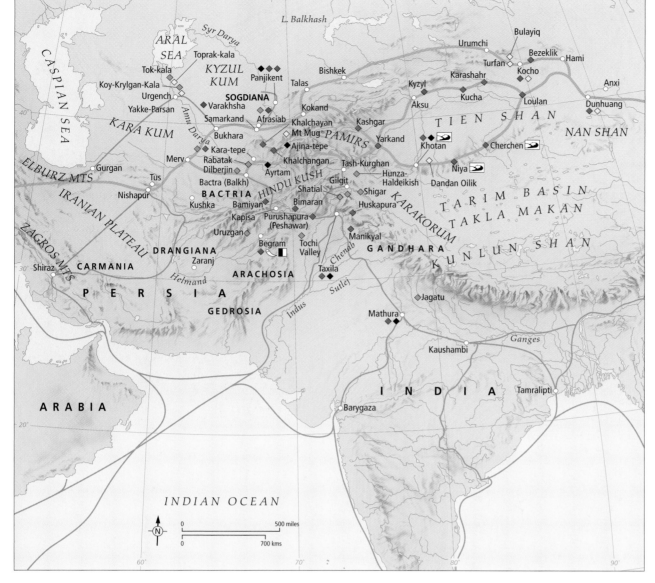

2	**Trade and Art Production**
	Silk Road
	other trade routes
◆	sites with Buddhist/Kushan art
◆	sites with Buddhist art/Chinese silk/lacquerware
✎	ivory
▮	glass
◇	manuscripts
◆	murals
◆	statues/friezes
◆	petroglyphs/graffiti/inscriptions
⊠	mummy remains

PAINTED SCRIPTURES similar to this surviving fragment from an illuminated codex of Kocho, Xinjiang, attracted adherents along the Silk Road to Manichaeism, a gnostic dualism originating in Iraq in the third century. The fragment is from a later period (11th–12th century) but its subject-matter is probably a scene that would have been familiar in earlier centuries: the Manichaean 'Sermon Scene'. Gold leaf, ink and pigments have been used to portray Manichaean leaders with the figures wearing Uyghur royal headdress.

THE BUDDHIST IMPACT

The birth of the Lord Buddha at Lumbini in Nepal in c.560 BC had a major impact on ideology in Central Asia, envisaging a means for many of escaping the reincarnation cycle of Hinduism. Buddhism also had an impact on art through Ashoka and the later Kushans. Ashoka's aim was to spread his version of the *dharma* or teachings, and he did this through a series of edicts carved into boulders and pillars across the whole of northern Nepal, India and Pakistan. The Kushans, a branch of a nomadic Chinese tribe spread through Central Asia, Bactria and down into northern India, and had united this whole region by the early second century AD. Kanishka is one of the best known Kushan rulers, and like Ashoka he converted to Buddhism and was ardent in the spread of Buddhist teachings, building new monasteries and repairing old.

During Kanishka's rule the style of art known as 'Gandharan Art' which comprises representations of the Buddha and scenes from his life spread and developed. Gandharan Art is so called because it is broadly spread throughout the area of old Gandhara, a former Achaemenid province. Gandharan stone sculptures and reliefs draw heavily on Greco-Roman styles of human depiction.

THE SILK ROAD

During Kushan rule another major development was crucial in the spread of goods and ideas: the Silk Road. This international trading link increased in importance from the early centuries AD as the Chinese realized the potential market for their valuable silk in the west, particularly the Roman world. Trade along the road meant that the Kushans were able to take advantage of demand for products such as precious stones and metals, and spices from India, while receiving silks and jade and other rare goods from China. Indeed, excavations at the Kushan summer capital of Kapisa (north of Kabul), reveal the richness of the Empire. A treasure store, with carved ivories from India, Chinese lacquers, Roman bonzes, Alexandrian glass was uncovered. Yet the trade was not only in rare goods – Buddhism also spread east along the

Silk Road at this time, becoming a major religion in eastern Asia, and there are many Kushan Buddhist sites with stupas decorated with sculpted scenes from the life of the Buddha in distinct Gandharan style to attest to this movement.

Central Asia between the mid-first millennia BC and AD is an area where the very rich artistic traditions are the result of human contact and movement – conquerors from the east absorb indigenous styles and influences from the north and east to produce distinctive regional artistic cultures.

SOUTH ASIA 500 BC–AD 600

An ENORMOUS BODY of artistic and material remains and literary sources survive from the period 500 BC–AD 600 from South Asia. They reveal the establishment of some of the most defining characteristics of Indian civilization. From the sixth century BC onward states formed as monarchies and tribal confederacies. This was accompanied by the development of urban centres, artisanal classes, agriculture and trade. Major artistic and architectural projects were supplied with an increasingly wide range of raw materials as India's natural resources were exploited. Trade in precious and semi-precious stones, such as sapphire, coral, diamond and agate, and in perfumes and ivory generated a surplus that furnished crafts guilds with raw materials.

As an increasing number of peoples were incorporated into wider organized trade and agricultural networks, their various shamanistic cults, wandering ascetics and local theistic pantheons contrasted with the existing Vedic liturgy. In the fifth century BC, Siddhartha (later Gautama Buddha), a prince of the northeastern state of the Shakyas and founder of Buddhism, emerged from this tradition of heterodox sects. So too did Vardhamana Mahavira, the founder of Jainism. Although there are few artistic remains of this early period, the early heterodox sects and other pre-existing theistic cults perpetuated the sanctity of sites associated with their seers and myths. These sites consequently became major centres of Hindu, Buddhist and Jain pilgrimage, trade and artistic activity.

THE FIRST EMPIRE
The mountain passes of the northwest frontier have always been India's vital corridors for links to the west, whether for overland trade, or, as in the case of Alexander in the third century BC, for conquest. Following Alexander's retreat from the Jhelum River in 326–5 BC, his possessions in northwest India and Afghanistan were divided between his generals. By the period of the establishment of the subcontinent-wide Mauryan Empire in the third century BC, therefore, indigenous and foreign models of statecraft, administration and, moreover, control over a standing army were well-known.

The extensive diplomatic and trade exchanges of the Mauryan emperors Chandragupta (r.321–297 BC) and Ashoka (r.268–232 BC) with Iran, Greece, Egypt, Sri Lanka and Southeast Asia are reflected in not just the influences on their art, but the conscious choice to leave lasting legacies in stone. Imperial Mauryan freestanding monolithic pillars were all quarried near Varanasi and then transported over river networks to far-flung regions of the empire. Ashokan stone inscriptions concern a variety of social, religious and economic matters. They

1 WHILE HUNDREDS OF megalithic burial sites were dotted across India in this period and traces of civilization and rural dwellings can be found across the subcontinent, this map shows only major sites or regions that either manufactured or supplied materials for the production of 'art'. Several cities and monastic dwellings have revealed structures, coins, paintings and artefacts for what is called the 'early-historic' period in India. The structures are mostly Buddhist, Jain or Hindu, although there are traces of others which can no longer be clearly identified. The map uses only the most commonly known names of dynasties.

1 Early Historic India, 500–100 BC

SUNGAS dynasty
— major trade route
— Alexander's route

material remains:
- ▦ painting
- I pillar
- ⊞ monastery remains
- ⌂ stupa
- ◣ cave: sculpted or painted
- ◼ structural remains
- ◼ bronze sculpture
- ◼ stone sculpture
- ▢ terracotta/stucco imagery
- ∿ ivory carving
- ⬭ jewellery
- ◡ coins

economic commodities/ raw materials:
- 🐎 horses
- 🐘 elephants
- ◌ cotton
- ◎ silk
- ▦ spices
- ◼ iron/coal
- ✎ gold
- ◈ diamonds
- ◇ gems
- ⬭ pearls

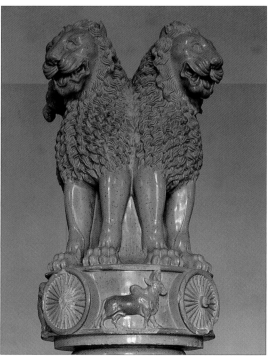

LION CAPITAL, SARNATH, 3RD CENTRY BC. This monolithic pillar capital was one of many erected by King Ashoka. The capital is made from spectacularly polished cream sandstone. Sarnath is the site where the Buddha delivered his first sermon, thereby establishing the religious order of Buddhism. Interestingly, the pillar bears an inscription left by Ashoka threatening dissenting monks with expulsion from the order.

also preserve two of the earliest readable Indian scripts: Brahmi and Kharoshti.

POST-MAURYAN ART

Early Buddhist and Jain worship was centred on the cult of the veneration of relics housed in stupas. In the politically fragmented Post-Mauryan period (roughly c.250 BC–AD 100) pre-existing brick and clay stupas, such as those at Sanchi, Amaravati and Mathura, began to attract a vibrant tradition of stone sculptures and buildings sponsored by the growing middle classes. Some of the earliest Hindu sculptures of Shiva, Vishnu, Lakshmi and other forms of the goddess also made their first appearance in stone. At the same time vast amounts of sculpture in terracotta, made from

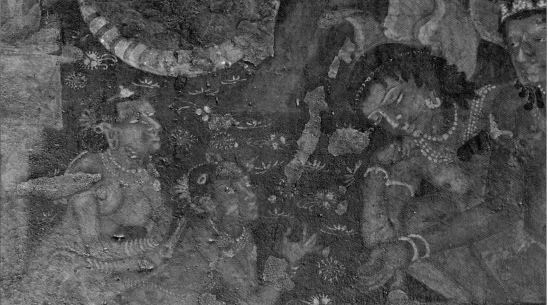

DETAIL OF A WALL PAINTING from Ajanta caves, c. fifth century AD, in the domain of the Vakataka dynasty. These Buddhist paintings are celebrated for their sophisticated compositions that burst with life. Set in palaces and gardens, they show kings, ascetics, animals and the most seductive women in self-consciously languid poses. The depictions of textiles, furniture and ornament allow us a vivid window into early India.

locally produced clay and pressed from moulds, would have served the needs of the burgeoning urban population. In addition to Sanskrit, these growing cults often expressed themselves in the local vernacular, the prototypes of various modern Indian languages. The earliest body of Dravidian literature written in Tamil is the Sangam poetry of the early centuries AD.

WIDER CONTACTS

Large areas of the northern parts of the subcontinent were closely linked to developments in Central Asia during the first to the fourth centuries AD. The Kushan Empire's control over the Silk Road was aided by the links between their twin capitals near modern Peshawar in Gandhara, and Mathura in northern India. Each region engendered a prolific centre of artistic activity. Although largely Greek or Roman and, to a lesser extent, Central Asian in inspiration and expression, the distinctive sculptural art of Gandhara was mostly Indian in its content. Large Buddhist stupas sculpted at first in local grey schist and later in stucco were covered with narratives from the Buddha's biography and Jatakas (mythological stories) that monks carried with them from Indian stupas and monasteries. At the same time, extensive maritime trade between Rome and southern India is evident from archaeological finds, texts and art.

Mainland India's own artistic ideals reached another apogee under her final empire in the ancient period during the reign of the Guptas and their tributaries, when previous iconographic, structural and literary experiments were given a fixed, classically Indian form. Their bronze, stone and terracotta sculpture forms a standard to which all subsequent Indian art refers. The influence of the visual arts of this period spread far beyond India, to Sri Lanka, Southeast Asia and the Far East.

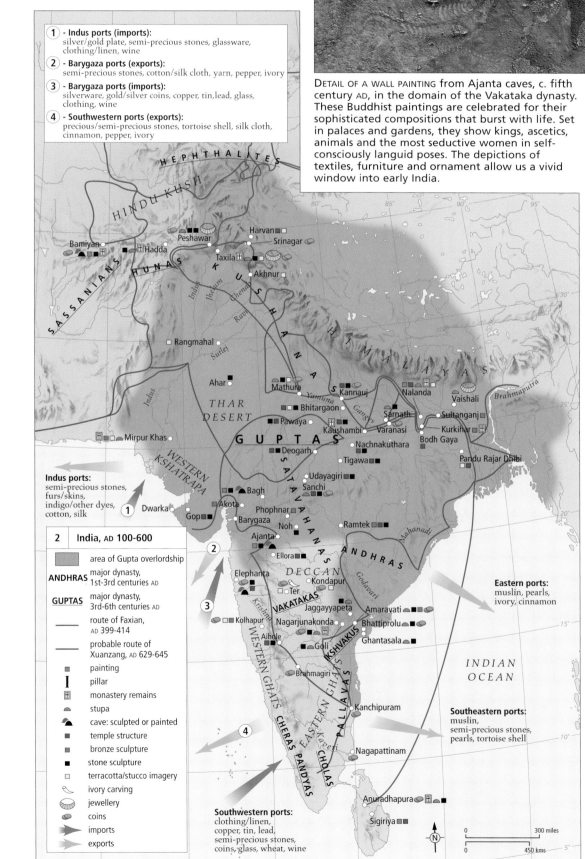

1 - Indus ports (imports):
silver/gold plate, semi-precious stones, glassware, clothing/linen, wine

2 - Barygaza ports (exports):
semi-precious stones, cotton/silk cloth, yarn, pepper, ivory

3 - Barygaza ports (imports):
silverware, gold/silver coins, copper, tin,lead, glass, clothing, wine

4 - Southwestern ports (exports):
precious/semi-precious stones, tortoise shell, silk cloth, cinnamon, pepper, ivory

Indus ports:
semi-precious stones, furs/skins, indigo/other dyes, cotton, silk

2 India, AD 100-600

area of Gupta overlordship

ANDHRAS major dynasty, 1st-3rd centuries AD

GUPTAS major dynasty, 3rd-6th centuries AD

route of Faxian, AD 399-414

probable route of Xuanzang, AD 629-645

■ painting
I pillar
⊞ monastery remains
⌒ stupa
▲ cave: sculpted or painted
■ temple structure
■ bronze sculpture
■ stone sculpture
□ terracotta/stucco imagery
✎ ivory carving
◡ jewellery
◔ coins
➤ imports
➤ exports

Eastern ports:
muslin, pearls, ivory, cinnamon

Southeastern ports:
muslin, semi-precious stones, pearls, tortoise shell

INDIAN OCEAN

Southwestern ports:
clothing/linen, copper, tin, lead, semi-precious stones, coins, glass, wheat, wine

2 THE TRAVEL ACCOUNTS from the pilgrimages of the two Chinese Buddhists Faxian and Xuanzang to ancient Indian sites in the fourth and seventh centuries have greatly assisted archaeologists. Their descriptions of sites, the routes of their travels and a wealth of other detail often ties in well with interpretations of ancient Indian literary sources and what has been excavated to reveal one of the greatest phases of Indian art. Maritime, riverine and overland trade both within South Asia and with the rest of the world saw the exchange of not just the listed commodities but also ideas and artistic ideals.

CHINA 500 BC-AD 600

THE EASTERN, OR LATE, ZHOU dynasty (770–221 BC) witnessed the waning and eventual collapse of the central power of the Zhou royal house, as dukes and lords began to develop their own states more or less independently.

ZHOU DIVERSITY

The names of the two periods of the Eastern Zhou reflect these political changes: the Spring and Autumn period (770–475 BC) and the Warring States period (475–221 BC). These changes are manifested in the great diversity of the cultural development and art of the Eastern Zhou. Many Eastern Zhou finds have been traditionally interpreted as ritual art, but in such diverse cultural contexts, and without a clear understanding of the beliefs of the people, this interpretation is no longer appropriate.

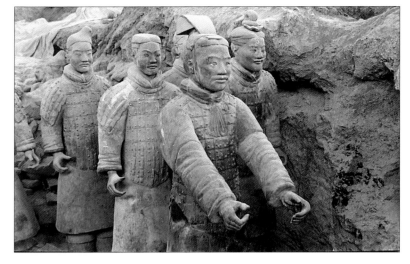

TERRACOTTA CAVALRYMAN and saddled horse, Qin Dynasty, 221–202 BC. In the 1960s thousands of terracotta warriors and horses were discovered near the tumulus of the first emperor, Qin Shihuangdi, in Xi'an. They are all life-size and made in a realistic manner. Great attention was paid to details such as hairstyle and armour, and originally both the human and animal figures were painted. Both the scale of the burial and the exquisite artistic representation of these tomb figurines are unique in Chinese history.

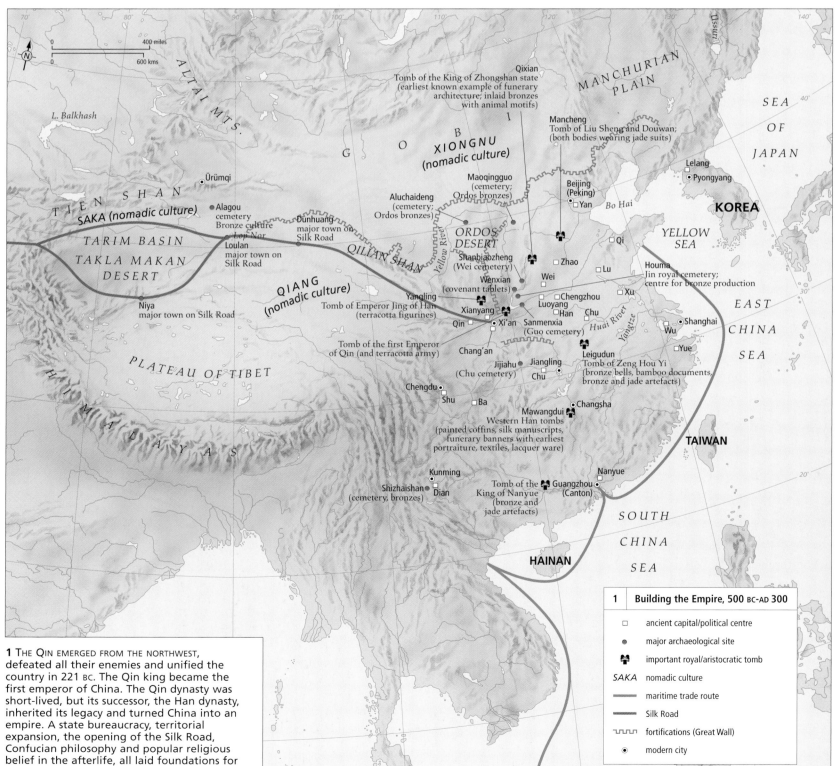

1 THE QIN EMERGED FROM THE NORTHWEST, defeated all their enemies and unified the country in 221 BC. The Qin king became the first emperor of China. The Qin dynasty was short-lived, but its successor, the Han dynasty, inherited its legacy and turned China into an empire. A state bureaucracy, territorial expansion, the opening of the Silk Road, Confucian philosophy and popular religious belief in the afterlife, all laid foundations for Chinese society for centuries to come.

1	Building the Empire, 500 BC-AD 300	
□	ancient capital/political centre	
●	major archaeological site	
♣	important royal/aristocratic tomb	
SAKA	nomadic culture	
	maritime trade route	
	Silk Road	
	fortifications (Great Wall)	
◉	modern city	

2 THE CHINESE EMPIRE fragmented into many small states from 220 to 581. There was a short period of unity under the Western Jin dynasty (AD 265–316), but during this 200-year period the political landscape was dominated by nomadic invaders, who adopted the culture and way of life of the Chinese. In 581 the Sui dynasty reunified China.

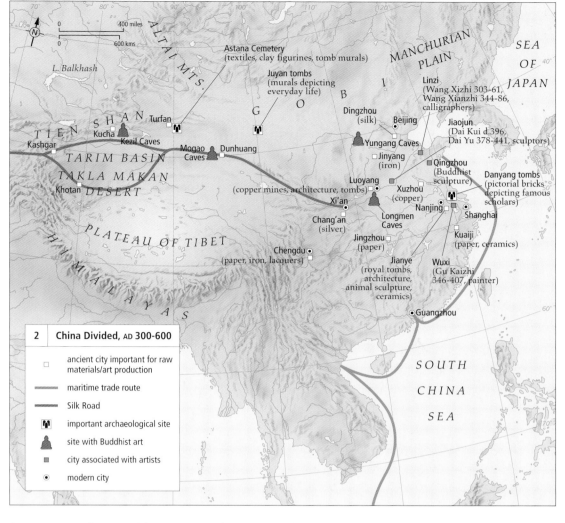

Bronze vessels remained one of the highest art forms, and innovations in metalwork, such as new inlay techniques and the lost-wax method, allowed for a much more sophisticated scheme of decoration. At the same time, particularly in the more southern Chu state, there was significant development in textiles and lacquerware. The status of such objects was raised higher than ever before, and this in turn stimulated new approaches to the forms and decorations of mainstream bronze art.

There was also influence from further afield, particularly from the nomadic art of the northern steppes. Bronzes found at the tombs of the kings of the Zhongshan state included winged animals, a motif typical of western and Central Asia. The influence was not one-way: Chinese artworks, especially bronzes and silk, now became sought-after commodities and were exported to the west.

A UNIFIED STATE
In 221 BC the ruler of the northwestern Qin state brought the Warring States to an end, unifying them to create the Qin dynasty. He became the First Emperor of China, Qin Shihuangdi. His reforms included a series of standardizations: of weights, measurements, currency and written script. He amassed great wealth and summoned skilled craftsmen to his capital at Xianyang to build his palaces and his tomb complex. The architectural remains of his massive palaces show decorated ornaments and walls. Most famous of all was the discovery in the 1970s of the thousands of terracotta warriors near his enormous tomb mound, which revealed unprecedented achievements in sculpture and human representation in early Chinese art. The warriors are life-size and hold real weapons, as though heading out for war in the other world. They were created by modelling on a mass-production line.

The Qin dynasty was overthrown by a peasant uprising in 206 BC. The new ruler, Liu Bang, established the Han Dynasty (202 BC–AD 220) and as peace prevailed, the Han dynasty flourished. The two periods of the Han dynasty reflect the location of the capital city: the Western Han (206 BC–AD 24) with the capital at Chang'an, and the Eastern Han (AD 25–220) with its capital at Luoyang.

The Western Han capital at Chang'an was the largest urban centre in Asia, with a population of almost half a million, and a thriving centre for art. The main themes in Han art were paradise and immortality. Contemporary belief and funerary practice ensured that valuable objects were buried with the dead for use in the afterlife. Indeed, many funerary objects were made especially for the burial. Archaeologists have excavated decorated tombs, sometimes with several chambers, which were intended to imitate real

living space. Their wealthy occupants have been discovered wearing elaborate suits of jade, or with the bodies preserved in silks. The construction of the 'Hall of Brightness', which symbolized the cosmos, demonstrated a strong trend in architectural innovation (using earth platforms and timbers for multi-storey buildings), which would continue into later periods.

RELIGIOUS AND LANDSCAPE ART
After the fall of the Han dynasty, China split into several small dynasties and was fragmented until the sixth century. The importance of art for the afterlife persisted:

huge stone sculptures of exotic animals were placed at royal cemeteries, and small luxury items are often found in tombs. Religious art flourished under the patronage of the Northern and Southern dynasties (420–581). The introduction of Buddhism inspired an enormous output of Buddhist icons, paintings and scriptures. This in turn stimulated artistic creativity in the indigenous religion, Taoism.

As urbanization intensified in the third and fourth centuries, landscape architecture, painting and poetry, which represented a desire to be closer to nature, became the major new passion of the elite. It coincided with the transformation of calligraphy into a fine art.

'THE ADMONITIONS OF THE INSTRUCTRESS TO COURT LADIES', attributed to Gu Kaizhi (c.AD 344–406), though this is still a matter of scholastic dispute. This silk painting is based on an essay by the Jin scholar Zhang Hua. It has eleven different scenes, with Chinese text written between each scene. The importance of the painting lies in its fine draftsmanship. It represents the highest achievement ever of Chinese figurative painting.

JAPAN AND KOREA 500 BC-AD 600

RICE CULTIVATION and bronze working were well-established on the Korean peninsula by 1000 BC, and within 600 years had spread to the Japanese archipelago. From the later part of the first millennium BC, contacts between Korea and Japan, as well as with China, under the control of the expansionist Han empire, became a major factor influencing the development of visual, material culture and technology: In Japan the last centuries of the forager Jomon period saw the appearance of plainer pottery vessels in the southwest, and an increase in ritual activity involving clay figurines, possibly indicating a resistance to the advent of rice-paddy agriculture.

THE RICE REVOLUTION

The material culture of the Yayoi period in the archipelago (c.400 BC–c. AD300) had much in common with that of the Korean Iron Age (c.500 BC–c.AD 300). In addition to the technology associated with growing rice in specially constructed paddy fields, such as semilunar-shaped stone reaping knives, new items included polished stone arrowheads, megalithic burials (quickly replaced by jar burials in Japan), and settlements enclosed by ditches. These cultural traits gestated in Kyushu during the Initial Yayoi (400–300 BC), rapidly spreading throughout Honshu, and displacing the preceding Jomon cultures. Yayoi pottery differed from the elaborately decorated Jomon traditions in terms of decoration, form and fabrication. The shallow bowls which had become common during the later Jomon had all but disappeared by the end of the first century AD, and the jar-shaped *tsubo* became a distinctive Yayoi form.

Although many bronze artefacts are found in Korea before 500 BC, in particular mirrors and weapons such as daggers and halberds, it is only in the later part of the first millennium BC that bronze became an important medium, when bronze assemblages included mirrors, weapons, bells, belt hooks, horse trappings and chariot ornaments. In Japan bronze was used in rituals, and certain forms became very stylized and ceremonial, in particular bronze bells, or *dotaku*, and spears. Sometimes – at sites such as Kojindani – bronzes were deliberately deposited. At the end of the Yayoi period, some of the newly emerging elite groups engaged in deliberate iconoclasm, breaking and smashing bronze objects and burying them in pits.

Pictorial representation became much more common during the Yayoi period. Deer, which may have represented important local deities or had symbolic associations with rice agriculture,

1 THE ADOPTION OF AGRICULTURAL LIFESTYLES on the Korean peninsula and subsequently in the Japanese archipelago was associated with major technological, social and cultural transformations, along with some degree of human migration and higher population densities. These changes also heralded changes in the landscape, with forests gradually being cleared to make way for both dry and irrigated fields. Competition for good agricultural land and trends towards increasing social differentiation were associated with rising tensions leading to the appearance of defended sites and warfare.

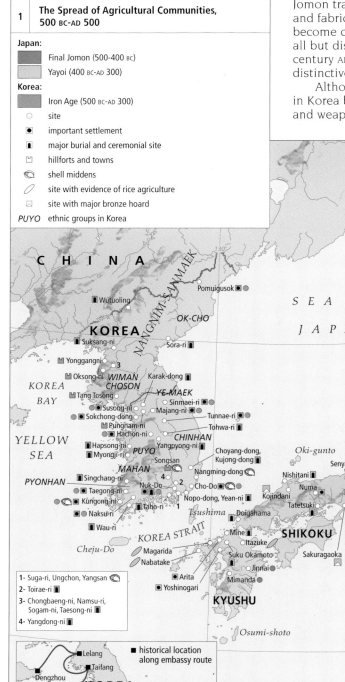

1	The Spread of Agricultural Communities, 500 BC-AD 500

Japan:
Final Jomon (500-400 BC)
Yayoi (400 BC-AD 300)

Korea:
Iron Age (500 BC-AD 300)
○ site
◉ important settlement
▪ major burial and ceremonial site
⌂ hillforts and towns
◎ shell middens
∅ site with evidence of rice agriculture
⊡ site with major bronze hoard
PUYO ethnic groups in Korea

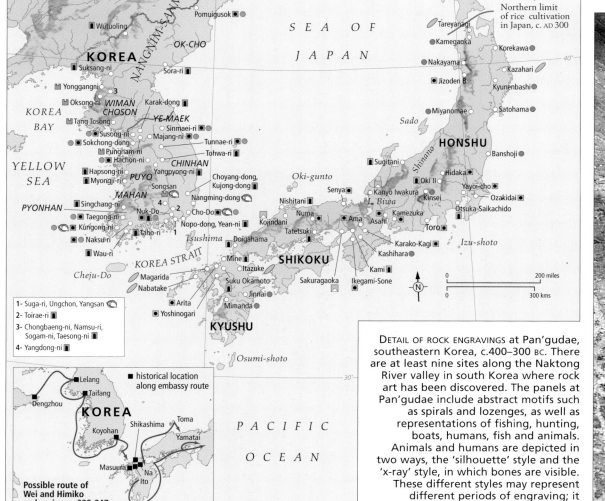

1- Suga-ri, Ungchon, Yangsan
2- Toirae-ri
3- Chongbaeng-ni, Namsu-ri, Sogam-ni, Taesong-ni
4- Yangdong-ni

■ historical location along embassy route

KOREA

Possible route of Wei and Himiko embassies, AD 239-247

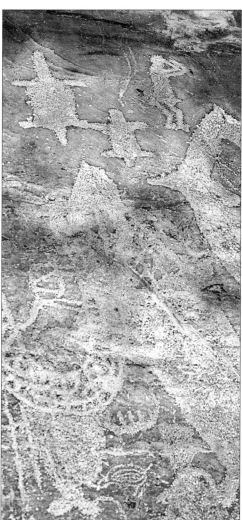

DETAIL OF ROCK ENGRAVINGS at Pan'gudae, southeastern Korea, c.400–300 BC. There are at least nine sites along the Naktong River valley in south Korea where rock art has been discovered. The panels at Pan'gudae include abstract motifs such as spirals and lozenges, as well as representations of fishing, hunting, boats, humans, fish and animals. Animals and humans are depicted in two ways, the 'silhouette' style and the 'x-ray' style, in which bones are visible. These different styles may represent different periods of engraving; it appears that some of the incisions required the use of metal tools.

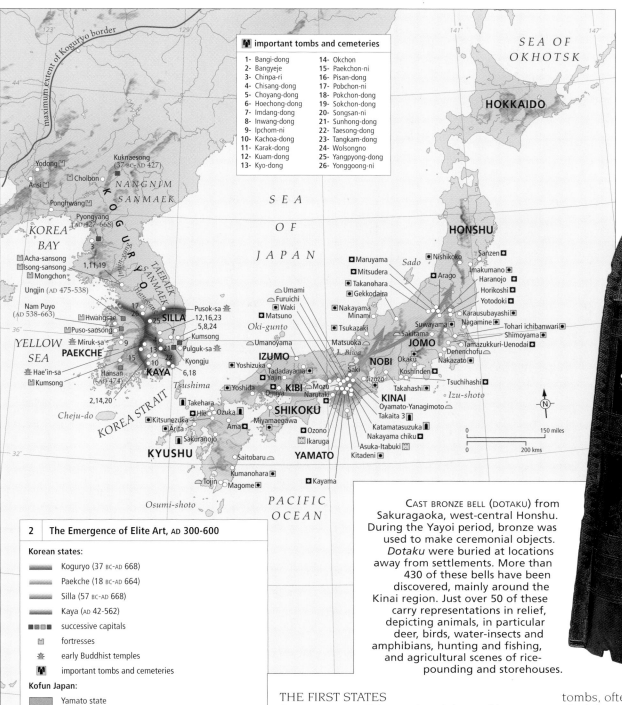

important tombs and cemeteries
1- Bangi-dong
2- Bangyeje
3- Chinpa-ri
4- Chisang-dong
5- Choyang-dong
6- Hoechong-dong
7- Imdang-dong
8- Inwang-dong
9- Ipchom-ni
10- Kachoa-dong
11- Karak-dong
12- Kuam-dong
13- Kyo-dong
14- Okchon
15- Paekchon-ni
16- Pisan-dong
17- Pobchon-ni
18- Pokchon-dong
19- Sokchon-dong
20- Songsan-ni
21- Sunhong-dong
22- Taesong-ni
23- Tangkam-dong
24- Wolsongno
25- Yangpyong-dong
26- Yonggoong-ni

2 The Emergence of Elite Art, AD 300–600

Korean states:
- Koguryo (37 BC–AD 668)
- Paekche (18 BC–AD 664)
- Silla (57 BC–AD 668)
- Kaya (AD 42–562)
- ▪▪▪▪ successive capitals
- ⊔ fortresses
- 盒 early Buddhist temples
- ⊞ important tombs and cemeteries

Kofun Japan:
- Yamato state
- peripheral areas of state formation
- → expansion of state
- ⊡ major Kofun settlements
- ⊠ early palace sites
- ⊡ elite compounds
- ⌂ mound cemeteries
- ⌷ major decorated tombs

2 WITH THE APPEARANCE of highly structured states on the Korean peninsula and the Japanese archipelago elite groups used art to differentiate themselves from the rest of society. Elaborate monumental burials were the visual expression of social and ritual power as well as the receptacles for large quantities of prestige items. As these early states expanded, their elite rulers built palaces, fortresses and, eventually, Buddhist temples.

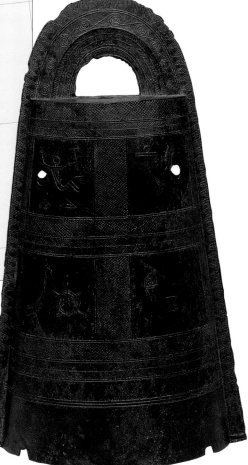

CAST BRONZE BELL (DOTAKU) from Sakuragaoka, west-central Honshu. During the Yayoi period, bronze was used to make ceremonial objects. *Dotaku* were buried at locations away from settlements. More than 430 of these bells have been discovered, mainly around the Kinai region. Just over 50 of these carry representations in relief, depicting animals, in particular deer, birds, water-insects and amphibians, hunting and fishing, and agricultural scenes of rice-pounding and storehouses.

THE FIRST STATES

Contemporary Chinese chronicles and later Korean and Japanese sources refer to the many regional polities which flourished in the first few centuries of the first millennium AD. The influence of China is well-demonstrated by the existence of colonies or commanderies established by the Han Empire on the Korean peninsula. The best-known is Lelang, near present-day Pyongyang, where there was a Chinese city and over 1500 tombs.

The agricultural communities on the Korean peninsula and the Japanese archipelago gave rise to a series of political entities which, by the end of the sixth century AD, had developed into states, ruled by elites which interacted with each other and with the Chinese empire. These included the three kingdoms of Koguryo, Paekche and Silla on the Korean peninsula and the Yamato polity in the Kinai region of central Honshu. These elites, which monopolized both secular and ritual power, expressed themselves through new forms of art, which often involved technological advance, as seen in the production of stoneware pottery, and the control of key resources, such as iron and gold.

The emergence of this new social hierarchy, complete with strict class divisions, is best reflected in the tradition of burying members of the elite in monumental mounded tombs, often along with splendid treasures. The labour invested in these great funerary monuments is testimony to the unparalleled development of social power.

These elites used material culture to great effect, manipulating it to legitimize their own position. Military prowess and the symbolism associated with it, including weaponry and armour, were valued, as the contents of tombs from fifth-century Japan attest. Elites were not only buried apart from the commoners, but also began to live in separate enclosures. This trend, which led from demarcated enclosures within settlements, as at Yoshinogari, to the appearance of entirely separate elite compounds at sites such as Mitsudera, ultimately resulted in the construction of early palace sites in the Kansai region of Japan.

On the Korean peninsula, towns and fortifications on the Chinese model had appeared at Kyongju from the third century AD onwards. It was in this context that Buddhism appeared, introduced to Korea in the fourth century and into Japan early in the sixth century. The beliefs and practices associated with Buddhism were taken up by the elites and, along with the increased use of writing, accompanied the gradual Sinification of elite lifestyles, which helped to create further distinctions between the elite classes and commoners.

were the animals most commonly depicted on bronzes and incised on pottery, with birds also being important, in particular water birds such as cranes and herons. Wooden models of birds have been found in many Yayoi settlements, perhaps representing spiritual guardians. Dogs, lizards, frogs and other animals also appear. Scenes of fighting, pounding rice, storing rice and hunting have also been found. Many deer scapulae are known from Yayoi sites; they bear deliberate burns and scratches, probably used in divination, a practice which was also important on the Korean peninsula. Ritual authority based on the ability to communicate with the spirit world seems to have been a major factor in Yayoi society and Chinese accounts, such as the *Wei Zhi*, provide vivid descriptions of the way in which ritual power came to be vested in the rulers of chiefdoms, such as the legendary Queen of Yamataikoku, Himiko.

SOUTHEAST ASIA 500 BC-AD 600

IT IS GENERALLY ACCEPTED that the Bronze Age in mainland Southeast Asia had begun in earnest by the middle of the second millennium BC. Some archaeologists claim to have discovered bronze-working sites in northeast Thailand dating to 3500 BC, much earlier than bronze-working in China. Newer dating of related sites suggests this industry is much later than previously thought, placing serious doubt on the emergence of a pre-Chinese bronze technology in Southeast Asia. It is now believed that the earliest bronze working in northeast Thailand dates to about 1500 BC. Although bronze objects of Chinese origin had already been available in some mainland Southeast Asian settlements for nearly a thousand years, they made little impact on local art traditions until c.500 BC.

BRONZE-AGE CULTURES

The fifth century BC saw the emergence of what has come to be known as the Dong Son culture situated on the coast and Red River delta of northern Vietnam. Dong Son is probably the best-known Bronze Age tradition in Southeast Asia. The most notable and famous Dong Son objects are the large bronze kettle drums made with the lost-wax technique. These drums often weighed more than 80 kg (176 lb) and were made by specialized and highly skilled,

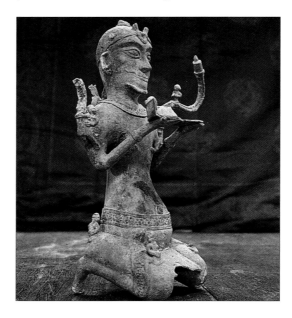

craftsmen. Both the sides of these drums and the tympanum are decorated with scenes that provide some of the most important evidence of Dong Son ritual and cultural life. Scenes of dancers wearing bird-of-paradise plumes, for example, document the increasing importance of trade with New Guinea and other exotic places as well as the emergence of social stratification. Dong Son craftsmen also produced many other bronze objects such as bowls, beads, spears, daggers and ornaments, and by this period iron tools are increasingly important. Ceramic dishes, bowls and jars elaborated on earlier ceramic traditions. From the archaeological distribution Dong Son kettle drums, it is clear that they played a key role in the trade networks that were gradually extending across island Southeast Asia.

About the same period as the emergence of Dong Son culture, the Sa Huynh culture developed in southern Vietnam. Most of what we know of Sa Huynh culture comes from excavations of large pottery burial jars. These

DONG SON LOST-WAX BRONZE TOMB FIGURE of a lamp bearer. Dong Son culture flourished in northern Vietnam from the fifth to the second century BC. Besides figures, burial bronzes included ornate kettle drums, ankle bells, axes, daggers and belt buckles. Burials also included pottery and wood-carved boat-shaped coffins, oars, spear handles, axe handles and lacquered boxes.

1 THE DISTRIBUTION OF DONG SON KETTLE DRUMS reveals a key role for the Dong Son culture in trade networks that were gradually expanding to encompass all of Southeast Asia. The bronze drums, each requiring 1 to 7 tons of copper ore were made by lost-wax casting and were richly decorated with scenes of daily life and ritual.

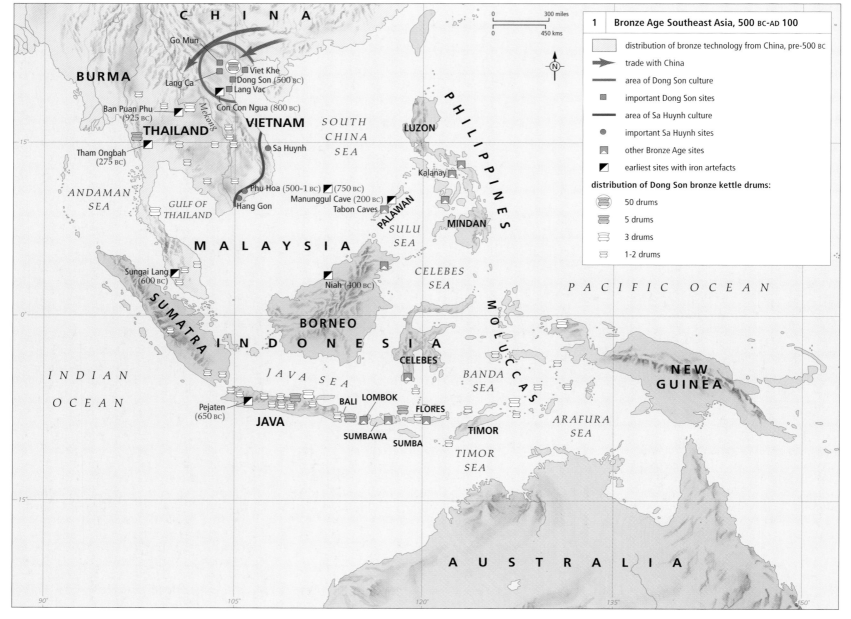

1	Bronze Age Southeast Asia, 500 BC-AD 100
	distribution of bronze technology from China, pre-500 BC
	trade with China
	area of Dong Son culture
	important Dong Son sites
	area of Sa Huynh culture
	important Sa Huynh sites
	other Bronze Age sites
	earliest sites with iron artefacts

distribution of Dong Son bronze kettle drums:
- 50 drums
- 5 drums
- 3 drums
- 1-2 drums

2 SOUTHEAST ASIAN TRADE ROUTES by AD 100 were oriented especially towards India, although northern Vietnam was a province of China. The Indianized Funan culture of southern Vietnam was the dominant trading centre of the region. Archaeological finds at the Funan city of Oc Eo include amulets of Hindu gods, Roman glass, coins and medals, as well as mirrors and Buddhist statuettes from China. From the fourth century, China, by then deprived of trade through central Asia, turned its attention south. Chinese maritime traders developed a commercial route through the Strait of Malacca and developed contacts with western Java and Sumatra. Funan trade was now eclipsed by that of the Khmer and Cham centres.

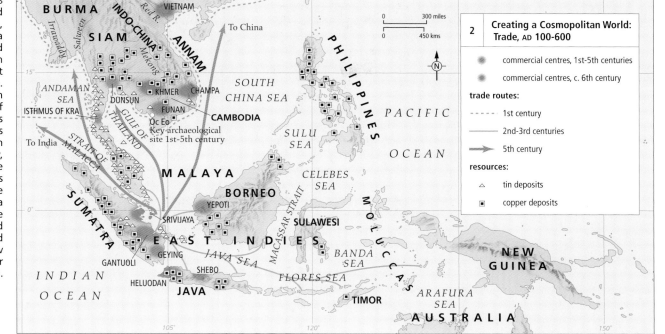

sites include both bronze and iron objects as well as carved stone ornaments, particularly earrings, that are common in these excavations. The Sa Huynh seem to be ancestral to the Cham, who became prominent by the sixth century AD.

THE RISE OF STATES

In about the first century BC, a series of entrepôts and economic centres at the mouth of the Mekong appear to have formed one of the earliest indigenous states in Southeast Asia. We know of this empire from Chinese texts where it is called 'Funan'. Funan's rise in significance is linked to two developments in the region. Firstly, an advanced agrarian system that included intensive rice agriculture and swamp drainage had emerged, later evolving into an elaborate irrigation system. Secondly, these entrepôts had a strategic location opposite the Isthmus of Kra on the Malay Peninsula, which had come to dominate trade between China to the east and India, Persia, and the Roman world to the west. Early sources suggest that a high-caste Indian visitor had married a local woman to become the first 'king' of Funan. Contemporary texts have led some scholars to speculate that Indian immigrants were responsible for transforming the style and structure of Funan society, economics and politics. Migration of Brahman clerks to the kingdom effectively Indianized the state. More recent scholars tend to view the introduction of Indian cultural and religious forms as inspired by a local initiative to adopt sophisticated foreign practices and ideas rather than as the imposition of Indian culture by immigrants. These scholars also argue that while Chinese sources may write of Funan as a kingdom, it was probably not a unitary state in the modern sense, but a series of tribal communities linked through kin ties and marriage to form a coalition for military and economic purposes. Some scholars suggest that this coalition never reached the level of integration where the chief was transformed into a divine king, a crucial process in later Southeast Asian states.

From its centre on the Mekong, Funan used its superior naval power to expand its control to the west, capturing the polity of Dunsun at the base of the Malay Peninsula. Dunsun was already an Indianized commercial centre, monopolizing trade across the Isthmus

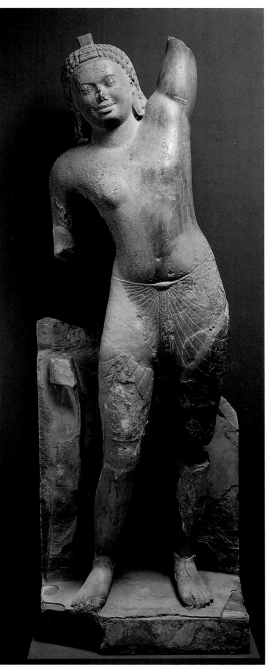

KRISHNA GOVARDHANA, first half of the sixth century AD. This Indianized grey limestone sculpture belongs to the early Phnom Da style of pre-Angkorean Cambodia. In spite of expanding Chinese trade by the fourth century AD, the Hindu and Buddhist states of Southeast Asia retained a profoundly Indian cultural orientation.

of Kra. This expansion enhanced Funan's wealth, stimulating the local production of art.

Archaeological finds at Oc Eo include an abundance of objects associated with Funan's role in trade: imported jewels, gold rings, merchant seals, ceramics, tin amulets of Visnu and Shiva, Roman glass, a gold coin minted during the reign of Marcus Aurelius (AD 161–180), a gold medal of Antoninus Pius (dated AD 152), a Chinese bronze mirror (late Han dynasty, first to third century) and several Buddhist statuettes from the Wei period (AD 386–534). But besides these trade goods, archaeologists have also found numerous glass beads of local manufacture, interpreted as a Funan adaptation of Roman technology, as well as many moulded and engraved tin plaques. Sculpture and stone architecture in Funan show evidence of locally adapted Indian religious art. These include wall reliefs as well as wooden and stone sculptures of both Visnu and Buddha.

TRADE AND CONTACT

While artefacts reveal little evidence for direct Chinese contact in island Southeast Asia until after the end of this period, the ties with India were profound and influenced all forms of art, religion and rituals, as well as the structure of the Southeast Asian states that would form in the following centuries. Only in Vietnam, which became a Chinese province in about 111 BC, was Hinduization not the predominant cultural influence on art.

By the fourth century the Chin dynasty in China lost access to caravan routes through central Asia and the Chinese turned their attention to maritime trade routes through Southeast Asia. Chinese contacts with the less-developed centres of Heluodan in western Java and Geying in Sumatra allowed Chinese traders to circumvent Funan's monopoly over the portage across the Kra Isthmus by sailing through the Strait of Malacca. This shift in trade led to the demise of Funan as a coastal entrepôt, Funan yielding to growing Khmer and Cham centres in Cambodia and southern Vietnam respectively. Chinese economic influences in Sumatra encouraged the rise of Srivijaya and other Hindu and Buddhist states in neighbouring Java, but these states retained their Indian cultural influences, suggesting just how weak the cultural influences from China still were.

THE PACIFIC 500 BC-AD 600

BY ABOUT 500 BC the diverse peoples who made and used Lapita pottery had expanded into newly settled areas of western Polynesia, most notably Tonga, Samoa, and Fiji. People in all three of these archipelagos were in regular and frequent contact through trade and probably intermarriage. Such interactions explain why the art and material culture as well as political formations developed in concert with one another.

THE CULTURE OF WESTERN POLYNESIA
Ceramics become less and less important after 500 BC, and the distinctive Lapita designs disappeared altogether in the Polynesian area. Archaeologists have suggested that these

designs persisted for more than a millennium in other media, and are most visible today in designs on Polynesian bark cloth (tapa) and tattoos. It appears that this newly settled hub of western Polynesian culture emerged with fully developed horticulture, sedentary settlement, and the beginnings of stratified political systems. In these respects, western Polynesia differs only slightly in form from chiefly societies that were developing in New Caledonia and the New Hebrides.

While most archaeologists have associated all of these traits with the so-called Lapita Expansion, there remain several uncertainties about how Polynesian cultural forms actually emerged. One school of thought sees

Polynesians as Southeast Asians who moved through the north of Melanesia to Fiji, Tonga and Samoa. A second school sees the Bismarck Archipelago, northeast of New Guinea, as the Lapita homeland, despatching people, arts and culture to the Fiji-Tonga-Samoa region; here, Lapita art, culture, and society regrouped before expanding into more remote parts of Polynesia. A third school acknowledges that Lapita culture emerged in the Bismarcks, but sees the emergence of Polynesian culture as essentially a local development that drew heavily on earlier social and artistic forms in Melanesia. More evidence is needed to explain when, where and how early Polynesian culture developed.

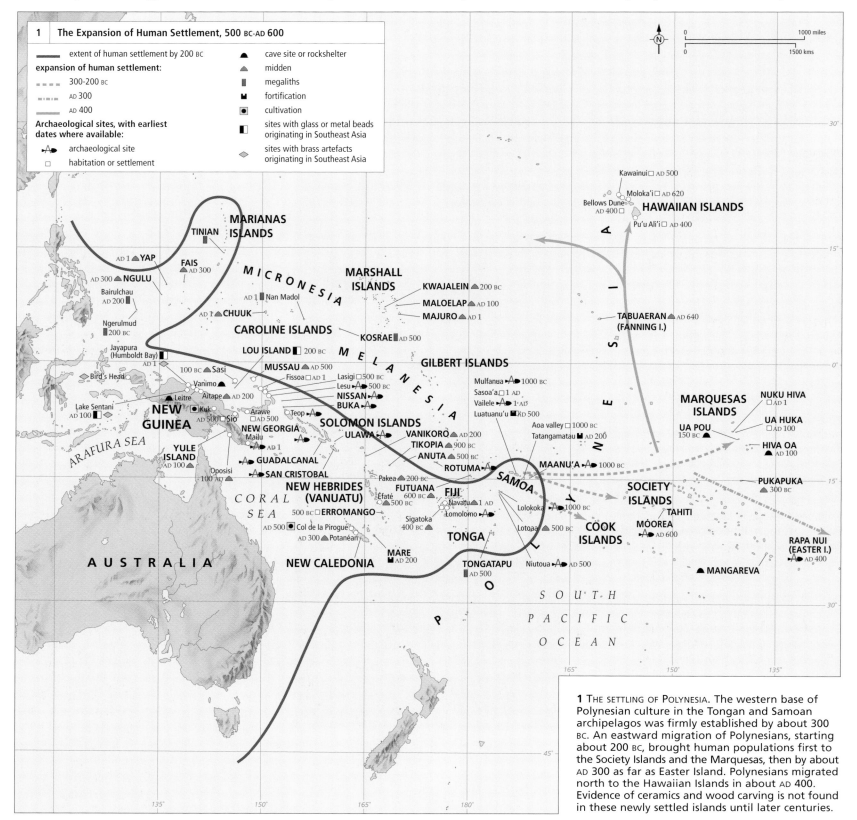

1 THE SETTLING OF POLYNESIA. The western base of Polynesian culture in the Tongan and Samoan archipelagos was firmly established by about 300 BC. An eastward migration of Polynesians, starting about 200 BC, brought human populations first to the Society Islands and the Marquesas, then by about AD 300 as far as Easter Island. Polynesians migrated north to the Hawaiian Islands in about AD 400. Evidence of ceramics and wood carving is not found in these newly settled islands until later centuries.

2 WESTERN PACIFIC ART. Inferior late-Lapita pottery dominated ceramic styles in most of Melanesia, but northern New Guinea witnessed a vigorous development of paddle-and-anvil techniques, in which pots as much as a metre in diameter were built up by a potter holding a support (the anvil) on the inside of the vessel while shaping the outside with a wooden paddle. Spiral-coiling and slab-building techniques were also in use. This period saw the wide diffusion of two Melanesian art traditions that have survived: the stringing of shells into rings and strings for body ornamentation, and carving in stone.

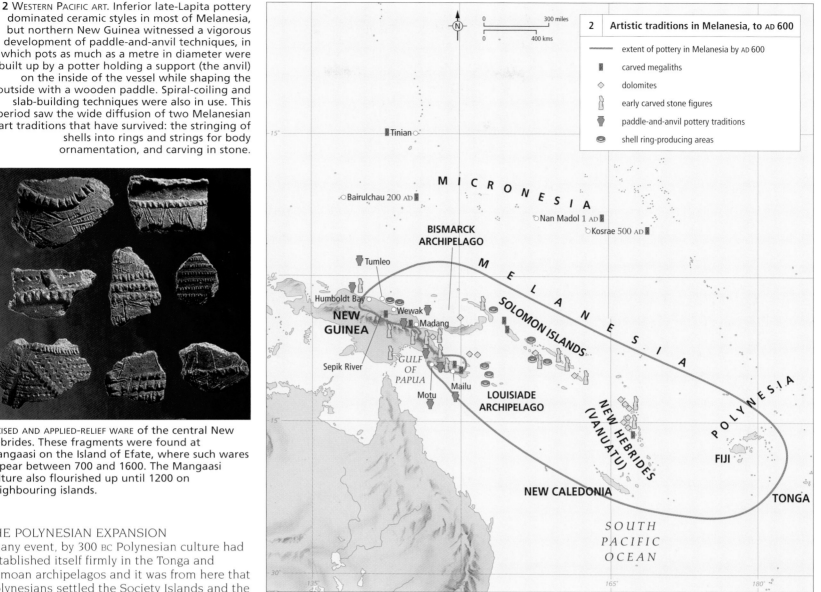

2 | Artistic traditions in Melanesia, to AD 600

— extent of pottery in Melanesia by AD 600
▮ carved megaliths
◇ dolomites
⬘ early carved stone figures
⬗ paddle-and-anvil pottery traditions
⬯ shell ring-producing areas

INCISED AND APPLIED-RELIEF WARE of the central New Hebrides. These fragments were found at Mangaasi on the Island of Efate, where such wares appear between 700 and 1600. The Mangaasi culture also flourished up until 1200 on neighbouring islands.

THE POLYNESIAN EXPANSION

In any event, by 300 BC Polynesian culture had established itself firmly in the Tonga and Samoan archipelagos and it was from here that Polynesians settled the Society Islands and the Marquesas, in about 200 BC. After establishing stable communities in both archipelagos, Polynesian settlement expanded to the east as far as Easter Island (by about AD 300) and to the Hawaiian Islands in the north (about 400).

Unfortunately, little is known about the art of any of these central, eastern and northern Polynesian communities from this period. Ceramics were absent, as were the carving traditions in wood – prominent in the later art styles of Hawaii and Tahiti – and megalithic carving, which was to play so important a role in later Marquesan and Easter Island art.

Further west in Melanesia and New Guinea archaeologists are only just beginning to piece together ceramic sequences for this period. Pottery, which appeared only in a few places in New Guinea up to this period, spread to most areas along the north coast of the island and along the south coast into the Papuan Gulf and to the southeastern coast. Ceramic technologies included spiral-coiling, slab-building and paddle-and-anvil techniques. Only the paddle-and-anvil techniques seem to have developed into major commodity-producing industries, with large-sized pots as much as a metre in diameter. These ceramic centres were situated at Tumleo, Wewak, Madang, Mailu and the Motu area. Pottery technologies seem to have expanded inland up-river into the Sepik basin or perhaps across the mountain ranges in the east of the island.

In much of island Melanesia ceramic technologies declined. Late Lapita styles are crude as compared with early designs. In many of the islands in southern Melanesia where Lapita shards have been found, pottery either

disappears completely or becomes a plainware tradition. We know that the arts were developing in many diverse directions, but few examples of wood carving, featherwork, plaiting and the like have come down to us.

SURVIVING TRADITIONS

Two aspects of the art traditions of Melanesia have survived. The first involves the use of shell for ornaments. It is likely that during this period rings of tridacna, trocus, and conus shell emerge as fully developed traditions found on the north coast of New Guinea. Large shell arm-rings were produced in the islands of the Louisiade archipelago – a local industry that would later become part of the Kula

exchange network, a cycle of gift exchange practised among a group of islands off eastern New Guinea. Everywhere the people of New Guinea and Melanesia began to develop a plethora of local styles of shell ornaments, shell beads, pendants and armbands.

Stone-working traditions were also developing in the Melanesian region during this period, although archaeologists have only been able to date some of the utilitarian axe and adze industries. The more important art traditions in stone have proven much harder to date in Melanesia, but it is probably during this period that we see the efflorescence of carved stone clubs, mortars and pestles, and simple megaliths.

PARTLY RESTORED PAEPAE (house platform in stone) at Hiva Oa on Taa'oa Island in the Marquesas. Well-preserved examples like this date from 1300 or later, but some stone accumulations in the Marquesas provide evidence that paepae were being constructed by eastern Polynesians as early as AD 200.

ART, RELIGION AND THE RULER 600-1500

FIFTEEN HUNDRED YEARS AGO art began to take on a new importance. The use of permanent materials, which had previously been concentrated in western Asia, North Africa and southern Europe, became increasingly frequent in other areas. It spread to Central, South, and East Asia, to northern Europe and Sub-Saharan Africa, and developed independently in the Americas and the Polynesian islands in the eastern Pacific.

IN THIS PROCESS ECONOMIC DEVELOPMENTS and the diffusion of technologies were, as always, powerful factors, but the trend towards grander and often more durable buildings, sculptures and paintings was greatly accelerated by the increasing numbers of connections between religious and political institutions, especially where individual rulers encouraged religions that also focused on a single deity, teacher or concept. These included not only the descendants of Jewish monotheism, with its single creator, Christianity and Islam, but Indian religions, such as Buddhism and the cults of Vishnu and Shiva, and the Chinese belief in the 'Way' (Dao), Daoism. Monarchs across Europe, North Africa and Asia indirectly enhanced their positions by pouring resources into such religions, and these resources were often turned into buildings and other works of art. For populations looking for order in a world destabilized by the collapse of the great empires of Rome, Sasanian

Persia, Mauryan India and Han China, there was great reassurance in religions and states that mirrored each other in their concentration on one supreme authority. Since the religions involved were all based on texts, and the texts themselves could be made the subject of art, that reassurance was always liable to be given material expression. This was particularly so when the missionary nature of Buddhism, Islam and Christianity brought them into competition.

FROM EUROPE TO JAPAN DYNASTIES SOUGHT to secure their positions by sponsoring exclusively, or primarily, one religion. At the beginning of the period dynasties in most of Europe adopted Christianity, those in Spain, North Africa and much of Asia chose Islam, and those in Southeast Asia adhered to Buddhism, often combined with related forms of Hinduism. Buildings were essential for devotion, and in each area churches, mosques or temples were constructed. Islam was perhaps the religion that best represents the new trend. After the death of its founder, Mohammed, in 632, it expanded rapidly from the Arabian peninsula into West Asia before establishing itself from West Africa to Indonesia. Mosques, decorated not with images but texts, were built with great halls for prayer and preaching, often associated with educational and other charitable institutions; new cities, such as Haroun al-Rashid's circular Baghdad, were laid out.

By the end of the period individual Muslims were building monuments of unprecedented refinement and luxury, such as the Alhambra palace at Granada or the tomb of Timur (Tamerlane) at Samarkand. In Europe, Christianity, already established in the Mediterranean area, spread northwards, reaching most of Scandinavia by the eleventh century. In 800 Charlemagne was crowned western emperor by the pope in Rome, while another Christian emperor based in Constantinople continued to rule the East. Churches were built from Ireland to Armenia, becoming progressively larger and more elaborate, especially in western Europe, where first feudal rulers and then wealthy citizens competed in the patronage of sculpture, paintings, stained glass, metalwork and manuscripts. Activity eventually became most intense in Italy, where the cult of the leading individual resulted in artists like Leonardo and Michelangelo also being called monarchs and creators. In the East Buddhism was sponsored enthusiastically by the Sui Dynasty and then, along with Daoism, by the Tang (619–907), whose capital of Chang'an (modern Xi'an) became the greatest city in the world. It was also taken up by the Japanese empire, founded in imitation of the Chinese in 645, and by the Silla Dynasty who unified Korea in 688. In Southeast Asia Buddhism was also adopted by the Sailendra Dynasty in Indonesia in the mid-eighth century, and by later dynasties in Burma and Cambodia. Such cooperations resulted in two of the biggest and most complex masonry structures ever built: Borobudur on Java and Angkor Wat in Cambodia.

Elsewhere, the increase in artistic activity was more simply the product of economic growth and the increasing concentration of wealth in the hands of particular groups. In West Africa the wealthy kingdom of Benin became established about 1100, and far to the south and east another royal capital, Great Zimbabwe, was built surrounded by vast stone ramparts. In Central America the Maya had their pyramidal temples and their pictorial script, and the Aztecs their violent sculptures, their palaces and gardens. In modern Peru the Chimu on the coast were great builders in clay, the Inca in the Andes in stone. The Nazca, also in Peru, and the mound-builders of Ohio, far to the north, even shaped the earth into extraordinary, gigantic images of birds and other animals. All these cultures had flourishing ceramic industries, but on the islands of the Pacific, from Hawaii to the Marquesas, the hierarchical seafarers of Polynesia abandoned pottery to concentrate on wood and stone, building great platforms and erecting scuptures of ancestors, of which those of Easter Island are the most remarkable.

One of the main reasons for the increase in wealth during this period was the growth of trade, and it was the impact of this growth on Europe that was to have the greatest effect on the next five centuries. West African entrepreneurs in the thirteenth century sent Europe the gold needed for new hard currencies, such as the Florentine florin, while from China came vital technologies. Printing, paper production and multiple-copy book publishing, which had been firmly established in China in the Sung period, greatly accelerated the circulation of knowledge when introduced to Europe after 1450, and the adoption of the equally Chinese compass, rudder and gunpowder allowed the more sinister worldwide circulation of a new breed of merchant warriors.

The Buddhist stupa at Borobudur in Java.

NORTH AMERICA 600-1500

THE EARLY HUNTING-GATHERING cultures of North America had adapted to a diverse range of environmental factors by 600 and had developed highly specialized economies, social structures and arts. The North American habitats range from Arctic in the far north to sub-tropical in the south, with rainforest, desert, woodlands and grasslands in between.

Prior to the arrival of Europeans the tribes of North America had devised ingenious ways of using virtually all the resources available to them, and were doing so with an unrivalled sense for form and aesthetics. Although materials varied according to local conditions, they included extensive use of skins and furs, plant fibres, feathers, bird and porcupine quills, wood, stone,

shells, and copper and mica, as well as the high development of pottery and weaving. Even mosses and lichens were used in Florida to weave delicate lace-like aprons, while California tribes made exquisite miniature gift baskets decorated with shells and hummingbird feathers.

ART AND SOCIETY
Since many of the tribes were small nomadic family bands, this led to the development of sophisticated portable

1 NORTH AMERICA is usually divided into culture areas that reflect the distribution of resources. Archaeological evidence suggests there was a blending of traits at the boundaries between culture areas rather than clear-cut distinctions. The density of archaeological sites in any particular region does not necessarily indicate higher occupancy. Many archaeological sites in originally populous areas, such as the eastern seaboard, have been destroyed or are beneath more recent developments and therefore inaccessible.

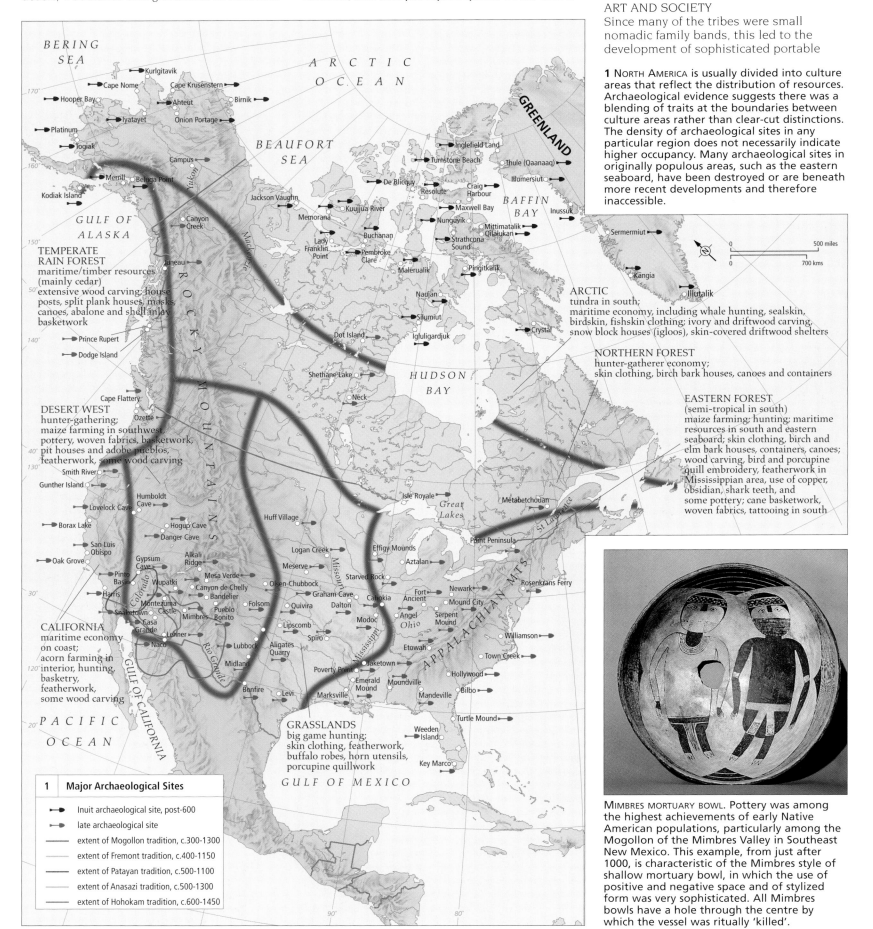

TEMPERATE RAIN FOREST
maritime/timber resources (mainly cedar) extensive wood carving; house posts, split plank houses, masks, canoes, abalone and shell inlay, basketwork

DESERT WEST
hunter-gathering; maize farming in southwest, pottery, woven fabrics, basketwork, pit houses and adobe pueblos, featherwork, some wood carving

CALIFORNIA
maritime economy on coast; acorn farming in interior, hunting, basketry, featherwork, some wood carving

GRASSLANDS
big game hunting; skin clothing, featherwork, buffalo robes, horn utensils, porcupine quillwork

ARCTIC
tundra in south; maritime economy, including whale hunting, sealskin, birdskin, fishskin clothing; ivory and driftwood carving, snow block houses (igloos), skin-covered driftwood shelters

NORTHERN FOREST
hunter-gatherer economy; skin clothing, birch bark houses, canoes and containers

EASTERN FOREST
(semi-tropical in south) maize farming; hunting; maritime resources in south and eastern seaboard; skin clothing, birch and elm bark houses, containers, canoes; wood carving, bird and porcupine quill embroidery, featherwork in Mississippian area, use of copper, obsidian, shark teeth, and some pottery; cane basketwork, woven fabrics, tattooing in south

1	Major Archaeological Sites
➤	Inuit archaeological site, post-600
➤	late archaeological site
——	extent of Mogollon tradition, c.300-1300
——	extent of Fremont tradition, c.400-1150
——	extent of Patayan tradition, c.500-1100
——	extent of Anasazi tradition, c.500-1300
——	extent of Hohokam tradition, c.600-1450

MIMBRES MORTUARY BOWL. Pottery was among the highest achievements of early Native American populations, particularly among the Mogollon of the Mimbres Valley in Southeast New Mexico. This example, from just after 1000, is characteristic of the Mimbres style of shallow mortuary bowl, in which the use of positive and negative space and of stylized form was very sophisticated. All Mimbres bowls have a hole through the centre by which the vessel was ritually 'killed'.

artforms using locally available materials. In the Subarctic, for instance, extensive use was made of sheets of rolled birchbark in the production of canoes and as house coverings, whereas on the Great Plains there was use of buffalo hide *tipis*. Many of these *tipis* were painted with emblematic designs detailing tribal affiliation and the status of the family that lived there.

The two major population centres were the Mississippians in the Eastern Woodlands, based on the Ohio Valley, and the pueblo cultures of the Anasazi, Hohokam and Mogollon in the Southwest, although by 1500 the cultures of the Mississippians and of the Anasazi, Hohokam and Mogollon had declined, to be replaced by the tribes recorded in historical accounts. There were also sizable village settlements on the British Columbia coast of western Canada, where there was a flourishing maritime economy. In each of these areas settled communities enabled the production of more permanent art as well as the growth of significant architectural forms.

MISSISSIPPIAN CULTURE

Mississippian culture displaced the earlier Adena-Hopewell people of the Woodlands region, and there followed an increased construction of earth mounds that served as bases for wooden temples used by a governing priesthood. Many of these mounds have complex geometric and interlocking patterns and designs, including animal and bird effigy figures that served as clan markers. It is also apparent that Mississippian culture, like that of the Adena-Hopewell, was based on ritual sites that attracted large urban populations. Cahokia, the largest of the Mississippian settlements, was founded about 700 and contains over 100 mounds in an area of 13 square kilometres (5 square miles).

Mississippian art was intended to demonstrate the wealth and status of a ruling hierarchy, and to this end exotic materials such as obsidian, shells, shark teeth, mica, copper and silver were traded into the region from as far afield as the Rocky Mountains and Mexico. Much of the work made from these materials has a fragile delicacy, such as translucent

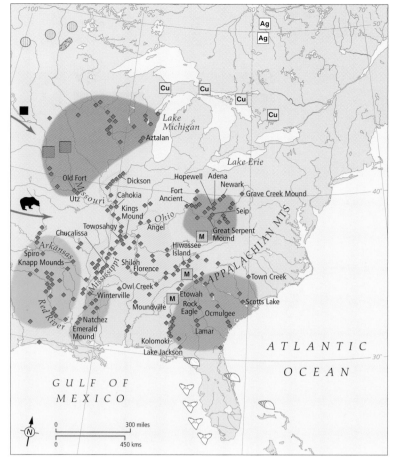

2 MISSISSIPPIAN CULTURE centred on the Ohio River Valley, but there were many regional variations. Each of these has minor, but distinguishing, features. The spread of distinctive Mississippian cultural traits from Ohio to outlying regions was largely through trade networks.

paper-thin mica cut-outs of bird claws and hands, that indicates they were made as show pieces rather than for utilitarian purposes.

SOUTHWESTERN CULTURE

Southwestern architecture, by contrast, was based on adobe (mud brick), multi-storied communal dwellings and a democratic sharing of resources. There were high achievements here in pottery – this is the most important pottery region of North America – as well as in basketwork and in cotton weaving. Pottery was in fact so important here that much of the chronology of the region is dated from pot sherds. Probably the most striking pottery was made by the Mimbres, a subgroup of the

Mogollon, whose shallow bowls contain masterful depictions of birds, animals and human figures that seem to dance on the bowl surfaces and interlock with complex geometric borders and patterns.

THE NORTHWEST COAST

The other major population area, the Northwest Coast of British Columbia and southern Alaska, had an economy based on salmon, eulachon (candle-fish) and sea mammal hunting. The resources here were so rich that only half the year was spent in economic pursuits, and the remainder was devoted to a sacred ceremonial season. The dominant influence on Northwest Coast art was the massive cedars of the rain forest. Carved and painted house posts were the largest wood carvings on the continent and depicted complex figures detailing a family's lineage. In fact, family and clan lineage was so dominant here that everything was carved and painted with these ownership marks. Cedar plank houses, as much as 30 metres (100 feet) long, had painted fronts, and wooden storage boxes, sea going dug-out canoes, utensils, bowls, house screens, fish hooks, masks, even clan hats and cedar bark capes all carried these intricate designs. A unique characteristic of this art is the use of split-representation, in which the clan animal being shown is depicted as if split down the middle and laid out flat so that the entire animal can be seen. This is a highly sophisticated form of abstract representation, combining symbolism and geometry with stylized animal features.

HOPEWELL/MISSISSIPPIAN MICA CUT-OUT. Decorative arts were highly developed among the Hopewell and Mississippian peoples of the Woodlands, where artisans traded widely to obtain precious materials that were unavailable locally. This exquisite carving of an eagle's claw is from thin sheet mica and demonstrates their refined use of abstraction. Such objects served no practical purpose, other than to attest to the skill of the carver and the status of the person for whom it was made. It dates to just before 1000.

CENTRAL AMERICA 600-1500

DURING THIS PERIOD, boundaries became increasingly fluid between three cultural regions: Northern Mexico/Greater Southwest, Mesoamerica and Lower Central America.

NORTHERN MEXICO AND THE SOUTHWEST
More farmers occupied this land and established larger settlements linked with the increasing trade between the American Southwest and Mesoamerica. The Toltecs imported turquoise from the Southwest and exported birds and feathers. La Quemada, on a hilltop and occupied from 500 to 900, features defensive walls, a Mesoamerican-style I-shaped ball court, and a skull rack earlier than the one at Tula, the Toltec capital. After

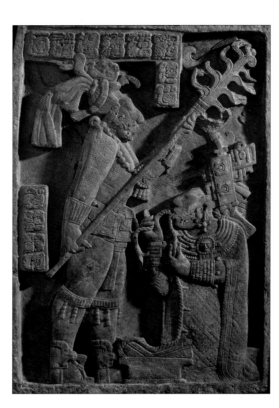

1 MANY FORMERLY IMPORTANT STATES in Mesoamerica, such as Teotihuacán and Monte Albán, declined after 600. While southern Maya cities succumbed by 900, Maya centres flourished in the Yucatán peninsula. In Central Mexico the Aztecs controlled more territory than did their predecessors, the Toltecs. The inset map indicates the arrangement of Aztec city-states around Lake Texcoco. While the boundaries of the Aztec Empire in 1519 are based on ethno-historic sources, only ballcourts documented archaeologically are shown.

1300, Paquimé, a huge site with three ballcourts and ceremonial effigy mounds, would have been central to any interaction. The Aztecs viewed the people of northern Mexico as both nomadic barbarians and skilled craftsmen.

MESOAMERICA
After the fall of Teotihuacán, cities throughout Mesoamerica declined. In Central Mexico the period from 700 to 900 was a time of migrations and competition. At the hilltop city of Cacaxtla Mayan-style murals show a battle – real or metaphorical – between Mayan-like bird warriors and Central Mexican-like jaguar warriors.

From 950 to 1150, the Toltecs dominated much of the Valley of Mexico, although their influence beyond Central Mexico (usually marked by finds of Tohil Plumbate ware, an unusual glazed ceramic) is still a matter of debate. The Toltecs' blocky, militaristic art and

YAXCHILÁN LINTEL 24, MEXICO. This Maya lintel graphically depicts a royal bloodletting ritual, which the text dates to October 28, 709. While the ruler holds a torch, his wife – Lady Xoc – draws a rope with thorns through her tongue. The details of Lady Xoc's garment suggest the great artistry of Maya textiles.

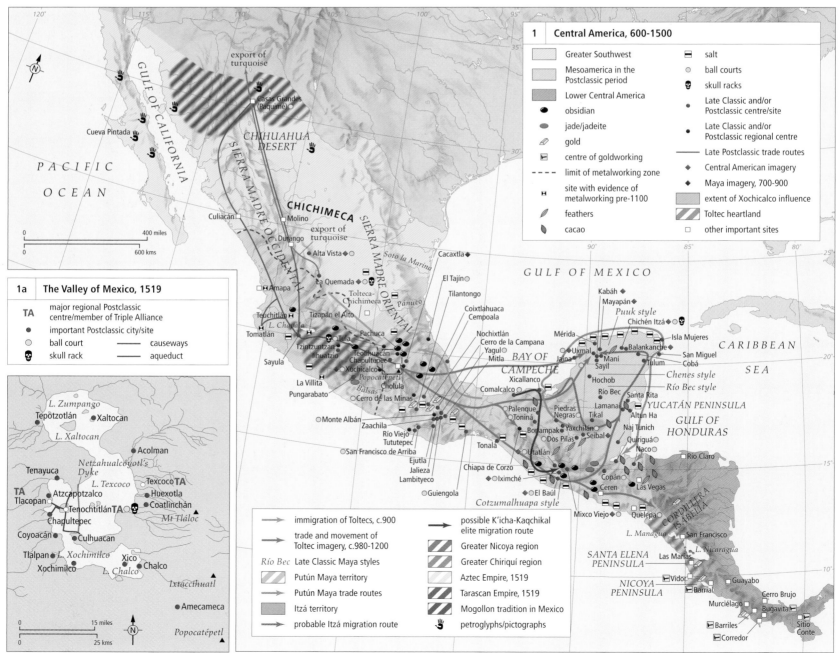

architecture – such as colonnaded halls fronting structures supported by feathered serpent columns and monumental Atlantean figures – borrowed from the past but was also innovative. The appearance of this style at the distant Mayan site of Chichén Itzá is often considered a Toltec invasion of the Yucatán, but supporting evidence remains unconvincing. Recumbent life-size stone figures called chacmools, used for holding blood offerings, appear at this time at Tula and Chichén Itzá.

The Aztecs incorporated vast amounts of Mesoamerica into a tribute-generating empire in the final century before the Spanish invasion. Emulating the earlier Toltecs, Aztec sculptors created powerful works that both embodied sacred concepts and glorified the Aztec state. They arranged the twin pyramids of the Templo Mayor (Great temple) in

Tenochtitlán as sacred mountains – a replica of the cosmos, with the Aztecs at the centre

In Oaxaca, after the decline of the Zapotec state at Monte Albán, smaller city-states competed for control over portions of the Valley of Oaxaca and Mixteca Alta. A series of indigenous painted books, called codices, show the political intrigues of rulers such as the Mixtec king known as 8 Deer, who around 1100 extended his control over other cities from his base at Tilantongo through marriages, alliances and conquest. The Mixtecs were master craftsmen of raw materials such as rock crystal, alabaster and turquoise. Although metalworking probably did not enter West Mexico until after AD 600, the Mixtecs mastered gold-working, using the lost-wax technique.

Many great Mayan cities flourished until the end of the Classic period. Mayan artists focused on activities of the ruling elite, who are often shown incorporating supernatural imagery to legitimize their rule and whose blood was holy and offered at select dates. While portraiture flourished at Palenque, in most Mayan cities the ruler's regalia is carefully depicted with little attention to physiognomy. Increasing warfare, shown in the Bonampak murals, coincides with the Classic Maya collapse. Mayan civilization continued to thrive until after 900 in the Yucatán Peninsula, with a series of nearby competing styles (such as the Puuk and Chenes styles) exuberantly expressed in architecture. The final series of small states in the Yucatán were still in place when the Spanish arrived.

LOWER CENTRAL AMERICA
Gold replaced jade in importance after 900. As more organized chiefdoms developed, upheavals occurred in trade routes and politics. In central Costa Rica, clear site hierarchies appeared, with elaborate status differentiation expressed in burials. Some sites, such as Quelepa in El Salvador, became essentially Mesoamerican by AD 650. Despite

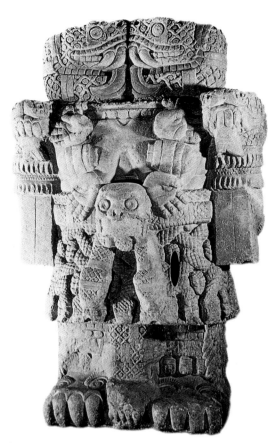

COATLICUE, TENOCHTITLÁN, MEXICO. This massive Aztec sculpture shows the earth and mother goddess Coatlicue at the moment in which she gives birth to the Aztec tribal deity Huitzilopochtli. Her jealous children have decapitated her; blood gushes from her neck, forming serpents. Snakes writhe on her skirt while she wears a necklace of human hearts and hands.

these influences, areas such as the Nicoya maintained a very unified material culture with little foreign impact. In Panama the Chiriquí region was famed for its exquisite goldwork.

THE CARIBBEAN
By the seventh century maize and manioc cultivators in the Saladoid and Dabajuroid ceramic traditions displaced Ciboney hunter-gatherers as far as eastern Puerto Rico. Saladoid pendants of amethyst, quartz crystal, fossilized wood, carnelian, lapis lazuli, turquoise and garnet were traded throughout the Caribbean and northern South America.

By 600 the Saladoid tradition began to lose its homogeneity as long-distance trade in the Antilles declined. The richly decorated Ostionoid ceramic tradition arose in Puerto Rico and the western Virgin Islands, together with Mesoamerican-influenced petroglyphs lining the perimeters of batey (central plazas used for sacred ball games and ceremonies). Arawakan-speaking immigrants to Trinidad and Tobago in the Barrancoid ceramic tradition strongly influenced the Ostionoid after 700.

Beginning about 1200 Chican Ostionoid ceramic styles from southeastern Hispaniola spread widely. These were the ceramics of the Taino culture that the invading Spaniards met in the Bahamas and Greater Antilles. The Taino had batey and hereditary chiefs; they ruled partly by ownership of cohuba idols and sacred objects, which controlled zemi (powerful spirits). Expanding southeast into the Leeward Islands, the Taino conflicted with practitioners of more egalitarian village cultures that predominated in the Lesser Antilles. They called them 'Caribs'. Their decorative arts included woven cotton textiles, feather headdresses and amulets in stone, conch-shell, bone, clay and guañín.

2	The Caribbean, 600-1500

Caribbean cultures, c.600:

———	Ciboney hunter-gatherers
———	Saladoid agriculturalists
———	Dabajuroid agriculturalists
➔	settlement by Barrancoid agriculturalists, c.700

changing pottery traditions:

———	post-Saladoid with little decorated ware, c.600-1500
▲	Ostionian Ostionoid, c.600-1200
▲	Elenan Ostionoid, c.600-1200
▲	origin of Chican Ostionoid, c.1200

Caribbean cultures, 1500:

- - - -	Caquetian	●	islands with rock carving-lined ball courts
- - - -	mixed Arawakan and Cariban speakers	▱	islands with rock carvings at sacred sites
- - - -	egalitarian village culture	●	islands with wooden cohuba idols
- - - -	Taino heartland	✎	gold
- - - -	western Taino	→	import of guañín (copper-gold alloy)
- - - -	eastern Taino		
- - - -	Ciboney hunter-gatherers	🐚	conch pearls

2 AT THE END OF THE SIXTEENTH CENTURY Spaniards arriving in Central America encountered populations they knew as 'Arawaks' and 'Caribs'. Arawaks (the Taino) had a hierarchical social structure with complex visual elements. The Caribs had an egalitarian village-based culture combining agriculture with marine exploitation. Both groups spoke Arawakan languages.

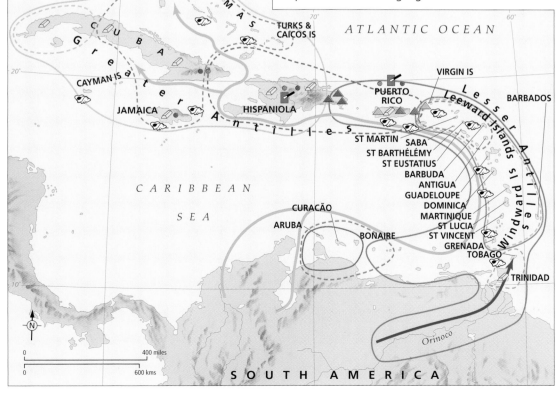

SOUTH AMERICA 600-1500

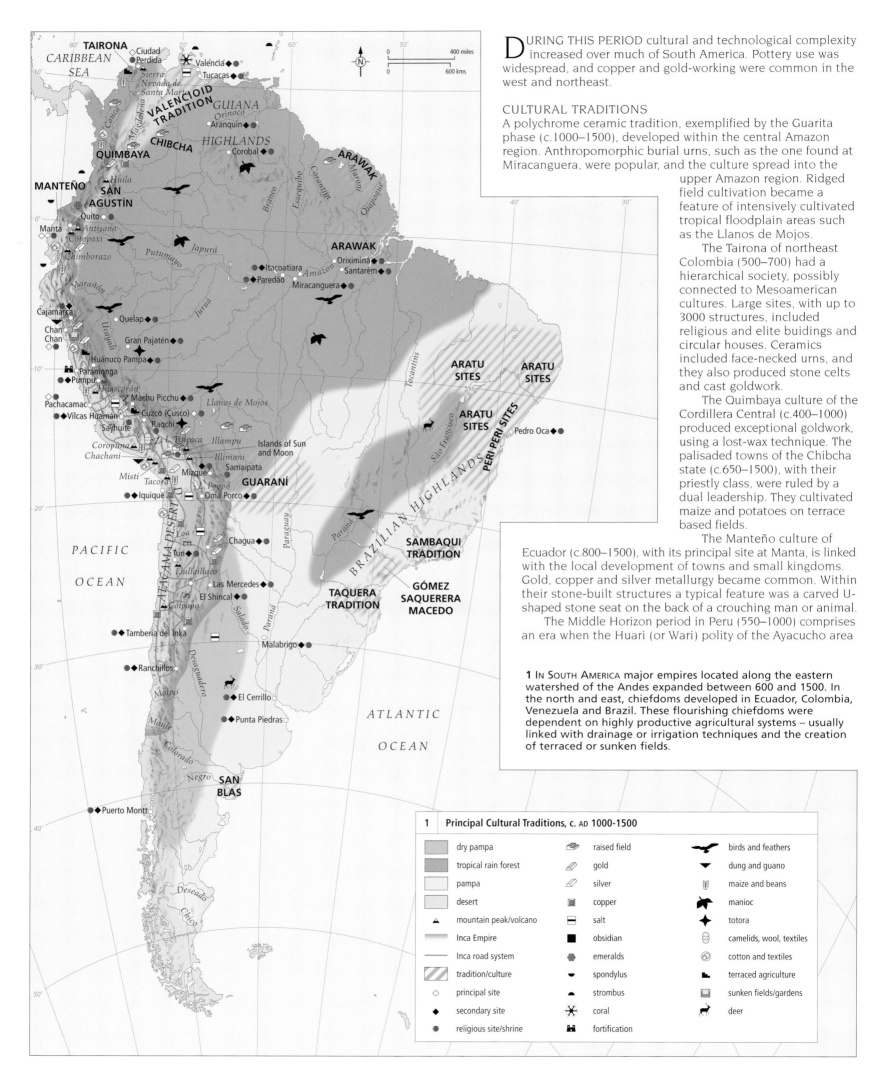

TAIRONA
CARIBBEAN SEA
Ciudad Perdida
Valencia
Tucacas
Sierra Nevada de Santa Marta
VALENCIOID TRADITION
Cauca
Magdalena
QUIMBAYA
CHIBCHA
GUIANA HIGHLANDS
Orinoco
Aranquin
Corobal
Essequibo
Corantijn
Maroni
Oyapoque
ARAWAK
MANTEÑO
SAN AGUSTÍN
Huila
Quito
Antisana
Manta
Cotopaxi
Chimborazo
Putumayo
Japurá
Marañón
Branco
ARAWAK
Oximiná
Santarém
Itacoatiara
Paredão
Miracanguera
Amazon
Cajamarca
Chan Chan
Quelap
Gran Pajatén
Ucayali
Juruá
Huánuco Pampa
Huascarán
Paramonga
Pumpu
Pachacamac
Machu Picchu
Llanos de Mojos
Vilcas Huamán
Cuzco (Cusco)
Sayhuite
Raqchi
L. Titicaca
Illampu
Coropuna
Chachani
Illimani
Islands of Sun and Moon
Samaipata
Mizque
Misti
Tacora
L. Poopó
Oma Porco
GUARANÍ
Iquique
Paraguay
Loa
Chagua
Lullaillaco
Turi
Las Mercedes
El Shincal
Paraná
Salado
Colpapo
Tamberia del Inka
Desaguadero
Malabrigo
Ranchillos
Maipo
El Cerrillo
Maule
Punta Piedras
Colorado
Negro
SAN BLAS
Puerto Montt
Deseado
Chico

ARATU SITES
ARATU SITES
ARATU SITES
Pedro Oca
Tocantins
São Francisco
PERI PERI SITES
BRAZILIAN HIGHLANDS
SAMBAQUI TRADITION
TAQUERA TRADITION
GÓMEZ SAQUERERA MACEDO

ATACAMA DESERT
PACIFIC OCEAN
ATLANTIC OCEAN

URING THIS PERIOD cultural and technological complexity increased over much of South America. Pottery use was widespread, and copper and gold-working were common in the west and northeast.

CULTURAL TRADITIONS

A polychrome ceramic tradition, exemplified by the Guarita phase (c.1000–1500), developed within the central Amazon region. Anthropomorphic burial urns, such as the one found at Miracanguera, were popular, and the culture spread into the upper Amazon region. Ridged field cultivation became a feature of intensively cultivated tropical floodplain areas such as the Llanos de Mojos.

The Tairona of northeast Colombia (500–700) had a hierarchical society, possibly connected to Mesoamerican cultures. Large sites, with up to 3000 structures, included religious and elite buidings and circular houses. Ceramics included face-necked urns, and they also produced stone celts and cast goldwork.

The Quimbaya culture of the Cordillera Central (c.400–1000) produced exceptional goldwork, using a lost-wax technique. The palisaded towns of the Chibcha state (c.650–1500), with their priestly class, were ruled by a dual leadership. They cultivated maize and potatoes on terrace based fields.

The Manteño culture of Ecuador (c.800–1500), with its principal site at Manta, is linked with the local development of towns and small kingdoms. Gold, copper and silver metallurgy became common. Within their stone-built structures a typical feature was a carved U-shaped stone seat on the back of a crouching man or animal.

The Middle Horizon period in Peru (550–1000) comprises an era when the Huari (or Wari) polity of the Ayacucho area

1 IN SOUTH AMERICA major empires located along the eastern watershed of the Andes expanded between 600 and 1500. In the north and east, chiefdoms developed in Ecuador, Colombia, Venezuela and Brazil. These flourishing chiefdoms were dependent on highly productive agricultural systems – usually linked with drainage or irrigation techniques and the creation of terraced or sunken fields.

1 Principal Cultural Traditions, c. AD 1000-1500

dry pampa	raised field	birds and feathers
tropical rain forest	gold	dung and guano
pampa	silver	maize and beans
desert	copper	manioc
mountain peak/volcano	salt	totora
Inca Empire	obsidian	camelids, wool, textiles
Inca road system	emeralds	cotton and textiles
tradition/culture	spondylus	terraced agriculture
principal site	strombus	sunken fields/gardens
secondary site	coral	deer
religious site/shrine	fortification	

achieved dominance. The agricultural success of the Huari was based on the development of hillside terracing and irrigation. Huari iconography has its roots in earlier Chavín and Pucará concepts. The state was characterized by corporate art styles (such as Ocros, Chakipampa, Black Decorated, Viñaque, Atarco), rectangular compound architecture and D-shaped 'temple' structures. There is evidence, at Niño Korin, of the use of the *quipu*, a kind of knotted string used for record-keeping. Worship of ancestors and cultural heroes was a major element of the ideological framework.

Tihuanaco, on the margins of Lake Titicaca (c.500–1000), had a marked influence on Huari iconography. The large ceremonial core of Tiwanaku included monolithic gateways and stelae, sunken courts and a pyramid with great drains, as well as an area of elite residences. This centre was surrounded by up to 10 square km (3.8 square miles) of lower status housing.

LATE INTERMEDIATE PERIOD
During the Late Intermediate Period (c.1000–1476) there was a return to dispersed political control with large numbers of regional states. The Collao and Lupaka were located in southern Peru. The Chanca confederation comprised a loosely knit series of polities within the Ayacucho and Apurimac areas, which were characterized by terraced agriculture, camelid herding, fortified sites on hilltop locations and badly fired, roughly modelled ceramics. The Chincha merchants of the Ica area on the south coast dominated the trade in spondylus shell from Ecuador. The Chancay culture of the central coast produced black-on-white coloured ceramics, including face-neck jars and figurines, as well as very high-quality gauze textiles.

The Chimú (c.1000–1470) were in control of irrigated lands and population along the north coast. Their corporate buildings were *tapia*-walled (made of adobe and sun-dried mud) and their craft production was centrally organized and managed. Chan Chan was the centre of Chimú power. It measured c.20 square kilometres (7.7 square miles) and comprised ten large rectangular compounds. These were the palaces and administrative

complexes of individual rulers, as well as their tombs. Approximately 25,000 single irregular, agglutinated rooms were used as living quarters and for craft production.

The Incas, who may have came from Lake Titicaca or Paucartambo, settled in Cuzco. Their empire began to expand after their defeat of their rivals, the Chancas, during the reign of Pachacuti Inca Yupanqui (c.1438–1463).

The Inca state reached from the southern borders of Colombia to southwest Argentina and southern Chile. The Inca administration demanded tribute, which was paid in labour.

Exchange and trade were based largely on kinship obligations rather than a market system. Administration in an empire without reading or writing was maintained by highly structured work practices, as well as the use of formalized *aides mémoire*, such as the *quipu*. These knotted, multi-coloured strings were used as accounting tools, as well as a record of histories, legends and song. Inca shrines, or *huacas*, included boulders frequently carved in abstract geometric forms. These forms often remained unseen as the rocks were covered in elaborately woven textiles.

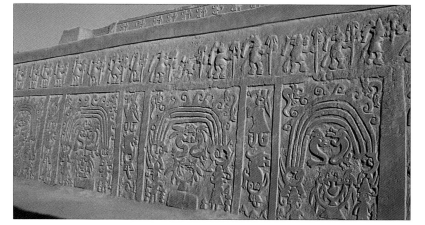

THE HUACA EL DRAGÓN in what is now Trujillo, Peru. This was a Chimú storage site with a highly specialized and effective ventilation system that supported the long-term storage of organic produce. The façades are decorated in modelled mud-plasterwork, depicting a 'Sky serpent' design.

INCA SHIRT in a fine tapestry weave, depicting miniature examples of other Inca shirt designs. This may reflect the high status of the individual who was allowed to wear the example below, who would have been superior in the hierarchy to those who wore the shirts depicted in miniature.

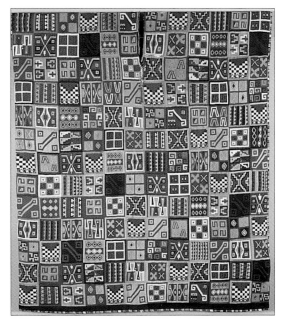

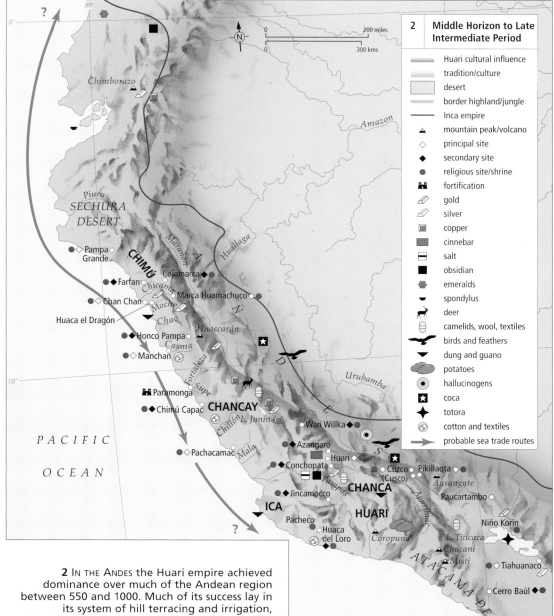

2 Middle Horizon to Late Intermediate Period

▬ Huari cultural influence
▬ tradition/culture
▢ desert
▬ border highland/jungle
— Inca empire
▲ mountain peak/volcano
◇ principal site
◆ secondary site
● religious site/shrine
⊞ fortification
✎ gold
✎ silver
▤ copper
▬ cinnabar
▭ salt
■ obsidian
⌣ emeralds
⊕ spondylus
🦌 deer
⊞ camelids, wool, textiles
🦅 birds and feathers
▼ dung and guano
☁ potatoes
◉ hallucinogens
★ coca
✦ totora
◎ cotton and textiles
→ probable sea trade routes

2 IN THE ANDES the Huari empire achieved dominance over much of the Andean region between 550 and 1000. Much of its success lay in its system of hill terracing and irrigation, developed during a period of severe drought in the sixth and seventh centuries. The Huari empire lay the foundations of many of the administrative systems and infrastructure that were later used to even greater effect by the Inca empire.

EUROPE 600-800

FROM THE LATER SIXTH CENTURY the Roman Empire ceased to dominate the western Mediterranean and European world. Associated with this political change – the emergence of new 'barbarian' rulers – was the decline of the urban centres that had been the focus of Greco-Roman civilization and its artistic production.

NEW PATTERNS OF TRADE

Constantinople and, especially, Rome shrank considerably. Alexandria was conquered by Islam. Carthage and Ephesus virtually ceased to exist. Smaller cities in the west such as Trier, Winchester, Metz or Tours became primarily military and episcopal administrative centres. Trade also declined, especially long-distance trade in bulk cargoes like grain, wine and pottery. For example, the eastern and

1 CHURCHMEN'S TRAVELS played a large role in artistic exchanges, as they brought gifts and returned with new acquisitions. Benedict Biscop travelled five times from Northumbria to Rome as a pilgrim, returning to the monastery he founded laden with books and pictures, and in 669 brought with him Theodore of Tarsus (in Asia Minor), the new Archbishop of Canterbury.

THE TASSILO CHALICE, a liturgical chalice in copper, with silver and gold inlay and niello, Salzburg region c.770 (Kremsmünster, Abbey Treasury). A Latin inscription names Duke Tassilo, last ruler of independent Bavaria, and his wife Liutpirc, a Lombard princess. Images in medallions represent four patron saints of the family, and Christ and the four evangelists.

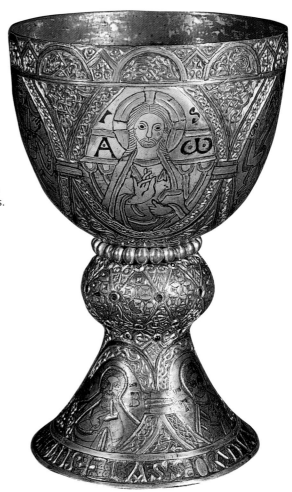

African pottery found at many fifth- and early sixth-century sites in western Europe is absent at later sites. From the seventh century trade tended to be more localized for such items, with the emerging new economic and cultural centres in suburban and rural estates founded essentially upon agriculture.

Some north–south trade continued, using the Rhine and Rhône valleys, and northern trade around the North Sea and Baltic Sea became significant, by the end of the period reaching across modern Russia to the Islamic world. Sites like Hedeby (Haithabu) on the Baltic, Dorestad in the Netherlands on the North Sea, and Southampton (Hamwih) on the Channel grew rapidly in the eighth century, and are associated with the production of small silver coins (*sceattas*). Trade shifted toward luxury items, such as precious

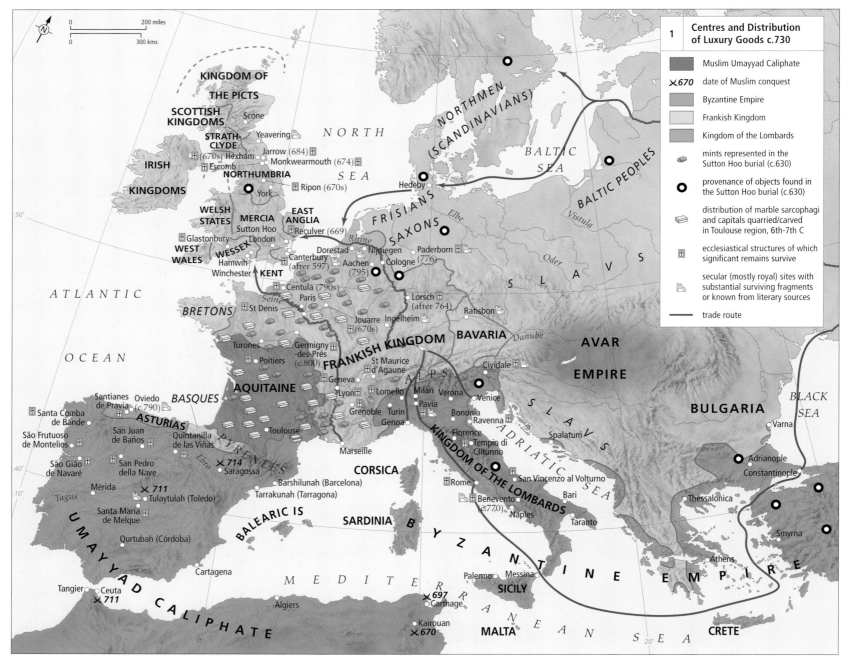

1 Centres and Distribution of Luxury Goods c.730

- Muslim Umayyad Caliphate
- ✕*670* date of Muslim conquest
- Byzantine Empire
- Frankish Kingdom
- Kingdom of the Lombards
- mints represented in the Sutton Hoo burial (c.630)
- ○ provenance of objects found in the Sutton Hoo burial (c.630)
- distribution of marble sarcophagi and capitals quarried/carved in Toulouse region, 6th-7th C
- ⊞ ecclesiastical structures of which significant remains survive
- secular (mostly royal) sites with substantial surviving fragments or known from literary sources
- —— trade route

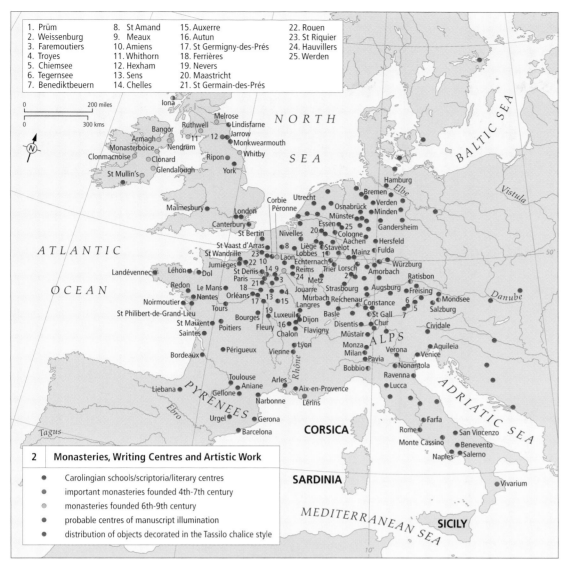

1. Prüm	8. St Amand	15. Auxerre	22. Rouen	
2. Weissenburg	9. Meaux	16. Autun	23. St Riquier	
3. Faremoutiers	10. Amiens	17. St Germigny-des-Prés	24. Hauvillers	
4. Troyes	11. Whithorn	18. Ferrières	25. Werden	
5. Chiemsee	12. Hexham	19. Nevers		
6. Tegernsee	13. Sens	20. Maastricht		
7. Benediktbeuern	14. Chelles	21. St Germain-des-Prés		

2 Monasteries, Writing Centres and Artistic Work

- Carolingian schools/scriptoria/literary centres
- important monasteries founded 4th-7th century
- monasteries founded 6th-9th century
- probable centres of manuscript illumination
- distribution of objects decorated in the Tassilo chalice style

2 MONASTERIES WERE FOUNDED by local saints, often with the support of local aristocracies, sometimes also by missionaries, often coming from the British Isles. A few were large and wealthy, but even the many small and poor ones required liturgical implements of valued materials and workmanship, along with reliquaries and books. A few were engaged in production, but all provided a market for artistic works.

similarly incorporated in liturgical crosses and luxury bookbindings.

The Roman tradition survived chiefly in and through Christianity, Rome becoming to contemporaries not the city of Caesar and Augustus but of saints Peter and Paul. The great churches built in late Antiquity by Constantine and his followers continued in use, but during this period only one pagan building was converted for Christian use, when Hadrian's domed Pantheon was rededicated as S. Maria ad Martyres in 609. In a fundamentally new phenomenon, large painted wooden panels representing Christ or his mother were created and displayed in many churches, and sometimes carried in processions through the city, for example the so-called Christ image kept in the Lateran chapel of the Sancta Sanctorum ('the Holy of Holies') in Rome from at least the end of the eighth century.

Greco-Roman civilization was a literary culture in which books played a large role, but their role was both altered and intensified through the emergence and triumph of Christianity and Islam (established in Spain in the 8th century). Each of them had a sacred book at its core and both developed a new form of decorated book commonly referred to as 'illuminated'. Even in late Antiquity and with the triumph of Christianity, from the fifth century or even earlier, the new form of bound codex that replaced the ancient book roll had been provided on some occasions with elaborate coloured pictures. These most commonly were portraits of the authors or of the patrons who either received or commissioned books of unusual and outstanding luxury.

Only in the seventh century did the text itself come to be a focus for decoration, with coloured ornament around and within and sometimes altogether comprising the letters. Pages were provided also with ornamental embellishment, beautifying as well as communicating the written word. Not all new manuscripts were made in monasteries or by monks, but many were, and the monasteries were a major patron of this art form, and of precious metalwork, and thye became the eventual repositories of nearly all examples that survive.

metalwork and textiles, sometimes exchanged not for purely economic reasons but as gift-exchanges that forged ties between the various rulers.

The range of places of origin for the material collected in the Sutton Hoo ship-burial (c.630), indicates the direct and indirect connections stretching from southeastern England to Scandinavia, the Frankish kingdom, even to Constantinople and Egypt. Towards the end of the eighth century occurred the converse phenomenon: the wide distribution of objects produced in a single or closely related centres, including both objects for Christian use, like the Tassilo Chalice (*opposite*), and others in a similar style primarily for secular use (swords, jewellery and riding equipment). The common denominators are a new style,

combining elements of the Mediterranean tradition, such as vine ornament, with recent varieties of northern animal ornament and aristocratic patronage and functions.

ROMAN CONTINUITY

Royal and ecclesiastical patrons achieved prestige and conveyed authority through monumental stone architecture, especially churches, using Roman structural and decorative features such as columns and large arches. Some quarries were exploited for building stone, fine carving in marble for sarcophagi and architectural ornament such as columns and capitals. However, when employed, such features were frequently actual remnants (*spolia*) taken from Roman buildings, appropriated to new uses. Ancient gems were

RECALLING ROMAN NUMISMATIC PRACTICE, a silver *denarius*, with profile portrait, issued by Charlemagne after about 806. Around the portrait is the inscription KAROLUS IMP AUG (Charles Emperor Augustus). On the reverse, however, the central role of the Christian religion is explicitly stated. The temple-like structure is based on Roman imperial coinage, but is now crowned with a cross and inscribed XPICTIANA RELIGIO (Christian Religion).

SACRAMENTARY MANUSCRIPT from Chelles (Vat. Reg. lat. 316, fols. 131v-132r). Produced probably by and for the use of nuns in a convent founded by St Balthilde, a queen of the Merovingian Franks, in the 660s. The codex form, still used today, makes possible the kind of large pictorial spread on facing pages fundamental also for this atlas.

EUROPE 800-1000

THE FRANKISH KINGDOMS of Charlemagne (r.768–814) and his successors were the dominant political and military force in ninth-century western Europe, and also the main cultural centre. In the early tenth century, artists were supported by Anglo-Saxon Wessex, and later by the Ottonian empire in Germany.

CAROLINGIAN EUROPE

Central power in the Carolingian empire depended upon the personal qualities and presence of the ruler. Charlemagne travelled incessantly for decades, and his 'court', including the queen, travelled with him four times to Italy, around the scattered royal estates, and on annual military campaigns which took them as far afield as northern Spain or modern Hungary.

The construction on one of the royal estates of a new fixed capital, at Aachen (after 794) was a new phenomenon. It contained the first large palace chapel in the Western

THE WUOLVINIUS ALTAR, centre-rear view (Milan, S. Ambrogio), mid-ninth century. On its front this elaborately enamelled silver and gold altar displayed Christ enthroned in majesty, with scenes from his life at both sides. Access to the relic (the entire preserved body of the patron saint) is through these doors on the back displaying archangels and the current Archbishop Angilbertus and the craftsman Wuolvinius bowing before and being blessed by the saint.

1 RAIDS BY VIKINGS and others destroyed many of the works of art produced during the peak of Carolingian culture, roughly 780–880. Nevertheless, by the end of the tenth century Christendom had expanded. Kings, increasingly powerful aristocratic lords, and clergymen (especially bishops and abbots) were patrons of books, fine metalwork and architecture. Urban centres were also renascent, especially in Italy.

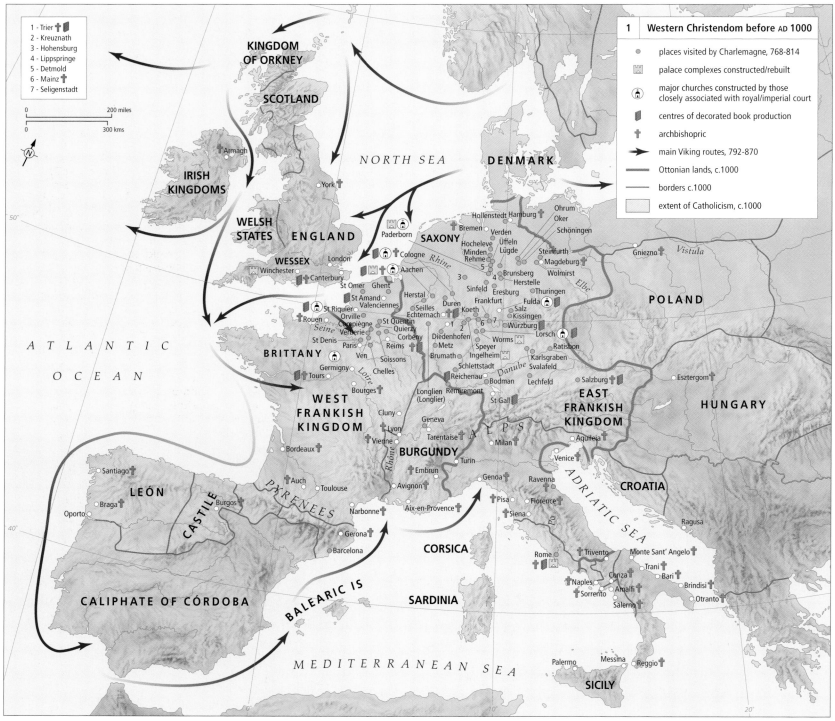

1 - Trier
2 - Kreuznath
3 - Hohensburg
4 - Lippspringe
5 - Detmold
6 - Mainz
7 - Seligenstadt

	1	Western Christendom before AD 1000
	places visited by Charlemagne, 768-814	
	palace complexes constructed/rebuilt	
	major churches constructed by those closely associated with royal/imperial court	
	centres of decorated book production	
	archbishopric	
	main Viking routes, 792-870	
	Ottonian lands, c.1000	
	borders c.1000	
	extent of Catholicism, c.1000	

2 FROM THE MID-EIGHTH CENTURY until the end of the tenth century St Gall, supported largely by its land holdings, was a centre for illuminated manuscripts. Although the most elaborate books, ivory carvings and metalwork were for the abbey itself, some were sent to the many dependent monasteries, priories and churches in the wide region dominated by St Gall as an administrative as well as artistic centre. The map shows how widely dispersed the administrative work of the abbey was – each site 'with charters' is a place where these property documents were drawn up.

2	The Abbey of St Gall
·	sites with abbey properties
●	places with 10 charters or more
●	places with 5-10 charters
●	places with 3 or 4 charters
●	places with 2 charters

tradition, and for it was made the earliest preserved luxury illuminated manuscript for a ruler, known after its scribe and painter as the Godescalc Evangelistary (781–83). Although we do not know where that book was made, it and a group of other extraordinarily luxurious books were made for Charlemagne.

After a hiatus of more than three centuries, carvings on ivory were produced under court patronage. As there was no current supply of new ivory, many were made by turning over Late Roman secular (never Christian) ivories and carving the back.

Also for the court were made large-scale works in bronze, including the doors and railings for the palace chapel. How the difficult art of bronze casting was recovered remains something of a mystery, as is also the case with the wall mosaics at Aachen and at Theodulf's chapel at Germigny, another technique revived after several centuries abeyance other than in the city of Rome.

The Frankish royal courts became the first court centre of cultural and artistic patronage in the post-Roman period, and drew many creative figures from beyond the Frankish realm, including Alcuin from northern England, Theodulf from northern Spain, Paulinus of Aquileia and others from Italy, and later John the Scot Eriugena from Ireland.

OTTONIAN EUROPE
From the later ninth century the Frankish kingdoms were in decline, but Alfred the Great's Wessex began a major royal-sponsored campaign of literary and artistic production, which continued into the tenth century. From the later tenth century the Roman empire ruled by a Saxon dynasty in Germany, commonly called the Ottonian dynasty, also drew scholars and artists from afar, including the Byzantine empire.

For a small group, the world suddenly became much smaller, and men such as Gerbert of Aurillac took advantage of the new range of possibilities. Born and educated in southern France, he became a famous teacher at Reims in northern France, then became tutor to the future Emperor Otto III, and was appointed by him Pope Sylvester II in 997.

Artists similarly travelled. We know of a Carolingian painter in the employ of abbots travelling from central France to central Germany and returning, of Anglo-Saxon artists active at Fleury and probably in the Meuse region, and one famous master who worked for the Archbishop of Trier in the late tenth century probably visited Rome.

Gerbert's career exemplifies the relative insignificance of borders. Latin was the shared language of written culture and administration nearly everywhere in the West, and there was an emerging sense of a special Western Christendom, represented by the enlargement of Christendom westwards to encompass all of Scandinavia, including Iceland and Greenland, and eastwards to include Poland and Hungary. Borders were very much in flux in any event, prompted only in part by the raids and subsequent invasions of the Vikings. By the end of the period the core of the later English and French nations had been defined.

Monasteries, already important in preceding centuries, played if anything an enhanced role in the ninth and tenth. Many received royal support, or the support of major local aristocratic patrons, and in turn were expected to contribute to royal projects, providing not only books and teachers but also money and even soldiers. Some of the royal monasteries became major centres of artistic production, the monastery at Tours, for example, producing something like two complete bibles and a gospel book annually during the second quarter of the ninth century.

The ties between state and church were especially intimate in Ottonian Germany, culminating in the eleventh century in intense conflicts. Some monasteries sought to insulate themselves from secular ties; the great monastery of Cluny (founded 919) was chartered as dependent only upon the pope, and also strengthened its independence by creating an order, an alliance of many monasteries scattered across Christendom with the Burgundian mother house at its head. The well-documented case of the abbey of St Gall, just south of Lake Constance in modern Switzerland, shows the extent of monastic involvement in land-holding patterns and also of literary and administrative culture.

Monasteries were also important as the home of holy men, specialists in prayer, and of the holy men and women of the past, present through their relics, whose cult became increasingly important through the period. Relics were required in association with every altar, usually small portions of holy bodies in small but elaborately decorated reliquaries. Charlemagne's biographer, Einhard, tells how holy relics were acquired from Rome. Other famous relics were rescued or stolen by new owners, including St Foi at Conques and St Mark at Venice.

THE EGMOND GOSPELS, facing miniatures added c.950 to a ninth-century manuscript by Count Theoderic II of West Frisia and his wife Hildegard. The couple present the book at the monastery's altar, and then are presented to Christ by the monastery's patron saint, St Adalbert.

EASTERN EUROPE AND SOUTHWEST ASIA 600-1500

PROFOUND SOCIAL, political and economic changes in the seventh century transformed the civilization of late antiquity into the medieval Greek world, known as Byzantium. For centuries the Byzantine Empire, with Constantinople at its centre, provided a powerful cultural and artistic model to neighbouring cultures, while also absorbing cultural influences from neighbours such as the Islamic world. The Vikings and Slavs of Rus were incorporated into the political and ecclesiastical orbit of Byzantium in the ninth and tenth centuries; the introduction of both Christianity and the Cyrillic alphabet to Rus were manifestations of this process. Contacts with western Europe existed throughout the period, but became particularly intense in the aftermath of the Crusades in the twelfth and thirteenth centuries. The influence of Byzantium declined after the Sack of Constantinople by the participants of the Fourth Crusade in 1204. After the fall of Constantinople in 1453 Byzantine art and Orthodox religion lived on only in eastern Europe and the Balkans. Until the late Byzantine period the emperor was a major patron of the arts. His example was imitated by rulers of Norman Sicily, Serbia and Bulgaria.

ART AND SOCIETY
Although silks and ceramics are testimony to the widespread production of secular arts, the surviving arts of the period are mainly Christian. Religious diversity is a key factor in

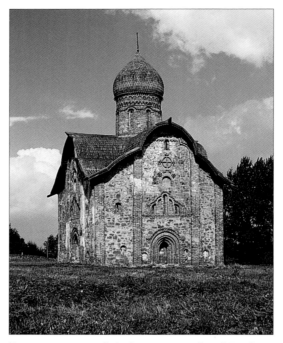

THE CLOSE CULTURAL links between medieval Russia and Byzantium are reflected in the art and architecture of medieval Rus. Byzantine craftsmen and architects introduced artistic ideas to Rus, but its art and architecture are not slavish copies of Byzantine models. The Church of SS Peter and Paul, Kozhevniki in Novgorod, northern Russia, is dated 1406. It is centrally planned, radiating from a central point, like a Byzantine church. Its onion dome, however, is a local adaptation.

an understanding of the art of this region. Parts of eastern Europe, including Poland, Hungary and regions of the Balkans, followed the Latin rite, whereas the dominant religion in Byzantium and Rus was Orthodox Christianity. Georgia was Orthodox, neighbouring Armenia Monophysite. Such diversity is reflected in the visual arts, with each region presenting distinctive artistic idioms. Throughout the Byzantine world, religious cult sites provided a stimulus for the production of art and architecture. Many smaller pilgrimage sites existed alongside the major international pilgrimage centres of Jerusalem and Constantinople.

The influence of the Islamic world was also profound. The Iconoclast controversy of the eighth and ninth centuries, which concerned the role and extent of religious imagery in Christian worship, cannot be understood without reference to the Islamic prohibition of iconic imagery for religious purposes. In the secular sphere, tenth-century courtly ceremonies of the imperial court in Constantinople were very similar to those practised in Baghdad.

1 BYZANTINE CRAFTSMEN, mostly from Constantinople, were much in demand abroad. Byzantine craftsmen made mosaics in southern Italy, Sicily and Rus. Byzantine artefacts, in particular icons or liturgical objects, also reached Rus through trade and diplomatic missions. Many Byzantine artefacts in western church treasuries were looted during the sack of Constantinople in 1204.

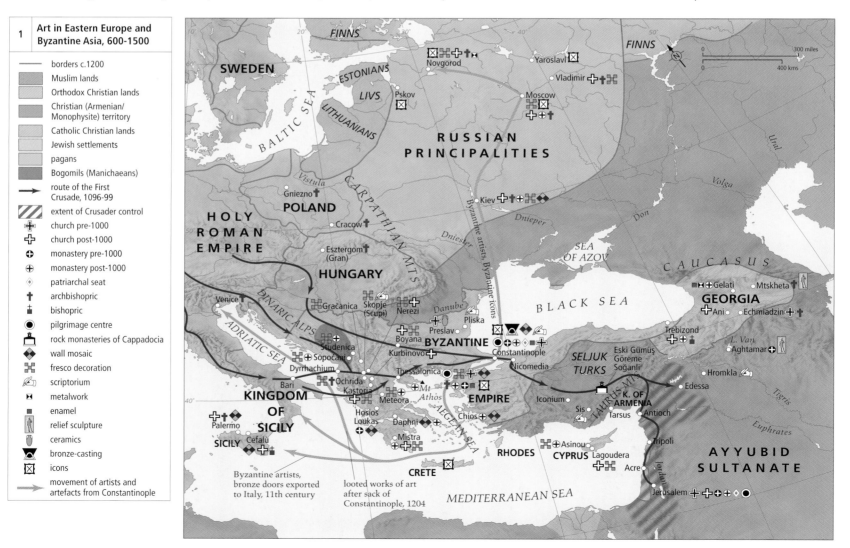

1	Art in Eastern Europe and Byzantine Asia, 600-1500

- —— borders c.1200
- Muslim lands
- Orthodox Christian lands
- Christian (Armenian/Monophysite) territory
- Catholic Christian lands
- Jewish settlements
- pagans
- Bogomils (Manichaeans)
- → route of the First Crusade, 1096-99
- ▨ extent of Crusader control
- ✛ church pre-1000
- ✚ church post-1000
- ✪ monastery pre-1000
- ⊕ monastery post-1000
- ◈ patriarchal seat
- † archbishopric
- ‡ bishopric
- ● pilgrimage centre
- ⌂ rock monasteries of Cappadocia
- ◆ wall mosaic
- ✖ fresco decoration
- 🖎 scriptorium
- ⋈ metalwork
- ▪ enamel
- relief sculpture
- ceramics
- ▼ bronze-casting
- ⊠ icons
- → movement of artists and artefacts from Constantinople

Byzantine artists, bronze doors exported to Italy, 11th century

looted works of art after sack of Constantinople, 1204

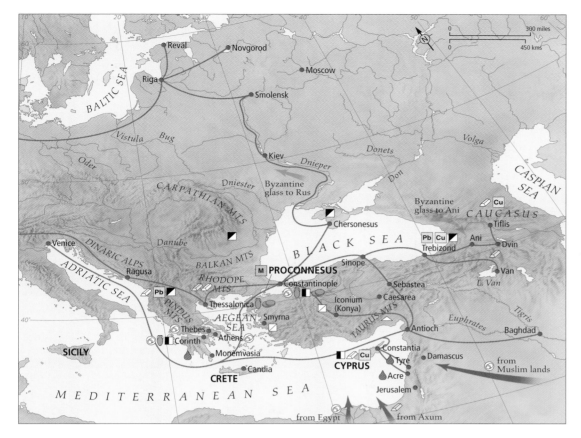

2 EASTERN EUROPE AND THE MEDITERRANEAN were linked by an extensive trading network. Luxury goods from Byzantium were exported to Rus, the River Dnieper forming an important trade route, and overland and across the Black Sea to the Caucasus. Raw materials from Byzantium, such as alum, were exported to western Europe. Even though Byzantium had its own silk production, silks and dyes were also imported from the Islamic world. The Caucasus, Cyprus and the mountains near Thessalonica were mined for silver and copper. Some gold was imported from Africa.

The Crusades increased knowledge of Byzantine art in western Europe. In the late Byzantine period, Byzantine art also showed an increasing awareness of western art, reflecting the close contact between Byzantium and the West from the twelfth century onwards.

ARTISTIC CENTRES
Constantinople and Thessaloniki were major artistic centres. A local artistic tradition is exemplified by the ninth- to eleventh-century frescoes in the cave churches of Cappadocia, in eastern Turkey. Church decoration in Cyprus and Serbia provides important insights into artistic developments in the late Byzantine period

3 CONSTANTINOPLE formed the hub of a vast, long-distance trade network, which carried commodities as far afield as Russia and the Caucasus. The city's wealth is reflected in the religious topography of the capital. Monasteries were lavishly decorated with mosaics. Cult images, kept at individual monasteries, formed an integral part of religious life in Constantinople, attracting worshippers from within and without the Byzantine Empire.

(12th–15th centuries). Alongside Constantinople major centres of manuscript production existed in Armenia, Cilicia (13th–14th centuries) and Bulgaria (14th–15th centuries).

MATERIALS AND TECHNIQUES
Marble from the island of Proconnesus in the Sea of Marmara was the main construction medium in the early Byzantine period, while in later centuries brick became dominant. Mosaic was the prime medium of Byzantine monumental decoration. Glass workshops are thought to have produced mosaic *tesserae* as well as glass vessels – Byzantine glass has been found in Russia and Armenia. Glass was also used in enamel production, with *cloisonné* being the most widely practised technique. From the early Byzantine period Constantinople was the centre of a silk industry; from the tenth century silk workshops also existed in Greece. Silk was also imported from the Islamic world. Various pigments were used to dye silk, the most expensive being purple produced from murex shells. Mordants, such as alum, found primarily in Asia Minor, were used to

fix the dyes. Some metals were mined within the Byzantine Empire. Others, such as gold, were imported. Mints producing coins in precious and base metal existed in both Constantinople and Thessalonica.

MOVEMENTS OF ART AND ARTISTS
Knowledge of Byzantine art was disseminated through trade, diplomatic contacts, pilgrimage and, starting in the late eleventh century, the Crusades. Byzantine art looted in Constantinople in 1204 is still housed in church treasuries in Venice and France. In Russia, the activities of traders, who imported honey, wax and furs from Rus to Byzantium, and sold Byzantine silks and glass in Rus, were complemented by the activities of Byzantine missionaries. Following the elevation of Christianity to the status of official religion in Rus in 988, Byzantine icons and liturgical silver were also imported. The skills of Byzantine craftsmen were highly sought after outside Byzantium. Byzantine mosaicists were active in Kiev in the eleventh century and in Norman Sicily in the twelfth century.

BYZANTINE SILK PRODUCTION was strictly regulated, being an imperial monopoly. Silks were highly prized in the West where, as in the example below, they were often used to decorate the inside of saints' reliquaries. The woven patterns, such as the birds and griffins visible in this twelfth-century fabric known as the Shroud of St Potentien (Cathedral Treasury, Sens), find parallels in Islamic silks.

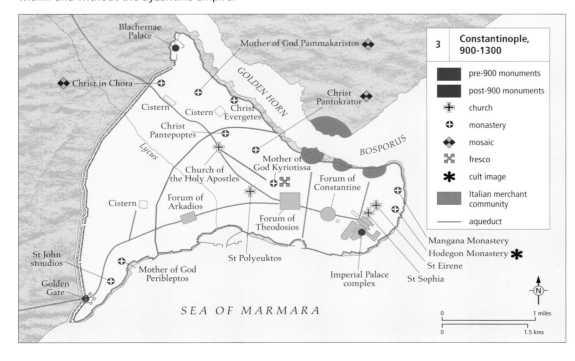

NORTHERN EUROPE 1000-1200

THE FIRST TWO HUNDRED YEARS of the second millennium were a period of expansion and economic growth for northern Europe. This prosperity stimulated an increased production of art and architecture. Though the time of the great invasions from the east had passed, political boundaries continued to shift. Notionally the German Emperors dominated western Europe. Nevertheless, it was often smaller barons and counts who held real power, and many were able to extend their power base. The Normans of northern France, for example, conquered England in 1066. They brought with them their system of government, as well as their artistic tastes and their

1 WITH LESS THREAT from eastern invasions, new cathedrals, abbeys, castles and palaces began to cover northern Europe, including the recently Christianized areas of Scandinavia and eastern Europe. Rulers like Duke Henry the Lion of Saxony (c.1129–1195) continued to suppress pagan religions. By conquering lands to the east Christianity extended ever further, bringing with it Christian art and architecture and establishing important centres of metalwork.

architects to rebuild the cathedrals, such as Durham and Ely, and to construct new castles, like Norwich and Rochester.

Next to the secular courts, cathedrals and monasteries were the main centres of authority and culture in this period. Bishops and abbots recruited themselves from the same families as secular rulers, and as major landowners they held comparable power. They were also influential patrons of the arts, commissioning works of art for their own personal use but also for their religious institutions. The cathedral-monastery of Canterbury in England, the cathedral of Lund in Sweden and the monastery of Hirsau were all important sites.

Between 1100 and 1200 society became much more stable. New trade links opened up to the north and south. A thriving agricultural base brought wealth to many regions. New towns and universities developed, and roads allowed safer travel for artists and merchants. In this flourishing society, visual art and architecture were increasingly put into the service of individuals and institutions. Often, they were intended to convey multiple

messages, and to express the beliefs and the attitudes of the time.

CHRISTIANITY
In the early decades of the second millennium Christianity finally established itself as the dominant religion in northern Europe. The Scandinavian rulers were the last of the European rulers to be baptized. The evangelizing church demonstrated its increased influence by associating itself with opulent art and imposing architecture. All over Europe cathedrals, abbeys and parish churches were built or rebuilt. The churches were filled with paintings, altarpieces, sculpture and stained glass. These objects performed a part in the visual display of the Christian faith and the rituals of the daily liturgy. The funding was supplied mainly by donations from the faithful. Laity and clergy alike invested in the religious spectacle in order to illustrate their personal devotion and to attain salvation.

Only the most famous artists and the most precious metals were suitable for these pious aspirations: good building stone and timber

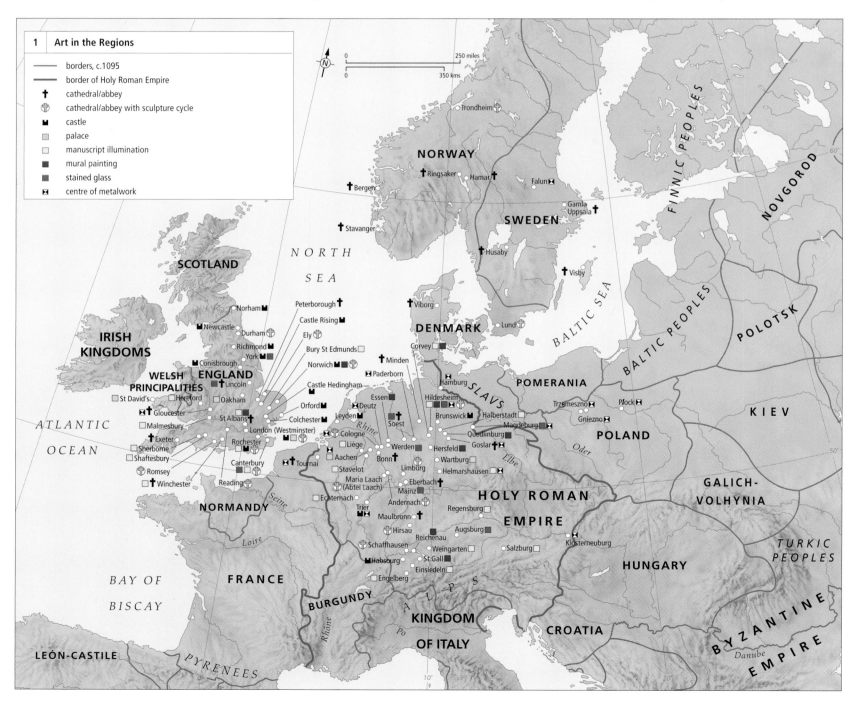

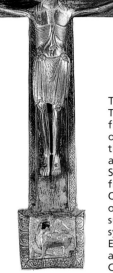

THE TOWER OF LONDON was built by William the Conqueror soon after his invasion of England in 1066. For the design William's architects looked to castle architecture in western France. The square plan was to become typical for English castle building. Inside were apartments, a hall and a well. Situated on the banks of the River Thames the dominant building was meant to impress anyone coming from the sea up to London.

and palaces that reflected their authority and position in society, for example at Trier, Leyden and Hildesheim. At the same time, they also demanded religious objects for their personal devotional practices.

The personalities and working methods of artists are little documented at this time, and only few artists signed a finished work. Most art production was collaborative and often several generations of a family worked in the same workshop. If a wealthy patron wished it, foreign artists travelled great distances to bring their specialized knowledge with them. Some areas developed a reputation for the manufacture and sale of luxury goods, like alabaster from England. In this way craftsmen became entrepreneurs. Other artists worked over long periods at the same court, for example at Westminster and Aachen. In this case a close consultation between artist and patron could develop, so that works were created that were specifically designed to fulfill the wishes of the patron.

THE LUND CRUCIFIX. This crucifix comes from the cathedral of Lund, since 1103 the seat of the archbishopric for Scandinavia. It is made from gilded metal. Originally, the figure of Christ was surrounded by the symbols of the four Evangelists on the arms of the cross. Crucifixes like this were treasured items.

had to be found for constructions, gold, silver and gems were needed for the liturgical furnishings. Such materials were sometimes found in the local vicinity but they were often imported. Iron, copper and tin, for example, were brought from the east to centres of metalwork, such as Cologne and Tours. The perfection of the material and of the craftsmanship was a vital factor in the production of Christian art created for the honour of God.

ARTISTS AND PATRONS
The European secular elite also underlined their newly found positions of power by patronizing the arts. They constructed castles

CENTRES OF ART AND LEARNING
The religious institutions of the time were also the seats of education and learning. Schools developed around many of the newly built cathedrals. The monasteries that dotted the landscape were also important centres of

teaching and art production. Many had scriptoria famous for manuscript illumination, such as the monastery of Echternach which in turn inspired the mural painters. The combination of religion, learning and artistic production is symptomatic of this time when much of the intellectual creativity was concentrated on devotional subjects.

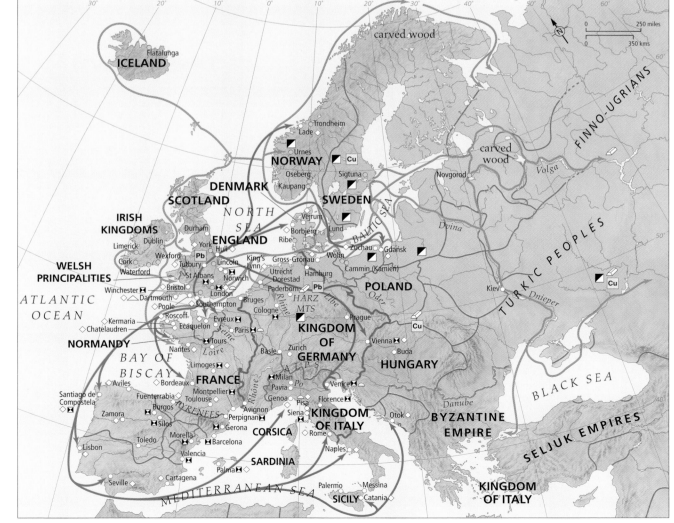

2	Art and Trade

border of Holy Roman Empire, c.1095

sources of:

silver

Cu copper

iron

Pb lead

tin

◉ trade centre for Viking sculpture (wood/stone/bone) and metalwork

⊟ centres of metalwork

◇ centres of alabaster

△ centres of ivory-working

→ export of alabaster

→ trade route

2 THE SUPPLY OF MATERIALS was essential for art production. In Germany and in England, local stone was in good supply and was a perfect source for buildings and sculpture, while in Scandinavia patrons and artists exploited the rich timber resources. Rare materials like alabaster and metal were exploited at source and then exported to other regions. Trade, a crucial factor in the growing European economy, fuelled the arts. In turn, trade routes contributed to the dispersal of craftsmen and their methods.

SOUTHERN EUROPE 1000-1200

IN SOUTHERN EUROPE the long-forgotten artistic traditions of ancient Rome became an important source of artistic models. The city's early Christian monuments, such as St Peter's, were a constant reminder that the religion had originated there. Roman buildings and sculpture survived elsewhere in what had been the Roman Empire, as for example at Autun, Arles and Tarragona. Now they became an inspiration for artists and craftsman. The art of the eleventh and twelfth centuries is therefore called Romanesque, or 'Roman-like'.

During this period France emerged as one of the leading centres of art production. The Capetian rulers had established a stable dynasty, and the country was blessed with ample resources. In the 1140s, Abbot Suger (c.1080–1151) of St Denis near Paris and his un-named architect created a new lightweight architecture for the apse of the abbey church which came to be called Gothic. It was further developed in the northeast of France, for example at Laon and Chartres. Although it initially co-existed with the Romanesque, this new Gothic style eventually dominated both northern and southern Europe.

While the economy and the arts flourished, European rulers continued to wrestle for power. In the eleventh century Sicily and southern Italy were captured by the Normans, in 1194 they were taken over by the Hohenstaufen Emperor Henry VI (d.1197) and became the Kingdom of Sicily. The pope in Rome quarrelled constantly with the Emperor

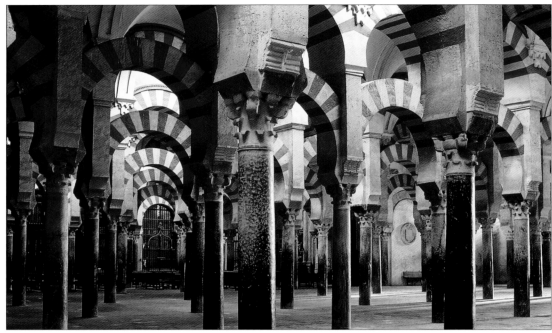

THE GREAT MOSQUE AT CÓRDOBA was built soon after the Islamic conquest of Spain and inaugurated in 786. It was continually enlarged until the late tenth century. When the Christians recaptured Córdoba in 1236 the mosque became a cathedral, but long before this time the architecture impressed Christian artists, in particular the horseshoe arches consisting of *voussoirs* in alternating colours. The marble columns and the use of Roman capitals can be compared to contemporary Christian architecture.

1 DESPITE FREQUENT POWER SHIFTS IN the territories of southern Europe, art production increased drastically after 1000. Cathedrals, abbeys, castles and palaces began to cover the landscape. In some cities specialized centres of art production developed. Limoges and Pisa became famous for their metalwork, while Strasbourg and St Denis had important workshops of stained glass. In the mid to late twelfth century, the northeast of France became a hub of building activity when churches were rebuilt in the Gothic style.

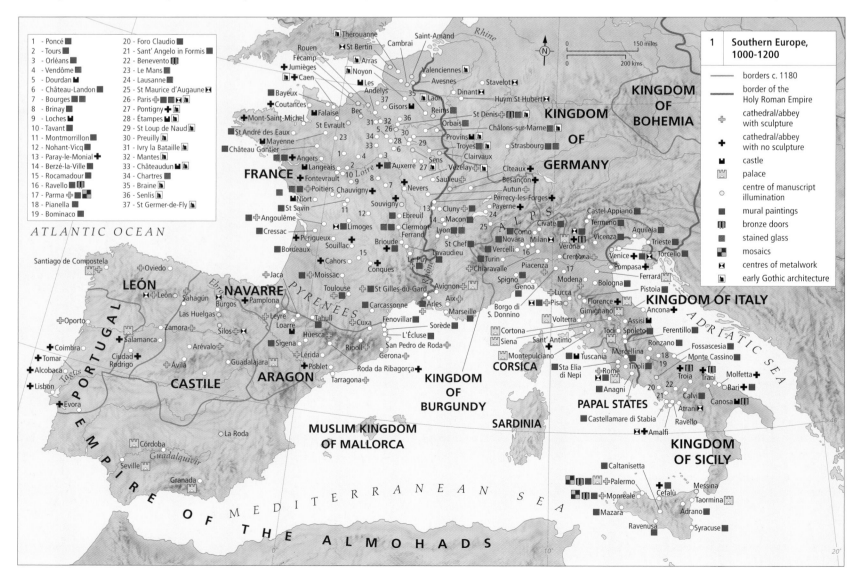

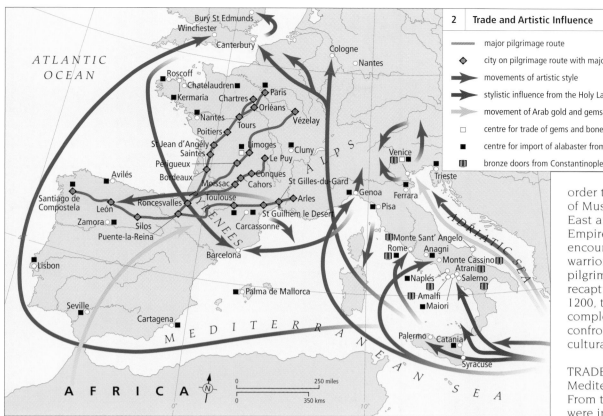

2 IN THE ELEVENTH CENTURY southern Europe was criss-crossed by a network of roads. From the late eleventh century, four of these roads developed into specific pilgrimage roads, leading towards Santiago de Compostela. Despite conflict with the Arabs in the south and a strained relationship with the Byzantine Empire, trade with the east was flourishing and southern Europe depended on artistic influences from the Holy Land and the east.

order to keep the main pilgrimage places out of Muslim control. Possessions in the Near East and good contacts with the Byzantine Empire opened up new trade routes and encouraged artistic exchange. In Spain, the warrior image of Saint James fused the idea of pilgrimage with that of the *Reconquista*, the recapture of Islamic Spain. Between 1000 and 1200, the Caliphate of Córdoba was almost completely defeated. Despite this confrontation, the north of Spain enjoyed cultural interaction with Islamic art.

TRADE AND ARTISTS

Mediterranean trade continued to flourish. From the Islamic coast of Africa gold and gems were imported into Spain and France. Italian towns like Genoa and Venice became major trading centres linking the European west with the south and the Near East. At Venice, buyers could find alabaster from England, and gems, bone and ivory from Byzantium. Artists and craftsman from the Byzantine Empire, where Roman artistic traditions survived, brought their experience to the west. At Monte Cassino in Italy, Abbot Desiderius (1058–87) rebuilt Saint Benedict's church in a splendour not seen since early Christian times. A set of majestic bronze doors was imported from Constantinople, and artists were invited to help to create mosaics and wall paintings. The pope in Rome and other patrons soon followed Desiderius' example.

in Germany. A major confrontation developed between European Christians and Muslims in southern Spain and in the Holy Land, and in the mid-twelfth century the Plantagenet king of England owned more land in France than the king of France himself. Artistic production reflects these complex relationships. There is evidence for cross-cultural exchanges between Islamic and Christian art, and between French and English art. On an ideological level, the popes used the revival of the art and architecture of imperial Rome to underline their authority and to emphasize the continuing power of the Christian church.

PILGRIMAGE

The cult of relics became a major focus of medieval life and art. Imposing churches were built to house the precious remains of saints and Christian martyrs. Numerous chapels and tall towers advertised their power to the world, and attracted pilgrims from far and wide. Inside the churches, the story of the saints was told in paintings and sculpture, their bones were displayed in richly decorated gold or silver reliquaries, and manuscripts depicted their lives and their miracles. Here pilgrims could pray for the atonement of sins and hope for cures of illnesses. Their pious donations sustained monastic communities and helped fund churches and art works.

The main sites to be visited by Christian pilgrims were traditionally Rome and the Holy Land. During the eleventh century a pilgrimage developed to Compostela in northern Spain where the remains of James, the apostle of Christ, were kept. Pilgrims from eastern Europe travelled to Spain along pilgrimage routes starting from Paris, Vézelay, Le Puy and Arles, which took in many celebrated shrines on the way, such as Conques, St Gilles, Limoges and Toulouse. Relics became a major object of trade between northern Europe and the south where early Christian martyrs were in greater supply. The acquisition of relics and free access to their sites was a fundamental requirement of Christian society, which saw saints as its defenders, an essential part of its faith, and a crucial factor for its economy.

CRUSADES AND ISLAM

In the seventh century, the south of the Mediterranean world became detached from the north by the advance of Islam. In 711 Islamic troops moved into Spain and then into France. In the eleventh century, the Near East was conquered by the Seljuks, separating Christians from sites in the Holy Land, especially from Jerusalem. In the face of this perceived danger, Christian Europe united behind the idea of reconquest. Initiated by the pope, Christian knights from all over Europe set out in 1096 on the first crusade to win back the Holy Land. This was the beginning of continuing Christian invasions of the east in

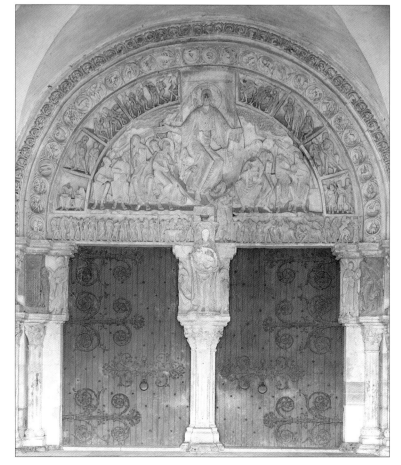

THE CENTRAL PORTAL of the narthex at Vézelay, France. The pilgrimage church was one of the four starting points on the route to Santiago de Compostela. This portal was carved in c.1120 to welcome medieval pilgrims who had come to visit the shrine of Saint Mary Magdalene. The tympanum shows, at the centre, the figure of Christ at Pentecost investing his apostles with the power to commence their mission and preach the Christian message to non-Christians. On the lintel and in the square fields surrounding the central scene the people of the world are shown. The outer *voussoirs* are decorated with the signs of the Zodiac and a decorative scroll. On the *trumeau*, or central support of the doorway, the figure of John the Baptist can be seen presenting a now damaged lamb of God. The abbey's fame reached a peak when at Easter 1146, the second crusade was launched at Vézelay.

NORTHERN EUROPE 1200-1300

I N THE YEARS 1200–1300, northern Europe initiated a remarkable geographic shift in its production of culture from isolated, rural monasteries to urban centres. As enduring landmarks of this shift, the century has left us numerous light-filled churches which still dominate the urban landscapes of Europe today, a potent visual reminder of the medieval sense of the presence of God and the power of the Church that connected the earthly to the divine. Often covered with elaborate programmes of figural sculpture, these edifices were enormous billboards in stone that towered physically and psychologically over the cultural landscape, so much so that craftsmen and -women in other media quickly adopted the slender proportions and graceful lines of this first 'modern' style.

MEDIEVAL CITIES

Known in the Middle Ages as *opus francigenum* (literally 'French work'), the Gothic style spread rapidly from city to city in and near the royal domains in the Île-de-France and then on to Germany, Flanders, Spain and England. Its home was in rapidly growing cities; with a few exceptions, such as Rome and Cologne, important medieval cities developed as mercantile centres in the suburbs of former Roman towns. In northern Europe, the largest of these cities formed at the nexus of Alpine passes and sea- and river-routes in Flanders, northern Germany, northern France and southern England. These cities were fed from

1 NORTHERN EUROPE in the years from 1200 to 1300 was characterized by increased long-distance trade, especially in luxury goods. Paris and northern France rapidly grew in importance as the leading international centre for art and architecture. Artisans in and around Paris developed highly specialized workshops, especially for the carving of ivory and miniature painting in a fashionable and appealing style known then as *opus francigenum* ('French work'). Recognizably idiosyncratic styles emerged in England, Germany and France, which had a regional appeal, though both Limoges (enamels) and East Anglia (manuscripts) produced work that found much wider markets.

PICTURE OF AN ELEPHANT given to King Henry III of England by Louis IX of France in 1255. As Matthew Paris, a monk at St Albans, tells us, this elephant is drawn from life. A suitable prefatory illustration to Matthew's *World Chronicle*, the elephant demonstrates European political relationships and the increasing regularity of trade with areas outside Europe. While monks such as Matthew would continue to illuminate manuscripts, lay artists were increasingly becoming more important in the commercial book-trade for universities and aristocrats.

1	Northern Europe, 1200-1300
——	borders, c. 1270
■	major church
■	church with important sculpture
■	church with important stained glass
■	church related to *opus francigenum*
□	hall church
⊌	castle/fortification
A	alabaster
→	export of alabaster
◆	centre of manuscript painting
→	diffusion of manuscript styles
△	ivory carving
⋈	metalworking centre
→	spread of metalwork
▥	university, with date of foundation
●	city visited by the French draughtsman Villard de Honnecourt (fl. c.1220-40)
→	diffusion of artistic styles

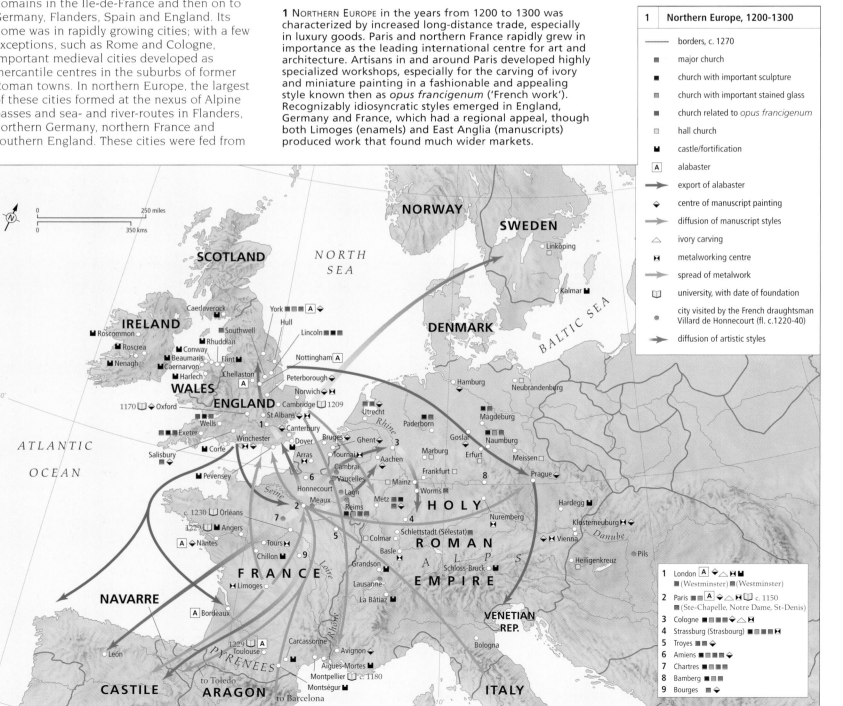

1	London A ◆ △ ⋈ ⊌
	■ (Westminster) ■ (Westminster)
2	Paris ■ ■ A ◆ △ ⋈ ▥ c. 1150
	■ (Ste-Chapelle, Notre Dame, St-Denis)
3	Cologne ■ ■ ■ ■ ◆ △ ⋈
4	Strassburg (Strasbourg) ■ ■ ■ ■ ⋈
5	Troyes ■ ■ ◆
6	Amiens ■ ■ ■ ■ ◆
7	Chartres ■ ■ ■ ■
8	Bamberg ■ ■ ■
9	Bourges ■ ◆

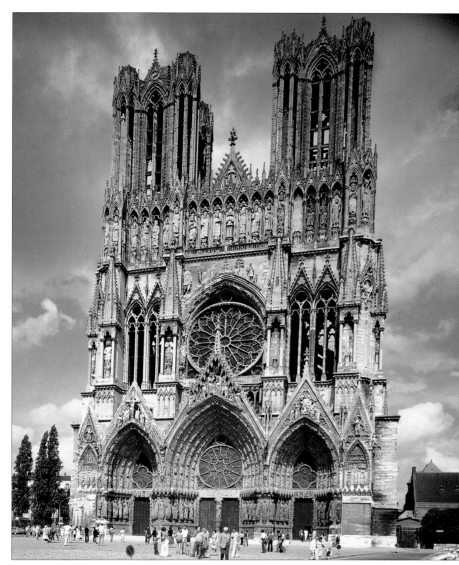

REIMS CATHEDRAL. Pierced by deep porches, covered with elaborate sculptural programmes and supported by pointed arches and flying buttresses, Gothic cathedrals such as this one at Rheims dominated the European cities of the thirteenth century. These enormous buildings required a huge expenditure of capital for their construction, money made available by a growing agricultural economy. Records of chapter meetings at Reims demonstrate that demands for funds were not always welcomed by either the lay or ecclesiastical communities.

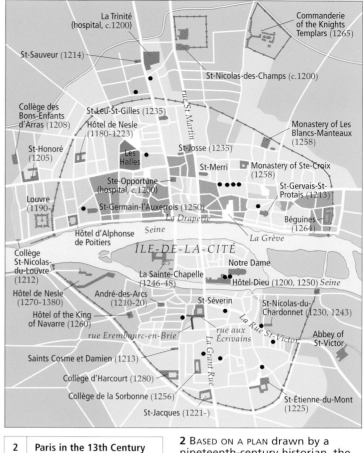

2	Paris in the 13th Century

- workshops of glaziers 1296/1297
— home to a concentration of Paris illuminators
— home to parchment-makers and scribes
▨ major building

relative wealth of areas of Paris (taxes paid in 1297):

less than 10 sous per household
10-20 sous
20-30 sous
more than 30 sous

2 BASED ON A PLAN drawn by a nineteenth-century historian, the map above reconstructs Paris in the late thirteenth century. Details derived from the records of special taxes levied in the 1290s demonstrate the distinct differences in the wealth among the city's parishes, as well providing a glimpse of where various artisans, for example, glaziers lived and worked throughout the city. Illuminators, parchment dealers and book traders tended to congregate on the left bank of the Seine, near the University, founded in the twelfth century.

the agricultural surplus that resulted from the development of better technology such as ploughs and crop rotation. The population of the medieval cities adjusted economically and socially to improved living conditions, moving toward ever greater specialization in the production of goods. Controlled by organizations known as guilds, specialized workers served as engines of economic development whose most lucrative products were luxury goods. Because these goods were relatively light and thus readily transported, they could be profitably carried overland to the fairs of Champagne in northeast France, or alternatively traded by the merchants of the Hanseatic League (a commercial confederation originating in German-speaking areas surrounding the Baltic Sea).

CULTURAL CONTACTS

These continental trades routes extended further eastwards and southwards as Europeans continued to make contact with the civilizations of Asia, Africa and the Middle East. Four major Crusades offered opportunities for cultural contact through conquest; they resulted in the capture of Constantinople in 1204, the brief control over Jerusalem (negotiated by the German Emperor Fredrick II in 1229), and two spectacularly unsuccessful campaigns by the French King Louis IX in 1248 and 1270. The strategic failures of the Crusaders may have been countered by the

cultural effects of their interaction with the relatively more advanced Arabic Middle Eastern civilization, though some modern historians argue that the Crusades did not inspire intellectual and economic development as much as they promoted religious, ethnic and even national intolerance, not only between Christians and Arabs, but also between Christians and Jews, Latins and Greeks.

The growth of cities also provided a new geographic focus for learning, marking a shift from the predominantly rural monasteries to major universities such as Paris and Bologna. Even more than monasteries and cathedral schools before them, universities provided access to learning for children of non-noble classes, especially as secular rulers looked to university graduates to fill the administrative ranks of government.

As universities developed their own curricula to fill this need, they created a demand for very different books: illustrated anatomical treatises, law books (especially Gratian's *Decretals*), the newly fashionable texts of Aristotle and their accompanying commentaries, and traditional bibles, now made in smaller 'pocket versions' suitable for university students. This demand in turn stimulated a greater specialization in the book trade, a market that was increasingly dominated by lay artisans in major urban areas. University books developed a unique 'visual geography' in their own layouts – the text being studied was

written in large letters in the centre of the manuscript page, around which was gathered marginal glosses of relevant citations from key authorities in smaller letters, with space left in the margins for the owner's annotations.

PARIS: A CULTURAL CENTRE

A regional centre for artistic production in the early Middle Ages, Paris emerged in the course of the thirteenth century as the premier capital city in western Europe, recognized widely for its leading role as a producer of high-quality manuscripts, painting and ivory carving. Paris' reputation as an intellectual centre grew with the establishment of its university on the left bank of the Seine in the late twelfth century; the presence of scholars such as Peter Abelard ensured that the university was widely recognized as the pre-eminent school of theology and liberal arts by the early 1200s. King Phillipe Auguste (r.1180–1223) established Paris as the political and administrative centre of an aggressively expanding kingdom. In an age when most rulers criss-crossed their domains, dragging along the people and equipment necessary for government, Phillipe permanently installed the royal archives, treasury and staff in one place, on the Île-de-la-Cité in the middle of the Seine. Under his successors, Louis IX and Phillipe the Fair, Paris emerged as the locus of French national government and as an international capital of art, learning and fashion.

Southern Europe 1200-1300

CENTRED BETWEEN the burgeoning markets of northern Europe and the resource-rich provinces of Africa and the Middle East, the cities of southern Europe became key points of contact for the cultures bordering the Mediterranean Sea.

MEDIEVAL ITALY

With its long coastline and well-established tradition of civil government, Italy enjoyed an interlinked network of cities connected by sailors and merchants. The most extensive of these trading networks in the thirteenth century belong to Genoa and Venice, both of which established fleets that traded between the eastern Mediterranean, Africa and far northern ports. Venice, in particular, was able to use its trading connections to forge a wide sphere of influence, re-directing the armies of the Fourth Crusade towards the conquest of the city of Constantinople in 1204.

1 SOUTHERN EUROPE SERVED as an important gateway for goods and ideas in the years 1200–1300. Italy inherited a dense pattern of urban communities from Late Antiquity. These cities increasingly competed with one another economically and socially. In Spain the Christian kingdoms of the north continued to extend their political control over the Muslim south through conquest, often appropriating key aspects of the rich tradition of Islamic art and literature as they did so.

1	**Southern Europe, 1200-1300**
——	border of Holy Roman Empire, c. 1223
●	ecclesiastical building
♜	castle
●	notable municipal building/palace/tower
🕮	university (with date of foundation)
◆	centre of manuscript production
▣	painting
🧍	sculpture
▦	mosaics
⋈	metalworking centre

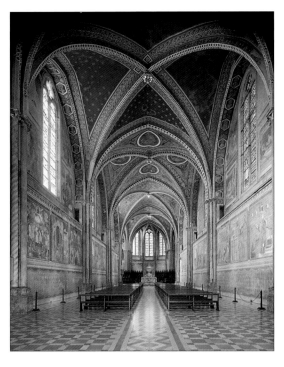

Italy also led the way in the development of other trans-European networks. Perhaps the most visible belonged to the new religious organizations of the Dominicans and Franscicans. Both orders were founded in the 1220s and rejected wealth, espousing dedication to study and simple devotion. They were the first of the medieval monastic orders to target cities as their special areas of interest and influence. By the mid-thirteenth century each order allowed its members to settle in permanent foundations dedicated to the memory of their sainted founders, Francis and Dominic. Priories and churches dedicated to preaching to large audiences sprang up in nearly all urban communities of note across Europe, forming vast and often competing networks.

INTERIOR VIEW OF UPPER CHURCH AT ASSISI. Though sometimes influenced by northern styles, Italian architects sought to provide room for painted narrative cycles such as this one at Assisi, dedicated to the Life of St. Francis. Commissions for such frescoes inspired competition, bringing painters from various cities across the peninsula, including the young Giotto. This led to the development of innovative techniques for picturing stories with careful observation and drama.

Italy pioneered the establishment of another trans-European network, based on the international market for money. The Florentine banking families of the Bardi and the Peruzzi, for example, financed the papacy and royalty across Europe, even providing a type of 'venture capital' to certain monasteries as they cleared more land for agricultural production.

THE CHRISTIAN 'RECONQUEST' OF SPAIN

In Spain, the renewed conquest of the peninsula from its Islamic inhabitants was driven in large measure by Ferdinand III, King of Castile (1217–52) and León (1230–52) and King James of Aragon. With re-conquest, Christian rulers were able to extend cultural patronage in ways that rivalled the legendary Muslim caliphs of Córdoba and Granada. For men such as Ferdinand, new French styles represented an identifiably modern and Christian visual symbol of the recent triumphs over his Moorish opponents. Cathedrals in Burgos (1226), Toledo (1227) and León (1255) were built following patterns directly influenced by French models, complete with stained glass and elaborate portal sculpture. By the century's end, however, the Catalan region produced its own identifiable variant of the Gothic style, one in which spaciousness derived from the breadth of the church rather than height. The peninsula also boasted not only some of the leading thinkers of the age, but also institutions to nurture them, as

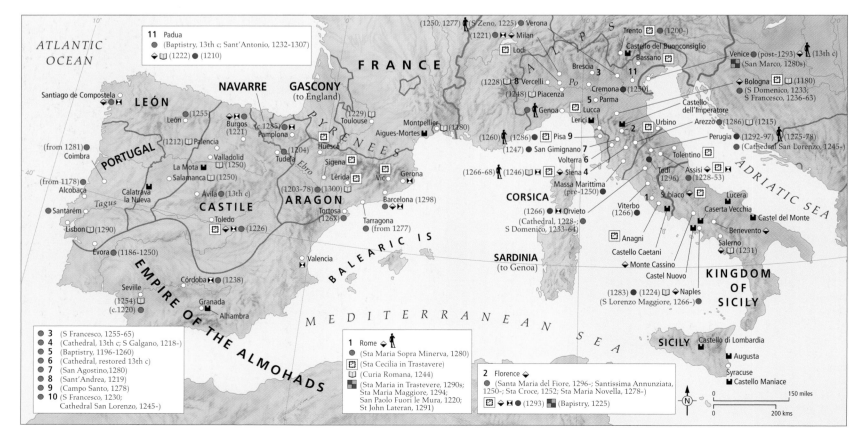

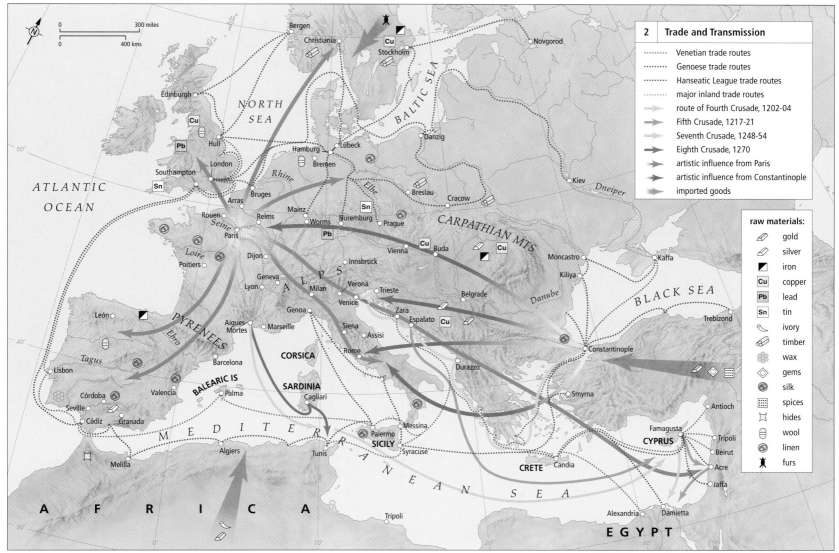

2 THE DISPARATE GEOGRAPHIC REGIONS of Europe in the thirteenth century were interlinked by trade routes controlled by the members of the German Hanseatic League and by the Italian city states of Genoa and Venice. The same cities provided entryways for gold, silk, ivory and spices from Asia and Africa, and furs and timber from Russia and the Baltic. Artistic influences radiated out from cultural centres such as Paris and Constantinople.

witnessed by the foundation of well-respected universities in a number of Iberian cities: Palencia, Salamanca, Seville, Valladolid, Lérida and Lisbon.

ROMANESQUE FOUNDATIONS
As in Spain, the struggle for political supremacy helped determine the spread of artistic styles in Italy. Long a temptation for northerners with designs on imperial dignity, Italy experienced a decades-long struggle between supporters of the Holy Roman Emperor Frederick II and his enemies, which to a large measure merely masked local rivalries between burgeoning cities. The collapse of the German Hohenstaufen dynasty with the death of Frederick II permitted greater French influence both in the political realm, through the rise of the house of Charles of Anjou, brother of Louis IX, in Naples, and in the artistic realm, through the patronage of French styles. In northern Italy, Siena and Florence led the way in the import of Gothic elements, especially in the Florentine church of Sta Maria Novella. The most important stylistic influences in Italy, however, were those 'imported' from its own Roman and Early Christian past. Classicizing styles are evident in the work of the sculptor Nicola Pisano (d. c.1284) and in the products of the artisans in southern Italy associated with the court of

the Holy Roman Emperor. Mosaics in Rome were derived from styles considered to be from the earliest, formative days of the Christian church, while the mosaics at St Mark's in Venice are influenced by illustrations from a revered sixth-century Bible. Italian painting in the thirteenth century developed on the foundation of Classically derived Romanesque, spiced with influences from Byzantium. In Rome Pietro Cavallini and Jacopo Torriti developed mural painting influenced by the influx of Byzantine artists following the capture of Constantinople. Tuscan painting in the last half of the century was dominated by Cimabue

EASTERN (PERSIAN) INSPIRED DESIGNS, expertly woven on silk with gold and silk threads, celebrated the pleasures of aristocratic pastimes of hunting and feasting. A refined object of secular luxury, this textile formed part of the grave wrappings of a Spanish bishop, demonstrating the interrelationships of secular and sacred and the mutual appreciation of the visual culture of the Christian, Islamic and Jewish inhabitants of Spain.

(d.1302) who is credited with influencing the young Florentine, Giotto (d.1337). The connection and competition among these artists mirror the larger networks of trade, religion and cultures, and set the stage for the creative explosions of the century that followed.

NORTHERN EUROPE 1300-1500

IN THE FOURTEENTH CENTURY centres of artistic practice were often primarily determined by the needs of the Church. By the fifteenth century, as new forms of patronage developed, artists were increasingly required to provide decoration for secular residences where collections might be displayed, admired and used to impress.

PARIS AS A CULTURAL CENTRE
Throughout the fourteenth century the most active and widely admired centre for the production of the visual arts in northern Europe was Paris, a position the city owed to the primacy it had assumed in the French realm. It was in Paris that guilds formed to support artists – including goldsmiths, painters, ivory carvers – and first became well organized and numerous, effectively streamlining artistic output and providing models for developments further afield. The city's prosperity attracted merchants who

provided desirable materials for creating the finest luxury objects of the period, such as ivory (from Africa) and pigments for the most dazzling kinds of painting (from Asia).

Interest in lavish decorative arts on the part of the royal family furnished artists with a key incentive for refining the intricacies of their work and striving for novel effects. By c.1410 Parisian illumination, for example, was the most ostentatious, meticulous and detailed in Europe, and significant commissions involved teams of artists, each dedicated to distinct processes. The exquisite nature of such artistry partly inspired, perhaps for the first time since Antiquity, a desire on the part of royal patrons to form significant collections of objects; craftsmanship was valued above utility.

The dominance of Paris attracted artists from many areas (especially the Netherlands), including prosperous regions such as Italy. Patrons from countries like Navarre, Scotland and Bohemia also looked to Paris to form their

tastes. In many other regions of Europe, local materials were adapted to produce devotional and commemorative works of art for those concerned with display, but whose financial resources were limited. Among the most successful of these was English alabaster, quarried near Nottingham and used for carved altarpieces and tombs. Alabasters were exported across all regions of Western Europe throughout this period. Though technically standards are rarely distinguished, the results were clearly considered widely desirable.

BURGUNDIAN INFLUENCE
By the 1420s the artistic predominance of Paris sharply declined, one consequence of civil conflict and English occupation. Perhaps the principal political development of the period c.1380–c.1450 was the ascendancy of the Valois dukes of Burgundy. The power they commanded had major cultural implications, many aspects of their taste and patronage being admired and imitated at courts throughout Europe. Taking advantage of the weakness of the French monarch, the first duke, Philip the Bold (d.1404) was able to manipulate himself into a position of considerable prestige following a marriage that brought him authority over Flanders. His descendants extended Burgundian control throughout the Low Countries, a region that had traditionally furnished the courts of France with skilled artists. Philip's political ambitions are to some extent reflected in the decorative schemes he commissioned for his grandest foundation, the Chartreuse de Champmol, near

1	Northern Europe, 1300-1500

	English possessions, c.1430	■	major schemes of wall painting
—	border of Holy Roman Empire	▯	major programmes of stained glass
→	export of oak for painted panels	◆	castle/château with associated decoration
	area of limewood carving	◇	centre for wood sculpture
	area of ivory carving	▭	centre of printing/print-making
→	wool imports to Flanders for tapestry/cloth	◆	centre for panel painting/ manuscript illumination
	area of alabaster sculpture	◎	goldsmiths
→	export of English alabasters	▨	monumental brass engraving/ bronze work
●	ecclesiastical centre with major building projects and associated sculpture		

1 IN THE FOURTEENTH CENTURY arts suitable for decorating ecclesiastical structures continued to flourish. Stained glass, for example, remained much in demand. Increasing literacy led to demand for illustrated books, especially prayer-books which were decorated by illuminators. The development of printed images (woodcuts and engravings) during the later fifteenth century also served to increase opportunities for artists and their audiences.

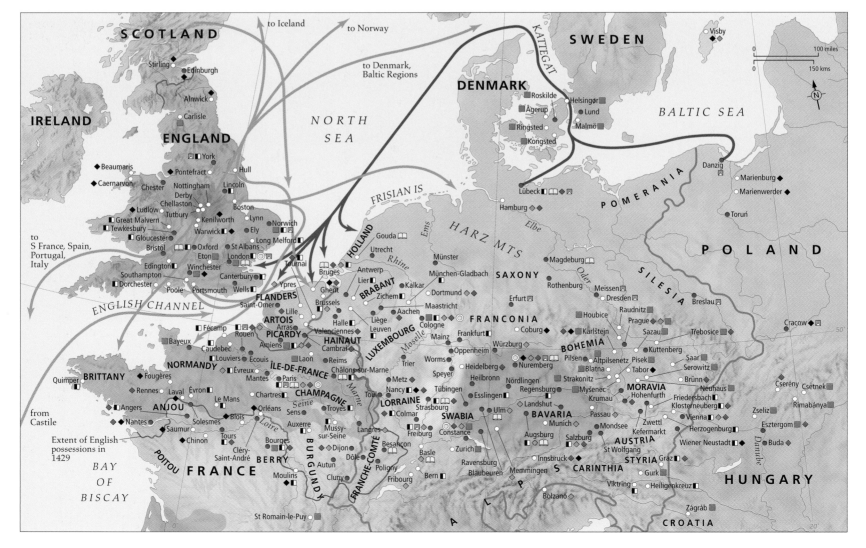

JAN VAN EYCK, *Portrait of a Man (Leal Souvenir)*, oil on oak panel, dated 1432. The detailed naturalism developed by Jan van Eyck and his contemporaries led to the development of new genres of painting not practised since Antiquity, such as portraiture based on observation from life. Painters succeeded in rendering precise detail and subtle changes in lighting by refining the use of oils as the binding medium for their pigments. The identity of the man in this portrait is unclear from the inscriptions on the panel. Perhaps the man's name was recorded on the original frame, now lost. This is the case with other portraits by Jan van Eyck. Here, the words 'LEAL SOVVENIR' ('Loyal remembrance'), painted to appear as though carved into the parapet immediately above the date and the artist's signature, suggest that the sitter may have been acquainted with the artist.

Dijon in Burgundy. Leading artists from the Low Countries, such as the sculptor Claus Sluter, were charged with creating an impressive mausoleum for the dynasty he founded. The most notable aspect of this work is how strikingly naturalistic, forceful and expressive it appears by comparison with Paris-based productions. Arguably these qualities were encouraged to distinguish a specific Burgundian outlook. They were quickly and widely imitated; Philip's tomb, for example, acted as a model for numerous prominent monuments over several decades.

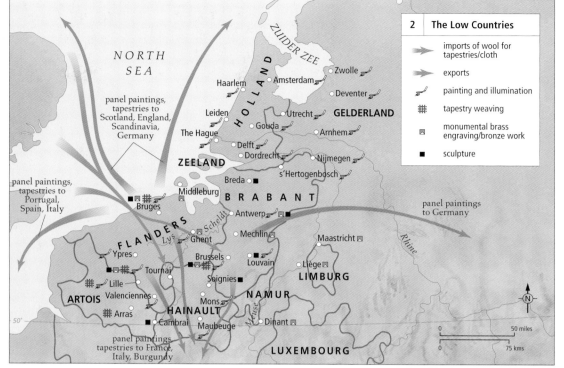

2 The Low Countries

→ imports of wool for tapestries/cloth
→ exports
🖊 painting and illumination
▦ tapestry weaving
▨ monumental brass engraving/bronze work
■ sculpture

The third Valois duke of Burgundy, Philip the Good (d.1467), extended his grandfather's political and cultural aspirations. Since he chose to reside principally within his southern Netherlandish territories, the patronage of his court meant that Netherlandish artists no longer needed to look abroad to develop their careers. This was especially important for the development of panel painting, which flourished in several centres submitting to Philip's authority, becoming a more widely affordable commodity by the later fifteenth century. Detailed naturalism remained a distinguishing characteristic of many artists working in these centres; it may be seen at its most refined in the work of the painter Philip appointed to his own employment, Jan van Eyck (d.1441). The meticulous style of van Eyck, his contemporaries and followers, with its bewildering range of light effects, notably reflective surfaces and gleaming jewels, was quickly taken up abroad. Among the earliest reflections of these pictorial preoccupations is the altarpiece by Lucas Moser at Tiefenbronn in Germany (1432). Such were the reputations of later Netherlandish artists that patrons from distant regions frequently sought their works or used them as models.

Philip the Good also developed further policies to stimulate economic activity in the Netherlands, encouraging fresh activities in tapestry, illumination and wood-carving (in oak). Elsewhere in Europe, artists responded

2 THE REGION STRADDLING the Rhine and Meuse was already associated with intense artistic activity through the wealth and number of its ecclesiastical foundations. Rapid development of trade with other major centres across Europe, combined with Burgundian patronage, ensured that this region continued to expand its prestige. Bruges and Antwerp imported materials for the new art of painting in oil: high-quality oak from the Baltic regions for the panels; pigments and oils from southern Europe and further afield. Burgundian alliances with England (against France) ensured that wool from the Cotswolds and other English regions, the best in Europe, continued to feed the cloth and tapestry industries of Flanders and neighbouring counties. Merchants involved in this trade were often Italians, who ensured that the manufactured goods were exported to the Mediterranean world. No other region of Europe during this period could claim such a cosmopolitan economic structure, providing a productive environment for artistic creativity.

to the demand for more naturalistic images by adapting local traditions or developing new materials. For example, in southern Germany, indigenous limewood, with its dense though elastic properties, was found to be ideally suited to carving complicated details and forms unworkable in other woods. In such regions, the development of organized religion meant that altarpieces, often large and imposing, were in great demand. Large examples, like Michael Pacher's Saint Wolfgang Altarpiece (carved in limewood and pine), might take as long as a decade to complete (1471–81).

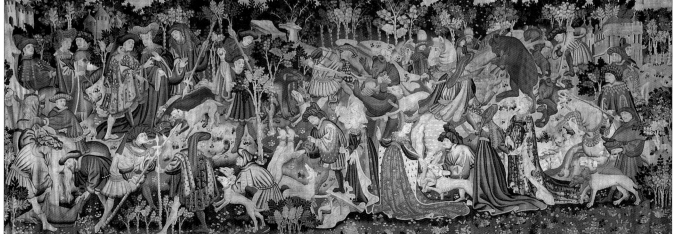

BEAR AND BOAR HUNT, part of the Devonshire Hunting Tapestries, c.1425–30. Tapestries were manufactured in several centres in the Low Countries throughout this period. The most luxurious tapestries were woven from wool imported from England and included precious metals formed into threads. Sets of these tapestries, perhaps the most expensive products of the period, were exported to all regions of Europe, for use in larger churches and secular residences, including castles.

SOUTHERN EUROPE 1300-1500

THE WESTERN MEDITERRANEAN world had a well-established system of maritime trade routes facilitating artistic contacts between regions (including many Italian cities) by c.1300. Several factors intensified these links over the next two centuries, particularly in Provence and Catalonia.

PROVENCE AND THE PAPACY

In 1307 the papacy, politically insecure in Rome, moved to southern France, soon settling in Avignon, where the imposing Papal Palace (among the grandest structures of the fourteenth century in Europe) still testifies to the role the city played in acting temporarily as the focus of Western Christianity. Although France had earlier received leading artists from Italy, the papal presence stimulated northern European interest in issues that had first been addressed by artists in Italy, such as concern with pictorial perspective and expression. Notable among the goldsmiths, sculptors, weavers, masons and painters who were attracted to Avignon was Simone Martini (d.1344) who worked in fresco and panel painting. The activities of prominent Italian merchants, such as Francesco Datini (d.1410) emphasize how the city played a crucial part in introducing luxury Italian objects to the north. But the wealth of ecclesiastic patronage provided by southern France during this period as a result of hosting the papal court also drew artists from other countries, including the English sculptors responsible for the tomb of John XXII (d.1334).

Long after the papacy left, Avignon remained a focus for artists from the north seeking new sources of patronage. For example,

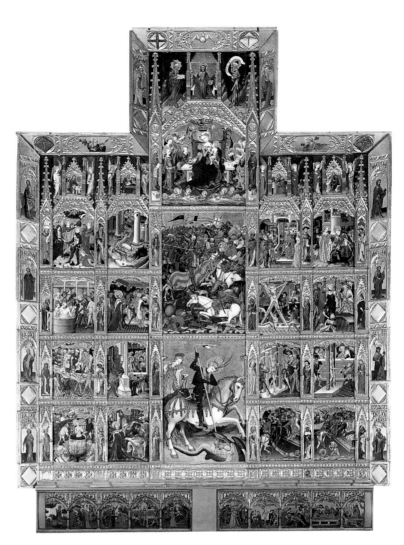

SCENES FROM THE LIFE of St George, painted *retable* (c.1410–20, tempera and gilt on pine), attributed to Maraal de Sas. This large altar *retable*, painted for a military confraternity in Valencia, is typical of Spanish altarpieces of this period in consisting of several tiers and many scenes, set within an architectural frame. This arrangement is a more elaborate version of a type of altarpiece design originating in Tuscany. The style of this example, however, shows many features suggesting the artist was trained in northern Europe. Maraal de Sas is documented working in Valencia from 1396, when he is described as German. His style illustrates the success talented foreign artists often met with in establishing careers in Spain.

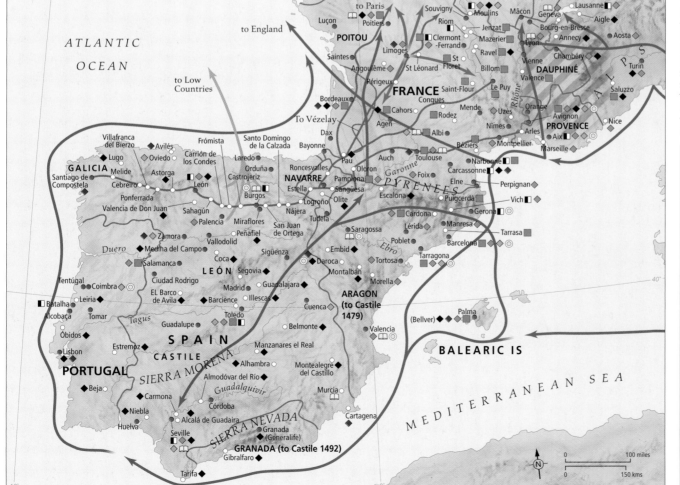

1 THE ARTISTS OF SOUTHERN Europe looked to the North for inspiration. But in Spain, Islamic forms of decoration long remained popular. Some northern European art forms, such as extensive schemes of stained glass, did not lend themselves easily to the hotter climate of the south, where churches tended to have smaller windows.

1	Southern Europe, 1300-1500
——	border of the Holy Roman Empire, c.1430
——	pilgrimage routes to Santiago de Compostela
→	major trade routes
→	export of wool
→	export of enamel products
▨	area of walnut-carving
◆	distribution of English alabasters
●	ecclesiastical centre with major building projects and associated sculpture
■	major programmes of wall painting
▯	major schemes of stained glass
◆	castle/château
◇	centre for wood sculpture
📖	centre of printing/ print-making
◈	centre for panel painting/ manuscript illumination
◎	goldsmiths

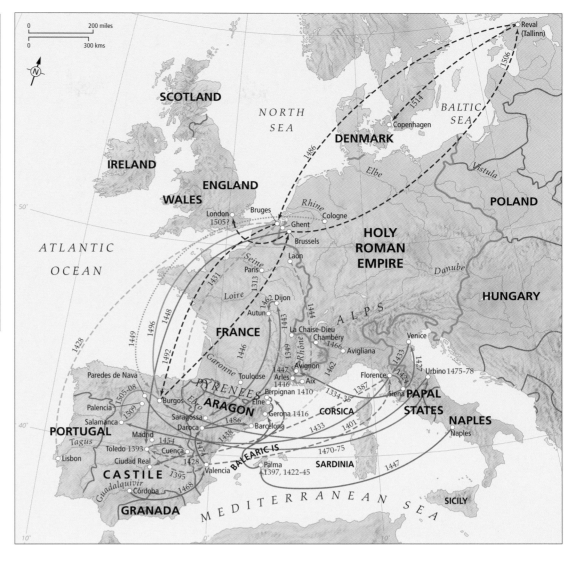

2 ARTISTS AND ARCHITECTS often travelled considerable distances to secure patronage during the fourteenth and fifteenth centuries.

the painter Enguerrand Quarton (d. after 1466), who came from northern France, resided in Avignon for most of his working career. Other Provençal cities during the later fifteenth century also attracted leading northern (generally Netherlandish) painters at this time, such as Nicolas Froment (d.1484) who was active in Aix-en-Provence. This city was also the frequent residence of one of the most active patrons of the visual arts in the French royal family, René of Anjou (d.1480), who himself gained a reputation for practising as a painter. As a claimant to the throne of Naples, René occupied that city from 1438 to 1442, accompanied by several French court artists. Some Italians were subsequently encouraged to follow him home. These circumstances may account for stylistic connections – figure types, similar details and colour range – between the work of the leading Neapolitan painter of the time, Niccolò Colantonio (d. after 1460), and the painter of an important altarpiece made for Aix Cathedral, attributable to René's favourite painter, Barthélemy d'Eyck (d.1469).

ARTISTIC INTERACTIONS
The rival who succeeded in ousting René from Naples was Alfonso V of Aragon (d.1458), among the leading advocates from the Iberian Peninsula for artistic tastes stemming from the Burgundian court. Alfonso acquired from merchants a number of works by leading Netherlandish painters, including Jan van Eyck, and encouraged painters active in cities under his authority to follow their example, clearly fascinated (as indeed René was) by the profusion of naturalistic detail included in paintings created in Flanders. Later Spanish monarchs and court officials furthered these trends, partly for dynastic reasons, encouraging such Netherlandish-trained painters as Juan de Flandes and Michel Sittow to develop their careers in Spain.

Alfonso's combined rule in southern Italy and in Aragon, one of the wealthiest regions of Spain, facilitated other kinds of artistic interaction. In 1447, for instance, the Spanish architect and sculptor Guillem Sagrera was summoned to Naples to participate in reconstructing the royal residence, having previously worked extensively in Catalonia, southern France and Majorca. Most Spanish

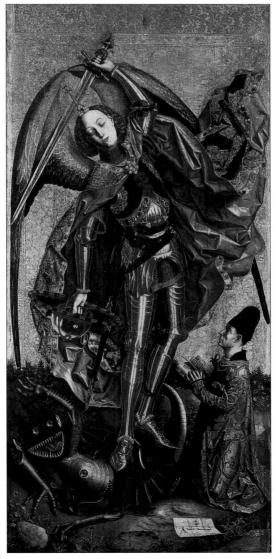

artists, however, were obliged to devote their careers exclusively to devotional images. Iberia was subjected to numerous conflicts that meant concerted programmes of secular patronage were harder to establish than in northern Europe. In Spain, decoration of the altar, and areas associated with it, became increasingly imposing and eye-catching during this period. Even after Netherlandish stylistic traits became widely practised in Spain (by c.1450), Spanish taste favoured increasingly imposing *retables*, with many panels. This conspicuous emphasis is perhaps one outcome of large parts of Iberia remaining Islamic during the later Middle Ages. The Christian reconquest of Granada was only completed in 1492.

In northern Spain, reconquered much earlier, the new order was consolidated through visual means. Catalonia in particular developed an intense pictorial culture with a significantly high proportion of ecclesiastical foundations acquiring striking painted decorations for their altars. The development of pilgrimage sites across northern Spain provided a further incentive for using images and artefacts to guide, reassure and inspire the faithful. The most popular pilgrimage was from France to Santiago de Compostela, a major channel for artistic exchange.

ST MICHAEL WITH A DONOR, central panel from a painted *retable* (oil and gilt on panel), Bartolomé Bermejo, 1468. Bermejo is a good example of a very skilful Spanish artist who travelled widely. This magnificent figure of St Michael, with its vivid reflections in shining armour, may be paralleled in works by leading Netherlandish painters such as Rogier van der Weyden and Memling. Contracts for later Spanish altarpieces often stipulate that colours were to be worked in oil.

ITALY 1300-1400

ITALY'S CITY-STATES prospered from international trade: by 1300 Milan and Venice had populations of 120,000. Money had challenged the traditional structure of feudal power as rich merchants expelled aristocratic rulers and set up their own elected governments. The rise of this elite had a momentous impact on society. The old canonical hours, which varied according to the season were rejected – time was now measured logically, dividing the day into 24 equal hours, which were made audible by new mechanical clocks on public buildings. Education, once the preserve of the clergy, became widely accessible: merchants had a real need to read and write. Intellectual debate was encouraged, stimulating the foundation of universities and the revival of the literature of antiquity. Humanists found sources for their republican governments in classical political theory, while theologians sought to reconcile Aristotle and Plato with Christian tradition.

Inevitably, the economic boom did not last. Poor harvests contributed to a general decline and the Black Death (1347–48) reduced Italy's population by a third. Widely perceived as a display of divine wrath against corruption and greed, this disaster benefitted the arts. Donations to religious institutions rose dramatically, notably to two influential new orders, the Dominicans and the Franciscans, established in the early thirteenth century in response to calls for Church reform.

FRANCISCAN ART
The Franciscans had a profound impact on religious life, their ideas visible in artistic innovations which changed the course of Western art. Franciscan preachers exhorted their audience to visualize the life of Christ in order to understand the nature of Christian faith. Painters, working on church walls, did the same. Starting with the frescoes in S. Francesco in Assisi and popularized by Giotto's work in Florence and Padua, artists rejected the ethereal frontality of Byzantine art in favour of more prosaic scenes with solid figures set in convincingly three-dimensional spaces. The image of the Virgin enthroned as Queen of Heaven was increasingly replaced by the Madonna seated on the ground, or simply a mother suckling her child at her breast. Perhaps Giotto's major achievement was the introduction of realistic gestures and facial expressions to convey the range of human emotions, giving human meaning to the mysteries of religious belief.

Mercantile wealth produced a new type of patron. Few merchants went as far as St Francis and renounced their material goods to live in holy poverty but most allocated part of their profits to the Church. Extravagant chapels, tombs and altars proclaimed their patrons' wealth, their faith, but also their guilt. The banker Enrico Scrovegni built the Arena Chapel to expiate the sin of usury, which was banned by the Church, commissioning Giotto to decorate the interior. On the entrance wall, a massive scene of the Last Judgement showed Scrovegni offering his chapel to the Virgin in the hope that she would intercede for him.

IMAGES OF CIVIC POWER
The new republican governments gave visual expression to civic prosperity and religious devotion in ostentatious cathedrals. Preferring traditional Romanesque groin-vault construction,

they showed little interest in the structural innovations that accompanied the emergence of Gothic in northern Europe. Extravagant decoration was justifiable in a religious context. Costly multi-coloured marble facades ornamented cathedrals in Florence, Pisa, Siena and Orvieto. Competition encouraged increasing elaboration, though the ambitious plans to enlarge Siena Cathedral were abruptly halted by the plague. Duccio's *Maestà* (1308), commissioned by the Sienese government for the high altar, was lavish in its use of gold, detail and number of

figures, all features that visibly displayed the cost of a painting. And the Tuscan fashion for richly carved marble pulpits offered Nicolò and Giovanni Pisano the opportunity to adapt classical pagan imagery to a Christian context, such as the Venus used by Giovanni for his figure of Prudence on the pulpit in Pisa (1302–10).

Political authority was manifest in new town halls. Conspicuously cheaper than the cathedrals, they were designed to convey an image of moral government. Built of local sandstone and austerely plain, the Palazzo

AMBROGIO LORENZETTI, *Well-Governed Town* (1338–9) Siena, Palazzo Pubblico. As civic power grew, moral government was promoted. Wealthy revellers, industrious tradesmen and children at school show the ideal aspired to by the Sienese state.

1 THE PROSPERITY OF the city-states was based on trade. Venetian merchants sailed to markets in the eastern Mediterranean, filling their galleys with luxury goods. Florence and Siena both had thriving textile industries, while Florentine bankers dominated the European credit market.

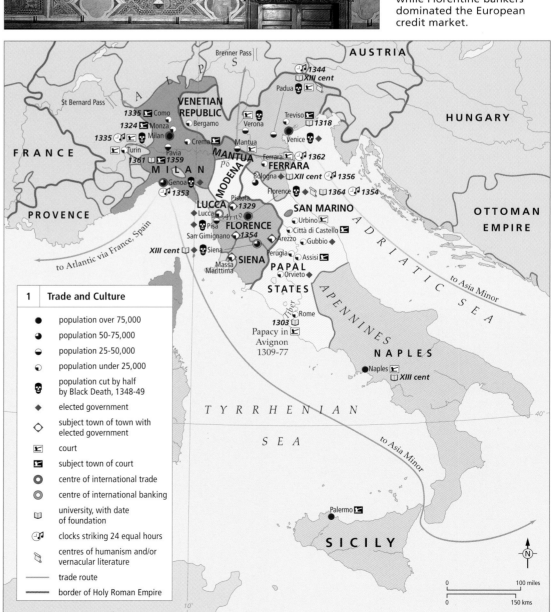

1	**Trade and Culture**
●	population over 75,000
◗	population 50-75,000
◔	population 25-50,000
◔	population under 25,000
💀	population cut by half by Black Death, 1348-49
◆	elected government
◇	subject town of town with elected government
⌘	court
⌘	subject town of court
◎	centre of international trade
◉	centre of international banking
🕮	university, with date of foundation
🕰	clocks striking 24 equal hours
📜	centres of humanism and/or vernacular literature
—	trade route
—	border of Holy Roman Empire

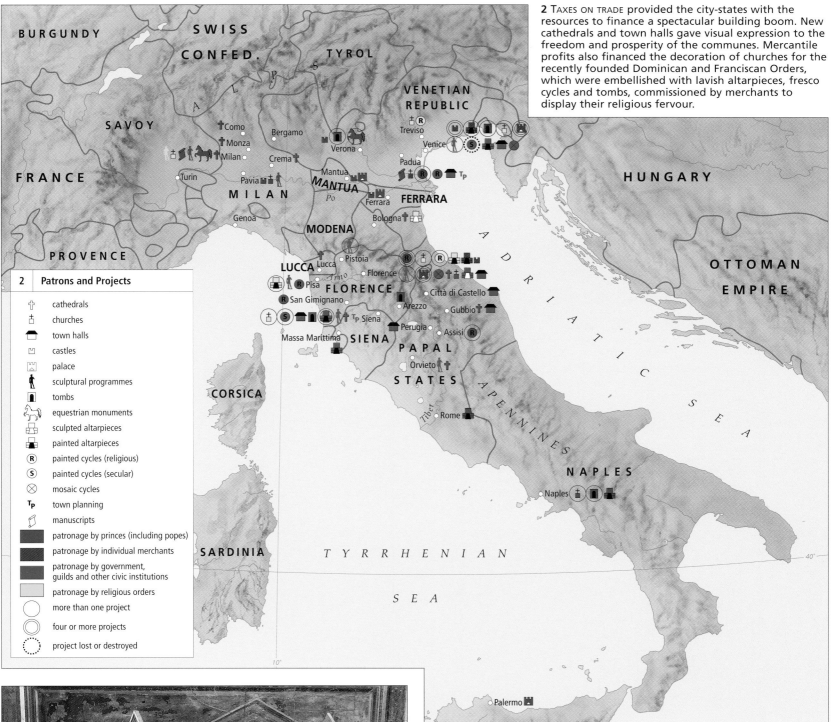

2 TAXES ON TRADE provided the city-states with the resources to finance a spectacular building boom. New cathedrals and town halls gave visual expression to the freedom and prosperity of the communes. Mercantile profits also financed the decoration of churches for the recently founded Dominican and Franciscan Orders, which were embellished with lavish altarpieces, fresco cycles and tombs, commissioned by merchants to display their religious fervour.

2	Patrons and Projects
†	cathedrals
⚐	churches
⌂	town halls
⌂	castles
⌂	palace
🯅	sculptural programmes
🯅	tombs
🐎	equestrian monuments
⊞	sculpted altarpieces
⊞	painted altarpieces
Ⓡ	painted cycles (religious)
Ⓢ	painted cycles (secular)
⊗	mosaic cycles
ᴛᴘ	town planning
⎘	manuscripts
■	patronage by princes (including popes)
▨	patronage by individual merchants
■	patronage by government, guilds and other civic institutions
▢	patronage by religious orders
◯	more than one project
◎	four or more projects
⦿	project lost or destroyed

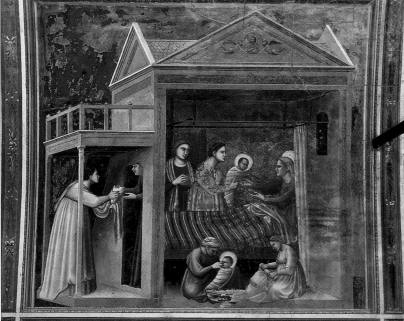

GIOTTO, *Birth of the Virgin* (1304–13) Padua, Arena Chapel. Built by the banker, Enrico Scrovegni, to expiate the sin of usury, the decoration of the Arena Chapel illustrates the new artistic developments in Italy, inspired by the Franciscans and pioneered by Giotto. In this scene Giotto created a convincing architectural space, filled with solid figures and domestic objects, which would have been easily recognizable to viewers, making it possible for them to identify with the event.

della Signoria in Florence (begun 1299) contrasted deliberately with the costly imported marble facade of the Duomo. Town planners exploited the value of architecture as propaganda: both the Palazzo Pubblico (1298) in Siena and the Doge's palace (1340) in Venice opened onto enormous public spaces, deliberate contrasts to the narrow streets behind. These town halls provided a forum for the display of local history: Siena commissioned a portrait (c.1330) of Guidoriccio da Fogliano, who led her armies to victory in southern Tuscany.

COURTLY DISPLAY

Italy's courts had a different agenda. The Angevin rulers of Naples and the Visconti of Milan cemented their power with strategic marriages into the royal houses of northern Europe and gave visual expression to their dynastic ambitions by adopting International Gothic, the elaborate style of the powerful French monarchy. The Visconti library included several Books of Hours, a type of devotional text rare in Italy, decorated with miniatures influenced by French courtly art, while the ornate Gothic structure of Milan Cathedral contrasted with the cathedrals in the city-states.

Italy 1400-1500

E VIDENCE OF ROME'S mighty empire survived in literary sources and ruins, and stimulated innovation in fifteenth-century Italy. Inspired by Vitruvius, Alberti wrote a treatise (1452) outlining the rules of classical architecture, while Francesco di Giorgio's treatise included drawings of ancient Roman ruins. Julius Caesar had a seaside villa near Naples, and Pliny's description of his own country retreat encouraged the fashion for patrician villas. Painters began to investigate the structure of the human body: Leonardo filled his notebooks with anatomical drawings and novel ideas. The culture of antiquity was exploited by artists to develop new styles and themes. The pattern was not uniform but reflected the differing economic, social and political traditions of each centre.

FLORENCE AND VENICE
Wealthy merchants in Florence and Venice gave visual expression to their prosperity in chapels, altarpieces and palaces, and, as members of elected governments, embellished the images of state authority. In Florence humanists studied

1 RENAISSANCE CITIES varied enormously in history, size and politics. Milan and Naples, both dynastic courts and important centres in Roman times, were two of Europe's largest cities, as was Venice, a mercantile republic boasting Christian origins. Florence, also a republic, was much smaller, as were the courts of Rimini, Mantua, Ferrara and Urbino. Rome, once the capital of a mighty Empire, was similar in size.

Cicero to praise republican ideals and the virtue of moral civic duty. Pride in the city's achievement was visibly evident when the cathedral was finally crowned with its massive dome. It was also evident in a boom in palace building. The grandest of the Florentine palaces, crowned by an *all'antica* cornice, belonged to the Medici family, rich bankers who used their money to create a powerful faction in government and establish *de facto* control of Florence.

Patriotism was evident in new artistic styles. The round arches of local Tuscan Romanesque replaced Gothic while painters used *all'antica* details such as capitals and fluted pilasters to provide new settings for traditional religious themes. Donatello and Masaccio developed new figurative styles, solid human figures that belonged to the real world, while Brunelleschi and Masaccio pioneered the use of perspective, a device based on the same mathematical and spatial skills used daily by merchants in commercial calculations.

Venice celebrated her unique achievements in a different way. Showing little interest in antiquity, her patricians built residences that deliberately imitated the Doge's Palace. The Christian origins of the city were asserted in church plans and decorative details derived from the basilica of St Mark, built to imitate Constantine's church of the Apostles in Constantinople. Venetian patriotism was also evident in painting as artists like Giovanni Bellini

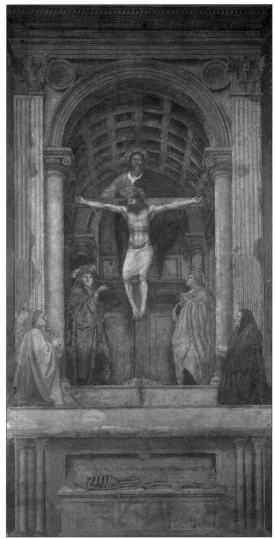

MASACCIO, *Trinity* (c.1427), Florence, S. Maria Novella. Masaccio's solid figures and his use of perspective were intended to create the illusion of reality. Inspired by the architecture of ancient Rome, the classical Ionic and Corinthian capitals, fluted pilasters and a coffered barrel vault provided an innovative setting for this traditional theme and made a decisive break with contemporary preferences for ornate and decorative Gothic details.

developed their own unique style, filling their canvases with anecdotal detail to give a convincing sense of reality to their scenes.

ANTIQUITY AT THE ITALIAN COURTS
The absolute rulers of dynastic courts promoted themselves as heirs to the culture of imperial Rome. Inspired by the coins of ancient Roman emperors, Leonello d'Este, the Marquis of Ferrara, pioneered the fashion for *all'antica* portrait medals, which was widely adopted by other dynastic rulers, such as Alfonso I of Naples, to display their imperial associations. The humanist intellectuals who surrounded Alfonso justified his conquest of Naples by drawing parallels with the Spanish-born Emperor Trajan. Alfonso asserted his new authority in a massive sculptured gate inspired by the triumphal arches of Ancient Rome.

Alberti designed innovative churches for Sigismondo Malatesta in Rimini, inspired by the city's Arch of Augustus, and in Mantua for Ludovico Gonzaga (who also employed Mantegna, whose *all'antica* painting style was based on his study of antique reliefs). Both rulers abandoned traditional Gothic in favour of the language of imperial Rome to promote the prestige of their relatively unimportant states. Federigo da Montefeltro, Duke of Urbino, employed Piero della Francesca and Francesco di Giorgio to exploit the new style and transform his

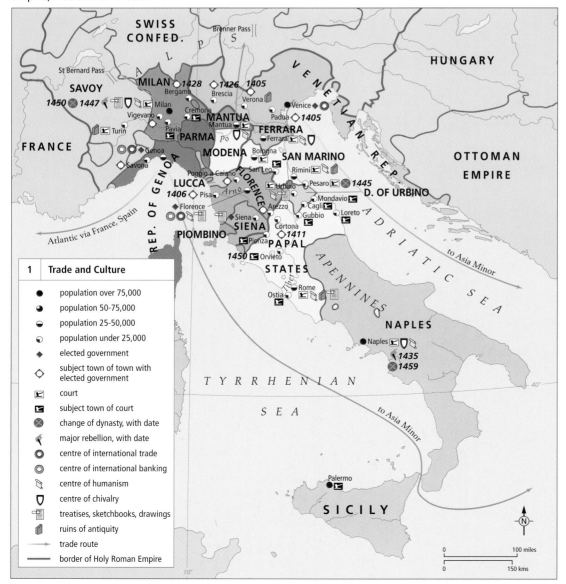

1	Trade and Culture
●	population over 75,000
◕	population 50-75,000
◐	population 25-50,000
○	population under 25,000
◆	elected government
◇	subject town of town with elected government
⌂	court
⌂	subject town of court
⊗	change of dynasty, with date
⚑	major rebellion, with date
◎	centre of international trade
◉	centre of international banking
✎	centre of humanism
⛉	centre of chivalry
▤	treatises, sketchbooks, drawings
▥	ruins of antiquity
→	trade route
—	border of Holy Roman Empire

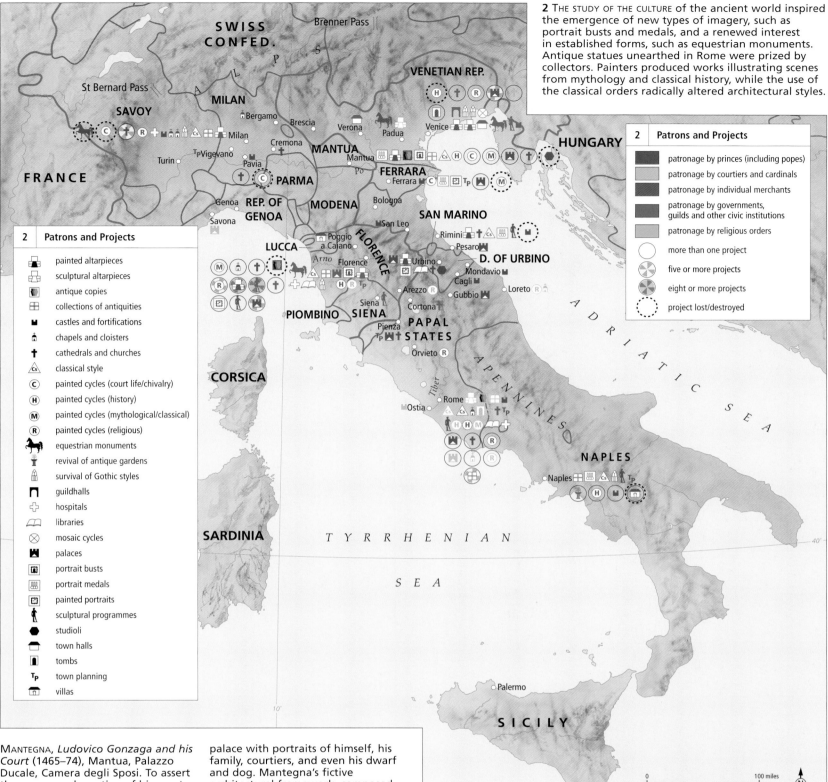

2 THE STUDY OF THE CULTURE of the ancient world inspired the emergence of new types of imagery, such as portrait busts and medals, and a renewed interest in established forms, such as equestrian monuments. Antique statues unearthed in Rome were prized by collectors. Painters produced works illustrating scenes from mythology and classical history, while the use of the classical orders radically altered architectural styles.

2 Patrons and Projects

- painted altarpieces
- sculptural altarpieces
- antique copies
- collections of antiquities
- castles and fortifications
- chapels and cloisters
- cathedrals and churches
- (c) classical style
- (C) painted cycles (court life/chivalry)
- (H) painted cycles (history)
- (M) painted cycles (mythological/classical)
- (R) painted cycles (religious)
- equestrian monuments
- revival of antique gardens
- survival of Gothic styles
- guildhalls
- hospitals
- libraries
- mosaic cycles
- palaces
- portrait busts
- portrait medals
- painted portraits
- sculptural programmes
- studioli
- town halls
- tombs
- Tp town planning
- villas

2 Patrons and Projects

- patronage by princes (including popes)
- patronage by courtiers and cardinals
- patronage by individual merchants
- patronage by governments, guilds and other civic institutions
- patronage by religious orders
- more than one project
- five or more projects
- eight or more projects
- project lost/destroyed

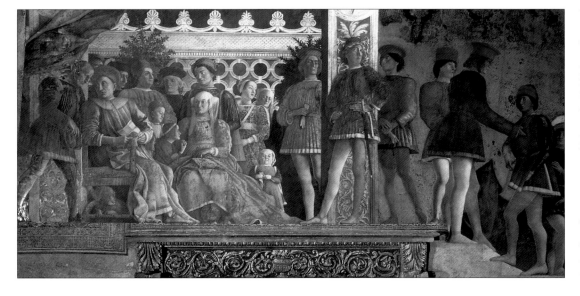

MANTEGNA, *Ludovico Gonzaga and his Court* (1465–74), Mantua, Palazzo Ducale, Camera degli Sposi. To assert the power and prestige of his court, Ludovico Gonzaga, Marquis of Mantua, decorated a room in his palace with portraits of himself, his family, courtiers, and even his dwarf and dog. Mantegna's fictive architectural framework, composed of *all'antica* motifs, associated the Gonzaga court with imperial Rome.

tiny hilltop fortress into one of the most impressive courts of the period. Bramante's archaeological interest in antiquity was evident in his drawings of S. Lorenzo, once the imperial palace chapel in Milan, and provided inspiration for the churches he designed for Ludovico Sforza, who also commissioned Leonardo's experimental oil fresco, the *Last Supper* (1496–7).

In Rome the adoption of antique forms posed particular problems for the Papacy. Pius II, the first humanist pope, rebuilt the facade of St Peter's, underlining his links with pagan imperial Rome with his use of columns from ancient ruins. By contrast, the Franciscan Sixtus IV displayed no interest in classical antiquity. Inside his austere and defensive Sistine Chapel the decoration had strong early Christian resonances while the frescoes by Botticelli, Perugino and others emphasized papal primacy and the superiority of the Christian faith.

NORTH AFRICA 600-1500

THE MAJOR FACTOR that affected the production of art in this period was the advent of Islam, which became the dominant religion of North Africa, largely supplanting Judaism, Christianity and indigenous cults. Arabic, the language of Islam, replaced local languages in religious, intellectual, administrative and commercial matters. The region's distance from the centres of Arab-Islamic civilization in West Asia made it an attractive destination for dissidents, who often established their own principalities.

The new Muslim rulers occupied many of the cities and towns established in antiquity, but they also founded many new centres, showing the extraordinary prosperity of this agricultural region. These new foundations were often located inland, rather than on the coast as in Roman times. With the decline of Mediterranean shipping in the early Middle Ages, traders relied increasingly on caravans for long-distance trade, particularly across the Sahara to tropical West Africa. By the ninth century Muslim fleets were raiding the Mediterranean islands and northern coasts

from strongholds on the Tunisian coast. For several centuries Sicily was dependent on Tunisia, and the Arab-Islamic cultural legacy lasted even after the Normans conquered the island in the late eleventh century. The revival of maritime trade in the tenth century had led to the transformation of North African ports into Mediterranean entrepôts. The central role of North Africa in trade between Africa, Europe and Asia funded a cultural florescence.

In the eleventh century invasions by Arab nomads despatched from Egypt devastated the countryside and destroyed the agricultural basis on which much urban life depended. The ensuing chaos led to the emergence of Berber dynasties, first in the western Sahara and then in the Atlas Mountains. These dynasties included the Almoravids (1062–1147) and the Almohads (1130–1269), who ruled in both northwest Africa and Spain, and the Marinids (1217–1465), who ruled in Morocco.

The ongoing Christian re-conquest of Muslim principalities in Spain, which was completed in 1492, and the opening up of oceanic trade routes from European Atlantic ports to the New World and around Africa, cut North Africa out of the global economy. The region became a backwater, exacerbating inherent conservatism in the arts.

NORTH AFRICA TOGETHER
Despite political differences between the Islamic rulers of West Asia and of the Maghreb (the Arabic word for 'west' and the term

1 THE SOUTHERN SHORES of the Mediterranean basin prospered under Islam as trade routes linked it to tropical Africa, Europe and West Asia. Inland cities became centres of commerce, scholarship and art and were embellished with hypostyle mosques, often built with debris taken from Roman and Byzantine ruins. Kairouan was the centre of religious learning, and its mosque has yielded an important cache of early leather-bound parchment codices of the Koran.

THE COURTYARD OF THE ATTARIN MADRASA in Fez (1323–5) shows the distinctive style of architecture that developed in the Maghreb, with tiled walls surmounted by carved stucco and a wooden cornice. Rooms and cells behind these decorated walls provided places for prayer, classrooms for study, and accommodation for students.

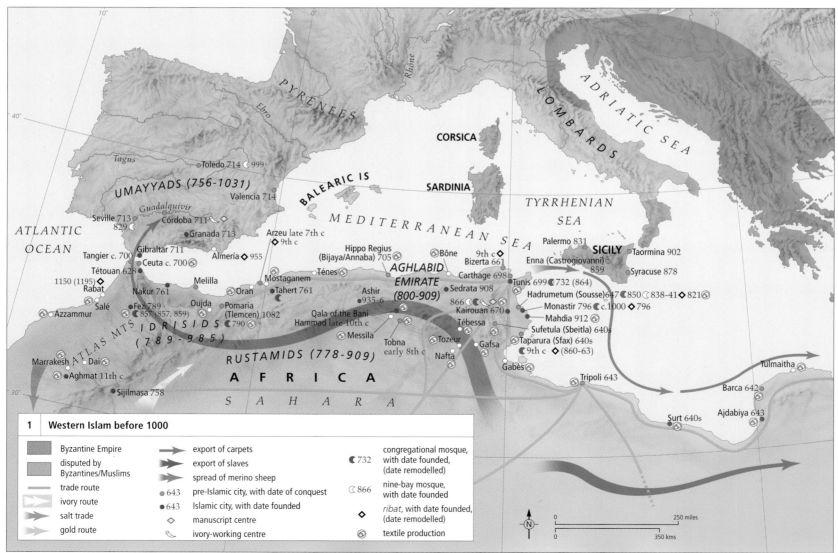

1	Western Islam before 1000				
	Byzantine Empire	→	export of carpets		congregational mosque, with date founded, (date remodelled)
	disputed by Byzantines/Muslims	→	export of slaves	☾ 732	
		→	spread of merino sheep		nine-bay mosque, with date founded
	trade route	● 643	pre-Islamic city, with date of conquest	☾ 866	
	ivory route	● 643	Islamic city, with date founded		
	salt trade	◇	manuscript centre	◆	*ribat*, with date founded, (date remodelled)
	gold route	✎	ivory-working centre	⊚	textile production

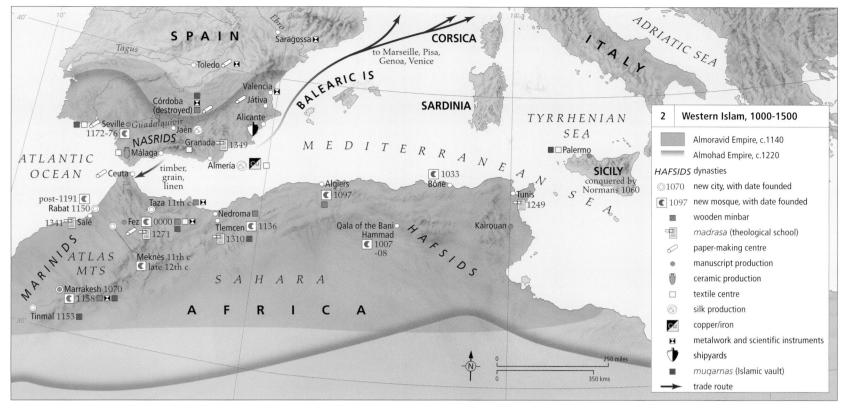

2	**Western Islam, 1000-1500**
	Almoravid Empire, c.1140
	Almohad Empire, c.1220
HAFSIDS	dynasties
◎1070	new city, with date founded
▣1097	new mosque, with date founded
▪	wooden minbar
	madrasa (theological school)
⬭	paper-making centre
•	manuscript production
	ceramic production
□	textile centre
◉	silk production
	copper/iron
	metalwork and scientific instruments
	shipyards
▪	*muqarnas* (Islamic vault)
→	trade route

2 IN THE PERIOD AFTER 1000, distinct architectural and artistic styles evolved in the western Maghreb. Almohad mosques at Marrakesh, Rabat and Seville were distinguished by monumental minarets. Following the precedent of the Great Mosque at Córdoba, inlaid wooden *minbars* (pulpits) were installed in the major cities. A shared artistic tradition continued in the second half of this period, despite increasing political fragmentation.

applied to the region of North Africa and Spain), the area initially shared a remarkable cultural homogeneity with West Asia, as artistic ideas from the Abbasid capitals in Mesopotamia were enthusiastically adopted in the Maghreb. For example, hypostyle and nine-bay mosques, architectural types developed in the central Islamic lands, were carried to North Africa and Spain, where they were realized with the use of local materials and techniques of construction, particularly stone masonry. Lustre tiles and teakwood panels produced in Iraq were installed in the mosque of Kairouan (Tunisia), and the Mesopotamian technique of carved plaster revetments became a hallmark of Umayyad architecture in Spain. Scribes used the same angular ('Kufic') scripts for copying manuscripts of the Koran in brown ink on parchment codices, produced from the skins of

the many sheep herded in the region. Textile factories in North Africa supplied the courts of the caliphates in West Asia with inscribed 'tiraz' fabrics and woollen carpets.

International trade and diplomacy between Byzantium, Fatimid rulers in North Africa and Umayyad rulers in Spain led to the exchange of materials, artistic ideas and traditions. In Tunisia Muslim scribes emulated the murex-dyed purple manuscripts made for the Byzantine court. The Córdoban rulers hosted Byzantine mosaicists to decorate their congregational mosque with a re-creation of the mosaics commissioned two centuries earlier by their Umayyad forebears in Syria. Trans-Saharan trade supplied the ivory tusks carved in Tunisia, Córdoba and Byzantium, as well as the gold minted into coins and made into fine filigreed and granulated jewellery popular throughout the region.

NORTH AFRICA APART
The rise of the heterodox Fatimid dynasty in the tenth century created a wedge that began to split North Africa from West Asia and – from the eleventh century – delayed or interrupted the east-west exchange of ideas. For example, the four-*iwan* plan, which became ubiquitous

for mosques and other buildings in the central Islamic lands and even in Egypt, was rarely if ever used in North Africa. The *muqarnas*, a series of serried tiers of niches used for architectural decoration and often likened to stalactites, were introduced to the region from the east by the twelfth century, but the system underwent a distinctive development in the Maghreb. While scribes in West Asia were developing new rounded scripts in black ink on paper, their contemporaries in North Africa adhered for centuries to the old materials and styles and developed a distinctive Maghrebi script characterized by bowl-shaped descenders and strokes of uniform thickness. In the Maghreb, parchment remained the preferred medium for copying manuscripts of the Koran until the fourteenth century, although paper had been introduced to the region in the tenth century and papermaking became an important industry of such cities as Fez and Jativa in the eleventh. Artistic conservatism in the production of Koran manuscripts reflects the religious conservatism of the region, which largely followed the Maliki school of religious law.

The increased isolation of the Maghreb from developments in West Asia led artists in the region to look for inspiration in their own artistic traditions, resulting in the creation of a distinctly Maghrebi architectural style under the Almoravids and Almohads. Often dubbed 'Hispano-Moresque', this style is characterized by cusped arches, *muqarnas* cornices and vaults, and colourful revetments of glazed tiles arranged in geometric patterns. Typical walls had a tiled dado, a carved plaster upper surface, and an elaborate wooden cornice, reflecting the perennial availability of timber from the mountain forests of Spain and North Africa. These techniques were used not only for mosques but also for palaces (of which the Alhambra in Granada is the only one to survive in the region) and *madrasas* (theological colleges, which spread across North Africa to Spain in the thirteenth century). The city of Fez, particularly under the Marinids, became a centre of intellectual and artistic life, remarkable for the many *madrasas* commissioned by the sultans.

PAGE FROM THE 'Blue Koran', copied in tenth-century Tunisia. As Arabic replaced local languages in religious, intellectual, administrative and commercial matters, copies of the Koran became the most important type of manuscript produced in North Africa. This unique Koran was written in gold and silver ink on parchment dyed blue to imitate Byzantine imperial purple-dyed manuscripts.

SUB-SAHARAN AFRICA 600-1500

THE VARIED GEOGRAPHY of Africa south of the Sahara includes the drainage systems of three great rivers: the Niger, the Congo and the Nile, which with their tributaries embrace forest, savannah, and mountain zones constituting a large percentage of the continent. Most forest-region peoples and some living in the savannah were agriculturalists (apart from small hunter-gatherer populations in central and southern areas) while savannah and sahel dwellers were often pastoral or semi-pastoral.

Major population movements during the early centuries of this period included the Bantu migrations from eastern West Africa (present-day Nigeria, Cameroon and Chad) into the vast Congo drainage and further south, often displacing hunter-gatherers. European maps of the continent were often very inaccurate regarding interior regions. Trans-Saharan trade was very active during this entire period, and remains difficult to map accurately, although oases were obvious stopping points and trade centres.

MATERIALS AND TECHNIQUES
Pottery (including some ceramic sculpture), woodcarving, iron-smithing, leather-working and basketry were surely practised by many,

perhaps most, agricultural peoples during this entire period. Lost-wax casting and loomed weavings, however, were introduced in the ninth or tenth centuries, presumably across the Sahara. They were probably transmitted by Muslims, in the same era that Islam penetrated areas just south of the Sahara and coastal zones of east Africa. Christianity entered Egypt and Ethiopia still earlier, by around the fourth century. Stone architectural complexes are known from the western Sudan and in southern Africa.

Excavations in Kumbi Saleh in southern Mauritania – probably the capital city of the ancient Ghana empire (c.800–1100) – revealed foundations of a stone mosque dating to the tenth century and a fragment of a female terra-cotta figure made several centuries earlier. Great Zimbabwe and other sites in what is now Zimbabwe dating from about 1000 to 1500 feature elaborate stone buildings and enclosing walls. Churches hewn out of bedrock in Lalibela, Ethiopia, date from the twelfth and thirteenth centuries. Rock art, probably no longer made in Sahara regions, was being made in southern Africa during the whole period, apparently mostly by San peoples.

Lost-wax castings in several styles were made from about the ninth or tenth century in what is now southern Nigeria (Igbo Ukwu), from about 1000 in the inland Delta region of the Niger River, and in Ile Ife from around 1100. These are all distinctive, well-resolved art styles. That of Igbo Ukwu is very refined, with almost fussy decorative surfaces on objects of many types associated with early priest-leaders who conferred titles on worthy

men. That of Ile-Ife shows an exceptionally sensitive naturalism, including mimetic portraiture on idealized, life-size human heads, along with terracottas of several styles and types. That of the Inland Delta involved rather stylized human figures in many poses, and animals, especially snakes, which appear to have been sacred to the local people. Most of the latter have come from illegal excavations. Ile-Ife also contains some eleventh- and twelfth-century granite sculpture and decorative pavements, presumably for royal precincts, made of inlaid potsherds.

ART AND SOCIETY
Socio-political organization for this era ranged from small headless bands – the San in southern Africa continued to paint on rock-wall surfaces – to centralized kingdoms, empires, and city-states, the arts of some of the latter having been mentioned by medieval Muslim travellers and chroniclers such as Al Bakri, Ibn Battuta and Ibn Khaldun. Gold regalia and horse trappings, for example, are reported at the court of ancient Ghana, which also had a divided capital city (Kumbi Saleh) part Muslim, partly traditional believers. Many of the early

1 WEAVING AND LOST-WAX CASTING appear to have entered West African savannah and forest regions during this period. Presumably, they were brought south across the Sahara by Muslims, who at the same time were establishing their own trading and learning centres in the western Sudan. Islam also became a political presence in states located in the savannah, but the majority of peoples south of this zone (apart from Christianized Ethiopia) worshipped local nature spirits and ancestors, and were unaffected by Islam or Christianity.

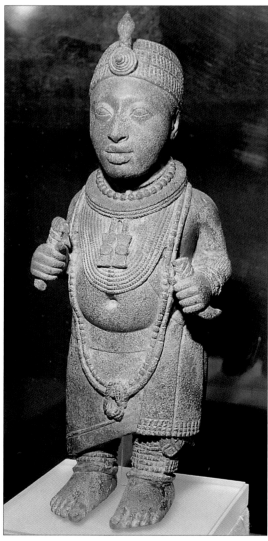

FIGURE OF A SACRED KING, the Oni of Ile-Ife, excavated at Ita Yemoo, Nigeria, in 1957 (47 cm – 18½ ins – high, cast copper alloy, eleventh or twelfth century, Museum of Ife Antiquities). The king is shown in bead-rich regalia. The fleshy naturalism is typical of the finest of Ife works, and the ideologically skewed proportions emphasize his sacred head.

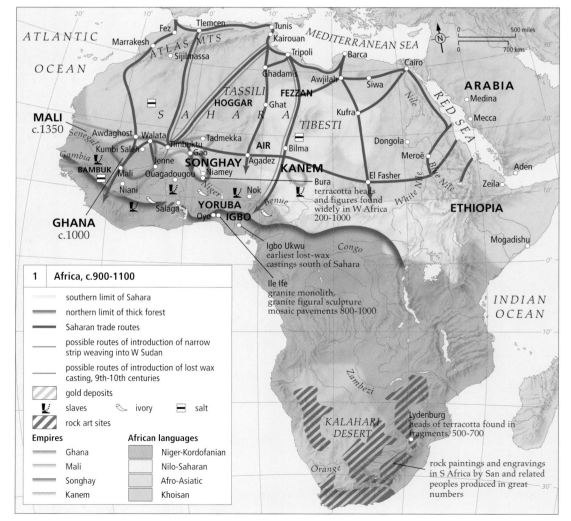

1 Africa, c.900-1100

- southern limit of Sahara
- northern limit of thick forest
- Saharan trade routes
- possible routes of introduction of narrow strip weaving into W Sudan
- possible routes of introduction of lost wax casting, 9th-10th centuries
- gold deposits
- slaves ivory salt
- rock art sites

Empires
- Ghana
- Mali
- Songhay
- Kanem

African languages
- Niger-Kordofanian
- Nilo-Saharan
- Afro-Asiatic
- Khoisan

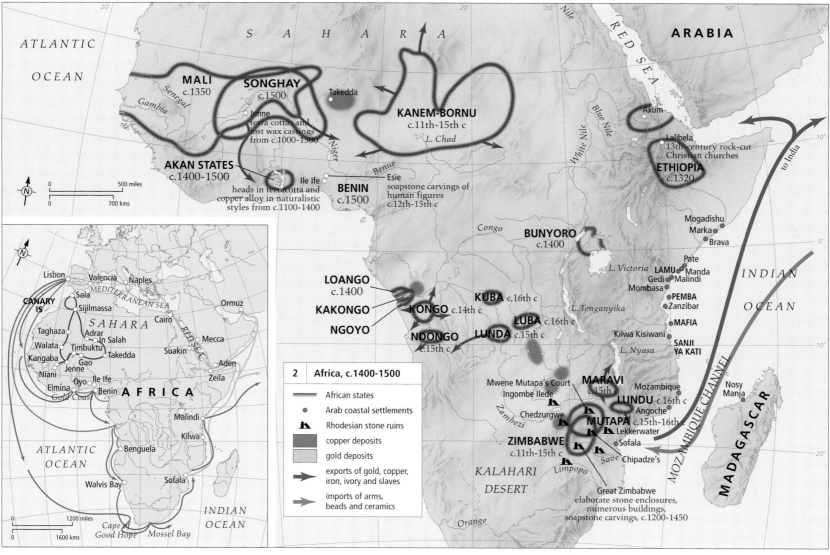

2 AND 3 IN RESPONSE TO VISITS first of Portuguese, then of other European merchants and travellers, a shift occurs in West Africa – from its orientation to Islam and the Saharan trade – towards the coast. Islam continues its spread, especially on the Swahili Coast, and Ethiopian Christianity became stronger. Despite these incursions, native religions and values hold sway over most of the continent.

copper alloy and terracotta artefacts just mentioned probably served elite people and especially rulers, sometimes as part of their identifying regalia, sometimes in ceremonial and ritual contexts. Other more democratic forms, such as pottery and woodcarving, were undoubtedly made and used by the people at large.

THREE ARTISTIC STREAMS
Traditional religions, cultural and political structures, and domestic life account for the great majority of art and architecture from this period. Two other influential streams, Christian and Muslim, are also important in certain areas: across the Sudan from east to west (Islam), and on the eastern coast, especially, where they account for distinctive forms of both visual art and architecture.

Both Christian churches and Muslim mosques, for example, proliferated in this era,

in stone and in less durable materials. Many Christian paintings are known from the later centuries in Ethiopia, such as the fifteenth-century painting of Mary and Christ, which was part of a socio-political cult promulgated by the emperor Zara Yaqob (r.1434-68). Metal vessels with Arabic inscriptions from fourteenth-century Mamluk Egypt were traded all the way to what is now central Ghana, where some are still in service as shrines among Akan peoples. These also served as prototypes for

later Akan metalwork of local manufacture. Merged Arab and Indian influences are also detectable in the art and architecture of the Swahili coast of eastern Africa.

DIPTYCH OF THE MADONNA AND CHILD, APOSTLES, ST GEORGE AND THEODORE by Fere Seyou(?). Tempera on gessoed wood, 44 x 31.5 cm (17⅜ x 12⅜ ins). Institute of Ethiopian Studies, Addis Ababa, Ethiopia. This is one of countless works commissioned as part of the emperor Zara Yaqob's mandatory cult of Mary.

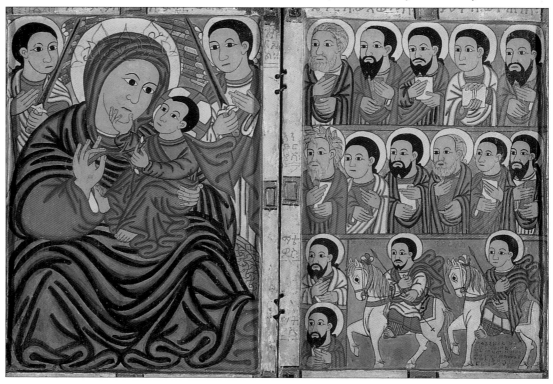

WEST ASIA AND EGYPT 600-1000

THE RISE OF ISLAM in seventh-century Arabia and its rapid spread throughout western Asia, Mesopotamia and Egypt (as well as North Africa, Spain and Central Asia) dramatically affected the nature and production of art in this enormous region. The new rulers initially adopted and adapted indigenous artistic and architectural traditions, only gradually creating a distinctly Islamic style by the ninth century.

Following the death of the prophet Muhammad in 632, Muslim armies crossed the Arabian peninsula and neighbouring regions, founding new cantonments for the troops at Basra, Kufa (both 638), Fustat (641), Wasit (702) and Ramla (715). Older buildings, whether Persian audience halls or Christian churches in established cities, were transformed into mosques. They had to be large enough to house the male population for Friday noon worship and had to point in the direction of Mecca, the centre of the faith. Elsewhere Muslims built new mosques, usually hypostyle (many-column) structures arranged around an open courtyard.

In order to preserve the integrity of the Koran, God's revelation to Muhammad in Arabic, Muslims soon began transcribing onto parchment codices the message that the Prophet had relayed orally. In doing this, they transformed Arabic script into one of extraordinary elegance and beauty.

THE CONTINUATION OF ANTIQUITY
The first dynasty of Muslim rulers was the Umayyad line (r.661–750), who made Syria their capital province. They continued to

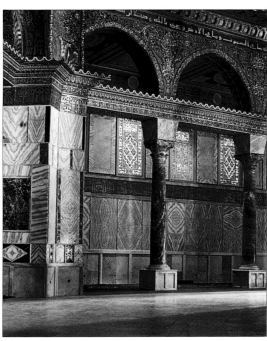

THE INTERIOR OF THE DOME OF THE ROCK in Jerusalem shows how early Muslim patrons wholeheartedly adopted the forms and decoration of late-Antique and early Byzantine architecture. The only distinctively Islamic feature is the Arabic inscription beneath the ceiling.

develop the artistic traditions of late Antiquity in such buildings as the Dome of the Rock in Jerusalem (begun 692) and the Great Mosque of Damascus (705–15): classical structures of stone with marble columns and veneers, decorated with glittering glass mosaics.

Uncompromisingly monotheistic, Islam strongly discouraged the use of figural imagery in religious settings. Subsidiary themes of late-Antique art, such as vine scrolls or geometric patterns, thus became the major subjects of decoration. The one new decorative element was Arabic script, the language of Koranic revelation. Its use soon became a hallmark of Islamic art, as inscriptions became important elements in the design of buildings, elegant textiles and even humble ceramics. In private settings, however, particularly on the country estates erected by the Umayyad rulers in the Syrian steppe, exuberant figural art remained popular at such sites as Khirbat al Mafjar and Qusayr Amra.

THE NEW ABBASID STYLE
With the destruction of the Umayyads by the Abbasids (749–1258), the centre of art and patronage shifted from Syria to Mesopotamia, as the new rulers established a series of capitals there, including Baghdad (762), Raqqa (772) and Samarra (836). The Abbasids had come to power with the help of disaffected Iranians, many from the wealthy province of Khurasan, and the eastern lands became increasingly important in the evolution of Abbasid art and society.

Brick rendered with plaster, the ubiquitous building material of Mesopotamia and Iran, replaced the stone and mosaics of the Mediterranean coast. To render the walls of their sprawling palaces – the Dar al Khilafa at Samarra, for example, covers 125 hectares (over 300 acres) – Abbasid artisans developed a carved and moulded style of abstract vegetal decoration with bevelled edges. This technique allowed the plaster to be released easily from the mould and was suitable for covering extensive wall surfaces. The bevelled style was also used in other architectural media, such as carved teakwood doors and shutters and stone capitals. It soon was applied to other arts, such as carved rock-crystal, and was exported throughout the empire, as far as Kairouan in North Africa and Balkh in Central Asia.

1 THE HEARTLAND OF THE UMAYYAD EMPIRE was Syria, for the founder of the dynasty, Mu'awiya, had been governor of Damascus before he seized power in 661. His successors, after consolidating their power over the next three decades, turned the region into an enormous public works project, with the construction of cities, mosques, urban palaces and enormous rural agricultural estates. The major Islamic shrines at Mecca (centre of the faith), Medina (burial place of the Prophet) and Jerusalem were transformed into major architectural ensembles. These projects were funded by the enormous booty gained from the continuing conquests of outlying areas – from North Africa to Central Asia.

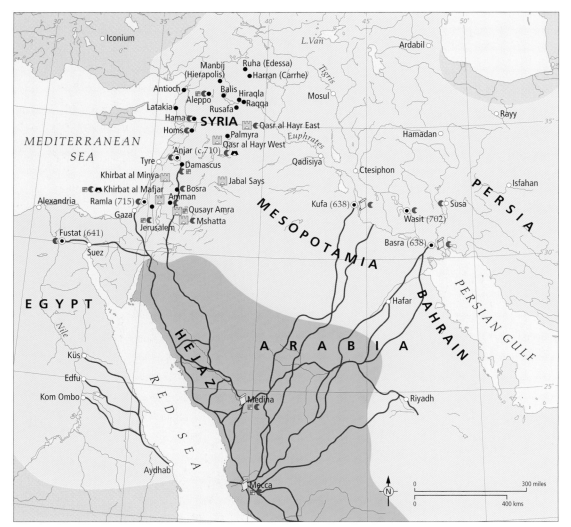

1	Umayyad Syria and the Levant	
	extent of Islam to 632	rural palaces/ agricultural estates
	extent of Islam to 750	centres of manuscript production
	pilgrimage routes to Mecca	site with mosaic
•	old cities	site with stucco
⊙	new cities, with date of foundation	Umayyad mosque

Under the Abbasids, the congregational mosque evolved from an early community centre into a more strictly religious institution under the control of the *ulema*, or religious scholars. To signal this change, towers were added to congregational mosques to advertise their presence from afar. Small mosques were erected to serve the needs of smaller communities; one popular type was a square structure with nine domed bays. This type, which has been found from Spain to Central Asia, was probably developed in the Abbasid heartlands and disseminated by pilgrims returning from Mecca.

Abbasid patrons were fabulously rich and enjoyed imported luxuries, including stonewares and porcelains from China. These were imported either by sea, across the Indian Ocean and up the Persian Gulf, or overland along the Silk Road through Central Asia. The taste for imported ceramics led Mesopotamian potters to develop fine earthenwares covered by a white opaque glaze imitating Chinese porcelain. Other potters applied to ceramics the Syrian technique of painting glass with

metallic oxides and firing it in a reducing atmosphere. Thereby they created the technique for lustreware. Abbasid four-colour lustrewares represent the acme of the art.

The art of the book was also transformed in this period. Parchment manuscripts were supplanted by paper codices, and the traditional angular script, often called kufic after the city of Kufa in southern Iraq, gave way to rounder, cursive styles of writing more suitable for the smoother surface. Brown tannin inks which stained the parchment surface were replaced by carbon-based black

ink, which did not degrade the paper. Calligraphers specializing in the transcription of the Koran were slow to adopt the new medium of paper, perhaps because of the sacredness of the text, but by the year 1000, they, too, had realized its artistic potential.

2 THE ABBASID CAPITALS in Mesopotamia attracted intellectual and artistic talent from all over their enormous empire, particularly from the eastern provinces that had helped the Abbasids seize power. Following the conquest of Central Asia, paper was introduced to fuel the enormous Abbasid bureaucracy, and as its use and manufacture spread, it led to fundamental changes in styles of writing and the production and distribution of manuscripts. Major cities had hypostyle mosques with minarets and bevelled style carving, showing the dissemination of metropolitan Abbasid styles and taste. Fine textiles of linen, cotton, silk and wool to be distributed to courtiers were produced in state manufactures established throughout the empire, but especially in Egypt and lower Iraq. Luxury goods, such as teak, carpets and porcelain, were imported from India, Armenia and China.

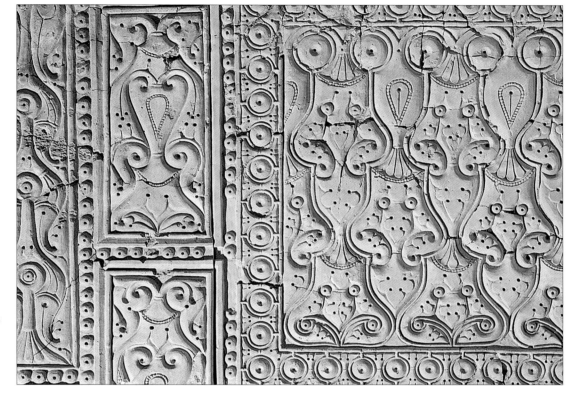

STUCCO REVETMENT from the Balkuwara palace at Samarra, c.850. The huge scale of the palaces at the sprawling new Abbasid capital demanded cheap and efficient techniques. The slanted or bevelled technique of moulding was imitated in other media, such as carved wood and rock-crystal, and became a hallmark of the period.

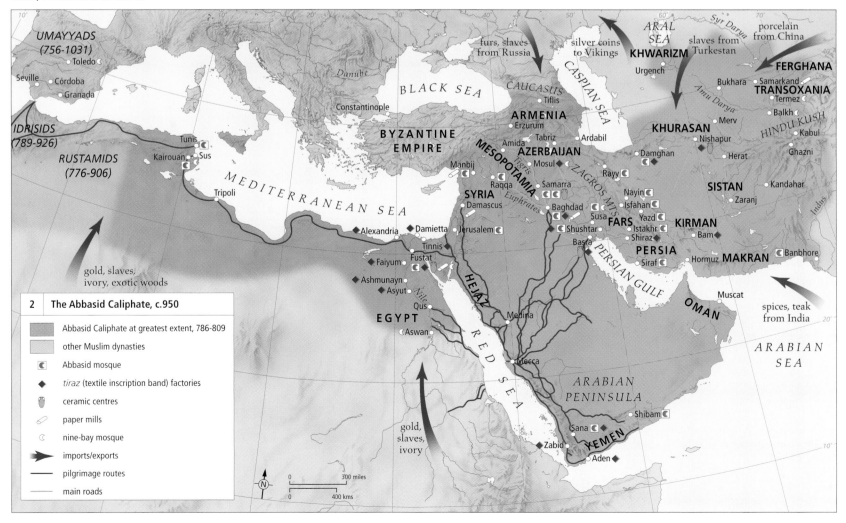

2	The Abbasid Caliphate, c.950
	Abbasid Caliphate at greatest extent, 786-809
	other Muslim dynasties
◖	Abbasid mosque
◆	*tiraz* (textile inscription band) factories
	ceramic centres
	paper mills
◖	nine-bay mosque
➤	imports/exports
—	pilgrimage routes
—	main roads

WEST ASIA 1000-1500

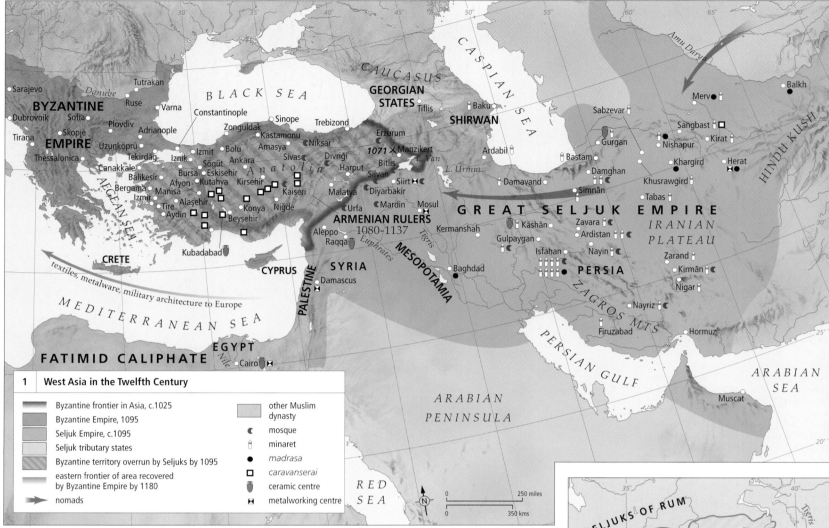

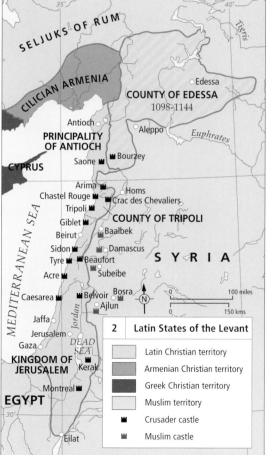

DURING THE ELEVENTH CENTURY the unified Abbasid caliphate came apart at the seams. Egypt, Syria and Arabia (as well as most of North Africa) were controlled by Fatimid caliphs from their capital at Cairo, but the major threat came from the east, as groups of Turkish nomads moved southwest from the Central Asian steppe, converted to Islam, and came to dominate political, intellectual and artistic life.

THE DOMINATION OF IRANIAN IDEAS
Iranian techniques, themes and motifs began to play a dominant role in all the arts of the region, from architecture to ceramics and metalwares. The old type of hypostyle (many-column) congregational mosque was supplanted by the four-*iwan* plan, in which vaulted open rooms are arranged around the four sides of a rectangular court and connected by vaulted halls. The *iwan*, which had been used in Iranian architecture since Parthian times, was often combined with a great brick dome, as the arched and vaulted techniques of the Iranian plateau replaced the stone post-and-beam system that Muslims had inherited from the Mediterranean lands. The *iwan* was inherently flexibile, being suitable for all types of buildings, whether mosques, palaces, schools or *caravanserais* (caravan motels).

Iranian ideas also dominated the decorative arts. Paper became the ubiquitous support for manuscripts produced in the region. These included not only the illuminated manuscripts of the Koran produced in earlier times but also illustrated works of many types, from scientific

1 AROUND THE YEAR 1100 much of western Asia came under the control of the Seljuks, a Turkish tribe from Central Asia, while Egypt remained under the control of the Fatimid dynasty. Militant Muslims, the Seljuks promulgated their version of Islam by building monuments for the faith, such as mosques, minarets and madrasas. A collateral branch, the Seljuks of Rum, settled along with other Turkish tribes in Anatolia. They too built mosques and madrasas to promulgate the faith, as well as caravanserais to foster trade, but the typical brick and plaster forms of Iranian Seljuk architecture were translated into stone. Seljuk patrons commissioned splendid lustre ceramics and inlaid metalwares to decorate their mosques and palaces.

and technical manuals to epic and lyric poetry. Potters exploited the artistic potential of the fritted (or stone-paste) ceramic body that emulated the fine white Chinese Song porcelains imported in great quantity. New shapes and techniques (including overglaze lustre and enamel and underglaze painting) resulted in a period of great ceramic innovation. Weavers also exploited increasingly sophisticated structures and designs. Colour suffused all the arts, as monochrome metalwares were inlaid with copper, silver and gold, and buildings were enveloped in glittering webs of glazed tile and painted plaster.

DISSEMINATION OF THE FAITH
The major work of conversion had been accomplished by this time, but the ethnic composition of western Asia changed dramatically as Turko-Mongolian peoples resettled and converted to Islam, adapting the norms of Persian-Islamic culture. The Seljuk

2 CRUSADERS FROM EUROPE intent on rescuing Jerusalem from the Muslims established principalities in the eastern Mediterranean. These invaders – and Muslim defenders – built some of the finest medieval military architecture to survive. Crusaders returned to Europe from western Asian bazaars with fabulous souvenirs, including textiles and metalwares.

Turks arrived in Iran during the eleventh century. Following the defeat of the Byzantines at the battle of Manzikert (Malazgird) in 1071, Anatolia was opened to Turkish settlement and Islamization, creating a demand for new buildings to serve the faith.

The Byzantine defeat led European Crusaders to invade the region, capture Jerusalem and carve out four principalities. The Muslims were unable to mount effective resistance until the rise of Saladin (r.1169–93), who defeated the Crusaders under the banner of a resurgent Islam. In these uncertain times artists – whether builders, potters, or metalworkers – were often forced to move, thus further disseminating Iranian artistic forms and techniques.

THE INTEGRATION OF OLD AND NEW
The Mongol invasions of the thirteenth century reconfigured the artistic map of western Asia, as Iran became the entrepôt of an international trading system linking Europe and China. The Mongols adapted and refined the four-*iwan* mosque, the brick dome, glazed tile and lustre ceramics. Traditional mosques, minarets, *madrasas* (theological colleges) and *khanaqahs* (hospices for mystics) were combined into multi-functional complexes,

3 IN THE FOURTEENTH CENTURY much of Eurasia was ruled by various descendants of Genghis Khan, of whom the Ilkhan rulers of Iran and Iraq controlled the central region. The ensuing *pax Mongolica* fostered overland trade and communication between Italy and China. The arts created in Iran under the patronage of the Ilkhanids, who had converted to Islam by the late thirteenth century, reflect this extraordinarily broad range of sources. The Ilkhans wholeheartedly adopted Persian and Islamic cultural traditions; their great rivals in the west were the Mamluks, whose capital at Cairo became the centre of Arab-Islamic civilization after the Mongols conquered Baghdad in 1258.

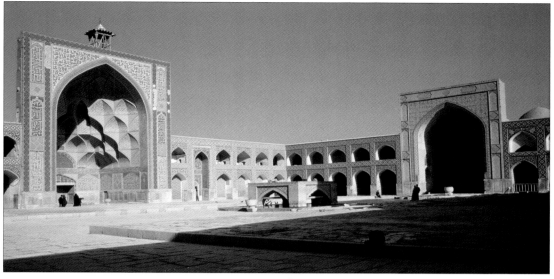

often arranged around the tomb of the founder in order to perpetuate his memory.

The major artistic innovation of the fourteenth century was the new role played by the illustrated book, which became a major vehicle for the dissemination of Persian literature and political ideologies. This was made possible in part by papermakers' new capability to produce large sheets of fine white paper, perhaps due to knowledge of Chinese technology. The most able painters in western Asia now turned from the ceramic surface to paper, drawing upon the traditions of Chinese landscape scrolls and Italian panel painting alike.

Iranian artistic ideas were adopted by the the Mamluks in Egypt – the four-*iwan* plan, stucco decoration, *Chinoiserie* ornament – testifying to the international prestige of Ilkhanid art. Traditional rivalries obscured the meteoric rise of the Ottoman Turks, who

COURTYARD OF THE CONGREGATIONAL MOSQUE in Isfahan, Iran. The large open court with *iwans*, or vaulted halls, in the middle of each side, epitomizes the new mosque plan introduced and popularized by the Seljuks from the early twelfth century. Much of the present tile decoration was added later, as the form remained standard until modern times.

would, by the end of the period, become the most powerful force in western Asia and southeastern Europe.

Drawing on the architectural and artistic heritage of Seljuk Anatolia as well as Byzantium and the Classical past, Ottoman artists developed a new idiom of Islamic art in the Mediterranean region. In the years before and after the conquest of Constantinople in 1453, Ottoman builders refined a third type of congregational mosque characterized by a huge single dome surrounded by pencil-thin minarets: a style that became the symbol of Ottoman domination in the region.

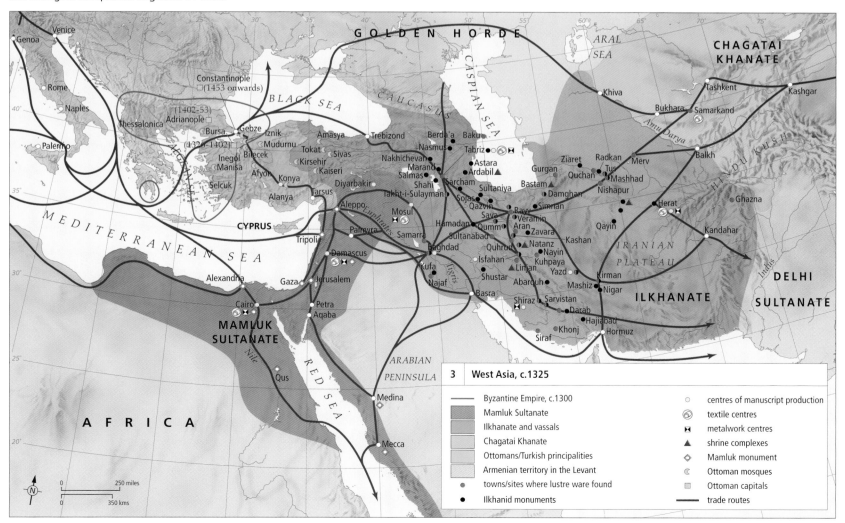

3	West Asia, c.1325

- ——— Byzantine Empire, c.1300
- Mamluk Sultanate
- Ilkhanate and vassals
- Chagatai Khanate
- Ottomans/Turkish principalities
- Armenian territory in the Levant
- ● towns/sites where lustre ware found
- ● Ilkhanid monuments
- ○ centres of manuscript production
- ⑤ textile centres
- ⊠ metalwork centres
- ▲ shrine complexes
- ◇ Mamluk monument
- ☾ Ottoman mosques
- ▢ Ottoman capitals
- ——— trade routes

CENTRAL ASIA 600-1500

CENTRAL ASIA CHANGED dramatically as it was transformed from an independent centre under the Turkic Khanates to a peripheral border region which lay between the great empires of the Abbasids in southwest Asia and the Tang in China. From the late seventh century, Arab armies brought Islam and the Arabic language to this region where many religions, including Zoroastrianism, Manichaeism, Buddhism, Judaism, and Nestorian Christianity, had been practised for centuries and where Iranian and Turkic languages were spoken. The Arabs knew the region as 'The Land Beyond the River', or Transoxiana. The Islamic conquest increased the region's prosperity, as it was integrated into the nexus of trans-Asian trade along the ancient Silk Road.

Far from the capitals of Arab-Islamic civilization in Syria and Mesopotamia, more-or-less independent dynasties of Persian and Turkish governors and rulers emerged, including the Saffarids, Samanids, Karakhanids, Ghaznavids, Ghurids and Khwarazmshahs. They enlarged old cities or created new capitals such as Merv, Bukhara, Nishapur, Balkh, Shash (Tashkent), Kabul and Delhi. In the period after 1000 many Central Asian Turks migrated westward to Anatolia and

southeast into the Indian subcontinent, integrating Central Asia further into the Eurasian network.

A second great migration of Turko-Mongolian peoples in the late twelfth and early thirteenth centuries devastated the region, destroying the hydraulic infrastructure, particularly the subterranean aqueducts (*qanat*) which supplied cities, towns, villages and farms with water from distant mountain ranges. The region flowered again under the patronage of the Timurids, who made Samarkand and Herat sparkling centres of intellectual and artistic life. The conquests of Timur (r.1370–1405), known in the West as Tamerlane, were rapid and ephemeral; at its height his empire stretched to Syria and Anatolia on the west and India on the east,

and he was preparing to conquer China on his deathbed. Although the Timurid empire shrank as fast as it had grown, its artistic impact was long-lived: the architects and craftsmen who had been forcibly brought to Central Asia created an international Timurid style which became the common language for virtually all Islamic art produced between Istanbul and Delhi after 1500. Timurid artists refined the Persian art of the book, which combined paper, calligraphy, illumination, illustration and binding in a brilliant and colourful whole.

THE IMPACT OF THE LANDSCAPE
Geography continued to play a pivotal role in the evolution of artistic life. The region's accessibility and location put it at the intersection of transcontinental routes and

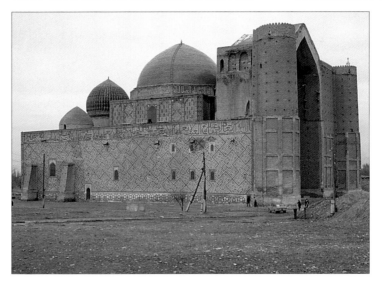

1 THE CONSTRUCTION of new types of buildings associated with Islam, particularly mosques, minarets and tombs, reflects the spread of the faith. Congregational mosques were an essential feature of urban life, but minarets and tombs over the graves of local saints were erected in rural areas as well, particularly along the trade routes that spanned the region, probably because they came to symbolize the presence of Islam.

THE GRAVE SITE OF the Sufi sheikh Ahmad Yasavi (d.1166) had long been venerated by the Turks of Central Asia and the Volga. In 1397–9 Timur used the vast booty amassed from his victory over the Golden Horde to transform his modest brick tomb at Yasi (now Turkestan City) into one of the most spectacular buildings in the region. Built of brick and glazed tile, the rectangular complex looms above the steppe and projects the presence of Islam from afar. A giant *iwan* leads to a domed central hall with an enormous basin holding water for pilgrims, and a smaller ribbed dome in the back corner marks the site of the sheikh's grave.

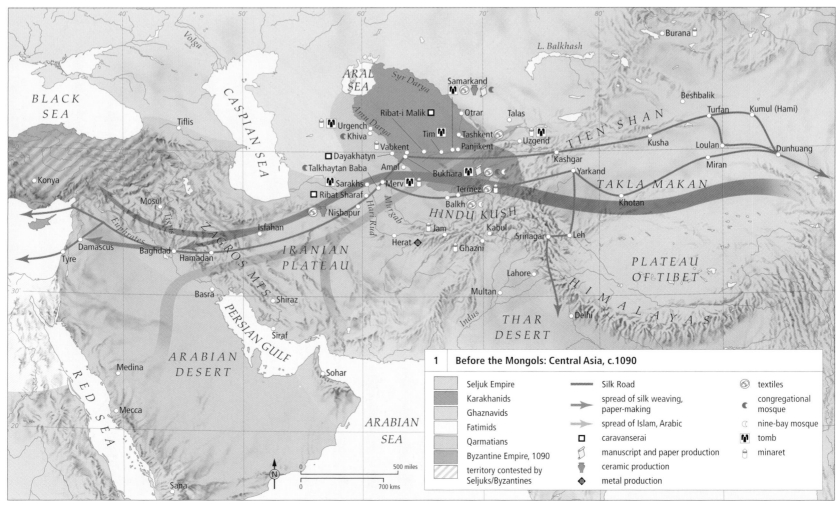

1 **Before the Mongols: Central Asia, c.1090**

Seljuk Empire	Silk Road	textiles
Karakhanids	spread of silk weaving, paper-making	congregational mosque
Ghaznavids	spread of Islam, Arabic	nine-bay mosque
Fatimids	caravanserai	tomb
Qarmatians	manuscript and paper production	minaret
Byzantine Empire, 1090	ceramic production	
territory contested by Seljuks/Byzantines	metal production	

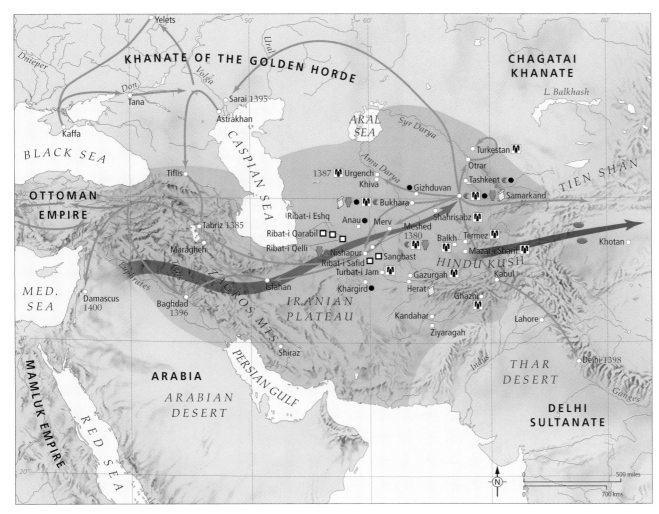

Timurid Empire

conquests of Timur, with date

movement of metalworkers, builders, ceramicists

movement of weavers

☾ mosque

tomb/shrine

• madrasa

□ caravanserai

jade sources

ceramics

manuscript production

2 TIMUR AND HIS SUCCESSORS used the arts to enhance prestige. The scale of his constructions – at his capital Samarkand, his birthplace Shahrisabz, or the grave site of the Sufi sheikh Ahmad Yasavi in Turkestan – matched his ambitions. These mammoth works were created by artisans who came – often involuntarily – from afar to the court to make intricate plaster vaults and glittering tile revetments. Timur's successors had fewer resources, but they still commissioned fine manuscripts, metalwares, and carved jades.

integrated its people into a vast zone that stretched from North Africa to the Tien-Shan mountains. The importance of trade is reflected in the superb caravanserais set up by officials along major trade routes.

Another constant was the unusually harsh climate, ranging from torrid summers to frigid winters. Despite little rainfall, water is available from subterranean aqueducts or the few great rivers flowing from distant mountains into landlocked seas and lakes. The settled population was concentrated in oasis towns, while the deserts and steppes were inhabited by the nomads. Despite the constant tension between nomads and settled peoples over the sparse resources, the two groups were interdependent: the nomads' sheep supplied wool, meat and fertilizer for the settled peoples, who in turn supplied the nomads with grain, metals, fibres and ceramics.

MATERIALS AND TECHNIQUES

The vast number of sheep raised on the steppes made woollen textiles pre-eminent, although cotton and silk were cultivated by settled populations. The knotted carpet came to the fore as the ancient nomadic craft was transformed, especially in West Asia, into a village and urban industry. The earliest examples, small carpets showing stylized animals were exported as luxury goods and have been found as far apart as Sweden, Italy and Tibet; they are also depicted in Persian manuscripts and Italian panel paintings of the early fourteenth century. Village and urban weavers were also known for their fine silk textiles. Zandaniji textiles made in the village of Zandane near Bukhara for several centuries after the Islamic conquest were exported as far as Europe and China. By the thirteenth century, Central Asian textiles, particularly the silks woven with gold-wrapped threads known in Europe as *panni tartarici*, were so appreciated

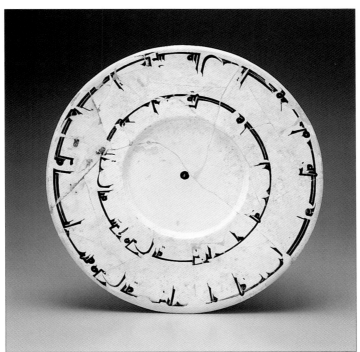

that the Yuan rulers of China moved weavers from Samarkand to Beshbalik and Daidu (Beijing) in north China where they introduced the silk tapestry technique.

Little if any stone was available for building, but earth – whether as rammed earth, sun-dried brick, baked brick, or glazed tile – and a surprising quantity of timber (from the forested mountains) were readily exploited for construction. Columns and beams were used for hypostyle mosques, as at Khiva, and for the ubiquitous columned verandas found on houses and other buildings. Baked bricks and tiles were exploited for their decorative potential: the early tenth-century Samanid mausoleum at Bukhara is the earliest surviving example of the decorative brick style that later

THOUSANDS OF SLIP-DECORATED earthenwares have been unearthed at the sites of medieval Nishapur and Afrasiyab (Old Samarkand). Many are decorated with phrases or aphorisms in Arabic, such as 'Blessings to its owner', while others are decorated with vegetal, geometric and figural motifs. These aphorisms are written in a stylized script, which is often difficult to decipher. Nevertheless, the inscriptions are carefully planned and deserve to be called calligraphy, literally 'beautiful writing' and one of the hallmarks of Islamic art. The texts reflect the literate society of the time, in which Arabic, the language of the faith, co-existed with the vernacular Persian. The latter soon came to the fore as a literary language, and the first surviving manuscript in Persian, which dates from the mid-eleventh century, uses a similar stylized script for headings.

became pre-eminent throughout the region. In addition to mosques, found everywhere in the Islamic lands, tombs became popular in this region. These were typically domed cubic structures, many of which honoured the local saints and mystics who had been responsible for converting the steppe nomads to Islam.

The earth also provided the raw materials for other arts, including metalwares and ceramics. Tenth-century potters in Samarkand and Nishapur covered earthenwares with colourful slip decoration, whether abstract, figural or epigraphic, and glazed wares soon followed. The epigraphic wares, calligraphic with moralizing aphorisms in Arabic, show how quickly the region had been integrated into the Arabophone world of Islam.

133

SOUTH ASIA 600-1500

THE DEVELOPMENT OF art and material culture in India from 600 to1500 is impressive. As an increasingly integrated economy, society and culture emerged in the Indian subcontinent, regional styles and identities emerged which often formed the precursors to later cultural developments.

KINGDOMS AND EMPIRES
At the beginning of this period numerous Hindu temple-kingdoms spread throughout key regions in the subcontinent and struggled for local and pan-regional supremacy. A highly refined and complex court culture flourished upon a largely agrarian economy and feudal social order. With the rise and triumph of the theistic cults of Saivism (Siva) and Vaisnavis (Vishnu), Hindu temples, which were often endowed with massive landholdings by secular lords, dominated the landscape from about the sixth century AD. Heavily decorated with sumptuous and ornate sculpture, their spires rose dramatically from the surrounding countryside. Temples functioned as points of

1 THE PERIOD BETWEEN 600 AND 1500 saw the proliferation of a bewildering number of small kingdoms and larger pan-regional empires throughout the subcontinent. While many major towns known from ancient India declined, a subsequent phase of urban development saw new networks of towns, more closely integrated with the expanding agrarian economy, spread throughout the landscape. Larger urban centres were integrated into the world economy through the export of luxury goods to the Middle East and China. Through this trade India developed its reputation for finely wrought metal objects (like swords), jewellery textiles and precious stones.

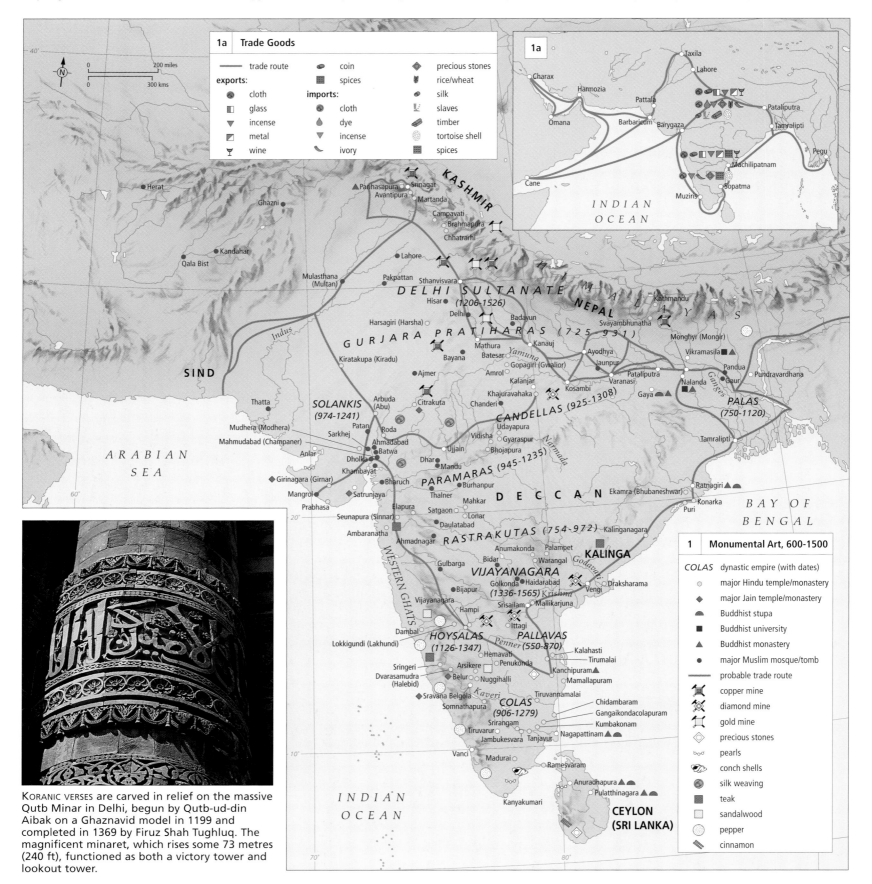

KORANIC VERSES are carved in relief on the massive Qutb Minar in Delhi, begun by Qutb-ud-din Aibak on a Ghaznavid model in 1199 and completed in 1369 by Firuz Shah Tughluq. The magnificent minaret, which rises some 73 metres (240 ft), functioned as both a victory tower and lookout tower.

consumption and exchange for various luxury goods, and in a sense represented not only the spiritual but material aspirations of the age.

From the thirteenth century a Turkish Muslim empire, known as the Delhi Sultanate, was founded in northern India, an event which was to have a dramatic impact on Indian life as well as exerting more subtle, long-term cultural and economic influences. In one sense at least, the Delhi Sultanate succumbed to the centrifugal rhythms of Indian history. By 1400 regional sultanates had emerged in the west, east and south, each of which exhibited a distinctive regional identity. Islamic rulers introduced new forms of monumental architecture such as the mosque and tomb, as well as providing a conduit for Central Asian craft techniques and fashions to enter into the subcontinent.

Despite destroying a number of politically important temples in northern India and interrupting traditional Hindu structures of patronage, Muslim rulers did not attempt to convert the large mass of their subjects to Islam. Instead, the two cultures interacted with one another. Beyond the southern borders of the Delhi Sultanate flourished both the Sultanates of the Deccan and the kingdom of Vijayanagara, the last great Hindu empire, which loosely united much of southern India during the fifteenth and sixteenth centuries. Vijayanagara and Delhi were among the most cosmopolitan and dynamic cities of their day, importing materials and men of culture from as far away as Portugal and China.

Luxury goods at court typically had both economic as well as ceremonial or ritual value and were transacted as emblems of political and moral rank and authority. These objects (robes, tunics, turbans, crowns, necklaces, armbands and rings), along with a host of less permanent substances such as betelnut and sandalwood paste, were the object of great concern in medieval sumptuary manuals designed for the king and his nobility.

MATERIALS, TECHNIQUES AND EVIDENCE
In India climate has had a significant influence on the development of material culture and, unfortunately, on its survival. High levels of heat and moisture have made the survival of ephemeral materials, such as palm leaf, paper, wood, textiles and plasters, sporadic from periods before the sixteenth century. For this reason many art forms, which we know to have existed from other sources, cannot be reconstructed with a satisfactory degree of precision. Since the surviving record is only partial, stone, terracotta monuments and sculpture and durable decorative arts must therefore remain our chief artefacts.

The most palpable legacy of the past has been stone architecture, which flourished during this period in both Hindu and Muslim kingdoms. Temple architecture was based on the combination of vertical and horizontal stonework held together by weight. Large monoliths were transported from quarries using elephants or water and, having been worked, were either hoisted or rolled into place via earthen ramps. The arrival of Islamic architecture in the subcontinent brought with it new architectural styles such as the true arch, the dome and the vault, built with the extensive use of lime-mortar as a cementing material. The emphasis in Islamic architecture was primarily on the manipulation of line, space and movement, though decorative techniques were also developed in calligraphy and mosaic.

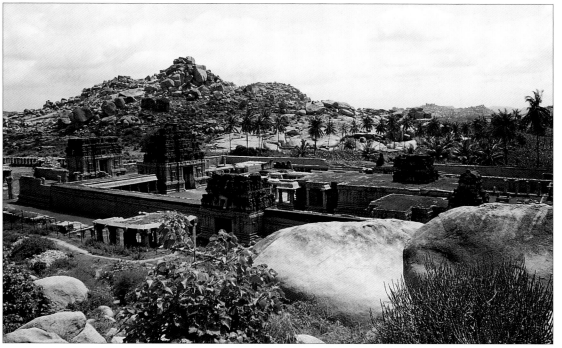

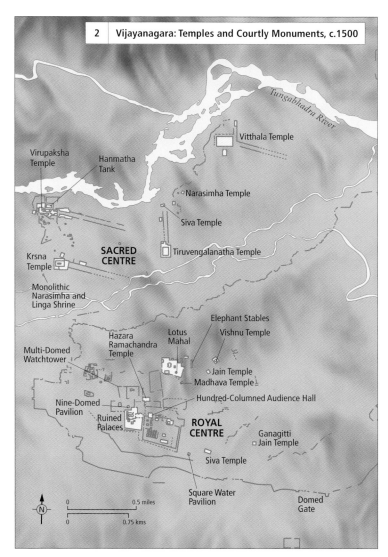

THE TIRUVENGALANATHA TEMPLE at Vijayanagara, dedicated to Vishnu in 1534, is set in the rugged terrain of the land immediately south of the Tungabhadra River. This temple was sponsored by a prominent courtier (a brother-in-law and minister) of the Vijayanagar king Achyutaraya (r.1529–42).

2 WHILE LARGE NUMBERS of temples survive throughout India from the sixth century, the empire of Vijayanagara is unique among Hindu dyanstic realms in preserving a copious amount of both secular and religious architecture. The city of Vijayanagara may be divided into distinct zones. Immediately south of the Tungabhadra River, within the urban area but outside the city walls, are a large number of temples, which scholars have designated the sacred centre of the city. Further south, surrounded by massive outer fortifications, is the urban core, where most of the population lived. In the south-east corner of the fortified city is the royal centre, a complex of many buildings, surrounded by another tier of fortifications. It is here where the king, his family, and a large retinue of courtiers, ritualists and palace servants lived together.

While few specimens have survived, other sources suggest that the production of silk and cotton textiles formed an important industry during this period. Sources provide scores of names of fabric styles which remain only dimly understood by historians today. The quality of cotton production was improved by the introduction of the spinning-wheel and carder's bow in the eleventh century, probably from Central Asia, which must have significantly cheapened the cost of spun yarn. Weaving techniques during this period are not very well understood, but the expansion of the profession, as reflected in the increased prominence of weaver castes in the historical record, suggests the retention of traditional methods. Printing and dyeing techniques are also unclear, although some methods, like the famous tie-dye technique, are mentioned as early as the seventh century. Carpet-making also seems to have been introduced into the subcontinent between the eleventh and thirteenth centuries, again from Central Asia. In addition to textiles, there were rich traditions of regionally differentiated, decorative arts, but centres of production and regional styles still remain elusive.

CHINA 600-1300

THE TRANSITION FROM Tang society (618–907) to Song society (960–1268) was a watershed in world history. Tang China shared much in common with late Medieval and early Renaissance Europe. Political authority was dominated by a hereditary, military aristocracy and serfdom was common. The Buddhist authorities bolstered the power of the nobility and assumed charge of education, hospitals and charity. There was no clear distinction between the royal budget and the state budget, and formal checks on central authority were weak. Many artists worked in the service of the religious authorities or nobility on large architectural projects such as palace and temple sculpture or murals, with the nobility competing for the services of the greatest masters. An artistic canon was evolving and the notion of 'genius' was well-developed, but it was the courts and their intellectuals which determined standards of taste.

THE NEW EGALITARIANISM

By the eleventh century, however, educated men of almost any background could acquire positions of authority through egalitarian examinations and performance in office. The nobility had lost most of its fiscal and political privileges, while private and public schools overtook monastic schools as centres of education. The state assumed responsibility for welfare, and most farmers were either freeholders or tenants. The state was separate from the court in budget and administration, and major resources were invested in providing checks on abuses of power.

Paper production had become big business. By 1000 Hunan paper-makers were producing 1.78 million sheets for official use annually, while Huizhou produced 500,000 sheets for paper money, all this in addition to commercial products, ranging from toilet paper and fans to paper for books, painting and calligraphy. Artists produced for an open market – some accepted commissions, some

sold their work through restaurants or painting galleries, while others sold out of their studios. Private publishers provided outlets for non-establishment views, while the state supported major publishing projects such as the ambitious, 1000-chapter Taiping Yulan encyclopedia (published in 982). Printing also encouraged a lively literature on art, with critics aiming to influence public opinion (gonglun). In other words, Song social practice incorporated many phenomena associated with more modern times.

ATTRIBUTED TO QIAO ZHONGCHANG (after Su Shi), *Latter Prose-poem on the Red Cliff*, handscroll, ink on paper, detail showing a pond and rocks. Critics said of Su Shi's painting that 'the texture strokes on rocks were... original and bizarre, just like the pent-up twistings in his heart'. Qiao's painting, a homage to Su's poetry, echoes these values, rejecting the deep space and subtle shading of courtly painting in favour of a style that flattens and distorts for expressive effect, with every stroke of the brush visible.

1 DURING THE TANG DYNASTY it was common for the nobility to donate monumental sculpture and murals for newly constructed Buddhist temples. Many such testaments to devotion exist even today at cave temple sites throughout China. Ceramics and porcelain enriched the daily lives of nobility and officials, and adorned their tombs as well. The upper classes collected paintings and calligraphy, but most paintings from the period have not survived.

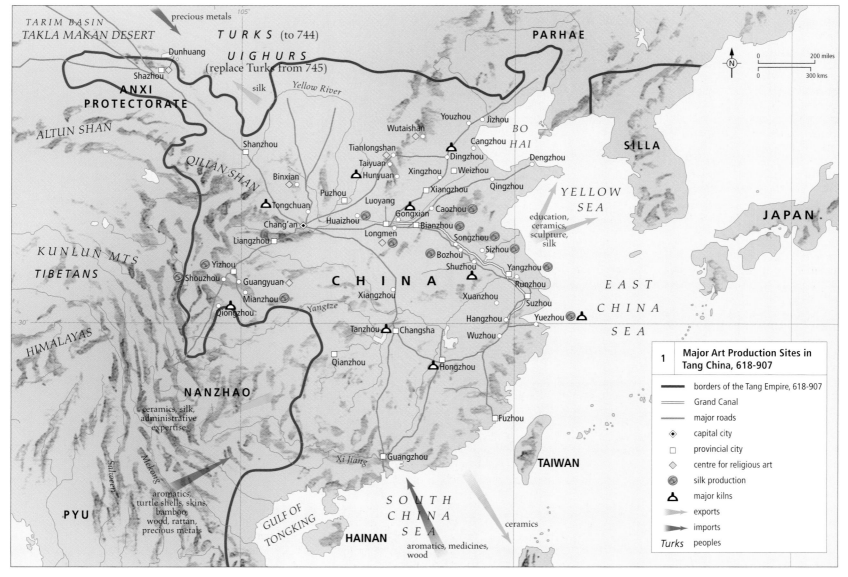

1	Major Art Production Sites in Tang China, 618-907
▬▬▬	borders of the Tang Empire, 618-907
═══	Grand Canal
────	major roads
◈	capital city
□	provincial city
◇	centre for religious art
Ⓢ	silk production
△	major kilns
➤	exports
➤	imports
Turks	peoples

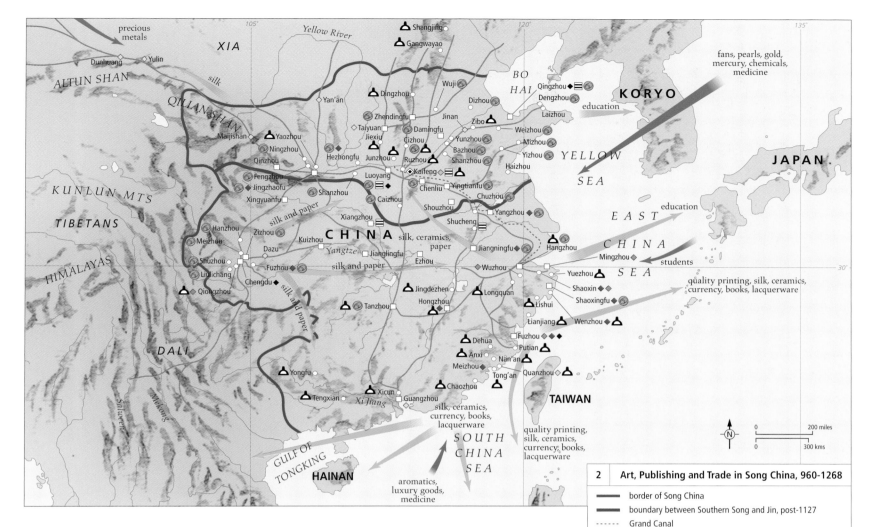

2 | Art, Publishing and Trade in Song China, 960-1268

--- border of Song China
--- boundary between Southern Song and Jin, post-1127
----- Grand Canal
--- major roads
◈ capital city
□ provincial city
◇ centre for religious art
◉ silk production
⛰ major kilns
◆ paper production
◇ commercial print centre
◆ high-quality printing centre
◇ large-scale government publishing
▤ important private art collection
→ exports
→ imports
XIA peoples

THE NEW MOBILITY

Modern institutions require the ability to move consumers, materials or commodities rapidly. Mobility of ideas and human resources is even more important. Song China was able to move commodities rapidly because of better nautical technology (the compass and movable rudder), better roads, and a more rational administration. Ideas circulated rapidly because of paper, printing and private publishers. Talent was valued above birth in the assignment of social roles, ensuring greater social mobility. All these developments laid the foundation for more modern forms of social practice, first in China and later in the West as Europeans learned of China's pioneering innovations.

One product of enhanced mobility was a lively art market offering a range of styles and genres for buyers from different walks of life, including women. This made it possible for ordinary people to fashion an individual persona by displaying personal art – decorated silk or paper fans, calligraphy, paintings, ceramics or antiques – reflecting the values they embraced. Art histories of the period reveal how men of plebeian background gained social access by acquiring fine-art collections. Private scholars, such as the poetess Li Qingzhao and her husband, built collections of national renown. The imperial collection became but one among many, with private collections influencing the taste of the court. Eventually, in deference to scholarly values, the royal academy, formerly under the Privy Treasury, was placed under the state, with its own faculty, curriculum and academic degrees.

Critics of the period distinguished mainstream work by court and professional artists from the art of nonconformist painters. The former worked in naturalistic styles permitting artists to portray bamboo, insect bodies or the technology of ships in

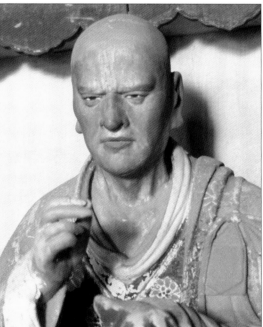

MONK MENDING CLOTHING. Near life-sized clay sculpture, c. twelfth century, Lingyansi Temple, Shandong. One of 40 clay statues of famous monks, this work exemplifies Song naturalism. The monk is shown as fully human, mending his clothing with a look of puzzlement and wonder. His parted lips and expression of deep thought suggest he may be undergoing enlightenment while pursuing ordinary tasks, as is described in Chan (Zen) anecdotes of the period.

astonishing detail. The latter set themselves in opposition to established styles, either adopting a wild, bohemian approach or an intellectualized rebellion against courtly taste. Among the latter, the most influential were known as wenren or 'literati'. Some literati championed greater recognition for women artists, and so women first appear in formal art

2 THE RISE OF PRINT CULTURE in the eleventh century made paper a major commodity, but it was also the preferred medium for works by literati masters. An active market for porcelain encouraged a great variety of wares for display and ordinary uses. Art collecting spread to the broader populace, and regional styles evolved that were independent of courtly taste. In general, naturalistic styles were favoured, to the extent that even Buddhist images appear more human and worldly than their Tang predecessors.

historical writings at this time. The literatus Su Shi (1036–1101) exemplifies the new styles of social practice. Son of a clerk, Su won first place in the national examinations, after which his answers were printed and sold as models. His published poems criticized unjust policies, and he was framed and exiled by political enemies. Although formally a criminal, public opinion treated him as a hero, and Su's publications continued to influence political sentiment and artistic taste. While in exile he remained a social activist, organizing trust funds for the needy. As an artist and critic he laid the foundations for literati criticism with its stress on personal expression, originality and integrity over naturalism and finish.

CHINA AND TIBET 1300-1500

BETWEEN 1300 AND 1500 the significant political and geographic transformation of the Chinese empire, including the extension of its relationship to Tibet, created a tumultuous but vibrant environment for artistic production.

MONGOL CHINA

The Mongol conquest of China resulted in the founding of the Yuan Dynasty (1279–1368), which had close links to Mongol polities across northern and inner Asia. The Yuan Dynasty acknowledged its northern origins by building a new imperial capital, Dadu, in northern China, at modern Beijing. Although the capital at Dadu was based on canonical principles of Chinese urban planning, two other Mongol capitals at Karakorum (c.1229–1241) and at Shangdu (begun 1256) reflect both nomadic and Chinese traditions. The former capital of Hangzhou continued to flourish and grow beyond its walls, as did Quanzhou, China's pre-eminent port for maritime trade. Resistance to the Mongols resulted in their overthrow in 1368 by forces led by Zhu Yuanzhang (1328–98), a peasant who became the founding emperor of the Ming ('Bright') Dynasty. The Ming established its first capital in southern China, at Nanjing, to reaffirm its ties to native Chinese culture; in 1420 Beijing was proclaimed the sole capital.

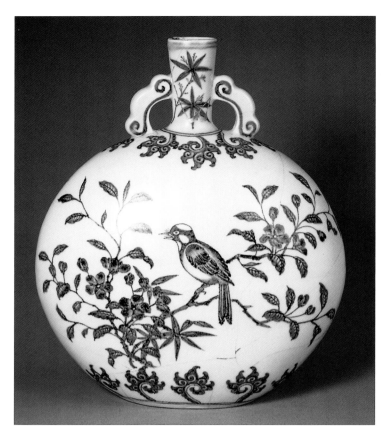

AFTER THE FALL OF MONGOL RULE in 1368, the Ming imperium articulated new aesthetic preferences in ceramic production, the effect of which was felt beyond the court. While the Ming imperial family patronized wares with red glazes and with red underglaze painting, their patronage of underglaze blue and white ceramics, such as the Xuande era (1426–35) flask from Jingdezhen shown here, promoted native Chinese traditions of pictorial representation as ceramic decoration.

1 UNDER MONGOL RULE, China became more politically and culturally integrated with North and Central Asia. Although this period has traditionally been viewed as one in which the Chinese literary elite retreated from the advance of Mongol culture, this was, in fact, a vibrant and multicultural era. For the Chinese *literati*, whose records dominate our knowledge of the period, the southeast remained the cultural centre of the empire, as evidenced by the concentration of famous kilns and painting centres in that part of China.

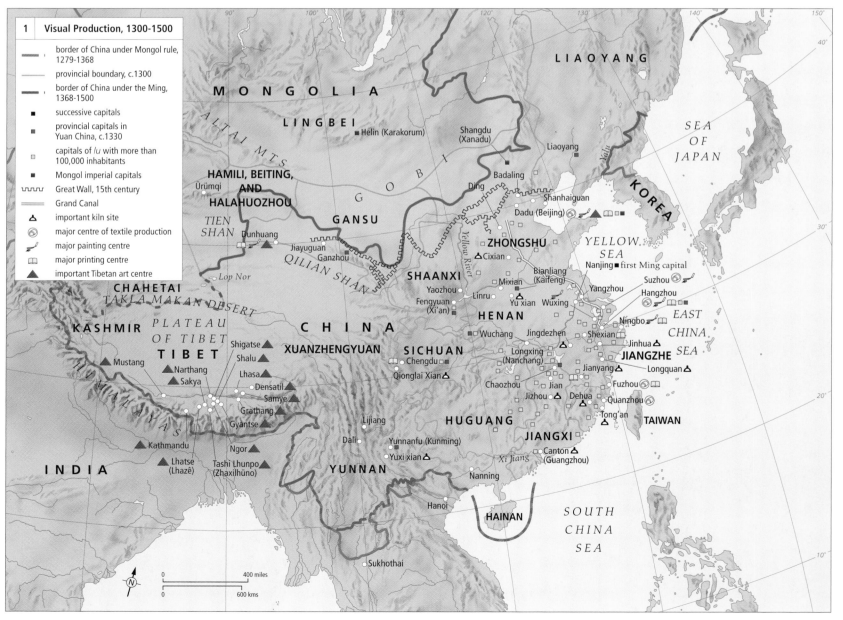

2 ARTISTIC PRODUCTION IN CHINA during the Yuan and early Ming dynasties was permeated by global contacts, including those made during the expeditions of Zheng He. Influences ranged from people and objects as diverse as Franciscan missionaries and their paintings on cloth, Inner Asian Buddhist monks and their devotional objects, and animal and material specimens brought from as far away as the East African coast.

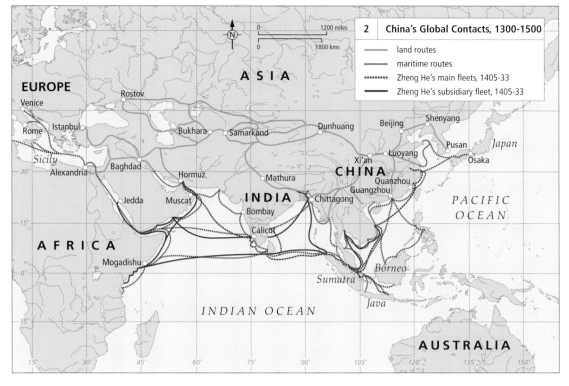

The decorative arts produced in China under Mongol rule reflect the variety of influences available to artisans through a nearly global range of cultural contacts. Ceramics and lacquerware began to include a number of Islamic ornaments, including the *mihrab* shape; ceramic production began to rely heavily on the use of cobalt, mined in Persia, for underglaze and overglaze decoration. The export of ceramics and silk was also a major source of revenue for individuals and for the government; finds of ceramics and textiles from sunken cargo ships extend through much of Southeast Asia. Sculpture was influenced by Mongol patronage of Tibetan Buddhism, which led to the production of Tibetan Buddhist images in many parts of China.

COURTLY ART

The Yuan court patronized a great diversity of pictorial objects, from portrait tapestry of Mongol origin to Chinese-style painting. Unlike the Chinese, who restricted the role and visibility of women, Mongol princesses were given income-earning fiefs. One of the greatest painting collectors of the era was the Mongol princess Sengge Ragi (c.1283–1331), who collected canonical masterpieces of Chinese painting. Her approximate contemporary Guan Daosheng (1262–1319), a renowned painter of bamboo and the wife of the prime minister, the painter and painting theorist Zhao Mengfu (1254–1322), was less sequestered than most women of the gentry at this time, consorting with her husband's coterie of artist friends. Although a wide variety of pictorial practices existed under Mongol rule, the best-known, documented practitioners of painting were men from southeastern China like Zhao Mengfu, many of whom painted works that

they and their associates inscribed with anti-Mongol texts. Painting theory of the period stressed the importance of historical models.

THE INDIGENOUS REVIVAL

During the Yuan and Ming dynasties the visual arts were practised throughout China's provinces and localities, especially in and near provincial and county seats. Archaeological evidence suggests that everyday ceramics were manufactured in local kilns throughout China; these wares differed qualitatively from those of empire-wide reputation and distribution. During the early Ming period the practice of painting based on the indigenous Chinese models of the Southern Song court underwent a widespread revival in southeastern China as part of a broader rediscovery of native cultural practices. However, the production of painting and printing were undertaken throughout China, with only the highest-quality products

having an empire-wide audience. Under early Ming rule, the decoration of porcelain emphasized native Chinese cultural emblems, rather than imported Islamic ones; sculpture focused on both indigenous and imported Tibetan deities.

The period 1300–1500 has been termed a Tibetan renaissance, during which the Tibetan Buddhist canon was compiled, edited and revised; it was subsequently printed in Beijing. The Muslim conquest of northern India sent scholars and artists into Nepal as refugees, reinvigorating Nepalese painting and sculpture. The transmission of Indo-Nepalese work to Tibet expanded the stylistic repertoire of Tibetan art at this time. Tibetan religious leaders were invited to the Ming court generating both an exchange of Buddhist images and texts, as well as of monks, especially under the auspices of the Yongle emperor (r.1403–1424).

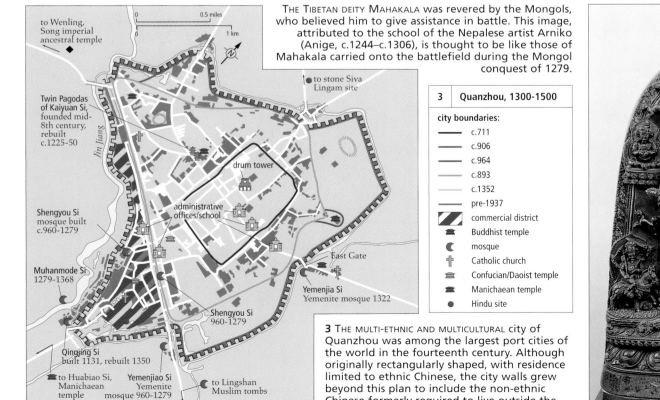

THE TIBETAN DEITY MAHAKALA was revered by the Mongols, who believed him to give assistance in battle. This image, attributed to the school of the Nepalese artist Arniko (Anige, c.1244–c.1306), is thought to be like those of Mahakala carried onto the battlefield during the Mongol conquest of 1279.

3	Quanzhou, 1300-1500

city boundaries:
— c.711
— c.906
— c.964
— c.893
— c.1352
— pre-1937
▨ commercial district
🏛 Buddhist temple
☾ mosque
✝ Catholic church
⛩ Confucian/Daoist temple
🏛 Manichaean temple
● Hindu site

to Wenling, Song imperial ancestral temple

Twin Pagodas of Kaiyuan Si, founded mid-8th century, rebuilt c.1225-50

Shengyou Si mosque built c.960-1279

Muhanmode Si 1279-1368

drum tower

administrative offices/school

to stone Siva Lingam site

East Gate

Yemenjia Si Yemenite mosque 1322

Shengyou Si 960-1279

Jin liang

Qingjing Si built 1131, rebuilt 1350

to Huabiao Si, Manichaean temple

Yemenjiao Si Yemenite mosque 960-1279

to Lingshan Muslim tombs

3 THE MULTI-ETHNIC AND MULTICULTURAL city of Quanzhou was among the largest port cities of the world in the fourteenth century. Although originally rectangularly shaped, with residence limited to ethnic Chinese, the city walls grew beyond this plan to include the non-ethnic Chinese formerly required to live outside the walls, resulting in its unusual shape.

JAPAN AND KOREA 600-1500

BY THE EIGHTH CENTURY both Korea and Japan had direct, though limited, contacts with China and India. All art forms were influenced by continental models, but from the ninth to twelfth centuries Japan developed distinctly different art forms (*kana* calligraphy, *yamato-e* scroll painting, and Shinto arts), while Korea created a culture that refined and altered Chinese prototypes.

MATERIALS AND TECHNIQUES
In architecture, Chinese-style post-and-beam wooden structures, with clay tile roofs, plastered walls and raised flooring (often surfaced with tile, dressed stone or polished wood), were used for government-sponsored structures, such as palaces and Buddhist temples. Less important buildings were also post and beam structures, built to withstand earthquakes, although roofed with lighter-weight materials like reeds or thatch.

Paintings followed Chinese prototypes, using ink and/or mineral pigments on silk or paper, which was then mounted in album, hand scroll or hanging-scroll formats. Within compositions, images were commonly outlined with either thin fine lines or thicker modulated brushwork. Calligraphy was considered a major art form, and a close relationship between image and text is found in both religious and secular paintings.

Buddhist sculptures, executed in a variety of media, followed Chinese models. Extant examples of non-Buddhist sculpture are rare, although in Japan some Shinto deities were depicted as court figures and some portrait statues were made for memorial services. Some stylized images of deer, dogs, or 'Chinese lions' in wood or stone have also survived.

Furniture was primarily low tables and cabinets, for both Koreans and Japanese sat on the floor in private and public buildings. Textiles included both cotton and silk, used for clothing and interior decorations in residential and government buildings. Glazed and unglazed ceramics were locally produced; imported Chinese ceramics were highly prized and copied. In the eleventh century distinctive pale green celadon wares were first produced in Korea for court and Buddhist temple use,

SEATED BUDDHA, with Bodhisattvas and guardian figures, Sokkuram Cave, near Kyongju, Korea, c.751–74. Buddhist sculpture in Korea and Japan was modelled after Chinese and Indian examples, which were either imported statues or iconographic drawings, reflecting international artistic styles. Images were created in a variety of media – carved stone (as in this example) or wood, polychromed clay or lacquer on wood structures, or cast bronze and iron. The idealized forms of these deities followed a strict iconography, but the facial features and clothing often reflected regional styles.

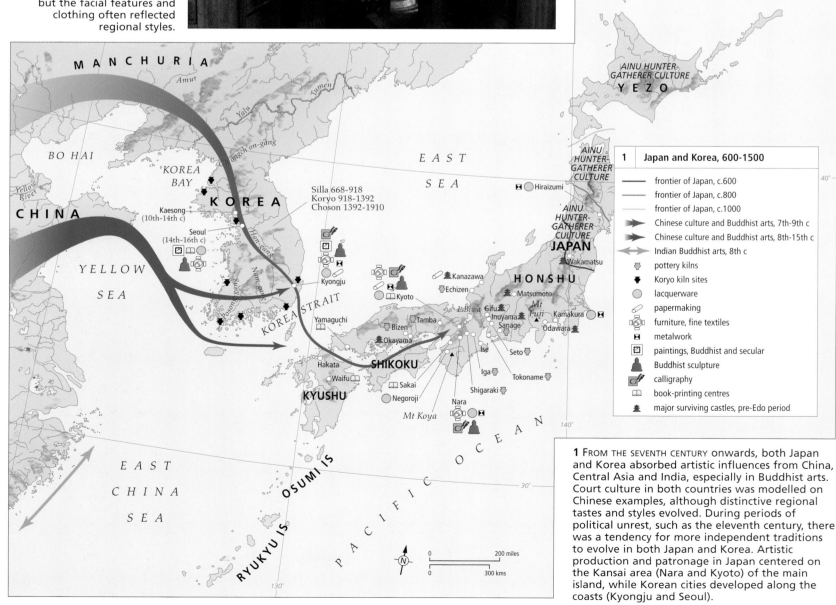

1 FROM THE SEVENTH CENTURY onwards, both Japan and Korea absorbed artistic influences from China, Central Asia and India, especially in Buddhist arts. Court culture in both countries was modelled on Chinese examples, although distinctive regional tastes and styles evolved. During periods of political unrest, such as the eleventh century, there was a tendency for more independent traditions to evolve in both Japan and Korea. Artistic production and patronage in Japan centered on the Kansai area (Nara and Kyoto) of the main island, while Korean cities developed along the coasts (Kyongju and Seoul).

1 Japan and Korea, 600-1500

- frontier of Japan, c.600
- frontier of Japan, c.800
- frontier of Japan, c.1000
- Chinese culture and Buddhist arts, 7th-9th c
- Chinese culture and Buddhist arts, 8th-15th c
- Indian Buddhist arts, 8th c
- pottery kilns
- Koryo kiln sites
- lacquerware
- papermaking
- furniture, fine textiles
- metalwork
- paintings, Buddhist and secular
- Buddhist sculpture
- calligraphy
- book-printing centres
- major surviving castles, pre-Edo period

Silla 668-918
Koryo 918-1392
Choson 1392-1910

2 MOST OF JAPAN'S TRADE with China and Korea flowed through the Inland Sea to the urban centres of Kyoto and Nara. These imperial capitals imported continental arts and also produced objects for use by aristocrats, as well as the Buddhist temples which were located in, and near, these cultural centres.

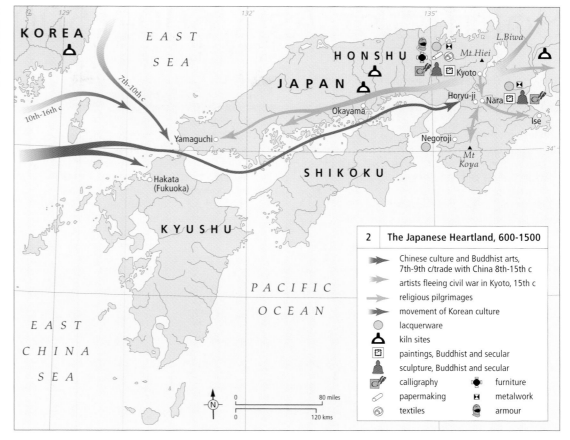

2 The Japanese Heartland, 600-1500

- Chinese culture and Buddhist arts, 7th-9th c/trade with China 8th-15th c
- artists fleeing civil war in Kyoto, 15th c
- religious pilgrimages
- movement of Korean culture
- ○ lacquerware
- △ kiln sites
- paintings, Buddhist and secular
- sculpture, Buddhist and secular
- calligraphy / furniture
- papermaking / metalwork
- textiles / armour

and in the fifteenth century white porcelain ware became widespread on the peninsula. Lacquered objects included ritual vessels and statuary as well as daily utensils, since neither Korea nor Japan produced glass during this period. Most metalwork was small in scale and was used for religious objects, swords or horse trappings.

ART AND SOCIETY
The political consolidations of the seventh century led to the development of urban centres. Kyongju became the capital of the Korean state of Unified Silla in the seventh century; in Japan. Nara (called Heijokyo) was founded in the eighth century, and Kyoto (called Heiankyo) in the ninth century. These cities followed the pattern of Tang China's imperial capital, Chang'an. They were laid out in a grid pattern of streets and densely populated residential areas. Large Buddhist temples, government buildings and imperial palaces and gardens were closely modelled on Chinese examples and furnished with imported goods or locally produced artwork that copied Chinese-style paintings, sculpture, metalwork, textiles and ceramics. The Shosoin imperial repository in Nara has survived as a time-capsule containing luxury goods from the time of Emperor Shomu (r.724–49), with items from Persia, Central Asia and China clearly demonstrating the extent of international trade along the Silk Road. By the tenth century, however, Korea and Japan had begun to change these imported traditions, establishing distinctive styles and artistic production lineages.

In 918 the Koryo Dynasty replaced declining Silla leadership in Korea and relocated the capital to Kaesong, which became the new cultural centre for the peninsula until 1394. Buddhism continued to flourish in Korea, with the construction of extensive temple compounds and the production of printed and illustrated *sutras*. A new sect of distinctly Korean Buddhism was established by the monk Chinul (1158–1210), and in 1234 movable metal type was first used to print Buddhist texts.

During the tenth century, the Japanese aristocracy developed an elaborate court culture (now considered a 'classic' age) with new aesthetic concepts that would influence

Japanese arts for the next 1000 years. While Kyoto remained the imperial capital from 794 to 1868, Kamakura and Hiraizumi emerged in the late twelfth century as political and cultural centres in the eastern provinces of Japan.

INDEPENDENT TRADITIONS
Due to political unrest in China, Korea and Japan both reduced their contacts with the mainland from the eleventh century, resulting in artistic developments that were independent of Chinese traditions. Distinctive ceramic techniques and forms, for example twelfth-century inlaid celadons, evolved in Korea. New calligraphy and painting styles were created in Japan. While temple and palace architecture in both countries continued to follow Chinese prototypes, different types of secular residential buildings were constructed that better suited their climates and lifestyles. Sculptural production in both countries was still closely associated with Buddhism, but now hereditary workshops independent of the temples developed in Japan with particular artistic styles maintained over many generations.

In 1392 the Yi (Choson) Dynasty was established in Korea, and the capital was moved to Seoul two years later. A gradual shift of artistic patronage from Buddhist temples to imperial court and Neo-Confucian institutions followed. Also in 1392, recent political turmoil in Japan was resolved with Kyoto resuming its place as the political and cultural centre under the Ashikaga military dictatorship.

During the fourteenth and fifteenth centuries China again influenced artistic production in Korea and Japan, especially in architecture and painting. Trade missions carried goods among various ports in East Asia, with both raw materials and finished artworks being imported and exported. Japan sent gold and gold-leafed paintings to China and Korea, while Korea traded gold, silver, paper, ink sticks and fan paintings to China for textiles, porcelains, books and musical instruments. Japanese Zen temples were sending monks to study in China and to bring back Chinese paintings, ceramics and lacquer-ware, much of which became associated with the social rituals of the tea ceremony.

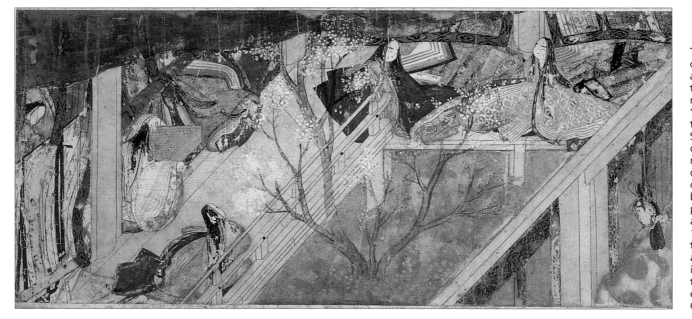

TALE OF GENJI SCROLL, ink and colours on paper, by court artists in Kyoto, Japan, twelfth century. The monumental narrative of the 'Tale of Genji', written by the court lady Murasaki Shikibu (c.1000) is often described as the world's first novel. The 54 chapters describing three generations of Kyoto aritoscrats have been illustrated by painters, printmakers, fabric designers and other artists for over 1000 years, including twentieth-century *manga* and *anime* (comic strip) illustrators. This example is taken from the earliest extant handscroll depicting Genji scenes.

ART, EXPLOITATION AND DISPLAY 1500~1800

T HE MAKING OF ART HAD ALWAYS BEGUN with the exploitation of resources, and its use involved display, but after 1500 both took on a new importance. This was largely as a result of the expansion of global exchange networks. If trade overland and via coastal shipping had been dominant before 1500, especially in and around the land mass of Asia and Europe, new developments in shipbuilding and navigation for the first time allowed commerce across the oceans. Magellan's expedition around the world in 1519–22, linking Europe to the Americas, the islands of the Pacific, Asia and Africa, showed what could be done. The volume of goods carried increased, speeds of transport accelerated, and movement could be in any direction permitted by wind and current. Possession of superior firearms meant that trading privileges and rights of settlement that previously would have had to be negotiated could now be forcibly imposed. Those countries and individuals that were in a position to exploit the new situation – first the Portuguese and Spanish and later the Dutch, French and English – could gain access to an unprecedented range of natural resources, from slaves and animals to plants and minerals. They, and those they traded with,

could also learn from each other how to use the art and artefacts they made from these materials in a competitive display. Such competitive displays had developed earlier in evolution as a desirable substitute for physical conflict, and now that wars between humans had become so destructive, as the Thirty Years' War in Germany most tragically demonstrated, they became a particularly wise investment. Competitive displays took place among the Ming and Qing emperors of China, the Mughal rulers of India, the Ottoman sultans, the tsars of Russia and the monarchs and ecclesiastics, princes and merchants of the rest of Europe. They all vied with each other in the collection and display both of precious materials, such as gold and silver from South America, gems from India, hard timbers from Southeast Asia, ivory from Africa and furs from North America and Siberia, and of art in which these and other materials were used, from 'cabinets of curiosities' and buildings to sculptures and clothes. Also involved were the princes, chiefs and other members of the smaller communities with which they dealt, first in areas such as Indonesia and Sub-Saharan Africa, and then, in the eighteenth century, in more remote places, such as the islands

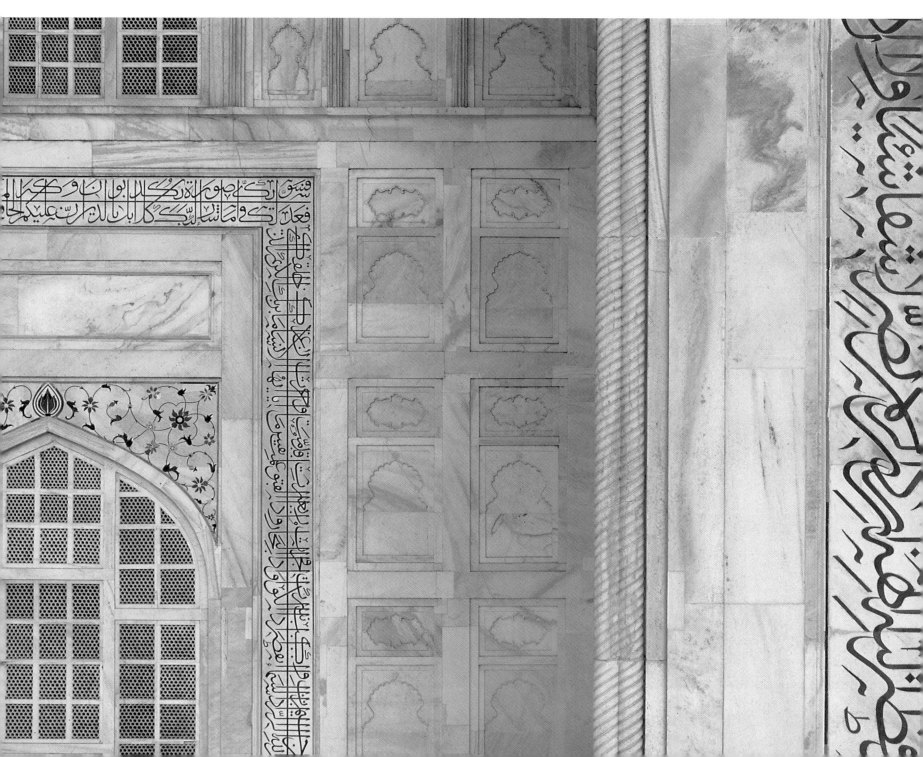

of the Pacific. Beads, buttons and silken threads had the same appeal for them as coral and mother-of-pearl did for Chinese and Europeans. The eyes of all involved in the worldwide trade, whether buyers or sellers, consumers or producers, were sharpened by growing rivalry in the pursuit of quality products, and in this climate of heightened sensual alertness all the visual arts took on a new prominence globally.

SIGHT ITSELF WAS A RESOURCE THAT WAS EXPLOITED to a new degree. The Italians showed how a knowledge of optics could help architects, sculptors and especially painters with their tasks, from simply describing reality to amazing the viewer with *trompe l'oeil* deceptions. The same knowledge was used to develop new aids to vision. Glass lenses made by the Dutch and fitted to telescopes and microscopes brought a new understanding, both of the minutiae of nature on earth and the grand order of the universe, while in England Newton could use the prism to break light down into a spectrum of colours. These discoveries were immediately recognized far to the East, where the Chinese emperor welcomed both European knowledge and European artists.

EYES WERE OPENING EVERYWHERE, and the growth of larger and larger towns meant greater numbers of potential viewers and a greater concentration of visual attention. By the eighteenth century cities such as Naples, Paris and London set new standards for size and splendour, as did the capitals of the Ottoman and Safavid dominions, Istanbul and Isfahan, and the Chinese cities of Beijing and Nanjing. But the largest of all was Edo, modern Tokyo. In the Japanese capital large numbers of refined craftsmen and artists fed the privileged elite's passion for display, while printmakers, as in China and western Europe, met the needs of the less well-off. These and other cities also provided the labour for the increasing mass-production of often highly ornamented ceramics and textiles. In Asia these products were often sent for sale in Europe. China exported pottery, India cotton, and the Ottoman Empire carpets, setting examples soon to be followed, and surpassed, by Britain. There, by 1800, the combined impact of the inflow of wealth generated by the use of slave labour in Caribbean colonies, the rapid growth of population supported by improved agriculture at home, and industrial mechanization made possible by the exploitation of local coal and iron, brought the beginning of the large-scale production of what had previously been luxury goods for a greatly enlarged market.

OUTSIDE EUROPE AND ASIA the patterns of mutual influence were more complex. In the vast Spanish and Portuguese colonies of Central and South America in the western hemisphere, and smaller colonies such as Goa and the Philipines in the East, wealth was invested in the building of churches, which were decorated by indigenous craftsmen with a combination of European and local forms and techniques. In West Africa and elsewhere the influence of taste was reversed as local rulers, enriched by the trade in slaves and other commodities, expanded their use of cast bronze and carved wood, often based on European models. The new phenomenon with the deepest long-term impact, however, was the arrival, even in the remotest communities, of cheaper and more effective new tools from the factories of Britain.

INLAID DECORATION on the Taj Mahal, Agra, India, 1631-48.

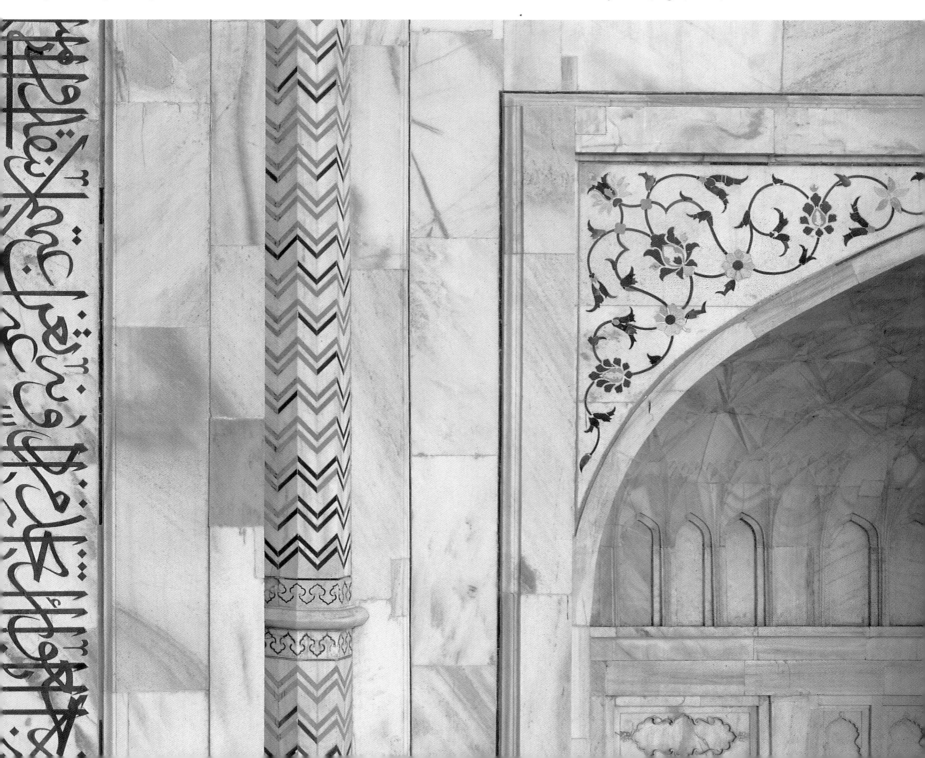

NORTH AMERICA 1500-1800

MOST OF THE EARLY North American cultures had evolved into the historic tribes by the time of European arrival and, for convenience, are generally grouped according to culture area. These culture areas are environmental niches that shaped the material arts and social organizations of the regions. For the most part these were developments of earlier cultural trends, and traditional materials and techniques were being practised well into the early historic period.

There had, however, been some major population shifts immediately prior to 1500. In particular, the Mississippian groups of the Eastern Woodlands had waned and been replaced by the Algonquian tribes and the Iroquois Confederacy. Although these new occupants maintained Mississippian trade routes and farming traditions, they were more democratic and usually had elected leaders rather than hierarchical systems. In the Southwest, earlier groups had abandoned large settlements, possibly as a consequence of prolonged droughts, and coalesced into the more compact, modern Pueblo tribes of the Rio Grande Valley: the Hopi and Zuni.

MATERIALS AND TECHNIQUES

Traditional materials such as skins and furs, feathers and quillwork, basketry, pottery and weaving continued to be utilized throughout this period, although these began to be supplemented by new trade materials and techniques introduced by Europeans. In most cases these changes were positive ones. Northwest Coast woodcarving reached new heights after the introduction of metal bladed tools replaced the earlier use of stone and shell blades. The new ease of carving led to a rapid increase in the production of ceremonial and clan items, and former carved house posts evolved into much larger free standing totem poles. Trade beads, copper cones, and small bells were important trade items, often used to supplement rather than replace earlier quill embroidery. Ribbon appliqué was a new technique introduced to the Woodland areas, while the ready availability of commercial dyes introduced vibrant colour. The Navajo of the Southwest obtained sheep and silver that started the jewellery and blanket traditions for which they are renowned, and at the same time began a change from nomadic hunting to pastoral herding. All of these introductions and changes saw a floresence of Native American arts.

CULTURE AND SOCIETY

While the European presence remained small and dependent on favourable trade, the native cultures and beliefs remained stable and largely intact. There was a wide variety of native cultures:

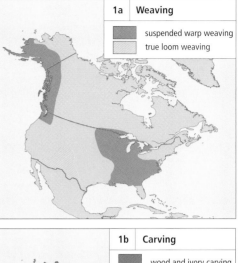

1a	Weaving
	suspended warp weaving
	true loom weaving

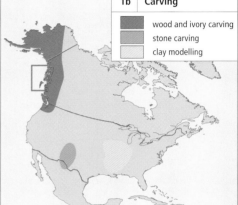

1b	Carving
	wood and ivory carving
	stone carving
	clay modelling

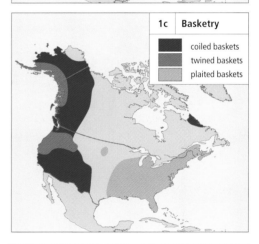

1c	Basketry
	coiled baskets
	twined baskets
	plaited baskets

1	Tribal North America

clothing materials:

	mainly hide and fur		hide, fur and various plant materials
	mainly cotton	• Hopi	tribe

1 THIS MAP SHOWS LOCATIONS OF TRIBES when they were first contacted, although this occurred much earlier in the east and Southwest than in central and northern regions. Following contact with Europeans, a number of the tribes were displaced and moved to new areas or became extinct.

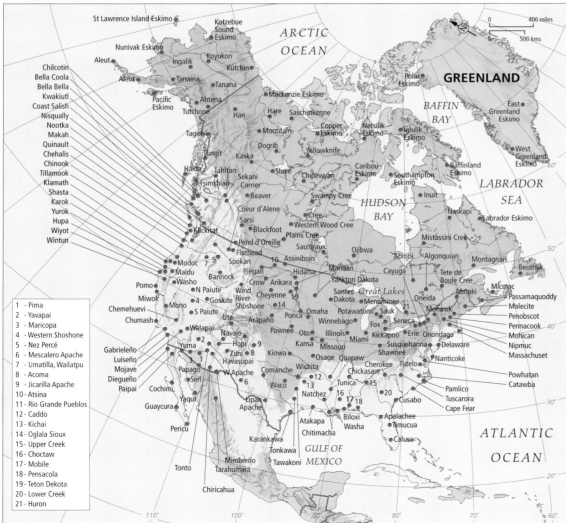

1 - Pima
2 - Yavapai
3 - Maricopa
4 - Western Shoshone
5 - Nez Percé
6 - Mescalero Apache
7 - Umatilla, Wailatpu
8 - Acoma
9 - Jicarilla Apache
10 - Atsina
11 - Rio Grande Pueblos
12 - Caddo
13 - Kichai
14 - Oglala Sioux
15 - Upper Creek
16 - Choctaw
17 - Mobile
18 - Pensacola
19 - Teton Dekota
20 - Lower Creek
21 - Huron

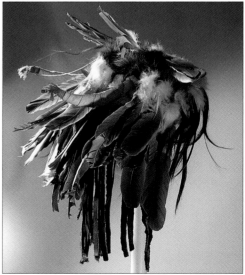

BUFFALO HORN SOCIETY HEADDRESS. Blackfoot Feathers were used by Plains tribes as symbolic links with the forces of nature and were frequently given sacred meaning. This buffalo horn and feather headdress was worn by a shaman in the Buffalo Horn Society.

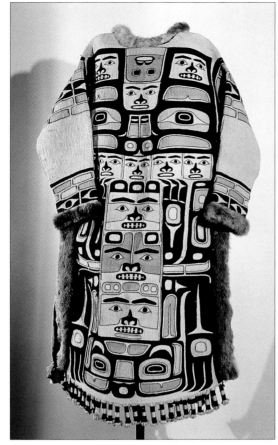

BROWN BEAR CLAN COAT, CHILKAT. Split-representation, in which a figure is depicted as if split and laid out so all its features can be seen simultaneously, was a characteristic element in Northwest Coast art. The animal featured on this Chilkat shirt is the Brown Bear, an important clan crest of the Tlingit tribes, which also appeared in carved form on crest helmets and on totem poles and house posts. Such an elaborate costume would have been reserved for socially significant occasions and worn by a member of a prestigious household.

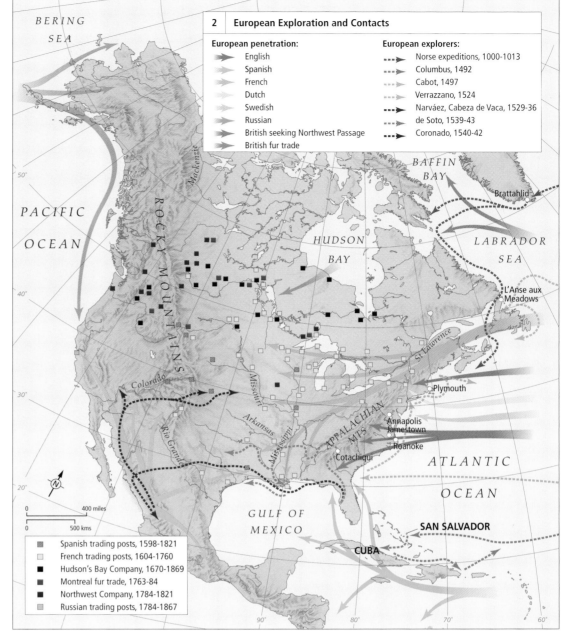

2 European Exploration and Contacts

European penetration:
→ English
→ Spanish
→ French
→ Dutch
→ Swedish
→ Russian
→ British seeking Northwest Passage
→ British fur trade

European explorers:
⤍ Norse expeditions, 1000-1013
⤍ Columbus, 1492
⤍ Cabot, 1497
⤍ Verrazzano, 1524
⤍ Narváez, Cabeza de Vaca, 1529-36
⤍ de Soto, 1539-43
⤍ Coronado, 1540-42

■ Spanish trading posts, 1598-1821
□ French trading posts, 1604-1760
■ Hudson's Bay Company, 1670-1869
■ Montreal fur trade, 1763-84
■ Northwest Company, 1784-1821
■ Russian trading posts, 1784-1867

coastal and loosely organized hunting tribes of the Inuit (Eskimo) and the Subarctic; organized confederacies such as the Iroquois in the Woodlands; ranked hierarchies on the Northwest Coast; family bands and very localized groups in California; nomadic and highly democratic hunting bands and tribes on the Plains; and *kiva* (ceremonial) organizations of the Southwestern Pueblos.

EUROPEAN EXPANSION
Aggressive expansionist and trade policies of Europeans began, however, to undermine the material culture and beliefs of many of these groups. Also, in some areas tribes had become dependent on the supply of trade goods such as weapons and ammunition, the withdrawal of which left these groups without the means for hunting or defence. The effect that European policy had on the tribes was largely dependent on which European power happened to be dominant in the area.

English policy was one of both colonization and trade. The growth of the English colonies and shifting politics and aggression between Britain and France led to the decimation of the Algonquian tribes of the Woodlands by the mid-1600s. Other tribes of the region, especially the Creeks who were already adept agriculturalists, adapted to the changing conditions by adopting English farming techniques and livestock, items of English dress, and even used English names. In fact, so successful were they at these adaptations that the English married into their leading families and during the eighteenth

century Alexander McGillivray, the son of a Scots trader and a half-French Creek mother, became the undisputed leader of the Creek Confederacy.

Spanish incursions into the Southwest and California were driven by religious zeal and a search for wealth, leading to the establishment of missions and military governments in the area during the 1770s and the virtual loss of a Californian cultural identity. Although the Pueblo groups of the Southwest had nominally converted to Catholicism, they retained more of their beliefs and arts than groups in the other regions. They continued to conduct secret ceremonies in their underground *kivas* that featured elaborately masked and costumed *kachina* dancers.

In other regions influence was expressed primarily through trade. The Hudson's Bay Company agents, although dominating the fur trade in the north, were too widely scattered to alter the nomadic hunting life of the Subarctic groups, even though these tribes had become dependent on European weapons and other trade goods. Some changes, such as the replacement of birchbark containers by trade kettles, did occur but these were insufficient to cause massive upheaval. In fact, among the Athapascan tribes in the western reaches of the Subarctic material culture and beliefs underwent no significant change at all, while the tribes of the far north of the area, including the Inuit, were virtually unknown during this

2 THE FIRST EXPEDITIONS TO NORTH AMERICA were ones of discovery and a search for knowledge. The uncharted regions of the continent offered unparalleled scope for the advancement of scientific knowledge as well as promising opportunities for trade. Following first contacts, numerous European nations vied with each other for control of North America's resources. Although the fur trade dominated the central and northern regions and the north Pacific coast, interest on the eastern seaboard was in land for settlement while the Spanish in the Southwest sought silver.

period and obtained trade items only through native intermediaries.

Curiously, the area that most typifies the general perception of Native American culture and art was almost entirely a consequence of the late introduction of European trade items. This was the Great Plains, where mounted, nomadic buffalo hunting and warrior elites developed in the early 1700s after the introduction of guns from the east and Spanish horses from the south.

Few of these tribes were original to the area. They came from all directions and formed a complex mix of culture traits. Flowing eagle feather war bonnets, for instance, came originally from the eastern Sioux, some decorative techniques such as quillwork were from the Woodlands, other ideas came from the south. They met on the Great Plains in a brilliant and spectacular, but short-lived, explosion of colour and motion.

CENTRAL AMERICA 1500-1800

THE BEGINNING OF THIS PERIOD saw a collision between two vastly different cultures: the Aztec and the Spanish. Neither of these cultures had any real understanding of the beliefs and artistic expression of the other, leading to the confrontation in which the Aztec Empire was effectively dismantled by Hernán Cortés between 1519 and 1521.

A CLASH OF CULTURES

That this clash occurred so suddenly and irrevocably changed the artistic production of the region can be understood by considering the ideologies that were involved. The Spanish came from a European background of powerful and wealthy state and religious institutions based on a belief in one true god. Spanish ideals were to convert and Christianize the people they came into contact with, and to use wealth to establish the state and religious buildings that supported this. The Aztec ideal also had an architectural base that combined state and religion, but leadership was vested in the Tlatoani (Great Speaker) and Cihuacoatl (Female Serpent), who were considered deities. The Aztecs did not impose their beliefs on subjugated groups but instead exacted punitive taxes to maintain the Aztec centres. Thus Cortés encountered many disaffected groups to support him, and with the killing of the Tlatoani and Cihuacoatl, effectively destroyed the entire Aztec state and religious foundation, leading to an immediate collapse.

SANTO DOMINGO CATHEDRAL, DOMINICAN REPUBLIC. The Cathedral of Santa María la Menor in Santo Domingo is the oldest cathedral in the Americas. Founded in 1519, when the Spanish used Santo Domingo as a staging post for their incursions into Mexico and Central America, it was from here that Cortés launched his attacks against the Aztecs. A marble sarcophagus in the cathedral is said, controversially, to contain the bones of Christopher Columbus. There is also a Madonna by Murillo (1617–82).

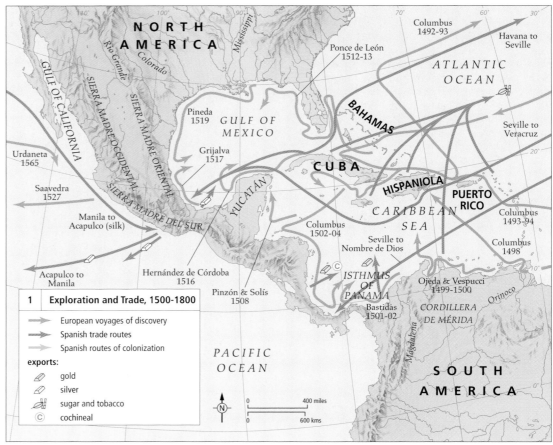

1 Exploration and Trade, 1500-1800

→ European voyages of discovery
→ Spanish trade routes
→ Spanish routes of colonization

exports:
⬧ gold
⬧ silver
⬧ sugar and tobacco
ⓒ cochineal

EARLY COLONIAL ARTS

The first acts of the Spanish were to destroy the religious symbols of the old culture and replace them with their own. Temples built on the tops of imposing pyramids were dismantled, their elaborate frescoed surfaces studded with gold, silver and mosaic defaced, and the images of their gods destroyed. Materials from these were re-used to erect the buildings of the new religion, using indigenous labour under the guidance of Spanish

1 THE SPANISH DOMINATED both exploration and trade in Mexico, Central America and the Caribbean. After the conquest of the Aztecs in 1521, most of the region was declared a province of Spain and placed under the control of Spanish governors. Silver from this region financed Spain's colonial ambitions and, indirectly through the looting of Spanish treasure ships, the ambitions of other European nations as well. Silver was a trade mainstay, but other goods such as gold, sugar, tobacco and cochineal were also important.

missionaries. The inevitable fusion resulted in a mix of European and indigenous styles during the sixteenth century. There is, for instance, a post-Conquest Aztec frieze in the church at Cholula, and a carving of the Virgin at the Augustinian monastery of Acolman that is derived from Coatlicue, the Aztec goddess of life and death. Similarly, angels carved at the Franciscan monastery at Tlalmanalco are depicted with monkey faces in reference to Ozomatli, the Aztec god of writing and sacred knowledge. The style of colonial buildings also had to change in response to local circumstances and environments; for instance, open chapels (capilla abierta) were included to accommodate the large native populations.

Some elaborate European filigree work is noticeable from the early sixteenth century, and this is generally referred to as Plateresque: from the phrase Plasteros de yeso (silversmiths in plaster), referring to the fine detailing of plaster over stonework. The Santo Domingo Cathedral (1519, the oldest cathedral in the Americas) and the Hospital of San Nicolás de Bari (1522) are outstanding examples of Plateresque work by Spanish artists.

THE RISE OF NATIONALISM

The late sixteenth and seventeenth centuries saw two changes in population demographics that affected the arts. First was a dramatic decline in the indigenous populations, due

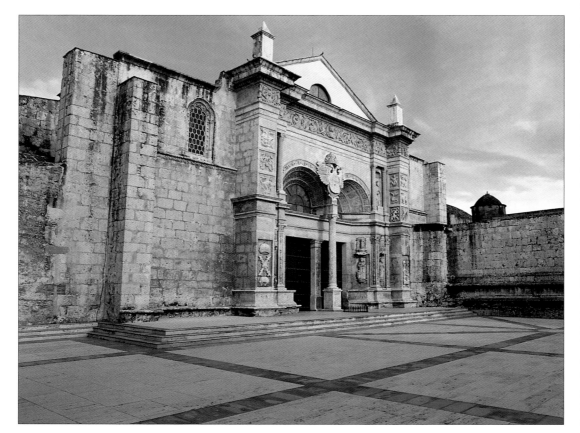

primarily to European diseases against which they had little or no natural resistance. Second was the arrival of increasing numbers of Europeans, many of them with better architectural skill and artistic ability than the early *conquistadores* and missionaries.

At the same time there was a considerable increase in the numbers of people who were of Spanish descent but who had been born in the New World, as well as offspring of mixed marriages. While welcoming the ideas and inspiration of the new arrivals, these people did not claim the same cultural and family ties to Spain. Thus new art forms began to emerge that were based on a European tradition but which incorporated elements of a Central American national identity. This gave rise to distinctive arts in furniture, metalwork, ceramics, mural painting and votive offerings, as well as in building, that were no longer confined to the religious sphere but were also seen in the domestic environment. For example, carved figures placed at street

corners and even house fronts with elaborate murals were used as a means of identifying districts in the absence of names and numbers.

CENTRAL AMERICAN BAROQUE
Central American Baroque reached its climax in Mexico during the eighteenth century, although there are also good examples in Guatemala and Cuba, where the ornate Churrigueresque style imported from Spain is combined with the exaggerated ornamentation of the Mayans and Aztecs. The resemblance between the façade decorations of Mayan buildings and Mexican Baroque churches is so striking that there has to be a direct relationship.

In Baroque architecture there was a deliberate play of light and shade through the application of raised plasterwork, further enriched with polychrome decoration and, often, glazed tiles. Scrolls and arabesques, lines and geometric interlocking forms, and other decorative motifs were twined and twisted around figures in niches of Mexicanized saints. No part of the surface was left untouched by carving, plaster or paint.

The interior of the Cathedral of Mexico City contains a retable that was completed in 1737, and which is so massive and ornate that it has been referred to as 'Ultra-Baroque'. Other extreme examples of Mexican Baroque can be seen in the vault of the Rosary Chapel in the Church of Santo Domingo, Oaxaca (1729) and at the Cathedral of Zacatecas (1761).

2 PART OF SPANISH PHILOSOPHY was that the people they conquered should become subjects of Spain. This, however, was not possible unless they embraced the Catholic faith. Missionaries of various Catholic denominations travelled with the *conquistadores*, and Spanish military garrisons were often part of the fabric of the church. Much of Spanish colonial architecture therefore consists of monasteries, churches, and cathedrals, although there were also imposing buildings erected for the governors of the provinces.

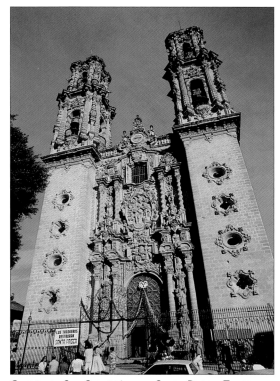

CHURCH OF SAN SEBASTIÁN AND SANTA PRISCA, TAXCO, built between 1748 and 1758 with money donated by José de la Borda, the owner of Taxco's silver mine. It is one of the finest examples of Mexican Baroque with a façade that combines finely worked pink stone with plaster decoration that has detail picked out in gold.

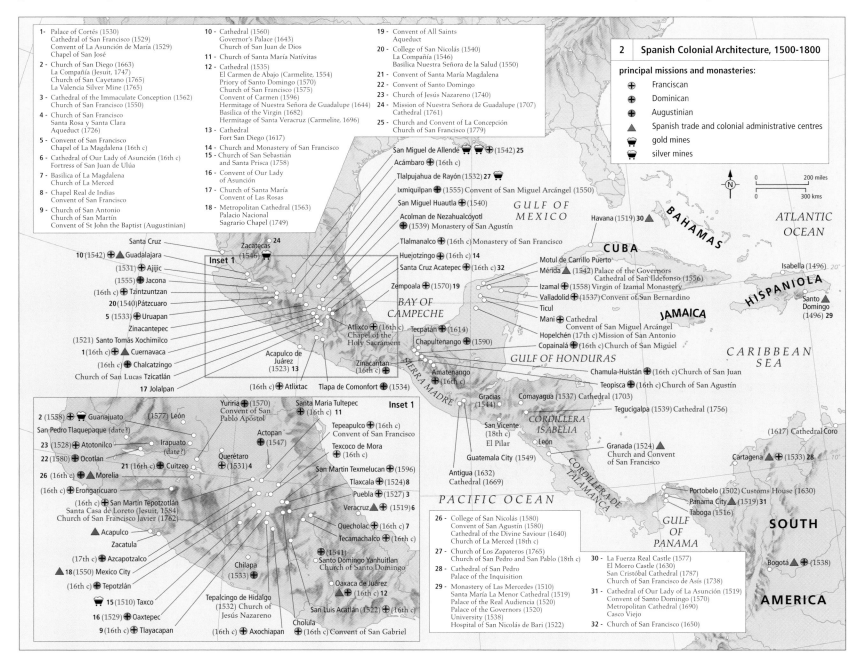

1- Palace of Cortés (1530)
 Cathedral of San Francisco (1529)
 Convent of La Asunción de María (1529)
 Chapel of San José
2- Church of San Diego (1663)
 La Compañía (Jesuit, 1747)
 Church of San Cayetano (1765)
 La Valencia Silver Mine (1765)
3- Cathedral of the Immaculate Conception (1562)
 Church of San Francisco (1550)
4- Church of San Francisco
 Santa Rosa y Santa Clara
 Aqueduct (1726)
5- Convent of San Francisco
 Chapel of La Magdalena (16th c)
6- Cathedral of Our Lady of Asunción (16th c)
 Fortress of San Juan de Ulúa
7- Basilica of La Magdalena
 Church of La Merced
8- Chapel Real de Indias
 Convent of San Francisco
9- Church of San Antonio
 Church of San Martín
 Convent of St John the Baptist (Augustinian)

10- Cathedral (1560)
 Governor's Palace (1643)
 Church of San Juan de Dios
11- Church of Santa María Natívitas
12- Cathedral (1535)
 El Carmen de Abajo (Carmelite, 1554)
 Priory of Santo Domingo (1570)
 Church of San Francisco (1575)
 Convent of Carmen (1596)
 Hermitage of Nuestra Señora de Guadalupe (1644)
 Basilica of the Virgin (1682)
 Hermitage of Santa Veracruz (Carmelite, 1696)
13- Cathedral
 Fort San Diego (1617)
14- Church and Monastery of San Francisco
15- Church of San Sebastián
 and Santa Prisca (1758)
16- Convent of Our Lady
 of Asunción
17- Church of Santa María
 Convent of Las Rosas
18- Metropolitan Cathedral (1563)
 Palacio Nacional
 Sagrario Chapel (1749)

19- Convent of All Saints
 Aqueduct
20- College of San Nicolás (1540)
 La Compañía (1546)
 Basílica Nuestra Señora de la Salud (1550)
21- Convent of Santa María Magdalena
22- Convent of Santo Domingo
23- Church of Jesús Nazareno (1740)
24- Mission of Nuestra Señora de Guadalupe (1707)
 Cathedral (1761)
25- Church and Convent of La Concepción
 Church of San Francisco (1779)

2 Spanish Colonial Architecture, 1500-1800

principal missions and monasteries:
⊕ Franciscan
⊕ Dominican
⊕ Augustinian
▲ Spanish trade and colonial administrative centres
⛏ gold mines
⛏ silver mines

0 200 miles
0 300 kms

26- College of San Nicolás (1580)
 Convent of San Agustín (1580)
 Cathedral of the Divine Saviour (1640)
 Church of La Merced (18th c)
27- Cathedral of Los Zapateros (1765)
 Church of San Pedro and San Pablo (18th c)
28- Cathedral of San Pedro
 Palace of the Inquisition
29- Monastery of Las Mercedes (1510)
 Santa María La Menor Cathedral (1519)
 Palace of the Real Audiencia (1520)
 Palace of the Governors (1520)
 University (1538)
 Hospital of San Nicolás de Bari (1522)

30- La Fuerza Real Castle (1577)
 El Morro Castle (1630)
 San Cristóbal Cathedral (1787)
 Church of San Francisco de Asís (1738)
31- Cathedral of Our Lady of La Asunción (1519)
 Convent of Santo Domingo (1570)
 Metropolitan Cathedral (1690)
 Casco Viejo
32- Church of San Francisco (1650)

Map labels:
San Miguel de Allende (1542) 25
Acámbaro (16th c)
Tlalpujahua de Rayón (1532) 27
Ixmiquilpan (1555) Convent of San Miguel Arcángel (1550)
San Miguel Huautla (1540)
Acolman de Nezahualcóyotl (1539) Monastery of San Agustín
GULF OF MEXICO
Havana (1519) 30
Tlalmanalco (16th c) Monastery of San Francisco
Huejotzingo (16th c) 14
Santa Cruz Acatepec (16th c) 32
Motul de Carrillo Puerto
Mérida (1542) Palace of the Governors
 Cathedral of San Ildefonso (1556)
Izamal (1558) Virgin of Izamal Monastery
Valladolid (1537) Convent of San Bernardino
Ticul
Mani Cathedral
 Convent of San Miguel Arcángel
Hopelchén (17th c) Mission of San Antonio
Copainalá (16th c) Church of San Migúel
Zempoala (1570) 19
BAY OF CAMPECHE
CUBA
BAHAMAS
ATLANTIC OCEAN
Isabella (1496)
HISPANIOLA
Santo Domingo (1496) 29
JAMAICA
CARIBBEAN SEA
Santa Cruz
Zacatecas 24 (1546)
10 (1542) Guadalajara
Inset 1
(1531) Ajijic
(1555) Jacona
(16th c) Tzintzuntzan
20 (1540) Pátzcuaro
5 (1533) Uruapan
Zinacantepec
(1521) Santo Tomás Xochimilco
1 (16th c) Cuernavaca
(16th c) Chalcatzingo
Church of San Lucas Tzicatlán
17 Jolalpan
Atlixco (16th c)
Chapel of the Holy Sacrament
Zinacantan (16th c)
Acapulco de Juárez (1523) 13
(16th c) Atlixtac
Tlapa de Comonfort (1534)
Tecpatán (1614)
Chapultenango (1590)
Amatenango (16th c)
SIERRA MADRE
Chamula-Huistán (16th c) Church of San Juan
Teopisca (16th c) Church of San Agustín
Gracias (1544)
Comayagua (1537) Cathedral (1703)
Tegucigalpa (1539) Cathedral (1756)
GULF OF HONDURAS
CORDILLERA ISABELIA
(1617) Cathedral Coro
SOUTH AMERICA
Bogotá (1538)

Inset 1:
Yuriria (1570) Convent of San Pablo Apóstol
Santa Maria Tultepec (16th c) 11
2 (1558) Guanajuato
(1577) León
San Pedro Tlaquepaque (date?)
23 (1528) Atotonilco
Irapuato (date?)
22 (1580) Ocotlan
21 (16th c) Cuitzeo
26 (16th c) Morelia
(16th c) Erongarícuaro
(16th c) San Martín Tepotzotlán
Santa Casa de Loreto (Jesuit, 1584)
Church of San Francisco Javier (1762)
Acapulco
Zacatula
(17th c) Azcapotzalco
18 (1550) Mexico City
(16th c) Tepotzlán
15 (1510) Taxco
16 (1529) Oaxtepec
9 (16th c) Tlalcapan
Actopan (1547)
Querétaro (1531) 4
Tepeapulco (16th c) Convent of San Francisco
Texcoco de Mora
San Martin Texmelucan (1596)
Tlaxcala (1524) 8
Puebla (1527) 3
Veracruz (1519) 6
Quecholac (16th c) 7
Tecamachalco (16th c)
Chilapa (1533)
Santo Domingo Yanhuitlan Church of Santo Domingo
Oaxaca de Juárez (16th c) 12
Tepalcingo de Hidalgo (1532) Church of Jesús Nazareno
San Luis Acatlan (1522)
Cholula
(16th c) Axochiapan
(16th c) Convent of San Gabriel
San Vicente (18th c) El Pilar
León
Guatemala City (1549)
Antigua (1632) Cathedral (1669)
Granada (1524) Church and Convent of San Francisco
Cartagena (1533) 28
PACIFIC OCEAN
GULF OF PANAMA
Portobelo (1502) Customs House (1630)
Panama City (1519) 31
Taboga (1516)
CORDILLERA DE TALAMANCA

SOUTH AMERICA 1500-1800

THE CONQUEST OF SOUTH AMERICA by Europeans largely eradicated the cultures of the indigenous peoples with whom they came in contact. Although Europeans did not actually take over the whole continent until the nineteenth century – the southernmost regions, and Amazonian interior were not occupied until then, and some sites such as Machu Pichu in Peru actually may postdate the subjugation of the Inca Empire – the Spanish levelled previously existing sites and built on top of them; the indigenous populations of the Brazilian coast were largely eradicated. European forms thus often literally supplanted or stood on top of indigenous architecture. Native American and African artists and artisans worked mainly in the service of the hegemonic culture, and traces of their artistic input can be seen at best only in elements of iconography, construction and forms of manufacture.

ARTISTIC CENTRES

Because of the vast distances, formidable terrain, including high mountain ranges and jungles, and the forbidding (and ever changing) climates, architectural forms in particular depended on local materials, and many independent artistic centres also came into existence. Since stone was largely lacking on the Brazilian littoral, building techniques utilizing mud, earth, or clay were often employed there, although limestone (sometimes imported) and soapstone were used for ornament on façades, and for sculpture. In contrast, many local stones, with varying degrees of hardness, hence difficulty for carving, were used in the Andean regions: Andesite in what is central Peru, varieties of granite around La Paz, volcanic tufa in Arequipa. Earthquakes, which are frequent in this region, also affected

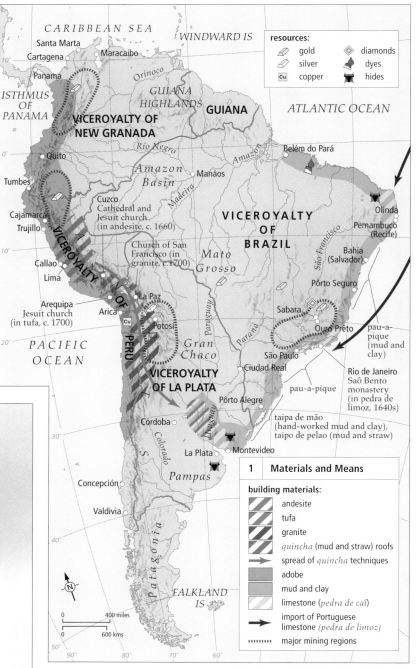

THE CHURCH OF SÃO FRANCISCO in Ouro Prêto was built for lay brethren of the Franciscan order, as Franciscan regulars were not allowed into the mining province of Minas Gerais. The artist Aleijandinho, the child of European and African parents, carved the sculpture on the façade, but the building's design echoes Italian and central European prototypes.

1 SOUTH AMERICAN architecture is notable for its use local materials, including different kinds of metamorphic stones in the Andes, and, where stone was not at hand, other building materials, such as adobe. However, materials used were also often brought from great distances (limestone from Portugal), and new solutions (*quincha* roofs) were devised to deal with specia, for example, seismic circumstances.

construction techniques (massive walls were a common feature): Europeans adapted wattle-and-daub thatching for roofing construction.

Two of the most important artistic sites during the period were located in what had been the Inca capitals, the present cities of Cuzco and Quito. Paintings were exported throughout the region of the vice-royalty of Peru from Cuzco. The first art school on the continent was already established in Quito in the sixteenth century, and the first South American art treatise was written there in the eighteenth; Quito was also home to an important school of sculptors. The Spanish, however, established their vice-regal capital at the new city of Lima, a more accessible site near the sea. Lima had buildings designed by Europeans, and a grid plan, which was a standard

model for new foundations throughout Spanish America. Lima itself eventually exported art.

The search for precious metals also affected economic, and consequently cultural, developments. The discovery of silver near Potosí in the mid-sixteenth century created a boom town whose population in the seventeenth century exceeded that of most European cities. New wealth paid for the explosion of buildings and furnishing in Potosí – it was to do the same in the cities that became Sucre and La Paz in Bolivia.

Some gold was also found in what is now Colombia, where the Spanish had settled at an early date, creating cities (Tunja) with a European aspect and even with Renaissance wall paintings. Towns on the coast such as Cartagena, with extensive fortifications and churches in stone, originated as points of embarkation for the treasure fleets.

THE DISSEMINATION OF ART
The Jesuits played a special role in the dissemination of art, especially by Europeans who were not of Iberian origin. In the sixteenth century the Jesuit Bernardo Bitti, from Camerino in Italy, made paintings and sculpture while *en route* from Ecuador to Bolivia. In the eighteenth century, German Jesuits established workshops in what is now Chile to supply works to that Captaincy General. The Jesuits also established several new sorts of institutions, notably *estancias* (ranches) in what is now Argentina, which were often designed by Italian or Germanic architects. Even more remarkable are the European-style art and architecture produced on Jesuit missions by rainforest people like the Guaraní in Paraguay.

THE SILVER MOUNTAIN (the *cerro rico*) outside Potosí was a source of enormous wealth. It is depicted by an unknown artist (c.1740) as the mantle of the Virgin, who is crowned by the Trinity – the Father and Son represented as priests. The possible conflation with pre-conquest indigenous beliefs, in which mountains, rocks, and a mother goddess were venerated, is striking.

The Jesuits left some of the first surviving monuments in Portuguese America as well, but because of the unsettled and long-contested political situation, most early surviving monuments in Brazil are of a later, seventeenth-century date. In fact, some of the most noteworthy works made in Brazil during the seventeenth century were produced by Dutch artists during the period of the Netherlandish incursion, especially in the region around Pernambuco (Recife). Frans Post painted some of the first landscapes of the continent, and Albert Eckhout recorded its inhabitants and fauna. While Benedictines, Jesuits and other religious orders played an important role along the coast, their activities were forbidden in the interior province of Minas Gerais, where diamonds and gold were found in the eighteenth century.

In the mining regions several boom towns grew up in mountain valleys: the most remarkable of them is Ouro Prêto, whose name means 'black gold'. The monuments of this region were built by peoples of African as well as European origin, and draw on many different European artistic sources – they even reveal elements of *chinoiserie*. Such details provide more evidence for the multicultural aspects of art and architecture in colonial South America.

2 ARTISTIC CENTRES CRYSTALLIZED in several colonial sites. Aside from the schools established by the Franciscans (Quito), and Jesuit ateliers (Chile and Argentina), cities such as Cuzco, Quito and Lima housed many artists, who produced vast quantities of painting and sculpture. Brazil was home to numerous regional centres: most conspicuous were the architects, sculptors and painters in Minas Gerais (Ouro Prêto).

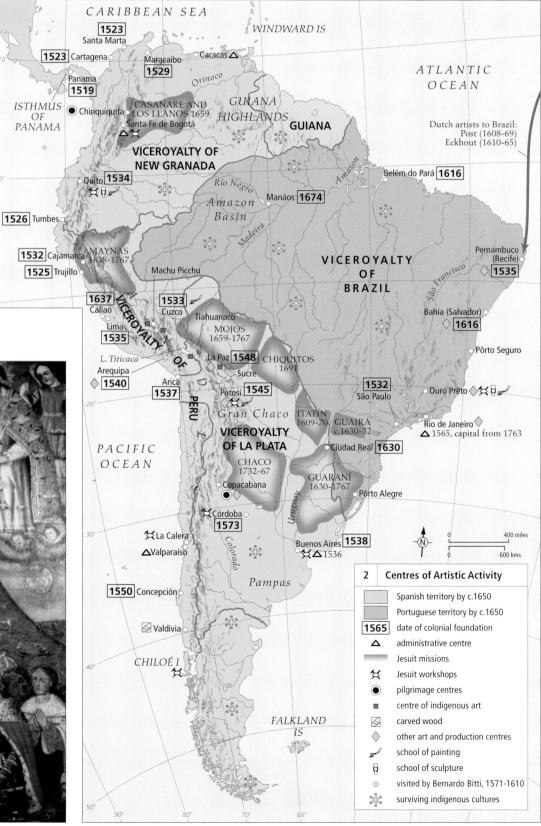

2	Centres of Artistic Activity
	Spanish territory by c.1650
	Portuguese territory by c.1650
1565	date of colonial foundation
△	administrative centre
	Jesuit missions
⚒	Jesuit workshops
●	pilgrimage centres
■	centre of indigenous art
⊠	carved wood
◇	other art and production centres
	school of painting
	school of sculpture
○	visited by Bernardo Bitti, 1571-1610
✳	surviving indigenous cultures

EUROPE 1500-1600

Sixteenth-century Europe experienced an unprecedented intermingling of its various artistic and architectural traditions. Of these, the Italian tradition had the broadest impact, extending from Portugal to Scandinavia, France to Russia, and Scotland to the Balkans. Even as the influence of Italy spread, other exchanges between different regions took place, creating an era of artistic cross-fertilization.

ARTISTIC CROSS-CURRENTS
Untold numbers of artists and craftsmen traversed the continent in search of patronage or training. Foreigners flocked to Italy to study its

monuments and learn from Italian masters. Relocated or new court centres, including those at Fontainebleau, Dresden, Madrid and Prague, attracted fresh mixtures of international artists. Through their personal travels, patrons, too, became important conduits for ideas about art. Finally, events like the sack of Rome (1527), the French Wars of Religion (1562–98), and the Spanish conquest of Antwerp (1585) prompted many artists to flee these areas and seek their livelihoods elsewhere.

Prints and printed books played a key role in the artistic interchange. Mass-produced, easily transportable prints from Italy, Germany, France

and the Low Countries circulated throughout Europe. Leading print publishers joined printmakers to reproduce the treasures of antiquity and works of Raphael, Michelangelo, Heemskerck and Bruegel, among others. The writings of Vitruvius and Sebastiano Serlio had immense bearing on architectural developments. Others in western Europe authored vernacular, sometimes nationalistic, theoretical texts which typically responded to Italian ideas.

The burgeoning art market and formation of multi-faceted art collections propagated styles and trends. Artists sold their wares to local merchants, at regional fairs, and to foreign

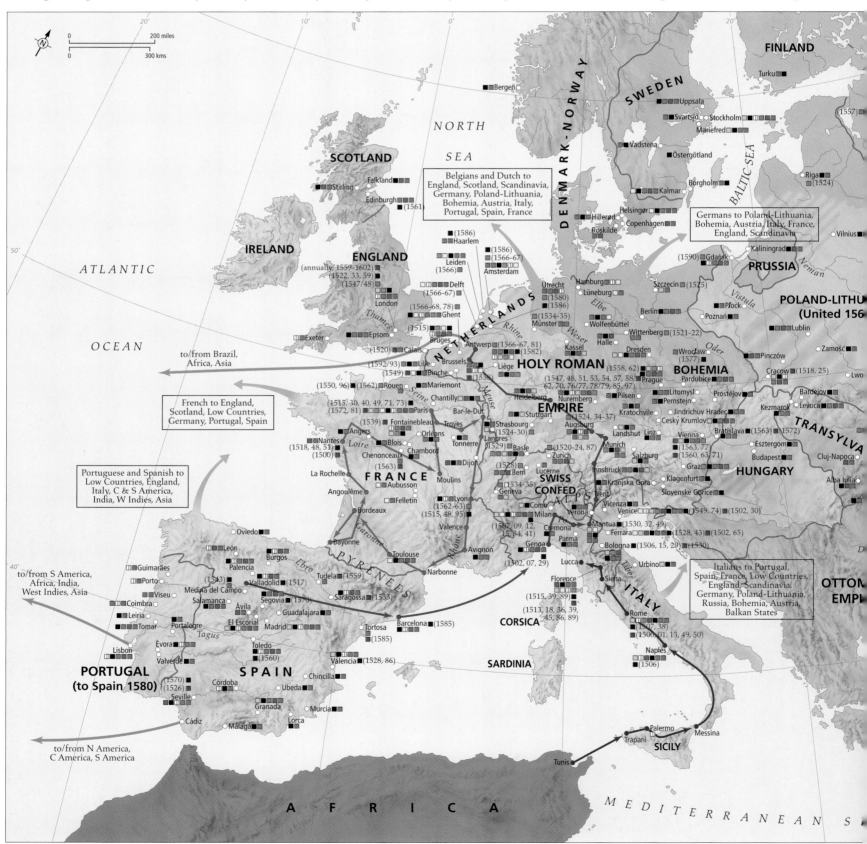

royalty. Many cities participated in the network, but as a hub for the production and distribution of art objects none equalled Antwerp in variety, scale and geographic reach. Working with personal agents or art dealers, major collectors supported the art and artistic trades through their eclectic acquisitions. Philip II of Spain, for example, favoured works by Bosch and Titian, but had little interest in El Greco. Knowledge gained through such interaction allowed artists,

1 THE PROTESTANT REFORMATION in the sixteenth century had a profound impact on religious art. Catholics maintained their worship traditions and patronage patterns, but Calvinists, Anglicans and others rejected the role of images in worship and cleansed their sanctuaries of art. Lutherans believed Christian art was inherently neither good nor bad; religious art was destroyed, modified, and even commissioned in Lutheran churches.

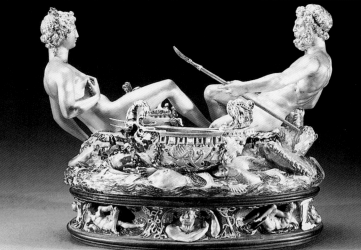

BENVENUTO CELLINI, *Salt Cellar*, 1540–43. During his second trip to France, the great Florentine goldsmith created this masterpiece for King Francis I. The salt cellar exemplifies contemporary European courts' interest in both artistic virtuosity and microcosmic collections of art, antiquities, *naturalia*, scientific instruments and artefacts from around the world. In 1570 King Charles IX gave the salt cellar to Archduke Ferdinand II of Austria, who added it to his Innsbruck *Kunstkammer*.

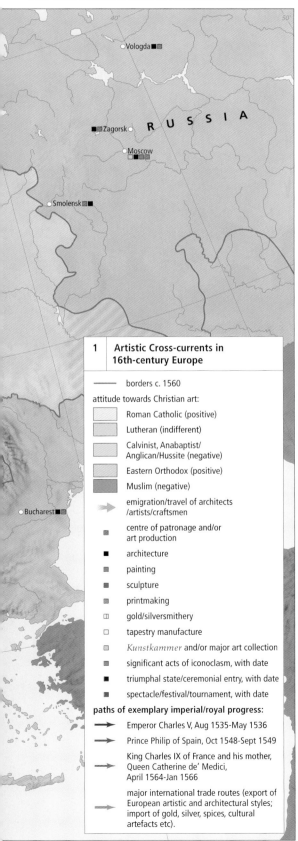

1 Artistic Cross-currents in 16th-century Europe

— borders c. 1560

attitude towards Christian art:

- Roman Catholic (positive)
- Lutheran (indifferent)
- Calvinist, Anabaptist/ Anglican/Hussite (negative)
- Eastern Orthodox (positive)
- Muslim (negative)

→ emigration/travel of architects /artists/craftsmen

■ centre of patronage and/or art production

■ architecture

■ painting

■ sculpture

■ printmaking

⊞ gold/silversmithery

□ tapestry manufacture

▨ *Kunstkammer* and/or major art collection

■ significant acts of iconoclasm, with date

■ triumphal state/ceremonial entry, with date

■ spectacle/festival/tournament, with date

paths of exemplary imperial/royal progress:

→ Emperor Charles V, Aug 1535-May 1536

→ Prince Philip of Spain, Oct 1548-Sept 1549

→ King Charles IX of France and his mother, Queen Catherine de' Medici, April 1564-Jan 1566

→ major international trade routes (export of European artistic and architectural styles; import of gold, silver, spices, cultural artefacts etc).

architects and patrons to select, mix and adapt from a palette of concepts and styles.

The Italians set new standards by creating paradigmatic High Renaissance, Mannerist and then early Baroque works. If stylistic diversity ultimately dominated at the international and regional levels, the pervasive effect of Italy and the Italianate linked all of Europe. This often first involved an update of native or current architectural traditions, a transition that might then follow in other arts. Outside Italy, a purer expression of Renaissance architectural ideals was also made in places like Granada, Munich, Landshut, Cracow, Esztergom and Alba Iulia. Punctuated by the 1541 capture of Budapest, once a Renaissance cultural centre, the Ottoman surge into southeastern Europe essentially halted that area's classicizing tendencies.

THE WORLDLY COURT

Artists and architects benefited immensely from Church patronage in Catholic territories and that of prosperous merchants in commercial centres, but princely courts of all ranks, confessions and locations remained their most consistent employers. Two special, somewhat reciprocal phenomena contributed to this arrangement: the formation of 'art chambers' (*Kunstkammern*) and the staging of festivals, triumphal entries and other spectacles.

In his private *Kunstkammer*, a prince distilled the spectrum of divine and human creation down to displayable highlights. Mineral samples, flora and fauna specimens and nature's abnormalities found a place in the *Kunstkammer* next to fine tools, intricate mechanisms and classical, scientific or architectural texts. A *Kunstkammer*'s inventory also included works of art such as paintings, prints, statuettes, medals or meticulously crafted works of goldsmithery. The proprietor of such an assemblage symbolically possessed and ruled over the known world, albeit in miniature. The *Kunstkammer* also projected its keeper's magnificence, intellect, worldliness, and tastes to whomever viewed it. The *Kunstkammern* of the Central European courts were the most impressive; the Prague *Kunstkammer* of Emperor Rudolf II surpassed all others.

A more public form of court expression matured during the sixteenth century. On special occasions, European courts frequently sponsored ostentatious productions for audiences. These varied spectacles could last for days, and incorporated everything from costumes, scenery, floats and music to fireworks, automata, parades and competitions. Triumphal entries were especially important. Organized around the arrival of a regent or distinguished guest into a town or city, some ceremonial entries were isolated events, others preludes to extended

festivities. Entries often dotted the path of a territorial or international progress. Multiple grand entries were included, for example, in the journeys of Charles V through Italy following his conquest of Tunis. Leading artists and artisans provided the many temporary props and backdrops that lent such events their pomp. Imagery invariably referred to the virtues, achievements, authority, and territorial possessions of the arriving dignitary using classical, mythological and biblical iconography. Just as the *Kunstkammer* brought the outside world to a prince's court, these spectacles brought a prince's court to the outside world.

The gradual advance of European seafaring powers into the Americas, Africa, India, South Pacific, China and Japan had important consequences. The fortunes created through intercontinental commercial ventures and military conquests translated into copious artistic commissions. The extensive artistic and architectural patronage of the royal courts and Catholic institutions in both Portugal and Spain speaks to their successes overseas. Artefacts from faraway cultures also arrived in Europe and were often absorbed into *Kunstkammern*.

ST BASIL'S CATHEDRAL, 1555–60, Moscow, Russia, was built following Ivan IV's conquest of Kazan. This dynamic structure consists of eight churches grouped around a ninth. Despite trends in Moscow towards the employment of Italian architects and adoption of Renaissance architectural idioms, St Basil's is the product of native architects. Here, traditional Russian forms dominate and make the cathedral an enduring national symbol.

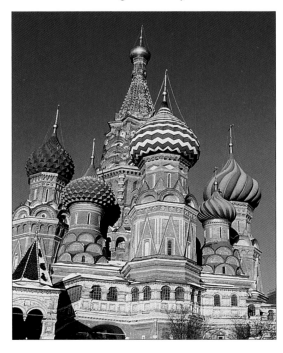

SCANDINAVIA AND THE BALTIC 1500-1800

SCANDINAVIA IN 1500 was dominated by Denmark politically and artistically, but the entire Baltic region was connected with northern European culture through the trade routes of the Hansa (a series of trading alliances linking the cities of northern Europe). Sweden-Finland gained independence from Denmark in 1523. The Protestant Reformation was fundamental to the establishment of the Swedish state, for King Gustav Vasa (r.1523–60) seized church lands and wealth, which he used to pay state debts. Denmark converted to Lutheranism soon after. Thus by the 1530s Denmark ruled Norway, and Sweden ruled the duchy of Finland; all were Protestant lands.

THE DOMINANCE OF DENMARK

Although there was a certain artistic unity throughout the Baltic region, Denmark provided the artistic leadership for Scandinavia until the seventeenth century. The high point of the Danish Renaissance was the reign of Christian IV (r.1588–1648). Most of the artists he patronized were of Netherlandish origin. Pieter Isaacz (1569–1625) and Karel van Mander III (1610–70) were resident at the court, but Christian commissioned significant works from Gerrit van Honthorst (1592–1656), Abraham Bloemaert (1566–1651), Jacob Jordaens (1593–1678) and Adriaen de Vries (1545–1626), among others, which adorned Kronborg, Rosenborg and Frederiksborg palaces. These were built in the Netherlandish tradition of brick with stone decoration.

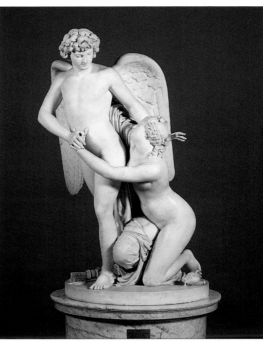

JOHAN TOBIAS SERGEL, *CUPID AND PSYCHE*. Sergel studied in Paris and received a medal from the Académie Royale. He worked in Rome for a number of years before returning in 1779 to Stockholm, where he became head of the Royal Academy of Fine Arts. He was highly regarded and sought by internationally important patrons. This sculpture was commissioned around 1772 by Louis XV for his mistress, Madame du Barry. When the French king died two years later, King Gustav III of Sweden took over the commission.

THE RISE OF SWEDEN

Denmark and Sweden both took part in the Thirty Years War (1618–48), which crippled the former and greatly enriched the latter. Under Gustav II Adolf (r.1611–32) Sweden expanded its territories to include the eastern Baltic lands and parts of northern Germany. Accordingly, many German artists moved to Stockholm, a new centre of patronage. Among them were the painter David Klöcker Ehrenstrahl (1629–98) and the architect Nicodemus Tessin the Elder (1615–81). Tessin used locally available materials (particularly wood), but he and his patrons willfully disregarded traditional, provincial building practices as they sought international recognition.

In the mid-seventeenth century, Queen Christina became a cultural patron, bringing René Descartes and other intellectuals to the court. She also encouraged the seizure of the remains of Emperor Rudolf II's collection at Prague, which brought many first-rate Italian paintings to Stockholm. She took most of these with her to Rome when she abdicated in 1654, but the larger works remained in Sweden. In Rome she remained an important patron for Swedish artists, commissioning works from them and using her contacts to introduce them to leading Italian artists.

The influence of the Stockholm court was felt as far away as the eastern Baltic lands. Classicizing buildings, similar to those built by Tessin, may be found in Tallinn. The artists in

1 THE BALTIC REGION's rich natural resources brought income and international contacts. Sweden's copper and iron, for example, were exported all over Europe. Wealthy foreign merchants moved to Scandinavia, bringing artistic contacts and building influential residences.

1	Scandinavia and the Baltic, c. 1500
——	international borders, c.1500
- - -	semi-independent territories
▨	Swedish-speaking areas of Finland
▨	Saami region of Finland
→	trade routes

Raw materials:

⚶	grain
✎	timber
Cu	copper
▱	iron
◉	flax
◉	hemp
⚊	hides
◗	tallow
⊟	leather
◠	potash

Natural resources:

Cu	copper mines
▱	iron mines
◔	silver mines
◔	gold mines
⚏	limestone quarries
⚏	sandstone

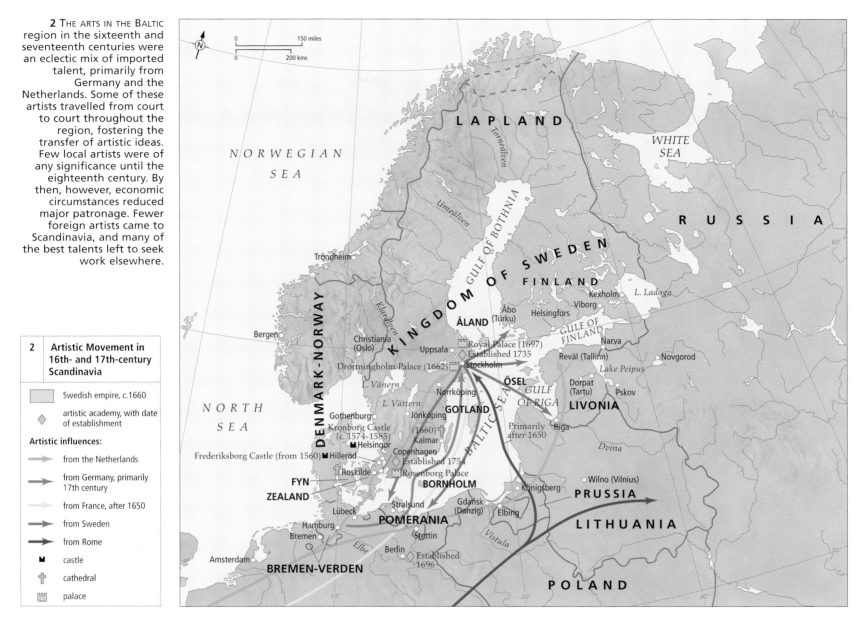

2 THE ARTS IN THE BALTIC region in the sixteenth and seventeenth centuries were an eclectic mix of imported talent, primarily from Germany and the Netherlands. Some of these artists travelled from court to court throughout the region, fostering the transfer of artistic ideas. Few local artists were of any significance until the eighteenth century. By then, however, economic circumstances reduced major patronage. Fewer foreign artists came to Scandinavia, and many of the best talents left to seek work elsewhere.

2	Artistic Movement in 16th- and 17th-century Scandinavia

Swedish empire, c.1660

◇ artistic academy, with date of establishment

Artistic influences:

→ from the Netherlands

→ from Germany, primarily 17th century

→ from France, after 1650

→ from Sweden

→ from Rome

▪ castle

✝ cathedral

⌂ palace

these regions were not necessarily derivative or inferior to those of the capital. Arent Passer (c.1560–1637), perhaps the finest sculptor in the region, worked exclusively for the Swedish governor in Estonia.

Sweden remained the great Baltic power into the eighteenth century, by which time the artistic orientation of the state had shifted from the Netherlands and Germany to France. The architect Nicodemus Tessin the Younger (1654–1728) was an ambassador at the court of Versailles, and arranged for a permanent agent there to inform him of all developments in French arts and culture. The loss of territories and stature following the Great Northern War (1700–21), led to a sharp drop in resources for artistic production. Thus Tessin represents the culmination of the arts in Sweden; after his death, most of the finest Swedish artists lived and worked in other European capitals, Alexander Roslin (1718–93) in Paris, Martin van Meytens the Younger (1695–1770) in Vienna, Michael Dahl (1659–1743) in London, and Georg Desmarées (1697–1776) in Munich.

FREDERIKSBORG CASTLE AT HILLERØD, DENMARK, represents the international importance of Christian IV's work particularly well. The sculptural Neptune fountain was designed and cast by the imperial sculptor Adriaen de Vries in Prague. Hendrick de Keyser, an Amsterdam sculptor and builder who pioneered Dutch classical architecture, provided a number of decorative sculptures and reliefs. The palace was built between 1602 and 1623 as an enlargement of a much smaller sixteenth-century hunting lodge. The architect is unknown, but it may have been the Netherlandish Hans van Steenwinckel.

NEOCLASSICISM

French Rococo surrendered to Neoclassicism throughout the Baltic in the later eighteenth century. In Sweden this is associated with King Gustav III and the sculptor Johan Tobias Sergel (1740–1814). Denmark experienced similar developments under the leadership of the painter Nicolai Abildgaard (1743–1809), the architect Christian Frederik Hansen (1756–1845), and especially the sculptor Bertel

Thorvaldsen (1770–1844), who worked primarily in Rome, but was the greatest Scandinavian Neoclassical artist. While Sweden and Denmark both sent their leading students to Rome to train, Danish artists also established ties with the pioneering theorist Johann Joachim Winckelmann and with the Prussian architect Karl Friedrich Schinkel (1781–1841), and thus drew on the whole spectrum of European Neoclassicism.

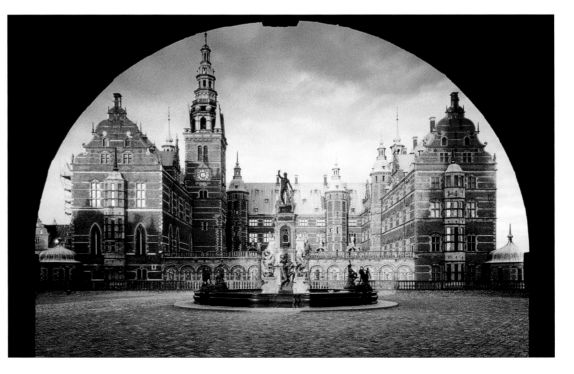

POLAND AND LITHUANIA 1500-1800

MULTI-ETHNIC AND MULTICONFESSIONAL, the Polish Commonwealth of Two Nations united the Catholic Kingdom of Poland and the Grand Duchy of Lithuania. The long process of unification, begun in 1385, was finalized in 1569 by annexation of the western Ukraine, mainly Orthodox and bordering the Ottoman empire and Persia. The commonwealth lasted almost two and a half centuries more, until swallowed by the expanding empires of Russia, Prussia and Austria in 1795.

The union dislodged Poland's alignments with the Latin west, redirecting them to the east and south-east. This outpost of Latin Christendom saw a confrontation between an emerging Eurocentrist modernity, with its paradigms of the modern territorial state and of the rational western self, and, on the other hand, the nomadic values of Crimean Tartars and Ottoman Turks, and oriental fluidity and excess. A primary identification with the Occidental merged with an experience of and desire for the Oriental. The myth of Poland as the bulwark of Christendom intertwined itself with a contradictory ethos of Sarmatism – of the nobility's descendance from the Sarmatians, a legendary tribe of horsemen from the Black Sea steppe.

WESTERN IMPORTS
In the sixteenth and early seventeenth centuries fabulous wealth from landholding enabled the nobility to acquire foreign consumer goods and artefacts, as well as commission builders, artists and craftsmen from all over Europe. Mainly from Italy, artists were also summoned from Nuremberg and the Netherlands, France, Saxony and Habsburgian countries. At this stage the union was a society of consumers, rather than producers, of

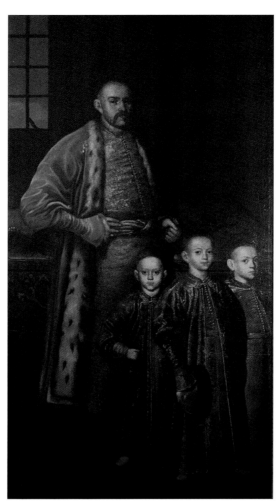

ZBIGNIEW OSSOLINSKI WITH HIS SONS, c.1654, oil on canvas, 210 x 110 cm (82 x 43 ins), Castle Museum, Liw. A forceful Sarmatian portrait showing details of the 'Polish dress', which reserves its most lavish display for male progenitors.

artefacts. In the aftermath of disasters in the mid-seventeenth century and the Great Northern War (1700–21) – which ruined towns and halted the grain trade – kings and nobility established various manufactories.

Renaissance 'high art' was imported directly from Italy by Poland's kings of the Jagiellonian dynasty redeveloping the Wawel Castle in Cracow. The Sigismundus chapel in the Wawel Cathedral, by Florentine Bartolomeo Berrecci (1519–31), provided a model of a central funerary chapel and tomb with recumbent figures, widely reproduced by the nobility and even the bourgeoisie. Another new type of building was the suburban villa, erected for the nobility by Italian builders on the outskirts of Cracow. Royal patronage, extensive building by the Catholic Church, and, above all, the spending power of the high nobility changed the cultural landscape. They built new towns on an 'ideal city' plan, such as Zamość, designed for the Lord Chancellor Jan Zamoyski by Bernardo Morando of Venice; they gave funds for Baroque churches following the models of Il Gesù (Cracow, Nieswiez) and Santa Maria della Salute (Gostyń); they multiplied their country residences and palaces in Warsaw, designed by fashionable architects such as Andrea del'Aqua (Podhorce), the Polonized Dutchman, Tylman van Gameren (Pulawy, Stary Otwock, Warsaw, Wegrów), Johann Sigmund Deybel of Dresden (Warsaw, Bialystok), and Juste-Aurèle Meissonier (interiors in Warsaw and Pulawy).

LOCAL AND ORIENTAL INFLUENCES
Elitist architecture was of brick, decorated with sandstone masonry and furnished in local marble. A dominant building material was timber, used for the abundant manor houses of

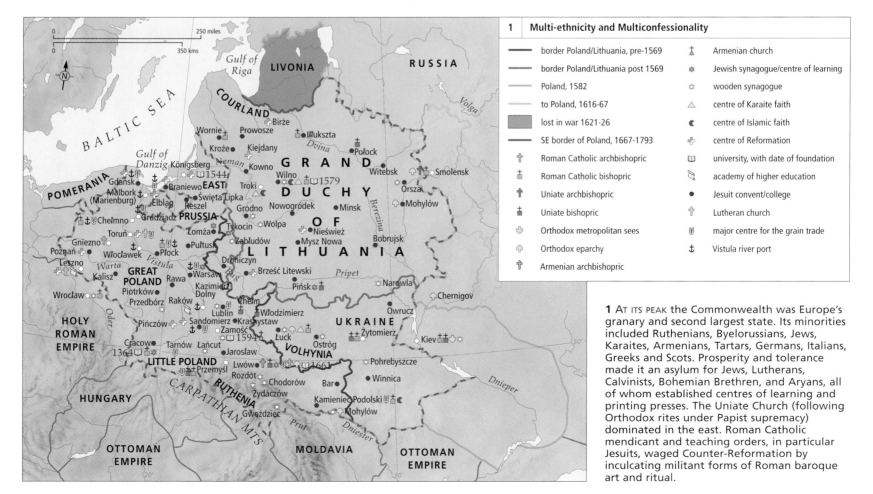

1 Multi-ethnicity and Multiconfessionality

—— border Poland/Lithuania, pre-1569	⚒ Armenian church
—— border Poland/Lithuania post 1569	✿ Jewish synagogue/centre of learning
—— Poland, 1582	✦ wooden synagogue
—— to Poland, 1616-67	△ centre of Karaite faith
▨ lost in war 1621-26	☾ centre of Islamic faith
—— SE border of Poland, 1667-1793	⚜ centre of Reformation
✝ Roman Catholic archbishopric	▱ university, with date of foundation
✝ Roman Catholic bishopric	✎ academy of higher education
✝ Uniate archbishopric	• Jesuit convent/college
✝ Uniate bishopric	✝ Lutheran church
☇ Orthodox metropolitan sees	▯ major centre for the grain trade
☌ Orthodox eparchy	‡ Vistula river port
✝ Armenian archbishopric	

1 AT ITS PEAK the Commonwealth was Europe's granary and second largest state. Its minorities included Ruthenians, Byelorussians, Jews, Karaites, Armenians, Tartars, Germans, Italians, Greeks and Scots. Prosperity and tolerance made it an asylum for Jews, Lutherans, Calvinists, Bohemian Brethren, and Aryans, all of whom established centres of learning and printing presses. The Uniate Church (following Orthodox rites under Papist supremacy) dominated in the east. Roman Catholic mendicant and teaching orders, in particular Jesuits, waged Counter-Reformation by inculcating militant forms of Roman baroque art and ritual.

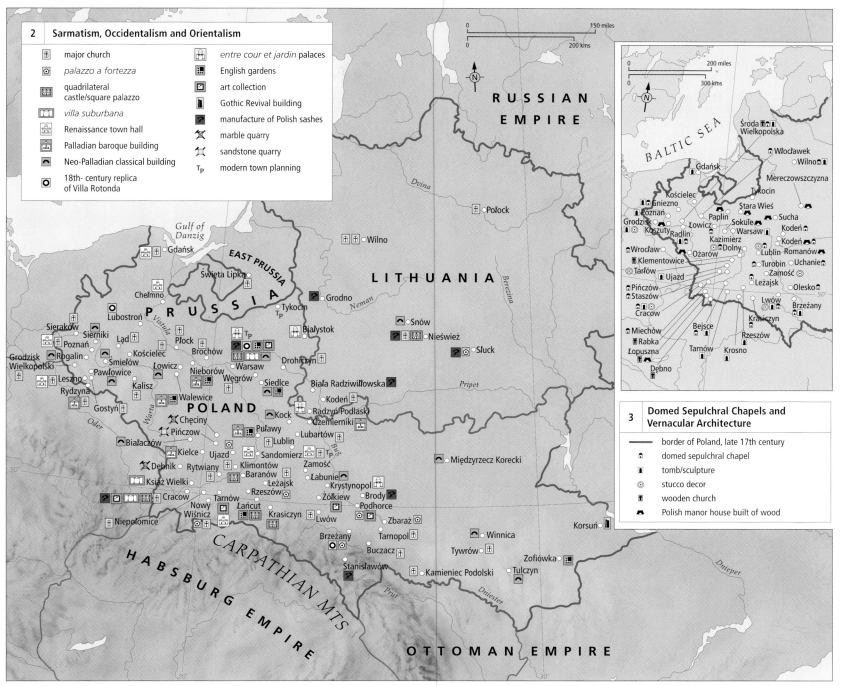

2 Sarmatism, Occidentalism and Orientalism

Symbol	Description
✚	major church
⊙	*palazzo a fortezza*
▦	quadrilateral castle/square palazzo
▭	*villa suburbana*
▥	Renaissance town hall
▦	Palladian baroque building
▩	Neo-Palladian classical building
◉	18th- century replica of Villa Rotonda
▦	*entre cour et jardin* palaces
▣	English gardens
▢	art collection
▮	Gothic Revival building
◪	manufacture of Polish sashes
✗	marble quarry
⊞	sandstone quarry
T_P	modern town planning

3 Domed Sepulchral Chapels and Vernacular Architecture

Symbol	Description
—	border of Poland, late 17th century
⬠	domed sepulchral chapel
▯	tomb/sculpture
◎	stucco decor
▥	wooden church
⌂	Polish manor house built of wood

Polish lesser gentry and for churches of all denominations, including Lutheran, Roman Catholic, Uniate and Orthodox, as well as mosques, and elaborate wooden synagogues. The majority of these places of worship have been destroyed. Sculpted plaster decor was another architectural feature. Italian-inspired and initiated by the Lublin guild of master masons, it embellished townhouses in Kazimierz and Zamość, and church vaults all over Poland. Its fantastical plaster ornaments of somewhat blunted, pudding-like texture displayed an untamed richness of detail.

Orientalization went hand in hand with Latinization. The 'Polish attica', a decorative parapet at the top of buildings in Venetian style, surmounted sturdy synagogues. Paintings by Western artists were covered with 'Orthodox' silver robes, icons dovetailing with northern-European prints and Bohemian rococo dressed the façades of Uniate churches. Perhaps the most Polish art-form of this period was the Sarmatian portrait. A Western-style full-length likeness was used as a frame to enunciate the 'defining features' of Polish-Lithuanian nobility, which were visualized by the details of Orientalized attire, complete with *zhupan*, *kontusz*, *delia* and the Armenian silk sash belt, Turkish haircut and Morocco leather boots. These served as an adopted skin, the exteriorization of the Sarmatian identity. The form was also significant: the decorativeness of these portraits' two-dimensionality and the flat patches of local colour pronounced a disregard for Western *chiaroscuro* and linear perspective.

2–3 SOUTHEAST EXPANSION introduced oriental styles, including dress and manners used by the Polish-Lithuanian nobility to underline their claim of descent from the legendary Sarmatians. However, dynastic alliances of the royalty and the fabulous buying power of the elite promoted a rapid absorption of 'high' forms of Western art.

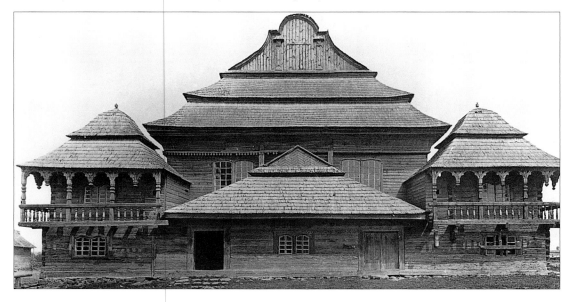

WOODEN SYNAGOGUE in Wolpa near Grodno, early eighteenth century. Timber was used in Polish manor houses and village churches of all denominations and occasionally also in large and complex religious structures, with domes and high pitched, multi-tiered roofs.

RUSSIA 1500-1800

RUSSIA ACHIEVED a distinctive cultural identity in this period, separate from but at times rivalling those of the Renaissance, Baroque and Enlightenment in western Europe. Traditionally, the arts had served religion, with architecture and icon painting controlled by rigorous orthodoxy, but the sixteenth century introduced some secularization.

THE RISE OF MOSCOW

At the end of the fourteenth century, Muscovite princes began driving back the Mongols who had occupied Russian territories for 250 years. The city of Novgorod, in the northwest, maintained trading contacts with the Hanseatic League, but most of Russia was virtually isolated. Reforging ties with both Orthodox east and the Latin west, Ivan III was the first Russian ruler to take the title Tsar or Czar (derived from Caesar). Ivan and his successors brought architects from Italy to build the great stone cathedrals of the Moscow Kremlin, Dormition, the Annunciation and St Michael the Archangel, the Faceted Palace and the crenellated walls around the citadel, combining Russian and European architectural forms.

Ivan IV ('The Terrible') initiated major building and reconstruction projects after a fire destroyed much of Moscow. He annexed Novgorod and Tver', brought both loot and artists to the Kremlin, and established workshops of icon painters and metalsmiths in the Armoury Palace. Ivan's conquest of Kazan (1555) brought the plains east of the Volga River and their pagan and Islamic inhabitants under his control. Later campaigns pushed Russia's boundaries south to Astrakhan and east into Siberia. To commemorate his victory, Ivan commissioned St Basil's Cathedral on Red Square, just outside the Kremlin walls (see p.155). It was based on the central 'tent-roof' design of wooden churches and contained eight separate churches, each set off by multiple domes embellished with polychrome tiles and paint. This cathedral, with its inventive use of both Russian and Asian features, marked a new stage in Russia's political and cultural identity.

Ivan IV's reign ended in violence and confusion in 1584. In the following 'Time of Troubles', Moscow's authority diminished as Poland conquered much of western Russia. While central control declined, new centres of icon painting, metalwork and enamel developed in the northeastern regions, around Veliky Ustyug, Sol'vychegodsk and Perm'. These towns were settled by merchant clans from Novgorod, notably the Stroganov family, who established a renowned school of icon painting. The election of Mikhail Romanov as tsar in 1613 began a period of political retrenchment and ecclesiastical reform lasting two generations.

Tsar Alexey Mikhailovich encouraged foreign traders to settle in an eastern suburb of Moscow known as the 'German Suburb' and opened new routes north of Moscow to the White Sea. The port of Arkhangel'sk on the Northern Dvina River became the major hub of commerce during the summer months when it was free of ice. Alexey's son Peter I, known as Peter the Great (r.1696–1725), recognized that only a permanent commercial and naval port would allow Russia to interact fully with western nations, and after winning the region from Sweden, he founded St Petersburg at the

1 THE FOUNDING OF ST PETERSBURG in 1703 signalled a shift to the West, but efforts to modernize the country confronted the beliefs and practices of many nationalities and religious groups, including the Old Believers, who rejected reforms and settled in northern forests. Serfdom was the economic base of the central 'black soil' farming regions. Bound to the land, serfs endured harsh conditions, but some received training in the arts. St. Petersburg and Moscow were the centers of culture, but other cities were famed for special resources and crafts.

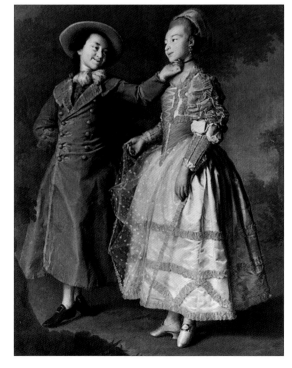

DMITRY LEVITSKY, *Princess Khovanskaia and Mlle Khrushcheva* (1773), State Russian Museum, St Petersburg. Acclaimed for imposing portraits of Catherine II, Levitsky introduced an informal style in seven paintings of Catherine's favourite pupils in the school she founded for well-born girls, the Smolny Institute. Shown in a performance at the school for the Empress, the girls display an engaging concentration, in contrast to the stilted poses of earlier portraiture.

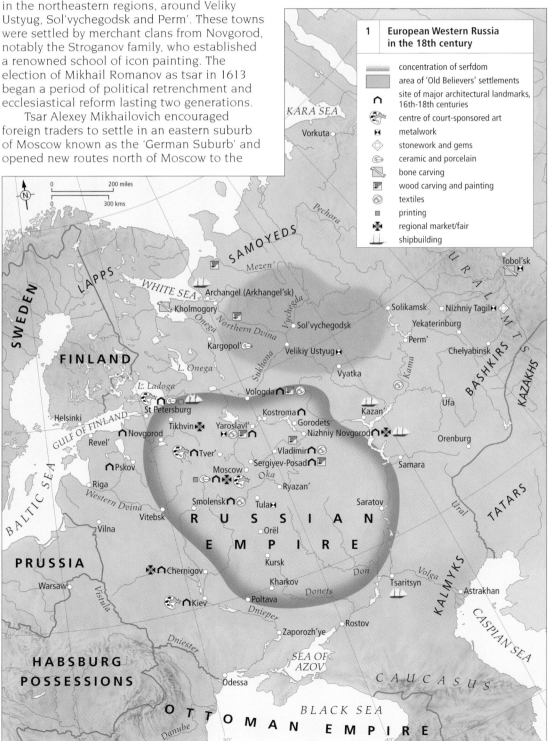

1	European Western Russia in the 18th century
	concentration of serfdom
	area of 'Old Believers' settlements
⌂	site of major architectural landmarks, 16th-18th centuries
	centre of court-sponsored art
	metalwork
◇	stonework and gems
	ceramic and porcelain
	bone carving
	wood carving and painting
◎	textiles
▪	printing
	regional market/fair
	shipbuilding

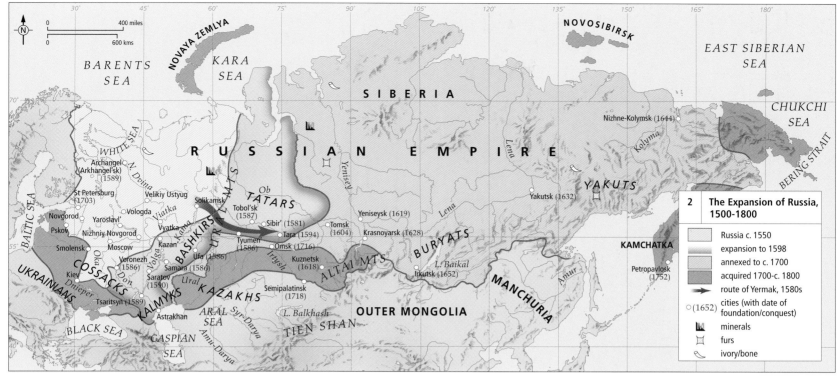

eastern point of the Gulf of Finland in 1703. Moving his capital to the new city in 1712, he inaugurated an unprecedented era of grand architecture and city planning that lasted well into the next century.

CULTURAL EXPANSION

Peter I's efforts to modernize Russia brought the country into the cultural orbit of Europe. He invited European architects and artists to St Petersburg and provided training and study abroad for Russian-born artists. It fell to his successors, Elizabeth I and Catherine II ('The Great', r.1762–96) to consolidate Peter's European model for the Russian empire. Their reigns were marked by exploration and development of resources; establishment of Russian porcelain, lapidary, metalwork and tapestry factories; creation of a university and academy of arts; art collecting on a grand scale and major building projects. St Petersburg became a microcosm of architectural evolution from Peter's northern European Baroque (for example, the Cathedral of Saints Peter and Paul by Domenico Tressini) to Elizabeth's French-Italian Rococo (Bartollomeo Rastrelli's Catherine Palace, Winter Palace and Smolny Cathedral), and Catherine's international classicism (Charles Cameron's Pavolvsk Palace and Giacomo Quarenghi's Hermitage Theatre).

The Academy of Fine Arts, housed in an imposing classical edifice in 1772, fulfilled

2 RUSSIA EXPANDED through military conquests. Ivan IV victory conquered Kazan in 1555. The Cossack Yermak pushed into Siberia in quest of furs in the 1580s. Peter I and Catherine II campaigned in the west and the south in the eighteenth century. Cities were both fortresses and trade outposts for gold, and precious stones that enriched the decorative arts.

Peter's goal of creating a cohort of Russian-born artists trained in European traditions. Among the early graduates were Anton Losenko (honoured as the first Russian historical painter), portraitists Dmitry Levitsky and Vladimir Borovikovsky, and sculptors Mikhail Kozlovsky and Ivan Martos.

Meanwhile, outside the cities, in the northern regions of Arkhangel'sk and Vologda provinces settled by merchants from Novgorod, distinctive folk arts flourished. Along the Volga and the other rivers that served as trade arteries, local decorative traditions cross-fertilized with forms and motifs adapted from western models. In the central agricultural lands, vast and productive estates were worked largely by serfs: peasants tied to the land. Folk customs and traditions in music and the arts enriched all levels of culture.

This period witnessed Russia's transformation from a regional principality to a multi-ethnic empire bridging east and west, and saw a corresponding change in the role of the arts. Initially serving the church, the arts expanded their secular functions as Russia's rulers and the nobility began collecting art. The transfer from Moscow to St Petersburg replaced older Russian values with a new, European-oriented, rational and bureaucratic culture, initiating the dilemma of eastern or western identification that would trouble Russian thinkers of the following centuries. By the end of Catherine's reign, Russian elite culture, especially in St Petersburg, embodied the themes of expansion and display.

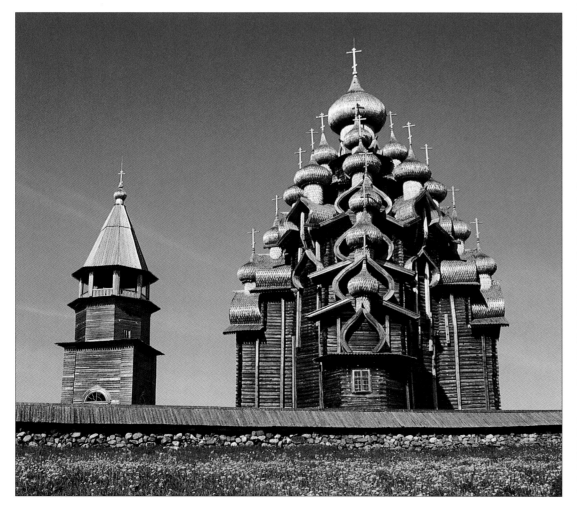

CHURCH OF THE TRANSFIGURATION (1714), Kizhi, Lake Onega. Traditional carpenters used no plans, only simple hand tools, and no metal nails, but they inventively combined pine, ash, and other woods for pleasing effects. The ash 'fish-scale' shingles on the twenty-two domes glisten with gold or silver tones, depending on the light.

BRITAIN 1500-1666

IN 1500 MANY ASPECTS of life and culture in the British Isles continued much as they had throughout the medieval era. The period covered here, concluding with the Great Fire of London in 1666, was one of remarkable achievement and innovation in architecture and the visual arts, coupled with social, economic, political and religious convulsions.

REFORMATION ICONOCLASM
For the first three decades of the sixteenth century, the Church, and especially the great monastic foundations across Britain, remained centres of wealth and artistic excellence. The richness of late-medieval sacred visual culture was abruptly terminated by the Reformation. Henry VIII's Act of Supremacy of 1534 was aimed primarily at securing him a divorce. It was followed swiftly by the dissolution of the monasteries, ending a major source of patronage for the arts, and a wave of iconoclasm which swept away many of the glories of Gothic stained glass, ceramics, metalwork, textiles and wall-paintings.

In many cases (such as Rievaulx in Yorkshire, and Bury St Edmunds in Suffolk), the monastic buildings themselves were left as ruins. Monastic wealth was distributed to Henry's supporters among the aristocracy, resulting in an expansion in the building of country houses.

THE COURT OF THE VIRGIN QUEEN
The age of Elizabeth I (r.1558–1603) revealed the full possibilities for the arts under a Protestant regime. The rich literary and musical culture of the period found counterparts in the secular decorative arts, and miniature painting attained the highest levels of excellence.

The growing wealth and confidence of the aristocracy and gentry found cultural expression in the design and decoration of country houses, which became the defining architectural form of the period. Fortifications were no longer necessary, and the availability of glass, as well as the influence of classicizing styles, produced new architectural forms.

Noblemen who occupied the highest ranks of government received large financial rewards, and were able to create grandiose country houses. Elizabeth's chief minister, William Cecil (1520–98), built Burghley House. Edward Seymour (c.1506–1552), ruler ('Protector') during the reign of the boy king Edward VI (r.1547–53) created Longleat House, Wiltshire.

THE STUART ASCENDANCY
Scotland and England were united when James VI of Scotland succeeded Elizabeth I in 1603. During the previous century Scottish architecture had absorbed Renaissance influences, seen in the portrait medallions and buttresses at Falkland Palace, Fife. Little survives of the sacred arts of medieval Scotland as a result of the extreme iconoclasm of the sixteenth century.

A unified Britain, renowned for its maritime expertise, began to trade with the East and West Indies. Exotic imports – silk and spices from the East, timber from the Caribbean – became available. This period saw the founding of the earliest British colonies, and international trade greatly increased the country's wealth.

THE ENGLISH BAROQUE
After the Act of Union, the Stuart dynasty, under James I (r.1603–25) and his son Charles I (r.1625–49), gradually assumed the cultural trappings of an absolute monarchy. Vernacular architectural traditions were abandoned. The work of Inigo Jones (1573–1652), such as the Banqueting House, Whitehall (1619–22), brought Classical and Palladian influences to England. The Flemish artist Peter Paul Rubens (1577–1640)

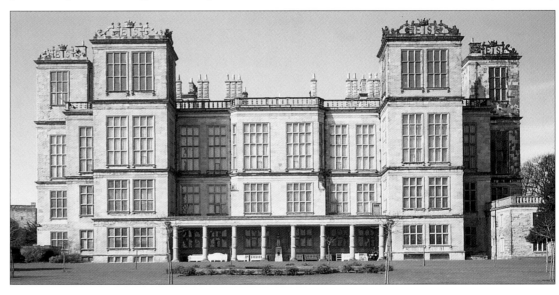

HARDWICK HALL, built of local Derbyshire sandstone, impresses upon the viewer a sense of the dynastic ambitions of Elizabeth, Countess of Shrewsbury ('Bess of Hardwick'), by whom it was built between 1591 and 1597. The architect, Robert Smythson, incorporated medieval elements, such as the tall, encircling towers, as well as the Renaissance loggia and balustrade. The interiors feature rich tapestries, portraits in oils and elaborate decorative plasterwork.

2 TUDOR AND STUART LONDON. London was by far the largest city in Britain in 1500 and has remained so ever since. The centre of court and government and a major mercantile and financial centre, London was home to the finest practitioners of the arts, from silversmiths and silk-weavers to plasterers and painters. Continental artists from Holbein to Van Dyck, Rubens and Lely found patronage at the English court. The theatre, though considered suspect by Puritans, thrived during this period, the age of Marlowe, Shakespeare and Jonson.

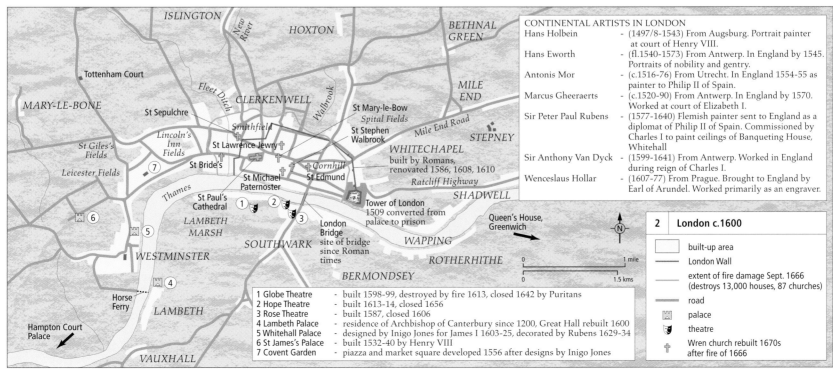

CONTINENTAL ARTISTS IN LONDON

Hans Holbein	- (1497/8-1543) From Augsburg. Portrait painter at court of Henry VIII.
Hans Eworth	- (fl.1540-1573) From Antwerp. In England by 1545. Portraits of nobility and gentry.
Antonis Mor	- (c.1516-76) From Utrecht. In England 1554-55 as painter to Philip II of Spain.
Marcus Gheeraerts	- (c.1520-90) From Antwerp. In England by 1570. Worked at court of Elizabeth I.
Sir Peter Paul Rubens	- (1577-1640) Flemish painter sent to England as a diplomat of Philip II of Spain. Commissioned by Charles I to paint ceilings of Banqueting House, Whitehall
Sir Anthony Van Dyck	- (1599-1641) From Antwerp. Worked in England during reign of Charles I.
Wenceslaus Hollar	- (1607-77) From Prague. Brought to England by Earl of Arundel. Worked primarily as an engraver.

2	London c.1600

- □ built-up area
- —— London Wall
- —— extent of fire damage Sept. 1666 (destroys 13,000 houses, 87 churches)
- —— road
- ⌂ palace
- ⚑ theatre
- ✝ Wren church rebuilt 1670s after fire of 1666

1 Globe Theatre - built 1598-99, destroyed by fire 1613, closed 1642 by Puritans
2 Hope Theatre - built 1613-14, closed 1656
3 Rose Theatre - built 1587, closed 1606
4 Lambeth Palace - residence of Archbishop of Canterbury since 1200, Great Hall rebuilt 1600
5 Whitehall Palace - designed by Inigo Jones for James I 1603-25, decorated by Rubens 1629-34
6 St James's Palace - built 1532-40 by Henry VIII
7 Covent Garden - piazza and market square developed 1556 after designs by Inigo Jones

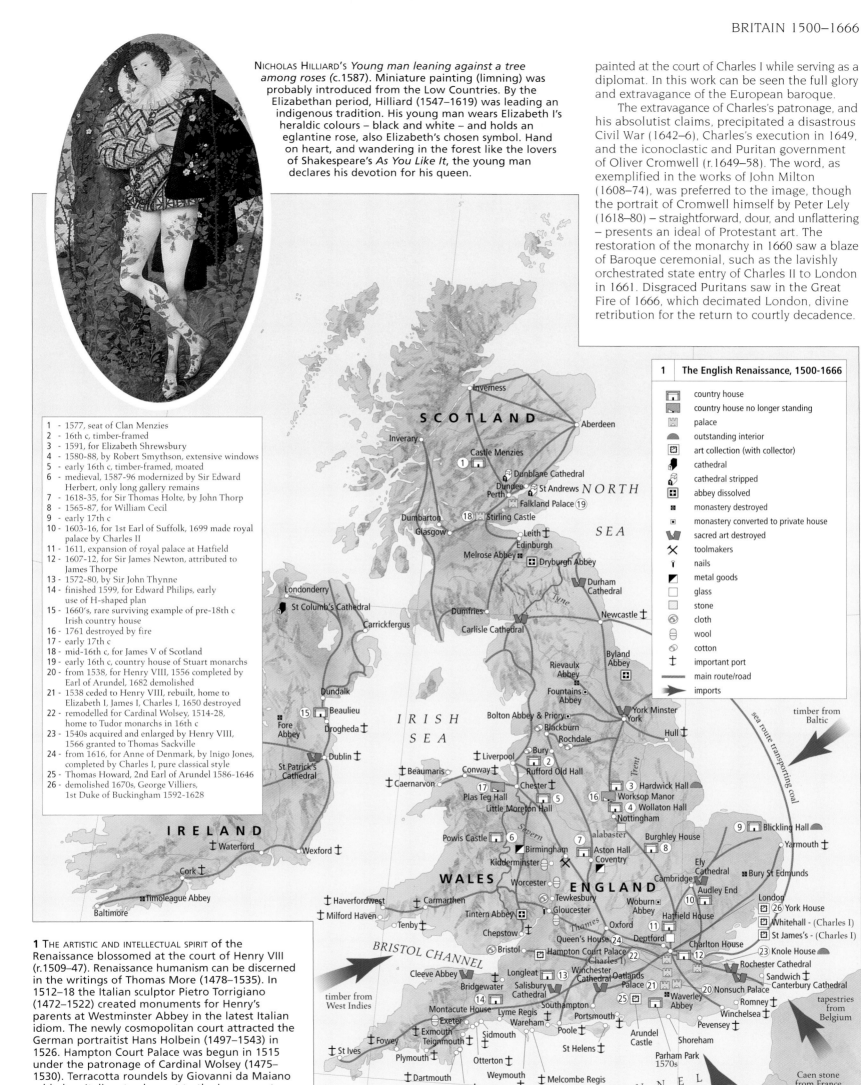

NICHOLAS HILLIARD'S *Young man leaning against a tree among roses* (c.1587). Miniature painting (limning) was probably introduced from the Low Countries. By the Elizabethan period, Hilliard (1547–1619) was leading an indigenous tradition. His young man wears Elizabeth I's heraldic colours – black and white – and holds an eglantine rose, also Elizabeth's chosen symbol. Hand on heart, and wandering in the forest like the lovers of Shakespeare's *As You Like It*, the young man declares his devotion for his queen.

painted at the court of Charles I while serving as a diplomat. In this work can be seen the full glory and extravagance of the European baroque.

The extravagance of Charles's patronage, and his absolutist claims, precipitated a disastrous Civil War (1642–6), Charles's execution in 1649, and the iconoclastic and Puritan government of Oliver Cromwell (r.1649–58). The word, as exemplified in the works of John Milton (1608–74), was preferred to the image, though the portrait of Cromwell himself by Peter Lely (1618–80) – straightforward, dour, and unflattering – presents an ideal of Protestant art. The restoration of the monarchy in 1660 saw a blaze of Baroque ceremonial, such as the lavishly orchestrated state entry of Charles II to London in 1661. Disgraced Puritans saw in the Great Fire of 1666, which decimated London, divine retribution for the return to courtly decadence.

1 - 1577, seat of Clan Menzies
2 - 16th c, timber-framed
3 - 1591, for Elizabeth Shrewsbury
4 - 1580-88, by Robert Smythson, extensive windows
5 - early 16th c, timber-framed, moated
6 - medieval, 1587-96 modernized by Sir Edward Herbert, only long gallery remains
7 - 1618-35, for Sir Thomas Holte, by John Thorp
8 - 1565-87, for William Cecil
9 - early 17th c
10 - 1603-16, for 1st Earl of Suffolk, 1699 made royal palace by Charles II
11 - 1611, expansion of royal palace at Hatfield
12 - 1607-12, for Sir James Newton, attributed to James Thorpe
13 - 1572-80, by Sir John Thynne
14 - finished 1599, for Edward Philips, early use of H-shaped plan
15 - 1660's, rare surviving example of pre-18th c Irish country house
16 - 1761 destroyed by fire
17 - early 17th c
18 - mid-16th c, for James V of Scotland
19 - early 16th c, country house of Stuart monarchs
20 - from 1538, for Henry VIII, 1556 completed by Earl of Arundel, 1682 demolished
21 - 1538 ceded to Henry VIII, rebuilt, home to Elizabeth I, James I, Charles I, 1650 destroyed
22 - remodelled for Cardinal Wolsey, 1514-28, home to Tudor monarchs in 16th c
23 - 1540s acquired by Henry VIII, 1566 granted to Thomas Sackville
24 - from 1616, for Anne of Denmark, by Inigo Jones, completed by Charles I, pure classical style
25 - Thomas Howard, 2nd Earl of Arundel 1586-1646
26 - demolished 1670s, George Villiers, 1st Duke of Buckingham 1592-1628

1 | **The English Renaissance, 1500-1666**

- country house
- country house no longer standing
- palace
- outstanding interior
- art collection (with collector)
- cathedral
- cathedral stripped
- abbey dissolved
- monastery destroyed
- monastery converted to private house
- sacred art destroyed
- toolmakers
- nails
- metal goods
- glass
- stone
- cloth
- wool
- cotton
- important port
- main route/road
- imports

1 THE ARTISTIC AND INTELLECTUAL SPIRIT of the Renaissance blossomed at the court of Henry VIII (r.1509–47). Renaissance humanism can be discerned in the writings of Thomas More (1478–1535). In 1512–18 the Italian sculptor Pietro Torrigiano (1472–1522) created monuments for Henry's parents at Westminster Abbey in the latest Italian idiom. The newly cosmopolitan court attracted the German portraitist Hans Holbein (1497–1543) in 1526. Hampton Court Palace was begun in 1515 under the patronage of Cardinal Wolsey (1475–1530). Terracotta roundels by Giovanni da Maiano added an Italianate element to the inner court-yard. The interiors, with superbly decorated ceilings, imported and domestic tapestries, were by English and Continental craftsmen. England's growing mercantile prowess during the sixteenth century, gradually securing dominance over key trade routes, underpinned artistic production.

Map labels (England, Scotland, Ireland, Wales): Inverness, SCOTLAND, Aberdeen, Inverary, Castle Menzies (1), Dunblane Cathedral, Dundee, Perth, St Andrews, NORTH SEA, Falkland Palace (19), Dumbarton, (18) Stirling Castle, Glasgow, Leith, Edinburgh, Melrose Abbey, Dryburgh Abbey, Durham Cathedral, Tyne, Dumfries, Newcastle, Carlisle Cathedral, Londonderry, St Columb's Cathedral, Carrickfergus, Byland Abbey, Rievaulx Abbey, Fountains Abbey, York Minster, York, Hull, Dundalk, Bolton Abbey & Priory, Blackburn, Rochdale, Bury, Beaulieu, Drogheda, IRISH SEA, Liverpool, Conway, Rufford Old Hall (2), Chester, Fore Abbey, (15) Beaumaris, Caernarvon, (17) Plas Teg Hall, Little Moreton Hall, (5), Hardwick Hall (3), Worksop Manor (16), Wollaton Hall (4), Nottingham, Dublin, St Patrick's Cathedral, Powis Castle (6), Severn, Trent, (9) Blickling Hall, Yarmouth, Waterford, Wexford, alabaster, Birmingham, Burghley House, (7), Aston Hall, Coventry, (8), Kidderminster, Cork, Ely Cathedral, Bury St Edmunds, Cambridge, IRELAND, Timoleague Abbey, WALES, Worcester, ENGLAND, Audley End, (10), Baltimore, Haverfordwest, Carmarthen, Tewkesbury, Woburn Abbey, Gloucester, Hatfield House, London, (26) York House, Whitehall - (Charles I), St James's - (Charles I), Milford Haven, Tintern Abbey, Oxford, (11), Charlton House, Knole House (23), Tenby, Chepstow, Queen's House (24), Deptford, Rochester Cathedral, (12), BRISTOL CHANNEL, Bristol, Thames, Hampton Court Palace (Charles I) (22), Cleeve Abbey, Longleat (13), Winchester Cathedral, Oatlands Palace (21), Sandwich, Canterbury Cathedral, Nonsuch Palace (20), Bridgewater, Salisbury Cathedral, Waverley Abbey (25), Romney, Winchelsea, (14), Montacute House, Southampton, Pevensey, Lyme Regis, Wareham, Portsmouth, Shoreham, Exeter, Poole, Arundel Castle, Teignmouth, Sidmouth, St Helens, Fowey, Parham Park 1570s, St Ives, Plymouth, Otterton, Weymouth, Melcombe Regis, Dartmouth, Kingswear, ENGLISH CHANNEL

Arrows: timber from Baltic, sea route transporting coal, timber from West Indies, tapestries from Belgium, Caen stone from France, skilled labourers from Low Countries, France, Italy, furniture, leather goods from Low Countries

100 miles / 150 kms

BRITAIN 1666-1800

THE GREAT FIRE of London (1666) destroyed much of the medieval city, including the great Gothic structure of St Paul's Cathedral. Despite various proposals, one by Christopher Wren, the capital was not transformed into a great Baroque city, but largely retained its medieval street plan. The lavish culture of the Restoration court was epitomized by Sir Peter Lely's portraits of the King Charles II's courtiers and mistresses.

THE AESTHETICS OF THE GREAT ESTATE

This was the great age of country-house building, as profits from landed estates burgeoned, owing to new farming techniques, and the aristocracy invested in profitable mercantile and industrial ventures. Country seats of the aristocracy included such palatial structures as Chatsworth House in Derbyshire, Blenheim Palace in Oxfordshire and Powerscourt House near Dublin in Ireland. Distinguished not only by their sophisticated adaptation of Palladian architecture, these 'stately homes' contain superlative examples of a wide range of decorative arts, from the work of the wood carver Grinling Gibbons at Petworth in Sussex to furniture by Thomas Chippendale at Nostell

Priory in Yorkshire. Great collections of classical antiquities, particularly sculpture, were acquired by the British aristocracy and gentry – the 'milordi' – on the European Grand Tour. This was also the age of the landscape garden. At Stowe, temples designed by John Vanburgh, William Kent and James Gibbs are situated in an informal garden designed in its evolving forms by Charles Bridgeman and Lancelot 'Capability' Brown. The Gothic 'folly' became a favourite adornment, for example at Harewood House in Yorkshire, and Horace Walpole, author of *The Castle of Otranto* (1765) transformed a Twickenham farmhouse, Strawberry Hill, into an early masterpiece of 'Gothick', whose style contrasts with the Palladian villas of Alexander Pope and David Garrick nearby.

TRAVEL, TOURISM AND LANDSCAPE

Towards the end of the eighteenth century, educated tourists and artists alike began to turn their attention to the natural scenery of the British Isles. Guided by Rev. William Gilpin's picturesque tours of areas such as the Western Highlands, the Lake District and the Wye Valley,

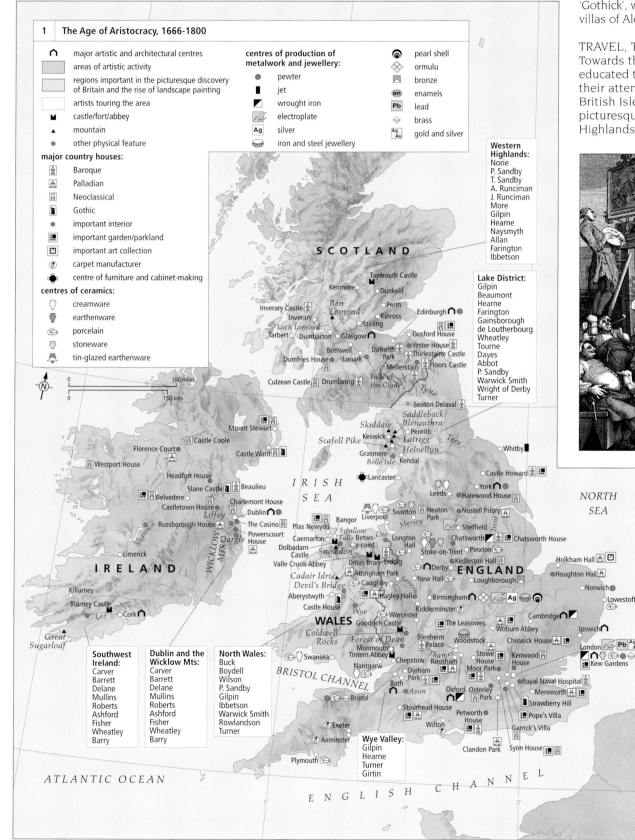

1 | The Age of Aristocracy, 1666-1800

Symbol	Legend
∩	major artistic and architectural centres
▨	areas of artistic activity
▤	regions important in the picturesque discovery of Britain and the rise of landscape painting
☐	artists touring the area
◨	castle/fort/abbey
▲	mountain
●	other physical feature

major country houses:
- 🏠 Baroque
- 🏠 Palladian
- 🏠 Neoclassical
- 🏠 Gothic
- ● important interior
- 🏠 important garden/parkland
- ⊡ important art collection
- ⊗ carpet manufacturer
- ⊛ centre of furniture and cabinet-making

centres of ceramics:
- ▽ creamware
- ▼ earthenware
- ⊚ porcelain
- ⊠ stoneware
- ⊠ tin-glazed earthenware

centres of production of metalwork and jewellery:
- ● pewter
- ▮ jet
- ◪ wrought iron
- ▨ electroplate
- Ag silver
- ⊠ iron and steel jewellery
- ◎ pearl shell
- ◇ ormulu
- ◪ bronze
- en enamels
- Pb lead
- ◇ brass
- Ag Au gold and silver

Western Highlands:
Norie
P. Sandby
T. Sandby
A. Runciman
J. Runciman
More
Gilpin
Hearne
Naysmyth
Allan
Farington
Ibbetson

Lake District:
Gilpin
Beaumont
Hearne
Farington
Gainsborough
de Loutherbourg
Wheatley
Tourne
Dayes
Abbot
P. Sandby
Warwick Smith
Wright of Derby
Turner

SCOTLAND

Taymouth Castle
Kenmore
Dunkeld
Inverary Castle
Inverary
Perth
Ben Lomond
Kinross
Edinburgh ∩
Loch Lomond
Stirling
Tarbert
Dumbarton Glasgow ∩
Gosford House
Bothwell
Dalkeith
Yester House
Dumfries House
Park
Thirlestaine Castle
Lanark
Mellerstain
Floors Castle
Culzean Castle
Drumlanrig
Falls of the Clyde

N

0 100 miles
0 150 kms

Mount Stewart
Florence Court
Castle Coole
Castle Ward
Westport House

Saddleback/
Blencathra
Skiddaw
Scafell Pike
Keswick
Penrith
Latrigg
Helvellyn
Grasmere
Belle Isle
Kendal
Whitby
Castle Howard

IRISH SEA

Headfort House
Slane Castle
Beaulieu
Belvedere
Castletown House
Charlemont House
Dublin ∩●
Liffey
Russborough House
The Casino
Powerscourt House

Lancaster
Leeds
York ∩
Harewood House
Nostell Priory
NORTH SEA
Liverpool
Swinton
Heaton Park
Mersey
Sheffield
Chatsworth
Chatsworth House
Bangor
Plas Newydd
Stoke-on-Trent
Longton Hall
Swallow Falls
Betws-y-coed
Dee
Pinxton
Caernarfon
Dolbadarn Castle
Kedleston Hall
Holkham Hall

IRELAND
Shannon
WICKLOW MTS
Dargle
Limerick
Killarney
Blarney Castle
Lee
Cork ∩
Great Sugarloaf

Snowdon
Valle Crucis Abbey
Dinas Bran
Erddig
Cadair Idris
Devil's Bridge
Attingham Park
New Hall
Caughley
Severn
Birmingham ∩
Hagley Hall
Ag
Aberystwyth
Castle House
Wye
Worcester
Kidderminster
WALES Goodrich Castle
The Leasowes
Woburn Abbey
Coldwell Rocks
Forest of Dean
Blenheim Palace
Woodstock
Chiswick House
Swansea
Monmouth
Tintern Abbey
Nantgarw
Chepstow
Rousham
Stowe
Moor Park
Kenwood House
London
Thames
Dyrham Park
Bath
Avon
Oxford
Osterley Park
Mereworth
BRISTOL CHANNEL
Bristol
Stourhead House
Petworth House
Wilton
Strawberry Hill
Pope's Villa
Garrick's Villa
Exeter
Clandon Park
Syon House

ENGLAND
New Hall
Loughborough
Houghton Hall
Norwich
Cambridge ∩
Lowestoft
Ipswich

Pb Ag en
Royal Naval Hospital
Kew Gardens

Axminster
Plymouth

Wye Valley:
Gilpin
Hearne
Turner
Girtin

Southwest Ireland:
Carver
Barrett
Delane
Mullins
Roberts
Ashford
Fisher
Wheatley
Barry

Dublin and the Wicklow Mts:
Carver
Barrett
Delane
Mullins
Roberts
Ashford
Fisher
Wheatley
Barry

North Wales:
Buck
Boydell
Wilson
P. Sandby
Gilpin
Ibbetson
Warwick Smith
Rowlandson
Turner

ATLANTIC OCEAN

ENGLISH CHANNEL

WILLIAM HOGARTH'S *Beer Street* epitomizes the robust humour of this most profound satirist. Published in 1749 with a pendant *Gin Lane*, the plate extolls the wholesome virtues of beer: everyone except the pawnbroker thrives under its influence.

1 DESPITE THE increasing influence of the bourgeoisie, the eighteenth century was dominated culturally, politically and socially by the aristocracy and gentry. A large number of great country houses from this period have survived intact, revealing the extremely high quality of decorative art production in this period, as well as the lavish collections acquired at home and abroad.

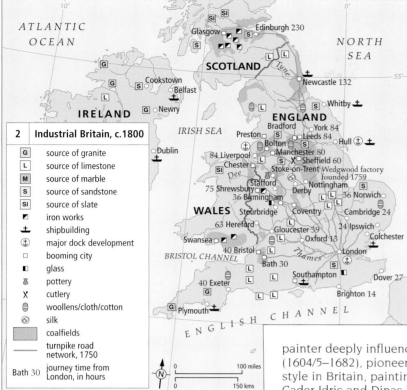

2 Industrial Britain, c.1800

G	source of granite
L	source of limestone
M	source of marble
S	source of sandstone
Sl	source of slate
	iron works
	shipbuilding
	major dock development
	booming city
	glass
	pottery
X	cutlery
	woollens/cloth/cotton
	silk
	coalfields
	turnpike road network, 1750
Bath 30	journey time from London, in hours

0 100 miles
0 150 kms

BEGUN IN 1699, Castle Howard is a magnificent country house set in the Yorkshire countryside. Various members of the Howard family financed its construction and decoration, which was completed only in 1811. Its dramatic outline and spectacular detailing belie the fact that it was the first building designed by the dramatist John Vanburgh.

2 BETWEEN 1760–80 industrial production burgeoned, benefitting from the availability of fast-flowing water, coal and iron. The Staffordshire pottery of Josiah Wedgwood cutlery and silverware from Sheffield or woollen cloth from Leeds achieved growing renown.

painter deeply influenced by Claude (1604/5–1682), pioneered a classical landscape style in Britain, painting subjects such as the Cader Idris and Dinas Bran mountains in Wales, but received scant patronage.

BIRTH OF A MODERN ART WORLD
The organization of artistic life in London underwent profound changes during this period. The court painters Godfrey Kneller and James Thornhill had led small academies in the early eighteenth century, which were succeeded by William Hogarth's St Martin's Lane Academy (active 1735–67). None of the many attempts to organize the profession, however, had a fraction of the impact made by the Royal Academy of Arts. Founded in 1768, with Joshua Reynolds (1723–92) as its first President, the Academy assured its forty members of social and intellectual status,

while offering an annual juried exhibition for the sale of work. It also provided a thorough artistic education to generations of aspiring artists and, in Reynolds's *Discourses* (1769–90) it was underpinned by a fully articulated body of theory. The Academy was housed in William Chambers's grandiose Somerset House, where densely hung exhibitions became fashionable events. It signalled a new status for the arts, which Reynolds considered to be commensurate with the status of Britain as a major imperial power and a centre of scientific innovation.

The Royal Academy of Arts successfully established a professional elite, and its members included two women artists, Mary Moser and Angelica Kauffman. Art education was placed on a professional footing. The middle-class public who flocked to the Academy's exhibitions were, however, more enthusiastic as patrons of landscape and portraiture than for the history paintings which Reynolds aimed to promote. The stage was set for the triumph of English landscape painting in the Romantic decades from the 1790s to the 1840s.

amateur draughtsmen of the leisured classes would be accompanied by a drawing teacher. The artists Paul Sandby and Thomas Hearne were among their number. After the beginning of the French Revolution in 1789, travel in Europe became more difficult, sometimes impossible, focusing even greater attention on the beauties of the local landscape. Landscape painting, however, was a precarious profession. Thomas Gainsborough (1727–88), a native of Suffolk, sustained his fashionable lifestyle by selling portraits of exceptional elegance; but his letters reveal a preference for the creation of idyllic rustic landscapes. Richard Wilson, a Welsh landscape

3 EIGHTEENTH-CENTURY LONDON was a recognizably modern city, as seen in Hogarth's lively 'modern moral subjects'. Coffee houses provided meeting places for artists and literary figures, patronized by wealthy merchants as well as the aristocracy whose Palladian townhouses dignified the city. Elegant West End developments, such as Hanover Square, provided an ideal backdrop for polite society.

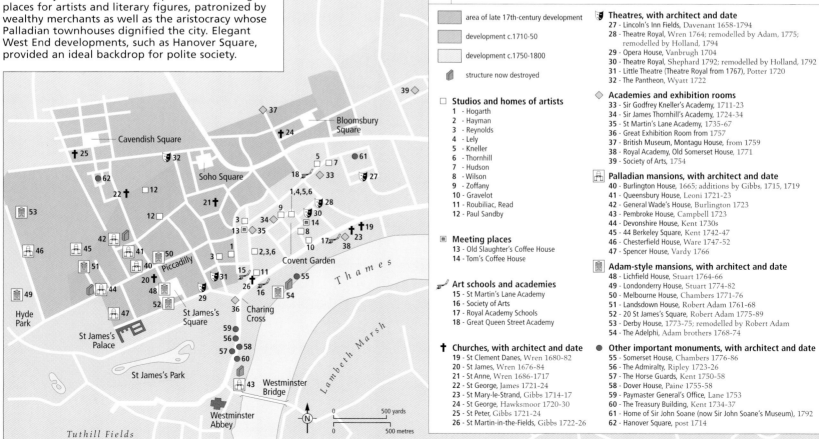

3 London

	area of late 17th-century development
	development c.1710-50
	development c.1750-1800
	structure now destroyed

Studios and homes of artists
1 - Hogarth
2 - Hayman
3 - Reynolds
4 - Lely
5 - Kneller
6 - Thornhill
7 - Hudson
8 - Wilson
9 - Zoffany
10 - Gravelot
11 - Roubiliac, Read
12 - Paul Sandby

Meeting places
13 - Old Slaughter's Coffee House
14 - Tom's Coffee House

Art schools and academies
15 - St Martin's Lane Academy
16 - Society of Arts
17 - Royal Academy Schools
18 - Great Queen Street Academy

Churches, with architect and date
19 - St Clement Danes, Wren 1680-82
20 - St James, Wren 1676-84
21 - St Anne, Wren 1686-1717
22 - St George, James 1721-24
23 - St Mary-le-Strand, Gibbs 1714-17
24 - St George, Hawksmoor 1720-30
25 - St Peter, Gibbs 1721-24
26 - St Martin-in-the-Fields, Gibbs 1722-26

Theatres, with architect and date
27 - Lincoln's Inn Fields, Davenant 1658-1794
28 - Theatre Royal, Wren 1764; remodelled by Adam, 1775; remodelled by Holland, 1794
29 - Opera House, Vanbrugh 1704
30 - Theatre Royal, Shephard 1792; remodelled by Holland, 1792
31 - Little Theatre (Theatre Royal from 1767), Potter 1720
32 - The Pantheon, Wyatt 1722

Academies and exhibition rooms
33 - Sir Godfrey Kneller's Academy, 1711-23
34 - Sir James Thornhill's Academy, 1724-34
35 - St Martin's Lane Academy, 1735-67
36 - Great Exhibition Room from 1757
37 - British Museum, Montagu House, from 1759
38 - Royal Academy, Old Somerset House, 1771
39 - Society of Arts, 1754

Palladian mansions, with architect and date
40 - Burlington House, 1665; additions by Gibbs, 1715, 1719
41 - Queensbury House, Leoni 1721-23
42 - General Wade's House, Burlington 1723
43 - Pembroke House, Campbell 1723
44 - Devonshire House, Kent 1730s
45 - 44 Berkeley Square, Kent 1742-47
46 - Chesterfield House, Ware 1747-52
47 - Spencer House, Vardy 1766

Adam-style mansions, with architect and date
48 - Lichfield House, Stuart 1764-66
49 - Londonderry House, Stuart 1774-82
50 - Melbourne House, Chambers 1771-76
51 - Landsdown House, Robert Adam 1761-68
52 - 20 St James's Square, Robert Adam 1775-89
53 - Derby House, 1773-75; remodelled by Robert Adam
54 - The Adelphi, Adam brothers 1768-74

Other important monuments, with architect and date
55 - Somerset House, Chambers 1776-86
56 - The Admiralty, Ripley 1723-26
57 - The Horse Guards, Kent 1750-58
58 - Dover House, Paine 1755-58
59 - Paymaster General's Office, Lane 1753
60 - The Treasury Building, Kent 1734-37
61 - Home of Sir John Soane (now Sir John Soane's Museum), 1792
62 - Hanover Square, post 1714

0 500 yards
0 500 metres

THE NORTH NETHERLANDS 1500-1800

SINCE THEIR ORIGINS in around the twelfth century the cities in the fertile delta of the two great northern European rivers, the Rhine and Meuse, had enjoyed growing prosperity mainly due to agriculture and trade. At first, they concentrated on architecture – religious, feudal and civic. But, by 1500, at the end of the Burgundian period, towns such as Haarlem and Leiden had started to support other artistic activities as well. The Church and the governing classes patronized expensive art, for example painted or sculpted altarpieces, silver vessels, portraits and illuminated manuscripts. Simultaneously the young print industry satisfied a new bourgeoisie with images of a more varied subject-matter, distributed more widely at lower cost.

THE DUTCH REPUBLIC

Yet artistic production came to a virtual halt in 1568 when different, discontented groups brought about a revolt against the 'foreign' Roman Catholic Church and the centralized government of the equally 'foreign' Spanish Habsburgs, who in 1515 had inherited the feudal titles to the Netherlands. Although this conflict was to continue for 80 years, in 1579 the Seven Northern Provinces succeeded in establishing a new state, a federal republic.

The young republic's fate was strongly influenced by her embargo of Antwerp after this formidable trading and banking centre had come under control of the Spanish enemy (1585). The exodus of Protestant merchants and craftspeople, including artists, benefited the northern cities, above all Amsterdam. The character of Amsterdam's citizens was shaped by the disadvantages of their original landless, waterlogged situation, which spurred them on to take advantage of their geographical position, first by trading on the

AMSTERDAM'S NEW TOWN HALL (1648), the largest secular structure in Europe before Louis XIV erected his palace in Versailles, was constructed from German Bentheim stone, with the grandiose citizen's hall entirely clad in white Italian marble. With its floor inlaid with maps of the earth and the heavens, the building epitomized in its use of materials and decoration the city's prime position in world trade.

1 THE DIFFERENT SOIL and water conditions that influenced the first siting of the Dutch cities resulted in their acquiring different civic characters, experiencing different historical developments and ultimately creating different types of art. After 1500 the medieval towns grew phenomenally, some supported by newly drained polderland. The most decisive change in civic life took place between 1590 and 1630, when Protestants fleeing persecution in Catholic countries took advantage of new possibilities for world trade. Commerce was fed by imports from all parts of the globe. Earlier established industries, such as dairy and textile production and brewing, were turned into more capitalist and specialized enterprises, profiting from fresh export opportunities. Painting and printmaking enjoyed a similar expansion, becoming part of a prestigious luxury trade. Sculpture, by contrast, became a rare art form used for civic display – for example within the Amsterdam townhall or for tombs of naval heroes.

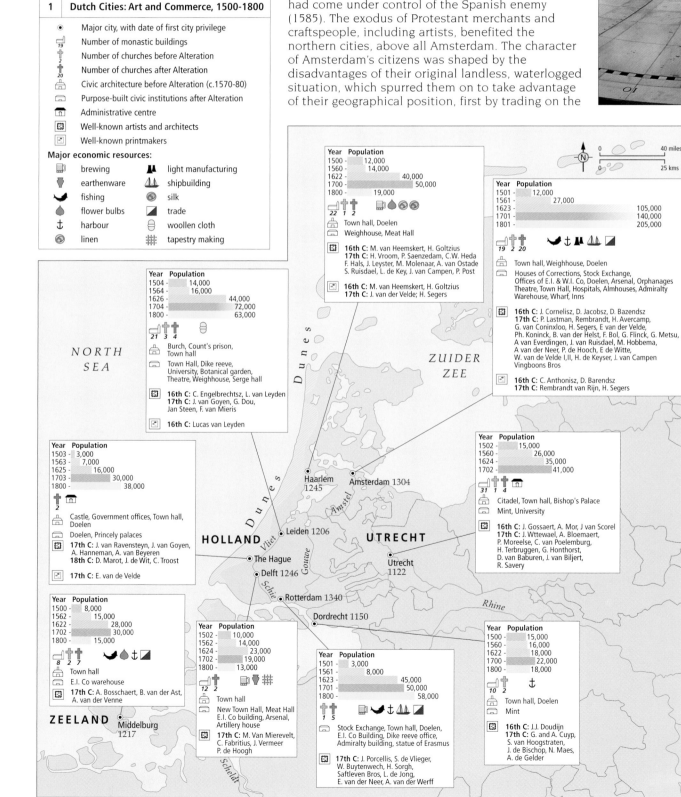

1 | Dutch Cities: Art and Commerce, 1500-1800

- Major city, with date of first city privilege
- Number of monastic buildings
- Number of churches before Alteration
- Number of churches after Alteration
- Civic architecture before Alteration (c.1570-80)
- Purpose-built civic institutions after Alteration
- Administrative centre
- Well-known artists and architects
- Well-known printmakers

Major economic resources:

brewing		light manufacturing	
earthenware		shipbuilding	
fishing		silk	
flower bulbs		trade	
harbour		woollen cloth	
linen		tapestry making	

Haarlem 1245

Year	Population
1504	14,000
1564	16,000
1626	44,000
1704	72,000
1800	63,000

21 3 4

Burch, Count's prison, Town hall
Town Hall, Dike reeve, University, Botanical garden, Theatre, Weighhouse, Serge hall

16th C: C. Engelbrechtsz, L. van Leyden
17th C: J. van Goyen, G. Dou, Jan Steen, F. van Mieris

16th C: Lucas van Leyden

Leiden 1206

Year	Population
1503	3,000
1563	7,000
1625	16,000
1703	30,000
1800	38,000

2

Castle, Government offices, Town hall, Doelen
Doelen, Princely palaces

17th C: J. van Ravensteyn, J. van Goyen, A. Hanneman, A. van Beyeren
18th C: D. Marot, J. de Wit, C. Troost

17th C: E. van de Velde

The Hague

Year	Population
1500	8,000
1562	15,000
1622	28,000
1702	30,000
1800	15,000

8 2 7

Town hall
E.I. Co warehouse

17th C: A. Bosschaert, B. van der Ast, A. van de Venne

ZEELAND

Middelburg 1217

NORTH SEA

Dunes

HOLLAND

Vliet Gouwe Gouwe Schie Scheldt Amstel

Delft 1246

Year	Population
1502	10,000
1562	14,000
1624	23,000
1702	19,000
1800	13,000

12 2

Town hall
New Town Hall, Meat Hall E.I. Co building, Arsenal, Artillery house

17th C: M. Van Mierevelt, C. Fabritius, J. Vermeer, P. de Hoogh

Rotterdam 1340

Dordrecht 1150

Year	Population
1501	3,000
1561	8,000
1623	45,000
1701	50,000
1800	58,000

1 5

Town hall
Stock Exchange, Town hall, Doelen, E.I. Co Building, Dike reeve office, Admiralty building, statue of Erasmus

17th C: J. Porcellis, S. de Vlieger, W. Buytenwech, H. Sorgh, Saftleven Bros, L. de Jong, E. van der Neer, A. van der Werff

Amsterdam 1304

Year	Population
1500	12,000
1560	14,000
1622	40,000
1700	50,000
1800	19,000

22 1 2

Town hall, Doelen
Weighhouse, Meat Hall

16th C: M. van Heemskert, H. Goltzius
17th C: H. Vroom, P. Saenzedam, C.W. Heda F. Hals, J. Leyster, M. Molenaar, A. van Ostade S. Ruisdael, L. de Key, J. van Campen, P. Post

16th C: M. van Heemskert, H. Goltzius
17th C: J. van de Velde; H. Segers

Year	Population
1501	12,000
1561	27,000
1623	105,000
1701	140,000
1801	205,000

19 2 20

Town hall, Weighhouse, Doelen
Houses of Corrections, Stock Exchange, Offices of E.I. & W.I. Co, Doelen, Arsenal, Orphanages Theatre, Town Hall, Hospitals, Almhouses, Admiralty Warehouse, Wharf, Inns

16th C: J. Cornelisz, D. Jacobsz, D. Bazendsz
17th C: P. Lastman, Rembrandt, H. Avercamp, G. van Coninxloo, H. Segers, E van der Velde, Ph. Koninck, B. van der Helst, F. Bol, G. Flinck, G. Metsu, A van Everdingen, J. van Ruisdael, M. Hobbema, A van der Neer, P. de Hooch, E de Witte, W. van de Velde I,II, H. de Keyser, J. van Campen Vingboons Bros

16th C: C. Anthonisz, D. Barendsz
17th C: Rembrandt van Rijn, H. Segers

ZUIDER ZEE

Utrecht 1122

Year	Population
1502	15,000
1560	26,000
1624	35,000
1702	41,000

31 1 4

Citadel, Town hall, Bishop's Palace
Mint, University

16th C: J. Gossaert, A. Mor, J van Scorel
17th C: J. Wttewael, A. Bloemaert, P. Moreelse, C. van Poelemburg, H. Terbruggen, G. Honthorst, D. van Baburen, J. van Biljert, R. Savery

UTRECHT

Rhine

Year	Population
1500	15,000
1560	16,000
1622	18,000
1700	22,000
1800	18,000

10 2

Town hall, Doelen
Mint

16th C: J.J. Doudijn
17th C: G. and A. Cuyp, S. van Hoogstraten, J. de Bischop, N. Maes, A. de Gelder

N

0 40 miles
25 kms

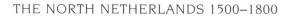

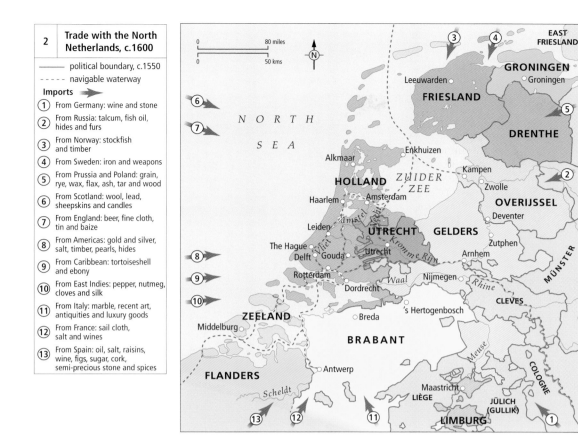

2	Trade with the North Netherlands, c.1600

— political boundary, c.1550

----- navigable waterway

Imports →

① From Germany: wine and stone

② From Russia: talcum, fish oil, hides and furs

③ From Norway: stockfish and timber

④ From Sweden: iron and weapons

⑤ From Prussia and Poland: grain, rye, wax, flax, ash, tar and wood

⑥ From Scotland: wool, lead, sheepskins and candles

⑦ From England: beer, fine cloth, tin and baize

⑧ From Americas: gold and silver, salt, timber, pearls, hides

⑨ From Caribbean: tortoiseshell and ebony

⑩ From East Indies: pepper, nutmeg, cloves and silk

⑪ From Italy: marble, recent art, antiquities and luxury goods

⑫ From France: sail cloth, salt and wines

⑬ From Spain: oil, salt, raisins, wine, figs, sugar, cork, semi-precious stone and spices

2 THE FOUNDATION of the East Indies Company in 1602 followed by that of the West Indies Company in 1621, fortified single enterprises through unification. Some individual merchant families continued within established trades such as grain.

Jan Vermeer could create his genteel, light and spacious interiors, draped with tapestries and peopled with dreamy, dignified citizens. Leiden, in contrast, needed a large workforce to ensure that her labour-intensive wool industry flourished. Immigrants filled all available living space, providing the context for the small paintings of shallow and dark interiors by Leiden's most famous painter Gerrit Dou. The elite of Utrecht, on the other hand, continued the traditions of the former bishopric and its landed aristocracy and patronized painters who travelled as a matter of course to Rome. They became the major importers of Italian style and subject matter.

THE END OF AN ERA

The eighteenth century was a reaction to the previous period of aggressive wealth and art accumulation. Capital was invested, and art collections were passed on from generation to generation, meaning that fewer painters found a market. If they succeeded, it was often with decorative work, such as painted ceilings and wall hangings with pastoral landscapes and classical allegories (De Lairesse) or with flower paintings (Ruysch). Genre painting concentrated on refined interiors (Ochtervelt, Schalcken, Van der Werff). Cornelis Troost (1696–1750) in Amsterdam was the only painter who satirized this establishment satisfied with living off its former glory.

Baltic and later by extensive global exploits. At the beginning of the sixteenth century Amsterdam, with little more than 10,000 inhabitants, still lagged behind her local competitors; a century later she had overtaken all, not only in size, but also in wealth, which was increasingly related to the import of precious commodities and raw materials often from halfway around the globe. Iron from Sweden was forged into arms, which guaranteed the hegemony of the trading classes in their worldwide ventures.

Amsterdam's sudden riches, the envy of Europe, forced her 'upstart' rulers to present visual apologies in the shape of small oil paintings with internationally recognizable, moral stories. This genre of predominantly Biblical history painting was the most popular in Amsterdam until the second half of the century, and was made famous by the city's most celebrated immigrant, Rembrandt.

THE DUTCH ART MARKET

Rembrandt first left Leiden for Amsterdam soon after the concentric canal expansion (1612–20) had created thousands of prosperous homes which were seeking visual aggrandizement and display. Besides history paintings, many landscapes and portraits were produced and an active art market developed. The print industry also expanded, developing a particular specialization in map-making. With a second town expansion in the 1660s up to 300 more painters arrived, their work exported by an increasing number of art dealers.

The clientele, boasting by then three or more generations of established wealth, was increasingly seeking refined opulence. This was introduced in all genres, but best expressed in exquisite still-lifes, full of allusions to exotic imports. In the first half of the century Amsterdam had asserted her power through militia paintings, culminating in Rembrandt's *Nightwatch* (1642, Amsterdam, Rijksmuseum). During the second half of the century marine painting reflected the Anglo-Dutch conflicts, fought out in a series of spectacular sea battles.

Other cities like Amsterdam profited from immigration and overseas exploits, but

variations in these and other factors may explain the striking differences in the type of painting produced in each of them. For example, Delft allowed only a limited import of skilled labour mainly for her new, capital-intensive, tapestry industry. It remained a small, clean, conservative community in which

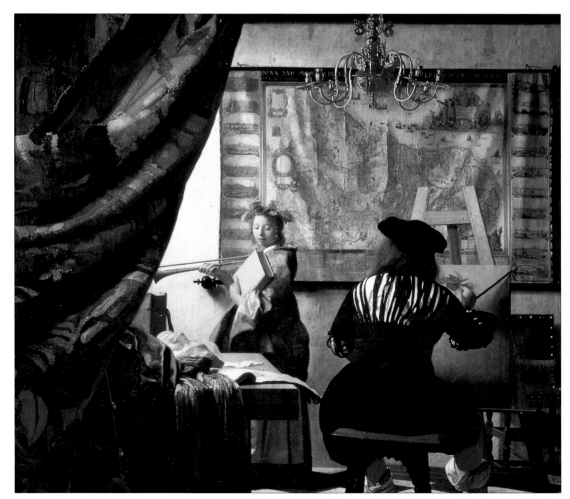

JAN VERMEER, *THE ART OF PAINTING*, 1662–5. Probably made in connection with a new building for the Delft painters' guild, this large work not only documents the city's refinement, but celebrates the art of painting in general. The painter, dressed according to a much earlier fashion, portrays an introverted young woman, elegantly attired as the muse of history. In an interior richly decorated with marble and aristocratic Delft tapestry, she poses against a wall map of the Northern and Southern Netherlands. The values represented in the painting include an interest in the long pedigree of local painting, in secretive female beauty, in learning, in spacious, high-class environments and patriotism.

THE SOUTH NETHERLANDS 1500-1800

THE SOUTH NETHERLANDS, a sovereignty only during the reign of Albert and Isabella (1598–1621), was a Habsburg territory governed from afar. Still, it profited from its integration within the Empire, as three examples illustrate. The art cabinet originated in Antwerp c.1620, when collecting rarities became fashionable. Its fabrication required ebony and tortoiseshell from the Indies and ivory from Ceylon and west Africa; these arrived in Antwerp via Lisbon and Cádiz. Another instance is diamonds, carried by Portuguese merchants from India for cutting in Antwerp. Antwerp's dyeing industry depended on American cochineal and indigo.

The Iberian peninsula was a primary market for products from the South Netherlands. Numerous art cabinets were exported there, as well as oil paintings on copper and inexpensive watercolours on linen. Thousands of pictures were sent on to New Spain and the West Indies. Markets outside the Empire were tapped too. One estimate claims that one-third of the sixteenth-century pictures collected in Florence, Genoa and Venice were of Netherlandish origin, with landscape the preferred subject.

AN ABUNDANT LAND

Natural resources abounded for architecture, sculpture and church furnishings: clay (for brick), sandstone, limestone, bluestone and marble. The latter included touchstone from Dinant and Namur, Tournai blue-black, and red and variegated colours from Rance. A brownish-ochre

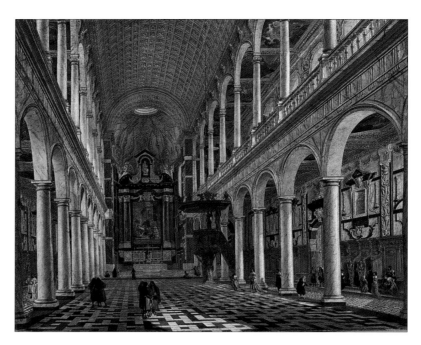

THE ANTWERP JESUIT CHURCH (as depicted by William Schubart von Ehrenberg, oil on canvas, 1667) was completed in 1621. The church was built in anticipation of the canonization of the order's founder Ignatius of Loyola, and in recognition of the Jesuits as Catholicism's most militant defenders. The edifice symbolized the triumph of the Counter-Reformation in the Habsburg Netherlands. No expense was spared: Italian marble dressed the severe interior, while Rubens, the foremost Netherlandish master, furnished paintings and sculptural designs, and advised the Jesuit architect Huyssens.

marble from Hainault was used at St Peter's in Rome. Only white marble was unavailable locally and had to be imported from Italy. Coal and iron from the Ardennnes and Liège supported small arms and armour industries in Antwerp and Liège, but other manufactures – engraving plates, picture supports and scientific instruments – depended on copper imported via Hamburg. Extensive oak and walnut stands furnished

wood for sculpture, picture supports and timber. Flax from Flanders was used to make thread for damask, linen, canvas and lace.

Two periods are remarkable. The years between 1500 and the 1560s were characterized by entrepreneurial innovations. The period from 1600 to 1650 was distinguished by the Counter-Refomation and court culture. The most notable sixteenth-century innovation is the quasi-

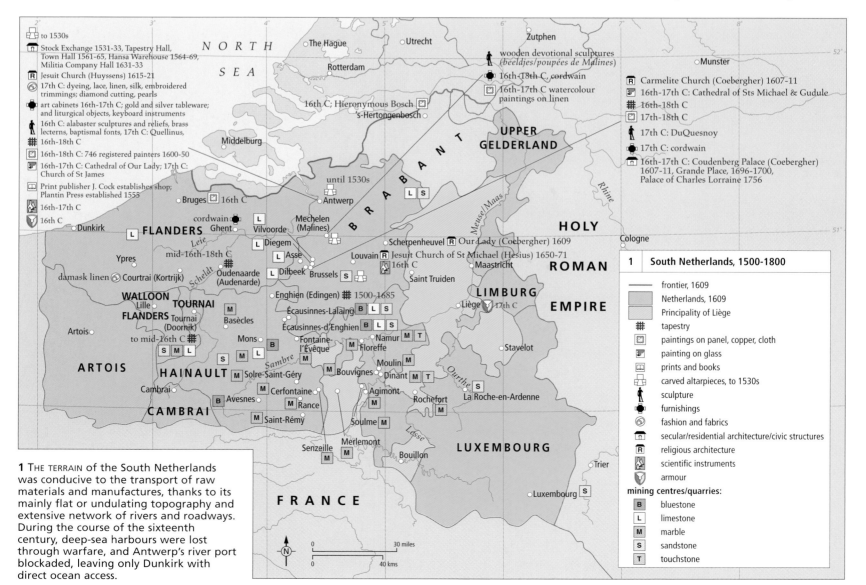

1 THE TERRAIN of the South Netherlands was conducive to the transport of raw materials and manufactures, thanks to its mainly flat or undulating topography and extensive network of rivers and roadways. During the course of the sixteenth century, deep-sea harbours were lost through warfare, and Antwerp's river port blockaded, leaving only Dunkirk with direct ocean access.

1	South Netherlands, 1500-1800
	frontier, 1609
	Netherlands, 1609
	Principality of Liège
⌗	tapestry
	paintings on panel, copper, cloth
	painting on glass
	prints and books
	carved altarpieces, to 1530s
	sculpture
	furnishings
	fashion and fabrics
	secular/residential architecture/civic structures
R	religious architecture
	scientific instruments
	armour
mining centres/quarries:	
B	bluestone
L	limestone
M	marble
S	sandstone
T	touchstone

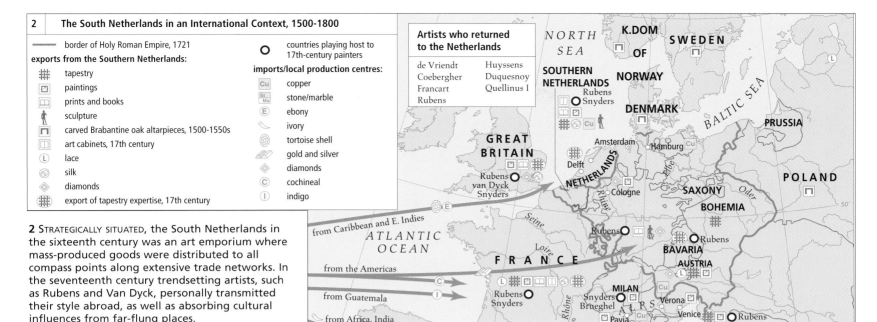

2 STRATEGICALLY SITUATED, the South Netherlands in the sixteenth century was an art emporium where mass-produced goods were distributed to all compass points along extensive trade networks. In the seventeenth century trendsetting artists, such as Rubens and Van Dyck, personally transmitted their style abroad, as well as absorbing cultural influences from far-flung places.

industrial production of art by anonymous masters. Purchased speculatively by merchants, goods were marketed along the trade networks. Examples are sizable oak altarpieces with painted wings and sculpture-filled interiors; oak and walnut polychromed statuettes of Jesus and Mary, whose nurturant appeal explains Magellan's gift of a Jesus 'poupée' to a Philippine princess; and devotional reliefs carved in Mechelen from English (Nottingham) alabaster.

THE CROSSROADS OF THE NORTH

Antwerp's commercial supremacy was established after the Portuguese spice staple moved there in 1501. Merchants poured in, making Antwerp the pivot of global trade networks and Europe's most cosmopolitan metropolis. Many of its notable sixteenth-century buildings were commercial: the Beurs, the world's first stock exchange, with 100 stalls reserved for art; the German merchants' warehouse; shops publishing quality copper engravings; the Plantin Press, which monopolized the sale of religious texts in Spain and its colonies; and a tapestry sales hall.

Tapestry, the most sumptuous commodity, woven in Brabantine and Flemish cities, required Spanish wool and Italian silk thread. By the

seventeenth century, Flemish expertise was in such demand that princely patrons lured weavers to foreign cities to found competitive shops. Another wall covering, cordwain (made of leather), was a Mechelen specialty.

With the arrival of the Archdukes, the region became the northernmost Habsburg bulwark against Protestantism. To this end, ecclesiastical institutions assumed a formidable propagandistic role. Substantial sums were expended on pilgrimage centres, such as Scherpenheuvel, new churches were styled in the Roman Baroque manner, old churches were repaired, and up-to-date decor – windows, choirscreens, altarpieces –

was incorporated. Antwerp gives some indication of this intense activity: ten cloisters were founded between 1607 and 1621 and, at roughly the same time, Rubens's shop turned out some 60 altarpieces. Court culture offered Flemish painters international opportunities to fashion political imagery, court portraits and paintings for picture galleries, a new symbol of princely or aristocratic status. Flemish painters had always travelled south; in the seventeenth century many, such as Rubens and Van Dyck, embarked on lengthy Italian sojourns. Their reputations spread south of the Alps, and the international Baroque idiom was widely diffused.

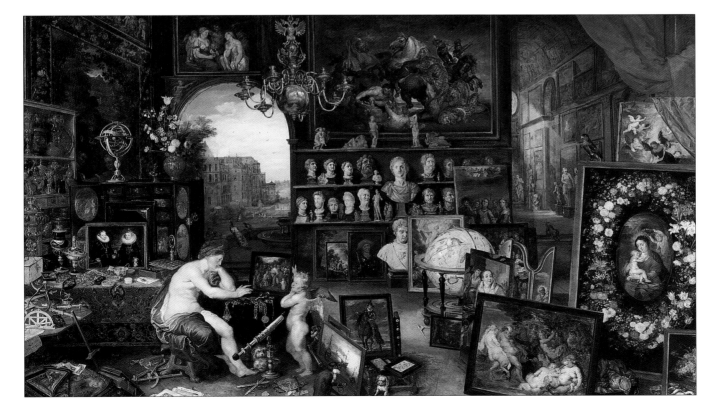

THE COLLECTION pictured in this painting, *The Allegory of Sight* (1617) by Jan Brueghel the Elder and Peter Paul Rubens, reflects the eminence of the South Netherlands as an art centre. When hostilities ceased in the early seventeenth century, money which had previously been used for warfare was now redirected to peacetime concerns, notably the arts and sciences. The Archdukes gave their enthusiastic support to these pursuits. In this painting, Flemish art predominates, but classical sculpture, scientific instruments and rarities are also well represented, evidence of the cultivated milieu of this Habsburg court.

GERMANY AND SWITZERLAND 1500-1650

THE FIRST HALF of the sixteenth century marks a high point in the art of the German lands, which were a collection of principalities grouped under the rule of the elected Holy Roman Emperor. The painters Albrecht Dürer (1471–1528), Matthias Nithart, called Grünewald (1475/80–1528), and Lucas Cranach (1472–1553) are the most familiar artists of the period, but the artistic flowering extended far beyond their works. Limewood, abundant in the southern German lands, was ideal for delicately sculpted figures and altarpieces, and was exploited to its limits by Tilman Riemenschneider (c.1460–1531) and others of his generation. Masters in the north worked in oak and walnut, harder woods that tend to yield somewhat more blocky figures. Especially in Augsburg and Nuremberg, where Italian Renaissance principles were accepted almost unconditionally, cast bronze sculpture was produced at a very high level by Peter Vischer (c.1460–1529), Peter Flötner (1485/96–1546), and others. Printmaking was developed in the

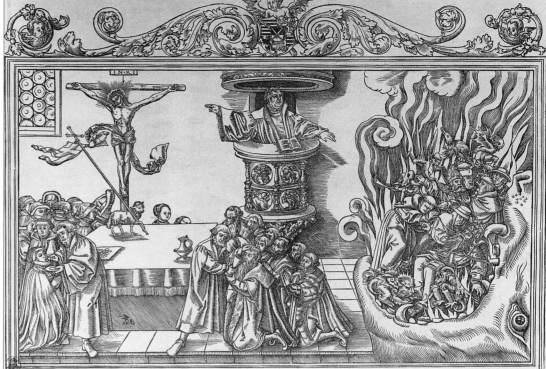

LUCAS CRANACH THE YOUNGER, *Last Supper of the Protestants and the Pope's Descent to Hell* (c.1546). Cheap to produce and distribute, prints were used widely in the bitter religious struggles of the Reformation. Here Martin Luther stands in the pulpit, blessing the Protestants receiving the host on the left. On the right, flaming hell consumes monks, bishops, cardinals and a pope.

1 DIFFERENT REGIONS of Germany provided different materials used in artistic production, helping to define distinct local styles. While many German and Swiss cities specialized in the production of certain goods, other centres, including Augsburg and Nuremberg, produced a variety of arts at a high level for patrons throughout Europe.

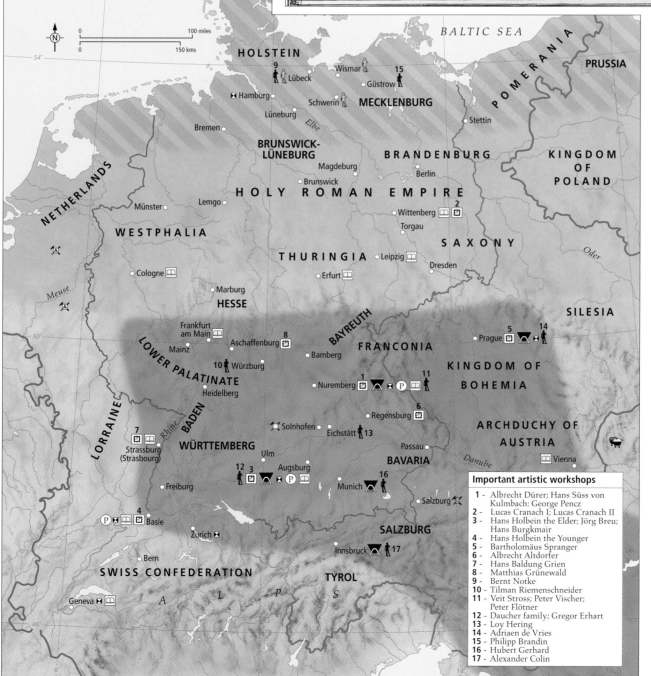

Important artistic workshops

1 - Albrecht Dürer; Hans Süss von Kulmbach: George Pencz
2 - Lucas Cranach I; Lucas Cranach II
3 - Hans Holbein the Elder; Jörg Breu; Hans Burgkmair
4 - Hans Holbein the Younger
5 - Bartholomäus Spranger
6 - Albrecht Altdorfer
7 - Hans Baldung Grien
8 - Matthias Grünewald
9 - Bernt Notke
10 - Tilman Riemenschneider
11 - Veit Stross; Peter Vischer; Peter Flötner
12 - Daucher family; Gregor Erhart
13 - Loy Hering
14 - Adriaen de Vries
15 - Philipp Brandin
16 - Hubert Gerhard
17 - Alexander Colin

1	Germanic Art in the 16th Century

Holy Roman Empire
borders of Swiss Confederation
modern borders of Germany
region of brick construction
region of oak and walnut sculpture
region of limewood sculpture
important painting workshops
important sculpture workshops
centres of large-scale bronze casting
terracotta decorative sculpture
centres of fine metalwork
(P) centres of printmaking and distribution
centres of book production

Natural resources:

marble quarries
limestone quarries
alabaster quarries
copper and silver mines

mid-fifteenth century, almost simultaneously in Italy and Germany. Although many early prints were either cheap devotional images or propaganda, those made by the best masters in Augsburg and Nuremberg were art objects of the highest standard. Dürer's engravings and woodcuts were prized throughout Europe.

Dürer was fundamental to the artistic culture of this period, for he embodied the ideal 'Renaissance man' more completely than any of his contemporaries. He was interested in classical antiquity, and, unlike his peers, he studied in Italy (1494–5 and 1505–7). He was a close friend of humanists and intellectuals and wrote a treatise on human proportion. All of this influenced his work profoundly. More than any other German painter, he approached art as an intellectual.

RENAISSANCE ART IN SWITZERLAND

Dürer's younger contemporary, Hans Holbein the Younger (1497/8–1543), was born and trained in Augsburg, but moved to Basle in 1515. Basle was a thriving intellectual and artistic centre in the early sixteenth century, drawing Dürer (as a student) and the humanist Erasmus of Rotterdam, as well as Swiss artists such as the goldsmith and draftsman Urs Graf (c.1485–1527/29). There was a long tradition of artistic contacts between Germany and Switzerland. In the fifteenth century, the German Konrad Witz (1400/10–1445/46) was the most important painter working in Basle and Geneva. Likewise, Italian-speaking parts of Switzerland profited from close contacts with northern Italy; the prominent Milanese painter Bernardino Luini (c.1480/85–1532) provided a number of works for the Catholic city of Lugano.

Many other Swiss cities, including Basle, Geneva and Zurich, converted to Protestantism in the 1520s. Religious painting, the most attractive work for a painter, was banished in the ensuing iconoclasm. Frustrated with this artistic climate, Holbein left Basle in 1526 for the court of Henry VIII (r.1509–47) in England. Although the Catholic regions continued to support devotional art, and there was still a market for graphic works, portraits, and other non-religious art in other regions, few internationally important artists settled in Switzerland after the 1520s.

REFORMATION GERMANY

It is often assumed that the arts in Germany declined precipitously after the deaths of Cranach and Dürer. The Reformation initiated in Saxony by Martin Luther (1483–1546), and the devastating Thirty Years' War (1618–48), are supposed to have crippled the artistic life of the region. Significant projects were undertaken throughout this period, however. The Ottheinrichsbau of Heidelberg Castle was begun around 1556, and the Friedrichsbau of the same complex in 1601, both with rich sculptural decoration. Munich prospered in the same period. The ornate Antiquarium (begun 1563), which housed the Duke of Bavaria's collection of antique sculpture, was designed by the Italian architect and antiquarian Jacopo Strada (1515–88).

Strada, who was trained by Giulio Romano (c.1499–1546), was crucial for the transmission of Italian and classical forms and ideas to northern Europe, but he was not alone. The imperial sculptor Adriaen de Vries (1556–1626) was trained in Florence by Giambologna (1529–1608). He worked primarily in Prague, but completed significant commissions for German patrons, including two monumental fountains for the city of Augsburg. The Dutch

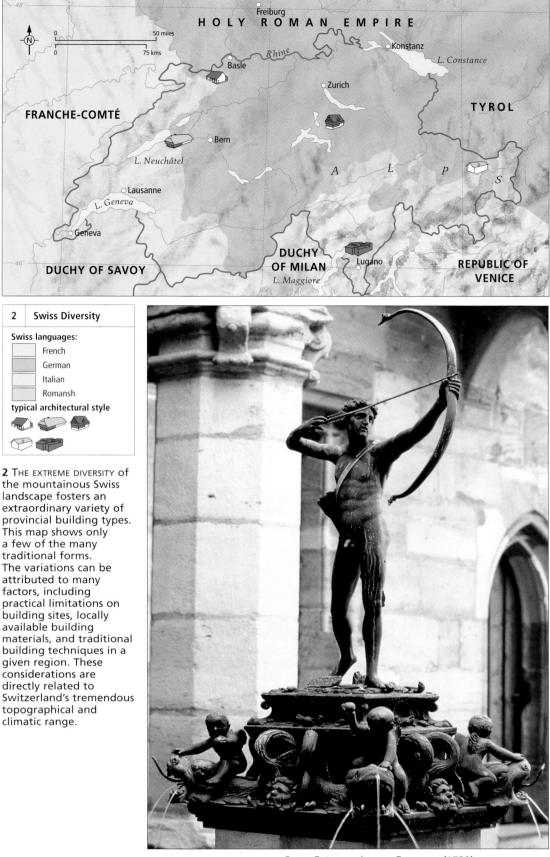

Peter Flötner, Apollo Fountain (1532). This fountain, which stood in the house of the Nuremberg archers' company, reveals the sophisticated Renaissance interests of patricians in that city. Its classical subject, form and proportions were inspired by prints by Albrecht Dürer and the Venetian Jacopo de' Barbari (1460/70–1516), the first Italian to work extensively in Germany.

2 | **Swiss Diversity**

Swiss languages:
- French
- German
- Italian
- Romansh

typical architectural style

2 THE EXTREME DIVERSITY of the mountainous Swiss landscape fosters an extraordinary variety of provincial building types. This map shows only a few of the many traditional forms. The variations can be attributed to many factors, including practical limitations on building sites, locally available building materials, and traditional building techniques in a given region. These considerations are directly related to Switzerland's tremendous topographical and climatic range.

sculptor Hubert Gerhard (1540/50–before 1621), who may also have trained in Florence, worked in Munich, Augsburg and Innsbruck. More broadly, Counter-Reformation patronage by the Jesuit order provided many opportunities for artists in the second half of the sixteenth century. Roman Catholics were not the only ecclesiastical patrons in Germany. Martin Luther himself dedicated the palace chapel at Torgau, which has significant classicizing decoration. It is considered the first chapel conceived specifically for Protestant worship.

The German lands suffered terribly in the Thirty Years' War, and it is often thought that artistic production stopped in these years. This view comes largely from the painter and writer Joachim von Sandrart (1606–88). But while

Magdeburg and Heidelberg were destroyed (including Heidelberg Castle, which survives as a ruin), many other centres survived largely unharmed, including Augsburg and Nuremberg. Although there is some truth to Sandrart's comments, the German artistic tradition survived this period, and was thus poised for renewed growth at the end of the seventeenth century.

GERMANY AND SWITZERLAND 1650-1800

'GERMANY' WAS A LARGE GROUP of semi-independent principalities until unified in 1871. Until 1806, these were grouped together in the Holy Roman Empire, ruled by the Austrian Habsburg dynasty. Some of these territories were Roman Catholic, others (particularly in the north) were fiercely Protestant. The German lands are at the heart of Europe, and have always been influenced by the arts and culture of neighbouring countries. In the Baroque period, the dominant influences came from France and Rome, but variants were found in each region.

COURTLY SPLENDOUR
Frederick II of Prussia (r.1740–86) commented that every German prince considered his court a reflection of Louis XIV's Versailles, and indeed a number of magnificent courts emerged in the early eighteenth century, many with a distinct French character. Brandenburg, for example, had been a minor provincial region, but Berlin emerged as an important artistic centre at the end of the century when the court patronized the work of the sculptor and architect Andreas Schlüter (1659?–1714). In Dresden, the Saxon Electors commissioned

new works and collected old-master paintings on a grand scale beginning in this period. The Palais im Grossen Garten (destroyed 1945) was built in a French manner, but other influences were at play as well. The architect Matthäus Daniel Pöppelmann (1662–1736) and sculptor Balthasar Permöser (1651–1732) developed a flamboyant and distinctive baroque that recalls the Roman tradition, which is best seen in the Zwinger pavilion. This dichotomy of French and Roman influences characterizes much of German artistic production in this period, and indeed much of central European art as well. They were synthesized particularly successfully in Vienna by the imperial architect Johann Bernhard Fischer von Erlach (1656–1723).

A different resolution of these influences was achieved in southern Germany. François Cuvilliés (1695–1768), who was trained in France, brought a glittery French Rococo to Bavaria. In the same region the brothers Cosmas Damian and Egid Quirin Asam (1686–1739 and 1692–1750) developed an almost seamless blend of architecture and decoration that is often described as 'total artwork'. The Asams were strongly influenced

EINSIEDELN ABBEY. The German architect Caspar Moosbrugger (1656–1723) began work in 1702 on the Benedictine Abbey of Einsiedeln, which was completed in 1735. Moosbrugger, who became a monk there, was involved in the design of a number of other monasteries in Switzerland and southern Germany. The church was decorated by the Asam brothers, showing the close cultural contact between German-speaking Switzerland and Germany. The monastery is southeast of Zurich.

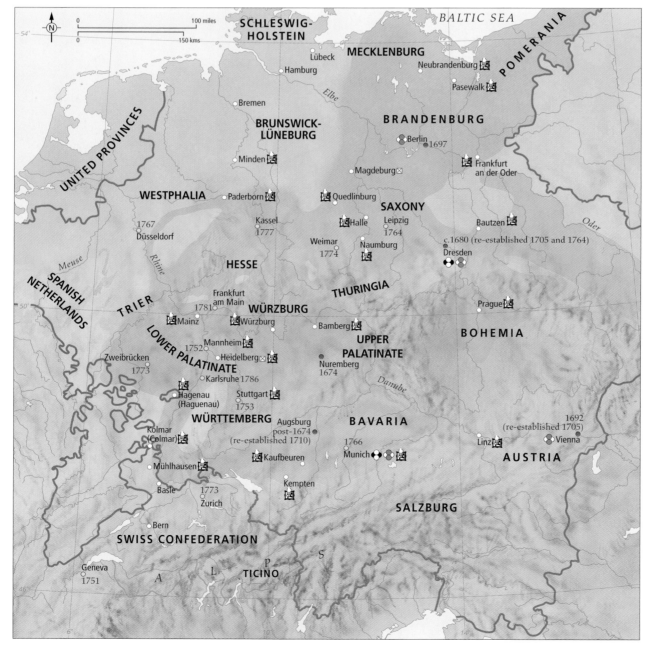

1 AFTER THE THIRTY YEARS' WAR, the Académie Royale in Paris, founded in 1648, and the academies in Rome, Florence and Bologna provided a model for artistic education that was eagerly absorbed in the German lands. Often supported by the courts, these academies provided training in artistic theory and practice. Many of the earliest German academies were little more than informal meetings to draw from nature. In the eighteenth century most northern European academies were reorganized with a more formal curriculum.

1	Recovery and Transformation after the Thirty Years' War
——	Holy Roman Empire
——	borders of Swiss Confederation
▢	regions that suffered greatly during the Thirty Years' War
◓	major art collections pre-Thirty Years' War
◉	major art collections post-Thirty Years' War
⊠	centres destroyed in the Thirty Years' War
▦	art collections plundered in the Thirty Years' War
●	academies and dates of foundation
○	major regional academies, post 1750

by Roman fresco painting, but other aspects of their work come from Vienna and elsewhere. A distinctive, highly decorative Rococo architecture is found throughout southern Germany, the legacy of the Asams, Johann Baptist and Dominikus Zimmermann (1680–1758 and 1685–1766), and others.

But if Roman and French styles were prevalent in Germany, one need not look far to discover other international influences. The architecture of Johann Conrad Schlaun (1695–1773) in Westphalia, for example, shows the influence of nearby Holland, which is also visible in Brandenburg. Balthasar Neumann (1687–1753), perhaps the greatest German architect of the eighteenth century, drew freely on the work of Guarino Guarini (1624–1683) in Turin. His best-known building, the residence of the Prince-Bishop at Würzburg, demonstrates the international interests of patrons and artists. The fresco on the vault above the monumental staircase is a masterpiece by the Venetian painter Giambattista Tiepolo (1696–1770).

SWISS ARTISTS ABROAD
Switzerland has four official languages, twenty-six cantons (confederate regions) and a variety of religious confessions, all of which conspire against artistic unity. Moreover, Switzerland has always been strongly influenced by its larger neighbours, and the reception of these influences is to a large degree determined by linguistic region. Thus when French-speaking Geneva became a major financial centre in the eighteenth century, its residents built Parisian-style apartments. Despite religious differences, this region maintained close cultural ties with France – Rousseau and Voltaire both lived in Geneva. The German-speaking parts identified more closely with Germany, and artistic developments and exchange generally reflect this. Likewise, the arts of the Roman Catholic, Italian-speaking canton of Ticino were more dependent on northern Italy.

After the Swiss Reformation, still lifes, landscapes, portraits and civic paintings were always in demand, and there were significant religious commissions in Ticino. Nonetheless, most of the finest Swiss artists pursued careers elsewhere. Among many others, Angelica Kauffman (1741–1807) worked in London and Rome, Henry Fuseli (Johann Heinrich Füssli, 1741–1825) in London, and Anton Graff (1736–1813) in Dresden.

Kauffman was an internationally important proponent of Neoclassicism. Neoclassicism dominated Europe and North America, but German theorists and artists were central to its formation. The writer and historian Johann Joachim Winckelmann (1717–68) and his acquaintance, the painter Anton Raphael Mengs (1728–79), were essential to the rise of historicism. Winckelmann and Mengs were Saxon, but both worked in Rome (Mengs also worked in Madrid). Their principles were practised at the highest level by the architects Karl Friedrich Schinkel (1781–1841) in Berlin and Leo von Klenze (1784–1864) in Munich.

DRESDEN FROM THE RIGHT BANK OF THE ELBE (1748) by Bernardo Bellotto (1721–80), born in Venice and trained by his uncle, the famous Venetian painter Canaletto (1697–1768). He made a career as a view painter in Central Europe, working in Dresden, Vienna, Munich and Warsaw. A number of artists travelled from centre to centre in this manner, carrying artistic ideas with them from one region to another.

2 THE POSITION OF GERMANY AND SWITZERLAND at the heart of Europe guaranteed the reception of artistic ideas from all sides. Paris and Rome were most important, but Amsterdam, Turin, Stockholm, Venice, and other centres also exerted more limited influences. International and regional ideas mixed, creating a remarkable variety of artistic forms. Some German centres were artistically strong enough to exert their own influence on other regions, particularly to the east.

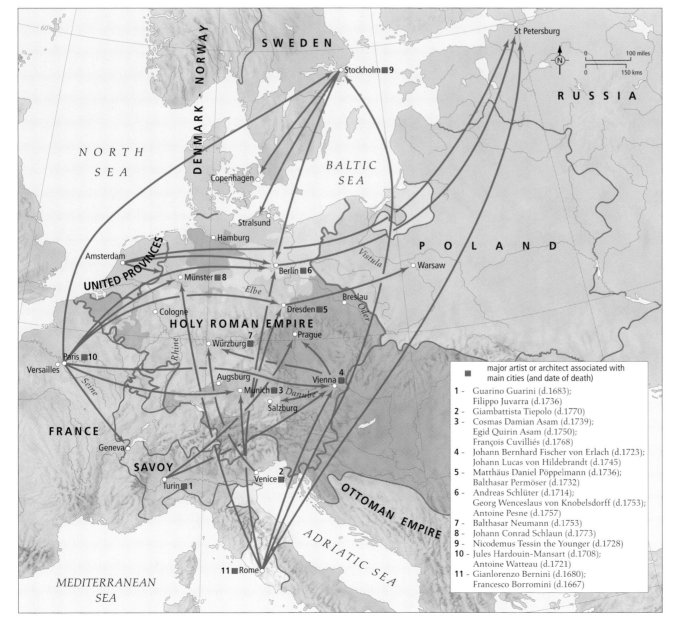

major artist or architect associated with main cities (and date of death)

1 - Guarino Guarini (d.1683);
 Filippo Juvarra (d.1736)
2 - Giambattista Tiepolo (d.1770)
3 - Cosmas Damian Asam (d.1739);
 Egid Quirin Asam (d.1750);
 François Cuvilliés (d.1768)
4 - Johann Bernhard Fischer von Erlach (d.1723);
 Johann Lucas von Hildebrandt (d.1745)
5 - Matthäus Daniel Pöppelmann (d.1736);
 Balthasar Permöser (d.1732)
6 - Andreas Schlüter (d.1714);
 Georg Wenceslaus von Knobelsdorff (d.1753);
 Antoine Pesne (d.1757)
7 - Balthasar Neumann (d.1753)
8 - Johann Conrad Schlaun (d.1773)
9 - Nicodemus Tessin the Younger (d.1728)
10 - Jules Hardouin-Mansart (d.1708);
 Antoine Watteau (d.1721)
11 - Gianlorenzo Bernini (d.1680);
 Francesco Borromini (d.1667)

2	Germany at the Crossroads of Europe, 1680–1750
——	Holy Roman Empire
——	borders, c.1721
☐	Papal States
☐	Brandenburg-Prussia
☐	Poland and Electorate of Saxony (united under same ruler 1697–1763)
☐	Lands of the House of Habsburg
☐	Hanover (united with Great Britain since 1714)
☐	Venetian lands
☐	Bavaria
→	spread of artistic influences

FRANCE 1500-1650

THE REIGN OF FRANCIS I, from 1515 to 1547, was a time of remarkable artistic florescence in France. Unprecedented building initiatives were undertaken by the crown in the Loire Valley and the Île-de-France, and works by Leonardo (who died in France), Raphael, Andrea del Sarto and other Italian High Renaissance masters were acquired for Fontainebleau. In the Loire Valley at Blois a new wing in an imperfectly Italianate manner was begun within two years of the accession of Francis I. The focus of the court on the Loire engendered a proliferation of houses built for senior royal servants, such as Bury and Beauregard, largely known from drawings and engravings. The king's most ambitious undertaking was Chambord.

1 THE REUNIFICATION OF FRANCE was substantially completed between 1500 and the conclusion of the last religious civil war in 1594. In 1528 Francis I announced he was to make Paris his customary residence, and the royal wardrobe of the most valuable royal possessions became a central depository adjacent to the Louvre.

THE CHÂTEAU AT CHAMBORD. Begun in 1519, Chambord is the most sensational and spectacular fusion of medieval and romantic castle with its round, bastion-like angle pavilions with Franco-Italian decorative detail. Its purpose was solely for the reception of a select few, for entertainment and for the recreations of country blood sports. It was a deliberate expression of the king's cult of magnificence, which makes it all the more surprising to learn that Francis I spent no more than eight nights there after 1528, when the focus of court and government life shifted permanently to Paris.

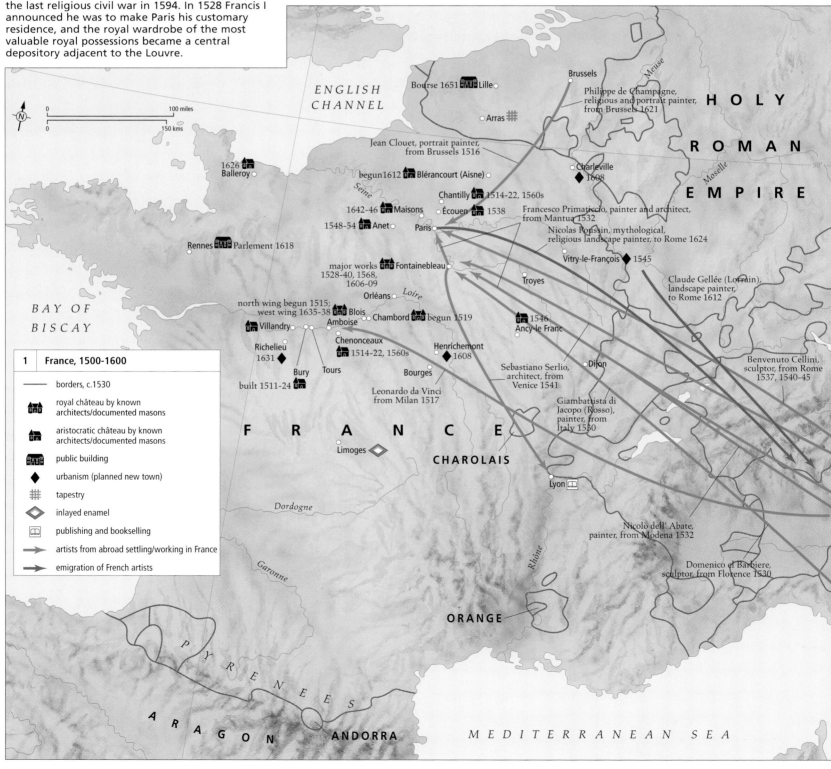

1	France, 1500-1600
—	borders, c.1530
🏰	royal château by known architects/documented masons
🏚	aristocratic château by known architects/documented masons
🏛	public building
◆	urbanism (planned new town)
▦	tapestry
◇	inlayed enamel
📖	publishing and bookselling
→	artists from abroad settling/working in France
→	emigration of French artists

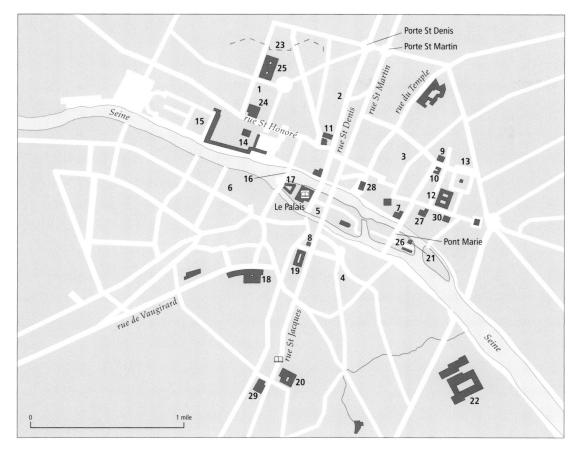

2	Central Paris, c.1650
1	- Quartier St Honoré
2	- Quartier St Denis
3	- Quartier St Antoine (the Marais)
4	- L'Université/Montagne St Geneviève
5	- Quartier St Michel/Quartier Latin
6	- Quartier St Germain-des-Prés
7	- Hôtel de Sens; begun 1498, completed c.1521
8	- Hôtel de Cluny; begun c.1485, completed c. 1519
9	- Hôtel de Ligneris/Carnavalet; begun 1548
10	- Hôtel d'Angoulême/Lemoignon; begun c. 1580
11	- Church of St Eustache; built 1532-1640
12	- Hotel de Sully; built 1624-29
13	- Place Royale (later Place des Vosges); begun 1605
14	- The Louvre; square court begun 1551, enlarged 1578, 1624. Grande Galérie along the Seine begun 1603
15	- Tuileries Palace; first building begun 1566, extended from 1603
16	- Pont Neuf; begun 1578, completed 1607
17	- Place Dauphine; begun 1607
18	- Luxembourg Palace; begun 1615
19	- Sorbonne College and Church; begun 1635
20	- Church of Val-de-Grâce; begun 1645
21	- Hôtel Lambert; begun 1640
22	- Salpêtrière; gunpowder factory from 1634, hospital from 1656
23	- Fosses Jaunes; new ramparts built 1630s, 1640s
24	- Palais Richelieu (later Royal); built 1625-39
25	- Palais Mazarin; begun 1634
26	- Île Saint-Louis; developments begun 1612
27	- Jesuit Church of St Paul and St Louis; begun 1627
28	- Hôtel de Ville; begun 1533
29	- Port Royal; built 1628-53
30	- Church of the Visitation; built 1632-34
📖	bookselling
📖	publishing and printmaking

THE RISE OF PARIS

After the French defeat at Pavia in 1525, Francis was captured by Emperor Charles V and detained in Madrid. In 1528 Francis announced he was to make Paris his customary residence. As a result, the Loire rapidly faded as the 'locus' of royal and court patronage. This was a watershed for the centres of arts and manufactures of the Loire, above all Tours and, to a lesser extent, Orléans, long-established centres for painters, book illuminators, sculptors, luxury fabric manufacture, enamellers, and tapestry makers.

From the 1520s Francis strove to make Fontainebleau and its gardens a European centre for the arts. He nurtured a school of etchers and engravers at Fontainebleau, which consisted of Italians, Frenchmen and Flemings. He used his Venetian ambassador and agents to acquire a fine collection of Greek and Latin manuscripts. After the Sack of Rome in 1527 he procured Rosso to paint frescoes and design stucco frames in his gallery, and Scibec da Carpi for woodwork inlay. Later, from Mantua he lured Giulio Romano's chief assistant, Francesco Primaticcio. Benvenuto Cellini was Francis's star recruit in sculpture.

The second half of the sixteenth century was dominated by three ruinous civil wars of religion, spanning the reigns of the last of the kings of the House of Valois, Francis II, Charles IX and Henry III, who was assassinated in 1589. A subsidiary cause of dissent and bloodshed was the considerable number of Italians in and around the French court, presided over by the queen mother, Catherine de Medici. Because of the crisis, a succession of grand royal architectural projects, planned for the Tuileries and elsewhere, foundered. Sporadic destruction of church artefacts and Calvinist iconoclasm occurred across France.

THE BOURBON DYNASTY

In 1592 the last of the wars ended with the siege and taking of Paris by Henri de Navarre, the first of the House of Bourbon. As Henry IV, he pursued a series of ambitious building projects with indefatigable energy, all cut short or put on ice by his assassination in 1610. The lengthy and colossal 'Grande Galerie' linking the Louvre to the Tuileries was, however, begun and completed. The repopulation and rebuilding of the capital was Henry IV's key political and economic priority, leading to two urban

NICOLAS POUSSIN: *The Kingdom of Flora*, 1631. This picture for long has been held to be the first full refinement in the synthesis of literary symbolism and the painter's poetry. It is based on the world of Ovid's *Metamorphoses*, but consciously does not depict a scene or episode lifted from the text. Poussin's patrons were the 'cognoscenti' of Rome and Paris, and every history of art casts him as the father of Neoclassicism of the next century.

2 THE RESIDENTIAL, COMMERCIAL AND INDUSTRIAL area of Paris did not grow to any significant extent beyond the fourteenth-century circuit of walls and fortifications built by Charles V. In 1500, over a third of the city within the walls consisted of market gardens belonging to religious houses. By 1650, half of all these had been subdivided and developed for upper and middle class houses. The reclaiming and development of the Île-Saint-Louis from 1612 onwards required immensely costly bridges and embankments.

initiatives, the Place Royale (now Vosges) and the Place Dauphine, which were designed to settle and root the elite and their attendant trades and services in the capital. Henry even tried to establish mulberry bushes for silk works adjacent to the Place Royale, a failed attempt to expand the industry north from Lyon.

Henry's queen, who acted as regent for the Dauphin Louis (XIII), was Marie de' Medici. The Luxembourg Palace was built for her on the southern perimeter of Paris in a style reminiscent of the Pitti Palace in Florence. Between 1622 and 1625 Rubens produced 24 allegorical panels for one of the galleries of the Luxembourg evoking events of 1620–21, for which he was paid the immense sum of 20,000 crowns. Otherwise, patronage of foreign artists was minimal. In the third quarter of the century, many leading figures of the French school, including Poussin and Claude, were centred at Rome.

Louis XIII's first ministers, the cardinals Richelieu (d.1642) and his successor Mazarin (d.1661), were both avid builders of enormous town houses and of châteaux, and were eager to fill them with artistic acquisitions. Richelieu's country palace at the model town of Richelieu in Poitou was destined for the display of works by Mantegna, Perugino and Michelangelo, as well as those of French contemporaries such as Poussin, patronized by Richelieu himself. In 1652–3 Cardinal Mazarin acquired the art collection of King Charles I of England. A high proportion of the most famous works, including Caravaggio's *Death of the Virgin* and Van Dyck's full-length portrait of Charles I, can now be found in the Louvre.

FRANCE 1650-1800

LOUIS XIV ASSUMED his right to power in 1661, but it was not until May 1682 that a great symbolic event for the arts took place, when he took possession of the Palace of Versailles. The huge complex was designed to accommodate both government and the court. It was also intended to be an overwhelming showcase of French art and manufactures, the pre-eminent symbol of State mercantalism. The ideology of mercantilism focused on long-term planning for industry and agriculture, as well as those fine arts which might best be enlisted to broadcast the glory of the monarchy, and the manufactures and decorative arts that could satisfy demand at home and create demand abroad. The architect of it all was Louis XIV's first minister, Colbert.

This policy of state centralization had an impact on the artistic academies in Paris. The academy for painting and sculpture, founded in 1648, was reorganized in 1663 to focus on official subject-matters. The academy for architecture was set up in 1671 under royal auspices. The French Academy in Rome was founded in 1666, to serve as a training school for French-born artists.

State initiatives and investments focused on famous French manufacturers. In 1663 the Gobelins tapestry workshop in the southern suburbs of Paris was reformed; a high- and low-weave tapestry workshop was set up to produce furnishings for royal palaces.

1 DURING THE REIGNS of the last three Bourbon kings Versailles became an integral part of the history of the capital. With the death of Louis XIV in 1715, however, there was an inexorable drift of aristocrats wishing to live in the metropolis and commute to Versailles when required, resulting in the wholesale development of the Faubourg St Honoré on the Right bank and the Faubourg St Germain on the Left.

Louis XIV visiting the Gobelins. Tapestry after Charles Le Brun, c.1670. This image evokes the army of painters, sculptors, engravers, weavers, dyers, goldsmiths, embroiderers, cabinet-makers, woodcarvers, marble workers, mosaicists and many more, who worked under and to the designs of Charles Le Brun. The diversity of the luxury objects produced for the king's inspection and approval is a symbol of his munificence, omnipotence and glory, but more subtly might be read as as allegory of the fruits and abundance of peace.

The Savonnerie factory for premier-quality carpets, based in the southeastern suburbs of Paris, achieved both national and international recognition. Another initiative focused on the development of processes to make mirror glass in considerably larger sheets than could be furnished by Venice, the European centre of mirror manufacture. The glorification of this development is the Galerie des Glaces, the pivot and climax of Versailles.

THE HUGUENOT EXPULSION

After Colbert's death in 1683, the king's obsession with his absolute authority led, in 1689, to the Revocation of the Edict of Nantes. The Edict of Nantes of 1599 had established criteria for conditional toleration of Protestants (Huguenots) within the realm, resolving the crises perpetrated by the French civil wars of religion of the second half of the sixteenth century. Its revocation was a disaster for French manufacturers, especially those

working in specialized crafts and luxury goods, such as precious metalwork or fashion fabrics and tailoring. Poor Huguenots had no choice but to abjure their religion, but the affluent urban class moved in their tens of thousands. Within a year of the Revocation, communities of French Huguenots had been established in Amsterdam, Frankfurt and, above all, London. Significant numbers were able to escape sequestration of their moveable assets of light machinery, tools, materials and money, which allowed for quite rapid re-establishment of their businesses, many of which had pre-existing agents or connections outside France. Refugees they may have been, but very few were destitute.

A LUXURIOUS ERA

The two most significant luxury commodities produced in the mid- and late eighteenth century, in terms of immediate export and volume produced, were tapestry and

1	**Paris, c.1700**
1	- Louvre; east wing 1667-70
2	- Saint Roch; begun 1653
3	- Place Louis-le-Grand (Vendôme); begun 1685
4	- Place des Victoires; begun 1685
5	- Hôtel des Invalides; hospital built 1670-77, church built 1679-91
6	- Collège des Quatre Nations; begun 1662
7	- Pont Royal; built 1685-87
8	- Porte St Denis; built 1672
9	- Porte St Martin; built 1674
10	- Porte St Antoine; remodelled c.1670
11	- Porte St Bernard; built 1670
12	- Hôtel de Lauzun; built 1656-57
13	- Grands Boulevards; replace walls of Charles V, begun early 1670s, completed 1705
14	- Salpêtrière; hospital buildings begun 1658
15	- Hôtel de Beauvais; built 1652-55
16	- Gobelins; tapestry factory, reformed as Manufacture Royal 1687
17	- Hôtel de Soubise; built 1705-09
18	- Hôtel de Rohan; built 1705-08
19	- Hôtel Aubert de Fontenay dit Sale; begun 1656
20	- Tuileries Palace; extensions to the north 1659-66
21	- Tuileries Gardens; redesigned 1664 onwards
22	- Val de Grâce; conventual buildings 1655-63, church completed 1669
23	- St Joseph des Carmes; completion of conventual buildings 1674
24	- Church of the Assumption; built 1670-76

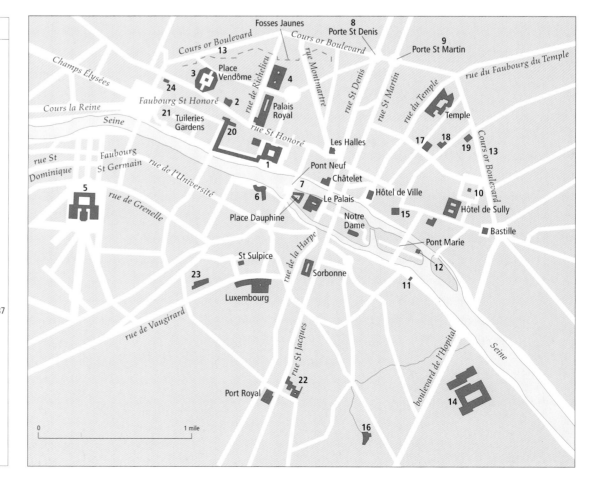

particularly porcelain. The Gobelins workshops produced not only popular pastoral and hunting scenes after drawings by leading painters, but also door curtains and upholstery covers. Ready markets were found in almost all European capitals. In the provinces the most successful porcelain manufacturer was Moustiers, based at Marseille from the 1740s. The most prestigious porcelain producer was, however, Sèvres, founded in 1753 by the Marquis de Marigny to quench the thirst for modish imports. Deep blue was, and is, the trademark colour. Novel combinations drawn from a variety of decorative arts kept their ever-changing wares in demand nationally and internationally. In 1768 the discovery of kaolin at Limoges created ideal conditions for manufacturing hard-paste porcelain.

The newly crowned Louis XVI (r.1774–92) subscribed to a philosophy that saw art as an essential element in man's moral formation.

2 THE ARTISTIC ACADEMIES founded by Louis XIV, especially the French Academy in Rome, continued to be of primary importance for official artistic policy. But after the death of Louis XIV their significance remained only in the spheres of history painting, sculpture and architecture. Their influence waned as a proliferation of new genres and tastes began to flourish amongst major private patrons.

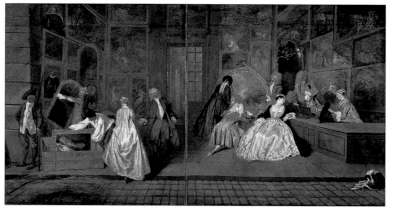

JEAN-ANTOINE WATTEAU, *L'Enseigne de Gersaint*, 1720. Gersaint's little gallery was in an arcade on the Pont Notre-Dame in Paris. Young men and women in their finery loll about, while only one periwigged man and a priest scrutinize a painting. On the left a portrait of Louis XIV is being loaded into a crate, suggesting the passing of an age of glory to one of fashionable slothfulness. Everything is merchandise.

Thus, moral and historical subjects in painting and sculpture mattered most, and Neoclassicism of the school of painters led by Jacques-Louis David was the future.

By the mid-eighteenth century French, the language of diplomacy, was spoken in courts in the Rhineland, Parma and St Petersburg. All over Europe, French art, culture, luxury goods and fashions were emulated. However, the proliferation of the newer order of French art around Europe was destined to be stalled by the revolution of 1789 and the Napoleonic era. The French Academy in Rome, established in 1666, was to play a vital role in the artistic developments of the later eighteenth century and beyond.

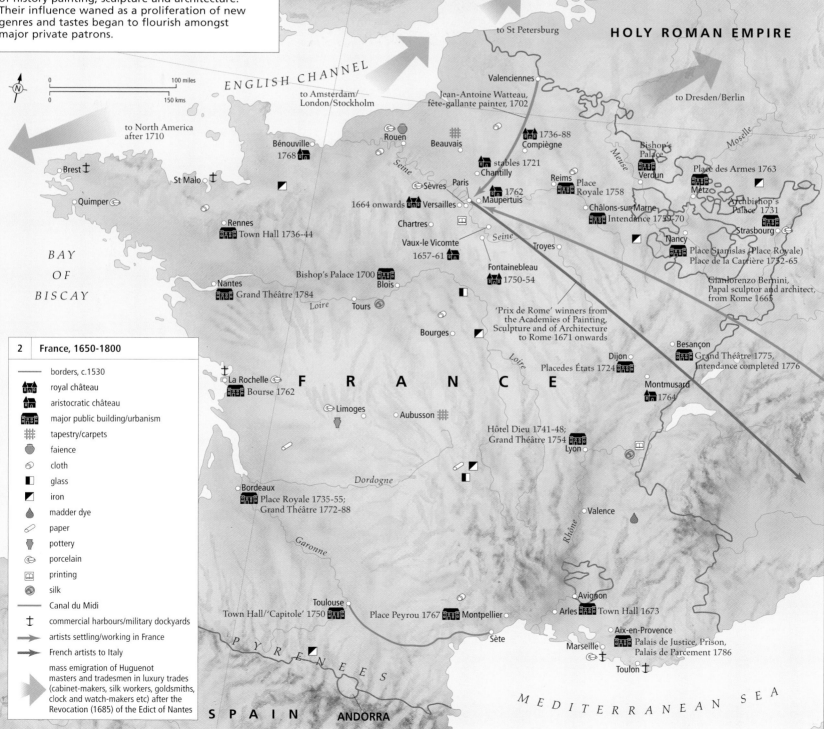

2 France, 1650-1800

- borders, c.1530
- royal château
- aristocratic château
- major public building/urbanism
- tapestry/carpets
- faience
- cloth
- glass
- iron
- madder dye
- paper
- pottery
- porcelain
- printing
- silk
- Canal du Midi
- commercial harbours/military dockyards
- artists settling/working in France
- French artists to Italy
- mass emigration of Huguenot masters and tradesmen in luxury trades (cabinet-makers, silk workers, goldsmiths, clock and watch-makers etc) after the Revocation (1685) of the Edict of Nantes

Map labels:

HOLY ROMAN EMPIRE
to St Petersburg
to Dresden/Berlin
to Amsterdam/London/Stockholm
to North America after 1710
ENGLISH CHANNEL
Jean-Antoine Watteau, fête-gallante painter, 1702
Valenciennes
Brest
St Malo
Quimper
Bénouville 1768
Rouen
Beauvais
Compiègne 1736-88
stables 1721
Chantilly
Reims
Place Royale 1758
Bishop's Palace
Verdun
Place des Armes 1763
Metz
Sèvres
Paris
1762 Maupertuis
Châlons-sur-Marne
Intendance 1759-70
Archbishop's Palace 1731
Strasbourg
1664 onwards Versailles
Chartres
Nancy
Place Stanislas (Place Royale)
Place de la Carrière 1752-65
Rennes
Town Hall 1736-44
Vaux-le Vicomte 1657-61
Troyes
Fontainebleau 1750-54
Gianlorenzo Bernini, Papal sculptor and architect, from Rome 1665
BAY OF BISCAY
Bishop's Palace 1700
Blois
Nantes
Grand Théâtre 1784
Loire
Tours
Bourges
'Prix de Rome' winners from the Academies of Painting, Sculpture and of Architecture to Rome 1671 onwards
Besançon
Grand Théâtre 1775, Intendance completed 1776
Dijon
Placedes États 1724
Montmusard 1764
La Rochelle
Bourse 1762
FRANCE
Limoges
Aubusson
Hôtel Dieu 1741-48; Grand Théâtre 1754
Lyon
Bordeaux
Place Royale 1735-55; Grand Théâtre 1772-88
Dordogne
Valence
Garonne
Rhône
Toulouse
Town Hall/'Capitole' 1750
Place Peyrou 1767
Montpellier
Sète
Avignon
Arles Town Hall 1673
Aix-en-Provence
Palais de Justice, Prison, Palais de Parcement 1786
Marseille
Toulon
PYRENEES
SPAIN
ANDORRA
MEDITERRANEAN SEA
Seine
Meuse
Moselle
0 100 miles
0 150 kms

SPAIN AND PORTUGAL 1500-1800

IN THE MID-FOURTEENTH CENTURY, Portugal had initiated what was to become an ever-expanding European conquest of all the rest of the known world. The initial impetus for the momentous European shift from a Mediterranean to an Atlantic focus was spices, necessary to make palatable the meat-based diets of Europeans before the invention of refrigeration. With land-routes to the Spice Islands blocked by Islam, Portugal went to sea, sailing to India via Africa, in order to secure the coveted goods. With that sea-route co-opted by the Portuguese, Spain instead went west towards India, finding its way blocked by a wholly unknown 'New World', one rich in gold and advanced, pagan civilizations. All this the Spanish appropriated with dazzling alacrity – including, in 1581, the Kingdom of Portugal.

WEALTH ATTRACTS ART

The gold of the Indies paid for an eruption of ecclesiastical monuments and transfiguring artworks throughout Iberia. In Portugal, the 'Manueline' style of architecture was briefly established, a curious blend of flamboyant late Gothic and Hindu sensuality that died out after 1530.

Both as a worldwide empire and the wealthiest European nation, Spain became a magnet for foreign artworks and artists. Initially the stylistic influences were from the Spanish dependency of the Netherlands, providing a pious, late-medieval realism suited to ecclesiastical commissions. In Madrid, the imperial capital since 1561, imperial taste

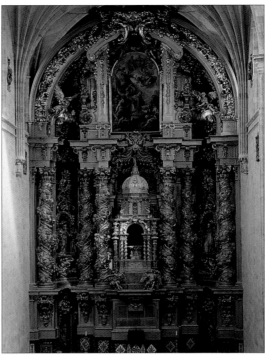

JOSÉ BENITO CHURRIGUERA, 'RETABLO MAYOR' in San Esteban, Salamanca, 1692. Besides providing the English word 'churrigueresque', this altarpiece defines the Baroque look of both Spain and Latin America. This is a gilded, highly elaborate piece of 'micro-architecture' which focuses on the centrally placed 'custodia' containing the eucharistic wafer. Glittering and theatrical, populist and emotion-stirring, structures like this example provided the stylistic model for hundreds of altarpieces in Spanish America.

increasingly focused upon the prestige associated with Italian Renaissance art. The artworks aquired by Habsburg imperial agents today provide the basis for the collection of the Museo del Prado.

HABSBURG INFLUENCE AND PATRONAGE

The classicistic mould was set by Charles V, who ruled from 1519 until 1555. Regarding himself as the personal champion of a Universal Christendom, this monarch was to become the most determined sponsor in Spain of an antiquarian Classical style which he encountered in Italy during his various state visits and triumphal entries. Contemporary Italian classicism represented to Charles V a timely recreation of the content of ancient 'Imperial' Roman art, the concrete expression of absolute temporal power. Pure Classicism, at odds with the traditional medieval expressionism still attached to religious commissions, was to become the preferred iconographic language of the imperial court. This idiom was best expressed in architecture, long since made an ideological vehicle by Spanish rulers. The Palace of Charles V in Granada and the Escorial built outside Madrid by Philip II served these purposes.

Beside importing Italian painters (mostly mediocre) to decorate the Escorial, Philip II also patronized native painters, especially Juan Fernández de Navarrete ('el Mudo', c.1520–1579), for he was most able to work in the manner of his favourite Titian. Since El Greco (Domenikos Theotokopoulos,

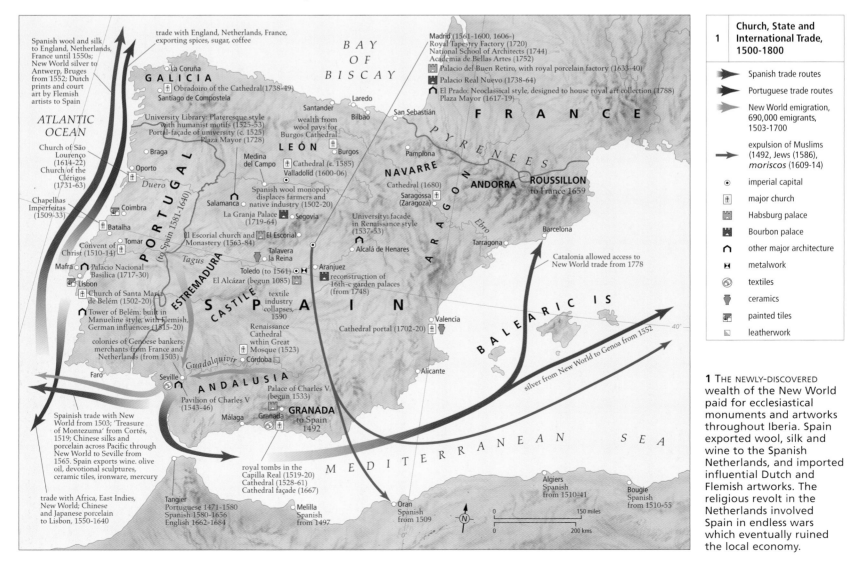

1	Church, State and International Trade, 1500-1800

- Spanish trade routes
- Portuguese trade routes
- New World emigration, 690,000 emigrants, 1503-1700
- expulsion of Muslims (1492, Jews (1586), *moriscos* (1609-14)
- ⊙ imperial capital
- ☩ major church
- 🏰 Habsburg palace
- 🏛 Bourbon palace
- ⌂ other major architecture
- ⋈ metalwork
- ◎ textiles
- ⚱ ceramics
- ▦ painted tiles
- ▱ leatherwork

1 THE NEWLY-DISCOVERED wealth of the New World paid for ecclesiastical monuments and artworks throughout Iberia. Spain exported wool, silk and wine to the Spanish Netherlands, and imported influential Dutch and Flemish artworks. The religious revolt in the Netherlands involved Spain in endless wars which eventually ruined the local economy.

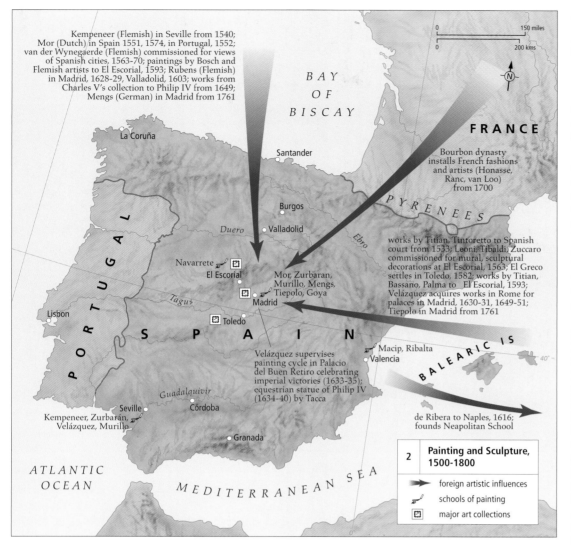

Kempeneer (Flemish) in Seville from 1540;
Mor (Dutch) in Spain 1551, 1574, in Portugal, 1552;
van der Wynegaerde (Flemish) commissioned for views
of Spanish cities, 1563-70; paintings by Bosch and
Flemish artists to El Escorial, 1593; Rubens (Flemish)
in Madrid, 1628-29, Valladolid, 1603; works from
Charles V's collection to Philip IV from 1649;
Mengs (German) in Madrid from 1761

Bourbon dynasty
installs French fashions
and artists (Honasse,
Ranc, van Loo)
from 1700

works by Titian, Tintoretto to Spanish
court from 1533; Leoni, Tibaldi, Zuccaro
commissioned for mural, sculptural
decorations at El Escorial, 1563; El Greco
settles in Toledo, 1582; works by Titian,
Bassano, Palma to El Escorial, 1593;
Velázquez acquires works in Rome for
palaces in Madrid, 1630-31, 1649-51;
Tiepolo in Madrid from 1761

Velázquez supervises
painting cycle in Palacio
del Buen Retiro celebrating
imperial victories (1633-35);
equestrian statue of Philip IV
(1634-40) by Tacca

de Ribera to Naples, 1616;
founds Neapolitan School

2 Painting and Sculpture,
1500-1800

→ foreign artistic influences
↝ schools of painting
▣ major art collections

2 A WORLDWIDE EMPIRE and the wealthiest European nation, Spain became a magnet for foreign artworks and artists. Madrid, the imperial capital since 1561, became the beachhead for the artistic invasion. The initial stylistic influences were Netherlandish, providing a pious, late-medieval realism suited to ecclesiastical commissions. However, imperial taste increasingly focused upon the prestige associated with Italian Renaissance art, expanding the artistic canon to include pagan subjects and idealizing form.

or go underground. An exception was Francisco de Goya y Lucientes (1746–1828), appointed a court artist in 1786, though his most characteristic work only appears in the next century. In the courtly culture created under Bourbon sponsorship the motivating idea was a reform of a perceived 'decadence' suffered under the last Habsburgs. The 'national style', with its traits of austere simplicity and iconic veracity, was often superseded by Rococo complexity and artifice, even frivolity.

The architectural embodiment of the new regal taste is Philip's reformed summer palace, La Granja ('The Grange', 1735–64), seemingly the very antithesis of the Escorial. Even though La Granja nostalgically evokes Versailles, particularly its strict axial alignment between a regal residence and a series of formal gardens, the plan of the palace itself adheres to the traditional layout of Spanish *Alcázares reales* (royal palaces). This comprises a rectangular grid plan with towers at the corners. The gardens include (as at Versailles) a mythological-allegorical sculptural theme, including Psyche, symbol of the soul, and Apollo, a poet-musician embodying the Sun and surrounded by adoring Muses, just as the enlightened patron-king surrounded himself with court artists. The two architects responsible, Felipe Juvarra and Juan Bautista Sachetti, later designed the Palacio Nuevo in Madrid (1738–64), also conforming to the rectangle-with-courtyards scheme. The 'New Palace', as befits a monument set within a capital city, is more conspicuously 'Roman' in style, its regal and theatrical sculptures draw on national history. Its political agenda is demonstrated in the fact that inscriptions appear in Castilian and not in Latin.

1541–1614) was not willing to do so, he was rejected as a court painter. Later Habsburg rulers, especially Philip IV, actively worked to create a native school of artists who would surpass the Italians; these uniquely Spanish luminaries include the likes of Francisco de Zurburán (1598–1664), Jusepe de Ribera (1591–1652), Bartolomé Esteban Murillo (1617–82), and the greatest of them all: Diego Velázquez (1599–1660).

THE BOURBON IMPACT
In 1700 Philip of Anjou was proclaimed King Philip V (reigning to 1746), and the Spanish throne passed from the Habsburgs to the French house of Bourbon. The next year saw the beginning of the War of the Spanish Succession, lasting until 1715, in which Spain lost most of her European possessions, including Gibraltar. Even while the rest of Europe was experiencing an 'Age of Enlightenment', south of the Pyrenees the eighteenth century began as a period of political humiliation, waning military power, and material and intellectual privation. It was also seen as a period of decline in the arts, as many of the familiar attributes of native culture gave way under foreign influences. Palomino made Velázquez, long dead, the hero of his pioneering history of Spanish art. This

was an era of academicism: an Escuela Nacional for architects was founded in 1744 and the Real Academia de Bellas Artes de San Fernando opened in 1752. Artists were strictly controlled: a royal decree prohibited the construction of any public building, the plans of which had not been previously approved by the Academy. The many foreign artists invited to Spain by the Bourbon court – Mengs, Tiepolo, Juvarra, Houasse, Van Loo, Ranc and so on – forced native talent either to conform

PEDRO MACHUCA, GRANADA, PALACE OF CHARLES V,
begun 1533 (unfinished). When the Emperor
visited Granada in 1526, he ordered the Islamic
acropolis of the Alhambra transformed into a
visual symbol of triumphant Universal
Christendom. The result was the most
severely classical structure of the European
Renaissance. The ground-plan is a
purely geometrical abstraction: a circle
inscribed within a square, as in Leonardo's
famous drawing of 'The Vitruvian Man'.

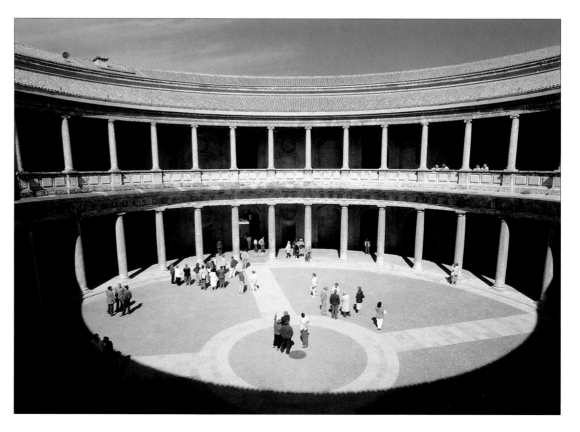

ITALY 1500-1600

THIS WAS A period of great political upheaval in Italy, during which there were extraordinary levels of artistic expenditure. Rulers exploited the culture of antiquity to promote their authority. Classical mythology provided new decorative imagery and new fashions emerged, such as the revival of classical theatre, villas, gardens and art collections.

HIGH RENAISSANCE IN ROME

Early sixteenth-century popes promoted Rome as the capital of a new empire. Inspired by descriptions of the palaces of Roman emperors, Julius II massively enlarged the Vatican: his impressive collection of antique sculpture was reached via a staircase designed by Bramante that incorporated all the Classical orders. His major projects, Michelangelo's Sistine Chapel ceiling, Raphael's Vatican frescoes and Bramante's radical design for rebuilding St Peter's, established the High Renaissance.

His successors continued the pattern of extravagance and the style soon spread throughout Italy. Leo X built the Villa Madama, with its theatre and gardens, and embellished the Sistine Chapel with priceless tapestries, designed by Raphael. Paul III exploited the talents of Michelangelo, commissioning his *Last Judgement*, the decoration of the Sala Regia, the dome of St Peter's and the remodelling of the Capitol. The papal court further embellished the city, building lavish palaces and villas, set in gardens inspired by descriptions in Roman literature, filled with grottoes, fountains and mythological sculptures.

INDEPENDENT VENICE

Venice remained neutral and celebrated her independence in a building boom that radically transformed the city. Abandoning tradition, the Venetian government voted to adopt the language of ancient Rome to remodel the focus of political power, adding a new library, mint and loggetta, all designed by the Roman-trained Sansovino, to the government buildings around St Mark's. Inside the Doge's Palace artists recorded Venetian triumphs and celebrated the doges in votive portraits, many painted by Titian, the official state artist. Mythological themes were exploited to provide allegories to replace the religious imagery that had traditionally promoted state authority. Rich patricians also adopted the new language, advertising their rank in palaces and chapels, and *all'antica* villas designed by Palladio on their mainland estates.

THE ITALIAN COURTS

The rulers of Italy's courts were also conspicuous spenders. New streets and piazzas ornamented with allegorical fountains testified to their authority. They built fortifications to resist modern artillery, and provide protection against Turkish navies. Above all, they built palaces, villas and gardens, expensively decorated with tapestries, paintings and antique sculpture. Alfonso d'Este, Duke of Ferrara, commissioned Titian to paint mythological scenes for his *studiolo*, where he kept his antiques and curios. Federigo

Gonzaga, Duke of Mantua, employed the Roman-trained Giulio Romano as his court artist, commissioning him to build and decorate his palaces, villas and churches. His art collection contained Flemish landscapes as well as over 30 paintings by Titian, including his portrait. Titian's portraits were fashionable among allies of Holy Roman Emperor Charles V: Federigo Gonzaga had himself portrayed with his lapdog, while his brother-in-law, the Duke of Urbino, sent his armour to Venice for Titian to copy.

Italy's nobility expanded as Charles V rewarded his generals with titles and as popes established their families as rulers of their own states. New dynasties, like the Medici and the Farnese, had a particularly pressing need to justify their claims to power. Determined to impose his authority, Duke Cosimo transformed Florence with new palaces and churches. He also converted the old town hall into the ducal palace, commissioning an ancestor cycle which conveniently ignored the Medicis' commercial

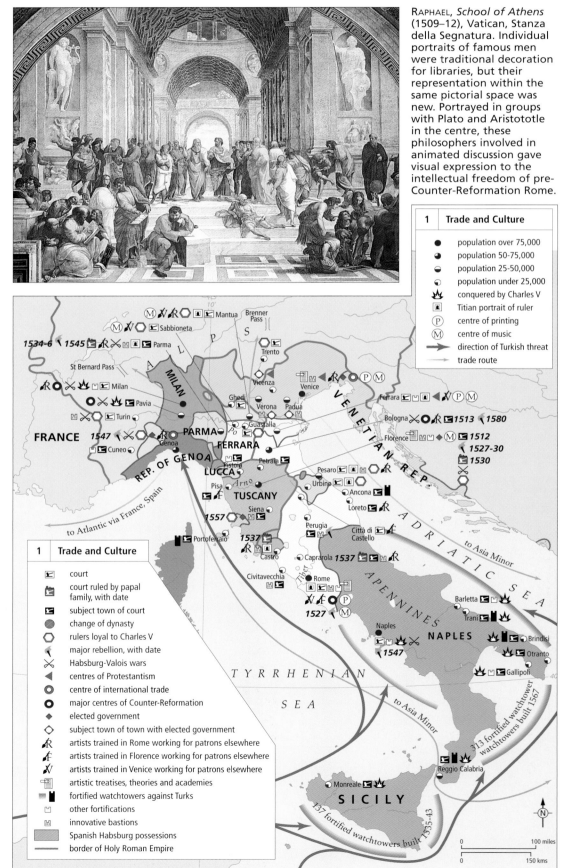

RAPHAEL, *School of Athens* (1509–12), Vatican, Stanza della Segnatura. Individual portraits of famous men were traditional decoration for libraries, but their representation within the same pictorial space was new. Portrayed in groups with Plato and Aristototle in the centre, these philosophers involved in animated discussion gave visual expression to the intellectual freedom of pre-Counter-Reformation Rome.

1	Trade and Culture
●	population over 75,000
◗	population 50-75,000
◔	population 25-50,000
○	population under 25,000
♛	conquered by Charles V
▪	Titian portrait of ruler
Ⓟ	centre of printing
Ⓜ	centre of music
→	direction of Turkish threat
→	trade route

1	Trade and Culture
▣	court
▣	court ruled by papal family, with date
▣	subject town of court
●	change of dynasty
⬡	rulers loyal to Charles V
◄	major rebellion, with date
✕	Habsburg-Valois wars
◄	centres of Protestantism
○	centre of international trade
◉	major centres of Counter-Reformation
◆	elected government
◇	subject town of town with elected government
ℛ	artists trained in Rome working for patrons elsewhere
ℱ	artists trained in Florence working for patrons elsewhere
℣	artists trained in Venice working for patrons elsewhere
▬	artistic treatises, theories and academies
▮	fortified watchtowers against Turks
⌂	other fortifications
▥	innovative bastions
▨	Spanish Habsburg possessions
—	border of Holy Roman Empire

1 THIS WAS A VIOLENT CENTURY. The Habsburg-Valois wars changed the balance of power in Italy: Charles V conquered Milan and Naples, installing imperial governors, and Florence was brutally besieged by his armies before accepting the Medici restoration. Süleyman, the Turkish sultan, seriously threatened Venetian trade.

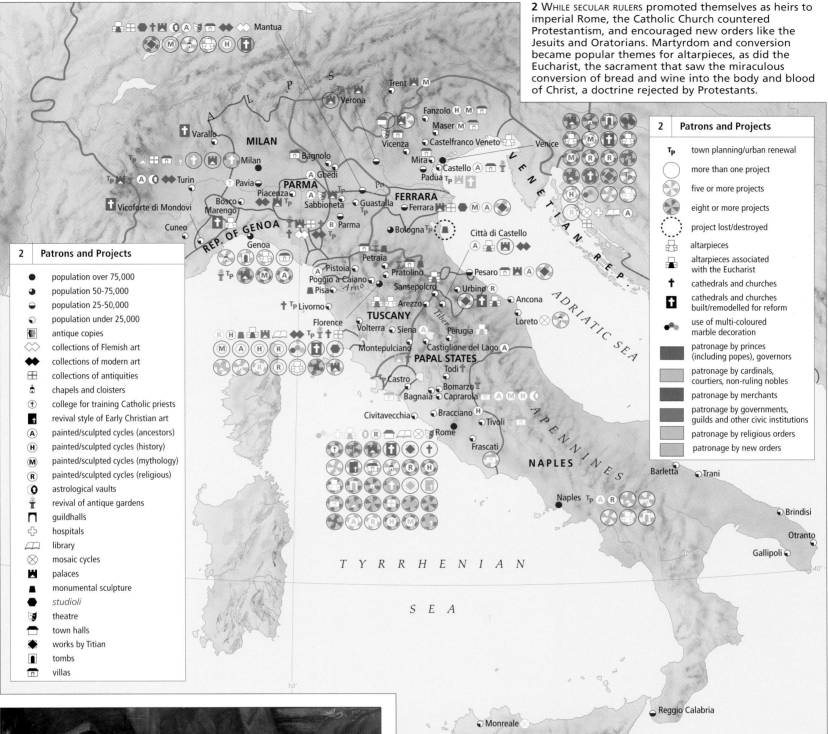

2 WHILE SECULAR RULERS promoted themselves as heirs to imperial Rome, the Catholic Church countered Protestantism, and encouraged new orders like the Jesuits and Oratorians. Martyrdom and conversion became popular themes for altarpieces, as did the Eucharist, the sacrament that saw the miraculous conversion of bread and wine into the body and blood of Christ, a doctrine rejected by Protestants.

2 Patrons and Projects

- T_P town planning/urban renewal
- more than one project
- five or more projects
- eight or more projects
- project lost/destroyed
- altarpieces
- altarpieces associated with the Eucharist
- cathedrals and churches
- cathedrals and churches built/remodelled for reform
- use of multi-coloured marble decoration
- patronage by princes (including popes), governors
- patronage by cardinals, courtiers, non-ruling nobles
- patronage by merchants
- patronage by governments, guilds and other civic institutions
- patronage by religious orders
- patronage by new orders

2 Patrons and Projects

- population over 75,000
- population 50–75,000
- population 25–50,000
- population under 25,000
- antique copies
- collections of Flemish art
- collections of modern art
- collections of antiquities
- chapels and cloisters
- college for training Catholic priests
- revival style of Early Christian art
- (A) painted/sculpted cycles (ancestors)
- (H) painted/sculpted cycles (history)
- (M) painted/sculpted cycles (mythology)
- (R) painted/sculpted cycles (religious)
- astrological vaults
- revival of antique gardens
- guildhalls
- hospitals
- library
- mosaic cycles
- palaces
- monumental sculpture
- *studioli*
- theatre
- town halls
- works by Titian
- tombs
- villas

TITIAN, *Paul III & his Grandsons* (1545), Naples, Museo Capodimonte. The Farnese family rose from minor Roman nobility to become major European rulers in the space of just 50 years, and owed their success largely to the political acumen of Alessandro Farnese, Pope Paul III (1534–49). Titian's skilful portrayal of this wily ruler underlined the Pope's dynastic ambitions for his family by including his grandsons: Alessandro, whom he made a cardinal aged 14, and Ottavio, whom he married to Emperor Charles V's daughter.

origins: Vasari's frescoes praised them as enlightened patrons, a theme he underlined in his famous biographies of artists.

THE COUNTER-REFORMATION

The Protestant Reformation finally forced the Papacy to reform. The Council of Trent (1545–63) set new standards for religious life, art and music. The proliferation of new confraternities encouraged piety. Cardinal Borromeo, working with the Jesuits and other new orders in Milan, promoted Christian renewal in a series of churches, their open naves testifying to his belief that all should see the altar. New churches transformed the city of Rome. Above all, the papacy rejected links with pagan antiquity, reviving the styles of early Christian art to promote Rome as the capital of Christendom.

ITALY 1600-1800

IN THE SEVENTEENTH and eighteenth centuries the Italian peninsula was not yet a unified nation. There were continual changes in its diverse political entities and considerable regional differences to its shared language and culture. Artists and architects continued to develop traditional techniques and to work in traditional materials, some associated with particular regions – fresco painting in central Italy, marble sculpture throughout, with abundant sources in the quarries of Massa and Carrara (from which area came many masons and stonecutters), travertine architecture in Rome, and so on. Painters, sculptors and architects worked in various combinations with different types of artisans and craftsmen, especially as required by projects for the multimedia decorative ensembles characteristic of the period.

THE ACADEMIC SYSTEM
Among the forces unifying artistic practice during this time was the growth and institutionalization of the academic system, founded on the artistic

1 THE SEVENTEENTH CENTURY initiated a period of intensive building and artistic activity throughout Italy, and important collections of ancient and 'modern' art were formed. By the end of the eighteenth century art academies had been established in all the major cities and many smaller ones, museums dotted the peninsula, and archaeological excavations were increasing.

tradition that had emerged in the Renaissance. This was in turn based upon the art of classical antiquity, considered a 'native' tradition in Italy, with attendant political implications. The academic system was disseminated not only through art academies and related writings, but also through artistic practice and production. It did not so much replace traditional workshops as training grounds for artists and architects as function alongside them. Academicism did not promulgate any specific 'style' in the modern sense of the term, and Italian artists and architects worked during the period in an ever-evolving range of modes, now usually classified under the rubric 'Baroque'. In the mid-eighteenth century 'Neoclassicism' was introduced in Rome, less as a break with those modes than as another, not entirely new, alternative.

From its development in sixteenth-century Italy, the academic system had spread all over Europe, and with it the establishment of Italian art as an international standard. Foreign collectors and patrons acquired examples of Italian art, both ancient and 'modern' (Renaissance and later), in the original and in various kinds of reproductions. Italian artists, such as Luca Giordano and Giambattista Tiepolo, worked throughout Europe. The many foreign artists, like Peter Paul Rubens, who came to study and work in Italy influenced Italian art and carried its influence back to their own countries.

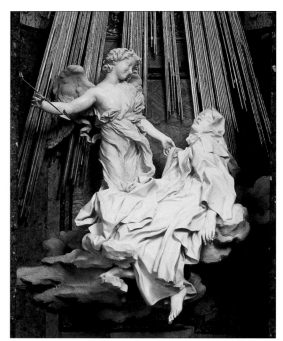

GIANLORENZO BERNINI, *The Ecstasy of S. Teresa*, 1645–52, marble and gilded wood, Rome, S. Maria della Vittoria, Cornaro Chapel. This famous altarpiece is the quintessential example of post-Counter-Reformation art: 'divinely' illuminated by a hidden window, the sensual figures of Teresa and the angel compellingly enact the dramatic visionary experiences of the revered saint.

THE CATHOLIC CHURCH
The presence of the papacy in the peninsula underscored the continuing influence of the ideals of the Counter-Reformation on artistic production, especially in the seventeenth century. Although no particular 'style' was promoted, urban planning, church architecture and decoration, the manufacture of liturgical objects and vestments and the choice of subjects and their treatment in painting and sculpture were all affected. In Piedmont and Lombardy, in the town of Varallo and near that of Varese, the *Sacri Monti* (Sacred Mountains) were built as popular devotional simulacra for those pilgrims to whom the Holy Land was inaccessible. These hillside complexes of chapels and churches, marking the venerated sites of Christ's life and Passion, were ornamented with frescoes and lifesize, unidealized polychromed wood or terracotta figures composing tableaux, such as the scene of the Crucifixion. In Rome, the wealth of the papal court and its associates attracted artists from Italy and abroad seeking patronage, both ecclesiastical and secular. Caravaggio, Gianlorenzo Bernini, Francesco Borromini, Giovanni Battista Piranesi, and Antonio Canova were among those who came from other parts of Italy, while Claude Lorrain and Nicolas Poussin arrived from France.

TRAVEL AND TOURISM
During this period, Italy was a travel destination not only for artists and pilgrims, but also for aristocrats, dilettantes and scholars, who served as well to diffuse the taste for Italian art throughout Europe and the New World. Tourism rose sharply in the eighteenth century and came to be ritualized, in the case of the British, in the itinerary of the Grand Tour. While travellers went to Italy primarily to view its incomparable artworks and monuments, they were also attracted by its natural sights and wonders – such as the volcanic eruptions of Mount Vesuvius, near

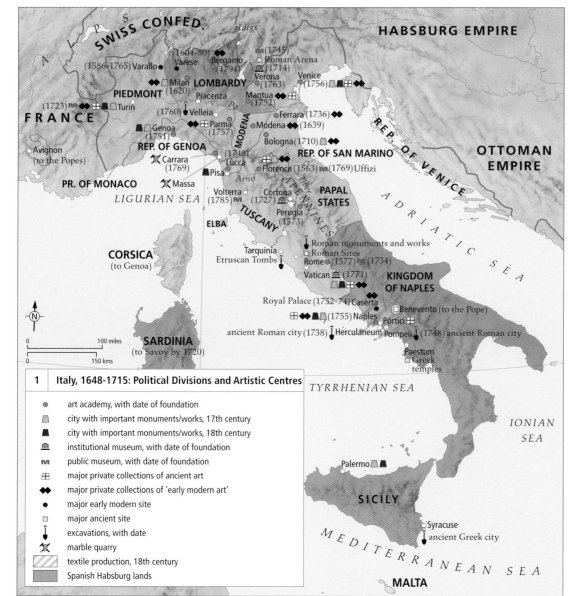

1	Italy, 1648-1715: Political Divisions and Artistic Centres
●	art academy, with date of foundation
⌂	city with important monuments/works, 17th century
▲	city with important monuments/works, 18th century
🏛	institutional museum, with date of foundation
M	public museum, with date of foundation
⊞	major private collections of ancient art
◆◆	major private collections of 'early modern art'
●	major early modern site
□	major ancient site
↓	excavations, with date
⚒	marble quarry
▨	textile production, 18th century
▓	Spanish Habsburg lands

Naples – which in turn made their way into artistic depictions. Italian patrons, for their part, helped to satisfy the interests of tourists by opening their residences on a semi-public basis, so that visitors could view their art collections. In the eighteenth century some of the first public museums in Europe were established on the peninsula.

Rome, the 'Academy of Europe', was the climactic destination of most travellers, mainly for its antiquities, and in the eighteenth century this interest coordinated with a rash of excavations throughout Italy, such as those of the ancient cities of Herculaneum and Pompeii, buried since AD 79 by an eruption of Vesuvius.

Although the majority of art dealers and agents were stationed in Rome, in the eighteenth century the market for souvenirs, both large and small, fostered a veritable Italian industry in restored antiquities and newly made objects and works *all'antica*, as well as painted and engraved views of various monuments and sights by artists such as Canaletto, Francesco Guardi and Giovanni Paolo Panini. By the end of the century this demand gave rise to modes of production geared toward serving a mass market and to the development of new techniques, such as miniature mosaics and tinted prints, and the revival of ancient ones, such as encaustic painting.

CANALETTO (GIOVANNI ANTONIO CANAL), *Piazza S. Marco with the Cathedral*, 1735–40?, oil on canvas. Canaletto's artfully topographical *vedute*, or views, were among Grand Tourists' most coveted souvenirs of Venice. Commissions for the artist's paintings were exclusively arranged, for at least a time, by the British consular representative in Venice, Joseph Smith, a noted businessman, art dealer, collector and patron. At his palace on the Grand Canal, the consul's own collection of Canaletto's paintings offered potential patrons examples of what they could order. Engraved and drawn views were less costly alternatives to painted *vedute*. As appreciation for drawings rose in the eighteenth century, the market expanded, and drawn views were created as independent works of art.

2 IN THE SEVENTEENTH CENTURY Rome had established itself as the artistic capital of Europe, and in the eighteenth century it continued to be the great international training ground for artists and the premier attraction of the Grand Tour. During the later period, the Via del Babuino (26) was occupied by the shops of antiquarians, art dealers and restorers, while artists lived at either end. The central urban fabric of the city, where most of Rome's incomparable treasures of ancient, medieval and 'modern' art and architecture are clustered, was surrounded by the natural beauty of its villa parks and gardens.

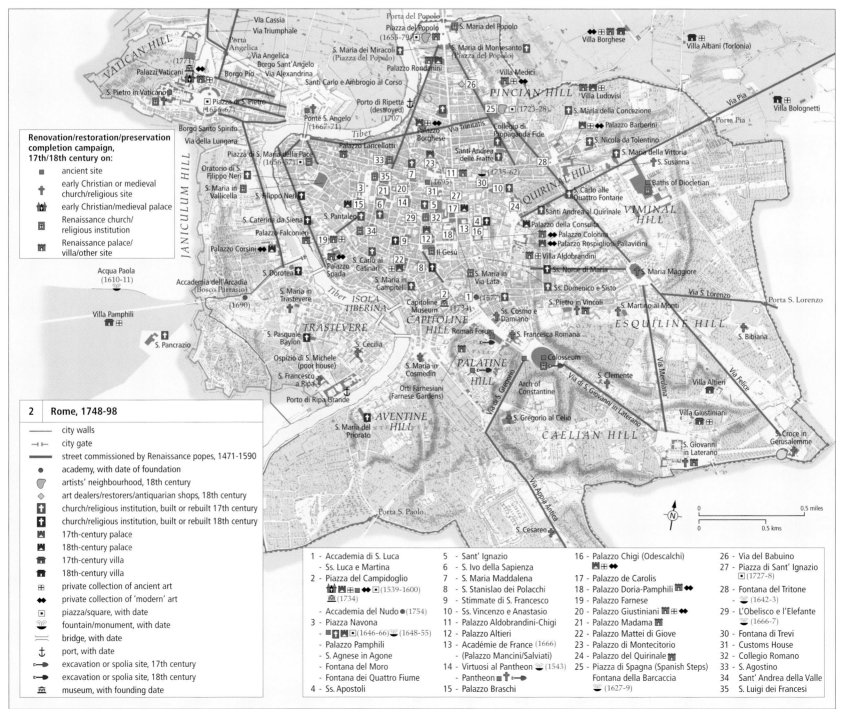

Renovation/restoration/preservation completion campaign, 17th/18th century on:
- ▪ ancient site
- ✝ early Christian or medieval church/religious site
- ⛪ early Christian/medieval palace
- ⊞ Renaissance church/religious institution
- 🏛 Renaissance palace/villa/other site

2 Rome, 1748–98

- ── city walls
- ⊣⊢ city gate
- ── street commissioned by Renaissance popes, 1471–1590
- ● academy, with date of foundation
- ◗ artists' neighbourhood, 18th century
- ◇ art dealers/restorers/antiquarian shops, 18th century
- ✝ church/religious institution, built or rebuilt 17th century
- ✝ church/religious institution, built or rebuilt 18th century
- 🏰 17th-century palace
- 🏰 18th-century palace
- 🏠 17th-century villa
- 🏠 18th-century villa
- ⊞ private collection of ancient art
- ◆◆ private collection of 'modern' art
- ▣ piazza/square, with date
- ⛲ fountain/monument, with date
- ═ bridge, with date
- ⚓ port, with date
- ⤚ excavation or spolia site, 17th century
- ⤚ excavation or spolia site, 18th century
- 🏛 museum, with founding date

1 - Accademia di S. Luca
 - Ss. Luca e Martina
2 - Piazza del Campidoglio (1539–1600)
 - Accademia del Nudo ● (1754)
3 - Piazza Navona (1646–66) (1648–55)
 - Palazzo Pamphili
 - S. Agnese in Agone
 - Fontana del Moro
 - Fontana dei Quattro Fiume
4 - Ss. Apostoli
5 - Sant' Ignazio
6 - S. Ivo della Sapienza
7 - S. Maria Maddalena
8 - S. Stanislao dei Polacchi
9 - Stimmate di S. Francesco
10 - Ss. Vincenzo e Anastasio
11 - Palazzo Aldobrandini-Chigi
12 - Palazzo Altieri
13 - Académie de France (1666) (Palazzo Mancini/Salviati)
14 - Virtuosi al Pantheon (1543)
 - Pantheon
15 - Palazzo Braschi
16 - Palazzo Chigi (Odescalchi) (1727–8)
17 - Palazzo de Carolis
18 - Palazzo Doria-Pamphili
19 - Palazzo Farnese
20 - Palazzo Giustiniani
21 - Palazzo Madama
22 - Palazzo Mattei di Giove
23 - Palazzo di Montecitorio
24 - Palazzo del Quirinale
25 - Piazza di Spagna (Spanish Steps) Fontana della Barcaccia (1627–9)
26 - Via del Babuino
27 - Piazza di Sant' Ignazio (1727–8)
28 - Fontana del Tritone (1642–3)
29 - L'Obelisco e l'Elefante (1666–7)
30 - Fontana di Trevi
31 - Customs House
32 - Collegio Romano
33 - S. Agostino
34 - Sant' Andrea della Valle
35 - S. Luigi dei Francesi

SOUTHEAST EUROPE 1500-1800

THE POLITICAL BORDERS of the Balkans have undergone constant and dramatic changes. Dominated by Turkey between 1453 and 1683, the full pattern of national states in the region was not established until 1912–13, when Turkey's presence in Europe was all but eliminated. At this point, the Balkans lacked the consolidated, independent states of northern and western Europe. Statehood in almost all areas changed at least once, in some areas many times. Many towns bear three or even more names. Large parts of the region lacked a system of territorial units altogether; to some extent this was also due to low population density and a lack of towns.

Culturally, there are vast discrepancies in the region. Bulgaria may be said to have changed little from the ninth to the nineteenth centuries and Mount Athos in Greece has remained unchanged until the present day. Hungary, on the other hand, was intensely receptive to trends from outside. There was an immense contrast between areas into which strangers never strayed and those where a multitude of peoples lived (and still live) side by side, such as Transylvania. In general, the patronage of art was haphazard. The most stable institutions were probably the politically relatively independent monasteries.

RELIGIOUS COHESION
The southern and eastern parts of the region belong to the Orthodox Church, the northern and Western parts to the Roman Catholic Church, one of the oldest dividing lines in Europe. It was, ironically, perpetuated by the fact that the Orthodox areas remained much longer under Turkish rule, which allowed some freedom for the church. In these areas monasteries, usually in very remote locations, served as a refuge from foreign domination. The areas of the Roman Catholic Church, on the other hand, were always open to the West,

whether it was the Italian (Venetian) domination of Dalmatia, or the more generalized German-Austrian/southern and western European influence in Hungary and Croatia. A third, major religion, dispersed all over the region, was Judaism, but it was deprived of the possibility of architectural expression.

RELIGIOUS ARCHITECTURE
The most stable urban features of the region, reflecting the extent of Turkish occupation, are the mosques, which can even be found in western Hungary. But the Byzantine architectural style was also strikingly persistent. The churches of Bulgaria and Macedonia, in particular, and especially their painted decorations and icons, had hardly changed when they reached their last major florescence in the monastery of Rila in the nineteenth century. In Moldavia and Wallachia Byzantine models continued into the eighteenth century, although these principalities developed a special style in the sixteenth and seventeenth centuries that corresponded with their degree of political independence. All churches, even cathedrals, were small. A nave with a major apse and two side apses sufficed in Moldovia and it was high and narrow, crowned by one or two cupolas carried up in a complex system of vaulting. Wallachian churches adhered more to the multi-domed Byzantine models. In the sixteenth century many exteriors of the Moldavian churches were covered with frescoes. Occasionally Western imports, such as Gothic windows and Western-type buttresses, are found on the exterior of Moldavian churches.

1 THE BALKAN region was flanked by two great powers, the Ottoman empire, and the Holy Roman Empire, ruled by the Habsburg family from their seat in Vienna. Despite the fluid nature of states and borders within the region and the multitude of different ethnic groups there is one stable border that crosses the whole area, that of religion.

SUCEVITA MONASTERY CHURCH, Moldavia (Romania) 1582–1606, one of a group of monuments that highlights both the continuation and the modification of the Byzantine tradition.

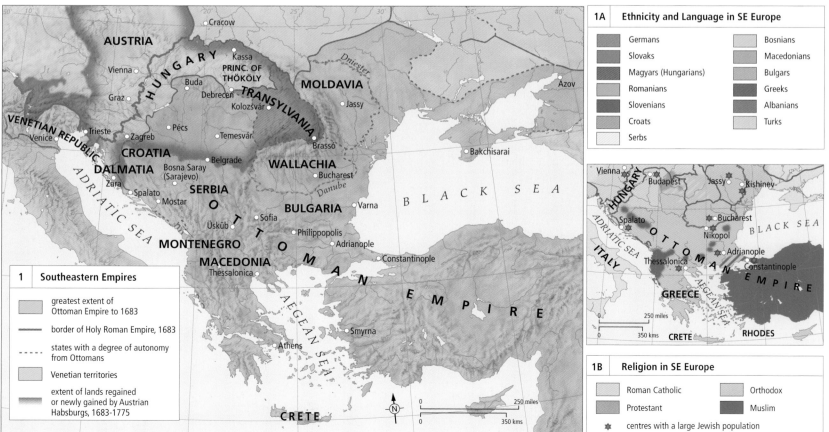

1A	Ethnicity and Language in SE Europe
Germans	Bosnians
Slovaks	Macedonians
Magyars (Hungarians)	Bulgars
Romanians	Greeks
Slovenians	Albanians
Croats	Turks
Serbs	

1	Southeastern Empires
	greatest extent of Ottoman Empire to 1683
	border of Holy Roman Empire, 1683
	states with a degree of autonomy from Ottomans
	Venetian territories
	extent of lands regained or newly gained by Austrian Habsburgs, 1683-1775

1B	Religion in SE Europe
Roman Catholic	Orthodox
Protestant	Muslim
✡ centres with a large Jewish population	

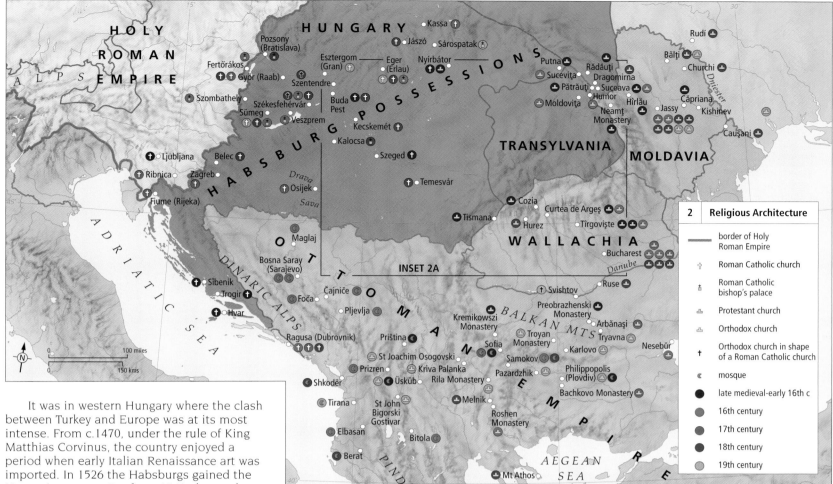

Religious Architecture

2	**Religious Architecture**
———	border of Holy Roman Empire
✝	Roman Catholic church
🏛	Roman Catholic bishop's palace
⛪	Protestant church
⛪	Orthodox church
†	Orthodox church in shape of a Roman Catholic church
☪	mosque
●	late medieval-early 16th c
●	16th century
●	17th century
●	18th century
●	19th century

It was in western Hungary where the clash between Turkey and Europe was at its most intense. From c.1470, under the rule of King Matthias Corvinus, the country enjoyed a period when early Italian Renaissance art was imported. In 1526 the Habsburgs gained the Hungarian crown. But from 1541 almost the whole country was occupied by Ottoman Turkey, and many of its monuments were destroyed. The occupation lasted until the late seventeenth century when German-Austrian power drove the Turks back. Artists from Vienna and the German lands, working under the banner of the Counter-Reformation movement, designed Hungarian urban churches, country houses, and, later on, bishops' palaces. The Hungarian artistic landscape is strongly divided into the dense western and northern parts (some of which now belong to Slovakia) and the poor south and east, with a third area, staunchly sober and Calvinist, in the northeast.

A CULTURAL CROSSROADS

The central region of Transylvania (Erdely/Siebenburgen) experienced extreme population diversity, but avoided antagonisms; Greater Hungary was the chief power for most of the time. Incorporating Roman remains, the Late Romanesque-Early Gothic Cathedral of Alba Iulia mixes forms from many western European countries, as do the late Gothic parish churches, built mainly by German settlers. These are fitted out with German-style altarpieces, which, in turn, existed side by side with monuments in the style of the Early Italian Renaissance, mediated by Hungarian cultural influences. Two-thirds of the population was Orthodox, and the Romanians built churches in the Wallachian style, though from the later eighteenth century urban Orthodox churches adopted Western Classical styles, too. By then, a certain standardization, often dubbed 'European', had set in.

THE MONASTERY of the Premostratensians (1745–65) at Jászó (Jasov, formerly in Hungary, now in Slovakia), by the Viennese architect Franz Anton Pilgram, shows what is probably the most accomplished of Hungary's eighteenth-century church complexes, contrasting strongly with the Byzantine continuity of Sucevița.

2 UNTIL WELL INTO the nineteenth century the significant works of architecture and decoration in the Balkans are religious, and it is the diverse denominations that account for the strong differences between them. In Transylvania, Roman Catholics, Germans Lutherans, Hungarian Calvinists, and Orthodox Romanians co-existed, creating a unique multi-cultural landscape.

EUROPE 1600-1800

ARTISTS AND ARCHITECTS, as well as works of art, moved around Europe to an unprecedented degree during the seventeenth and eighteenth centuries. While earlier individual Italian artists had worked abroad, now whole teams of painters, masons, sculptors and stuccoers, often from the Lombard lakes, travelled north to build or decorate churches, convents and palaces. From Luca Giordano and Tiepolo in Spain, to Rastrelli in Russia, Italian artists worked from one end of the Continent to the other. An entire chapel was shipped from Rome to Lisbon, and groups of paintings were also transported from Italy to Mafra, in Portugal.

AN ARTISTIC CROSSROADS
Italians were not unique. In the early seventeenth-century Netherlandish painters, sculptors and architects also worked

IN THE EARLY EIGHTEENTH century the Dresden *Kunstkammer* was broken up into its constituent elements. The collection of *objets d'art* and precious jewels was placed in a suite of rooms decorated with mirrors and woodwork known as the *Grünes Gewölbe*, on the ground floor of the Schloss. Opened to a larger public, the establishment of this collection marks one of the beginnings of the move towards modern public museums. The present *Kunstkammer* is a reconstruction made necessary by bombing of Dresden in World War II.

1 DURING THE SEVENTEENTH AND EIGHTEENTH centuries courts throughout Europe formed art collections, and an art market developed to serve royal, aristocratic and eventually bourgeois clients. Instruction in the arts was provided by academies, which, starting in *cinquecento* Florence, were also established throughout Europe. In the eighteenth century the foundation of public museums and the institution of public art displays in salons fostered increased familiarity with the arts.

1	Centres, Collections and Academies, 1600-1800
——	border of Holy Roman Empire, c.1700
●	major urban development project
⌂	major palace complex
▣	major art collection (with date of foundation)
▲	art academy (with date of foundation)
◇	major art centre

throughout the Continent. In the Baltic region they came to play an increasingly dominant role during the seventeenth century. Conversely, German artists and architects worked in the Netherlands and in Scandinavia.

As French taste came to replace Italian during the reign of Louis XIV, French artists

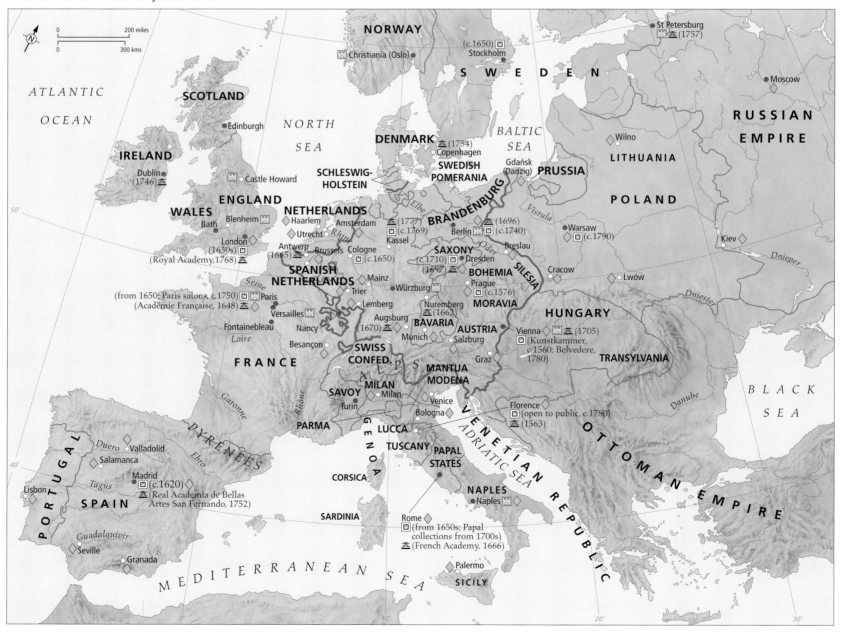

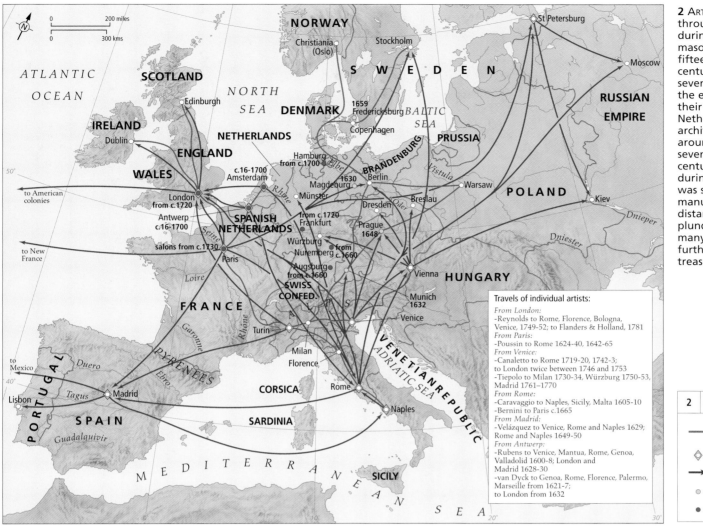

2 ART AND ARTISTS circulated throughout the continent during this period. Italian masons and stuccoists in the fifteenth and sixteenth centuries, sculptors in the seventeenth, and painters in the eighteenth century plied their trades abroad. Netherlandish sculptors and architects also travelled around Europe in the seventeenth and eighteenth century, as did French artists during the entire period. Art was shipped from manufacturers to clients in distant countries. The plunder of art in Europe's many conflicts also led to a further distribution of treasures across Europe.

Travels of individual artists:
From London:
-Reynolds to Rome, Florence, Bologna, Venice, 1749-52; to Flanders & Holland, 1781
From Paris:
-Poussin to Rome 1624-40, 1642-65
From Venice:
-Canaletto to Rome 1719-20, 1742-3; to London twice between 1746 and 1753
-Tiepolo to Milan 1730-34, Würzburg 1750-53, Madrid 1761–1770
From Rome:
-Caravaggio to Naples, Sicily, Malta 1605-10
-Bernini to Paris c.1665
From Madrid:
-Velázquez to Venice, Rome and Naples 1629; Rome and Naples 1649-50
From Antwerp:
-Rubens to Venice, Mantua, Rome, Genoa, Valladolid 1600-8; London and Madrid 1628-30
-van Dyck to Genoa, Rome, Florence, Palermo, Marseille from 1621-7; to London from 1632

2	**Cultural Contacts**
——	general routes of the 'Grand Tour'
◇	major art centre
→	travels of artists abroad
○	sacks of art
●	sales of art

THE INSTITUTION OF THE SALON in eighteenth-century Paris created a new public site for art. Paintings were placed on display in exhibitions accessible to a larger public. Salon exhibitions provided the impetus for a new form of often hotly contested discussion in which writers who were neither artists nor art theorists participated. The most famous eighteenth-century criticism of the Paris salons is that of the *philosophe* Denis Diderot.

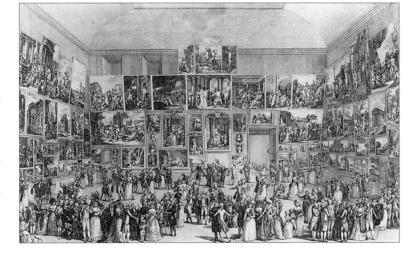

had a painting collection assembled for him (now in Dulwich College, England).

THE DISSEMINATION OF ART
Political rivalries resulted in frequent warfare, and art was plundered. Sometimes art vandalism was organized, for example the plunder of the German monasteries and the pillaging of the treasures of Prague and Frederiksborg in Denmark by Swedish troops. Plunder became an important means by which works of art moved around the continent.

Important sales of art collections – for example, that of the Gonzagas, which went in large measure to England – were another means by which art was dispersed. Private collectors, such as Eberhard Jabach in Cologne, also sold their collections to the French crown.

A burgeoning market provided the larger context for commerce in art. In the seventeenth century agents and auctions were centred in Antwerp and Amsterdam, with other locales in Nuremberg and Augsburg. In the eighteenth century auction houses were established in London and Hamburg.

Although Italian art academies, both state (in Florence) and private (in Rome) had been established already in the sixteenth century, many similar institutions were founded throughout Europe, beginning with the French Academy in 1648. These institutions involved primarily instruction in the rudiments of art, but also theoretical discussion and debate, and display, in the form of public salons. Other forms of public attention were encouraged by the development of aesthetics, independent criticism and art history, and the first public museums. Thus the eighteenth century provided both sources and sites for the origins of the modern reception of art.

also worked throughout the continent. In Spain the French Bourbon dynasty assumed the throne in the early eighteenth century, and French painters followed them. In the eighteenth century French architects and decorators were also active in many places in Germany, in Bohemia, and in Austria, after the court changed its previous orientation from Italy to France.

ART COLLECTIONS AND DISPLAY
In large measure the rise of princely courts stimulated the circulation of artists and art. Eager for prestige, many rulers made their residences into centres of patronage and collecting. The example set by Rudolf II's Prague (c.1600), which was singled out by the artist and art historian/biographer Karel van Mander as the best place to go and see art, provided a model, especially for German courts. In mid-seventeenth century Brussels and Vienna Archduke Leopold Wilhelm

assembled a major collection of paintings, to which eighteenth-century Habsburgs added and reorganized. In Spain, another dominion ruled by the Habsburgs through the seventeenth century, Philip IV became one of the first European mega-collectors.

In part because of rivalry, but also because of genuine interest, rulers in other lands followed, imitated or independently amassed their own collections. Notable examples include the English royal collections under Charles I, and the French royal collections of Louis XIV. In the mid-seventeenth century Queen Christina of Sweden also established an important collection of many kinds of works of art, taking much of it with her to the Continent, ultimately to Rome, when she converted to Catholicism and abdicated. The Papal and Neapolitan collections, especially of antiquities unearthed in ongoing excavations, were also significant. In the eighteenth century the last king of Poland, Stanisaw Poniatowski

NORTH AFRICA 1500-1800

ISLAMIC ORTHODOXY in North Africa supported the production of manuscripts, especially the Koran and other religious texts, sometimes illuminated and with fine bindings. The annual pilgrimage to Mecca encouraged the movement of artistic ideas. Cultural life was also characterized by networks of Sufi orders, and by religious fraternities organized around *zawiyas* (schools). During this period, *marabouts* (religious hermits) became a marked feature of North African life. Saints' tombs, often modest domed buildings, were constructed throughout the region.

Jewish minorities lived throughout North Africa. Christians in Egypt and Ethiopia gave architecture and art Christian purposes, producing items for church ritual, figural paintings, manuscripts and other artefacts.

The main centres for textiles, metalwork, pottery and other crafts were the larger urban communities. In Cairo each year the covering (*kiswa*) for the Ka'bah in Mecca was made from black silk brocade lined with cotton, with a band of Koranic inscriptions embroidered in silver-gilt and silver thread. The arts of urban centres were considered more refined than the rural ones, which served local needs.

FOREIGN INFLUENCES

The Christian conquest of Spain, completed in 1492, brought Muslim and Jewish refugees. They made important contributions in Morocco, Algeria and Tunisia. In Tunis, for example, the *zawiya* of the Andalusian refugee Sidi Qasim al-Jalizi was built in the Hispano-Moresque tradition, decorated with small glazed tiles of Andalusian type, which began to be manufactured in Tunis. When the Moroccan sultan Ahmad al-Mansur (r.1578–1603) built the Badi Palace (1578–93) in Marrakesh, its plan was based on that of the Court of the Lions in the Alhambra at Granada, though much larger in scale. This influence was also felt in the addition of pavilions at either end of the courtyard of the Qarawiyyin mosque in Fez.

COLOURED GLAZED TILES in the Qaramanli mosque in Tripoli, Libya (built 1711–44), probably from Tunis, then the major centre in the region for their manufacture. The floral designs are arranged in a geometric grid with pronounced borders.

1 EAST–WEST TRADE ROUTES linked the major cities of North Africa, and trade extended southwards across the Sahara. The arts were influenced by refugees from Muslim Spain, and by the artistic practices of the Ottomans, especially in the urban centres. Berber artistic traditions continued especially in the Rif and Atlas mountains of Morocco and the Kabylia and Aurès regions of Algeria.

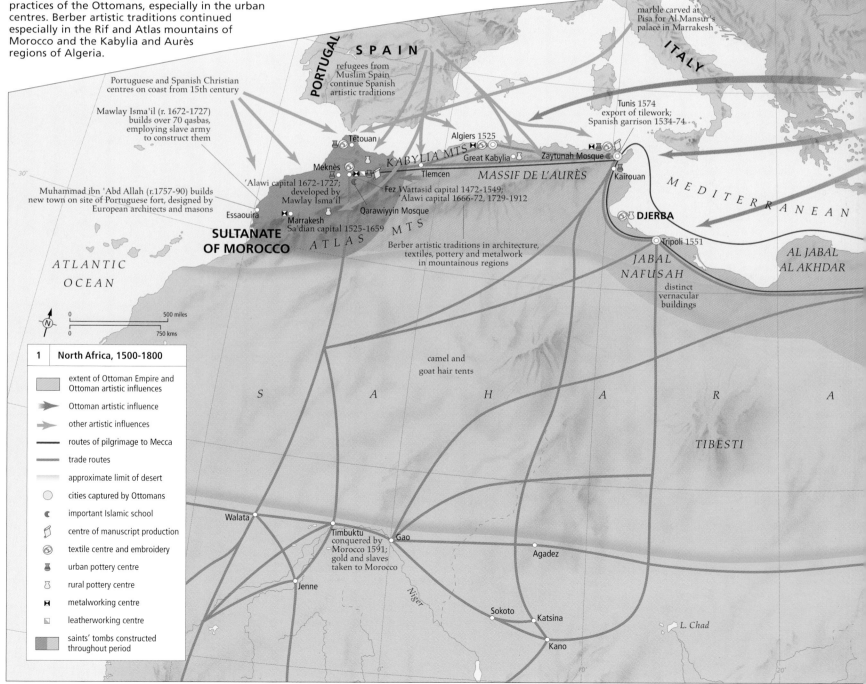

Portuguese and Spanish Christian centres on coast from 15th century

Mawlay Isma'il (r. 1672-1727) builds over 70 qasbas, employing slave army to construct them

Muhammad ibn 'Abd Allah (r.1757-90) builds new town on site of Portuguese fort, designed by European architects and masons

marble carved at Pisa for Al-Mansur's palace in Marrakesh

refugees from Muslim Spain continue Spanish artistic traditions

Tunis 1574 export of tilework; Spanish garrison 1534-74

PORTUGAL SPAIN ITALY

Tétouan

Algiers 1525

KABYLIA MTS Great Kabylia Zaytunah Mosque

Meknès

MASSIF DE L'AURÈS Kairouan

'Alawi capital 1672-1727; developed by Mawlay Isma'il

Tlemcen

Fez Wattasid capital 1472-1549; 'Alawi capital 1666-72, 1729-1912

MEDITERRANEAN

Essaouira

Qarawiyyin Mosque

DJERBA

Marrakesh Sa'dian capital 1525-1659

SULTANATE OF MOROCCO

ATLAS MTS

Berber artistic traditions in architecture, textiles, pottery and metalwork in mountainous regions

Tripoli 1551

JABAL NAFUSAH

AL JABAL AL AKHDAR

ATLANTIC OCEAN

distinct vernacular buildings

30°

camel and goat hair tents

S A H A R A

TIBESTI

1	North Africa, 1500-1800

- ▬ extent of Ottoman Empire and Ottoman artistic influences
- ➤ Ottoman artistic influence
- ➤ other artistic influences
- ▬ routes of pilgrimage to Mecca
- ▬ trade routes
- ▬ approximate limit of desert
- ○ cities captured by Ottomans
- ☾ important Islamic school
- ▱ centre of manuscript production
- ◉ textile centre and embroidery
- ♨ urban pottery centre
- ⚱ rural pottery centre
- ⋈ metalworking centre
- ▱ leatherworking centre
- ▬ saints' tombs constructed throughout period

Walata

Timbuktu conquered by Morocco 1591; gold and slaves taken to Morocco

Gao

Agadez

Jenne

Niger

Sokoto

Katsina

L. Chad

Kano

2 A VAST ROYAL COMPLEX was added to the Moroccan city of Meknès when sultan Mawlay Isma'il (r.1672–1727) moved his capital there. Materials came from the Roman remains of Volubilis, the Marinid necropolis at Chella and the Sa'dian Badi' Palace in Marrakesh. Marble also came from Pisa in Italy. The labour was provided by Christian renegades and slaves. Much of Mawlay Isma'il's city is now in ruins.

In the sixteenth century, the Ottoman Turks subdued all of North Africa with the exception of Morocco. New mosques, palaces and other buildings had Ottoman features, especially in Cairo, but also in the other capitals – for example, the mosque of Sidi Mahriz (built 1675–92) in Tunis. Turkish styles of dress were adopted among the urban elite. In Morocco, however, artistic patronage lay largely in the hands of the sultans of the Sa'dian (1511–1631) and 'Alawi (1631–present) dynasties. Marrakesh, Meknès and Fez maintained a distinct style of architectural decoration using tile mosaics (zillij), carved stucco and wood, though its quality declined from the seventeenth century.

European influence was evident in coastal enclaves eventually created by the Portuguese and Spanish. From 1765 the Moroccan coastal town of Essaouira, previously a Portuguese fort, was constructed following designs provided by European architects and masons. Some European influences, including Renaissance

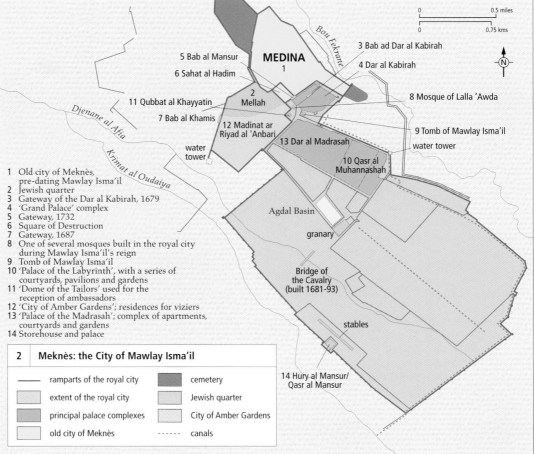

1 Old city of Meknès, pre-dating Mawlay Isma'il
2 Jewish quarter
3 Gateway of the Dar al Kabirah, 1679
4 'Grand Palace' complex
5 Gateway, 1732
6 Square of Destruction
7 Gateway, 1687
8 One of several mosques built in the royal city during Mawlay Isma'il's reign
9 Tomb of Mawlay Isma'il
10 'Palace of the Labyrinth', with a series of courtyards, pavilions and gardens
11 'Dome of the Tailors' used for the reception of ambassadors
12 'City of Amber Gardens'; residences for viziers
13 'Palace of the Madrasah'; complex of apartments, courtyards and gardens
14 Storehouse and palace

2	Meknès: the City of Mawlay Isma'il

— ramparts of the royal city
▭ extent of the royal city
▭ principal palace complexes
▭ old city of Meknès
▭ cemetery
▭ Jewish quarter
▭ City of Amber Gardens
⋯⋯ canals

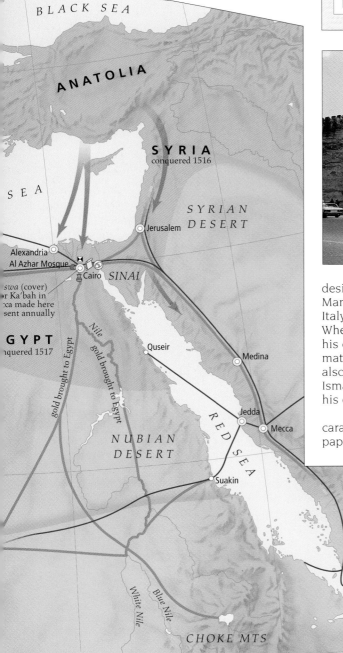

THE BAB AL MANSUR AL-'ILJ at Meknès in Morocco. It was the principal ceremonial gateway in the city, connecting the Medina and the Hadim Square with the Dar al Kabirah, the palace complex that was built by Mawlay Isma'il in 1679. The gateway was named after the government minister Mansur al-'Ilj, who was a Christian renegade. It was begun during the reign of Mawlay Isma'il and was completed in 1732, five years after his death, by his son Mawlay 'Abdallah.

designs, penetrated the interior. Ahmad al-Mansur procured carved marble from Pisa in Italy for the construction of his Badi' Palace. When Mawlay Isma'il (r.1672–1727) created his capital at Meknès, he plundered building materials from older sites in Morocco but also ordered marble from Italy. Mawlay Isma'il admired and perhaps tried to emulate his contemporary, Louis XIV of France.

Along trade routes across the Sahara, caravans from the north carried textiles, paper, swords and other merchandise, while

from the sub-Saharan regions came gold, slaves, ivory, ostrich feathers and hides. In the east an important corridor for trade was the Nile, along which gold was brought to Egypt.

INDIGENOUS RURAL TRADITIONS
Local traditions in architecture, textiles, metalwork, pottery and other crafts flourished especially in remote areas, with many regional variations. The sedentary Arabic-speaking Jbala tribes in northern Morocco lived in single-room thatched huts. The sedentary Berber-speaking Rif tribes built two-storey wooden houses. On the coastal plains, semi-nomadic Arabic-speaking tribes lived in tents and conical huts made of reeds, cane and thatch. The traditions of the High Atlas and Anti Atlas included qasbas (individual houses, communal fortified granaries or whole towns made of mud-brick and pisé). In the Berber-speaking Kabylia and Aurès regions of Algeria, dwellings of stone and brick were made with tile roofs.

The Mzab oases of the Sahara had adobe tapering horned minarets and domes. Tunisia had the domed houses and mosques of Djerba Island, the barrel-vaulted granaries of Matmata and cave dwellings in the south. Libya had the distinct buildings of the Jabal Nafusah.

SUB-SAHARAN AFRICA 1500-1800

THIS IS THE FIRST PERIOD for which firm documentation survives for what Westerners term works of African art, and indeed often the works themselves are extant. Most art was made by, and for, local peoples using local materials, according to inherited styles and purposes. Yet this is also a period when Islamic culture was continuing to penetrate the east coast and interior. At the same time, there was increasing coastal contact and trade with Europe and the Americas, including the slave trade. Around 1500 the first 'tourist' arts were produced: the famed Afro-Portuguese ivories. European colonization of southern Africa began in 1652. Christianity, long established in Ethiopia, persisted there, and was also introduced into the interior Kongo kingdom early in this period.

MATERIALS AND TECHNIQUES
Most art forms and material culture collected in the nineteenth and twentieth centuries had antecedents in this period. Art was used in daily life, in spiritual and political rituals and for rites of passage. Figural sculptures and masks were broadly distributed. Iron-smithing and copper alloy casting were widespread, whereas silver, gold and stone sculptures were rare. Arab-influenced chip-carved architectural elements were made in east coast Swahili towns, and distinctive architectural forms prevailed in countless areas. Bead-making and varied forms of personal decoration, such as scarification, hairstyling and body painting, were important. Probably festivals and other performances were the artforms that were most highly valued by local African peoples during this era.

THE ARTISTIC CONSEQUENCES OF SLAVERY
Slavery and related trading had widespread effects in Africa. European ships became royal emblems in the arts of Dahomey in the eighteenth century, after Dahomean troops gained access to coastal slaving and other trading ships and their luxury material goods. Bound captives (some doubtless slaves) appear in the Ife sculptures of the twelfth to thirteenth centuries, and the Inland Niger Delta sculpture of the fourteenth to fifteenth centuries, as well as in eighteenth-century Asante goldweights, as do slave manacles. Many other European artefacts

IVORY SAPI-PORTUGUESE SALT CELLAR, c.1490–1530, Berlin, Museum für Volkerkunde. Originally carved by an African for Europeans, probably for the curiosity cabinets of the wealthy or nobility. The snakes and humans are African in style and type, whereas the covered sphere-on-pedestal derives from European chalices.

and motifs entered Africa partly as a result of slave trading. Locks, keys and bells, for example, occur in brass goldweights and gold beads; such motifs can be considered at least a metaphor for the control African leaders and Europeans had over coastal slave trade.

In the seventeenth century European chairs were adapted by many African peoples, serving as high-status symbols. Their direct relationship to slavery – like aspects of European dress adopted by coastal traders – remains to be established. However, there can be little doubt that chairs, dress items and other imports were among the treasured goods that were exchanged for slaves from the sixteenth to the nineteeth centuries.

FOUR ARTISTIC COMPLEXES
Four complexes of artistic ideas, objects and styles characterize this period: indigenous, Muslim, Christian and European secular. Most artefacts, made for domestic, ritual and political use by hundreds of peoples, were created without influence from outside forms and ideologies. This is true despite the inroads of Islam and the contacts made along the western coast with both secular and Christian Europe.

Exceptionally, the Christian art of Ethiopia is, in fact, indigenous. The Kongo peoples also

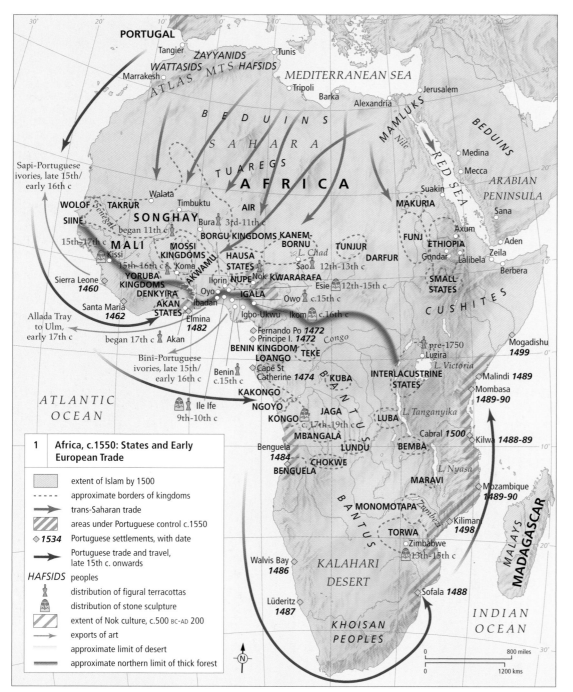

1 Africa, c.1550: States and Early European Trade

- ▨ extent of Islam by 1500
- ---- approximate borders of kingdoms
- → trans-Saharan trade
- ▨ areas under Portuguese control c.1550
- ◇ 1534 Portuguese settlements, with date
- → Portuguese trade and travel, late 15th c. onwards
- *HAFSIDS* peoples
- ♟ distribution of figural terracottas
- ♝ distribution of stone sculpture
- ▨ extent of Nok culture, c.500 BC-AD 200
- → exports of art
- approximate limit of desert
- approximate northern limit of thick forest

1 IN THE CENTURIES before 1500, most non-internal African trade was across the Sahara. After 1500, however, the centre of 'trade gravity' shifted to the coasts. First the Portuguese, then later most other European powers, had extensive coastal interchange with many diverse African peoples. Trade relations thrived, and European contacts had a strong impact on African art and culture.

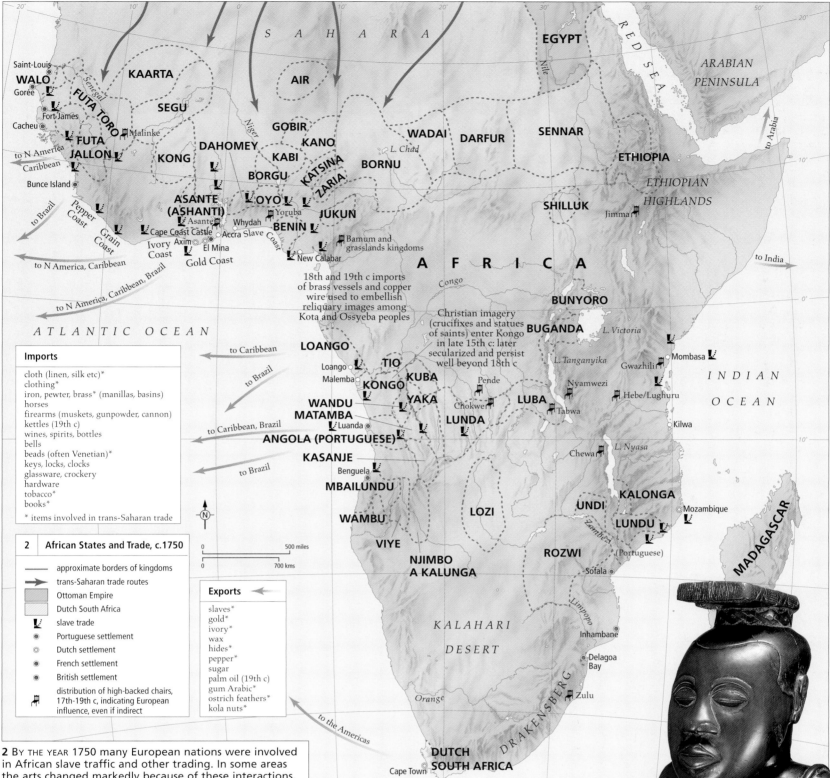

Imports

cloth (linen, silk etc)*
clothing*
iron, pewter, brass* (manillas, basins)
horses
firearms (muskets, gunpowder, cannon)
kettles (19th c)
wines, spirits, bottles
bells
beads (often Venetian)*
keys, locks, clocks
glassware, crockery
hardware
tobacco*
books*

* items involved in trans-Saharan trade

2	African States and Trade, c.1750

— approximate borders of kingdoms
→ trans-Saharan trade routes
Ottoman Empire
Dutch South Africa
slave trade
◉ Portuguese settlement
○ Dutch settlement
◉ French settlement
◉ British settlement
distribution of high-backed chairs, 17th–19th c, indicating European influence, even if indirect

Exports

slaves*
gold*
ivory*
wax
hides*
pepper*
sugar
palm oil (19th c)
gum Arabic*
ostrich feathers*
kola nuts*

18th and 19th c imports of brass vessels and copper wire used to embellish reliquary images among Kota and Ossyeba peoples

Christian imagery (crucifixes and statues of saints) enter Kongo in late 15th c; later secularized and persist well beyond 18th c

2 BY THE YEAR 1750 many European nations were involved in African slave traffic and other trading. In some areas the arts changed markedly because of these interactions, resulting in new object and architecture types, new materials, motifs, and sometimes, styles. Islam continued its expansion southwards and along the East African coast. Christianity was perhaps less influential in 1750 than in 1550, but its legacies remained in art and architecture.

adopted Christian symbols, using some forms, such as crucifixes, in secular political and judicial contexts after abandoning Christianity. Islamic/Arabic styles prevailed on the Swahili coast and islands, in the emirates of northern Nigeria, and in the mosques and architecture of the western Sudan. Leatherwork and embroidery on cotton garments in the same areas also betray Muslim influence. Secular Europe is present along coastal West Africa in forts and castles, and also in motifs (weapons, clocks, bells, hats and many other items) that were assimilated into local iconography.

European art, architecture and material culture entered southern Africa with the Boers and later the British who colonized large areas. These forms – metalwork, glassware, furniture and other household goods, plus architectural forms and styles – were adopted by the separatist European colonies

established from the mid-seventeenth century. Such arts, still present today, evolved alongside the indigenous art forms and styles of black African peoples.

Black peoples were frequently moved off their original lands, yet in new locations many were able to maintain, partly modified, their arts of personal decoration, carved domestic objects and their distinctive construction of houses and compounds, sometimes decorated with wall paintings. Wood-carving was apparently never highly developed among southern African Bantu and Khoisan peoples who were displaced by European colonists. Although some instances of figural sculpture remain, carvers mostly made everyday, useful objects, such as stools and neck rests, staffs, beer containers and meat plates.

PORTRAIT OF KING MISHE MISHYAANG MAMBUL. Wood, c. eighteenth century, Kongo. This work was commissioned and carved during the king's lifetime, and housed in his harem. Each Kuba monarch since the seventeenth-century King Shayaam nMbul aNgoong has commissioned a similar commemorative image.

191

ASIA 1500-1800

IN THIS PERIOD Asia entered a new global economic system, based on long-distance maritime trade and dominated by Europeans. The treaty of Tordesillas (1494) promised the Spanish control over much of the New World, while allotting Portugal all the trade from the Cape Verde Islands east to the Moluccas. After the Portuguese explorer Vasco da Gama rounded Africa in 1498, the Spanish and the Portuguese, followed closely by the English and the Dutch, began to establish trading colonies along the coasts of Southwest, South, Southeast and East Asia.

EMPIRE, RELIGION AND ART

The land-based empires of Asia, while conceding control of the seas to European fleets, expanded at each other's expense. Ming and Qing rulers moved west from China into Tibet and Turkestan, while both the Japanese and the Chinese invaded Korea. Muscovy pushed south into the Caucasus and Central Asia. Timurid princes decamped from Central

Asia into northern India where they established the Mughal Dynasty, which itself expanded southward at the expense of the Hindu rulers of the Deccan. The Shi'ite Safavids of Iran were wedged between two Sunni and Turkish rivals, the Uzbeks of Central Asia and the Ottomans of Anatolia, the Levant and the Balkans. Everywhere, these courts took inspiration from the fine arts of times past.

This age of empires went hand-in-hand with the creation of imperial styles and capital cities. Throughout West and South Asia, for example, the Persian language and the artistic

CHINESE EXPORT WALLPAPER, gouache on paper, second half of the eighteenth century. Beginning in the late seventeenth century, European merchants imported hand-painted Chinese wallpapers to decorate private sitting and bedrooms. They were so valuable that they were not pasted directly on walls, but on canvas stretched over battens, which were then nailed to the walls. They were supplied in sets of 25 to 40 rolls, each about 1 metre wide.

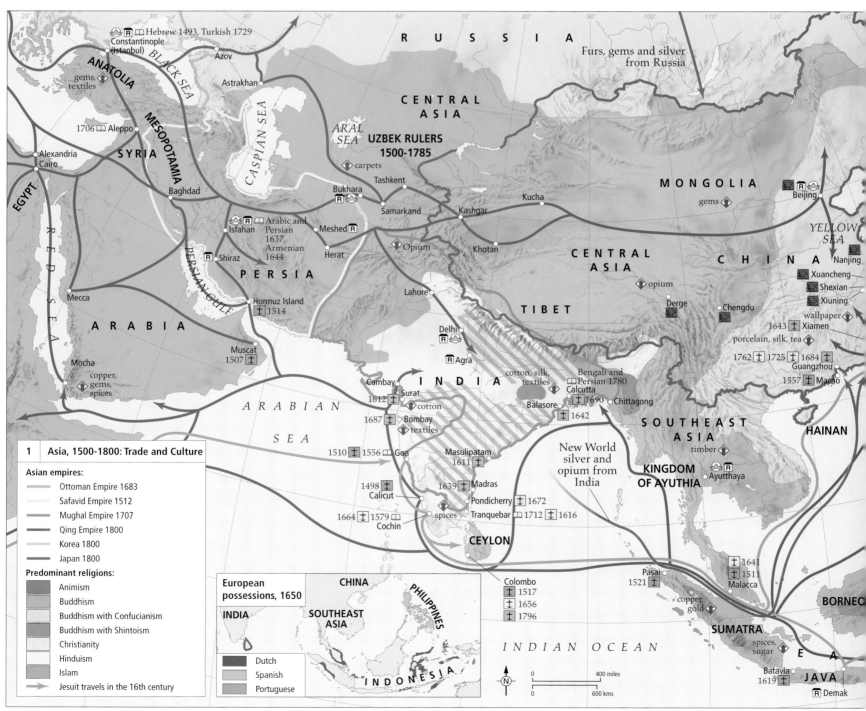

1 Asia, 1500-1800: Trade and Culture

Asian empires:

- Ottoman Empire 1683
- Safavid Empire 1512
- Mughal Empire 1707
- Qing Empire 1800
- Korea 1800
- Japan 1800

Predominant religions:

- Animism
- Buddhism
- Buddhism with Confucianism
- Buddhism with Shintoism
- Christianity
- Hinduism
- Islam
- → Jesuit travels in the 16th century

European possessions, 1650

- Dutch
- Spanish
- Portuguese

style that had developed under the Timurid rulers of Central Asia in the fifteenth century was adopted by Muslim courts from Istanbul to Delhi. An international visual language was created that united disparate – and often antagonistic – political entities (although architectural styles remained regionally distinct). Throughout Asia imperial rulers created magnificent capital cities that proclaimed their grand – and often grandiose – aspirations. From Edo (now Tokyo) to Ayutthaya and Constantinople (Istanbul), the finest buildings in these cities – whether temples, pagodas or mosques – were designed to express imperial power and prestige.

Rulers, their courtiers and even merchants amassed the wealth necessary to transform the landscape, and large and lavish gardens became a hallmark of this period. Persian hydraulic gardens, however pleasant and beautiful, were first and foremost designed for growing food in an arid land, whereas Chinese and especially Japanese gardens were aimed primarily at aesthetic delight, especially with the development of the tea ceremony in Japan.

Conflicting territorial claims often led to the displacement of artists and the consequent commingling of artistic techniques and ideas.

The Persian artists and works of art captured by the Ottomans at the Battle of Chaldiran in 1517 brought a new wave of Persian artistic culture to the court at Constantinople. Following the Japanese invasions of Korea in the 1590s, Korean artists, especially potters, were captured and taken to northern Japan, where their rustic wares captivated Japanese connoisseurs. The enormous booty brought back to Iran following the brilliantly successful invasion of India by the Afghan Nadir Khan in 1738–89 included the jewel-encrusted Peacock Throne, which not only became the symbol of the Iranian monarchy but also inspired a new taste for bejewelled excess.

Along with the expansion of empires came the spread of West Asian monotheism, especially Islam and Christianity, at the expense of the traditional Asian religions, ranging from Shamanism to neo-Confucianism. Muslim merchants and Sufis (mystics) brought Islam to western China and Southeast Asia, along with new forms of architecture (such as the mosque) and new attitudes towards the visual arts (such as the discouraging of figural sculpture). The Spanish and Portuguese brought Catholicism to their trading colonies along the coasts of South, Southeast and East Asia, where they built Mannerist and Baroque churches and promoted painting and sculpture depicting Christ, the Virgin and a host of saints. The various manifestations of Buddhism, long displaced in its Indian homeland by Hinduism and Islam, remained dominant in Tibet, Mongolia, Southeast Asia, Korea and Japan.

COMMERCE AND ART

Exquisite blue-and-white porcelains, which had been produced since the fourteenth century at the great kilns of Jingdezhen in southern China, were exported by European merchants east to Korea and Japan and west to Iran, Turkey and eventually Italy and the rest of

Europe. Chinese blue-and-white porcelains inspired not only the production of local pottery imitations, but also the incorporation of Chinese motifs, such as the lotus, peony and dragon, in a wide range of other media. Europeans resident in Asia as well as back at home coveted Asian arts – Polish ambassadors to Iran and British merchants in India commissioned splendid carpets in which traditional arabesques were combined with European coats-of-arms. At the same time Asian artists took inspiration from the arts of the West, adopting such techniques as painting in oils on canvas and the overglaze painting of ceramics with colloidal gold.

The techniques of papermaking and printing, which had been used in East Asia for centuries to disseminate Buddhism and had already spread across Asia to Europe by the fifteenth century, became major vehicles of both artistic dissemination and expression. Chinese painted papers were exported to decorate European walls, while European biblical and allegorical prints were brought by Jesuit missionaries to India, where they were copied by Mughal artists, who adopted the European imagery and techniques of perspective and shading, if not the meanings, of the originals. Jesuits also introduced printing with moveable type to the Philippines, where only Chinese-inspired block printing had been known. Indian block-printed cottons were exported to Southeast Asia and Europe, where they inspired a fashion revolution as bright patterned colour at last became affordable. In Japan, which alone had closed its ports to European traders, woodblock printing became a major industry, as artists perfected the technique of colour printing for a burgeoning merchant class. Nevertheless, Dutch merchants managed to export some Japanese paper to Holland, where Rembrandt used it for printing some of his etchings.

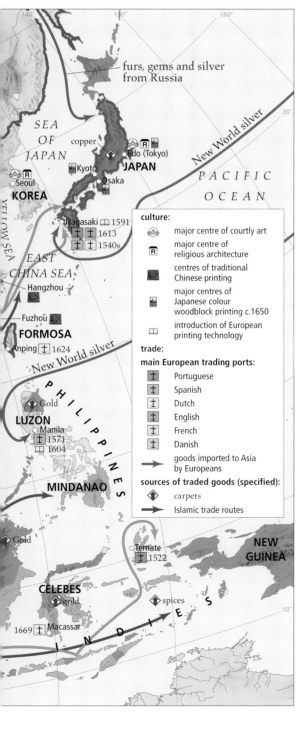

1 A NEW WORLD ECONOMIC SYSTEM replaced the ancient Silk Road, which had served for millennia to link China with the Mediterranean. The major commodities traded were the spices and textiles traditionally made throughout South and East Asia, but European merchants also sought out ceramics, lacquerwares, gems and exotic Asian woods. Even American silver was brought across the Pacific Ocean via the Spanish Philippines to Southeast Asia. While long-distance trade had a decisive impact on the arts of Asia, Asian arts in turn exercised an impact on the arts of Europe.

MASJID AGUNG, OR GREAT MOSQUE OF DEMAK, central Java, Indonesia, 1477–79. The oldest mosque in Indonesia is located in a trading settlement on the north coast of Java. The building is based on the traditional Javanese *pendopo*, a square, open pavilion whose four enormous timber pillars support a high, multi-tiered roof. A broad pillared verandah extending from the entrance is used for teaching and meetings, and instead of a tower minaret, a drum is used to call the faithful to prayer. This form became standard for mosques throughout Indonesia and Malaysia.

WEST ASIA 1500-1800

DURING THIS PERIOD West Asia was contested between two rival Muslim dynasties of Turkish origin. The more powerful were the Ottomans (r. 1282–1924), who had grown from a minor principality in north-western Anatolia to rule a vast empire that encompassed Anatolia, Syria, the Levant, Arabia and Mesopotamia, as well as the Balkans, much of southwestern Europe, all of Egypt and all of North Africa except Morocco. The Ottomans challenged the Christian powers of Europe for control of the Mediterranean and challenged the Habsburgs and Romanovs for control of eastern Europe and southern Russia.

The Ottomans' rivals to the east, the Safavids (r.1501–1732), ruled Persia and made the Shi'i sect of Islam the state religion. Their borders were constantly harrassed on the west by the Ottomans, who vied with them for control of the Shi'i shrines at Najaf and Kerbela, and on the east by the Uzbeks, who vied for control of the Shi'i shrine at Meshed. Eventually the moribund Safavid dynasty was overthrown by the Turkmen chieftain Nadir, who re-established the territorial integrity of Persia through constant wars financed by invading India in 1738–9. This brilliant campaign brought him enormous booty, including the Mughals' fabled Peacock Throne.

INTERNATIONAL TRADE

After European ships rounded the Cape of Good Hope, the traditional land routes across Eurasia were displaced. Inland caravan cities were supplanted by Persian Gulf ports which linked Persia directly into the European mercantile system. Persian silk cultivated on the Caspian littoral was shipped to Europe through Ottoman-controlled Aleppo in northern Syria, while the Ottomans themselves exported silk from Bursa. Both the Safavids and the Ottomans also exported fine finished textiles including silks, velvets and carpets. Most carpets exported to Europe came from the Ottoman Empire. Their

2 THE NEW CAPITAL OF **Shah Abbas (r.1587–1628)** at Isfahan reflected the role of the city as the hub of the Safavid order. A long covered market led from the old city to the New Meydan (square) with a congregational mosque at the south and the palace precinct to the west. Beyond, a broad avenue, flanked by the mansions of the nobility, led across the river to the suburb of the Armenian merchants and hunting preserves for the court.

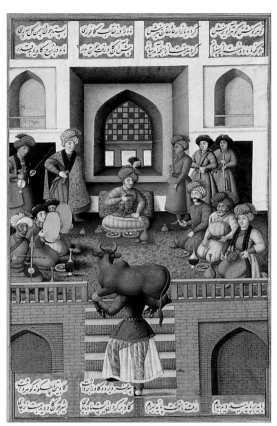

MUHAMMAD ZAMAN, *Fitna Astonishing Bahram Gur*, added in 1675 to a copy of Nizami's *Khamsa* (Quintet) made in 1539–43 for the Safavid shah Tahmasp. Seventeenth-century Persian miniature painters adopted such features of European art as single-point-perspective and shading, used here within a traditional Persian tripartite composition and subject to create a sense of space and to focus attention on the figure of the ruler.

maker Thomas Dallam, the Huguenot jeweller Jean Chardin, the German physician Engelbert Kaempfer and the Capuchin father Raphael du Mans. Most were impressed by what they found and wrote long accounts of their journeys, often illustrated with engravings of these exotic lands.

These emissaries brought European goods as gifts, thereby introducing new media and artistic techniques to the region. Venetian plate-glass mirrors and oil painting on canvas, for example, were introduced to Isfahan in the seventeenth century, as were single-point perspective and shading. The Hungarian convert Ibrahim Müteferrika introduced printing with moveable type to Istanbul in the early eighteenth century. An Armenian press was established in Isfahan and a Maronite press in Lebanon, although printing was not fully exploited in the region until the nineteenth century. European

increased presence is amply documented in European paintings, and they are consequently known as, for example, 'Holbein', 'Bellini' or 'Crivelli' carpets. Other carpets – and works of art – were made on commission for Europeans. The Armenian merchant Sefer Muratowicz, for example, ordered 'Polonaise' carpets woven in Isfahan with the arms of the Czartowski family. Ottoman potters at Iznik made polychrome ceramics bearing European coats of arms.

European trade was encouraged by merchants, missionaries, adventurers and ambassadors, including the English organ-

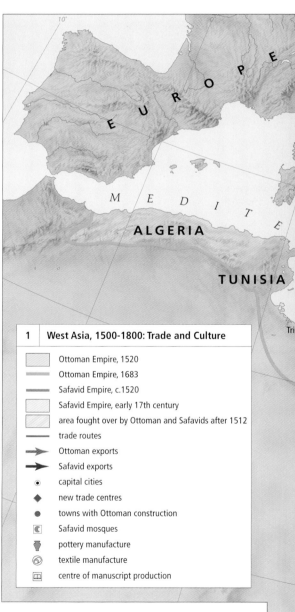

1	**West Asia, 1500-1800: Trade and Culture**
	Ottoman Empire, 1520
	Ottoman Empire, 1683
	Safavid Empire, c.1520
	Safavid Empire, early 17th century
	area fought over by Ottoman and Safavids after 1512
	trade routes
	Ottoman exports
	Safavid exports
	capital cities
	new trade centres
	towns with Ottoman construction
	Safavid mosques
	pottery manufacture
	textile manufacture
	centre of manuscript production

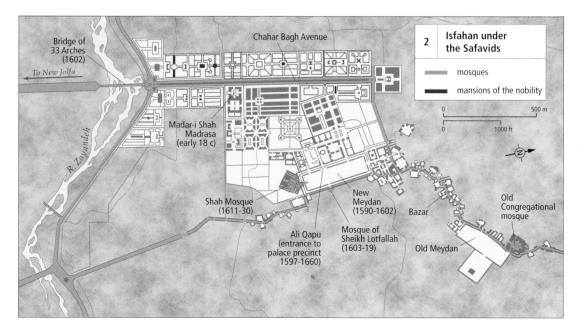

2	**Isfahan under the Safavids**
	mosques
	mansions of the nobility

1 THE TWO MAJOR POWERS in the region, the Ottomans and the Safavids, were active traders in the global market, exporting many goods to Europe overland and by sea. The most important were fibres and textiles, which were cultivated and produced throughout their realms. Both dynasties also used architecture as a nationalist symbol, creating dynastic styles of architecture displayed in the many cities that flourished during this period. Although they were sometimes forced to move their capitals, their final choices – Istanbul and Isfahan – became the showpieces of their empires.

UNDERGLAZED PAINTED DISH with floral design. Royal design studios allowed the Ottomans and Safavids to develop dynastic styles of art with common motifs in many media. The jagged leaf painted on this large dish in the Ottoman workshops at Iznik, for example, is also found on contemporary textiles and metalwork.

travellers also brought back many exotic goods, which in turn influenced European taste. Ogier Ghislain de Busbecq, Habsburg ambassador to the Ottoman sultan Süleyman, for example, imported tulip bulbs to Austria, thereby laying the foundation for the tulip mania of 1636–7.

THE IMPERIAL STYLE

To bolster their creation of nation-states, the Ottomans and Safavids not only played upon sectarian rivalries (for example, between the Sunni and Shi'i sects) and ethnic divisions (Arab/Persian/Turk), but also created glorious capital cities. For reasons of politics and security, they sometimes had to move their capitals, but their final choices – Istanbul and Isfahan – become the showpieces of their empires. Each power also created an imperial style of architecture, which was used to define territory. Thus the distinctive Ottoman style of mosque – built of limestone masonry with a large domed hall surrounded by cascading semi-domes and pencil-point minarets – was erected throughout the empire. The message of these

mosques as signifiers of the dynasty was so clear that when conservative Wahhabi clerics came to power in eighteenth-century Arabia, they ordered Ottoman minarets and domes destroyed. Safavid mosques are equally distinct. They were built of brick and glazed tile with an open courtyard, which was surrounded by two storeys of rooms and four *iwans* on the sides, and a large portal with an *iwan* flanked by minarets.

Although both the Ottomans and Safavids drew on the common heritage of Persian culture promulgated by the Timurids in fifteenth-century Central Asia, each dynasty created a distinct artistic style by establishing state control over manufactures. As in architecture, royal design studios ensured stylistic coherence through the use of paper patterns and designs. The same motif, such as a jagged leaf (*saz*), appears on Ottoman tiles, ceramic vessels, textiles, carpets and metalwork. Distinct artistic personalities also emerged in this period, notably Sinan (d.1588), the premier Ottoman architect, and Reza (d.1635), who was the foremost painter of Safavid Iran.

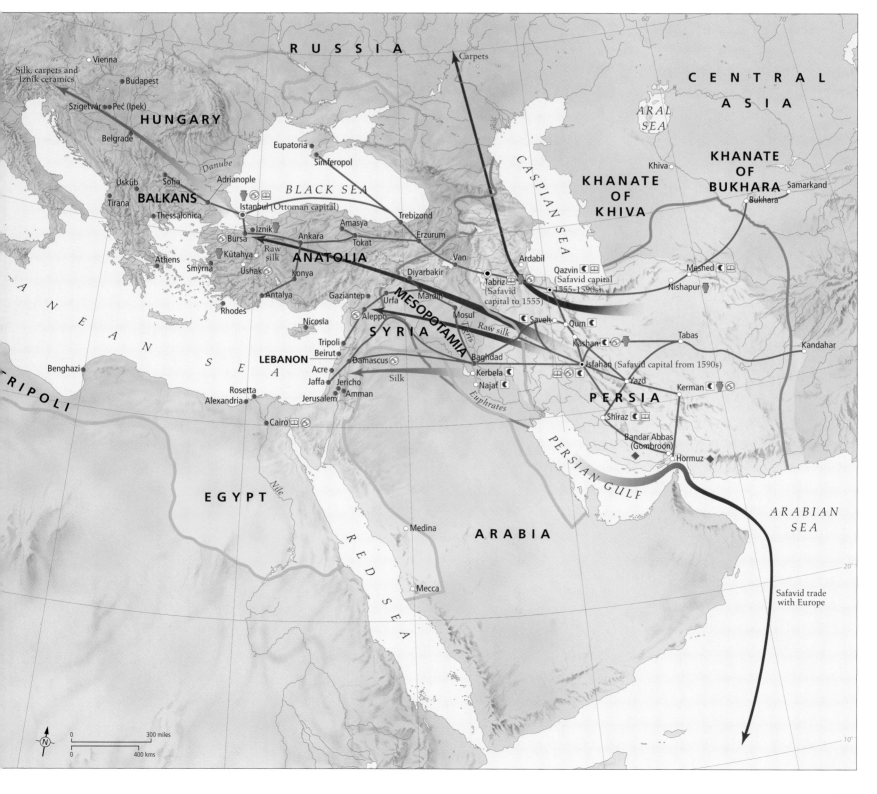

CENTRAL ASIA 1500-1800

IN THE THREE CENTURIES following the collapse of the last remnants of the Timurid Empire in 1506, the Turko-Mongolian rulers of Central Asia were challenged by the advances of two powerful rivals, the Chinese and the Russians. The area to the east of the Tien-Shan mountains fell increasingly under Chinese control, and in 1757 it was made a Chinese province called Sinkiang ('new frontiers'). The region to the west became tied to the growing economic power of Muscovy. After defeating the Tartars and annexing the Khanate of Kazan in 1552, Muscovy extended its political and economic reach south and eastward. Anthony Jenkins, representative of the English Muscovy Company, established the first diplomatic exchange with the Central Asian khanates in 1558, and Russia became the region's main trading partner.

SETTLEMENT PATTERNS

During this period authority reverted to descendants of Genghis Khan who exercised their power from oasis cities irrigated by rivers and irrigation systems fed by waters collected in distant mountain ranges. In western Central Asia the political system was organized into fiefdoms led by khans descended from Genghis's eldest son, Jochi. The main lines were the Shibanids (1500–1599) and the Toqay-Timurids (1599–1747), who ruled from

1 SANDWICHED BETWEEN GREAT POWERS in China, India, Persia and Russia, Central Asia was fragmented among principalties and city-states ruled by descendants of Genghis Khan, and artistic patronage became inwardly focused. To display their might and cement their authority, patrons in the western part of the region commissioned buildings and objects resembling those that had been commisioned by the Timurids, their richer and more powerful ancestors in the fifteenth century.

capitals at Bukhara, Samarkand, Tashkent and Balkh. Military and bureaucratic figures from the Turko-Mongolian tribes were sometimes even more important than the khans, while the learned class, which included traditional Muslim scholars and members of Sufi (mystical Islamic) brotherhoods, often served as mediators between the disenfranchised and the ruling classes.

In eastern Central Asia descendants of Genghis Khan's second son, Chaghatay, ruled in the Altishahr, the 'six cities' of Kucha, Aksu,

Uch Turfan, Khotan, Kashgar and Yarkand. By the middle of the seventeenth century, power passed from the Chaghatayids to the Khojas (1658–1759), descendants of Naqshbandi Sufi sheikhs, who cemented their authority by marriage into the Chaghatayid family.

ARTISTIC PATRONAGE

The khans, emirs and sufis were all important patrons of architecture and art, especially the arts of the book. In form and style, the works of art produced under Uzbek patronage in Central Asia were dependent upon models the Timurids had established in the fifteenth century. The repetition of the same forms for the next three centuries means that these works of art, although copious, are often mediocre in quality, particularly when they are compared with contemporary works produced by Safavid and Ottoman patrons in West Asia or by the Mughals in South Asia, all of whom had far greater resources at their disposal.

The European discovery of direct sea links with Asia and the Americas at the end of the fifteenth century had a crucial impact on the economy of this region, which was an entrepôt on the intercontinental trade route linking China to South and West Asia. By the mid-sixteenth century, precious metals from the New World had found their way into the pockets of Central Asian businessmen and politicians. The ensuing prosperity of the

PAGE FROM SAADI'S MASTERPIECE in prose and poetry, the *Bustan* ('Orchard'), made at Bukhara in 1616. Rich patrons continued to commission illustrated copies of Persian classics. This manuscript of the famous poem by the thirteenth-century Persian master from Shiraz, for example, was made for the library of a Juybari sheikh who represented the Naqshbandi order of Sufis in the Transoxanian city of Bukhara. It gives a good idea of court life there.

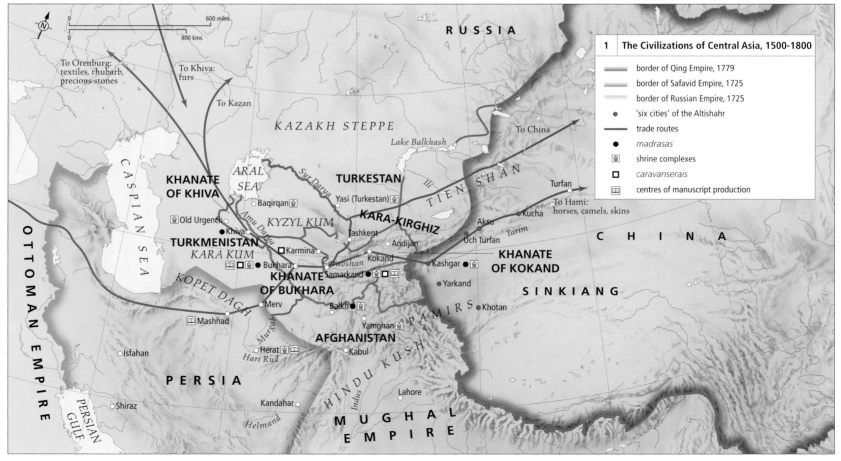

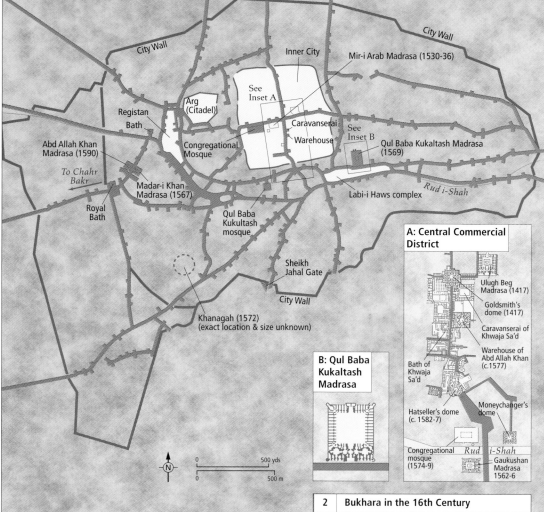

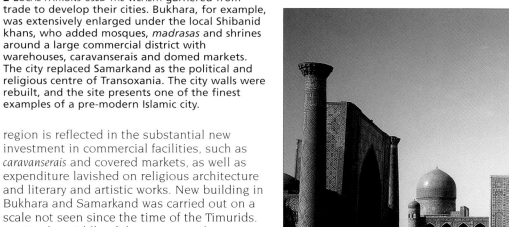

A: Central Commercial District

Ulugh Beg Madrasa (1417)

Goldsmith's dome (1417)

Caravanserai of Khwaja Sa'd

Warehouse of Abd Allah Khan (c.1577)

Bath of Khwaja Sa'd

Hatseller's dome (c. 1582-7)

Moneychanger's dome

Congregational mosque (1574-9)

Rud i-Shah

Gaukushan Madrasa 1562-6

B: Qul Baba Kukaltash Madrasa

| 2 | Bukhara in the 16th Century |

Sufis, or mystics, had been responsible for much of the conversion of Central Asia to Islam, and Sufi orders remained important. Shrine complexes were developed around the graves of Sufi saints. The most famous is the Char Bakr complex (1559–69) outside Bukhara, which comprises a *khanaqah* (hospice), *madrasa* and mosque in the midst of the cemetery for the Jubayri family of Naqshbandi sheikhs.

Illustrated manuscripts produced in the region became increasingly repetitive in subject, composition and style. Following successive incursions into Khurasan, the northeastern province of the Safavid realm, painters in Central Asia began to incorporate the classical elements of Persian manuscript painting as had been practised in fifteenth-century court *ateliers* at the Timurid capital of Herat. The most important texts were the classics of Persian literature, illustrated for emirs and members of the learned class, as well as for local princes.

Many of the other arts also followed earlier traditions. Fine metalwares, not only inlaid bronzes but especially tinned coppers, continued to be produced, but few are dated. Polychrome ceramics were replaced by blue-and-white wares imitating Chinese porcelains. Typical pieces, mainly bowls, were covered with a slip and decorated under a transparent glaze with flowers, fruits, birds and geometric designs. The expensive cobalt pigment used in the fifteenth century was replaced with cheaper manganese and copper that produced dark-green, turquoise and purple-brown hues. To judge from earlier and later examples, fine textiles and carpets in wool, silk and cotton were also made in this period, but so far it is difficult to date or localize many of them.

2 LOCAL PATRONS USED THE WEALTH garnered from trade to develop their cities. Bukhara, for example, was extensively enlarged under the local Shibanid khans, who added mosques, *madrasas* and shrines around a large commercial district with warehouses, caravanserais and domed markets. The city replaced Samarkand as the political and religious centre of Transoxania. The city walls were rebuilt, and the site presents one of the finest examples of a pre-modern Islamic city.

region is reflected in the substantial new investment in commercial facilities, such as *caravanserais* and covered markets, as well as expenditure lavished on religious architecture and literary and artistic works. New building in Bukhara and Samarkand was carried out on a scale not seen since the time of the Timurids.

By the middle of the seventeenth century, however, the traditional land routes across Central Asia were insufficient to meet the growing world demand for goods created by European industrialization. Prosperity dramatically slackened as the economic significance of the region diminished. Deprived of their Mediterranean markets, Central Asian merchants turned northwards towards Russia and Siberia, developing reciprocal trade in textiles, furs, precious stones and rhubarb (used as a medicine).

THE RELIGIOUS ART OF CENTRAL ASIA
In reaction to the establishment of Shi'i Islam as the state religion of Persia under the Safavids, Central Asia became a staunch centre of Sunni Islam. It was taught by religious scholars who presided over many large *madrasas* (theological colleges) constructed in the major cities, which attracted students from across Asia. The typical *madrasa*, like most buildings in the region, was a large brick structure with a central open court surrounded

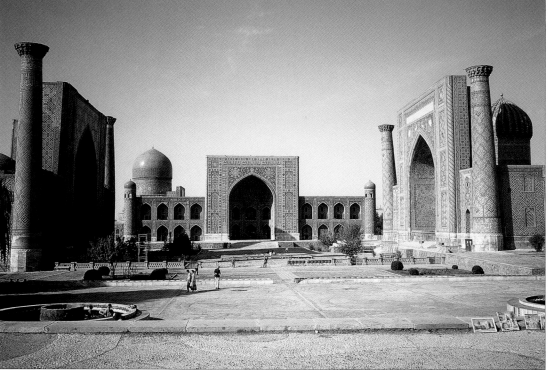

by two stories of rooms and an *iwan* in the middle of each of its four sides. The largest (73 x 55 metres; 237 x 179 ft) is the Mir-i Arab *madrasa* (1530–36) in Bukhara. As in Timurid times, surfaces were decorated with brilliantly glazed tiles which were set in geometric or figural patterns. These buildings were often arranged in beautifully laid-out complexes, either facing other structures, as at the Registan complex in Samarkand, or set around reservoirs, as at Bukhara.

THE REGISTAN, OR TOWN SQUARE, IN SAMARKAND. Most public buildings erected in Central Asia during this period were made of brick and glazed tile. Many were set in complexes, often around a pool. The Registan, the most spectacular ensemble, was laid out in the early fifteenth century by the Timurids. It was redeveloped in the seventeenth century when governor Yalangtush Bi Alchin built a new *madrasa* known as the Shirdar ('lion-possessing') from the decoration of rampant lions on the spandrels on the entrance. Erected between 1616 and 1636, it replaced a large *madrasa* built by the Timurid ruler Ulugh Beg.

SOUTH ASIA 1500-1800

THE PERIOD BETWEEN 1500 and 1800 has traditionally been seen as an epoch of imperial grandeur followed by political and economic decay and stagnation, setting the stage for the arrival of European powers and colonial rule. Recent research suggests that this period instead saw steady but remarkable economic growth and socio-political dynamism.

ART AND SOCIETY

In 1526 Babur (r.1526–30), who had been forced from his homeland in Samarkand by the Uzbeks, defeated the acting Sultan of Delhi, and established what was to become the last great imperium before the arrival of European powers, the Mughal empire. Throughout the sixteenth century, the Mughal emperors established control throughout the subcontinent. The Deccan, where the kingdom of Vijayanagara had fallen to a confederation of sultanates in 1565, saw a power vacuum and was soon swallowed up by the expanding Mughal Empire under the dynamic leadership of Emperor Akbar (r.1556–1605). The Mughal Empire, with its complex system of flexible political alliances with Hindu kings called Rajputs, was one of the most remarkable states witnessed in the subcontinent. By the latter half of the seventeenth century, however, it had been weakened by internal divisions (which included the rise of the independent state of the Marathas in the Deccan) and fiscal overspending. At the same time, European merchant companies began to arrive in India seeking precious materials and finely worked goods. At first they excercised trading

1 THE EXPANSION OF THE MUGHAL STATE from the end of the sixteenth century was facilitated by centralizing economic and political reforms put in place by Emperor Akbar to maximize state revenue and curb rebellions. Persian sources of the period, combined with early European trade records make it possible to reconstruct numerous zones of agricultural and mineral production as well as centres of exchange and industry. During Mughal times India was more integrated into the world economy than ever before, in part through the presence, from as early as the sixteenth century, of Portugese, Dutch, British and French trading interests at different ports throughout the subcontinent.

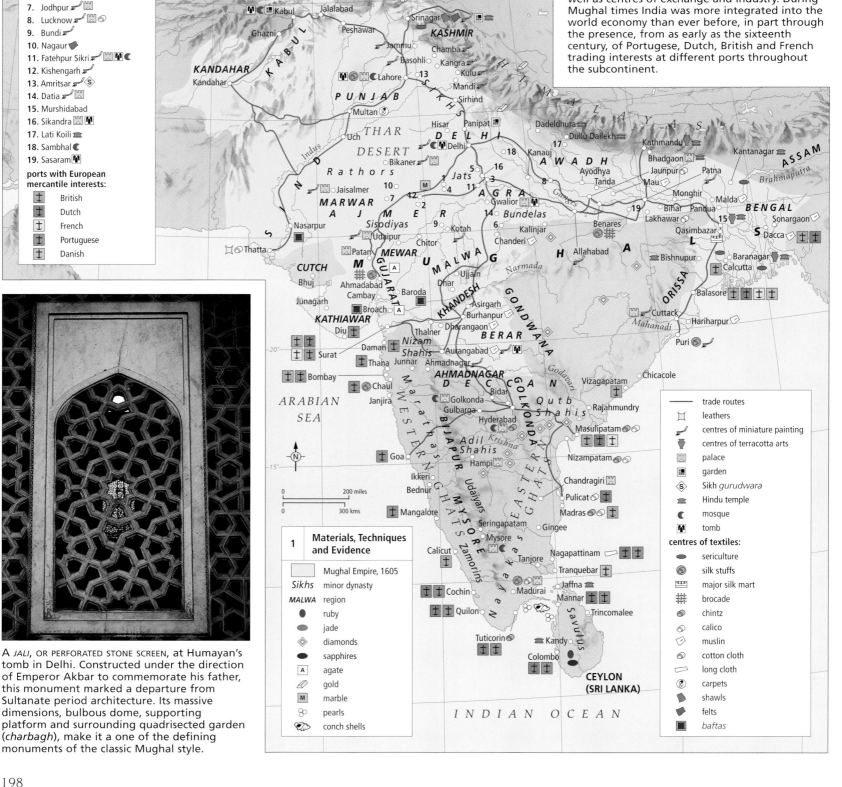

1. Amber
2. Ajmer
3. Agra
4. Jaipur
5. Mathura
6. Orccha
7. Jodhpur
8. Lucknow
9. Bundi
10. Nagaur
11. Fatehpur Sikri
12. Kishengarh
13. Amritsar
14. Datia
15. Murshidabad
16. Sikandra
17. Lati Koili
18. Sambhal
19. Sasaram

ports with European mercantile interests:
- British
- Dutch
- French
- Portuguese
- Danish

	trade routes
	leathers
	centres of miniature painting
	centres of terracotta arts
	palace
	garden
	Sikh *gurudwara*
	Hindu temple
	mosque
	tomb

centres of textiles:
- sericulture
- silk stuffs
- major silk mart
- brocade
- chintz
- calico
- muslin
- cotton cloth
- long cloth
- carpets
- shawls
- felts
- *baftas*

1	Materials, Techniques and Evidence
	Mughal Empire, 1605
Sikhs	minor dynasty
MALWA	region
	ruby
	jade
	diamonds
	sapphires
A	agate
	gold
M	marble
	pearls
	conch shells

A *JALI*, OR PERFORATED STONE SCREEN, at Humayan's tomb in Delhi. Constructed under the direction of Emperor Akbar to commemorate his father, this monument marked a departure from Sultanate period architecture. Its massive dimensions, bulbous dome, supporting platform and surrounding quadrisected garden (*charbagh*), make it a one of the defining monuments of the classic Mughal style.

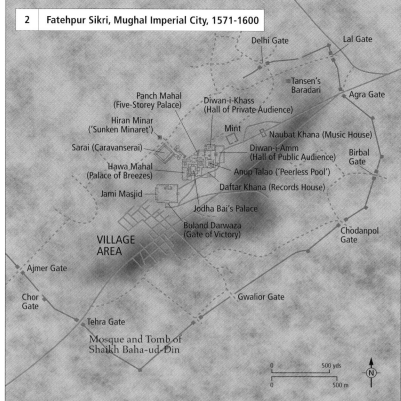

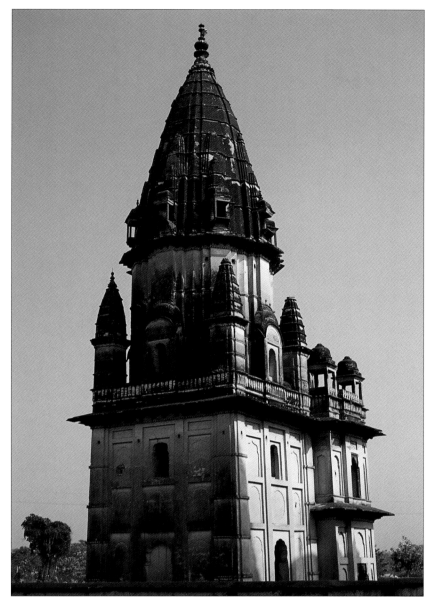

ONE OF FOURTEEN CENOTAPHS (*chhatries*) constructed in the seventeenth century to commemorate the kings of the Rajput dyansty of the Bundelas in their capital city of Orccha. While their form resembles a common north-Indian-style Hindu temple, their function, to commemorate the dead, reflects the influence of Islam, as mausolea and tombs are unknown among Hindus, who bury their dead. Interestingly, the cenotaphs contain no human remains.

2 THE CITY OF FATEHPUR SIKRI was constructed under the patronage of Emperor Akbar over a fifteen-year span (1571–85), to celebrate a prophecy made by the Chisti saint Shaikh Salim, of the birth of a son. A brilliant combination of Persian principles with an Indian flavour, the city is built of red sandstone with contrasting marble inlays. Fatehpur Sikri was not destined to last, however, and was abandoned by 1600.

privileges alone but by the end of the eighteenth century had come to acquire limited diplomatic and administrative powers, a process which would eventually lead to full-scale colonial rule.

Despite the rapidly changing political landscape, this was a period of increasing economic dynamism. A significant rise in the flow of commodities during the Mughal period led to a corresponding expansion in the demand for manufactured products, including luxury goods and crafts. This demand was reinforced by the development (and imitation) of an impressive courtly culture in the major imperial metropolises, as well as vigorous and distinctive provincial courtly styles. These were manifested in architecture, painting, textiles and portable decorative arts.

COURTLY CULTURE

Early Mughal courtly culture was heavily influenced by contemporary Persia, particularly in painting and architecture. While painting (both Hindu and Muslim) was by no means unknown in pre-Mughal India, it was developed extensively as a courtly art from early Mughal times, partly as a result of the emperor Humayun's exile to the court of Tahmasp in Persia, where he witnessed the spendours of Persian miniature painting, and partly due to the subsequent arrival of Persian artists at the Mughal court seeking refuge from religious iconoclasts. Miniature paintings were essentially book illustrations and were closely associated with the culture of books in Mughal India. Considered rare and precious objects

(particularly when decorated), books were exchanged at ceremonial occasions and are often mentioned as war spoils by court historians. Painters were usually commissioned personally by patrons to illustrate manuals, court histories and biographies, a fact often reflected in the highly individualized nature of miniature painting.

MUGHAL ARCHITCTURE

The Mughal emperors constructed palaces, mosques, forts and cities. Mughal architecture blended Persian and Central Asian prototypes with indigenous Indian techniques and styles. Mughal monuments in the sixteenth century, like the city of Fatepuhr Sikri, were largely built in distinctive red sandstone with contrasting marble inlays, while those of the seventeenth century, such as the Taj Mahal (*see* pp.146–7), a mausoleum sponsored by Emperor Shah Jahan (r.1627–58), were constructed in white marble and inlaid with semi-precious stones. Decorative techniques were distinctive: perforated screens, tesselated designs of alternating stone types, inlaid floral motifs and glazed tiling.

One of the more remarkable architectural developments of the Mughal period was the proliferation of garden architecture (and culture) among the courtly elite. The Mughal prototypes came from Persia, where the Islamic concept of paradise as a utopian garden of plants and flowers arranged in geometrical symmetry around pools of water had developed. Though inspired by Persian prototypes, Mughal gardens, like painting, were quickly adapted to Mughal taste.

TEXTILES AND DECORATIVE ARTS

Sources suggest that the Indian textile industry was truly mammoth, with every part of the country producing textiles for both local consumption and distant markets. The English factory records alone mention some 150 varieties of cotton fabric available for export. There were many regional specialities, such as painted cloth from the Deccan and mixed silk and cotton from Gujarat. Indian fabrics were printed, painted, dyed and often embroidered and appliquéd. Yet technologies remained comparatively simple and rudimentary.

Inlaid jewellery was a Mughal speciality, particularly under the patronage of Shah Jahan, whose famous golden 'peacock throne' was encrusted with precious stones. Exports of fine cotton and silk textiles, precious and semi-precious stones, spices and other luxury items reached Persia, Turkey, Muscovy, Poland, Egypt and Arabia. It is no surprise that European merchants were drawn in the seventeenth century to trading entrepôts along the coast of India, where they established factories.

The art of miniature painting involved a variety of artisans – painters, paper-makers, binders, gilders and calligraphers. The studio masters drew models on paper with graphite or ink, which were then coated with a white translucent layer of paint. Details were added and then paint, made of plant, animal and mineral-based pigments mixed with glue or gum arabic, was applied with squirrel-hair brushes. Finally, the surface of the paintings was burnished.

CHINA AND TIBET 1500-1650

THE PERIOD 1500–1650 in China was characterized by a rich visual field that included the rise of a society of spectacle, in which life was as much watched as lived. The emergence of a media culture allowed printing technology to translate spectacle into widely disseminated images. The stability of native rule permitted the demographic expansion of urban centres: by the late Ming, the population of Beijing may have been as high as 1.15 million people; the population of Suzhou was approximately 500,000 during the sixteenth century. Other urban centres were commensurately large. Well-developed urban economies were concomitant with such large populations; in fact, the economies of Beijing and Suzhou were integrated to some degree through their proximity to the Grand Canal.

Stability and prosperity during this period began to decline through regionalist and eunuch political factionalism at the Ming court, which became especially pronounced at the turn of the seventeenth century. The imperial ambitions of the Manchus, whose incursions across the Chinese border became more frequent and sustained, resulted in the Manchu conquest of China, leading to the establishment of the Qing ('Pure') Dynasty in 1644. Remnants of the Ming Dynasty remained intact in southern China until 1662, when the eradication of all claimants to the Ming throne completed the Manchu conquest.

THE AESTHETIC VISION of the later Ming was one informed by simplicity and restraint on the one hand, and by conspicuous consumption on the other. These ideals produced objects such as this *huanghuali* (Chinese rosewood) painting table. Its simple lines and mortise-and-tenon joinery bespeak restraint, while the material, *huanghuali*, was one of the most valuable woods of the time. Such tables were used by scholar-officials for painting works often exchanged with friends or traded for favours.

1 NATIVE RULE UNDER THE MING DYNASTY created the climate of political and economic stability that fostered an era of cultural florescence, despite China's self-imposed isolation from maritime and overland communication. The large urban centres of southeastern China were vibrant sites of artistic production and commerce, producing new developments in painting, printing, ceramics and textiles and the creation of optical devices. This multidimensional visual culture was enriched by the engagements between the various media in play in the visual field.

ARTS IN THE LATE MING PERIOD

The late Ming was a period in which the arts flourished. The boundaries between the decorative and fine arts were eroded as the pictorial quality of decorative arts came close to that of painting itself. Production of blue-and-white porcelain at Jingdezhen reached new heights, both through indigenous development, and through contact with foreign traders who circulated Chinese porcelain throughout maritime Asia, and to Europe, where it was highly valued. Chinese porcelain, especially that from Jingdezhen, revolutionized both the European taste for ceramics as well as their production processes. The Medici were among the first to try to replicate Chinese porcelain in Europe, and were subsequently joined by the Dutch and others. Silver, brought to China from New Spain via Manila, was used for currency, and

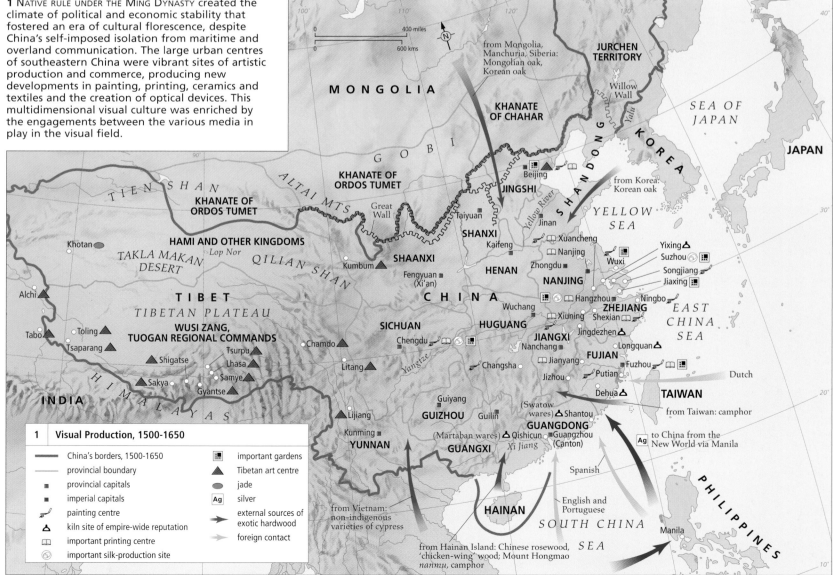

1	Visual Production, 1500-1650	
▬▬▬	China's borders, 1500-1650	
▬▬	provincial boundary	
■	provincial capitals	🏠 important gardens
■	imperial capitals	▲ Tibetan art centre
🖊	painting centre	⬭ jade
△	kiln site of empire-wide reputation	Ag silver
📖	important printing centre	➡ external sources of exotic hardwood
◎	important silk-production site	➡ foreign contact

2 Modern Remains of the Gardens of Suzhou, 1500-1650

- gardens
- pagoda/temple/pavilion
- non-Buddhist temple/government offices
- canal
- old city walls

Tiger Hill

Lingering Garden

West Garden

Cold Mountain Temple

Pingqi Lu

Guangji Lu

Fengqiao Lu

North Temple Pagoda

Humble Administrator's Garden

Dongbei Jie

Lion Grove

East Garden

Coupling Garden

Baita Dongli

Dong Zhongshi

Baita Xilu

Wu County offices

Jingde Lu

Guanqian Jie

Garden of Harmony

Twin Pagodas

Prefectural offices

Department of prefectural defence (Ming)

Local government inspection office (Ming)

Shizi Jie

Garden of the Master of the Nets and Fishing

Daoqian Jie

Shiquan Jie

Changzhou county offices

Blue-Wave Pavilion

Outer moat

Inner moat

Prefectural school

Ruigang Pagoda

0 0.5 miles
0 1 km

N

2 AFFLUENT CHINESE of the late Ming were avid consumers of luxury goods, curiosities and art objects. Among the most extravagant possessions of the period were large gardens, consisting of buildings, landscaping and rare plants and rocks. Suzhou was famous for the number and magnificence of its gardens, the most famous extant examples of which are marked here. Suzhou gardens artfully re-created nature in all of its asymmetrical and seemingly random beauty, and were favoured gathering places of literary salons and venues for private theatrical performances.

SCHOLARS IN A GARDEN and its accompanying text are the painter Ding Yunpeng's (1547–c.1621) designs for the front and back of an ink-cake. They were published by the ink producer Cheng Dayue (1541–c.1616) in a 1606 catalogue of such designs, *Master Cheng's Ink Garden*. The images in such catalogues evoke the *literati* ideals of the famous men who created and signed them, presumably to attract status-conscious buyers of ink.

increasingly for the manufacture of luxury goods such as chopsticks.

Furniture-making reached an apex in the late Ming. Utilization of mortise-and-tenon joinery on hardwoods, many of which were imported from Southeast Asia, produced architectonically engineered pieces of extreme simplicity and great value. Such furniture was complemented by advances in textile manufacture; complex and intricate brocades and embroidery were made in great volume. Such textiles were used, for example, for chair covers and cushions, as well as for wall hangings and robes.

Lacquer was another indigenous material prized during the late Ming. Small lacquer objects circulated easily among the urban elites, but large, expensive pieces of lacquer furniture were considered particularly ostentatious – sets of lacquer furniture were commissioned for imperial palaces, and were regarded as decadent outside that context. Major urban centres were homes to celebrated artists and artisans of national reputation; they were also important sites of artistic production for more local consumption and reputation.

CONNOISSEURS AND THEORISTS
The late Ming was also a period in which antiques collecting flourished. Collecting enabled men of means to engage with the past through its material culture, and to assert their cultivation. As social mobility was broadly possible through the accumulation of wealth, or through success in the civil service examinations, the need to assert cultural sophistication was pressing. In addition to its ancient associations as a metaphor for the ability to make political decisions, connoisseurship legitimized the semi-public assertion of one's cultural sophistication. Together with poetry writing and painting, it became a component of literary gatherings. Connoisseurship manuals, for example, Wen Zhengheng's (1585–1625) *Superfluous Things*, became an important genre at this time. Interest in connoisseurship paralleled the

expansion of theoretical writing about painting. Extrapolating from Buddhist history and literary theory of the early Ming period, the painter Dong Qichang (1555–1636) described lineages of past painters in order to establish 'orthodox' models for current practitioners. Dong, whose work as an amateur painter complemented a successful political career, rejected the work of artisan painters in favour of those of his *literati* predecessors. Although Dong's historical knowledge of painting made him famous as a connoisseur, extant paintings appraised by Dong indicate that political expedience, rather than authenticity, was a frequent factor in his attribution. Increases in women's literacy are perhaps responsible for the larger number of recorded female artists, who included professional artisans, courtesans and gentry women. During the late Ming, traditional disciplinary boundaries between the visual arts eroded: while Dong, for example, stressed the interrelationship of painting and calligraphy, elite literary culture found expression in all media of the visual arts, and many forms of popular visual phenomena were manifest in literati texts and images.

The Tibetan Renaissance of c.1300–1500 fostered considerable artistic heterogeneity. Under the rule of the Gelugpa sect and the auspices of the Dalai Lama, there was a political consolidation of an unprecedented territory from the western border of modern Ladakh to the eastern borders of modern Sichuan and Yunnan. This political unification thus encouraged consolidation of Tibetan artistic production, especially in painting and sculpture. Tibetan art history was born in the writings of Pemo Karpa (1527–92), a Karma Kagyu religious master and painter who distinguished Tibetan religious art in historical and regional terms, and continued in the writings of Taranatha (1575–1635).

CHINA AND TIBET 1650-1800

THE MANCHU CONQUEST of China was consolidated in 1644 with the proclamation of the Qing (literally 'pure') dynasty. Under Ming rule, the capital of the empire had shifted north to Beijing despite the cultural primacy of south-eastern China. As nomadic people from northern Asia, the Manchu occupation and renovation of Beijing as a capital allowed China's new rulers to assimilate to pre-existing paradigms of imperial mandate and to place themselves in proximity to their ancestral lands to the north of China proper. The Qing imperium made its mark on the capital city by dividing it into an inner and outer city, inhabited by hereditary military families, Manchu and Chinese, and ethnic Chinese, respectively. The population may have reached 800,000 people.

DECORATIVE ARTS UNDER THE MANCHU
The Manchus were arbiters of popular custom, for example, requiring men under their power

1 THE MANCHU CONQUEST of China re-established stable but non-indigenous rule after the political infighting of the late Ming. As nomadic people, with ties to North and Central Asia, the Manchus had different customs from the Chinese. However, their policies maintained the economic stability of the empire, and encouraged greater contact with North and Central Asia, especially Tibet.

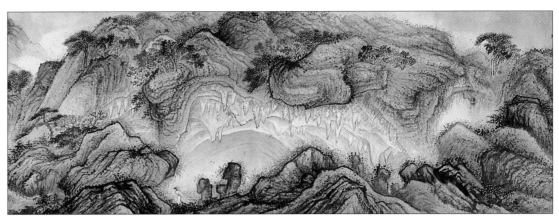

to wear the 'queue' – shaving the front of their head and wearing a long braid down the back. As patrons of the arts they promoted indigenous Chinese traditions, supported Western arts and artistic technology transmitted to China, and developed their own Manchu tastes. The imperial kiln at Jingdezhen continued to operate during the Qing Dynasty under the auspices of Chinese administrators, for example, Tang Ying (1728–56). In addition to production of blue-and-white wares, the Manchus increasingly used overglaze enamel to achieve new decorative effects. These included the development, circa 1723–35, of

Visit to Master Zhang's Grotto by Shitao. A scion of the first Ming emperor, Shitao was raised in a Buddhist monastery, unaware of his origins. He left monastic life to paint professionally and to explore Daoist philosophy. His treatise, *Huayu lu*, reinscribed individual creativity in a theoretical discourse of painting preoccupied with past models. This copy of Shen Zhou's (1427–1509) work of the same name represents the use of subjective visual experience to reinvent a past model.

so-called *famille rose* decoration, which used colloidal gold to create the pinks for which it was named, and lead-arsenic to create whites and opaque enamels. This technical transformation permitted greater verisimilitude

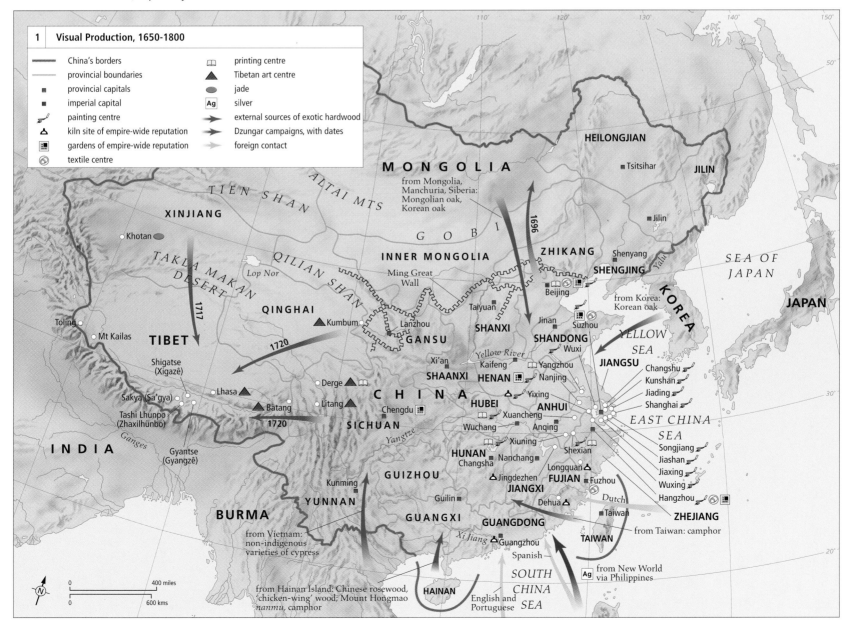

1	Visual Production, 1650-1800	
——	China's borders	📖 printing centre
——	provincial boundaries	▲ Tibetan art centre
▪	provincial capitals	⬮ jade
■	imperial capital	Ag silver
🖌	painting centre	➡ external sources of exotic hardwood
△	kiln site of empire-wide reputation	➡ Dzungar campaigns, with dates
▦	gardens of empire-wide reputation	➡ foreign contact
◎	textile centre	

2 THE CITY OF BEIJING and its enclosed Forbidden City, or Imperial Palace Complex, remained the centre of government administration under Qing Dynasty rule. The plan of Ming Dynasty Beijing was said to be based on the body of an eight-armed boy, Nezha, who had killed the son of the dragon king. Independently, during the Qing dynasty the Inner City was divided into designated quarters for the Eight Banners, the hereditary military class established under Manchu rule. The Outer City housed the ethnic Chinese strata of society.

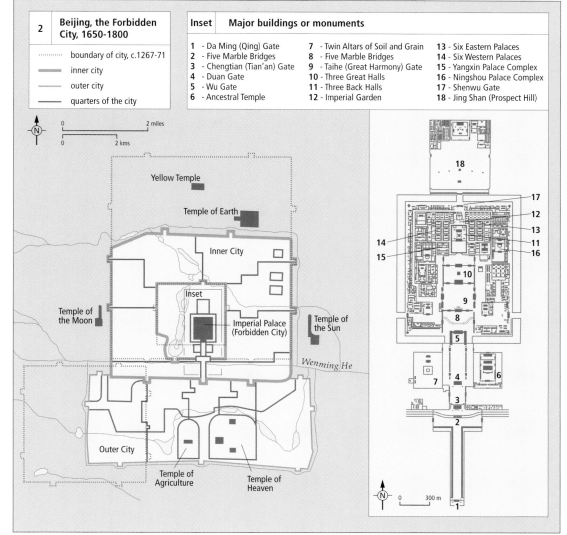

2	Beijing, the Forbidden City, 1650-1800
........	boundary of city, c.1267-71
	inner city
	outer city
	quarters of the city

Inset	Major buildings or monuments	
1 - Da Ming (Qing) Gate	7 - Twin Altars of Soil and Grain	13 - Six Eastern Palaces
2 - Five Marble Bridges	8 - Five Marble Bridges	14 - Six Western Palaces
3 - Chengtian (Tian'an) Gate	9 - Taihe (Great Harmony) Gate	15 - Yangxin Palace Complex
4 - Duan Gate	10 - Three Great Halls	16 - Ningshou Palace Complex
5 - Wu Gate	11 - Three Back Halls	17 - Shenwu Gate
6 - Ancestral Temple	12 - Imperial Garden	18 - Jing Shan (Prospect Hill)

in painting on porcelain, and is presumed to be the result of Dutch transmission of a technique already known in Vienna by 1725. Simultaneously, the Qing also developed highly vitreous enamelled monochrome wares for palace use.

Pictorial culture in China under Manchu rule developed in a number of directions. Firstly, the Orthodox tradition of Dong Qichang (1555–1636) was developed by practitioners in the southeast who retreated from the reality of Manchu rule into an art-historical past. These men, including Wang Shimin (1592–1680), Wang Jian (1598–1677), Wang Hui (1632–1717), and Wang Yuanqi (1642–1715) copied canonical works and creatively reworked the ideas of the canonical masters established by Dong. They perpetuated art-historical ideas in painted form as well as in their writings. Individualist painters, such as Shitao (1642–1707) and Bada Shanren (1626–1705), sought to address the question of Manchu rule through their exploration of self and subjectivity, creating works steeped in personal visual perception and psychological introspection.

At the Manchu court, patronage of painting reflected a willingness to experiment with divergent representational sensibilities. The

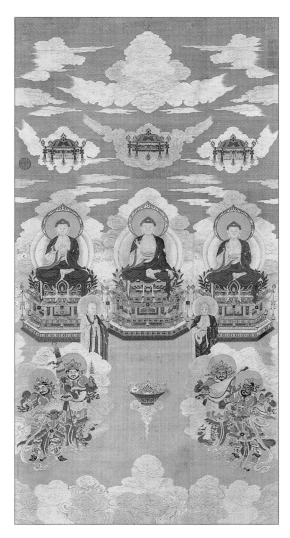

'BUDDHAS OF THE THREE GENERATIONS' is a silk tapestry manufactured in 1744 on behalf of the Qianlong emperor. Created in the style of the famous Buddhist painter Lu Lengjia (active c.730–60), the work depicts, left to right: Kashyapa, a Buddha of the past; Shakyamuni, Buddha of the present; and, Maitreya, Buddha of the future, and thus suggests the unbroken continuity of Buddhism. A nearly identical work was presented to the Dalai Lama by Qianlong.

Jesuit Giuseppe Castiglione (1688–1766), also known by the Chinese name of Lang Shining, introduced Western single-point perspective to the court, as well as colouristic techniques and *chiaroscuro*. However, Castiglione worked in traditional Chinese materials, and frequently painted traditional Chinese subjects, producing a remarkable hybrid European-Chinese painting style perpetuated by other Qing court painters.

THE DISSEMINATION OF MANCHU ART
As in previous dynasties, fine and decorative arts of local and regional reputation were produced throughout the Qing empire in urban centres such as provincial and prefectural seats. Unlike works of national reputation, few such works survive. The development of Chinese decorative arts during the Qing Dynasty was also affected by past traditions, Manchu culture and European influence.

The export of Chinese decorative arts, together with Chinese philosophy, created the craze for *chinoiserie* in Europe and her colonies during the eighteenth century. Although the Qing court was a patron of ornate lacquered furniture, Qing hardwood furniture maintained the clean, classical lines of the best Ming pieces. The export of Ming-style furniture to

Europe is thought to have resulted in the Queen Anne style, and in a heightened understanding of joinery, especially the use of mortise and tenons. Ceramics produced outside Jingdezhen, for example the teapots of Yixing, explored three-dimensional natural and geometric forms. These pots, as well as Jingdezhen wares, influenced the rise of porcelain manufacture in Europe, for example the 1710 establishment of the Meissen factory under the patronage of Augustus the Strong (1670–1733). Chinese ceramics also influenced the forms of English and American silver of the late seventeenth and early eighteenth centuries. Traditionally, Chinese pasted plain paper to their walls; European knowledge of this custom and access to inexpensive Chinese artisanal painting led to the development of hand-painted wallpaper for export to Europe.

As a result of civil unrest, Manchu troops were garrisoned in eastern Tibet, which subsequently became a Manchu protectorate under local Tibetan rule in 1725. Manchu control of the area was further consolidated by the installation of two Manchu imperial representatives in Lhasa from 1728 through to the end of the dynasty. The Qianlong emperor (r.1735–96) was a significant patron of Tibetan Buddhist teachers and Buddhist art; his patronage produced a hybrid Sino-Tibetan Buddhist art. Under Manchu rule, Eastern Tibet flourished, especially the city of Derge, whose princes supported Buddhist art and literature. Not only did painting flourish, for example as practised by Tshultrim Rinchen (1698–1774), but the existence of a large printing industry facilitated the empire-wide distribution of Derge images and texts, including Tshultrim Rinchen's work and a 1744 edition of the Buddhist canon.

JAPAN AND KOREA 1500-1800

WHILE THE CHOSON DYNASTY of Korea was fairly stable during much of the sixteenth century, Japan was torn apart by constant civil wars, which devastated Kyoto and dispersed many artists to provincial towns where they sought the patronage and protection of regional military rulers. The 1590s saw the reunification of Japan, and then the massive destruction of Korea by Japanese armies. Many Korean artists were forcibly taken to Japan and kept in isolated communities where they produced ceramics and other goods for their captors. This tragic situation changed the arts in both Japan and Korea; Korean potters significantly influenced Japanese ceramics in the following century, while Korea was struggling to recover its cultural heritage.

RECOVERY AND RENEWAL
When Japan was reunified in the 1590s, Kyoto – which had been destroyed repeatedly during the

1 ARTISTIC INFLUENCES reached Japan and Korea from China (and from Europe through China), inspiring individual artists to experiment with greater realism, *chiaroscuro* and one-point perspective while still using traditional materials and painting techniques. Some direct exposure to European arts was available in the sixteenth and early seventeeth centuries through foreign merchants and missionaries, and images of Europeans ('southern barbarians') were used in painting, ceramics, lacquer goods and textiles. But, from the seventeenth century, Japan and Korea tried to restrict contact with European culture.

civil wars – was rebuilt and flourished again as a centre of traditional arts. New urban centres (Osaka, Edo [Tokyo], Nagoya and Nagasaki) emerged as places of artistic experimentation, especially with arts connected to the *kabuki* theatres and the pleasure quarters. The newly enriched merchant class strongly supported the production of wood-block prints (*ukiyoe*) and illustrated books, textiles, ceramics and lacquerware. While professional painting guilds still provided traditional works for the imperial court and for military patrons, artists from the merchant and scholar classes explored new styles, often influenced by imported Chinese and Western prints and paintings.

Korea was invaded twice by Japan during the 1590s, and in the early seventeenth century Manchus also invaded, further destroying the economy and dispersing artists. From 1724 to 1800 two successive Korean rulers provided unity and stability for the kingdom, and the arts recovered, achieving new prominence and distinction. In painting attention was given to depicting 'true views' of the country and its people, rather than imaginary scenes, and a strong sense of national identity developed which emphasized how Korea could be different from China and Japan in the arts. Ancestral shrines were rebuilt, using architectural forms and layouts that differed from earlier Chinese-style buildings, and portrait paintings used in memorial ceremonies displayed a high degree of realism.

MATERIALS AND TECHNIQUES
In architecture, government buildings and Buddhist temples were still built using Chinese-style wooden post-and-beam construction. However, modifications were made to these continental prototypes, especially in residential structures, where the Koreans developed an underfloor heating system (*ondol*) and the Japanese used thick rice straw matting (*tatami*) to provide comfortable living spaces.

During the sixteenth and seventeenth centuries castles (a new architectural form) were constructed throughout Japan, and small rustic pavilions set in elaborate gardens were specially built for the tea ceremony. The aesthetic of 'refined rusticity' combined expensive materials with farm cottage forms to create a fantasy environment for the elaborate rituals of making and drinking tea. Country retreats, like Katsura Rikyu outside Kyoto, featured elegantly understated palace buildings and extensive plantings that made allusions to classical literature. In some urban centres, large *kabuki* theatres were constructed of wood,

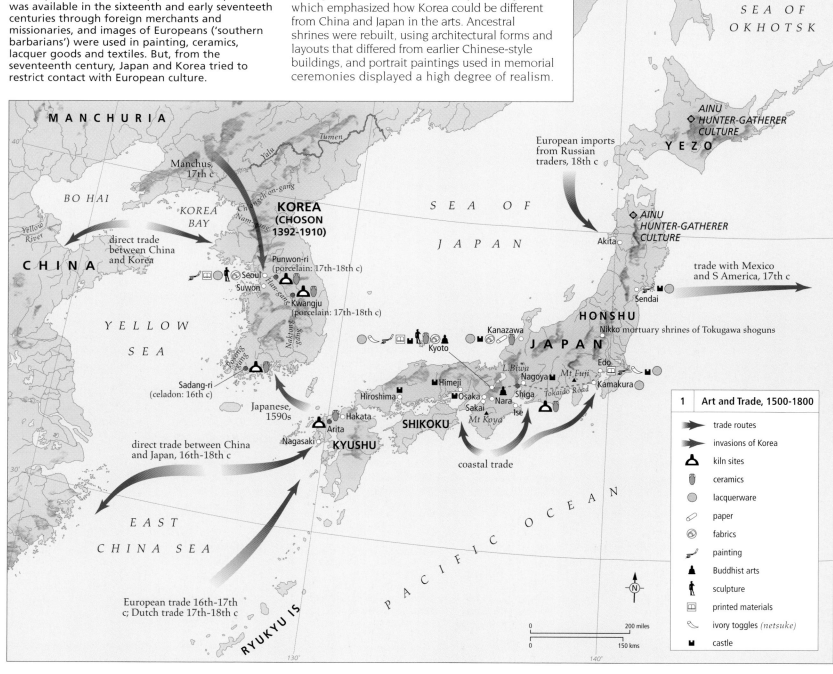

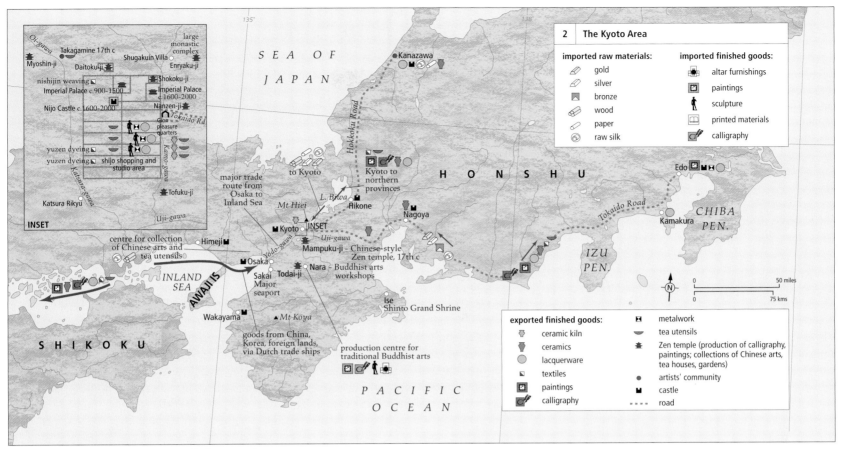

2 | The Kyoto Area

imported raw materials:		imported finished goods:	
	gold		altar furnishings
	silver		paintings
	bronze		sculpture
	wood		printed materials
	paper		calligraphy
	raw silk		

exported finished goods:			
	ceramic kiln		metalwork
	ceramics		tea utensils
	lacquerware		Zen temple (production of calligraphy, paintings; collections of Chinese arts, tea houses, gardens)
	textiles		artists' community
	paintings		castle
	calligraphy		road

2 IN THE EARLY SEVENTEENTH CENTURY, Edo became the headquarters of the Tokugawa shogunate. Concurrently, Kyoto was rebuilt with new palaces, gardens and temples, and regained its position as the primary centre for traditional arts. New castle towns (Himeji, Kanazawa, Nagoya and Osaka being the largest), linked by major roadways, also developed distinctive arts and crafts, usually funded by their military governors. Thus, regional styles in ceramics, lacquer ware, fabrics, paper and even paintings were encouraged.

with innovative staging devices for quick set changes and for dramatic entrances through trap doors or ramps in the audience area.

VISUAL ARTS

Painting in Japan and Korea continued to follow Chinese prototypes of ink and colours on silk or paper, though specific aspects of style and subject-matter varied such that each country developed distinctive characteristics. Professional guilds in Kyoto and Edo dominated official commissions; Kano artists generally maintained a modified Zhe School style of boldly brushed forms, while Tosa and Sumiyoshi painters revived delicately outlined and thickly coloured shapes. Most artists worked in a variety of formats, from large wall panels and folding screens to small albums, hand-scrolls and fans. Their clients were mainly military and imperial court officials.

In both Korea and Japan during the eighteenth century, some amateur and professional artists began to emulate the literati painting styles of the Chinese Wu School, who painted for themselves and friends, primarily as a means of self-expression and philosophical exchange. Chinese illustrated books on 'how to paint' (such as the M*ustard Seed Garden Painting Manual*) were imported and copied.

Wood-block printing became a major industry in Japan during this period, with illustrated guidebooks, histories and fictional works being produced inexpensively in Kyoto, Edo and Osaka. Initially, black-ink printed images on paper were hand-coloured, but by the mid-eighteenth century full-colour printing was widespread. *Kabuki* theatres and brothels in these urban centres also used printed broadsheets for advertising, and by the end of the eighteenth century some of Japan's best artists were creating designs for the print media. Publishers like Tsutaya Jusaburo in Edo produced works by Shunsho, Kitao Masanobu, Kiyonaga, Sharaku and Utamaro, some of the finest print designers of the late eighteenth century.

Large-scale sculptures in wood, metal and lacquered materials tended to follow earlier conservative prototypes, but small works such as ivory toggles (*netsuke*) and desk ornaments in stone, wood or bamboo were often both inventive and humorous. Household furnishings, especially lacquerware and ceramics, became elegantly refined in shape and decoration. Creamy white porcelains in Korea were not only favoured at court but also exported to China and Japan. A variety of painted ceramics were developed in Japan – many new shapes and glazes were developed for tea ceremony utensils. Extensive

kiln sites were established in northern Kyushu around Arita, in Honshu at Kyoto and in the Nagoya region. Metalworking focused on sword production and military paraphernalia.

Government-sponsored kilns at Punwon-ri, near Seoul, produced an exquisite and distinctive white porcelain for use at court and for export to China. Its undecorated cream-colored surfaces and austere elegant shapes were thought to reflect a purity of mind and moral character appropriate for Neo-Confucian patrons.

SELF-PORTRAIT by Yun Du-so (1668–1715). This portrait exemplifies the new realism that characterized Korean painting in the eighteenth century. A detailed 'true image' of a person was important for Neo-Confucian ancestral ceremonies.

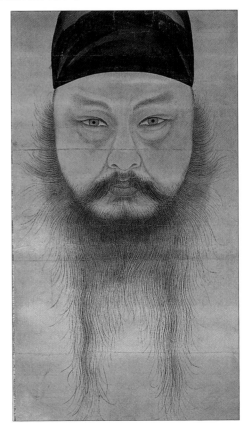

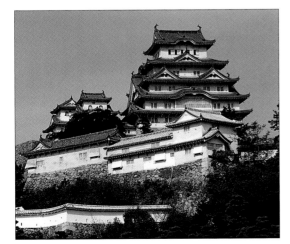

HIMEJI CASTLE, C.1600. In Japan during the sixteenth and seventeenth centuries fortified towns were built with multistoried towers, complex moats, and elaborate halls (*shoin*) for entertaining. Some of these military compounds included naturalistic gardens designed for strolling, boating and the tea ceremony. These compounds were probably inspired by reports from foreign traders and missionaries about European castles.

SOUTHEAST ASIA 1500-1800

BY THE BEGINNING of the sixteenth century the great empires of Angkor and Sukhothai had fallen into decline, to be overtaken by Ayutthaya in the central Thai plains.

TRADING NATIONS

During this period trade continued with China, India and the Arab world. Trading patterns in Southeast Asia were governed by the trade winds, which blow in a southerly direction into the Indian Ocean and South China Sea between December and March, and in a northerly direction between April and August. Chinese and Japanese ships sailed south in January or February and returned home in June or July, and the merchants spent the intervening months in Southeast Asia trading their wares as they waited for the winds to change. Gujaratis used the same winds in order to meet the Chinese ships while they were based in the region.

The traders formed sizeable communities in the major trading centres. They would spend many months living in the region, conducting trade with each other and with local merchants. This ethnic diversity, concentrated in coastal ports and delta cities, affected the religious and artistic climate of the region, and intermarriage added to the mingling of ideas. Ayutthaya, for example, although not a seafaring nation, was powerful on an international level, with a cosmopolitan population and a strong trade network. Malay and Chinese ships carried the bulk of its produce. There was a profitable commerce in export ceramics, particularly to Japan and the Philippines. Trade also flourished along the river routes: deerskins, benzoin (for incense), musk, lacquerware and other items were brought along overland routes and downriver in exchange for Indian cottons, Chinese silks and metalware.

European interests were now also aimed at the region. There was high demand in Europe for trade profits, and the lure of the spices (cloves, nutmeg and mace), grown only in the Moluccas, was the draw for Western trade companies such as the East India Company, which now competed with the traditional traders. Apart from these highly valued spices, trade items included pepper, ceramics, textiles, gems, exotic woods and lacquerware. As Portuguese, Spanish, Dutch, British and French communities appeared, the demand for items 'in the European taste' increased. Textiles, furniture and silverware were commissioned purely for the European market.

THE IMPACT OF RELIGION

Southeast Asia was characterized by its diverse religious beliefs. The Mahayana form of Buddhism was accepted in Vietnam, producing images such as the thousand-armed *bodhisattva* Kuan Yin, dating from the seventeenth century. In the other mainland countries, Theravaddha Buddhism was the

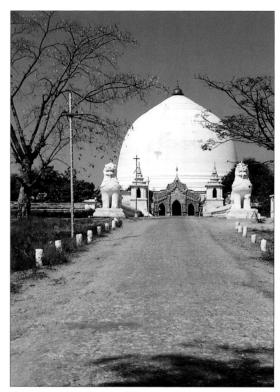

KAUNGHMUDAW PAGODA, Sagaing, Burma. Modelled on the Mahaceti Pagoda in Sri Lanka, it is the only one of its kind in Burma. Reaching a height of 46 metres (151 ft), it was built in 1636 by King Thalun to mark the return of the court to Ava. It enshrines a tooth of the Buddha.

1 THE DOMINANT POLITY on the mainland in the early sixteenth century was Ayutthaya in Thailand, which was to prosper for 400 years. Ayutthaya was an extremely wealthy cosmopolitan city-state because of its enlightened trading policies. In the south, Islam had entered the islands and Malaya and was now a major cultural force, influencing the artistic output of the region. Sculpture was no longer produced here, but craftsmen became skilled at creating the ornate designs and metalwork associated with Islamic art.

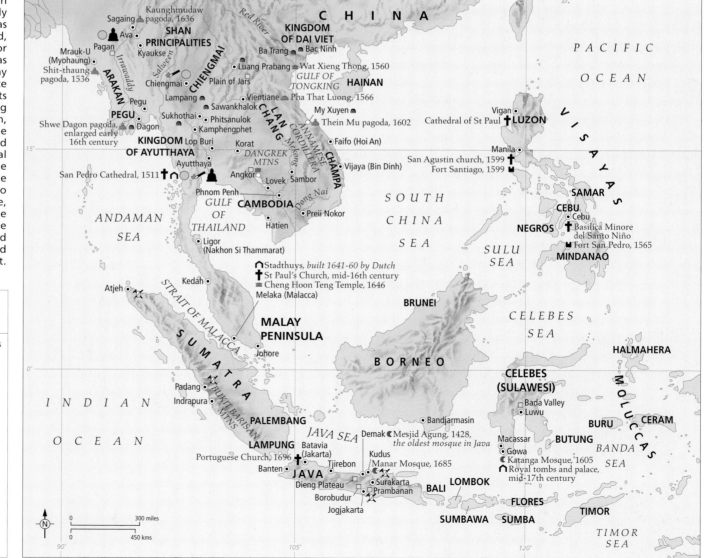

1	The Kingdoms of Southeast Asia, mid-17th Century
•	important towns and cities
▫	ancient religious sites
▲	centre of sculpture
▲	pagoda (*stupa*)
▬	*wat* or temple
†	cathedral / church
☪	mosque
⌂	fort
∩	other buildings of interest
▲	kiln site
⚒	gold and silver workshop
○	lacquerware
✎	wood carving

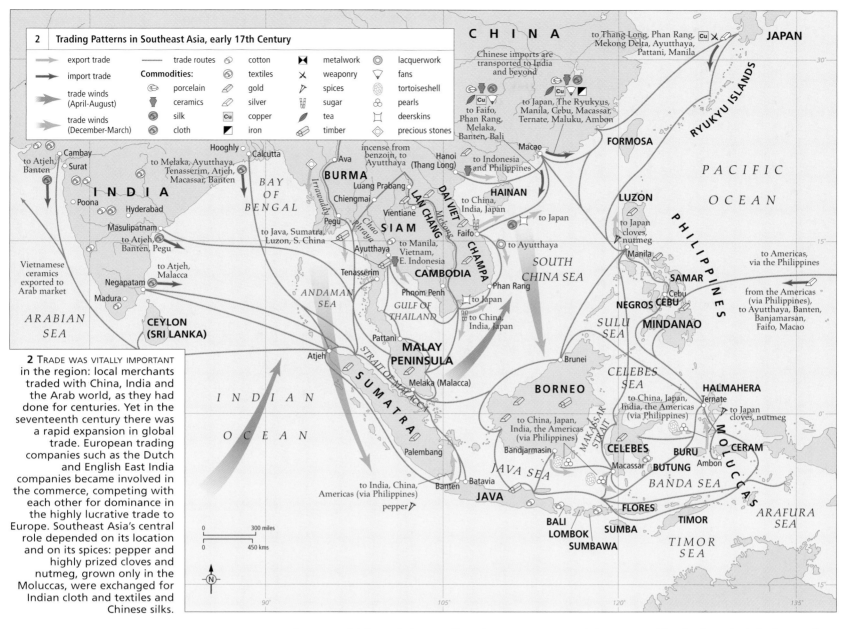

2 Trading Patterns in Southeast Asia, early 17th Century

2 TRADE WAS VITALLY IMPORTANT in the region: local merchants traded with China, India and the Arab world, as they had done for centuries. Yet in the seventeenth century there was a rapid expansion in global trade. European trading companies such as the Dutch and English East India companies became involved in the commerce, competing with each other for dominance in the highly lucrative trade to Europe. Southeast Asia's central role depended on its location and on its spices: pepper and highly prized cloves and nutmeg, grown only in the Moluccas, were exchanged for Indian cloth and textiles and Chinese silks.

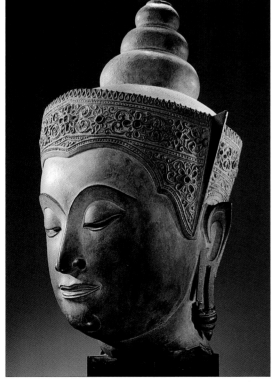

CROWNED BUDDHA, Ayutthaya, Thailand, sixteenth century. This magnificent bronze head shows many characteristics of the classical period of Thai art in the fourteenth and fifteenth centuries. The strongly arched brows over heavily lidded, downcast eyes, the strongly defined nose and incised mouth are typical. The Buddha wears a crown ornamented in the court style of the period.

dominant faith, and almost all sculpture was Buddhist, the most common work being of the Buddha seated in *bhumisparsa mudra* – calling the earth to witness his worthiness to attain Buddhahood.

Although Buddhism was the principal religion of the mainland, Confucianism and Taoism were also practised in Vietnam, while in the islands and in Malaya, Islam was the dominant faith. In the major Islamic cities of the south – where sculpture had once been very fine – art was now mainly non-figurative, in accordance with Islamic norms. However, bronze weaponry and other metalware was produced in great quantities. During this period, Christianity became popular amongst some hill tribe groups in the highland regions.

In the Philippines, Catholicism, introduced by the Spanish, rapidly replaced Islam and led to sculpture and painting in which the Virgin Mary and the saints were depicted. Christianity spread into eastern Indonesia and New Guinea. Bali alone retained the ancient Hindu beliefs, once widespread.

Everywhere, however, animistic beliefs underlay these world religions. Southeast Asians had a strong belief in the spirit world, in spirits that inhabited the trees, water and mountains, and which influenced human life for good or ill according to the respect accorded to them. Some of these spirits – the earth goddess, for instance – became merged in some cases with Hindu deities and were also accepted into the Buddhist pantheon. Everywhere death rituals were characterized by

celebration and by the burial of cloth, jewellery and ceramics with the deceased. Wooden ancestral sculpture and masks played an important role in ritual life.

CULTURAL INFLUENCES
Countries within the region influenced each other's artistic production in complex ways, partly through trade, and partly due to the widespread custom of taking captives in great numbers after battle. Skilled craftsmen were often transported between countries and courts in this way. The resulting fresh artistic input was felt particularly in the fields of sculpture and architecture but was also evident in crafts such as ceramics and lacquerware. Portable items were also carried off as booty during warfare, further complicating later identification. The finest works of art were produced in the major cities. Rulers were the major benefactors and commissioners of religious architecture and fine sculpture, and royal cities with their magnificent courts were magnets for craftsmen of all types.

Fine textiles were produced in every region. Textiles were usually woven on simple backstrap looms and bore designs and motifs particular to their community. The tie-dye method was widespread. There was also a demand for Indian textiles, which formed a large proportion of trade imports into Southeast Asia. Silks were produced in some parts, and *batik* was popular in Java and the neighbouring islands.

THE PACIFIC 1500-1800

THE KEY EVENT of this period was the intensive exploration of the Pacific by Europeans in the eighteenth century, including English, French and Spanish voyagers. This

1 THE COOK VOYAGE COLLECTIONS show a direct correlation between the length of time spent at an island and both the quantity and nature of the objects collected. With long acquaintance, voyagers were more likely to acquire valuable and sacred items in trade or gift exchanges. The exception was Hawaii, where Cook's arrival coincided with rituals for the god Lono – Hawaiians included Cook in the celebrations, and bestowed precious gifts on him. Even so, for all island groups, sacred or valuable objects are less prevalent in the collections than ordinary items such as tools and fishhooks.

meant that Pacific Islanders and Europeans came into more sustained contact than ever before. The Enlightenment scientific spirit of enquiry also meant that such encounters were more thoroughly documented and widely published than previously. The knowledge gained from these voyages contributed not only to European geography and natural history, but also to philosophy – the idea of the Noble Savage, for example, was widely debated via accounts of Pacific peoples – and the arts.

For Pacific Islanders, extensive contact with Europeans also changed their worlds in profound ways. New trade goods, including woven cotton cloth, glass beads, nails, chisels and axes, transformed artistic traditions and

prompted the creation of new images and styles. At the same time, the arrival of outsiders sometimes threatened to upset the local balance of power. Virulent new diseases, land claims and deadly conflicts between Europeans and Islanders also formed part of the contact experience.

THE COOK VOYAGES
The three Pacific voyages of Captain James Cook (1728–79) between 1769 and 1780 were the most comprehensive undertaken by any European nation at that time. Accompanied by astronomers, naturalists and artists, each voyage had a scientific goal: to trace the transit of Venus across the sun (in an attempt to

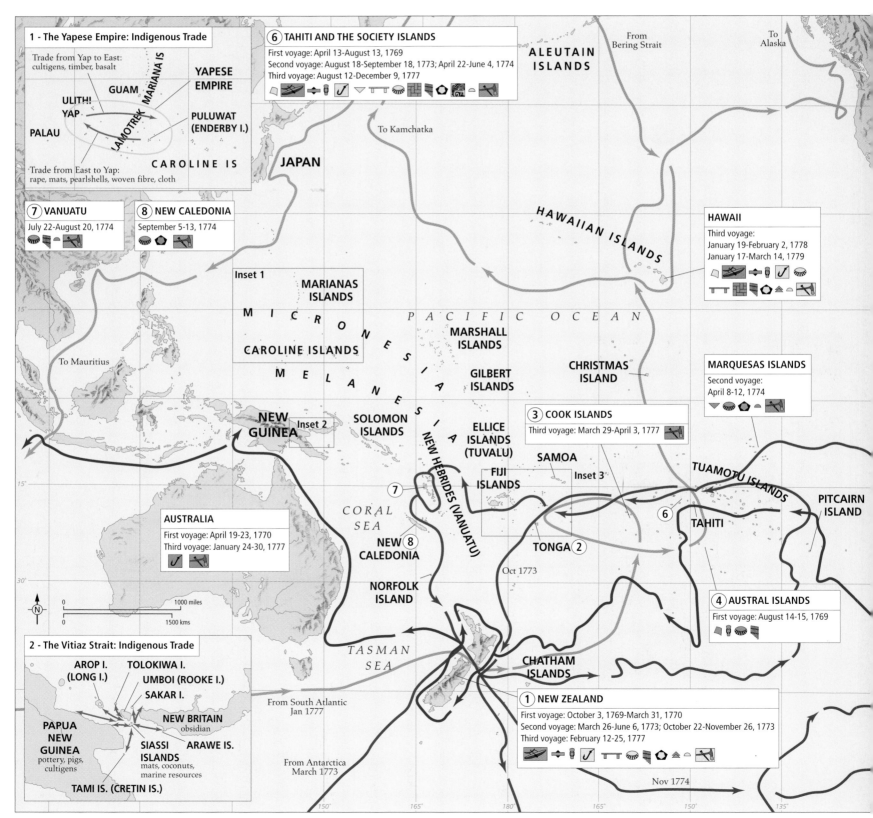

DANCE APRON, TONGA. During his Second Voyage (1772–5), when Captain James Cook and his crew visited Tahiti for the second time, they found, to their surprise, that the dance aprons they had collected in Tonga were valuable trade items – not in themselves, but for the red feathers they incorporated. In Tahiti, red feathers were a medium for the gods, and ornamented both god figures and the girdles worn by the highest-ranking titleholders.

improve navigational techniques), to find the Southern Continent and to find the Northwest Passage. Of course, these goals were not purely scientific, but had important military and economic implications as well. Significantly, the Royal Society, a scientific association, and the Admiralty sponsored the voyages together. The separate instructions Cook received from these organizations reflect their sometimes conflicting ideas about the voyages – the Admiralty, for example, ordered Cook to claim newly discovered land in the name of the king, while the Royal Society instructed him to respect the land rights of indigenous peoples.

In pursuit of these scientific goals, the voyagers sometimes spent weeks, even months, in various island groups, including New Zealand, Tahiti, Tonga and Hawaii. They developed sustained relationships with many individual Islanders and had an unprecedented opportunity to observe Pacific cultures. The arts played a key role in the exchanges between Islanders and voyagers. Islanders gave the voyagers gifts of regalia, cloth, tools and other objects to indicate goodwill and cement relationships, and they also traded such things for the new materials and objects brought by the voyagers. The collections and journals created on these voyages are today a major source of knowledge about eighteenth-century Pacific cultures, complementing Islanders' own oral histories and the archaeological record.

'FATAL' IMPACT?

The contact experience is sometimes discussed in terms of the 'fatal' impact of Europeans on Pacific Islanders, but it is essential to separate the issues of health and government from cultural practice. The severely negative impact of Europeans on the Pacific Islanders in terms of disease, violence and dispossession of land cannot be overstated. Some of these effects were experienced immediately in the eighteenth century, others only fully so in the nineteenth century.

The idea of fatal impact works rather differently when the focus turns to culture. If populations were decimated, the argument goes, then culture must have been destroyed as well. This viewpoint implies, mistakenly, that Pacific cultures were weak and inferior to European culture, and that they had no control over the degree to which they assimilated

European practices. For the visual arts, a fresh examination of the archival and material record suggests that in the eighteenth century, Pacific Islanders responded very strongly to certain materials and images introduced by Europeans. At the same time, artistic styles, forms, and usages showed tremendous continuity. It is important to remember that innovation is a fundamental part of tradition, and that Pacific cultures were never timeless and unchanging.

A good example of this is Tahitian resistance to trading mourning dresses during Cook's first and second voyages. The mourning dress, a spectacular costume incorporating a pearl-shell mask and feather cape, was worn to mark the death of high-ranking titleholders. Cook voyagers greatly admired them, and offered desirable items in trade, but Tahitians refused. Only on Cook's third visit to Tahiti, during his Second Voyage, did Tahitians consent to trade mourning dresses. This was because the voyagers had inadvertently brought something more valuable: red feathers that ornamented artefacts collected in Tonga. With time, trading and gift-giving patterns changed. When the ill-fated *Bounty* arrived in 1788, the powerful titleholder Pomare I (c.1750–1803) chose to entrust Captain William Bligh (1754–1817) with a gift of two mourning dresses for George III.

In fact, the experience of interacting with such foreign visitors was not entirely new for many of the Pacific peoples encountered by Cook and other voyagers – long before the arrival of Europeans, trade, warfare and diplomatic alliances took place between islands and between island groups. In western Polynesia, for example, Samoa, Tonga and Fiji maintained active relations. Tongan canoe builders often went to Fiji to work, and pottery, bark cloth and mats were traded widely. In eastern Polynesia, the Tuamotu Islanders traded pearl shells and bundles of white dog hair (used to ornament regalia) to Tahiti and the Society Islands. While the arrival of European visitors may have been remarkable in many respects, it was not long before they were encompassed within long-standing frameworks of human relations.

GABLE FRONT. The Maori people of New Zealand already had a remarkable sculptural tradition before the arrival of Europeans. Imposing architectural panels depicted gods, ancestors and mythic creatures, as did smaller figures and objects in wood and stone. During the late eighteenth and early nineteenth centuries, Maori traded for nails, chisels, axes and other tools that transformed their sculptural style. Surface decoration became increasingly elaborate, both on large architectural works and small items like treasure boxes.

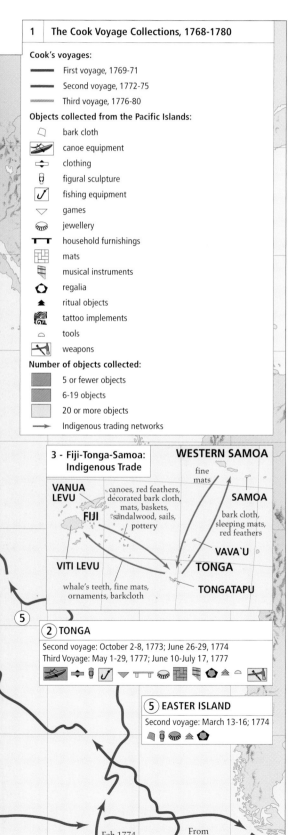

1	The Cook Voyage Collections, 1768-1780

Cook's voyages:
— First voyage, 1769-71
— Second voyage, 1772-75
— Third voyage, 1776-80

Objects collected from the Pacific Islands:
- bark cloth
- canoe equipment
- clothing
- figural sculpture
- fishing equipment
- games
- jewellery
- household furnishings
- mats
- musical instruments
- regalia
- ritual objects
- tattoo implements
- tools
- weapons

Number of objects collected:
- 5 or fewer objects
- 6-19 objects
- 20 or more objects
- → Indigenous trading networks

3 - Fiji-Tonga-Samoa: Indigenous Trade

WESTERN SAMOA

fine mats

VANUA LEVU

canoes, red feathers, decorated bark cloth, mats, baskets, sandalwood, sails, pottery

FIJI

SAMOA

bark cloth, sleeping mats, red feathers

VAVA`U

VITI LEVU

TONGA

whale's teeth, fine mats, ornaments, barkcloth

TONGATAPU

(2) TONGA

Second voyage: October 2-8, 1773; June 26-29, 1774
Third Voyage: May 1-29, 1777; June 10-July 17, 1777

(5) EASTER ISLAND

Second voyage: March 13-16; 1774

Feb 1774 From Cape Horn

105° 90° 75°

ART, INDUSTRY AND SCIENCE 1800-1900

THE MAKING, THE USE AND THE UNDERSTANDING OF ART were all transformed during the nineteenth century under the impact of industry and science, which for the first time put all parts of the world in touch with each other. Engines, powered first by steam and later by electricity and internal combustion, allowed mechanization, which in turn brought an acceleration of everything from the production and distribution of goods to travel. Objects, from printed textiles to lithographic images, from furniture to the parts of buildings, could be replicated cheaply, making them available to new markets. People could travel farther, faster and in larger numbers, whether locally or globally, whether to commute or to emigrate, whether for leisure or for research.

MACHINES MAY HAVE BEEN DEVELOPED FIRST in Britain and continental Europe, but they were used increasingly widely and came to affect lives all over the world. The raw materials required by an industry might be found in one place and turned into goods in another, while those goods would then be sold in many more, in a circulation involving many individuals. All the processes involved became more effective as the knowledge on which they were based became more reliable, and that stimulated the improvement of science. Science as such was a European creation, but worldwide there was a more limited expansion of less formal knowledge, as people everywhere had new experiences, either because they were imposed on them, as by missionaries and colonial administrators, or because they were the result of chance contacts. In the field of the visual arts, everyone had access to a wider range of models. In Europe, museum collections expanded to accommodate the arts of every continent. Worldwide, all sorts of foreign artefacts were displayed on streets, in markets and in public buildings. Thus, everyone had some freedom to choose between their own way of making and using art and those of others who might live thousands of miles away.

THE WAY THIS NEW FREEDOM COULD PROVOKE CHANGE is well demonstrated by one particular response to London's Great Exhibition of 1851. The Crystal Palace, a vast glazed hall put together in a few months out of standard cast-iron components, displayed goods from many countries to over six million visitors with surprising results. Many of the British visitors were disturbed to find that their own products, however clever the process by which they were made, were surpassed in the quality of both craftsmanship and design by those created by people they thought of as their cultural inferiors. Owen Jones, who had himself based the colours of the Crystal Palace on Islamic tastes, was a leader in this self-criticism, and his *Grammar of Ornament* (1856) published designs

from many periods and peoples, including modern Oceania and ancient India. The *Grammar* was intended to improve British art by encouraging the imitation of early and distant cultures that were less advanced, and soon William Morris and others had extended this preference for the less sophisticated to Europe's own local folk and vernacular traditions. By the end of the century, alongside the traditional galleries filled with Classical statues and Old Masters, there were permanent collections of both folk and exotic objects. The products of East European peasants and Japanese artisans were influencing art from Vienna to Paris.

IN OTHER REGIONS THIS SITUATION WAS OFTEN REVERSED. Centralized empires such as the Turkish, and, even more decisively, the Japanese, abandoned policies of relative isolation and set out to imitate the industry, science and art of Europe, as did the newly independent Spanish and Portuguese colonies of Latin America. This, though, was only part of the story outside Europe. In many places local art foms took on a new lease of life. New and much more efficient and cheap steel tools, for example, allowed communities that had previously had to rely on stone implements to improve their own traditions by making works that were both larger and more permanent. This was most strikingly the case with the carved houses of the Maori and the totem poles of the peoples of the northwest coast of America, but the same phenomenon was found throughout Africa. New styles were also developed around new imported artefacts. Mass-produced glass beads allowed refined beadwork objects to be made by many of the native populations of both the United States and sub-Saharan Africa. Even more intriguingly, a wide variety of European objects, from nails and locks to buttons and mirrors, were used to enhance the appearance and the magic of many African ritual objects at the very moment that their power was threatened by Christianity. Hence, at the same time that much art was being either destroyed by missionaries or seized as booty – as in the sack of Benin in 1897, which distributed a great collection of Nigerian bronzes around Britain, France and Germany – much more was being created in an invigoration of local traditions.

IN EUROPE ITSELF, one of the main factors revitalizing art was a reaction against industrialization, often in the name of science and the pursuit of the natural. Owen Jones saw 'savage' cultures as more natural in a positive sense, while William Morris rejected the machine in favour of the hand and eventually the imitation of nature created the organic forms of Art Nouveau. In painting the French Impressionists tried to capture something of external nature, often by analogy with a camera, while the Post-Impressionists were influenced by Chevreul's theory of colour and Helmholtz's physiology of perception. Behind these developments, though, the most important advance was the progressive improvement in the understanding of the nervous system and the brain, and it was this that, before 1900, inspired the first truly professional art historians, those in the German-speaking world led by the Swiss Heinrich Wölfflin. With the ability, for the first time, to travel great distances easily by train, his knowledge surpassed that of his predecessors, enabling him to imagine a history of art as a worldwide project founded in a scientific psychology.

BIBLIOTHÈQUE SAINTE-GENEVIÈVE in Paris, 1839-51, by Henri Labrouste showing the exposed cast-iron frame.

NORTH AMERICA 1800-1860

BEFORE THE NINETEENTH century was fifteen years old, the new nation of the USA had, in the War of 1812, repelled the British from the East Coast for a second time and, in the expedition (1803–6) of Meriwether Lewis and William Clark, blazed trails to the shores of the Pacific. In Canada, whose explorers had reached the Pacific in the 1790s, British-trained topographical engineers were also surveying and recording the landscape. Painters and photographers – from John Vanderlyn (1775–1852) at Niagara Falls in 1801 to Paul Kane (1810–71) in Vancouver in 1848, Albert Bierstadt in the American West in 1858, and Frederic Church in Labrador in 1859 – set forth across the continent capturing visions of the uncharted terrain and its inhabitants.

PIONEERING ARTS
Regions of the continent attracted artists of different temperament. Karl Bodmer (1809–93), George Catlin, and Paul Kane set out west with an eye toward documenting the native peoples as much as the landscape. Eastern artists such as Thomas Cole (1801–48), Asher B. Durand (1796–1886) and Frederic Church travelled up the Hudson River from New York City in search of sublime vistas empty of inhabitants.

NIAGARA FALLS, 1867, by Frederic Edwin Church (1826–1900), oil on canvas. By the 1860s, Niagara Falls had provided generations of American artists with the most dramatic scene of the national landscape. As Roebling was spanning the river with suspension bridges of stone and steel, Church gave this symbol of the force of the continent a palpably physical and comfortingly visible form.

1 ANGLO-AMERICAN ARTISTS found inspiration in the landscape and culture of North America as they spread the reach of European culture west to the Pacific. The routes and communities of artist-explorers are charted against the activities of indigenous cultures. Architecture of the period was marked by the spread of Neoclassicism, evident in the capitol buildings from Washington DC to California or plantations in Louisiana. The historicism of the period found its complement in new modern markets, prisons and bridges.

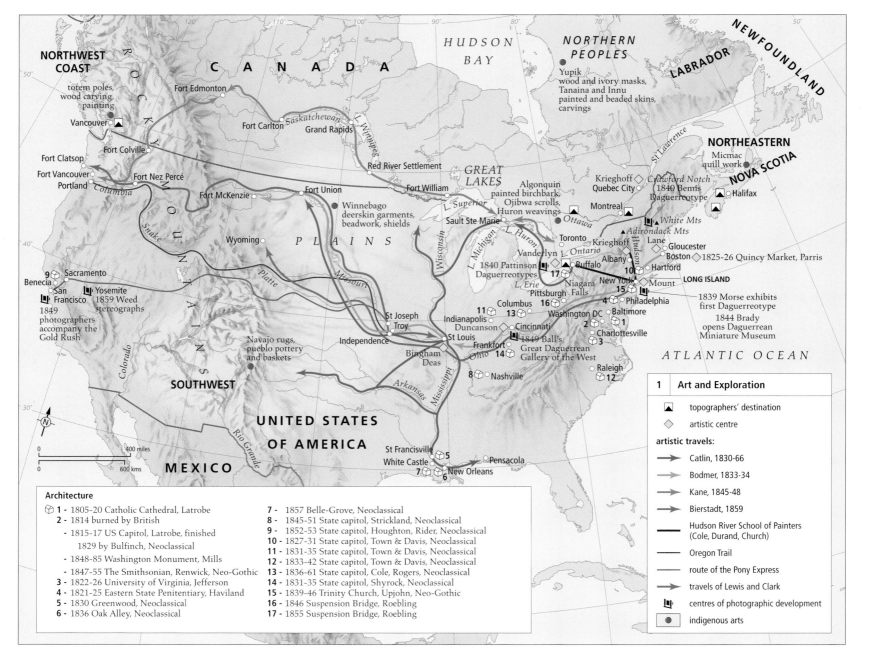

Architecture

1 - 1805-20 Catholic Cathedral, Latrobe	**7** - 1857 Belle-Grove, Neoclassical		
2 - 1814 burned by British	**8** - 1845-51 State capitol, Strickland, Neoclassical		
- 1815-17 US Capitol, Latrobe, finished 1829 by Bulfinch, Neoclassical	**9** - 1852-53 State capitol, Houghton, Rider, Neoclassical		
- 1848-85 Washington Monument, Mills	**10** - 1827-31 State capitol, Town & Davis, Neoclassical		
- 1847-55 The Smithsonian, Renwick, Neo-Gothic	**11** - 1831-35 State capitol, Town & Davis, Neoclassical		
3 - 1822-26 University of Virginia, Jefferson	**12** - 1833-42 State capitol, Town & Davis, Neoclassical		
4 - 1821-25 Eastern State Penitentiary, Haviland	**13** - 1836-61 State capitol, Cole, Rogers, Neoclassical		
5 - 1830 Greenwood, Neoclassical	**14** - 1831-35 State capitol, Shyrock, Neoclassical		
6 - 1836 Oak Alley, Neoclassical	**15** - 1839-46 Trinity Church, Upjohn, Neo-Gothic		
	16 - 1846 Suspension Bridge, Roebling		
	17 - 1855 Suspension Bridge, Roebling		

1 Art and Exploration

▲ topographers' destination
◇ artistic centre

artistic travels:
→ Catlin, 1830-66
→ Bodmer, 1833-34
→ Kane, 1845-48
→ Bierstadt, 1859
— Hudson River School of Painters (Cole, Durand, Church)
— Oregon Trail
— route of the Pony Express
→ travels of Lewis and Clark
▮ centres of photographic development
● indigenous arts

Numerous artists made careers for themselves away from the metropolitan centres of the east. George Caleb Bingham (1811–79) began a long career as artist and statesman in St Louis, Missouri, in 1819 and others, like Charles Deas (1818–67), followed suit. By the end of the next decade William Sidney Mount (1807–68) was painting local scenes with local pigments in Long Island, New York, while in Gloucester, Massachusetts, Fitz Hugh Lane (1804–65) would soon establish his national reputation. Regional centres often supported artists whose nationality or ethnicity mark the changing demographics of the continent. Painting in the outskirts of Quebec City, the German immigrant Cornelius Krieghoff (1815–72) established himself as the foremost Canadian painter. Cincinnati, Ohio, across the Ohio River from the slave state of Kentucky, supported the only African American associate of the Hudson River School: the American- and Scottish-trained Robert Duncanson (1821–72). Cincinnati also facilitated the photographic activities of free blacks, including James Presley Ball (1825–1904/5) who opened 'Ball's Great Daguerrean Gallery of the West' there in 1849.

When Ball opened his gallery, North American photography was only a decade old. Daguerreotypes had been introduced in New York by Samuel F. B. Morse (1791–1872) in 1839, and within a year H. L. Pattinson (1796–1858) was at Niagara Falls in New York State and Samuel Bemis (1789–1881) was in the White Mountains in New Hampshire pioneering landscape photography. By 1844, there was enough interest in photography to convince Mathew Brady (1823–96) to open his Daguerrean Miniature Museum in New York City. With the Gold Rush of the late forties, photographers followed prospectors out west to document the natural wonders of Yosemite and outpost cities such as San Francisco.

INDIGENOUS ARTS
A wealth of Native American art was being discovered as the artist explorers moved west. Typical of the pioneers, Paul Kane reported his distaste for most of what he saw as he crossed

2 EDUCATION AND CULTURE continued to draw North Americans to Europe. Rome, London, Paris and Düsseldorf provided artists with advanced training. As the continent entered the new century, returning artists joined the cultural elite to foster the arts. The Library of Congress, founded in 1800, was the first of many institutions that dotted the eastern seaboard.

the Canadian south, but still pocketed small utilitarian items he found artfully crafted. Indigenous art was encountered on the Northwest Coast through the Plains and the Great Lakes region south to the American Southwest. The variety of native arts, all of which would become part of western collections in the second half of the century and would then be circulated in exhibitions in the next, included objects as diverse as Ojibwa scrolls and Tlingit totem poles.

ARCHITECTURE AND SCULPTURE
Significant architectural developments also followed the westward expansion. Two English-trained architects, Benjamin H. Latrobe (1764–1820) and John Haviland (1792–1852), led the way. Latrobe, made Surveyor of Public Buildings by US President Thomas Jefferson in 1803, laid the groundwork for rebuilding Washington DC after the British razed the city in 1814. As Latrobe and his successors were creating a classical monument to American democracy in the form of the Capitol building, Jefferson himself was perfecting his colonial classicism in his city of knowledge, the University of Virginia, which he founded at Charlottesville in 1825. Haviland's fusion of knowledge and architecture proved quite different from Jefferson's. His Eastern State Penitentiary in Philadelphia of 1821–5 was built as a set of radial arms that permitted a centrally posted guard to watch over inmates.

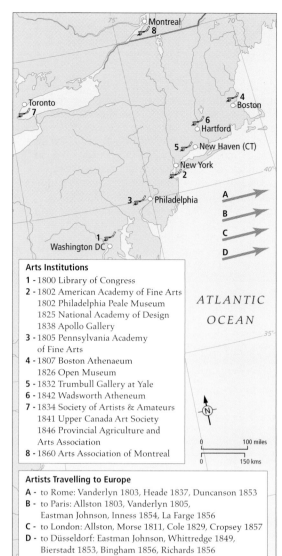

Arts Institutions
1 - 1800 Library of Congress
2 - 1802 American Academy of Fine Arts
 1802 Philadelphia Peale Museum
 1825 National Academy of Design
 1838 Apollo Gallery
3 - 1805 Pennsylvania Academy
 of Fine Arts
4 - 1807 Boston Athenaeum
 1826 Open Museum
5 - 1832 Trumbull Gallery at Yale
6 - 1842 Wadsworth Atheneum
7 - 1834 Society of Artists & Amateurs
 1841 Upper Canada Art Society
 1846 Provincial Agriculture and
 Arts Association
8 - 1860 Arts Association of Montreal

Artists Travelling to Europe
A - to Rome: Vanderlyn 1803, Heade 1837, Duncanson 1853
B - to Paris: Allston 1803, Vanderlyn 1805,
 Eastman Johnson, Inness 1854, La Farge 1856
C - to London: Allston, Morse 1811, Cole 1829, Cropsey 1857
D - to Düsseldorf: Eastman Johnson, Whittredge 1849,
 Bierstadt 1853, Bingham 1856, Richards 1856

PORTRAIT OF BLACK HAWK, Indian chief, colour lithograph by George Catlin (1796–1872), National Portrait Gallery, Smithsonian Institution, Washington DC. Travelling west from eastern cities in the US and Canada, artists such as Catlin, Bodmer and Kane sought to document the indigenous cultures of North America. Catlin's Indian Gallery, from which this image of Black Hawk derives, was a collection of paintings and artefacts that toured North America and Europe, producing a record of native peoples that continues to impress viewers with its interest in the humanity as well as the individuality of its subjects. Black Hawk was the leader of the Sauk and Fox tribes during the Black Hawk War of 1832, a struggle against white settlers encroaching on native lands in the states of Illinois and Wisconsin. This image demonstrates Catlin's sensitivity to detail and personality as well as his interest in circulating his vision of North America's First Peoples.

While Haviland was experimenting with new techniques of observation and control, more conventional technologies were being developed. In the 1820s the mining of granite at Quincy, Massachusetts, aided by the first railroad in North America, shaped the appearance of contemporary municipal architecture. The most conspicuous destination for Quincy granite was the Quincy Market in Boston by Alexander Parris (1780–1850). Parris used the stone to dress a skeleton of cast-iron supports, a novelty that soon became essential to construction. In the mid-century John A. Roebling (1806–69) created the great suspension bridges over the Monongahela River in Pittsburgh and the Niagara River in New York, prototypes for his Brooklyn Bridge begun the following decade.

The Greek revival of Latrobe and Jefferson was adopted in state capitols from Hartford, Connecticut, to Benecia, California. Plantation estates built near New Orleans, beginning in the 1830s, mark the southern migration of Greek revival architecture. A tour from New York to Cincinnati of Hiram Powers's Neoclassical sculpture Greek Slave (1843) signalled a similar revivalist taste in sculpture. The picturesque Neo-Gothic that came of age in Pugin's Houses of Parliament, begun in London in 1836, was also successfully transplanted to the Americas. Taste for the medieval is evident in such monuments as Richard Upjohn's 1839–46 Trinity Church in New York City and James Renwick's Smithsonian Institution (1847–55) in Washington DC. From the late 1840s into the 1880s, the great Egyptian obelisk of Robert Mills's Washington Monument rose as a testament to the eclecticism and energy of the century.

NORTH AMERICA 1860-1900

THE PEACE THAT FOLLOWED the Civil War (1861–5) enabled North America to concentrate on the creation and disposition of colossal wealth. New technologies altered the physical and aesthetic relationships between human beings and landscape. Photographers had enlisted the new art of photography to comprehend the catastrophe of the Civil War. Mathew Brady and Alexander Gardner published photo albums that transformed the image of war from one glorifying patriotic battle to one concerned with recording the sites and mourning the dead.

As the nation healed, its artists looked beyond the technology of the camera to the needs of the growing cities. America's new art form was the massive rectilinear structure of the city – the steel grids of skyscrapers pushing ever higher, the spreading grid of streets and the straight-drawn lines of property claims and of new city layouts. The construction of skyscrapers was finally perfected in the late 1880s, their form conditioned not only by steel-beam technology, but by the prior inventions of the lift (1852), the telephone (1872) and the light bulb (1879). Technology, cartography and perspective possessed the land. Photography documented the untamed and, in so doing, tamed it.

1 AS THE CITIES OF AMERICA GREW, the spectacular landscapes of the West became better-known. Scientists and surveyors, railroad speculators, painters and inventors like George Eastman (1854–1932), whose Kodak camera was brought out in 1888, made the landscape a commodity – bringing home images, stimulating mass travel and drawing the boundaries of parks and reserves.

Older art forms survived and a style of painting was developed that was vividly perspectival, evoking and measuring immense distances. *Grand Canyon of the Yellowstone* by Thomas Moran (1837–1926) brought the dramatic scenery of the West to Washington in full colour. Bought by Congress, it played a key role in starting the National Parks programme. Moran went out West as a guest of a national scientific and survey expedition led by Dr Ferdinand Vandiveer Hayden, but he used the Northern Pacific railroad to get there. The railroad financiers had their eye on the scenery and on bringing tourists out West to look at geysers and gorges. In the USA and Canada artists provided the imagery for the public perception of the railroads. In 1882 just a year after construction on the Canadian Pacific Railway began, Lucius O'Brien instructed artists to travel from the Gaspé Peninsula to the Rocky Mountains for *Picturesque Canada* (ed. Principal Grant, Queens University, Kingston Ont.). Upon completion of the railway in 1885, Sir William Van Horne of Montreal commissioned artists to travel West and send back images of the Canadian Rockies for eastern galleries.

THE ACQUISITION OF EUROPEAN ART
The same economic power that generated all this invention and industry also created enormous surpluses of private wealth. To fill these empty rooms, to flesh out this unprecedented prosperity, came the biggest transfer of cultural property in history: European artworks – Barbizon landscapes, Old Masters, altarpieces and allegories, marbles,

ANONYMOUS TLINGIT CARVER: mask of a land-otter man, to be worn by a shaman. Made from wood, copper, bearskin, hide, nails and pigment, c.1850, it was collected before 1875 by James G. Swan in Alaska. The Tlingit considered the land otter a go-between for shamans attempting to control potent spirits.

manuscripts, porcelain and genre paintings. The huge collections of bankers, industrialists and their heirs laid the foundations of the great civic, state and national US museums and art galleries. But America was not just filling its empty rooms at random. In 1888 Isabella Stewart Gardner, advised by Bernard Berenson, bought a Madonna by Zurbarán and during the following years bought works by Titian and Raphael, medieval panelling and tapestries, carved cabinets, ancient stonework and coloured glass, turning her house into an inward-looking dream of a Venetian palace. This was the flowering of that North American

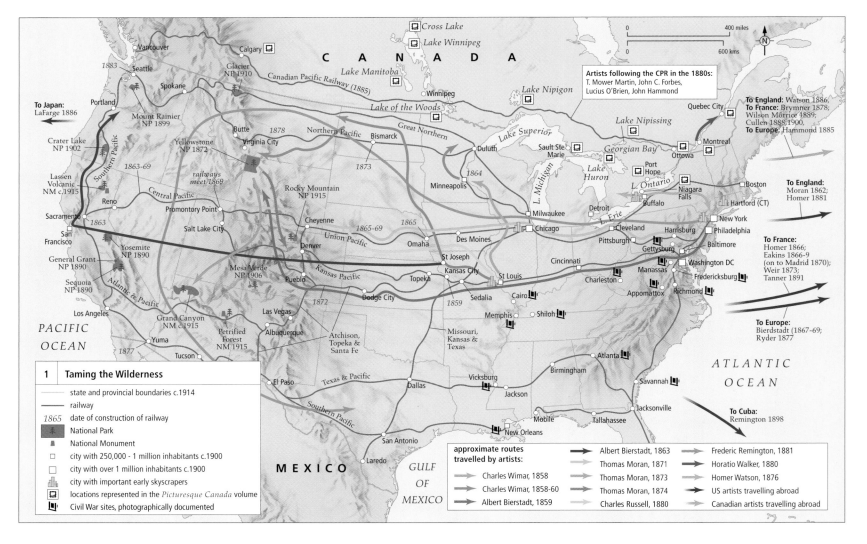

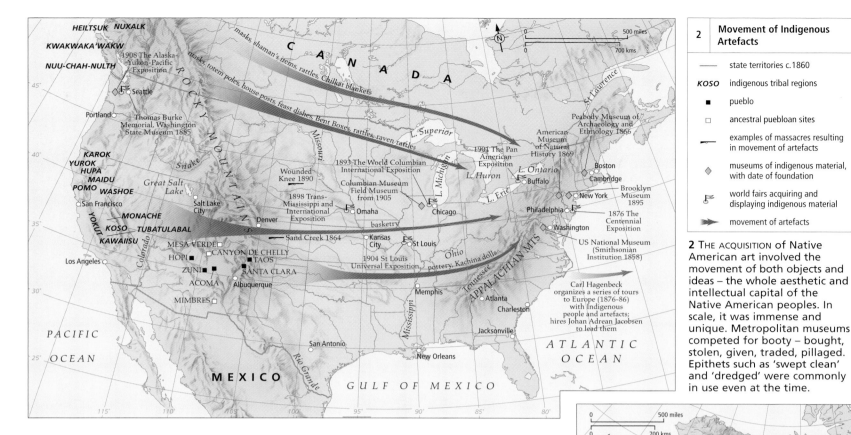

2 Movement of Indigenous Artefacts

— state territories c.1860

KOSO indigenous tribal regions

■ pueblo

□ ancestral puebloan sites

— examples of massacres resulting in movement of artefacts

◆ museums of indigenous material, with date of foundation

⚑ world fairs acquiring and displaying indigenous material

➤ movement of artefacts

2 THE ACQUISITION of Native American art involved the movement of both objects and ideas – the whole aesthetic and intellectual capital of the Native American peoples. In scale, it was immense and unique. Metropolitan museums competed for booty – bought, stolen, given, traded, pillaged. Epithets such as 'swept clean' and 'dredged' were commonly in use even at the time.

THOMAS MORAN: *Grand Canyon of the Yellowstone* (detail), 1872, oil on canvas. Moran used photographs as well as his own sketches for the final composition, which freely interprets the scene in the interests of drama. His participation in the 1871 expedition was partly funded by the Northern Pacific Railroad, eager to publicize Western scenery.

3 THE VAST EXPLOSION in wealth and prosperity following the Civil War led to an unprecedented acquisition of European art. Bankers and industrialists laid the foundations of an impressive array of museums and art galleries. Accompanying the transfer of European art to North America was a continued American interest in exploring Europe and beyond.

East Coast aesthetic most eloquently expressed by Henry James – which perceived Europe as having everything to offer and the USA nothing. Whistler, Sargent and many others joined James in exile in Europe.

NATIVE AMERICAN ART

After Native American artefacts were first shown in quantity to a mass audience at the Centennial Exhibition in Philadelphia in 1876, major collecting institutions competed to acquire hundreds of thousands of objects. From the Northwest came graves, houses, totem poles, masks, clothing, boxes, spoons, weapons, canoes – no item too small or too large. From the pueblos of the Southwest came staggering volumes of pottery and kachina dolls (*tihus*). Thousands of baskets were collected in California. From the battle- and killing-fields of the Plains came war shirts, feather bonnets, drawings in ledger books. Essentially, the entire material culture of Native America was removed to storerooms and glass-fronted cabinets in the metropolis.

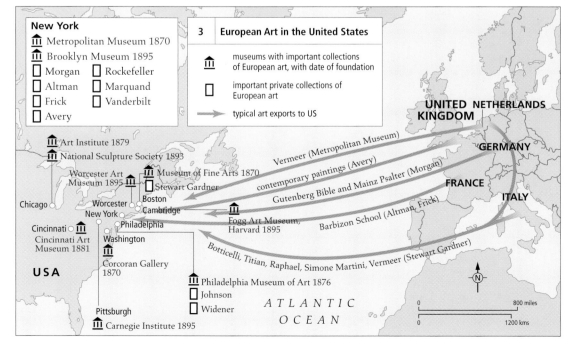

New York

🏛 Metropolitan Museum 1870

🏛 Brooklyn Museum 1895

□ Morgan □ Rockefeller

□ Altman □ Marquand

□ Frick □ Vanderbilt

□ Avery

3 European Art in the United States

🏛 museums with important collections of European art, with date of foundation

□ important private collections of European art

➤ typical art exports to US

CENTRAL AMERICA AND THE CARIBBEAN 1800-1900

IN 1800 THE SEEDS OF NATIONALISM established during the preceding Baroque period rested uneasily with the ideals of academic Classicism being taught by professors who came to the Americas from Spain. While much of the argument was political and questioned the continuing role of a European-dominated government and aristocracy, the debate was fuelled and even encouraged by divisions in the arts between liberal and conservative practitioners.

1 THE MOVE TOWARDS POLITICAL INDEPENDENCE led to divisions and factionalism, and this was reflected in the diversity of art movements from this period. The main division was between the Neoclassicism of scholars based in the Academies and the populist movements, although there were also divisions between ethnic groups on the Caribbean islands. Influences from non-Spanish Europe, especially France, were apparent in the Caribbean and, to a lesser extent, on the mainland.

In 1810 these conflicts led to armed struggle between the Nationalists and Spain, resulting in the declaration of independence by Mexico in 1821, followed shortly after by Guatemala, Honduras, Nicaragua and Costa Rica. Despite its avowed aims, independence strengthened the Creole (Spanish American) power base and created further instability: Mexico, for instance, had 30 different presidents during its first 50 years of independence.

THE ROLE OF THE ACADEMY
In attempts to reassert Spanish intellectual dominance, the Royal Academy of San Carlos, Mexico City, was founded on 4 November 1785 under the sponsorship of the San Fernando Academy in Madrid. Its first director, Manuel Tolsá (1757–1816), and all its professors had been trained in Madrid. The Royal Academy, however, immediately broke links with its

HERMENEGILDO BUSTOS, *Still Life with Fruit and Toad*. Unlike many of the 'primitive' artists of the period, Hermenegildo Bustos (1832–1907) was too poor to afford formal academic training and supported himself and his family by making and selling ice-cream. Bustos painted for the people of his community, making portraits of local dignitaries, *retablos* for the church, and festival masks, and his work was only 'discovered' in 1942 by the art historian Walter Pach. The fruits shown in this painting are those Bustos used to flavour his ice-creams.

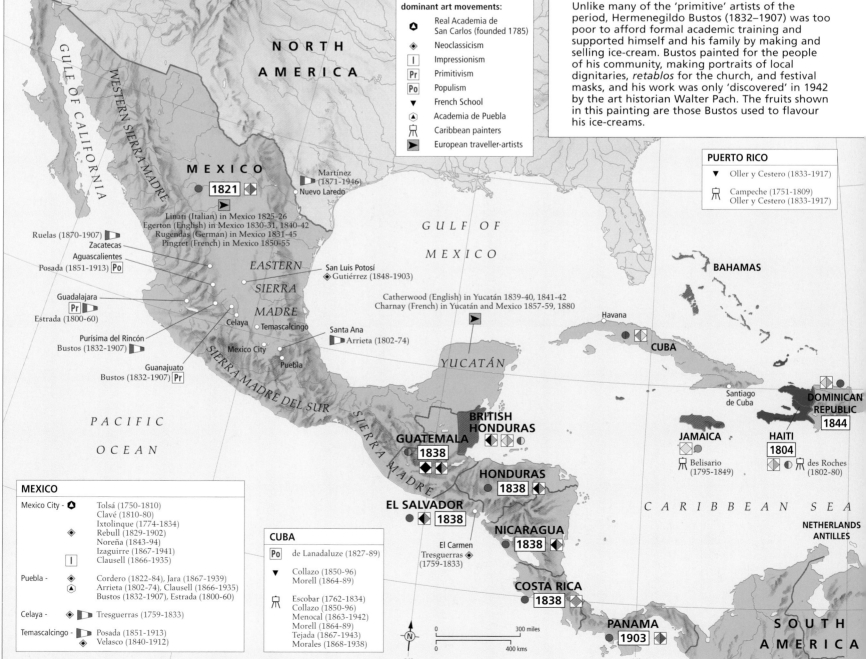

dominant art movements:

- Real Academia de San Carlos (founded 1785)
- Neoclassicism
- Impressionism
- Primitivism
- Populism
- French School
- Academia de Puebla
- Caribbean painters
- European traveller-artists

PUERTO RICO
- Oller y Cestero (1833-1917)
- Campeche (1751-1809)
- Oller y Cestero (1833-1917)

Linati (Italian) in Mexico 1825-26
Egerton (English) in Mexico 1830-31, 1840-42
Rugendas (German) in Mexico 1831-45
Pingret (French) in Mexico 1850-55

Martínez (1871-1946)
Nuevo Laredo

Ruelas (1870-1907)
Zacatecas
Aguascalientes
Posada (1851-1913) Po

Guadalajara
Estrada (1800-60)

Purísima del Rincón
Bustos (1832-1907)

Guanajuato
Bustos (1832-1907) Pr

San Luis Potosí
Gutiérrez (1848-1903)

Catherwood (English) in Yucatán 1839-40, 1841-42
Charnay (French) in Yucatán and Mexico 1857-59, 1880

Santa Ana
Arrieta (1802-74)

Celaya
Temascalcingo
Mexico City
Puebla

Havana

CUBA
Santiago de Cuba
DOMINICAN REPUBLIC 1844

BAHAMAS

BRITISH HONDURAS
GUATEMALA 1838
HONDURAS 1838
EL SALVADOR 1838
NICARAGUA 1838
El Carmen
Tresguerras (1759-1833)
COSTA RICA 1838
PANAMA 1903

JAMAICA
Belisario (1795-1849)

HAITI 1804
des Roches (1802-80)

NETHERLANDS ANTILLES

MEXICO

Mexico City -		Tolsá (1750-1810) Clavé (1810-80) Ixtolinque (1774-1834) Rebull (1829-1902) Noreña (1843-94) Izaguirre (1867-1941) Clausell (1866-1935)
Puebla -		Cordero (1822-84), Jara (1867-1939) Arrieta (1802-74), Clausell (1866-1935) Bustos (1832-1907), Estrada (1800-60)
Celaya -		Tresguerras (1759-1833)
Temascalcingo -		Posada (1851-1913) Velasco (1840-1912)

CUBA

Po	de Lanadaluze (1827-89)
▼	Collazo (1850-96) Morell (1864-89)
	Escobar (1762-1834) Collazo (1850-96) Menocal (1863-1942) Morell (1864-89) Tejada (1867-1943) Morales (1868-1938)

0 300 miles
0 400 kms

NORTH AMERICA
GULF OF CALIFORNIA
WESTERN SIERRA MADRE
MEXICO 1821
EASTERN SIERRA MADRE
GULF OF MEXICO
YUCATÁN
SIERRA MADRE DEL SUR
SIERRA MADRE
PACIFIC OCEAN
CARIBBEAN SEA
SOUTH AMERICA

sponsoring institution. It sought to further the aim of democratic debate and promote thinking that led to calls for political as well as intellectual independence. After independence new academies were established, such as that at Puebla, with the express purpose of developing a national intellectual and artistic life that was freed from the constraints of the old colonial powers.

NEOCLASSICISM
The Academies were originally based on the concept that art should be learned by study of the work of the Old Masters and that true aesthetics lay in historical precedent. This Classical tradition was enthusiastically espoused by some artists, such as Santiago Rebull (1829–1902), who was directly influenced by Jacques-Louis David.

Others, although working in a distinctly European aesthetic tradition, began to turn to local history for their inspiration. Francisco Eduardo Tresguerras (1759–1833), an architect, painter and engraver, attempted to use Classical style in his work but was nevertheless clearly influenced by regional Baroque. Similarly, José María Velasco (1840–1912) considered himself to be a 'scientific' painter who drew his understanding from many different academic disciplines, and gained a rich knowledge of zoology, botany, physics, mathematics, geometry, geography and architecture, in addition to Classical aesthetics. He is best-known as an academic landscape painter whose work was exhibited in international fairs in Paris, Philadelphia and Chicago, yet his inspiration was drawn almost entirely from the Valley of Mexico and its surroundings. He was a major influence on Diego Rivera in the twentieth century.

PRIMITIVISM
The search for historical truth also led to reaction against the academies and the development of popular art. Many of these artists had formal training, and the Primitivist movement was an attempt to express a sense of regional pride and local values. One of the most important artists of this movement was Hermenegildo Bustos (1832–1907) who, in addition to painting portraits, also produced religious murals and sculptures, and made festival masks for his local parish of Purísima del Rincón in Guanajuato. Another significant artist was José María Estrada. Estrada had trained at the Puebla Academy and became director of the Academy of Fine Arts in the state of Jalisco, but throughout his working life he never left his native state. His own output consisted entirely of portraits of local people and of regional history and myths.

The search for a popular art culminated in the work of José Guadalupe Posada (1851–1913), who came from a peasant family in Aguascalientes and died in poverty in Mexico City. He thought of himself as a craftsman and a voice for the people. Throughout his life he produced printed work in the form of broadsheets with illustrated, and often satirical, texts that were intended to be read to a largely illiterate peasant population, and which became the inspiration for much of the revolutionary art that would follow in the twentieth century.

CARIBBEAN ART
The history of Caribbean art is different from that of Mexico and Central America. Following European colonization, the indigenous populations were annihilated at an early date and replaced by slave labour from Africa. Used by Spain as a stepping-stone for its conquests in the sixteenth century, the area had become politically and culturally divided by the seventeenth century and Spanish dominance was challenged by the British, French and Dutch. Slavery was abolished during the course of the nineteenth century, and wage workers from India and China were brought in to the region.

This political and cultural mix resulted in unique art forms and styles. These often incorporated ideas derived from the original homelands of the new arrivals, such as Vodoun in Haiti and Santos in Puerto Rico. While popular sacred art was of significant importance in the region during the nineteenth century, much of our knowledge of this derives from a later period. Expressions of local mixed customs, especially of Carnival, were produced by artists such as the Jamaican painter Isaac Belisario (1795–1849), who made a series of lithographs which depicted the Christmas Masquerade.

There were influences from some major French painters. Paul Gauguin (1848–1903) visited here in 1887, and Camille Pissarro (1830–1903) was the son of French merchants from the island of St Thomas. A French School was established in Havana, Cuba, in 1817 at the San Alejandro Academy under the direction of Jean-Baptiste Vernay (1786–1833), a French painter and student of David. Francisco Oller (1833–1917), a Puerto Rican painter, was a friend of both Pissarro and Cézanne, but nevertheless failed in his successive attempts to establish a French academy at San Juan.

As in Mexico and Central America, Caribbean artists were often actively involved in the independence wars and the struggles between liberal and conservative factions. Armando Menocal (1863–1942) and Eduardo Morales (1868–1938), for instance, were both active combatants during Cuba's wars for independence and both artists painted scenes of the conflicts.

JOSÉ MARÍA VELASCO, *Valley of Mexico*. José María Velasco (1840–1912) was the most famous of the Mexican academic painters and achieved international recognition. He received many awards and honours, including Chevalier de la Légion d'Honneur, Paris, the Franz Joseph Cross, Austria, and First prize at the Chicago World Fair. He was Professor of Perspective (1868) and Professor of Landscape (1875) at the San Carlos Academy. His subject-matter was nevertheless Mexican, particularly the volcanoes and landscapes of the Valley of Mexico.

1	Mexico and Central America, 1800-1900	

Spanish ⬜
British ▨
French ⬛
Danish ▤
Dutch ⬜

Spanish ◆
African ◇
Amerindian ◆
East Indian ◆

1838 date of independence

▷ Mexican artists of the Independence period

ethnic groups:
◆ Maya
◆ European

religious groups:
● Roman Catholic
◐ Protestant
○ Anglican
● Santera
○ Voodoo
○ Hindu

ATLANTIC OCEAN — 20°

VIRGIN IS
San Juan
ANGUILLA
PUERTO RICO
ANTIGUA
GUADELOUPE
DOMINICA
MARTINIQUE
ST LUCIA
ST VINCENT
BARBADOS
GRENADA

TRINIDAD — Cazabon (1813–88)
— 10°

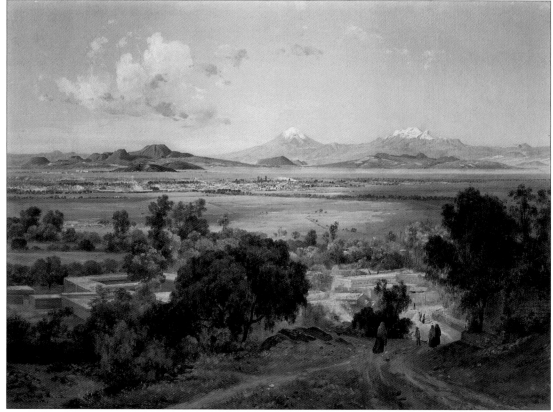

SOUTH AMERICA 1800-1900

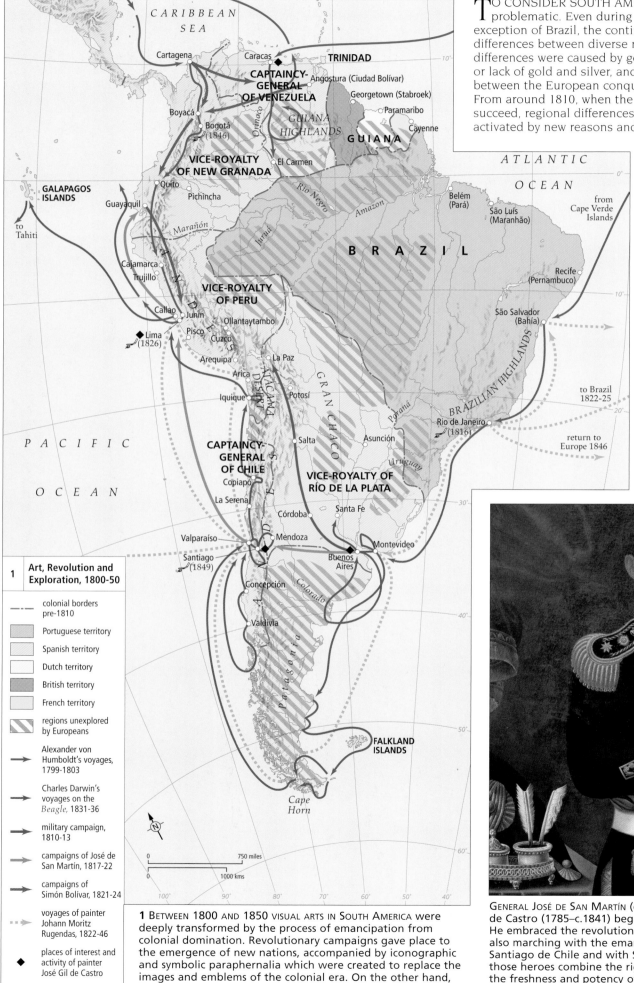

TO CONSIDER SOUTH AMERICA as a unity is always problematic. Even during colonial times when, with the exception of Brazil, the continent was a Spanish domain the differences between diverse regions were huge. These differences were caused by geographical diversity, the existence or lack of gold and silver, and the particularities of the conflicts between the European conquerors and many different cultures. From around 1810, when the wars of independence began to succeed, regional differences persisted, although they were activated by new reasons and circumstances. During the first half of the nineteenth century South America suffered a long period of violence and warfare, initially directed against the former colonial powers. Civil confrontations and divisions between the emerging nations led to further violent conflicts, creating new and shifting boundaries.

ART AND CONFLICT

Revolutions, war and civil conflicts did not create a propitious atmosphere for the flourishing of fine arts. Nevertheless, the field of visual representations played a crucial role in the emergence of the new nations. In the first decades of independent life the images and symbols of colonial power were dramatically transformed and substituted: national anthems, flags, images and allegories of the new nations were created,

Map legend

1 Art, Revolution and Exploration, 1800-50

- – – – colonial borders pre-1810
- Portuguese territory
- Spanish territory
- Dutch territory
- British territory
- French territory
- regions unexplored by Europeans
- → Alexander von Humboldt's voyages, 1799-1803
- → Charles Darwin's voyages on the *Beagle*, 1831-36
- → military campaign, 1810-13
- → campaigns of José de San Martín, 1817-22
- → campaigns of Simón Bolívar, 1821-24
- ⋯▸ voyages of painter Johann Moritz Rugendas, 1822-46
- ◆ places of interest and activity of painter José Gil de Castro
- academies/schools of fine art

1 BETWEEN 1800 AND 1850 VISUAL ARTS IN SOUTH AMERICA were deeply transformed by the process of emancipation from colonial domination. Revolutionary campaigns gave place to the emergence of new nations, accompanied by iconographic and symbolic paraphernalia which were created to replace the images and emblems of the colonial era. On the other hand, the growing interest of other European countries (England, Germany, France) in South America encouraged many artistic and scientific expeditions across the continent.

GENERAL JOSÉ DE SAN MARTÍN (detail) by José Gil de Castro, 1818. Gil de Castro (1785–c.1841) began his career in Lima as a portraitist. He embraced the revolutionary cause not only as a painter but also marching with the emancipating forces: with Bolívar to Santiago de Chile and with San Martín to Lima. His portraits of those heroes combine the rigidity of the colonial tradition with the freshness and potency of his political ideals. The careful depiction of the subject's garment, paying special attention to the gold trimmings, may indicate the persistence of elements of colonial religious images.

together with the popularization of portraits of heroes of independence, like the *Libertadores* Simón Bolívar and José de San Martín, whose campaigns acquired a continental dimension. Painters such as the Peruvian mulatto José Gil de Castro (1785–c.1841) accompanied the revolutionary campaigns, and with the images they created they took an active part in the process of emancipation.

THE SOUTH AMERICAN LANDSCAPE

The end of the colonial era signified that other imperial interests could explore, map and evaluate the commercial and economic potential of South America. The growing attention of modern European industrialized countries (England, Germany, France) on South America was manifested in the European expeditions to the continent, which brought together a confluence of artistic, scientific, geographic, economic and political aims. Among the most significant expeditions were those of Alexander von Humboldt between 1799 and 1803 and Charles Darwin's voyage on the *Beagle* (1831–6). During the first half of the nineteenth century, several different European cultural traditions became established in Latin America: the Neoclassical rhetoric of revolutionary France; the Romantic approach to Nature; and the topographical and naturalistic interest in the detailed description of geography, fauna and vegetation.

Large areas of the continent, such as the extensive forests and deserts, continued to be almost inaccessible for Europeans. Areas such as Patagonia, Amazonia and Chaco were already occupied by native peoples who were resistant to colonization and European occupation. They continued with their traditional production of artefacts, which they sometimes traded with Europeans in order to survive in hostile new locations.

European artists such as Johann Moritz Rugendas (who travelled in South America between 1822 and 1846) produced the first modern landscapes, which imposed their European conventions and representational schemes on South American nature. They looked for the picturesque and the sublime in South American rainforests, volcanoes, mountains and valleys, and also in the different regional lifestyles and costumes of the inhabitants. Most of these images were transformed into engravings and widely published in England, France, Germany, and so on. These albums of 'picturesque views' also circulated in South America. From about 1850, photographic albums superseded artistic engravings. The construction of a landscape (giving shape to the relationship between human societies and nature) was not easy in regions too far from the European experience and patterns of perception. The vast deserts of the south, the pampas and Patagonia were regarded by many Europeans (as the English traveller John Miers wrote in 1826) as a place where nature was 'empty of landscape'.

EMERGING NATIONAL IDENTITIES

During the second half of the nineteenth century the end of the civil wars paved the way for the consolidation of South American nations. Increasingly, natural resources were exploited which could be traded with the nations of Europe. Towards the end of the nineteenth century most South American countries were ruled by authoritarian and conservative governments, which were at the same time liberal and progressive in their economic policies.

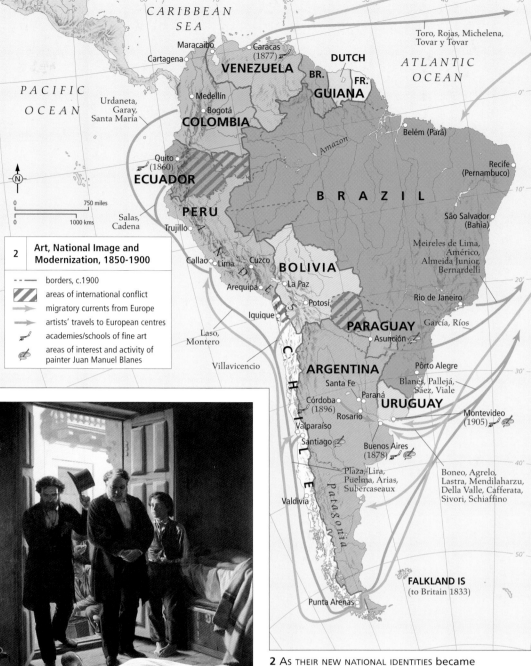

THE URUGUAYAN PAINTER Juan Manuel Blanes (1830–1901) studied in Florence. Identified with the ideals of the modern urban bourgeoisie, his intention was to become a 'South American painter', creating a national imagery for the countries in the south of the continent. *Un episodio de la fiebre amarilla en Buenos Aires* ('An episode of yellow fever in Buenos Aires') exhibited in 1871, consecrated him as a great painter in Argentina, Uruguay and Chile.

More regions became integrated in modern economic systems – cattle-raising, agriculture, mining and so on, producing raw materials and food for the international market. At the same time, hundreds of thousands of impoverished European immigrants arrived in South America. In large cities like Buenos Aires urban life was so dramatically transformed by immigration that it seemed to threaten the budding sense of national identity.

Young painters and sculptors began to be sent by their national governments to European academies and ateliers in order to study there and return as 'national artists'. Museums, academies of fine arts and schools

2 AS THEIR NEW NATIONAL IDENTITIES became established, South American countries integrated into the international economic system as producers of raw materials. There was a vast influx of European immigrants and cities grew and modernized very rapidly. An emerging urban bourgeoisie emulated European culture and fashion. It was a period of intense interaction with European artistic centres. South American artists travelled to Rome, Florence and Paris to study in academies and *ateliers*, while new art schools were opened in the capital cities.

of arts and crafts were opened in the main cities, and several European artists established in South America also acted as professors in these new institutions.

During the latter decades of the nineteenth century, national historical narratives and iconographies were created and consolidated, and at the same time, a number of important monuments were built in the cities. Latin American countries occupied a peculiar place in the global economic system: they were neither developed and industrialized countries, nor colonies. As young, independent nations they tried to create positions for themselves and national identities on the periphery. One way of fulfilling this aim was to participate in International Exhibitions and World Fairs – not only as producers of raw materials and food but as civilized nations with a European-like fine-arts culture.

EUROPE 1800-1900

NAPOLEON'S CONQUESTS LED to an unprecedented movement and creation of artworks around Europe in the form of war trophies, art publications and research, official portraits and monuments celebrating victories or the fallen. The Napoleonic era also saw the formation of the great state museums of Europe: the Louvre, the British Museum, and the

Pinakotheks of Berlin and Munich. These institutions formulated the artistic heritage just as State patronage of contemporary art through acquisitions and exhibitions shaped art's future. The technological advances and atrocities of warfare inspired complex artistic responses from the conflicted heroism of Gros's and Turner's battle paintings to Goya's horrific etchings.

1 THE EMERGENCE AND SUPPRESSION of national cultures by conflicting imperial ambitions forged the aims and vocabularies of artistic movements such as Romanticism and Art Nouveau. Booming industrialization inspired exhilarating collaborations between art and the new needs of entrepreneurial and urban culture, but also inspired a mood of nostalgia for traditional, rural life manifest in artists' colonies.

1 - Royal Pavilion (Nash 1815-22)
2 - East Bergholt (Constable)
 - R. Stour (Constable)
 - Dedham (Constable)
3 - Fonthill Abbey (Beckford 1796)
 - Salisbury Cathedral (Turner, Constable)
4 - Abbotsford (Walter Scott's castle)
5 - Shoreham (Palmer)
6 - Cologne Cathedral (Schinkel 1824-80)
7 - Walhalla Donaustauf (von Klenze 1814-42)
8 - Neuschwanstein Castle (Riedel, Jank, Dollmann, Hoffmann 1868-92)
9 - Uppsala University botanical collections (Runge, Friedrich)
10 - Port Sunlight (Lever, Owen 1887-1900)
11 - Glasshouse (Kibble 1860)
 - Iron Building (Baird 1855-56)
12 - Chiswick, Great Conservatory, Syon house (Fowler 1820-27)
 - Kew Palm House (Turner, Burton 1845-47)
13 - University Museum (Woodward, Ruskin 1855-60)
14 - Communal housing (Familistère 1859-70)
15 - Deptford
16 - Horta and van de Velde houses
17 - Liberal Volkhuis 'Help U Zelve' (1898)
 - Art Nouveau Wijk (c. 1900)
18 - Watts Memorial Chapel (1897)
19 - L. Windermere, Broadleys Gill Head (Voysey 1898-1900)
20 - Hale, Halecroft (1890)
21 - Windy Hill (Mackintosh 1899-1901)
22 - Knutsford, (Richard Harding Watt 1895-1908)
23 - Bexleyheath, The Red House (Webb, Morris 1859-60)
24 - Chiswick, Bedford Park, South Parade (Shaw 1874-90, Voysey 1889-94)
 - Sanderson and Sons Wallpaper Factory (Voysey 1900-02)
25 - Harrow Weald, Grims Dyke (Shaw 1870-72)
26 - Wightwick Manor (Ould 1887-93)
27 - Maison Hennebique (1900-04)
 - Maison Coilliot Lille (Guimard 1898-1900)
28 - Villa Majorelle (Sauvage 1900-01)
29 - Alexandraweg (Olbrich, Glückert, Behrens 1899-1901)
30 - De Beurs (Berlage 1897-1903)
 - American Hotel & Cafe (Kromhout 1898-1901)
31 - Menier Factory (Saunier 1869-74)

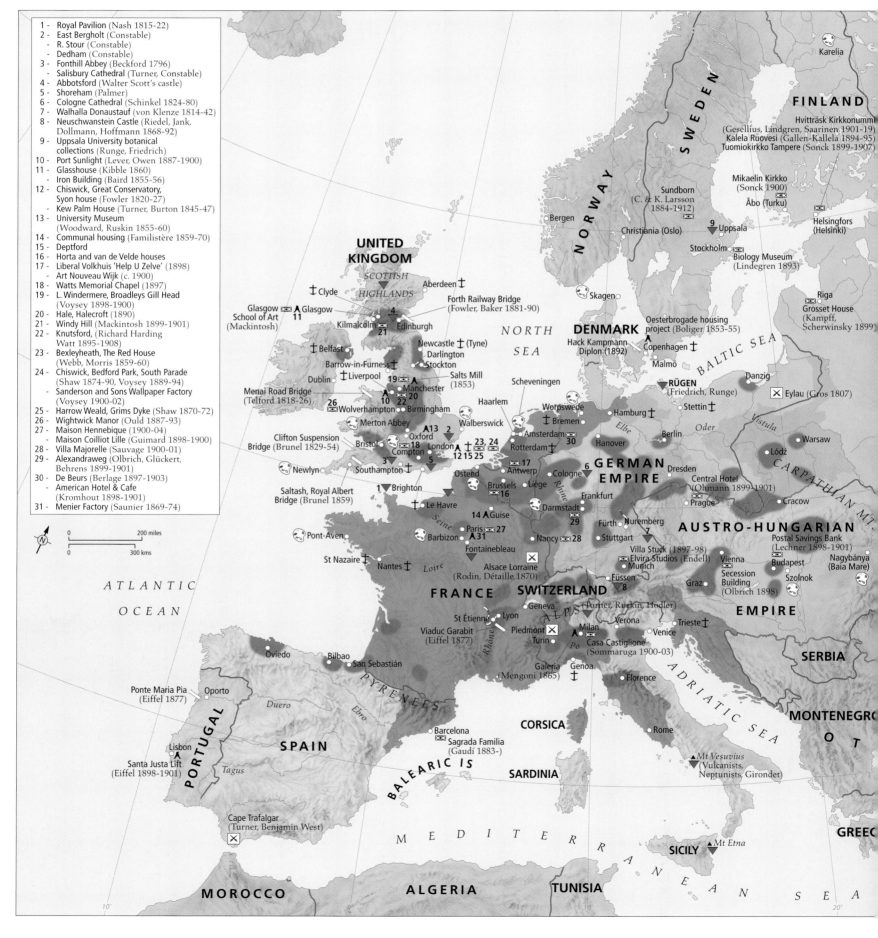

NATURE AND NATIONALISM

The attempted centralization of Europe into an imperial culture prescribed from Paris also inspired Romantic expressions of dissent. Discredited traditions were reclaimed, for example Schinkel's reconstructed Gothic Cologne Cathedral, Beckford's Fonthill Abbey or Scott's Abbotsford. These, as well as heroic landscapes such as the desolate Baltic coasts and dense Alpine forests of Friedrich or the idyllic rusticity of Constable and Repton, revealed a new-found determination to assert alternative national identities amidst the Napoleonic bloodshed. The

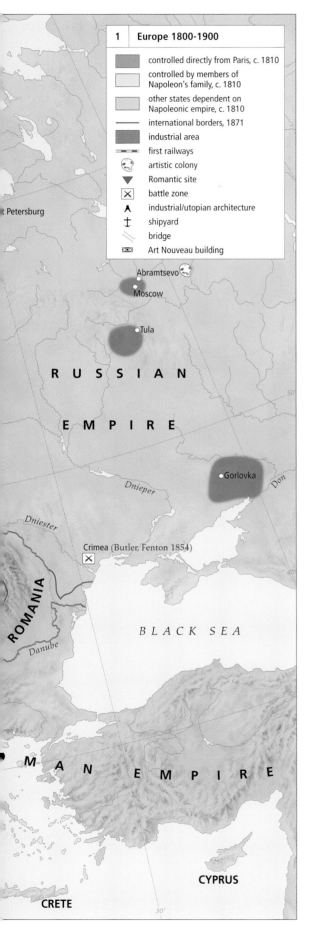

1 Europe 1800-1900

controlled directly from Paris, c. 1810
controlled by members of Napoleon's family, c. 1810
other states dependent on Napoleonic empire, c. 1810
——— international borders, 1871
industrial area
first railways
artistic colony
Romantic site
battle zone
industrial/utopian architecture
shipyard
bridge
Art Nouveau building

St Petersburg

Abramtsevo
Moscow
Tula

R U S S I A N

E M P I R E

Dnieper
Gorlovka
Don

Dniester

Crimea (Butler, Fenton 1854)

ROMANIA

Danube

BLACK SEA

M A N E M P I R E

CYPRUS

CRETE

COALBROOKDALE BY NIGHT, 1801, by Philip James De Loutherbourg (1740–1812). De Loutherbourg described this dramatic view of newly industrialized Shropshire in western England as appealing equally to an economist and a Romantic artist. This landscape celebrates both the exhilarating 'satanic' blaze of blast furnaces abhorred by Blake and the idyllic surrounding woodland valley and its rustic inhabitants.

drama of the natural world encouraged not only scientific measurement and study (the Vulcanists' examination of mounts Etna and Vesuvius, for example), but also the visionary landscapes of Martin and Girodet. At the same time, this period of socio-political dislocation inspired complex alternative visions – the ecstatic horror of the 'Sublime', witnessed in Goya's and Géricault's imagery of madness and dehumanized brutality, or the retreat into esotericism of Runge's Masonic decorations, or Blake's and Fuseli's mystic utopianism.

INDUSTRIALIZATION AND THE ARTS

The first four railway lines (1825–37), succeeded by a construction boom in the 1860s, linked the most far-flung corners of Europe, allowing more widespread diffusion of raw materials, artworks and ideas. At the same time, new forms of transportation led to mass tourism and international exhibitions, which encouraged national manufactures such as Sèvres and Meissen porcelain and the Gobelins' tapestry works. New techniques of reproduction processes helped the proliferation of photography as an art medium, and many illustrated periodicals appeared, from *The Illustrated London News* to the Vienna Secessionist journal *Ver Sacrum*.

New processes led to the more efficient exploitation of natural resources (the coal mines of Britain and Russia, the iron ore deposits of northern France and Spain, the expansion of metal industries and armaments led by Germany, textile production in Britain, Belgium and France). These industries created a vibrant yet volatile economic climate. They also provided the materials and patronage that facilitated the new industrial architecture of production, transport and display such as Saunier's Menier Factory (1869–74, Noisel-sur-Marne), Eiffel's Ponte Maria Pia Bridge (1877, Oporto), Mengoni's Galleria (1865–77, Milan) and the luxury-liner ships decorated by artists.

Many paternalist entrepreneurs embarked on utopian communal housing projects such as Boliger's Laegeforeningens, which replaced Copenhagen's slums, Lever's Port Sunlight near Liverpool and Godin's Familistère project in Guise. The experience of the working-class was a motif that inspired many nineteenth-century artists, from the bleak ennui of Toulouse-Lautrec and Seurat's proletarians to the heroic mill workers of Menzel.

FIN DE SIÈCLE EUROPE

A complex climate of internationalism and competition was created by the unification of Germany and Italy, the expansion of Austria-Hungary and Russia, and European colonization in Africa and Asia. Experimentation in architecture and design, known as 'Art Nouveau', flowered against this background. New unusual materials inspired new forms. Wolfers's chryselephantine *objets d'art* relied upon ivory from the new Belgian Congo. Advances in metallurgy allowed Guimard and Horta to create their extraordinary ironwork arabesques. Gallé's participation in the latest discoveries in chemistry and botany emerged in the themes and techniques of his glassware. Art Nouveau often emerged in secondary metropolitan centres, and celebrated these area's distinctive materials and skills; Mackintosh's furniture relied upon the skills of Glasgow's ship fitters, and Eliel Saarinen, Lindgren and Gesellius deployed Finnish granite and timber as their signature materials. Industrial entrepreneurs were key patrons (Güell for Gaudí or Solvay for Horta), and their urban townhouses became one of Art Nouveau's principal forms.

Nostalgia for traditional life also inspired a revival of traditional techniques and art forms. This was evident in the art colonies in Brittany, Abramtsevo and Worpswede as well as the Arts and Crafts collectives formed across Europe, which were inspired by Ruskin's and Morris's championing of medieval and folk craftsmanship and sincerity. Lechner drew upon Hungarian folk lace for his architectural ornament in the Postal Savings Bank (Budapest 1898–1901). The Watts' Chapel and Pottery (Compton 1897) not only taught local people techniques of Celtic interlace but also helped the village economically by marketing the artworks to Liberty's in London.

HÔTEL TASSEL, BRUSSELS 1892–93, Victor Horta (1861–1947). Horta's townhouse typifies the lavish ornament and modern structural achievements of the pan-European phenomenon of 'Art Nouveau'. Many disparate examples of architecture and design are classified as Art Nouveau; most embrace new materials and technologies whilst still celebrating local motifs, such as flora and folklore.

SCANDINAVIA AND THE BALTIC 1800-1900

THE GEOGRAPHY OF SCANDINAVIA was redefined in the early nineteenth century. Sweden ceded Finland to Russia in 1809, losing the last vestige of its former dominance of the eastern Baltic. Sweden's loss was compensated in 1814 when Denmark, which had been an ally of Napoleon, lost Norway to Sweden. There was a great deal of new building in both of these territories, much of it in a strictly Neoclassical style, which suited both international taste and imperial themes as rulers asserted their superiority over new lands. For example, the new palace for the Swedish king in Christiania (now Oslo), built in the 1820s, imposingly established the Swedish monarchy in Norway.

THE NEOCLASSICAL APOGEE

The Finnish capital was moved from Åbo (Turku) to the little fishing village of Helsinki after the transfer of the duchy to Russia. This was in part because Turku was the capital of Swedish Finland, and even today takes Swedish as its first language. Helsinki was much closer to St Petersburg, and Tsar Alexander I (r.1801–25) hoped to make the new city reflect Russian rule. Already in 1811 Alexander planned the highly symbolic Neoclassical Senate Square in Helsinki, which was to include the senate, the governor-general's residence, and a grand-ducal palace

1 THE POLITICAL STRUCTURE of the Baltic region was fundamentally realigned in the early nineteenth century. Russia expanded on gains made in the eighteenth century, and dominated the eastern Baltic lands. Sweden gained Norway, but lost territories in Pomerania, the last vestige of its former imperialism. All of this had a profound effect on the arts of the colonial territories. Cultural patronage came from new centres with different traditions and often had thinly veiled political implications – new buildings represented the new order.

(not built). Carl Ludwig Engel (1778–1840), who had studied with Karl Friedrich Schinkel (1781–1841) at the Berlin Academy of Architecture, carried out these plans.

Neoclassicism lingered longer in Denmark than in the other Scandinavian countries, largely because of the influence of the sculptor Bertel Thorvaldsen (1770–1844). Thorvaldsen was active in Rome for nearly his entire career, but was a celebrity in his own country. When he returned home in 1838 he oversaw the opening of a museum for his works, which included sketches, plaster models and full-size marble copies of his complete *oeuvre*. Thorvaldsen's work continued to cast a long shadow over the arts in Denmark.

CARL LUDWIG ENGEL's design for the Imperial Alexander University Library in Helsinki. Born and trained in Berlin, Engel settled in St Petersburg in 1814, where he soon impressed Tsar Alexander I. The tsar worked closely with the architect in the planning of the Neoclassical core of Helsinki, and ultimately chose the plans. He wanted the architecture of the city to reflect Russian rule, but also the broad independence granted the Finnish grand duchy.

SCANDINAVIAN REALISM

In the 1820s, a different trend began to emerge among painters in Denmark, particularly in Copenhagen, which stressed a carefully observed realism, with subjects often taken from national history, local landscape and everyday life. C. W. Eckersberg (1783–1853) and J. L. Lund (1771–1867) led this movement. They were prominent professors at the academy, and thus influenced a generation of painters. Often considered the 'Golden Age' of Danish painting, this was really part of a broader trend. Lund in particular maintained close ties with the leading academies in Düsseldorf and Munich, and so this development is linked to German Romanticism.

In the second decade of the century in Sweden many figural artists and writers considered Neoclassicism both exhausted and foreign, and looked instead to regional traditions and Norse mythology. Even King Karl XIV Johan of Sweden and Norway (r.1818–44), who had earlier portrayed himself as the Roman god Mars, identified himself as the Norse ruler-god Odin from the later 1810s. In Finland, Neoclassicism can be associated with imperial rule, while in Sweden the crown supported both the internationally current style as well as displaying an interest in regional subjects. Thus the interest in Norse heritage cannot be dismissed as little more than a provincial trend. The continuing adherence to the Neoclassical style and the interest in Norse heritage are equally important aspects of the arts in this period.

In 1850, the explicit influence of the Düsseldorf School became apparent in Sweden, when the Stockholm Academy mounted an important exhibition in which a

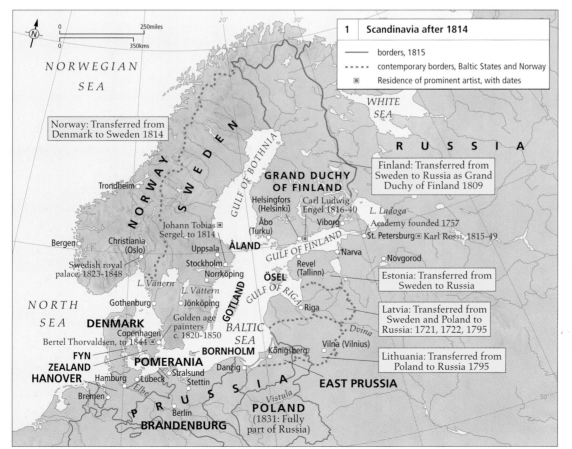

1 | **Scandinavia after 1814**

— borders, 1815

----- contemporary borders, Baltic States and Norway

▣ Residence of prominent artist, with dates

Norway: Transferred from Denmark to Sweden 1814

Finland: Transferred from Sweden to Russia as Grand Duchy of Finland 1809

Estonia: Transferred from Sweden to Russia

Latvia: Transferred from Sweden and Poland to Russia: 1721, 1722, 1795

Lithuania: Transferred from Poland to Russia 1795

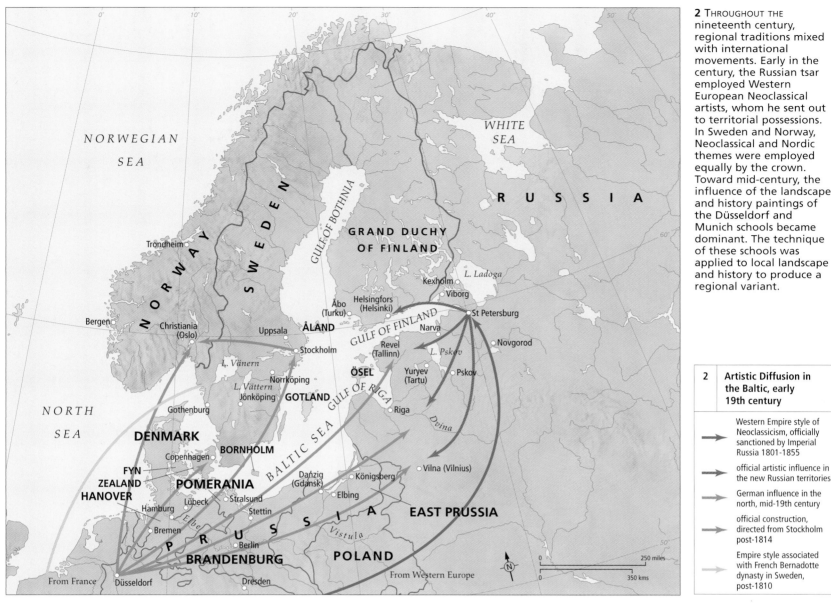

2 THROUGHOUT THE nineteenth century, regional traditions mixed with international movements. Early in the century, the Russian tsar employed Western European Neoclassical artists, whom he sent out to territorial possessions. In Sweden and Norway, Neoclassical and Nordic themes were employed equally by the crown. Toward mid-century, the influence of the landscape and history paintings of the Düsseldorf and Munich schools became dominant. The technique of these schools was applied to local landscape and history to produce a regional variant.

2	Artistic Diffusion in the Baltic, early 19th century
→	Western Empire style of Neoclassicism, officially sanctioned by Imperial Russia 1801–1855
→	official artistic influence in the new Russian territories
→	German influence in the north, mid-19th century
→	official construction, directed from Stockholm post-1814
→	Empire style associated with French Bernadotte dynasty in Sweden, post-1810

group of Norwegian artists displayed works inspired by German painting. The Swedish king immediately offered a scholarship to the first painter to study in Düsseldorf, and the pattern was established for the next 30 years. There was a significant Scandinavian community there until about 1880. The Düsseldorf painters were a revelation, but this also indicates the retardation of Swedish painting at mid-century. Their influence came just at the time when Johan Christian Dahl (1788–1857), a Norwegian painter who had been a close friend of Caspar David Friedrich (1774–1840) in Dresden, advised painters to go to Paris, as German artistic leadership had waned.

NATIONAL ROMANTICISM AND IDENTITY
In the 1890s the long-standing search for inspiration from beyond Scandinavia was overturned when nearly all the important Scandinavian painters returned home, determined to paint subjects specifically related to local traditions. This movement, called National Romanticism, accompanied a growth of patriotic or nationalistic sentiment in all the Baltic lands. This can be related to a desire for independence in lands ruled by foreign powers. Akseli Gallen-Kallela's (1865–1931) paintings of the Finnish saga, *Kalevala*, can be understood in this way. This yearning for independence from Russia, the dominant power, is even more apparent in Lithuania at mid-century. Folk woodcuts with inscriptions in the vernacular were banned in the 1860s for fear that they would incite revolt against Russia. Traditional Lithuanian images

were considered so provocative that national antiquities were seized and sent to Moscow, and artistic life in general was dampened; only one school in Vilnius trained painters between 1866 and 1914.

National Romanticism dominated the arts in sovereign countries as well, however. Anders Zorn (1860–1920), who had been in France in the 1880s, took the techniques he had learned

there and painted Swedish folk dances and rustic life with a crystalline light and an impressionistic touch. Carl Larsson (1853–1919) is widely loved for his depictions of the seasonal activities of a typical Swedish home in the provinces. Both painters' studios were far from the capital. Larsson refused to accept a position at the Royal Academy in Stockholm, believing that its conservatism would compromise his artistic convictions. National Romanticism extended far beyond the fine arts, and became a broader cultural phenomenon; traditional building techniques and handcrafts were also embraced.

While most Scandinavian artists in the 1890s worked with a regional focus, the Norwegian Edvard Munch (1863–1944) pioneered a haunting style of painting that pointed the way to Expressionism, one of the most important international movements of the early twentieth century. More than any Scandinavian since Thorvaldsen, Munch was recognized as a leading international figure, and was indeed the most important Scandinavian artist of the century.

ANDERS ZORN, *MIDSUMMER DANCE* (1897). Farmers are shown in provincial costume, dancing at the summer solstice. The midsummer pole is visible in silhouette against the sky on the right. The scene is set in a farmyard. A fiddler sits on the stoop of a rustic log shed on the left. The farmhouse is visible behind the shed, painted the dark red with white trim traditional for rural buildings. Zorn's gift for painting light and atmosphere allowed him to capture the warm glow of the midnight sun on the longest day of the year, which is celebrated as a holiday throughout Scandinavia.

RUSSIA 1800-1900

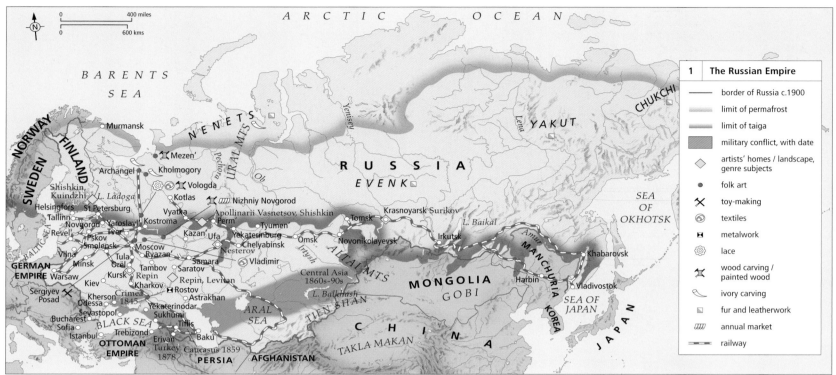

1 RUSSIAN EXPANSES. Cities clustering east of the Urals, new territories in Central Asia, Vladivostok as a Pacific port from 1860 – all these were barely accessible until the Trans–Siberian Railway linked them. Siberia – home of many distinct ethnic groups with their own arts – continued to be a place of exile for political dissidents, prisoners of foreign wars and revolutionaries – by 1890, some 3400 a week passed through holding stations at Chelyabinsk and Irkutsk. But artists such as Vasily Surikov (1848–1916), a native of Krasnoyarsk, celebrated the distinctive landscapes and peoples of Asian Russia.

N INETEENTH-CENTURY RUSSIA saw a shift from court display to a broader audience and a corresponding shift from classicism to realism and individual styles. Underlying this change were improved technology and transport and expanded territory in Central Asia, which led to expanding trade. Growth of the middle classes brought a pragmatic concern for production, distribution and profit.

THE EUPHORIA OF VICTORY
The formative event for early nineteenth-century Russia was Napoleon's invasion in 1812 and his defeat. Portraits, sculptures and prints celebrated the Russian victory. The rebuilding of Moscow (burnt in the conflict) stimulated architectural and city planning in St Petersburg and other cities. This reached a high point in the Neoclassical architecture and sculpture of such ensembles as the General Staff Arch adjacent to the Winter Palace, the Academic Theatre and the Michael Palace by architect Karl Rossi (1775–1849).

The court-controlled Academy of Art based instruction on classical and Renaissance models that harmonized with the autocratic rule of Tsar Nicholas I (r.1825–55). The leading Russian artists resident in Rome, including Karl Bryullov (1799–1852), Orest Kiprensky (1782–1836) and Aleksandr Ivanov (1806–58), earned international recognition. The highest prestige attached to history painting.

Some artists, though, preferred landscape and genre. Venetsianov began painting scenes of peasant life in the 1820s. He taught young

peasants and serfs to paint 'according to nature'. This set the stage for the realist movement of the second half of the century. The Academy gradually modified its curriculum, and the Moscow School of Painting and Sculpture, founded in the 1840s, gained a reputation for high standards in genre and landscape. Instruction became widely available through drawing schools in the capitals and art studios at Azarmas near Nizhniy Novgorod, in Vilna, Kharkov, Kiev, Sevastopol and Odessa.

Peasant crafts were exhibited at trade fairs – bone and ivory carving in the far north, wood carving in forested areas along the Dvina and Volga rivers, metalwork in Rostov and Tula, textiles in Vladimir, Vologda and Smolensk provinces, toy-making in Sergiyev Posad.

GROWING SOCIAL TENSIONS
By mid-century, military campaigns brought more non-Russians into the empire and sent Russian soldiers to far-flung outposts. Within European Russia, the social order, especially the institution of serfdom, accentuated class divisions. Tsar Alexander II (r.1855–81), though, brought a period of peace and liberalization. Essayists questioned the classical conventions

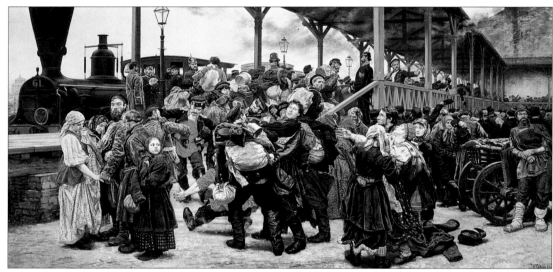

KONSTANTIN SAVITSKY (1844–1905), *Off to War*, 1880–88, oil on canvas, Russian Museum, St Petersburg. This scene of peasant recruits being separated from their families contradicts the heroic images of war in academic historical painting. The emotional turbulence of the crowd is set against the sleek steam engine, sharpening the disparity between backward peasantry and modern machine.

and announced that art must serve reality and expose the conditions of real life.

In 1863, Academy students led by Ivan Kramskoy (1837–87) formed a cooperative. Like-minded artists from the Moscow School joined them in 1871 in the Association of Travelling Art Exhibitions. Among *Peredvizhniki* ('travellers') were Kramskoy, Vasily Perov (1833–82) and Repin. They produced portraits of Tolstoy, Dostoevsky, Musorgsky, and genre works such as Repin's *Barge Haulers on the Volga* (1871) and Savitsky's *Repair Work on the Railroad* (1874). Russia's waterways and growing railways gave Aleksey Savrasov (1830–97), Ivan Shishkin (1831–98), Polenov and Levitan access to much of their subject matter: forests, plains, rivers and provincial towns. As a railway promotion, Serov and Korovin painted northern scenes. Savitsky, Repin and their

2 TOWN AND COUNTRY. Serfdom dominated agriculture until emancipation in 1861, and many peasants were left impoverished after the reforms. Yet improved transport and regional trade centres, especially the market at Nizhniy Novgorod, created demand for cultural amenities in the provinces. Many artists came from provincial towns – for example, Saratov (Aleksey Bogolyubov 1824–96), Chuguyev (Ilya Repin 1844–1930), Vyatka (Viktor, 1848–1926, and Apollinary, 1856–1933, Vasnetsov) and Ufa (Mikhail Nesterov 1862–1942). Some chose to paint in rural areas: Aleksey Venetsianov (1780–1847) at Vyshny Volochëk in Tver' Province, Valentin Serov (1865–1911) at Domotkanovo near Tver', Levitan at Plës on the Volga; and many participated in the artists' colonies at Abramtsevo and Talashkino. Some artists spent parts of their careers in Rome early in the century, and by the 1870s in France (Repin, Vasely Polenov, 1844–1927, Serov, Konstantin Korovin, 1861–1939, Konstantin Somov, 1869-1939) and Aleksandr Benua, 1870–1960, among others). Folk and applied arts were exhibited at regional fairs and, late in the century, abroad.

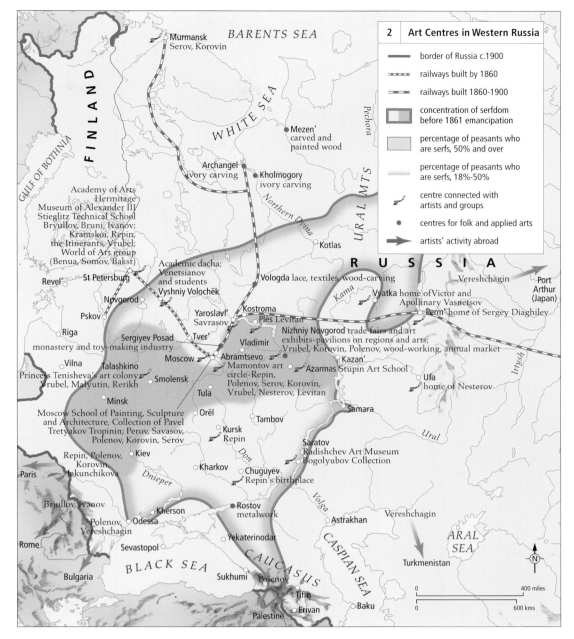

colleagues Vladimir Makovsky (1846–1920) and Nikolay Iaroshenko (1846–98) all dealt with issues and images of the populist and revolutionary movements of the 1870s, depicting young, educated men and women from the cities travelling to the countryside, 'to the people', as teachers, doctors and advisers to the former serfs about their legal rights.

PATRONAGE AND NEW GOALS
Independent-minded merchant-class collectors supported the *Peredvizhniki*. In 1892 Pavel Tretyakov (1832–98) donated to the city of Moscow a collection that ranged from icons to works by his contemporaries and friends. Savva Mamontov (1841–1918), railway magnate and art amateur, formed one of Russia's first art colonies at Abramtsevo, near Moscow, in the 1870s. Among the members were Repin, Polenov, history painters Viktor Vasnetsov and Vasily Surikov (1848–1916), Korovin, Levitan and Mikhail Vrubel (1856–1910), who became the most innovative artists of the last decades of the century.

Alexander III (r.1881–94), while politically conservative and authoritarian, collected art

for his own museum, opened to the public in 1898 in the Neoclassical Michael Palace (today the Russian Museum). By the 1890s, the

Academy was becoming open to new ideas, and some of the *Peredvizhniki* taught there.

The younger generation of artists avoided socially critical realism and instead explored a variety of new styles related to Impressionism, Post-Impressionism, Symbolism and *Art Nouveau* (called *style moderne* in Russia). A Slavic revival (retrospective and nationalist in content and often highly decorative in style) based itself in Moscow and Abramtsevo. A Western-oriented, urban, sophisticated style was associated with the St Petersburg 'World of Art' group. Some artists participated in both groups. The new sense of the importance of style itself marked a significant change in ideas.

The World of Art group, including Benua, Lev Bakst (1866–1924) and Konstantin Somov (1869–1939), joined by the impresario Sergey Diaghilev (1872–1929), effectively bridged the art worlds of the two centuries while deliberately linking Russia with the West. Their exhibitions and the journal M*ir iskusstva*, (1898–1904) emphasized form and design as much as text and content, and their theatrical productions united the best efforts of writers, musicians, choreographers and visual artists.

ISAAK LEVITAN (1861–1900) *March*, 1895, oil on canvas, Tretyakov Gallery, Moscow. Levitan presents a moment in the country in early spring, without the message or narrative typical of the previous decades. A Jew and extremely poor, Levitan overcame great obstacles to study at the Academy of Art, and became one of Russia's greatest landscape painters.

BRITAIN 1800-1900

THE NINETEENTH CENTURY saw Britain's industrial development, imperial power and artistic creativity reach a climax. As urbanization and industrialization, along with population growth and new forms of transport, transformed the British landscape, artists turned more than ever before to the picturesque and sublime modes of landscape painting for solace.

THE CULT OF NATURE
James Ward pioneered the genre of large-scale sublime, landscape with *Gordale Scar* (1812–14), based on Yorkshire scenery. For five decades until his death in 1851, Turner travelled tirelessly both within and beyond Britain. Like the work of his contemporary, John Constable, Turner's oil paintings, watercolours and engravings were vastly more ambitious than any that had gone before. While returning to familiar subjects such as Tintern Abbey, and Bamburgh and

FORD MADOX BROWN'S *Work* (1852–63) has come to symbolize the Victorian era's obsession with labour, on the part of the working classes, intellectuals (such as Thomas Carlyle and F. D. Maurice, seen to the right) and also of artists: Madox Brown worked on this elaborate Pre-Raphaelite paintings of modern life for 13 years.

Norham Castles, Turner also painted industrial subjects such as Leeds. Constable, whose finest works depicted his native Stour Valley in Suffolk, lived and painted in Hampstead on the outskirts of London, acknowledging the need to be close to the burgeoning art market. While some Victorian artists such as Edwin Landseer painted the Scottish subjects dear to Queen Victoria, who spent much time at Balmoral Castle, most preferred the rolling landscapes of southern England. John Linnell depicted a rural paradise at Redhill in Surrey, while William Dyce and William Powell Frith created contrasting visions of tourism on the Kent coast in Pegwell Bay (1859, Tate) and Ramsgate Sands (1853, Royal Collection).

THE INDUSTRIAL REVOLUTION
The industrial development of Britain shifted the economic and manufacturing centre of the country from the southeast to the north and Midlands. By the 1850s industrial profits had created a new generation of middle-class patrons based in Manchester, Liverpool,

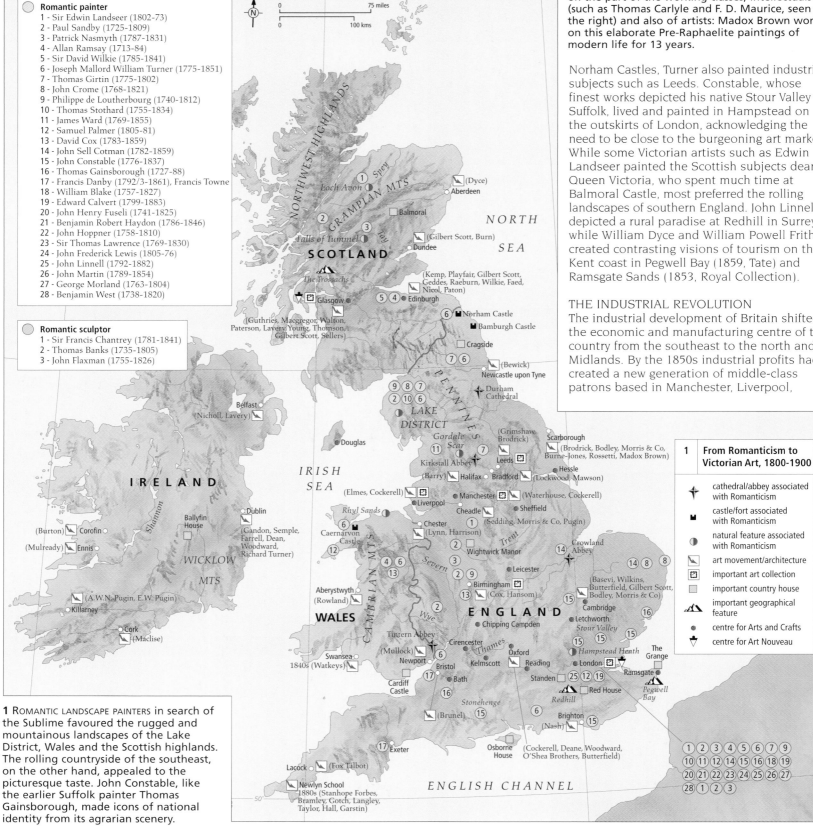

Romantic painter
1 - Sir Edwin Landseer (1802-73)
2 - Paul Sandby (1725-1809)
3 - Patrick Nasmyth (1787-1831)
4 - Allan Ramsay (1713-84)
5 - Sir David Wilkie (1785-1841)
6 - Joseph Mallord William Turner (1775-1851)
7 - Thomas Girtin (1775-1802)
8 - John Crome (1768-1821)
9 - Philippe de Loutherbourg (1740-1812)
10 - Thomas Stothard (1755-1834)
11 - James Ward (1769-1855)
12 - Samuel Palmer (1805-81)
13 - David Cox (1783-1859)
14 - John Sell Cotman (1782-1859)
15 - John Constable (1776-1837)
16 - Thomas Gainsborough (1727-88)
17 - Francis Danby (1792/3-1861), Francis Towne
18 - William Blake (1757-1827)
19 - Edward Calvert (1799-1883)
20 - John Henry Fuseli (1741-1825)
21 - Benjamin Robert Haydon (1786-1846)
22 - John Hoppner (1758-1810)
23 - Sir Thomas Lawrence (1769-1830)
24 - John Frederick Lewis (1805-76)
25 - John Linnell (1792-1882)
26 - John Martin (1789-1854)
27 - George Morland (1763-1804)
28 - Benjamin West (1738-1820)

Romantic sculptor
1 - Sir Francis Chantrey (1781-1841)
2 - Thomas Banks (1735-1805)
3 - John Flaxman (1755-1826)

1	**From Romanticism to Victorian Art, 1800-1900**
✝	cathedral/abbey associated with Romanticism
■	castle/fort associated with Romanticism
◑	natural feature associated with Romanticism
◩	art movement/architecture
▣	important art collection
□	important country house
⛰	important geographical feature
●	centre for Arts and Crafts
⚓	centre for Art Nouveau

1 ROMANTIC LANDSCAPE PAINTERS in search of the Sublime favoured the rugged and mountainous landscapes of the Lake District, Wales and the Scottish highlands. The rolling countryside of the southeast, on the other hand, appealed to the picturesque taste. John Constable, like the earlier Suffolk painter Thomas Gainsborough, made icons of national identity from its agrarian scenery.

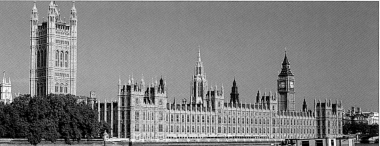

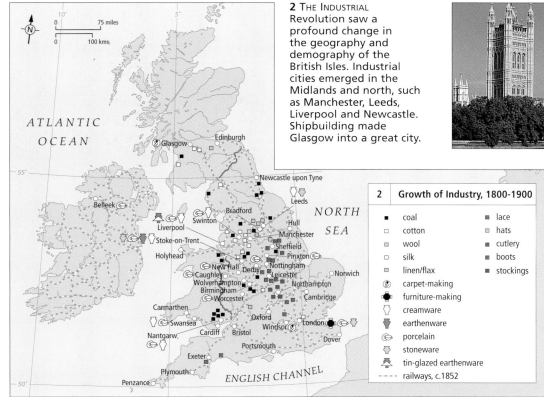

2 THE INDUSTRIAL Revolution saw a profound change in the geography and demography of the British Isles. Industrial cities emerged in the Midlands and north, such as Manchester, Leeds, Liverpool and Newcastle. Shipbuilding made Glasgow into a great city.

2	**Growth of Industry, 1800-1900**
■ coal	■ lace
□ cotton	▣ hats
▣ wool	■ cutlery
□ silk	■ boots
▣ linen/flax	■ stockings
⊘ carpet-making	
⬢ furniture-making	
▽ creamware	
⬙ earthenware	
⬠ porcelain	
⬡ stoneware	
⚲ tin-glazed earthenware	
---- railways, c.1852	

THE GOTHIC REVIVAL. A.W.N. Pugin and Charles Barry designed a spectacular Neo-Gothic Palace of Westminster (1840–60) to replace the medieval structure destroyed by fire in 1834. Universally known as the 'Houses of Parliament' the design was intended to recreate the grandeur and spiritual purity of the Middle Ages, though modern techniques were utilized.

follower William Morris moved from London to an idyllic Thames side residence at Kelmscott, pursuing his medieval ideal by reviving various craft techniques and eventually adopting Socialist politics. Towards the end of the century, the Arts and Crafts Movement distilled from nostalgic Medievalism a pioneering form of Modernist design.

THE AESTHETIC MOVEMENT

From the 1860s, British artists and designers abandoned the excessive elaboration of early Victorian styles in favour of formal simplification. The subtle, tonal paintings of James McNeill Whistler, entitled as 'symphonies' and 'nocturnes', aspired, in the phrase of the aesthete Walter Pater 'to the condition of music'. Artists such as Frederic Leighton and Edward Burne-Jones created subjectless canvases which were pure meditations on beauty. The Aesthetic Movement influenced interior design for the rest of the century. Oscar Wilde was a prominent aesthete – his advocacy of blue-and-white china and his use of the lily emblem were satirized in Gilbert and Sullivan's operetta *Patience* (1881).

Birmingham and Leeds, who tended to purchase the work of contemporary artists. The railway system, which linked every major city by 1852, also allowed for the free circulation of decorative arts, such as Sheffield cutlery, and textiles from Leeds and Bradford. The Crystal Palace, designed by Joseph Paxton and assembled in London in 1851 to house the Great Exhibition, was made from iron elements pre-fabricated in Birmingham. The cornucopia of goods shown there displayed British manufacturing skill, but were often in poor taste. The South Kensington Museum, which opened in 1857, was intended to promote design reform.

REVIVALISM

London architecture underwent dramatic changes during this period. John Nash's elegantly stuccoed Neoclassical development in Regent's Park, dating to 1811, was vehemently criticised by A. W. N. Pugin and the great art critic John Ruskin. Pugin and Barry's Palace of Westminster (1840–60) joined William Butterfield's All Saints, Margaret Street (1849–59) and George Gilbert Scott's Albert Memorial (1863–76) to form a corpus of major Gothic Revival structures. Ruskin supported the Pre-Raphaelites, a group of young artists turning to naturalism as a means of countering their academic education, and his

3 IN LONDON the focus of artistic life shifted from Bloomsbury and Soho, where many artists lived until 1850, to fashionable Kensington, where leading figures included Frederic Leighton and John Everett Millais, successive presidents of the Royal Academy who lived in opulent mansions. Chelsea acquired a bohemian reputation at the height of the Aesthetic Movement in the 1860s and 1870s.

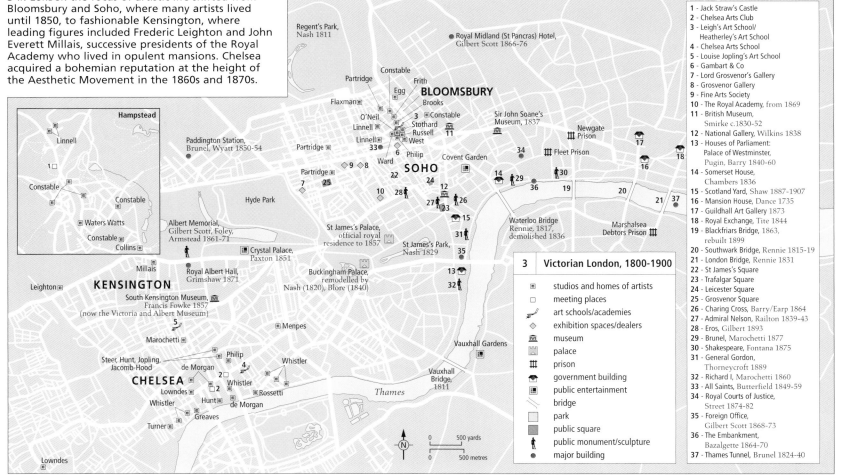

3	**Victorian London, 1800-1900**
▣	studios and homes of artists
□	meeting places
⚓	art schools/academies
◇	exhibition spaces/dealers
⛭	museum
⛪	palace
⫿	prison
⬛	government building
▦	public entertainment
⛲	bridge
□	park
⬛	public square
⬩	public monument/sculpture
●	major building

1 - Jack Straw's Castle
2 - Chelsea Arts Club
3 - Leigh's Art School/ Heatherley's Art School
4 - Chelsea Arts School
5 - Louise Jopling's Art School
6 - Gambart & Co
7 - Lord Grosvenor's Gallery
8 - Grosvenor Gallery
9 - Fine Arts Society
10 - The Royal Academy, from 1869
11 - British Museum, Smirke c.1830-52
12 - National Gallery, Wilkins 1838
13 - Houses of Parliament: Palace of Westminster, Pugin, Barry 1840-60
14 - Somerset House, Chambers 1836
15 - Scotland Yard, Shaw 1887-1907
16 - Mansion House, Dance 1735
17 - Guildhall Art Gallery 1873
18 - Royal Exchange, Tite 1844
19 - Blackfriars Bridge, 1863, rebuilt 1899
20 - Southwark Bridge, Rennie 1815-19
21 - London Bridge, Rennie 1831
22 - St James's Square
23 - Trafalgar Square
24 - Leicester Square
25 - Grosvenor Square
26 - Charing Cross, Barry/Earp 1864
27 - Admiral Nelson, Railton 1839-43
28 - Eros, Gilbert 1893
29 - Brunel, Marochetti 1877
30 - Shakespeare, Fontana 1875
31 - General Gordon, Thorneycroft 1889
32 - Richard I, Marochetti 1860
33 - All Saints, Butterfield 1849-59
34 - Royal Courts of Justice, Street 1874-82
35 - Foreign Office, Gilbert Scott 1868-73
36 - The Embankment, Bazalgette 1864-70
37 - Thames Tunnel, Brunel 1824-40

THE NETHERLANDS AND BELGIUM 1800-1900

THE NETHERLANDS AND BELGIUM were under Austrian then French domination (1794–1813), becoming one nation, the United Kingdom of the Netherlands (1815–30), following victory over Napoleon at Waterloo. French Beaux Arts traditions in art and architecture remained strong, particularly the Romantic tradition, seen in the work of Antoine Wiertz. In 1830 Belgian independence was established under Leopold of Saxe-Coburg-Gotha. The cultural institutions, museums and galleries of each new state were fundamental to the formation of national unity and identity.

BELGIUM AFTER 1830
Belgium became the fifth-largest industrial state in Europe, dominated after 1848 by a wealthy urban bourgeoisie. Heavy industries expanded in the Wallonian French-speaking provinces, while the development of the port of Antwerp and a rail network allowed the global circulation of goods from, and into, Belgium. Working-class radicalism flourished in the poor conditions of factory workers in the textile, mining, steel and glass industries. The emergent Socialist movement had a profound cultural impact in Belgium. Artists committed to social change and reform in industrial production depicted these workers; Vincent van Gogh (1853–90) worked among Borinage miners, and Constantin Meunier (1831–1905) painted and drew in the industrial Liège basin and Antwerp docks. His *Monument to Labour* was installed in the Place de Trooz, Brussels.

THE NETHERLANDS AFTER 1830
Land, water and wind, the natural elements of the Dutch landscape, remained its most valuable natural resources. Agriculture, mainly dairy and potatoes, and fishing flourished. Engineering and scientific skills were built on traditional expertise, used over the centuries to drain sea and lakes. The Dutch landscape provided rich subject matter for artists, who were inspired by seventeenth-century precedents. The English artist J. M. W. Turner chose a Jan van Goyen subject on his first visit in 1817, while artists from France, England, Germany, Japan and North America were drawn to the atmospheric land- and seascapes. Utilizing the rail networks, art colonies flourished along the Dutch coast, at Egmond, the island of Marken, Volendam, Zandvoort, Katwijk and Domburg, and inland at Laren,

STAIRWELL OF THE ART NOUVEAU Hotel van Eetvelde, Brussels, designed in 1895 by Victor Horta for Baron van Eetvelde, state secretary to the Independent Congo state. Like other houses Horta designed for wealthy Brussels clients, the stairwell is the pivot of the design, creating spatial fluidity and complexity.

Heeze and Laethem-Saint-Maarten in Belgium. Van Gogh made numerous drawings and paintings of agricultural landscapes and workers, weavers and their looms, potato production and consumption on the moors and peat bogs of Drenthe (1883) and in Brabant (1881 and 1883–5).

The market for Dutch landscape painting expanded to America, Europe, Australia, New Zealand and Britain. The Hague School (1870–85) formed when a number of artists including Jozef Israëls, Anton Mauve, the Maris brothers and H. W. Mesdag, began painting the landscape, sea and fishing communities at nearby Scheveningen in a characteristic sketchy style with a grey palette. The land reclamation schemes of engineers had created the unique Dutch landscape, and railways now made it accessible. It was artists and photographers, however, who now turned the landscape into a popular tourist attraction.

METROPOLITAN CENTRES
Wealth and power resided in the metropolitan centres, where collections of national and global artefacts were displayed in private and public collections. Symbolism and Impressionism flourished in Brussels where artists and writers embraced socialist and anarchistic politics. Les XX ('Les Vingt', 1883–93), became the leading exhibition space and forum for avant-garde ideas and included European, British and American artists. James Ensor's giant canvas *Christ's Entry into Brussels in 1889*, was rejected by Les Vingt. The painting represents the imagined entry of Christ into Brussels as part of a socialist demonstration and a Mardi Gras, drawing on long-standing Belgian traditions of masked carnival.

The flourishing of the Belgian iron, glass and steel industries underpinned the development of Art Nouveau, which became

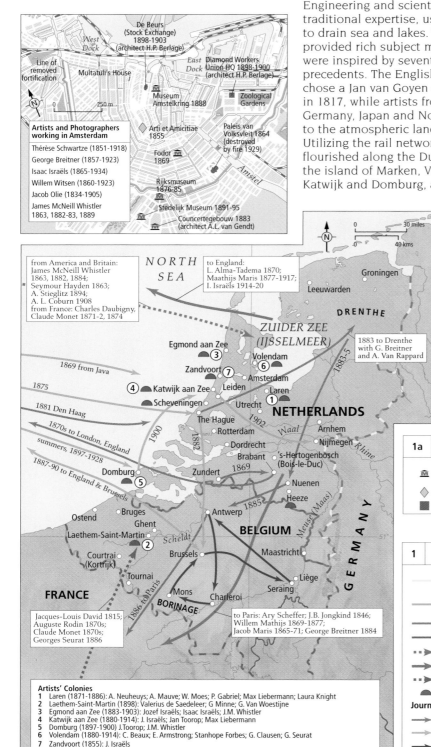

Artists and Photographers working in Amsterdam
Thérèse Schwartze (1851-1918)
George Breitner (1857-1923)
Isaac Israëls (1865-1934)
Willem Witsen (1860-1923)
Jacob Olie (1834-1905)
James McNeill Whistler 1863, 1882-83, 1889

De Beurs (Stock Exchange) 1898-1903 (architect H.P. Berlage)
West Dock
East Dock
Line of removed fortification
Multatuli's House
Diamond Workers Union HQ 1898-1900 (architect H.P. Berlage)
Museum Amstelkring 1888
Zoological Gardens
Arti et Amicitiae 1855
Paleis van Volksvlijt 1864 (destroyed by fire 1929)
Fodor 1869
Rijksmuseum 1876-85
Stedelijk Museum 1891-95
Concertgebouw 1883 (architect A.L. van Gendt)

from America and Britain:
James McNeill Whistler 1863, 1882, 1884;
Seymour Hayden 1863;
A. Stieglitz 1894;
A. L. Coburn 1908
from France: Charles Daubigny;
Claude Monet 1871-2, 1874

to England:
L. Alma-Tadema 1870;
Maathijs Maris 1877-1917;
I. Israëls 1914-20

NORTH SEA
Groningen
Leeuwarden
DRENTHE
ZUIDER ZEE (IJSSELMEER)
Egmond aan Zee ③
1869 from Java
Volendam ⑥
Zandvoort ⑦
Amsterdam
1875
④ Katwijk aan Zee Leiden
Scheveningen
1881 Den Haag
Utrecht Laren ①
1870s to London, England
The Hague
summers, 1897-1928
Rotterdam
Waal
Arnhem
NETHERLANDS
1887-90 to England & Brussels
Dordrecht
Nijmegen
Rhine
1883 to Drenthe with G. Breitner and A. Van Rappard
Domburg ⑤
Zundert
's-Hertogenbosch (Bois-le-Duc)
Brabant 1869
Nuenen
Heeze
Ostend
Bruges
Antwerp
Ghent
Laethem-Saint-Martin ②
Scheldt
BELGIUM
Maastricht
Meuse (Maas)
Courtrai (Kortrijk)
Brussels
Tournai
Mons
Charleroi
Liège
Seraing
FRANCE
BORINAGE

Jacques-Louis David 1815;
Auguste Rodin 1870s;
Claude Monet 1870s;
Georges Seurat 1886

to Paris: Ary Scheffer; J.B. Jongkind 1846;
Willem Mathijs 1869-1877;
Jacob Maris 1865-71; George Breitner 1884

0 — 30 miles
0 — 40 kms

1 HISTORIC WORKS from Belgium and the Netherlands were acquired by American museums and European, British and American artists came to Dutch and Belgian art colonies. Colonial expansion brought imports of African, East Asian and Japanese art. Amsterdam was a major marketplace for colonial products and a cultural centre for artists, photographers and tourists.

1a	Amsterdam
🏛	new museums with historical and contemporary European art
◇	artists' societies
◼	key buildings

1	Cross-Border Contacts
	French state of Belgium and Holland 1799-1813
	United Kingdom of the Netherlands 1813-30
	Holland 1813
	Belgium 1830
▪▶	artists arriving in the Netherlands
▶	artists leaving the Netherlands
▪▶	artists arriving in Belgium
◗	artistic colonies

Journeys made by individual artists:
→ Vincent Van Gogh 1853-90
→ Jan Toorop 1858-1928
→ Constant Meunier 1831-1905

Artists' Colonies
1 Laren (1871-1886): A. Neuheuys; A. Mauve; W. Moes; P. Gabriel; Max Liebermann; Laura Knight
2 Laethem-Saint-Martin (1898): Valerius de Saedeleer; G Minne; G. Van Woestijne
3 Egmond aan Zee (1883-1903): Jozef Israëls; Isaac Israëls; J.M. Whistler
4 Katwijk aan Zee (1880-1914): J. Israëls; Jan Toorop; Max Liebermann
5 Domburg (1897-1900) J.Toorop; J.M. Whistler
6 Volendam (1880-1914): C. Beaux; E. Armstrong; Stanhope Forbes; G. Clausen; G. Seurat
7 Zandvoort (1855): J. Israëls

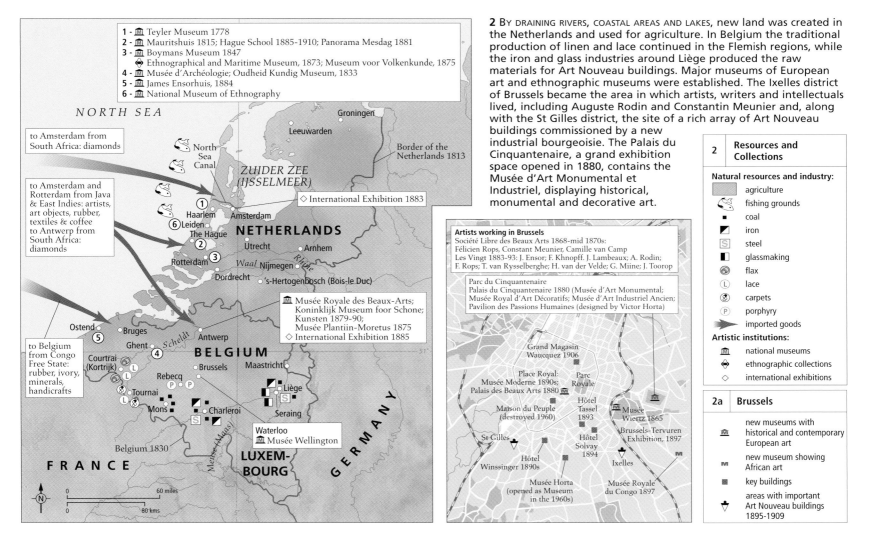

1 - 🏛 Teyler Museum 1778
2 - 🏛 Mauritshuis 1815; Hague School 1885-1910; Panorama Mesdag 1881
3 - 🏛 Boymans Museum 1847
 ⬡ Ethnographical and Maritime Museum, 1873; Museum voor Volkenkunde, 1875
4 - 🏛 Musée d'Archéologie; Oudheid Kundig Museum, 1833
5 - 🏛 James Ensorhuis, 1884
6 - 🏛 National Museum of Ethnography

to Amsterdam from South Africa: diamonds

to Amsterdam and Rotterdam from Java & East Indies: artists, art objects, rubber, textiles & coffee
to Antwerp from South Africa: diamonds

to Belgium from Congo Free State: rubber, ivory, minerals, handicrafts

NORTH SEA

Groningen
Leeuwarden
North Sea Canal
ZUIDER ZEE (IJSSELMEER)
Border of the Netherlands 1813
◇ International Exhibition 1883
Haarlem
Leiden
Amsterdam
NETHERLANDS
The Hague
Utrecht
Arnhem
Waal Nijmegen
Rhine
Rotterdam
Dordrecht
's-Hertogenbosch (Bois-le Duc)

🏛 Musée Royale des Beaux-Arts; Koninklijk Museum foor Schone; Kunsten 1879-90; Musée Plantiin-Moretus 1875
◇ International Exhibition 1885

Ostend
Bruges
Ghent
Scheldt
Antwerp
BELGIUM
Maastricht
Courtrai (Kortrijk)
Rebecq
Brussels
Liège
Tournai
Mons
Charleroi
Seraing
Waterloo 🏛 Musée Wellington
Belgium 1830
FRANCE
LUXEM-BOURG
GERMANY

0 60 miles
0 80 kms

Artists working in Brussels
Société Libre des Beaux Arts 1868-mid 1870s:
Félicien Rops, Constant Meunier, Camille van Camp
Les Vingt 1883-93: J. Ensor; F. Khnopff. J. Lambeaux; A. Rodin; F. Rops; T. van Rysselberghe; H. van der Velde; G. Miine; J. Toorop

Parc du Cinquantenaire
Palais du Cinquantenaire 1880 (Musée d'Art Monumental; Musée Royal d'Art Décoratifs; Musée d'Art Industriel Ancien; Pavilion des Passions Humaines (designed by Victor Horta)

Grand Magasin Wauquez 1906
Place Royal: Musée Moderne 1890s;
Palais des Beaux Arts 1880
Parc Royale
Hôtel Tassel 1893
Maison du Peuple (destroyed 1960)
St Gilles
Musée Wiertz 1865
Brussels-Tervuren Exhibition, 1897
Hôtel Solvay 1894
Ixelles
Hôtel Winssinger 1890s
Musée Horta (opened as Museum in the 1960s)
Musée Royale du Congo 1897

2 BY DRAINING RIVERS, COASTAL AREAS AND LAKES, new land was created in the Netherlands and used for agriculture. In Belgium the traditional production of linen and lace continued in the Flemish regions, while the iron and glass industries around Liège produced the raw materials for Art Nouveau buildings. Major museums of European art and ethnographic museums were established. The Ixelles district of Brussels became the area in which artists, writers and intellectuals lived, including Auguste Rodin and Constantin Meunier and, along with the St Gilles district, the site of a rich array of Art Nouveau buildings commissioned by a new industrial bourgeoisie. The Palais du Cinquantenaire, a grand exhibition space opened in 1880, contains the Musée d'Art Monumental et Industriel, displaying historical, monumental and decorative art.

2	Resources and Collections

Natural resources and industry:
- agriculture
- 🐟 fishing grounds
- ▪ coal
- iron
- Ⓢ steel
- ▮ glassmaking
- ⊚ flax
- Ⓛ lace
- ⊛ carpets
- Ⓟ porphyry
- ➡ imported goods

Artistic institutions:
- 🏛 national museums
- ⬡ ethnographic collections
- ◇ international exhibitions

2a	Brussels

- 🏛 new museums with historical and contemporary European art
- Ⓜ new museum showing African art
- ▪ key buildings
- ⬥ areas with important Art Nouveau buildings 1895-1909

one of the first modern styles to rework the languages of Classical art, architecture and the decorative arts. Fundamental to Art Nouveau are flowing organic forms employed as both decorative and structural elements. In Brussels, Victor Horta and Paul Hankar built private houses and department stores, such as the Grand Magasin Waucquez, for wealthy bankers and industrialists and the socialist Maison du Peuple (1896–9; destroyed 1965).

Individual wealth and state funding supported national collections of historical and modern European art. Rembrandt's *Nightwatch* was placed in a pre-eminent position in the new Rijksmuseum, Amsterdam, which displayed ceramics, furniture, gold, silver and glass. The impressionistic style and sombre tonalities of Amsterdam School (1890–1910) painters George Breitner and Isaac Israëls forged a new iconography in paintings and photographs of city spaces, shops, workers and entertainment. The robust financial sector in Amsterdam commissioned new buildings, notably De Beurs (the stock exchange), designed by H. P. Berlage. Rooted in arts and crafts ideals, it contained a rich decorative interior, paradoxically symbolizing both the financial strength of the Netherlands and Amsterdam's Socialism.

COLONIAL ACQUISITIONS
Numerous art objects and artefacts entered both countries from the Netherlands' colonies and Léopold II's central African territories, (1878–1908). Scientific researchers and traders in Africa collected souvenirs and curios which were sold and exhibited in western Europe until Léopold insisted that significant material was state property; 250,000 agricultural and musical objects, masks, sacred objects and weapons from central Africa acquired by Léopold were exhibited in the Brussels-Tervuren Exposition 1897.

Dutch trade in raw materials, dyes, spices, coffee and sugar with the East Indies was extensive. Exchange trade in textiles brought *batik* and art objects from Southeast and East Asia into the hands of Dutch private collectors and into ethnographic museums and galleries. Javanese art influenced the Dutch Symbolists, particularly Jan Toorop.

Japanese art and artefacts were collected by colonial officials and brought to the Netherlands, although the Dutch monopoly on trade with Japan was broken by America in 1850. Japanese material was displayed in the Hague in the Royal Cabinet of Curiosities before 1835, and formed the nucleus of the National Museum of Ethnology, Leiden. Japanese goods and prints were exhibited in Antwerp's Exposition Universelles in 1885 and sold in Belgian and Dutch cities. Prints bought by artists, including van Gogh, offered new visual forms to western artists.

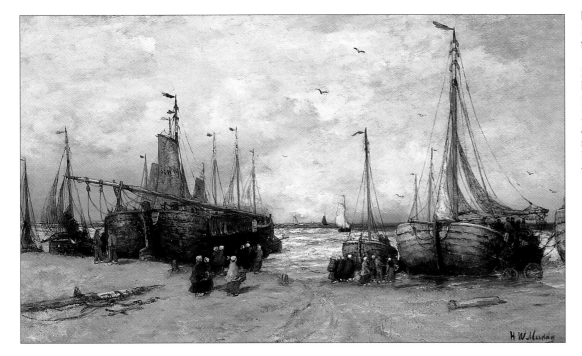

HENDRIK WILLEM MESDAG, *Bluff-bowed Fishing Boats on the Beach*, 1870s, oil on panel. Scheveningen, near The Hague, offered numerous subjects for artists; the men and women of the fishing industry, the boats, sea and tourists. Mesdag's grandest work, *Panorama Mesdag*, was funded by a Belgian entrepreneur. It is a huge circular painting made with assistance from five artists, including Sientje Mesdag, from topographical sketches and photographs panoramically representing the old fishing village of Scheveningen.

GERMANY AND SWITZERLAND 1800-1900

IT IS WELL KNOWN that the history of German-speaking Europe is one of drastically shifting external borders. However, what is less often realized is that there are traditionally strong internal borders that have changed little. As far as many regionally minded Germans are concerned, they are still very much with us today. They developed during many centuries preceding the abolition of the old Roman/German empire in 1803 and they continued through the unification process of the Second German Empire under Prussian rule from 1866 to 1918. Furthermore, there has never been a real centre in Germany; the country was and is truly federal. Competition between centres has always been inbuilt.

GERMAN DIVERSITY

One major difference between regions that carried on from the centuries before was religion. During the Reformation the principle was *Cuius regio, eius religio* ('of that kingdom, of that religion'): it was each prince's decision

whether his principality would become Protestant or remain Catholic.

Another difference between German regions is the vast range of sizes of regional units. What is singular in Germany is that there is not the same number of similarly medium-sized regions as found in France or Italy. Between 1815 and 1866 Prussia and Bavaria were virtually independent countries on a European scale. Their capitals, Berlin and Munich, both ranked among the top ten European art centres. But there were also the small, and even the diminutive princelings and their 'capitals'.

PRINCELY PATRONAGE AND PUBLIC SPIRIT
The Grand Duchy of Oldenburg, largely rural, comprised about 250,000 inhabitants. Its capital, Oldenburg, with some 30,000 inhabitants, sported a picture gallery, a museum of natural history, a theatre and a public library, all purpose-built. In even smaller Meiningen, in the dukedom of Saxe-

Meiningen, the Duke's Van Ruisdaels and Botticellis were accessible in his palace, and the town's large, purpose-built theatre/opera house became world famous for its first performances of works by Brahms and Richard Strauss and for its historicist stage sets.

Of course, one may compare this kind of patronage with that of the aristocracy throughout Europe, but as the German princes were still to some extent sovereigns (until 1918) there was a unique process that gradually transformed privately funded institutions into state ones. Today, the tiny principality of Liechtenstein is a lone survivor of this ancient tradition. A somewhat different kind of public spirit can be found in the ancient 'free cities' of the old Roman/German empire and in other large cities that were not capitals of principalities, such as Frankfurt am Main, Hamburg, Bremen, Strassburg, Cologne, Leipzig or Breslau (Wroclaw). Patronage came from local citizens and corporate bodies. Most towns also had art societies (*Kunstvereine*).

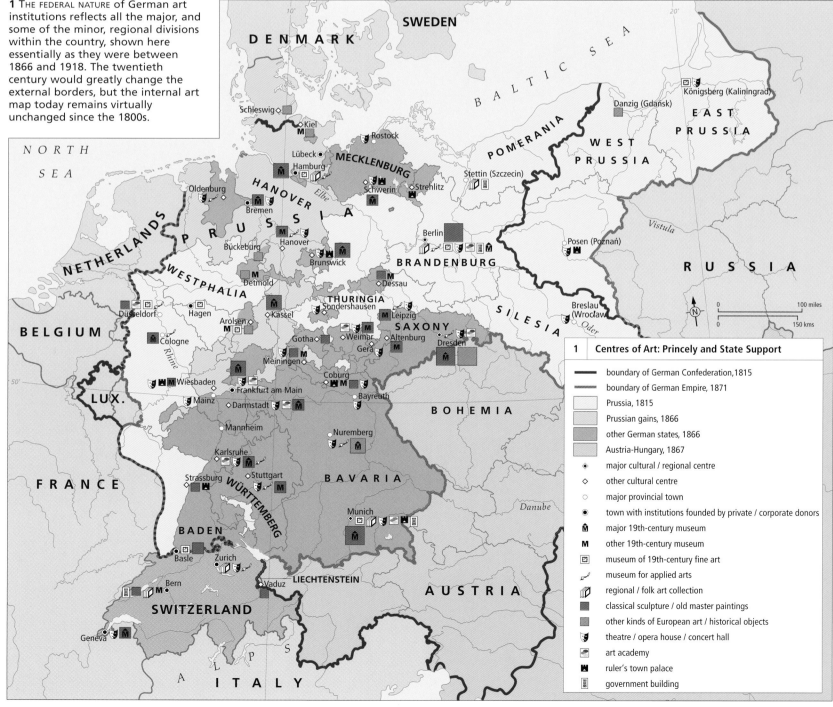

1 THE FEDERAL NATURE of German art institutions reflects all the major, and some of the minor, regional divisions within the country, shown here essentially as they were between 1866 and 1918. The twentieth century would greatly change the external borders, but the internal art map today remains virtually unchanged since the 1800s.

1	Centres of Art: Princely and State Support
———	boundary of German Confederation, 1815
———	boundary of German Empire, 1871
	Prussia, 1815
	Prussian gains, 1866
	other German states, 1866
	Austria-Hungary, 1867
◉	major cultural / regional centre
◇	other cultural centre
○	major provincial town
◉	town with institutions founded by private / corporate donors
M̂	major 19th-century museum
M	other 19th-century museum
▣	museum of 19th-century fine art
✎	museum for applied arts
◫	regional / folk art collection
■	classical sculpture / old master paintings
■	other kinds of European art / historical objects
♔	theatre / opera house / concert hall
✍	art academy
⚔	ruler's town palace
▦	government building

Industrialization and commercialization had become nationwide by late in the century. They made the towns of the new German Empire look more alike, and the primarily industrial towns of the Ruhr, Upper Saxony or eastern Upper-Silesia assumed some cultural status, too. Finally, the rise of art publishing on a mass scale, centred in Leipzig and Munich, led to a further democratization of fine art.

SWITZERLAND

Swiss patronage in the nineteenth century also reflected a background context of urban and regional independence. Within the old Roman/German empire (which included the lands that became French- and Italian-speaking Switzerland) the Swiss had gradually gained their independence and kept their religious freedom (which mostly meant Protestantism). Unlike the Germans, however, the Swiss virtually eliminated rule by princelings.

Like Germany, Switzerland was a federal state, and, typically, the federal capital, Bern (from 1848), was only the fourth city in most other respects, after Basle, Zurich and Geneva. Thus one expects no 'official' patronage, but the situation is more complex. Most museums were founded by artists' associations, but the Basle collection was municipal from the seventeenth century onwards, and the Schweizerisches Landesmuseum in Zurich was a federal institution.

ARTISTIC MOVEMENTS

Regional institutionalism was counterbalanced by artistic movements. Almost by definition, Classicism, Romanticism, Medievalism, Realism, Impressionism and Modernism ignore political boundaries. In any case, many of the movements were directed not from within Germany, but by the major European art centres outside. Rome had been a centre of 'German' art since the growth of the Grand Tour from the 1770s. During the 1860s and from the late 1890s Germans joined most other Europeans in flocking to Paris. There were also Copenhagen (in the early nineteenth century), Brussels (in the 1840s) and England (for late nineteenth-century painting and applied arts).

Art-geography in German-speaking countries is highly complex where pan-Europeanism interacts with nationalism – for instance, the Nazarene Brotherhood preached a new love of medieval German painting from Rome, and Gothic Revivalists looked to England. Pan-German nationalism increasingly interacted with, or conflicted with, the revival of regional vernacular styles. Its first manifestations were artists' colonies in the countryside. Did Bavarianism, to name the most pervasive of them, belong to greater German culture or to the wider current of 'Alpinism' which included the Tyroleans and the Swiss? The fundamental German problem was that a definition of pan-German art remained elusive.

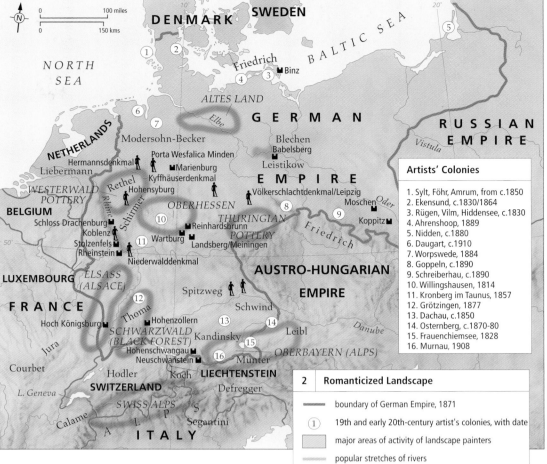

Artists' Colonies

1. Sylt, Föhr, Amrum, from c.1850
2. Ekensund, c.1830/1864
3. Rügen, Vilm, Hiddensee, c.1830
4. Ahrenshoop, 1889
5. Nidden, c.1880
6. Daugart, c.1910
7. Worpswede, 1884
8. Goppeln, c.1890
9. Schreiberhau, c.1890
10. Willingshausen, 1814
11. Kronberg im Taunus, 1857
12. Grötzingen, 1877
13. Dachau, c.1850
14. Osternberg, c.1870-80
15. Frauenchiemsee, 1828
16. Murnau, 1908

2	Romanticized Landscape
————	boundary of German Empire, 1871
①	19th and early 20th-century artist's colonies, with date
	major areas of activity of landscape painters
	popular stretches of rivers
	areas of mid-/late 19th-century interest in folklore/crafts revivals
	castellated country houses/extensively rebuilt medieval ruined castles
	sculptural/architectural public monument in landscaped surroundings

2 THE DIVERSITY OF LANDSCAPES Artists and antiquarians liked to emphasize the diversity of landscapes in West-Central Europe; folklore studies drew attention to regional peasant dress and later indigenous craft products. Large-scale sculptural and architectonic monuments, celebrating moments of German history, as well as the numerous castellated mansions, also interpreted the landscape.

ABOVE: THE KÖNIGSPLATZ IN MUNICH (1815–60). In the early nineteenth century Bavaria became a kingdom under Ludwig I (r.1825–48), who was personally acquainted with the artistic avant-garde. He made Munich his seat of government, the art capital of Germany, by creating grandiose avenues, squares, monuments (including the Propylaen, bottom right) and museums, the first being the Glyptothek (right), for Antique sculpture.

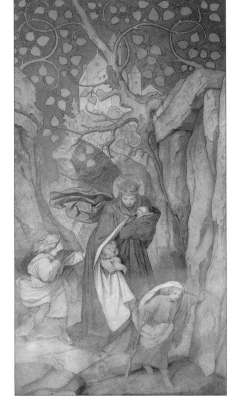

RIGHT: THE EXPULSION OF ST. ELISABETH (of Hungary) (1855) by Moritz von Schwind (1804–71), fresco, Wartburg Castle. The Grand-Duchy of Sachsen-Weimar-Eisenach had few equals for cultural influence. It played host to the poets Goethe and Schiller and initiated the Bauhaus movement of the architect Walter Gropius (1883–1969). The castle, near Eisenach, was fitted out with frescoes, romantically depicting episodes from its own medieval history.

FRANCE 1800-1900

THE LEGACY of Napoleon cannot be overstated. During his brief regime, he not only centralized most of Europe and the Near East politically, but also culturally, setting a precedent for France's invasion and pillaging of each new territory by sending legions of scholars and artists as well as soldiers. Baron Vivant Denon's *Description de l'Egypte* of 1809–29 informed the distinctive Orientalism of Maxime Du Camp's photo albums or the paintings of Vernet, Fromentin, Delacroix and Gérome of the second half of the century. The popularity and refinement of French design emanating from the national

manufactures of porcelain at Sèvres (near Paris) and textiles at Gobelins, set up by Napoleon, fostered the culture of technical innovation and skill required by Art Nouveau designers such as Lalique or Guimard at the end of the century.

THE ESCAPE TO THE COUNTRY

The volatility of France's political identity over the century, the unrelenting migration to cities such as Paris, Lyon and Marseille by workmen, artists and the middle classes, and the expansion of the railways fostered the vogue for landscape painting. The nineteenth-century

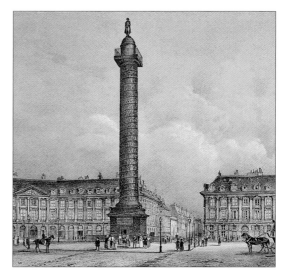

THE VENDÔME COLUMN Forged from cannons from the Battle of Austerlitz (1805), Bergeret's bas-reliefs of Napoleon's victories and Gondouin's and Lepère's toga-clad emperor were replaced by a fleur-de-lys during the Restoration. Louis Philippe erected a new statue of Napoleon in a frock coat. The column, toppled by Courbet during the 1870 Commune, was re-erected in 1874.

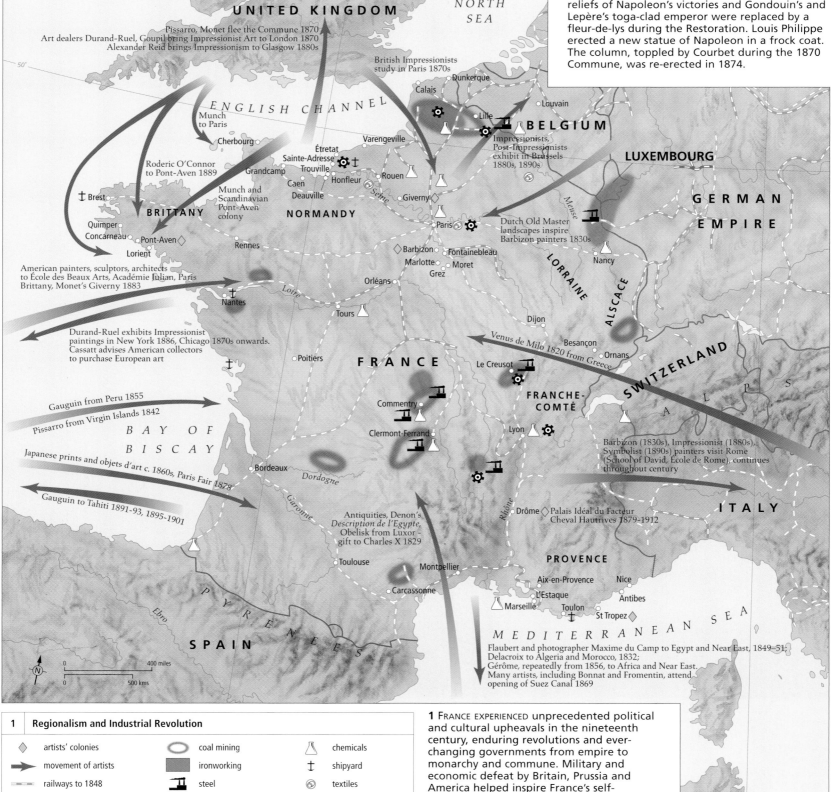

Pissarro, Monet flee the Commune 1870
Art dealers Durand-Ruel, Goupil bring Impressionist Art to London 1870
Alexander Reid brings Impressionism to Glasgow 1880s

British Impressionists study in Paris 1870s

Munch to Paris

Roderic O'Connor to Pont-Aven 1889

Munch and Scandinavian Pont-Aven colony

Impressionists, Post-Impressionists exhibit in Brussels 1880s, 1890s

Dutch Old Master landscapes inspire Barbizon painters 1830s

American painters, sculptors, architects to École des Beaux Arts, Académie Julian, Paris Brittany, Monet's Giverny 1883

Venus de Milo 1820 from Greece

Durand-Ruel exhibits Impressionist paintings in New York 1886, Chicago 1870s onwards. Cassatt advises American collectors to purchase European art

Gauguin from Peru 1855
Pissarro from Virgin Islands 1842

Japanese prints and objets d'art c. 1860s, Paris Fair 1878

Gauguin to Tahiti 1891-93, 1895-1901

Barbizon (1830s), Impressionist (1880s), Symbolist (1890s) painters visit Rome (School of David, École de Rome), continues throughout century

Palais Idéal du Facteur Cheval Hautrives 1879-1912

Antiquities, Denon's *Description de l'Egypte*, Obelisk from Luxor - gift to Charles X 1829

Flaubert and photographer Maxime du Camp to Egypt and Near East, 1849–51; Delacroix to Algeria and Morocco, 1832; Gérôme, repeatedly from 1856, to Africa and Near East. Many artists, including Bonnat and Fromentin, attend opening of Suez Canal 1869

Map labels: UNITED KINGDOM · NORTH SEA · ENGLISH CHANNEL · Dunkerque · Calais · Lille · Louvain · BELGIUM · LUXEMBOURG · Cherbourg · Varengeville · Étretat · Sainte-Adresse · Trouville · Honfleur · Rouen · Grandcamp · Caen · Deauville · Giverny · Seine · GERMAN EMPIRE · Meuse · Brest · BRITTANY · NORMANDY · Paris · LORRAINE · Nancy · Quimper · Concarneau · Pont-Aven · Rennes · Barbizon · Fontainebleau · Marlotte · Moret · ALSACE · Lorient · Grez · Nantes · Loire · Orléans · Dijon · Besançon · Ornans · SWITZERLAND · Tours · Le Creusot · Poitiers · FRANCE · FRANCHE-COMTÉ · ALPS · Commentry · Bordeaux · Dordogne · Clermont-Ferrand · Lyon · ITALY · Garonne · Drôme · Rhône · Toulouse · Montpellier · PROVENCE · Aix-en-Provence · Nice · L'Estaque · Antibes · Carcassonne · Marseille · Toulon · St Tropez · Ebro · PYRENEES · SPAIN · BAY OF BISCAY · MEDITERRANEAN SEA

0 400 miles
0 500 kms

1	Regionalism and Industrial Revolution

- ◇ artists' colonies
- ⟶ movement of artists
- ⋯ railways to 1848
- ⋯ railways to 1860
- ⬭ coal mining
- ▨ ironworking
- 🏭 steel
- ⚙ engineering
- ⚗ chemicals
- ‡ shipyard
- ◎ textiles

1 FRANCE EXPERIENCED unprecedented political and cultural upheavals in the nineteenth century, enduring revolutions and ever-changing governments from empire to monarchy and commune. Military and economic defeat by Britain, Prussia and America helped inspire France's self-promotion as a centre for luxury goods and the arts rather than industrial might.

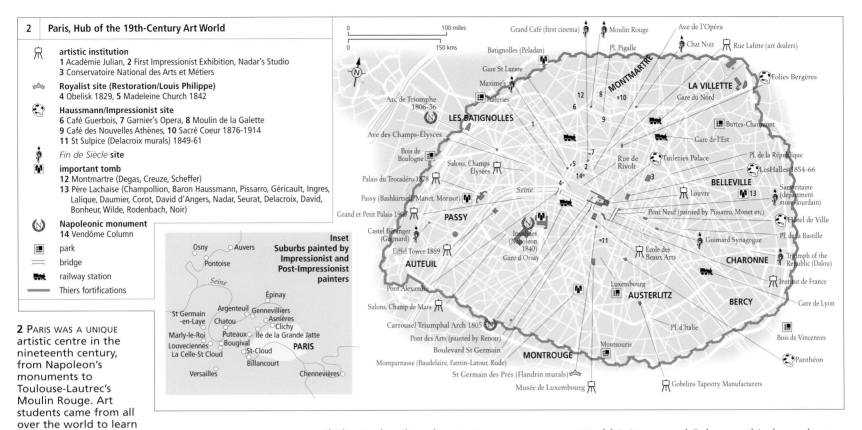

2 | Paris, Hub of the 19th-Century Art World

🏛 **artistic institution**
1 Académie Julian, 2 First Impressionist Exhibition, Nadar's Studio
3 Conservatoire National des Arts et Métiers

👑 **Royalist site (Restoration/Louis Philippe)**
4 Obelisk 1829, 5 Madeleine Church 1842

🎨 **Haussmann/Impressionist site**
6 Café Guerbois, 7 Garnier's Opera, 8 Moulin de la Galette
9 Café des Nouvelles Athènes, 10 Sacré Coeur 1876-1914
11 St Sulpice (Delacroix murals) 1849-61

🎨 *Fin de Siècle* site

🏛 **important tomb**
12 Montmartre (Degas, Creuze, Scheffer)
13 Père Lachaise (Champollion, Baron Haussmann, Pissarro, Géricault, Ingres, Lalique, Daumier, Corot, David d'Angers, Nadar, Seurat, Delacroix, David, Bonheur, Wilde, Rodenbach, Noir)

Ⓝ **Napoleonic monument**
14 Vendôme Column

▦ park
= bridge
🚂 railway station
— Thiers fortifications

2 Paris was a unique artistic centre in the nineteenth century, from Napoleon's monuments to Toulouse-Lautrec's Moulin Rouge. Art students came from all over the world to learn in its museums, studios and cafés, while ambitious artists battled for fame and commissions at its Salons, World Fairs and exhibitions. Posthumous celebrity could be assured in the pantheon of cemeteries like Père Lachaise.

Inset Suburbs painted by Impressionist and Post-Impressionist painters

passion for the lush, individualistic images of a timeless countryside, be it Rousseau's Fontainebleau forest, Monet's Normandy or Gauguin's Pont-Aven, reflects the blend of nostalgia and anxiety which the new predominance of the industrial city fuelled.

Paris's dominance also inspired a contrasting desire to escape the uniformity and functionalism of modern metropolitan life. Artists of every style and vision sought out a dream of a simple and artistically sincere life amidst the regional peasantry. Bernard's and Gauguin's sojourn in Brittany in the late 1880s drew generations of artists to this distinctive maritime and medieval region. Monet was besieged by eager American acolytes at Giverny. American, British and Scandinavian artists created their own riverside Barbizon at Grez. While Van Gogh and Cézanne each

wrestled in isolated studios in Provence, Signac founded an anarchist collective in the then unknown fishing village of St Tropez. The cultural hegemony of Paris was also undermined by the artistic revival of provincial cities. This can be seen, for example, in the flowering of Art Nouveau design in Nancy, around Gallé and Majorelle, or the decoration in public buildings such as Puvis de Chavannes's murals for the Palace of Fine Arts in Lyon.

PARIS: CAPITAL OF THE ARTS
The psychological and architectural axis of Paris, from the Arc de Triomphe to the Tuileries and the Louvre initiated by Napoleon I, was fully realized by Baron Haussmann for Napoleon III. Paris was transformed into a city of radial vistas, elegant if anonymous façades and entertainments from the Opéra to the brothel. It became the icon of the modern and the metropolitan in art. This unprecedented display of arts, from antiquities like the Luxor obelisk and the Venus de Milo to Dutch seventeenth-century landscapes to the panorama of contemporary trends in art at the

World Fairs, annual Salons and independent exhibitions, drew art students, critics and collectors from every corner of the globe. Paris was the essential artistic début for any nineteenth-century artist of ambition. The eminent École des Beaux-Arts, coupled with more informal studios such as the Académie Julian, which accepted women students, made Paris an unsurpassed educational centre.

The city and its environs also offered a vast array of more bohemian sites of learning. Urban cafés, such as Manet's and Baudelaire's Café Guerbois and the Café des Nouvelles Athènes, were frequented by the Impressionists, while suburban *guingettes* (riverside cafés) like La Grenouillère were immortalized by Renoir and Monet. The *fin de siècle* cabarets of Montmartre, the Chat Noir and the Moulin Rouge were celebrated by Toulouse-Lautrec and drew the young Picasso to Paris in 1899.

Paris had an unprecedented concentration of artistic spaces, from the private art galleries and auction houses of international repute on the rue Lafitte, to elegant restaurants such as Maxime's and the Café Anglais. Exclusive proponents of *haute couture* and design, such as fashion designer Worth, the jeweller Fouquet or the interior design impresario Siegfried Bing, chose to open their boutiques in Paris. Both these more elite shops and the vast departments stores such as the Bon Marché or the Samaritaine fostered some of the most innovative architectural and sociological experiments of the age. Franz Jourdain's Samaritaine, for example, was the apotheosis of Art Nouveau extravagance, as well as being systematically functional.

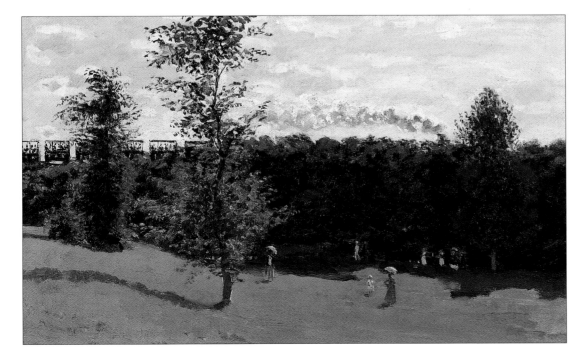

CLAUDE MONET, *A Train in the Countryside,* 1870. More affordable and easy travel by rail facilitated a blossoming of French landscape painting. Impressionist paintings of the 1860s highlighted the encroachment of metropolitan 'modernity' upon the verdant riverside suburbs of Paris, as with Monet's suburban commuter train and promenading day-tripper. However, by the 1890s, much Impressionist and Post-Impressionist painting celebrated a nostalgic vision of unpopulated nature, typified by Monet's Giverny water garden or Van Gogh's and Cézanne's Provence.

SPAIN AND PORTUGAL 1800-1900

THE NINETEENTH CENTURY was a time of social unrest and economic upheaval throughout the Iberian Peninsula, beginning dramatically with the Napoleonic invasions of 1808–12. Spain's political impotence led to the loss of its American colonies – and their trade – (some 50 percent of all Spanish trade in 1800), starting with Paraguay, in 1811. In 1822, Brazil seceded from Portugal, precipitating an economic crisis. The disruptive Carlist Wars in Spain (1833–76) paralleled the Miguelista upheavals in Portugal; both involved revolts against the installation of a female ruler. In 1898, the loss of Cuba and the Philippines to the United States signalled the end of the Spanish Empire.

GOYA'S 'TERRIBLE' VISION

Against this backdrop of foreign domination and national debilitation, the culminating stages of outraged expression attained in the art of Francisco de Goya y Lucientes (1746–1828) after 1799 seem astonishing. Goya's artistic evolution points to a delayed reaffirmation of Spanish paradigms of spontaneous, direct expression and ethical 'naturalism', an attitude which seeks to capture life as it is, without the distortions of idealism. By his increasing attachment to social commentary, he returned to that native tradition which considers painting as a vehicle for moral instruction as opposed to the concept of painting for art's sake. In so doing, Goya seemed also to have invented modern art; at least one underlying modernist

conviction – nihilism – propelled much of his anarchic pessimism, irrationality and anti-conventionality. Goya's 'terrible' vision bears objective witness and is a precocious parallel to the best of modern journalism.

SCHOOLS OF PAINTING

Celebrated by visiting Romantic writers and major French artists – including Victor Hugo, Washington Irving, Alexandre Dumas, Prosper Mérimée, Eugène Delacroix and Gustave Doré – Spain suddenly became an exotic tourist mecca. The impact of these foreign men of letters on Spanish visual culture was to encourage *Costumbrismo*, genre paintings that were a studied, anecdotal depiction of native life and contemporary customs. Major practitioners were José Domínguez Bécquer (1810–41), Manuel Cabral Bejarano (1827–91) and Valeriano Domínguez Bécquer (1833–70). Outside of the School of Seville, the most prominent exponent was the Catalan painter Mariano Fortuny (1838–74).

In Madrid Goya, appointed 'Principal Painter to the King' in 1799, devoted much of his time to society portraits. He published the 'underground' engraving series, the *Caprichos*, in 1799; another 'underground' engraving series, the *Disparates* or *Proverbios*, was only published posthumously, in 1864. This vision reached an unprecedented climax in Goya's cycle of 'black paintings' (c.1820–22) placed in his private villa, the Quinta del Sordo.

The Fine Arts Academy of San Fernando in Madrid, given a royal charter in 1744,

continued to be the central art school well into the twentieth century. The most important art collection in Iberia was in Madrid, where the Prado was made a public museum of painting in 1819 (it was originally built, in 1785–1808, to serve as a museum of natural history). In Lisbon the Academy of Fine Arts was founded in 1836, but no figures of international status emerged. After Goya's death, a dour and wholly secular 'history' painting predominated in government commissions; major artists were Antonio Esquivel (1806–57), Antonio Gisbert Pérez (1834–1901) and Eduardo Rosales (1836–73). Later, in Valencia an Impressionist-type of folklorish genre painting was popularized by Joaquín Sorolla (1863–1923); in Barcelona a Spanish version of French Symbolist art was practised by Santiago Rusiñol (1861–1931), Ramón Casas (1866–1932) and Joaquim Míro (1873–1940).

Following the precedent set by grandiose (and profitable) trade-fair 'international expositions' mounted in England and France, the Universal Exposition of 1888 was staged in

1 NAPOLEONIC INVASIONS of the Iberian peninsula from 1808–12 resulted in a 'War of Independence', commemorated by Goya. Loss of the American colonies was accompanied by fragmentation in Spain (Carlist Wars, 1833–76) and the Miguelista revolts in Portugal. The economy revived with the rise of the cotton cloth industry in Catalonia. In 1848, the first railway linked Barcelona to Mataró. From 1826–87, the population of Barcelona rose 500 per cent. In 1898, the loss of Cuba and the Philippines marked the end of the Spanish Empire.

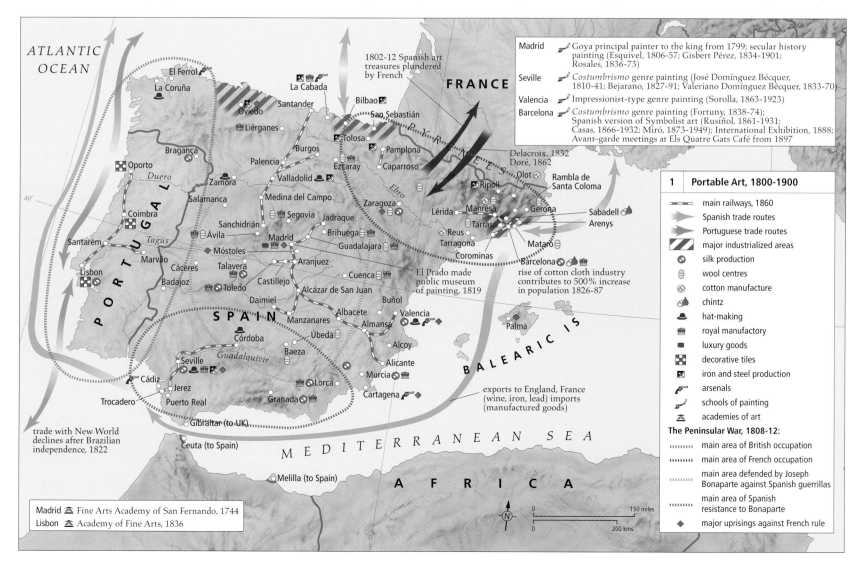

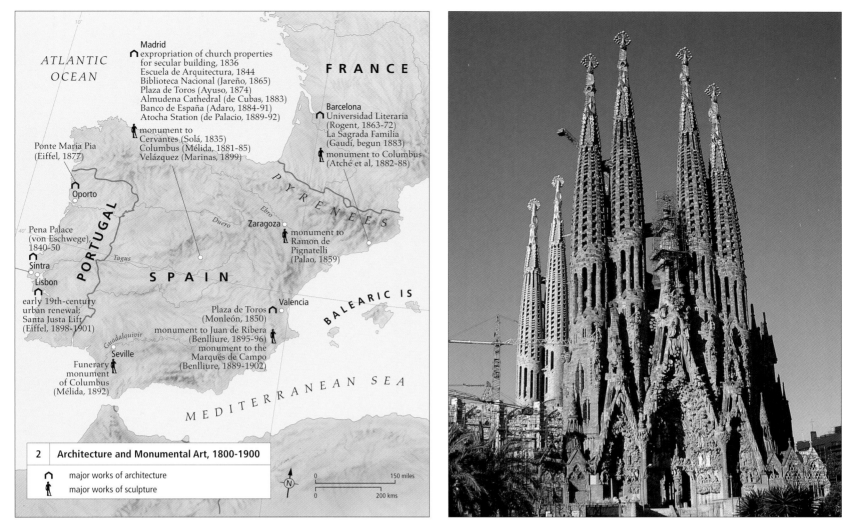

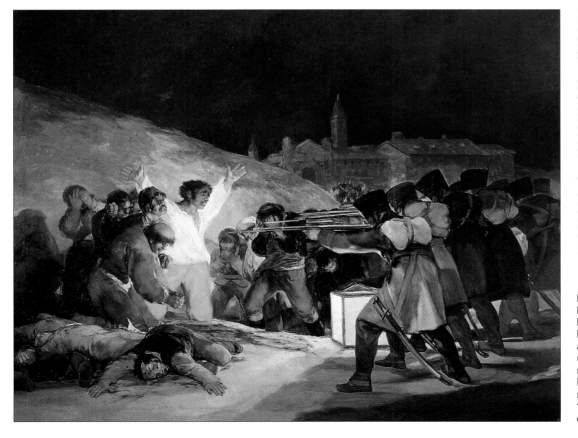

2 AN ACADEMY OF FINE ARTS was founded in Lisbon in 1836. As a result of Napoleonic looting, the Galerie Espagnol opened in 1838 in the Louvre, Paris. Spain became an 'exotic' tourist mecca. Major French artists who visited Spain and depicted local scenes were Eugène Delacroix (1832) and Gustave Doré (1862). In Seville the *Costumbrismo* school of genre painting depicting exotic local customs, flourished, while Valencia espoused Impressionism, and Barcelona fostered a Spanish version of French Symbolist art.

Barcelona. Els Quartre Gats café, founded in 1897, became a gathering place of the avant-garde in Barcelona; Picasso had his first show there in 1900.

IBERIAN ARCHITECTURE
In 1758, an earthquake levelled the city of Lisbon. A comprehensive project for urban renewal commenced with the plan by Manuel da Maia, approved in April 1756, for the Baixa district facing the harbour. The Peña Palace at Sintra, near Lisbon, designed by a German, Baron Wilhelm von

ANTONÍ GAUDÍ, EXPIATORY CHURCH of the Sagrada Familia, Barcelona, begun 1883. The Sagrada Familia by Gaudí (1852–1926) provokes questions about whether it should be called architecture or sculpture. For Gaudí, the architect was only the humble instrument of a Divine Power, and each form was to be fraught with mystical symbolism. He said his architectural operations led to 'the physical revelation of Divinity', conforming to 'the laws of Creation and Nature' to achieve a spiritual result.

Eschwege, was built between 1840 and 1850. Inspired by Ludwig II's Neuschwanstein Palace in Bavaria, it inaugurated a Portuguese taste for Wagnerian fantasy.

In Madrid the expropriation of church properties by the state in 1836 freed up three-quarters of the centre of the capital for secular rebuilding, administrative buildings and mass housing. In 1844 the Escuela de Arquitectura, independent of the Royal Academy of Art, was founded in Madrid; it declared architecture a 'technical science', one advancing modern technology in the service of pragmatic goals, especially mass housing. A multi-volume *Monumentos arquitectónicos de España*, published in 1859, defined the 'national artistic identity'. Giving new prominence to Arabic monuments, it encouraged historical eclecticism, and a Neo-Gothic revival.

FRANCISCO GOYA, *The Third of May, 1808*, 1814. Responding to the Napoleonic invasion of his homeland, Goya (1746–1828) recreated in horrifying detail the vengeance of the French against mostly innocent civilians following an uprising in Madrid. Here Goya invented a wholly modern variation of history painting which may be called the 'atrocity picture'. Goya's modern mutation puts a conventional religious subject, 'The Massacre of the Innocents', into a secular and contemporary, anonymous and politicized context.

ITALY 1800-1900

ITALY'S CULTURAL GLORIES, dating from many eras, were a major attraction to artists from all over Europe. Art academies encouraged their students to compete for scholarships and prizes to travel to Rome to consolidate their skills by copying Roman sculpture and the paintings of the Old Masters. French artists of every aesthetic allegiance recognized the importance of the Italian tradition; Corot, Renoir and Rodin as well as Ingres sketched in the Rome collections and surrounding *campagna*. The light and scenery of nineteenth-century Italy inspired both local and international artists to create a distinctive idiom of landscape painting known as *veduta* which was particularly attentive to the play of light and water and the picturesque festivals and architecture of Venice and Naples.

1 THE ENDURING CULTURAL authority of the Roman Empire and the Renaissance ensured that the Italian peninsula maintained its centrality in the artistic life of the nineteenth century. Artists, designers, collectors, writers and tourists from around the globe flocked to Italy to experience the importance of classical and humanist aesthetics and art production at first hand.

to London:
Botticelli Room for Leyland,
49 Prince's Gate
to Paris: Canova's Napoleon statuary

to Stuttgart:
Garson & Weber
Company

from Germany:
Nazarenes

to Vienna:
Bernhard Ludwig
furniture factory

SWITZERLAND

to Paris: Canova, de
Tivoli, Boldini, de Nittis,
Zandomeneghi

LOMBARDY

VENETIA

Veduta painters,
Signorini, Turner,
Cooke, Whistler

AUSTRO-HUNGARIAN

SAVOY PIEDMONT

Gilded Salon of Poldi Pezzoli
Palazzo Bagatti Valsecchi

Verona
Cabianca

Zandomeneghi
Venice

EMPIRE

Spalla statues,
Palazzo Stupinigi
Palazzo Imperiale
Benvenuti
Turin

Milan ★ Appiani

to Venice: Sargent, Whistler,
Turner, E.W. Cooke, Sickert

(KINGDOM
OF SARDINIA)

FRANCE

PARMA

to Palladian villas
of N Italy:
Soane, Nash

Po

MODENA

Ferrara
★ Boldini

GENOA

ROMAGNA

Bologna

NICE

Modigliana ★ Lega

Martelli,
Signorini ★
Borrani ★ ★ Titian memorial
Pisa Florence
Fattori ◆ Livorno Arno Café
Tivoli, Fattori ★ Santa Michangiolo
 Croce
Castiglioncello sull'Arno
Martelli, Borrani ◆ ★ Banti

Pesaro
d'Ancona

TUSCANY

PAPAL

from France to School
of David: Robert, Corot,
Ingres, Degas, Renoir,
Rodin, Péladan

ELBA

MAREMMA

STATES

CORSICA

Abbati,
Cabianca,
Fattori

A D R I A T I C S E A

Rome ○ ★ Canova,
Cammuccini, Costa

to United
Kingdom:
Signorini

to Rome, Royal Academy
Schools: Westmacott, Barry

Veduta painters ◆
Naples ★ Abbati

KINGDOM

to Florence:
Holman Hunt,
Leighton,
Burne-Jones,
Powers

to Naples:
Eastlake,
Anderson,
Rossetti

OF

to USA:
Ames-Webster House,
Boston 1890-1900

SARDINIA

S I C I L I E S

from United
Kingdom/USA:

T Y R R H E N I A N S E A

T H E T W O

M E D I T E R R A N E A N S E A

KINGDOM OF THE TWO SICILIES

1 **Italy, 1800-1900**

➤ influx of artists/patrons

➤ Italian artists' travels outside Italy

★ birthplace of Italian artist

major arts school/exhibition

Classical and Renaissance revival

➤ Classical and Renaissance revival outside Italy

◆ landscape site/artists' colony

N

0 100 miles

0 150 kms

40°

THE ARTISTIC LEGACY

Direct experience of the achievements of classical architecture and Palladio's later re-articulation of these vocabularies informed the work of many of the great nineteenth-century architects, from Sir John Soane to Charles Barry. New industrial millionaires commissioned Classical and Renaissance interiors to house their art collections. In this way, they cloaked their *nouveau riche* anxieties in the cultural authority of these golden ages, from the shipping magnate Frederick Leyland's 'Botticelli Room' in his London town house to the Renaissance extravaganza in the Ames-Webster House in Boston, Massachusetts. Important furniture firms such as the Gerson Weber Company in Stuttgart or the Bernhard Ludwig factory in Vienna specialized in historicist Italianate designs.

Although overshadowed by the Classical tradition, the art and architecture of late medieval Italy attracted new attention in the nineteenth century. The German Nazarenes emulated idioms and techniques, such as fresco, favoured by late-medieval Italian artists. The Victorian aesthetician and supporter of the

Napoleon as Mars, 1806, by Antonio Canova (1757–1822). Through an unconventional deployment of classical formulae, Canova typifies the emperor's ambiguous status for Italians. Napoleon's colossal scale and heroic posture as peaceful and victorious ruler is undermined by his hesitant step and distracted gaze.

Pre-Raphaelites, John Ruskin, championed the sincerity and virtue of unknown medieval artisans who created the splendours of Italy's cathedrals; they were alternative role models and antidotes for the slick, soulless paintings that mimicked Raphael and which he abhorred on the walls of the Royal Academy in London.

ART OF THE RISORGIMENTO

The importance of earlier masters was celebrated locally through initiatives such as the Titian memorial in Venice, but many young Italian painters sought new subjects and rhetorics for their art. Before the unification (*see* map 2) each of the regions had its own academy and local art schools; the tuition in these institutions centred on developing a *capo*

lavoro, or masterwork, which was the test of matriculation. A group of young radical painters, principally from the northern regions of Italy, rejected such highly finished works and allegorical subjects, envisioning Italy's desired nationhood by representing the events of local, contemporary life in dramatic sketchy paintings. Critics coined a resonant name for this group of young artists who met at the Café Michelangiolo in Florence, the *Macchiaioli*. This name couples *macchia* a term invoking the unusual rough touch of their brushwork – often likened to the vibrant surfaces and colouristic effects of the Impressionist painters working in France – and *aiolo*, a Latin name for the socially marginal plebeians of Florence. This direct correspondence between artistic and political identity reflected the direct involvement of these young artists in the struggle for nationhood and egalitarianism embodied in the figure of Giuseppe Garibaldi (1807–82). Several members of the Macchiaioli group were wounded veterans of Garibaldi's fighting force, known as 'The 1000'.

Unification inspired artists to portray unusual themes as well as to attempt the centralization of exhibitions beginning with the First National Exhibition in Florence in 1861. The struggle for nationhood underlies many works of art: the battle paintings of Giovanni Fattori (1825–1908); the portraits and memorials to Victor Emanuel and Garibaldi by Silvestro Lega (1826–93) and Pietro Aldi (1852–88); landscapes by Odardo Borrani (1833–1905) of the post-unification reclaimed Maremma; and the modern life paintings of Giuseppe Abbati (1836–68), Telemaco Signorini (1835–1901), Borrani and Lega which subtly capture the complexities of visualizing nationhood and class in this brave new world.

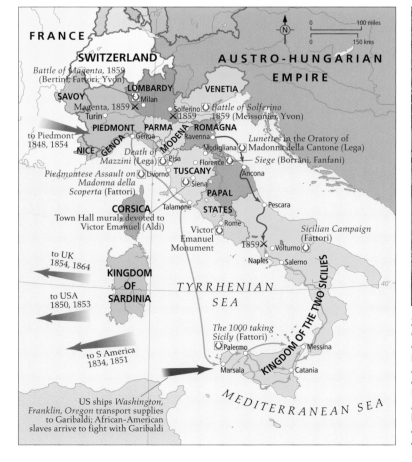

2 THE IMPACT OF ITALIAN unification and Garibaldi's central role in this transformation of Italian cultural and political life cannot be underestimated. New artistic idioms and institutions that were enlisted to express national identity were intimately linked to the battles and personalities of the *Risorgimento*. Garibaldi's romantic persona helped create the rhetoric of individualism and local pride developed by the Macchiaioli, a group of young artists based in Florence.

PIETRO ALDI (1852–88) *Victor Emanuel II with Garibaldi at the Gates of Teano*, 1886–1891 Town Hall, Siena. Near Ambrogio Lorenzetti's *Good and Bad Government* (1337–39), this later mural decoration memorializes the *Risorgimento*'s triumphs, celebrating Italy's regions, the military victories and alliances leading to reunification.

AUSTRIA-HUNGARY AND SOUTHEAST EUROPE 1800-1900

THE COMPLEX CULTURAL GEOGRAPHY of Southeast Europe, from the long-standing perspective of western and central Europe, showed a decline in civilization from northwest to southeast. At the 'bottom' end the Ottoman Turks personified the threat from unbelievers and barbarians. At the 'top' were the German lands of Austria.

During the nineteenth century Austria separated itself from Germany, and its ruler, as Emperor of Austria and King of Hungary, became the head of a new 'double monarchy', with respective capital cities, Vienna and Budapest. For much of the century, this state was trying to expand its hold over an area where numerous smaller ethnic groups were on the rise. As a result of this complex history, we inherit today both urban and 'folk' images, through which, by 1914, the initial perception of the lowering cultural standards towards the east had already been somewhat moderated.

URBAN DEVELOPMENT

Until about 1850 Vienna and Constantinople were the only really large cities in the region. In 1857 an imperial fiat abolished the ring of fortifications surrounding the old inner city of Vienna. In its place arose the celebrated Ringstrasse, essentially a boulevard. This entailed the rebuilding of many of the city's, and thus the empire's, major public places. The relative openness of Vienna's later nineteenth-century developments contrasted strongly with the square grid layout and dense assembly of public buildings that characterized the plan of Athens under Otto, Greece's Bavarian king (r.1832-62).

By 1900 a considerable number of towns throughout the Balkans had over 100,000 inhabitants. Most significantly, a great many of them had acquired a 'European' look, largely based on the Viennese model, with large squares, and straight, wide streets, often of the boulevard

THE BUCHAREST ATHENAEUM (1886–8) by the French architect P. L. Albert Galleron is Bucharest's most splendid building of the period. Built to serve the educated public as a concert hall, gallery and library, it represents the craving for western European splendour in Southeast Europe in the late nineteenth century, typically manifest in a very late Neoclassical style.

type. They were focused on, or lined by, imposing buildings, three to five stories high, richly decorated in the Renaissance style, serving the commerce of the towns. Invariably there was a grand theatre or opera house. This was a

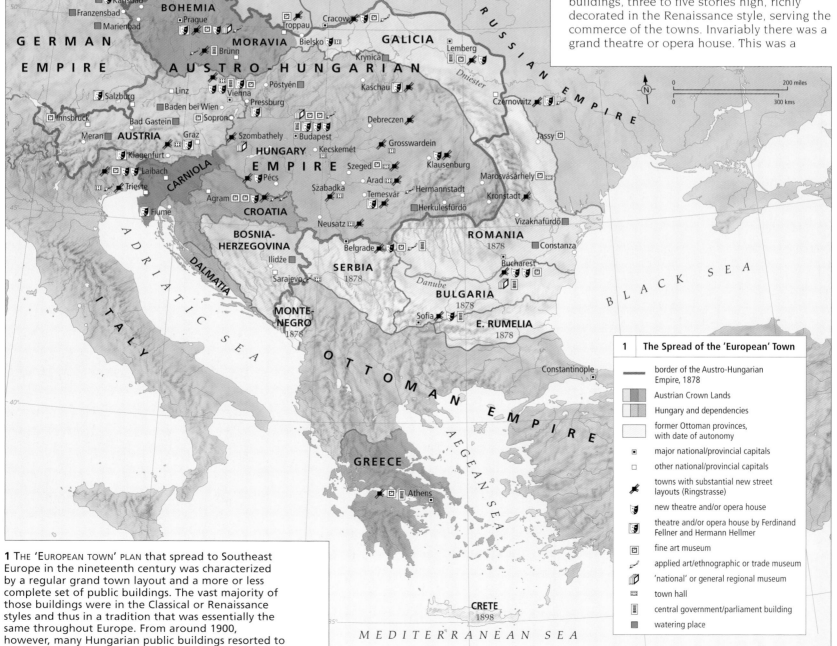

1 THE 'EUROPEAN TOWN' PLAN that spread to Southeast Europe in the nineteenth century was characterized by a regular grand town layout and a more or less complete set of public buildings. The vast majority of those buildings were in the Classical or Renaissance styles and thus in a tradition that was essentially the same throughout Europe. From around 1900, however, many Hungarian public buildings resorted to a new folksy national style.

1	The Spread of the 'European' Town
—	border of the Austro-Hungarian Empire, 1878
	Austrian Crown Lands
	Hungary and dependencies
	former Ottoman provinces, with date of autonomy
▪	major national/provincial capitals
□	other national/provincial capitals
✗	towns with substantial new street layouts (Ringstrasse)
	new theatre and/or opera house
	theatre and/or opera house by Ferdinand Fellner and Hermann Hellmer
	fine art museum
	applied art/ethnographic or trade museum
	'national' or general regional museum
	town hall
	central government/parliament building
	watering place

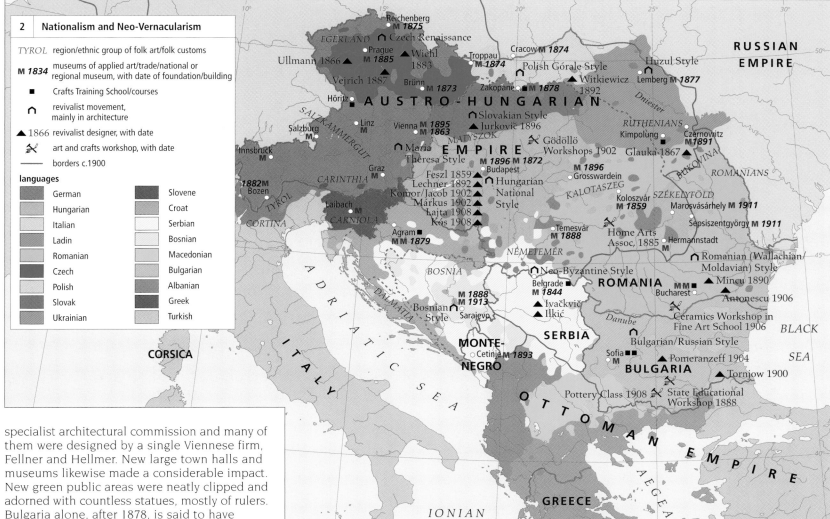

2 | Nationalism and Neo-Vernacularism

TYROL region/ethnic group of folk art/folk customs

M *1834* museums of applied art/trade/national or regional museum, with date of foundation/building

■ Crafts Training School/courses

⌂ revivalist movement, mainly in architecture

▲ 1866 revivalist designer, with date

⚒ art and crafts workshop, with date

——— borders c.1900

languages

German | Slovene
Hungarian | Croat
Italian | Serbian
Ladin | Bosnian
Romanian | Macedonian
Czech | Bulgarian
Polish | Albanian
Slovak | Greek
Ukrainian | Turkish

2 In the late nineteenth century, the spread of 'Westernization' led to the development of a counter-movement. While wary of the political nationalisms of the smaller ethnicities, the Austrian and Hungarian governments strongly supported the diversity of ethnic applied arts.

specialist architectural commission and many of them were designed by a single Viennese firm, Fellner and Hellmer. New large town halls and museums likewise made a considerable impact. New green public areas were neatly clipped and adorned with countless statues, mostly of rulers. Bulgaria alone, after 1878, is said to have erected over 400 public monuments. All this was in stark contrast to the traditional look of the towns of the region: low, small-scale, dense and mostly very irregular, with each property tending (in Hungarian lands) to close in on itself.

NATIONALIST COUNTER-CURRENTS

Paradoxically, the great wave of 'progress' during the later nineteenth century was met with a counter-movement that re-emphasized precisely some of those factors progress was meant to overcome. The key was a new kind of nationalism. It held that borders should be determined by ethnicity and language. In the Turkish areas, ethnic and religious minorities had long enjoyed a certain amount of autonomy. In parts of the Austro-Hungarian empire – particularly in the Slav provinces – dominance by the German or Hungarian-speaking populations began to be strongly resented. Czechoslovakia and Yugoslavia were the eventual political outcomes of these movements after World War I.

After 1867 the Austrian Empire tried to confront these problems with tolerance and Hungary was given complete cultural autonomy. After the World Fairs of 1867 (Paris) and especially of 1873 in Vienna, the diversity of nationalities began to be seen as an asset, but within the strictly limited field of ethnic crafts. A further curious twist occurred in the 1860s. The Austrian state decided to 'reform' the artistic aspects of most of the major manufactures, based on what it saw as the model of the schools and the museum at South Kensington in London. Schools and museums for 'art and industry' were created whose first aim was to bring up standards to the international styles of Classical and Renaissance design. Indeed, the vast majority of new town buildings followed these precepts.

But by the 1880s a major function of the regional museums had become that of collecting ethnic, 'folk', or 'peasant' art – mainly textiles,

but also metalwork, ceramics and leatherwork. The designs were usually the opposite of Renaissance naturalism and illusionism, or Classical 'refinement'. They presented abstract, often crude patterns with motifs held to be characteristic of the ethnicity of the producers.

Above all it was the lively colours that delighted late Victorian connoisseurs. Soon the interest of a few academics and designers turned into active state and commercial support for the old production methods. It ran parallel with a Europe-wide interest in philological studies of linguistic roots, painters' new interpretations of local landscapes and musicians' interest in folksong.

By 1900 young and ambitious designers were taking up 'folk' motifs. Arts and Crafts groups, to some extent based on English models, started workshops emphasizing 'work by hand'. Even architecture began to adopt folk styles. In some cases this approximated, paradoxically, to international Art Nouveau and even Vienna Secession styles.

Tulip Chest (1910), by the Hungarian István Csók. It represents the love of local and national folk art that developed in the last quarter of the nineteenth century, here shown not in actual folk art but in a fantasy on folk objects, with the main emphasis being on brilliant colour.

NORTH AFRICA 1800-1900

BY THE EARLY nineteenth century the arts of North Africa had a well-established, continuous tradition (partly because of widespread Ottoman influences), with substantial regional variations. Over the course of the century these cultures were transformed by European colonial expansion. Algeria, which was invaded by the French as early as 1830, was the most intensively colonized. With the arrival of European settlers (including workers from Spain, Italy and Greece), land was purchased or appropriated while indigenous craft traditions were undermined by the importation of low-cost European manufactures. French also began to be widely spoken.

Sure of their belief in the European 'fine-art' traditions of painting and sculpture, for which they could find no evidence, the colonists saw the indigenous North African culture as being one of decline. Despite an admiration for craft techniques, 'real' Arab cultural achievements were, for them, located firmly in the medieval past. Such attitudes helped justify colonial expansion.

1 BEFORE EUROPEAN COLONIZATION North Africa as far as the Moroccan-Algerian border remained within the sphere of Ottoman cultural influences. Artistic traditions showed a high degree of continuity, with distinct regional variations. Following the French occupation (1798–1801), however, a modernizing Egypt under Muhammad 'Ali (r.1805–48) began to challenge the political and cultural hegemony of Istanbul, and by the late 19th century Cairo had emerged as the dominant centre in the region.

INDIGENOUS ART TRADITIONS

Despite the colonial presence across North Africa some indigenous art traditions continued, especially in the remote mountainous regions, such as the Kabilya and Aurès mountains in Algeria and the Rif and Atlas mountains in Morocco. In such areas, there were distinctive Berber traditions in architecture, textiles, jewellery and other arts. Further south in the Sahara Desert, where nomadic lifestyles prevailed, European influences were minimal, although there were profound changes in overland trade patterns because of the rise of the steamship and colonial prohibitions against slavery, which passed along these routes.

The Islamic schools and the network of pilgrimage routes to Mecca helped to bind together the traditional cultures. There were also long-established centres for the production of manuscripts, silks, pottery, metalwork and leatherwork. These continued to operate, though in some cases they adapted their products to suit European tastes – most notably Cairo began to produce Mamluk-style metalwork from the latter part of the century. The major centres of manuscript production were closely associated with Islamic schools, calligraphy being the most esteemed art in the Muslim world. Rural pottery, made for local consumption, remained largely untouched, but

POLYCHROME BOWL from Fez, Morocco, mid-nineteenth century. The tin-glazed pottery manufactured in Morocco in the nineteenth century continued a long and relatively conservative ceramic tradition. This polychrome bowl on a high foot is typical of the urban pottery manufactured in Fez. The bowl has an interior design with a central rosette and radiating 'tortoise' motifs.

the more sophisticated and refined urban pottery was again affected by European tastes.

COLONIAL ART INSTITUTIONS

A number of institutes and schools opened in the nineteenth century to promote indigenous arts and crafts, but equally significant was the promotion of Western notions of 'fine' art. In Algeria in 1851 the Société des Beaux-Arts was founded to encourage art in the European community. In 1894 an annual salon was inaugurated by the French in Tunis, although it was not until 1912 that a Tunisian artist exhibited there. By 1908 a School of Fine art was opened by Prince Yusuf Kamal to train Egyptian painters and sculptors in Western

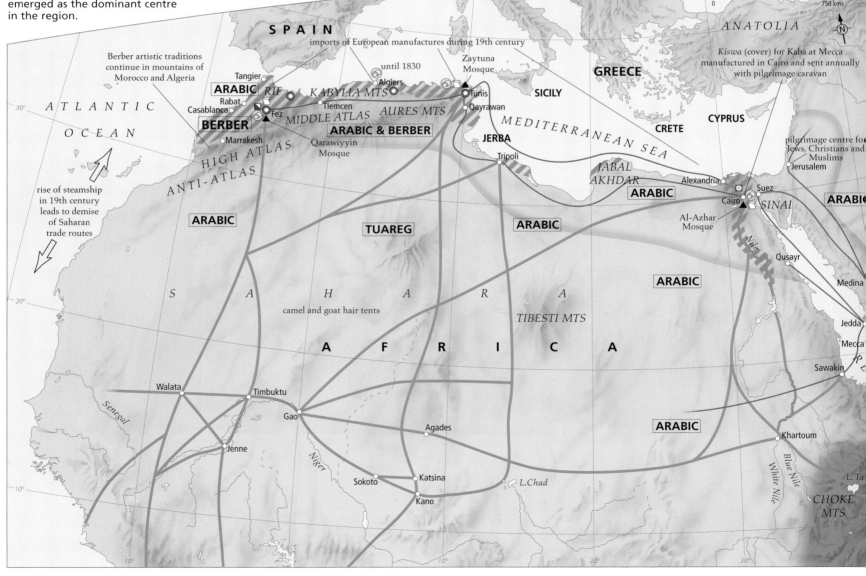

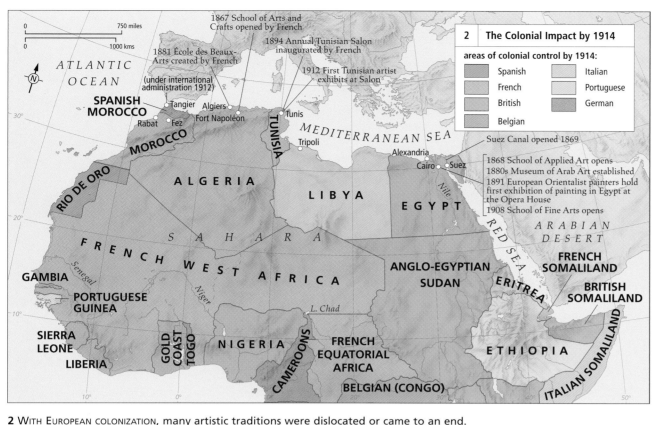

MOSQUE OF MUHAMMAD 'ALI in Cairo, Egypt, 1828–57. The large mosque was erected by Muhammad 'Ali (r.1805-48) in a prominent location on the Citadel. Built in a style inspired by the Ottoman mosques of Istanbul, it marks a departure from earlier traditions of mosque architecture in Cairo.

2 WITH EUROPEAN COLONIZATION, many artistic traditions were dislocated or came to an end. East–west trade routes were interrupted, and there was a decline of trans-Saharan trade. In cities, European architectural styles were introduced and indigenous craft traditions were undermined by European imports. Western notions of fine art also began to be disseminated, and Europeans started to document the indigenous architecture and arts they encountered.

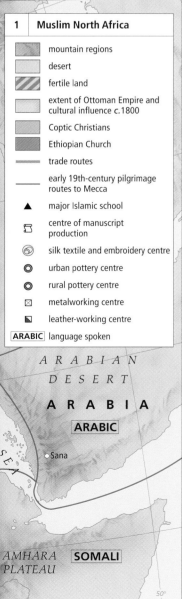

1	Muslim North Africa
	mountain regions
	desert
	fertile land
	extent of Ottoman Empire and cultural influence c.1800
	Coptic Christians
	Ethiopian Church
	trade routes
	early 19th-century pilgrimage routes to Mecca
▲	major Islamic school
	centre of manuscript production
	silk textile and embroidery centre
	urban pottery centre
	rural pottery centre
	metalworking centre
	leather-working centre
ARABIC	language spoken

techniques. European artists developed a style of painting that has come to be called 'Orientalist' and which embodied a heavily romanticized view of the Arab world.

Under European influence archaeological exploration was initiated at a range of sites. Indeed, the French invasion of Egypt in 1798 (which they held until 1801) marked the emergence of Egyptology as a new field of enquiry. By the late nineteenth century various departments of antiquities had been established. This prompted concerns over the conservation of artefacts; in Cairo, for example, the Committee for the Conservation of the Monuments of Arab Art was created in 1881. Museums were founded to preserve Ancient Egyptian, Classical, Phoenician, Byzantine and Islamic remains. In Cairo the Museum of Arab Art was established in 1884, and the Coptic Museum in 1908.

URBAN DEVELOPMENT
In the French colonies European-style quarters were created within or beside many Arab cities. Between 1830 and 1870 the *medina* of Algiers was partly destroyed by the French and then rebuilt. New public buildings were constructed in Neoclassical or neo-Islamic idioms (pastiches of Arab styles). Even before colonization in late nineteenth-century Morocco, rich merchants and officials were building palatial houses in the major cities, using imported European materials and designs.

In Egypt modernization began under Muhammad 'Ali (r.1805–48), and during the reign of Khedive Isma'il a new European-style urban environment emerged in Cairo, implemented by the engineer and statesman 'Ali Mubarak. Public buildings and apartments were constructed to the west of the Arab city in styles similar to those found in Paris or Rome, and Isma'il moved his residence from the Citadel to the 'Abdin Palace (built 1863–74). Transport was facilitated by the construction of wide boulevards, tramlines and railways, and in 1869 the Suez Canal opened. Some buildings such as the royal mosque of Al-Rifa'i (built 1869–1912) were constructed in a new neo-Islamic idiom that alluded to the architecture of the Mamluks (r.1250–1517); the reliance on foreign expertise for the design and construction of this mosque was extensive.

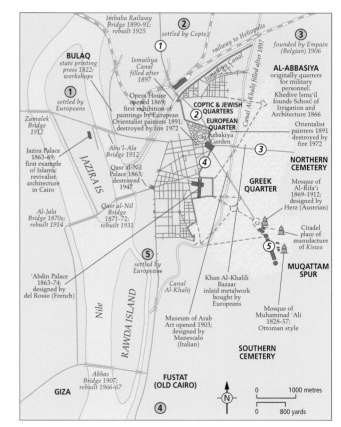

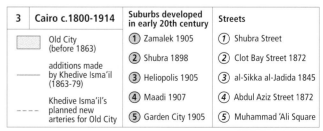

3	Cairo c.1800-1914	Suburbs developed in early 20th century	Streets
	Old City (before 1863)	① Zamalek 1905	① Shubra Street
	additions made by Khedive Isma'il (1863-79)	② Shubra 1898	② Clot Bay Street 1872
		③ Heliopolis 1905	③ al-Sikka al-Jadida 1845
	Khedive Isma'il's planned new arteries for Old City	④ Maadi 1907	④ Abdul Aziz Street 1872
		⑤ Garden City 1905	⑤ Muhammad 'Ali Square

3 CAIRO BECAME A DYNAMIC CULTURAL CENTRE during the nineteenth century and the hub of the Arab cultural revival. The city expanded rapidly, especially late in the century, and new suburbs were constructed. Along with European styles of architecture, Islamic revival architecture in a historicizing manner was adopted. Cairo was the first city in the Arab world to witness the emergence of a conservation movement (Committee for the Conservation of Monuments of Arab Art, 1881). It saw the founding of the Museum of Arab Art in 1884 and the opening of the School of Fine Art in 1908.

SUB-SAHARAN AFRICA 1800-1900

THE NINETEENTH CENTURY saw many changes in sub-Saharan Africa wrought by the increasingly insistent presence of Europeans. The slave trade persisted during the first half of the century and Islam continued its conversions. On the other hand, traditional religious practices and political structures accounted for extensive patronage of artists and craftspeople in all media, and the century was very active artistically. Apart from the European arts and crafts in Southern Africa, the wholesale influence of Europe on the arts was relatively slight. The export of art from the continent to Europe, however, began towards the end of the century, in some cases as war booty, in others, adding to the collections of museums of natural history (pointedly not art museums), successors to the

'curiosity cabinets' formed by nobility and the wealthy since the Renaissance. The following three main categories of nineteenth-century art may be discerned.

ART FOR AFRICAN LEADERS
Virtually all African kings and chiefs, as well as religious leaders (often secular and spiritual leadership merge in the same person), invoked myriad arts to legitimize and reinforce their

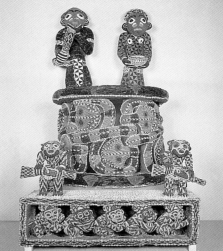

WOOD STOOL AND FOOT REST covered with African and European beads and cowrie shells. Commissioned for King Njoya of Bamum, Cameroon, c.1885, Museum für Volkerkunde, Berlin. Only high-ranking or wealthy chiefs and kings could command such elaborate thrones.

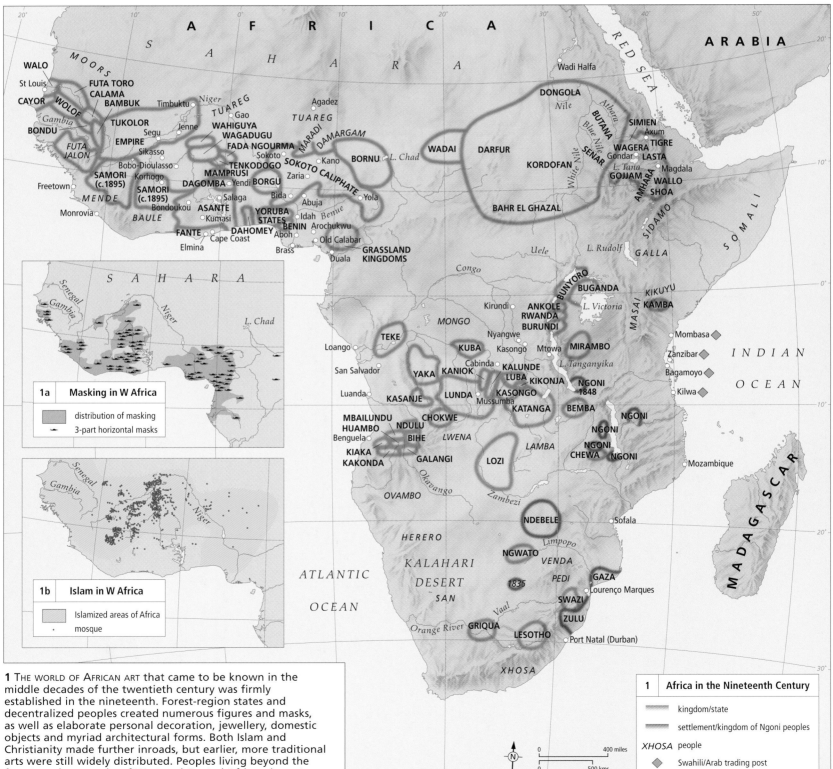

1a **Masking in W Africa**
- distribution of masking
- 3-part horizontal masks

1b **Islam in W Africa**
- Islamized areas of Africa
- · mosque

1 THE WORLD OF AFRICAN ART that came to be known in the middle decades of the twentieth century was firmly established in the nineteenth. Forest-region states and decentralized peoples created numerous figures and masks, as well as elaborate personal decoration, jewellery, domestic objects and myriad architectural forms. Both Islam and Christianity made further inroads, but earlier, more traditional arts were still widely distributed. Peoples living beyond the forests and savannahs of West and Central Africa – in eastern and southern areas – had fewer sculptural forms.

1 **Africa in the Nineteenth Century**
- kingdom/state
- settlement/kingdom of Ngoni peoples
- *XHOSA* people
- ◆ Swahili/Arab trading post

0 400 miles
0 500 kms

positions and to help effect policy. From the regalia of kings and courtiers to palace architecture and planning, leaders had the power and wealth to commission and maintain art forms that projected their position and stature. Art elevated, framed, dramatized, embellished and otherwise expanded the image of leaders across the continent. Wealthy leaders were able to command rich, durable and rare materials: ivory, cast copper alloys, gold, silver and imported goods. Similarly, they employed the finest artists, often moving them from conquered areas to their own capitals.

ART FOR RELIGION
On a local level, masks and figural sculptures, and sometimes more practical objects such as stools, were used as symbols or representations of ancestors, deities and spirits. Unlike Leadership arts, this symbolic art tended to be confined to the forest and savannah regions of west and central Africa, but was also found among Bantu-speakers in some eastern and southern regions, mostly among settled agricultural peoples. A large majority of both figural sculptures and masks were associated with religious institutions, many of which also supported leaders. Wooden figures and sometimes small copper alloy castings were also used by diviners and fortune tellers. Much figural sculpture now in western museums and private collections was originally housed in shrines, and served as a point of contact between this world and that of varied supernatural beings.

ART IN EVERYDAY LIFE
A third category constitutes furniture and household goods (pottery, gourds and baskets), implements (spoons, staffs, dance wands) and personal possessions such as cloth, neckrests and snuff containers. These objects are often of a modest size and made of common, readily available materials. Included in this category is a vast array of textiles, as well as non-woven fabric such as barkcloth.

Perhaps the most widely distributed objects on the African continent are beads made of wood, stone, shell and, in earlier times, bone, as well as glass beads of European manufacture. They were used by common people, while rarer specimens served as markers of status for elites. There are no known African peoples who did not focus their artistic sensibility on personal decoration, often marshalling quite spectacular effects for special occasions. Pastoral and nomadic peoples in particular were masters of personal adornment.

INFLUENCES FROM ABROAD
Some of the above-mentioned objects were more or less strongly affected by ideas from beyond the locales in which they were made. Islamic design ideas can be found in architecture (Asante, Fulani or Fulbe), metalwork and gourd decoration, textile patterns, leatherwork and charm-making. Christianity is ancient enough in Ethiopia to be considered both traditional and indigenous, but this is not the case for churches built along the west African coast in the nineteenth century. Much secular influence from Europe, in dress styles and object types, assimilated motifs, materials and even manufacturing techniques (such as carpentry as opposed to monoxylous – single piece – carving) can also be found wherever there was sustained contact with European strangers.

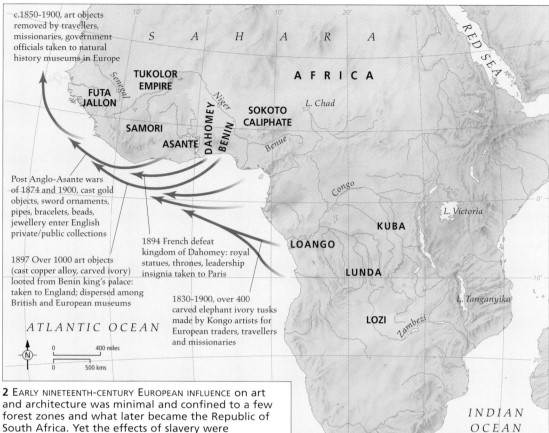

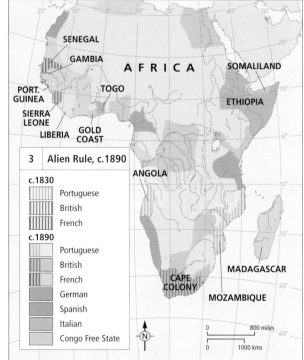

2 EARLY NINETEENTH-CENTURY EUROPEAN INFLUENCE on art and architecture was minimal and confined to a few forest zones and what later became the Republic of South Africa. Yet the effects of slavery were significant if often indirect – for example, in the formation and artistic character of the kingdom of Dahomey, and in the increasingly coastal orientation of strong West African kingdoms. European beads were very widely distributed in the nineteenth century, but for the most part they were a wholly indigenous form of decoration. During the final years of the century wars were fought to subjugate African peoples, and in some cases substantial numbers of art objects were exported to Europe.

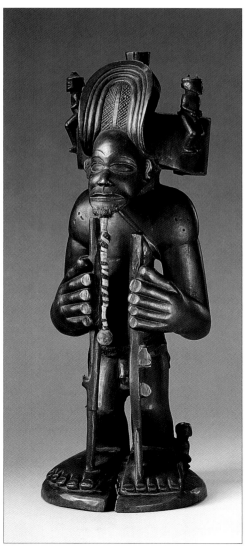

FIGURE OF THE 'CIVILIZING CULTURAL HERO', Chibunda Ilunga, Angola, before 1850, 39 cm (15 ins) high, made of wood, hair, cotton fibre and bead (Museum für Volkerkunde, Berlin). This legendary Luba hunter is credited with leading political and technical advances for Chowke, Lunda and other Central African peoples around 1600. He exemplifies internally inspired historical change.

3 ALIEN RULE in about 1890. The Berlin Conference (1884–5) partitioned much of the continent, establishing 'national' boundaries without reference to the distribution and borders of ethnic groups and/or indigenous polities.

WEST ASIA 1800-1900

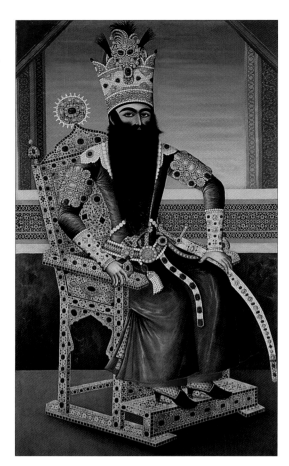

LOCAL POWERS IN WEST ASIA came in contact and conflict with the superior military and economic might of Western Europe and Russia as the region was increasingly marginalized by the oceanic economic system and the Industrial Revolution. The main powers in the region were the Ottomans (who continued to rule from Istanbul until 1922), the Qajars in Persia (1799–1924), who made Tehran their capital, and the Russians, who expanded southwards into the Crimea, the Caucasus, and Transcaucasia, as well as Central Asia at the expense of the Ottomans, the Qajars and the Uzbek Khans. Russia locked horns with the Ottomans in the Crimean War (1854–56), and the Russians lost Sebastopol, their major port on the Black Sea, to the British. The Ottomans themselves lost much territory in Eastern Europe,

1 THE EUROPEAN POWERS encroached on the lands of West Asia in the nineteenth century bringing, new technologies such as telegraphs and railways and new institutions, including museums and schools of art and architecture. Europeans returned home with 'Oriental' furnishings, including carpets, souvenirs and works of art for their own museum collections. Railways and telegraph lines made access to and control of the region easier.

OIL PAINTING OF THE QAJAR RULER Fath Ali Shah. Intended as a royal gift to Napoleon, this oil painting was presented by Fath Ali Shah to the French envoy Amédée Jaubert on July 11, 1806. Attributed to the court painter Mihr Ali, it shows the ruler impassive, rigidly posed on a chair-throne, and bedecked with jewels, including the Kayani crown. It is the state image, par excellence.

the Balkans, the Levant and Iraq. Egypt became virtually independent under Muhammad 'Ali (r.1805–48) in the aftermath of Napoleon's abortive expedition to Egypt (1798–1800), and much of Arabia fell under the sway of conservative Wahhabi reformers. The Russians annexed Georgia in 1801, extending the Russian frontier westwards by the Treaty of Gulistan (1813) and the Treaty of Turkmanchay (1828). Persia, blocked on the west and north by the Ottomans and the Russians, turned its attention to the east, invading what is now Afghanistan.

EUROPEAN ECONOMIC INVOLVEMENT
Although the Qajars strove to maintain Persia's territorial integrity, both they and the Ottomans became increasingly dependent on European capital. European involvement increased in the

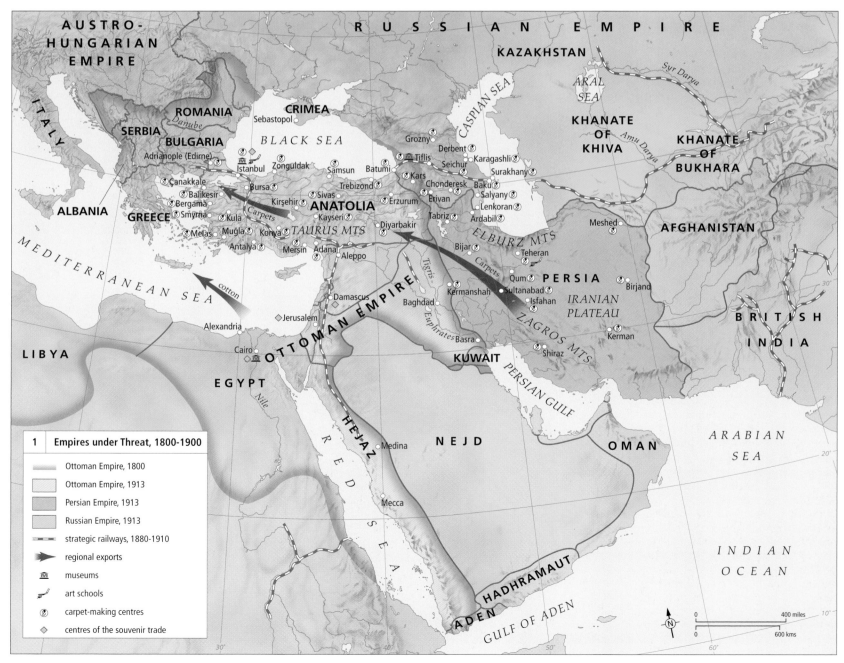

1	Empires under Threat, 1800-1900
	Ottoman Empire, 1800
	Ottoman Empire, 1913
	Persian Empire, 1913
	Russian Empire, 1913
	strategic railways, 1880-1910
	regional exports
	museums
	art schools
	carpet-making centres
	centres of the souvenir trade

2 SPURRED BY AN INTEREST in ancient and biblical history, Europeans and Americans began excavating ancient Egyptian and Near Eastern sites in the nineteenth century. They brought back many of the finds which were prominently displayed in European national museums Only at the very end of the period were museums established in the major cities of the region in an attempt to staunch the flow of archaeological material from the area.

THE DOLMABAHCE PALACE in Istanbul, designed by Garabed Balyan in 1853. In contrast to traditional Islamic palaces, which were enclosed behind high, blank walls, the Europeanizing Dolmabahce Palace was built on a river-bank site overlooking the Bosphorus with classicizing and luxurious details, including a grand staircase with rock-crystal balustrades.

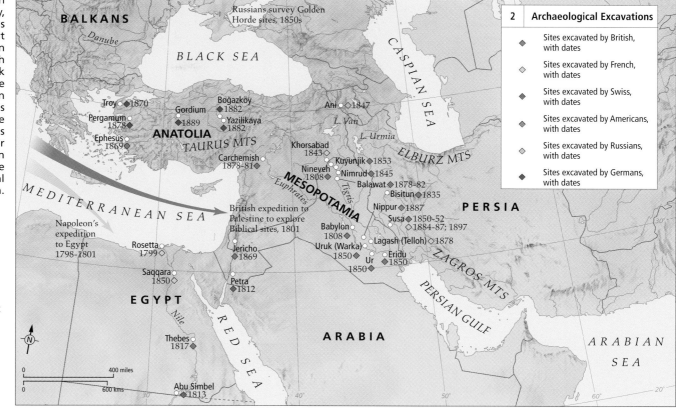

region after 1842 when petroleum wells were sunk at Baku on the Caspian Sea, known since antiquity for its oil seeps. The British, anxious to maintain quick communications with India, ran telegraph wires across the Ottoman Empire in the 1850s and 1860s. Major General Sir Robert Murdoch-Smith continued the project across Persia, incidentally acquiring large collections of Persian art for the South Kensington (later Victoria and Albert) and Royal Scottish museums. Other Europeans built railway lines across the Balkans to Istanbul, and the Ottomans began work on a rail system that would link Istanbul to Baghdad, Damascus, Jerusalem and the Hejaz in western Arabia, which they hoped would facilitate the pilgrimage to Mecca and assert their authority over the region. The project was interrupted by the outbreak of World War I.

ART LIFE
Traditional craft techniques were supplanted as local bazaars were flooded with European manufactured goods, ranging from Manchester cottons and aniline dyes to Russian glass and paper. Carpet-weaving, for example, was transformed from a traditional village and nomad craft to a factory-driven enterprise – rugged floor-coverings were made in standard sizes to fit European and American drawing-rooms. The Manchester firm of Ziegler and Co went so far as to supply woollen yarns dyed in

appropriate shades to weavers working around Sultanabad. Many traditional craftsmen in Istanbul, Damascus, Jerusalem, and Cairo turned to making souvenir replicas for the tourist trade.

Impressed with the technical superiority of Europe, the Ottomans sent students to study abroad. Krikor Balyan, the first Ottoman architect to study in Europe, returned to design the Nusretiye Mosque (1826) and the Selimiye Barracks (1828) in Istanbul; his son Garabed designed the Dolmabahce Palace (1853) following European models. Sultan Abdülaziz (r.1861–76) was the first Ottoman ruler to visit Western Europe, attending the 1867 Exposition Universelle in Paris. He was soon followed by the Qajar shah Nasir al-Din (r.1848–96) who toured Europe in 1873, visiting the Vienna World Fair. These visits led to the introduction of European skills and techniques to West Asia. The Ottoman and Qajar armies, for example, were reorganized along European lines, and European-style schools of architecture and art were established in Tehran (1851 - Polytechnic/ Dar al-Funun) and Istanbul (1883 - Imperial Academy of Fine Arts; 1884 - College of Civil Engineering). Photography, which had been introduced by European travellers, was taken up by both the court (Nasir al-Din was an avid photographer) and professionals, such as the Russian-Armenian Antoine Sevruguin, who established studios in Tabriz and Teheran.

REDISCOVERING THE PAST
Following Napoleon's expedition to Egypt in 1798–1800, European interest in ancient Egypt had waxed, particularly after the Frenchman Jean François Champollion deciphered the Rosetta Stone in 1822. Similarly, after the English Orientalist and historian Sir Henry Rawlinson unravelled the trilingual (Old Persian, Elamite and Babylonian) inscription from Bisutun in Persia and unlocked the secrets of the cuneiform script, interest in ancient Near Eastern antiquities flourished and ancient sites, such as Nimrud and Nineveh, began to be excavated.

Museums were founded to house these antiquities. A museum of Arab art was envisioned for Cairo as early as 1869 but not realized until 1880; the Egyptian Museum (for antiquities) was the brainchild of Auguste Mariette (d.1881), although it did not open in its present location until 1902. In 1876 Sultan Abdülhamid established the Imperial Ottoman Museum at the Çinili Kiosk in the Topkapi Palace under the directorship of the European-trained Orientalist painter Osman Hamdi. In 1891 the Ottomans founded an archaeological museum in Istanbul, partly in an effort to stem the traffic in illegal antiquities. The Kavkazsky Muzei, the precursor to the Georgian national museums of art and archaeology, was founded at Tiflis (Tbilisi) in the 1870s, achieving an international reputation under its director, Countess P. S. Uvarova.

CENTRAL ASIA 1800-1900

CENTRAL ASIA WAS TORN apart as imperial rivalries invaded the region in the 'Great Game'. The British gradually expanded their presence up the Ganges from India against the Russians, who had been spreading south since the mid-sixteenth century. Following the loss of Sebastopol in the Crimean War, the Russians embarked on a 22-year offensive (1864–86) in Central Asia, conquering the khanates of Bukhara (1868), Kokand (1871) and Khiva (1873). The 1881 Battle of Geoktepe, in which 15,000 Tekke Turkmen were slaughtered, and the 1884 capture of Merv established Russian pre-eminence from the Caspian Sea to the Tien Shan. The Anglo-Russian Agreement of 1887 set the Amu River as the boundary between the Russian-dominated territory of Central Asia and the British client state of Afghanistan.

ECONOMIC EXPANSION

The Russians made Tashkent, historically the least important of all the oases in western Central Asia, the capital of Russian Turkestan.

1 THE RUSSIAN CONQUEST OF CENTRAL ASIA 1800–1900. The Russians moved south in the second half of the nineteenth century, conquering the khanates of Khiva, Kokand and Bukhara and establishing political and economic control over Central Asia, from their newly built capital at Tashkent. They developed the production of cotton which they made the mainstay of the economy, exporting it to European factories along newly constructed railways.

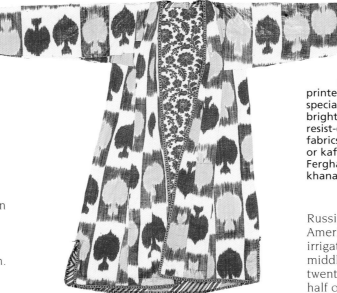

ROBE OF RESIST-DYED silk and cotton *ikat*, late nineteenth-century Bukhara. Red and yellow stylized fruits appear on a blue and white chequered ground. The garment is trimmed with needlebraid borders and lined in Russian printed cloth. Many Central Asian Jews specialized in weaving spectacular *ikat* silks, with bright colours and bold patterns created by resist-dyeing the warps before weaving. The fabrics were typically tailored into large robes or kaftans. The centre of production was the Ferghana Valley, roughly equivalent to the khanate of Kokand.

They laid out a new town modelled on European patterns with European-style buildings and residential quarters. Tashkent was linked by rail to other cities, as the Transcaspian Railway ensured Russian control over, and exploitation of, the region.

Russian demand for Central Asian cotton had increased during the American Civil War (1860–65), and the Transcaspian Railway facilitated cotton shipments to factories in European Russia and Europe. In the 1880s the

Russians introduced improved long-staple American strains of cotton and expanded irrigation in the Ferghana Valley and the middle reaches of the Syr River. By the twentieth century cotton provided more than half of Russian Turkestan's agricultural income.

Textiles made of cotton, wool or silk were the other major export. Carpets, though marketed in urban bazaars, were traditionally made by nomads, who also made small saddlebags, door covers and tent bands. Weavers combined undyed yarns with others dyed bright red with madder; they favoured geometric designs, often characterized by an octagonal emblem known as a *gol*. As carpet-weaving was transformed by mass production, European aniline dyes were introduced and traditional compositions compressed. Nomadic women also embroidered large

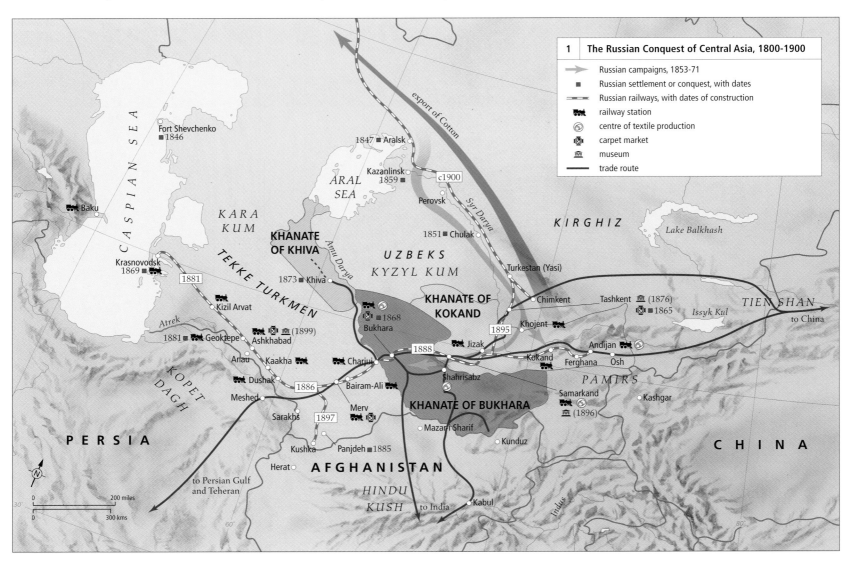

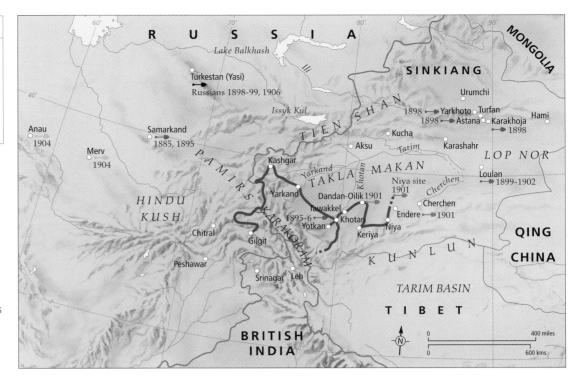

2 Archaeological Surveys

Sites excavated by:

→ Sven Hedin (Sweden), 1895-99, 1899-1902
→ Dmitry Klementz (Russia) 1898
→ N. I. Veselovsky (Russia) 1885, 1895
→ Aurel Stein (Great Britain), 1900-1901
→ R. Pumpelly (US) 1904
— expedition of Aurel Stein, 1900-1901

2 DECIPHERMENT BY A. F. R. HOERNLEIN in 1884 of ancient Buddhist documents, found near Kucha, led to a series of archaeological expeditions to eastern Turkestan. Explorers, some of them spies for their European governments, uncovered the remains of many sites that had once thrived along the Silk Road, the transcontinental network of trade routes connecting ancient China, India and the Mediterranean.

coverlets of cotton with brightly coloured birds and flowers (*suzani*) for their dowries.

Urban weavers, particularly Jews, made spectacular silk *ikats*, in which resist-dyed warps create colourful kaleidoscopic designs. Other traditional crafts included silver jewellery encrusted with turquoise and carnelian or coral. Metalsmiths and potters repeated traditional forms and designs, but local production was increasingly replaced by European and Far Eastern export wares.

CULTURAL INCURSIONS
Orientalist painters accompanied the Russian army, and travellers compiled albums of photographs, drawings and watercolours of exotic eastern locales. The Russians began excavation in the western half of the region to explore its pre-Islamic history. In 1885 the Imperial Archaeological Commission appointed N. I. Veselovsky to excavate old Samarkand, and the Turkestan Archaeological Society was created in 1893. Other national archaeological surveys soon followed.

Western explorers, some also spies, made expeditions to the eastern half of the region in search of ancient Buddhist remains along what

Ferdinand von Richtoven had named the 'Silk Road'. In the 1880s local treasure hunters found several ancient Buddhist manuscripts near Kucha, and their decipherment led to a series of Russian, Swedish, British, German, French and Japanese expeditions.

Sven Hedin (1865–1952) set out from Tehran via Meshed, Merv, Bukhara, Samarkand, to Kashgar, whence he made expeditions to the Takla Makan. During his second expedition to East Turkestan and Tibet, he discovered Loulan and explored the Gobi Desert. More famous was Aurel Stein, who made his first expedition from British India to Central Asia in 1900–01. In 1898 the Russian Dmitry Klementz set out with his botanist wife to explore the area around Turfan.

Some historical and archaeological museums were created in the region, for example at Ashkhabad, Samarkand and Tashkent, but many of the finest objects

became the centrepieces of Russian and European museums. The inlaid wooden doors from the Gur-i Mir, Timur's tomb in Samarkand, went to the Hermitage, along with many other objects from the area. Turkoman tribal weaving began to be studied seriously in late nineteenth-century Russia, and the collection of Turkmen rugs amassed by General A. A. Bogolyubov, Russian governor of Transcaspia, formed the core of the Ethnographic Museum in St Petersburg. The imperial armoury in the Moscow Kremlin acquired a rich collection of clothes, carpets and jewellery. Silk *ikats* collected by the English tea-planter Robert Shaw during a visit to Yarkand in 1868 are now in the Ashmolean Museum in Oxford. Henri Moser, who accompanied the Prince of Wittgenstein to Central Asia in 1882–3, was presented with 140 robes of honour and 17 sets of horse trappings and harnesses; his collection is now in the Historisches Museum, Bern.

WOOL, COTTON AND SILK textiles and carpets were the mainstay of the Central Asian economy. Though sometimes made by nomads for their own use, others were typically sold in urban bazaars, whose small shops had wooden doors which could be closed at night. The Russian photographer Sergei Mikhailovich Prokudin-Gorskii took some of the earliest colour photographs of the region, including this one of a Samarkand merchant in 1911.

SOUTH ASIA 1800-1900

BY 1800 THE BRITISH EAST INDIA Company was firmly entrenched in India. The Company exported textile goods (cotton and silk) as well as foodstuffs (sugar cane, tea, coffee, rice, spices) and indigo. It contributed to the Opium Wars by exporting quantities of Indian opium to China. Oddly, the Indian cotton trade was nearly obliterated by cheap imports from Britain's Lancashire mills. While Surat, Madras, Bombay and Calcutta were the primary Company seaports and major cities, Calcutta became the capital and undisputed cultural centre. *Kalighat Pat*, a style of painting that was a syncretic blend of Bengali folk and

Western realism, was produced and sold at the Kali temple on the outskirts of urban Calcutta, epitomizing the ingenuity of local artists in a socially and economically compromised climate. Ironically, the Calcutta fine-art print industry, so greatly influenced by Kalighat art, caused the demise of that folk tradition by the end of the 1930s. In addition to the print industry, Kalighat had an impact on other art movements, notably that of the Modernist painter, Jamini Roy (1887–1972).

COMPANY ART
European artists (amateur and professional) had been travelling the breadth of India since the 1780s, painting scenic landscapes, Hindu and Mughal architecture and making sketches and watercolours of the various ethnic groups, trades and castes. Most were freelance artists, but the more famous were commissioned to paint *nawabs'* and *rajas'* portraits in oil on canvas. A number of British artists made etchings and aquatints in Calcutta studios and later in London. The Company needed artists to map the country, and make

1 THE BRITISH EAST INDIA COMPANY expanded their interests and land holdings in India which fostered trade with the home country and the Far East. Imported British cotton cloth almost ruined Indian cloth production and export of opium to China contributed to the Opium Wars. As Company cities proliferated and grew, displaced artists learnt Western techniques to make maps, geological surveys and ethnographic studies. The British government created art schools to instill Western taste and revive the applied arts.

KALIGHAT PAINTING: *The Tarakeshwar Murder*, artist unknown, c.1875, watercolour and silver on paper. Folk artists from Bengal gathered at the Kali temple in Calcutta. The syncretic folk and Western watercolour style met the demands of the mass pilgrim market. Subject-matter focused on mythology, but artists also drew from the local social-political milieu, particularly life around the temple, local prostitutes, exotic Europeans and scandals, such as the Tarakeshwar murder. This painting is part of a series in which a husband murdered his wife when he discovered that she had an adulterous affair with a Hindu *mahant* (abbott of a monastic foundation).

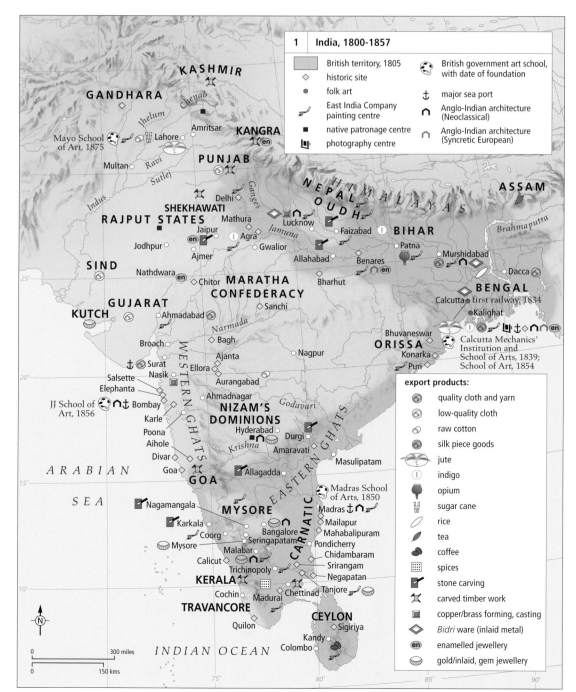

export products:
- quality cloth and yarn
- low-quality cloth
- raw cotton
- silk piece goods
- jute
- indigo
- opium
- sugar cane
- rice
- tea
- coffee
- spices
- stone carving
- carved timber work
- copper/brass forming, casting
- *Bidri* ware (inlaid metal)
- enamelled jewellery
- gold/inlaid, gem jewellery

1	India, 1800-1857

- British territory, 1805
- historic site
- folk art
- East India Company painting centre
- native patronage centre
- photography centre
- British government art school, with date of foundation
- major sea port
- Anglo-Indian architecture (Neoclassical)
- Anglo-Indian architecture (Syncretic European)

ethnographic studies and other surveys. To accommodate the foreign employer, Indian artists, from hereditary painting families and those newly inducted, learned techniques of illusionism – Western perspective and shading.

As Company towns grew, native artists painted family scenes and homesteads for foreign residents, who also bought picturesque scenes of India to send to friends and family back home. While the languishing courts in Rajasthan, the Punjab Hills and at Hyderabad continued to produce Indian miniature painting (referred to as 'provincial' to distinguish it from the highly refined painting of the seventeenth- and eighteenth-century Mughal and Hindu courts), a style of Indo-European painting called 'Company Art', evolved and flourished in cities under British domination. Provenance and style have distinguished a large body of these Indo-European paintings from southern India, eastern and upper India, northern and western India, even Nepal, Burma, Sri Lanka and Malacca.

COLONIAL ARCHITECTURE
European and Indo-European architecture was not the invention of the East India Company. In the seventeenth century the Portuguese erected Mannerist- and Baroque-style churches in Goa and created a blended Indo-Portuguese form. However, while Portuguese influence was geographically concentrated, British-inspired architecture spread throughout India. Cantonments, the hub of Company towns and cities, constituted a segregated community of

2 AFTER 1857 INDIA BECAME part of the British Empire and while nationalist movements proliferated, more Indians were Westernized. Calcutta was the centre of culture and trade. Calcutta presses rolled out art prints as well as Bengali literature and English magazines and newspapers. Anglo-Indian architecture spread across the country creating the impression of wealth and ingenuity.

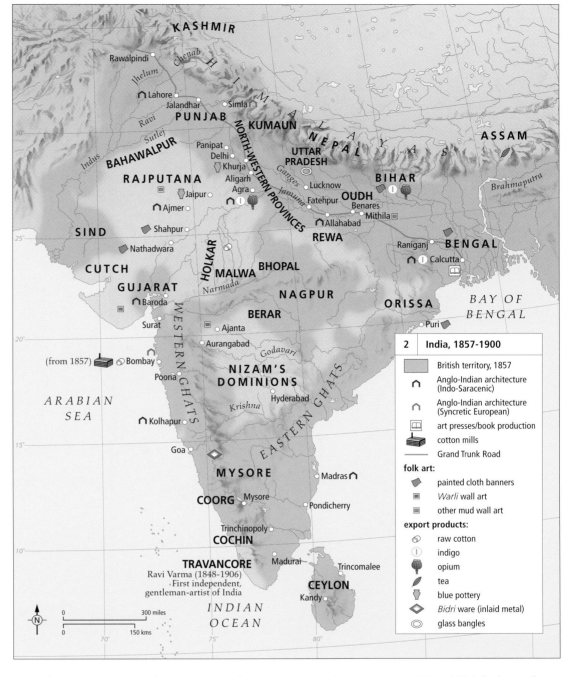

2	India, 1857-1900
▨	British territory, 1857
∩	Anglo-Indian architecture (Indo-Saracenic)
∩	Anglo-Indian architecture (Syncretic European)
▥	art presses/book production
▨	cotton mills
—	Grand Trunk Road
folk art:	
◆	painted cloth banners
▨	*Warli* wall art
▨	other mud wall art
export products:	
◎	raw cotton
①	indigo
♣	opium
♠	tea
♦	blue pottery
◇	*Bidri* ware (inlaid metal)
◎	glass bangles

European civil and military personnel, constructed with army barracks behind an open parade ground. Pre-mid-century public buildings and personal residences, intended to promote the grandeur of the Raj and show off individual wealth and status, were often Neoclassical – modelled on British prototypes. After the Uprising of 1857 when the Company was replaced by the British Raj (1858), urban architecture became recognizably hybrid, as Indo-Saracenic (of Islamic-Syrian origin) style took precedence. Laxmi Vilas Palace, Baroda and the Victoria Terminus, Mumbai (Bombay) are among the best examples of this native Indian category, while Government House and the Marble Palace, both in Calcutta, represent the imported Neoclassical. Though modest, the domestic bungalow (a rustic Bengali-style hut with high ceilings and other European adaptations) may be the most noteworthy architectural innovation of the Raj.

THE REVIVAL OF INDIAN ART
Alarmed by the erosion of native craft and decorative arts, the British began to establish art schools to improve native taste and revive the industrial and applied arts. Based on the industrial arts curriculum practised at London's South Kensington School of Art, painting and sculpture courses were not a priority and were often omitted at government art schools in India. Plagued by a conflict between fine and applied art, the art-school dilemma is yet to be resolved. The growth of Art Societies – Calcutta Art Society, founded in 1831, was the first – eventually benefited native artists after years of exclusion from exhibitions and social events.

As upper- and middle-class Indian society was being Westernized, its notion of art and the artist was changing. While the upper classes bought European oil paintings on canvas, art that hung on walls or sculpture that was intended to decorate house and garden were new concepts. Indian artists were apprenticed to learn the trade and worked in *karkhanas* (group workshops, like an *atelier*) for

an exclusive patron (royalty or gentry). The small-size paintings they produced were kept in leather containers or placed in a *muraqqa* (bound like a book) to be hand-held and viewed at close range. If Company Art was an initial break from the *karkhana*, the first independent Indian 'gentleman artist' could come only from wealth and royalty.

Raja Ravi Varma (1848–1906) belonged to the royal family of Travancore. He learned to paint by watching European artists at court and travelled around India earning fame and lucrative commissions. By the turn of the century his work was hailed as the renaissance in Indian art. Varma painted familiar subjects – mythology and Indian literature – in the Western academic tradition and had oleograph reproductions made for mass consumption. Nevertheless, by the time of his death, the rising tide of Indian nationalism rejected his Western style in favour of a new, more spiritual, Oriental approach to painting.

The ethnic and religious diversity that comprises Indian culture of this period reflects upheaval and compromise. The Sikh religious centre at Amritsar is a living museum of distinctive art and architecture. The Jains have recorded their ancient religious literature on brilliantly painted palm-leaf manuscripts. Nothing is lost from India's past.

COMPANY ART: *A Groom with Horse and Carriage*, Shakykh Muhammad Amir, c.1840–50, gouache on paper. Displaced Indian artists learned Western techniques of shading and perspective to find employment with the East India Company. Some were commissioned to paint family scenes and homesteads by foreigners who kept the art as mementoes or sent it to friends and relatives.

CHINA AND TIBET 1800-1900

AFTER THE DEATH of the Qianlong emperor in 1795, peasant revolts, the rebellion of non-ethnic Chinese peoples in Hunan and Guizhou in China's southwest and the incursion of piracy on the Guangdong and Fujian coasts began to destabilize China. Peasant unrest persisted throughout the first quarter of the nineteenth century, most notably in southern China. Simultaneously, non-ethnic Chinese populations on China's borders, including the Tibetans, the Yao of Guizhou, and the Muslims of Xinjiang also rebelled. In 1816 China's political and economic situation was complicated by the British East India Company's development of the opium trade, outlawed by China in 1729, to offset its China Trade imbalances.

CHINA IN TURMOIL

The 1839 ban on opium by the official Lin Zexu (1785–1850), a traditional Chinese *literatus* also active as an amateur painter and calligrapher, resulted in British piracy and other acts of military aggression on China's south coast. China's military failed to contain the foreign threat, and China consequently agreed to negotiate an end to hostilities. Through the Treaty of Nanjing of 1842 Britain acquired Hong Kong island and trading rights in five Chinese ports; Britain also received payment in silver of large indemnities. The Second Opium War, resolved by the Treaty of Tianjin in 1858, opened up further ports – the 'Treaty Ports' – to foreign influence, as did other further diplomatic negotiation.

China's attempts to modernize along Western lines were undercut by social, political and economic instability. Nonetheless, railroads, steamship

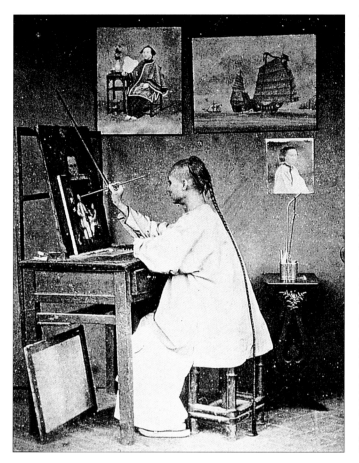

THE INTRODUCTION of photography to China during the nineteenth century transformed the pictorial practices, documentary habits and established media culture of the Chinese visual field, as represented by this image, *A Hong Kong Artist,* from John Thompson's 1873 *Illustrations of China and Its People*. Photography disseminated knowledge of China and her pictorial practices abroad; domestically it became an important tool for creating Chinese ritual images for ancestral worship.

1 THE LAST CENTURY of Manchu rule was shaped by Western interest in China. The Opium Wars led to the opening of treaty ports; the Taiping rebellions, led by the 'new Messiah' Hong Xiuquan (1813–64), sought to refashion Chinese society from within. In the Treaty Ports modern Western art forms were practised alongside traditional Chinese ones; in this setting a range of hybrid Euro-Chinese forms emerged.

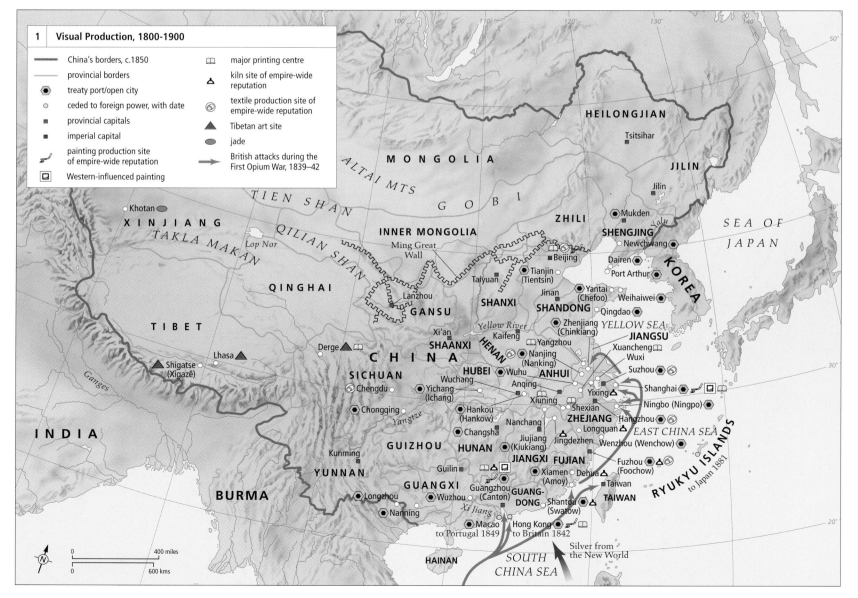

1 Visual Production, 1800-1900

— China's borders, c.1850

— provincial borders

◉ treaty port/open city

○ ceded to foreign power, with date

■ provincial capitals

■ imperial capital

✈ painting production site of empire-wide reputation

▣ Western-influenced painting

▥ major printing centre

△ kiln site of empire-wide reputation

◉ textile production site of empire-wide reputation

▲ Tibetan art site

⬭ jade

⟶ British attacks during the First Opium War, 1839–42

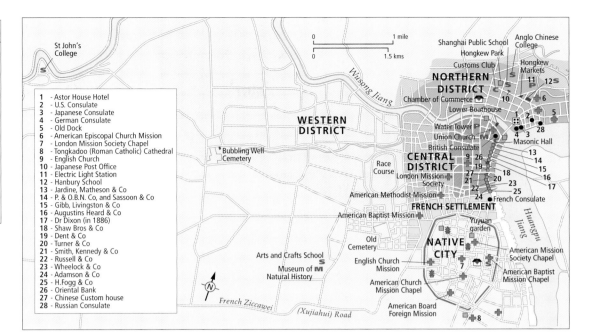

1 - Astor House Hotel
2 - U.S. Consulate
3 - Japanese Consulate
4 - German Consulate
5 - Old Dock
6 - American Episcopal Church Mission
7 - London Mission Society Chapel
8 - Tongkadoo (Roman Catholic) Cathedral
9 - English Church
10 - Japanese Post Office
11 - Electric Light Station
12 - Hanbury School
13 - Jardine, Matheson & Co
14 - P. & O.B.N. Co, and Sassoon & Co
15 - Gibb, Livingston & Co
16 - Augustins Heard & Co
17 - Dr Dixon (in 1886)
18 - Shaw Bros & Co
19 - Dent & Co
20 - Turner & Co
21 - Smith, Kennedy & Co
22 - Russell & Co
23 - Wheelock & Co
24 - Adamson & Co
25 - H.Fogg & Co
26 - Oriental Bank
27 - Chinese Custom house
28 - Russian Consulate

2 SHANGHAI was the richest and most populous of China's Treaty Ports. Foreign extraterritorial rights created the foreign concession areas, distinct from the old Chinese city. Western expatriates in Shanghai recreated their native visual cultures in the construction and decoration of governmental and commercial buildings, schools, churches, clubs and houses. Tea houses, artists' studios, and antique dealers catered to Chinese interested in the visual arts; in contrast, expatriates replicated the emergent museum culture of their homelands by founding 'modern' musems in Shanghai at this time.

companies, electric plants, telegraph companies, iron mines and foundries and Western schools were founded at this time. Such engines of modernity were unevenly distributed, existing primarily in the Treaty Ports and along their connecting routes. Chinese intellectuals such as Kang Youwei (1858–1927) sought to reconcile traditional Chinese thought with the need for modernization by retaining and rethinking China's intellectual history while embracing Western contributions to knowledge, especially in science and technology.

THE VISUAL ARTS IN CHINA
Visual production in nineteenth-century China was similarly informed by indigenous tradition and imported modernity. Localized production of traditional arts continued to flourish throughout the empire, especially in county, prefectural and provincial seats. A number of sites continued to have an empire-wide reputation for specialized artistic production, such as ceramics from Jingdezhen, Dehua, Longquan and Yixing, and paintings from Suzhou and Yangzhou. In the Treaty Ports, Western techniques for the representation and reproduction of images, including single-point perspective and colourism, lithography and photography, challenged traditional modes of making images, as did exposure to new materials, especially oil-paint. A new interest in colour, shading and perspective is found in the works of members of the so-called Shanghai School, for example, Ren Xiong (1820–57).

The introduction of photography to China by foreigners, for example, Felice Beato (1820–1907) and John Thompson (1837–1921), documented China's social and political conditions and challenged established traditional Chinese notions of realism and representation articulated in classical Chinese painting theory. Photography also advanced Western imperial ideology, while recording and disseminating knowledge of China abroad. Cinema was also introduced to China through foreign interests in Shanghai in 1896 by a representative of the Lumière brothers. Early viewing of cinema in China was limited to the Treaty Ports, where it co-existed together with traditional forms of spectacular entertainment such as shadow puppetry, acrobatics, juggling, and magic.

In the second half of the nineteenth century, China's media culture, previously dependent on woodblock printing, with some mid-Qing experiments with metal-plate engraving, was transformed by the Western technology of lithography, and Western-style printed books and newspapers were produced. The development of an alternative, non-traditionally Chinese media culture is evident, for example, in the advertisement and review of imported movies in the new newspapers, and in the turn-of-the-century filming of Chinese street life.

ART IN THE TREATY PORTS
In the Treaty Ports, traditional Chinese architectural and social forms were articulated within walled Chinese cities. Western and hybrid Sino-European architectural and social practices – including clothing styles – transformed extramural suburbs into small approximations of Western cities. Commercial, administrative, religious and residential structures were built for expatriate residents. To furnish the interiors of these buildings, Western-style paintings, stained glass, furniture, and other decorative arts were locally produced. Techniques for their manufacture were taught to the Chinese, for example, in Shanghai at the Jesuit-run Tushanwan Arts and Crafts Centre in the Xujiawei suburb.

The new visual forms of modern life in the Treaty Ports were underscored by the foundation of museums. China's first museum, the Shanghai Museum of Natural History, was founded in 1868 by Father Pierre Heude in Xujiawei, Shanghai; in 1874 the Northern Branch of the Royal Asiatic Society founded its museum, which became the Shanghai Museum of Art. Establishment of museums meant that objects were on public view under scientific conditions, as opposed to the teahouses, restaurants, antique and curio dealers, and elite private gatherings of traditional China.

SELF-PORTRAIT by Ren Xiong (1820–57) epitomizes the intellectual tensions of nineteenth-century China. The poetic inscription recounts a dialogue between the artist and his image (as reflected in a mirror) that probes questions of moral and ethical conduct, and the value of classical Chinese learning in the modern world. Ren represents the contradictions of the era by contrasting a Western-influenced realistic depiction of Ren's body with the traditional, calligraphic rendering of his robes.

ART IN TIBET
A more independent and unified Tibet emerged in the nineteenth century from the political turmoil of border rebellion. Kongtrul Lama (1813–99), who headed the Ri *mé* (literally 'without partisan views') religious movement, oversaw the compilation of a Tibetan encyclopedia, which included esoteric Buddhism, Sanskrit grammar, Tibetan medicine, iconometry and Tibetan painting traditions, and authored an important treatise on Tibetan art history. Although the thirteenth Dalai Lama (1876–1933) encouraged study abroad, there is little evidence of the impact of such study on Tibetan art.

JAPAN AND KOREA 1800-1900

DURING THE EARLY nineteenth century, Japan and Korea feared the destruction of their own national identities by Western imperialism and tried to isolate themselves from outside political and cultural incursions. But by the end of the nineteenth century both Japan and Korea were adopting and adapting to outside artistic influences.

THE MODERNIZATION OF JAPAN
By the mid-nineteenth century in Japan, government corruption, nationwide economic hardships and the appearance of foreign

1 IN THE LATE EDO PERIOD, Japanese ceramics were made in a number of provinces, and in a wide variety of styles. While mass production in the early nineteenth century was still controlled by regional military governors, who used ceramic sales as a source of income, certain kilns provided distinctive wares for the tea ceremony and others were geared to the export trade. Modern factory production of textiles, *cloisonné*, ceramics and lacquer developed quickly in the 1880–90s, with significant amounts intended for export to Europe, the USA and Asia.

gunboats in Japanese waters led to the overthrow of the Tokugawa military government which had controlled the islands for over 250 years. Reform groups moved the young emperor to Tokyo and initiated a process of 'modernization' that included inviting foreign artists and technicians to teach in Japan and sending Japanese representatives to study in Europe and the USA. In the 1860s and 1870s Japanese prints, paintings and traditional decorative objects were becoming extremely popular in the West, sparking '*Japonisme*' and influencing Impressionist painters. By the end of the nineteenth century the government had established art schools and museums in Tokyo and Kyoto, where both traditional and modern arts were taught and displayed.

Japanese architecture was significantly changed by the introduction of Western building techniques and materials, especially brick and glass. Wood construction traditions, which essentially had been the same for centuries, were affected by the rapid modernization of Japan in the 1870s–90s. Tokyo and Yokohama were linked by a rail line, and in both cities new

building forms, such as factories, banks, train stations, and public halls, were modelled after examples in Europe and the USA.

Japanese painting in the nineteenth century was greatly affected by Western influences. Japanese woodblock prints were extremely popular in the nineteenth century, with landscape images by Hokusai and Hiroshige being produced in large sets ('36 Views of Mt. Fuji', '53 Stations of the Tokaido', '100 Views of Edo') and in many editions. The more traditional subject matter of *ukiyo-e*, such as kabuki actors and courtesans, continued to sell well, although more intense colours and more intricate carving techniques reflected Western influence and fashionable 'modern' tastes.

Not all Japanese painters reacted to Western techniques, and eighteenth-century trends in *literati* painting derived from Chinese models still flourished, especially in the Kyoto-Osaka area, and particularly among 'amateur' artists. Among these, Uragami Gyokudo (1745–1820) sought self-expression through the harmony of music and visual art in the gentleman-scholar tradition.

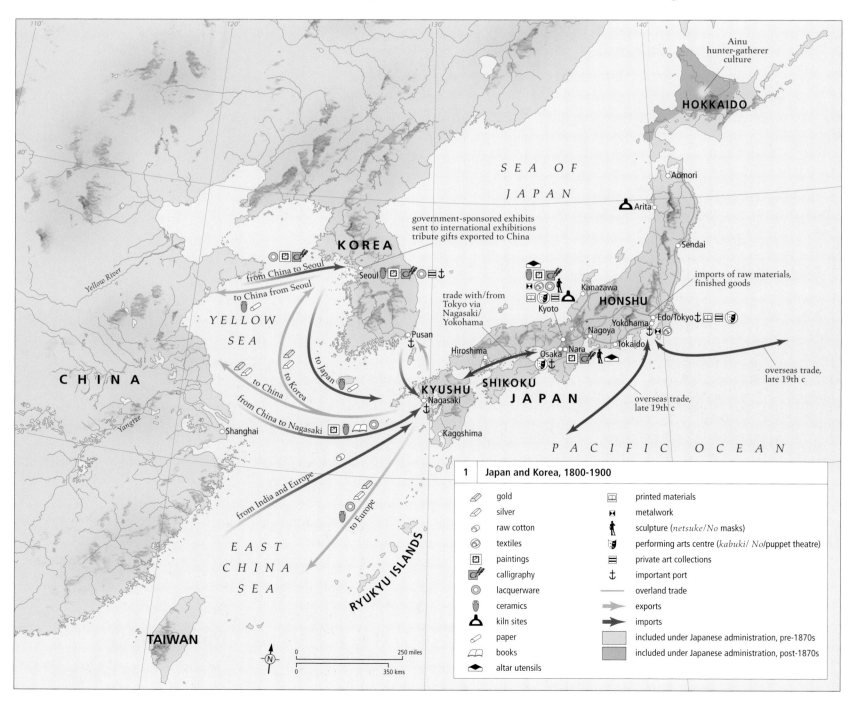

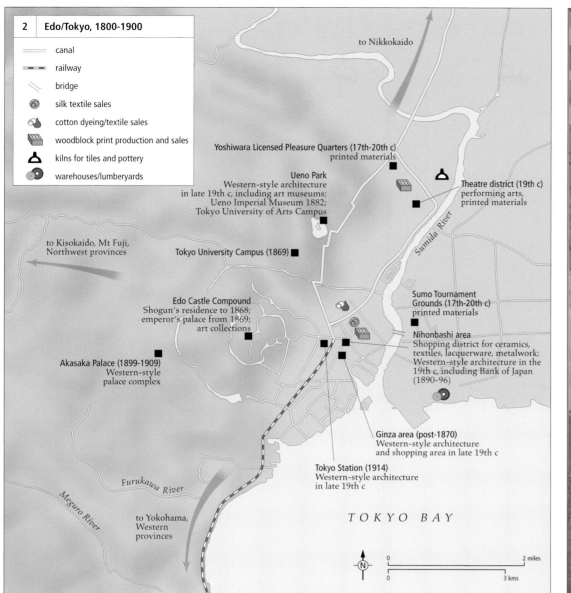

2	Edo/Tokyo, 1800-1900

- ═══ canal
- ▬▬ railway
- ╱ bridge
- ⊚ silk textile sales
- ⊚ cotton dyeing/textile sales
- ▥ woodblock print production and sales
- △ kilns for tiles and pottery
- ⊚ warehouses/lumberyards

to Nikkokaido

Yoshiwara Licensed Pleasure Quarters (17th-20th c)
printed materials

Ueno Park
Western-style architecture
in late 19th c, including art museums;
Ueno Imperial Museum 1882;
Tokyo University of Arts Campus

Theatre district (19th c)
performing arts,
printed materials

to Kisokaido, Mt Fuji,
Northwest provinces

Tokyo University Campus (1869)

Sumo Tournament
Grounds (17th-20th c)
printed materials

Edo Castle Compound
Shogun's residence to 1868;
emperor's palace from 1869;
art collections

Nihonbashi area
Shopping district for ceramics,
textiles, lacquerware, metalwork;
Western-style architecture in the
19th c, including Bank of Japan
(1890-96)

Akasaka Palace (1899-1909)
Western-style
palace complex

Ginza area (post-1870)
Western-style architecture
and shopping area in late 19th c

Tokyo Station (1914)
Western-style architecture
in late 19th c

Furukawa River

Meguro River

to Yokohama,
Western
provinces

TOKYO BAY

Suniida River

N

0 2 miles
0 3 kms

2 ARTISTIC PRODUCTION IN JAPAN was concentrated in Kyoto, the imperial city, and in Edo (Tokyo), the government's political centre. Kyoto focused on traditional arts developed for the aristocracy, wealthy merchants, Buddhist temples and tourists. Edo was associated with innovation, especially in response to foreign imports, and with material goods, produced for the growing middle class.

SWIMMING DUCKS by Korean artist Hong Se-sop (1832–84). The eighteenth-century scholar-artist tradition was vigorously continued as part of the overall efforts of the Korean elite to preserve and protect Confucian, Chinese and Korean cultural values from foreign influences. Bird and flower paintings, both in ink on paper and in colours on silk, were extremely popular.

HIROSHIGE'S PRINT *SURUGACHO* from *100 Famous Views of Edo*, 1856. Western techniques of one-point perspective and shading were widely known among Japanese painters and print designers. Some artists, like Ando Hiroshige (1797–1858) and Katsushika Hokusai (1760–1849), used traditional Japanese materials to create woodblock prints and paintings that were influenced by illustrated books from Europe and China.

KOREA: THE SURVIVAL OF TRADITION

At the start of the nineteenth century Korean rulers, observing the dismemberment of China by European colonial forces, felt that their country was now the last bastion of Confucian traditions in Asia and made efforts to officially sponsor and protect Korean values and arts. Seoul, the capital city, continued to be the centre of artistic production, and most artists, scholars and aristocrats (*yangban*) preferred conservative Chinese styles of painting, calligraphy, ceramics and sculpture. Plain white porcelain wares that had developed during the Chosun Period (1392–1910) were viewed as distinctly Korean and valued for their simplicity and purity, as physical manifestations of Confucian virtues. These continued to be produced in the imperial factories in the Kwangju area southeast of Seoul. Some Korean artists continued to experiment with genre and 'true view' landscape (*chin'gyong sansu*) painting styles begun in the eighteenth century, depicting the Korean people and actual countryside rather than imaginary figures and landscapes. However, Western art seen by Koreans visiting China or brought to Korea by Christian missionaries during the nineteenth century gradually began to affect the traditional arts – especially

portraiture, which became increasingly detailed and realistic. Western architecture had a limited impact on Korea in the nineteenth century, being identified primarily with buildings for the foreign consulates and Christian missionaries, such as the Gothic-Revival style Myodong Catholic Cathedral, completed in 1898.

As part of mid-nineteenth century efforts to affirm Korea's identity and independence, the old imperial palace compounds in Seoul, which had been in ruins since their destruction by Japanese armies in the 1590s, were elaborately rebuilt. These brightly painted Chinese-style wooden pavilions were raised on stone platforms above paved courtyards, where grand ceremonies of state and Confucian rituals were held as part of the revival of ancient traditions.

Korea, like Japan, participated in international expositions, sending artworks to Chicago (1893) and Paris (1900), but outside interests in traditional Korean culture did not really materialize. After 1895 Japan became increasingly involved in Korean politics, eventually annexing the peninsula in 1910, and began sending Korean artists to train in Japan. Efforts to preserve Korean national identity and cultural traditions would be severely challenged in the next century.

SOUTHEAST ASIA 1800-1900

AT THE OUTSET of the nineteenth century the last of the great Southeast Asian empires had been formed: the Konbaung (1752–1885) in Burma, the Chakri (1782–present) in Siam, and the Nguyen (1802–1945) in Vietnam. In Java, the Mataram dynasty had divided into two lines: the houses of Surakata and Jogjakarta, neither of which held much power beyond their capitals. These kingdoms functioned in the traditional manner but their rulers were increasingly aware of external influence in the form of European trade and power. During this period the European powers made rapid political and territorial advances into the region, aware of the enormous profits to be made from the trade in spices and other commodities.

Government-appointed officials now took the place of representatives of companies such as the East India Company, and territorial revenues replaced trading profits. Natural resources were developed for export, particularly in the form of plantation crops. The French controlled the trade of Indochina: Vietnam, Laos and Cambodia, where huge plantations produced export crops such as rubber and tobacco. Very few areas remained unaffected by Western influence. Even in the inaccessible interior regions, trade brought exotic items and ideas.

FUNERARY EFFIGIES, Torajaland, Celebes (Sulawesi). These effigies, almost life-size, stand guard high on the cliff face overlooking their village. After a person's death an effigy (*tao tao*) was carved to represent the deceased, and placed high above the village close to the upper realm. In this way the ancestors retained an important protective role in society and provided a sense of continuity within the group. This custom still continues despite the inroads of Islam and Christianity.

1 THE NINETEENTH CENTURY saw the consolidation of Western control over the region. Whereas previously the Dutch and English East India Companies had concentrated purely on trade with India, China and the Arab world, Western governments now took over the administration of large areas. Gradually the various Southeast Asian countries became part of the empires of the Netherlands, England, France and the United States. By 1900 only Siam remained independent.

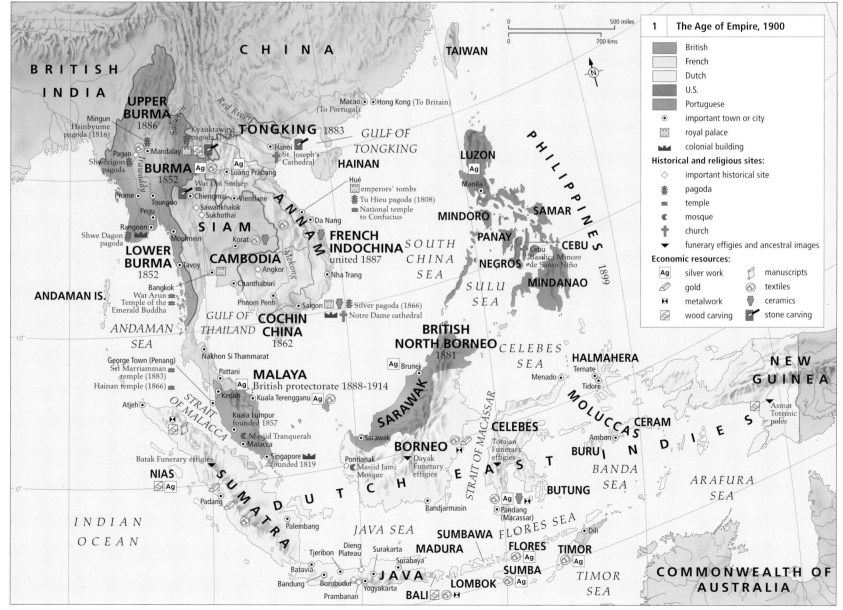

With the growing strength of the European powers there was also a change in the structuring of local society. Local leaders were in many cases now answerable to European district officers. Christian missionaries were active in the hill regions of the interior and in the outer islands. Mission schools were established in many areas, teaching in the language of the European power, which created an educated elite unable to assume control of government.

ART AND ARCHITECTURE

In the field of art, lacquerware and wood carving were particularly fine at this time, although little wood carving remains from the period, due to climatic conditions. A few wooden monastic buildings dating from the nineteenth century remain in Burma. Carved with foliate and floral designs, fabulous beasts and other motifs, they show remarkable skill and delicacy. Another – secular – architectural gem from this period is the Lacquer Pavilion in Thailand. This small wooden pavilion, the walls of which are lined with exquisite lacquer panels, escaped destruction in the sacking of Ayutthaya by being moved to the grounds of a summer palace at a safe distance from the city.

Southeast Asian houses were very distinctive, as they still are; traditionally the roof generally formed the greater part of the building, which was usually raised on stilts – an ancient design. Longhouses were still built in many parts of the region including the Philippines, Borneo, New Guinea, Vietnam and Malaya. In these houses, which were raised high above the ground on wooden piles, a communal area stretched the length of the house, with individual sleeping areas leading off. These houses were particularly common in head-hunting regions, where safety in numbers was the rule. However, they gradually became scarcer as Christian missionaries discouraged the building of traditional longhouses, considering them to be both unhygienic and conducive to immorality.

In the field of architecture and sculpture, the emphasis, as in the past, was on the recreation of earlier forms, although in many cases in a more ornate manner than before. In the Buddhist sculpture of Siam and Cambodia for example, there was an echoing of earlier Ayutthayan forms, but crowned Buddha images wore more decorative robes and crowns. Stupas built in the new city of Bangkok were taller than before, and blended Khmer and Thai forms. One innovation of this period was the use of broken ceramic mosaic to cover stupa walls, creating a brilliant and colourful effect, as can be seen at the soaring Wat Arun in Bangkok and in some buildings within the palace walls.

Also noticeable here, however, is the influence of European architecture. Bangkok's palace, constructed in 1867, is topped with stepped roofs covered with coloured tiles in the Siamese style, but it has a classical façade in marble. Although rather startling, this adopting of different styles and influences is typical of the Southeast Asian approach to the visual over many centuries. In the Philippines, too, Spanish influence could be seen both in the colonial-style architecture of the period and in the sculpture, much of which was catholic in inspiration.

ART AND SOCIETY

The social framework of Southeast Asia was reflected in the textiles of the region. The thread used, the colours and motifs, all

2 OVER THE COURSE of the nineteenth century Burma underwent dramatic political changes. In three Anglo-Burmese wars British forces gained control of most of its territory. Their movement northward culminated in the fall of the Burmese monarchy at Mandalay in 1885, when the royal family was exiled to India. Administrative change quickly followed, and the British government also encouraged migrant workers from India and China. With the departure of the court, many traditional crafts became less widespread but some craftsmen made items to suit European taste.

WOODEN MASK, Bbohnar-Jolong people, central Vietnam. This rare mask shows that in the nineteenth century masks were used in ritual, as they still are today in many parts of Southeast Asia. Masks had a sacred function and were used either to invoke the ancestors or the spirits, usually in dance. In some regions it was the custom for men to carve their own masks which represented their ancestor and which performed a protective function.

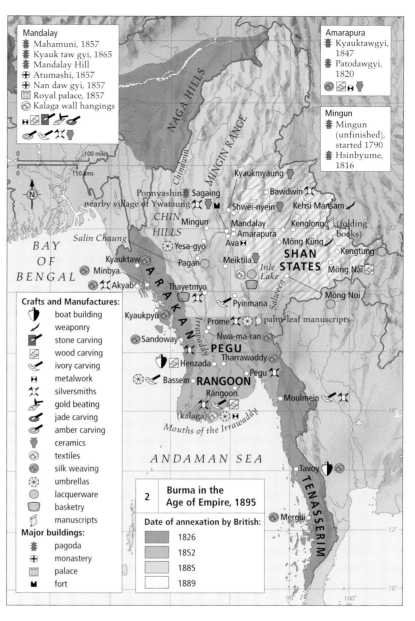

Crafts and Manufactures:
- boat building
- weaponry
- stone carving
- wood carving
- ivory carving
- metalwork
- silversmiths
- gold beating
- jade carving
- amber carving
- ceramics
- textiles
- silk weaving
- umbrellas
- lacquerware
- basketry
- manuscripts

Major buildings:
- pagoda
- monastery
- palace
- fort

Mandalay
- Mahamuni, 1857
- Kyauk taw gyi, 1865
- Mandalay Hill
- Atumashi, 1857
- Nan daw gyi, 1857
- Royal palace, 1857
- Kalaga wall hangings

Amarapura
- Kyauktawgyi, 1847
- Patodawgyi, 1820

Mingun
- Mingun (unfinished), started 1790
- Hsinbyume, 1816

2 Burma in the Age of Empire, 1895

Date of annexation by British:
- 1826
- 1852
- 1885
- 1889

signified wealth, rank and family connections. Fine sarongs were worn at weddings, funerals and other occasions where status and group membership were important. Imported textiles, usually from India, were also popular. Ikat or tie-dyed textiles were woven on backstrap looms, and batik – wax-resistant cloth – was produced in Java, and more widely. The most sacred cloths – those kept for ritual occasions – were kept as family heirlooms. In many of the great, tall-roofed houses of Indonesia, such heirlooms were kept, along with heads taken in head-hunting raids, in the upper roof space, which was considered to relate to and symbolize the upper realm. In some of the more remote areas of Borneo, the Philippines and New Guinea, soft, painted bark-cloth fabric was produced.

In more populous areas, the European developers, aware of native hostility, continued to rely on foreign middlemen to build up the businesses, and Chinese and Indian immigration increased. In Siam local Chinese merchants were increasingly involved in trade, and the Chinese quickly became a wealthy group. They brought with them Confucianist and Taoist ideals and built family temples and houses of brick directly on the ground. These they surrounded with high walls. To reflect their status, the more successful among them both imported and commissioned artworks, particularly ceramics, silverware, textiles and furniture. Most of these items were of a highly ornate design, many of them designed specifically for the overseas Chinese or Peranakan market.

THE PACIFIC 1800-1900

BETWEEN 1800 AND 1900 Pacific islanders fought to maintain their own traditions and identities against a number of new factors, including the arrival of missionaries who attempted to civilize the 'heathen native'; traders and later colonialists, who exploited many of the resources and people; and the related introduction of diseases, land loss, commercialization and breakdown of traditional status and relationships.

Although the Pacific covers an area of 165,384,000 sq km, and over 20,000 islands, there are a number of similarities in art and architecture, as well as noteworthy differences. Throughout the Pacific the human body becomes a cultural art piece through the application of tattoo, scarification or other

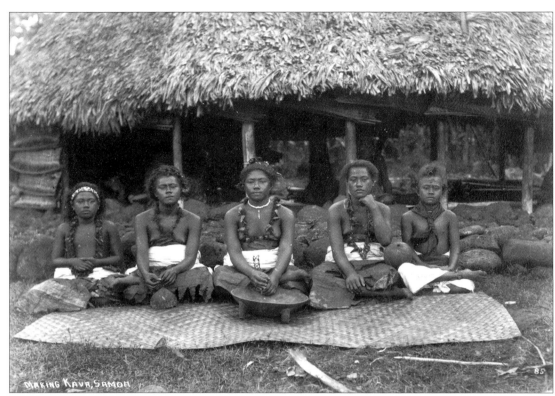

PHOTOGRAPH BY JOSIAH MARTIN, C.1880. Images such as this posed photograph of five young Samoan women recreating the *kava* ceremony, led to increased tourism to the Pacific Islands and thereby the establishment of cultural centres.

1 THE INCREASING CONTACT between Europeans and islanders, and also between different groups of islanders, enabled exchange of cultural ideas and objects, as well as providing exposure to differing materials and techniques for the production of arts, crafts and architecture.

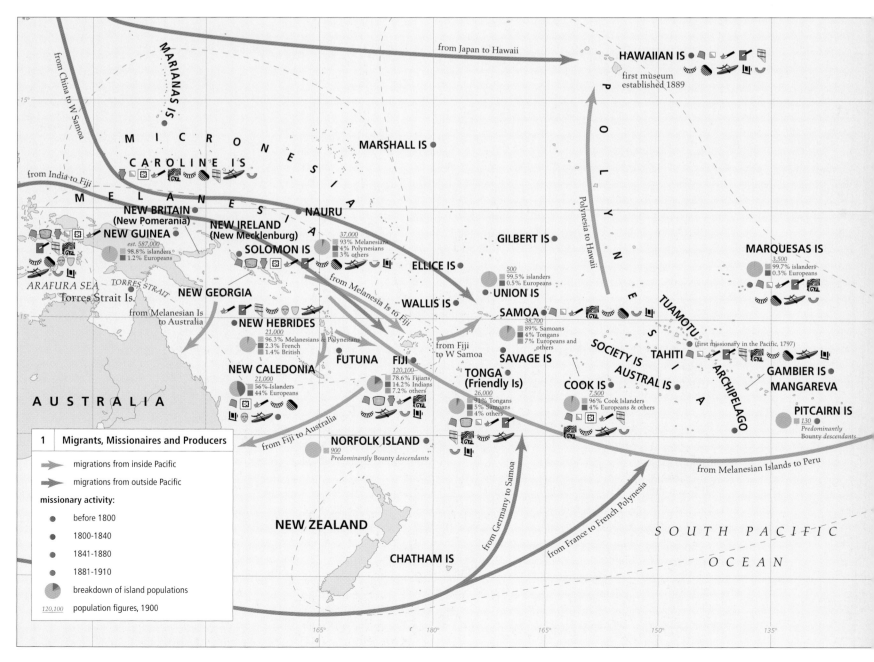

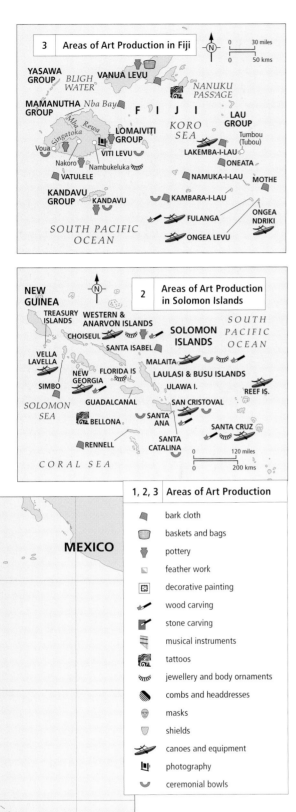

3 Areas of Art Production in Fiji

YASAWA GROUP
BLIGH WATER
VANUA LEVU
MAMANUTHA GROUP
Nba Bay
NANUKU PASSAGE
F I J I
Singatoka *Rewa*
LOMAIVITI GROUP
KORO SEA
LAU GROUP
Voua
Nakoro
VITI LEVU
Nambukeluka
Tumbou (Tubou)
LAKEMBA-I-LAU
ONEATA
VATULELE
NAMUKA-I-LAU
MOTHE
KANDAVU GROUP
KANDAVU
KAMBARA-I-LAU
ONGEA NDRIKI
SOUTH PACIFIC OCEAN
FULANGA
ONGEA LEVU

2 Areas of Art Production in Solomon Islands

NEW GUINEA
TREASURY ISLANDS
WESTERN & ANARVON ISLANDS
CHOISEUL
SANTA ISABEL
SOLOMON ISLANDS
SOUTH PACIFIC OCEAN
VELLA LAVELLA
MALAITA
NEW GEORGIA
FLORIDA IS
LAULASI & BUSU ISLANDS
SIMBO
ULAWA I.
REEF IS.
SOLOMON SEA
GUADALCANAL
SAN CRISTOVAL
BELLONA
SANTA ANA
SANTA CRUZ
RENNELL
SANTA CATALINA
CORAL SEA

1, 2, 3 Areas of Art Production

- bark cloth
- baskets and bags
- pottery
- feather work
- decorative painting
- wood carving
- stone carving
- musical instruments
- tattoos
- jewellery and body ornaments
- combs and headdresses
- masks
- shields
- canoes and equipment
- photography
- ceremonial bowls

MEXICO

EASTER I.

2/3 THE TRANSFERENCE OF IDEAS regarding art was not a one-way process, but rather a mutual interchange. Important items of adornment and status such as red feathers, tortoise-shell and mother-of-pearl ornaments were taken back to Europe where they were quickly adopted into Western fashion. Western colonialists and missionaries discouraged 'heathen' practices, including tattooing, and abstract and decorative styles were encouraged, or replaced with 'acceptable' and 'productive' crafts – such as sewing and quilt-making. Due to this emphasis, woman's arts and cultural practices have survived longer and more intact than men's.

body art. Religious structures, the 'big house' or 'meeting house', are also widely distributed. In contrast, while diverse and intricate masks and shields appear in Melanesia, neither are conspicuous in either Micronesia or Polynesia.

THE EUROPEAN IMPACT
By the turn of the nineteenth century all but a few of the islands had experienced contact with Europeans, bringing their materials and technologies. As these early European explorers required water and food supplies, barter systems were quickly established. Islanders sought iron nails, which they re-appropriated as tools, particularly as carving points for fine ivory work. Nails did not significantly influence the architecture of many islands; in the eastern Pacific construction is based on complex lashings for securing joints. Although nails are now used in house-building, these joints are still covered with traditional lashings. The introduction of saw and timber mills, however, did have an impact on architecture. Hewn logs were used to provide uniform, thinner planks than previously used, and this was particularly noticeable in the meeting houses of New Zealand. The availability of metal chisels also reduced the time taken to complete pieces with greater detail, thus encouraging more ornate styles of design to develop.

One of the most significant factors influencing Pacific art and architecture was the arrival of the missionary. The first missionaries to arrive in the Pacific were sent from the London Missionary Society (LMS) in 1797 to Tahiti. As part of the evangelist movement, islanders themselves trained as missionaries, and over 1200 of these native evangelists travelled to other islands to spread the word. The introduction of a new belief system attempted to

destabilize local belief systems, but instead often just added further layers to already complex practices of taboo.

Missionaries, like explorers, whalers, and traders, also brought with them iron tools, cloth and guns – all of which became sources of power and prestige. (Alcohol also became a bartering object, with the resulting, connected social problems.)

COLLECTING PACIFIC ART
As part of the process of 'civilization', islanders were encouraged to destroy representations of gods, although the LMS in particular collected many of these pieces and brought them back to London, where many suffered emasculation in order to become suitable for public viewing.

Explorers, sailors and traders also collected artefacts to take home to Europe, Australia and America, where they frequently made their way into museums, private collections and commercial institutes, often without proper documentation. Although many museums are now established in the Pacific archipelago, only the Bishop Museum in Honolulu came into existence during the nineteenth century, and as a result the majority of collections in Pacific museums are contemporary.

Islanders soon recognized the value of their artefacts, and as early as the 1770s the productions of 'tourist art' began. In Fiji, for example, traditional oversized pots were reduced to compact pottery bowls that could easily be packed and transported. In New Zealand clubs that were traditionally carved using greenstone (nephrite) were replaced with wood, as the softer material was more readily available as well as quicker to produce.

Colonial officers also banned, confiscated and destroyed artefacts and cultural practices. When the Solomon Islands came under a British protectorate in 1893, the administrator Charles Woodford, in an attempt to wipe out the practice of headhunting, destroyed many of the canoes and canoe houses that required heads for their inauguration. In New Zealand war canoes were similarly destroyed or banned as a method of decreasing inter-tribal fighting and the Maori Wars.

Along with the destruction or loss of 'idols', rituals and the related dances and songs were also banned by the missionaries and colonialists and supplemented with Christian practices and hymns. Missionaries formalized spoken languages into written formats and thereafter manipulated traditional practices and influenced inter-island communication through their newspapers and newsletters.

Despite a century of intensive and considerable change, the majority of islands still maintained a sense of unique cultural practices, arts and architecture. Their arts and cultures have not remained unaffected by increased contact among differing islands and with the wider world, but instead they have increasingly chosen what traditions they wish to retain and what new materials, techniques and styles they wish to adopt and adapt for their own purposes.

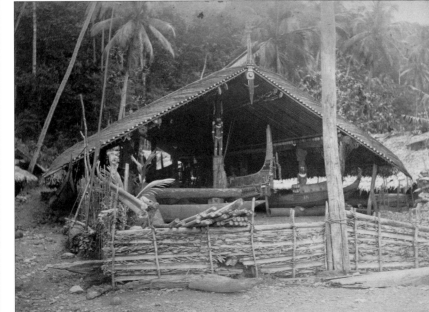

AN EXAMPLE OF CEREMONIAL and decorative architecture from San Cristoval, Solomon Islands. This canoe house has upright posts in human form, carved purlin ends, a bamboo palisade fence, and the interior is decorated with carved figures and human and animal skulls.
Photographer: George Smith, 1873.

AUSTRALIA AND NEW ZEALAND 1800-1900

AUSTRALIA AND NEW ZEALAND were relatively isolated from the rest of the world (and from each other) until the arrival of European settlers in the late eighteenth and early nineteenth centuries. Even then, the long and arduous voyage necessary for the movement of objects and ideas between the colonial centre and its periphery kept both antipodean colonies in a cultural time lag.

INDIGENOUS CULTURES
The indigenous cultures of Australia and New Zealand were unknown to the Western world until the white man arrived to disrupt and destroy them. In New Zealand, the distinctive carving of the Maori people was improved and accelerated by the introduction of iron tools. Maori artists adapted so quickly to European influence that few examples of pre-contact art remain. Indeed, the earliest surviving carved ceremonial house was built with iron tools in

1842. Maori artefacts were turned out quickly for commercial rather than traditional purposes: North Island wood-carvers produced small objects for tourists from the 1870s, while South Island greenstone carvers substituted bowenite, previously despised for its softness, for their original nephrite.

In Australia traditional Aboriginal culture retreated from encroaching white settlement, rather than engaging with it. Despite the rich variety of the sandstone carvings, bark paintings and cave paintings described by white explorers, they were regarded as mere ethnographic specimens. Some Aborigines, however, crossed the cultural divide by drawing on paper (as Aborigines of the Sydney district did for the Baudin expedition as early as 1802). The pencil portraits that Eugène von Guérard (1811–1901) and Black Johnny (c.1842–1883) made of each other in 1855 are rare examples of Aboriginal-European cultural reciprocity.

COLONIAL ART
The earliest white art produced in the Australian colonies and in New Zealand was produced for a British audience. The first white settlement at Sydney Cove in 1788 was documented by British First Fleet officers, and from the 1790s by convict artists transported to the Australian colonies. From the 1820s professional artists visited both Australia and New Zealand. Augustus Earle's (1793–1838) views of Hobart (1825), Sydney (1827), and the Bay of Islands (1828) were exhibited as circular panoramas in London and New York. Other artists – Conrad Martens (1801–78) in South Australia, George French Angas (1822–86) in South Australia and New Zealand, and Charles Heaphy (1820–81) in New Zealand – were employed to produce flattering views as inducements for potential immigrants.

Colonial art was not limited to practical objectives. John Glover (1767–1849) sent thity-eight of his Tasmanian views for exhibition in

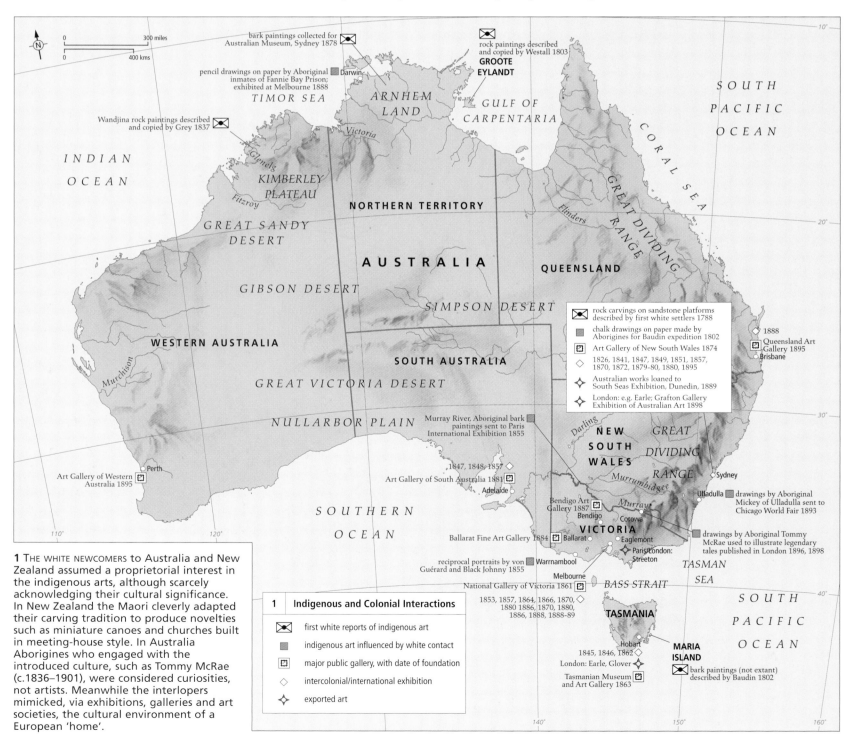

1 THE WHITE NEWCOMERS to Australia and New Zealand assumed a proprietorial interest in the indigenous arts, although scarcely acknowledging their cultural significance. In New Zealand the Maori cleverly adapted their carving tradition to produce novelties such as miniature canoes and churches built in meeting-house style. In Australia Aborigines who engaged with the introduced culture, such as Tommy McRae (c.1836–1901), were considered curiosities, not artists. Meanwhile the interlopers mimicked, via exhibitions, galleries and art societies, the cultural environment of a European 'home'.

1	Indigenous and Colonial Interactions
⊠	first white reports of indigenous art
▪	indigenous art influenced by white contact
▣	major public gallery, with date of foundation
◇	intercolonial/international exhibition
✦	exported art

Golden Summer, Eaglemont (1889) by Arthur Streeton (1867–1943) exemplifies the nationalistic landscapes painted by young Australian *plein-airists* in the late 1880s, coinciding with the centenary of white settlement. The group, now known as the Heidelberg School, flouted convention by painting scenes that were clearly Australian. Streeton's blue-and-gold vista has since come to stand for the very essence of Australia.

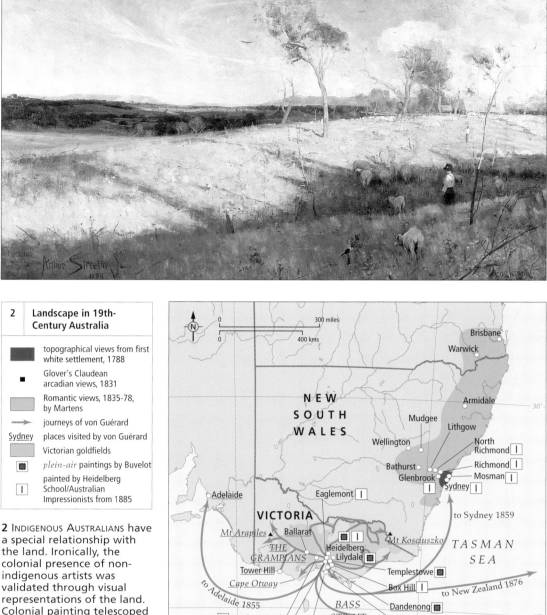

London in 1835; Benjamin Duterrau (1767–1851) recorded *The Conciliation* of the remaining Tasmanian Aborigines as a modern history painting in 1840; Marshall Claxton (1813–81) used Sydney residents as models for his *Christ Blessing the Little Children* in 1851, a colonial event considered so droll that it was written up in Dickens's *Household Words*.

The colonial balance changed with the discovery of gold in New South Wales and Victoria in 1851, and in Otago in 1861. Among the immigrant prospectors were artists who found a society extravagant enough to support their artistic endeavours. Sydney, a growing town in the 1840s employing local sandstone and imported cast iron for its substantial buildings, was supplanted in the 1850s and 1860s by Melbourne (known as 'Marvellous Melbourne' by the 1880s), where grandiose Italianate buildings were erected on unsealed streets with no footpaths. In New Zealand the South Island goldfields upset the North Island's hegemony. The earliest white settlers had built simply, using basalt rubble with imported Sydney sandstone trim. Even the British Resident's house, where the Treaty of Waitangi was signed in 1840, had been prefabricated in Sydney in 1833. The discovery of gold, however, encouraged architectural development in both islands, especially in the southern cities of Dunedin and Christchurch where public buildings were erected in grey basalt and white Oamaru limestone.

The exotic distinction of the colonial terrain remained the key feature of antipodean painting even as it progressed aesthetically from simple topographical views to the grandiose landscapes of the 1860s and 1870s. A near-panoramic format was thought to suit the vastness of Australia; a sublime prospect matched the grandeur of New Zealand scenery. Von Guérard's painting of *Milford Sound* (1877), considered to be the quintessential image of New Zealand, was exhibited as such in

2 | Landscape in 19th-Century Australia

- ■ topographical views from first white settlement, 1788
- ■ Glover's Claudean arcadian views, 1831
- ■ Romantic views, 1835–78, by Martens
- → journeys of von Guérard
- Sydney places visited by von Guérard
- ■ Victorian goldfields
- ⊡ *plein-air* paintings by Buvelot
- Ⅰ painted by Heidelberg School/Australian Impressionists from 1885

2 INDIGENOUS AUSTRALIANS have a special relationship with the land. Ironically, the colonial presence of non-indigenous artists was validated through visual representations of the land. Colonial painting telescoped European landscape tradition into a single century – from topography to arcadian nostalgia, picturesque romanticism and panoramic grandeur. Finally, the Heidelberg *plein-airist* landscapes proclaimed national self-confidence.

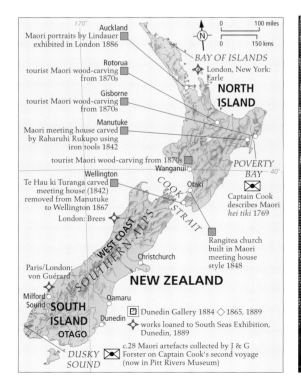

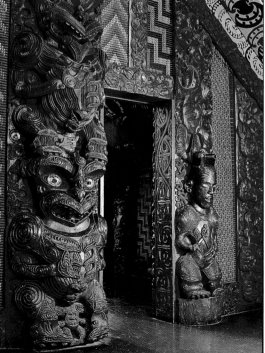

Melbourne, Paris, Sydney, Melbourne (again) and London between 1877 and 1886. Following the example of the Swiss-born painter Buvelot (1814–88), Australian landscape painting became less formal in the mid-1880s as it responded to the introduction of *plein-air* painting, the influx of (inaccurate) reports on French Impressionism, and the growth of nationalist feeling.

By the last decades of the nineteenth century, the white newcomers to both Australia and New Zealand firmly believed that the indigenous peoples they had supplanted were doomed to extinction. The twentieth century was to prove the white colonists wrong, not only in the physical survival of the indigenous population, but in their cultural renaissance.

Maori hardwood meeting house, carved by Raharuhi Rukupo (c.1800–1873) in 1842. Ceremonial houses often evoked a male ancestor, with the ridgepole symbolizing his spine, the rafters his ribs, the interior his belly. This intricately carved example (Te Hau ki Turanga), made with iron tools rather than traditional implements, was removed from its original site in 1867 and is now installed at the Museum of New Zealand/Te Papa Tongarewa.

ART, IDEAS AND TECHNOLOGY 1900-2000

ART HAS ALWAYS BEEN CONNECTED to the worlds of ideas and technology, but in the twentieth century the connections tightened. Indeed for many the 'idea' has been that twentieth-century art should directly reflect technology, and this notion lay behind American skyscrapers, Italian Futurism, Russian Constructivism and the International Modernist architecture of the Bauhaus and Le Corbusier before the Second World War, and Jean Tinguely's motorized sculptures, Nam Jun Paik's video installations and Tony Oursler's projections after it. One reason why this convergence occurred was because, thanks to new technologies, ideas could be disseminated much quicker and more effectively than before. Another was that some of these technologies, such as those of the cinema, television and computer screen, were themselves visual.

OF THE MANY OTHER IDEAS that affected twentieth-century art, none were more recurrent than those of nationalism and internationalism. The search for visual expressions of national or regional identity, which has roots in tendencies humans share with other animals and has long been important in culture, strengthened in the nineteenth century before further intensifiying in the twentieth. For many communities, as in the countries of eastern

Europe that acquired independence after 1918, the starting point was a new awareness of vernacular and folk traditions, but in Fascist Italy and National Socialist Germany new political and moral ideologies were also involved. Outside Europe, on the other hand, where the suppression of local artistic traditions had been part of the policy both of colonial powers and of the classes that succeeded them, aesthetic and political ideologies were more likely to be combined in some revival of local cultural traditions, as in the Mexican revival of Aztec and the Indian revival of Hindu imagery. In such movements art was an important way for a people to strengthen its sense of a political identity recovered after independence. The vigorous new regional and ethnic art forms that emerged after 1950 were ore economically driven, only loosely inspired by earlier traditions that were fostered and marketed, often by just one or two individuals. Prominent examples are the stone sculptures of the Canadian Inuit, of the Shona in present-day Zimbabwe and of the Makonde on the borders between Tanzania and Mozambique. But the most successful, perhaps because painting is always liable to be taken more seriously than sculpture, have been the acrylic paintings of the Australian Aborigines, which, since 1970, have allowed male and female members of one of the world's most victimized communities isolated in the desert to

become world-famous celebrities. These successes, however, have not been easy. For many ethnic communities the regional arts are much lower in the scale than art that claims to be international, as does that displayed in the great international exhibitions in the tradition of the Venice Biennale. Artists represented in such venues, whose work may unconsciously betray a background in the savannah of Africa or the jungles of Southeast Asia, often prefer to play down their origins and claim instead to be artists in a sense that corresponds to some transcendent European and US norm. Their overriding idea is that they are not craftsmen, but 'artists'.

ONE OF THE SOURCES of the concept of an 'international' art is the socialist theory of a worldwide human community, and socialism, in its different forms, has been the idea shaping the work of many individuals and movements. Sometimes it has been associated with conservative tendencies, as in the Soviet Union, where, after the brief innovative episode of Constructivism, there was a move to Socialist Realism with its nineteenth-century roots. The same style was then taken up by many other countries in the Russian orbit, and when China became Communist in 1948 it, too, adapted the same mode until after the Cultural Revolution. Sometimes socialism has been associated with more progressive tendencies, as with the worldwide post-Second World War diffusion of architecture in concrete, a material untainted by elitist associations and inherently sharing properties with the 'masses'. Le Corbusier was the leader in this trend, as at Chandigarh, the capital of the Punjab, but he also had many local followers, such as Oscar Niemeyer in Brasilia. Other types of art driven by socialist political ideas were

the more aggressive mural art of the Sandinistas in Nicaragua and the softer, but still threatening, art of Latinos in the United States. Less necessarily political has been the much longer tradition of Black or African-American art, which now has its parallels in Britain and elsewhere in an art of People of Colour by immigrants from Asia and Africa. Another art which may be more or less political is that driven by the idea of feminism, which emerged strongly in the United States in the 1960s and 1970s, before manifesting itself in most other countries in an effort to reclaim an activity from which women have been systematically excluded. Around the world art has now be harnessed to a myriad causes or 'ideas'.

FINALLY, THERE ARE CATEGORIES OF ART that relate to an idea embedded in art-making itself. Dada set out to smash artistic norms, while Surrealism, taking its cue from Sigmund Freud's writing on dreams, sought to give all forms of creativity a new starting point in the unconscious. These two connected movements were centred on Europe and the United States, but post-Second World War Conceptual Art – which typically argues that art is less about making, and more about an idea – has, from the beginning, engaged artists worldwide. Its success, like that of so-called Post-Modernist art, often depends on the use of different technologies, videos, lights, lasers, and even containers of formaldehyde. As such it illustrates to what extent, by 2000, art was often only an idea embedded in a technology.

MIRIAM SCHAPIRO *Anatomy of a Kimono* (detail), 1975–6, acrylic and fabric on canvas, one of ten panels.

NORTH AMERICA 1900-1950

THE FIRST HALF of the twentieth century saw the United States come to the fore as the economic and political global power. The centrality of North America to the cultural life of the Western world was seen most dramatically in the dominance of New York City. Home to both Wall Street and the Museum of Modern Art, New York was the heart of the American arts in the early twentieth century.

PATHS TO MODERNIZATION
Already host to the nation's premier cultural institutions, New York saw the formation of five museums of modern art and numerous

exhibitions. Moreover, the city was the home of many of the most significant American artists and, in the late 1930s, it was also a refuge to European artists.

Accompanying the rise of New York as a global capital was the importance of the industrial cities of the Midwest. During the first decades of the century the cities of the west consolidated their cultural capital. Between 1900 and 1920 museums were opened in Toronto (1900), Toledo (1901), Buffalo (1905), Indianapolis (1906), Minneapolis (1915), Cleveland (1916), Detroit (1918) and Dayton (1919). The Midwest also played host to several

early exhibitions of European Modernist art, most notably the Armory Show of 1913 that travelled from New York to Boston and Chicago. Over a decade later, the Société Anonyme (1920) curated the International Exhibition of 1926 that carried European modernism from the Brooklyn Museum of Art and the Anderson Galleries, Manhattan, to the Albright Art Gallery, Buffalo, and the Art Museum of Toronto.

THE ARTISTIC COLONIZATION OF AMERICA
As European modernism toured the continents so did the artists of the USA and Canada. No longer sharing in the Manifest Destiny of the

1 IN AN AGE OF MODERNIZATION, signs of power – from the automotive industry in Detroit to the cultural dynamism of New York – attracted artists of all races and nationalities. The century began with the rapid and unceasing transportation of artists and ideas from Mexico through to Canada and from America overseas. Throughout the 'Roaring Twenties' and the Great Depression artists and collectors gathered in the cities and cultural enclaves that spanned the continent.

EXHIBITION PANEL

1908 *The Eight*, Macbeth Gallery, New York

1913 *Armory Show*, New York, Boston, Chicago

1917 *Exhibition of the Society of Independent Artists*, New York

1926 *Société Anonyme International Exhibition*, Brooklyn Museum of Art, New York, Buffalo, Toronto

1942-44 Jacob Lawrence *Migration Series* exhibition tour, Museum of Modern Art, New York, Manchester, San Francisco, Portland, Sacramento, Los Angeles, St Louis

1943 Jackson Pollock, *Art of this Century*, New York

1948 Willem de Kooning, Charles Egan Gallery, New York

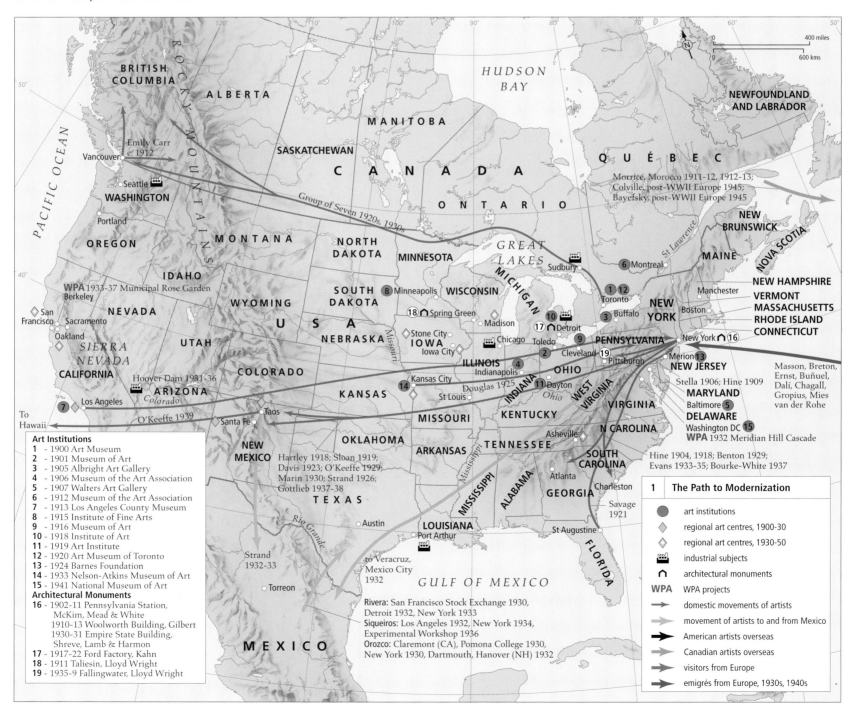

Art Institutions
1 - 1900 Art Museum
2 - 1901 Museum of Art
3 - 1905 Albright Art Gallery
4 - 1906 Museum of the Art Association
5 - 1907 Walters Art Gallery
6 - 1912 Museum of the Art Association
7 - 1913 Los Angeles County Museum
8 - 1915 Institute of Fine Arts
9 - 1916 Museum of Art
10 - 1918 Institute of Art
11 - 1919 Art Institute
12 - 1920 Art Museum of Toronto
13 - 1924 Barnes Foundation
14 - 1933 Nelson-Atkins Museum of Art
15 - 1941 National Museum of Art

Architectural Monuments
16 - 1902-11 Pennsylvania Station, McKim, Mead & White
1910-13 Woolworth Building, Gilbert
1930-31 Empire State Building, Shreve, Lamb & Harmon
17 - 1917-22 Ford Factory, Kahn
18 - 1911 Taliesin, Lloyd Wright
19 - 1935-9 Fallingwater, Lloyd Wright

Hartley 1918; Sloan 1919; Davis 1923; O'Keeffe 1929; Marin 1930; Strand 1926; Gottlieb 1937-38

Rivera: San Francisco Stock Exchange 1930, Detroit 1932, New York 1933
Siqueiros: Los Angeles 1932, New York 1934, Experimental Workshop 1936
Orozco: Claremont (CA), Pomona College 1930, New York 1930, Dartmouth, Hanover (NH) 1932

Morrice, Morocco 1911-12, 1912-13; Colville, post-WWII Europe 1945; Bayefsky, post-WWII Europe 1945

Masson, Breton, Ernst, Buñuel, Dalí, Chagall, Gropius, Mies van der Rohe

Stella 1906; Hine 1909

Hine 1904, 1918; Benton 1929; Evans 1933-35; Bourke-White 1937

WPA 1932 Meridian Hill Cascade

WPA 1933-37 Municipal Rose Garden

1 The Path to Modernization
● art institutions
◇ regional art centres, 1900-30
◇ regional art centres, 1930-50
🏭 industrial subjects
∩ architectural monuments
WPA WPA projects
→ domestic movements of artists
→ movement of artists to and from Mexico
→ American artists overseas
→ Canadian artists overseas
→ visitors from Europe
→ emigrés from Europe, 1930s, 1940s

previous century, artists often took to the northern and western landscape as a refuge from the growing metropolitan centres. Destinations such as Taos, New Mexico, Stone City, Iowa, or Algonquin Park, Ontario, became meeting places for artists interested in creating art that was connected to the American continent. Georgia O'Keeffe, an artist who was deeply committed to the environment, went as far as distant Hawaii.

A similarly modern and romantic impulse drove artists from the cities to explore the industrial landscapes of the USA and Canada. From Port Arthur, Texas, where Edward Weston photographed oil refineries, to the Georgian Bay mining town of Sudbury, Ontario, which was painted by associates of the Canadian Group of Seven, artists crossed the continent, depicting the sites of modern production. Pittsburgh, Cleveland and Detroit now held an allure that in the previous century was reserved for natural wonders of the American West.

ART OF THE DEPRESSION ERA
Beginning as early as the first decade of the century, artists such as Lewis Hine and Joseph Stella, men sensitive to the human cost of modernization, toured the country, investigating the conditions of the working classes in places as far-flung as Ellis Island (New York), Pittsburgh, and South Carolina. Two decades later, artists such as Thomas Hart Benton, Walker Evans and Margaret Bourke-White re-examined Southern poverty during the Depression. The explosion of

2 EVEN AS AMERICAN and Canadian artists grew secure as capable modernists, few resisted the urge to travel abroad. Artists of this century, however, travelled for research, money or love rather than for training and refinement. Education was found in the company of other artists or in excursions into the American landscape. For the first time, numerous European artists visited America. Famous figures from Freud to Dalí came to gaze at the wonders of skyscrapers and grain silos and, in some cases, to find new homes after the Fascist incursions of the 1930s.

GEORGIA O'KEEFFE: *Cow's Skull, Red, White, and Blue* 1931, oil on canvas. O'Keeffe's answer to the great American novel applied the modernist abstraction she had perfected in paintings of nature and skyscrapers with the evocative detritus of the New Mexican desert. Resonating with the hues of the desert and the colours of the flag, O'Keeffe joined abstraction with a patriotic love of the West.

industrial jobs in the north occurred in direct contrast to changes in economic conditions in the South, the region of the United States that had been suffering from insufficient industrial advancement since before the Civil War.

The plight of rural America led to the migration of American Blacks, sending thousands of people to northern cities. Artists such as Augusta Savage from Florida and Aaron Douglas from Kansas moved to New York City to participate in the Harlem Renaissance of the 1920s and 1930s. At the end of the period, Jacob Lawrence depicted this dramatic uprooting in a portfolio of prints titled *The Migration Series* that toured the USA from Manchester, New Hampshire, to Los Angeles, California, between 1942 and 1944.

New York City remained the dominant urban centre of the early twentieth century. As well as a destination for artists of all cultures and countries, New York was the site of the most dramatic architectural achievements of the period. Three of the world's tallest buildings, the Woolworth, Chrysler and Empire State Buildings, were all constructed here before the boom of the 1920s became the bust of the Great Depression.

As engineers and architects filled American cities of the 1920s with vertical metaphors of American progress, Frank Lloyd Wright was creating his masterpieces of earth-bound prairie architecture. Wright began his residence and studio, Taliesin, in Spring Green, Wisconsin, in 1911. Over a quarter of a decade later, in southern Pennsylvania, he married the prairie aesthetic to the woodlands of Bear Run in his picturesque Fallingwater of 1935-9.

Industrial architecture was also developed as methods of production were modernized. Most significant were the Michigan Ford Plants at River Rouge – the model for mass production all over the world. In 1922 Albert Kahn designed the Ford Motor Company facilities, and late in the decade Charles Sheeler created a documentary record of the factories, using an experimental approach that transformed the factories into paradigmatic examples of modernist photography.

During the Depression the government became a primary contractor, building structures as great as the Hoover Dam in Nevada or as small as cascades in Washington DC or rose gardens in California. Shortly after the projects of the Works Progress Administration (WPA) – a federal relief agency initiated by President Franklin D. Roosevelt as a means of generating employment and infrastructure during the Great Depression – the North American nations shifted into war production as the global community braced itself for the World War II.

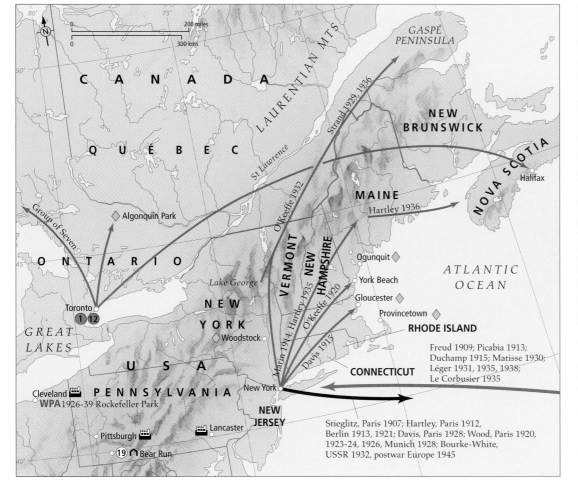

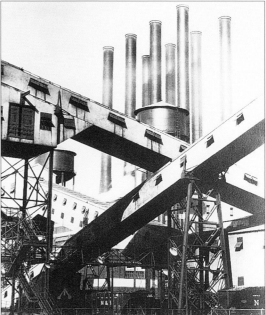

CHARLES SHEELER, *Crisscrossed Conveyors, River Rouge Plant, Ford Motor Company*, 1927. Sheeler documented the factory as it was secretly re-tooled to produce the Model A. The photographs were published in the USA and as far as Japan and Russia. In 1932 a two-metre (7-ft) enlargement of this image hung at the Museum of Modern Art, New York. Capitalizing on the refined geometry of modern architecture and an experimental approach to printing that included using multiple negatives and liberal cropping, Sheeler produced lasting images of American industry in the 1920s.

NORTH AMERICA 1950-2000

THE CONSEQUENCES of space in North America changed dramatically following World War II. Images from places as far away as May Lai or the moon and as close as Kent State University, Ohio, or Dallas, Texas, circulated quickly into the public eye. Following the expansion of mass media, experimental printing houses opened in cities from Long Island to Los Angeles. By the end of the century, the ease of air travel and the invention of cyberspace collapsed nearly all the geographic obstacles that had localized art production in the past.

A CHANGING WORLD
Confronted with change, some artists and intellectuals sought to preserve the separation of art and everyday life. Exhibitions such as 'New American Painting' and 'Post Painterly Abstraction', consisting largely of work produced in New York in the 1950s and 1960s, crossed the USA and Canada and toured Europe, spreading the influence of American Abstract Expressionism

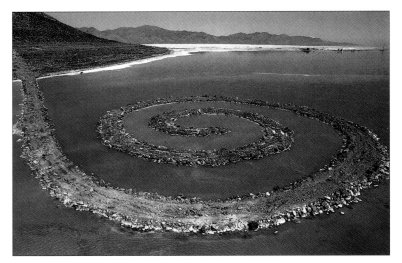

ROBERT SMITHSON's *Spiral Jetty*, Great Salt Lake, Utah, 1970. Now hidden beneath the red waters of the Great Salt Lake, *Spiral Jetty* suggests the artist's experience of land that seemed to move and water that resisted it. Unlike much Earth Art, *Spiral Jetty*, with its deliberate engagement of the entropic forces of water and crystals, courted the instability of the landscape rather than its permanence. An essay and a film are part of the artwork.

and its formalist and existentialist interpretations. Other artists demanded that art engage with contemporary social life. Dada-related activities such as the Duchamp retrospective (Pasadena, California, 1963) and 'The Sign of Dada' (Toronto, 1961–2), feminist productions such as 'Womanhouse' (Los Angeles, 1971) and Judy Chicago's 'Dinner Party' (San Francisco, 1979) and multi-cultural exhibitions such as 'Black American Art' (Boston, 1971) and 'The Decade Show' (New York, 1990) represented alternatives to the modernist activities.

In response to expanding interest in the arts in the USA and Canada, public and private institutions multiplied and expanded. In many cases the new institutions erected what have become highlights of post-war architecture. Attending collections at Frank Lloyd Wright's Solomon R. Guggenheim Museum (New York City, 1956–9), Arthur Erickson's Museum of Anthropology (Vancouver, 1971–6) or Richard Meier's Getty Center (Los Angeles, 1997) provides lessons in modern and Post-Modern architecture as well as the visual arts.

1 IN THE 1950s AND 1960s art museums vigorously supported American modernism at home and abroad. In the 1970s alternative spaces joined museums to exhibit contemporary work created on the local and international scene. By the end of the century, travelling exhibitions, new institutions and improved means of communication broadcast global contemporary culture to nearly every part of the continent.

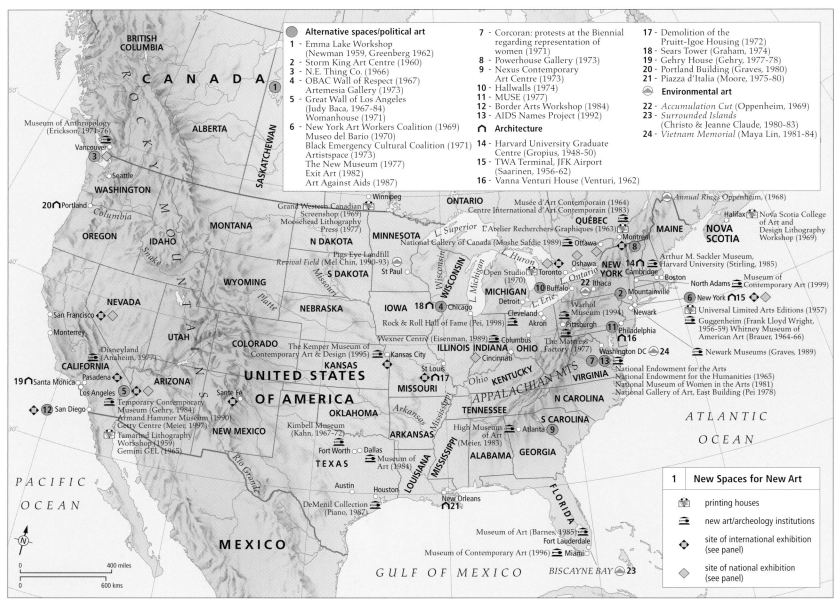

Alternative spaces/political art
1 - Emma Lake Workshop (Newman 1959, Greenberg 1962)
2 - Storm King Art Centre (1960)
3 - N.E. Thing Co. (1966)
4 - OBAC Wall of Respect (1967) Artemesia Gallery (1973)
5 - Great Wall of Los Angeles (Judy Baca, 1967-84) Womanhouse (1971)
6 - New York Art Workers Coalition (1969) Museo del Bario (1970) Black Emergency Cultural Coalition (1971) Artistspace (1973) The New Museum (1977) Exit Art (1982) Art Against Aids (1987)

7 - Corcoran: protests at the Biennial regarding representation of women (1971)
8 - Powerhouse Gallery (1973)
9 - Nexus Contemporary Art Centre (1973)
10 - Hallwalls (1974)
11 - MUSE (1977)
12 - Border Arts Workshop (1984)
13 - AIDS Names Project (1992)

∩ **Architecture**
14 - Harvard University Graduate Centre (Gropius, 1948-50)
15 - TWA Terminal, JFK Airport (Saarinen, 1956-62)
16 - Vanna Venturi House (Venturi, 1962)

17 - Demolition of the Pruitt-Igoe Housing (1972)
18 - Sears Tower (Graham, 1974)
19 - Gehry House (Gehry, 1977-78)
20 - Portland Building (Graves, 1980)
21 - Piazza d'Italia (Moore, 1975-80)

Environmental art
22 - *Accumulation Cut* (Oppenheim, 1969)
23 - *Surrounded Islands* (Christo & Jeanne Claude, 1980-83)
24 - *Vietnam Memorial* (Maya Lin, 1981-84)

1	**New Spaces for New Art**
	printing houses
	new art/archeology institutions
	site of international exhibition (see panel)
	site of national exhibition (see panel)

In addition to new buildings, the cultural politics of the era inspired the growth of new types of art institutions. Museums such as the National Museum of Women in the Arts (Washington DC, 1981) joined alternative spaces such as the Museo del Bario (New York City, 1970), the New Museum (New York City, 1977), the Artemesia Gallery (Chicago, 1973) and the Powerhouse Gallery (Montreal, 1973) to respond to the cultural demands of underrepresented artists and constituencies. By the end of the century, despite attacks on artistic freedom, including the 1990 censuring of the Robert Mapplethorpe (1946–89) retrospective in the USA and parliamentary debate over funding a Jana Sterbak (1955–) retrospective in Canada the following year, arts institutions in North America had become as widespread as they were diverse.

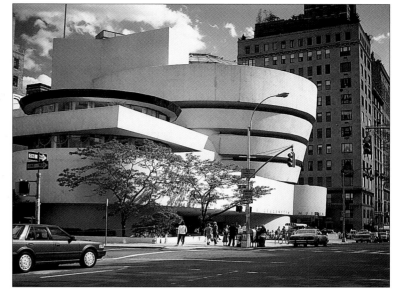

FRANK LLOYD WRIGHT'S Solomon R. Guggenheim Museum New York City, 1956–9. Wright's only building in New York City, the Guggenheim has become a symbol for the grace and insistence of modernist art as well as a flagship for the international network of Guggenheim museums. The structure was modified in 1992 by Charles Gwathmey to increase exhibition space with minimal intrusion on the original design

A NEW ARCHITECTURE

Architects enjoyed significant advances in scale and style in the second half of the twentieth century. Two of the world's tallest buildings were completed in North America: Minoru Yamasaki's World Trade Center, New York (1973, destroyed in the terrorist attack of 2001), Bruce Graham's Sears Tower, Chicago (1974), which has since passed on the accolade. The towers serve to accent the *dénouement* of late modernist architecture, a style beautifully illustrated in Eero Saarinen's soaring TWA Terminal (1962) at John F. Kennedy Airport, New York. As monuments erected to the advancement of trade and travel, these structures signal the constant international contact and commercial development of the era.

Accompanying globalization, Post Modernism, an eclectic and often historicist style, was articulated first in architecture of the years following World War II. Forms from Classical Greece to the International Style were copied and assembled into new compositions. Evident as early as Robert Venturi's Vanna Venturi House (1962), by 1980 the masters of the new style had created works from New Orleans, site of Charles Moore's Piazza d'Italia (1975–80) to Portland, Oregon and Michael Graves's Portland Building (1980).

BREAKING THE BOUNDARIES

Despite new facilities, many artists began constructing work that could not be contained in traditional or alternative exhibition spaces. Sculptors, particularly participants in the Earth Art movement such as Robert Smithson, Christo and Jeanne-Claude, and Nancy Holt, created monuments that depended on the vastness of the North American landscape. Deserts, beaches and rivers were transformed by massive earth-moving vehicles, explosives and concrete into the canvases and pedestals for this new art. Even such ephemeral materials as silk or ice and snow took on artistic form in the hands of Earth artists.

By the end of the 1970s, interest in such obdurate works of art waned. The 1980s market for saleable objects was booming, creating rich men and women out of some collectors and celebrities out of a few artists. In the auction houses and galleries of New York City, the arts of other cultures were explored as potential goods for the market. This was especially the case for contemporary Russian art as houses like Sotheby's went directly to the artist to secure works for sale.

Arts of non-Western and indigenous cultures were also in demand from North American institutions which were becoming increasingly receptive to alternative voices. Museums in both the USA and Canada sponsored major exhibitions of Russian, Japanese and Chinese art, while cities from San Diego to Montreal sponsored international showcases of the kind that proliferated all over the world. Into this environment appeared artists drawing upon experiences in any number of different cultures, transforming the shape of the art world and the content of art. By the turn of the millennium new art from around the world was regularly on view in any number of North American cities and, via the internet, available online for anyone who chose to investigate.

2 AN ARTISTIC CENTRE for decades, the American Southwest took on significance as the site of a new form of art, the earthwork. Earthworks were the result of individual engagements with nature, which could be as substantial as stone and earth or as ephemeral as lightning. By the 1990s, the region was host to cross-cultural exchanges in the multinational festivals in Santa Fe and San Diego.

EXHIBITION PANEL

International exhibitions:

Kansas City
International Sculpture Conference, 1960

Toronto
Isaacs Gallery
Sign of Dada, 1961-2

Pasadena
Pasadena Art Museum
Marcel Duchamp Retrospective, 1963

Los Angeles
County Museum of Art
Post Painterly Abstraction, 1964 (> Toronto)

St Louis
St Louis Art Museum
Expressions: New Art from Germany, 1983

New York
New Museum *Difference: On Representation and Sexuality,* 1985
(> Chicago > Boston > London, England)

New York
Sotheby's Auction of Russian Art, 1988

San Francisco
Museum of Modern Art
Against Nature: Japanese Art in the Eighties, 1989
(> Akron > Boston

> Seattle > Cincinnati
> New York > Houston)

San Diego
InSITE, 1992 (> Tijuana)

Santa Fe
Site Santa Fe, 1995

Montreal
Montreal Biennial, 1998

New York
Asia Society/PSI *Inside/Out New Chinese Art,* 1998
(> San Francisco
> Monterrey > Seattle)

New York
Brooklyn Museum of Art
Sensation, 1999

National exhibitions:

Ottawa
National Gallery of Canada
Canadian Abstract Painting, 1952
(> Montreal)

Toronto
Abstracts at Home, 1953

New York
New American Painting, 1958

Los Angeles
Ferus Gallery *Warhol Exhibition,* 1962

Vancouver
Arts of the Raven, 1967

Ottawa
National Gallery of Canada
Masterpieces of Indian and Eskimo Art in Canada, 1970

Boston
Museum of Fine Arts
Black American Art, 1971

New York
Whitney Museum of American Art
Contemporary Black Artists in America, 1971

Los Angeles
County Museum of Art
Women Artists 1550-1976, 1976 (> Austin
> Pittsburgh > Brooklyn)

San Francisco
Museum of Art *Judy Chicago's Dinner Party,* 1979

New York
Museum of Modern Art
Primitivism in 20th century Art, 1985
(> Detroit > Dallas)

Cincinnati
Contemporary Art Center
Robert Mapplethorpe, 1990

Ottawa
National Gallery of Canada
Jana Sterbak Exhibition, 1991

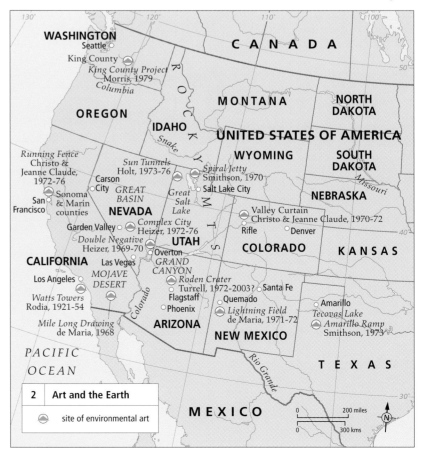

2 | **Art and the Earth**

⊙ site of environmental art

CENTRAL AMERICA AND THE CARIBBEAN 1900-2000

THE INDEPENDENCE MOVEMENTS of the nineteenth century caused considerable political, social and cultural upheaval throughout Mexico, Central America and the Caribbean. In the arts, conflict raged between schools of thought from Neo-classicism, through Impressionism, to a populist 'art of the people'. Independence had manifested itself in factionalism and dictatorships rather than national unity. This inherent instability erupted in 1910 with the Mexican Revolution, followed shortly after in the rest of Central America, and gave rise directly to dissident and political art forms that were first expressed through Mexican Muralism.

MEXICAN MURALISM

The revolution for social change in Mexico coincided with an artistic revolution, and its initiation can largely be credited to one man, Gerardo Murillo (1875–1964). After several years in Europe where he was inspired by Fauvism, Murillo returned to Mexico in 1903, changing his name to Dr Atl (Aztec for 'water') as a symbol of his return to cultural roots, and began mural painting. With two of his students, Joáquin Clausell (1866–1935) and José Clemente Orozco (1883–1949), he organized the first

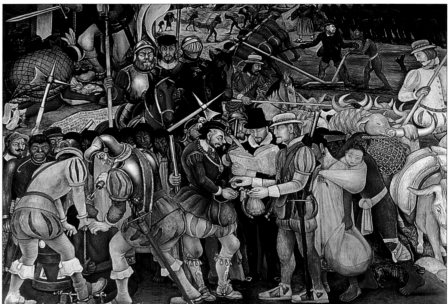

DIEGO RIVERA, *The Arrival of Cortés at Veracruz*. Diego Rivera (1886–1957) described his own art as 'narrative history': realistic portrayal – as in this detail of Cortés arriving at Veracruz – by which the people could learn the story of their culture and gain pride in nationhood. Rivera, together with other influential artists such as Dr Atl, Siqueiros, and Orozco, was at the forefront of Mexican Revolutionary art. Yet he enjoyed publicity and the company of high society and was denounced by Orozco as a betrayer of the socialist cause for accepting large sums to produce commissioned artwork.

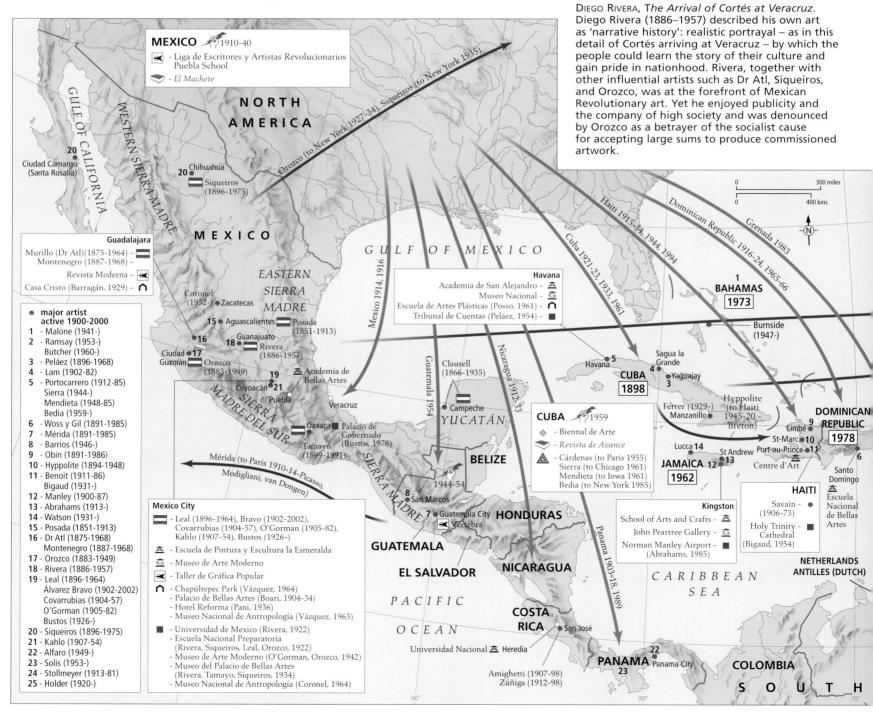

MEXICO 1910-40
- Liga de Escritores y Artistas Revolucionarios Puebla School
- *El Machete*

Guadalajara
Murillo (Dr Atl)(1875-1964) -
Montenegro (1887-1968) -
Revista Moderna -
Casa Cristo (Barragán, 1929) -

- ● major artist active 1900-2000
1 - Malone (1941-)
2 - Ramsay (1953-) Butcher (1960-)
3 - Peláez (1896-1968)
4 - Lam (1902-82)
5 - Portocarrero (1912-85) Sierra (1944-) Mendieta (1948-85) Bedia (1959-)
6 - Woss y Gil (1891-1985)
7 - Mérida (1891-1985)
8 - Barrios (1946-)
9 - Obin (1891-1986)
10 - Hyppolite (1894-1948)
11 - Benoit (1911-86) Bigaud (1931-)
12 - Manley (1900-87)
13 - Abrahams (1913-)
14 - Watson (1931-)
15 - Posada (1851-1913)
16 - Dr Atl (1875-1968) Montenegro (1887-1968)
17 - Orozco (1883-1949)
18 - Rivera (1886-1957)
19 - Leal (1896-1964) Álvarez Bravo (1902-2002) Covarrubias (1904-57) O'Gorman (1905-82) Bustos (1926-)
20 - Siqueiros (1896-1975)
21 - Kahlo (1907-54)
22 - Alfaro (1899-)
23 - Solis (1953-)
24 - Stollmeyer (1913-81)
25 - Holder (1920-)

Mexico City
- Leal (1896-1964), Bravo (1902-2002), Covarrubias (1904-57), O'Gorman (1905-82), Kahlo (1907-54), Bustos (1926-)
- Escuela de Pintura y Escultura la Esmeralda
- Museo de Arte Moderno
- Taller de Gráfica Popular
- Chapúltepec Park (Vázquez, 1964)
 - Palacio de Bellas Artes (Boari, 1904-34)
 - Hotel Reforma (Pani, 1936)
 - Museo Nacional de Antropología (Vázquez, 1963)
- Universidad de Mexico (Rivera, 1922)
 - Escuela Nacional Preparatoria (Rivera, Siqueiros, Leal, Orozco, 1922)
 - Museo de Arte Moderno (O'Gorman, Orozco, 1942)
 - Museo del Palacio de Bellas Artes (Rivera, Tamayo, Siqueiros, 1934)
 - Museo Nacional de Antropología (Coronel, 1964)

Havana
Academia de San Alejandro -
Museo Nacional -
Escuela de Artes Plásticas (Posso, 1961) -
Tribunal de Cuentas (Peláez, 1954) -

CUBA 1959
◇ - Biennal de Arte
- *Revista de Avance*
⚠ - Cárdenas (to Paris 1955) Sierra (to Chicago 1961) Mendieta (to Iowa 1961) Bedia (to New York 1985)

Kingston
School of Arts and Crafts -
John Peartree Gallery -
Norman Manley Airport - (Abrahams, 1985)

HAITI
Savain - (1906-73)
Holy Trinity - Cathedral (Bigaud, 1954)
Escuela Nacional de Bellas Artes

NORTH AMERICA

GULF OF CALIFORNIA

WESTERN SIERRA MADRE

20 Ciudad Camargo (Santa Rosalía)

20 Chihuahua

Siqueiros (1896-1975)

Orozco (to New York 1927-34), Siqueiros (to New York 1935)

MEXICO

GULF OF MEXICO

EASTERN SIERRA MADRE

Coronel (1932-) ● Zacatecas

15 Aguascalientes ● Posada (1851-1913)
● 16
18 Guanajuato
Ciudad ● 17 Rivera (1886-1957)
Guzmán Orozco (1883-1949)
19 ● Academia de Bellas Artes
Coyoacán 21
Puebla
Veracruz
Oaxaca ● Palacio de Gobernado (Bustos, 1978)
Tamayo (1899-1991)
8 San Marcos

SIERRA MADRE DEL SUR

Mérida (to Paris 1910-14-Picasso, Modigliani, van Dongen)

Mexico 1914, 1916

Guatemala 1954

Clausell (1866-1935)

Campeche

YUCATÁN

BELIZE

1944-54

7 ● Guatemala City
Vertebra

GUATEMALA

EL SALVADOR

HONDURAS

NICARAGUA

PACIFIC OCEAN

COSTA RICA ● San José

Universidad Nacional ☆ Heredia

Amighetti (1907-98)
Zúñiga (1912-98)

PANAMA ● Panama City
22
23

Nicaragua 1912-33

Panama 1903-18, 1989

Cuba 1921-23, 1933, 1961

Havana ● 5

Sagua la Grande
4 ● Yaguajay
3

CUBA
1898

Ferrer (1929-) Manzanillo ●

Lucca 14

JAMAICA 12 ● 13
St Andrew

Haiti 1915-34, 1944, 1994

Dominican Republic 1916-24, 1965-66

Grenada 1983

1 BAHAMAS 1973

Burnside (1947-)

Hyppolite (to Haiti 1945-20 - Breton)

Limbé ● 9
St-Marc ● 10
Port-au-Prince ● 11
Centre d'Art

DOMINICAN REPUBLIC 1978

6 ● Santo Domingo

CARIBBEAN SEA

NETHERLANDS ANTILLES (DUTCH)

COLOMBIA

SOUTH

0 300 miles
0 400 kms

N

90° 80° 70°

dissident exhibition in September 1910, two months before the outbreak of the Revolution. Through political connections he was appointed director of the Academy of Fine Arts in 1914, but in his inaugural address he claimed that art belonged on the walls of buildings and then proceeded to close the academy down.

Another of Dr Atl's students, David Alfaro Siqueiros (1896–1975), published his *Manifesto* in 1922 in which he claimed that Muralism was the only valid art form and that it should deal with Revolutionary themes. Siqueiros' political activism was even more extreme than that of Dr Atl, including leadership of an assassination squad that made an attempt on the life of Trotsky in 1940, who was at that time in exile in Mexico.

Muralism was largely expressed through the work of Orozco, Siqueiros, and a then relatively unknown Diego Rivera (1886–1957), who had also been one of Dr Atl's pupils. Although they shared the ideal that Muralism should represent revolutionary thoughts and deal with issues of nationalism, poverty and social reform, they disagreed intensely on how this should be done. Rivera broke with his mentor Dr Atl and painted over the work of other Muralists whom he considered inferior; Siqueiros accused Rivera of romanticism, while Orozco, taking Siqueiros' *Manifesto* literally, destroyed all his 'easel paintings' when he embarked on Muralism. Of the three Mexican muralists, Rivera has gained the most acclaim, partly on the strength of his massive mural for the National Palace in Mexico City, and this has secured him the accolade of 'The First Great Mexican Artist'.

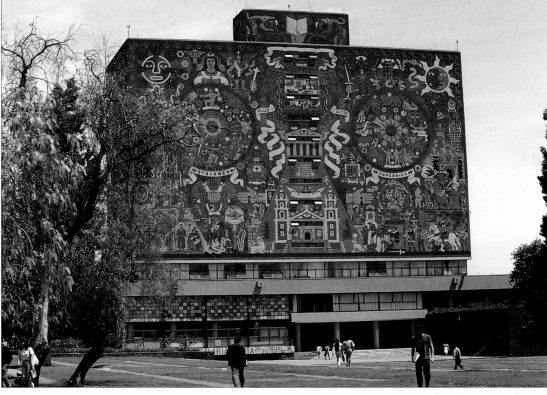

JOSÉ CLEMENTE OROZCO, University Library, Mexico City. This magnificent mural by José Clemente Orozco (1883–1949) was created towards the end of his career. The use of colour and figurative detail to cover large wall spaces is very characteristic of Mexican Muralism and is reminiscent of the manner in which wall spaces were used by the earlier Mayans and Aztecs. Orozco, unlike the other Muralists, abandoned all easel art early in his career and concentrated solely on producing large public artworks such as this.

BEYOND MURALISM

Muralism engendered ideas of national pride that can be best be summed up by the term *Indigenista*, but it was not only through Muralism and not only in Mexico that these *Indigenista* views were expressed. Juan O'Gorman (1905–82), an Irish-Mexican architect, believed in a return to organic form that was archaeologically and socially significant and was a founder member of the *Liga de Escritores y Artistas Revolucionarios* (League of Revolutionary Writers and Artists). Frida Kahlo (1907–54), wife of Diego Rivera, was instrumental in the development of what has been called Mexican Surrealism, although this was deeply rooted in her personal life and in Mexican folk culture. Both Carlos Orozco Romero (1898–1984) and Rufino Tamayo (1899–1991) explored indigenous themes through their paintings.

Similar ideas were taken up in Cuba by Amelia Peláez (1896–1968) and Wilfredo Lam (1902–82). Both travelled extensively in Europe, but on their returns to Cuba started using themes of indigenous significance. Peláez's work, both in painting and murals, draws on the Cubist movement but reinterprets this in terms of Cuban architecture. Lam, also influenced by Picasso and Cubism, explores his Afro-Caribbean heritage and has gained international acclaim. In Haiti, Hector Hyppolite (1894–1948) explored his own spiritual life as a Vodoun priest and painted mystic narratives; while Wilson Bigaud (b.1931), Hyppolite's neighbour and pupil, turned his attention to the

depiction of everyday street scenes. After suffering a series of breakdowns in the 1960s, Bigaud's work since 1970 has focussed more on themes relating to his illness.

NEW ART

While much of the work of the new generation of artists continues to explore the idea of opposition between the old and the new, it has increasingly seen this as a sense of inner and personal struggle which finds an outlet not only within the region but also in an international context. Influences are drawn from the international art community and from such diverse areas as Conceptual Art, Concrete Art, Abstract Expressionism, Performance, and Photography. Yet there is always a sense that these movements are viewed purely as the medium through which expression takes place and that meaning is located within the Central American and Caribbean context.

These new artists have not formed particular schools, and, therefore, comment on individual work would be that of the art critic, not the art historian. There are, however, some generalized trends. In Mexico contemporary art tends to deal with ideas of space and architectural form. Cuban art is exploring new parameters, although the cultural context remains restrictive and many young Cuban artists are in exile, whereas in Jamaica and Haiti there remains a focus on an Afro-Caribbean heritage and, in particular, the use of sculptural and votive forms. Central American and Caribbean art is appreciated as a valid expressive form that has gained worldwide recognition. Artists are exhibiting globally and are represented in major collections, such as the Tate Gallery in London and the Museum of Modern Art, New York.

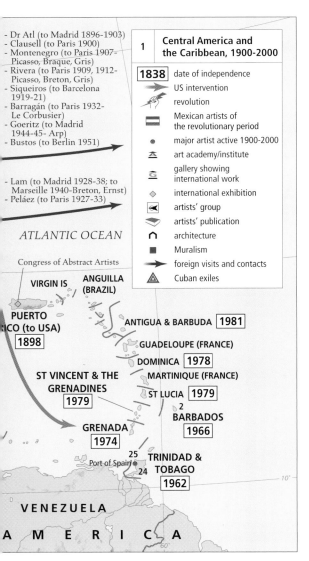

- Dr Atl (to Madrid 1896-1903)
- Clausell (to Paris 1900)
- Montenegro (to Paris 1907– Picasso, Braque, Gris)
- Rivera (to Paris 1909, 1912- Picasso, Breton, Gris)
- Siqueiros (to Barcelona 1919-21)
- Barragán (to Paris 1932- Le Corbusier)
- Goeritz (to Madrid 1944-45- Arp)
- Bustos (to Berlin 1951)

- Lam (to Madrid 1928-38; to Marseille 1940-Breton, Ernst)
- Peláez (to Paris 1927-33)

ATLANTIC OCEAN

Congress of Abstract Artists

	Central America and the Caribbean, 1900-2000
1838	date of independence
→	US intervention
	revolution
=	Mexican artists of the revolutionary period
●	major artist active 1900-2000
⛰	art academy/institute
	gallery showing international work
◇	international exhibition
◄	artists' group
	artists' publication
∩	architecture
■	Muralism
	foreign visits and contacts
⚠	Cuban exiles

VIRGIN IS
ANGUILLA (BRAZIL)

PUERTO RICO (to USA)
1898

ANTIGUA & BARBUDA **1981**

GUADELOUPE (FRANCE)

DOMINICA **1978**

ST VINCENT & THE GRENADINES **1979**

MARTINIQUE (FRANCE)

ST LUCIA **1979**

BARBADOS **1966**

GRENADA **1974**

Port of Spain

TRINIDAD & TOBAGO **1962**

VENEZUELA

A M E R I C A

1 THE MEXICAN REVOLUTION and its impact throughout the area attracted international attention. It was during this period that artists actively sought to state a national consciousness that would find its place within the international arena, through distinctive architecture and painting, and especially through Muralism. Many artists travelled widely and drew on influences from outside the area, international exhibitions were promoted, and public manifestos of indigenous awareness were published. Although Modernism has led to artists being recognized in their own right, for the majority this is clearly rooted in a sense of national pride and heritage.

SOUTH AMERICA 1900-2000

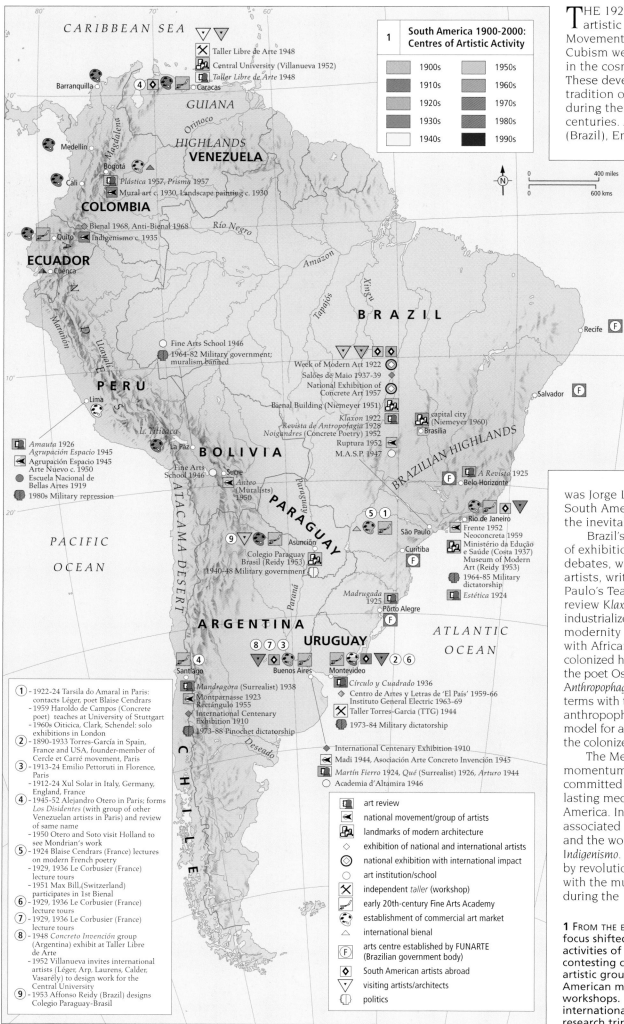

1 South America 1900-2000: Centres of Artistic Activity

1900s	1950s
1910s	1960s
1920s	1970s
1930s	1980s
1940s	1990s

Taller Libre de Arte 1948
Central University (Villanueva 1952)
Taller Libre de Arte 1948
Caracas

GUIANA

Barranquilla

Orinoco
HIGHLANDS
VENEZUELA

Medellín

Bogotá
Plástica 1957, Prisma 1957
Cali
Mural art c. 1930, Landscape painting c. 1930
COLOMBIA

Río Negro

Bienal 1968, Anti-Bienal 1968
Quito
Indigenismo c. 1935
ECUADOR
Cuenca

Amazon

B R A Z I L

Recife F

Fine Arts School 1946
1964-82 Military government; muralism banned

P E R U

Xingu
Tapajós

Salvador F

Lima

Week of Modern Art 1922
Salões de Maio 1937-39
National Exhibition of Concrete Art 1957
Bienal Building (Niemeyer 1951)
Klaxon 1922
Revista de Antropofagia 1928
Noigandres (Concrete Poetry) 1952
Ruptura 1952
M.A.S.P. 1947

capital city (Niemeyer 1960)
Brasília

L. Titicaca
Amauta 1926
Agrupación Espacio 1945
Agrupación Espacio 1945
Arte Nuevo c. 1950
Escuela Nacional de Bellas Artes 1919
1980s Military repression

La Paz
B O L I V I A

BRAZILIAN HIGHLANDS

A Revista 1925
Belo Horizonte F

Sucre
Fine Arts School 1946
Anteo (Muralists) 1950

Rio de Janeiro
Frente 1952
Neoconcreta 1959
Ministério da Eduçāo e Saúde (Costa 1937)
Museum of Modern Art (Reidy 1953)
1964-85 Military dictatorship

PACIFIC OCEAN

ATACAMA DESERT

PARAGUAY

Asunción
Colegio Paraguay Brasil (Reidy 1953)
1940-48 Military government

São Paulo
Curitiba

Estética 1924

Madrugada 1925
Pôrto Alegre F

Paraná

A R G E N T I N A
URUGUAY

ATLANTIC OCEAN

Santiago
Buenos Aires
Montevideo

Mandragora (Surrealist) 1938
Montparnasse 1923
Rectángulo 1955
International Centenary Exhibition 1910
1973-88 Pinochet dictatorship

Deseado

Círculo y Cuadrado 1936
Centro de Artes y Letras de 'El País' 1959-66 Instituto General Electric 1963-69
Taller Torres-García (TTG) 1944
1973-84 Military dictatorship

International Centenary Exhibition 1910
Madi 1944, Asociación Arte Concreto Invención 1945
Martín Fierro 1924, Qué (Surrealist) 1926, Arturo 1944
Academia d'Altamira 1946

C H I L E

1. - 1922-24 Tarsila do Amaral in Paris: contacts Léger, poet Blaise Cendrars
 - 1959 Haroldo de Campos (Concrete poet) teaches at University of Stuttgart
 - 1960s Oiticica, Clark, Schendel: solo exhibitions in London
2. - 1890-1933 Torres-García in Spain, France and USA, founder-member of Cercle et Carré movement, Paris
3. - 1913-24 Emilio Pettoruti in Florence, Paris
 - 1912-24 Xul Solar in Italy, Germany, England, France
4. - 1945-52 Alejandro Otero in Paris; forms Los Disidentes (with group of other Venezuelan artists in Paris) and review of same name
 - 1950 Otero and Soto visit Holland to see Mondrian's work
5. - 1924 Blaise Cendrars (France) lectures on modern French poetry
 - 1929, 1936 Le Corbusier (France) lecture tours
 - 1951 Max Bill (Switzerland) participates in 1st Bienal
6. - 1929, 1936 Le Corbusier (France) lecture tours
7. - 1929, 1936 Le Corbusier (France) lecture tours
8. - 1948 Concreto Invención group (Argentina) exhibit at Taller Libre de Arte
 - 1952 Villanueva invites international artists (Léger, Arp, Laurens, Calder, Vasarély) to design work for the Central University
9. - 1953 Affonso Reidy (Brazil) designs Colegio Paraguay-Brasil

art review
national movement/group of artists
landmarks of modern architecture
exhibition of national and international artists
national exhibition with international impact
art institution/school
independent *taller* (workshop)
early 20th-century Fine Arts Academy
establishment of commercial art market
international bienal
arts centre established by FUNARTE (Brazilian government body)
South American artists abroad
visiting artists/architects
politics

THE 1920s SAW the emergence of radical artistic developments in South America. Movements such as Expressionism, Dada and Cubism were translated into innovative forms in the cosmopolitan art centres of the region. These developments ruptured the conservative tradition of fine art institutions established during the late nineteenth and early twentieth centuries. Artists such as Tarsila do Amaral (Brazil), Emilio Pettoruti and Xul Solar (Argentina) and Luis Vargas (Chile) returned to their respective countries after intense involvement with the Parisian avant-garde. Modern artists established themselves in South America with exhibitions and lectures, and reviews that circulated and debated ideas beyond national boundaries.

CRUCIAL OPPOSITIONS

The review *Amauta* (Peru) linked avant-garde aesthetics with revolutionary politics. Although international in scope, it emphasized a Peruvian identity: its title (a Quecha word meaning 'wise man') stating adherence to *Indigenismo*. *Martín Fierro*, (Argentina), on the other hand, rejected any nationalistic promotion of ancient cultural traditions; its leading writer was Jorge Luis Borges, and the review asserted South American independence but conceded the inevitable presence of European influence.

Brazil's 'Semana de Arte Moderna', a week of exhibitions, poetry readings, concerts, and debates, was organized by a group of young artists, writers and musicians and held at São Paulo's Teatro Municipal in 1922. The monthly review *Klaxon* embraced a new, modern and industrialized context for art. The phenomenon of modernity in a country of economic contrasts, with African and Indian populations and a colonized history, was examined in the writings of the poet Oswald de Andrade. His 1928 *Anthropophagite Manifesto*, attempted to come to terms with the contradictions of this position. The anthropophagite (cannibal) personified a critical model for art from Brazil: the notion of devouring the colonizer in order to appropriate his power.

The Mexican Muralist movement gave momentum to a broad current of socially committed art in the 1920s, and established a lasting medium for public art throughout South America. In the 1920s Muralism was often associated with social protest (as in Ecuador and the work of Eduardo Kingman) and *Indigenismo*. Elsewhere Muralism was encouraged by revolutionary political reform, as was the case with the muralist group 'Anteo,' which emerged during the 1952 Revolución Nacional in Bolivia.

1 FROM THE EARLY DECADES of the twentieth century, focus shifted from the traditional academy to the activities of independent groups of artists, contesting conservatism on both political and artistic grounds and supporting an independent American modernism with exhibitions and workshops. Contacts were maintained with the international avant-garde via art reviews and research trips in and out of the region.

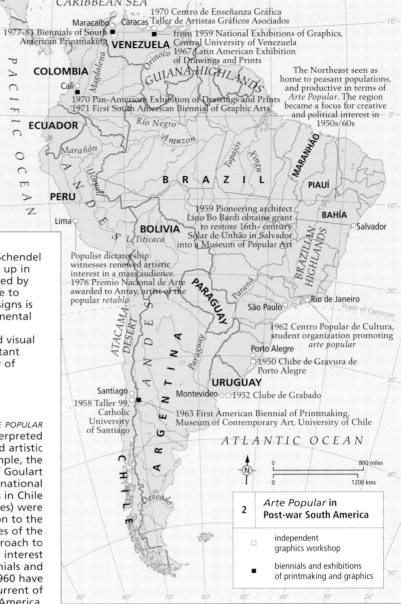

In 1935, the Uruguayan Joaquín Torres-García founded the Asociación de Arte Constructivo and the review *Círculo y Cuadrado*, containing contributions by leading international Constructivists. Torres-García's workshop, and his writings and lectures, were a source of encouragement for a generation of younger artists in Uruguay and Argentina. He contributed to the review *Arturo* (Buenos Aires 1944), a publication bringing together artists who subsequently formed the two Concrete art movements, Madi and Concreto Invención.

THE POST-WAR BOOM
While Europe suffered in the aftermath of the Second World War, some of the economies in South America thrived. Concrete and kinetic art movements were particularly strong in Brazil and Venezuela, where the demand for urban housing and other public building also generated a boom in modern architecture. The war also prompted the immigration of many artists, including Mira Schendel (Italy to Brazil) and Gego (Germany to Venezuela), into South America.

The São Paulo Bienal was launched in 1951, establishing a lasting focus for contemporary art in South America and beyond. Outstanding modern museums were constructed in Rio and São Paulo, where groups of non-figurative artists were formed, encompassing both visual art and experimental poetry and causing heated discussion both in the Brazilian press (an active forum for contemporary art) and internationally. Artists from the Rio Frente group later formed the Grupo Neoconcreta, members of which (Lygia Clark and Hélio Oiticica) were invited to London for solo exhibitions during the 1960s. A climate of modernization, and opportunities for public commission, encouraged a strong current of abstract and kinetic art in Venezuela, the leading artists of which were Alejandro Otero, Jesús Soto and Carlos Cruz-Diez.

In the later decades of the twentieth century local art markets in Venezuela and Colombia were buoyant, international art magazines were launched and dealers supported the work of young artists. In Brazil, Uruguay, Chile and Peru, political and

MIRA SCHENDEL, *DISKS*, 1972. Schendel was born in Zurich, brought up in Italy and after being displaced by the Second World War, came to Brazil. Her use of linguistic signs is representative of an experimental attitude towards language, encouraged by concrete and visual poetry, an active and important current in the recent history of Brazilian art.

2 CHARACTERISTICS OF *ARTE POPULAR* have been diversely reinterpreted according to political and artistic demands. In Brazil, for example, the populist government of Goulart (1961–4) encouraged a national focus on tradition, whereas in Chile *arpilleras* (patchwork pictures) were produced in opposition to the dictatorship, by the families of the disappeared. Another approach to the popular was a renewed interest in printmaking; biennials and competitions held since 1960 have established a lasting current of graphic art in South America.

economic instability forced many artists to continue their careers in exile. Diverse strategies were used to overcome censorship and the withdrawal of government support. Collective groups of artists remaining in Chile and Brazil during repressive dictatorships appropriated urban spaces for 'happenings' and installations, mail art, and later internet art, was pioneered in South America as a means to

come to terms with its growing diaspora. By the close of the twentieth century democracy was restored throughout South America, although economic instability continued to be a problem for artists. A burgeoning internationalism in art history and criticism has led to greater recognition in Europe and the USA of the significant role played by South America in the history of twentieth-century art and architecture.

AULA MAGNA AUDITORIUM, Carlos Raúl Villanueva, Central University of Venezuela, Caracas, 1948–57. Alongside the work of Costa, Niemeyer and Reidy, this project is representative of South America's groundbreaking modern architecture. Villanueva supported and encouraged the work of young Venezuelan abstract artists Jésus Soto and Alejandro Otero, inviting them to collaborate on the University's design. Other artists involved in the project included Alexander Calder, who designed the auditorium's 'acoustic clouds'.

EUROPE 1900-2000

FOLLOWING PATTERNS that had emerged during the previous century, many early twentieth-century artists sought to escape the ever-expanding urban centres of Europe in favour of more secluded, sparsely populated and less industrially developed rural centres.

MODERNITY AND MIGRATION

In France, artists associated with both Fauvism and Cubism travelled south from their Parisian studios in search of remote landscapes at St Tropez, Collioure and L'Estaque. Conversely, other European artists travelled great distances to live and work in Paris, recognized at this time

as the centre of the art world. The outbreak of the World War I further exacerbated the patterns of international migration already established. German and Russian artists in particular were forced to abandon their Parisian studios and return home, bringing with them their knowledge and experiences of modern art practices. In the midst of the conflict the city of Zurich in neutral Switzerland, little renowned at this point as a haunt for modern artists, became home to some of the most experimental art produced in the twentieth century as a host of international exiles joined forces to launch the Dada movement, soon to spread its influence far and wide.

During the 1920s and 1930s, the rise of Fascism in Italy, Germany and Spain further contributed to artistic migrations. But it was the outbreak of World War II in 1939 that was to generate social movements on a scale that was barely conceivable in previous epochs. Throughout the conflict many of Europe's most respected artists, not least of all those who had played a major role in developing the Surrealist movement, fled the battlefields of Europe for more peaceful and receptive surroundings, many eventually reaching the shores of the United States. In the post-war era Europe fought to regain the cultural dominance that it

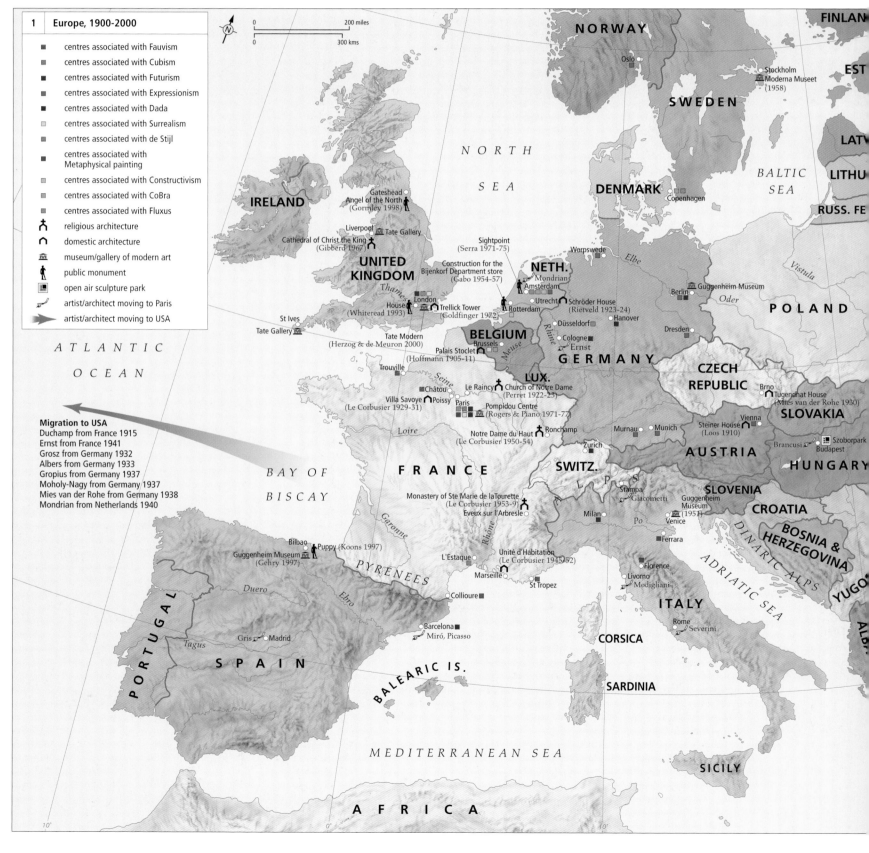

PABLO PICASSO, *Guernica*, 1937. Picasso's large-scale mural *Guernica* depicts the atrocities committed against innocent civilians during the Spanish Civil War. Here Picasso presents, in his own Cubist style, women, children and animals in the midst of a terrifying conflagration. The work has been exhibited throughout the world and stands as a powerful symbol of anti-war protest.

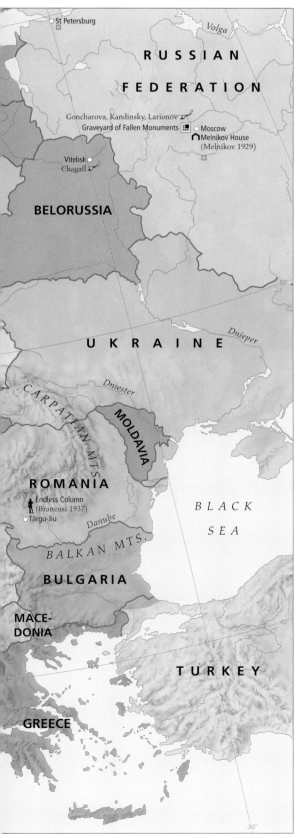

had once taken for granted, but it was now increasingly forced to take second place to the growing strength and authority of the United States. New York was gradually to establish its primacy over Paris as the capital of the art world.

THE IMPACT OF TECHNOLOGY

From the very dawn of the twentieth century, scientific and technological developments had a considerable impact upon art production throughout Europe. In Italy, new industries such as automobile manufacture, significantly influenced artists such as the Futurists. Based in the north of the country, where hydroelectric power from the Alps was needed to run the turbines of the new factories, Futurism celebrated speed and modernity. Moreover, through the energetic proselytizing of the movement by its founder and chief spokesman Filippo Tommaso Marinetti, Futurism gained a foothold in many countries throughout Europe.

Technology also made a huge impact in the newly established Soviet Union where artists associated with the Constructivist movement embraced new materials and techniques in an attempt to link the worlds of art and industry. Many of the Constructivists' ideas were gradually exported throughout Europe through dialogues established with artists such as Vasily Kandinsky and El Lissitzky.

In architecture, too, new technological developments played a major role in forming a new aesthetic. In the first half of the century an increased emphasis on machine and mass production opposed the more decorative approach to architecture and design that had characterized the late nineteenth century. Reinforced concrete in particular facilitated greater freedom in the design of interior spaces. External walls were also liberated from their previous load-bearing requirement. Throughout Europe architects such as Adolf Loos, Le Corbusier, Ludwig Mies van der Rohe and Konstantin Melnikov erected modern, geometrically inspired and sparsely decorated houses and villas that were to have a marked, and continuing, influence on the development of twentieth-century architecture.

These experiments with new technology also went on to influence post-World War II religious architecture such as Le Corbusier's works at Ronchamp and Eveux and Frederick Gibberd's Cathedral of Christ the King in Liverpool. Brutalist mass housing projects, such as Le Corbusier's Unité d'Habitation in Marseille, and Ernö Goldfinger's Trellick Tower in London also exploited the possibilities of new building technology.

PUBLIC ART

Public monuments also played a key part in the cultural landscape of twentieth-century Europe. While most of these monuments occupy urban centres some, including Konstantin Brancusi's trio of sculptures entitled *Endless Column*, *The Table of Silence* and *The Gate of the Kiss*, and Antony Gormley's *Angel of the North*, have been positioned further afield at sites, respectively, at Târgu-Jiu in Romania and Gateshead in England. These works serve more distant audiences for public art, as well as attracting the more determined art pilgrim.

The principle of making art available to a mass public audience generated the development of many new museums throughout Europe in the latter half of the twentieth century. Many of these, such as the Moderna Museet in Stockholm, the Pompidou Centre in Paris and the recently opened Guggenheim Museum in Bilbao have commissioned famous architects to build ultra-modern buildings to house the works of the modernist era. Others have redesigned old industrial buildings, most notably London's Tate Modern at Bankside, to reinforce the link between modern art and the industrial era.

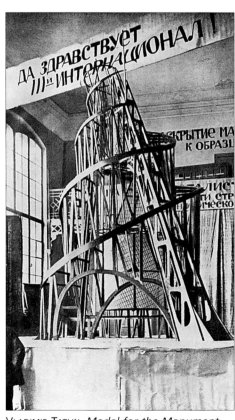

VLADIMIR TATLIN, *Model for the Monument to the Third International*, 1919–20. Tatlin's proposed monument in honour of the 1917 Bolshevik Revolution reflected the utopian and internationalist aspirations of the new Soviet state. Planned to be 300 metres (975 ft) high and to include within its structure vast rotating rooms for state agencies, Tatlin's tower was never, and probably could never have been, built.

1 THE TWENTIETH CENTURY was a period of intense socio-political change resulting in the map of Europe being redrawn many times over. Two world wars, the rise and fall of Fascism and the emergence, consolidation and eventual collapse of the world's first communist state all contributed to mass changes in national and international identities and to dramatic shifts in practice in the visual arts.

SCANDINAVIA AND THE BALTIC STATES 1900-2000

AT THE TURN OF THE CENTURY, the Symbolism of the 1890s, combined with national Romanticism, resulted in 'atmospheric' painting, in which the revealing daylight of Naturalism gave way to the thoughtful, soft light of the long summer evenings. Older-generation exponents of this type of art included Richard Berg and Karl Nordström, while representatives of the younger generation included J. F. Willumsen, Hugo Simberg and Magnus Enckell.

SCANDINAVIAN MODERNISM
The landscape and culture of Scandinavia had a marked impact on artistic trends that were imported from elsewhere in Europe. Continental Art Nouveau, which utilized flourishing plant motifs in interiors and design, led to a more rustic style in Scandinavia, reflecting local plant life with its use of motifs featuring pineneedles and cones. The many brickworks in Denmark and southern Sweden infused local architecture

with a special character – façades of dark brick were frequently used to give a sense of weight and simplicity. In Finland the local materials of wood and granite made their mark on buildings, and Helsinki evolved a unique style of Art Nouveau within the Baltic region.

Many Scandinavian artists travelled to Europe, where they mixed Continental Modernism with local traditions. A generation of artists, born in the 1880s, went to Paris around 1908, to study under Matisse. Among them were the Swedes, Isaac Grünewald, Sigrid Hjertén,

1 DURING THE TWENTIETH CENTURY art in Scandinavia became more and more accessible to the people. Art museums were built in every major town. Many of these museums were based on donations of private collections, while others have gradually built up their collections through purchases. Regional art museums specialize in locally-based work, but are also able to increase their impact by featuring a range of temporary exhibitions.

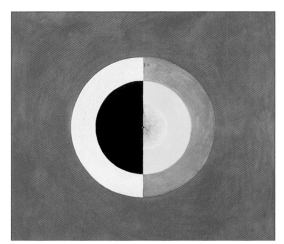

HILMA AF KLINT (1862–1944) *The Swan, No. 17*, 1914–15, oil on canvas. Trained at the Academy of Art in Stockholm, Klint was inspired by Spiritualism and Theosophy. In 1906 she embarked on an abstract and symbolic painting, guided by spirits. From that date she never showed her works in public, but she was 'discovered' in the late 1980s, and hailed as a pioneer of abstract art.

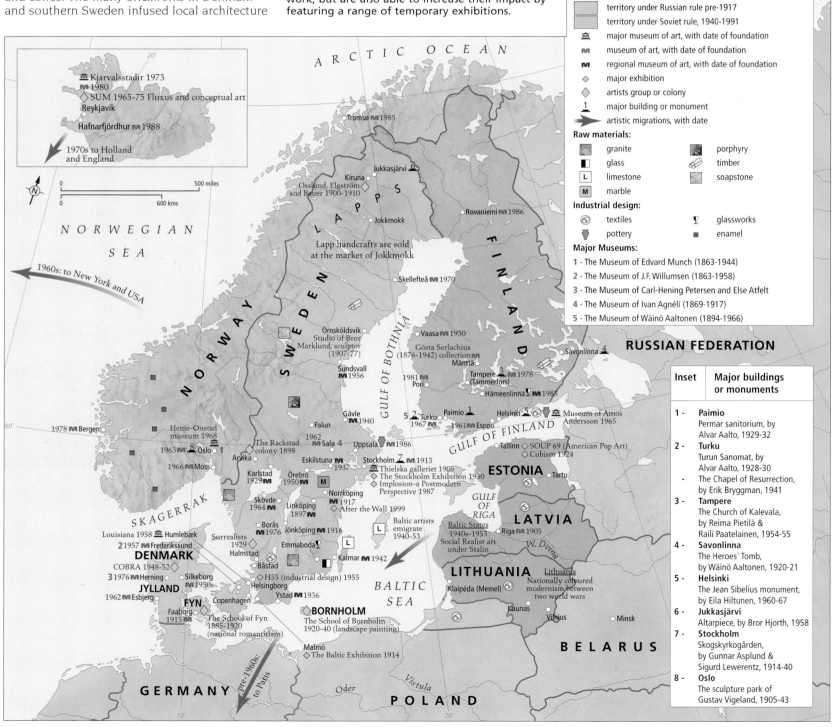

1	From Symbolism to Post-Modernism, 1900-1987

- territory under Russian rule pre-1917
- territory under Soviet rule, 1940-1991
- major museum of art, with date of foundation
- museum of art, with date of foundation
- regional museum of art, with date of foundation
- major exhibition
- artists group or colony
- major building or monument
- artistic migrations, with date

Raw materials:
- granite
- glass
- limestone
- marble
- porphyry
- timber
- soapstone

Industrial design:
- textiles
- pottery
- glassworks
- enamel

Major Museums:
1 - The Museum of Edvard Munch (1863-1944)
2 - The Museum of J.F. Willumsen (1863-1958)
3 - The Museum of Carl-Hening Petersen and Else Atfelt
4 - The Museum of Ivan Agnéli (1869-1917)
5 - The Museum of Wäinö Aaltonen (1894-1966)

Inset	Major buildings or monuments
1 -	**Paimio** Permar sanitorium, by Alvar Aalto, 1929-32
2 -	**Turku** Turun Sanomat, by Alvar Aalto, 1928-30
-	The Chapel of Resurrection, by Erik Bryggman, 1941
3 -	**Tampere** The Church of Kalevala, by Reima Pietilä & Raili Paatelainen, 1954-55
4 -	**Savonlinna** The Heroes' Tomb, by Wäinö Aaltonen, 1920-21
5 -	**Helsinki** The Jean Sibelius monument, by Eila Hiltunen, 1960-67
6 -	**Jukkasjärvi** Altarpiece, by Bror Hjorth, 1958
7 -	**Stockholm** Skogskyrkogården, by Gunnar Asplund & Sigurd Lewerentz, 1914-40
8 -	**Oslo** The sculpture park of Gustav Vigeland, 1905-43

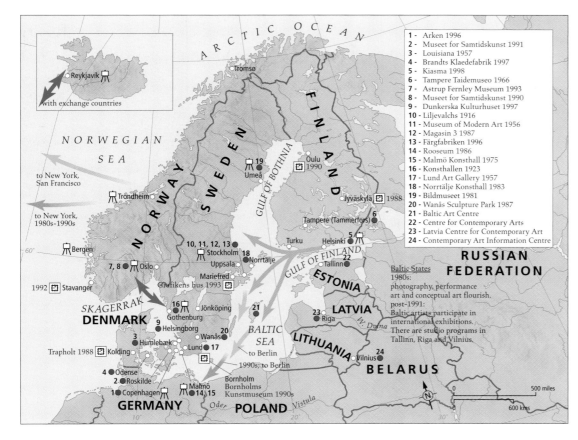

1 - Arken 1996
2 - Museet for Samtidskunst 1991
3 - Louisiana 1957
4 - Brandts Klaedefabrik 1997
5 - Kiasma 1998
6 - Tampere Taidemuseo 1966
7 - Astrup Fernley Museum 1993
8 - Museet for Samtidskunst 1990
9 - Dunkerska Kulturhuset 1997
10 - Liljevalchs 1916
11 - Museum of Modern Art 1956
12 - Magasin 3 1987
13 - Färgfabriken 1996
14 - Rooseum 1986
15 - Malmö Konsthall 1975
16 - Konsthallen 1923
17 - Lund Art Gallery 1957
18 - Norrtälje Konsthall 1983
19 - Bildmuseet 1981
20 - Wanås Sculpture Park 1987
21 - Baltic Art Centre
22 - Centre for Contemporary Arts
23 - Latvia Centre for Contemporary Art
24 - Contemporary Art Information Centre

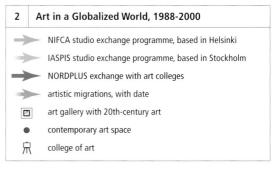

2 | Art in a Globalized World, 1988-2000

- NIFCA studio exchange programme, based in Helsinki
- IASPIS studio exchange programme, based in Stockholm
- NORDPLUS exchange with art colleges
- artistic migrations, with date
- art gallery with 20th-century art
- contemporary art space
- college of art

2 THE SCANDINAVIAN COUNTRIES and the Baltic states are on the periphery of the art world, but since the early 1990s this perspective has been greeted as something interesting and refreshing, and – in a global art market – the periphery is having an increasing influence on the centre. Since the 1990s, many Scandinavian and Baltic artists have made careers on the international art scene. The most reputable Scandinavian artists are, in fact, women. The most popular media used by contemporary artists are photography, video and computer art.

THE POST-WAR WORLD
After World War II international art trends became significant. In Denmark, an expressive, abstract painting style was created in the 1940s mainly by the internationally active CoBra group (1948–52). A group calling itself '1947 års män' ('The Men of 1947') appeared in Sweden during the same period. Their espousal of non-figurative art came to have considerable influence in the following decade.

Pop Art has an internationally famous Scandinavian exponent in Öiyvind Fahlström. He lived and worked in New York, and represents the shift between French and American influence on art in the early 1960s. The Moderna Museet in Stockholm, under the leadership of Pontus Hultén, had an all-important role in developing artistic contacts with the USA.

The Danish painter and sculptor Per Kirkeby represented the new Expressionism in the first half of the 1980s, while others who used photography marked the way for a conceptual-based art which flourished in the late 1980s and 1990s. Scandinavian art has recently attracted much attention for its anti-Expressionist style.

Einar Jolin and Leander Engström; the Icelander, Jón Stefánsson; the Dane, Harald Giersing, and the Norwegians, Ludvig Karsten and Henrik Sørensen.

ART AND POLITICS
Public art, which sought to express a unifying national purpose, came to have increasing importance in Norway after the dissolution of the Union between Sweden and Norway in 1905. Monumental frescoes were produced by both Edvard Munch and Gerhard Munthe, while the country's major sculptural decoration is the Vigeland Park (1905–43), in Oslo, created by Gustav Vigeland. During World War II, when Norway was occupied by the Germans, a parallel art emerged which sought to examine topical subjects away from the public arena – Hannah Ryggen, for example, reflected contemporary subjects in her textile work.

The political situation in Finland had a decisive role in the strongly national presentation of art – attempts were made to manifest genuinely Finnish qualities, rather than merely absorbing international trends. In Finland, the influence of international Modernism is first noticeable around 1915, with the formation of the Septem and November groups. The Expressionist Tyko Sallinen, whose wild painting was inspired by the French Fauvistes and Edvard Munch, attracted violent criticism when he first exhibited in 1912. One of the most radical Finnish Modernists was Helene Schjerfbeck, who distinguished herself in a series of self-portraits. The sculptor Wäinö Aaltonen dominated the 1920s and 1930s in Finland, producing granite sculptures that are steeped in patriotic heroism and classicism. It was not until the 1960s that Finnish public art experienced a new era with the monument to Jean Sibelius by Eila Hiltunen, which, among others, paved the way for abstract sculpture.

EIJA-LIISA AHTILA (b.1959 in Finland), *Anne, Aki and God*, 1998, DVD-installation. Ahtila is one of the most famous young contemporary Scandinavian artists. Her works often deal with questions of identity and psychoanalysis mixed with the melancholy tradition of Nordic film. *Anne, Aki and God* is ostensibly based on the diary of a schizophrenic.

Conscious Naïvism – in which the subjects were bucolic and idyllic – grew and flourished in Sweden during the 1910s, especially at a time when World War I was preventing artists from working abroad. This trend, together with Expressionism, continued to dominate the Swedish art world over the following two decades, although by the 1930s post-Cubism and Surrealism were also having a marked impact in both Sweden and Denmark.

Alvar Aalto from Finland and Gunnar Asplund, from Sweden, have had the greatest influence as pioneers for Functionalism in Scandinavian design. Asplund was the chief architect for the Stockholm Exhibition of 1930, which was Functionalism's greatest showcase – revealing the impact of the movement on art, architecture and design.

There was always something going on in my head

Russia 1900-2000

LEADERS OF VANGUARD movements in Russia knew contemporary European art in the collections of Moscow merchants, and several maintained contact with counterparts in France, Germany and Italy. Besides this international cross-fertilization, new regional perspectives were introduced by artists from provincial backgrounds. Neo-primitivist and futurist groups exploited the bold forms and lively motifs of folk and popular arts.

REVOLUTIONARY ART
The Bolshevik Revolution of 1917 galvanized artists to invent new forms and venues: to use the streets and squares as their canvases. Revolutionary anniversaries generated parades and decorations on landmarks throughout the country. Embodying the aspirations of the new state was the steel, glass and wood Monument to the Third International (see p.271) by Vladimir Tatlin (1885–1953), never erected but displayed as a model. Besides Tatlin, Malevich and others in the Constructivist and Suprematist movements many artists identified themselves with revolutionary art. After Lenin's death in 1924 realism gained authority, and abstract art was suppressed. The doctrine of Soviet Socialist Realism announced in 1934 required that subjects and styles of all the arts reflect 'revolutionary reality'.

While Stalin's government marshalled resources for transport, industry and collectivization of farmland, the official Union of Artists commissioned appropriate works in all media – from textiles and ceramics to murals and monumental sculptures for stadiums and metro stations. Themes of industry and agriculture dominated major exhibitions and the Soviet pavilions at the World Fairs in Paris (1937) and New York (1939). Art projects highlighted geographical and ethnic variety in ways that accentuated cultural unity. Scenes of daily life showed citizens working together in the community, building strong bodies, reading and studying in workers' clubs or village reading rooms.

While official arts celebrated unity and prosperity, multitudes starved in the famines caused by collectivization, and thousands of intellectuals, politicians and ordinary citizens

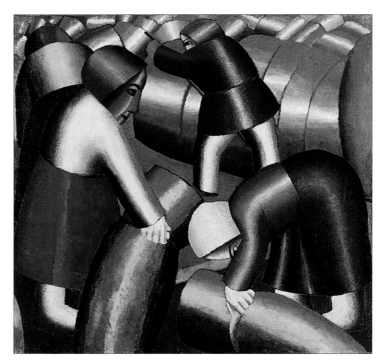

KAZIMIR MALEVICH (1878–1935), *Rye Harvest* (1912), oil on canvas, Amsterdam, Stedelijk Museum. Malevich, stimulated by French Modernist art and by Russian neo-primitivists, took motifs from folk and popular life. Here, the women binding sheaves resemble painted wooden toys. In 1915 Malevich announced his invention of purely abstract Suprematism.

1 THE MAGNITUDE OF RUSSIA was a challenge to development and a recurrent theme in art. New industrial centres, hydro-electric dams, canals and railways transformed the landscape. A network of forced-labour camps lined the Kotlas–Vorkuta railway, the Belomor canal and other projects. Vast areas of Siberia became state prison-camp (*gulag*) zones. While art celebrated prosperity, the Russian heartland suffered crop failures, then brutal occupation by the Nazis.

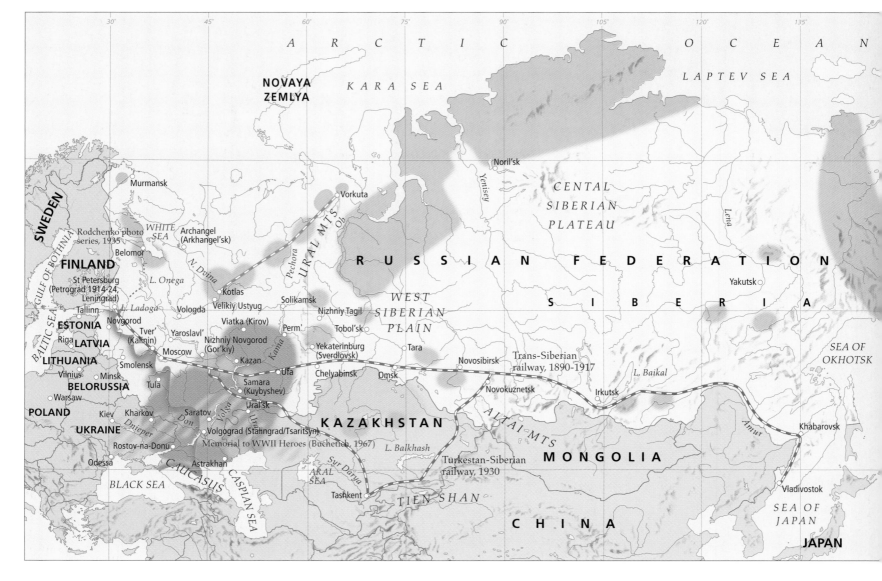

2 BEFORE AND AFTER THE REVOLUTION, provincial centres flourished. Both artists of the avant-garde and leaders of Socialist Realism worked at state art schools. 'Agit-prop' trains and steamboats carried posters and revolutionary theatre to outlying regions. Soviet authorities renamed many towns to honour political and cultural heroes (most have now resumed their traditional names).

were sent to the state prison camps (*gulags*) in the far north and Siberia. Survivors testify that Stalin's secret terror was more insidious than the invasion in 1941. World War II, the Great Patriotic War, marshalled artists to intensify patriotism and national identity. Films, symphonies, operas, paintings, sculptures and photographs documented the war and exhorted the population. Socialist Realism proved capable of rising above propaganda to express tragedy.

NONCONFORMIST ART
The return to normality after the war was signalled by depictions of new settlements in the eastern 'virgin lands', new housing projects and the achievements of the Soviet cosmonauts. Khrushchev's denunciation of Stalin in 1956 released a current of unrest that evolved into an unofficial and illegal art underground. The first public display of nonconformist art occurred in 1962 at the Manezh exhibition hall in Moscow, where artists such as Ernst Neizvestny (1926–) defended their right to determine their own subjects and styles of work. Khrushchev's 'thaw' was soon over, but some artists managed to work outside of the official system. Unofficial art became known abroad in the mid-1970s, when an outdoor exhibition was

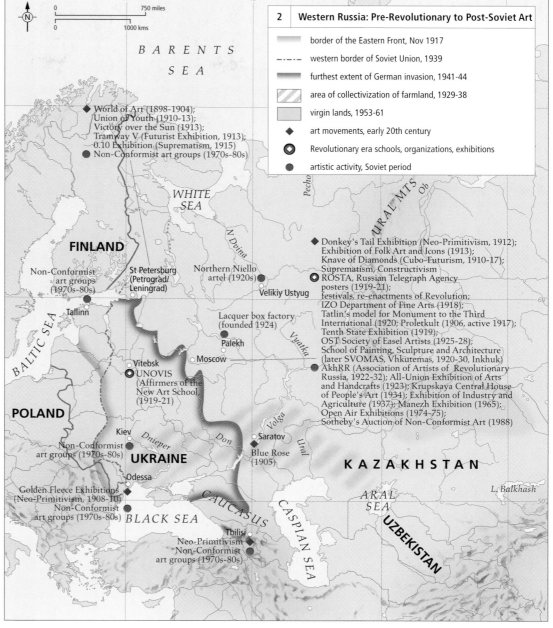

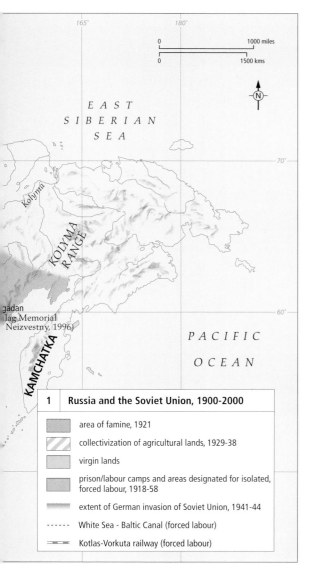

deliberately wrecked by bulldozers and fire-hoses. The government eventually permitted independent exhibits, though under tight restrictions. During the 'era of stagnation' under Brezhnev, artists developed networks for mutual support. They asserted their right to treat any subject and to employ any style, including Expressionism, Surrealism, Photorealism, Abstract, Kinetic and Conceptual art. Some of the most radical innovations came from the Baltic republics of Estonia, Latvia and Lithuania, and from Georgia and Armenia in the Caucasus, far from Moscow, where control was less strict.

Near the end of the Soviet period, conceptualist groups such as Collective Action became adept at evoking the sense of chaos as Soviet traditions and standards came into question. Sots Art (based on Pop Art, with the premise that the Soviet Union, lacking consumer goods, had an over-abundance of ideology) featured absurd slogans and Post-Modernist pastiches of heroic portraits of Lenin and Stalin. When the Soviet Union dissolved in 1991, many artists considered themselves to be both Russian (or Jewish, Ukrainian, Estonian, Georgian) and international in their allegiance. The challenge before them today is to find ways to relate their individual visions and national traditions to a realistic understanding of modern markets and audiences in an international art world.

SERGEY GERASIMOV (1875–1970), *Holiday on the Kolkhoz* (1937), oil on canvas, Moscow, Tretyakov Gallery. True to the tenets of Soviet Socialist Realism, Gerasimov celebrates community life on the collective farm. The clear, sunshine-yellow tones in the landscape amplify the sense of relaxation and festivity in the gathering. Avoiding the reality of crop failure and widespread famine, the artist offers what Communist Party spokesman Andrey Zhdanov called 'a glimpse of our tomorrow'.

BRITAIN AND IRELAND 1900-2000

AN AMBIVALENCE towards Continental Modernism and a sensitive exploration of vernacular traditions characterized the work of British artists in the twentieth century. The opulent culture of the Edwardian era (1901–10) balanced an idealization of rural life with a celebration of London as the centre of the British Empire at its fullest extent. Victorian political certainties were undermined by a constitutional crisis and the Suffragette movement, demanding votes for women. Although London was to remain the undisputed centre for artistic production throughout the

century, many artists chose to abandon the city for remote rural locations. Adopting French *plein-air* techniques, painters moved to artists' colonies amid the unspoilt coastal scenery of Walberswick, Staithes and Newlyn.

MODERNISM AND RURALISM
The attempt to balance both the urban and rural in architecture and town planning resulted in Garden Cities at Letchworth (1903) and Welwyn (c.1920). Incorporating natural forms, Charles Rennie Mackintosh pioneered a uniquely decorative form of architectural

Modernism in Glasgow, epitomized by his suburban masterpiece, Hill House.

Challenging forms of Modernist painting definitively entered British culture through a series of exhibitions held in London between 1910 and 1914. The most important of these were curated by the critic and painter Roger Fry who, with the painters Vanessa Bell and Duncan Grant, became a central member of the Bloomsbury Group, based in central London. At the Omega Workshop, the Bloomsbury Group created innovative decorative art objects: one of their most completely realized collective creations is the interior of Charleston Farmhouse near Lewes, the rural home of the art writer Clive Bell and his wife Vanessa from 1916. In London, the Camden Town Group, founded in North London in 1911 and led by Walter Richard Sickert, Spencer Gore and Harold Gilman, pioneered a sensitive Post-Impressionist vision of the modern city.

THE GREAT WAR AND ITS AFTERMATH
The catastrophic loss of life in World War I (1914–18) found expression in the work of numerous artists. Stanley Spencer's Sandham Memorial Chapel at Burghclere, near his home at Cookham, memorialized his experiences in Macedonia in a visionary, naive, figurative style.

While British culture was preoccupied with mourning during the early 1920s, often articulated through the use of traditional styles, this decade also saw the impact of Modernist influences in Britain. A distinctive Modernist architecture based on the style of Le Corbusier appeared in Wells Coates' Isokon Building in Hampstead

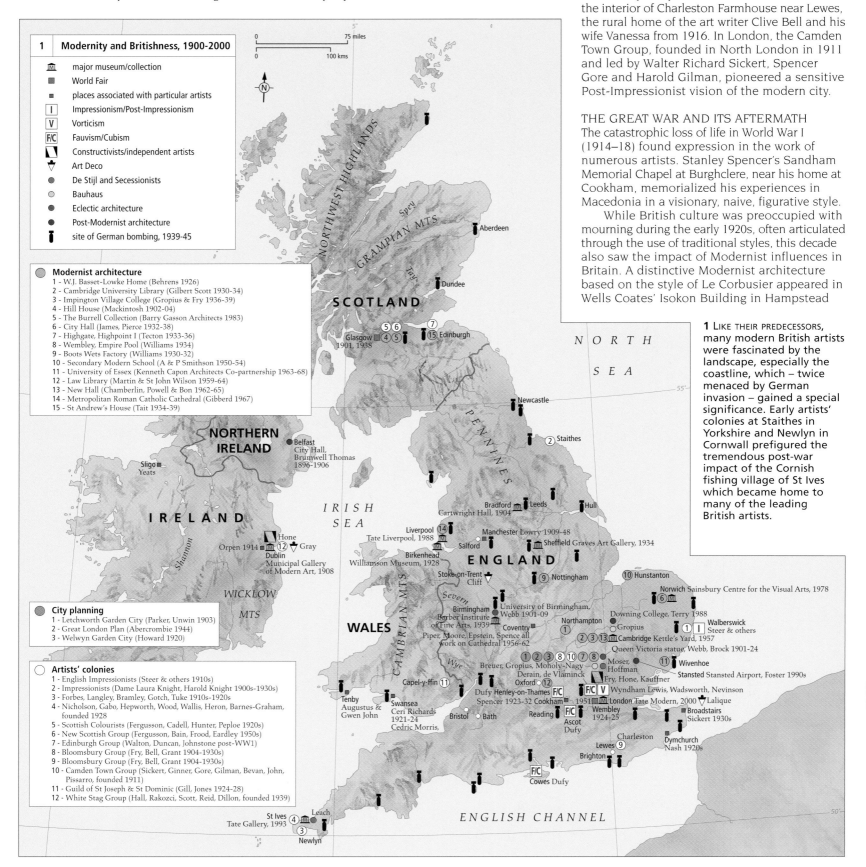

1 Modernity and Britishness, 1900-2000

🏛 major museum/collection
■ World Fair
▪ places associated with particular artists
I Impressionism/Post-Impressionism
V Vorticism
F/C Fauvism/Cubism
↖ Constructivists/independent artists
▽ Art Deco
● De Stijl and Secessionists
○ Bauhaus
● Eclectic architecture
● Post-Modernist architecture
▮ site of German bombing, 1939-45

Modernist architecture
1 - W.J. Basset-Lowke Home (Behrens 1926)
2 - Cambridge University Library (Gilbert Scott 1930-34)
3 - Impington Village College (Gropius & Fry 1936-39)
4 - Hill House (Mackintosh 1902-04)
5 - The Burrell Collection (Barry Gasson Architects 1983)
6 - City Hall (James, Pierce 1932-38)
7 - Highgate, Highpoint I (Tecton 1933-36)
8 - Wembley, Empire Pool (Williams 1934)
9 - Boots Wets Factory (Williams 1930-32)
10 - Secondary Modern School (A & P Smithson 1950-54)
11 - University of Essex (Kenneth Capon Architects Co-partnership 1963-68)
12 - Law Library (Martin & St John Wilson 1959-64)
13 - New Hall (Chamberlin, Powell & Bon 1962-65)
14 - Metropolitan Roman Catholic Cathedral (Gibberd 1967)
15 - St Andrew's House (Tait 1934-39)

City planning
1 - Letchworth Garden City (Parker, Unwin 1903)
2 - Great London Plan (Abercrombie 1944)
3 - Welwyn Garden City (Howard 1920)

Artists' colonies
1 - English Impressionists (Steer & others 1910s)
2 - Impressionists (Dame Laura Knight, Harold Knight 1900s-1930s)
3 - Forbes, Langley, Bramley, Gotch, Tuke 1910s-1920s
4 - Nicholson, Gabo, Hepworth, Wood, Wallis, Heron, Barnes-Graham, founded 1928
5 - Scottish Colourists (Fergusson, Cadell, Hunter, Peploe 1920s)
6 - New Scottish Group (Fergusson, Bain, Frood, Eardley 1950s)
7 - Edinburgh Group (Walton, Duncan, Johnstone post-WW1)
8 - Bloomsbury Group (Fry, Bell, Grant 1904-1930s)
9 - Bloomsbury Group (Fry, Bell, Grant 1904-1930s)
10 - Camden Town Group (Sickert, Ginner, Gore, Gilman, Bevan, John, Pissarro, founded 1911)
11 - Guild of St Joseph & St Dominic (Gill, Jones 1924-28)
12 - White Stag Group (Hall, Rakozci, Scott, Reid, Dillon, founded 1939)

1 LIKE THEIR PREDECESSORS, many modern British artists were fascinated by the landscape, especially the coastline, which – twice menaced by German invasion – gained a special significance. Early artists' colonies at Staithes in Yorkshire and Newlyn in Cornwall prefigured the tremendous post-war impact of the Cornish fishing village of St Ives which became home to many of the leading British artists.

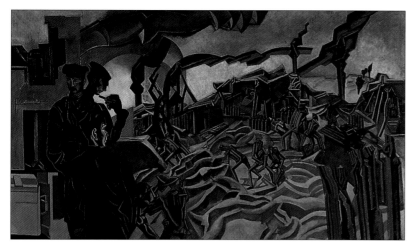

WYNDHAM LEWIS, *A Battery Shelled*, 1919. Vorticism, an angular near-abstract style, was pioneered by Wyndham Lewis in the years before the First World War. His Futurist-inspired publication *Blast* (1914) advocated a celebration of the machine and of war. Lewis's experiences as a combatant in the First World War undermined these beliefs, however, and he returned to the more figurative style seen here.

the 1950s onwards. The 1970s saw various forms of conceptual art, notably 'the walks'. These were effectively geographical performance pieces, by Bristol-based Richard Long which hark back to the traditions of English landscape painting.

There was a period of artistic decline under Margaret Thatcher's premiership in the early 1980s, an era epitomized by the commercial brashness of Richard Rogers's Post-Modernist Lloyd's Building (1979–86). Later, a young generation of artists led by Damien Hirst and Rachel Whiteread, many trained at Goldsmiths' School of Art, began to exhibit challenging conceptual work under the patronage of a new generation of collectors, notably Charles Saatchi, as well as that of galleries such as White Cube. By 2000, London once again held a central place in the international art world.

(1932–4), whose form frankly expressed the functional requirements of modern urban living.

After a period of experimentation with what were considered 'primitive' sources, such as Pre-Columbian figures, Henry Moore and Barbara Hepworth pioneered a new and distinctively British approach to modern sculpture in the 1930s. Among the most distinguished work to be produced in London in the 1930s was Ben Nicholson's series of white reliefs exploring the purest forms of abstraction. Following the pattern established earlier in the century, Nicholson, Hepworth and Christopher Wood moved to the picturesque fishing village of St Ives in Cornwall, which remained a centre for the production of sculpture, ceramics and painting for the rest of the century. Questions of landscape, national identity and history preoccupied many Neo-Romantic artists, such as Graham Sutherland, in the late 1930s, a concern which intensified with the threat of World War II.

POST-WAR RECONSTRUCTION

The Labour government initiated a welfare state and sponsored the Festival of Britain in 1951, whose lasting memorial is the Royal Festival Hall

(1951, Leslie Martin). Economic austerity and post-war shortages were reflected in the gritty social realism of much art produced at this time, such as L.S. Lowry's canvases of working class life in industrial Lancashire. The 'School of London'. led by Francis Bacon and Lucien Freud, was the focus of bohemian culture in the 1950s. The reconstruction of Coventry Cathedral (1956–62), to Basil Spence's designs included work by Henry Moore and Graham Sutherland.

By the 1960s government-funded initiatives led to ambitious experiments in modernist architecture, such as the National Theatre (1967–76, Denys Lasdun) and Kenneth Capon's University of Essex (1963–8). Away from London, St Ives continued to be an artistic hub, reflected in the work of Peter Lanyon and Patrick Heron.

The lure of American consumerism and the mass media was irresistible to a generation of young artists in the 1950s and 1960s. The Independent Group, who met at the Institute of Contemporary Arts in Westminster, and a group of artists such as Peter Blake and David Hockney, students together at the Royal College of Art in Kensington, created a new style – 'Pop' – which is a keynote for the analysis of British culture from

RACHEL WHITEREAD, *House*, East London, 1993. Whiteread is among the 'young British artists' who revived interest in contemporary art in the 1990s. She filled the interior of a Victorian terrace house with concrete prior to its demolition, preserving a ghostly simulacrum of its interior space. *House* won her the prestigious Turner Prize in 1993.

2 POST-WAR LONDON spawned a bohemian culture, based in the pubs and clubs of Soho, in central London, such as the Colony Room, favourite watering hole of such luminaries as Francis Bacon and Lucien Freud. In recent years the East End has become the centre of a thriving art scene, while the opening of Tate Modern at Bankside marked a major geo-cultural shift

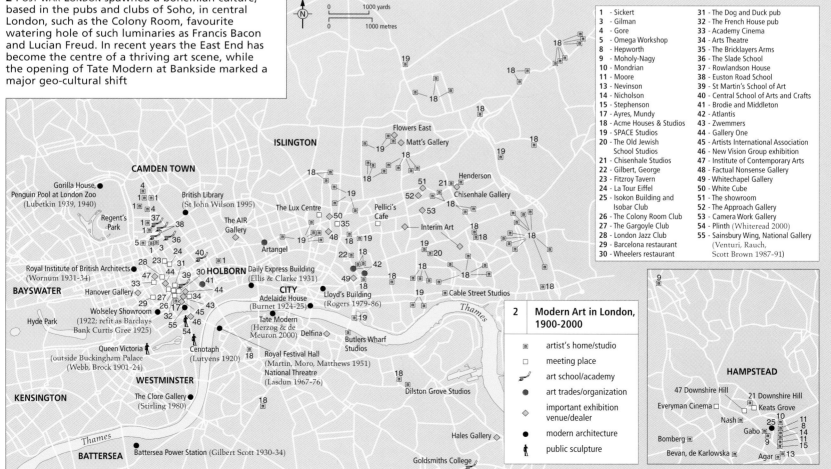

2	Modern Art in London, 1900-2000
▣	artist's home/studio
□	meeting place
⚒	art school/academy
●	art trades/organization
◇	important exhibition venue/dealer
●	modern architecture
🚶	public sculpture

1 - Sickert
3 - Gilman
4 - Gore
5 - Omega Workshop
8 - Hepworth
9 - Moholy-Nagy
10 - Mondrian
11 - Moore
13 - Nevinson
14 - Nicholson
15 - Stephenson
17 - Ayres, Mundy
18 - Acme Houses & Studios
19 - SPACE Studios
20 - The Old Jewish School Studios
21 - Chisenhale Studios
22 - Gilbert, George
23 - Fitzroy Tavern
24 - La Tour Eiffel
25 - Isokon Building and Isobar Club
26 - The Colony Room Club
27 - The Gargoyle Club
28 - London Jazz Club
29 - Barcelona restaurant
30 - Wheelers restaurant
31 - The Dog and Duck pub
32 - The French House pub
33 - Academy Cinema
34 - Arts Theatre
35 - The Bricklayers Arms
36 - The Slade School
37 - Rowlandson House
38 - Euston Road School
39 - St Martin's School of Art
40 - Central School of Arts and Crafts
41 - Brodie and Middleton
42 - Atlantis
43 - Zwemmers
44 - Gallery One
45 - Artists International Association
46 - New Vision Group exhibition
47 - Institute of Contemporary Arts
48 - Factual Nonsense Gallery
49 - Whitechapel Gallery
50 - White Cube
51 - The showroom
52 - The Approach Gallery
53 - Camera Work Gallery
54 - Plinth (Whiteread 2000)
55 - Sainsbury Wing, National Gallery (Venturi, Rauch, Scott Brown 1987-91)

THE NETHERLANDS AND BELGIUM 1900-2000

THE OUTBREAK OF WAR in 1914 halted the economic buoyancy and cultural expansion of both the Netherlands and Belgium. In 1940, despite neutrality, both countries were occupied for four years. Post-war land-reclamation programmes rebuilt a Dutch landscape that had been partly flooded through destruction of the dykes during occupation. In 1957 the European Community was established, with its headquarters in Brussels; the Benelux trade area, including Luxembourg, followed in 1958.

GLOBAL COLLECTING AND TRADING
Léopold II founded the Musée Royal de l'Afrique Centrale at Tervuren (Brussels) in 1907 to display his collections. Global artefacts, textiles and peoples had been included in the Brussels 1910 Expositions Universelles and at the Palais du Congo,

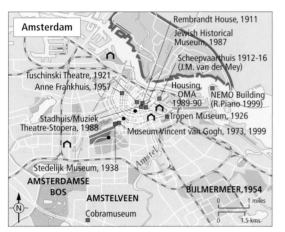

Antwerp, in 1930. Although international condemnation prompted Belgium to annex Léopold II's African territories in 1908, colonial exploitation of Congo's resources continued until its independence as Zaire in 1960.

The Dutch presence in Indonesia continued until the Japanese invasion in 1942; their withdrawal marked the beginning of the struggle for independence, which was achieved in 1949. The foundation of the Openlucht Museum for architecture and folklore in Arnhem in 1913 enabled Dutch architects to study the detailing and structure of Sumatran buildings. The Tropen Museum in Amsterdam (previously the Dutch Colonial Institute, 1926) displayed Indonesian textiles, *batiks*, shadow puppets and other objects and now includes objects from Southeast Asia, Oceania, West Asia, Africa, Latin America and the Caribbean.

THE AVANT-GARDES
Luminism, Expressionism, Abstraction and Surrealism were the principle movements in the first half of the twentieth century. Whereas Expressionism was important in Belgian painting, notably in the work of Constant Permeke (1886–1952), it was manifested most strongly in Dutch sculpture and architecture. Expressionist buildings, using traditional Dutch brickwork in expressive and playful forms, were built throughout the Netherlands

1 THE MOVEMENT OF ARTISTS AND ART OBJECTS in and out of Belgium and the Netherlands was determined by wars and the growth of collections of international modern art. Art historian Hans Jaffé fled to Amsterdam in 1936 and Expressionist painter Max Beckmann lived there 1937–47. Innovative Post Modern buildings were constructed on Amsterdam's eastern harbour.

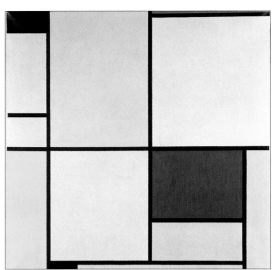

PIET MONDRIAN, *Tableau 1 with Red, Black, Blue and Yellow* (1921), oil on canvas. A central figure of De Stijl, Mondrian developed his mature *nieuwe beelding* paintings in Paris (1919–30), London (1939–40) and New York, where his theoretical writings and exhilarating paintings, such as *Broadway Boogie-Woogie* (1942–3, in the collection of the Museum of Modern Art, New York), influenced post-war abstraction, architecture, industrial design and the graphic arts.

between 1890 and 1939. The work of the Amsterdam School elaborated on the expressive form of H. P. Berlage's De Beurs and J. M. van der Mey's Scheepvaarthuis. M. de Klerk (1884–1923) and K. P. C. de Bazel (1869–1923) developed an architecture of decorative and organic form including stylish housing projects for Amsterdam's socialist Office of Public Works.

The theory and practice of De Stijl dominated the international avant-garde, setting agendas for the twentieth century. Founded in Leiden in 1917, De Stijl advocated a universal style. In painting, formal elements were reduced to the rectangle and pure primary colours; in architecture and sculpture these concepts were extended to include volume and space. Influences from America, Japan and Indonesia shaped the work, which retained strong idealist and spiritual dimensions. Theo van Doesburg (1883–1931), Gerrit Rietveld (1888–1964), J. J. P. Oud (1890–1963) and Piet Mondrian (1872–1944) were, with Belgian sculptor Georges Vantongerloo, the leading figures. De Stijl artists participated in Parisian avant-garde circles such as: Abstraction Création, Cercle et Carré and Art Concret; at the Bauhaus in Germany, and in the Dada movement, staging a famous Dada Tour of the Netherlands in 1923.

In De Stijl architecture van Doesburg introduced axonometric drawing to exemplify the dynamic interrelation of interior and exterior space partly carried out in Rietveld's Schroder House, Utrecht (1924). By the late 1920s architecture in Belgium and the Netherlands drew on the immateriality and formal abstraction of De Stijl but linked it to a more Russian constructivist aesthetic of machine-like surfaces and smooth glazing. In buildings such as the van Nelle Factory, Rotterdam (J. A. Brinckman and L. C. van der Vlught, 1925–31) and the Zonnestraal Sanatorium at Hilversum (J. Duiker, 1926–31) a unified architectural style was developed for the modern world.

Although René Magritte (1898–1967) flirted briefly with De Stijl abstraction, by 1926 he was

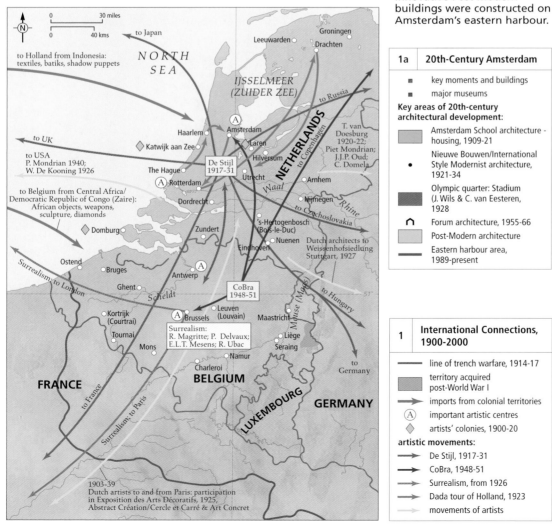

1a 20th-Century Amsterdam

- ■ key moments and buildings
- ■ major museums

Key areas of 20th-century architectural development:

- Amsterdam School architecture - housing, 1909-21
- • Nieuwe Bouwen/International Style Modernist architecture, 1921-34
- Olympic quarter: Stadium (J. Wils & C. van Eesteren, 1928
- ∩ Forum architecture, 1955-66
- Post-Modern architecture
- Eastern harbour area, 1989-present

1 International Connections, 1900-2000

- —— line of trench warfare, 1914-17
- territory acquired post-World War I
- ⇒ imports from colonial territories
- Ⓐ important artistic centres
- ◇ artists' colonies, 1900-20

artistic movements:
- ➡ De Stijl, 1917-31
- ➡ CoBra, 1948-51
- ➡ Surrealism, from 1926
- ➡ Dada tour of Holland, 1923
- ➡ movements of artists

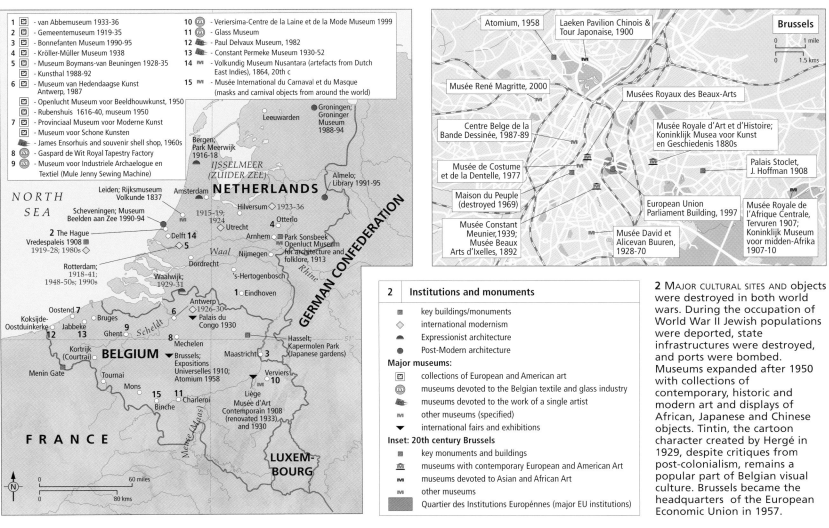

Map legend:

1 - van Abbemuseum 1933-36
2 - Gemeentemuseum 1919-35
3 - Bonnefanten Museum 1990-95
4 - Kröller-Müller Museum 1938
5 - Museum Boymans-van Beuningen 1928-35
 - Kunsthal 1988-92
6 - Museum van Hedendaagse Kunst
 Antwerp, 1987
 - Openlucht Museum voor Beeldhouwkunst, 1950
 - Rubenshuis 1616-40, museum 1950
7 - Provinciaal Museum voor Moderne Kunst
 - Museum voor Schone Kunsten
 - James Ensorhuis and souvenir shell shop, 1960s
8 - Gaspard de Wit Royal Tapestry Factory
9 - Museum voor Industriele Archaelogue en
 Textiel (Mule Jenny Sewing Machine)

10 - Veriersima-Centre de la Laine et de la Mode Museum 1999
11 - Glass Museum
12 - Paul Delvaux Museum, 1982
13 - Constant Permeke Museum 1930-52
14 - Volkundig Museum Nusantara (artefacts from Dutch
 East Indies), 1864, 20th c
15 - Musée International du Carnaval et du Masque
 (masks and carnival objects from around the world)

Brussels

Atomium, 1958
Laeken Pavilion Chinois & Tour Japonaise, 1900
Musée René Magritte, 2000
Musées Royaux des Beaux-Arts
Centre Belge de la Bande Dessinée, 1987-89
Musée Royale d'Art et d'Histoire; Koninklijk Musea voor Kunst en Geschiedenis 1880s
Musée de Costume et de la Dentelle, 1977
Palais Stoclet, J. Hoffman 1908
Maison du Peuple (destroyed 1969)
European Union Parliament Building, 1997
Musée Royale de l'Afrique Centrale, Tervuren 1907; Koninklijk Museum voor midden-Afrika 1907-10
Musée Constant Meunier,1939; Musée Beaux Arts d'Ixelles, 1892
Musée David et Alicevan Buuren, 1928-70

2 | Institutions and monuments

key buildings/monuments
international modernism
Expressionist architecture
Post-Modern architecture

Major museums:
collections of European and American art
museums devoted to the Belgian textile and glass industry
museums devoted to the work of a single artist
other museums (specified)
international fairs and exhibitions

Inset: 20th century Brussels
key monuments and buildings
museums with contemporary European and American Art
museums devoted to Asian and African Art
other museums
Quartier des Institutions Européennes (major EU institutions)

2 MAJOR CULTURAL SITES AND objects were destroyed in both world wars. During the occupation of World War II Jewish populations were deported, state infrastructures were destroyed, and ports were bombed. Museums expanded after 1950 with collections of contemporary, historic and modern art and displays of African, Japanese and Chinese objects. Tintin, the cartoon character created by Hergé in 1929, despite critiques from post-colonialism, remains a popular part of Belgian visual culture. Brussels became the headquarters of the European Economic Union in 1957.

committed to the pictorial language and theory of Surrealism. With the Belgian artist Paul Delvaux (1897–1994), Magritte produced a form of poetic Surrealism, moving across dream imagery to amplify the Surrealist concept of the power of desire and eroticism to 'change life'.

RECONSTRUCTION AND EXPANSION
During wartime occupation, art objects were taken to Germany and after the war an extensive recovery programme was instituted.

The Atomium, a steel and aluminium structure of a magnified molecule of iron, built for the Brussels World Fair in 1958, signified post-war reconstruction. Devastated by bombing, Rotterdam embarked on urban restructuring, commissioning Dutch and international architects and sculptors. Marcel Breuer designed the De Bijenkorf department store, 1955–7, with sculpture by Naum Gabo.
 Museums were reformulated after 1945. Memorial museums to Jewish history were established, significantly the Anne Frankhuis

in Amsterdam (1957). The collections of the Kröller-Müller shipping and mining dynasty offered a model for museum policy at Otterlo, celebrating the international canon of modern art. At the Stedelijk Museum, Amsterdam, curated by Willem Sandberg and Hans Jaffé (1945–63), a commitment to European Modernism was strengthened by acquisitions of Suprematist work by Malevich, American Abstract Expressionism and Pop Art. The first exhibition of CoBra (Copenhagen [Co] Brussels [Br] and Amsterdam [A] 1948–55), an avant-garde group of abstract artists, provoked huge uproar, and was held here in 1949. Aided by international competitions, public sculpture in parks and cities developed in both countries. Museums dedicated to individual artists flourished, notably the Van Gogh Museum, Amsterdam, designed by Rietveld (1973), with a Post-Modern extension (1999) by the Japanese architect Kisho Kurokawa .
 In the late twentieth century, Brussels, Antwerp and Amsterdam were centres for the international fashion trade. Artists such as Jan Dibbets, Ger van Elk and Marcel Broodthaers have been central to Conceptual art and the formation of global Post Modernism which references a wide range of cultural phenomena. Dutch architects, such as Rem Koolhaas's Office of Metropolitan Architecture (OMA), have achieved international standing with their rich interpretation of architectural form.

RENÉ MAGRITTE, THE MENACED ASSASSIN, 1926, oil on canvas. A central figure of the Surrealist movement in Brussels and Paris, using a meticulous academic style, Magritte developed a disturbing relationship between the world and objects in his paintings, placing the familiar in unfamiliar situations and spaces, enlarging elements of familiar objects, animating inanimate everyday objects such as bowler hats, baguettes, shoes and dresses, or reconfiguring anatomical parts.

GERMANY, SWITZERLAND, AUSTRIA 1900-2000

GERMANY, SWITZERLAND AND AUSTRIA, situated geographically at the very epicentre of Europe, witnessed major social and political turmoil throughout the twentieth century. These changes were to have a considerable impact upon art and artists and, as a result, the centres of artistic activity shifted around the region.

CITY AND COUNTRYSIDE

The early German Expressionist artists of the group called *Die Brücke* explored the relationship between city and countryside. Trained originally as architects in Dresden, many *Die Brücke* artists spent their early careers working in the idyllic countryside of the Moritzburg Lakes, thus following in the footsteps of artists such as Paula Modersohn-Becker who had worked extensively at a rural colony in Worpswede between 1897 and her early death in 1907. In southern Germany too, Vasily Kandinsky and Gabriele Münter left the city of Munich behind for the rural, timeless pleasures of Murnau.

However, the *Die Brücke* artists did not actually avoid the city. In 1911 many of them moved to Berlin where they painted images of modern urban life with all its glamour, excitement and dangers. In Vienna artists including Oskar Kokoschka, Gustav Klimt and Egon Schiele were also experimenting with modern art styles. Their work explored the social anxieties and sexual mores so intrinsically linked to turn-of-the-century bourgeois society.

BATHERS AT MORITZBURG, 1909–26, by Ernst Ludwig Kirchner, one of *Die Brücke* artists. Kirchner's exuberant and celebratory painting of figures bathing in the Moritzburg Lakes near Dresden epitomizes the artist's desire to go 'back to nature'. Here the bathers' bodies take on a green cast as if they are part of the natural surroundings in which they are represented. Kirchner's mythic Eden is here situated in the idyllic surroundings of the German countryside.

WORLD WARS AND ARTISTIC EXPRESSION

World War I inevitably transformed the cultural climate. The city of Zurich, in neutral Switzerland, soon became a mecca for artists escaping the conflict. This hotbed of political and pacifist activity became the spawning ground for the Dada movement that was soon to spread its influence to cities such as Cologne, Hanover, Dresden and Berlin. In the confused years of post-war reconstruction Germany became a centre of artistic experimentation in many media. Artists such as George Grosz, John Heartfield and Hannah Höch all produced illustrations for popular journals while training centres such as the Bauhaus contributed to a design revolution. Founded in Weimar in 1919, the Bauhaus drew artists from throughout the region and beyond. Forced to move to Dessau in 1925 and again to Berlin in 1932 before eventually being closed the following year, the

1 IN CONTRAST TO FRANCE, where many modern artists established their reputations and their studios almost exclusively in Paris, Germany was home to a diverse number of artistic centres from Hanover in the north to Munich in the south. Important developments also took place in the Austrian city of Vienna and, during World War I, in Zurich in Switzerland.

1	**The Modern Movement**
D	Dada site
🏕	rural site for modern painting
✍	centre of artistic training
○	Bauhaus site (Kandinsky and Gabo from Moscow; Moholy-Nagy from Budapest; Klee from Bern; Kokoschka from Vienna to Bauhaus to teach)
😊	Expressionism site
⌂	architectural site

Bauhaus has come to symbolize experimentation and innovation in all forms of art and design as well as in its teaching methods.

When the National Socialists came to power in 1933, the cultural landscape of central Europe was once again transformed. Art was of vital importance to Hitler's regime and he moved early on to control the production and display of art throughout the region. Munich was destined to be the new capital of the arts of the Third Reich, and with this objective in mind Hitler called upon the architect Paul Troost to build a new museum in his favoured Neoclassical style: the House of German Art. To coincide with the opening of this new museum, however, the National Socialist regime also launched an exhibition showing the art that it regarded as anathema to its ideals. The works of modern German, Swiss and Austrian artists such as Otto Dix, Paul Klee and Oskar Kokoschka were subsequently confiscated from museums throughout the territories of the Third Reich and

MILLIONS STAND BEHIND ME, 1932, by John Heartfield. Heartfield was a highly political artist whose images were mass-produced and disseminated throughout the country in the workers' journals of the day. In this work Heartfield condemns those who funded Hitler's rise to power. Heartfield was best known for his use of the photomontage technique.

were put on exhibition in a deliberately negative light in the so-called 'Degenerate Art' exhibitions. These exhibitions toured throughout Germany, Switzerland and Austria from 1937 onwards.

In this grim climate, many of the nation's best-known artists fled the country, spending the war years in England or the United States. Hitler's grandest plan for the arts was, however, never to be completed. In 1939 he called upon his favourite architect, Albert Speer, to build a monumental museum in Linz, in Hitler's native Austria. The so-called *Fuhrermuseum* was planned on a gigantic scale and was intended to house the greatest collection of art ever assembled. This museum was planned to be the culmination of Hitler's policy of confiscating works of art from private and public collections throughout the territories conquered by the military might of the Third Reich.

POST-WAR TURMOIL
Following the defeat of National Socialism in 1945, Germany entered a new period of instability and turmoil. With the occupation of the east of the country by the victorious Soviet army Germany was now divided into two separate states and thus became one of the key cultural battlegrounds upon which the Cold War was metaphorically fought. The dialogue between east and west was largely restricted by the Berlin Wall, yet some artists, such as Georg Baselitz and Gerhard Richter, did manage to move from east to west.

As in many other countries in Europe, the early post-war period was characterized by debates between proponents of abstraction and realism. Artists such as Willi Baumeister, whose works had been exhibited in the 'Degenerate Art' exhibitions of the 1930s, staunchly supported abstraction as the way forward for German art in the wake of the Nazi period. Having been deprived of his teaching rights during the 1930s, he now took up an influential post at the Stuttgart Academy of Arts. The tensions between abstraction and realism were, however, most keenly felt in the divided city of Berlin. Here Georg Baselitz, an artist who had been trained on both sides of the Berlin Wall, strove throughout the 1960s to find a new way to bring together figurative painting and abstraction.

It was the city of Düsseldorf, however, that was to become the primary centre of experimental art production and teaching in the second half of the twentieth century. Joseph Beuys first entered the State Academy of Art in Düsseldorf as a student in 1947. By the early 1960s he was a key figure in this prestigious teaching institution which had attracted artists of the stature of Jörg Immendorf, Sigmar Polke and Gerhard Richter. Beuys was active in the conceptual art movement known as *Fluxus* and participated in many of their exhibitions throughout Europe. The intense political climate of post-war Germany took its toll on Beuys, however, whose increasing political activism alienated him from the Düsseldorf Academy and led to his summary dismissal in 1972.

The shadow of the Nazi atrocities continues to haunt Germany, Austria and Switzerland, a factor made evident by the continuing practice of building Holocaust and anti-Nazi monuments. Some of these, constructed on the sites of former concentration camps, pay tribute to the victims of the Hitler era whilst others, erected during the 1980s, emphasize the need for continuing vigilance against a resurgence of Fascism. Such monuments, sited at strategic spots throughout the region, attest to the continuing influence of art in people's lives.

2 THE RISE AND FALL of National Socialism had a massive impact across the region. Hitler's grandiose architectural plans called for monumental public buildings in cities throughout the territories of the Third Reich as well as an extensive *autobahn* network to connect these sites. With the conclusion of the war, however, Germany was divided into two opposing states which remained in place until the nation was finally reunited in 1990.

2	Politics and the Division of Germany
	Federal Republic of Germany, 1945
	German Democratic Republic, 1945
	border of United Germany from 1990
	city where museums had modern works confiscated by the National Socialists
	venue of *Entartete Kunst* (Degenerate Art) exhibition
	site of auction of modern art under the Third Reich
	National Socialist architectural project (completed)
	National Socialist architectural project (not completed)
	routes of artists emigrating after the National Socialists took power in Germany
	anti-Nazi/Holocaust memorial
	memorial erected at former concentration camp
	autobahns, 1939: open to traffic / under construction / authorized

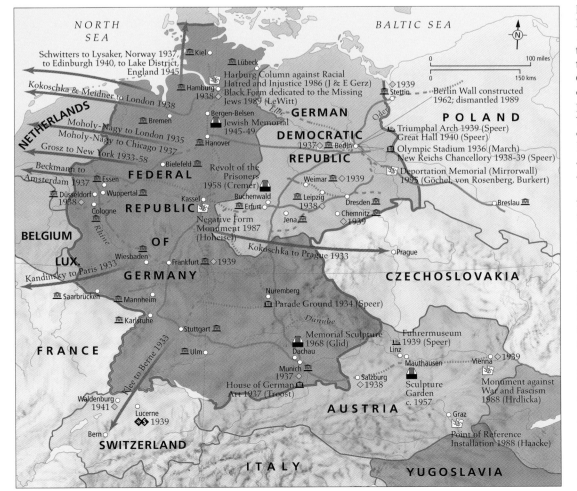

EASTERN EUROPE 1900-2000

CENTRAL AND EASTERN EUROPE is a swathe of fertile agricultural land incised by waterways that drain into the Black Sea. Until the end of World War I, this region, coveted for its rich resources, was parcelled out among four great empires, resulting in a free-flowing migration of art influences from the East and West. With the collapse of the Hapsburgs, Romanovs and Ottomans, and the redrawing of political borders after World War I, the preservation of the local material ethnographic culture, disrupted by industrialization, brought about a rise in small cottage industries of peasant handiwork. Folk-inspired decorative ceramic tiles and brick

ornament were integrated into modern regional-style architecture from Cracow to Poltava. Swedish-style outdoor architectural museums (skansen) were set up in Czechoslovakia, Poland, Romania and Hungary to physically reconstruct and preserve the degrading wooden architecture typical of village life. Naïve and primitivist art meshed long-standing folk traditions with modern urban and agricultural themes, especially throughout Yugoslavia and the Balkans. In Greece, the revival of an indigenous style reexamined and rehabilitated Byzantine and rural traditions, and the separation of Greece from its Balkan neighbours was emphasized.

THE FINE ARTS
Art colonies began to proliferate in towns and rural areas. A homegrown ethnic modernism flourished in many artists' collectives, represented by variously named societies: the Czech Eight in Prague; Polish Formists in Warsaw; Hungarian Activists in Budapest. Avant-garde exhibitions in most major cities showed works of Cubism, Futurism and Expressionism transported from France and Germany. Individual artists made long journeys away from their homelands to study at Paris' Académie Julian and the painting school of Slovenian artist, Anton Ažbè in Munich. In general, East European art of the twentieth

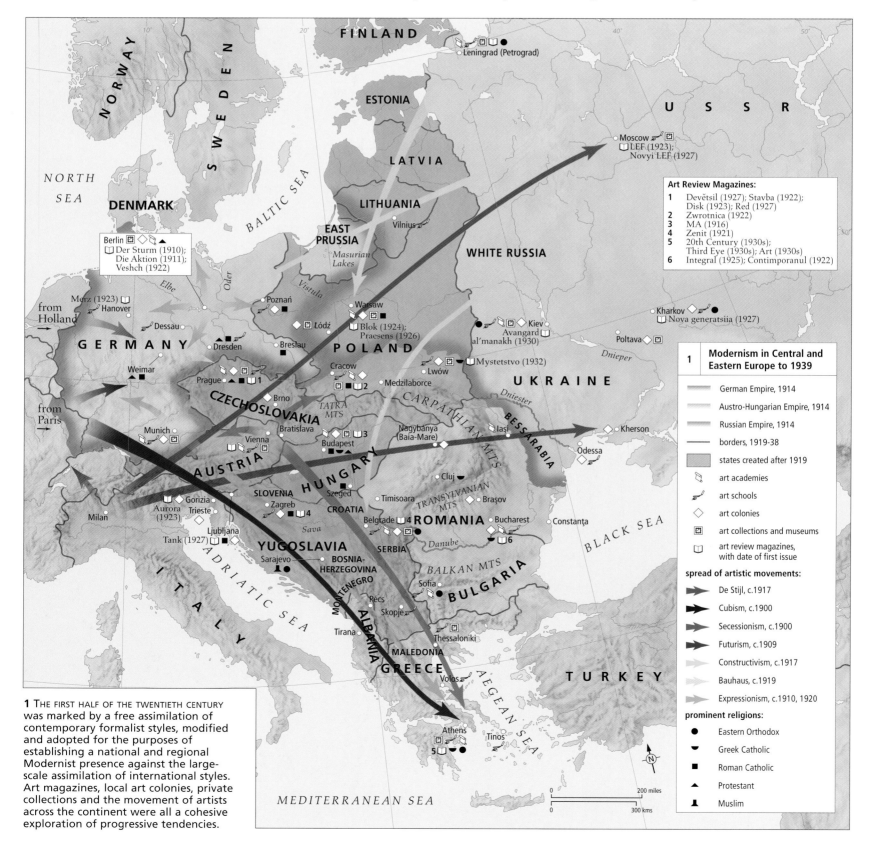

Art Review Magazines:

1 Devětsil (1927); Stavba (1922); Disk (1923); Red (1927)
2 Zwrotnica (1922)
3 MA (1916)
4 Zenit (1921)
5 20th Century (1930s); Third Eye (1930s); Art (1930s)
6 Integral (1925); Contimporanul (1922)

1 Modernism in Central and Eastern Europe to 1939

- German Empire, 1914
- Austro-Hungarian Empire, 1914
- Russian Empire, 1914
- borders, 1919-38
- states created after 1919
- art academies
- art schools
- art colonies
- art collections and museums
- art review magazines, with date of first issue

spread of artistic movements:
- De Stijl, c.1917
- Cubism, c.1900
- Secessionism, c.1900
- Futurism, c.1909
- Constructivism, c.1917
- Bauhaus, c.1919
- Expressionism, c.1910, 1920

prominent religions:
- Eastern Orthodox
- Greek Catholic
- Roman Catholic
- Protestant
- Muslim

1 THE FIRST HALF OF THE TWENTIETH CENTURY was marked by a free assimilation of contemporary formalist styles, modified and adopted for the purposes of establishing a national and regional Modernist presence against the large-scale assimilation of international styles. Art magazines, local art colonies, private collections and the movement of artists across the continent were all a cohesive exploration of progressive tendencies.

BERLIN'S *DER STURM* covers (1910–32) often featured Hungarian artists, including, as here, Lajos Kassák.

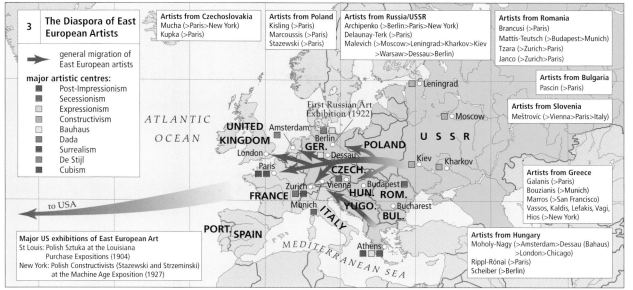

3 The Diaspora of East European Artists

general migration of East European artists

major artistic centres:
- Post-Impressionism
- Secessionism
- Expressionism
- Constructivism
- Bauhaus
- Dada
- Surrealism
- De Stijl
- Cubism

Artists from Czechoslovakia
Mucha (>Paris>New York)
Kupka (>Paris)

Artists from Poland
Kisling (>Paris)
Marcoussis (>Paris)
Stazewski (>Paris)

Artists from Russia/USSR
Archipenko (>Berlin>Paris>New York)
Delaunay-Terk (>Paris)
Malevich (>Moscow>Leningrad>Kharkov>Kiev >Warsaw>Dessau>Berlin)

Artists from Romania
Brancusi (>Paris)
Mattis-Teutsch (>Budapest>Munich)
Tzara (>Zurich>Paris)
Janco (>Zurich>Paris)

Artists from Bulgaria
Pascin (>Paris)

Artists from Slovenia
Meštrović (>Vienna>Paris>Italy)

Artists from Greece
Galanis (>Paris)
Bouzianis (>Munich)
Marros (>San Francisco)
Vassos, Kaldis, Lefakis, Vagi, Hios (>New York)

Artists from Hungary
Moholy-Nagy (>Amsterdam>Dessau (Bauhaus) >London>Chicago)
Rippl-Rónai (>Paris)
Scheiber (>Berlin)

Major US exhibitions of East European Art
St Louis: Polish Sztuka at the Louisiana Purchase Expositions (1904)
New York: Polish Constructivists (Stazewski and Strzeminski) at the Machine Age Exposition (1927)

century was marked by its uniquely peripatetic nature as national artistic identity gave way to international contact across Europe. Romanian artists Tristan Tzara and Marcel Janco originated the Dada movement in Zurich, while the Czech group, Devětsíl, staged a Dada-like Bazaar of Modern Art in Prague and Brno in 1923–4. The East European presence was strong at the 1925 Exposition Internationale des Arts Décoratifs et Industriels in Paris, and even more pronounced in frequent exhibitions as the Galerie Der Sturm in Berlin and the Bauhaus, where Hungarian László Moholy-Nagy was put in charge of the curriculum.

Artists adapted formal experimentation to the field of industry and design, creating hybridized art forms such as photomontage (Karel Teige) and 'picture architecture' (Lajos Kassák). Private collectors (Vincenc Kramář of Prague) amassed significant works of French Cubism and the first national collection and museum of contemporary art was created by Polish Constructivists in the industrial town of Łódź. Multilingual art magazines published in every East European capital facilitated the dissemination of Modernist theory. Political unrest forced artists to seek better conditions abroad, where they were absorbed into the Modernist culture of their adopted countries.

ISOLATION AND RECOVERY
After World War II Eastern Europe was subject to increasing isolation along an ideological divide. The politicized aesthetics of Soviet Socialist Realism established an artificial artistic cordon. Conventional, academic-style painting and cast bronze sculpture were reinstated for propaganda purposes on a

3 MANY EAST EUROPEAN ARTISTS made long journeys westwards, establishing their reputations abroad. Their migration reinforced the peripatetic nature of early Modernism in Eastern Europe, and exposed the effects of politically restrictive systems.

monumental scale. Foundries were erected to supply every city with its requisite statues of revolutionary heroes. Architecture resorted to classical large-scale Roman imperial models or grand 'wedding-cake' forms. Huge complexes of prefabricated high-rises replaced the visionary experimental architecture of the 1920s. In Greece, on the other hand, the regimes – even the dictatorship of Metaxas (1936–40) – encouraged modernist tendencies, with public sculptures displaying a late-romantic style and nationalist iconography.

The Khrushchev Thaw of the 1960s brought about a dissident underground movement that exchanged artistic ideas through clandestinely disseminated art materials, books, and photographs smuggled in from the West. With the destruction of the Berlin Wall in 1989, authoritarian rule and state control over artists disintegrated. Centres of Contemporary Art were set up in every major East European city facilitating a discourse over the nature of art in post-totalitarian society, and making possible a viable global exchange of art. As Communist rule became a fading memory, the restoration of sovereign national borders reinforced the rich ethnic diversity and regional integrity of East European Modernist culture.

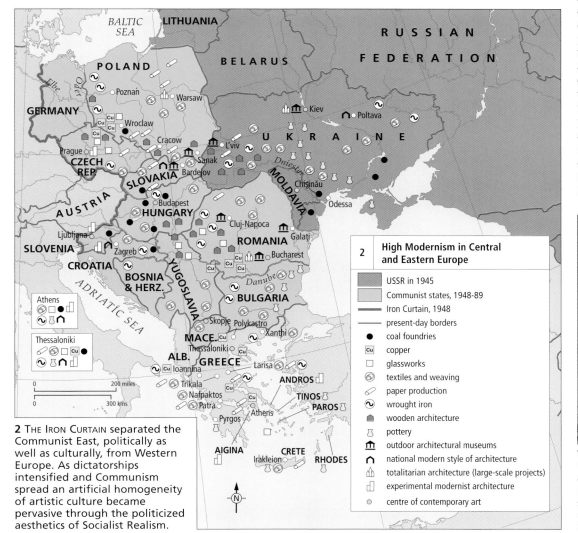

2 High Modernism in Central and Eastern Europe

- USSR in 1945
- Communist states, 1948-89
- Iron Curtain, 1948
- present-day borders
- ● coal foundries
- Cu copper
- □ glassworks
- ◉ textiles and weaving
- ✎ paper production
- ∿ wrought iron
- ⌂ wooden architecture
- ♗ pottery
- 🏛 outdoor architectural museums
- national modern style of architecture
- totalitarian architecture (large-scale projects)
- experimental modernist architecture
- ◉ centre of contemporary art

2 THE IRON CURTAIN separated the Communist East, politically as well as culturally, from Western Europe. As dictatorships intensified and Communism spread an artificial homogeneity of artistic culture became pervasive through the politicized aesthetics of Socialist Realism.

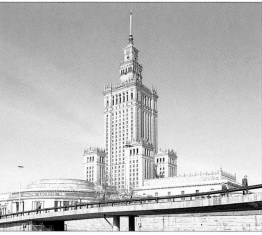

WARSAW'S PALACE OF CULTURE AND SCIENCE, built in the 1950s, is the only one of the Stalinist 'wedding cake' structures to be erected outside of Moscow. Its towering scale and dark stone symbolize the severity of authoritarian rule – a brute imposition of the Stalinist 'vampire' style on its neighbouring Soviet satellite.

FRANCE 1900-2000

MUCH OF THE ART of the pre-1914 period in France is a continuation of the late-nineteenth century commitment to stylistic experimentation. During this period foreign artists, collectors and critics converged on Paris and worked alongside native artists to create a community informally dubbed the 'School of Paris'. These included the Spanish painter Pablo Picasso (1881–1973), who settled in the city in 1904, the American author Gertrude Stein (1874–1946), who established a salon around 1905 in Montparnasse, and the Italian poet Filippo Marinetti (1876–1944), who published his manifesto of Futurism in the Paris newspaper Le Figaro in 1909.

1 CENTRED IN MONTMARTRE AND MONTPARNASSE, a 'School of Paris' developed in the French capital in the first half of the century but declined in World War II. In the 1960s the French government began funding modern museums and public sculpture that created a new and flourishing environment for contemporary art in Paris. Parisian architecture began the century with the experimental forms and materials of Auguste Perret, Le Corbusier and others, and climaxed in the 1980s and 1990s with the spectacle of President François Mitterand's *Grands Projets*.

1	Paris, Artistic Capital of the 20th Century
●	studio/patron's address
🏛	architecture
👤	sculpture
⌂	museum

THE SCHOOL OF PARIS

The two key art movements that emerged before World War I were Fauvism, unofficially led by the artist Henri Matisse (1869–1954), and a little later Cubism, which was developed by Picasso and Georges Braque (1882–1963), but taken up and disseminated by several other artists, including the Puteaux Cubists (named after the Paris suburb where they lived), whose members included the Franco-American Marcel Duchamp (1877–1968), the Spaniard Juan Gris (1887–1927), Fernand Léger (1881–1955), and Francis Picabia (1879–1953), one of the few French artists in Paris who was actually a native of the city.

In the interwar period artists profited from the support of an established group of collectors and galleries. The dominant Surrealist movement, which grew out of Dadaism, was led by the poet André Breton (1896–1966) and included painters such as the German Max Ernst (1891–1976), André Masson (1896–1987), and the Spaniards Joan Miró (1893–1983) and Salvador Dalí (1904–89). It also spawned many Surrealist groups in other nations. Breton, insisting that political engagement was key to the arts, eschewed the apolitical formalism of the pre-war period. France's cultural pre-eminence at this time was demonstrated by the major International Exhibitions of 1925 and 1937, both held in Paris.

All these early artistic movements looked beyond the traditions of Western art for inspiration: both Fauvism and Cubism were influenced by African sculpture, while the

GERTRUDE STEIN, by Pablo Picasso, 1906. A major patron, she supported the work of both Picasso and Henri Matisse. This portrait displays the flattening of form charcteristic of Cubism.

Surrealists were particularly fascinated by the art of the Pacific.

Beginning with the Fauvists' extended sojourns in St Tropez and Collioure, many major artists worked in the south of France both before and after the war. Several museums are dedicated to their work in this region, such as Matisse's Chapelle du Rosaire in Vence, the Musée Matisse in Nice, the Musée National Message Biblique of the Russian Marc Chagall (1887–1985) in Nice, the Musée Léger in Biot and the Musée Picasso in Antibes.

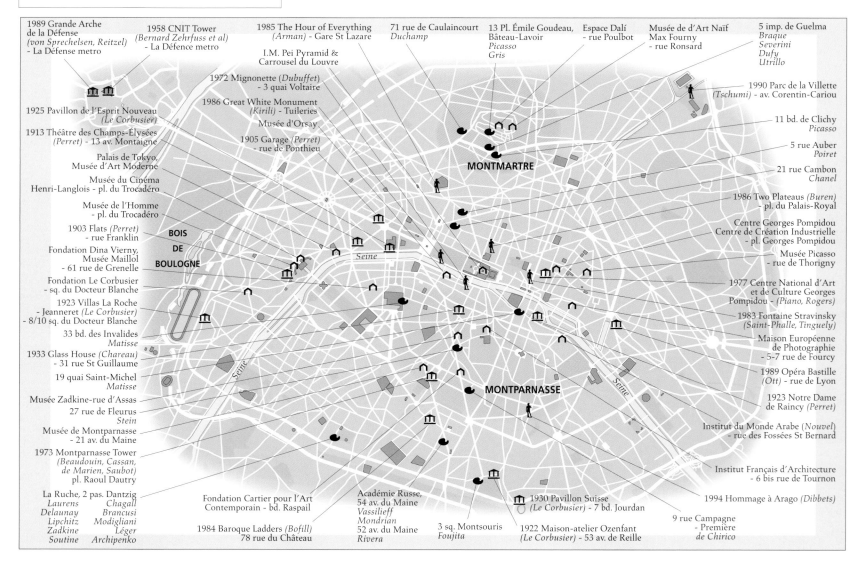

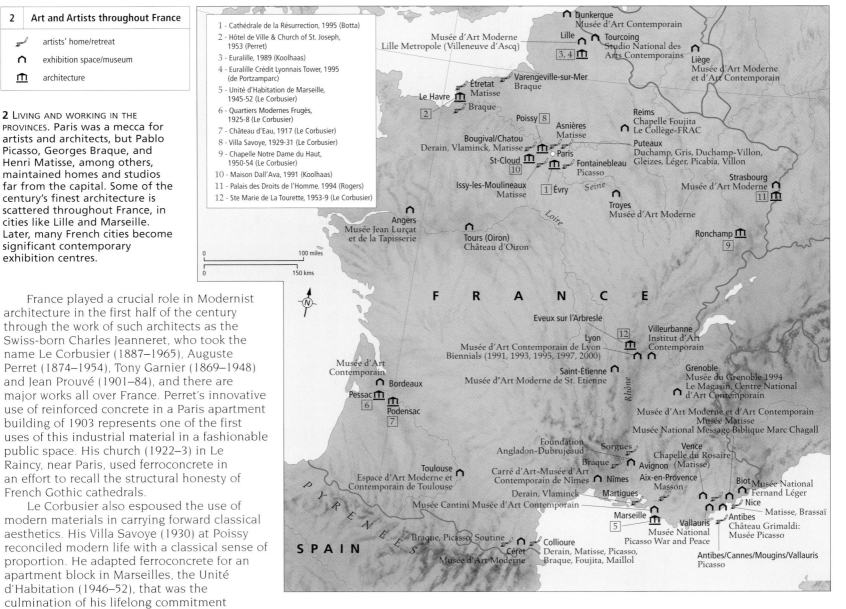

2 Art and Artists throughout France

✈ artists' home/retreat

∩ exhibition space/museum

血 architecture

1 - Cathédrale de la Résurrection, 1995 (Botta)
2 - Hôtel de Ville & Church of St. Joseph, 1953 (Perret)
3 - Euralille, 1989 (Koolhaas)
4 - Euralille Crédit Lyonnais Tower, 1995 (de Portzamparc)
5 - Unité d'Habitation de Marseille, 1945-52 (Le Corbusier)
6 - Quartiers Modernes Frugès, 1925-8 (Le Corbusier)
7 - Château d'Eau, 1917 (Le Corbusier)
8 - Villa Savoye, 1929-31 (Le Corbusier)
9 - Chapelle Notre Dame du Haut, 1950-54 (Le Corbusier)
10 - Maison Dall'Ava, 1991 (Koolhaas)
11 - Palais des Droits de l'Homme, 1994 (Rogers)
12 - Ste Marie de La Tourette, 1953-9 (Le Corbusier)

2 Living and working in the provinces. Paris was a mecca for artists and architects, but Pablo Picasso, Georges Braque, and Henri Matisse, among others, maintained homes and studios far from the capital. Some of the century's finest architecture is scattered throughout France, in cities like Lille and Marseille. Later, many French cities become significant contemporary exhibition centres.

France played a crucial role in Modernist architecture in the first half of the century through the work of such architects as the Swiss-born Charles Jeanneret, who took the name Le Corbusier (1887–1965), Auguste Perret (1874–1954), Tony Garnier (1869–1948) and Jean Prouvé (1901–84), and there are major works all over France. Perret's innovative use of reinforced concrete in a Paris apartment building of 1903 represents one of the first uses of this industrial material in a fashionable public space. His church (1922–3) in Le Raincy, near Paris, used ferroconcrete in an effort to recall the structural honesty of French Gothic cathedrals.

Le Corbusier also espoused the use of modern materials in carrying forward classical aesthetics. His Villa Savoye (1930) at Poissy reconciled modern life with a classical sense of proportion. He adapted ferroconcrete for an apartment block in Marseilles, the Unité d'Habitation (1946–52), that was the culmination of his lifelong commitment to inexpensive urban housing.

WORLD WAR II AND LATER

In the 1930s there was an exodus of French and foreign-born artists from Paris as Fascism spread across the Continent. Many artists returned to their home countries, while a substantial number, notably many Surrealists,

emigrated to the United States. However, following a period of recovery after World War II, France again established itself as a major art centre, though without recovering its earlier supremacy.

In the 1960s the Nouveaux Réalistes, which included such artists as Yves Klein (1928–62), Arman (1928–) and Jean Tinguely (1925–91), successfully asserted themselves in the international art market. Paris once again became a magnet for foreign artists, as Tinguely collaborated with his American wife Niki de Saint-Phalle (1930–2002) while the French artist Jeanne-Claude (1935–) worked exclusively with her Bulgarian husband Christo Javacheff (1935–). French contemporary art was further helped in the 1970s when the government began devoting large resources to its creation and exhibition. In the 1980s this project was expanded with the establishment of a series of collecting centres, called Regional Collections of Contemporary Art.

In the last decade of the century, artists such as Christian Boltanski (1944–) and Pierre et Gilles (working from 1976), have continued to treat contemporary art themes, particularly the search for personal identity in a fractured postmodern world. The Dutch architect Rem Koolhaas's (1944–) master plan for the transportation hub near Lille, dubbed Euralille, is notable and features buildings by Koolhaas and Christian de Portzamparc (1944–). Cities outside of Paris have become more significant in a decentralized, global art market. For example, the Lyon biennials of the 1990s established that city as a major contemporary art exhibition centre.

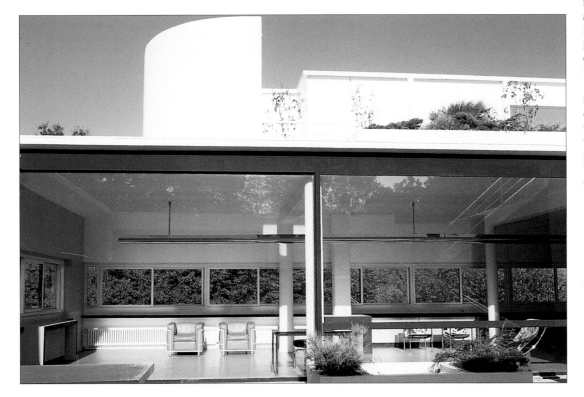

LE CORBUSIER'S VILLA SAVOYE (1929–31), POISSY: a view into the living room. Built as a traditional French country home, but of concrete, the villa is designed to display the geometric clarity of the machine aesthetic. Le Corbusier argued that this type of 'House-Machine' demonstrated classical beauty in the modern industrial world.

SPAIN AND PORTUGAL 1900-2000

IN 1900 THE IBERIAN PENINSULA was confronted with a century of upheaval, revolution and modernization. In 1898 Spain's loss of colonies in the Spanish-American War was the final blow to its imperialist pretentions, causing continuing economic distress. By declaring itself neutral during World War I, Spain benefitted economically, but rampant inflation caused much civil unrest, and a military *coup d'état* seized control of the government in 1923. In 1931 a Second Republic was declared; in 1934, the Fascist Falangist Party was founded. Between 1936 and 1939, and after 1945, Fascist Spain was ostracized by the international community. The tourist boom of the 1960s finally led Spain towards economic modernization.

In Portugal a revolution in 1910 unseated the ruling house of Bragança and a republic was declared, but true democracy was never practised and the army changed governments at will. In 1932 Antonio de Oliviera Salazar seized power, creating a 'New State' modelled on Italian Fascism, which served as a precursor for the Spanish state later shaped by Francisco Franco. Salazar died in 1970 and Franco died in 1975, when Spain became a constitutional monarchy. Both Iberian states entered the EU, but Portugal remained the poorest member.

ARTISTIC TRENDS AND INFLUENCE

After the turn of the century, the literary 'Generation of '98' set out to renew Spanish culture through reappraisals of its moribund traditions. At the same time, another progressive group sought to formulate a 'modernistic' spirit to cope with the profoundly altered world in which they found themselves. This sense of modernity was later to acquire a more aggressive political tone (*el vanguardismo*). The major centre of creative ferment was Barcelona, newly wealthy from its manufacturing economy and always more culturally energetic and centrifugally 'European' than dour and centralist Madrid. Catalans themselves were keenly aware that they were taking part in a renaissance – not merely artistic, but also musical, literary, industrial, scientific, even political. This Catalan creative fervour came to the attention

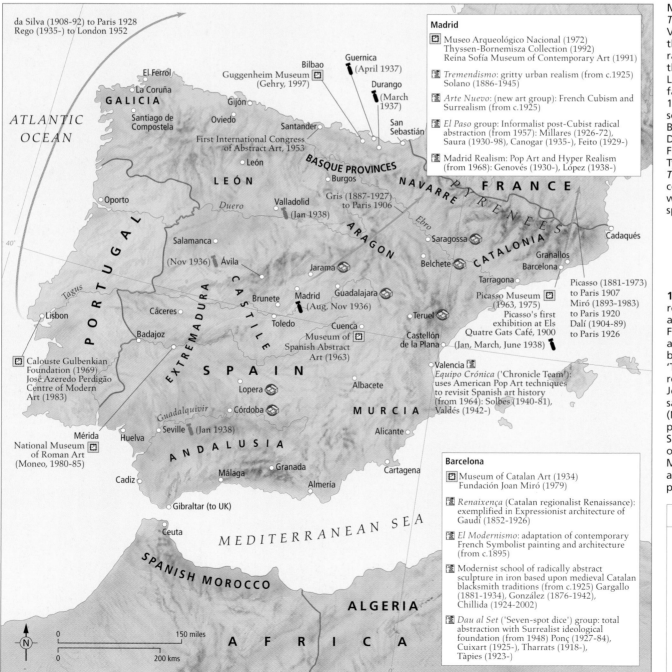

Madrid

- 📷 Museo Arqueológico Nacional (1972)
 Thyssen-Bornemisza Collection (1992)
 Reina Sofía Museum of Contemporary Art (1991)
- 🖼 *Tremendismo*: gritty urban realism (from c.1925)
 Solano (1886-1945)
- 🖼 *Arte Nuevo*: (new art group): French Cubism and Surrealism (from c.1925)
- 🖼 *El Paso* group: Informalist post-Cubist radical abstraction (from 1957): Millares (1926-72), Saura (1930-98), Canogar (1935-), Feito (1929-)
- 🖼 Madrid Realism: Pop Art and Hyper Realism (from 1968): Genovés (1930-), López (1938-)

Barcelona

- 📷 Museum of Catalan Art (1934)
 Fundación Joan Miró (1979)
- 🖼 *Renaixença* (Catalan regionalist Renaissance): exemplified in Expressionist architecture of Gaudí (1852-1926)
- 🖼 *El Modernismo*: adaptation of contemporary French Symbolist painting and architecture (from c.1895)
- 🖼 Modernist school of radically abstract sculpture in iron based upon medieval Catalan blacksmith traditions (from c.1925) Gargallo (1881-1934), González (1876-1942), Chillida (1924-2002)
- 🖼 *Dau al Set* ('Seven-spot dice') group: total abstraction with Surrealist ideological foundation (from 1948) Ponç (1927-84), Cuixart (1925-), Tharrats (1918-), Tàpies (1923-)

MARÍA-ELENA VIEIRA DA SILVA, *The Town*, 1955, oil on canvas. Vieira da Silva (1908–92) was the only internationally ranked Portuguese painter of the twentieth century. Born in Lisbon into a rich, liberal family, she moved to Paris in 1928, where she studied sculpture with Antoine Bourdelle and Charles Despiau, later painting at Fernand Léger's academy. Typical of her mature work, *The Town* is abstract and wiry, composed of prismatic forms which stretch out through space.

1 FROM C.1895, 'El modernismo' represented the local adaptation of contemporary French Symbolist painting and architecture. In Madrid beginning around 1925 'Tremendismo', a gritty urban realism, was championed by José Gutiérrez Solano. At the same time The 'Arte Nuevo' (New Art) group timidly pursued French Cubism and Surrealism until the outbreak of the Civil War. In Barcelona a Modernist school of radically abstract sculpture in iron was pioneered from c.1925.

1	Portable Art, 1900-2000
→	Iberian painters' travels abroad
🖼	schools of painting/sculpture
📷	major art collections

Spanish Civil War, 1936-39:

▨	Nationalist territory by July 1938
⚑	Nationalist air raid (with date)
⚑	Republican air raid (with date)
⚙	'International Brigade' operations

of the outside world through the work of an inspired architect, Antoní Gaudí (1852–1926).

After a permanent exhibition of Iberian art was installed in the Louvre in 1906, Paris became the chosen residence for most of the memorable artists of the Spanish avant-garde – Juan Gris, Pablo Picasso, Joan Miró and Salvador Dalí (who also made regular visits to Cadaqués in northeast Spain). After 1906, 'primitive' Iberian art suddenly became popular among avant-garde artists. In 1907, Picasso began to use 'primitive' Iberian motifs. Picasso's *Guernica* was commissioned for the Republican Spanish Pavillion in Paris, and exhibited there in 1937. The Surrealist canvases of Joan Miró were exhibited in New York after 1941, and these influenced future American practitioners of Abstract Expressionism.

SCHOOLS OF PAINTING
In Barcelona the *Renaixença* ('Renaissance') is exemplified in the expressionist architecture of Gaudí. *El modernismo* represents the local adaptation of contemporary French Symbolist painting and architecture. A later offshoot of these tendencies is seen in the work of the Catalan painter Joan Miró (1893–1983). In Madrid, *Tremendismo*, a gritty urban realism, was championed by José Gutiérrez Solano (1886–1945) from around 1925. The *Arte Nuevo* ('New Art') group timidly pursued French Cubism and Surrealism before the outbreak of the Civil War. The only internationally ranked Portuguese painter, María Elena Vieira da Silva, worked in exile in France; a rising star following in her lead is Paula Rego (1935–), based in London.

2 Notable Iberian twentieth-century architectural monuments exemplify various approaches to Modernism beginning in Barcelona with the Casa Calvet (1904) by Antoní Gaudí. Architectural conservatism characterized Castile after the Civil War. In Madrid, the Air Ministry, 1941–57, by L. Gutiérrez Soto, was a prime example of Franco-era Fascist architecture derived from the Escorial, nostalgically symbolizing Catholic imperialism. After the death of Franco, architecture joined the European mainstream, as characterized by commissions designed by Rafael Moneo and Philip Johnson. The flashy Guggenheim Museum, designed by Frank Gehry, opened in 1997, making Bilbao a tourist mecca.

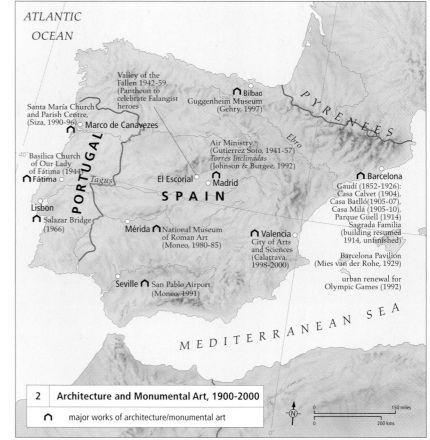

2	Architecture and Monumental Art, 1900-2000
⌂	major works of architecture/monumental art

SCULPTURE AND ARCHITECTURE
In Barcelona a Modernist school of radically abstract sculpture in iron based on medieval Catalan blacksmith traditions, was pioneered by Pablo Gargallo (1881–1934) and Julio González (1876–1942). The sculptor Eduardo Chillida (1924–2002) later followed similar lines of reductive abstraction. In Barcelona, the *Dau al Set* ('Seven-spot Dice') group, founded in 1948, practised total abstraction with a surrealist ideological foundation; its major exponents were Joan Ponç (1927–84), Modest Cuixart (1925–), Joan-Josep Tharrats (1918–), and Antoní Tàpies (1923–). Founded in 1957 in Madrid, the *El Paso* group adopted 'Informalist' post-Cubist radical abstraction; its central figures are Manuel Millares (1926–72), Antonio Saura (1930–98), Rafael Canogar (1935–), Luis Feito (1929–). Founded in 1964, the *Equipo Crónica* ('Chronicle Team'), centred in Valencia, used American Pop Art techniques to revisit Spanish art history; its founders were Rafael Solbes (1940–81), and Manuel Valdés (1942–). Founded in 1968, the school of Madrid Realism melded Pop Art and Hyper Realism; the principal practitioners are Juan Genovés (1930–) and Antonio López (1936–).

An outstanding twentieth-century architectural legacy in Iberia is spearheaded by the work of Gaudí, who died in a traffic accident in 1926, leaving the Sagrada Familia project, begun in 1914, unfinished. In Madrid, the Air Ministry (1941–57), designed by L. Gutiérrez Soto, is a prime example of Franco-era Fascist architecture. It is derived from the Escorial palace, In contrast, Madrid also boasts the *Torres Inclinadas*, financial headquarters of the Caja de Madrid, designed by Philip Johnson and John Burgee and opened in 1992. In Bilbao the Guggenheim Museum, designed by Frank Gehry, and opened in 1997, made the city a tourist mecca.

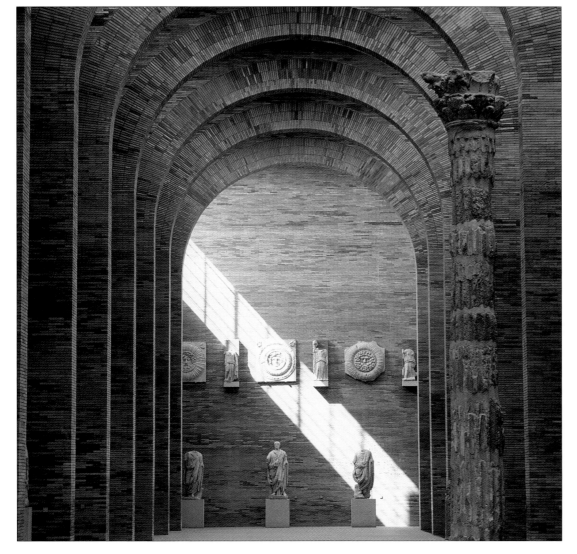

Rafael Moneo, National Museum of Roman Art, Mérida, 1980–85. Suspended above the excavated ruins of Roman Mérida, the archaeological museum designed by this widely acclaimed architect (1937–) achieves a brilliant Post-Modern synthesis of indigenous forms and materials. This is a building which partakes at once of the ancient and of the modern; while employing the Modernist format of a concrete core, the soaring, light-filled interior arcades are revetted in bricks deliberately proportioned to simulate ancient Roman terracotta building blocks.

ITALY 1900-2000

THROUGHOUT THE TWENTIETH CENTURY, Italy underwent major social and political changes that inevitably impacted considerably on the production of art. One theme, however, remained dominant throughout the century; namely, the tension between Italy's Classical past and its desire to be recognized as a modern nation-state.

FROM SYMBOLISM TO FUTURISM
At the turn of the twentieth century Italian art remained much influenced by current trends in Paris. Symbolism and Neo-Impressionism continued to dominate modern art exhibitions as evidenced in the work of artists such as Giovanni Pelizza da Valpedo (1868–1907) and Gaetano Previati (1852–1920). However, the new national identity which had been forged in 1870 with the movement for unification was soon to explode dramatically onto the art scene through the activities of one of Italy's most influential twentieth-century cultural figures, Filippo Tommaso Marinetti (1876–1944). In 1909 Marinetti launched the movement known as Futurism upon the world stage. Futurism demanded the rejection of all past art and called upon artists and writers to celebrate the modern age. The ultimate symbol of modernity for Marinetti and his Futurist colleagues was the motor car. The industrial centres of Milan and Turin, where much Futurist activity was based, were also home to the Fiat and Pirelli factories, both major players in the burgeoning automobile industry in the early twentieth century.

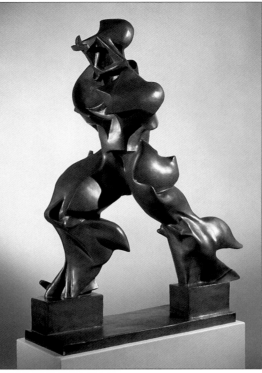

UMBERTO BOCCIONI, *Unique Forms of Continuity in Space,* 1913. Boccioni's most famous sculpture represents, in true Futurist style, an aggressive, powerfully striding figure whose dynamic movement forward cannot be captured by reference to a static moment. Yet, despite the Futurist cry to reject art of the past, the work has most frequently been compared to the Classical sculpture, the *Victory of Samothrace.*

Futurism, however, did not confine itself to Milan and Turin. From the start Marinetti looked to promote the movement nationally and internationally. Exhibitions drew attention to the movement while artists' clubs were formed in Ferrara, Florence, Rome and Taranto. Journals such as *Poesia* and *Lacerba* also promoted Futurism. Within three years of Marinetti's announcement of the birth of the movement, Futurist exhibitions were staged in Paris, London, Berlin, Amsterdam, Zurich, Vienna and Budapest and Futurist groups were formed as far afield as England, France, Germany, Russia, Mexico and Japan.

METAPHYSICAL PAINTING
While Futurism staunchly rejected the past, other modern movements identified a nostalgia for the now faded Classical grandeur of Italy as a major influence in their art. Giorgio de Chirico (1888–1978) first developed the style that he later called Metaphysical Painting while in Milan. It was in the more sedate surroundings of Florence, however, that he subsequently developed his emphasis on strange, eerie spaces, based upon the Italian piazza. Many of de Chirico's works from his Florence period evoke a sense of dislocation between past and present, between the individual subject and the space he or she inhabits. These works soon drew the attention of other artists such as Carlo Carrà (1881–1966) and Giorgio Morandi (1890–1964). In 1917, in the midst of the First World War, Carrà and de Chirico spent time in Ferarra where they further developed the Metaphysical Painting style that was later to attract the attention of the French Surrealists.

ART UNDER MUSSOLINI
The initial phase of Italian Futurism effectively collapsed with the outbreak of the First World War. Although many Futurist artists had openly supported military conflict the experiences of war transformed many attitudes. Some artists, such as Umberto Boccioni (1882–1916) were killed during the conflict. The rise to power of

1 THROUGHOUT THE TWENTIETH CENTURY Italy struggled to overcome the sharp divisions between the industrial north and rural south. The growth of cities like Milan and Turin in the north acted as the catalyst for the emergence and development of Futurism, a movement much enamoured of modernity, and symbolized by the Italian car industry. Through both the rise and subsequent fall of Fascism, however, Rome has retained a pre-eminence as the first cultural city of the nation.

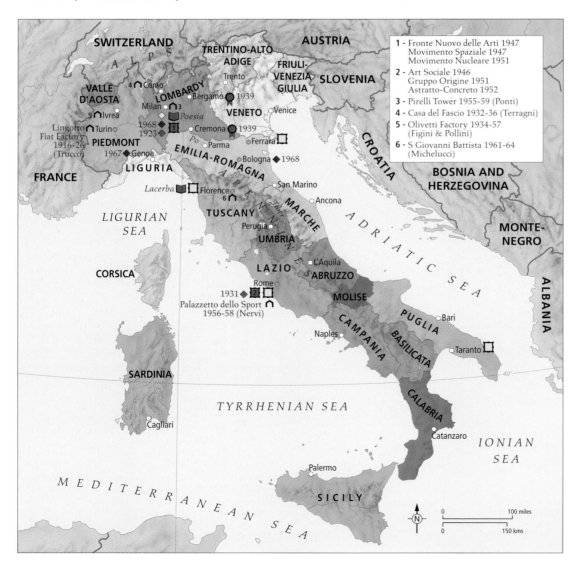

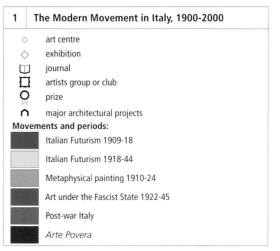

1	The Modern Movement in Italy, 1900-2000
○	art centre
◇	exhibition
⬓	journal
☐	artists group or club
♀	prize
∩	major architectural projects

Movements and periods:

	Italian Futurism 1909-18
	Italian Futurism 1918-44
	Metaphysical painting 1910-24
	Art under the Fascist State 1922-45
	Post-war Italy
	Arte Povera

Map labels:

1 - Fronte Nuovo delle Arti 1947
Movimento Spaziale 1947
Movimento Nucleare 1951
2 - Art Sociale 1946
Gruppo Origine 1951
Astratto-Concreto 1952
3 - Pirelli Tower 1955-59 (Ponti)
4 - Casa del Fascio 1932-36 (Terragni)
5 - Olivetti Factory 1934-57 (Figini & Pollini)
6 - S Giovanni Battista 1961-64 (Michelucci)

SWITZERLAND, AUSTRIA, TRENTINO-ALTO ADIGE, FRIULI-VENEZIA GIULIA, SLOVENIA, VALLE D'AOSTA, LOMBARDY, VENETO, PIEDMONT, EMILIA-ROMAGNA, CROATIA, BOSNIA AND HERZEGOVINA, FRANCE, LIGURIA, LIGURIAN SEA, TUSCANY, MARCHE, MONTE-NEGRO, CORSICA, UMBRIA, ADRIATIC SEA, LAZIO, ABRUZZO, ALBANIA, MOLISE, PUGLIA, CAMPANIA, BASILICATA, SARDINIA, CALABRIA, TYRRHENIAN SEA, IONIAN SEA, MEDITERRANEAN SEA, SICILY

Como, Trento, Bergamo 1939, Milan, Ivrea, *Poesia*, 1968, 1923, Cremona 1939, Venice, Lingotto Fiat Factory 1916-26 (Trucco), Turin, Po, Parma, Ferrara, 1967 Genoa, Bologna 1968, *Lacerba*, Florence, San Marino, Ancona, Perugia, L'Aquila, Rome, 1931, Palazzetto dello Sport 1956-58 (Nervi), Bari, Naples, Taranto, Cagliari, Palermo, Catanzaro

0 100 miles
0 150 kms

sites of archaeological interest cleared and promoted during Mussolini's reconstruction of Rome

Via dell'Impero triumphal route

1 - Mausoleum of Augustus & Ara Pacis Augustae 1934-38
2 - Theatre of Marcellus
3 - Campidoglio
4 - Basilica of Maxentius
5 - Piazza Venezia
6 - Palazzo delle Esposizioni
7 - Castel Sant' Angelo
8 - Piazza Navona
9 - Piazza della Rotonda
10 - Colosseum
11 - Palazzo del Lithorio

2 THE RISE OF FASCISM during the inter-war years led to the wholesale reconstruction of Rome. The Fascists, under Mussolini, sought to exploit Rome's past grandeur and used architecture and planning to declare the notional power and legitimacy of the new regime. Sites of Roman archaeological and historical interest, such as the Mausoleum of Augustus, the Theatre of Marcellus, the Campidoglio and the Basilica of Maxentius were all systematically cleared and integrated into a new city plan. Great triumphal routes such as the Via dell'Impero were also designed to form the theatrical backdrop to the excesses of Mussolini's own self image.

Communist Party. At the other extreme lay the abstract works of Alberto Burri (1915–95), frequently deploying unconventional materials such as sacking, pieces of wood and rusted metal. Similar experiments in abstraction and in the exploration of the qualities of materials were conducted in Milan by the painter, sculptor and ceramicist Lucio Fontana (1899–1968).

FROM ARTE POVERA TO THE PRESENT
Both Burri and Fontana were highly influential for the generation of artists who emerged in the late 1960s and whose works are frequently characterized under the label *Arte Povera*. This term covers the experimental works of artists as diverse as Michelangelo Pistoletto (1933–) and Jannis Kounellis (1936–). *Arte Povera* was, in essence, a fragmented movement and had centres of activity in Genoa, Bologna, Rome and Milan. Despite its adherence to the use of new and radical materials, however, a sense of the Italian Renaissance tradition often lurked just below the surface.

the Fascists under Benito Mussolini ushered in a new and complex era in Italian history. Yet, unlike art policies in Nazi Germany or the Soviet Union, the state remained open to certain aspects of modern art, as can be seen in the diverse works exhibited at the major exhibitions staged throughout the period and in the selection of winners for two new art competitions, the Cremona and Bergamo prizes, launched in 1939. The key figure here was, once again, Marinetti, who had emerged relatively unscathed from the war and was now a staunch supporter of the Fascist dictator. In 1925 he moved to Rome, now capital of the new Fascist Empire, soon to be transformed by a major building programme resulting in the clearing of major sites from ancient Roman history. It was from here in 1929 that Marinetti, along with a new wave of artists including Fortunato Depero (1892–1960), Gerardo Dottori (1884–1977) and Enrico Prampolini (1894–1956), launched a new Futurist manifesto dedicated to *Aeropittura* or Air Painting. The aeroplane was now to become the archetypal symbol of post-war Futurism.

THE AFTERMATH OF WAR
The final defeat of Mussolini in 1945 threw Italy once more into a period of great political and cultural instability. The city of Rome

remained the major cultural arena during this period as the debate between Realism and Abstraction that characterized artistic positions throughout much of Europe, continued to rage. At one end of the spectrum lay Renato Guttuso (1912–87), whose large-scale images of Sicilian peasants were inspired by, but never subordinated to, the cultural policies of the

GERARDO DOTTORI, *Portrait of the Duce,* 1933. Dottori's powerful portrait of Benito Mussolini notably represents the Italian Fascist leader in a style derived from Cubism and early Italian Futurism. Here, Mussolini's bust bursts forth from a landscape setting as if he is as powerful and indestructible as nature itself. His monumental presence, emphasized by his strong, jutting chin and robust forehead, towers over the viewer who is forced to gaze upwards at this awe-inspiring, yet profoundly intimidating, figure. Mussolini's head is here framed by a halo of aeroplanes. Thus, nature and technology are deployed to evoke the eternity and modernity of the Italian state.

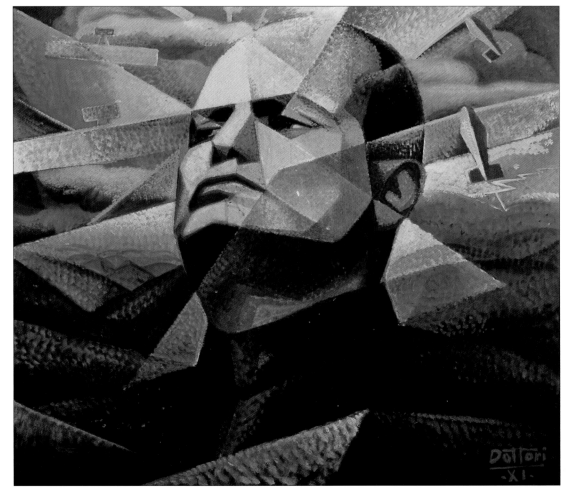

NORTH AFRICA 1900-2000

IN THE TWENTIETH CENTURY Western cultural and artistic ideas had a great impact across North Africa. Europeans administered the area as colonial rulers until the 1950s and 1960s. New movements in architecture and art then arose to reflect the indigenous heritages of the newly independent states, although Western cultural influences remained powerful.

ARCHITECTURE

Colonial rule and the arrival of settlers, especially in the Maghreb, had numerous consequences. European-style quarters were built, often using imported European materials. The buildings were erected in European styles and also in revivalist 'Arab' styles. New types of buildings, such as railway stations and banks, were introduced, and several industrial centres emerged, the most notable in the Maghreb being Casablanca, where the dock installations were begun in 1915. Some cities, especially Algiers, became a focus for European Modernist ideas. In the 1930s Le Corbusier drew up plans for the development of the city, and he designed a plan for the town of Nemours on the Algerian coast. These projects were documented in his book *Poésie sur Alger* (1950).

Although European influences remained minimal in the Sahara, the new political situation, together with the development of maritime routes and aviation, led to the demise of trans-Saharan trade. In sub-Saharan West Africa, artistic traditions were also disrupted by rapid colonization. Thus, new congregational mosques that were built under French supervision at Djenné in 1909 and at Mopti in 1935 marked the emergence of an official colonial style for the region, which also became accepted for secular buildings.

Even after independence in North Africa, many architectural projects relied on Western architects and expertise. In Libya, for example, the University of Garyounis (built 1966–77) at Benghazi was designed by James Cubitt. High-rise buildings were introduced to the major cities, such as the Hotel Meridien Africa (built 1970) in Tunis, which rose to twenty-one storeys. Japanese companies also became involved in the region: the National Cultural Centre (built 1985–8) in Cairo, for example,

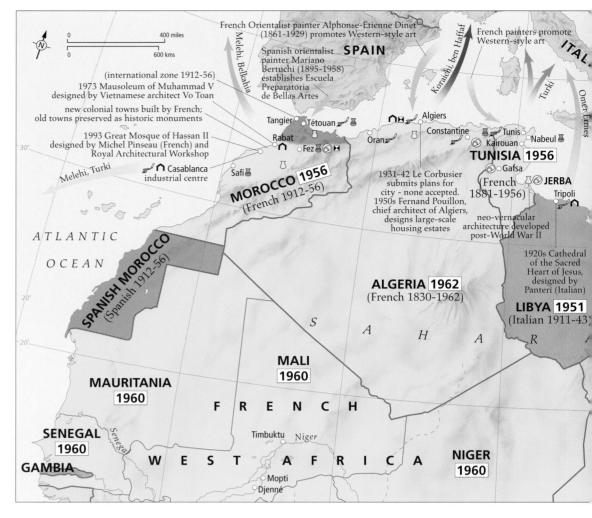

was designed by a team of architects from the Japanese firm of Nikken Sekkei.

It was against this background that some Arab architects began to examine their indigenous architectural traditions. The most influential was the Egyptian architect Hassan Fathy (1900–89). After the Second World War he designed the village of New Gourna, near Luxor, an experiment in rural regeneration that aimed at the relocation of 7,000 villagers. The inhabitants, some of whom had depended on tomb robbing for their livelihood, were to be moved there from the village of Gourna in the Valley of the Kings. The project encountered

social and administrative problems. Fathy also designed many individual buildings and by the end of his life had won international acclaim. In Tunisia, meanwhile, a neo-vernacular style of architecture was attempted, based on the traditions of Djerba Island. Regenerative projects were also implemented, such as the redevelopment of the Hafsia quarter of the Tunis *medina*, completed in 1977.

Independence led to a new role for state sponsorship in architecture. This took a number of forms, depending on the desired self-image of the state. In Morocco, for example, the monarchy promoted its legitimacy by fostering traditionalism in architecture, although often with recourse to modern techniques and foreign architects. In this category can be placed the mausoleum of Muhammad V (completed 1973) in Rabat, designed by the Vietnamese architect Vo Toan, and the vast Great Mosque of Hassan II (completed 1993) in Casablanca, designed by French architect Michel Pinseau in association with the Royal Architectural Workshop.

PAINTING AND SCULPTURE

The European belief that the so-called 'fine' art traditions of painting and sculpture represent

STUDY IN GOUACHE by Hassan Fathy of his Nasr House, Egypt (1945). Fathy graduated from the High School of Engineering in Cairo in 1926 and worked for the Egyptian Department of Municipal Affairs. From 1930 to 1946 he taught in the Faculty of Fine Arts in Cairo and, from 1946 to 1953, worked for the Antiquities Department. Active until his death in 1989, he was influential as an architect and theorist concerning the environmental significance of low-cost indigenous construction techniques.

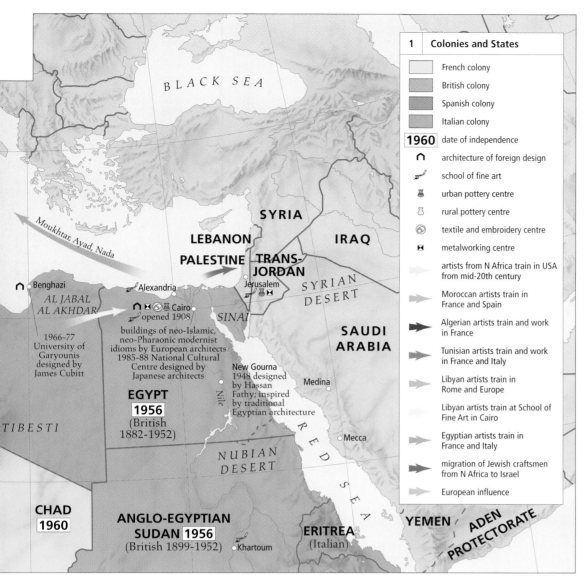

1 Colonies and States

	French colony
	British colony
	Spanish colony
	Italian colony
1960	date of independence
∩	architecture of foreign design
	school of fine art
	urban pottery centre
	rural pottery centre
	textile and embroidery centre
⊢	metalworking centre
	artists from N Africa train in USA from mid-20th century
	Moroccan artists train in France and Spain
	Algerian artists train and work in France
	Tunisian artists train and work in France and Italy
	Libyan artists train in Rome and Europe
	Libyan artists train at School of Fine Art in Cairo
	Egyptian artists train in France and Italy
	migration of Jewish craftsmen from N Africa to Israel
	European influence

1 THE CULTURAL LIFE OF NORTH AFRICA was dominated in the first half of the century by colonialism, but with the emergence of independent nations (in the years shown in white boxes), new movements in architecture and art reflected the indigenous heritage. At the same time, Western artistic influences remained powerful, with attention shifting increasingly to the United States.

(1945–) from Libya, Rachid Koraichi (1947–) from Algeria, and Mehdi Qotbi (1951–) from Morocco. In the Maghreb some artists employed Berber motifs in a similar manner.

TRADITIONAL CRAFTS
Textiles, metalwork, woodwork, pottery and other crafts continued to be produced in many of the traditional urban centres, such as Fez, Tunis and Cairo. With the European colonial presence, however, some new styles and techniques were adopted, and imported materials became available. In Morocco, where the French implemented policies to protect indigenous traditions, there was greater continuity and more conservatism. Rural Berber traditions in architecture, textiles, jewellery and other arts were also given a measure of protection. In general, urban rather than rural arts were most affected by Western influences. From the 1960s, mass tourism constituted a new form of patronage.

NJA MAHDAOUI *Calligram,* 1994, 40 × 50cm (15½ × 19½ in). Calligraphy was a dominant theme in the work of this Tunisian painter. With his emphasis on visual, painterly qualities rather than on calligraphy *per se*, he created a lyrical and abstract style that was at once relevant in the context of Western art yet distinct from it.

the apogee of artistic achievement had a notable impact in the colonized lands. Although there was some admiration in Europe for North African craft techniques, it was generally believed that Arab cultural and artistic achievements belonged to the medieval era, and that since then there had been a decline.

Influenced by European artistic norms, fine-art movements developed across North Africa. In 1908 a School of Fine Art was founded in Cairo to train Egyptian artists in Western styles and techniques – the first to open in Arab lands. Among the first graduates were some of the pioneering figures of the new Egyptian fine-art movement. They included the sculptor Mahmoud Moukhtar (1891–1934), whose large granite statue *The Awakening of Egypt* (1927) dominated the entrance to Cairo University, and the painters Mohamed Naghi (1880–1956), Mahmoud Said (1897–1964) and Ragheb Ayad (1892–1980). Similar movements were encouraged in other regions. In Algeria, for example, Western-style art was promoted by the French Orientalist painter Alphonse-Etienne Dinet (1861–1929), while in Morocco the Spanish Orientalist painter Mariano Bertuchi (1895–1958) established the Escuela Preparatoria de Bellas Artes in Tétouan.

Following independence, North African artists working in the fine-art context

continued to visit Europe or, increasingly, the United States as part of their training and to exhibit their work. While absorbing the current preoccupations of the Western tradition, they also began to search for new ways to express their own identity. One result was calligraphic painting, which started to appear in North Africa and elsewhere in the Muslim world in the 1950s and 1960s. Representatives of this movement in North Africa include Nja Mahdaoui (1937–) from Tunisia, Ahmed Moustafa (1943–) from Egypt, Ali Omar Ermes

2 NEW GOURNA by Hassan Fathy. The village, built from the late 1940s, did not attract residents, and the design was only partially implemented. Clearly seen on the plan are Fathy's use of domed mud-brick houses with courtyards, and clusters of houses arranged around small open spaces.

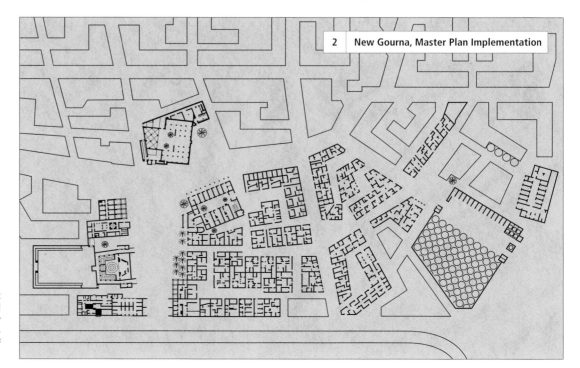

2 New Gourna, Master Plan Implementation

EAST AND CENTRAL AFRICA 1900-2000

THE SO-CALLED 'TRADITIONAL' ARTS of wood carving (figures, masks, and domestic implements), pottery making, blacksmithing, house-building and personal decoration continued fairly well intact from the late nineteenth century into the 1930s and 1940s in East and Central Africa. Fine Arab- and Islam-influenced wood portals survived into the twentieth century in Zanzibar and other coastal trading centres, as did varied figural memorial posts. Yet as in most of the

continent, this was a time of overwhelming change and adaptation to the structures, ideas and materials of colonial overlords who established hegemony around 1900.

THE COLONIAL IMPACT

In the period prior to the 1950s the following forms were introduced: a money economy, Western schooling, Christian missions, European political forms, dress, trains and automobiles. By 1950 arts were being affected by these imports. Many earlier forms were eroding, some becoming extinct. By 1965, in most places, governments established by the French and British had become independent, yet foreign impact continued to the end of the millennium. Nevertheless, there were exceptions; masked dances continued to

feature in coming-of-age and agricultural rituals in remote Angola, Zambia and Zaire into the 1970s and later.

By 1950 tourism was common in East and Central Africa, with emerging cities such as Kampala, Nairobi, Mombasa, Dar es Salaam, Kinshasa becoming sites of tourist art production, often by Kamba or Makonde men. As many as 10,000 men were involved in making tourist arts at any one time. Cottage industries also produced stamped, batiked and tie-dyed fabrics, as well as baskets and some toys.

Cities also became sites for instruction in painting, sculpture, pottery and textile design in art schools which had been established by Europeans and continued to be influenced by European teachers, styles and materials rather

ELABORATELY DECORATED SWAHILI portals with interlocking parts such as this (in the collection of the Museum für Volkerkunde), some dating as early as the sixteenth century, were concentrated in Zanzibar, Lamu and Mombasa. Most were in place in the early decades of the twentieth century, but by the end of the century had largely been removed to museums or private collections. In place, these doorways reflected the wealth of their owners from trade in the Muslim-dominated Indian Ocean.

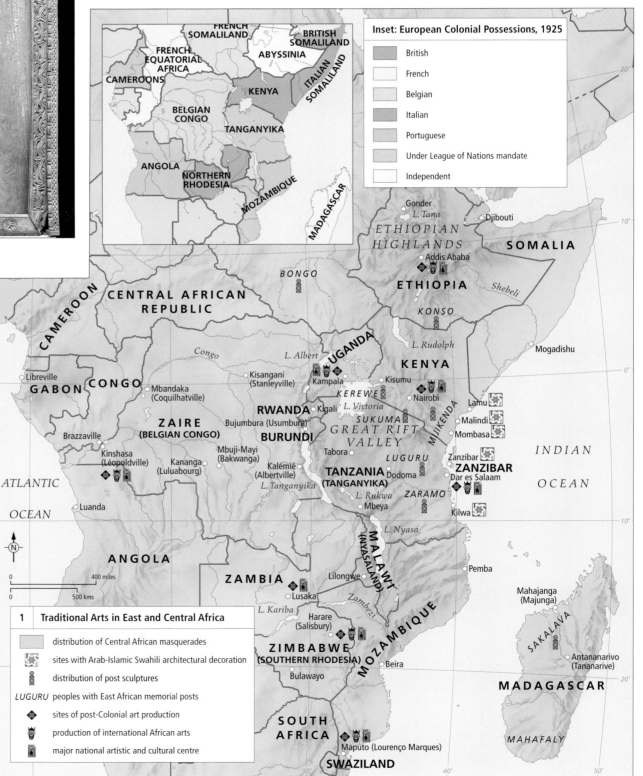

1 AS IN THE WHOLE of the African continent, the overwhelming impact of European colonial powers transformed the visual, material and ideological cultures of East and Central Africa irrevocably in the twentieth century. Changes that had begun in the late nineteenth century accelerated by the 1930s and 1940s, and by the era of Independence (c.1960–65), had become wholesale and extreme, especially in expanding urban regions. Traditional dress, household material culture and architectural forms remained intact, if modified, in remote rural areas, however, until the end of the century.

Inset: European Colonial Possessions, 1925

- British
- French
- Belgian
- Italian
- Portuguese
- Under League of Nations mandate
- Independent

1	**Traditional Arts in East and Central Africa**
	distribution of Central African masquerades
	sites with Arab-Islamic Swahili architectural decoration
	distribution of post sculptures
LUGURU	peoples with East African memorial posts
	sites of post-Colonial art production
	production of international African arts
	major national artistic and cultural centre

than by village-based traditions. These included centres at Makerere University in Uganda, founded by M. Trowell in 1939, and the Atelier d'Art Le Hangar, established by P. Roman-Desfosses in Elizabethville, Congo, in 1953. Europeans were the main patrons of these art forms. The late 1960s saw the invention of a form of popular urban painting in Zaire (now Congo) called *Colonie Belge* which depicted apparently earlier colonial topics but actually referred to then current political violence under the corrupt presidency of Mobutu Sese Seko. These were painted on flour sacks and sold cheaply in great numbers in many cities.

Thus in 1975, there was a multiplicity of art forms in the region. It would have been possible to visit a university-trained painter of figures or landscapes in acrylics by European conventions, a *mukanda* initiation among Chokwe-related groups in Angola or Zambia with masked dances, a self-trained sign painter in Mombasa, an urban painter of political themes in Lubumbashi, or a workshop near Dar es Salaam where Makonde carvers daily turned out hundreds of tourist carvings of animals or stacked human figures in ebony.

AFRICAN-INSPIRED ART

Towards 2000 few rural arts (which could be described as pre-colonial), such as masquerades or shrines with figural sculptures, were to be found, apart from occasional masquerading, and continuing personal decoration among East African pastoralists. Many portable artworks had been stolen or purchased from their original sites in Congo, Angola, Gabon and Kenya, ending up on the international art market in Paris, Brussels, London or New York. By the 1980s most countries boasted a number of self-taught and school-trained painters, and modern, manifestly post-colonial artists whose work was sold in galleries or hung in museums. Painting often replaced sculpture as the dominant form. Artists' workshops were held in a number of places in the late 1980s and 1990s, and some African artists were invited to biennial exhibitions in Dakar, Johannesburg, or Venice.

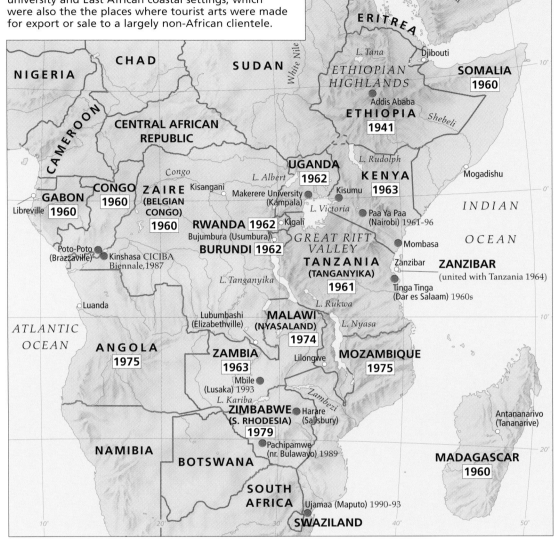

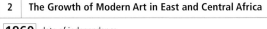

2 | The Growth of Modern Art in East and Central Africa

1960 date of independence

● Centres of tourist and modern art / craft production

2 POST-COLONIAL EAST AND CENTRAL AFRICA extended and expanded upon the European forms of visual and material culture in place at independence. Painting and graphic arts became more important than sculpture. The visual arts were centred in urban, university and East African coastal settings, which were also the the places where tourist arts were made for export or sale to a largely non-African clientele.

Towards the end of the twentieth century a significant shift had occurred in art, from stimulus by whites to African-led discourses. In the 1980s and 1990s many books, journals and catalogues also featured contemporary arts, most from university or urban centres. Some artists migrated to Paris or New York either because of socio-political unrest at home and/or because their primary markets were abroad. By the 1990s a great plurality of styles and types of art could be discerned, most betraying an interdependence of Western and African ideas, motifs, materials and themes. While in rural East Africa, on the one hand, modified forms of earlier, very striking personal adornment were still viable in the 1990s, in much of central Africa, the final decade saw the production of very few art forms due to prevailing patterns of warfare and civil unrest.

COLONIE BELGE, 1885–1959. Prison yard, with prisoner being flogged by guard, with officer watching. Painted on a flour sack, 21 November 1974, by Tchibumba Kanda Matulu. Such images, ostensibly about the early colonial era, are actually a critical commentary on the repressive, violent regime of Mobutu Sese Seko, president of Zaire from 1960 until 1997, after the painting was completed.

WEST AFRICA 1900-2000

THE PAST 100 YEARS have seen changes in art and lifestyle that are unprecedented in African history. Colonial governments, which had imposed rule over much of the continent from around 1900, were mostly gone by 1965 with incalculable impact.

NEW INFLUENCES ON TRADITIONAL ART
The century began with traditional arts and architectures intact. Until the mid-century and later, a number of traditional items were still made: woodcarving (masks and figures); ironwork and copper-alloy casting; jewellery,

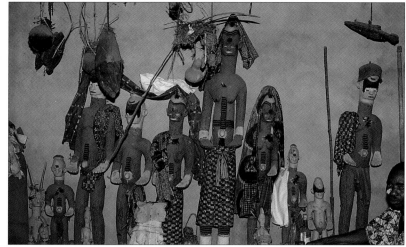

IGBO SHRINE to major tutelary deities in Oba Uke, eastern Nigeria. Photograph by Herbert M. Cole, 1983. The wooden figures are 'traditional' but the impact of Europe can be seen in the clothing the priest has provided for them. By the close of the twentieth century few such shrines remained. Figures were either destroyed or sold to art dealers for export to Europe or the USA. Figures such as these can now be found in museums and private collections. Some sell for very high prices.

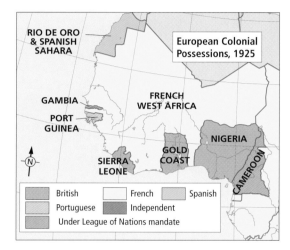

personal decoration and leadership regalia; sun-dried mud buildings, some with painted walls. In rural areas these traditional forms remained viable until the 1970s or 1980s. Most areas, however, were influenced increasingly by both a more insistent European presence in coastal regions and cities, and by further conversions to Islam.

Colonial regimes helped to stimulate changes in the arts: from the 1920s conversions to Christianity meant a loss of patronage for local religions, and the traditional arts associated with them. As well as a money economy and new educational and political structures, Europeans also introduced new materials, pigments, styles,

technologies and motifs. Glass painting in Senegal and cement sculpture in urban and rural areas are examples of these developments. Islam had a dampening effect on the arts due to its proscription of figurative arts, although textile production and some dress styles, as well as mosque building and other architecture, thrived. By the 1990s most West African peoples were either nominally Muslim or Christian, so most traditional arts were no longer viable.

ART BEFORE INDEPENDENCE
A handful of artists such as Aina Onobulu (1882–1963), Ben Enwonwu (1918–94), Christian Lattier (1925–78), Iba Ndiaye (1928–)

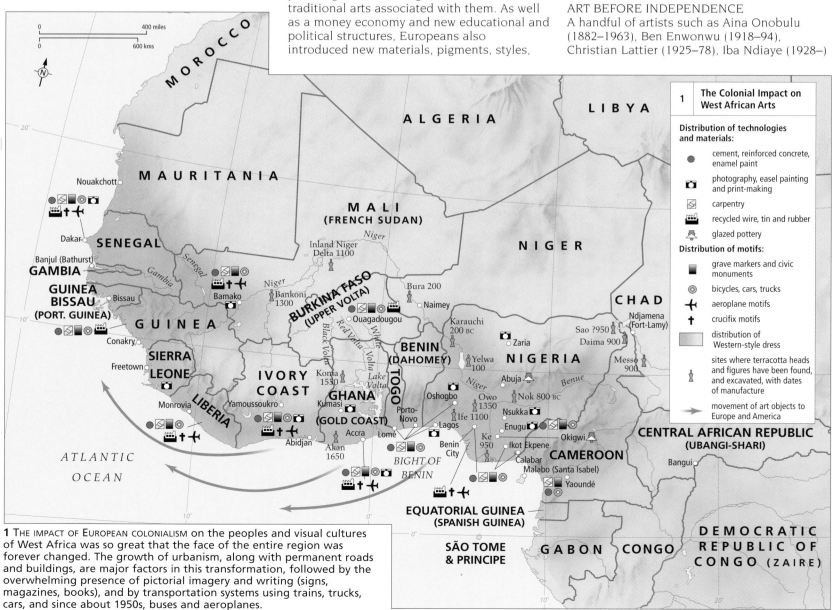

1 THE IMPACT OF EUROPEAN COLONIALISM on the peoples and visual cultures of West Africa was so great that the face of the entire region was forever changed. The growth of urbanism, along with permanent roads and buildings, are major factors in this transformation, followed by the overwhelming presence of pictorial imagery and writing (signs, magazines, books), and by transportation systems using trains, trucks, cars, and since about 1950s, buses and aeroplanes.

and Uzo Egonu (1931–94) worked in modern traditions of painting and sculpture, taught by Europeans (some in Europe) from around 1950. The Negritude movement was established in Francophone Africa in the late 1930s, where it was the reigning artistic philosophy into the independence period. Around then (the 1960s), many artists, still trained by Europeans, entered studio practice, producing modern art which often used African motifs self-consciously, even if styles and materials were mostly imported. Unlike most earlier artists, often anonymous and usually identified with the style of an ethnic group, these artists had personal styles tied more to internationalism than to local canons. There was relatively little wood sculpture among the modern works, that of El Anatsui (1944–) being a notable exception.

Colonial governments in most West African nations established museums and art schools by 1950–60, usually in growing urban centres. These cities also experienced the infusion of European-style architecture, urban planning and imported materials: cinder block, reinforced concrete, steel and glass. From the 1920s to the 1950s colonial education officers and mission schools introduced drawing and easel painting, gallery exhibitions, new theatrical forms and other new ideas.

NEW BEGINNINGS

In the independence period (1957–65) new nations took over colonial-inspired art institutions, and art centres and workshops were born and sometimes quickly died. Those at Oshogbo, Nigeria, and Dakar, Senegal (Ecole de Dakar), are the best-known.

The same period saw the growth of African art history programmes, mostly in the USA, which fostered fieldwork across Africa. As the use of earlier, 'traditional' forms decreased or ceased, new types of art came into being. These included commercial forms (signs, posters), tourist-oriented work (copies, fakes, thorn and gourd carvings, ebony busts), glazed pottery, recycled materials (tin, wire) for toys, cement sculpture (memorials, urban monuments), and carpentered works ('fantasy' coffins in Ghana, Ode-lay masks in Freetown).

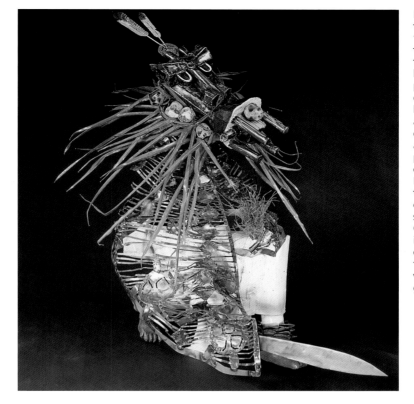

MASQUERADES WERE perhaps the quintessential 'traditional' African art in the nineteenth and early twentieth centuries. They had many vital social, political, judicial and educational roles, as well as being an entertainment and a means of aesthetic expression – verbal, visual and kinetic. This installation photograph of contemporary arts of the Kalabari Ijo is displayed in the British Museum. Here a contemporary woman sculptor, Sokari Douglas Camp, who lives and works in England, has recreated an earlier wood, cloth and feather masquerade in welded steel for display in a gallery setting.

In the latter part of the century, painting and sculpture were made for display, enjoyment and sale across West Africa. Yoruba *adire* (starch resist indigo) cloth, Bamana *bogolan* (mud-dyed resist) and Asante and Ewe *kente* cloth, all long used in local dress, plus innovative tie-dyes and *batiks*, were made for sale. At first most new arts and crafts found expatriate patronage, but by the end of the century they were supported by middle-class Africans. *Kente* and *bogolan* were brought into the international fashion industry.

By the 1980s and 1990s studio artists had become the teachers of their younger compatriots, usually in university settings. This work was showcased at pan-African venues: the 1st World Festival of Negro Arts, (Dakar, 1966), then at the larger Second World Black Festival of Arts and Culture (FESTAC, Lagos, 1977), followed by Dak'Art, the First Dakar Biennale (1992). While many artists

remained in African urban centres, the structures supporting West African arts had undergone fundamental change, and some artists had moved to Europe or the USA. Overwhelmingly, late twentieth-century arts were secular, made not for local but for national or international audiences and a few African collectors, corporations and government projects.

ART FOR AFRICANS?

Towards the year 2000 both 'traditional' and more recent art, including street and studio photography, had gained international recognition, as shown by numerous exhibitions and books such as *Magiciens de la Terre* (1989, Paris) and *Africa Explores: 20th-Century African Art* (1991, New York), and several exhibitions known as 'Africa 95' (London, 1995). The new interest in African arts also stimulated the publication of several journals.

Yet traditional or 'classical' African art rarely upheld the values of African communities, and indeed, much of it had left Africa to enter the lucrative international antiquities market. It is a troubling irony that the finest West African art, from ancient times until the final years of the 20th century, is in museum and private collections in England, Europe and the United States.

2 THE EUROPEAN IMPACT ON ALL REALMS of visual and material culture continues to be felt in post-colonial, late twentieth-century West Africa. European imports – transportation systems, urban architecture, signs, publications – were only slightly 'Africanized' in their local manifestations. In dress, however, local and even nationalistic inventions or adaptations (such as industrialized wax prints all over the region and *kente* and *adinkra* cloth in Ghana) prevailed alongside more strongly Western-influenced fabrics and styles for both men and women.

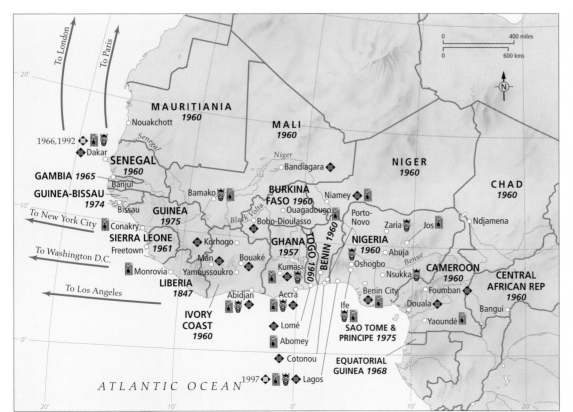

2	Post-Colonial West Africa
1960	date of independence
◆	sites of post-Colonial art production
⚏	production of international African arts
⛨	major national artistic and cultural centre
◈	sites (and years) of international art festivals
→	international dispersal of West African artists

SOUTHERN AFRICA 1900-2000

THE DISTRIBUTION OF ART CENTRES throughout Southern Africa, both collections of art and formal educational institutions, reflects the political and economic history of the region – as well as colonial debates over the definition of the term 'art'. Art, in the European sense, was practised as a rule by people of European origin in the great urban centres of the region. For a long time, this understanding of art was

1 SOUTHERN AFRICAN ECONOMIC HISTORY reflects the geography of the region, for example the gold seam underlying Johannesburg and the Witwatersrand. However, the distribution of art centres in southern Africa follows economic and political dictates. European-inspired art, both in museum collections and fine art schools, clusters around the major cities. Both traditionalist art forms and philanthropically-founded community art and craft centres are distributed in the vast, and generally impoverished, rural areas.

denied to African peoples, whose traditional practice in rural areas was generally thought of as 'material culture' and whose production in mission schools and other philanthropic foundations was widely regarded as 'craft'.

THE COLONIAL LEGACY

Similarly, collections of art in the region were affected by changes in the understanding of this concept. Thus the earliest collections of art were made with the purpose of instilling European cultural values, and occasionally craft-manufacturing techniques, in a supposedly unrefined colonial population. Gradually art produced locally in the European mould, mainly by white people but eventually by blacks also, was admitted into the collections, a trend accelerated, of course, by the decline in value of local currencies. Traditionalist African art, meanwhile, if it was

collected at all, was displayed in natural history museums, where it remains to this day in Maputo, for example. Post-colonial developments in museum practice vary throughout the region and include: the integration of African art into the major art galleries of Cape Town and Johannesburg; the establishment of schools of carving within the precincts of the national art museums in Harare and Maputo; the displacement of the colonial collection by the work of such revolutionary artists as Malangatana in the national museum in Maputo; and the creation of a new series of museums celebrating the achievements of national heroes in Botswana.

The oldest art schools in the region are in South Africa and they are attached to universities – in Cape Town, Pietermaritzburg and Johannesburg – that had as part of their original mission the function of civilizing the

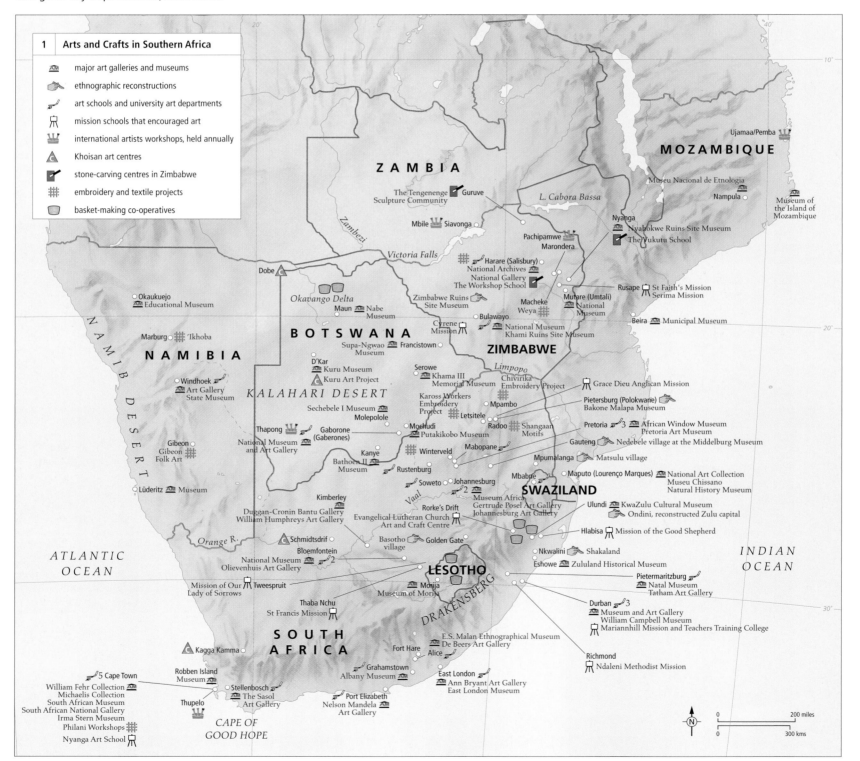

colonial population. Soon these schools, and those founded at Afrikaans-language universities such as Pretoria, Stellenbosch and Bloemfontein, assumed the role of promoting European culture in support of white claims to power. As in other parts of the world at that time, these institutions distinguished their product not only from craft (both black and white), but also from the various forms of commercial art. As the urban centres grew, the demands from industry for graphic design, illustration and photography were satisfied at first by a number of technical schools established not only in South Africa but throughout the region. For economic reasons, and because of changes in the understanding of art, the South African universities that continue to teach Fine Art now also include commercial subjects in their curricula.

COMMUNITY ART

The apartheid Bantu education policy denied young South African black people the qualifications to study either fine art or commercial art at tertiary level, and for the most part prevented admission to such courses at white institutions to those few black students who survived the system. A number of well-qualified black students enrolled at such private art schools as the Frank Joubert Art School in Cape Town and the Johannesburg Arts Foundation. In a few urban areas, or 'townships', municipalities set up a variety of art courses at community art centres, such as the influential but short-lived Polly Street Art School in Johannesburg, and the Katlehong Art Centre, near Germiston. Other community centres, such as the Community Arts Project in Cape Town, operated with the help of overseas funding. Many community schools quickly acquired a political dimension, and several of them combined regular art classes with workshops on the making of posters, banners and community murals.

In rural areas throughout the region, the major proponents of art training were the mission schools. From the middle of the nineteenth century, mission schools

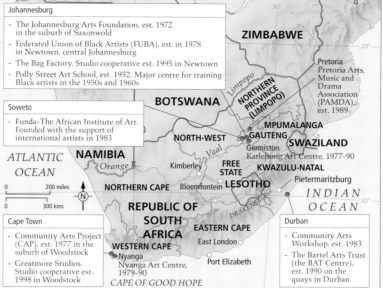

Johannesburg
- The Johannesburg Arts Foundation, est. 1972 in the suburb of Saxonwold
- Federated Union of Black Artists (FUBA), est. in 1978 in Newtown, central Johannesburg
- The Bag Factory. Studio cooperative est. 1995 in Newtown
- Polly Street Art School, est. 1952. Major centre for training Black artists in the 1950s and 1960s

Soweto
- Funda-The African Institute of Art. Founded with the support of international artists in 1983

Cape Town
- Community Arts Project (CAP), est. 1977 in the suburb of Woodstock
- Greatmore Studios. Studio cooperative est. 1998 in Woodstock

Durban
- Community Arts Workshop, est. 1983
- The Bartel Arts Trust (the BAT Centre), est. 1990 on the quays in Durban

Pretoria Arts, Music and Drama Association (PAMDA), est. 1989.

Katlehong Art Centre, 1977-90

Nyanga Art Centre, 1979-90

2 **Community Art Centres in South Africa**

● community art centre, with date of foundation

2 PUBLICLY FUNDED ART CENTRES like the Polly Street Art School in Johannesburg played a crucial role in nurturing the creativity of black artists as early as the 1950s. In the 1970s these attempts to empower black artists were further promoted through independent, often privately funded centres, most with increasingly radical political agendas of black consciousness. State funding retained as its primary aim the generation of employment in impoverished black townships.

THE SOUTH AFRICAN National Gallery in Cape Town, by Francis Kendall, includes elements of European classical tradition and Cape Dutch architecture. Since its completion in 1930, the colonial appearance of the façade has been modified by the introduction of later artwork, notably, after the first democratic elections in 1994, the decoration of the niches by the Ndebele artists, Isa Kabini and Rose Mahlangu, in an African mural style. The sculpture in the foreground is Bruce Arnott's *Numinous Beast*.

THE BASOTHO CULTURAL VILLAGE in the Free State was opened in 1994, evidently as part of the policy of the new South African government to restore the history of African peoples that had been systematically denied by the previous apartheid government. The village traces the evolution of South Sotho material culture, especially architecture, from pre-historic times to the present, thereby avoiding the trap of many tourist villages that work uncritically with the idea of an ethnographic present. This illustration shows the contemporary version of painted clay shelving, of which there are several earlier forms in the village.

encouraged their scholars to produce both liturgical objects and religious themes in three and two dimensions. Around the mid-twentieth century mission teachers seem to have recognized generally that, in a hostile economic climate, communities could sustain themselves by making art- and some individuals could actually make a career from art. Thus, in the 1960s, at the Art and Craft Centre at Rorke's Drift in KwaZulu-Natal, the Swedish Evangelical Lutheran Church introduced ceramic and textile workshops, which employed mainly local women, and a fine art school, which attracted mainly urban black men. The political aspirations of the black art students disturbed the peace of the mission and it was closed after only a few years. In the short time of its existence, however, it not only produced Azaria Mbatha and John Muafangejo from Namibia, two of southern Africa's most significant artists of recent years, but it also established the linocut as a major medium of South African artistic expression. Similarly, mission schools in Rhodesia/Zimbabwe played a significant role in establishing the genre of soapstone carving, and they launched the careers of several notable sculptors.

As the world economic climate deteriorates, on the one hand, and global tourism proliferates, on the other, philanthropic enterprises have founded community craft centres throughout southern Africa. Thus basket-making centres have been set up in KwaZulu-Natal and Botswana; textile and embroidery cooperatives have been established throughout the region; and San, or Bushman, art and craft schools have been founded in Namibia, South Africa and Botswana. While not all of these would be seen as centres of art in some countries, they are performing the significant function of bringing traditional craft practices into the new global economy, while providing much-needed employment for their practitioners.

ASIA 1900-2000

A T THE BEGINNING of the twentieth
century Asia was largely controlled,
directly or indirectly, by European powers,
which exploited the region for its raw materials
as well as its markets for European
manufactured goods. By the end of the century
Asia was totally independent and poised to be
the economic powerhouse of the new
millennium. In the interval, the continent was
wracked by political and social upheavals
resulting from two world wars, wars of national
liberation, civil wars and other regional
conflicts.

The Japanese victory over the Russians in
1905, the first Asian defeat of a European
colonial power, encouraged the Japanese to
embark on their own programme of imperial
expansion over East and South Asia, from
which the continent was rescued,
paradoxically, by a new wave of Western
intervention. The end of World War II was
followed not only by the American occupation

of Japan, but also by the collapse of European
colonial empires in much of the region and
the establishment of Communist regimes
from Eastern Europe to Southeast Asia.
By the end of the century, most of the
Communist systems had collapsed in the
face of freewheeling market capitalism, which
came to rule Asia along with the rest of the
world. Nevertheless, millions of Asians in
isolated and rural areas were untouched by
world developments and largely maintained
their traditional lifestyles.

CAST BRONZE by the Italian-trained Iranian artist
Parviz Tanavoli (1937–), who used sculpture,
which is not a traditional art form in Islamic
societies, for calligraphy, the most appreciated
Islamic art form. His most famous theme is the
sculptural representation of the Persian word
heech, meaning 'nothing'. Here the word
becomes a complex visual pun, appearing to
represent something but saying 'nothing'.

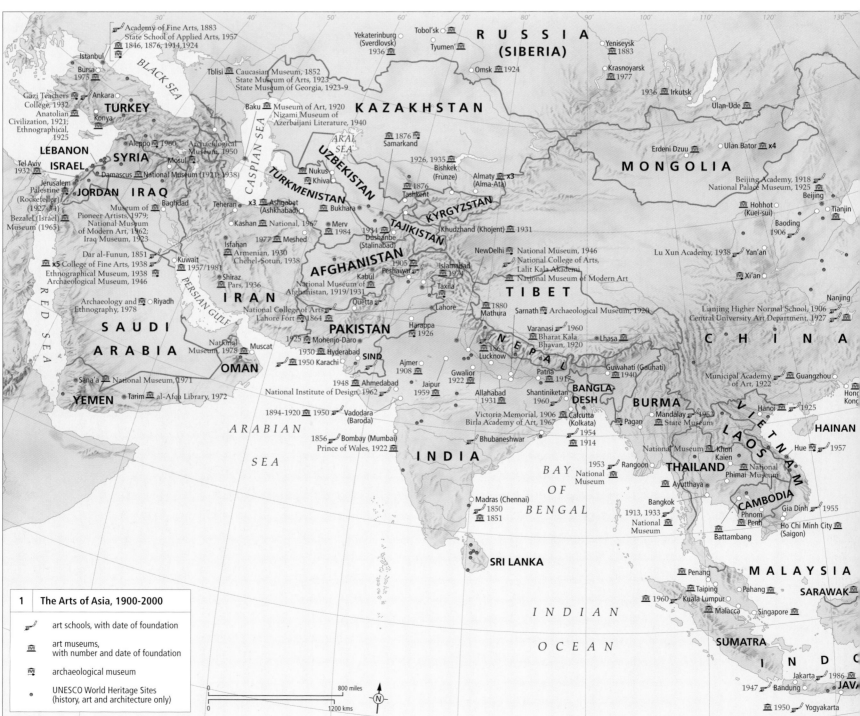

1 The Arts of Asia, 1900-2000

art schools, with date of foundation

art museums,
with number and date of foundation

archaeological museum

UNESCO World Heritage Sites
(history, art and architecture only)

GLOBALIZATION

New means of transport – from steamships and railways to cars and aeroplanes – globalized the arts throughout the region. With the advent of radio, television and the internet, images were instantaneously transmitted to the remotest corners of the world. During this period Asian urban culture was assaulted by the latest in world developments, ranging from Parisian Cubism and the International Style to Soviet realism and American Post-Modernism. Conversely Asian arts and artists became familiar in the West, as Asian cinematographers, designers, architects, sculptors and painters developed worldwide reputations.

Enhanced communication encouraged individuals to travel, and artists from one culture studied in another. Iranian architects trained in the USA, while British potters studied in Japan. Le Corbusier and Louis Kahn designed regional capitals in South Asia, while the Chinese-born I. M. Pei redesigned the Louvre in Paris and the Japanese Kenzo Tange redesigned the Italian cities of Bologna and Catania. Communication also encouraged group tourism on an unprecedented scale, as some people became wealthier and had more leisure time in the post-war period. The popularization of cheap portable still and video cameras led to a proliferation of images worldwide. From the late 1970s UNESCO, itself a creation of a post-war desire for world improvement, began designating cultural complexes throughout the region as World Heritage Sites to preserve them from destruction, unrestricted development and industrial pollution.

Concrete and steel construction replaced brick and wood, as skyscrapers supplanted traditional low structures, and Western-style rooms with particular functions and furniture replaced traditional multi-functional spaces defined only by their furnishings. Iranian artists turned calligraphy into sculpture, and Indian artists realized traditional subjects using Japanese washes and Chinese brushwork. Artists also looked for inspiration in their endangered folk art traditions and in their own cultural past, newly-revealed through archaeology and art history. West and Central Asian carpets and *kilims* became collectable worldwide, and Japanese *raku* pottery was in vogue everwhere, as was the traditional Indonesian textile technique of *batik* resist-dyeing. Indeed, some individuals held up these traditional crafts as the antidote for what they saw as the poison of globalization and Modernism, and many artists combined traditional craft techniques with modern tools and sensibilities in their work.

Archaeology, which had been introduced to Asia by Europeans at the beginning of the century to fill European museums, became a means of establishing national identities in the post-war period. From Syria and Saudi Arabia through Iran and Pakistan to China and Mongolia, archaeologists made startling discoveries that revolutionized knowledge of the arts of the distant past. National and regional museums were established throughout Asia to house the finds and old royal collections. Although the bulk of their collections was local material, some museums, particularly in wealthy countries like Japan and pre-revolutionary Iran, not only repurchased their country's own antiquities but also became players in the international art market for European painting.

THE ARTIST IN ASIA

Continuing a process begun earlier, the individual artist emerged as a distinct personality throughout Asia. The traditional master-pupil system of individual instruction, where the best a student could do was to imitate his master flawlessly, was replaced by training in government-sponsored art schools that offered a variety of courses in many media and techniques, both traditional and foreign. Innovation and individual expression were emphasized over tradition and continuity. The exit of *maharajas* and emperors from the political stage closed artists' traditional source of patronage. It was replaced on the one hand by government sponsorship, particularly for large projects, and on the other hand by private patronage, whether by newly-enriched industrialists or – at a more modest level – by the emerging middle class.

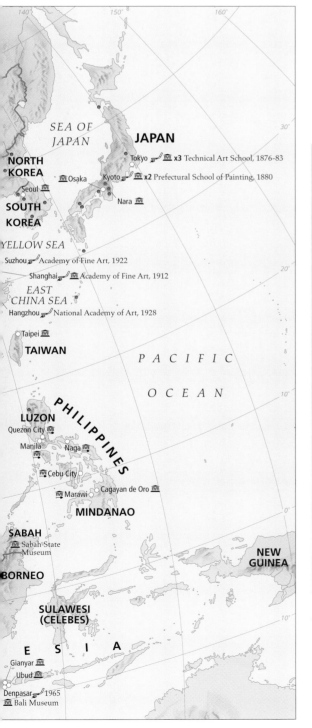

1 The entire Asian continent became integrated into the global world of art in the twentieth century as newly-independent nations established Western-style institutions, including museums of art and archaeology as well as schools for teaching the fine and applied arts. World organizations identified cultural sites throughout the region as having significance not only for local histories but also – and more importantly – in the shared heritage of civilization on earth.

National Stadiums, Tokyo, 1961–64. Kenzo Tange (1913–) designed these two stunning pavilions for the 1964 Olympic Games held in Tokyo. Two asymmetrically arranged steel suspension structures with sweeping curved roofs recall traditional Japanese architecture as well as contemporary structures by Le Corbusier and Eero Saarinen. Tange's work thus encapsulates the fruitful conjunction of East and West and won him the Pritzker Prize for architecture in 1987.

WEST ASIA 1900-2000

THE ARTISTIC TRADITIONS of Western Asia underwent a profound transformation after World War I, when new states were created in former Ottoman lands; these included the British Mandates of Palestine, Jordan and Iraq, and the French Mandates of Lebanon and Syria. The new states were later bolstered by the promotion of 'national' schools of art, and the foundation of national museums and galleries of fine art – a concept that was imported from the West. In Turkey and Iran modernization programmes were also implemented. After World War II, cultural links were established with Western Europe and the United States, or with the Soviet Union.

1 THE TWENTIETH CENTURY was marked by the emergence of many new states in the region, each of which attempted to create a specific cultural identity. Money from oil, which was produced in Saudi Arabia and Kuwait from the 1940s, and Iraq and Iran from the 1950s, was invested in various cultural programmes. Although Western ideas about fine art were adopted throughout the region, many artists strove to integrate them with indigenous traditions.

ARCHITECTURE

Traditional building practices, which used mud-brick and baked brick or stone, disappeared as buildings were increasingly built with concrete, glass, steel and aluminium. Architectural styles imported from the West, such as Art Nouveau, changed the character of many cities. Turkish architects developed an eclectic style for their public buildings, grafting Ottoman elements onto reinforced concrete structures. The monumentalizing national idiom of the 1930s was influenced by contemporary Italian and German architecture. After the Second World War, the International Style gained favour.

In Palestine, Jewish immigrants introduced European modernism, while after the creation of Israel the International and Post-Modernist idioms were employed. In Saudi Arabia and

THE MARTYR'S MONUMENT, Baghdad (1981–3). The monument was conceived by the Iraqi artist Ismail Fattah (1934–) and built by the Mitsubishi Corporation to the specifications of Ove Arup and Partners. It was constructed to commemorate the dead in the Iran-Iraq war (1980–88). The giant turquoise ceramic-tile dome (40 metres, 130 ft, high) is, split into halves and encloses a twisted metal flag. The monument stands on a circular platform, situated in the middle of an artificial lake.

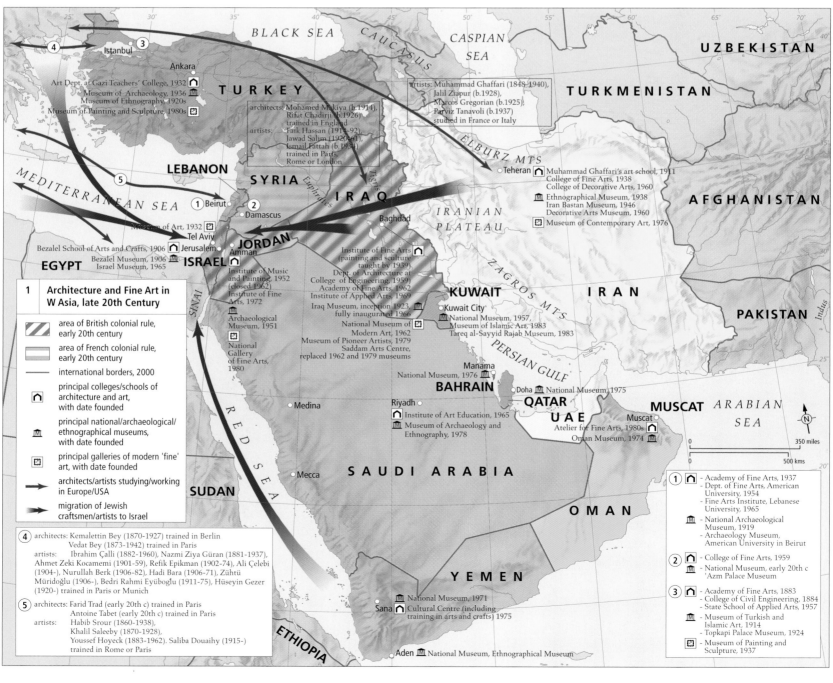

1 Architecture and Fine Art in W Asia, late 20th Century

- ▨ area of British colonial rule, early 20th century
- ▤ area of French colonial rule, early 20th century
- —— international borders, 2000
- ⌂ principal colleges/schools of architecture and art, with date founded
- 🏛 principal national/archaeological/ ethnographical museums, with date founded
- ⊡ principal galleries of modern 'fine' art, with date founded
- → architects/artists studying/working in Europe/USA
- ➡ migration of Jewish craftsmen/artists to Israel

4 architects: Kemalettin Bey (1870-1927) trained in Berlin
Vedat Bey (1873-1942) trained in Paris
artists: Ibrahim Çalli (1882-1960), Nazmi Ziya Güran (1881-1937), Ahmet Zeki Kocamemi (1901-59), Refik Epikman (1902-74), Ali Çelebi (1904-), Nurullah Berk (1906-82), Hadi Bara (1906-71), Zühtü Müridoğlu (1906-), Bedri Rahmi Eyüboglu (1911-75), Hüseyin Gezer (1920-) trained in Paris or Munich

5 architects: Farid Trad (early 20th c) trained in Paris
Antoine Tabet (early 20th c) trained in Paris
artists: Habib Srour (1860-1938), Khalil Saleeby (1870-1928), Youssef Hoyeck (1883-1962). Saliba Douaihy (1915-) trained in Rome or Paris

Art Dept. at Gazi Teachers' College, 1932 ⌂
Museum of Archaeology, 1936 🏛
Museum of Ethnography, 1920s
Museum of Painting and Sculpture, 1980s ⊡

architects: Mohamed Makiya (b.1914), Rifat Chadirji (b.1926) trained in England
artists: Faik Hassan (1914-92), Jawad Salim (1920-61), Ismail Fattah (b.1934) trained in Paris, Rome or London

artists: Muhammad Ghaffari (1848-1940), Jalil Ziapur (b.1928), Marcos Gregorian (b.1925), Parviz Tanavoli (b.1937) studied in France or Italy

Muhammad Ghaffari's art school, 1911 ⌂
College of Fine Arts, 1938
College of Decorative Arts, 1960
Ethnographical Museum, 1938 🏛
Iran Bastan Museum, 1946
Decorative Arts Museum, 1960
Museum of Contemporary Art, 1976 ⊡

Museum of Art, 1932 ⊡
Bezalel School of Arts and Crafts, 1906 ⌂
Bezalel Museum, 1906 🏛
Israel Museum, 1965

Institute of Music and Painting, 1952 (closed 1962)
Institute of Fine Arts, 1972
Archaeological Museum, 1951 🏛
National Gallery of Fine Arts, 1980 ⊡

Institute of Fine Arts (painting and sculture taught by 1939),
Dept. of Architecture at College of Engineering, 1959
Academy of Fine Arts, 1962
Institute of Applied Arts, 1969
Iraq Museum, inception 1923, fully inaugurated 1966 🏛
National Museum of Modern Art, 1962 ⊡
Museum of Pioneer Artists, 1979
Saddam Arts Centre, replaced 1962 and 1979 museums

National Museum, 1957
Museum of Islamic Art, 1983
Tareq al-Sayyid Rajab Museum, 1983

National Museum, 1976 🏛
Doha 🏛 National Museum, 1975

Institute of Art Education, 1965 ⌂
Museum of Archaeology and Ethnography, 1978 🏛

Atelier for Fine Arts, 1980s ⌂
Oman Museum, 1974 🏛

National Museum, 1971 🏛
Cultural Centre (including training in arts and crafts) 1975 ⌂

Aden 🏛 National Museum, Ethnographical Museum

350 miles
500 kms

1 ⌂ - Academy of Fine Arts, 1937
- Dept. of Fine Arts, American University, 1954
- Fine Arts Institute, Lebanese University, 1965
🏛 - National Archaeological Museum, 1919
- Archaeology Museum, American University in Beirut

2 ⌂ - College of Fine Arts, 1959
🏛 - National Museum, early 20th c
- 'Azm Palace Museum

3 ⌂ - Academy of Fine Arts, 1883
- College of Civil Engineering, 1884
- State School of Applied Arts, 1957
🏛 - Museum of Turkish and Islamic Art, 1914
- Topkapi Palace Museum, 1924
⊡ - Museum of Painting and Sculpture, 1937

- extent of the Ottoman Empire
- Anatolian carpet area
- Persian carpet area
- Kurdish textile area
- influence of Ottoman patronage and cosmopolitan styles
- influence of Qajar patronage and cosmopolitan styles
- European mass-produced goods (undermining local craft traditions)
- holy city
- calligraphy and the arts of the book
- centres of woodworking
- centres of metalworking
- centres of ceramics

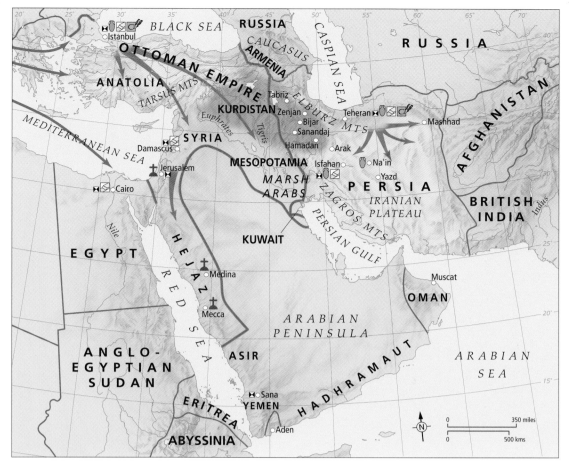

2 THERE WAS A DECLINE in indigenous artistic practices across much of the region as mass-produced imported goods undermined local craft traditions. Nomadism, which had favoured portable art forms, also declined. Carpets, however, remained an important export. Tourism provided a new but limited market in the late twentieth century. The manufacture of Jewish ritual objects in Palestine and Israel was expanded and revitalized.

the Gulf states most of the architectural development occurred during the construction boom between the 1960s and the 1980s, for which both Arab and Western architects were employed. Both Riyadh and Jiddah became centres for modern architecture.

PAINTING AND SCULPTURE

The Academy of Fine Arts was founded in Istanbul in 1883 by Osman Hamdi (1842–1910). From the outset the academy employed Europeans on its staff. Various artists from the academy continued their training in Europe, and then returned to Turkey as instructors of the next generation of artists. Some Lebanese artists also studied in Europe: the writer and painter Gibran Khalil Gibran (1883–1931) trained in Paris and settled in New York, while Saliba Douaihy (1915–) trained in Paris, returned to Beirut, and moved to New York in 1950. Turkish and Lebanese painters in turn influenced artists in Iraq, Jordan, Palestine and Syria, some of whom also trained in the West.

The Iraqi sculptor Jawad Salim (1920–61), who studied in Paris, Rome and London, founded the Baghdad Group of Modern Art (1951), which was concerned with forging a modern identity for Iraqi art. In the 1970s Iraq made a bid for cultural leadership in the Arab world and Iraqi cultural centres were set up in many countries. The regime of Saddam Hussein extolled ancient Assyrian history in an attempt to create a strong national consciousness. However, there was also an exodus of artists from Iraq for political reasons.

In Iran the court painter Muhammad Ghaffari (1848–1940) studied in Europe and set up an art school in Tehran in 1911. Modernism was promoted by Jalil Ziapur (1928–), Marcos Gregorian (1925–) and others. From the 1960s the Shah, Muhammad Reza, identified himself with the pre-Islamic Iranian heritage and held cultural events at Persepolis. Meanwhile, the painter Hussein Zenderoudi (1937–), the sculptor Parviz Tanavoli (1937–) and other artists of the Saqqakhana school in Iran were inspired by indigenous Shi'a iconography and folklore. After 1979 art that affirmed the ideals of the Iranian Revolution was promoted.

CALLIGRAPHY AND TRADITIONAL ARTS

The art of calligraphy was undermined by the advent of printing. The situation was greatly exacerbated in Turkey, where the Roman alphabet was adopted in 1928. Some Turkish calligraphers emigrated, and the Ottoman tradition of calligraphy was kept alive in Cairo and Baghdad. In Iran the calligraphic tradition was more vibrant. From the 1950s a new genre known as calligraphic painting developed throughout the region, which fused elements of calligraphy with Western-style painting.

West Asia, especially Iran and Turkey, is noted for its carpets. Metalwork, ceramics and woodwork are found in the major centres such as Istanbul, Cairo, Damascus, Teheran and Isfahan. Textile and metalworking traditions are found in the Kurdish region, and also among the Lur and Bakhtyari tribes in western Iran and among the Baluchs in the east. Circassian émigrés brought niello work on silver to Jordan, and there were traditions of silversmithing in Yemen and Oman.

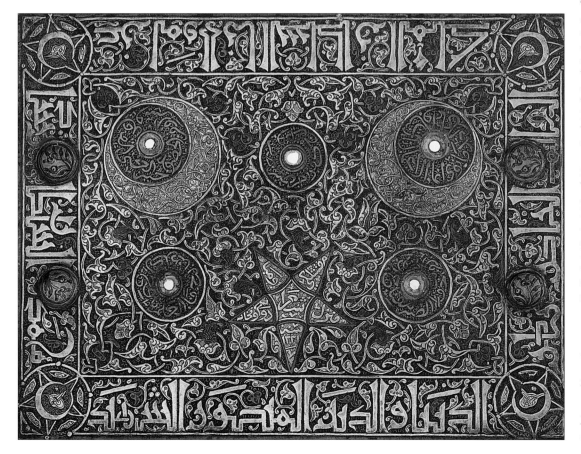

PLAQUE OF BRASS SHEET, inlaid with silver and copper, and silver appliqué bosses with niello, Damascus, 1912–13. The inscriptions in the roundels consist of Arabic proverbs and sayings. The inscription in Turkish within the arms of the star reads 'Bomb Foundry of the Inspectorate of Long-range Artillery, Damascus 1331'. The Kufic inscription on the band surrounding the central field praises the Ottoman sultan Mehmed V Rashad (r.1906–18).

CENTRAL ASIA 1900-2000

WESTERN CENTRAL ASIAN ART of the twentieth century can be divided into three stages. The first stage, from 1900 to 1917, covers the period of the Russian conquest of Western Turkestan. The second stage is from 1917 to 1991. After the Great October revolution in 1917, Russian Central Asian states joined the USSR in the early 1920s. During the Soviet period, Central Asian art adopted some Communist ideological doctrine. The third stage starts from 1991 when, following the dissolution of the USSR, Central Asian republics became five independent countries. Many types of traditional art and artefacts formerly forbidden on ideological grounds, were revived.

THE ECONOMIC BACKGROUND
Natural resources such as oil, gas and gold were found in Central Asia, but the main

resource in the Soviet period was cotton. Uzbekistan alone contributed 61.8 percent to total Soviet cotton production. Today, cotton is still over-planted, and the area lacks natural irrigation. The Aral Sea has become a synonym for ecological disaster. Water is scarce in Central Asia and the two rivers that feed the Aral Sea, the Amu Darya and the Syr Darya, have been taxed to the limit for irrigation. Now their waters are nearly depleted by the time they reach the Aral Sea, which has shrunk to half its former size and is four times more salty. Vast western segments of Kazakhstan and Uzbekistan now suffer from the millions of tons of salt and dust which are swept off the dried sea floor every year.

CENTRAL ASIAN ART
During the Soviet period, statues of Lenin and Stalin, along with some propaganda monuments, were established in the city centres of Tashkent, Bukhara, Samarkand, and Khiva, standing alongside thousands of ancient *madrasas*, mausolea and mosques. After the dissolution of the USSR, some of these statues were removed, and replaced with statues of Central Asian historical heroes. Statues of figures such as the medical scientist Abu Ibn Sina (Avicenna, 980–1037),

'THE END OF THE BAZAAR', REYIMU SELIMU, 1992 This painting shows the end of a local bazaar in Kashgar, when people carry their goods back home. The perspective of the painting is distorted, such that the camel and the donkey in the foreground are much smaller than the young couple at the top left corner, in the distance. The naive art of Kashgar, which depicts everyday events in a childish, but lyrical manner, has been well known since the 1960s.

1 THE REGIONS OF CENTRAL ASIA have spent much of the twentieth century under the sway of imperial regimes and Communist orthodoxies. However, their emergence as independent countries, with the exception of Tibet, in the 1990s has been accompanied by an outpouring of art, which seeks to integrate the lessons learnt from the past with a celebration of the newly rediscovered indigenous cultures, traditions and oriental philosophy of the region.

1	Arts and Crafts of Central Asia		
🏛	museum		wood carving/printing
	ceramics		copper embossing
	embroidery		lacquered miniature painting
	carpet weaving		leather processing
	metalwork		silk
	jade ware		

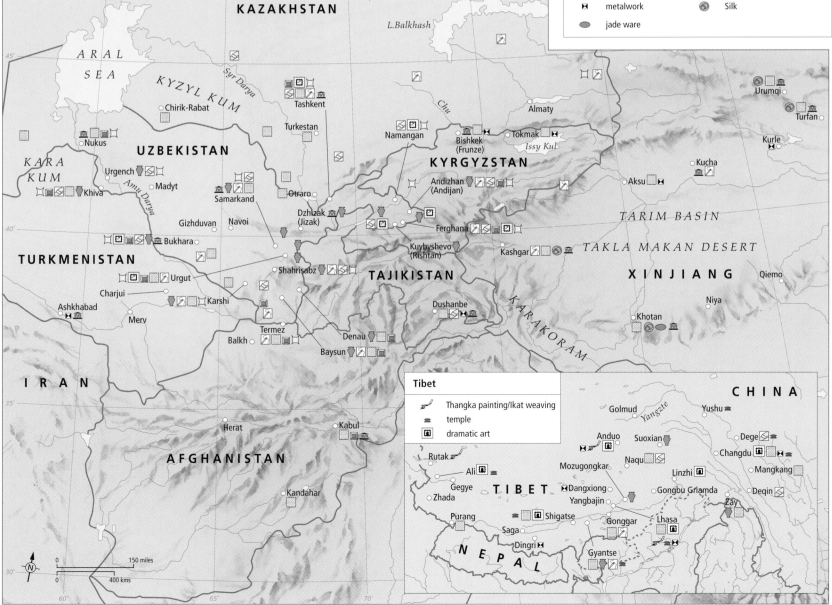

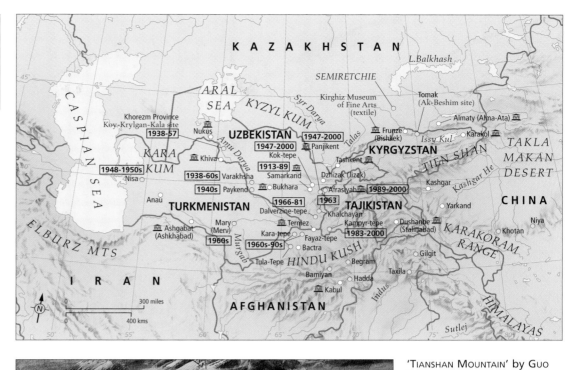

2 CENTRAL ASIA is rich in ancient sites and Soviet scientists organized a great number of excavations in Russian Central Asia. In the 1930s and 1940s they investigated Varakhsha, Paykend, Koy-Krylgan-Kala, Khalchayan, Dalverzine-tepe, Kampyr-tepe, Kara-tepe and Fayaz-tepe. Subsequent expeditions have excavated Pandjikent, old Nisa and new Nisa. In the east important archaeological excavations occurred in the Turfan Basin, Khotan and elsewhere.

the poet Alisher Navoi (1441–1501) and the astronomer Ulug Bek (1397–1449), were made during the 1960s–1980s in Bukhara, Tashkent and Samarkand respectively.

Many government buildings at this time were typically Soviet 'wedding cake' in style, especially in Dushanbe, Beshkek, Tashkent and Almaty. Nevertheless, some old mosques and monuments were repaired or reconstructed and traditional interior and exterior Islamic designs remained popular.

Artists who formed the Central Asian School of Art, brought to this area the spirit and traditions of the Russian avant-garde and modern Western art, which were transformed and enriched by oriental culture and philosophy. Important artists who lived in Central Asia during this time include P. P. Benkov, Isupov, R. Falk, R. Mazel, V. Ufimtsev, A. Volkov, N. Karakhan, Usto-Mumin and E. Korovay. For Russian artists, Central Asia provided an opportunity to indulge in Orientalist themes. A young mother breast-feeding her baby on a summer night, an old man cutting a boy's hair, village girls collecting grapes, a wife calling her husband in the fields back for lunch, were among the favourite topics for modern Central Asian artists. Most of these paintings are kept in the Uzbekistan National Museum of Fine Art in Tashkent and the Savitsky Art Museum of the Karakalpakstan in Nukus, Northern Uzbekistan.

The traditional art of miniature painting has been an inexhaustible source of inspiration for Central Asian artists. Influenced by this, in 1968 Iskander Azimov (1945–) painted the mural *Ibn Sina and his Students* in the Institute of Oriental Studies, Uzbekistan Academy of Sciences, Tashkent. Likewise, in 1968 Chingiv Ashmarov, inspired by Navoi's lyrics, painted many murals which were used to decorate the metro station of Alisher Navoi in Tashkent.

TRADITIONAL CRAFTS
Today, the heritage of craftsmen of the past is lovingly preserved and developed. Among the famous crafts of Central Asia are carpet-weaving, embroidery, wood carving, including *Ustun uyma*-carved columns, ceramics such as the blue-and-white ware of Rishtan and Gurumsaray, metal wares such as copper-embossing, and leather crafts.

At the beginning of the twentieth century, Russian factory production undermined the development of local handicrafts. In the first half of the twentieth century technological developments meant that a number of traditional handicraft products became obsolete and were no longer made. For instance, the appearance of porcelain

production in Uzbekistan in the early 1950s and the mass use of porcelain in everyday life caused a sharp drop in demand for the traditional handmade pottery; the decrease in the production of copper-embossed utensils had the same cause. The impact of Soviet ideological doctrine, backed by corresponding economic programmes, was another important factor in the decline of traditional handicrafts.

After independence, the transition to a market economy changed the organization of handicrafts. Traditional gold-embroidered wedding gowns and wooden cradles (*beshik*) had been banned during the Soviet period as survivals of feudalism, but they soon became widespread again. The openness of the new countries to the world community also provided craftsmen with new resources and inspiration.

XINJIANG ART
After lengthy exposure to Chinese and Soviet influences, traditional Central Asian, Chinese and Western modern art inspired Xinjiang artists after 1980. Some Xinxiang artists used traditional Chinese ink and brush techniques to interpret the splendour of nature, especially evident in Xinjiang's spectacular scenery of

'TIANSHAN MOUNTAIN' by GUO BU, ink on paper, 1988. This painting uses Chinese ink and brush to interpret the splendour of nature, depicting the rocky Tianshan Mountain in the golden sunset. The abstract image is more or less Western in style, but the taste is still very Central Asian. It embodies the so-called New Humanistic Movement, which emerged in Xinjiang from 1986 to 2000, when Xinjiang artists were inspired by traditional Central Asian, Chinese and Western modern art. Guo Bu was born in 1957 in Xinjiang, and graduated from the Art Institute of Xinjiang and Xi'an Academy of Fine Arts,

deserts, snow-capped mountains, and vast grassy plains. Kashgar rural artisans were highly appreciated, especially for their naive but lyrical depictions of lively local bazaars and festivals. Traditional artefacts, such as the woven carpets of Kashgar and the silk and jade of Khotan, were also famous.

THE ART OF TIBET
Tibet's traditional art was influenced by India and Nepal, swept away by Mao's Communist propaganda, and rediscovered after 1980. While railways and highways have opened this mysterious land to the world and introducing modern technology, traditional artefacts, such as wool carpets and decorated metal knives, are still well-known.

Thangka scroll paintings, depicting Buddhist scenes, are the most famous art of Tibet. Several Thangka schools survived the vandalism of China's cultural revolution, and each year competitions are held among different Thangka schools during festivals. Tibetan artists, such as Anduo Qianngba, also excelled at Buddhist figure paintings. Tibetan dramatic art, especially the dancing masks called *'cham'*, sometimes exaggerated as demons or beasts, are unique and fabulous.

SOUTH ASIA 1900-2000

CALCUTTA WAS THE PRE-EMINENT city of art and culture for most of the twentieth century, even though New Delhi became the administrative capital in 1911. While British institutions permeated society and infrastructure, the impact of Calcutta's leading family, the Tagores, on art and culture cannot be overestimated. The poet and novelist Rabindranath Tagore (1861–1941) was awarded the Nobel Prize for Literature in 1913, and his darkly Expressionist paintings – which he began only at the age of 65 – were highly acclaimed in Paris and London. In 1920 he began a revolutionary fine arts and language university at Santiniketan, a short train ride north of Calcutta. At the Tagore ancestral home, Joresanko, the famous Japanese philosopher Okakura Kazuko wrote *Ideals of the East*, which fuelled the idea of pan-Asianism. Influenced by the two Japanese painters who had accompanied Okakura (1902–4), Abanindranath Tagore (1871–1951), nephew of the poet, devised the distinctive wash technique that became the keynote of his style.

THE BENGAL SCHOOL
Abanindranath's Bengal School movement evolved with encouragement from E. B. Havell, principal of the Calcutta School of Art. Havell, in pursuit of a

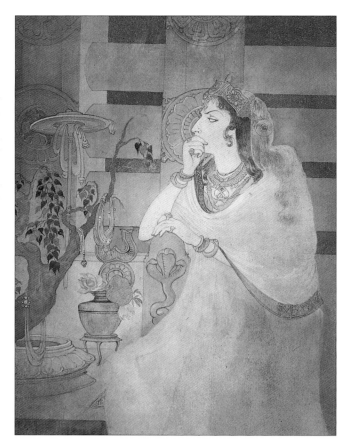

TISSARAKSHITA, QUEEN OF ASHOKA, c.1910, watercolour on paper, by Abanindranath Tagore. Tagore's Bengal School style of painting defied the British declaration that Indian painting was not fine art. A mix of East and West, the misty, effeminate style was deemed spiritual, while historical themes revived the past. One of the most famous of Indian kings, the third-century BC king, Ashoka Maurya, converted to Buddhism. His queen is shown pondering her future.

1 INDIAN ARTISTS in the twentieth century absorbed Western influences and merged them with elements of the native culture. However, traditional arts and crafts continued alongside these Western-oriented developments. Pakistan, Bangladesh and Sri Lanka evolved independent art institutions and artistic personalities after 1947. Later in the century Bollywood (Bombay cinema) came to rival Hollywood in terms of its prolific output.

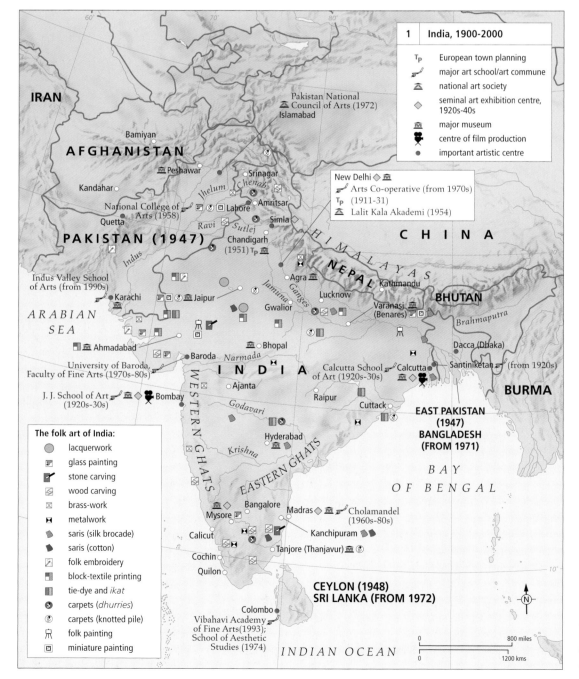

1 India, 1900-2000

Symbol	Description
Tp	European town planning
	major art school/art commune
	national art society
◇	seminal art exhibition centre, 1920s-40s
	major museum
	centre of film production
●	important artistic centre

New Delhi ◇
Arts Co-operative (from 1970s)
Tp (1911-31)
Lalit Kala Akademi (1954)

Pakistan National Council of Arts (1972) Islamabad

National College of Arts (1958)

Indus Valley School of Arts (from 1990s)

University of Baroda, Faculty of Fine Arts (1970s-80s)

J. J. School of Art (1920s-30s)

Calcutta School of Art (1920s-30s)

Santiniketan (from 1920s)

Cholamandel (1960s-80s)

EAST PAKISTAN (1947) BANGLADESH (FROM 1971)

CEYLON (1948) SRI LANKA (FROM 1972)

Vibahavi Academy of Fine Arts(1993); School of Aesthetic Studies (1974)

IRAN
AFGHANISTAN
Bamiyan
Peshawar
Kandahar
Quetta
PAKISTAN (1947)
Karachi
ARABIAN SEA
Ahmadabad
Baroda
INDIA
Ajanta
Bombay
Hyderabad
Bangalore
Mysore
Calicut
Cochin
Quilon
Colombo
Srinagar
Amritsar
Lahore
Simla
Chandigarh (1951)
Agra
Lucknow
Gwalior
Varanasi (Benares)
Bhopal
Raipur
Cuttack
Madras
Kanchipuram
Tanjore (Thanjavur)
CHINA
NEPAL
Kathmandu
BHUTAN
Brahmaputra
Dacca (Dhaka)
Calcutta
BURMA
BAY OF BENGAL
INDIAN OCEAN

HIMALAYAS
WESTERN GHATS
EASTERN GHATS

Jhelum, Chenab, Ravi, Sutlej, Indus, Jamuna, Ganges, Godavari, Narmada, Krishna

The folk art of India:
Symbol	Description
●	lacquerwork
	glass painting
	stone carving
	wood carving
	brass-work
	metalwork
	saris (silk brocade)
	saris (cotton)
	folk embroidery
	block-textile printing
	tie-dye and *ikat*
◉	carpets (*dhurries*)
◉	carpets (knotted pile)
	folk painting
	miniature painting

0 — 800 miles
0 — 1200 kms

return to Indian artistic ideals and style, sold the gallery's European paintings and replaced them with Mughal miniatures and other Indian art. He made Abanindranath vice-principal of the art school in 1905, and when Tagore's painting students graduated and took teaching positions in other art schools, the movement spread across the country. The resulting delicate, softly coloured, small watercolours were praised for their esoteric, spiritual qualities, countering the West's declaration that Indian painting was not fine art, but only craft. Avid nationalists and Theosophists supported Abanindranath's art, most notably Ananda Kentish Coomaraswamy, art historian and friend of the family, as well as the political activist, Sister Nivideta and Calcutta publisher O. C. Ganguli.

The style and subject-matter of Ajanta wall painting permeated Bengal School painting after its students copied the fifth-century masterpieces in 1910. Yet it was an exhibition of works on paper by German Bauhaus artists in Calcutta in 1922 that pointed to the future. Gagendranath Tagore may have been the first artist influenced by the show, implementing a technique that resembled the Orphism of the French painter Robert Delaunay. Gagendranath, however, is best remembered for his cynical cartoons making fun of *baboos* (Westernized Indians), not unlike the humour of Kalighat artists from the seamier side of the city.

The national debate over Bengal School Orientalism versus Western realism created serious competitive tensions between the Calcutta School of Art and the J. J. School in Bombay from the 1920s to 1940s. Indicative of a contemporaneous Bengali initiative to revive folk and native arts, the academically trained artist Jamini Roy created a new idiom inspired by Kalighat *pat* (folk art) and then by indigenous Bengali craft and architectural decoration. The Punjabi artist Amrita Sher Gil, with his Hungarian and Punjabi heritage and a master's degree from the École des Beaux-Arts, Paris, mixed the colour and style of Rajput miniatures with that of Gauguin and Matisse. Roy and Sher Gil were the first Indian Modernists.

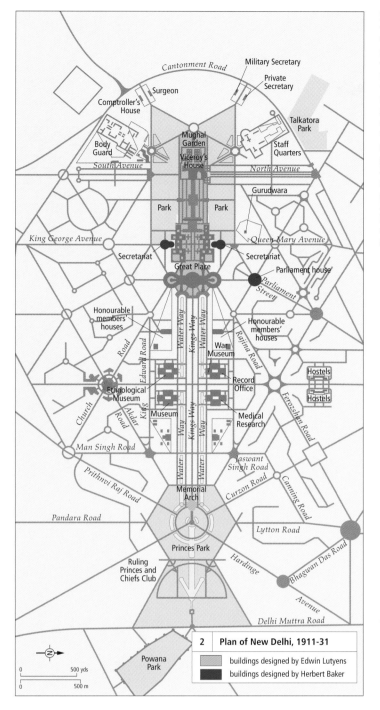

2 NEW DELHI was founded by the the British government of India, the Raj, after a decision to move the capital from Calcutta to Delhi in 1911. The masterplan was drawn up by the chief architect Edwin Lutyens (1869–1944), who created a regal, symmetrically designed administrative centre with a wide central axis to carry on the imperial tradition of grand processions. Predominantly Neoclassical, reflecting Lutyens' own taste, some of the structures were Indianized by his collaborator, Herbert Baker (1862–1946), who organized the interior decoration by Indian artists.

2	Plan of New Delhi, 1911-31
	buildings designed by Edwin Lutyens
	buildings designed by Herbert Baker

YATRA, 1956, oil on canvas by Maqbool Fida Husain. Husain was the most significant Indian artist of the mid-twentieth century. Among the few artists who remained in India after Independence, he evolved a quasi-Cubist style. He treated myriad themes – from mythology and history to socio-political commentary – with intelligence and humour. Going on *yatra* (pilgrimage) in a bullock cart is still a familiar sight in India. So, too, is mixing myth and reality. Here the standing figure is Hanuman, the monkey god, racing to save a dying hero in the epic *Ramayana*. The scantily clad woman derives from the *yakshi* (female fertility figure) on Hindu and Buddhist monuments.

incompatibility of Indian identity with the dominance of Western art.

MODERNISM IN PAKISTAN
In Pakistan artists also struggled in finding a national, cultural or religious identity. Some artists, such as A. R. Chughtai (1894–1975), painted in a modified Bengal School style, others, such as Anna Molka Ahmed (head of the art department at Punjab University) and Khalid Iqbal (principal at the National College of Arts [NCA]), used Western realism. Shakir Ali, the first Pakistani principal of the Mayo School of Arts (now NCA) who studied with André Lhote in France, introduced Cubism in the 1950s. Artists from East Pakistan, notably Zain ul Abedin, further popularized abstraction.

A movement featuring abstracted calligraphy swept the country from the 1960s to 1980s. It satisfied the need to be modern, but also fulfilled Muslim religious and Asian cultural identity. Contemporary themes were combined with age-old painting techniques to update traditional Indian miniature art. Bashir Ahmed, trained by two court painters, started a degree programme in miniature painting at the NCA in 1982. The movement had eager patronage in Pakistan as well as in Europe. Shahzia Sikander, a Pakistani *wunderkind* in America, studied miniature painting at NCA.

ART IN SRI LANKA
Like India, Sri Lanka was heavily influenced by British Victorian art. Harry Pieris, the foremost academic portrait painter, earned a diploma from the Royal College of Art in London in 1927 and worked in Paris until 1935. He later became secretary of the 43 Group – an organization formed in 1943 by ten artists offering an alternative to the Victorian naturalism espoused by the Ceylon Society of Arts.

The most famous mid-century painter was self-taught George Keyt (1901–93), whose images of robust, sensous women derive from Léger, Matisse and Picasso as well as Indian poetry. Tissa De Alwis and Jagath Weerasinghe made sculpture and installations with social and political content. The acclaimed architect Geoffrey Bawa (1919–2002) was also a major patron of the arts.

WESTERN INFLUENCES
Abstraction competed with realistic portraiture, landscape and still-life throughout India, but Bombay, New Delhi and Calcutta were centres for Modernist art. In 1946 Francis Newton Souza (1924–2002) founded the Bombay Progressives, a Leftist group that wished to be part of the global art scene. India's fascination with modernity was further evidenced by the choice of the French architect Le Corbusier to create a new state capital for Chandigarh in 1951. In the 1950–70s there arose a popular painting movement, called Neo-Tantric, which was both abstract and modern, yet reflected Indian identity.

Maqbool Fida Husain (1915–) was the major Indian artist of the mid-twentieth-century. Though Muslim, he treated the spectrum of Indian themes, from Hindu myth to Islamic history to social and political commentary, favouring realism with a Cubist edge. In the 1970s the Faculty of Fine Arts at the University of Baroda became pre-eminent in India under the artist and teacher K. G. Subramanyan (1924–). In 1980 Subramanyan transferred to Santiniketan and there gathered together a talented group of artists and art historians. By the 1980s women – among the most prominent artists in the country – helped to reconcile the

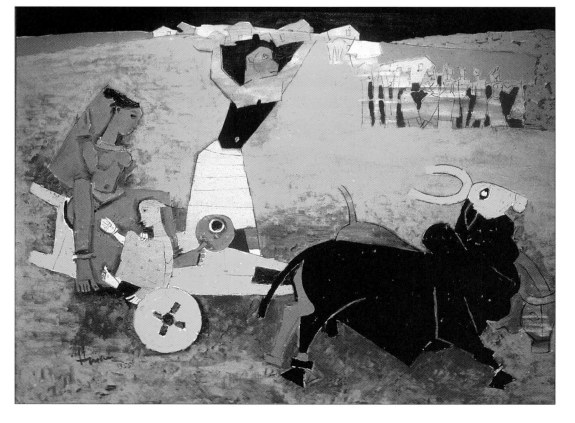

CHINA 1900-2000

THE TWENTIETH CENTURY IN CHINA was an era of political and social upheaval, marked by war and civil war, rapid but uneven modernization and an ever-widening involvement with Western ideas, technology and culture.

THE WESTERN IMPACT
By 1900, the alien Manchu Dynasty was in terminal decline, its death-blow being dealt by the revolution of 1911. Thereafter the era of the warlords (1912–26) was followed by the establishment of a central government by the Guomindang Party under Chiang Kaishek (Jiang Jieshi), ruling from Nanjing. The early and mid-1930s was a time of rapid development. New architecture sprang up in the cities and towns touched by Western culture. The commercial buildings tended to be Western in style, while government buildings, such as those in the new national

capital at Nanjing, were essentially Western in form and construction, enriched with the traditional Chinese roof and ornament.

At the beginning of the twentieth century, tombs were robbed of their treasures, as has always happened in Chinese history. Many of these treasures enriched foreign museums. The first archaeological excavations were carried out in the early 1920s at Neolithic pottery sites in central China, while in 1927 scientific excavation began at the site of the late Shang royal tombs at Anyang (c.1300–1050 BC).

Although traditional painting continued to flourish, the need for teachers of the more useful Western methods grew rapidly, leading to the founding of the first Western-style art schools in Nanjing, Shanghai and Hangzhou. In Canton the *Lingnan pai* (Southern School) promoted a modernized form of traditional painting modelled on the Japanese *Nihonga*

HUANG BINHONG (1864–1955), *A Ferry in Sichuan,* ink and colour on paper, 1948. Huang Binhong was a leading member of the traditional school of scholarly landscape painting which was revived in the twentieth century.

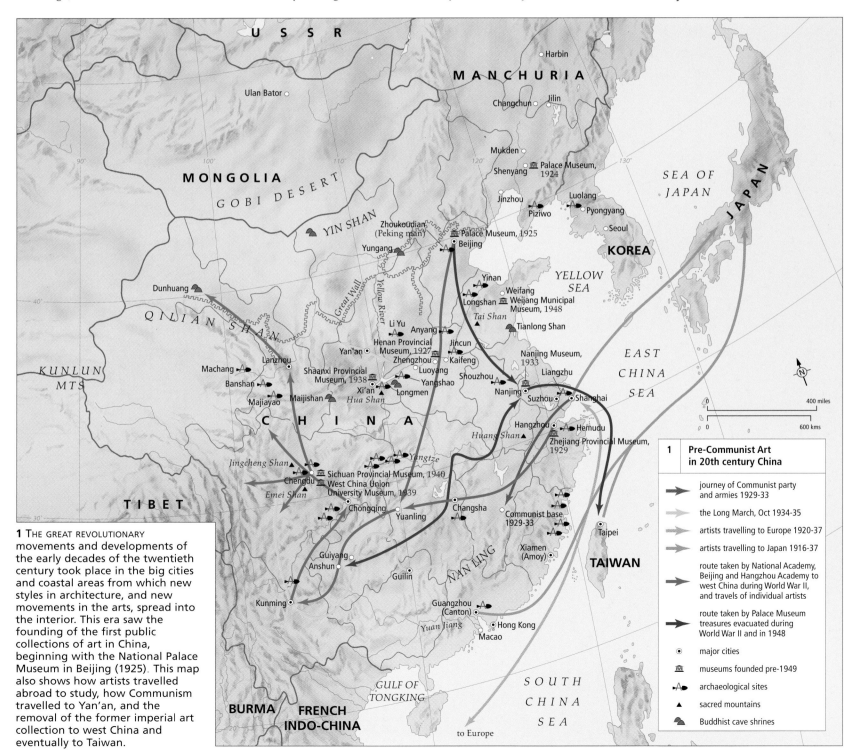

1 THE GREAT REVOLUTIONARY movements and developments of the early decades of the twentieth century took place in the big cities and coastal areas from which new styles in architecture, and new movements in the arts, spread into the interior. This era saw the founding of the first public collections of art in China, beginning with the National Palace Museum in Beijing (1925). This map also shows how artists travelled abroad to study, how Communism travelled to Yan'an, and the removal of the former imperial art collection to west China and eventually to Taiwan.

1	Pre-Communist Art in 20th century China
→	journey of Communist party and armies 1929-33
→	the Long March, Oct 1934-35
→	artists travelling to Europe 1920-37
→	artists travelling to Japan 1916-37
→	route taken by National Academy, Beijing and Hangzhou Academy to west China during World War II, and travels of individual artists
→	route taken by Palace Museum treasures evacuated during World War II and in 1948
⊙	major cities
🏛	museums founded pre-1949
▲⊙	archaeological sites
▲	sacred mountains
⛰	Buddhist cave shrines

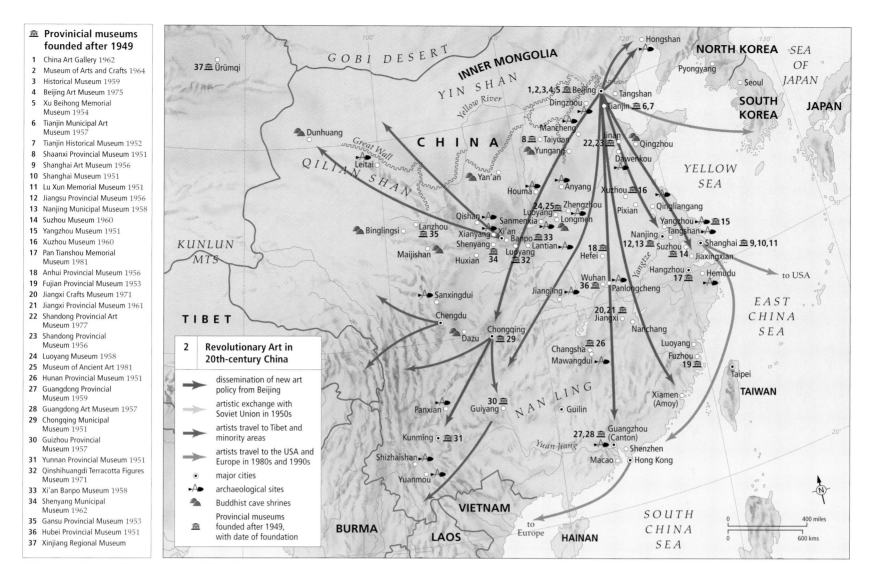

2 **Revolutionary Art in 20th-century China**

→ dissemination of new art policy from Beijing
→ artistic exchange with Soviet Union in 1950s
→ artists travel to Tibet and minority areas
→ artists travel to the USA and Europe in 1980s and 1990s
⊙ major cities
🔺A archaeological sites
🔻 Buddhist cave shrines
🏛 Provincial museums founded after 1949, with date of foundation

2 FROM 1949 UNTIL MAO'S DEATH IN 1976, China's artistic life was largely controlled by the Ministry of Culture, acting through the art schools and the local brances of the Artists Association.

School. Ambitious young artists went to Japan and, increasingly, to Paris, where they were influenced by a range of artistic trends.

The conflict between the Communists and the ruling Guomindang led, in 1927, to the expulsion of the former from Shanghai to a rural base, from which they set out seven years later on their Long March round south and west China to their new base at Yan'an. There they disseminated anti-Japanese propaganda making effective use of the woodcut, which had been developed as a revolutionary tool under the inspiration of the writer and polemicist Lu Xun (1881–1936).

WARTIME EXILE

During the years of the war with Japan (1937–45), the government, schools and universities, as well as teachers and students, migrated to the western provinces of 'Free China'. Cut off from the coastal cities, artists discovered the wild beauty of the West, many of them travelling among the minority people. This gave the art of the period a new urgency and realism. The traditional painter Zhang Daqian (Chang Dai Chien, 1899–1983) spent the years 1942–3 copying the wall-paintings at the remote desert site of Dunhuang, leading to the creation of the Dunhuang Research Institute, still active today. When the war ended, dreams of reconstruction were soon shattered by civil war and rising inflation. In 1948, the Guomindang moved its seat of government, together with treasures, from the Palace Museum to Taiwan.

THE COMMUNIST ERA

On 1 October 1949, Mao Zedong declared the establishment of the People's Republic of China. The early years after Liberation, as it was called, were devoted to political education of the masses, reconstruction, and social and economic levelling, in which there was both idealism and tight Party control. Brief periods of liberalization were followed by reaction and chaos. The turmoil of the Cultural Revolution only ended with Mao's death in 1976.

During the early years after Liberation the influence of Soviet Russia on architecture and art was dominant, although the Great Hall of the People, opened in 1959, was in a new compromise style embodying Chinese and Western elements. The Central Art Academy in Beijing, under direct control of the Ministry of Culture, was the centre where new policies and styles in art were tried out, and disseminated across the country. Monumental sculpture was created for propaganda purposes. Much attention was given to archaeology and the preservation of ancient monuments. Meantime, the art of the peasants was officially promoted. More recently regional schools, with strong local character, have developed.

After the death of Mao, a freer cultural atmosphere began to develop, sparked by the first exhibition of dissident art in 1979. During the 1980s contacts were renewed with the whole tradition of Western art and culture. The departure to the West of independent artists accelerated after the crushing of the pro-democracy demonstration at Tiananmen on 4 June 1989. More recently, booming consumerism and the rebirth of a 'middle class' in China have brought a degree of freedom, cynicism and new sources of patronage beyond the state, while major exhibitions in China, and shows abroad of the work of modern Chinese artists, have helped to establish a place for China in the international world of contemporary art.

THE NATIONAL LIBRARY, Beijing, 1987, by architects Yang Tingbao and others. The straight roof-line and emphasized frame structure of this building represent a rejection of both the Soviet style and the synthesis of Western elements with the elaborate bracketing and curved roof of later dynasties, which characterized many buildings in modern China. Here, the architect went back to the simpler style of the Han Dynasty, which was perceived to be more expressive of modern taste and needs.

JAPAN AND KOREA 1900-2000

JAPANESE AND KOREAN ARTISTS in the twentieth century responded to modernization and imperialism, to various powerful outside influences, to strong traditions from within their cultures, and to many decades of warfare.

A TURBULENT CENTURY
The first half of the twentieth century was overshadowed by the rise of Japanese militarism and by the social disruptions caused by Japanese imperialism in Asia and the South Pacific. In 1910 Japan annexed Korea and tried to impose its own culture on the Koreans. In the 1930s, the Japanese government's increasing focus on militarization and colonial expansion in Manchuria, China and South Asia

1 BY THE END OF THE TWENTIETH CENTURY, Japan and South Korea had become important industrial nations with modern urban centres, numerous public and private art museums, important public and private art collections and vigorous artistic communities. North Korea was influenced by artistic styles developed in the Soviet Union, particularly in monumental works of architecture, sculpture and painting designed to celebrate the communist government's policies and personalities.

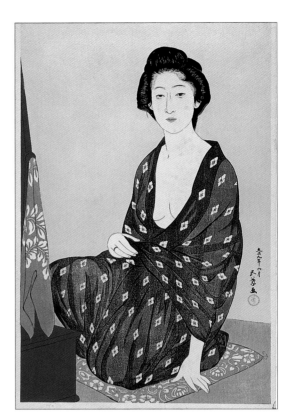

NAKATANI TSURU DRESSING BY HASHIGUCHI GOYO (1880–1921). Modern Japanese print artists like Goyo studied both Western art and traditional *ukiyo-e* and then combined features from each to create distinctive new images. In this portrait of a specific, identified woman rather than an idealized anonymous female, Goyo subtly combines the three-dimensionality of European figure painting with a flatness of patterns and lines in her sheer silk robe, which displays an understanding of eighteenth-century prints designed by Utamaro.

caused a gradual reduction in support for the arts, especially those not linked in some way to the increasing sense of nationalism. As military efforts overseas expanded, Japanese and Korean artists were placed under greater and greater control.

In the final years of World War II Japan was devastated but recovered industrial strength by the 1960s. Korea had barely emerged from the war when the country was divided and then immersed in the Korean War, which further decimated the population and its resources. Although a truce was signed in 1953, the peninsula is still partitioned, and the economic 'miracle' of South Korea has not been matched by North Korea. Both governments exerted strict controls over

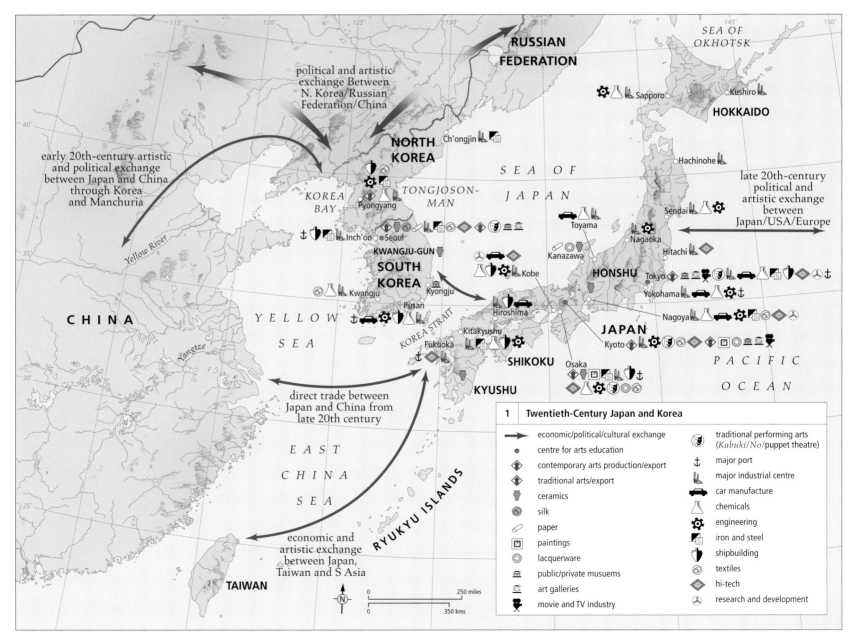

1	Twentieth-Century Japan and Korea
→ economic/political/cultural exchange	traditional performing arts (*Kabuki/No/*puppet theatre)
• centre for arts education	‡ major port
◈ contemporary arts production/export	⚓ major industrial centre
◆ traditional arts/export	🚗 car manufacture
▼ ceramics	△ chemicals
◉ silk	✿ engineering
✎ paper	iron and steel
▣ paintings	⚓ shipbuilding
◎ lacquerware	◉ textiles
🏛 public/private museums	◇ hi-tech
🖼 art galleries	research and development
✸ movie and TV industry	

political and artistic exchange Between N. Korea/Russian Federation/China

early 20th-century artistic and political exchange between Japan and China through Korea and Manchuria

late 20th-century political and artistic exchange between Japan/USA/Europe

direct trade between Japan and China from late 20th century

economic and artistic exchange between Japan, Taiwan and S Asia

society and the arts in the 1960s and 1970s, but the south gradually allowed more freedom of expression and experimentation in the arts. Both Japanese and South Korean artists were greatly affected by outside cultures, especially – because of the presence of military forces from the USA – by American culture. After the Second World War many young Japanese architects and artists pursued graduate studies abroad, especially in the USA, and began careers documented by the international press.

MATERIALS AND TECHNIQUES
In both Japan and Korea, Western construction techniques and materials were increasingly adopted throughout the twentieth century. The lightweight wooden framing and easily movable wall panels of traditional one-storey residential buildings in both countries have been replaced by concrete and steel multilevel construction with Western-style rooms and furnishings. The staging of the 1964 Tokyo Olympics was a significant moment for the revitalized city, with several strikingly beautiful new sports facilities designed by Kenzo Tange (1913–) and his studio. This group of young architects developed the idea of 'metabolism', believing that buildings must be considered as organic forms that expand and contract according to functional needs.

In the early twentieth century, *Nihonga* (Japanese painting) and *yoga* (Western painting) were taught in government-sponsored art schools in Tokyo and Kyoto. *Nihonga*, begun in the last decades of the nineteenth century, used traditional Japanese materials (ink and natural pigments on silk or paper) and formats (folding screens, hanging scrolls and hand-scrolls), but the subject matter was not limited to pre-twentieth-century topics. Japanese artists also studied abroad and had access to publications about Western art. As a result they followed the various changes in modern European and American painting materials and techniques.

There was a deliberate revival of Korean ink painting in the early twentieth century and a strong interest in folk-painting styles and materials. In both Japan and Korea, printmaking was influenced by the introduction of lithography, silk screening and other Western techniques, although artists in the post-war period had a renewed interest in

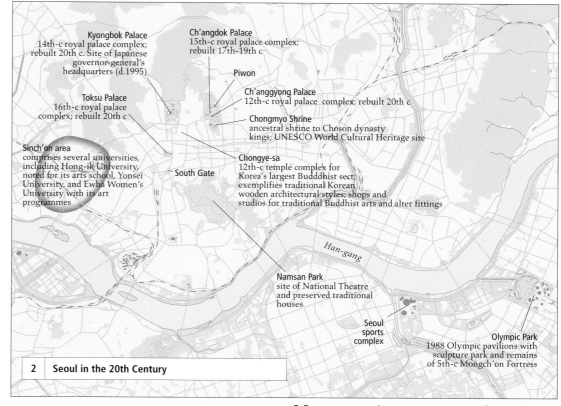

2 | Seoul in the 20th Century

Kyongbok Palace
14th-c royal palace complex; rebuilt 20th c. Site of Japanese governor-general's headquarters (d.1995)

Ch'angdok Palace
15th-c royal palace complex; rebuilt 17th-19th c

Piwon

Toksu Palace
16th-c royal palace complex; rebuilt 20th c

Ch'anggyong Palace
12th-c royal palace complex; rebuilt 20th c

Chongmyo Shrine
ancestral shrine to Choson dynasty kings; UNESCO World Cultural Heritage site

Sinch'on area
comprises several universities, including Hong-ik University, noted for its arts school, Yonsei University, and Ewha Women's University with its art programmes

South Gate

Chongye-sa
12th-c temple complex for Korea's largest Buddhist sect; exemplifies traditional Korean wooden architectural styles; shops and studios for traditional Buddhist arts and alter fittings

Han-gang

Namsan Park
site of National Theatre and preserved traditional houses

Seoul sports complex

Olympic Park
1988 Olympic pavilions with sculpture park and remains of 5th-c Mongch'on Fortress

traditional woodblock printing. Artists often used handmade papers to distinguish their work from Western prints.

The Japanese-American artist Isamu Noguchi (1904–88) proved to be an important link between modern abstract sculpture and Japanese three-dimensional arts. Multimedia installation artworks, such as those by the South Korean video artist Nam June Paik (1932–), have captured world attention. The government often sponsored North Korean sculptors to create large-scale public monuments celebrating the achievements of Communism.

In the areas of photography and film, both Japan and Korea initially followed Western models. Japan's success in the manufacture of cameras and electronics in the next few decades would also identify Japanese film artists as significant contributors to modern art internationally, and in the post-war era Japanese filmmakers developed worldwide audiences for their often evocative imagery. Directors like Akira Kurosawa (1910–98) were internationally respected and emulated. Television developed quickly in Japan, both as a new technology for export and in programming: samurai films and science fiction thrillers (like the Godzilla films) were seen worldwide in the 1960s–80s, and *manga* (cartoon) characters dominated international markets in the 1980s and 1990s.

While traditional Japanese textiles were popular in the USA and Europe, especially in *haute couture* circles, Japanese fashion designers like Issey Miyake and Hanae Mori created new shapes and developed new fabrics that made headlines. In both countries, government encouragement of traditional arts has helped

2 FOLLOWING THE JAPANESE OCCUPATION of Korea in 1910, areas of Seoul were bulldozed for the construction of office buildings and residences for the occupation authorities. The enormous Beaux Arts style Japanese government headquarters building became a symbol of this imposed 'modernization' and was knocked down in 1995 as a demonstration of Korea's cultural independence from Japan. The 1988 Seoul Olympics was an important moment culturally for the South Koreans, as their nation's heritage and potential were recognized internationally.

preserve many textile and costume making techniques, and has supported traditional performers (music, dance and theatre) who use such clothing and accessories.

ART AND SOCIETY
In Japan, both the military and industry were headquartered in Tokyo, and this city became the hub for modern art production and sales. Several wealthy Japanese businessmen formed important collections of both contemporary art and historical pieces, and these collections would later become the core of many small private museums in the Tokyo and Osaka areas. The economic boom in Japan during the 1970s and 1980s resulted in extraordinary public and private displays of support for the arts. Many brand-new prefectural museums were built to display travelling exhibitions of Japanese and foreign artists, and major department stores dedicated whole floors to the staging of art events. When the 'bubble economy' burst in the early 1990s, financial support for the arts was badly affected. Nevertheless, Japanese architects garnered major commissions to design important buildings outside Japan, and Japanese films and videos reached a worldwide audience.

Korean ceramics, both traditional and contemporary, are collected worldwide, and many museums in Europe and America have created separate galleries to feature Korean antiquities. Korean arts are increasingly seen as distinctive and worthy of special consideration. North Korea has remained isolated from the international arts community, and internal economic problems in the late twentieth century restricted both public and private support of the arts.

GRANDMOTHER by O YUN (1946–85), woodblock on paper. The anguish felt by many Koreans after a half century of war, territorial occupation and rapid modernization is vividly expressed in this print by O Yun, who was a leading member of the People's Art Protest Movement in the 1980s that sought both to revive traditional Korean arts and crafts and to comment on contemporary social issues. The bold outlines and flat colours suggest the personal strength and dignity of this woman who has suffered and survived the political and cultural transformations of her country.

SOUTHEAST ASIA 1900-2000

THE TWENTIETH CENTURY was a time of great political and social change in Southeast Asia. After a long period of Western encroachment and colonial rule, the outbreak of the Second World War brought a growing awareness that the Western nations could be defeated. After the war, Independence movements sprang up throughout Southeast Asia. The pattern of government established over the previous two hundred years crumbled, and the colonial powers were gradually forced into granting independence. The independence struggle was reflected in literature, painting and theatre.

PRESERVING THE PAST

The disruptions of this period meant that work on artefacts and on the great 'lost' cities of Southeast Asia was abruptly halted. The French, in particular, had undertaken extensive research into the great city of Angkor in Cambodia, and into the sculpture of the period, but they were forced to abandon this work, and for a long period no local archaeologists took their place. World War II, followed by the Vietnam War and the ensuing Cambodian holocaust, meant that the field of art was neglected. The systematic identification of sculpture and temples, and their conservation, ceased, and the humid conditions of the region caused deterioration of temples and sculpture.

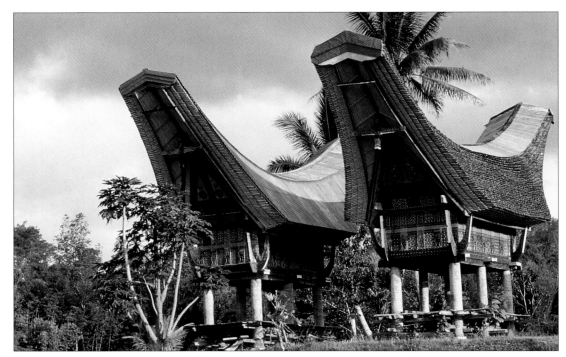

GRANARIES, TANA TORAJALAND, west Sulawesi. Buildings such as this exemplify the sweeping saddle-backed roof formations of Southeast Asia. The houses, which are raised on stilts, have a threefold symbolism: the area beneath the house symbolizes the underworld, the living area of the house is the world of men and the roof area represents the realm of the heavens.

1 A GRADUAL DECLINE in the production of many crafts occurred during the first half of the twentieth century, but the rise of tourism after the Second World War brought about a renewal of artistic production, and many old crafts were saved from extinction. Although tourism has brought problems to the region, it has done much to revitalize its creative life.

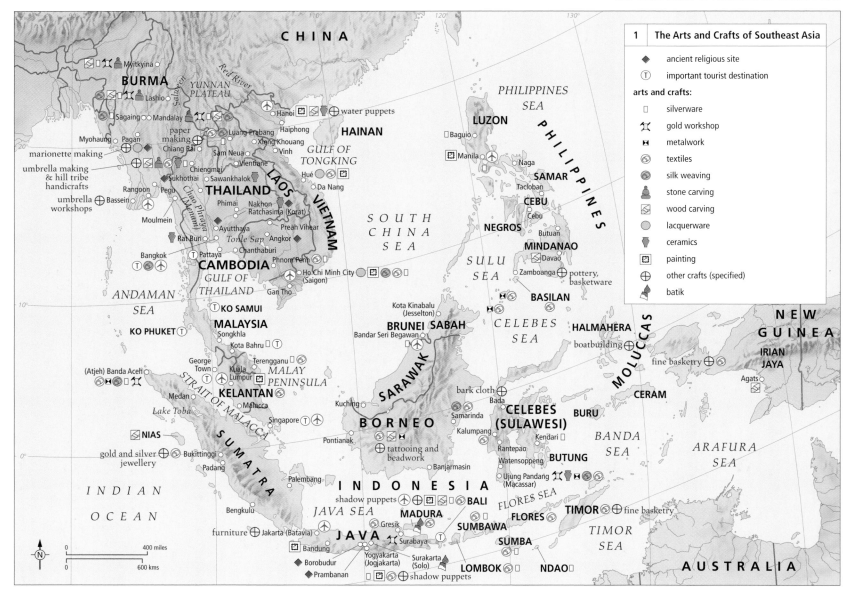

1	The Arts and Crafts of Southeast Asia
◆	ancient religious site
Ⓣ	important tourist destination
arts and crafts:	
▢	silverware
⚒	gold workshop
⋈	metalwork
◎	textiles
◎	silk weaving
⛏	stone carving
⊠	wood carving
○	lacquerware
▽	ceramics
▣	painting
⊕	other crafts (specified)
◭	batik

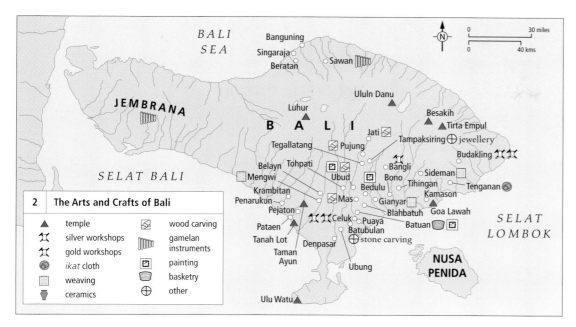

2 The Arts and Crafts of Bali

▲ temple	⬦ wood carving
⚒ silver workshops	▥ gamelan instruments
⚒ gold workshops	▣ painting
◉ *ikat* cloth	⬱ basketry
▢ weaving	⊕ other
▽ ceramics	

2 THE TINY ISLAND OF BALI has seen an explosion of creative talent over the last hundred years. In the fields of music, dance, painting, wood carving, weaving and metalwork, its originality is unrivalled, and the success of the tourist trade has meant that examples of Balinese work are found worldwide. Unlike craftsmen in some other areas who continue to produce traditional work, Balinese craftsmen are innovative, incorporating ideas and stylistic influences from other cultures, yet they retain a distinctively Balinese style.

With the eventual recovery from war there was little money available for restoration, and it was not until the latter part of the century that joint restoration programmes were conducted between the Southeast Asian countries and international organizations.

In 1973 a ten-year programme, with funding from the government, private organizations and UNESCO, was undertaken at Borobudur in central Java. This great monument was gradually collapsing due to water seepage from within the hill on which it was built. The stupa was dismantled and reassembled stone by stone, the galleries were strengthened and the reliefs cleaned. The area was turned into a national park, and now attracts thousands of visitors from all over the world. Other major sites throughout Southeast Asia were restored from the 1970s to the 1990s, and now attract local and foreign visitors.

NEW ARTISTIC TRADITIONS
Carving and painting had previously been for religious or ritual purposes. Originality was not valued and had little meaning. However, the West was to profoundly influence this aspect of art. An important influence on the art of Bali, which was to become famous for its painting tradition, was the residency of Walter Spies and Rudolf Bonnet, European artists who settled on the island in the 1920s and introduced materials and ideas which influenced young artists there to paint in a more expressionist manner, free from the constraints of earlier rigid conventions.

In countries such as Burma and Vietnam the fall of the monarchy had led to a lack of sponsorship of the arts. Many of the arts had fallen into decline, but the advent of large-scale tourism in the region during the second half of the twentieth century caused major changes both in production and approach to the arts. There was a new demand for crafts such as wood carving, lacquerware and painting, and creativity began to be seen as an

end in itself, not necessarily connected to religious beliefs. Many artists began to produce items – which once would have been used solely for ritual purposes – purely for commercial gain.

Western influence was discernible in many areas, but traditional styles were still the most popular. Buddha images continued to emulate earlier models, although Western naturalism can be seen in some of the Ratnakosin (Bangkok) Buddha images, which otherwise seek to recreate the stylized images of the Sukhothai period. In many parts of the region there was now a flourishing trade in small carvings, handicrafts and textiles, all objects which are easily portable. Many objects such

as lacquerware, which can take months to produce, showed a decrease in quality; however, fine pieces were also being made in smaller numbers, usually to order.

Textile production now made use of synthetic rather than vegetable dyes. Although traditional motifs were still used, most cloth was not of such a fine finish as in former days, when a garment might have taken months to complete; however, alongside this commercial production of objects the traditional methods continued on items that would be used in a sacred/ritual context.

Architecturally, the ability to blend cultural styles continued in the twentieth century. In several places, such as Papua New Guinea and Sumatra, government buildings or museums have been built in the distinctive traditional style but on a larger scale. Householders continue to build in the traditional style but many find it cheaper to roof their houses with corrugated iron rather than thatched or woven rattan roofs.

The major change in creativity within the region over the course of the century is that artists have become conscious of themselves as a distinct group. Their work has contributed enormously to the economy of Southeast Asia.

MALAY WALL HANGING, by Kelvin Chap Kok Leong. This work is a synthesis of the modern and the traditional in that the media used are western in inspiration, but the themes and images – the Iban culture of Sarawak – are of traditional society, often seen to be in conflict with Western ideology. The field of painting is developing rapidly in Southeast Asia. In contrast to earlier times, the identity of the artist is known, and the subject matter is usually secular rather than religious. Western influence was strong from the start of the century but a return to Asian roots began to manifest itself by the mid-1900s.

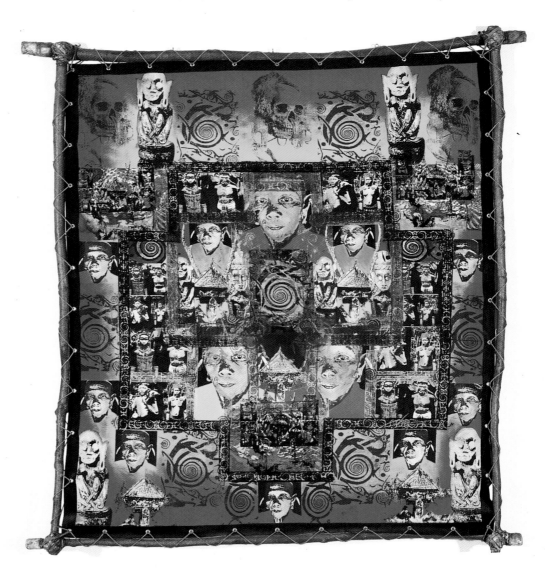

THE PACIFIC 1900-2000

POLITICALLY, BY 1900 the inhabited archipelagos in the Pacific had been divided up as colonies or protectorates controlled by one or another of the major European powers, as well as the United States. Several colonies, such as New Caledonia, Fiji and Samoa, had become important centres for a plantation economy and attracted significant European settlement. Others, like the tiny coconut-rich Micronesian islands of the Marianas, the Carolines, and the Marshalls were economically useful colonial possessions because of products such as copra or phosphate. Still others, such as New Guinea, the Solomon Islands and the New Hebrides, were inhabited by native peoples who fiercely resisted any form of European exploitation. For these Melanesian islands the only economic product they seemed to offer was human labour for plantations and sugar-cane fields in Australia, leading to slave raids by European 'blackbirding' ships.

In the post-war period all but the smallest island groups became either independent nations or self-governing states that relied on

A DIALOGUE BETWEEN TRADITION AND CHANGE. A member of the Pacific Sisters, a collective of performance artists based in Auckland, New Zealand, appearing at the Seventh Pacific Festival of Art, Western Samoa, 1996. The costumes worn by the Sisters juxtapose *tapa* (bark cloth) and raffia with coconut-shell bras, lycra and polyester. This playful body ornament incorporates long-established meanings, helping to recreate the spirit of the Polynesian legends that the Sisters frequently perform.

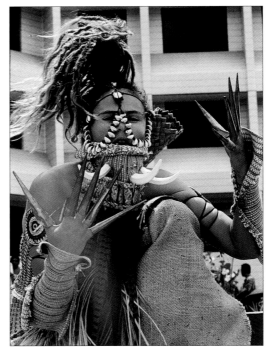

1 IN THE POST-WAR PERIOD the vast majority of the Pacific islands gained independence from colonial overlords, or achieved self-government. In nearly all of the new Pacific Island countries and self-governing states, governments have seen the local production of art as playing an important role in creating new national identities, both for their own peoples and for outsiders. Regular festivals of Pacific art have also promoted the preservation of traditional art.

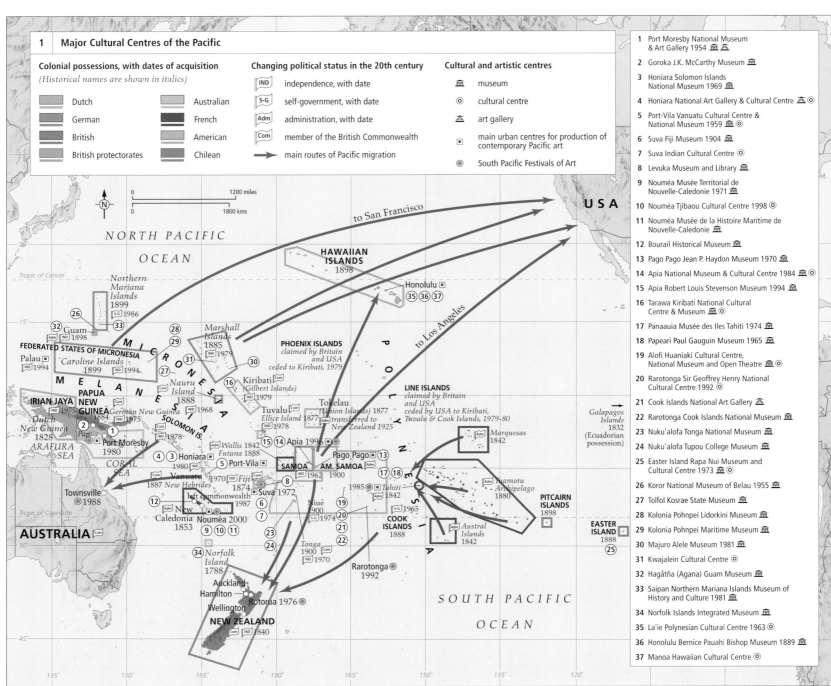

1 Major Cultural Centres of the Pacific

Colonial possessions, with dates of acquisition
(Historical names are shown in italics)

- Dutch
- German
- British
- British protectorates
- Australian
- French
- American
- Chilean

Changing political status in the 20th century

- IND independence, with date
- S-G self-government, with date
- Adm administration, with date
- Com member of the British Commonwealth
- → main routes of Pacific migration

Cultural and artistic centres

- 🏛 museum
- ◎ cultural centre
- ⛩ art gallery
- ▪ main urban centres for production of contemporary Pacific art
- ◉ South Pacific Festivals of Art

1 Port Moresby National Museum & Art Gallery 1954 🏛 ⛩
2 Goroka J.K. McCarthy Museum 🏛
3 Honiara Solomon Islands National Museum 1969 🏛
4 Honiara National Art Gallery & Cultural Centre ⛩ ◎
5 Port-Vila Vanuatu Cultural Centre & National Museum 1959 🏛 ◎
6 Suva Fiji Museum 1904 🏛
7 Suva Indian Cultural Centre ◎
8 Levuka Museum and Library 🏛
9 Nouméa Musée Territorial de Nouvelle-Caledonie 1971 🏛
10 Nouméa Tjibaou Cultural Centre 1998 ◎
11 Nouméa Musée de la Histoire Maritime de Nouvelle-Caledonie 🏛
12 Bourail Historical Museum 🏛
13 Pago Pago Jean P. Haydon Museum 1970 🏛
14 Apia National Museum & Cultural Centre 1984 🏛 ◎
15 Apia Robert Louis Stevenson Museum 1994 🏛
16 Tarawa Kiribati National Cultural Centre & Museum 🏛 ◎
17 Panaauia Musée des Iles Tahiti 1974 🏛
18 Papeari Paul Gauguin Museum 1965 🏛
19 Alofi Huaniaki Cultural Centre, National Museum and Open Theatre 🏛 ◎
20 Rarotonga Sir Geoffrey Henry National Cultural Centre 1992 ◎
21 Cook Islands National Art Gallery ⛩
22 Rarotonga Cook Islands National Museum 🏛
23 Nuku'alofa Tonga National Museum 🏛
24 Nuku'alofa Tupou College Museum 🏛
25 Easter Island Rapa Nui Museum and Cultural Centre 1973 🏛 ◎
26 Koror National Museum of Belau 1955 🏛
27 Tolfol Kosrae State Museum 🏛
28 Kolonia Pohnpei Lidorkini Museum 🏛
29 Kolonia Pohnpei Maritime Museum 🏛
30 Majuro Alele Museum 1981 🏛
31 Kwajalein Cultural Centre ◎
32 Hagåtña (Agana) Guam Museum 🏛
33 Saipan Northern Mariana Islands Museum of History and Culture 1981 🏛
34 Norfolk Islands Integrated Museum 🏛
35 La'ie Polynesian Cultural Centre 1963 ◎
36 Honolulu Bernice Pauahi Bishop Museum 1889 🏛
37 Manoa Hawaiian Cultural Centre ◎

2 DESPITE COLONIAL INFLUENCE traditional art flourished in New Guinea until the 1920s. Art from New Guinea was the focus for many European collections of Pacific art. The earliest collections from New Guinea and Melanesia emphasized carved clubs, spears, shields and other weapons, but collectors soon noticed the remarkable variety of wood, bark cloth and wickerwork masks, carved figures, ancestor boards, wooden bowls and ornaments made of shell. Since the 1960s the rise of tourism in Papua New Guinea has had a profound impact on art production as visitors have demanded 'traditional' art forms using traditional materials and pigments.

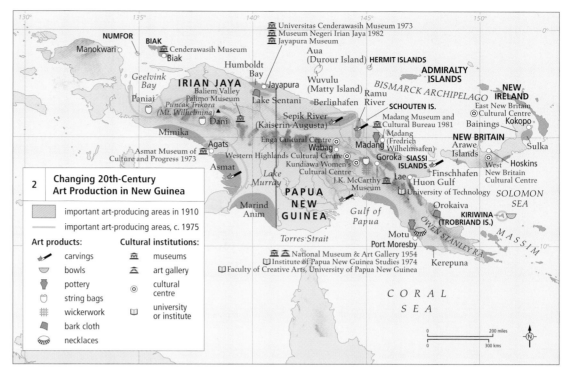

one of the major Pacific powers for international relations and defence. Only France and the United States have maintained colonies in the Pacific. Papua New Guinea, with more than 4 million, people and Fiji, with nearly 1 million, are clearly the largest and most important of these newly independent states.

ART AND COLONIALISM
During the twentieth century art throughout the Pacific was profoundly affected by the presence of these foreigners, and in each archipelago artists experienced a different impact from the interests and desires of their colonial elites. Modernization and missionaries led villagers to abandon customary religions and the art that so often accompanied them. Traders, curio collectors and missionaries bought up most of the major carved wooden figures that had previously been so central in Polynesian religions. Ironically, the introduction of steel tools in the nineteenth and early twentieth centuries, led to an increased production of art early on, allowing carvers to elaborate on detail and motifs that were difficult with traditional stone, bone and shell tools. The vast majority of objects in museum collections from Melanesia, for example, were made after the introduction of steel.

But between the World Wars production of traditional art in most areas of the Pacific was in decline, being replaced in some areas by production of art solely for overseas visitors and markets. These carved, painted, plaited, woven or netted objects began to incorporate imported media, especially paints, beads, and yarns, as well as increasingly realistic motifs that foreigners could easily recognize and appreciate. The carving that did persist in twentieth-century Polynesia was largely a nostalgic reinterpretation of traditional styles, made for sale to international travellers.

Production of bark cloth (*tapa*) continued into the twentieth century and flourished in Samoa, Tonga, Fiji and Hawaii. In Tonga and Fiji *tapa* cloths with intricate designs were used at royal ceremonies, such as weddings. During the same period *tapa* also took on many innovative design elements and motifs that islanders had obtained from contact with Europeans and natives from other island groups. Necklaces of shell and indigenous beads, together with grass skirts, became emblematic of the sexual freedom that Western visitors associated with the Polynesian islands.

TRADITIONAL ART COLLECTIONS
Traditional art continued to flourish in New Guinea and many of the Melanesian Islands until the 1920s. This was the period when most European, Australian and American museums built up huge collections of Melanesian art, by sending out anthropological expeditions to make field collections or by purchasing collections from traders, missionaries and

government officers living in various parts of this vast region. The Museum für Volkerkunde in Berlin assembled the largest collection from Melanesia, emphasizing material from its colony, German New Guinea, followed closely by Chicago's Field Museum of Natural History and Sydney's Australian Museum, both of which had much broader general collections. Within the Pacific region, only the Bernice P. Bishop Museum in Honolulu, the Fiji Museum in Suva and the Territorial Museum of New Caledonia contain early Pacific collections, each emphasizing collections from their own subregions. There are also Pacific collections in New Zealand: in the National Museum in Wellington and the Auckland Museum.

In the latter half of the twentieth century, as new countries and self-governing states have sought to assert a national identity, they have established museums and cultural centres as ways of promoting the arts. They have also sought to promote performances of customary dances. Among the most important of these are the National Museum and Art

Gallery in Port Moresby and the Tjibaou Cultural Centre in Nouméa. Both institutions have made use of innovative architecture that drew on indigenous house forms.

NEW DIRECTIONS
Around the 1960s, new artistic movements began to emerge in many Pacific Island countries. Centred on the growing cities, a new group of contemporary artists emerged, using innovative media, styles and forms. In Papua New Guinea, contemporary artists began painting on canvas in acrylics, tempera or oil. Some artists have begun sculptures that elaborate on traditional pottery, while others have begun sculpting in metals. Similar movements are present in most urban centres in the Pacific as well as in cities in New Zealand and Australia, where Pacific Islanders had migrated.

Contemporary artists throughout the Pacific have incorporated traditional elements into their art at the same time that they have made use of modern themes, motifs and situations to react to their changing social conditions. New Zealand, in particular, has played an important role in the development of contemporary Polynesian art by bringing together thousands of Pacific Islanders from other islands who now live in Auckland, Wellington, Hamilton and other New Zealand cities. Since 1972 Pacific Island states have participated in eight South Pacific Festivals of Art, each in a different Pacific country, with participation from more than twenty Pacific Island countries which send dance troops, artists and representatives from museums and cultural centres. These festivals have encouraged the preservation of traditional art forms as emblems of national and cultural identity, while simultaneously offering opportunities for islanders to innovate by drawing on themes from other Pacific countries.

NATIONAL MUSEUM AND ART GALLERY, Port Moresby, Papua New Guinea, 1974. The facade was designed by the New Ireland artist, David Lasisi, its mural executed by students of the National Arts School. Buildings like this aim to express *bung wantaim*, pidgin for 'a true coming together', here symbolized by cooperation and mixing of styles by artists from different regions, in celebration of the multicultural richness of Papua New Guinea, a more diverse nation than any other in the Pacific.

AUSTRALIA AND NEW ZEALAND 1900-2000

DESPITE GAINING INDEPENDENCE at the beginning of the twentieth century, the former British colonies of Australia (1901) and New Zealand (1907) remained culturally subordinate for much of the subsequent century. Antipodean artists who followed European trends were dismissed as derivative. Those who ignored them were regarded as provincial. Earnest debates on the merits of internationalism over regionalism, modernism over conservatism, and abstraction over figurative art – key issues of early twentieth-century Western visual culture – seemed somewhat comical to the wider world when argued at such a geographical remove.

Nevertheless, Australian and New Zealand artists developed their own distinctive responses to these new schools, as they had in the previous century. Some of the earliest modernist works were by the women artists Grace Cossington Smith (1892–1984) and

Margaret Preston (1875–1963) in Australia and Rita Angus (1908–70) in New Zealand. Later, the short-lived Australian magazine *Angry Penguins* (1941–6) gathered around it a group of like-minded figurative painters, such as Arthur Boyd (1920–99) and Sidney Nolan (1917–92), whose work drew on a range of influences, including Surrealism. In the latter half of the century, artists keenly followed the developments in abstract, performance and conceptual art that were prevalent in the international art world.

In architecture the earliest, considered response to modernism came from the work of the Austrian-born Harry Seidler (1923–), who moved to Sydney in 1948. The later work of the Australian Glenn Murcutt (1936–) showed a growing interest in vernacular building types: in particular the verandah-style house. However, the most significant single work of twentieth-century architecture in the region is the Sydney Opera House, designed by the

Danish architect Jørn Utzon after winning an international competition in 1957.

INDIGENOUS ROOTS

Despite these outside influences, Australia and New Zealand were largely defined by their indigenous cultures, even though the Aboriginal and Maori people were still considered – just as they had been at the end of the previous century – to be 'dying out'. Their physical appearance was recorded for posterity by white artists such as Percy Leason in his forty-six portraits of *The Last of the Victorian Aborigines* (1934) and Charles Goldie in his series of Maori portraits (1900–40). Similarly, their material culture was collected for its historic or nostalgic value. In 1912 the noted anthropologist Baldwin Spencer commissioned bark paintings from the Aboriginal people of Oenpelli for the Museum of Victoria. Spencer believed the Australian

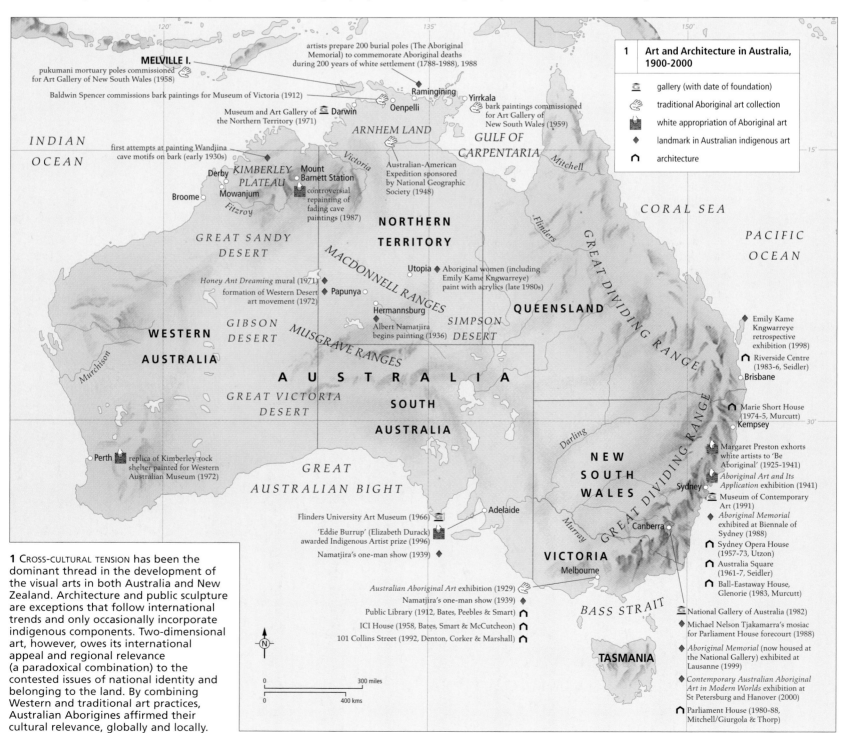

1 CROSS-CULTURAL TENSION has been the dominant thread in the development of the visual arts in both Australia and New Zealand. Architecture and public sculpture are exceptions that follow international trends and only occasionally incorporate indigenous components. Two-dimensional art, however, owes its international appeal and regional relevance (a paradoxical combination) to the contested issues of national identity and belonging to the land. By combining Western and traditional art practices, Australian Aborigines affirmed their cultural relevance, globally and locally.

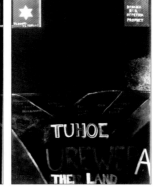

Aborigine to be 'a relic of the early childhood of mankind left stranded'. He could not see that, in agreeing to paint bark paintings to order, these Aboriginal artists demonstrated that they were not frozen in time, but willing to respond to new cultural circumstances.

Uncertain of their own national identity, white antipodean artists turned to indigenous culture for inspiration. In Australia Preston exhorted her fellow artists to 'Be Aboriginal'. Beginning with Jessie Traill in 1928, white artists visited remote Aboriginal communities in central Australia – a region unfamiliar to city-based Australians – and were influenced by the stark landscape and the rich indigenous culture.

Initially, Aboriginal motifs were respected in much the same way as the 'primitive' elements that had informed European Modernism earlier in the century. Later, they were used indiscriminately and carelessly as decoration, so that by the 1950s pseudo-Aboriginal ornamentation and furnishings overwhelmed Australian suburbia. This commercialization occurred without the collaboration of the Aboriginal originators of these designs and without acknowledgement of the cultural misappropriation involved.

There were, however, some reverse benefits from this contact between indigenous and non-indigenous artists. Albert Namatjira, an Arrernte resident of the Hermannsburg Lutheran mission, learned watercolour technique from the visitors. His idiosyncratic depictions of his own country were dismissed at the time as poor attempts at copying the Western landscape paradigm, but have since been critically rehabilitated as sophisticated reworkings of Aboriginal tradition. In the Kimberley district the monumental Wandjina figures characteristic of the region were transferred from rock faces to small bark panels for the first time in the 1930s, producing paintings that were both accessible and collectable.

COLIN MCCAHON, *Urewera Mural,* 1975, acrylic on three canvas panels, Aniwaniwa Park headquarters building, Lake Waikaremoana, New Zealand. It represents the theme 'The Mystery of Man in the Urewera', which was suggested by the Maori architect of the building, John Scott. The Urewera is a forested region of the North Island.

2 WHILE ART SCHOOL-TRAINED Maori artists combined Maori and Western (*Pakeha*) traditions to produce paintings that negotiated the cultural gap with wit and self-reflection, Maori elders maintained control over the more profound elements of their visual culture, encouraging a resurgence of traditional arts. New Zealand's biculturalism, which became official policy in 1990, was exemplified in 1998 by the opening of the Museum of New Zealand/Te Papa Tongarewa.

2 Govett-Brewster Art Gallery (1970)
- *Borrowing and Belonging* exhibition, and *The Raising of the Noxious answering* exhibition (1999)

3 - Colin McCahon's *Urewera Mural* stolen from Te Urewera National Park Visitor Centre (1997); rehung in Visitor Centre (2000)

4 - National Art Gallery of New Zealand (1936)
- *Kohia Ko Taikaka Anake* exhibition of contemporary Maori art (1990)
- Museum of New Zealand/ Te Papa Tongarewa (1998) (1994-8, JASMAX Architects)
- *Contemporary Painting in New Zealand* at Commonwealth Institute, London (1965)
- *Te Maori* exhibition to USA galleries (1984)
- Colin McCahon's exhibition *I Will Need Words* in Sydney, Edinburgh (1984)
- *Pacific Parallels* exhibition to seven USA galleries (1991-92)
- *Cultural Safety* exhibition in Frankfurt (1995)
- Massey House (1952-7, Plischke)

1 - *Urewera Mural* restored (1998); exhibited (1999)
- Maori portraits by Gottfried Lindauer at St Louis World Fair (1904)
- Arts Building, University of Auckland (1921-5, Lippincott)

- first exhibition of Maori Artists and Writers Society/Nga Puna Waihanga (1976)

Auckland **1**

Cross-Currents exhibition (1991)

Hamilton

Rotorua

New Plymouth **2**

NORTH ISLAND

3 Aniwaniwa

Napier - rebuilt in Art Deco style (1932-3)

Palmerston North
Manawatu Art Gallery (1977)

Lower Hutt - Dowse Art Gallery (1971)

Wellington **4**

TASMAN SEA

SOUTHERN ALPS

COOK STRAIT

Christchurch
Te Ao Marama exhibition of seven Maori artists tour Australia (1986)

Robert Mcdougall Gallery (1932)

New Zealand Maori Culture and the Contemporary Scene (1966)

Dorset Street Flats (1956, Warren)

SOUTH ISLAND

PACIFIC OCEAN

Dunedin

STEWART I.

0 200 miles
0 300 kms

2	Art and Architecture in New Zealand, 1900-2000
gallery (with date of foundation)	architecture
Maori and *Pakeha* interrelated art	
exported art	

Another significant innovation occurred in central Australia, where Aboriginal elders painted *The Honey Ant Dreaming* – sacred/secret knowledge, traditionally inscribed in ephemeral sand-paintings – as a mural on the external walls of the Papunya school in 1971. By the 1980s, Papunya artists were painting secularized versions of their dreamings with acrylic pigments on canvas or composition board, and the northwestern bark painters had extended their art practice to non-traditional screen prints and fabric panels. These Aboriginal artists of central and northern Australia retained the authenticity of their culture while altering its material base. Their work commercially overshadowed the art

produced by city-based Aborigines of the southeast, whose ironic visual responses to their urban environment were not considered authentically Aboriginal.

Maori artists had adapted to Western influences in the nineteenth century, so that, for most of the twentieth century, Maori decorative motifs were familiar to, and regarded as the cultural heritage of, all New Zealanders. Non-Maori artists, such as Gordon Walters, who incorporated the *koru* motif into his Modernist paintings from the mid-1960s to the mid-1980s, absorbed Maori design elements into their work, a practice that by the end of the century was considered exploitative.

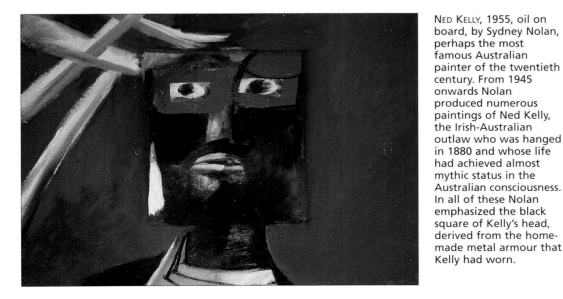

NED KELLY, 1955, oil on board, by Sydney Nolan, perhaps the most famous Australian painter of the twentieth century. From 1945 onwards Nolan produced numerous paintings of Ned Kelly, the Irish-Australian outlaw who was hanged in 1880 and whose life had achieved almost mythic status in the Australian consciousness. In all of these Nolan emphasized the black square of Kelly's head, derived from the home-made metal armour that Kelly had worn.

CULTURAL APPROPRIATIONS
The axiom that indigenous artists can 'borrow', whereas non-indigenous artists cannot 'appropriate' seems heavy-handed, but is necessary in light of persistent non-indigenous assumption of cultural authority. Australian examples include the unilateral decision to restore (by overpainting!) ancient rock paintings in the Kimberleys (1987), and the imposture of the white artist Elizabeth Durack as the fictitious indigenous painter Eddie Burrup in a misguided belief that her long association and empathy with the Aboriginal people allowed her to paint in their name (1997). The Maori text incorporated into the *Urewera Mural* (1975) by the non-indigenous painter, Colin McCahon, was judged an affront rather than the homage he perhaps intended, and the painting was taken hostage by radical Maoris in 1997.

ART INSTITUTIONS WORLDWIDE 2000

AROUND 2000 INTERCONTINENTAL travel and communication networks have enabled an unprecedented degree of reciprocal cultural awareness to develop around the world. New technologies make contact between artists amazingly quick and easy; they also affect heritage, its conservation and the tourism that depends upon it.

ART EVENTS
From the mid-twentieth century biennials and other art events have recast the geographical canon of art. Of late-nineteenth-century origins, the Venice Biennale remains primarily European; the São Paulo Biennial, founded in 1951, epitomizes Latin-American relations with the First World. Dating from the mid-1980s, the Havana Biennial has cast itself as the first transperipheral exhibition open to artists from Asia, Africa, Latin America, the Caribbean and the Middle East. Since the 1990s events such as the Zanzibar Film Festival and the Johannesburg, Dakar, Prague, Tirana and Sofia Biennials have helped to shift attention towards Africa and Eastern Europe. Reflecting how curatorial power is now shared more widely, the eleventh Documenta quadriennial in Kassel was curated by the Nigerian Okwui Enwezor.

Annual national and international prizes for art and architecture include the Turner Prize (1984–), administered from the Tate Gallery in London and, since 1991, only for artists under 50 and resident in Britain. Based in Los Angeles, the Pritzker Architecture Prize (1979–) is open to architects from around the world.

The most successful visual media of the twentieth century – photography, film and television – continue to attract a mass audience. Fine art's public is by comparison very restricted, even though for the last 100 years the parameters of 'art' have been expanded. One way artists and their supporters attempt to regain a wider appeal is by borrowing the tools and approaches of more popular media. The Turner and other such prizes are screened on television, and art events are normally publicized on the web.

The World Crafts Council is a nonprofit NGO that promotes contact between craftspeople worldwide. In 2001 its secretariat transferred from Kyoto to Ioannina in Greece.

1 WHILE ART AND ARCHITECTURAL initiatives beyond national boundaries continue to be largely financed and organized by wealthier nations, later twentieth-century educational and curatorial initiatives in Asia, Africa and Latin America have succeeded in transferring significant artistic clout to the eastern and southern hemispheres.

SPONSORSHIP
The USA remains the main centre of private sponsorship of artistic activity and heritage management worldwide, and a high proportion of international organizations are based in Paris – but in recent decades African, Asian, Australasian and Latin American banks, foundations and ministerial organizations have played an increasing part in the management of the artistic heritages of their respective continents. Worldwide, public sponsorship remains the most powerful force.

On the commercial side, London-based auction houses, with tentacles in well-to-do centres elsewhere, continue to enjoy the lion's share of the art market – although they are increasingly subject to legal challenges.

WORLD HERITAGE ORGANIZATIONS
UNESCO initiatives of the 1960s led to the 1972 Convention Concerning the Protection of World Cultural and Natural Heritage, and thence to the World Heritage List. Since the first List of 1978, new locations of 'outstanding universal value' have been added annually; by 2002, 730 sites in 125 countries were inscribed. Of these, 563 are cultural, 144 natural and the remaining twenty-odd 'mixed' – reflecting how nature and culture are now understood by many to be interrelated.

The World Monuments Fund, a coalition of philanthropic individuals loosely allied with UNESCO, was created in 1965. Based in New York and with subsidiary offices in London, Paris, Madrid and Lisbon, with the support of

PAGE FROM THE WEBSITE of the seventh Havana Biennial of 2000–01, showing the internet's effectiveness as a means of visual communication. The stills are from the South African William Kentridge's *Shadow Procession*, a video of hand-made cut-out figures. *Shadow Procession* revisited absurdist Ubu iconography in the nostalgic and slightly apocalyptic spirit of 1999. *Shadow Procession* now exists as a DVD.

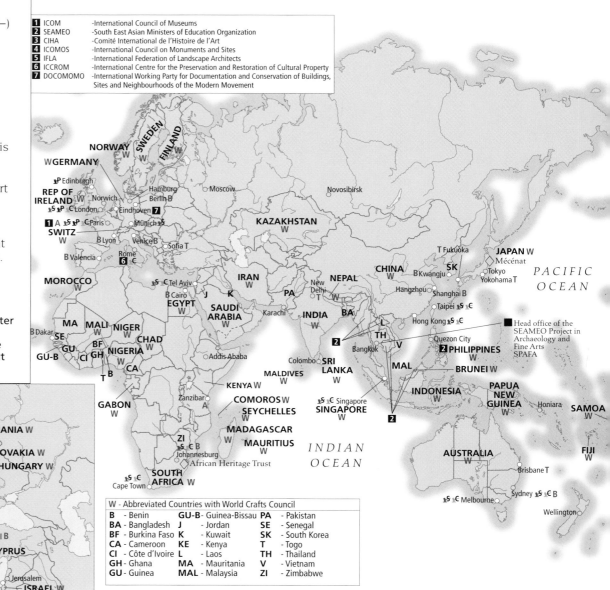

1 ICOM	-International Council of Museums	
2 SEAMEO	-South East Asian Ministers of Education Organization	
3 CIHA	-Comité International de l'Histoire de l'Art	
4 ICOMOS	-International Council on Monuments and Sites	
5 IFLA	-International Federation of Landscape Architects	
6 ICCROM	-International Centre for the Preservation and Restoration of Cultural Property	
7 DOCOMOMO	-International Working Party for Documentation and Conservation of Buildings, Sites and Neighbourhoods of the Modern Movement	

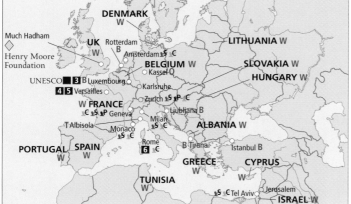

W - Abbreviated Countries with World Crafts Council					
B	- Benin	**GU-B**	- Guinea-Bissau	**PA**	- Pakistan
BA	- Bangladesh	**J**	- Jordan	**SE**	- Senegal
BF	- Burkina Faso	**K**	- Kuwait	**SK**	- South Korea
CA	- Cameroon	**KE**	- Kenya	**T**	- Togo
CI	- Côte d'Ivoire	**L**	- Laos	**TH**	- Thailand
GH	- Ghana	**MA**	- Mauritania	**V**	- Vietnam
GU	- Guinea	**MAL**	- Malaysia	**ZI**	- Zimbabwe

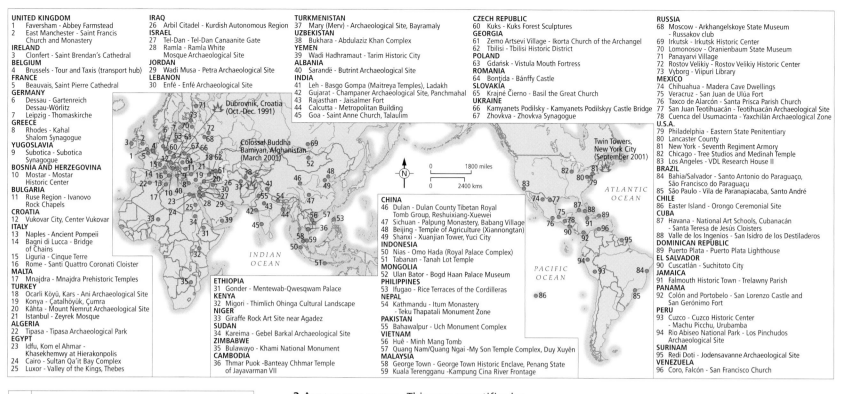

UNITED KINGDOM
1 Faversham - Abbey Farmstead
2 East Manchester - Saint Francis Church and Monastery
IRELAND
3 Clonfert - Saint Brendan's Cathedral
BELGIUM
4 Brussels - Tour and Taxis (transport hub)
FRANCE
5 Beauvais, Saint Pierre Cathedral
GERMANY
6 Dessau - Gartenreich Dessau-Wörlitz
7 Leipzig - Thomaskirche
GREECE
8 Rhodes - Kahal Shalom Synagogue
YUGOSLAVIA
9 Subotica - Subotica Synagogue
BOSNIA AND HERZEGOVINA
10 Mostar - Mostar Historic Center
BULGARIA
11 Ruse Region - Ivanovo Rock Chapels
CROATIA
12 Vukovar City, Center Vukovar
ITALY
13 Naples - Ancient Pompeii
14 Bagni di Lucca - Bridge of Chains
15 Liguria - Cinque Terre
16 Rome - Santi Quattro Coronati Cloister
MALTA
17 Mnajdra - Mnajdra Prehistoric Temples
TURKEY
18 Ocarli Köyü, Kars - Ani Archaeological Site
19 Konya - Çatalhöyük, Çumra
20 Kâhta - Mount Nemrut Archaeological Site
21 Istanbul - Zeyrek Mosque
ALGERIA
22 Tipasa - Tipasa Archaeological Park
EGYPT
23 Idfu, Kom el Ahmar - Khasekhemwy at Hierakonpolis
24 Cairo - Sultan Qa'it Bay Complex
25 Luxor - Valley of the Kings, Thebes

IRAQ
26 Arbil Citadel - Kurdish Autonomous Region
ISRAEL
27 Tel-Dan - Tel-Dan Canaanite Gate
28 Ramla - Ramla White Mosque Archaeological Site
JORDAN
29 Wadi Musa - Petra Archaeological Site
LEBANON
30 Enfé - Enfé Archaeological Site

ETHIOPIA
31 Gonder - Mentewab-Qwesqwam Palace
KENYA
32 Migori - Thimlich Ohinga Cultural Landscape
NIGER
33 Giraffe Rock Art Site near Agadez
SUDAN
34 Kareima - Gebel Barkal Archaeological Site
ZIMBABWE
35 Bulawayo - Khami National Monument
CAMBODIA
36 Thmar Puok -Banteay Chhmar Temple of Jayavarman VII

TURKMENISTAN
37 Mary (Merv) - Archaeological Site, Bayramaly
UZBEKISTAN
38 Bukhara - Abdulaziz Khan Complex
YEMEN
39 Wadi Hadhramaut - Tarim Historic City
ALBANIA
40 Sarandë - Butrint Archaeological Site
INDIA
41 Leh - Basgo Gompa (Maitreya Temples), Ladakh
42 Gujarat - Champaner Archaeological Site, Panchmahal
43 Rajasthan - Jaisalmer Fort
44 Calcutta - Metropolitan Building
45 Goa - Saint Anne Church, Talaulim

CHINA
46 Dulan - Dulan County Tibetan Royal Tomb Group, Reshuixiang-Xuewei
47 Sichuan - Palpung Monastery, Babang Village
48 Beijing - Temple of Agriculture (Xiannongtan)
49 Shanxi - Xuanjian Tower, Yuci City
INDONESIA
50 Nias - Omo Hada (Royal Palace Complex)
51 Tabanan - Tanah Lot Temple
MONGOLIA
52 Ulan Bator - Bogd Haan Palace Museum
PHILIPPINES
53 Ifugao - Rice Terraces of the Cordilleras
NEPAL
54 Kathmandu - Itum Monastery - Teku Thapatali Monument Zone
PAKISTAN
55 Bahawalpur - Uch Monument Complex
VIETNAM
56 Huê - Minh Mang Tomb
57 Quang Nam/Quang Ngai -My Son Temple Complex, Duy Xuyên
MALAYSIA
58 George Town - George Town Historic Enclave, Penang State
59 Kuala Terengganu -Kampung Cina River Frontage

CZECH REPUBLIC
60 Kuks - Kuks Forest Sculptures
GEORGIA
61 Zemo Artsevi Village - Ikorta Church of the Archangel
62 Tbilisi - Tbilisi Historic District
POLAND
63 Gdańsk - Vistula Mouth Fortress
ROMANIA
64 Bonţida - Bánffy Castle
SLOVAKIA
65 Krajné Čierno - Basil the Great Church
UKRAINE
66 Kamyanets Podilsky - Kamyanets Podilskyy Castle Bridge
67 Zhovkva - Zhovkva Synagogue

RUSSIA
68 Moscow - Arkhangelskoye State Museum - Russakov club
69 Irkutsk - Irkutsk Historic Center
70 Lomonosov - Oranienbaum State Museum
71 Panayarvi Village
72 Rostov Velikiy - Rostov Velikiy Historic Center
73 Vyborg - Viipuri Library
MEXICO
74 Chihuahua - Madera Cave Dwellings
75 Veracruz - San Juan de Ulúa Fort
76 Taxco del Alarcón - Santa Prisca Parish Church
77 San Juan Teotihuacán - Teotihuacán Archaeological Site
78 Cuenca del Usumacinta - Yaxchilán Archaeological Zone
U.S.A.
79 Philadelphia - Eastern State Penitentiary
80 Lancaster County
81 New York - Seventh Regiment Armory
82 Chicago - Tree Studios and Medinah Temple
83 Los Angeles - VDL Research House II
BRAZIL
84 Bahia/Salvador - Santo Antonio do Paraguaço, São Francisco do Paraguaçu
85 São Paulo - Vila de Paranapiacaba, Santo André
CHILE
86 Easter Island - Orongo Ceremonial Site
CUBA
87 Havana - National Art Schools, Cubanacán - Santa Teresa de Jesús Cloisters
88 Valle de los Ingenios - San Isidro de los Destiladeros
DOMINICAN REPUBLIC
89 Puerto Plata - Puerto Plata Lighthouse
EL SALVADOR
90 Cuscatlán - Suchitoto City
JAMAICA
91 Falmouth Historic Town - Trelawny Parish
PANAMA
92 Colón and Portobelo - San Lorenzo Castle and San Gerónimo Fort
PERU
93 Cuzco - Cuzco Historic Center - Machu Picchu, Urubamba
94 Rio Abiseo National Park - Los Pinchudos Archaeological Site
SURINAM
95 Redi Doti - Jodensavanne Archaeological Site
VENEZUELA
96 Coro, Falcón - San Francisco Church

2	Artistic Sites in Peril
•	World Monuments Fund sites in peril, c.2000
🔥	destruction of patrimony

2 ARTISTIC SITES IN PERIL. This map quantifies by country UNESCO World Heritage sites nominated in the quarter of a century up to 2002, and shows the '100 Sites in Peril' as listed by the World Monuments Fund in 2000; it also marks some of the important sites that were wilfully attacked either side of 2000.

American Express the WMF has since 1996 published biennial 'World Monuments Watch' reports on '100 Sites in Peril'. In September 2001 Lower Manhattan became the 101st site in the list for 2002.

Perceptions of cultural identity reflect a much more varied reality than does contemporary political rhetoric. For instance, recent exhibitions and publications in Bogotá, Buenos Aires and Mexico City have investigated the aesthetics of 'América', and consider the nomenclature of the USA as 'America' to be misleading.

The outreach of UNESCO and of the World Monuments Fund is broad but not ubiquitous. In many areas of post-colonial Africa it is felt that heritage is better managed through indigenous involvement than by the imposition of international guidelines.

TOURISM
Tourism increased over the latter part of the twentieth century to become in itself an important, even dominant, cultural phenomenon. Its effects are ambivalent. Tourist visits fund sites, both directly by way of admission fees and indirectly via the souvenir trade. However, many sites are unwittingly 'uglified' for the supposed benefit of visitors, and every tourist visit causes wear and tear.

Attacks on both tourists and monuments have contributed to a reduction in travel, but the destruction of the Buddhas at Bamiyan in Afghanistan has had the side effect of focussing global attention on heritage conservation.

WORLDWIDE WEB
The worldwide web enables the display and viewing of art. The internet is especially appreciated by artists operating outside the established cities for private exhibiting galleries because it lets them bypass intermediary gallery owners to find a public directly. Biennials' and other art events' web pages are an end in themselves as well as a means of self-publicity. The web also increasingly serves scholarship with online journals. The internet, a dynamic visual medium in its own right, makes art accessible to anyone who wants it.

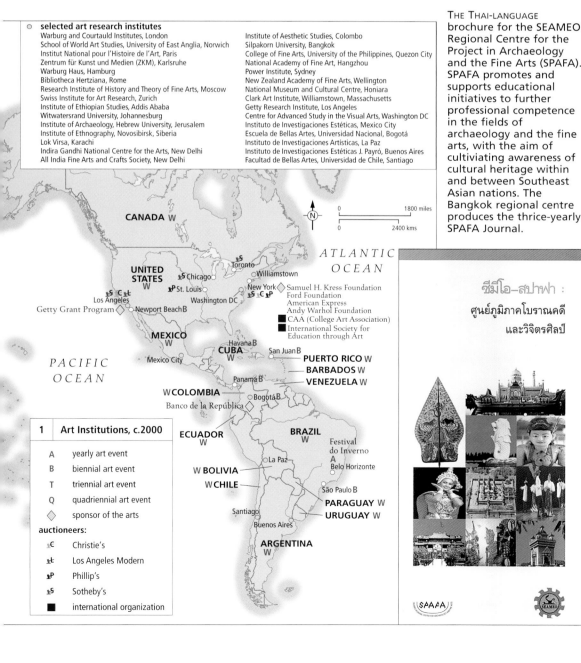

○ selected art research institutes
Warburg and Courtauld Institutes, London
School of World Art Studies, University of East Anglia, Norwich
Institut National pour l'Histoire de l'Art, Paris
Zentrum für Kunst und Medien (ZKM), Karlsruhe
Warburg Haus, Hamburg
Bibliotheca Hertziana, Rome
Research Institute of History and Theory of Fine Arts, Moscow
Swiss Institute for Art Research, Zurich
Institute of Ethiopian Studies, Addis Ababa
Witwatersrand University, Johannesburg
Institute of Archaeology, Hebrew University, Jerusalem
Institute of Ethnography, Novosibirsk, Siberia
Lok Virsa, Karachi
Indira Gandhi National Centre for the Arts, New Delhi
All India Fine Arts and Crafts Society, New Delhi

Institute of Aesthetic Studies, Colombo
Silpakorn University, Bangkok
College of Fine Arts, University of the Philippines, Quezon City
National Academy of Fine Art, Hangzhou
Power Institute, Sydney
New Zealand Academy of Fine Arts, Wellington
National Museum and Cultural Centre, Honiara
Clark Art Institute, Williamstown, Massachusetts
Getty Research Institute, Los Angeles
Centre for Advanced Study in the Visual Arts, Washington DC
Instituto de Investigaciones Estéticas, Mexico City
Escuela de Bellas Artes, Universidad Nacional, Bogotá
Instituto de Investigaciones Artísticas, La Paz
Instituto de Investigaciones Estéticas J. Payró, Buenos Aires
Facultad de Bellas Artes, Universidad de Chile, Santiago

THE THAI-LANGUAGE brochure for the SEAMEO Regional Centre for the Project in Archaeology and the Fine Arts (SPAFA). SPAFA promotes and supports educational initiatives to further professional competence in the fields of archaeology and the fine arts, with the aim of cultiviating awareness of cultural heritage within and between Southeast Asian nations. The Bangkok regional centre produces the thrice-yearly SPAFA Journal.

ซีมีโอ-สปาฟา :
ศูนย์ภูมิภาคโบราณคดี
และวิจิตรศิลป์

1	Art Institutions, c.2000
A	yearly art event
B	biennial art event
T	triennial art event
Q	quadriennial art event
◇	sponsor of the arts

auctioneers:

₅C	Christie's
₅L	Los Angeles Modern
₅P	Phillip's
₅S	Sotheby's
■	international organization

Samuel H. Kress Foundation
Ford Foundation
American Express
Andy Warhol Foundation
CAA (College Art Association)
International Society for Education through Art

BIBLIOGRAPHY

GENERAL READING ON WORLD ART

Hugh Honour and John Fleming A World History of Art 6th edn, London, 2002

Alfred Gell Art and Agency: An Anthropological Theory Oxford, 1998

E. H. Gombrich The Sense of Order: A Study in the Psychology of Decorative Art Oxford, 1979

Martin Kemp (ed.) The Oxford History of Western Art Oxford, 2000

David Summers Real Spaces: World Art History and the Rise of Western Modernism London, 2003

Jane Turner (ed.) The Dictionary of Art, 34 vols, London, 1996

Part I ART, HUNTING AND GATHERING 40,000-5000 BC

P. G. Bahn The Cambridge Illustrated History of Prehistoric Art Cambridge, 1998

P. Bahn and J. Vertut Journey Through the Ice Age London and Berkeley, 1997

M. Lorblanchet Les grottes ornées de la préhistoire Paris, 1995

M. Lorblanchet La naissance de l'art: Genèse de l'art préhistorique Paris, 1999

PART II ART, AGRICULTURE AND URBANIZATION 5000–500 BC

THE WORLD 10,000–3000 BC

S. Mithen After the Ice: A Global Human History 20,000–5000 BC. London, 2003

C. Scarre and B. M. Fagan Ancient Civilizations revised 2nd edn, New York, 2002

B. D. Smith The Emergence of Agriculture New York, 1995

THE AMERICAS 5000–500BC

B. T. Arriaza Beyond Death: The Chinchorro Mummies of Ancient Chile Washington, 1995

Thomas D. Hurst Exploring Ancient Native America: An Archaeological Guide New York, 1999

C. McEwan, C. Barreto and E. Neves (eds) Unknown Amazon: Culture in Nature in Ancient Brazil London, 2001

G. R. Willey and J. A. Sabloff A History of American Archaeology New York, 1993

EUROPE 7000-2500 BC

T. D. Price (ed.) Europe's First Farmers Cambridge, 2000

C. Scarre Exploring Prehistoric Europe New York, 1998

A. Whittle Europe in the Neolithic: The Creation of New Worlds Cambridge, 1996

EUROPE 2500 –500BC

B. Cunliffe Facing the Ocean: The Atlantic and its Peoples Oxford, 2001

K. Kristiansen Europe before History Cambridge,1998

A. F. Harding European Societies in the Bronze Age Cambridge, 2000

THE AEGEAN 2000–1000 BC

D. Preziosi and L. Hitchcock Aegean Art and Architecture Oxford, 1999

T. Cullen (ed.) Aegean Prehistory: A Review Boston, 2001

S. Sherratt (ed.) The Wall Paintings of Thera London, 2000

THE MEDITERRANEAN 1000-500 BC

John Boardman (ed.) The Oxford History of Classical Art Oxford, 1993

John Boardman The Greeks Overseas London, 1999

Otto Brendel, Etruscan Art New Haven, 1978

F. Briquel-Chatonnet and E. Gubel Les Phéniciens aux origines du Liban Paris, 1998

AFRICA 5000-500 BC

Werner Gillon A Short History of African Art Harmondsworth, 1984

Peter Garlake Early Art and Architecture of Africa Oxford, 2002

David Phillipson African Archaeology 2nd edn, Cambridge, 2001

THE NILE VALLEY 3000-500 BC

Gay Robins The Art of Ancient Egypt London, 1997

Paul.T. Nicholson and Ian Shaw (eds) Ancient Egyptian Materials and Technology Cambridge, 2000

Jaromir Malek Egypt: 4000 Years of Art London, 2003

WEST ASIA 3000-2000 BC

Dominique Collon Ancient Near Eastern Art London, 1995

Henri Frankfort The Art and Architecture of the Ancient Orient revised edn, Harmondsworth, 1970

Julian Reade Mesopotamia revised edn, London, 2000

WEST ASIA 2000-500 BC

Julian Reade Assyrian Sculpture London, 1998

Dominique Collon Ancient Near Eastern Art London, 1995

CENTRAL AND SOUTH ASIA 5000-500 BC

J. R. McIntosh A Peaceful Realm: The Rise and Fall of the Indus Civilization Boulder, Colorado, 2002

J. M. Kenoyer Ancient Cities of the Indus Valley Civilization Karachi, 1998

EAST ASIA AND CHINA 5000-500 BC

L. Sickman and A. Soper The Art and Architecture of China Harmondsworth, 1971

J. Rawson (ed.) The British Museum Book of Chinese Art London, 1992

C. Clunas Art in China Oxford, 1997

JAPAN AND KOREA 5000-500 BC

Sarah M. Nelson The Archaeology of Korea Cambridge, 1993

Jane Portal Korea: Art and Archaeology London, 2000

Koji Mizoguchi An Archaeological History of Japan Philadelphia, 2002

THE PACIFIC AND INDONESIA 5000-500 BC

Peter Bellwood Prehistory of the Indo-Malaysian Archipelago Honolulu, 1997

Charles Higham The Bronze Age of Southeast Asia Cambridge, 1996

Patrick V. Kirsch The Lapita Peoples: Ancestors of the Oceanic World Oxford, 1997

Matthew Spriggs The Island Melanesians Oxford, 1997

John Terrell Prehistory of the Pacific Islands Cambridge, 1986

J. Peter White, James F. O'Connell and Margrit Koettig (eds) A Prehistory of Australia, New Guinea, and Sahul Sydney, 1982

Part III ART, WAR AND EMPIRE, 500 BC-AD 600

NORTH AND CENTRAL AMERICA 600 BC-AD 600

Michael D. Coe, Dean Snow and Elizabeth Benson Atlas of Ancient America New York, 1986

Michael D. Coe and Rex Koontz Mexico 5th edn, London, 2002

Michael D. Coe The Maya 6th edn, London and New York, 1999

Alice Beck Kehoe America Before the European Invasions London and New York, 2002

SOUTH AMERICA 500 BC-AD 600

R. W. Keatinge Peruvian Prehistory New York, 1988

K. Olsen Bruhns Ancient South America Cambridge, 1994

H. Silverman and D. A. Proulx The Nasca Malden, Massachusetts and Oxford, 2002

EUROPE 500 BC-AD 300

Ruth and Vincent Megaw Celtic Art from its Beginnings to the Book of Kells London, 1989

Boris Piotrowsky, Luidmila Galanina and Nonna Grach Scythian Art Oxford,1987

Timothy Taylor, 'Thracians, Scythians and Dacians', in Barry Cunliffe (ed.) Prehistoric Europe Oxford, 1998

THE AEGEAN 500-300 BC

John Onians Classical Art and the Cultures of Greece and Rome New Haven and London, 1999

J. J. Pollitt Art and Experience in Classical Greece Cambridge, 1972

THE EASTERN MEDITERRANEAN 500-100 BC

Martin Robertson, A History of Greek Art Cambridge, 1975

John Onians Art and Thought in the Hellenistic Age: The Greek World View 350–50 BC London, 1979

Peter Levi Atlas of the Greek World Oxford, 1980

J. J. Pollitt Art in the Hellenistic Age Cambridge, 1986

THE WESTERN MEDITERRANEAN 500-100 BC

R. J. Harrison Spain at the Dawn of History: Iberians, Phoenicians and Greeks London, 1988

Sybille Haynes Etruscan Civilization: A Cultural History London and Malibu, 2000

Glenn Markoe Phoenicians London, 2000

Giovanni Pugliese Carratelli The Western Greeks: Classical Civilization in the Western Mediterranean London, 1996

THE MEDITERRANEAN 100 BC-AD 100

Tim Cornell and John Matthews Atlas of the Roman World Oxford, 1982

Susan Walker and Peter Higgs Cleopatra of Egypt: From History to Myth London, 2000

Mary Beard and John Henderson Classical Art from Greece to Rome Oxford, 2001

Karl Galinsky Augustan Culture: An Interpretative Introduction Princeton,1996

THE MEDITERRANEAN AD 100-300

M. Henig (ed.) A Handbook of Roman Art: A Survey of the Visual Arts of the Roman World Oxford, 1983

J. B. Ward-Perkins Roman Imperial Architecture 2nd edn, Harmondsworth, 1981

Donald Strong (ed. J. M. C. Toynbee) Roman Art revised edn (with further revisions and notes by R. Ling), Harmondsworth, 1988

Mary T. Boatwright Hadrian and the Cities of the Roman Empire Princeton, 2000

EUROPE AD 300-600

F. van der Meer and Christine Mohrmann Atlas of the Early Christian World 3rd edn (trans. M. Hedlund and H. H. Rowley), London, 1966

Jás Elsner Imperial Rome and Christian Triumph: The Art of the Roman Empire AD 100–450 Oxford, 1998

Peter Brown The World of Late Antiquity from Marcus Aurelius to Muhammad London, 1971

G. W. Bowersock, Peter Brown and Oleg Grabar Late Antiquity: A Guide to the Postclassical World Cambridge, Massachusetts and London,1999

AFRICA 500 BC-AD 600

Werner Gillon A Short History of African Art, Harmondsworth, 1984

Peter Garlake Early Art and Architecture of Africa Oxford, 2002

David Phillipson African Archaeology 2nd edn., Cambridge, 2001

THE NILE VALLEY 500 BC-AD 300

Paul. T. Nicholson and Ian Shaw (eds) Ancient Egyptian Materials and Technology Cambridge, 2000

Jaromir Malek Egypt: 4000 Years of Art London, 2003

NORTH AFRICA AD 300-600

R. Bagnall Egypt in Late Antiquity Princeton, 1993

K. Dunbabin The Mosaics of Roman North Africa Oxford, 1978

T. K. Thomas Egyptian Funerary Sculpture: Images for This World and the Next Princeton, 2000

WEST ASIA 500-300 BC

Margaret Cool Root The King and Kingship in Archaemenid Art Acta Iranica 19, Leiden, 1979

Pierre Birant From Cyrus to Alexander: A History of the Persian Empire (trans. Peter T. Daniels) Winona Lake, Indiana, 2002

Peter Green Alexander to Actavian Berkeley, 1990

WEST ASIA 300 BC-AD 600

M. A. R. Colledge The Parthian Period Leiden, 1986

V. S. Curtis, R. Hillenbrand and M. Rogers (eds) The Art and Archaeology of Ancient Persia: New Light on the Parthian and Sasanian Empires London,1996

N. C. Debevoise A Political History of Parthia Chicago, 1938

CENTRAL ASIA 500 BC-AD 600

E. Errington, J. Cribb and M. Claringbull (eds) The Crossroads of Asia: Transformation in Image and Symbol Cambridge, 1992

M. Hallade Gandharan Art of North India and the Graeco-Buddhist Tradition in India, Persia, and Central Asia New York, 1968

SOUTH ASIA 500 BC-AD 600

S. L. and J. C. Huntington The Art of Ancient India: Buddhist, Hindu, Jain New York, 1985

J. Schwartzberg (ed.) A Historical Atlas of South Asia Oxford, 1992

R. Thapar Early India: From the Origins to AD 1300 Berkeley, 2003

CHINA 500 BC-AD 600

L. Sickman and A. Soper The Art and Architecture of China Harmondsworth, 1971

J. Rawson (ed.) The British Museum Book of Chinese Art London, 1992

C. Clunas Art in China Oxford, 1997

JAPAN AND KOREA 500 BC-AD 600

Sarah. M. Nelson The Archaeology of Korea Cambridge, 1993

Jane Portal Korea, Art and Archaeology London. 2000

Koji Mizoguchi An Archaeological History of Japan Philadelphia, 2002

SOUTHEAST ASIA 500 BC-AD 600

Peter Bellwood Prehistory of the Indo-Malaysian Archipelago Honolulu, 1997

H. R. van Heekeren The Bronze-Iron Age of Indonesia 's-Gravenhage, 1958

Charles Higham The Bronze Age of Southeast Asia Cambridge, 1996

THE PACIFIC 500 BC-AD 600

Patrick V. Kirsch On the Road of the Winds: An Archaeological History of the Pacific Islands Before European Contact Berkeley, 2000

R. C. Green and M. Kelly Studies in Oceanic Culture History Honolulu, 1970

James R. Specht and J. Peter White Trade and Exchange in Oceania and Australia Sydney, 1978

Matthew Spriggs The Island Melanesians Oxford, 1997

PART IV ART, RELIGION AND THE RULER 600-1500

NORTH AMERICA 600-1500

Michael Coe, Dean Snow and Elizabeth Benson Atlas of Ancient America New York, 1986

James E. Dixon Bones, Boats, and Bison: Archaeology and the First Colonization of North America Albuquerque, New Mexico, 2000

Brian M. Fagan Ancient North America: The Archaeology of a Continent London, 1991

CENTRAL AMERICA 600-1500

Richard F. Townsend The Aztecs revised edn, London and New York, 2000

Michael E. Smith and Francis F. Berdan (eds) The Postclassic Mesoamerican World, Salt Lake City, 2003

Richard A. Diehl and Janet Catherine Berlo (eds) Mesoamerica After the Decline of Teotihuacan, A.D. 700–900 Washington D.C., 1989

Frederick W. Lange and Doris Z. Stone (eds) *The Archaeology of Lower Central America* Albuquerque, New Mexico, 1984

SOUTH AMERICA 600-1500

E. P. Benson and A. G. Cook *Ritual Sacrifice in Ancient Peru* Austin, Texas, 2001
M. E. Moseley *The Incas and Their Ancestors, The Archaeology of Peru* London, 1992
K. Olsen Bruhns *Ancient South America* Cambridge, 1994

EUROPE 600-800

Michael McCormick *Origins of the European Economy* Cambridge, 2001
Martin Carver (ed.) *The Age of Sutton Hoo: The Seventh Century in North-Western Europe* Woodbridge, Suffolk, 1992
Leslie Webster and Michelle Brown (eds) *The Transformation of the Roman World* AD 400–900 London, 1997

EUROPE 800-1000

Rosamond McKitterick (ed.) *The New Cambridge Medieval History* II, c.700–c.900 Cambridge, 1995
Timothy Reuter (ed.) *The New Cambridge Medieval History* III, c.900–c.1024 Cambridge, 1999
Mayke De Jong and Frans Theuws (eds) *Topographies of Power in the Early Middle Ages* (Transformations of the Roman World 6) Leiden, Boston and Cologne, 2001

EASTERN EUROPE AND SOUTHWEST ASIA 600-1500

H. E. Evans and W. Wixom (eds) *The Glory of Byzantium* New York, 1997
R. Cormack and D. Gaze (eds) *The Art of Holy Russia* London, 1998
R. Cormack *Byzantine Art* Oxford, 2000

NORTHERN EUROPE 1000-1200

R. W. Southern *The Making of the Middle Ages* London, 1953
Veronica Sekules *Medieval Art* Oxford and New York, 2001

SOUTHERN EUROPE 1000-1200

C. H. Lawrence *Medieval Monasticism* London and New York, 1984
Kenneth John Conant *Carolingean and Romanesque Architecture* 4th edn, New Haven and London, 1978

NORTHERN EUROPE 1200-1300

Michael Camille *Gothic Art: Glorious Visions* New York, 1996
Henry Kraus *Gold Was the Mortar: The Economics of Cathedral Building* London and Boston, 1979

SOUTHERN EUROPE 1200-1300

Xavier Barral i Altet *Art and Architecture of Spain* Boston, 1998
André Chastel *Italian Art* New York, 1963
Maria Romanini Angiola *Assisi: The Frescoes in the Basilica of St Francis* New York, 1998

NORTHERN EUROPE 1300-1500

James Snyder *Northern Renaissance Art: Painting, Sculpture and the Graphic Arts from 1350 to 1575* New York, 1985
Till-Holger Borchert et al. *The Age of Van Eyck: The Mediterranean World and Early Netherlandish Painting 1430–1530* London, 2002
Walter Prevenier and Wim Blockmans *The Burgundian Netherlands* (trans. P. Kin and Y. Mead), Cambridge, 1986

SOUTHERN EUROPE 1300-1500

Michel Laclotte and Dominique Thiébaut *L'École d'Avignon* Paris, 1983
Judith Berg Sobré *Behind the Altar Table: The Development of the Painted Retable in Spain, 1350–1500* Columbia, Missouri, 1989
Theodor Müller *Sculpture in the Netherlands, Germany, France, and Spain 1400 to 1500* Harmondsworth, 1966

ITALY 1300-1400

Giovanni Boccaccio *The Decameron* (trans. G. H. McWilliam) 2nd edn, Harmondsworth, 1995
John White *Art and Architecture in Italy 1250–1400* Harmondsworth, 1966
John White *The Birth and Rebirth of Pictorial Space* London, 1972

ITALY 1400-1500

Michael Baxandall *Painting and Experience in Fifteenth-Century Italy* Oxford, 1972
Mary Hollingsworth *Patronage in Renaissance Italy: From 1400 to the Early Sixteenth Century* London, 1994
Iris Origo *The Merchant of Prato* Harmondsworth, 1963

NORTH AFRICA 600-1500

Richard Ettinghausen, Oleg Grabar and Marilyn Jenkins-Madina *Islamic Art and Architecture 650–1250* New Haven and London, 2001
Sheila S. Blair and Jonathan M. Bloom *The Art and Architecture of Islam: 1250–1800* New Haven and London, 1994

SUB-SAHARAN AFRICA 600-1500

Peter Garlake *Early Art and Architecture of Africa* Oxford, 2002
M. B. Visona, R. Poyner, H. M. Cole et al. *A History of Art in Africa* New York, 2000

WEST ASIA AND EGYPT 600-1000

Richard Ettinghausen, Oleg Grabar and Marilyn Jenkins-Madina *Islamic Art and Architecture 650–1250* New Haven and London, 2001
Oleg Grabar *The Formation of Islamic Art* New Haven, 1990

WEST ASIA 1000-1500

Richard Ettinghausen, Oleg Grabar and Marilyn Jenkins-Madina *Islamic Art and Architecture 650–1250* New Haven and London, 2001
Sheila S. Blair and Jonathan M. Bloom *The Art and Architecture of Islam: 1250–1800* New Haven and London, 1994

CENTRAL ASIA 600-1500

Richard Ettinghausen, Oleg Grabar and Marilyn Jenkins-Madina *Islamic Art and Architecture 650–1250* New Haven and London, 2001
Sheila S. Blair and Jonathan M. Bloom *The Art and Architecture of Islam: 1250–1800* New Haven and London, 1994

SOUTH ASIA 600-1500

Lallanji Gopal *The Economic Life of Northern India*, c.AD 700–1200 Delhi, 1989
Vishaka N. Desai and Darielle Mason *Gods, Guardians and Lovers: Temple Sculptures from North India*, AD 700–1200 London, 1993
Gordon Johnson *Cultural Atlas of India* New York, 1996
Hamida Khatoon Naqvi *Agricultural, Industrial and Urban Dynamism Under the Sultans of Delhi, 1200–1555* Delhi, 1986
Tapan Rayachaudhuri and Irfan Habib *The Cambridge Economic History of India, c.1200–c.1750* vol. 1, Cambridge, 1982
John Fritz, George Michell and M. S. Nagaraja Rao *Where Kings and Gods Meet: The Royal Centre at Vijayanagara, India* Tuscon, Arizona, 2002

CHINA 600-1300

Peter K. Bol *This Culture of Ours: Intellectual Transitions in T'ang and Sung China* Stanford, 1991
Maxwell K. Hearn and Judith G. Smith (eds) *Arts of the Sung and Yuan* New York, 1996
Shiba Yoshinobu *Commerce and Society in Sung China* (trans. Mark Elvin) Ann Arbor, 1992

CHINA AND TIBET 1300-1500

Lauren Arnold *Princely Gifts and Papal Treasures: The Franciscan Mission to China and its Influence on the Art of the West, 1250–1350* San Francisco, 1999
Maggie Bickford *Ink Plum: The Making of a Chinese Scholar-Painting Genre* New York, 1996
Percival David *Chinese Connoisseurship: The 'Ke Ku Yao Lun', the Essential Criteria of Antiquities* London, 1971
Adam Kessler et al. *Empires Beyond the Great Wall: The Heritage of Genghis Khan* Los Angeles, 1993
Marco Polo *The Travels* (trans. Ronald Latham) New York, 1992

JAPAN AND KOREA 600-1500

Penelope Mason *History of Japanese Art* New York, 1993
Jane Portal *Korea: Art and Archeology* London, 2000
Kumya Paik Kim *Goryeo Dynasty: Korea's Age of Enlightenment* San Francisco, 2003

Quitman E. Phillips *The Practices of Painting in Japan, 1475-1500* Stanford, 2000
Naomi Richard (ed.) *Transmitting the Forms of Divinity: Early Buddhist Art from Korea and Japan* New York, 2003

SOUTHEAST ASIA 600-1500

Kenneth R. Hall *Maritime Trade and State Development in Early Southeast Asia* Honolulu, 1985
Charles Higham *The Civilization of Angkor* Berkeley, 2001
Philip Rawson *The Art of Southeast Asia: Cambodia, Vietnam, Thailand, Laos, Burma, Java, Bali* New York, 1967
Reimar Schefold and Han F. Vermeulen *Treasure Hunting?: Collectors and Collections of Indonesian Artifacts* Leiden, 2002
J. F. Scheltema *Monumental Java* London, 1912

THE PACIFIC 600-1500

Adrienne L. Kaeppler, Christian Kaufmann and Douglas Newton *Oceanic Art* New York, 1997
Patrick V. Kirsch *On the Road of the Winds: An Archaeological History of the Pacific Islands Before European Contact* Berkeley, 2000
Eric Kjellgren, with Jo Anne Van Tilburg and Adrienne L. Kaeppler, *Splendid Isolation: Art of Easter Island* New York, 2001
Sidney M. Mead *Te Maori: Maori Art from New Zealand Collections* New York, 1984

PART V ART, EXPLOITATION AND DISPLAY 1500-1800

NORTH AMERICA 1500-1800

Norman Bancroft Hunt *North American Indians: The Life and Culture of the Native American* London, 1991
Janet C. Berlo and Ruth B. Phillips *Native North American Art* Oxford, 1998
Jayne Sokolow *The Great Encounter: Native Peoples and European Settlers in the Americas, 1492–1800* New York, 2002
Carl Waldman *Atlas of the North American Indian* London, 2000

CENTRAL AMERICA 1500-1800

Norman Bancroft Hunt *Historical Atlas of Ancient America* New York, 2001
Samuel Y. Edgerton and Jorge Perez de Lara *Theaters of Conversion: Religious Architecture and Indian Artisans in Colonial Mexico* Albuquerque, New Mexico, 2001
Diane Fane *Converging Cultures: Art and Identity in Spanish America* New York, 1996
Alan Knight *Mexico, vol 2 The Colonial Era*, Cambridge, 2002

SOUTH AMERICA 1500-1800

Thomas DaCosta Kauffman *Toward a Geography of Art* Chicago and London, 2004
D. Bayón et al. *History of South American Colonial Art and Architecture* New York, 1992
R. Gutiérrez *Arquitectura y urbanismo en Iberoamérica* Madrid, 1983

EUROPE 1500-1600

Peter Burke *The European Renaissance: Centres and Peripheries* Oxford and Malden, Massachusetts, 1998
Thomas DaCosta Kauffman *Court, Cloister, and City* Chicago and London, 1995
Roy Strong *Art and Power: Renaissance Festivals, 1450–1650* Rochester, New York, 1984

SCANDINAVIA AND THE BALTIC 1500-1800

Marian C. Donnelly *Architecture in the Scandinavian Countries* Cambridge, Massachusetts, 1992
Christian IV and Europe: The 19th Council of Europe Exhibition, Denmark 1988 exh. cat., Copenhagen, 1988

POLAND AND LITHUANIA 1500-1800

Jan Bialostocki *The Art of the Renaissance in Eastern Europe* New York, 1976
Adam Milobedzki *The Architecture of Poland: A Chapter of the European Heritage* Cracow, 1994
Stefan Muthesius *Art, Architecture and Design in Poland: An Introduction* Königstein im Taunus, 1994
Jan K. Ostrowski et al. *Land of the Winged Horse: Art in Poland 1572–1764* exh. cat., Walters Art Galley, Baltimore, 1999

RUSSIA 1500-1800

William C. Brumfield *A History of Russian Architecture* New York and Cambridge, 1993
George Heard Hamilton *The Art and Architecture of Russia* New Haven and London, 1986
Alison Hilton *Russian Folk Art* Bloomington, Indiana, 1995
A. Opolovnikov and Y. Opolovnikova *The Wooden Architecture of Russia* New York, 1989

BRITAIN 1500-1666

Catharine MacLeod *Painted Ladies: Women at the Court of Charles II* London, 2001
Karen Hearn *Dynasties: Painting in Tudor and Jacobean England,1530–1630* London, 1995
Simon Thurley *The Royal Palaces of Tudor England* New Haven and London, 1993

BRITAIN 1666-1800

David Solkin *Painting for Money* New Haven and London, 1992
Marcia Pointon *Hanging the Head* New Haven and London, 1994
John Brewer *The Pleasures of the Imagination* London, 1997

THE NORTH NETHERLANDS 1500-1800

J. I. Israel *The Dutch Republic: Its Rise, Greatness and Fall, 1477–1806* Oxford, 1995
B. Haak *The Golden Age: Dutch Painters of the Seventeenth Century* London, 1984
A. Lambert *The Making of the Dutch Landscape* London, 1971

THE SOUTH NETHERLANDS 1500-1800

Luc Duerloo and Werner Thomas (eds) *Albert & Isabelle 1598–1621, Catalogue and Essays* exh. cat., 2 vols, Brussels,1998
Copper as Canvas: Two Centuries of Masterpiece Paintings on Copper, 1575–1775 exh. cat., Phoenix Art Museum, New York, 1998
Guy Delmarcel *Flemish Tapestry* New York, 2000
Lynn F. Jacobs *Early Netherlandish Carved Altarpieces 1380—1550: Medieval Tastes and Mass Marketing* Cambridge, 1998
Neil de Marchi, Hans J. van Miegroet and Matthew E. Raiff, 'Dealer–Dealer Pricing in the Mid Seventeenth-Century Antwerp to Paris Art Trade' in *Art Markets in Europe, 1400–1800*, ed. M. North and D. Ormond. Brookfield, Vermont, 1998

GERMANY AND SWITZERLAND 1500-1650

Ars Helvetica 13 vols. Bern, 1987–93
Henry Russell Hitchcock *German Renaissance Architecture* Princeton, 1981
Jeffrey Chipps Smith *German Sculpture of the Later Renaissance, c.1520–1580* Princeton, 1994

GERMANY AND SWITZERLAND 1650-1800

Ars Helvetica 13 vols. Bern, 1987–93
Thomas DaCosta Kauffman *Court, Cloister, and City* Chicago and London, 1995
Eberhard Hempel *Baroque Art and Architecture in Central Europe* Baltimore, 1965

FRANCE 1500-1650

Anthony Blunt *Art and Architecture in France 1500–1700* Harmondsworth, 1984
Ivan Cloules and Michèle Baimbenet-Privat *Treasures of the French Renaissance* New York, 1998
André Chastel *French Art: The Renaissance 1430–1620* Paris and New York, 1995

FRANCE 1650-1800

Walter Kalein and Michael Levey *Art and Architecture in France 1700–1800* Harmondsworth, 1976
Guy Walton *Louis XIV's Versailles* Chicago, 1980
John Fleming and Hugh Honour *Neo-Classicism* Harmondsworth, 1970

SPAIN AND PORTUGAL 1500-1800

John F. Moffitt *The Arts in Spain* London, 1999
Robert C. Smith *The Art of Portugal* New York, 1968

ITALY 1500-1600

Benvenuto Cellini *Autobiography* (trans. George Anthony Bull) revised edn, Harmondsworth, 1999

BIBLIOGRAPHY

Mary Hollingsworth *Patronage in Sixteenth-Century Italy* London, 1996

Peter Partner *Renaissance Rome 1500–1559* Los Angeles and London, 1976

ITALY 1600-1800

Francis Haskell *Patrons and Painters: A Study in the Relations between Italian Art and Society in the Age of the Baroque* revised edn, New Haven and London, 1980

SOUTHEAST EUROPE 1500-1800

R. Hootz (ed.) *Kunstmälerei in Ungarn* Leipzig and Munich, 1981

R. Hootz (ed.) *Kunstmälerei in Rumänien* Leipzig and Munich, 1986

R. Hootz (ed.) *Kunstmälerei in Jugoslavien* Leipzig and Munich, 1981

R. Hootz (ed.) *Kunstmälerei in Bulgarien* Leipzig and Munich, 1983

EUROPE 1600-1800

Thomas DaCosta Kauffman *Court, Cloister, and City* Chicago and London, 1995

E. Bergvelt, D. Meijers and M. Rijnders *Verzamelen: van rariteitenkabinet tot kunstmuseum* Houten, 1993

Thomas Crow *Painters and Public Life in Eighteenth-Century Paris* New Haven and London, 1985

NORTH AFRICA 1500-1800

André Raymond *Artisans et commerçants au Caire au XVIIIe siècle* 2 vols, Paris, 1973–4

J. Revault and B. Maury *Palais et maisons du Caire du XIVe au XVIIIe siècle* 3 vols, Paris, 1975–9

D. Hill, L. Golvin and R. Hillenbrand *Islamic Architecture in North Africa* London, 1976

Antony Hutt *Islamic Architecture: North Africa* London, 1977

John Hedgecoe and S. Samar Damluji (eds) *Zillij: The Art of Moroccan Ceramics* Reading, 1992

SUB-SAHARAN AFRICA 1500-1800

Paula BenAmos *The Art of Benin* London, 1980

M. B. Visona, R. Poyner, H. M. Cole et al. *A History of Art in Africa* New York, 2000

ASIA 1500-1800

Jane Turner (ed.) *The Dictionary of Art*, 34 vols, London, 1996

WEST ASIA 1500-1800

Sheila S. Blair and Jonathan M. Bloom *The Art and Architecture of Islam: 1250–1800* New Haven and London, 1994

J. M. Rogers *Islamic Art and Design: 1500–1700* London, 1983

CENTRAL ASIA 1500-1800

Sheila S. Blair and Jonathan M. Bloom *The Art and Architecture of Islam: 1250–1800* New Haven and London, 1994

Jane Turner (ed.) *The Dictionary of Art*, 34 vols, London, 1996

SOUTH ASIA 1500-1800

Bianca Maria Alfieri *Islamic Architecture of the Indian Subcontinent* London, 2000

Catherine Asher *Architecture of Mughal India* Cambridge, 1992

Milo Cleveland Beach *Mughal and Rajput Painting* Cambridge, 1992

CHINA AND TIBET 1500-1650

Sarah Handler *Austere Luminosity of Chinese Classical Furniture* Berkeley, 2001

Chu-tsing Li and James Watt (eds) *The Chinese Scholar's Studio: Artistic Life in the Later Ming Period* New York, 1987

Jonathan Spence *The Memory Palace of Matteo Ricci* London, 1983

Yinong Xu *The Chinese City in Space and Time: The Development of Urban Form in Suzhou* Honolulu, 2000

CHINA AND TIBET 1650-1800

Qianshen Bai *Fu Shan's World: The Transformation of Chinese Calligraphy in the Seventeenth Century* Cambridge, Massachusetts, 2003

Patricia Berger *Empire of Emptiness: Buddhist Art and Political Authority in Qing China* Honolulu, 2003

Jonathan Hay *Painting and Modernity in Early Qing China* New York, 2001

Tobie Meyer-Fong *Building Culture in Early Qing Yangzhou* Stanford, 2003

Susan Naquin *Peking: Temples and City Life, 1400–1900* Berkeley, 2000

Nancy Shatzman Steinhardt *Chinese Imperial City Planning* Honolulu, 1990

JAPAN AND KOREA 1500-1800

Penelope Mason *History of Japanese Art* New York, 1993

Jane Portal *Korea: Art and Archeology* London, 2000

Christine Guth *Art of Edo Japan: The Artist and the City 1615–1868* New York, 1996

Hongnam Kim *Korean Arts of the Eighteenth Century: Splendor and Simplicity* New York, 1993

Miyeko Murase (ed.) *Turning Point: Oribe and the Arts of Sixteenth-Century Japan* New York, 2003

Robert T. Singer *Edo: Art in Japan 1615–1868* New Haven, 1998

SOUTHEAST ASIA 1500-1800

Anthony Reid *Southeast Asia in the Age of Commerce* Volume One: *The Land Below the Winds* New Haven and London, 1988

Nicholas Tarling (ed.) *The Cambridge History of Southeast Asia* Volume One: *From Early Times to c.1800* Cambridge, 1992

Gwyneth Chaturachinda, Sunanda Krishnamurty and Pauline W. Tabtiang *Dictionary of South and Southeast Asian Art* Chiang Mai, 2000

THE PACIFIC 1500-1800

The Forster Collection, a website for Pacific artefacts collected by Johann Reinhold and George Forster on Captain Cook's second voyage (1772–75), Pitt Rivers Museum, Oxford: www.prm.ox.ac.uk/forster/

Anne Salmond *Two Worlds: First Meetings between Maori and Europeans 1642–1772* London, 1991

PART VI ART, INDUSTRY AND SCIENCE 1800-1900

NORTH AMERICA 1800-1860

David Bjelajac *American Art: A Cultural History* Upper Saddle River, New Jersey, 2000

Robert Hughes *American Visions: The Epic History of Art in America* New York, 1997

Janet Catherine Berlo and Ruth B. Phillips *Native North American Art* New York, 1998

Nancy Lou Patterson *Canadian Native Arts* Don Mills, Ontario, 1973

NORTH AMERICA 1860-1900

David Bjelajac *American Art: A Cultural History* Upper Saddle River, New Jersey, 2000

Robert Hughes *American Visions: The Epic History of Art in America* New York, 1997

Janet Catherine Berlo and Ruth B. Phillips *Native North American Art* New York, 1998

Nancy Lou Patterson *Canadian Native Arts* Don Mills, Ontario, 1973

CENTRAL AMERICA AND THE CARIBBEAN 1800-1900

Dawn Ades *Art in Latin America 1820–1980*; London, 1989

Timothy E. Anna *Forging Mexico, 1821–1835* Lincoln, Nebraska, 1998

Robert Harvey *The Liberators: Latin America's Struggle for Independence, 1810–1850* London, 2002

Elizabeth Netto Calil Zarur *Art and Faith in Mexico: The Nineteenth Century Retablo Tradition* Albuquerque, New Mexico, 2001

SOUTH AMERICA 1800-1900

Dawn Ades (ed.) *Art in Latin America: The Modern Era, 1820–1980* New Haven and London, 1974

Gustavo Curiel, Renato González Mello and Juana Gutiérrez Haces (eds) *Arte, Historia e Identidad en América: Visiones comparativas* Mexico City, 1994

Pablo Diener Ojeda (ed.) *Rugendas: América de punta a cabo* Santiago de Chile, 1992

EUROPE 1800-1900

Stephen F. Eisenman *Nineteenth Century Art: A Critical History* London, 1994

Paul Greenhalgh *Art Nouveau 1890–1914* London, 2000

Dennis and Elizabeth De Witt *Modern Architecture in Europe: A Guide to Buildings since the Industrial Revolution* London, 1987

SCANDINAVIA AND THE BALTIC 1800-1900

Marian C. Donnelly *Architecture in the Scandinavian Countries* Cambridge, Massachusetts, 1992

Neil Kent *The Soul of the North. A Social, Architectural and Cultural History of the Nordic Countries, 1700–1940* London, 2000

Barbara Miller Lane *National Romanticism and Modern Architecture in Germany and the Scandinavian Countries* Cambridge, 2000

RUSSIA 1800-1900

The Art of Russia 1800–1850 exh. cat., University of Minnesota Art Gallery, Minneapolis, 1977

Dmitry Sarabianov *Russian Art from Neoclassicism to the Avant-Garde* New York, 1990

G. T. Stavrou (ed.) *Art and Culture in Nineteenth-Century Russia* Bloomington, Indiana, 1983

Elizabeth Valkenier *Russian Realist Art: The Peredvizhniki and their Tradition* New York, 1989

BRITAIN 1800-1900

John Gage and J. M. W. Turner *A Wonderful Range of Mind* New Haven and London, 1984

Chris Brooks *The Gothic Revival* London, 1999

Elizabeth Prettejohn *Art of the Pre-Raphaelites* London, 2000

THE NETHERLANDS AND BELGIUM 1800-1900

H. Kossman *The Low Countries: 1780–1940* Oxford, 1978

Michael Wintle *An Economic and Social History of The Netherlands 1880–1920* Cambridge, 2000

Richard Bionda and Carel Blotkamp (eds.) *The Age of van Gogh: Dutch Painting 1880–1895* Zwolle, 1990

Auke van der Woude *The Art of Building, from Classicism to Modernity: The Dutch Architectural Debate 1840–1990* Aldershot, 2001

GERMANY AND SWITZERLAND 1800-1900

Harry Francis Mallgrave and Gottfried Semper *Architecture of the Nineteenth Century* New Haven and London, 1996

G. Wietek (ed.) *Deutsche Künstlerkolonien und Künstlerorte* Munich, 1976

FRANCE 1800-1900

John House *Landscapes of France: Impressionism and its Rivals* London, 1995

Charles Rearick *Pleasures of the Belle Époque: Entertainment and Festivity in Turn-of-the-Century France* London, 1985

Eugen Weber *France: Fin de Siècle* London, 1986

SPAIN AND PORTUGAL 1800-1900

John F. Moffitt *The Arts in Spain* London, 1999

Robert C. Smith *The Art of Portugal* New York, 1968

ITALY 1800-1900

Albert Boime *The Art of the Macchia and the Risorgimento: Representing Culture and Nationalism in Nineteenth-Century Italy* Chicago, 1993

Omar Calabrese (ed.) *Modern Italy: Images and History of a National Identity, from Unification to the New Century* Milan, 1982

AUSTRIA-HUNGARY AND SOUTHEAST EUROPE 1800-1900

Akos Moravánsky *Competing Visions: Aesthetic Invention and Social Imagination in Central European Architecture 1867–1918* Cambridge, Massachusetts, 1997

Gyöngyi Éri and Zsuzsa Tobbágyi *A Golden Age: Art and Society in Hungary 1896–1914* Budapest, London and Miami, 1990/91

NORTH AFRICA 1800-1900

Gaston Wiet *Mohammed Ali et les beaux-arts* Cairo, 1949

Caroline Stone *The Embroideries of North Africa* London, 1985

James F. Jereb *Arts and Crafts of Morocco* London, 1995

Christopher Spring and Julie Hudson *North African Textiles* London, 1995

Stephen Vernoit *Occidentalism: Islamic Art in the 19th Century* London, 1997

SUB-SAHARAN AFRICA 1800-1900

Suzanne P. Blier *The Royal Arts of Africa: The Majesty of Form* New York, 1998

Labelle Prussin *Hatumere: Islamic Design in West Africa* Berkeley, 1986

M. B. Visona, R. Poyner, H. M. Cole et al. *A History of Art in Africa* New York, 2000

WEST ASIA 1800-1900

Jane Turner (ed.) *The Dictionary of Art*, 34 vols, London, 1996

CENTRAL ASIA 1800-1900

Jane Turner (ed.) *The Dictionary of Art*, 34 vols, London, 1996

INDIA 1800-1900

Rosemary Crill, John Guy, Veronica Murphy, Susan Stronge and Deborah Swallow *Arts of India: 1550–1900* London, 1990

Tapati Guha-Thakurta *The Making of a New Indian Art: 1850–1920* Cambridge, 1992

Partha Mitter *Art and Nationalism in Colonial India:1850–1922* Cambridge, 1994

CHINA AND TIBET 1800-1900

Claudia Brown and Ju-hsi Chou *Transcending Turmoil: Painting at the Close of China's Empire, 1796–1911* Phoenix, Arizona, 1992

Carl Crossman *The Decorative Arts of the China Trade: Paintings, Furnishings, and Exotic Curiosities* Woodbridge, Suffolk, 1991

F. L. Hawkes Pott *A Short History of Shanghai* Shanghai, 1928

Richard Ellis Vinograd *Boundaries of the Self: Chinese Portraits 1600–1900* New York, 1992

JAPAN AND KOREA 1800-1900

Penelope Mason *History of Japanese Art* New York, 1993

Jane Portal *Korea: Art and Archeology* London, 2000

Dallas Finn *Meiji Revisited: The Sites of Victorian Japan* New York,1995

Young-pil Kwon (ed.) *The Fragrance of Ink: Korean Literati Paintings of the Choson Dynasty (1392–1910)* Seoul, 1996

Julia Meech-Pekarik *The World of the Meiji Print: Impressions of a New Civilization* New York, 1987

SOUTHEAST ASIA 1800-1900

Sylvia Fraser-Lu *Burmese Crafts Past and Present* Oxford, 1994

Jean-Paul Barbier and Douglas Newton (eds) *Islands and Ancestors: Indigenous Styles of Southeast Asia* New York and Geneva, 1988

Robyn Maxwell *Textiles of Southeast Asia: Tradition, Trade and Transformation* Melbourne, 1990

THE PACIFIC 1800-1900

A. Herle, N. Stanley, K. Stevenson and R. Welsch (eds) *Pacific Art: Persistence, Change and Meaning* Hawaii, 2002

R. Nile and C. Clerk *Cultural Atlas of Australia, New Zealand and the South Pacific* Oxford, 1996

Nicholas Thomas *Oceanic Art* London, 1995

AUSTRALIA AND NEW ZEALAND 1800-1900

Joan Kerr (ed.) *The Dictionary of Australian Artists: Painters, Sketchers, Photographers and Engravers to 1870* Melbourne, 1992

D. C. Starzecka (ed.) *Maori: Art and Culture* London, 1996

Jane Clark and Bridget Whitelaw *Golden Summers: Heidelberg and Beyond*, International Cultural Corporation of Australia Sydney, 1986

PART VII ART, IDEAS AND TECHNOLOGY 1900-2000

NORTH AMERICA 1900-1950

Abraham A. Davidson *Early American Modernist Painting, 1910–1935* New York, 1981

Terry Smith *Making the Modern: Industry, Art, and Design in America* Chicago, 1993

David Bjelajac *American Art: A Cultural History* Upper Saddle River, New Jersey, 2000

Robert Hughes *American Visions: The Epic History of Art in America* New York, 1997

Janet Catherine Berlo and Ruth B. Phillips *Native North American Art* New York, 1998

Joan Murray *Canadian Art in the Twentieth Century* Toronto, 1999

Nancy Lou Patterson *Canadian Native Arts* Don Mills, Ontario, 1973

NORTH AMERICA 1950-2000

David Hopkins *After Modern Art 1945–2000* New York, 2000

Mark Cheetham and Linda Hutcheon *Remembering Postmodernism: Trends in Recent Canadian Art* New York, 1991

David Bjelajac *American Art: A Cultural History* Upper Saddle River, New Jersey, 2000

Robert Hughes *American Visions: The Epic History of Art in America* New York, 1997

Janet Catherine Berlo and Ruth B. Phillips *Native North American Art* New York, 1998

Joan Murray *Canadian Art in the Twentieth Century* Toronto, 1999

Nancy Lou Patterson *Canadian Native Arts* Don Mills, Ontario, 1973

CENTRAL AMERICA AND THE CARIBBEAN 1900-2000

Veerle Poupeye *Caribbean Art* London, 1998

Desmond Rochfort *Mexican Muralists: Orozco, Rivera and Siqueiros* London, 1997

Edward Sullivan (ed.) *Latin American Art in the Twentieth Century* London, 2000

SOUTH AMERICA 1900-2000

Dawn Ades *Art in Latin America: The Modern Period* New Haven and London, 1989

Valerie Fraser *Building the New World: Studies in the Modern Architecture of Latin America 1930–1960* London and New York, 2000

Oriana Baddeley and Valerie Fraser *Drawing the Line: Art and Cultural Identity in Contemporary Latin America* London, 1989

EUROPE 1900-2000

Pam Meecham and Julie Sheldon *Modern Art: A Critical Introduction* London and New York, 2000

Robert Hughes *The Shock of the New: Art and the Century of Change* London, 1980

H. H. Arnason *A History of Modern Art: Painting, Sculpture, Architecture* London 1977

SCANDINAVIA AND THE BALTIC STATES 1900-2000

Cecilia Widenheim (ed.) *Utopia and Reality: Modernity in Sweden 1900–1960* New Haven, 2002

Charlotte Fiell, *Scandinavian Design* Cologne, 2002

RUSSIA 1900-2000

John E. Bowlt *Russian Art of the Avant-Garde: Theory and Criticism 1902–1934* New York, 1976

Norton Dodge and Alison Hilton (eds) *New Art from the Soviet Union: The Known and the Unknown* Washington DC, 1977

Norton Dodge and Alla Rosenfeld (eds) *Nonconformist Art from the Soviet Union* London, 1995

Camilla Gray *The Russian Experiment in Art* revised edn by M. Burleigh-Motley, London, 1986

The Great Utopia exh. cat., Solomon R. Guggenheim Museum and Tretyakov Gallery, New York and Moscow, 1993

Christina Lodder *Russian Constructivism* New Haven and London, 1990

Margarita Tupitsyn *The Soviet Photograph* New Haven and London, 1996

BRITAIN AND IRELAND 1900-2000

Lisa Tickner *Modern Life and Modern Subjects: British Art in the Early Twentieth Century* New Haven and London, 2000

Margaret Garlake *New Art, New World: British Art in Postwar Society* New Haven and London, 1998

Norman Rosenthal *Sensation: Young British Artists from the Saatchi Collection* London, 1997

THE NETHERLANDS AND BELGIUM 1900-2000

H. Kossman *The Low Countries: 1780–1940* Oxford, 1978

Michael Wintle *An Economic and Social History of The Netherlands 1880–1920* Cambridge, 2000

Auke van der Woude *The Art of Building, from Classicism to Modernity: The Dutch Architectural Debate 1840–1990* Aldershot, 2001

GERMANY, SWITZERLAND, AUSTRIA 1900-2000

Shearer West *The Visual Arts in Germany, 1890–1937: Utopia and Despair* Piscataway, New Jersey, 2001

Brandon Taylor and Wilfried van der Will (eds) *The Nazification of Art* Winchester, 1990

Christos Joachimides, Norman Rosenthal and Wieland Schmied (eds) *German Art in the Twentieth Century: Painting and Sculpture 1905–1985* exh cat., Royal Academy of Art, London, 1985

EASTERN EUROPE 1900-2000

S. A. Mansbach *Modern Art in Eastern Europe: From the Baltic to the Balkans, c.1890–1939* Cambridge, 1999

Bojana Pejic and David Elliott (eds) *After the Wall: Art and Culture in Post-Communist Europe* Stockholm, 1999

FRANCE 1900-2000

David Cottington *Cubism in the Shadow of War: The Avant-Garde and Politics in Paris,1905–1914* New Haven, 1998

Alexander Tzonis *Le Corbusier: The Poetics of Machine and Metaphor* Lincoln, Nebraska, 2002

Sidra Stich *Art-SITES France: Contemporary Art and Architecture Handbook* Chicago, 1999

Christopher Green *Art in France: 1900–1940* New Haven, 2001

SPAIN AND PORTUGAL 1900-2000

John F. Moffitt *The Arts in Spain* London, 1999

Robert C. Smith *The Art of Portugal* New York, 1968

ITALY 1900-2000

Italian Art in the Twentieth Century exh. cat., Royal Academy of Arts, London, 1989

Marjorie Perloff *The Futurist Moment* Chicago, 1986

NORTH AFRICA 1900-2000

Henriette Camps-Fabrer *Les bijoux de Grande Kabylie* Paris, 1970

Mohamed Sijelmassi *Les arts traditionnels au Maroc* Paris, 1986

Wijdan Ali (ed.) *Contemporary Art from the Islamic World* London, 1989

John Hedgecoe and S. Samar Damluji (eds) *Zillij: The Art of Moroccan Ceramics* Reading, 1992

Tarek Mohamed Refaat Sakr *Early Twentieth-Century Architecture in Cairo* Cairo, 1993

Christopher Spring and Julie Hudson *North African Textiles* London, 1995

EAST AND CENTRAL AFRICA 1900-2000

M. B. Visona, R. Poyner, H. M. Cole et al. *A History of Art in Africa* New York, 2000

André Magnin *Contemporary African Art* New York, 1995

WEST AFRICA 1900-2000

M. B. Visona, R. Poyner, H. M. Cole et al. *A History of Art in Africa* New York, 2000

Susan M. Vogel *Africa Explores: 20th Century African Art* New York, 1991

SOUTHERN AFRICA 1900-2000

Art and Ambiguity: Perspectives on the Brenthurst Collection of African Art exh. cat., Johannesburg Art Gallery, Johannesburg, 1991

Elizabeth Rankin *Images of Wood: Aspects of the History of Sculpture in 20th-Century South Africa* Johannesburg, 1989

Sue Williamson *Resistance Art in South Africa* Cape Town, 1989

Nigel Worden *The Making of Modern South Africa: Conquest, Segregation and Apartheid* Oxford, 1994

ASIA 1900-2000

Jane Turner (ed.) *The Dictionary of Art*, 34 vols, London, 1996

WEST ASIA 1900-2000

H. E. Wulff *The Traditional Crafts of Persia* Cambridge, Massachusetts, and London, 1966

Renata Holod and A. Evin (eds) *Modern Turkish Architecture* Philadelphia, 1984

Günsel Renda, Turan Erol, Adnan Turani, Kaya Özsezgin and Mustafa Aslıer *A History of Turkish Painting* Geneva, Seattle and London, 1988

Lebanon – the Artist's View: 200 Years of Lebanese Painting exh. cat., British Lebanese Association, London, 1989

Wijdan Ali (ed.) *Contemporary Art from the Islamic World* London, 1989

H. Glassie *Turkish Traditional Art Today* Bloomington and Indianapolis, 1993

Stephen Vernoit (ed.) *Discovering Islamic Art: Scholars, Collectors and Collections* London, 2000

CENTRAL ASIA 1900-2000

Gulina Pugachenkova Akbar Khakimov *The Art of Central Asia* Leningrad, 1988

Johannes Kalter and Margareta Pavaloi (eds) *Heirs to the Silk Road: Uzbekistan* London, 1997

Shakhalil Shayakubov *Modern Miniature Painting of Uzbekistan* Tashkent, 1994

SOUTH ASIA 1900-2000

Balraj Khanna and Aziz Kurtha *Art of Modern India* London, 1998

Marcella Sirhandi *Contemporary Painting in Pakistan* Lahore, 1992

CHINA 1900-2000

Julia F. Andrews *Painters and Politics in the People's Republic of China, 1949–1979* Berkeley, Los Angeles and London, 1994

Michael Sullivan *Art and Artists of Twentieth Century China* Berkeley, Los Angeles and London, 1996

JAPAN AND KOREA 1900-2000

Penelope Mason *History of Japanese Art* New York, 1993

Jane Portal *Korea: Art and Archeology* London, 2000

Ellen Conant *Nihonga, Transcending the Past: Japanese-Style Painting, 1868–1968* New York, 1995

SOUTHEAST ASIA 1900-2000

Fred B. Eiseman *Bali: Sekala and Niskala* Vol. 1 *Essays on Religion, Ritual and Art* Berkeley, 1989

Jacqueline M. Piper *Bamboo and Rattan: Traditional Uses and Beliefs* Oxford, 1992

Sylvia Fraser-Lu *Silverware of South-East Asia* Oxford, 1989

THE PACIFIC 1900-2000

Susan Cochrane *Contemporary Art in Papua New Guinea* Sydney, 1997

Anita Herle, Nick Stanley, Karen Stevenson and Robert L. Welsch (eds) *Pacific Art: Persistence, Change, and Meaning* Honolulu, 2002

Nicholas Thomas *Oceanic Art* London, 1995

Robert L. Welsch (ed.) *An American Anthropologist in Melanesia: A. B. Lewis and the Joseph N. Field South Pacific Expedition, 1909–1913* Honolulu, 1998

AUSTRALIA AND NEW ZEALAND 1900-2000

Sylvia Kleinert and Margo Neale (eds) *The Oxford Companion to Aboriginal Art and Culture* Melbourne, 2000

Francis Pound *The Space Between: Pakeha Use of Maori Motifs in Modernist New Zealand Art* Auckland, 1994

Bernard Smith, with additional chapters by Terry Smith and Christopher Heathcote, *Australian Painting, 1788–2000* 4th edn, Melbourne, 2001

ART INSTITUTIONS WORLDWIDE 2000

Global Conceptualism: Points of Origin, 1950s–1980s exh. cat., Queens Museum of Art, New York, 1999

PICTURE CREDITS AND LOCATIONS

Note on Spellings and Place Names

The names of all the countries, major physical features and regions, and cities (modern or historical) are spelled in accordance with English conventional usage, e.g. Burma, Nile, Anatolia, Carthage, Constantinople.

For all other names the general practice is to show them in terms of the contemporary forms that fit the time-scale of the maps concerned. Thus Latin names in the Classical world, Sanskrit names in the early dynastic states of India, e.g. Nicaea (modern Iznik), Pataliputra (modern Patna). All Chinese names, whether ancient or modern, are spelled in accordance with the now widely accepted Pinyin system. For the early modern period contemporary names may reflect a political administrative situation rather different from today's, e.g. Christiania (now Oslo), Pozsony (now Bratislava), Königsberg (now Kaliningrad).

All names in languages using Roman alphabet are spelled with all the diacritics appropriate to those languages, e.g. Córdoba, Århus, Šibenik, Chișinău. But names derived from transliteration or transcription from non-Roman alphabet languages, e.g. Arabic, Hebrew, Japanese, Korean, Persian, Sanskrit, are spelled without the often unfamiliar diacritics used in the scholarly romanisation of these languages, e.g. Sana (not Ṣanʻāʾ), Sravasti (not Śrāvastī).

INDEX

Figures in roman refer to main text references; figures in **bold** refer to maps; and figures in **extra bold** refer to illustration captions.